Photoshop CC

the missing manual®

The book that should have been in the box®

Lesa Snider

O'REILLY®

Beijing | Cambridge | Farnham | Köln | Sebastopol | Tokyo

Photoshop CC: The Missing Manual

by Lesa Snider

Published by O'Reilly Media, Inc.,
1005 Gravenstein Highway North, Sebastopol, CA 95472.

O'Reilly books may be purchased for educational, business, or sales promotional use. Online editions are also available for most titles (*http://safaribooksonline.com*). For more information, contact our corporate/institutional sales department: (800) 998-9938 or *corporate@oreilly.com*.

June 2013: First Edition.
August 2014: Second Edition.

Revision History for the Second Edition:

2014-08-05 First release
2014-12-19 Second release

See *http://oreilly.com/catalog/errata.csp?isbn=9781491947197* for release details.

ISBN-13: 978-1-491-94719-7

[TI]

Contents

Part Two: Editing Images

Part Three: **The Artistic Side of Photoshop**

Part Four: **Printing and the Web**

Part Six: **Appendixes**

Foreword

I n the short but crowded history of consumer technology, only two products ever became so common, influential, and powerful that their names become *verbs*.

Google is one.

Photoshop is the other.

("Did you Google that guy who asked you out?" "Yeah—he's crazy. He Photoshopped his last girlfriend out of all his pictures!")

It's safe to say that these days, not a single photograph gets published, in print or online, without having been processed in Photoshop first. It's usually perfectly innocent stuff: a little color adjustment, contrast boosting, or cropping.

But not always. Sometimes, the editing actually changes the photo so that it no longer represents the original, and all kinds of ethical questions arise. Remember when *TV Guide* Photoshopped Oprah's head onto Ann-Margaret's body? When *Time* magazine darkened O.J. Simpson's skin to make him look more menacing on the cover? Or when *National Geographic* moved two of the pyramids closer together to improve the composition?

Well, you get the point: Thanks to Photoshop, photography is no longer a reliable record of reality. Photoshop is magic.

And now, all that magic is in your hands. Use it wisely.

Trouble is, Photoshop is a monster. It's *huge*. Just opening it is like watching a slumbering beast heave into consciousness. Dudes, Photoshop has over *500 menu commands.*

In short, installing Photoshop is like being told that you've just won a 747 jumbo jet. You sit down in the cockpit and survey the endless panels of controls and switches. *Now what?*

You don't even get a printed manual.

If there were ever a piece of software that needed the Missing Manual treatment, it was Photoshop.

The beast has been tamed at last by its new master, Lesa Snider: a natural-born Missing Manual author with Photoshop credentials as long as your arm.

She had worked on Missing Manuals, side by side with me in my office, for four years, in all kinds of editorial and production capacities. Today, when she's not writing the bestselling Photoshop book (you're reading it), she's out in the real world, teaching Photoshop seminars, writing Photoshop articles, reviewing Photoshop for magazines, and generally serving as Photoshop guru to the masses.

The Missing Manual mantra runs through her blood: Make it clear, make it entertaining, make it complete (hence the thickness of this book). And above all, don't just identify a feature: Tell us *what it's for*. Tell us when to use it. (And if the answer is, "You'll *never* use it," tell us that, too.)

Now, I'll be the first to admit that this book isn't for everybody. In fact, it's aimed primarily at two kinds of people: people who have never used Photoshop, and people who have.

But seriously, folks. If you're new to Photoshop, you'll find patient, friendly introductions to all those nutty Photoshoppy concepts like layers, color spaces, image resolution, and so on. And, mercifully, you'll find a lot of loving attention to a time-honored Missing Manual specialty—tips and shortcuts. As Photoshop pros can tell you, you pretty much *have* to learn some of Photoshop's shortcuts or it will crush you like a bug.

On the other hand, if you already have some Photoshop experience, you'll appreciate this book's coverage of Photoshop CC 2014's new features: Focus Area, perspective warp, new blur filters, new font features, smarter smart guides, 3D printing, and so on.

In 2013, Adobe announced that from now on, you must *rent* Photoshop, monthly or yearly. You can no longer buy it outright. One of the motivations, Adobe said, was a desire to create an ever-changing, ever-improving Photoshop. There wouldn't be one megalithic new version every couple of years. Instead, little enhancements would come along all year long, added as soon as they were ready.

So what are we to make of this "Photoshop CC 2014" thing? Are we back to yearly megalithic releases? Has Adobe abandoned its Photoshop Forever concept?

Yes and no. The company still plans to update Photoshop all year long. But it also plans to create the periodic "milestone" edition of Photoshop, a breather, a catch-up

version that rolls in all the little changes (and a few more) since the last one. In part, this idea is a crumb thrown to people who write (and buy) books about Photoshop; nobody would be served well if Photoshop were a shape-shifting target forever.

In any case, get psyched. You now have both the most famous, powerful, magical piece of software on earth *and* a 900+-page treasure map to help you find your way.

The only missing ingredients are time, some photos to work on, and a little good taste. You'll have to supply those yourself.

Good luck!

—*David Pogue*

David Pogue is the founder and anchor columnist for YahooTech.com, having been groomed for the position by 13 years as the tech columnist for the New York Times. *He's an Emmy-winning TV correspondent (CBS News and NOVA on PBS), a* Scientific American *columnist, and the creator of the Missing Manual series.*

The Missing Credits

ABOUT THE AUTHOR

 Lesa Snider is on a mission to teach the world to create—and use!—better graphics. She's an internationally acclaimed speaker, a stock photographer, and the founder of the creative tutorial site PhotoLesa.com. Lesa is the author of The Skinny Book series of ebooks (*www.theskinnybooks.com*) many video-training workshops (*www.lesa.in/lesacl*) and the coauthor of *iPhoto: The Missing Manual*. She writes a regular column for *Photoshop User, Photographic Elements Techniques,* and *Macworld* magazines. Lesa is also a long-time member of the Photoshop World Dream Team of instructors and can be spotted teaching at many other conferences around the globe. You can connect with her online on Facebook (*www.facebook.com/PhotoLesa*), YouTube (*www.lesa.in/ytvideochannel*), Twitter (@PhotoLesa), and PhotoLesa.com.

During her free time, you'll find Lesa at the dojo practicing Muay Thai kickboxing, with her husband at a sci-fi convention dressed up in her *Star Trek* best, or cooking Italian meals. Email: *lesa@photolesa.com*.

ABOUT THE CREATIVE TEAM

Dawn Schanafelt (editor) is associate editor for the Missing Manual series. When not working, she plays soccer, makes beaded jewelry, and causes trouble. Email: *dawn@oreilly.com*.

Melanie Yarbrough (production editor) works and plays in Cambridge, Massachusetts, where she enjoys baking as much as possible and biking around the city. Email: *myarbrough@oreilly.com*.

Nan Reinhardt (proofreader) is not only a freelance copyeditor and proofreader, but she is also a multi-published romance novelist. Nan and her husband divide their time between a city home and a lake cottage (both in the Midwest), where they enjoy swimming, boating, and fishing. Email: *nan@nanreinhardt.com*.

Ron Strauss (indexer) specializes in the indexing of information technology publications of all kinds. Ron is also an accomplished classical violist and lives in Northern California with his wife and fellow indexer, Annie, and his miniature pinscher, Kanga. Email: *rstrauss@mchsi.com*.

Shangara Singh (technical reviewer) is the author of the popular exam aids for Photoshop and Lightroom—study guides for people who want to become an Adobe Certified Expert, or an Adobe Certified Associate—published by Examaids.com. He

has also authored a keyword hierarchy for stock photographers (Keyword-Catalog.com), and has his own stock photo website, SensaStockImages.com (*http://SensaStockImages.com*).

ACKNOWLEDGEMENTS

This book is dedicated to my husband, Jay Nelson, for making everyday life incredibly fun and for learning to appreciate heavy metal music, namely Ozzy Osbourne. 😃

I'd like to express galactic thanks to iStockphoto.com and Fotolia.com for providing some of the imagery in this book. A big hug and thanks to David Pogue who so graciously wrote the foreword for this book. To Jeff and Scott Kelby for believing in me and nurturing my career in immeasurable ways. To Derrick Story for his wisdom before I got started on this project, and a great big jug of Umbrian vino rosso to Dawn Schanafelt for editing this book and keeping me on track. Her input makes me a better writer and I'm lucky to have her on our team. To my brilliant and long-time tech editor, Shangara Singh, whose expertise has helped create the best Photoshop book yet and whose humorous comments always make me giggle.

Special thanks to Marcus Conge (*www.digitalmanipulation.com*) and Jay Nelson for helping with the 3D chapter, to Rod Harlan for consulting on video editing, to Richard Harrington (*www.photoshopforvideo.com*) for helping with actions, to Taz Tally (*www.taztallyphotography.com*) for helping with the print chapter, as well as Bert Monroy (*www.bertmonroy.com*) and Veronica Hanley for guidance on all things vector-related. To Deborah Fox (*www.deborahfoxart.com*) for the beautiful art in the painting chapter, to Tanya and Richard Horie for their expert advice on the painting chapter and brush customization options (as well as creating my logo), to Karen Nace Willmore (*www.karennace.com*) for her HDR and wide-angle photography, and to Jeff Gamet (*www.macobserver.com*) for keeping me sane and helping with the first edition of this book.

To my esteemed colleagues—and good friends—Jack Davis, Ben Willmore, Eddie Tapp, Judy Host, Peter Cohen, Gary-Paul Prince, Larry Becker, Kevin Ames, Terry White, Dave Moser, and Andy Ihnatko, who all expressed their pride and confidence in me. I'd also like to thank our creativeLIVE.com family for promoting this book, as well as LensProToGo.com for supplying me with incredible Canon gear to shoot with (if you need to rent camera gear, they're the best!).

Last but not least, buckets of appreciation to my friends who gave their support—or a cocktail!—when I needed it most: Master Vu Tran, Bob and Elsbeth Diehl, Kathryn Kroll, Leslie Fishlock, and most importantly, Fran Snider, the best mama a girl could have (wish Daddy could've held this book!). To our beautiful kitties, Samantha and Sherlock, who forced me to get out of my pretty purple Aeron chair and play The Laser Pointer Game with them at exactly 5:15 pm each day.

May the creative force be with you all!

—*Lesa Snider*

Introduction

Congratulations on buying one of the most complicated pieces of software ever created! Fortunately, it's also one of the most *rewarding*. No other program on the market lets you massage, beautify, and transform images like Photoshop. It's so popular that people use its name as a verb: "Dude, you Photoshopped the *heck* out of him!" You'd be hard-pressed to find a published image that *hasn't* spent some quality time in this program, and those that didn't probably should have.

The bad news is that it's a tough program to learn; you won't become a Photoshop guru overnight. Luckily, you hold in your hot little hands a book that covers the program from a *practical* standpoint, so you'll learn the kinds of techniques you can use every day. It's written in plain English for normal people, so you don't have to be any kind of expert to understand it. You'll also learn just enough theory (where appropriate) to help you understand *why* you're doing what you're doing.

> **NOTE** Prior to Photoshop CC, Adobe offered *two* versions of the program: Photoshop Standard and Photoshop Extended, which included extra features such as 3D tools. But they *combined* those two versions into Photoshop CC, so you get all the features.

What's New in Photoshop CC 2014

Adobe has added some incredibly useful new features to Photoshop CC 2014, especially where productivity is concerned. Graphic designers will be especially pleased with all the new features and timesaving goodies, although there's also a lot of good stuff for photographers, too.

Perhaps the first thing you'll notice is that Adobe redesigned most of the program's dialog boxes to accommodate Retina displays (Apple's super-high resolution monitors, called HiDPI on PCs), so they're noticeably shorter and wider (they're also a darker gray and the buttons are *square*, so they look more Windows-like than Mac-like in their design).

Here's a quick overview of all the new stuff (don't worry if you don't yet understand some of the terms used here—you'll learn them as you read through this book):

- **New blur filters.** This version of Photoshop CC sports two additions to the Blur Gallery family of filters that let you simulate motion in a photo that doesn't have any (or that doesn't have enough). The Path Blur filter lets you create the appearance of motion along a path that you draw—it can be straight or riddled with curves—and then fine-tune the blur's direction, angle, speed, and even how *much* blurring occurs at the path's start and end points. And the Spin Blur filter lets you put an incredibly realistic spin on any object by using a simple set of on-image controls. Both filters let you customize how blurry the object appears.

- **Typekit access, font searches, and instant font previews.** One of the great benefits of having a subscription to Adobe's Creative Cloud service (see the box on page xxvii) that it gives you access to hundreds of fonts via the online font service Typekit (*www.Typekit.com*). In this version of the program, you can get to these fonts right from Photoshop's font family menu and—once you install them (which is incredibly easy)—you can use them in *any* program on your machine that sports a font menu. Also new in the realm of text is the ability to search all your installed fonts by typing part of a font's name (or attribute) into the font family menu. And when a type layer is active, you can point to any font in the font family menu and Photoshop previews your existing text in that font, right there in your document.

- **Better smart guides.** These incredible layer alignment helpers are now turned on automatically, and now show you a *lot* more info about the spacing in your document. When you have the Move or Path Selection tool active, you can ⌘-click (Ctrl-click on a PC), and then point anywhere in your document to see distance measurements between the currently active layer's content and everything else in the document (even its edge). By Option-dragging (Alt-dragging) an object, you can both duplicate that layer and see the distance between the duplicate and the original object *as you drag*.

- **Sync layer comps and access them in smart objects.** Layer comps let you create multiple versions of an image or design without having to duplicate the document. New in this version of the program, you can update layer comps by syncing them with the layers you updated (a big timesaver when you make a global change to your project), plus you can access a document's layer comps after you've placed it into *another* document as a smart object—*without* opening (editing) the smart object.

- **Linked smart objects.** Instead of embedding smart object content into your documents, you can now *link* then to external content. This is great news for both designers and photographers who routinely combine large files into a single document. You can now also convert an embedded smart object into a linked one, or vice-versa. The Properties panel, Info panel, and status bar can all display handy info about linked smart objects, as well as help you fix any broken links (caused by renaming or moving the linked file on your hard drive) and update any content that you changed while the Photoshop document that contains it was closed. Finally, the new Package command copies the Photoshop document *and* all its linked content so you can easily hand the whole shebang off to someone else.

- **Select in-focus areas with Focus Area.** This new command summons a dialog box that *automatically* selects the in-focus parts of an image. It does a great job if the photo has a strong focal point and a blurry background, and the dialog box includes a couple of sliders and brushes that you can use to fine-tune the selection. You can also send the selection straight over to the Refine Edge dialog box for more tweaking.

- **Better color blending with content-aware tools.** All of Photoshop's content-aware tools now work faster and do a better job of blending colors, especially when you use them in an area that's a gradient (think skies, water, and so on). These days, instead of having adaptation *presets* for the Patch and Content-Aware Move tools, you get a Structure and a Color field that let you enter precise settings for more realistic blending. Adobe also updated the Fill command's Content-Aware option to perform better blending, and it now includes a Color Adaptation checkbox.

- **Editable scripted patterns.** Scripted patterns are a fantastic way to create new textures and backgrounds, although editing the JavaScript that powers 'em was a real pain. Now, choosing one of the eight built-in scripts summons a dialog box that lets you easily customize the pattern's density, size, and color variations. You can apply scripted patterns to paths, too, as well as save your customizations as handy presets that you can use again later.

- **Perspective warp.** This command lets you change the perspective of an image, but only in *certain areas* that you specify. By drawing a grid atop your image, you can warp that area to make stuff like buildings and flat surfaces look *correct* (in other words, straight instead of angled).

- **Editable masks for Camera Raw's Graduated and Radial filters.** Camera Raw's Graduated and Radial filters are perfect for applying gradual changes to a photo in a linear or circular fashion (respectively). And you can now edit the masks made by both filters by using a brush. (Camera Raw is discussed throughout this book, but the bulk of the coverage is in Chapter 9.)

- **Export web graphics with Generator.** To the delight of web designers world-wide, the new Generator feature lets you *instantly* export web graphics that you've designed in Photoshop—and even create subfolders to organize them—just by using certain layer names. You've got to try this feature to believe it.

- **3D printing.** You can now print 3D objects on a local 3D printer or send your file off to a 3D-printing service from *inside* Photoshop. The print preview that you get is incredible and even shows you the areas Photoshop filled in to make the object solid enough to print. If you go the printing-service route, the preview even estimates how much the project will cost. Chapter 21 helps you get started working in the increasingly popular realm of 3D.

There are also *tons* of little changes in Photoshop CC 2014, the direct result of Adobe's customer-feedback initiative called Just Do It (JDI). Here's a list: You can unlock a background layer by single-clicking its padlock icon (hooray!); you can turn the Color panel into a Color Picker that's *always* open; you no longer have to unlock a background layer to add a vector-based layer mask to it; you can create gradients with a single color stop; and the process for syncing your settings to the Creative Cloud is simpler and now includes workspaces, keyboard shortcuts, and menu customizations. You can also export 3D color lookup tables for use in Adobe's pro-level video editing apps; and the Copy CSS command now understands inner-shadow layer styles. When using the Liquify filter, you can pin the image's edges down so they don't get warped. The Brushes panel displays the last 30 brushes you used at the top of its panel for quick access, and uses a special highlight color to let you know when you've modified a brush's settings. There's also an Experimental Feature Manager tucked inside Photoshop's preferences that lets you access "not yet ready for prime time" features that Adobe periodically releases.

Unfortunately, Adobe removed some useful panels because they were Flash based, including the Mini Bridge, Kuler, and Adobe Exchange panels (though, as page 521 explains, you can download Kuler from the Adobe Add-On website as an HTML-based panel). The Oil Paint filter also went the way of the dodo bird in this version due to outdated code (easy come, easy go!).

Meet the Creative Cloud

Dude, what the heck happened to Photoshop CS7? What on earth does "CC" mean?

Great question. After CS6, Adobe decided to stop shipping boxed, perpetually licensed versions of their products. These days, your only option is to subscribe to—and then download—the software.

Using a service called the Adobe Creative Cloud, you can subscribe on an annual or monthly basis to one or all of Adobe's products. For example, a single-app Creative Cloud subscription for Photoshop CC costs about $20 a month and gives you access to both Mac and PC versions of the program that you can install on up to two machines (say, a desktop and laptop). If you use two or more Adobe programs (say, Photoshop and InDesign), it's cheaper to subscribe to *all* of their products for about $50 a month which, as of this writing, includes 24 programs and services (both Mac and PC versions)—including access to Adobe Typekit and the ability to share your projects via Behance (see the box on page 803). That said, Adobe offers a special subscription geared toward photographers wherein you get Photoshop *and* Photoshop Lightroom for a slick $10 per month (visit *www.lesa.in/pslrfor10* for details). These prices may change, of course, so check with Adobe for current pricing.

Whichever option you choose, you simply subscribe, and then download the software to your machine using the Creative Cloud application. After that, your Adobe software phones home once a month via the Internet to validate your account; if Adobe can't validate your account, your software stops working (along with your fonts). In other words, if you don't pay, you don't get to use the software (though there is a 30-day grace period if, for whatever reason, your computer can't connect to the Internet).

Once you're a Creative Cloud subscriber, you get 20 GB of storage space, which you can use to host websites and sync documents between computers and tablets (think iPads), and to back up documents or share them with others (regardless

of whether those folks have Creative Cloud subscriptions). You also get the ability to sync custom settings to the Cloud so they're accessible on other machines: When you subscribe to the Creative Cloud and then install Photoshop, your Adobe ID appears in the Photoshop menu (the Edit menu on a PC) with a submenu that contains Upload Settings and Download Settings commands.

You can also sync documents to the Creative Cloud so you can access 'em on other computers (home and work, say). For example, you can designate a folder on your hard drive, and then any items you put into it automatically sync to the Creative Cloud. Subscribers also get their hands on new features as soon as Adobe rolls 'em out; the Creative Cloud app notifies you of the update and you can install it whenever you want. With larger updates, such as the Photoshop CC 2014 update, you install a whole new copy of the program. If you don't need the older version, just delete it from your machine folder to reclaim some hard drive space. However, if your workflow depends on a feature that was changed or removed, you may want to keep it around. (To learn the current version number of your copy of Photoshop CC, choose Help→System Info.)

Adobe will continue to sell and support Photoshop CS6 for a while; but that's the last licensed copy you'll ever get (and there's nothing wrong with keeping it on your machine if you already own it—in fact, it's a good idea). Like it or not, we're now in the era of rental software. (To get the most from your Creative Cloud subscription, check out your author's ebook, *Making the Most of Adobe's Creative Cloud* at *www.theskinnybooks.com*.)

If you're in North America or the United Kingdom, you can purchase a Creative Cloud subscription through Adobe.com, Amazon.com, or Staples.com. Folks in other countries should go through Adobe.com.

And that, dear friends, is why the program is now called Photoshop Creative Cloud, a.k.a. Photoshop CC 2014.

◼ About This Book

Adobe has pulled together an amazing amount of information in its online help system (see online Appendix B, available from this book's Missing CD page at *www.missingmanuals.com/cds*), but despite all these efforts, it's geared toward seasoned Photoshop jockeys and assumes a level of skill that you may not have. The explanations are very clipped and to the point, which makes it difficult to get a real feel for the tool or technique you need help with.

That's where this book comes in. It's intended to make learning Photoshop CC tolerable—and even enjoyable—by avoiding technical jargon as much as possible and explaining *why* and *when* to use (or avoid) certain features of the program. This friendly, conversational approach is meant to appeal to beginners and seasoned pixel pushers alike.

Some of the tutorials in this book refer to files you can download from this book's Missing CD page on the Missing Manuals website (*www.missingmanuals.com/cds*) so you can practice the techniques you're reading about. And throughout the book, you'll find several kinds of sidebar articles. The ones labeled "Up to Speed" help newcomers to Photoshop do things or understand concepts that veterans are probably already familiar with. Those labeled "Power Users' Clinic" cover more advanced topics for the brave of heart.

NOTE Photoshop CC functions almost identically on Mac and Windows computers, but for the sake of consistency, the screenshots in this book were all taken on a Mac. However, the keyboard shortcuts for the two operating systems are different, so you'll find both included here—Mac shortcuts first, followed by Windows shortcuts in parentheses, like so: "press ⌘-A (Ctrl+A)." The locations of a few folders differ, too; in those cases, you get the directions for both operating systems.

About the Outline

This hefty book is divided into six parts, each devoted to the type of things you'll do in Photoshop CC:

- **Part One: The Basics.** Here's where you'll learn the essential skills you need to know before moving forward. Chapter 1 gives you the lay of the land and teaches you how to work with panels and make the Photoshop workspace your own. You'll also find out the many ways of undoing what you've done, which is crucial when you're learning. Chapter 2 covers how to open and view documents efficiently, and how to set up new documents so you have a solid foundation on which to build your masterpieces.

 Chapter 3 dives into the most powerful Photoshop feature of all: layers. You'll learn about the different kinds of layers and how to manage them, the power of layer masks, and how to use layer styles for special effects. Chapter 4 explains how to select part of an image so you can edit just that area. In Chapter 5, you'll dive headfirst into the science of color as you explore channels (which store

the colors that make up your images) and learn how to use channels to create selections; you'll also pick up some channel-specific editing tips along the way.

NOTE In this book, the word "select" is used *only* to refer to the act of creating *selections*. In most other instances, the word "activate" is used instead, as in "activate the layer" or "activate the Crop tool."

- **Part Two: Editing Images.** Chapter 6 starts off by explaining the various ways you can crop images—both in Photoshop and in Camera Raw—and then demystifies resolution so you'll understand how to resize images without reducing their quality. In Chapter 7, you'll learn how to combine images in a variety of ways, from simple techniques to more complex ones. Chapter 8 covers draining, changing, and adding color, arming you with several techniques for creating gorgeous black-and-white images, delicious duotones, partial-color effects, and more. You'll also learn how to change the color of almost anything.

 Chapter 9 focuses on color-correcting images, beginning with auto fixer-uppers, and then moving on to the wonderfully simple (yet powerful) world of Camera Raw and the more complicated realm of Levels and Curves. Chapter 10 is all about retouching images to change reality and is packed with practical techniques for slimming and trimming. This chapter also covers using the various content-aware tools to remove objects or scoot them from one spot to another, as well as how to use the Puppet Warp command to move just your subject's arms and legs. Chapter 11 explains what sharpening really is, and covers *which* sharpening method to use *when* to make your images look especially crisp.

UP TO SPEED

What Does "64-bit" Mean?

The cool phrase in computing circles for the past few years has been "64-bit." While that term may sound pretty geeky, it's actually not that intimidating: 64-bit programs (a.k.a. "applications" or "apps") simply know how to count higher than 32-bit programs.

So what does that mean in practice? 32-bit programs can open and work with files that are up to 4 gigabytes in size—which is huge. But 64-bit programs can open files that are *way* bigger than that, as long as your computer's operating system can handle 64-bit apps. (Mac OS X 10.5 [Leopard] and Microsoft Windows Vista [the 64-bit version, anyway] and later are up to the task.)

64-bit programs can also make use of more memory than their 32-bit counterparts, which is crucial when you're working with big honkin' files. For example, the 64-bit version of Photoshop lets you use more than 4 gigs of RAM, which makes it run faster. (You can change how your machine's memory is allotted by tweaking Photoshop's preferences as described on pages xx–xx.)

Older versions of Photoshop were available in both 32-bit and 64-bit versions, but Photoshop CC is available *only* in 64-bit (even on Windows computers), which is great news if you work with large files. And since most third-party plug-ins (Chapter 19) and filters (Chapter 15) now work in 64-bit mode, there's little reason to cast a single glance backward. That said, you can still share Photoshop files with both Mac and PC folks, just like you always have.

- **Part Three: The Artistic Side of Photoshop.** This part of the book is all about creativity. Chapter 12 explains the many ways of choosing colors, and teaches you how to create a painting from scratch. Chapter 13 focuses on using the mighty Pen tool to create complex illustrations and selections, along with how to use Photoshop's various shape tools. Chapter 14 teaches you the basics of typography, and then moves on to creating and formatting text in Photoshop. You'll find out how to outline, texturize, and place photos inside text, among other fun-yet-practical techniques. Chapter 15 covers the wide world of filters, including how to use smart filters; you'll come away with at *least* one practical use for one or more of the filters in every category.

- **Part Four: Printing and the Web.** In Chapter 16, you'll learn about printing images, beginning with an explanation of why it's so darn hard to make what comes out of your printer match what you see onscreen. You'll discover the programs different color modes and find out how to prepare images for printing, whether you're using an inkjet printer or a commercial printing press. Chapter 17 focuses on preparing images for the Web, walks you through the various file formats you can use, explains how to protect your images online, and explains how to export web graphics using Generator. Rounding out the chapter is info on using the Slice tool on a web page design, and step-by-step instructions for creating animated GIFs.

- **Part Five: Photoshop Power.** This part is all about working smarter and faster. Chapter 18 covers actions (which help you automate tasks you perform regularly), and explains how to create gorgeous watermarks. Chapter 19 covers installing and using plug-ins (small programs you can add to Photoshop), and recommends some of the best. Chapter 20 teaches you how to edit videos in Photoshop and create stunning video portfolios, Chapter 21 gets you started creating and working with 3D objects and text, and Chapter 22 explains how to use Adobe Bridge for some slick organization and batch-processing tricks.

- **Part Six: Appendixes.** Appendix A covers installing (and uninstalling) Photoshop. Appendix B offers some troubleshooting tips, explains Photoshop's help system, and points you to resources besides than this book. Appendix C gives you a tour of the mighty Tools panel. And Appendix D walks you through Photoshop CC's 200+ menu items. All the appendixes are available from this book's Missing CD page at *www.missingmanuals.com/cds*.

For Photographers

If you're relatively new to digital-image editing or you've always shot film and are taking your first brave steps into the world of digital cameras, you'll be amazed at what you can do in Photoshop, but it can also be a bit overwhelming. By breaking Photoshop down into digestible chunks that are most important to *you*, the learning process will feel less daunting. (There's no sense in tackling the whole program when you'll only use a quarter of it—if that much.)

The most important thing to remember is to be patient and try not to get frustrated. With time and practice, you *can* master the bits of Photoshop that you need to do your job better. And with the help of this book, you'll conquer everything faster than you might think. As you gain confidence, you can start branching out into other parts of the program to broaden your skills.

Here's a suggested roadmap for quickly learning the most useful aspects of the program:

1. **Read all of Chapters 1 and 2 (or at the very least skim them).**

 These two chapters show you where to find all of Photoshop's tools and features, and explain how the program is organized. You'll learn how to open, view, and save images, which is vital stuff to know.

2. **If your photos aren't on your computer already—*and* you don't use Photoshop Lightroom—read Chapter 22 about Adobe Bridge.**

 Bridge is an amazingly powerful image organizer and browser that can help get your images onto your computer. It takes care of importing, renaming, and even backing up your precious photos. That said, if you use Lightroom, you can skip the Bridge chapter.

3. **If you shoot in raw format (see the box on page 391) and need to color-correct your images in a hurry, read the section in Chapter 9 on editing in Camera Raw (page 385).**

 That chapter includes a whole section on practical editing techniques you can use in Camera Raw, and a quick reference that points you to where you'll find other Camera-Raw techniques throughout this book.

4. **If you *don't* shoot in raw and you need to resize your images before editing them, read Chapter 6.**

 That chapter explains resolution and how to resize images without reducing their quality.

5. **Proceed with Chapters 8, 9, and 10 to learn about color effects, correcting color and lighting, and all manner of retouching (retouching portraits, moving and removing objects, and so on), respectively.**

6. **When you're ready to sharpen your images, read Chapter 11.**

7. **Finally, when you want to print your photos, read the section on printing with an inkjet printer in Chapter 16 (page 731).**

 The chapter walks you through the printing process.

That's all you need to get started. When you're ready to dive further into Photoshop, pick back up at Chapter 3, which covers layers, and then move on through the book as time permits.

The Very Basics

This book assumes that you know how to use a computer and that, to some extent, you're an expert double-clicker and menu opener. If not, here's a quick refresher:

To *click* means to move the point of your cursor over an object onscreen, and then press the left mouse or trackpad button once. To *drag* means to click an object and then, while still holding down the mouse button, move the mouse to move the object. To *double-click* means to press the left button twice, quickly, without moving the cursor between clicks. To *right-click* means to press the right mouse button once, which produces a menu of special features called a *shortcut menu* (a.k.a. *contextual menu*). If you're on a Mac and have a mouse with only one button, you can simulate right-clicking by holding down the Control key while you click.

Most onscreen controls are pretty obvious, but you may not be familiar with *radio buttons*: To choose an option, you click one of these little empty circles that are arranged in a list.

You'll find tons of keyboard shortcuts throughout this book, and they're huge time-savers. If you see a sentence like, "Press ⌘-S (Ctrl+S) to save your file," that means to hold down the ⌘ key (or Ctrl key, if you're using a PC), and then press the S key, too; then let go of both keys. (This book lists Mac keyboard shortcuts first, followed by Windows shortcuts in parentheses.) Other keyboard shortcuts are so complex that you'll need to use multiple fingers, both hands, and a well-placed elbow. And sometimes you'll combine keystrokes with clicking. For example, to ⌘-click (Ctrl-click on a PC) means to press and hold the ⌘ (or Ctrl) key and then, while still pressing the key, click your left mouse button.

If you're comfortable with basic concepts like these, you're ready to get started with this book.

About→These→Arrows

In this book (and in all Missing Manuals, for that matter), you'll see arrows sprinkled throughout each chapter in sentences like this: "Choose Filter→Blur Gallery→Tilt-Shift." This is a shorthand way of helping you find files, folders, and menu items without having to read through painfully long, boring instructions. For example, the sentence quoted above is a short way of saying this: "At the top of the Photoshop window, locate the Filter menu. Click it and, in the list that appears, look for the Blur Gallery category. Point your cursor at the words "Blur Gallery" (without clicking) and, in the resulting submenu, click Tilt-Shift" (see Figure I-1).

FIGURE I-1

Choosing Filter→Blur Gallery→Tilt-Shift takes you to the menu item shown here.

▇ About the Online Resources

As the owner of a Missing Manual, you've got more than just a book to read. Online, you'll find example files so you can get some hands-on experience. You can also communicate with the Missing Manual team and tell us what you love (or hate) about the book. Head over to *www.missingmanuals.com*, or go directly to one of the following sections.

Missing CD

This book doesn't have a CD pasted inside the back cover, but you're not missing out on anything. Go to *www.missingmanuals.com/cds* to download sample files and the book's appendixes. And so you don't wear down your fingers typing long web addresses, the Missing CD page also offers clickable links to all the websites mentioned in this book.

Registration

If you register this book at oreilly.com, you'll be eligible for special offers—like discounts on future editions. Registering takes only a few clicks. To get started, head to *http://oreilly.com/register*.

Feedback

Got questions? Need more information? Fancy yourself a book reviewer? On our Feedback page, you can get answers to questions that come to you while reading and share your thoughts on this Missing Manual. To have your say, go to *www.missingmanuals.com/feedback*.

Errata

In an effort to keep this book as up-to-date and accurate as possible, each time we print more copies, we'll make any confirmed corrections you've suggested. We also note such changes on the book's website, so you can mark important corrections into your own copy of the book, if you like. Go to *http://tinyurl.com/psccmm2e* to report an error or view existing corrections.

Safari® Books Online

Safari® Books Online is an on-demand digital library that lets you easily search over 7,500 technology and creative reference books and videos to find the answers you need quickly.

With a subscription, you can read any page and watch any video from our library online. Read books on your cellphone and mobile devices. Access new titles before they're available for print, and get exclusive access to manuscripts in development and post feedback for the authors. Copy and paste code samples, organize your favorites, download chapters, bookmark key sections, create notes, print out pages, and benefit from tons of other timesaving features.

The Basics

Photoshop CC Guided Tour

Photoshop CC is bursting with fabulous features that'll help you edit and create your very own digital masterpieces. If this is your first foray into the world of Photoshop, all these features will be new to you. If you're an experienced pixel pusher, there are some surprises waiting for you, too. If you're upgrading from Photoshop CS5 or earlier, Adobe introduced *major* changes to the work environment back in CS6—like a brand-new color theme—and while these changes make Photoshop easier to use, they take some getting used to.

This chapter gives you a solid foundation on which to build your Photoshop skills. You'll learn how to work with the Application Frame, and how to wrangle document windows and panels. Once you've gotten them placed just right, you'll learn how to save your setup as a custom workspace. If you're a beginner, the section on using Undo commands and history states will teach you how to fix mistakes and back out of almost *anything* you've done. Finally, you'll learn how to fine-tune Photoshop's behavior through preferences and built-in tools (called *presets*) that let you personalize your experience even more. Let's dive in!

■ Meet the Application Frame

When you launch Photoshop CC for the first time, you're greeted by the *Application Frame* shown in Figure 1-1. This frame confines all things Photoshop to a single resizable, movable window. You can grab the whole mess—documents, panels, and all—and drag it to one side of your screen (or better yet, to another monitor) so it's out of the way. And if you open more than one document, they're displayed in handy tabs that you can rearrange by dragging.

Chances are, you'll either love the Application Frame or hate it. If you're on a computer running Windows, you're used to programs looking and behaving this way. But if you're on a Mac and you're coming from an older version of Photoshop (like CS3), this arrangement may feel odd; in that case, you can turn off the frame by choosing Window→Application Frame to make Photoshop switch to the floating-window view used in older versions of the program. (PC folks are stuck with the frame.)

> **NOTE** In Photoshop CC, you'll spot a special button at the bottom of each document window that looks like a rectangle with a curved arrow inside it. Clicking it uploads the current document to Adobe's portfolio-sharing community site *Behance*—a great way to get critical feedback on projects. To learn more about Behance, see the box on page 803 and check out your author's ebook "The Skinny on Behance" at *www.theskinnybooks.com*.

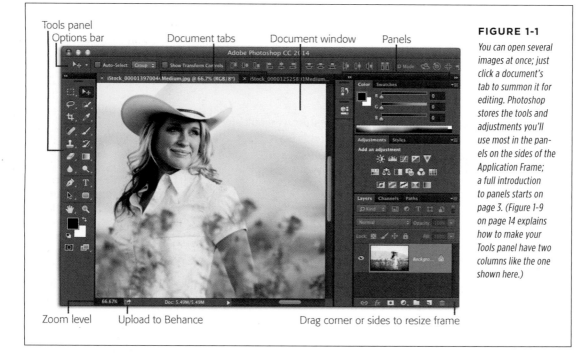

Tools panel
Options bar
Document tabs
Document window
Panels

Zoom level
Upload to Behance
Drag corner or sides to resize frame

FIGURE 1-1

You can open several images at once; just click a document's tab to summon it for editing. Photoshop stores the tools and adjustments you'll use most in the panels on the sides of the Application Frame; a full introduction to panels starts on page 3. (Figure 1-9 on page 14 explains how to make your Tools panel have two columns like the one shown here.)

> **NOTE** Adobe reduced clutter back in Photoshop CS6 by removing the Application bar, which used to house extras like guides, grids, and rulers, as well as several menus. As you learn in the next few pages, those items are now sprinkled throughout the Tools panel, the View menu, and the Window menu.
>
> Also, if you use Photoshop *alongside* other programs, the box on page 8 explains how to get Photoshop out of the way *without* quitting it.

The Almighty Options Bar

Lording over the document window is the Options bar (Figure 1-2, top), which lets you customize the behavior of nearly every item in the Tools panel. This bar automatically

changes to include settings related to the tool you're currently using. The Options bar also includes the workspace menu, which lets you change the way your Photoshop environment is set up (you learn about workspaces on page 12).

Unfortunately, the Options bar's labels are fairly cryptic, so it can be hard to figure out what the heck all those settings do. Luckily, you can point your cursor at any setting to see a little yellow pop-up description called a *tooltip* (you don't need to click—just don't move your mouse for a couple seconds).

TIP If the tooltips drive you crazy, you can hide 'em by choosing Photoshop→Preferences→Interface (Edit→Preferences→Interface on a PC) and turning off Show Tool Tips.

When you first install Photoshop, the Options bar is perched at the top of your screen, but it doesn't have to stay there. If you'd rather put it somewhere else, grab its left end and drag it wherever you want, as shown in Figure 1-2, middle. If you decide to put it back later (also called *docking*), just drag it to the top of the screen and, when you see a thin blue line appear (Figure 1-2, bottom), release your mouse button.

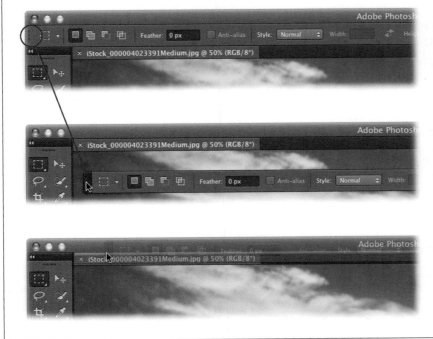

FIGURE 1-2

Top: The Options bar is customization central for whatever tool you're currently using. But it doesn't have to live at the top of the screen; you can undock it by dragging the tiny dotted lines circled here.

Middle: Once you've freed the Options bar, you can drag it anywhere you want by grabbing the dark gray bar on its far left.

Bottom: To redock the Options bar, drag it to the top of your screen. Once you see a thin blue line like the one visible here, release your mouse button.

TIP If a tool seems to be misbehaving, it's likely because you changed one of the Options bar's settings and forgot to change it back. These settings are *sticky:* Once you change them, they *stay* that way until you change them back. Figure 1-17 on page 32 explains how to reset a tool to its factory-fresh settings.

NOTE Adobe recently added the ability to *shrink* the Options bar to a narrower version, which is handy if you've got a small screen. Skip to page 8 for the scoop.

Swapping Screen Modes

Photoshop includes three different *screen modes* for your document-viewing plea-sure. Depending on what you're doing, one will suit you better than the others. For example, you can make an image take up your whole screen (with or without the menus and Options bar), hide Photoshop's panels, and so on (see Figure 1-3). To give each mode a spin, you first need to open an image: Choose File→Open, navigate to where an image lives, and then click Open.

TIP You can free up precious screen real estate by pressing the Tab key to hide the Options bar and panels (pressing Shift-Tab hides all the panels *except* the Tools panel). This trick is a great way to get rid of distractions when you're editing images, especially if you have a small monitor. To bring the panels back, press Tab again or mouse over to the edge of the Photoshop window where the panels *should* be; when you move your cursor away from the panels, they'll disappear again.

It's a snap to jump between modes. Just press the F key repeatedly—unless you're in the middle of cropping an image or using the Type tool (if you are, you'll type a bunch of Fs)—or use the Screen Modes menu at the bottom of the Tools panel (circled in Figure 1-3, top). These are your choices:

- **Standard Screen Mode** is the view you see when you launch Photoshop for the first time. This mode includes menus, the Application Frame, the Options bar, panels, and document windows. Use this mode when the Application Frame is active and you need to scoot the whole of Photoshop—windows and all—around on your monitor (except for undocked panels or free-floating windows).

- **Full Screen Mode With Menu Bar** completely takes over your screen, puts your document in the center on a dark gray canvas or frame, and attaches any open panels to the left and right edges of your screen. This mode is great for day-to-day editing because you can see all of Photoshop's tools and menus without being distracted by the files and folders on your desktop. The dark gray background is also easy on the eyes and a great choice when color-correcting images (a brightly colored desktop can affect your color perception).

TIP You can change Photoshop's canvas color anytime by Control-clicking (right-clicking on a PC) the canvas itself. From the shortcut menu that appears, choose from Default (the dark, charcoal gray you see now), Black, Dark Gray, Medium Gray, or Light Gray. If none of those colors float your boat, you can pick your own by choosing Select Custom Color to open the Color Picker, which is explained on page 522.

- **Full Screen Mode** hides all of Photoshop's menus and panels, centers the document on your screen, and puts it on a black background. (If you've got rulers turned on, they'll still appear, though you can turn 'em off by pressing ⌘-R [Ctrl+R].) This mode is *great* for displaying and evaluating your work or for

distraction-free editing. And the black background really makes images pop off the screen (though the next section shows you how to change it to another color).

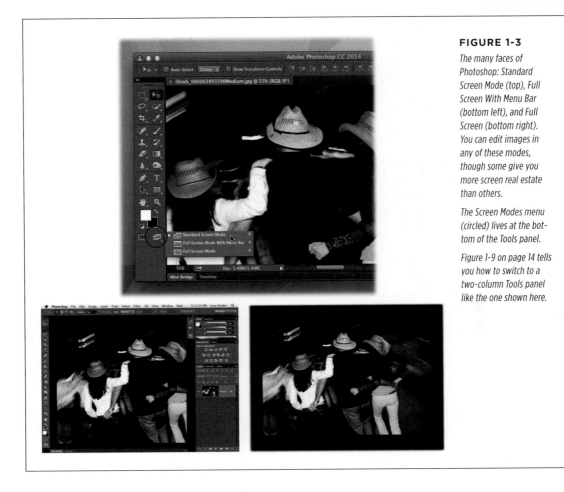

FIGURE 1-3

The many faces of Photoshop: Standard Screen Mode (top), Full Screen With Menu Bar (bottom left), and Full Screen (bottom right). You can edit images in any of these modes, though some give you more screen real estate than others.

The Screen Modes menu (circled) lives at the bottom of the Tools panel.

Figure 1-9 on page 14 tells you how to switch to a two-column Tools panel like the one shown here.

Changing Photoshop's Appearance

While the dark gray interface colors introduced in CS6 are supposed to be easier on the eyes and help you see the colors in images more accurately, you may disagree. You may also want to increase the size of the text labels in the Options bar and panels. Fortunately, you can change several aspects of the program's appearance by choosing Photoshop→Preferences→Interface (Edit→Preferences→Interface on a PC), as Figure 1-4 shows.

The next section tells you how to customize Photoshop's look and feel even *more* by opening, closing, rearranging, and resizing panels. Read on!

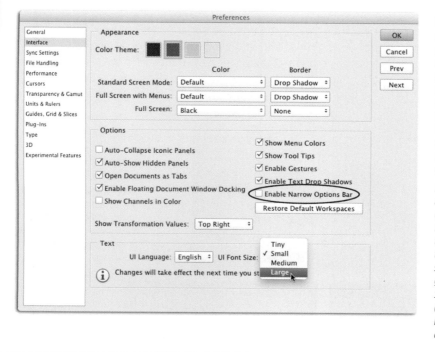

FIGURE 1-4

Not a fan of the dark gray color theme? Use these settings to pick something lighter (the light gray square reverts to CS5's color theme). To change Full Screen Mode's background color to something other than black, use the Full Screen drop-down menu.

Photoshop also sports a narrow Options bar (circled), which is nice for small screens. If the text labels throughout the program have you squinting, make 'em bigger by using the UI Font Size menu shown here (then quit and restart Photoshop to make your change take effect).

UP TO SPEED

Hiding vs. Quitting

If you need to do some work on your desktop or in another program, you can temporarily *hide* Photoshop, saving you the time and toe-tapping of quitting it and then *restarting* it again later.

On a Mac, press ⌘-Control-H or click the yellow dot at the top left of the Application Frame to minimize the window (if you've changed your Appearance system preferences to Graphite, the dot is gray instead). Your workspace disappears, but Photoshop keeps running in the background. To bring it back to the forefront, click its icon in the Dock. You can also make Photoshop temporarily disappear by pressing ⌘-H; the first time you do, a dialog box appears asking if you'd like to *assign* that keyboard shortcut to make it hide Photoshop instead of

hiding text highlighting, guides, and so on. (To change it back, edit your keyboard shortcuts as explained in the box on page 31, or delete Photoshop's preferences as described in the first Note on page 23.)

On a PC, you can minimize (hide) the program by clicking the minus button in Photoshop's upper right; Windows tucks the program down into your taskbar. To get it back, click its taskbar icon.

If your machine has at least 8 GB of memory (RAM), there's absolutely *no* downside to hiding Photoshop. However, if you're low on memory and your machine's fan is cranking away, then choose Photoshop→Quit Photoshop (File→Exit on a PC) instead.

■ Working with Panels

The right side of the Application Frame is home to a slew of small windows called *panels*, which let you work with frequently used features like colors, adjustments, layers, and so on. You're free to organize the panels however you like and position them anywhere you want. Panels can be free floating or *docked* (attached) to the top, bottom, left, or right sides of your screen. And you can link panels together into *groups*, which you can then move around. Each panel also has its very own menu, called (appropriately enough) a *panel menu*, located in its top-right corner; its icon looks like four little lines with a downward-pointing triangle and is labeled in Figure 1-5, left.

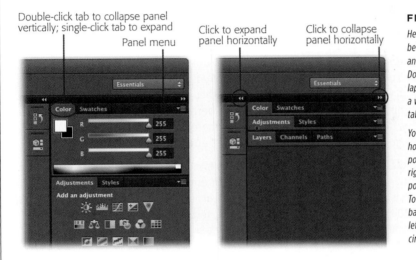

Double-click tab to collapse panel vertically; single-click tab to expand

Panel menu

Click to expand panel horizontally

Click to collapse panel horizontally

FIGURE 1-5

Here you can see the difference between expanded panels (left) and collapsed panels (right). Double-click a panel's tab to collapse it vertically, rolling it up like a window shade; single-click the tab again to expand the panel.

You can also collapse a panel horizontally by clicking the right-pointing double arrows in its top right (circled, right), at which point it turns into a small button. To expand one of these buttons back into a panel, just click the left-pointing double arrows circled here (circled, middle).

Take a peek at the right side of your screen and you'll see that Photoshop starts you off with three docked panel groups filled with goodies it thinks you'll use a lot (there's more on docked panels coming up shortly). The first group contains the Color and Swatches panels; the second group contains Adjustments and Styles; and the third contains Layers, Channels, and Paths. To work with a panel, activate it by clicking its tab.

Panels are like Silly Putty—they're incredibly flexible. You can collapse, expand, move, and resize them, or even swap 'em for other panels. Here's how:

- **Collapse or expand panels.** If panels are encroaching on your editing space, you can shrink them both horizontally and vertically so they look and behave like buttons. To collapse a panel (or panel group) horizontally so that it becomes a button nestled against the side of another panel or the edge of your screen, click the tiny double arrow in its top-right corner; click this same button again to expand the panel. To collapse a panel vertically against the bottom of the

panel above it, as shown in Figure 1-5, right, double-click the panel's *tab* or the empty area to its right; single-click the tab or double-click the empty area to roll the panel back down. To adjust a panel's width, point your cursor at its left edge and, when the cursor turns into a double-headed arrow, drag left or right to make the panel bigger or smaller (though some panels have a minimum width).

- **Add and modify panel groups.** You can open even *more* panels by opening the Window menu (which lists all of Photoshop's panels) and clicking the name of the one you want to open. When you do, Photoshop puts the panel in a column to the left of the ones that are already open and adds a tiny button to its right that you can click to collapse it both horizontally and vertically (just click the same button again to expand it). If the new panel is part of a group, like the Character and Paragraph panels, the extra panel tags along with it. If it's a panel you expect to use a lot, you can add it to an existing panel group by clicking and dragging the dotted lines above its button into a blank area in the panel group, as shown in Figure 1-6.

- **Undock, redock, and close panels.** From the factory, Photoshop docks three sets of panel groups to the right side of your screen (or Application Frame). But you're not stuck with the panels glued to this spot; you can set them free by turning them into *floating* panels. To liberate a panel, grab its tab, pull it out of the group it's in, and then move it anywhere you want (see Figure 1-7). When you let go of your mouse button, the panel appears where you put it—all by itself.

You can undock a whole panel group in nearly the same way: Click an empty spot in the group's tab area and drag it out of the dock. Once you release your mouse button, you can drag the group around by clicking the same empty spot in the tab area. Or, if the group is collapsed, click the tiny dotted lines at the top of the group, just below the dark gray bar.

To redock the panel (or panel group), drag it back to the right side of your screen. To *prevent* a panel from docking while you're moving it around, ⌘-drag (Ctrl-drag) it instead.

FIGURE 1-6

Top: When you open a new panel, Photoshop adds it to a column to the left of your other panels and gives it a handy button that you can click to collapse or expand it, like the Info panel's button circled here. The tiny dotted line above each button is its handle; click and drag one of these handles to reposition the panel in the column, add the panel to a panel group, and so on. If the panel you opened is related to another panel—like the Brush panel and the Brush Presets panel—then both panels will open as a panel group with a single handle.

Middle: When you're dragging a panel into a panel group, wait until you see a blue line around the inside of the group before you release your mouse button. Here, the Info panel is being added to a panel group. (You can see a faint version of the Info panel's button where the red arrow is pointing.)

Bottom: When you release your mouse button, the new panel becomes part of the group. To rearrange panels within a group, drag their tabs (circled) left or right.

If the blue highlight lines are hard to see when you're trying to group or dock panels, try dragging the panels more slowly. That way, when you drag the panel into a group or dockable area, the blue highlight hangs around a little longer and the panel becomes momentarily transparent.

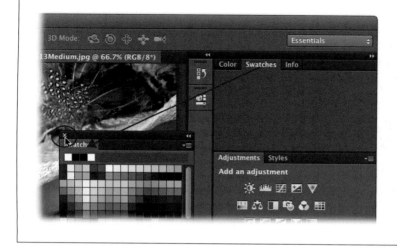

FIGURE 1-7

To undock a panel (or panel group), click the panel's tab (or a free area to the right of the group's tabs), and then drag the panel or group somewhere else on your screen.

To dock it again, drag it to the right side of your screen—on top of the other panels. When you see a thin blue line appear where you want the panel (or group) to land, release your mouse button.

NOTE The Timeline panel (which was called the Animation panel prior to Photoshop CS6) is docked to the *bottom* of your workspace, which is a docking hotspot, too. That said, Photoshop refuses to let you dock the Options bar down there.

To close a panel, click its tab and drag it out of the panel group to a different area of your screen (Figure 1-7); then click the tiny circle in the panel's top-left corner (on a PC, click the X in the panel's top-right corner instead). Don't worry—the panel isn't gone forever; if you want to reopen it, simply choose it from the Windows menu.

Getting the hang of undocking, redocking, and arranging panels takes a little practice because it's tough to control where the little rascals land. When the panel you're dragging is about to join a docking area (or a different panel group), a thin blue line appears showing you where the panel or group will go.

Customizing Your Workspace

Once you arrange Photoshop's panels just so, you can keep 'em that way by saving your setup as a *workspace,* using the unlabeled Workspace drop-down menu at the right end of the Options bar (see Figure 1-8). Straight from the factory, this menu is set to Essentials, which is a good general-use setup that includes panels that most people use regularly. The menu's other options are more specialized: 3D is designed for working with 3D objects (see Chapter 21), Motion is for video editing, Painting is for (you guessed it) painting, Photography is for working with photos, and Typography is for working with text. To swap workspaces, simply click one of these *presets* (built-in settings), and Photoshop rearranges your panels accordingly.

NOTE Gone in this version of Photoshop is the What's New workspace, which used to highlight all the menu items that included new features. However, all is not lost: you can choose Help→What's New to visit Adobe's site and see a handy summary of features, listed by the year they were released (for example, Photoshop CC June 2014, and so on).

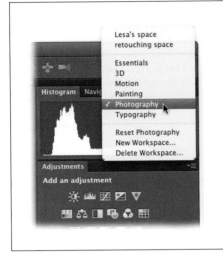

FIGURE 1-8

Most of the built-in workspaces are designed to help you perform specialized tasks. For example, the Photography workspace puts the Histogram and Navigation panels at the top right. Take the built-in workspaces for a test drive—they'll undoubtedly give you customization ideas you hadn't thought of!

If you don't see the Workspace menu and you've got the Application Frame turned on, point your cursor at the right side of the Photoshop window and, when it turns into a double-headed arrow, click and drag rightward to increase the frame's size.

To save your own custom workspace, first open and arrange the panels you want to include. Next, click the Workspace menu and choose New Workspace. In the resulting dialog box, give your setup a meaningful name and turn on the checkboxes for the customizations you want Photoshop to save. In addition to panel locations, you can save any keyboard shortcut and menu settings you've changed (see the box on page 31 for more on changing these items)—just be sure to turn on the options for *all* the features you changed or they won't be included in your custom workspace. When you click Save, your workspace shows up at the top of the Workspace menu.

If you've created a custom workspace that you'll never use again, you can send it packin'. First, make sure you aren't currently using the doomed workspace. Then, from the Workspace menu, choose Delete Workspace and, in the resulting dialog box, pick the offending workspace and then click Delete. Photoshop will ask if you're *sure;* click Yes to finish it off.

The Tools Panel

The Tools panel (Figure 1-9, left) is home base for all of Photoshop's editing tools, and it's included in all the built-in workspaces. Until you memorize tools' keyboard shortcuts, you can't do much without this panel! When you first launch the program, you'll see the Tools panel on the left side of the screen, but you can drag it anywhere you want by clicking the tiny row of vertical dashes near its top (Figure 1-9, right).

Click the tool's icon to expand its toolset

FIGURE 1-9

There's not enough room in the Tools panel for each tool to have its own spot, so related tools are grouped into toolsets. The microscopic triangle at the bottom right of each toolset's button lets you know it represents more than one tool (the Move and Zoom tools are the only ones that live alone). To see the other tools, click the tool's button and hold down your mouse button (or right-click the button instead); Photoshop then displays a list of the other tools it harbors in a fly-out menu, as shown here (left).

Photoshop starts you off with a one-column Tools panel (left), but you can collapse it into two columns (right) by clicking the tiny double triangles circled here (click 'em again to switch back to one column). To undock the Tools panel, grab the dotted bar labeled here and drag the panel wherever you want it. You can dock the Tools panel to the left or right edge of your screen, or leave it floating free.

Rectangular Marquee Tool — M
Elliptical Marquee Tool — M
Single Row Marquee Tool
Single Column Marquee Tool

Click to toggle between 1 or 2 column view

Click and drag to undock the Tools panel

Foreground/Background chips

Once you expand a toolset as explained in Figure 1-9, you'll see the tools' keyboard shortcuts listed to the right of their names. These shortcuts are great timesavers because they let you switch between tools without moving your hands off the keyboard. To access a tool that's hidden deep within a toolset, add the Shift key to the tool's shortcut key, and you'll cycle through all the tools in that toolset. For example, to activate the Elliptical Marquee tool, press Shift-M repeatedly until that tool's icon appears in the Tools panel.

TIP If you need to switch tools *temporarily*—for a quick edit—you can use the spring-loaded tools feature. Just press and hold a tool's keyboard shortcut to switch to that tool, and then perform your edit. As soon as you release the key, you'll jump back to the tool you were using before. For example, if you're painting with the Brush and suddenly make an error, press and hold E to switch to the Eraser and fix your mistake. Once you release the E key, you're back to using the Brush tool. Sweet!

You'll learn about the superpowers of each tool throughout this book. For a brief overview of each tool, check out Appendix C, which you can download from this book's Missing CD page at *www.missingmanuals.com/cds*.

TIP If you can't remember which tool an icon represents, point your cursor at the icon for a couple of seconds while keeping your mouse perfectly still. After a second or two, Photoshop displays a handy tooltip that includes the tool's name and keyboard shortcut.

■ FOREGROUND AND BACKGROUND COLOR CHIPS

Photoshop can handle millions of colors, but its tools let you work with only two at a time: a foreground color and a background color. Each of these is visible as a square *color chip* near the bottom of the Tools panel (labeled in Figure 1-9, where they're black and white, respectively). Photoshop uses your foreground color when you paint or fill something with color; it's where most of the action is. The program uses your background color to do things like set the second color of a *gradient* (a smooth transition from one color to another, or to transparency) or erase parts of a locked Background layer (page 88); this color is also helpful when you're running special effects like the Clouds filter (page 705).

To change either color, click its color chip once to open the Color Picker (page 522), which lets you select another color for that particular chip. To swap your foreground and background colors, click the curved, double-headed arrow just above the two chips or press X. To set both color chips to their factory-fresh setting of black and white, click the *tiny* chips to their upper left (in a two-column Tools panel, they're at the lower left) or press D. Remember those two keyboard shortcuts (X and D); they're extremely handy when you work with layer masks, which are covered in Chapter 3.

Common Panels

As mentioned earlier, when you first launch Photoshop, the program displays the Essentials workspace, which includes several useful panels. Here's a quick rundown of why Adobe considers these panels so important:

- **Color.** This panel in the upper-right part of your screen includes your current foreground and background color chips and, from the factory, a trio of sliders and a rainbow-colored bar that you can use to pick a new color for either chip. As you'll learn on page 527, you can now use this panel as a color picker that's always open!

- **Swatches.** This panel holds miniature color samples, giving you easy access to them for use in painting or colorizing images (and new in Photoshop CC 2014, the most recent swatches you've used show up in a handy row at the top of the panel). It also stores a variety of color libraries like the Pantone Matching System (special inks used in professional printing). You'll learn all about the Swatches panel in on page 525.

- **Adjustments.** This panel lets you create *adjustment layers*. Instead of making color and brightness changes to your original image, you can use adjustment layers to make these changes on a *separate* layer, giving you all kinds of editing flexibility and keeping your original image out of harm's way. They're explained in detail in Chapter 3, and you'll see 'em used throughout this book.

- **Styles.** *Styles* are special effects created with a variety of layer styles. For example, if you've created a glass-button look by adding several layer styles individually, you can save the whole lot of 'em as a *single* style so you can apply them all with one click. You can also choose from tons of built-in styles; they're discussed starting on page 144.

- **Layers.** This is the single most important panel in Photoshop. Layers let you work with images as if they were a stack of transparencies, so you can create one image from many. By using layers, you can adjust the size and opacity of—and add layer styles to—each item independently. Understanding layers is the *key* to Photoshop success and nondestructive editing; you'll learn all about them in Chapter 3.

- **Channels.** *Channels* are where Photoshop stores the color information your images are made from. Channels are extremely powerful, and you can use them to edit the individual colors in an image, which is helpful in sharpening images, creating selections (telling Photoshop which part of an image you want to work with), and so on. Chapter 5 has the scoop on channels.

- **Paths.** *Paths* are the outlines you make with the Pen and shape tools. But these aren't your average, run-of-the-mill lines: they're made up of points and paths instead of pixels, so they'll always look perfectly crisp when printed. You can also resize them without losing any quality. You'll conquer paths in Chapter 13.

- **History.** This panel is like your very own time machine: It tracks nearly everything you do to your image (the last 50 things, to be exact, though you can change this number using preferences [see page 17]). It appears docked as a button to the left of the Color panel group. The next section explains how to use it to undo what you've recently done (if only that worked in real life!).

- **Properties.** This panel, which is also docked to the left of the Color panel group, is where you access the settings for individual adjustment layers, shape layers, linked smart objects, and layer masks. You'll dive headfirst into masks in Chapter 3; for now, think of them as digital masking tape that lets you hide the contents of a layer.

■ The Power of Undo

Thankfully, Photoshop is extremely forgiving: It'll let you back out of almost anything you do, which is *muy importante*, especially when you're getting the hang of things.

You've got several ways to retrace your steps, including the lifesaving Undo command. Just choose Edit→Undo or press ⌘-Z (Ctrl+Z). This command lets you undo the very last edit you made.

If you need to go back *more* than one step, use the Step Backward command instead: Choose Edit→Step Backward or press Option-⌘-Z (Alt+Ctrl+Z). Straight from the factory, this command lets you undo the last 50 things you did, one at a time. If you

want to go back even further, you can change that number by digging into Photoshop's preferences, as the next section explains. You can step *forward* through your editing history, too, by choosing Edit→Step Forward or Shift-⌘-Z (Shift+Ctrl+Z).

NOTE Photoshop only lets you undo changes back to the point when you first opened the document you're working on, meaning you can't close a document and then undo changes you made *before* you closed it.

Changing How Far Back You Can Go

If you think you might someday need to go back further than your last 50 steps, you can make Photoshop remember up to *1,000* steps by changing the program's preferences. Here's how:

1. **Choose Photoshop→Preferences→Performance (Edit→Preferences→ Performance on a PC).**

2. **In the Preferences dialog box's History States field, pick the number of steps you want Photoshop to remember.**

 You can enter any number between 1 and 1,000 in this field. While increasing the number of history states might help you sleep better, doing so means Photoshop has to keep track of that many more versions of your document, which requires more hard drive space and processing power. So if you increase this setting and then notice that the program is running like molasses—or you're suddenly out of hard drive space—try lowering it.

3. **Click OK when you're finished.**

Turning Back Time with the History Panel

Whereas the Undo and Step Backward commands let you move back through changes one at a time, the History panel (Figure 1-10) kicks it up a notch and lets you jump back *several* steps at once. (You can step back through as many history states as you set in Photoshop's preferences—see the previous section.) Using the History panel is much quicker than undoing a long list of changes one by one, and it gives you a nice list of *exactly* what tools and menu items you used to alter the image—in chronological order from top to bottom—letting you pinpoint the exact state you want to jump back to. And, as explained in a moment, you can also take snapshots of an image at various points in the editing process to make it easier to hop back to the state you want.

After you make a few changes to an image, pop open the History panel by clicking its button (circled in Figure 1-10, top) or by choosing Window→History. When you do, Photoshop opens a list of the last 50 things you've done to the image, including opening it. To jump back in time, click the step you want to go back to, and Photoshop returns the image to the way it looked at that point. If you hop back further than you mean to, just click a more recent step in the list.

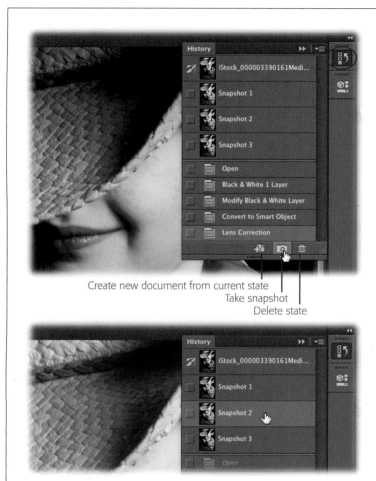

FIGURE 1-10

Top: The History panel keeps track of everything you do to your images, starting with opening them. You can even take snapshots of an image at crucial points during the editing process, such as when you convert it to black and white and then add a color tint.

Bottom: If you take a snapshot, you can revert to that state later with a single click. For example, if you've given your image a sepia (brown) tint and later changed it to blue, you can easily go back to the sepia version by clicking the snapshot you took of it, as shown here, without having to step back through all the other changes you made. What a timesaver!

History states don't hang around forever—as soon as you close the document, they're history (ha!). If you think you'll ever want to return to an earlier version of the document, click the "Create new document from current state" button at the bottom of the History panel (labeled in here). That way, you've got a totally separate document to return to so you don't have to recreate that particular state.

Create new document from current state
Take snapshot
Delete state

If you'd like the top of the History panel to include thumbnail previews showing what your image looks like each and every time you *save* the document—in addition to the thumbnail you automatically get by *opening* the image—open the History panel's menu and choose History Options. In the resulting dialog box, turn on Automatically Create New Snapshot When Saving. Clicking one of these saved-state thumbnails is a fast and easy way to jump back to the last saved version of the document.

> **TIP** You can also get back to the last saved version of a document by choosing File→Revert (page 21).

Taking snapshots of an image along the way lets you mark key points in the editing process. A snapshot is more than just a preview of the image—it also includes all

the edits you've made up to that point. Think of snapshots as milestones in your editing work: When you reach a critical point that you may want to return to, take a snapshot so you can easily get back to that version of the document. To take a snapshot, click the camera icon at the bottom of the History panel. Photoshop adds the snapshot to the top of the panel, just below the saved-state thumbnail(s). The snapshots you take appear in the list in the order you take them.

The History Brush

The History Brush takes the power of the History panel and lets you focus it on specific parts of an image. So instead of sending the *entire* image back in time, you can use this brush to paint edits away *selectively*, revealing the previous state of your choosing. For example, you could darken a portrait with the Burn tool (page 342) and then use the History Brush to undo some of the darkening if you went too far, as shown in Figure 1-11.

Here's how to use the History Brush to undo a serious burn you've applied:

1. **Open an image—in this example, a photo of a person—and duplicate the image layer.**

 You'll learn all about opening images in Chapter 2, but, for now, choose File→Open; navigate to where the image lives on your computer, and then click Open. Next, duplicate the layer by pressing ⌘-J (Ctrl+J).

2. **Activate the Burn tool by pressing Shift-O and then darken part of your image.**

 The Burn tool lives in a toolset, so cycle through those tools by pressing Shift-O a couple of times (its icon looks like a hand making an O shape). Then mouse over to your image and drag across an area that needs darkening. Straight from the factory, this tool darkens images pretty severely, giving you a *lot* to undo with the History Brush.

POWER USERS' CLINIC

Erasing to History

At some point, you'll realize that the perfect fix for your image is something you zapped 10 steps ago. For example, you may change the color of an object only to decide later that it looked better the way it was. Argh!

Happily, Photoshop's "Erase to History" feature lets you jump back in time and paint away the edits you no longer want. Erasing to history is a handy way to leave *some* changes in place while recovering your original image in other areas.

First, grab the Eraser tool by pressing E and then, in the Options bar, turn on the "Erase to History" checkbox. Next, in the Layers panel, click the layer you want to edit, and then in the main document window, start dragging over the areas you want to restore to their former glory.

How is erasing to history different from using the History Brush? They both do basically the same thing. The only benefit to using the History Brush instead of "Erase to History" is that the brush's Options bar lets you pick a blend mode menu to create different color effects as you erase to the previous state. (You'll learn more about blend modes in Part Two of this book; they control how the colors you add to an image—by painting, darkening, filling, and so on—blend with or cancel out the color that's already there.)

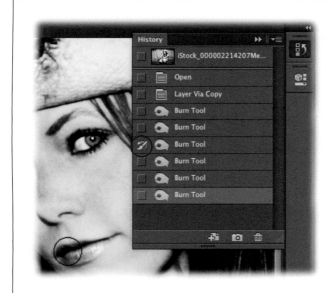

FIGURE 1-11

By using the History Brush set to the image's earlier state—see step 4 below—you can undo all kinds of effects, including a little over-darkening from using the Burn tool.

You can reduce the opacity of the History Brush in the Options bar to make the change more gradual.

The Art History Brush works similarly, but it adds bizarre, stylized effects as it returns your image to a previous state, as shown in the box on page 566.

3. **Grab the History Brush by pressing Y.**

 You'll learn all about brushes and their many options in Chapter 12.

4. **Open the History panel and then click a saved state or snapshot.**

 This is where you pick which version of the image you want to go back to. If you dragged more than once in step 2, you'll see several Burn states listed in the panel. To reduce just some of the darkening, choose one of the first Burn states; to get rid of *all* the darkening where you painted, choose the Open state. To pick a state, click in the panel's left-hand column next to a state, and you'll see the History Brush's icon appear in that column.

5. **Mouse over to your image and drag to paint the areas that are too dark to reveal the lighter version of the image.**

 To make your change more gradual—if, say, you clicked the Open state but you don't want to erase *all* the darkening—just lower the Opacity setting in the Options bar. That way, if you keep painting in the same place, you'll expose more and more of the original image.

 You can use the History Brush to easily undo anything you've done; just pick the state you want to revert to in the History panel, and then paint away!

The Revert Command

If you've taken your image down a path of craziness from which you *can't* rescue it by using Undo or the History panel, you can revert back to its most recent saved state by choosing File→Revert. This command opens the previously saved version of the image, giving you a quick escape route back to square one.

NOTE If you haven't made any changes to your image since it was last saved, you can't run the Revert command; it's dimmed in the File menu.

◼ Tweaking Photoshop's Preferences

As you learned earlier in this chapter, Photoshop is pretty darn customizable. In addition to personalizing the way its tools behave and how your workspace looks, you can make lots of changes using the program's preferences, which control different aspects of Photoshop and let you turn features on or off, change how tools act, and fine-tune how the program performs.

TIP Tooltips work on preference settings, too! So if you forget what a setting does, just point your cursor at it for a second or two and you'll get a tiny yellow explanation.

To open the Preferences dialog box, choose Photoshop→Preferences→General (Edit→Preferences→General on a PC), or press ⌘-K (Ctrl+K). When you choose a category on the left side of the dialog box, tons of settings related to that category appear on the right. The following pages give you an idea of the kinds of goodies in each category, and you'll find guidance on tweaking preferences sprinkled throughout this book.

TIP You can cycle through the preferences categories by pressing and holding the ⌘ key (Ctrl on a PC) while tapping the up and down arrow keys on your keyboard.

General

The General pane of the Preferences dialog box (Figure 1-12) is a sort of catchall for settings that don't fit anywhere else. Most of these options are either self-explanatory (Beep When Done, for example) or covered elsewhere in this book. A few, however, are worth taking a closer look at.

FIGURE 1-12

The General preferences include the incredibly powerful History Log settings. If you turn on History Log, Photoshop keeps track of everything you do to the document. This is an invaluable tool for folks who need to prove what they've done to an image in order to bill clients or produce legal documentation of all the edits they've made (think law enforcement professionals and criminal investigators). It's also a great way to bring an assistant or coworker up to speed on your workflow.

Unless you tell it otherwise, Photoshop displays the Adobe Color Picker (see page 522) anytime you choose a color. If you're more comfortable using your operating system's color picker instead, you can choose it from the Color Picker drop-down menu. If you download and install third-party color pickers, they show up in this menu, too. However, since the Adobe Color Picker is designed to work with Photoshop and all its built-in options, using another color picker may mean losing quick access to critical features like Color Libraries (page 524).

The HUD Color Picker setting refers to the on-image color picker you can summon when using a tool that paints, such as the Brush tool. (HUD is short for "heads-up display.") It's also available in a variety of shapes and sizes (strip or wheel in small, medium, and large), and you can choose among 'em here. See page 536 for more on using the HUD Color Picker.

The Image Interpolation menu controls the mathematical voodoo Photoshop performs when you resize an image with the Image Size dialog box (page 255) or the Crop tool (page 238). Back in CS6, Adobe added the Automatic option, which tells Photoshop to pick the method that it thinks will work best for your image. Will it always choose wisely? Only you can tell.

Other notable options here involve a couple of cool features: animated zoom and flick panning (both covered in Chapter 2). If your computer is running at a snail's pace, try turning off one or both features (they can *really* tax slower video cards).

The other noteworthy options in the General preferences have to do with painting and drawing vectors (Chapters 12 and 13, respectively). For example, "Vary Round Brush Hardness based on HUD vertical movement" means that dragging up or down with your mouse while changing paint color with the on-image (HUD) color picker (page 536) changes the brush's hardness; if you'd rather have that motion change opacity instead, turn this checkbox off. "Snap Vector Tools and Transforms to Pixel Grid" causes new vector shapes and paths to automatically snap to Photoshop's pixel grid, ensuring precise alignment when you're designing graphics for the Web. Both these settings are turned on straight from the factory.

NOTE Deleting Photoshop's preferences file can be a useful troubleshooting technique. (Doing so resets all the preferences to what they were when you first installed the program.) Just choose Photoshop→Quit Photoshop (File→Exit on a PC), and then press and hold Shift-Option-⌘ (Shift+Alt+Ctrl) when you restart Photoshop. Online Appendix B (available from this book's Missing CD page at *www.missingmanuals.com/cds*) has more about this procedure.

Interface

These preferences control how Photoshop looks on your screen. As you learned on page 8, you can use the Color Theme swatches at the top of these settings to change Photoshop's colors (click the light gray swatch to resurrect the color theme of CS5 and earlier versions). You can squeeze a little more performance out of slower computers by setting the three Border drop-down menus to None. That way, Photoshop won't waste any processing power generating pretty drop shadows around your images or around the Photoshop window itself.

If you're familiar with all of Photoshop's tools and don't care to see the little yellow tooltips that appear when you point your cursor at tools and field labels, turn off Show Tool Tips. And if you'd like new documents to open in separate windows instead of in new tabs, turn off "Open Documents as Tabs."

NOTE If you use Photoshop on a Mac laptop and you're constantly zooming and rotating your canvas with your trackpad by accident, turn off Enable Gestures.

Sync Settings

One of the benefits of Adobe's Creative Cloud (see the box on page xxvii) is the ability to store and thus *access* your custom settings on different machines—great if you happen to work in multiple locations. The Sync Settings preferences, shown in Figure 1-13, let you control which of your settings and preset goodies are stored on Adobe's Creative Cloud. They also let you trigger the process of uploading or downloading them.

Photoshop displays your Adobe ID at the top of this preference pane, and you use a series of checkboxes to tell Photoshop exactly what you want to sync. From left to right, your options are preferences, workspaces (a recent addition), actions, brushes, swatches, styles, gradients, custom shapes, tool presets, patterns, and contours.

Alternatively, you can leave the What To Sync menu set to Everything and, each time you click Upload, all the settings that *can* be uploaded *will* be.

> **NOTE** New in Photoshop CC 2014, if the Workspace checkbox is turned on, any keyboard shortcut or menu customizations you've made using the Keyboard Shortcuts dialog box (see the box on page 31) are included in your syncs. Nice!

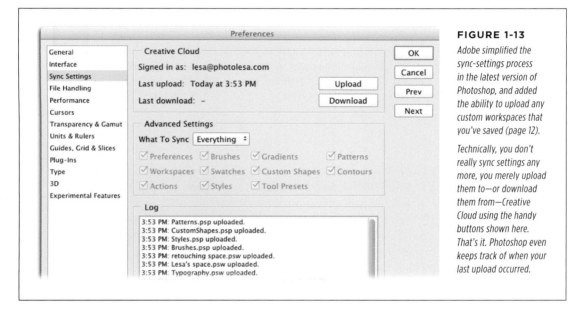

FIGURE 1-13

Adobe simplified the sync-settings process in the latest version of Photoshop, and added the ability to upload any custom workspaces that you've saved (page 12).

Technically, you don't really sync settings any more, you merely upload them to—or download them from—Creative Cloud using the handy buttons shown here. That's it. Photoshop even keeps track of when your last upload occurred.

Once you've clicked the Upload button to store your settings on Creative Cloud, you can access them on another machine by signing in with your Adobe ID. To do it, get comfy in front of the new machine, launch Photoshop, choose Help→Sign Out [Adobe ID], and in the Creative Cloud dialog box, click Sign Out. Then choose Help→Sign In, enter your credentials, and then click Sign In. Next, choose Photoshop→[Adobe ID]→Download Settings (Edit→[Adobe ID]→Download Settings on a PC), or pop open the Sync Settings preferences pane and click Download. Either way, Photoshop grabs the custom goodies you uploaded from your other computer and loads 'em so they're ready for you to use.

File Handling

These preferences, visible in Figure 1-14, control how Photoshop opens and saves files. If you're a Mac person and you plan on working with images that'll be opened on both Macs and PCs, make sure the Append File Extension menu is set to Always and that Use Lower Case is turned on. These settings improve the chances that your files will open on *either* type of computer without a hassle. (PC users can leave their File Handling settings alone because file extensions are *required* in Windows, whereas on a Mac they can be turned off.)

Since CS6, you've had the ability to keep working while Photoshop saves your file in the *background*—meaning you don't have to wait until it's finished to do something else—plus the program automatically saves your document at regular intervals. (CC lets you save *additional* documents before the first one finishes; there's more on that in Chapter 2.) The "Save in Background" setting lets you turn background saving on or off, and you can control how the Auto Recovery feature works. To have Photoshop save your file more often than every 10 minutes, pick another duration from the Automatically Save Recovery Information Every menu (your choices are 5, 10, 15, or 30 minutes, or 1 hour).

FIGURE 1-14

Photoshop's File Handling preferences mostly deal with saving and document compatibility settings.

This is also where you access the Adobe Camera Raw plug-in's preferences (it's installed with Photoshop, and you'll learn all about in Part Two of this book). Click Camera Raw Preferences to see them.

Straight from the factory, Photoshop is set to display a dialog box each time you save a file that asks if you want to save the image for maximum compatibility with *PSD* and *PSB* files (the native Photoshop format and the format for really big files, respectively; see page 45); doing so improves the chances that your files can be understood by other programs like Adobe InDesign or QuarkXPress. If that pesky dialog box annoys you, set the "Maximize PSD and PSB File Compatibility" menu to Always and you'll never see the dialog box again (plus you'll have the peace of mind that comes with knowing your images will play nice with other programs). You can also keep Photoshop from automatically compressing these files (to save 'em faster), but you'll end up with bigger files. If speed is more important to you than file size, then turn on "Disable Compression of PSD and PSB Files."

NOTE The Adobe Drive option lets you connect to a *digital asset management* program (also called a DAM) in order to organize, track, and store files in a central location that other folks can access (so they can work on those files, too). Visit *www.lesa.in/adobedrive* for more info.

Another handy option is the Recent File List Contains setting, which lets you change the number of documents Photoshop lists in the Recent files menu (found by choosing File→Open Recent). This field is automatically set to 20, but feel free to change it if you frequently need to reopen the same documents.

Performance

The Performance preferences control how efficiently Photoshop runs on your computer. For example, the amount of memory the program has to work with affects how well it performs. In the Memory Usage section, the Let Photoshop Use field's factory setting tells the program to use up to 60–70 percent of your machine's available memory (the exact number may vary). If you're tempted to increase it to 100 percent for better performance, *don't*. Other programs need to use your computer's memory, too, and leaving it set between 60 and 70 percent ensures that all of them get their fair share (after Photoshop takes the biggest chunk, that is).

The History & Cache section lets you change the number of history states that Photoshop remembers, as explained on page 17. You can also let the program set optimal cache levels and tile sizes *for* you; all you have to do is pick the kind of document you work on the most. Your options are "Tall and Thin," "Default," and "Big and Flat"; just click the one that's closest to what you regularly use. Here's why this matters: Cache levels controls how much image info is temporarily stored in your computer's memory for things like screen and histogram refreshing (histograms are covered on page 398). The cache tile size is the amount of info Photoshop can store and process at one time (for example, larger tile sizes can speed things up if you work with documents with really large pixel dimensions). See? Now you *appreciate* Photoshop managing these settings for you!

If your computer's hard drive is running low on space, consider adding another drive that Photoshop can use as a *scratch disk*—the place where it stashes the bazillions of temporary files it makes when you're editing images (so *that's* where those history states are stored!). If you don't have a separate scratch disk, Photoshop stores those temporary files on your computer's primary hard drive, taking up space you could be using for other documents. When you add a new internal hard drive or plug in an external drive, that drive appears in the Scratch Disks list shown in Figure 1-15.

To add one or more scratch disks, click the square in the "Active?" column next to each hard drive you want to use, and then drag the drives into the order you want Photoshop to use them. For the zippiest feel, use a solid-state drive (SSD) that's at least 256 GB in size (and is separate from the one where your operating system is installed). Also, avoid using USB2-based drives, as they tend to be sluggish and can actually make Photoshop run slower (USB3-based drives work just fine).

NOTE When it comes to Photoshop's scratch disk, speed matters, and faster is better. Since the speed the disk spins plays a big role in a scratch disk's performance, stick with disks rated at 7200 RPM (revolutions per minute) or faster. Slower 5400 RPM disks can take a toll on Photoshop's performance, and 4200 RPM drives slow... Photoshop...to...a...crawl. Better yet, spend the extra money for a solid state drive (SSD), which has no moving parts and uses an electronic system to read and write data, making it much faster than its spinning cousins.

**FIGURE
1-15**

To give Photoshop the green light to use the new drive, put a checkmark in the disk's "Active?" column, and then drag it up into the first position. After that, Photoshop will be a little zippier because it'll have two hard drives reading and writing info instead of one.

More than ever before, Photoshop CC takes advantage of your computer's built-in ability to draw and process graphics. This results in faster and smoother performance when you're doing things like resizing images with Free Transform, rotating your canvas temporarily with Rotate View, and using the HUD Color Picker (you'll learn about all these features throughout this book). If you turn off the Use Graphics Processor setting, you lose all these superpowers, though you might squeeze a little more performance out of your machine. If you've got a newer machine, be sure to leave this setting turned on. That said, you can control *how much* your graphics processor is being tapped by clicking Advanced Settings (your choices are Basic, Normal, and Advanced).

Cursors

These preferences control how your cursor looks when you're working with images. There are no right or wrong choices here, so try out the different styles and see what works best for you. Photoshop includes two types of cursors: painting cursors and everything else. When you choose different options here, Photoshop shows you a preview of each cursor. The Brush Preview color swatch controls the color of the brush preview that appears when you resize your brush by Control-Option-dragging (Alt+right-click+dragging on a PC) left or right. To change this color, click the color swatch, choose a new hue from the Color Picker dialog box, and then click OK. (See page 531 to learn how these options affect the Brush tool.)

TIP If you press Caps Lock on your keyboard when you're working with a tool that uses a brush cursor, Photoshop switches it to the precise cursor instead (it looks like a tiny crosshair). To switch back to the regular brush cursor, press Caps Lock again. This is a fantastic troubleshooting technique to remember!

Transparency and Gamut

The Transparency settings let you fine-tune what a layer looks like when part of it is transparent. Like the cursor settings, these options are purely cosmetic, so feel free to experiment. (You'll learn more about transparency in Chapter 3.) The Gamut Warning section lets you set a highlight color that shows where colors in your image fall outside the safe range for the color mode you're working in or the printer you're using. (Chapter 16 has more about these advanced color concerns.)

Units and Rulers

The Units & Rulers preferences (Figure 1-16) let you pick which unit of measurement Photoshop uses. The Rulers menu, not surprisingly, controls the units displayed in your document's rulers (though you can change them on the fly by right-clicking a ruler, as described on page 67); your choices are pixels, inches, centimeters, millimeters, points, picas, and percent. If you work on a lot of documents destined for print, inches, points, or picas are probably your best bet (in the USA, that is). If you create images primarily for the Web, choose pixels instead. Leave the Type menu set to Points unless you need to work with type measured in pixels or millimeters, which can be handy if you need to align text in a web page layout.

FIGURE 1-16

To really save some time, take a moment to adjust the settings in the New Document Preset Resolutions section (resolution, as you'll learn on page 254, controls pixel size).

From that point on, Photoshop automatically fills in the New Document dialog box with the settings you entered here (you'll learn about creating documents beginning on page 38).

The Column Size settings are handy when you're designing graphics to fit into specific-sized columns in a page-layout program like Adobe InDesign. Just ask the person who's creating the InDesign layout what measurements to use.

Guides, Grid, and Slices

These preferences let you choose the colors for your document guides (page 67), grid (page 69), and slice lines (page 787). You can also set the grid's spacing and the number of subdivisions that appear between each major gridline with the "Gridline every" and Subdivisions fields, respectively.

Plug-Ins

You can make Photoshop do even more cool stuff by installing third-party programs called *plug-ins*. There are several useful plug-ins out there, and this book has a whole chapter devoted to them (Chapter 19).

> **NOTE** These preferences *used* to let you store plug-ins somewhere other than your computer's Photoshop folder, but Adobe recently removed that option. Evidently it was causing confusion as some folks used the same Plug-ins folder for multiple versions of the program, which resulted in a lot of crashes.

Photoshop comes with several built-in plug-ins, such as Adobe Camera Raw (page 54) and most everything in the filter menu. And Photoshop CC 2014 sports a new plug-in named *Generator*, a JavaScript-based system used to create application programming interfaces (APIs). Generator's capabilities will expand over time, but for now you can use it to *generate* (hence its name) GIF, PNG, JPG, or SVG files for the Web simply by naming layers or layer groups with specific *tags* (you don't need to go near the File→Export or Save As commands). You'll learn more about using Generator on page 794, but this is where you turn it on.

The Filters & Extension Panels section lets you repopulate the Filter menu by turning on "Show all Filter Gallery groups and name" (page 674). Go ahead and leave both extension-related checkboxes in this section turned on so Photoshop can connect to the Internet if a plug-in or panel needs to grab information from a website. However, since Adobe removed Flash-based panels from this version of Photoshop (specifically, the Kuler, Mini Bridge, and Adobe Exchange panels), as of this writing, there *aren't* any panels in the Window menu's Extension category. (That said, if you download the HTML-based Kuler panel from the Adobe Add-Ons website, it shows up in the Extensions category. Page 521 has details.) Any changes you make in this section take effect after you restart Photoshop.

Type

Photoshop has an amazing text engine under its hood that you'll learn about in Chapter 14. The preferences here let you toggle smart quotes (the curly kind) on or off, as well as enable other languages. If you work with Asian characters, turn on the East Asian option and make sure Enable Missing Glyph Protection is also turned on. That way you won't end up with weird symbols or boxes if you try to use a letter or

symbol that isn't installed on your machine. Photoshop can work with Middle Eastern and South Asian languages, too. (Any changes you make in the Choose Text Engine Options section take effect only after you restart Photoshop.)

Because seeing a font in its typeface is so handy when you're choosing fonts, Adobe turned on font previews automatically back in CS5, and then in CS6 they *removed* the Font Preview Size from preferences altogether. These days, you adjust the preview size not in the Preferences dialog box, but by choosing Type→Font Preview Size, where you can pick among six handy options, from none to huge.

3D

As you learned in the note on page xxiii, Adobe merged the Extended and Standard versions of the program into Photoshop CC, meaning *everyone* now has access to the program's 3D tools. (Chapter 21 teaches you how to get started creating and working with 3D objects.)

You can use the preferences in this section to adjust the amount of video card memory (VRAM) Photoshop can use while you're working in the 3D environment, as well as the color and size of the various overlays you'll encounter when creating or editing 3D text and objects. The options on the right side of the preference pane let you change how Photoshop displays 3D objects, their interactive controls, and how much detail the program displays when you load a 3D object that was created in another program. Unless you're an expert in working with 3D objects, it's best to leave most of these settings alone.

Experimental Features

New in Photoshop 2014 is the ability to try new features before Adobe finalizes 'em. By doing so, you can give Adobe feedback that may help shape the final version of that particular feature. The list of experimental goodies available here will change over time, but as of this writing, it includes Enable Multitone 3D Printing (lets capable 3D printers print in more than one color), "Scale UI 200% for high-density displays (Windows only)" (uses a 200% zoom level for HiDPI displays), and "Use Touch Gestures (Windows only)" (allows gesturing on touchscreen monitors).

It's up to you whether you want to live on the cutting edge. To try a new feature, turn on its checkbox, click OK, and then restart Photoshop. If you decide you don't like that feature, pop open the Experimental Features preferences, turn the feature's checkbox *off*, click OK, and (you guessed it) restart Photoshop.

Customizing Keyboard Shortcuts and Menus

Keyboard shortcuts can make the difference between working quickly and working at warp speed. They can drastically reduce the amount of time you spend doing things like choosing menu items and grabbing tools. Photoshop has a ton of built-in keyboard shortcuts and menus, but that doesn't mean you're stuck with 'em. You can reassign shortcuts, add new ones, and show or hide menu options. Here's how to add or change keyboard shortcuts:

1. Choose Edit→Keyboard Shortcuts.

2. In the "Keyboard Shortcuts and Menus" dialog box, use the Shortcuts For menu to choose which type of shortcuts you want to add or change. Your options are Application Menus (like the File and Edit menus), Panel Menus (the menus on the program's various panels), and Tools.

3. In the long list below the Shortcuts For menu, pick the shortcut you want to change. (If a list item has a flippy triangle next to it, click the triangle to see all the options nested within that item.)

4. Enter a new shortcut in the Shortcut field, and then click Accept.

5. To save your new shortcut to Photoshop's *factory* set of shortcuts, click the first hard-disk icon near the top of the dialog box (to the right of the Set menu). In the resulting dialog box, click Save, and Photoshop names your shortcuts Photoshop Defaults (Modified). To create a brand-new set of shortcuts instead, click the *second* hard-disk icon with the little dots underneath it; in the dialog box that appears, give your custom shortcut set a meaningful name, and then click Save. (Creating separate keyboard shortcut sets lets you quickly switch back to Photoshop's factory shortcuts, or switch between sets you've made for specific tasks by choosing one from the Set menu at the top of the dialog box.)

You can also clear an existing keyboard shortcut for another use. First, make note of which menu the existing shortcut currently lives in. Next, find that menu's name in the "Keyboard Shortcuts and Menus" dialog box's list, click its flippy triangle to expand that item, and then click to highlight the shortcut. Finally, click the Delete Shortcut button on the right and consider it free at last.

To help you remember the new shortcuts, you can print a handy chart to tack up on the wall. In the "Keyboard Shortcuts and Menus" dialog box, pick your custom set from the Set menu, and then click Summarize. In the resulting Save dialog box, give the list of shortcuts a name, choose where to save it, and then click Save. Photoshop creates an HTML file that you can open in any Web browser or HTML-savvy program and then print. (You can impress your colleagues by telling them that you *reprogrammed* Photoshop to do your bidding; they'll likely have no idea how easy it is to change this stuff.)

What if you need to reinstall Photoshop or upgrade to a newer version? The Migrate Presets feature copies over your keyboard shortcuts so you don't lose 'em (see the Note on page 33).

The "Keyboard Shortcuts and Menus" dialog box also lets you modify the program's menus: If there are commands you rarely use, you can hide 'em to shorten and simplify menus. Click the Menus tab near the top of the dialog box and then, from the Menu For drop-down menu, choose Application Menus or Panel Menus, depending on which ones you want to tweak. Next, click the little flippy triangle next to each menu's name to see the items it includes. To hide a menu item, click the eye in its Visibility column; to show a hidden item, click then empty square in its Visibility column. (If you suddenly need to access a hidden menu item, choose Show All Menu Items from the very bottom of the affected menu.) You can even *colorize* menu items so they're easier to spot. To do that, pick the item you want to highlight, click the word None in the Color column, and then choose a color from the resulting drop-down menu. Click OK and enjoy your new customizations.

Working with Presets

Once you get comfortable in Photoshop, you can customize the behavior of almost every tool in the Tools panel. For example, if you find yourself entering the same Options bar settings over and over again for a certain tool, then saving those settings can save you time. In fact, Photoshop includes a bunch of built-in tool recipes, called *presets*, such as frequently used crop sizes, colorful gradient sets, patterns, shapes, and brush tips. You can access 'em through the tool's Preset Picker at the far left of the Options bar, as shown in Figure 1-17 (top).

Click a preset in the list to activate it, and then use the tool as you normally would. To save a new preset, enter your custom settings in the Options bar, and then click the Create New Preset icon labeled here. Give the preset a name in the resulting dialog box, click OK, and it appears in the Preset Picker list. To reset a tool to its factory-fresh settings, load additional presets, or access the Preset Manager (Figure 1-17, bottom), click the gear icon.

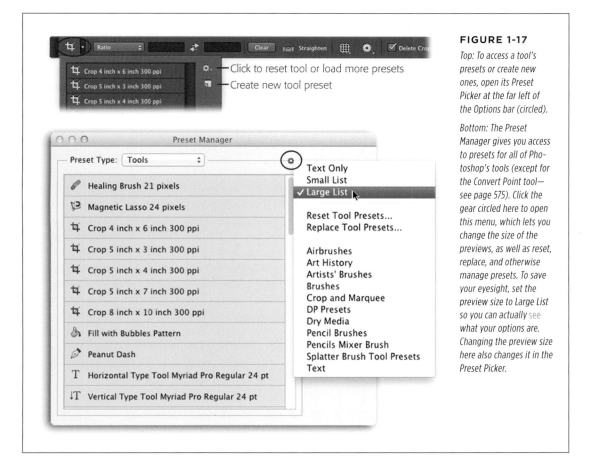

FIGURE 1-17

Top: To access a tool's presets or create new ones, open its Preset Picker at the far left of the Options bar (circled).

Bottom: The Preset Manager gives you access to presets for all of Photoshop's tools (except for the Convert Point tool—see page 575). Click the gear circled here to open this menu, which lets you change the size of the previews, as well as reset, replace, and otherwise manage presets. To save your eyesight, set the preview size to Large List so you can actually see what your options are. Changing the preview size here also changes it in the Preset Picker.

The Preset Manager (Figure 1-17, bottom) handles loading, saving, and sharing Photoshop's built-in presets, as well as any you create yourself. You can open it by choosing Edit→Presets→Preset Manager. Each group of settings, like a category of brushes, is called a *preset library*. To see a certain preset library, choose it from the Preset Type drop-down menu at the top of the Preset Manager.

Clicking the gear icon labeled in Figure 1-17 (bottom) lets you set the category of presets you're viewing to the factory-fresh settings (choose "Reset [name of category] Presets" and then click OK) or load new ones. You can make these adjustments when you're using the tools themselves, but the Preset Manager gives you a bigger preview space, which makes these organizational chores a little more tolerable.

NOTE Photoshop's Migrate Presets feature lets you easily transfer presets from the previous version of the program (in CC, it only transfers presets from the most *current* version of Photoshop; other versions are simply ignored). The first time you crack open Photoshop CC, the program kindly asks whether you want to transfer your presets from the most recent version hanging around on your machine. If you accept, your goodies are copied over to CC (if the older presets have the same name as the newer ones, Photoshop copies only the newer ones). If you don't encounter the Migrate Presets option when you first launch CC, it means the installer didn't find any presets to copy over.

If you didn't migrate your presets when you first launched the Photoshop, you can do it anytime by choosing Edit→Presets→Migrate Presets, or by resetting your preferences (the first Note on page 23 explains how). Happily, migrating presets in CC doesn't require you to *restart* the program before using 'em.

Sharing Presets

Once you've got your own custom settings for tools, styles, or what have you, feel free to share them with the masses. You can share them with other computers (handy when the whole team needs to use the same color swatches or brushes, say) and upload them to the Web (for the whole world to download).

In Photoshop CC, managing and sharing presets is easy:

- **To share *all* your presets**—including actions, keyboard shortcuts, menu customizations, workspaces, brushes, swatches, gradients, styles, patterns, contours, custom shapes, and tools—choose Edit→Presets→Export/Import Presets. In the resulting dialog box, use the Export Presets tab to tell Photoshop which goodies you want to share (say, actions and workspaces), and then click Export Presets (see Figure 1-18). Photoshop opens the "Choose a Folder" dialog box—just pick a spot that's easy for you to find, and then click Open. Photoshop creates a new folder named Exported Presets in the location you picked and dutifully lets you know that it has put your presets there.

 To *import* presets, click the Import Presets tab, and then click Select Import Folder. In the resulting dialog box, navigate to where the presets live on your hard drive and click Open. Back in the Export/Import Presets dialog box, choose the presets you want to import from the left-hand list (or click the Add All button), and then click Import Presets.

FIGURE 1-18

Using the Export/Import Presets command is a great way for big companies, schools, and design firms to share their presets across a whole army of computers. Doing this ensures consistency and accuracy in the artwork they create, and can boost production speed through the use of carefully crafted actions (see Chapter 18).

To choose an item for exporting or importing, double-click it in the column on the left, or single-click it and then use the direction buttons (circled) to add or remove presets from the list.

- **To share just a *few* presets** (excluding actions, keyboard shortcuts, menu customizations, and workspaces) create a preset library of your own by opening the Preset Manager (Edit→Presets→Preset Manager) and choosing the presets you want to share (Shift-click or ⌘-/Ctrl-click to highlight 'em). Next, click the Save Set button, and in the resulting Save dialog box, give your custom library a name. Unless you pick a different location on your hard drive, Photoshop automatically saves it in the folders where it stores *all* custom settings. When everything looks good, click Save.

Once you've saved your custom library, you can email it to folks or upload it to a website for others to download. If you're uploading it to the Web, make sure the file keeps the extension Photoshop gave it (.abr for brushes, for example), and that it doesn't have any spaces in its name (use "DragonScalesBrush" rather than "Dragon Scales Brush," say).

If you're on the receiving end of a preset library, open the Preset Manager and click Load. Navigate to where the library lives, and then click Open. (Alternatively, you can choose Edit→Presets→Export/Import Presets, and then click the Import Presets tab shown in Figure 1-18.) The next time you use a tool that has custom presets, you'll see the new library's options in the tool's Preset Picker menu.

To add to the fun, you can also rename individual presets. In the Preset Manager dialog box, choose the relevant library from the Preset Type menu, and then

click the soon-to-be-renamed preset to activate it. Click the Rename button, type a new moniker in the Name field, and then click OK.

To delete a preset library you never use, choose it from the Preset Manager's Preset Type menu, and then click Delete.

> **TIP** If you've managed to mess up one of Photoshop's built-in preset libraries by adding items that don't work the way you want, you can easily restore it: Open the Preset Manager and choose the library you want to reset. Then, click the gear icon circled back in Figure 1-17, bottom, and choose "Reset [type of preset]" (for example, Brushes). Photoshop asks if you want to replace the current brushes or append (add to) them. Click OK to replace the brushes, and you'll be back to the factory-fresh settings.

Opening, Viewing, and Saving Files

Chances are good that if you're holding this book, you're spending a *lot* of time in Photoshop. So the ability to shave off a minute here and there from routine stuff can really add up. Heck, if you're lucky, you'll save enough time to read a book, ride your bike, or catch an episode of *Marvel's Agents of Shield*.

One way to steal back some of that time is to work more *efficiently*, and that means learning tricks for the less glamorous stuff like opening, viewing, and saving files. And since you'll be doing these things so often, it's important to form good habits so your documents are set up properly from the get-go. (It would be truly heartbreaking to find that the artwork you've spent weeks creating is too small to print, or that you saved the file in such a way that you can't edit its contents later on.) Finally, since a key part of working with images is navigating vast pixel landscapes, this chapter teaches you some handy ways to move around *within* your images onscreen.

■ Creating a New Document

Photoshop gives you a variety of ways to accomplish most tasks, including creating a new document. Sure, you can choose File→New, but it's faster to press ⌘-N (Ctrl+N). Either way, you'll be greeted with the New dialog box shown in Figure 2-1, which Adobe recently simplified slightly.

FIGURE 2-1

Top: The New dialog box is where life begins for any Photoshop file you make from scratch. The settings here let you pick, among other things, the document's dimensions, resolution, and color mode, all of which affect the quality and size of the image. You'll learn more about these options in the following pages.

New in this version of Photoshop is the ability to pick a custom background color. To do so, click the swatch next to the Background Contents menu (circled) to summon the Color Picker.

Bottom: Whatever you enter in the Name box appears in the document's title bar (circled).

You'd think naming a document would be simple: Just type something in the Name box and you're done, right? Not quite. Here are a couple of things to keep in mind:

- If you're working on a Mac, don't start file names with periods. Files whose names start with periods are invisible in Mac OS X (meaning neither you *nor* Photoshop can see them), which makes 'em darn hard to work with. (That said, if you've got the know-how, you can dip into your Mac's Terminal app—or use a third-party program—to see hidden files.)

- If folks need to open your files on both Mac and Windows machines, don't put slashes (/), colons (:), angle brackets (<, >), pipes, (|), asterisks (*), or question marks (?) in the file names, either.

Photoshop's Ready-Made Documents

After you've named your document, you need to pick a size for it. You've got two choices here: Enter the dimensions you'd like in the New dialog box's Width and Height fields, or pick one of Photoshop's canned choices (4"×6" landscape photo, 640×480–pixel web page, and so on) from the Preset and Size menus shown in Figure 2-2.

FIGURE 2-2

Once you choose an option from the Preset menu (which includes different types of paper, electronic formats, and recently opened document sizes), Photoshop sets the Size menu and its related fields (including Width, Height, Resolution, and Color Mode) to the appropriate settings.

Presets are great timesavers, and they can help you avoid mistakes when creating new documents.

The advantage of picking a canned option is that, in addition to filling in the dimensions for you, Photoshop plugs in resolution and color-mode settings. You'll learn more about these two options in a minute, but if you're new to the program, these *presets* (document recipes) are a great way to make sure you're starting off with a well-configured document. If you use a preset in the Film & Video category, for instance, you automatically get document guides that help you keep important parts of the image or text within a safe viewing area (see page 67 for more on guides). Besides, the presets can be helpful even if they're not *exactly* what you need. For example, if you find one that's the right size but the wrong resolution, just pick it, adjust the resolution, and you're on your way. (The box below explains how to create a document that has the same size and resolution settings as an existing one.)

Stealing Document Settings

Need to create a document that's the same size and resolution as an *existing* document? No problem—just snag the original file's settings and use 'em to make another. You can swipe a document's settings in several ways:

- Open the existing document and then press ⌘-N (Ctrl+N) to open the New dialog box. Click the Preset drop-down menu, which includes the names of all open documents. Pick the document you want and Photoshop adjusts all the dialog box's settings to match.

- With the existing document open, press ⌘-A (Ctrl+A) to create a selection around the document's edges, and

then press ⌘-C (Ctrl+C) to copy the document's contents to your computer's memory (a.k.a. the Clipboard). Next, choose File→New or press ⌘-N (Ctrl+N) and Photoshop fills in the document's settings for you. (If you've created a selection that's smaller than the document itself, you can use this maneuver to create a new document that matches the selection's *rectangular* dimensions; see Chapter 4 for the full story on selections.)

- If you want to base your new document on the *last* new document you created since you launched the Photoshop, press ⌘-Option-N (Ctrl+Alt+N) or hold down the Option key (Alt on a PC) while you choose File→New.

TIP Photoshop includes a bunch of presets for common video formats as well as devices such as the iPhone and iPad. Choose Film & Video or Mobile & Devices from the New dialog box's Preset menu and you'll see a slew of useful goodies!

Setting Size and Resolution

In Photoshop, the word "size" refers to two different things: file size (640 kilobytes or 2.4 megabytes, for example) and document dimensions (like 4"×6" or 640×480 pixels). You'll find plenty of advice throughout this book on how to control file size, but this section is about the size of your document's *canvas*.

Photoshop can measure canvas size in pixels, inches, centimeters, millimeters, points, picas, and columns. In the New dialog box, just pick the unit of measurement that's appropriate for your project—or the easiest for you to work with—from the drop-down menus to the right of the Width and Height fields. If you're designing a piece for the Web or for use in presentation software, pixels are your best bet. If you're going to print the image, inches are a common choice. Columns come in handy when you're making an image that has to fit within a specific number of columns in a page-layout program, such as InDesign or QuarkXPress.

NOTE Photoshop assumes you want to use the same unit (say, inches) to measure width and height, so it automatically changes both fields when you adjust one. If you really *do* need to work with different units, just hold the Shift key while you pick the second unit to make Photoshop leave the other field alone.

The New dialog box's Resolution field controls pixel size by specifying the number of pixels per inch or per centimeter in your document. High-resolution documents have smaller pixels, as they contain more pixels per inch than low-resolution documents of the same size. You'll learn all about resolution in Chapter 6. For now, here's some ready-to-use guidance: If you're designing an image that will be viewed only onscreen (in a web browser or a slideshow presentation, for example) enter *72* in the Resolution field. If you're going to print the image at home, set the resolution to at least 240 pixels per inch; if it's headed to a professional printer, enter *300* or more instead.

TIP If you don't know the exact size your document needs to be, it's better to make it really big; you can always shrink it down later. See page 253 for more on resizing documents.

Once you enter values in the Width, Height, and Resolution fields, Photoshop calculates the document's *file size*—the amount of space it takes up on your computer's hard drive—and displays it in the New dialog box's lower-right corner (in Figure 2-1, for example, the file size is 2.25 MB).

Just because you make a document a certain size doesn't mean you can't have artwork in that file that's *bigger* than the document's dimensions. Photoshop is perfectly fine with objects that extend beyond the document's edges (also called *document boundaries*), but you can't see or print those parts. It may sound odd,

but if you paste a photo or a piece of vector art (see the box on page 52) that's larger than your document, those extra bits will dangle off the edges (text that you make with the Type tool can dangle off, too). To resize your document so you can see everything—even the stuff that doesn't quite fit—choose Image→Reveal All; Photoshop modifies the document's dimensions so everything fits.

Choosing a Color Mode

The New dialog box's Color Mode menu determines which colors you can use in the document. You'll spend most of your time in RGB mode (which stands for "red, green, blue"), but you can switch modes whenever you like. (The drop-down menu to the right of the Color Mode menu controls the document's *bit depth*, which is explained in the box on page 42.)

Unless you choose a different color mode, Photoshop automatically uses RGB. The Color Mode menu gives you the following options:

- **Bitmap** restricts you to two colors: black and white. (Shades of gray aren't welcome at the Bitmap party.) This mode is useful when you're scanning high-contrast items like black-and-white text documents or creating graphics for handheld devices that don't have color screens.

- **Grayscale** also contains no color, but expands on Bitmap mode by adding shades of gray between pure black and pure white. The higher the document's bit depth, the more shades of gray—and so the more details—it can contain. Eight-bit documents include 256 shades of gray; 16-bit documents extend that range to over 65,000; and 32-bit documents crank it up to over 4.2 *billion* (see the box on page 42 for more on bit depth). Use this mode if you're designing an ad for a newspaper printed in black and white.

- **RGB Color** is the color mode you'll use the most, and it's also the one your monitor and digital camera use to represent a wide range of colors. This mode shows colors as a mix of red, green, and blue light, with each having a numeric value between 0 and 255 that describes the brightness of each color present (for example, fire-engine red has an RGB value of 250 for red, 5 for green, and 5 for blue). As with Grayscale mode, the higher a document's bit depth, the more details it can contain. In this mode, you can choose among 8-, 16-, and 32-bit documents. (See Chapter 5 for more on RGB mode.)

- **CMYK Color** simulates the colored inks used in professional printing (its name stands for "Cyan, Magenta, Yellow, blacK"). This mode doesn't have as wide of a color range as RGB because it's limited to the colors a printer—whether it's an inkjet, commercial offset, or digital press—can reproduce with ink and dyes on paper. You'll learn more about CMYK in Chapter 5, and Chapter 16 explains when you should use this mode.

- **Lab Color** mode, which is based on the way we see color, lets you use all the colors human eyes can detect. It represents how colors *should look* no matter which device they're displayed on, whereas RGB and CMYK modes limit a file's colors to what's visible onscreen or in a printed document, respectively. The

downside to this mode is that many folks have a hard time creating the colors they want in it. You'll find various techniques involving Lab mode sprinkled throughout Part Two of this book.

Understanding Bit Depth

You may have heard the terms "8-bit" and "16-bit" tossed around in photographic circles (confusingly, neither has anything to do with Photoshop being a 64-bit program, as the box on page xxix explains). When people refer to bits, they're talking about how many colors an image contains. Photoshop's color modes determine whether a document is an 8- or a 16-bit image (other, less common options are 1-bit and 32-bit). Since you'll run into these labels fairly often, it helps to understand what they mean.

A *bit* is the smallest unit of measurement that computers use to store information: either a 1 or a 0 (on or off, respectively). Each pixel in an image has a *bit depth*, which controls how much color information that pixel can hold. So an image's bit depth determines how much color info the image contains. The higher the bit depth, the more colors the image can display. And the more colors in your image, the more info (details) you've got to play with in Photoshop.

To understand bit depth, you need to know a little about *channels*. Photoshop stores your image's color info separated into a single channel for each color (see Chapter 5 for details). For example, an RGB image has three channels: red, green, and blue. By viewing all three channels at once, you see a full color image.

With all that in mind, here's a quick tour of your various bit choices in Photoshop:

- In **Bitmap** color mode, your pixels can be only black or white. Images in this mode are called 1-bit images because each pixel can be only one color—black or white (they're also known simply as *bitmap* images).

- An **8-bit image** can hold two values in each bit, which equals 256 possible color values. Why 256? Since each of the eight bits can hold two possible values, you get 256 combinations. (For math fans, that's 2^8). Images in Grayscale mode contain one channel, so that's 8 bits per channel, equaling 256 colors. Since images in RGB mode contain three channels (red, green, and blue), folks refer to them as 24-bit images (8 bits per channel × 3 = 24), but they're still really just 8-bit images. With 256 combinations for each channel (that's $2^8 \times 2^8 \times 2^8$), you can have over 16 million colors in an RGB image. Since CMYK images have four channels, folks refer to them as 32-bit images (8 bits per channel × 4 = 32), but again, these are *still* 8-bit images. Over 200 combinations per channel and four channels add up to a massive number of possible color values, but since you're dealing with printed ink, your color range in CMYK is dictated by what can actually be reproduced on *paper*, which reduces it to about 55,000 colors.

- **16-bit images** contain 65,536 colors in a single channel and are produced by high-end *digital single-lens reflex* (DSLR) cameras shooting in raw format and/or by really good scanners. On your screen, these files don't look any different from other images, but they take up twice as much hard drive space. Pro photographers love 16-bit images because the extra color range gives them more editing flexibility, even though the larger file sizes can slow Photoshop down. Also, not all of Photoshop's tools and filters work on 16-bit images.

- **32-bit images**, referred to as *high dynamic range* (HDR), contain more colors than you can shake a stick at. See page 421 for more info.

For the most part, you'll deal with 8-bit images, but if you've got a camera that shoots at higher bit depths, by all means, take a weekend and experiment to see if the difference in quality is worth the sacrifice of hard drive space (and editing speed). And if you're restoring a really old photo, it may be helpful to scan it at a high bit depth so you have a wider range of colors to work with. (See the box on page 54 for more scanning tips.)

Choosing a Background

The New dialog box's Background Contents menu lets you choose what's on the *background layer*—the only layer you start out with in a new document or when you open a photo. Your choices are White, Background Color (uses the color your background color chip is set to [page 15]), Transparent (leaves the background completely empty), and a new option: Other. If you pick Other, the Color Picker opens to let you choose a custom color. (The same thing happens if you click the tiny white square to the right of the Background Contents menu.)

What you choose here isn't crucial—if you change your mind, you can fill the background layer with another color (page 92), turn off its visibility (page 84), or delete it once you start adding other layers (your document has to contain *at least* one layer). The Transparent option is handy if your document is part of a bigger project where it'll be placed on top of other artwork; when you choose this option, you see a gray-and-white checkerboard pattern, as explained in the box on page 43.

Advanced Options

The Advanced section at the bottom of the New dialog box contains the following menus:

- **Color Profile.** A *color profile* is a set of instructions that determine how computer monitors and printers display and print your document's colors. Unless you're using a document preset, this menu is set to the same profile listed in the Color Settings dialog box (page 722), which, unless you've changed it, is "sRGB IEC61966-2.1." Leave this setting alone unless you know you need to use a specific color profile for your project; otherwise, the image's colors may not look the way you expect them to. You'll learn all about color profiles on page 720.

FREQUENTLY ASKED QUESTION

Seeing Transparency

What's up with the gray-and-white checkerboard pattern in my new document? I thought it was supposed to be blank!

If you tell Photoshop to make your background layer transparent, then it fills your new document with a checkerboard pattern. Don't worry: That checkerboard is just what the program uses to *represent* transparency on the background layer. In other words, the checkered pattern is just a reminder that there aren't any pixels on that layer (or on that particular *part* of a layer).

If you want, you can change how the checkerboard pattern *looks* by choosing Photoshop→Preferences→Transparency & Gamut (Edit→Preferences→Transparency & Gamut on a PC). In the Transparency Settings area, tweak the options to make the squares bigger or smaller or change their colors. If you can't stand seeing the checkered pattern no matter *what* it looks like, turn it off by setting the Grid Size option to None. When you've got things set the way you want, click OK.

- **Pixel Aspect Ratio.** This setting determines the shape of the image's pixels by changing their size. This setting gets its name from the term *aspect ratio*—the relationship between an image's width and height. (For example, a widescreen television has an aspect ratio of 16:9.) From the factory, Photoshop's pixels are square. Although square pixels are fine for photos, printed images, and onscreen use, they look funky and distorted in video, which has a tendency to make everything appear short and fat (including people). So if you're using Photoshop to make a video, try to find out which video format you need and then choose Film & Video from the Preset menu, and the appropriate size from the Size menu. That way, Photoshop adjusts this setting accordingly.

■ SAVING YOUR CUSTOM SETTINGS

If you've gone to the trouble of getting your document's settings just right and you expect to create *lots* of similar documents, save those settings as a preset before you click OK to create your new document. In the New dialog box, click the Save Preset button to open the dialog box shown in Figure 2-3, and then type a descriptive name for your timesaving preset.

FIGURE 2-3

Use these checkboxes to tell Photoshop which settings you want it to remember. When you create a new document using a preset you've made, the program grabs any settings you didn't include in the preset from the last new document you created. For example, if you turn off the Color Profile checkbox shown here, your preset doesn't include a color profile, so Photoshop assigns the currently active color profile (from Color Settings—see page 722) to the new document.

■ Saving Files

After you've put a ton of work into whipping up a lovely creation, don't forget to save it or you'll never see it again. As in any program, be sure to save early and often so your efforts don't go to waste if your computer crashes or the power goes out.

> **TIP** Photoshop sports a life-saving Auto Recovery feature that automatically saves a backup copy of your document every 10 minutes (though you can change that interval; see the box on page 48). You can also keep working *while* Photoshop saves your file in the background, meaning you don't have to wait until it's finished to do something else. Even slicker is the ability to trigger yet *another* document save before the first one finishes!

The simplest method is to choose File→Save or press ⌘-S (Ctrl+S). If you haven't previously saved the file, Photoshop summons the Save As dialog box so you can pick where to save the file, give it a name, and choose a file format (your options are explained in the next section). If you *have* already saved the file, Photoshop replaces the previously saved version with the *current* version without asking if that's what you want to do. In some situations, that's fine, but it can be disastrous if you wanted to keep more than one version of the document.

NOTE When you're saving files, it's best to leave the *file extension* (the period and three letters, like .psd, or .jpg) on the end of the file name. The file extension makes it easier for your computer to tell what *kind* of file it is so it can pick a program that can open it.

You can play it safe by using the Save As dialog box every time you save. It *always* prompts you for a new file name (see Figure 2-4), which is handy when you want to save another version of the document or save it in a different format. Choose File→Save As or press Shift-⌘-S (Shift+Ctrl+S) to open the dialog box. For documents you create in Photoshop, the format menu is automatically set to Photoshop, which is perfect because that format keeps all your layers and smart objects intact in case you need to go back and change them later. This is the format you want to use while *editing* images. Then, when you're finished and ready to save the image for use in another program—or for posting on the Web or sending in an email—you can save it in a *different* file format, as the next section explains.

NOTE When you run the Save As command, Photoshop assumes you want to save the document in the original folder from whence it came. To change this behavior, choose Photoshop→Preferences→File Handling (Edit→Preferences→File Handling on a PC) and turn off "Save As to Original Folder."

File Formats

You'll learn all about file formats in Chapters 16 and 17, but this section provides a quick overview.

If you remember nothing else, remember to save your images as *PSD files* (Photoshop documents) because, as the previous section explained, that's the most flexible format. That said, sometimes you need to save a document in other formats because of where it's *headed*. For example, InDesign and recent versions of QuarkXPress (two popular page-layout programs) are adept at handling PSD files, but not all programs understand what the heck a PSD file is. In that case, try saving the document as a TIFF file; nearly every image-handling program on the planet can open TIFFs.

FIGURE 2-4

The Save As dialog box lets you save a copy of your file with a different name, in a different location, and in a different format.

When you save a file as a Photoshop document (also known as a PSD file), its layers remain intact and fully editable even after you close the document. In fact, you may want to store all your PSD files from a single photo shoot—right alongside the originals from your camera—in a folder named "in progress."

> **NOTE** If you need to save a document that's bigger than 2.51 GB (that's 30,000×30,000 pixels), save it in Large Document Format (PS*B* format), which gets you past Photoshop's 2 GB limit on PSD files. Photoshop also supports BIGTIFF format, which lets you circumvent the 4 GB size limit of TIFF format.

Graphics destined for the Web are a different animal because they're specially designed for onscreen viewing and faster downloading. Here's a quick cheat sheet to tide you over until you've got time and energy to make your way to Chapter 17:

- **JPEG** is commonly used for graphics that include a wide range of colors, like photos. It compresses images so they take up less space, but the smaller file size comes at a price: loss of quality.

> **NOTE** Because JPEGs can't be saved as 16-bit files, Photoshop automatically converts 'em to 8-bit. If that sentence is as clear as mud to you, flip back to the box on page 42 to learn more about image bit depth.

- **GIF** is a popular choice for graphics that include a limited number of colors (think cartoon art), have a transparent background, or are animated (page 780).

- **PNG** is the up-and-comer because it offers true transparency and a wide range of colors. It produces a higher-quality image than JPEG format, but it generates larger files. Metadata (page 54) and ICC profiles (page 721) are included with the file when you save it as a PNG, and Photoshop now lets you save PNG files that are up to 2 GB in size.

For more on creating and preparing images for the Web, hop over to Chapter 17. If your image is headed for a professional printer, visit Chapter 16 instead.

Opening an Existing Document

Opening files is simple in most programs, and that holds true in Photoshop, too. But Photoshop gives you a few more options than you'll find elsewhere because it's amazingly versatile at working with a wide range of formats. Photoshop knows how to open Adobe Illustrator, Camera Raw (page 54), JPEG, GIF, PNG, TIFF, EPS, and PDF files (page 53), along with Collada DAE, Google Earth 4 KMZ, Scitex CT, Targa, and several other file formats most folks have never *heard* of.

NOTE These days, Photoshop supports more formats than ever, including JPS and PNS (a stereo image pair that's captured by cameras with two lenses or one lens that's split in half to produce 3D images), as well as BIGTIFF (for TIFFs larger than 4 GB). It also allows for more bit depth (think "colors") in TIFF files. (For more on bit depth, see the box on page 42). Photoshop CC lets you open JPEGs that are 65,535 pixels in width or height (in CS6 the limit was 30,000 pixels).

You can open files in Photoshop in several ways, including the following:

- Double-clicking a file's icon whose format is associated with Photoshop (like JPEG or TIFF), no matter where it's stored on your computer.

TIP To change file association on a Mac, single-click the file's icon and then press ⌘-I. In the resulting Info dialog box, locate the Open With section, and then pick a program from the drop-down menu. If you want to change the association for *all* files of that kind on your computer, click Change All.

On a Windows machine, right-click the file's icon and choose "Open with"→"Choose default program." Select the program you want and make sure "Use this app for all [file format] files" is turned on, and then click OK.

Now you can double-click the file and the program you specified will pop open. Nifty, eh?

- On a Mac, dragging the file's icon onto the Photoshop icon (the blue square with "Ps" on it) in the Dock. (This trick *doesn't* work in the Windows taskbar.)

- Control-clicking (right-clicking on a PC) the document's icon and, from the resulting shortcut menu, choosing Open With→Adobe Photoshop CC 2014. (This method works only for file formats that are associated with Photoshop.)

- Launching Photoshop and then choosing File→Open or pressing ⌘-O (Ctrl+O) to rouse the Open dialog box, discussed in the next section.

- Dragging the document's icon into the Photoshop program window.

- Choosing File→"Open as smart object" as discussed on page 51.

You can also use Adobe Bridge to preview and open documents. Head over to Chapter 22 to learn more about using Bridge.

The Open Dialog Box

When you choose File→Open or press ⌘-O (Ctrl+O), Photoshop summons the dialog box shown in Figure 2-5. All you need to do from there is navigate to a file on your hard drive and then click Open.

Photoshop's Magical Auto Recovery

Every time you lose a Photoshop document to a computer crash, a baby frog dies.

OK, not really, but it sure can ruin an otherwise *perfectly* good day.

Happily, Photoshop includes an Auto Recovery feature that automatically saves a backup copy of all your open Photoshop documents as fully layered PSD files every 10 minutes. That's right: If the program crashes, the documents pop back open the next time you launch Photoshop.

These back-up, or *recovered*, documents are stored on you scratch disk (see page 26) in a folder named PSAutoRecover. The only caveat is that if you run out of hard-drive space on your scratch disk, the back-up documents won't be saved.

These back-up documents are temporary and don't hang around forever (which isn't a big deal if you remember to save your file every so often). They disappear if you do any of the following:

- Choose File→Save in your original document.
- Choose File→Revert in your original document.
- Close your original document without ever saving it.
- Close a back-up document without saving it first.
- Save a back-up document to another location.

This fabulous, derrière-saving feature is turned on straight from the factory, though all this automatic saving can take a toll on performance. If you notice that Photoshop feels sluggish—say, if you frequently work with a lot of big documents open at the same time—you can turn Auto Recovery off. Choose Photoshop→Preferences→File Handling (Edit→Preferences→File Handling on a PC) and turn off Automatically Save Recovery Information Every. You can also change the auto-save interval to every 5 minutes by using the drop-down menu to the right of that setting (handy if you're doing detailed retouching and your image is changing significantly every few minutes). If you want to leave Auto Recovery on but have it happen *less* frequently (to increase performance), you can set the auto-save interval to 15 minutes, 30 minutes, or an hour.

FIGURE 2-5

The Open dialog box lets you navigate to the image you want to open. The format drop-down menu at the bottom automatically changes to match the format of the document you pick.

PC users see slightly different options in the Open dialog box than the ones shown here. For example, they don't see the Enable drop-down menu, and the format drop-down menu is unlabeled.

NOTE The Windows version of Photoshop CC sports a recently redesigned Open dialog box that looks just like the standard Windows Explorer window, complete with a search box that helps you locate files faster. Nice!

On a Mac, in addition to letting you peruse the murky depths of your hard drive, the dialog box also lets you narrow your search by choosing a format from the Enable drop-down menu. (Sorry PC folks: The Open dialog box for the Windows version of Photoshop doesn't include this menu.) If you pick just the format you want to find, Photoshop will dutifully dim everything else (you can't choose dimmed items), which is handy when you've saved the same image in several different formats—like PSD, JPEG, and TIFF.

TIP To open more than one file from the Open dialog box, ⌘-click (Ctrl-click) to choose files that aren't next to each other in the list or Shift-click to choose files that are. When you click Open, Photoshop dutifully opens each file you picked.

If you leave the Enable drop-down menu set to All Readable Documents (or, on a PC, leave the unlabeled format menu set to All Formats), you're telling Photoshop

it's OK to open *any* file format it recognizes. If you try to open a format Photoshop *should* know how to open but for some mysterious reason thinks it doesn't (see page 47 for a list of formats Photoshop recognizes), someone may have saved the document with the wrong file extension. (Since all programs, including Photoshop, rely on the file extension to figure out which type of document they're looking at, be careful not to change these multi-letter codes that appear after a document's name.) If you run into this problem, Mac users can use the Format drop-down menu (PC users can choose File→Open As instead) to tell Photoshop which format the document *should* be, and the program will ignore the file's extension and try to open it based on the format you pick.

> **TIP** If you're looking for a specific image but can't remember its name, try using Bridge to find it (see Chapter 22). It gives you a nice preview of each image along with tons of other info like keywords, ratings, and more. Bridge also offers filtering and search options to help hunt down the image you want. Alas, you have to install Bridge *separately* from Photoshop CC; see page 910 for the details.

Opening Multiple Files within a Single Document

If you're creating one image from many—say, to combine several photos into a collage or several group shots into one perfect image where everyone's eyes are open—it's helpful to know how to open multiple files within the same document. As with most things in Photoshop, there are a few ways to get it done:

- **Dragging and dropping files into a Photoshop document.** Simply ⌘-click (Ctrl-click) to activate multiple files and then drag 'em into an open Photoshop document. One by one, the images appear in the document on separate *smart object* layers (you'll learn all about layers in Chapter 3). Photoshop surrounds each image with resizing handles; if you need to resize the image, you can go ahead and do that now (page 253 has more on resizing). To embed an externally linked smart object (page 134), Option-drag (Alt-drag) the file instead.

 Press Return (Enter) to accept the size change—even if you didn't make one—and the *next* image appears on a separate layer, also with resizing handles. Repeat this process until you're finished adding images to the document.

- **Using the "Load Files into Stack" command.** To use this command, choose File→Scripts→"Load Files into Stack." In the resulting Load Layers dialog box, the Use drop-down menu lets you choose what you want to open: individual image files or whole folders of images. Click the Browse button to tell Photoshop where the images or folders are stored on your hard drive; you can ⌘-click (Ctrl-click) files within the Browse dialog box to select more than one at a time. Click Open (OK on a PC) and you're deposited back in the Load Layers dialog box, where you can see the list of images you're about to load. If you're combining several shots into one, turn on "Attempt to Automatically Align Source Images." If you want Photoshop to convert all the layers into a single smart object, turn on "Create Smart Object after Loading Layers." (For more on using smart objects, flip to page 129.)

When you click OK, Photoshop opens the files at warp speed and then copies and pastes them into a *new* document, all on separate layers. (Unfortunately, you can't use this command to add files to an *existing* document. Bummer!)

TIP You can trigger the same behavior in Bridge by activating multiple files in Bridge's Content panel and then choosing Tools→Photoshop→"Load Files into Photoshop Layers." (For more on Bridge, see Chapter 22.)

Opening Files as Smart Objects

Smart objects are one of those glorious features that make Photoshop truly amazing. You'll learn a lot more about them in Chapter 3, but here's a quick overview: smart objects are basically containers that can store raster, vector, or raw files (page 54) in their original formats. (See the box on page 52 for info on rasters vs. vectors.) In this version of Photoshop, that content can be *embedded* inside the Photoshop document or *linked* to wherever the file lives on your hard drive (the latter helps keep your Photoshop document's file size down).

Using smart objects forces Photoshop to keep track of important information about the original file—including its original pixel dimensions and any superpowers inherent to that format, like the ability to resize vectors without sacrificing quality—so you can experiment with different sizes without losing quality, and quickly open the program from whence the image came (such as Illustrator or Camera Raw). In addition to the image types just mentioned, you can also open TIFF, PDF, and JPEG files as smart objects, as well as convert multiple layers or an *entire* Photoshop document into a smart object.

To open an image in a new document as a smart object, choose File→"Open as Smart Object." In the resulting dialog box, choose the file you want to open. When you click Open, Photoshop loads the file as a smart object in a new document. To include an image as a smart object in a document that's *already* open, choose File→Place Embedded or File→Place Linked instead. See Chapter 3 for more about layers and smart objects.

TIP Photoshop opens some images as smart objects *automatically*. Any time you choose File→Place Embedded or Place Linked, or drag a raster image into a Photoshop window, it'll open as a smart object without you having to think twice about it.

Opening Recent Files

This one's a real timesaver. Like many programs, Photoshop keeps track of the documents you've recently opened. Choose File→Open Recent to see a list of the last 20 documents you worked on, with the latest one at the top of the list. If you've moved or renamed the file since you last opened it in Photoshop—put it in a different folder on your hard drive, say—the program will try to find it for you when you choose it from this list. If the document isn't on your hard drive anymore, Photoshop displays a message letting you know it can't find the file.

If you want Photoshop to remember more (or fewer) than 20 files, choose Photoshop→Preferences→File Handling (Edit→Preferences→File Handling on a PC). Then change the number in the "Recent file list contains" field. You can set it as low as two or as high as 100. Just remember that a higher number means a longer list of recent documents to sift through!

Raster Images vs. Vector Images

The images you'll work with and create in Photoshop fall into two categories: those made from *pixels* and those made from *points and paths.* It's important to understand that they have different characteristics and that you need to open them in different ways to *preserve* those characteristics:

- **Raster images** are made from pixels, tiny blocks of color that are the smallest elements of a digital image. The number of pixels in an image depends on the device that captured it (a digital camera or scanner) or the settings you entered when you created the document in Photoshop. The *size* of the pixels depends on the image's resolution (see page 254), which specifies the number of pixels in an inch. Usually pixels are so small that you can't see them individually; but, if you zoom in on a raster image, the pixels get bigger and the image starts to look like a bunch of blocks instead of a smooth image. JPEGs, TIFFs, GIFs, and PNGs are all raster images. (Technically raw files are rasters too; that is, once you open 'em in a program that can *interpret* them, such as Camera Raw).

- **Vector images** are made up of points and paths that form shapes; these shapes are then filled and *stroked* (outlined)

with color. (In Photoshop CC, you can create vector images as easily as in drawing programs such as Adobe Illustrator or CorelDraw.) Paths are based on mathematical equations that tell monitors and printers exactly how to draw the image. Because there aren't any pixels involved, you can make vector images as big or small as you want, and they'll still look as smooth and crisp as the original. Photoshop can open vector images, but unless you open them as smart objects (page 51), Photoshop will turn them into pixel-based raster images through a process called *rasterizing*.

In the figure below, the image on the left is a raster image and the one on the right is a vector image (the right-hand version shows the paths it's made from). Vectors are handy when you're designing logos and other illustrations that you might need to make bigger at some point. You'll end up working with rasters more often than not because *photos* are raster images and Photoshop is a pixel-based program (as are all image-editing and painting programs). That said, Photoshop has a slew of tools you can use to draw vectors (see Chapter 13), and it lets you open vector files. And as page 320 explains, you can create amazing artwork by combining raster and vector images.

Working with PDFs

Saving a document as a PDF file is like taking a *picture* of it so others can open it without needing Photoshop—they just need the free Adobe Reader (or any other PDF-viewing program, like Preview on the Mac). PDFs can store text, images, and even video at a variety of quality settings. They're also *cross-platform*, which means they play nice with both Macs and PCs. It's an amazingly useful file format that's becoming more common every day (see Chapter 16).

You open PDFs the same way you open any file: Choose File→Open, find the PDF you want, and then click Open. If someone created the PDF in Photoshop, it opens right up. If someone created it in another program, Photoshop displays the Import PDF dialog box (Figure 2-6) so you can choose which parts of the document you want to import (full pages or just the images) and set the resolution, dimensions, and so on.

FIGURE 2-6

If you're lucky and the person who created the document was a PDF pro, she may have included size-specification goodies like crop size, bleed area, trim, and art size (you'll learn about most of these terms in Chapter 16). In that case, you can eliminate some resizing work on imported files by choosing one of the size options from the Crop To menu shown here. If you decide to import multiple pages, Photoshop creates a new document for each one.

Working with Scanned Images

It *used* to be the case that, if you had a scanner that knew how to talk to Photoshop, you could use it to import images straight into the program. However, the TWAIN plug-in, which lets Photoshop communicate with scanners, is an older technology that's no longer being updated. These days, Adobe wants you to use the scanning software that came with your scanner instead. Another option is to use the third-party program VueScan (*www.hamrick.com*). If you go that route, save your image as a TIFF *and then* open it in Photoshop.

TIP The Mac version of Photoshop CC includes an Import→"Images from Device" command; however, if you're using Mac OS 10.8 or later, it won't work (to find out why, read the educational yet complex *Macworld* article available at *www.lesa.in/scanninginps*). One solution is to use Apple's Image Capture program to scan the image, and *then* open it in Photoshop.

The bottom line is that these days Adobe *really* doesn't want you scanning images straight into Photoshop because they'd have to keep up with the ever-evolving technological gymnastics that allow scanners and different operating systems to communicate with each other.

Each scanner has its own software, so there's no standard set of steps to work through to perform an actual scan—they're all different. Unfortunately, that means you have to read the documentation that came with your scanner to figure out how to get it done (the nerve!). Nevertheless, the box below has some scanning tips to help you out.

Working with Raw Files

Of all the file formats you can work with, *raw* may be the most useful and flexible. Professional-grade digital cameras (and many high-end consumer cameras) can capture images in this format. The info in a raw file is the exact, unprocessed information the camera recorded when it took the picture. (By contrast, when shooting in JPEG format, the camera processes the image by applying a little noise reduction, sharpening, and color boosting.) Raw files contain the most detailed information you can get from a digital camera, including what's known as *metadata*: info on all the settings the camera used to capture the image, like shutter speed, aperture, and so on. You can edit raw files using the pre-installed Photoshop plug-in *Adobe Camera Raw* (shown in Figure 2-7), where it's *light years* easier to correct color and lighting than in Photoshop. You'll learn more about editing in Camera Raw in Chapter 9.

Scanning 101

Just because all scanning software is different doesn't mean there aren't a few guidelines you can follow to produce good scans. Keep these things in mind the next time you crank open your scanner:

- **Scan at a higher bit depth than you need for the edited image.** Yes, the files will be larger, but they'll contain more color info, which is helpful when you're editing them. (See the box on page 42 for more on bit depth.)

- **Scan at a higher resolution than you need for the finished image so the files include more details.** You can always lower the resolution later, but it's best not to increase it. However, Photoshop CC includes some updated math that makes it pretty darn good at creating enlargements (see the box on page 258 for the scoop).

- **If your scanner software lets you adjust the image's color before you import the file into Photoshop, do it.** Making adjustments before you import the image lets you take advantage of all the info your scanner picked up.

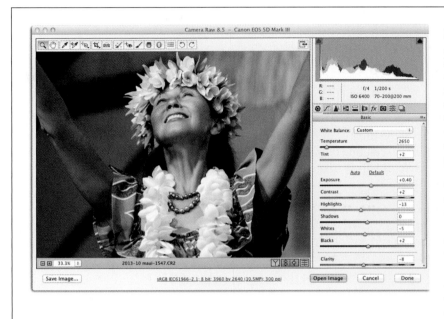

FIGURE 2-7

Adobe Camera Raw (a.k.a. ACR or just Camera Raw), launches automatically when you open a raw file. If you've got a brand-new camera, you may have to update Camera Raw before you can open your photos. To do that, open the Creative Cloud app by clicking its icon at the top of your screen and see if there's an update for Photoshop (online Appendix A has more on checking for updates).

You can also open Camera Raw from within Photoshop as a filter. The box on page 393 has the lowdown.

▩ OPENING RAW FILES

Opening a raw file in Photoshop is just like opening any other kind of image except that it opens in the Camera Raw window instead of the main Photoshop window. You can open raw files by:

- **Double-clicking the file's icon.** Your computer launches Photoshop (if it wasn't running already) and then opens the Camera Raw window.

- **Control-clicking (right-clicking on a PC) the file's icon, and then choosing Open With→Adobe Photoshop CC.** Since Camera Raw is a plug-in that runs in conjunction with Photoshop and Bridge, it isn't listed separately, but your computer knows to open the file in Camera Raw.

- **Using Bridge to find the file, and then choosing File→"Open in Camera Raw" or pressing ⌘-R (Ctrl+R).** You can also Control-click (right-click) the file in Bridge and choose "Open in Camera Raw" from the resulting shortcut menu. (You have to install Bridge separately from Photoshop, as discussed in Chapter 22.)

TIP If you've got a bunch of raw images that need similar edits (cropping, color-correcting, and so on), you can open them all at once by Shift- or ⌘-clicking (Ctrl-clicking) them in Bridge—if you've installed Bridge, that is; see page 910—or by choosing them on your desktop and then double-clicking or dragging them onto the Photoshop icon. When you click Select All at the top left of the Camera Raw window, any edits you make from then on affect *all* your open images. See the box on page 429 for more on editing multiple files.

Duplicating Files

If your client or boss asks you to alter an image and you suspect he'll change his mind later, it's wise to edit a *copy* of the image instead of the original. That way, when he asks you to change everything back, you don't have to sweat bullets hunting for a backup of the original or try to recreate the earlier version. Duplicating files is also handy when creating duotones (page 345) and when you want to experiment with a variety of different treatments.

You can duplicate an open file by choosing File→Save As and renaming the image, but there's a faster way: Make sure the file you want to copy is in the currently active window (just click its window to activate it), and then choose Image→Duplicate. In the Duplicate Image dialog box (Figure 2-8), give the file a new name and then click OK. You've just set yourself up to be the office hero.

FIGURE 2-8

A duplicate PSD file is exactly the same as the original, including layers, layer styles, and so on. If you need to create a single-layer (flattened) version—for use in a program that doesn't support PSD files, say—turn on the Duplicate Merged Layers Only setting shown here. (The section starting on page 118 has more about flattening files.)

◾ Changing Your View

Photoshop gives you a variety of ways to view images, and different views are better for different editing tasks. For example, you can get rid of the Application Frame (page 3), view images full screen, zoom in and out, or rotate your canvas to view images at an angle. This section teaches you how to do all that and more.

Zooming In and Out

Being able to zoom into your image is crucial; it makes fixing imperfections, doing detailed clean-up work, and drawing accurate selections a zillion times easier. One way to zoom is to use the Zoom tool, which looks like a magnifying glass. You can click its icon at the bottom of the Tools panel or simply press Z (see Figure 2-9); then click your image, hold down the mouse button, and drag right to zoom in or drag left to zoom out. Alternatively, you can click repeatedly with the Zoom tool to get as up close and personal with those pixels as you want, and then Option-click (Alt-click on

a PC) to zoom back out. You can also zoom using your keyboard, which is faster if your hands are already on it: Press ⌘ and the + or – key (Ctrl-+/– on a PC).

FIGURE 2-9

Top: You can also use the Zoom tool to focus in on a specific part of your image, but you have to turn off the Scrubby Zoom checkbox in the Options bar first. Then drag with the Zoom tool to draw a box around the pixels you want to look closely at. Release your mouse button, and Photoshop zooms in so the area you selected fills your document window.

Bottom: Zoom in to 501 percent or closer and you'll get the pixel-grid shown here.

TIP If you're moving items around, the pixel grid shown in Figure 2-9 makes it easy to see whether pixels are perfectly aligned horizontally and vertically. That said, you can turn it off by choosing View→Show→Pixel Grid.

If your computer has a graphics processor that supports *OpenGL* (see the box on page 66), you can hold down your mouse button while the Zoom tool is active to *fly* into your image, zooming to a maximum of 3,200 percent; simply Option-click (Alt-click) and hold down your mouse button to zoom back out. This animated zooming makes you feel like you're flying into and out of the image—and it saves you several mouse clicks along the way.

When the Zoom tool is active, the Options bar gives you the following choices:

- **Resize Windows to Fit.** To have Photoshop resize your document window to accommodate the current magnification level, turn on this setting.

- **Zoom All Windows.** Turn on this checkbox to use the Zoom tool to zoom in on *all* open windows by the same amount *simultaneously*. This setting is helpful if you've opened a duplicate of an image in order to see what your edits look like at roughly the size the image might print. You can also use the Window→Arrange submenu to do pretty much the same thing. Your options there include:

 - **Match Zoom.** Zooms all open windows to the same magnification level.

- **Match Location.** Zooms to the same spot in each window.

- **Match Rotation.** Rotates each window's canvas to the same angle.

- **Match All.** Does all of the above.

- **Scrubby Zoom.** This option lets you click and *drag* to zoom. Drag right to zoom in, or left to zoom out.

TIP If you've got a scroll wheel on your mouse, you can use that to zoom, too. Just choose Photoshop→Preferences→General (Edit→Preferences→General on a PC), turn on "Zoom with Scroll Wheel," and then click OK. You can also zoom by typing a percentage into the lower-left corner of the document window next to the status bar (see the box on page 61).

- **100%.** Click this button—which was labeled Actual Pixels in previous versions of Photoshop—to see your image at 100 percent magnification. You can do the same thing by pressing ⌘-1 (Ctrl+1), by double-clicking the Zoom tool in the Tools panel, by entering *100* into the zoom percentage field at the bottom-left corner of the document window, or by choosing View→100%. Whew!

- **Fit Screen.** Clicking this button makes Photoshop resize the image so the whole thing fits inside your document window. (You can also press ⌘-0 [Ctrl+0] or choose View→"Fit on Screen" to do the same thing.) This is incredibly handy when you're using Free Transform (page 276) on an image that's larger than your document—it's tough to grab bounding-box handles if you can't see 'em!

- **Fill Screen.** This button enlarges your image so that it fills all available space in the document window, both horizontally and vertically. Fill Screen makes your image a little bigger than Fit Screen does; you'll need to use the document window's scroll bars to see the whole thing.

The View menu also includes two additional zoom options that you won't find anywhere else:

- **200%.** This option lets you jump to a zoom level of 200% in order to compensate for the extra pixel density found in Apple's super high-resolution Retina displays (called HiDPI in Windows). Because those displays have twice as many pixels as regular displays, images designed for onscreen use look half their size. You can also zoom to 200% by ⌘-double-clicking (Ctrl-double-clicking) the Zoom tool in the Tools panel. To set the zoom of *all* open documents to 200%, Shift-⌘-double-click (Shift-Ctrl-double-click) the Zoom tool in the Tool's panel. Alternatively, you can Ctrl- or right-click your canvas while the Hand or Zoom tool is active and choose 200% from the shortcut menu. And if all that isn't fast enough for you, you can give this command its own keyboard shortcut; the box on page 31 explains how.

TIP Windows users with a HiDPI monitor can try out an experimental feature (page 30) that makes Photoshop *automatically* use a zoom level of 200%. Choose Edit→Preferences→Experimental Features and turn on "Scale UI 200% for high-density displays (Windows Only)."

- **Print Size.** This option used to be available in the Zoom tool's Options bar, but in CC, it lives solely in the View menu. When you choose it, Photoshop *previews* your image at the size it'll be when you print it. Keep in mind that your monitor's resolution settings can make the print-size preview look bigger or smaller than it will really be, so use this feature only as an approximation. (That said, you can use the Screen Resolution field in Photoshop's Units & Rulers preferences to control size in conjunction with monitor resolution.)

TIP If your image is smaller than the document window (meaning you see a gray border around the edges of the image) or if the document window is smaller than the available space in the Application Frame, double-click the Hand tool in the Tools panel and Photoshop enlarges the image to fill the program window.

Moving Around in an Image

Once you've zoomed in on an image, you can use the Hand tool to move to another area without zooming back out. Grab this tool from the Tools panel by clicking its icon (which, not surprisingly, looks like a hand) or pressing H, or just press and hold the space bar on your keyboard (unless you're typing with the Type tool—then you'll type a bunch of spaces!). When your cursor turns into a hand, hold your mouse button down and then drag to move the image. When you get to the right spot, let go of your mouse button.

TIP If you press and hold the Shift key while you're using the Hand tool, Photoshop moves the contents of *all* your open windows at the same time. (You can do the same thing by turning on Scroll All Windows in the Options bar.)

POWER USERS' CLINIC

Zooming with Gestures

If you use a Mac with a multitouch trackpad or a Wacom tablet, you've got yet *another* way to zoom even if the Zoom tool isn't active: Use the pinch and spread gestures. You can also flick left or right with two fingers to move across the image or twist with your finger and thumb to rotate the canvas.

You can see examples of each of these gestures in the Mouse Preference pane. Choose →System Preferences→Mouse, and then click the Trackpad tab. Pick an item in the action list on the left side of the pane to see that gesture in action.

Zooming with gestures is all well and good...until you accidentally zoom or rotate your canvas by *accident*. That's why it's helpful to have the ability to turn Photoshop gestures *off*. To do so, choose Photoshop→Preferences→Interface and turn off Enable Gestures.

If you're using Windows and you've got a touchscreen or a digital drawing tablet (see the box on page 552 for more on the latter), you can use gestures, too, though you don't get the Enable Gestures setting described above.

In recent years, Adobe introduced a couple of other ways to move around a document: *flick panning* and the *birds-eye view* feature. If you've got a computer that can run OpenGL (see the box on page 66), you can use these fast and efficient ways to scoot from one part of image to another. Here's how they work:

- **Flick panning** lets you "toss" an image from one side of the document window to the other, which is kinda fun. Just grab the Hand tool, click the image, and hold down the mouse button. Next, quickly move your mouse in the direction you want to go and then release the button—the image slides along and slowly comes to a stop. You can do the same thing by holding the space bar and then moving your mouse quickly while pressing the mouse button, or while using gestures on a Mac (see the box on page 59).

> **TIP** If you're not a fan of flick panning, you can disable it by choosing Photoshop→Preferences→General (Edit→Preferences→General on a PC) and turning off Enable Flick Panning.

- **Birds-eye view** lets you zoom out of a *magnified* document quickly to see the whole thing (helpful when you're zoomed in so far that you don't know *where* you are in the image). To use it, just press and hold the H key and then click your image and hold the mouse button down: You'll get an instant aerial view of your image with a box marking the area you're zoomed in on. Let go of your mouse button (and the H key) to zoom back in.

Getting Oriented with the Navigator Panel

You can think of the Navigator panel as your GPS within Photoshop. It shows you what part of an image you're zoomed in on. To open it, choose Window→Navigator. The panel displays a small version of your image called a *thumbnail* and marks the area you're zoomed in on with a red box called the *proxy preview*. At the bottom of the panel, the percentage field shows your current magnification level; enter another number here to change it. You can zoom into or out of the image by clicking the zoom buttons at the bottom of the panel (they look like little mountains) or by adjusting the slider nestled between them (see Figure 2-10).

The Status Bar: Document Info Central

At the bottom of each document window is the *status bar*, shown below, which displays important info about your document. When you first start using Photoshop, the status bar shows the size of the document; K stands for kilobytes and M for megabytes. (If you don't see any status information, the document's window may be too small. Just drag the lower-right corner of the window to enlarge it. The curved-arrow icon to the *left* of the status bar is discussed on page 61.)

Click the triangle next to the status bar (circled) and you get a menu that lets you control what the bar displays. Here's what you can choose from (the status bar only displays *one* of these bits of info at a time):

- **Adobe Drive** connects to *Version Cue* servers. Version Cue was Adobe's method of attaching versions and enabling asset management throughout all of its programs, but they discontinued Version Cue back in Photoshop CS5. For more on Adobe Drive, see the Note on page 25.

- **Document Sizes** displays the image's approximate printing size (on the left) and approximate saved size (on the right). This option is selected from the factory.

- **Document Profile** shows the image's color profile (page 720).

- **Document Dimensions** displays the width, height, and resolution of the image.

- **Measurement Scale** lets you see the scale of pixels compared with other units of measurement. For example, an image from a microscope can measure objects in microns, and each micron can equal a certain number of pixels.

- **Scratch Sizes** tells you how much memory and hard disk space Photoshop is using to display your open documents.

- **Efficiency** lets you know whether Photoshop is performing tasks as fast as it possibly can. A number below 100 percent means the program is running slowly because it's relying on scratch-disk space (page 26).

- **Timing** shows how long it took Photoshop to perform the most recent activity.

- **Current Tool** displays the name of the currently active tool.

- **32-bit Exposure** lets you adjust the preview image for 32-bit HDR images (see page 423).

- **Save Progress** displays the world's tiniest status bar, which indicates Photoshop's progress in saving a file.

- **Smart Objects** is a new option. It lets you monitor the status of *linked* smart objects (page 137) to see if any are missing (you placed a linked smart object and then *moved* the original file on your hard drive, say) or have changed (you modified the original file while the Photoshop document was closed, say).

25% © 8.333 in × 5.483 in (300 ppi) ►

Zoom
percentage

Status bar

Adobe Drive
Document Sizes
Document Profile
Document Dimensions
Measurement Scale
Scratch Sizes
Efficiency
Timing
Current Tool
32-bit Exposure
Save Progress
Smart Objects

FIGURE 2-10

As you zoom in on an image, the proxy preview box shrinks because you're looking at a smaller area. You can drag the box around to cruise to another spot in the image.

To change the color of the proxy preview box, choose Panel Options from the Navigator panel's menu. In the dialog box that appears, click the red color swatch, pick another color from the resulting Color Picker, and then click OK.

To make the Navigator panel bigger, drag its bottom-right corner downward.

Your current viewing area

Drag to increase panel size

Zoom out Zoom slider Zoom in

Rotating Your Canvas

If you're an artist, you're gonna love this feature! The Rotate View tool rotates your canvas—without harming any pixels—so you can edit, draw, and paint at a more natural angle (see Figure 2-11). It's like shifting a piece of paper or angling a canvas, but it doesn't rotate the actual image—just your *view* of the image. (The box on page 68 explains the difference between image size and canvas space.) Bear in mind, though, that your computer needs to be able to run OpenGL for this feature to work (see the box on page 66). To use this tool, press R or choose it from the Hand tool's toolset in the Tools panel.

NOTE MacBook, MacBook Air, and MacBook Pro users with multitouch trackpads can rotate the canvas by using the two-finger rotate gesture. See the box on page 59 for more on using Mac gestures.

FIGURE 2-11

Grab the Rotate View tool, mouse over to your image, and then drag diagonally up or down to rotate it. When you drag, a compass appears that shows how far from "north" you're rotating the canvas, as shown here. If you're not the dragging type, enter a number into the Options bar's Rotation Angle field or spin the little round dial to the field's right. To straighten your canvas back out, click Reset View in the Options bar. To rotate all open images, turn on the Rotate All Windows checkbox.

This tool is handy if you use a digital drawing tablet (see the box on page 552) and you're retouching people (Chapter 10) or painting (Chapter 12).

■ Arranging Open Images

The Application Frame and tabbed-document workspace help you manage several open documents; if you turn off the Application Frame, your documents can get scattered across your screen. However, you can herd open windows together by using the commands listed under Window→Arrange (see Figure 2-12).

FIGURE 2-12

Use the Window→ Arrange commands to create order out of chaos by tiling (top) or cascading (bottom) your windows. (You can't cascade tabbed documents because they're attached—or rather, docked—to the top of the Photoshop window. The fix is to choose Window→Arrange→ "Float All in Windows" first, and then choose Cascade.)

When the Application bar was removed back in CS6, the Arrange Documents menu disappeared along with it; however, Adobe moved its commands to the Window→Arrange submenu.

The Window→Arrange submenu offers a slew of choices:

- **Tile All Vertically** resizes your windows so you can see them all in columns.

- **Tile All Horizontally** does nearly the same thing, but arranges them in rows.

- **2-up, 3-up Horizontal** resizes two or three windows so they fit one on top of the other in rows.

- **2-up, 3-up Vertical** resizes two or three windows so they fit side by side in columns.

- **3-up Stacked** resizes three windows side by side with one in a column and two in rows.

- **4-up, 6-up** resizes four or six windows side by side in a tic tac toe–style grid.

- **Consolidate All to Tabs** groups your open images in a single, tabbed window as shown in Figure 2-13, top.

FIGURE 2-13

Tabbed documents are a handy way to organize open windows. You can slide the tabs left or right to rearrange them (top) or drag a tab out of the tab area to create a floating window (upper middle). To redock a floating window, just drag its tab back into the main tab area (lower middle).

To close all tabbed documents, choose File→Close All. If Photoshop sees that you've edited some or all of those images, it asks if you'd like to save each edited image before closing it. To apply your answer to all the documents you're closing, turn on "Apply to All," as shown here (bottom).

If the Move tool is active, you can Option-click (Shift-click) the tiny X at the far left (far right on a PC) of each document tab to close all open documents, but for unknown reasons you don't get the "Apply to All" option with this method. Weird!

- **Cascade** stacks your windows on top of one another, putting the largest one on the bottom and the smallest on the top.

- **Tile** resizes your windows to identical sizes and arranges them in rows and columns.

- **Float in Window** puts the current document in its own window if it's part of a tabbed group of documents that share the same window.

- **Float All in Windows** splits all tabbed documents out into their own windows and cascades these windows.

TIP You can Control-click (right-click) a document's tab to reveal a shortcut menu that lets you close that document's window, close all windows, create a new document, open an existing one, or reveal where that document lives on your hard drive.

And you can cycle through all open documents by using the ⌘-tilde (~) keyboard shortcut (Ctrl+Tab on a PC). To cycle through documents in the reverse order, press Shift-⌘-tilde (Shift+Ctrl+Tab) instead. This is especially handy when you're showing off images in Full Screen mode, as described on page 6.

UP TO SPEED

Understanding the GPU, OpenGL, and OpenCL

You might not know it, but your computer actually has *two* brains: a CPU (*central processing unit*) for interpreting and executing instructions, and a GPU (*graphics processing unit*, also called a *video card*) for displaying images and videos.

Newer GPUs take advantage of a technology called *OpenGL*, which helps computers draw and display graphics quickly and efficiently. (To learn more about it, go to *www.opengl.org*.) You can tell whether your GPU uses OpenGL by choosing Photoshop→Preferences→Performance (Edit→Preferences→Performance on a PC). In the Graphics Processor Settings section, check whether Use Graphics Processor is turned on (it probably will be). If the checkbox is dimmed (meaning you can't turn it on), then your computer's video card isn't fast enough or doesn't have enough memory to run OpenGL—le sigh.

If your computer can't run OpenGL, some Photoshop features will take a long time to run. Others won't work at all, includ-

ing the Rotate View tool, birds-eye view, smooth pan and zoom, pixel-grid overlay (Figure 2-9), flick panning, scrubby zoom, HUD Color Picker, rich cursor info, the Eyedropper tool's sampling ring, on-canvas brush resizing, and brush bristle tip preview. Other nifty features in CC that require OpenGL include all the 3D features, Auto Recovery, Free Transform's Warp option, Puppet Warp preview, the Liquify filter, the Adaptive Wide Angle filter, the Lighting Effects Gallery, as well as all the filters in the Blur Gallery (page 691).

GPUs that are brand-spanking-new also support *OpenCL*, a technology that lets Photoshop use the GPU for processing tasks that *aren't* specifically related to viewing graphics. Features that can use OpenCL include the Blur Gallery filters, which all perform better now than ever before.

Bet you feel like *you* have two brains now, too!

■ Guides, Grids, and Rulers

Placing all the components of your design in the right spots can be challenging, and if you're a real stickler for details, close isn't good enough. This section teaches you how to use Photoshop's guides, grids, and rulers to get everything positioned *perfectly*. Adobe calls these little helpers *extras*, and you access them via the View menu.

Rulers and Guides

Properly positioning objects on your canvas can be the difference between a basic design and a masterpiece. The quickest way to position and align objects is by drawing a straight line to nestle them against. You can do just that using Photoshop's nonprinting *guides*—vertical and horizontal lines you can place anywhere you want (see Figure 2-14).

FIGURE 2-14

Guides help you position items exactly where you want 'em. Here, the light blue (cyan) guides help make sure all the text is the same width and the edges of the poster are free of clutter. Guides don't show up when you print the image, so you don't have to worry about deleting them.

To add a guide in a certain spot, choose View→New Guide and then enter the position in the resulting dialog box. If you have trouble grabbing a guide to move it, try making the document window bigger than the canvas by dragging one of the window's edges, or its lower-right corner, diagonally. That way, the guides extend beyond the canvas and don't overlap other elements you might accidentally grab.

You can change the rulers' unit of measurement on the fly by Control-clicking (right-clicking) the ruler and then choosing the unit you want from the resulting shortcut menu. Alternatively, you can change it in the Units & Rulers preferences (page 28).

The easiest way to add guides is to drag 'em into your document, but before you can do that, you need to turn on Photoshop's *rulers* by pressing ⌘-R (Ctrl+R) or choosing View→Rulers. Either way, the rulers appear on the top and left edges of the document window.

Once the rulers are visible, you can add a guide by clicking either ruler, and then dragging the guide into your document as shown in Figure 2-14 (you won't see the guide until you start dragging). After that, you can do any of the following:

- **Move the guide** with the Move tool: press V (think "moVe") to activate the tool, and then drag the guide to a new spot (your cursor turns into a double-sided arrow like the one circled in Figure 2-14).

- **Snap objects to the guide** by turning on Photoshop's *snap* feature. When you're using the Move tool, snapping makes it super easy to align objects because, when they get close to one of your guides, they jump to it as if they were magnetized. You can tell that an object has snapped to the nearest guide because it pops into place. After the object aligns to a guide, you can move it along that line to snap it into place with other guides, too. If you don't want an object aligned with a certain guide, just keep moving it—it'll let go of the guide as soon as you move it far enough. This feature is turned *on* initially, though you can turn it off by choosing View→Snap To→Guides (handy when you can't position an object where you want to because it keeps snapping to align with a guide).

> **NOTE** Straight from the factory, layer content snaps to grids, layers (Chapter 3), slices (page 787), *and* the edges of your document. You can choose among these items by choosing View→Snap To and then picking the elements you *actually* want objects to align with. For example, choosing both Guides and Layers makes the object you're moving snap to guides and the edges of objects on other layers.

- **Hide all guides** by pressing ⌘-; (Ctrl+;) or by choosing View→Show→Guides.

- **Delete a guide** by dragging it into the ruler area.

- **Delete all guides** by choosing View→Clear Guides.

- **Lock all guides** by choosing View→Lock Guides or pressing Option-⌘-; (Alt+Ctrl+;)—useful when you don't want to accidentally move a guide.

UP TO SPEED

Image Size vs. Canvas Space

One thing that's super confusing to Photoshop beginners is the difference between image size and canvas size. In Photoshop, the *canvas* is the amount of viewable and editable area in a document (it's the same as the document's dimensions) and you can add to or subtract from it anytime. By doing so, you add or subtract pixels from the document—thereby increasing or decreasing its file size—but that doesn't change the size of your *image*. In other words, if you open an image and increase the document's canvas size, the image doesn't change size, but

you'll see extra space *around* it. To alter canvas size, you can either use the Crop tool (page 244) or choose Image→Canvas Size (page 270).

For example, say you're designing a postcard for an event and you're experimenting with the design. To add room for text, you can make the canvas bigger than the imagery you opened or placed. Then, once you've nailed down the final design, you can crop or trim (page 246) the document down to the size you want to print.

■ SMART GUIDES

Smart guides are a little different from regular guides in that they automatically appear onscreen to show the spatial relationship between objects. For example, they pop up when objects are aligned or evenly spaced in your document. As you drag an object, smart guides appear whenever the current object is horizontally, vertically, or centrally aligned with other objects on other layers.

In Photoshop CC 2014, smart guides are automatically turned *on*, plus they give you handy measurement readouts to help you precisely position layer content in relation to content on *other* layers. You'll see 'em in action on page 104.

■ USING THE DOCUMENT GRID

If you want *lots* of guides without all the work of placing them, you can add a grid to your image instead by choosing View→Show→Grid. Straight from the factory, Photoshop's gridlines are spaced an inch apart with four subdivisions, although you can change that by choosing Photoshop→Preferences→"Guides, Grid & Slices" (Edit→Preferences→"Guides, Grid & Slices" on a PC), as Figure 2-15 explains.

Bra/skirt with tassels: $325
Red cape: $75
Being seen belly-dancing
by your ex: Priceless

FIGURE 2-15

Photoshop's grid is helpful when you need to align lots of different items, like the text shown here. You can turn it on by pressing ⌘-' (Ctrl+' on a PC).

In the Preferences dialog box, adjust the gridline marks by changing the number in the Gridline Every field, and use the drop-down menu next to it to change the grid's unit of measurement: pixels, inches, centimeters, millimeters, points, picas, or percent. The Subdivisions field controls how many lines appear between each gridline—if any.

To turn off all of Photoshop's extras—that is, guides, grid, and slices—in one fell swoop, choose View→Extras. But even if you do that, any extra that's individually turned on in the View→Show menu will reappear the next time you open a document or create a new one, which could drive you bonkers. The fix is to specifically turn off the offending item—say, the grid—in the View→Show menu.

The Ruler Tool

In addition to the rulers you learned about earlier, Photoshop also gives you a virtual tape measure and protractor: the Ruler tool, which lets you measure the distance between two points in a document. Just grab the tool by pressing Shift-I repeatedly (it's hiding in the Eyedropper toolset and it looks like a little ruler), and then click and hold your mouse button where you want to start measuring. Drag across the area or object, and you'll see a line appear in your document (see Figure 2-16).

FIGURE 2-16

To measure a perfectly straight horizontal or vertical line, hold the Shift key as you drag. When you release your mouse button, the Options bar displays the measurement between the line's start and end points.

To change the angle of a line you drew with the Ruler tool, just grab one of its endpoints and drag it to another spot. To move a ruler line, grab it anywhere other than its endpoints and drag it to another location.

When you're using the Ruler tool, the Options bar's measurements get a little confusing. Here's what they mean:

- **X and Y.** These *axes* mark the horizontal and vertical coordinates (respectively) at the start of your ruler line. For example, if you start the line at the 4-inch mark on the horizontal ruler and the 7-inch mark on the vertical ruler, your coordinates are X: 4 and Y: 7.

- **W and H.** Calculates the distance your line has traveled from the X and Y axes.

- **A.** Displays the angle of the line relative to the X axis. If you have two lines, it indicates the angle *between* the two lines.

- **L1.** Indicates the length of the line.

- **L2.** You see a number here only if you use a virtual *protractor*. (Thought you left protractors behind in high school, didn't you? Quick refresher: Protractors help you measure angles.) To create a protractor, Option-drag (Alt-drag on a PC) at an angle from the end of your ruler line. This number represents the length of the second line.

- **Use Measurement Scale.** Photoshop includes a set of rulers, but it has nothing upon which to *base* the measurements you make with those rulers. For example, a photo of a garden gnome doesn't indicate the gnome's actual size. So if you use the Ruler tool to measure the width of the gnome in Photoshop, it could be .25 inch or 25 pixels—depending upon the unit of measurement you've picked in Units & Rulers preferences—rather than its real-world size of 6 inches. However, by choosing Image→Analysis→Set Measurement Scale→Custom and then entering the logical (real-world) length of an inch or pixel, you give Photoshop a scale upon which to base its measurements. Photoshop then uses this new scale when you turn on Use Measurement Scale in the Ruler tool's Options bar.

- **Straighten Layer.** To use the Ruler tool to straighten your image, draw a line across an area that should be straight (like the horizon), and then click this button. Photoshop straightens the image and crops it to get rid of crooked and transparent edges. To make Photoshop straighten the image *without* cropping it, Option-click (Alt-click) this button instead. (If you forget to press Option [Alt], you can undo the crop by pressing ⌘-Z [Ctrl+Z].)

NOTE You can straighten images while using the Crop tool, too (see page 247 for the scoop). And as luck would have it, you can also straighten images using Camera Raw (page 249).

- **Clear.** Any ruler line you draw hangs around until you tell it to go away by clicking this button or drawing another ruler line. But ruler lines don't print even if you forget to clear them, so don't lose any sleep over 'em.

Layers: The Key to Nondestructive Editing

Photoshop gives you two ways to edit files: destructively and nondestructively. *Destructive editing* means you're changing the original image—once you exceed the History panel's limit (page 17) and save your document, those changes are (gulp) permanent. *Nondestructive editing* means you're not changing the original file and you can go back to it at any time. Folks new to image editing tend to use the first method and experienced pixel-jockeys the second—and you'll likely see a tiny cloud of smugness floating above the latter.

When you're working in Photoshop, it's best to keep your documents as flexible as possible. People (even you!) change their minds hourly about what looks good, what they want, and where they want it—all of which is no big deal if you're prepared for that. But if you're not, you'll spend a ton of time *redoing* what you've already done from scratch. To avoid that kind of suffering, you can use *layers*, a set of stackable transparencies that together form a whole image (see Figure 3-1). Layers are your ticket to nondestructive and therefore safer, *non-committal* editing. (If only we had layers in real life!)

NOTE Another argument for using layers is that they let you easily apply the same effect you're creating in one image to other images (by dragging and dropping the relevant layers into another open document), as well as reverse-engineer a technique or effect that you created years ago in order to apply it to a *new* image today.

FIGURE 3-1

You can think of layers like the ingredients on this pizza (really!).

In the Photoshop workspace, most folks keep their document window on the left and Layers panel on the right. By looking straight down at this pizza, you get a bird's-eye view of it like the left-hand image here, which represents what you see in your document window. Even though the pizza is made up of many layers (the different toppings, sauces, and dough), you see a single image.

The Layers panel shows you an exploded view, like the right-hand image here. If some of the toppings don't cover the pizza's entire surface—like the bell peppers and mushrooms—you can see through that layer to what's on the other layers below: the pepperoni, cheese, sauce, and dough. This kind of image is called a composite, a seemingly single image that's made from many. The act of creating one image from many is called compositing.

With layers, you can make all kinds of changes to an image without altering the original. For example, you can use one layer to color-correct a photo (Chapter 9), another to whiten your subject's teeth (page 449), and yet *another* to add a backdrop of Maui to make it look like the photo shoot was held in the Hawaiian Islands instead of at the local park (page 291). Using layers also lets you:

- Resize an object independently of everything else in the document, without changing the document's size (page 253).

- Move an object or text around within the document without moving anything else (page 102).

- Combine several images into one document to make a collage (Chapter 7).

- Make most of an image black and white while leaving part of it in color (see page 338).

- Fix the color and lighting in a photo (or just parts of it) without harming the original (see Figure 3-31 on page 125).

- Remove blemishes and other objects without harming the original (Chapter 10).

- Add editable text on top of an image (pages 123 and 656).

The *best* part about using layers is that, once you save a document as a PSD file (page 45), you can close it, forget about it, and open it next week to find your layers—and thus all your changes—intact. Learning to love layers is *key* to a successful Photoshop career because they let you edit images with maximum flexibility.

In this chapter, you'll learn about the different kinds of layers, how to create them, and when to use them. You'll also find out about the fun and useful features that you can use *with* layers, such as layer styles, layer groups, layer comps and, the most useful of all, layer masks. By the time you're done, you'll be shouting the praises of nondestructive editing from the highest rooftop! (Whether you do it smugly is up to you.)

■ Layer Basics

Layers come in many flavors, all of which have their own special purpose:

- **Image layers.** These layers are pixel-based (see page 254)—in fact, some folks calls 'em *pixel layers*—and you'll work with them all the time. If you open a photo or add a new, empty layer and then paint on it (Chapter 12), you've got yourself an image layer.

- **Fill layers.** When it comes to adding color to an image, these layers are your best friends. They let you fill a layer with a solid color, gradient, or pattern—handy when you want to create new backgrounds or fill a selection with color. You can also use them to change the color of art that you've placed in Photoshop (page 347). Just like shape layers (which are explained in a sec), you can double-click a fill layer's thumbnail anytime to change its color. The next time you're tempted to add an empty layer and fill it with color (page 92), try using one of these layers instead.

- **Adjustment layers.** These ever-so-useful layers let you apply changes to one or all the layers underneath them, though the changes actually happen on the adjustment layer. For example, if you want to change a color image to black and white, you can use a black & white adjustment layer (page 330) so the color removal happens on its *own* layer, leaving the original unharmed. These layers don't contain any pixels, just instructions that tell Photoshop what changes you want to make (which is why you can't use any of the program's painting tools on them). Adjustment layers are also handy for creating *reusable* effects; to apply the same effect to another image, just drag the adjustment layer from one document to the other.

 You can access these handy helpers in the Adjustments panel on the right side of the Photoshop window (if you don't see it, choose Window→Adjustments), via the adjustment layer icon at the bottom of the Layers panel (the half-black/half-white circle), or in the Layer menu (choose Layer→New adjustment layer). There are 16 kinds of adjustment layers, and you'll learn how to use 'em in Part Two of this book.

- **Smart objects.** Adobe refers to this kind of layer as a *container*, though "layer wrapper" is a better description. You can put anything you want into the protective wrappings of a smart object—pixel-based images, raw images (page 54), vector files (see the box on page 52), other layers, or even whole Photoshop documents—and Photoshop keeps that content safe by making changes to the *wrapper* instead of the *content*. This lets you resize the contents of a smart object without trashing its quality (as long as you don't exceed the file's original pixel dimensions, unless it's a vector), swap content with another image, run filters nondestructively, and much more. Flip to page 129 for more info.

- **Shape layers.** These layers are vector-based, meaning they're made from points and paths, not pixels (see the box on page 52). Not only can you quickly create useful shapes with these babies, but you can also resize 'em without losing quality *and* change their fill color by double-clicking their layer thumbnails or using the Options bar's Fill and Stroke settings. Photoshop creates a shape layer automatically anytime you use a shape tool (unless you change the tool's drawing mode as explained on page 568).

- **Type layers.** Photoshop text isn't made from pixels, so it gets its own special kind of layer. Any time you grab the Type tool and start pecking away, Photoshop automatically creates a type layer. See Chapter 14 for the full story on creating gorgeous text.

- **Video layers.** Want to edit video in Photoshop? No problem. These layers give you the ability to import, trim, and split video clips, as well as add transitions, motion, and even audio tracks. You can use Photoshop to color-correct, apply filters, and add layer styles to video. You'll learn all about editing videos in Chapter 20.

- **3D layers.** As you might suspect, these layers let you create three-dimensional objects from scratch, make text that looks 3D, and import existing 3D files so you can add custom paint and other details to 'em. To get started using Photoshop's 3D tools, head on over to Chapter 21.

The Layers Panel

No matter how many or what kind of layers your document contains, the one that's most important to you at any given time is the *active* layer. You can tell which layer is active by peeking at the Layers panel, where Photoshop highlights it in blue, as shown in Figure 3-2. (If you don't see the Layers panel, click its tab in the panel dock on the right side of your screen, or choose Window→Layers.) The next edit you make will affect *only* that layer.

Activating Layers

About the easiest thing you'll ever do in Photoshop is activate a layer—just mouse over to the Layers panel and click the layer you want to work on. However, just because this process is easy doesn't mean it's unimportant. As you learned in the last section, most of Photoshop's tools and commands affect only the *currently active layer* (the exceptions are things like cropping or changing your document's color mode).

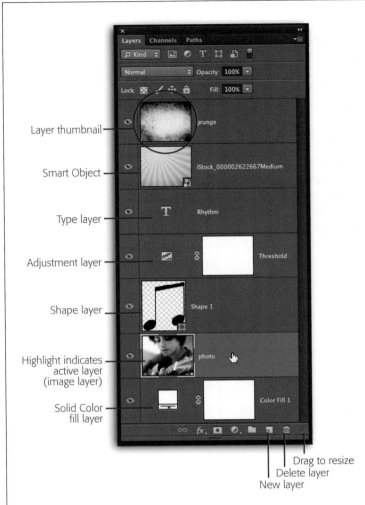

Layer thumbnail

Smart Object

Type layer

Adjustment layer

Shape layer

Highlight indicates
active layer
(image layer)

Solid Color
fill layer

Drag to resize
Delete layer
New layer

FIGURE 3-2

In the Layers panel, Photoshop highlights the currently active layer in blue, as shown here (the exact color of blue depends on the color theme you're using [page 8]).

Each layer has its own little preview of what the layer contains, called a layer thumbnail (circled). To make layer thumbnails bigger so they're easier to see, open the panel menu labeled here and choose Panel Options. The resulting dialog box includes a list of thumbnail sizes to choose from. Alternatively, you can Control-click (right-click) the layer thumbnail and choose a size from the resulting menu.

If you're trying to use a tool and Photoshop doesn't seem to be responding, take a peek at the Layers panel and make sure you've got the right layer activated. Nine times out of ten, you'll find that you don't!

As your document gets more complex and your Layers panel starts to grow (and it will), it can be hard to figure out *which* layer each part of your image lives on. If you want, you can make Photoshop *guess* which layer an object is on: Press V to activate the Move tool, head up to the Options bar at the top of your screen, turn on Auto-Select, and then choose Layer from the drop-down menu to its right. After that, when you click an object in the document, Photoshop activates the layer it *thinks* that object is on (it'll do this next time you use the Move tool, too, unless you turn off Auto-Select).

The program may or may not guess right, and this feature really works only if your layers don't completely cover each other up (in which case it may activate too many layers). If you've got a document full of isolated objects—ones without backgrounds—on different layers, give this feature a shot. But if you're working on a multilayered collage (or if you're editing video), forget it. For that reason, you'll probably want to leave Auto-Select turned *off*.

> **TIP** You can have Photoshop narrow down your layer-hunting options by prodding it to give you a list of layers it *thinks* an object is on. Press V to grab the Move tool, Control-click (right-click) an object in your document, and then choose one of the layers from the resulting shortcut menu. This trick is incredibly helpful, though it only works if the layer's visibility is turned on (page 84) and you click an area that's more than 10 percent opaque (in older versions of the program, the requirement was 50 percent opaque).

■ ACTIVATING MULTIPLE LAYERS

You'd be surprised how often you need to do the same thing to more than one layer. If you want to rearrange a few of them in your layer stack (page 85), move 'em around in your document together (page 102), *resize* them simultaneously (page 101), or change their opacity, fill, or even blend mode settings, you need to activate 'em first. Photoshop lets you activate as few or as many layers as you want, though how you go about it depends on where they live in the Layers panel:

- **All layers.** To activate *all* the layers in your Layers panel—*except* for the locked background layer, if you have one—choose Select→All Layers. Keyboard shortcut: Option-⌘-A (Alt+Ctrl+A). To deselect all your layers, choose Deselect→All Layers.

- **Consecutive layers.** To activate layers that are next to each other in the Layers panel, click the first one, and then Shift-click the last one; Photoshop automatically activates everything in between (see Figure 3-3, left).

- **Nonconsecutive layers.** To activate layers that *aren't* next to each other, click near the first one's name, and then ⌘-click (Ctrl-click on a PC) *near the layer name* of the rest of them (see Figure 3-3, right). If you ⌘-click (Ctrl-click) a layer's name, Photoshop loads the layer's content as a selection.

- **Linked layers.** If you've linked any layers together (page 109), you can activate them by clicking one, and then choosing Layer→Select Linked Layers; Photoshop activates all the layers that are linked to one you clicked. This command also lives in the Layers panel's menu—the one in its upper right—as well as the shortcut menu you get by Control-clicking (right-clicking) to the right of a layer thumbnail.

> **NOTE** Activating a layer is *completely* different from loading a layer's contents as a *selection*. When you load a layer as a selection, you see marching ants running around whatever is on that layer. Activating a layer simply makes that layer active so you can perform edits in it. See Chapter 4 for more on selections.

■ FILTERING LAYERS

If your list of layers is *really* long, you'll have to scroll through the Layers panel to find the ones you want to activate. However, you can make Photoshop *hide* layers based on conditions you specify using the filtering controls at the top of the Layers panel (labeled in Figure 3-4, top). When you tell Photoshop which layers you want to view, it temporarily *hides* the rest in the Layers panel (though the *content* of the hidden layers is still visible in your document).

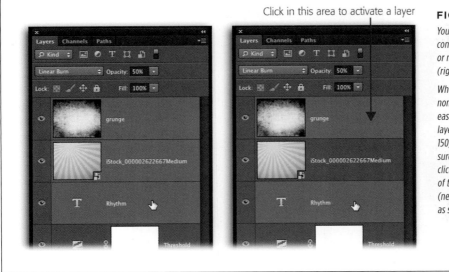

Click in this area to activate a layer

FIGURE 3-3

You can activate consecutive layers (left) or nonconsecutive layers (right).

When you're activating nonconsecutive layers, it's easy to accidentally load a layer as a selection (page 150). To avoid that, make sure you ⌘-click (Ctrl-click) the area to the right of the layer thumbnail (near the layer's name), as shown here.

To filter layers, pick an option from the drop-down menu in the top left of the Layers panel, and then use the controls to the menu's right to refine your search (these controls change depending on what you pick in the drop-down menu). Here are your options:

- **Kind.** This is what the drop-down menu is set to unless you change it. This option lets you tell Photoshop what *type* of layers you want to see. Use the icons to this menu's right to have Photoshop display only the image, adjustment, type, or shape layers, or smart objects. For example, to see only the type layers—so you can activate 'em all and change their fonts, say—click the T icon to this menu's right, and Photoshop hides all the layers in the Layers panel *except* the type layers (see Figure 3-4, bottom). You can also click more than one icon to see more than one kind of layer—type and shape layers, say.

- **Name.** If you've given your layers meaningful names, choose this option from the drop-down menu and a search field appears to its right. Enter some text (it's not case-sensitive) and Photoshop displays only layers whose names include what you typed. You don't need to press Return (Enter)—Photoshop begins filtering layers as soon as you start typing.

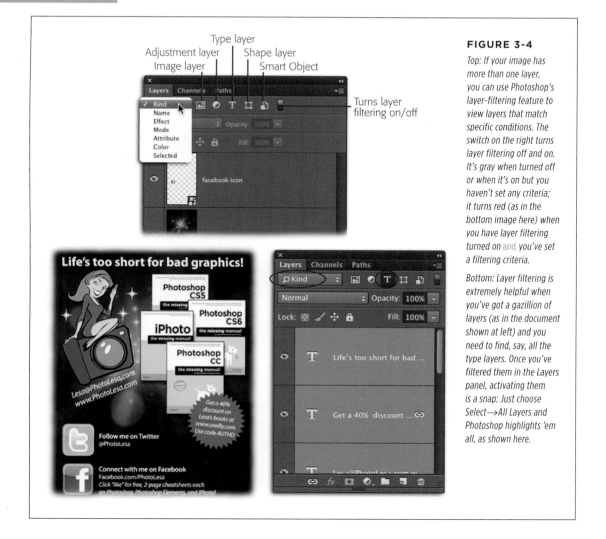

FIGURE 3-4

Top: If your image has more than one layer, you can use Photoshop's layer-filtering feature to view layers that match specific conditions. The switch on the right turns layer filtering off and on. It's gray when turned off or when it's on but you haven't set any criteria; it turns red (as in the bottom image here) when you have layer filtering turned on and you've set a filtering criteria.

Bottom: Layer filtering is extremely helpful when you've got a gazillion of layers (as in the document shown at left) and you need to find, say, all the type layers. Once you've filtered them in the Layers panel, activating them is a snap: Just choose Select→All Layers and Photoshop highlights 'em all, as shown here.

TIP When you choose Select→Find Layers or press Shift-Option-⌘-F (Shift+Alt+Ctrl+F), Photoshop automatically sets the filtering drop-down menu to Name and plops a cursor into the text field to its right so you can start typing.

- **Effect.** This option lets you filter layers based on layer styles (page 139). For example, to see only layers with drop shadows, choose this option and then choose Drop Shadow from the drop-down menu that appears to its right.

- **Mode.** To filter layers based on their blend modes (page 296), pick this option and then choose the blend mode you're after from the drop-down menu that appears on the right.

- **Attribute.** When you pick this option, a drop-down menu appears that lets you filter layers based on whether or not they're visible, empty, locked or linked to other layers (page 109), clipped to other layers (see the box on page 133 and page 331), include a pixel- or vector-based layer mask (page 120), include effects (think layer styles [page 139]), or use advanced blending options (page 309).

- **Color.** If you've color-coded your layers (page 108), you can use this option to view layers labeled with a certain color. For example, if you applied a red label to all the layers you used to fix skin imperfections in a portrait, choose this option and then pick Red from the drop-down menu that appears to its right, and Photoshop displays only those layers.

- **Smart Object.** New in this version of Photoshop CC, you can use this option to see the different *kinds* of smart objects your document contains. For example, click the first icon to the menu's right to see all the externally *linked* smart objects that are also up-to-date, meaning their content hasn't been changed (or, if it has been, the Photoshop document where those smart objects live was *open* at the time, so Photoshop automatically updated the smart object's content). The second icon lets you see all the linked smart objects that *need* updating. The third icon lets you see any linked smart objects whose content is missing, meaning the externally linked file was moved or renamed so Photoshop doesn't know where it is. The fourth icon lets you see all the embedded smart objects.

- **Selected.** This option lets you see only the layers that are currently *active* (see page 76 for more on activating layers); Adobe calls this maneuver *isolating layers*. This is handy when your Layers panel is long and you're experimenting with size, placement, or effects of certain layers that don't necessarily match any of the criteria listed above, or when you're editing certain shape layers in a document that contains several.

 Once you've isolated the active layers, you can deactivate 'em selectively—thus removing that particular layer from your current Layers panel list—by Control-clicking (right-clicking) the layer and choosing "Release from Isolation" from the resulting shortcut menu. If you add a new layer while Selected layer filtering is turned on, Photoshop adds it to the Layers panel's list (because new layers are active when you make 'em). To see all your layers again, choose Select→Isolate Layers or click the filtering switch labeled in Figure 3-4 (top).

TIP If you've used one of Photoshop's shape tools to create a shape layer, you can isolate that layer fast with the following trick: Activate the Path Selection or Direct Selection tool, trot up to the Options bar and set the Select menu to All Layers. Next, double-click the shape in your document and you see only that layer in the Layers panel. To see the other layers, double-click the shape again. However, if you double-click a path *outline*—say you drew the path using the Pen tool or a shape tool in Path drawing mode (page 568) and you haven't added a stroke or fill to it—Photoshop turns on layer filtering, hides all your other layers, and displays the text, "No layers match the filter" in the Layers panel. To view all your layers again, double-click the path outline again

After you've filtered the layers so that only the ones you're interested in are visible in the Layers panel, you can quickly activate all the visible ones—save for a locked background layer—by choosing Select→All Layers. You can work with filtered layers just like any other layers: Delete 'em, change their stacking order, and so on. Your filter remains in effect until you turn it *off* using the methods described in the next paragraph, or you close the document (Photoshop doesn't save layer filter settings when you save a document).

When you're ready to see all your layers again, you have a few choices. One method is to simply undo the filtering criteria you set to the right of the drop-down menu. For example, with the filtering menu set to Kind, and the T icon turned on to show all your type layers, just click the T icon again to turn it off, and you immediately see all your layers again. Or, with the menu set to Name, delete what you entered in the field to its right. You can also click the red switch near the top right of the Layers panel, but that turns layer filtering *off* instead of clearing your filtering criteria, so if you want to use layering filter again later, you have to click the switch *again* to turn it on before you can set new criteria. Happily, there's a better way: To keep layer filtering turn on *and* have Photoshop clear your filtering criteria *Option*-click (Alt-click on a PC) the little red switch.

> **NOTE** As of this writing, actions can't record the act of filtering layers (you'll learn all about actions in Chapter 18).

Creating Layers

Most of the time, Photoshop creates new layers *for* you, like when you copy and paste an image (page 91), create text (page 619), draw a shape (page 580), and so on. But if you want to do something like paint with the Brush tool, you need to create a new layer manually; otherwise, you'll paint right on your original image.

Photoshop gives you five ways to create a new layer:

- At the bottom of the Layers panel, click the "Create a new layer" icon (it looks like a piece of paper with a folded corner).

- Choose Layer→New→Layer.

- From the Layers panel's menu, choose New Layer.

- Press Shift-⌘-N (Shift+Ctrl+N).

- Drag a file from your desktop or Bridge (Chapter 22) into an open Photoshop document; the item you dragged appears on its own layer in the document—as a smart object to boot!

When you click the "Create a new layer" icon, Photoshop creates an empty layer cleverly named *Layer 1*, though you can double-click this name in the Layers panel to change it. (If you already have a layer called *Layer 1*, Photoshop names the new one *Layer 2*, and so on.) If you use the menu options or keyboard shortcut instead,

Photoshop displays the New Layer dialog box (Figure 3-5), where you can name the layer, color-code it (page 108), choose its blend mode (page 296), set its opacity, and use it in a clipping mask (see the box on page 133). Whichever method you use, Photoshop adds the new layer above the one that was active when you added it, and activates the new layer.

FIGURE 3-5

In the New Layer dialog box (top), you can give your new layer a name as well as a colored label. Color-coding layers makes them easier to spot in a long Layers panel (bottom), so it's especially helpful to use on layers that you may need to return to for additional editing (say, all the type layers in a postcard design).

In the Layers panel (bottom), you can double-click a layer's name to rename it, and turn its visibility on or off by clicking the little eye icon to the left of its thumbnail. The new layer's thumbnail shown here is a checkerboard pattern because the layer is empty and transparent. (See the box on page 43 for more on transparency.)

TIP If your fingers are flexible enough, you can create a new layer *and* bypass the New Layer dialog box by pressing Shift-*Option*-⌘-N (Shift+Alt+*Ctrl*+N). This shortcut is handy if you don't care what the new layer is named (shame on you!).

To create a new layer *below* the one that's currently active, ⌘-click (Ctrl-click) the "Create a new layer" icon at the bottom of the Layers panel. (If the only layer in your document is the locked background layer, before you can add a layer below it, you have to single-click its padlock icon or choose Layer→New→"Layer from Background.") This shortcut saves you the extra step of dragging the new layer to a lower position later; over the course of a year, this tip has been known to produce an *entire* vacation day!

Hiding and Showing Layers

In the Layers panel, the little visibility eye to the left of each layer thumbnail lets you turn that layer off and on (Figure 3-5, bottom). Adobe calls this incredibly useful feature *hiding*. Here are some examples of what hiding layers lets you do:

- **See an instant before-and-after preview.** If you've spent some time color-correcting (Chapter 9) or retouching people (Chapter 10) on duplicate layers, hiding the layers you used to do that is an easy way to see the effect of your handiwork.

- **Experiment with different looks.** If you're trying out different backgrounds or background colors, you can add them all to your document, hide them, and then turn them on one at a time to see which one looks best.

- **See what you're doing.** When you're working on a document that has a bunch of layers, some of them may hide an area in your document that you need to see or work on. The solution is to temporarily hide the in-the-way layers while you're working on those parts of the design, and then turn 'em back on when you're done.

- **Print certain layers.** Only layers that are visible in your document will print, so if you want to print only parts of an image, hide the other layers first.

To hide a single layer, simply click the little eye to the left of its layer thumbnail; to show it again, click the empty square where the eye was. To hide *all* layers except one, Option-click (Alt-click on a PC) the visibility eye of the layer you want to see; to display the other layers again, Option-click (Alt-click) the same layer's visibility eye again. Alternatively, you can Control-click (right-click) a layer's visibility eye (or, if the layer is hidden, the spot where the eye was) and then choose "Show/Hide this layer" or "Show/Hide all other layers" from the shortcut menu. There's also a Show/Hide Layers command in the Layer menu.

> **TIP** To quickly hide or show several layers, drag up or down over their visibility eyes in the Layers panel while holding down your mouse button. To hide *several* layers at once, with only one layer remaining visible, Option-click (Alt-click) the visibility eye of the one layer that you want to see; to see the other layers again, Option-click that same layer's visibility eye again. This maneuver is a handy way of seeing a quick before and after comparison of an image you've retouched using, say, several adjustment layers: Just Option-click (Alt-click) the image layer's visibility eye to turn off all the other layers in the document.

Restacking Layers

Once you start adding layers, you can change their *stacking order*—the order they're listed in the Layers panel—to control what's visible and what's not. When you think about stacking order, pretend you're peering down at the Layers panel from above: The layer at the very top can hide any layers below it. For example, if you fill a layer with color (page 92) and then place it above another layer containing a photo, the color will completely cover the photo. But if you've merely painted a swish or two with the Brush tool, only the part of the photo below the brushstrokes will be covered.

You can rearrange layers manually, or make Photoshop do it for you:

- **By dragging**. Click a layer's thumbnail and drag it up or down to change its position as shown in Figure 3-6. (Technically, you can click the layer *anywhere* to grab it, but targeting the thumbnail is a good habit to get into, lest Photoshop think you want to rename the layer instead.) When you get the layer in the right place, let go of your mouse button.

POWER USERS' CLINIC

Shortcuts for Activating and Moving Layers

It's a little-known fact that you can use keyboard shortcuts to activate and move layers. These tricks can be real timesavers since you don't have to lift your hands off the keyboard. It's also mission critical to use these shortcuts when you're creating *actions* (the box on page 816 tells you why). Here's the rather complicated list of shortcuts:

- To activate the layer *below* the current one (and deactivate the current layer), press Option-[(Alt+[on a PC). To activate the layer *above* the current one, press Option-] (Alt+]). By holding down Option (Alt) and tapping the square bracket keys, you can cycle through all your layers.

- To grab a bunch of layers in a row, activate the first layer, and then press Shift-Option-[(Shift+Alt+[) to activate the one below it (while keeping the first layer active), or Shift-Option-] (Shift+Alt+]) to activate the one above it. This shortcut lets you grab one layer at a time; just keep pressing the [or] key to grab more layers while continually holding down the other two keys.

- To activate the top layer in the Layers panel, press Option-. (Alt+.)—that's Option or Alt plus the period key. To activate

the bottom layer, press Option-, (Alt+,)—Option or Alt plus the comma key.

- To activate all the layers between the currently active layer and the top layer, press Shift-Option-. (Shift+Alt+.)—Option (or Alt) plus Shift and the period key. To activate all the layers between the currently active layer and the bottom layer, press Shift-Option-, (Shift+Alt+,)—Option or Alt plus Shift and the comma key.

- To activate every layer *except* the locked background layer, press ⌘-Option-A (Ctrl+Alt+A). If you've unlocked the background layer (by single-clicking its padlock icon), this shortcut activates it, too.

- To move the active layer up one slot in the layer stack, press ⌘-] (Ctrl+]). To move it down one slot, press ⌘-[(Ctrl+[).

- To move the active layer to the top of the layer stack, press Shift-⌘-] (Shift+Ctrl+]). To move it to the bottom of the layer stack—but still above the background layer, if you've got one—press Shift-⌘-[(Shift+Ctrl+[).

Page 102 has more about moving layers around.

FIGURE 3-6

To rearrange layers, simply drag a layer's thumbnail up or down. When you drag, your cursor turns into a tiny closed fist as shown here (left) and you see a ghosted image of the layer you're dragging. When the dividing line between two layers changes so it looks more like a gap (left), let go of the mouse button to make the layer you dragged hop in between them (right).

- **Using the Arrange command.** If you've got one or more layers activated, you can choose Layer→Arrange to move them somewhere else in the layer stack. Depending on the location of the layer(s) in the Layers panel, you can choose from these commands:

 - **Bring to Front** moves the layer(s) to the top of the layer stack. Keyboard shortcut: ⌘-Shift-] (Ctrl+Shift+] on a PC).

 - **Bring Forward** moves the layer(s) up one slot. Keyboard shortcut: ⌘-] (Ctrl+]).

 - **Send Backward** sends the layer(s) down one slot. Keyboard shortcut: ⌘-[(Ctrl+[).

 - **Send to Back** sends the layer(s) all the way to the bottom of the layer stack (or just above the background layer, if you've got one). Keyboard shortcut: ⌘-Shift-[(Ctrl+Shift+[).

 - **Reverse**. If you've got two or more layers activated, this command inverts their stacking order. (There's no keyboard shortcut for this command, but you can make one yourself if you use it a lot, as the box on page 31 explains).

NOTE If you've got a long Layers panel, these keyboard shortcuts can save you lots of time. And, as mentioned previously, these shortcuts are *mission critical* when creating actions (see Chapter 18).

The only layer you *can't* move around is a locked *background layer*. The background layer isn't really a layer, although it looks like one. It behaves a little differently from other layers, as the box on page 88 explains, so if you want to move it around it in the Layers panel, you first have to single-click its padlock icon to unlock it (in previous versions, you had to double-click instead). Once you do that, it becomes a normal, everyday layer that you can position wherever you want.

To *really* understand how layer stacking works, it helps to put theory into practice. Let's say you want to make a photo look like one side of it fades to white and then add some text on top of the white part. To do that, you'd place the photo at the bottom of the layer stack, the white paint layer in the middle, and the text layer on top (see Figure 3-7).

FIGURE 3-7

The stacking order of layers determines what you can and can't see.

Top: With the type layer at the top of the stack, you can see the text because it's sitting above everything else. And because the half-white gradient fill layer is partially transparent (you can tell by the checkerboard pattern in its thumbnail), you can see through it to the photo at the bottom of the stack.

This technique is great for ensuring that text remains readable atop a photo when creating postcards, invitations, and the like.

Bottom: If you drag the type layer below the gradient fill layer, you can't see the text anymore because it's hidden by the white paint.

Here's how to softly fade a photo to white and then add some text to it:

1. **Open a soon-to-be-faded photo and set your foreground color chip to white.**

 Peek at the color chips at the bottom of the Tools panel (page 15). If they're black and white, just press X to flip-flop them until white hops on top. If the chips are other colors, press D first to reset them to black and white.

2. **Create a gradient fill layer and pick the "Foreground to Transparent" gradient preset.**

 At the bottom of the Layers panel, click the half-black/half-white circle to open the adjustment layer menu, and then choose Gradient. In the resulting Gradient Fill dialog box, click the down-pointing triangle next to the gradient preview to open the Preset picker. In the drop-down menu of gradient previews, click the second preset in the top row for a "Foreground to Transparent" gradient. Don't close this dialog box just yet!

UP TO SPEED

The Background Layer and You

Only a handful of image file formats understand Photoshop's layer system; PSD (Photoshop) and TIFF are the two most popular. Most other image file formats can handle only *flat* images (unlayered files). So if you save a multilayered PSD file as a JPEG, EPS, or PNG file, for example, Photoshop flattens it, smashing all the layers into one. (See page 118 for more on flattening files.)

When you open an image created by a device or program that *doesn't* understand layers, like a digital camera or desktop scanner, Photoshop opens it as a flat image with a single layer named "Background." Though this background layer looks like a regular layer, it's not nearly as flexible as the layers you create in Photoshop. For example, you can paint on it with the Brush tool (page 528), select part of it and then fill the selection with color (page 198), or use any of the retouching tools on it (Chapter 10), but you can't use the Move tool to make it hang off the edges of your document or make any part of it transparent—if you try to use the Eraser tool, nothing happens other than painting with the background color (and you can almost *hear* Photoshop snickering at your efforts). Also, if you make a selection and then press Delete (Backspace on a PC) or use the Crop tool to make your canvas bigger (page 244), Photoshop fills that area with the color of your background chip (page 15).

The same thing happens when you create a *new* document in Photoshop: The program opens a more universally compatible flat file containing only a background layer.

You can unlock a background layer—and thereby make it fully editable and movable—in a couple of different ways. New in Photoshop CC 2014, in the Layers panel, you can single-click the padlock icon to the right of the layer's name. If you double-click its layer thumbnail instead, you'll unlock the layer *and* open the New Layer dialog box, where you can give the layer a new name. You can also activate the background layer in the Layers panel, and then choose Layer→New→"Layer from Background," or ⌘-click (right-click) the background layer and choose "New layer from Background" from the resulting menu. The only way to create a new document *without* a background layer is to open the New dialog box (File→New), and then choose Transparent from the Background Contents menu (see page 43).

You can convert a normal layer into a background layer by choosing Layer→New→"Background from Layer," but it's tough to think of a reason why you'd want to. If you do this, Photoshop politely moves the active layer to the bottom of the layer stack.

3. **Set the gradient's style to Linear, change its angle to 180 degrees, enter 10% for scale, and then click OK.**

 In the Gradient Fill dialog box, make sure the Style menu is set to Linear (it probably is unless you've changed it). Enter *180* in the Angle field so the color appears on the right side of your document. Next, enter *10* in the Scale field; this setting the gradient's size, or rather the size of the faded area between the two colors you picked (white and transparency, in this example). The lower the number, the narrower the fade; the higher the number, the wider the fade. (For more on gradients, see pages 333, 371, and 659.)

4. **Press T to grab the Type tool, and then add some text.**

 You haven't learned about the Type tool yet, but be brave and press T to activate it, and then hop up to the Options bar and pick a font and text size from the drop-down menus (see Chapter 14 for a proper introduction to this tool). Click once in your document where you want the text to begin, and then start typing. When you're finished, click the little checkmark in the Options bar to let Photoshop know you're done (pressing Enter on your keyboard's numeric keypad—*not* Return—or grabbing another tool works, too).

You're finished! If you want to move the text, you can temporarily activate the Move tool by holding down the V key. When your cursor turns into a little arrow, drag the text to where you want it.

Duplicating and Deleting Layers

Duplicating a layer comes in handy when you want to do something destructive like remove an object using the Content-Aware Fill command (page 436) or soften your model's skin (page 462). By duplicating the image layer first, you can work on a *copy* of the image instead of the original. But duplicating isn't limited to whole layers; you can also duplicate just *part* of a layer, like when you want to do some quality head swapping (page 197) or make multiple copies of an object and move it around (like the hippie chicks in Figure 3-8).

You can duplicate a layer in a gazillion ways:

- **Press ⌘-J (Ctrl+J) or choose Layer→New→"Layer via Copy"** to copy the active layer onto another layer just like it.

- **Drag the original layer atop the "Create a new layer" icon at the bottom of the Layers panel.** When Photoshop highlights the icon (which looks like a piece of paper with a folded corner), let go of your mouse button.

- **Option-drag (Alt-drag on a PC) the layer somewhere else in the Layers panel.** As soon as you start to drag, your cursor turns into double black-and-white arrowheads. When you let go of your mouse button, Photoshop duplicates the layer.

FIGURE 3-8

By selecting each of the silhouettes (top) and then pressing ⌘-J (Ctrl+J), you can put copies of them on their own layers (bottom). To move them around in your document, activate one of the new layers, press V to grab the Move tool, and then drag to reposition the selected figure. (Chapter 4 has tons of info on selections.)

Photoshop automatically adds the word "copy" to duplicated layers' names. To keep it from doing that, open the Layers panel's menu, choose Panel Options, and then, as the bottom of the resulting dialog box, turn off "Add 'copy' to Copied Layers and Groups."

To duplicate multiple layers at once, activate them by Shift- or ⌘-clicking (Ctrl-clicking), and then press ⌘-J (Ctrl+J).

Think of this technique as "jumping" the content onto other layers—it makes the keyboard shortcut easier to remember. (So many shortcuts, so little time to memorize 'em!).

To learn how to use the Clone Stamp tool to duplicate parts of an image, see page 448.

Follow along by visiting this book's Missing CD page at www.missing-manuals.com/cds and downloading the file Chicks.jpg.

- **Choose Layer→Duplicate Layer or, from the Layers panel's menu, choose Duplicate Layer.** This method gives you a chance to name the new layer, as well as to send it to a new document. If you decide to send it to a new document, in the Duplicate Layer dialog box, pick an open document from the Document drop-down menu or choose New to create a brand-new document (in the Name field, enter a name for the new document).

- **In the Layers panel, control-click (right-click) the layer.** From the resulting shortcut menu, choose Duplicate Layer.

- **To duplicate** *part* **of a layer, create a selection using any of the tools discussed in Chapter 4, and then press ⌘-J (Ctrl+J)** to move your selection onto its own layer. If you want to *delete* the selected area from the original layer and *duplicate* it onto another layer at the same time, press Shift-⌘-J (Shift+Ctrl+J). You can think of this trick as *cutting* to another layer since you'll have a hole in the original layer where the selection used to be.

Adding layers can *really* increase your document's file size, so it's always a good idea to delete layers you don't need (*especially* if you have a slow computer or very little memory). To delete a layer (even a locked background layer, provided your document has more than one layer), activate it in the Layers panel, and then do one of the following:

- **Press Delete (Backspace on a PC).** This is the fastest deletion method in the West.

- **Drag it onto the trash can icon at the bottom of the Layers panel.**

- **At the bottom of the Layers panel, click the trash can icon.** When Photoshop asks if you're *sure* you want to delete the layer, click Yes. (If you don't want to see this confirmation message in the future, turn on the "Don't show again" checkbox before you click Yes.)

> **TIP** If you delete a layer and then wish you had it back, just use the Undo command: Choose Edit→Undo or press ⌘-Z (Ctrl+Z).

- **In the Layers panel, Control-click (right-click) near the layer's name and choose Delete Layer from the shortcut menu.** Be sure not to Control-click the layer's thumbnail, or you won't see Delete Layer in the shortcut menu. When Photoshop asks if you really want to delete the layer, click Yes to send it packin'.

- **Choose Layer→Delete or, from the Layers panel's menu, choose Delete Layer.** You'll get a confirmation dialog box this way, too, so just smile, click Yes, and be on your way.

> **TIP** If you've hidden multiple layers (page 84), you can delete 'em all at once by opening the Layers panel's menu and choosing Delete→Hidden Layers (hey, if you're not using them, you might as well toss 'em!). Getting rid of extra layers shortens the Layers panel *and* reduces the document's file size.

Copying and Pasting Layers

You can use the regular ol' copy and paste commands to move whole or partial layers between Photoshop documents:

- **To copy and paste a whole layer into another document,** choose Select→All (or press ⌘-A [Ctrl+A]) to select everything on the layer, and then press ⌘-C (Ctrl+C). Next, click the other document's window, and then press ⌘-V (Ctrl+V) to add the layer.

- **To copy *part* of a layer into another document,** create your selection, and then press ⌘-C (Ctrl+C) to copy it. Then open the other document and press ⌘-V (Ctrl+V); Photoshop adds a new layer and pastes the copied pixels onto it.

Photoshop's Edit menu also includes the Paste Special command, which is incredibly handy when you're combining images. It's discussed at length starting on page 286.

TIP When you copy an image from another program and paste it into a Photoshop document, it lands on its very own layer. If the pasted image is *bigger* than your document, you may need to resize the new layer using Free Transform (page 276). Alternatively you can choose Image→Reveal All, and Photoshop resizes the canvas so you can see everything it contains. However, a better option is to use File→Place Embedded—or the new File→Place Linked command—because the image *automatically* lands on a separate layer surrounded by resizing handles. See page 134 for more on using the handy Place commands.

Filling a Layer with Color

One of the most common things you'll do with a new layer is fill it with color. If, for example, you've hidden your image's original background with a layer mask (page 120) or added an interesting edge effect (see pages 189 and 546), you can spice things up by adding a solid-colored background. Photoshop gives you a couple of different ways to tackle this task:

- **Fill an existing layer with color**. After you've created a new layer using one of the methods listed on page 82, choose Edit→Fill. In the resulting Fill dialog box (Figure 3-9), pick a color from the Use menu, and then click OK. You can also fill the active layer with your foreground color by pressing Option-Delete (Alt+Backspace on a PC), or your background color by pressing ⌘-Delete (Ctrl+Delete on a PC).

FIGURE 3-9

The Use menu lets you fill a layer with your foreground or background color, or summon the Color Picker by choosing Color.

The downside to this method is that, if you increase your canvas size (page 270) after filling a layer with color, you'll need to refill *the layer because it'll be smaller than your document. To avoid this extra step, use a fill layer instead, as discussed in this section.*

- **Create a fill layer.** If you're not sure which color you want to use, choose Layer→New Fill Layer→Solid Color or, at the bottom of the Layers panel, click the half-black/half-white circle and choose Solid Color. In the New Layer dialog box that appears, name the layer and then click OK. Photoshop summons the Color Picker so you can choose a fill color. If you decide to change this color later, simply double-click the fill layer's thumbnail and Photoshop re-opens the Color Picker so you can choose a new color or *steal* one from your image as shown in Figure 3-10. Fill layers come with their own layer masks, too, making it super simple to hide part of the color if you need to.

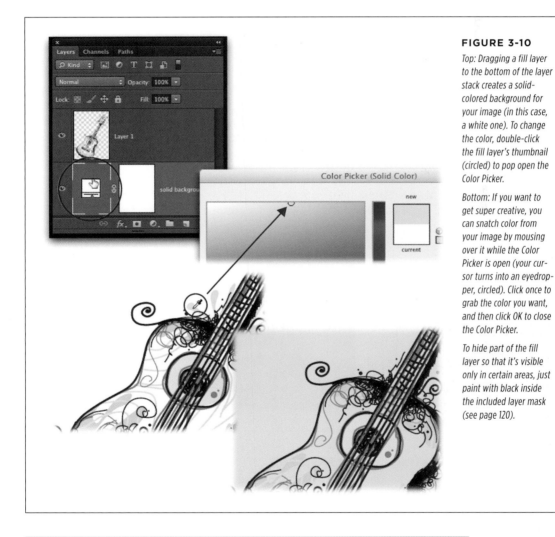

FIGURE 3-10

Top: Dragging a fill layer to the bottom of the layer stack creates a solid-colored background for your image (in this case, a white one). To change the color, double-click the fill layer's thumbnail (circled) to pop open the Color Picker.

Bottom: If you want to get super creative, you can snatch color from your image by mousing over it while the Color Picker is open (your cursor turns into an eyedropper, circled). Click once to grab the color you want, and then click OK to close the Color Picker.

To hide part of the fill layer so that it's visible only in certain areas, just paint with black inside the included layer mask (see page 120).

TIP If you create a selection before adding a fill layer, when you add the fill layer, Photoshop automatically fills the selection with color *and* fills in the layer's mask in the shape of your selection. Sweet!

One of the many advantages of using a fill layer is that, unlike an image layer, the *whole* layer gets filled with color even if you enlarge the document's canvas. In addition to using fill layers to create solid backgrounds, you can use 'em to fill a layer with a gradient or a repeating pattern, as shown in Figure 3-11. Simply choose Layer→New Fill Layer, and then pick either Gradient or Pattern.

FIGURE 3-11

Fill layers aren't just for adding solid color; you can use 'em to create gradient- and pattern-filled backgrounds, as shown here (top and bottom, respectively).

To change the fill layer's gradient or pattern, just double-click its thumbnail in the Layers panel and Photoshop opens the appropriate dialog box—Gradient Fill or Pattern Fill. By adjusting the Scale setting in these dialog boxes, you can make the gradient or pattern bigger or smaller. (See below to learn how to create custom patterns.)

The Pattern Fill dialog box gives you access to a bunch of pattern preset categories. Just click the down-pointing triangle (labeled here) and, in the resulting menu, click the gear icon (also labeled). For example, the Artists Brushes Canvas and Erodible Textures categories are useful when creating paintings from scratch, as described on page 536.

You can add a fill layer via the Layers panel: just click the half-black/half-white circle at the bottom of the panel to see a menu that includes Solid Color, Gradient, and Pattern.

CREATING CUSTOM PATTERNS

Photoshop includes oodles of pattern presets, though you can also create your own. The process for creating and using custom patterns is surprisingly simple:

1. **Open the image or document that contains the item you want to create a pattern from, such as the chili pepper photo in Figure 3-12.**

 You can create a pattern from just about anything that lives on a single layer: an object that you isolate in a photo, a brushstroke, a shape you drew

using one of Photoshop's shape tools, a smart object, 3D layer, and so on. To follow along, download *chili.jpg* from this book's Missing CD page at *www.missingmanuals.com/cds*.

2. **If you want the chili pepper's background to be transparent in the pattern, hide the background with a layer mask.**

 In order for your pattern to have a transparent background as it overlaps and repeats, the layer you create it from needs to have transparent areas, too. (If, on the other hand, you're creating a seamless pattern—one that repeats [tiles] with no apparent seams—you can skip this step.) Use the selection tool of your choice (see Chapter 4) to select the white background, choose Select→Inverse to select the chili pepper instead, and then click the circle-within-a-square icon at the bottom of the Layers panel; Photoshop adds a layer mask that hides the white background (see Figure 3-12, top).

FIGURE 3-12

Top: To create a pattern with a transparent background, you have to hide the original background with a layer mask, as described in step 2.

Bottom: The space between the pattern when it repeats is determined by how much space there is between the original object and either the document's edges or the edges of your selection. In this example, there won't be any space between peppers when you apply the pattern because the selection box is right next to the pepper's edges.

3. **If you like, use the Rectangular Marquee tool to draw a selection around the area that you want to turn into a pattern.**

You don't *have* to create a selection in order to create a pattern; if the space between your object and the document's edges is just right, you can skip this step.

But if you want to tweak the amount of space between objects in your pattern, activate the Rectangular Marquee tool by pressing M. If you want some space between the peppers when they repeat, make your selection larger than the pepper. If you want the peppers to be side by side, then draw the selection as close to the pepper as possible (see Figure 3-12, bottom). Alternatively, you can crop the document using the Image→Trim command (page 246) or the Crop tool (page 238).

4. **In the Layers panel, make sure the chili pepper layer's thumbnail is active, and then choose Edit→Define Pattern.**

In the Pattern Name dialog box (Figure 3-13, top), give your new pattern a meaningful name, and then click OK. Photoshop adds it to your list of pattern presets (Figure 3-13, bottom).

FIGURE 3-13

Top: Be sure to activate the appropriate image layer in the Layers panel or the Edit→Define Pattern command will be dimmed and you won't be able to open this dialog box.

Bottom: Once you define a new pattern, it appears in the Fill dialog box's Custom Pattern drop-down menu. Just give the down-pointing triangle a click, and then scroll within the resulting menu to find your fancy new pattern.

5. **Choose File→Save As and, in the resulting dialog box, give the document a name—say, "chili pattern"—pick Photoshop from the format drop-down menu, and then click Save.**

 Doing so lets you edit the document you created the pattern *from* (if, say, the object in the pattern needs to be a different size, or if it needs more or less space around it).

6. **Open the document you want to apply the pattern *to*, and then add a new layer by pressing Command-Shift-N (Ctrl-Shift-N).**

 In the resulting New Layer dialog box, name the layer "chili background," and then click OK.

 Alternatively, you can skip creating a new image layer and use a pattern fill layer instead. The upside of this technique is that you can resize your pattern using the Pattern Fill dialog box's Scale setting. The downside to this method is that the super cool scripted-pattern feature described in step 8 *doesn't* work with fill layers.

7. **Choose Edit→Fill and then, from the Fill dialog box's Use drop-down menu (visible in Figure 3-13, bottom), choose Pattern.**

8. **Tell Photoshop which pattern to use and how to treat it.**

 In the Fill dialog box, click the preview next to Custom Pattern (circled in Figure 3-14), and then click the pattern you created in step 4. Photoshop will repeat it in a grid-like pattern, spaced according to how much empty space you had around the object when you defined it as a pattern.

 If you want your pattern to be *random* in shape, color, size, and position, you can use *scripted patterns* instead. (In this context, "scripted" refers to the JavaScript code Photoshop uses to produce the random pattern.) To do that, turn on the Scripted Patterns checkbox at the bottom of the Fill dialog box and, from the Script drop-down menu, choose one of the eight built-in scripts (Brick Fill, Cross Weave, Picture Frame, Place Along Path, Random Fill, Spiral, Symmetry Fill, or Tree). For example, choosing Brick Fill makes Photoshop offset the pattern every second row by half the pattern's width, and introduce a variety of colors based on the original pattern's color. New in Photoshop CC, when you click OK, you get the chance to *customize* the scripted pattern (see Figure 3-14.)

In the dialog box shown in Figure 3-14, the Density slider controls the number of repeated objects—drag it left for fewer or right for more. Use the Minimum and Maximum Scale Factor sliders to control the smallest and largest objects' sizes (respectively). The "Rotate pattern" setting does just what you'd think: rotates the object(s) in the pattern. The last two sliders let you control how much color or brightness shift Photoshop applies to the objects; by setting them both to 0, you get no shifts in color or brightness.

TIP When you're finished customizing a scripted pattern fill, you can save it as a preset by choosing Save Preset from the Preset menu shown in Figure 3-14. This menu also lets you load presets you've snagged from someone else.

Click OK to close the scripted pattern's customization dialog box and Photoshop fills the empty image layer with your new pattern.

FIGURE 3-14

Photoshop uses a Java-Script file to vary scripted patterns you apply. And a nifty new feature of scripted patterns is this dialog box, which lets you customize them (you get slightly different settings depending on the scripted pattern you pick—Random Fill was used here).

Figure 3-15 shows the result of creating a random scripted pattern from a chili pepper (top) and a leaf (bottom).

The only downside to filling a layer with a pattern using the Fill dialog box—as opposed to using a pattern fill layer—is that you can't edit the fill after you've applied it. The only way to change the fill is to delete the layer you applied it to, create a new image layer, and then summon the Fill command again. That said, the creativity you can gain by using scripted patterns—especially now that there are more of 'em to choose from (there used to be only five) and they're so easy to customize—is well worth it.

Tweaking a Layer's Opacity and Fill

All layers begin life at 100 percent opacity, meaning you can't see through them (except where they're empty, as shown in Figure 3-7). To make a layer *semitransparent*, you can lower its Opacity setting, which is a good way to lessen the strength of a color or lighting adjustment (Chapter 9) or a strip of color you've added as a design element, as in Figure 3-16. The Opacity setting affects everything on a given layer equally.

FIGURE 3-16

Lowering the opacity of this fill layer to 60 percent makes the blue paint partially transparent, letting you see through to the photo layer below.

To look like a real Photoshop pro, at the top of the Layers panel, point your cursor at the word Opacity. When the cursor turns into a little pointing hand like the one shown here—known as a scrubby cursor—*you can drag to the left or right to lower or raise the layer's opacity, respectively (you can even drag the cursor off the Layers panel if you want to).*

This scrubby-cursor trick works for any Photoshop setting with similar controls, including the Fill setting, almost everything in the Options bar (no matter which tool is active), the settings in the Character and Paragraph panels, and more!

If you've hidden a layer by turning off its visibility eye, you can still *activate that layer to see its Opacity, Fill, and blend mode settings near the top of the Layers panel (though they're dimmed).*

The Opacity and Fill settings live near the top of the Layers panel (they're both circled in Figure 3-16). Unlike Opacity, the Fill setting *doesn't* always affect the whole layer. For example, if you create a shape layer or a type layer and then add a layer style to it (say, a stroke), then lowering its Fill setting will lower only the opacity of the color *inside the shape or letters*, not the opacity of the layer style you added.

To change Opacity or Fill, mouse over to the Layers panel, activate the layer you want to tweak, and then do one of the following:

- **Enter a new value in the Opacity or Fill field.** Double-click the current value in either field, enter a new value, and then press Return (Enter on a PC).

- **Use the field's slider.** Click the down arrow to the right of the Opacity or Fill field, and then drag the resulting slider to the left or right to decrease or increase that setting.

- **Use your keyboard.** Press V to activate the Move tool (think "moVe"), and then change the active layer's opacity by typing *1* for 10 percent, *2* for 20 percent, *3+5* for 35 percent, and so on (type *0* for 100 percent or *0+0* for 0 percent). If you're using any other tool that works with transparency *besides* the Move tool (such as the Brush or Healing tools), this trick changes the *tool's* opacity setting instead. You can use the same keyboard trick to adjust the Fill setting, too; just hold down the Shift key while you type the numbers.

> **TIP** Happily, you can change the opacity and/or fill of *multiple* layers at once: Just Shift- or ⌘-click (Ctrl-click on a PC) the layers in the Layers panel to activate them, and then adjust the Opacity and/or Fill settings.

Resizing and Rotating Layers

To resize the contents of a layer—or many layers—*without* changing the size of your document, use the Free Transform tool. (You'll learn a lot more about this tool in Chapter 6, so consider this a sneak peek.) To resize or rotate a layer, follow these steps:

1. **In the Layers panel, activate the layer(s) you want to adjust.**

 See page 78 for the scoop on activating multiple layers.

2. **Press ⌘-T (Ctrl+T) to summon the Free Transform tool.**

 Photoshop puts a box lined with small square handles (called a *bounding box*) around the contents of the active layer(s). If you're resizing a normal layer, the handles are white; if you're resizing a smart object (page 129), they're black instead, as in Figure 3-17. The difference is purely cosmetic—both versions work exactly the same way.

FIGURE 3-17

You can drag any of the bounding box's square handles to resize your object. To adjust all four sides of the box simultaneously, hold down Option (Alt) as you drag a corner handle.

When you drag a corner handle, the Free Transform tool shows you a handy heads-up display (HUD) of the object's size (the W and H numbers shown here). If you click within the bounding box and drag to reposition it, the display shows either your X and Y coordinates on the document relative to where you started dragging or—if you're rotating the object—an angle value. (The Move tool does the same thing.)

Don't forget to press Return (Enter) when you're finished because Photoshop won't let you do anything else while you've got an active bounding box.

3. **Drag one of the corner handles toward the center of the layer to make the layer's content smaller.**

 Grab any of the bounding box's corner handles and drag diagonally inward to decrease the layer content's size. To resize the content proportionately so it doesn't get squished or stretched, hold down the Shift key as you drag.

4. **To rotate the layer(s), position your cursor outside the bounding box and then—when the cursor turns into a curved, double-headed arrow—drag up or down in the direction you want to turn the layer(s).**

5. **Press Return (Enter on a PC) or double-click inside the bounding box to let Photoshop know you're done; to bail** *without* **changing your image, press Esc instead.**

> **TIP** To see the Free Transform tool's resizing handles whenever the Move tool is active—without actually using the Free Transform tool—press V to grab the Move tool, and then turn on the Options bar's Show Transform Controls setting. Seeing the handles is helpful if you're jumping between layers to resize or rotate objects and don't want to stop and summon Free Transform each time.

Do you risk reducing your image's quality by resizing layers this way? Sure. Anytime you alter pixel size, you change the image's quality, too, whether it's a single layer or the whole document. But as long as you *decrease* the image layer's size, you won't lose much quality (though you don't want to decrease its size *repeatedly*—unless it's a smart object (page 129), try to do it only once or twice). If you *increase* the size of a pixel-based image layer, you definitely risk losing quality because when pixels get bigger, they also get blockier. However, if you increase the size of an object just a *little*, nobody will be the wiser; plus, Photoshop CC is *far* better at enlarging images than previous versions of the program were.

That said, if you're working with a smart object (page 129), shape layer (page 580), or type layer (Chapter 14), you've got no worries. You can resize those babies all day long—larger or smaller, as many times as you want—and you won't affect their quality, which is why you should use those kinds of layers whenever possible. (However, you don't want to enlarge a raster-based smart object *too* much beyond its original dimensions because it could become pixelated and blocky.)

Moving and Aligning Layers

One of the many advantages of using layers is that you can scoot 'em around independently of everything else in your document. To move a layer, activate it in the Layers panel, press V to grab the Move tool, and then drag the layer wherever you want. (To move the layer in a perfectly vertical or horizontal line, hold down the Shift key while you drag.) As soon as you start dragging, you'll see a slightly transparent, dark gray border around the item you're dragging—and it moves as you drag. This is extremely helpful when you're moving items that are really small, and thus easy to lose sight of.

NOTE You can also nudge the layer one pixel at a time by pressing the arrows on your keyboard (holding down the Shift key while you do this scoots the layer by *10* pixels per keystroke).

To move only *part* of a layer, select that portion using one of the methods explained in Chapter 4, and then grab the Move tool and move just the selected bits.

■ ALIGNING LAYERS

When you need to position layers, Photoshop has several tools that can help you get 'em lined up just right, and in this version they're better than ever before. The program tries to help you align layers by *snapping* the one you're moving to the *boundaries* (content edges) of other layers. As you drag a layer with the Move tool, Photoshop tries to pop the layer into place when you get near another layer's edge. (To make the program stop doing this, choose View→Snap.) If you'd like to *see* the boundaries of your layer, press V to activate the Move tool, and then hop up to the Options bar and turn on Show Transform Controls (Figure 3-18).

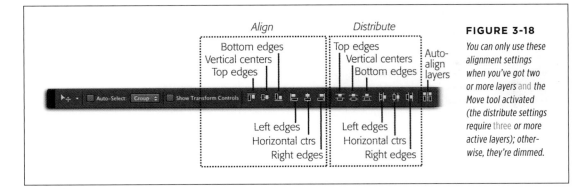

FIGURE 3-18

You can only use these alignment settings when you've got two or more layers and the Move tool activated (the distribute settings require three or more active layers); other-wise, they're dimmed.

TIP If you're trying to visually align one layer perfectly with the layer below it, it's a good idea to temporarily lower the top layer's opacity (page 99) so you can actually *see* the layer underneath. Alternatively, set one layer's blend mode to Difference (page 308).

In addition to snapping layers and showing their boundaries, Photoshop offers the following alignment helpers:

• **Alignment settings.** These settings come in handy if you need to align the edges of more than one layer. You'll see them in the Options bar when the Move tool is active, but you'll only be able to use 'em if you have *more than one layer* active (see Figure 3-18). You can also find them in the Layer→Align submenu (you still need to have more than one layer activated, but you don't have to activate the Move tool). Figure 3-19 shows you what each button does.

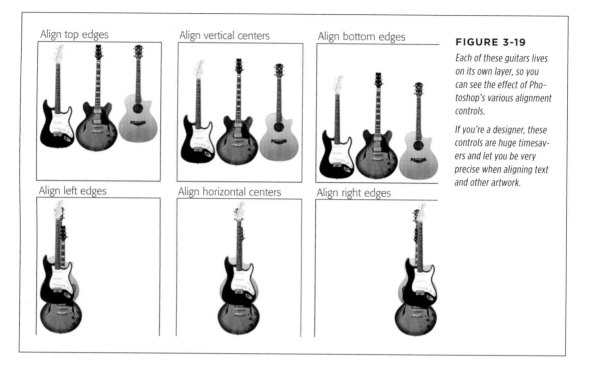

FIGURE 3-19

Each of these guitars lives on its own layer, so you can see the effect of Photoshop's various alignment controls.

If you're a designer, these controls are huge timesavers and let you be very precise when aligning text and other artwork.

- **Distribute settings.** To the right of the alignment settings are the distribute settings (Figure 3-18). Their mission is to evenly space the contents of the active layers based on each layer's horizontal or vertical center; you need to have at least *three layers* active to use them. These options are handy when you're designing buttons for website navigation because you can use them to space the buttons equally.

- **Auto-alignment.** If you choose Edit→Auto-Align Layers or click the Auto-Align Layers icon labeled in Figure 3-18, Photoshop does the aligning *for* you by looking at the corners and edges of the objects on the active layers. This command is really handy when you're combining multiple images of the same shot (see page 312), but it doesn't work on adjustment layers, smart objects, or shape layers.

- **Smart guides.** Unlike the *regular* guides you learned about in Chapter 2, smart guides alert you whenever you drag a layer near another layer's edge or center. These thin magenta lines are *extremely* helpful when you're manually aligning layers with the Move tool since they make it easier to position layers precisely in relation to each other. In this version of Photoshop CC, Adobe greatly improved smart guides; they can now show you more info when you use *modifier keys* (see the list below).

Smart guides are turned on straight from the factory; you can turn 'em off by choosing View→Show→Smart Guides (if you're a designer, leave 'em on). Here's what you can do with the new-and-improved smart guides:

- With either the Move or Path Selection tool active, **Option-drag (Alt-drag on a PC)** within your document to duplicate the active layer's content *and* see the distance (in pixels) between the duplicate and the original layer's content.

- **Press and hold ⌘ (Ctrl on a PC) and point your cursor** at an object to see the measurement guides shown in Figure 3-20. This is a great way to ensure you've got equal spacing between the objects in your design and the document's edges, equal spacing between objects, and so on.

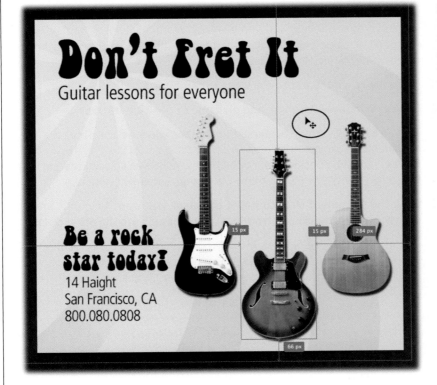

FIGURE 3-20

When you press and hold the ⌘ (Ctrl) key and point at an object, you see measurement guides related to the active layer's content—a box appears around the object; you see different guides depending on what you point at.

With the middle guitar's layer active, pointing your cursor (circled) at the background of this ad displays the distance between the guitar and the other guitars (which are all on separate layers), the distance between the bottom of the guitar and the document's edge, and more.

NOTE As of this writing, smart guides don't work well with clipping masks. (Never heard of clipping masks? The box on page 133 explains what they are.)

The only downside to using Photoshop's alignment commands is that they don't always accurately align layers that have a mask (page 120). Instead of aligning the layers according to what you've hidden with the mask (which is probably what you're trying to do), Photoshop ignores the mask and tries to align the layers based on *all* the pixels on that layer, regardless of whether they're hidden. In that situation, you may need to roll up your sleeves, turn on Photoshop's rulers (page 67), create a few guides (also on page 67), and then align the layers *manually* using the Move tool (page 102).

■ MOVING LAYERS BETWEEN DOCUMENTS

In addition to copying and pasting layers from one document to another (as described back on page 91), you can also drag and drop them straight from the Layers panel to another document. When you do that, Photoshop leaves the layer in the original document and places a *copy* in the target document, so you don't have to worry about losing anything from either file.

This maneuver is really helpful if you want to create a collage (Chapter 7), swap backgrounds, or share color corrections made with adjustment layers between documents (Chapter 9). Here's what you do:

1. **Open the two documents you want to combine.**

2. **Choose Window→Arrange, and pick one of the 2-up options.**

 To drag a layer from one document to another, you have to be able to *see* both documents, as explained in Figure 3-21. Choosing one of the 2-up display options makes Photoshop position your document windows so you can see 'em both at the same time. (Page 63 has more window-arrangement options.)

3. **Click the document that contains the layer you want to *move*, and then drag the layer's thumbnail from the Layers panel onto the other document.**

 As you drag, your cursor turns into a tiny closed fist like the one visible in Figure 3-21. When Photoshop highlights the inside border of the destination window in light gray, let go of your mouse button, and Photoshop adds the layer to that document.

> **TIP** To center the moved layer in its new home, hold the *Shift* key as you drag the layer from one document to another.

FIGURE 3-21

Top: To combine two images into one document, first arrange your workspace so you can see both windows. (The 2-up Vertical arrangement was used here.) Then drag one layer's thumbnail from the Layers panel into the other document.

Bottom: When you release your mouse button, the new layer appears in the other document's Layers panel, as shown here.

You can also drag an image file from your computer's desktop into an open Photoshop document and the object lands on its own layer as a smart object.

■ EXPORTING LAYERS TO SEPARATE FILES

If you've got a bunch of layers that you want to separate into individual files (with each layer in its own file), choose File→Scripts→"Export Layers to Files." In the resulting dialog box (Figure 3-22), use the Destination field to tell Photoshop where to save the files. In the File Name Prefix box, create a naming scheme. Photoshop uses whatever you enter in this field as the first part of your files' names, followed by a four-digit numeric sequence (0001, 0002, and so on), and then the individual layer names. Next, from the File Type drop-down menu, choose a format. When you're finished, click Run and sit back while Photoshop does all the work!

FIGURE 3-22

This dialog box lets you choose where to put the new files and what to name them. To exclude any hidden layers, turn on Visible Layers Only.

In the File Type drop-down menu, you can choose from BMP, JPEG, PDF, PSD, TARGA, TIFF, PNG-8, and PNG-24. Each format gives you different options; for example, choosing JPEG lets you pick a quality setting.

Unless you turn off the aptly named Include ICC Profile check-box, Photoshop includes your document's ICC profile in each file.

Export Layers To Files

Destination:
/Users/lesa/wishlist Browse... Run

File Name Prefix:
guitars Cancel

☐ Visible Layers Only

File Type:
JPEG ▾

☑ Include ICC Profile

JPEG Options:
Quality: 12

TIP If you've got a smart object in your document, you can export its contents to a new document by Control-clicking (right-clicking) near the layer's name in the Layers panel, and then choosing Export Contents. In the resulting dialog box, tell Photoshop where to save the document, and then click Save. (Smart objects are covered later in this chapter, beginning on page 129.)

◼ Managing Layers

If one thing's for certain in Photoshop, it's that your Layers panel will get long and unwieldy in a hurry. Now that you've seen a smidgen of the editing flexibility that layers give you, you'll want to put *everything* on its own layer—and you *should*. Learning a wee bit about organizing layers can keep you from spending ages digging through the Layers panel to find the layer you want.

TIP One of the best ways to manage a long Layers panel is Photoshop's layer-filtering feature (page 79).

Naming and Color-Coding Layers

The simplest way to organize layers is to name the darn things something other than Layer 1, Layer 2, and so on. If you didn't name them when you made 'em, you can always double-click a layer's name in the Layers panel and rename it right there (Photoshop highlights the name when you double-click it, so you can just start typing). When you're done, press Return (Enter on a PC).

TIP If you double-click in the Layers panel *near* the layer's name but not directly on it, Photoshop opens the Layer Style dialog box (shown on page 141) instead of highlighting the layer's name. Just close the dialog box and try again.

Another renaming maneuver is to choose Layer→Rename Layer. When you do, Photoshop highlights the name of the active layer; just type some text to rename it. To rename additional layers, press the Tab key to highlight the name of the next layer down the layer stack, or Shift-Tab to highlight the name of the next layer up. (You can assign a keyboard shortcut to the Rename Layer command, too, by going to Edit→Keyboard Shortcuts; the box on page 31 has the details.)

Color-coding is another great way to keep layers organized. For example, you could color-code the layers that make up various sections of a poster, like the header, footer, body, and so on. As you learned back on page 108, you can assign a color to a layer when you first create it. You can also activate the layer(s), and then Control-click (right-click) the layer(s) in the Layers panel and pick a color from the resulting shortcut menu. (To color-code a locked background layer, you first have to *unlock* it by double-clicking it.) To remove color-coding, do the same thing but choose No Color from the shortcut menu.

Linking and Locking Layers

Editing layers can be a lot of work, and once you get them just right, you want to make darn sure they stay that way. You can protect yourself from making accidental changes by linking layers together or locking down certain aspects of them.

If you need to move something in your image that's made from several layers, it'd be a real pain to move each layer individually and then reconstruct the image. Fortunately, you can *link* layers before you grab the Move tool so that they travel as a single unit; Figure 3-23 shows how. Linking related layers also helps avoid accidentally misaligning layers with a careless flick of the Move tool.

FIGURE 3-23

If you've zapped a blemish or removed a piercing in a portrait, for example, linking the layers you used to make the fixes with the image layer ensures that they all stay perfectly aligned.

Once you've got more than one layer activated, you can link them by clicking the tiny chain icon at the bottom of the Layers panel. When you do, the same icon appears to the right of each layer's name (circled) to show that the layers are linked. To unlink them, simply activate a layer, and then click the chain icon at the bottom of the Layers panel again. Easy, huh?

The two layers that involve retouching are color-coded with red (red for retouching—get it?).

Link layers

You can add a more serious level of protection with *layer locks*. The icons at the top of the Layers panel let you lock various aspects of layers (Figure 3-24). Simply activate the layer(s) you want to lock, and then click the appropriate lock icon:

- **Lock transparent pixels** protects the layer's transparent pixels so they don't change if you paint across them or run the Edit→Fill command. For example, if you created the faded-color effect shown on page 87, you could apply this lock to change the fade's color without affecting the layer's see-through bits.

- **Lock image pixels** won't let you do *anything* to a layer but nudge it around with the Move tool.

- **Lock position** locks the layer in place. You can still *edit* the layer, you just can't move it.

- **Lock all** is your deadbolt: It prevents you from editing or moving the layer.

Lock transparent pixels
Lock image pixels
Lock position
Lock all

Layer lock

FIGURE 3-24

Use these icons to protect your layers from accidental editing or repositioning. No matter which lock you apply, you'll see the padlock icon labeled here to the right of the locked layer's name.

When it comes to layer locks, your keyboard's forward slash key (/) acts like a switch for the last lock you applied. When a locked layer is active, tap this key once to remove its lock; press it again to turn the lock back on. When you have an unlocked layer, tapping this key makes Photoshop apply the "Lock transparent pixels" lock.

You can apply locks to multiple layers at once. Just activate the layers by Shift- or ⌘-clicking (Ctrl-clicking on a PC) them, and then click the appropriate lock icon.

TIP If you've taken the time to create a layer group (as explained next), you can lock *all* the layers in it by activating it, and then choosing Layer→"Lock All Layers in Group." (You can also find this command in the Layers panel's menu.) Photoshop pops open a dialog box where you can turn on any of the locks listed above; click OK to apply them.

Grouping Layers

You can rein in a fast-growing Layers panel—as well as manage layer visibility and make multiple layers easier to move—by tucking them into folders called *layer groups*. You can expand and collapse layer groups just like the folders on your hard drive, and they'll save you a *heck* of a lot of time if you're designing a piece that has specific components like a front and a back, as shown in Figure 3-25.

FIGURE 3-25

Just click a layer group's flippy triangle to expand or collapse that group.

Here, the down-pointing triangle next to the Front group's folder shows that the group is expanded, whereas the Back group is collapsed. You can collapse or expand all layer groups at the same time by Option-clicking (Alt-clicking on a PC) one group's flippy triangle.

Layer groups not only help you shorten your Layers panel, they also let you apply masks to all the layers in the group simultaneously.

Collapsed group —

Expanded group —

New group

Say you're creating a postcard for a concert, and you've got several layers that comprise the background, some photos of the band, some text, and so on. You can put all the layers associated with the postcard's background in a group named *Background*, the photos in a group called *Photos*, and the type layers in a group called *Text*. You could also add some color-coding (blue for background, red for photos, and so on) to make certain groups easier to spot in a long Layers panel.

Collecting layers into groups not only organizes your Layers panel, but also lets you *move* all the layers inside the group en masse without having to activate each layer individually: just activate the group, grab the Move tool, and then drag the layers into place. You can also change the visibility of all the layers in the group by clicking the group's visibility eye.

You can create layers groups in multiple ways:

- **Create the group first** by clicking the "Create a new group" icon at the bottom of the Layers panel (it looks like a tiny folder) or by choosing New Group from the Layers panel's menu. (If you go the latter route, you'll get a dialog box where you can name the group, assign it a color, and change its blend mode and opacity.) Either way, Photoshop adds the group to the Layers panel; just drag layers onto the group's folder icon to add them to it.

NOTE Straight from the factory, the blend mode of a layer group is set to Pass Through, meaning any adjustment layers or blend-mode changes you make to the layers within the group trickle down and affect any layers underneath it. (For more on this blend mode, see the box on page 309.)

- **Activate the layers first** and then press ⌘-G (Ctrl+G), choose "New Group from Layers" from the Layers panel's menu, or Shift-click the "Create a new group" icon at the bottom of the Layers panel. Photoshop creates a group named *Group 1* that includes all the layers you activated; double-click the group's name to rename it.

- **Option-drag (Alt-drag) layers** onto the "Create a new group" icon at the bottom of the Layers panel.

You can do the same things to layer groups that you can to regular layers. For example, you can duplicate them, hide them, lock them, color-code them, and even add a *layer mask* to them (masking is covered on page 120)—helpful when you need to mask multiple layers in the exact same way. You can also create *nested* groups by dragging and dropping one group into another one (see the box on page 114 for more info).

To split grouped layers apart, activate the group, and then choose Layer→Ungroup Layers, press Shift-⌘-G (Shift+Ctrl+G), or Control-click (right-click) the group and then choose Ungroup Layers from the shortcut menu. Whichever method you use, Photoshop deletes the group itself but leaves the layers it contained intact. To liberate just a few layers from a group—without getting rid of the group itself—activate the layer(s) and drag them up to the top of the Layers panel. When you see a thin white line appear just below the row of layer locks (page 109), release your mouse button.

To delete a group, activate it, and then either choose Layer→Delete→Group, or Control-click (right-click) the group and then choose Ungroup Layers. Either way, Photoshop displays a dialog box asking whether you want to delete the group *and* all the layers inside it, or just the group itself (leaving the layers within it in the Layers panel). (If the group doesn't contain any layers, you don't see this dialog box—Photoshop simply deletes the empty group.) If you activate a group and then press the Delete key, Photoshop deletes the group *and* all the layers inside it.

Layer Comps: Capturing Different Document Versions

Say you're creating a poster for an upcoming concert. You'll probably want to show your client different *versions* of it so she can pick the one she likes best. Photoshop can help by saving multiple versions of the document as *layer comps*—snapshots of your Layers panel in various states (see Figure 3-26). This method is much better than having to juggle multiple files you could lose track of. Layer comps can record the position and visibility of layers, as well as any blend modes (page 296) and layer styles (page 139) you've applied.

FIGURE 3-26

Like layer groups, layer comps work only if your document has more than one layer.

Top: Give each layer comp a name that describes that version of your design. To summon this panel, choose Window→Layer Comps. Then you can use the arrow buttons circled here to cycle through the various comps.

Bottom: Showing, hiding, and rearranging layers lets you quickly produce several versions of the same design.

Nested Layer Groups

Photoshop lets you nest layer groups up to 10 levels deep, meaning you can put a layer group inside of a layer group that lives inside yet *another* layer group that lives...well, you get the picture. This kind of nesting is helpful if you're a stickler for organization or are working on a complicated file and your Layers panel is a mile long. For example, a photographer might have a layer group named Retouching with another group inside it named Healing, which houses another group named Nose, and so on.

This kind of organization works great unless you have to share the file with someone using a version of Photoshop earlier than CS5. If you open the file with Photoshop CS3 or CS4, you'll be greeted with a dialog box stating, among other things, that it encountered "unknown data" and that "groups were altered." At this point, the program gives you two choices (you can also click Cancel to close the document, but what fun is that?):

- **Flatten** makes Photoshop preserve the appearance of the original document (provided the document was saved using the Maximum Compatibility option discussed on page 25) but not its layers, which makes further editing impossible.

- **Keep Layers** makes Photoshop *try* to preserve the document's appearance and layers, though this doesn't always work. For example, if you've changed a layer group's blend mode (page 296) or used advanced blending options (page 309), they're toast.

Once you've crossed your fingers and made a choice, Photoshop opens the document (which can take a while). If you chose Keep Layers, you'll see empty layers where the nested layer groups used to be.

You capture layer comp "snapshots" as you're working. For instance, you could start off with a baseline version and record what it looks like, then make some changes and record the new version, and so on. When you're ready to save your first layer comp, follow these steps:

1. **Choose Window→Layer Comps to summon the Layer Comps panel, and then click the Create New Layer Comp icon at the bottom of the panel.**

 The icon looks just like the New Layer icon—a piece of paper with a folded corner.

2. **In the New Layer Comp dialog box, give the snapshot a meaningful name, and then tell Photoshop what attributes to save.**

 The dialog box has three checkboxes:

 - **Visibility** captures the layers' current visibility status (on or off).

 - **Position** captures the layers' positions within the document (their *location*, not their stacking order).

 - **Appearance** captures layer blend modes and layer styles.

 It's a good idea to turn on all three settings *just in case* you decide to tweak that stuff later. Type a comment if you'd like, and then click OK.

3. **Back in the Layers panel, rearrange, show, or hide layers; add layer styles; or change blend modes to produce another version of the image.**

4. **In the Layer Comps panel, click the Create New Layer Comp icon again to create another layer comp and give it a name.**

 Repeat these steps as many times as you want to save different versions of your document.

When you're ready to stroll through the different versions, click the little arrows at the bottom of the Layer Comps panel (Figure 3-26). To get back to the way the document looked when you last tweaked it (or when you saved your last layer comp), at the top of the Layer Comps panel, click the empty square to the left of the words "Last Document State."

You can duplicate and delete layer comps just like layers and layer groups. To *edit* a layer comp, activate it in the Layer Comps panel, and then change whatever you want in the Layers panel, including opacity and fill settings. When you're finished, click the "Update layer comp" icon at the bottom of the Layer Comps panel (the curved arrows).

Happily, Photoshop CC 2014 sports some *additional* layer comp editing abilities. If you make a change to a layer's visibility, position, or appearance (meaning layer styles or layer blend modes, as mentioned earlier), you can *sync* those changes with existing layer comps. To do that, make sure the layer you've changed is active in your Layers panel, and then, in the Layer Comp panel, activate the layer comp(s) you want to update. Then click the appropriate icon at the bottom of the Layer Comp

panel: "Update visibility," "Update position," or "Update appearance" (they're all labeled in Figure 3-26).

To *add* a layer to an existing layer comp, activate the new layer in your Layers panel, and then activate the layer comps you want to update in the Layer Comp panel. Then, choose Update Layers from the Layer Comp panel's menu.

> **TIP** As you'll learn later in this chapter, you can place whole documents into other documents as smart objects. How does that relate to layer comps? In Photoshop CC 2014, Adobe added the ability to *manage* layer comps that you created in a Photoshop document that you've placed into *another* document as a smart object. When you activate the smart object in the other document, the Properties panel shows you all the layer comps that smart object contains, so you can pick the one you want to see. This lets you change the look of the smart object *without* having to edit the smart object itself.
>
> For example, say you've mocked up a magazine cover and made several versions of it using layer comps. Then you place that document into *another* document—say, an ad announcing the magazine's launch. This feature lets you access the various versions of the cover from *within* the ad document. See page 138 to learn how!

Even with these new features, editing layer comps isn't all happiness and light. Certain edits—cropping, deleting, and merging layers—make Photoshop cranky and unable to fully display some layer comps. You can tell which comps are affected because they have little warning triangles to the right of their names (see Figure 3-27). These triangles mean that Photoshop can't fully show you the layer comp because it couldn't keep track of every change you made. (Don't worry: it *doesn't* mean Photoshop lost your changes.) If you cropped the document, then fixing the problem is easy: Just activate the affected layer comp(s), and then click the "Update layer comp" icon labeled in Figure 3-26. If you deleted or merged layers, then unfortunately you need to create a new layer comp.

■ EXPORTING LAYER COMPS

When you're ready to show your client the layer comps you created, you've got a couple of handy options: you can export them as individual files or merge them into a single PDF that plays as a *slideshow* (talk about impressive!).

To export them as files, choose File→Scripts→"Layer Comps to Files." Photoshop then creates a separate file for each layer comp in whatever file format you choose (you get the same options as when you export layers to files; flip back to Figure 3-22 for details).

To export a PDF slideshow of your layer comps, choose File→Scripts→"Layer Comps to PDF," and Photoshop displays the dialog box shown in Figure 3-28.

FIGURE 3-27

If a little warning triangle appears next to your layer comp (circled), you can click it to see this dialog box, which gently chastises you for messing up the layer comp. Click Clear to get rid of the warning triangle and close the dialog box.

If you turn on the "Don't show again" checkbox, Photoshop won't display this message anymore, but you'll still have to update your layer comps when you see the warning triangle.

Layer comps can track most everything that happens in your Layers panel, but if you've run any smart filters on the document (page 670), layer comps can't keep track of any changes to the smart filters' settings.

FIGURE 3-28

Click Browse to tell Photoshop where to save the file (if you have multiple layer comps, Photoshop creates one PDF with multiple pages). To export only the comps you've activated in the Layer Comps panel (rather than all the document's comps), turn on Selected Layer Comps Only.

Unless you turn off Advance Every, the PDF will automatically advance like a slideshow (to make each layer comp remain onscreen for more than 5 seconds, enter a new number into the Advance Every field). To make the slideshow start over automatically, turn on "Loop after last page." When you're finished adjusting these settings, click Run.

Rasterizing Layers

If you try to paint or run a filter on a shape or type layer, Photoshop puts up a fuss: It displays a dialog box letting you know that you've got to *rasterize* that layer first. Why? Because, as you learned back in Chapter 2, vectors aren't made of pixels, and to use pixel-based tools—like the Brush, Eraser, and Clone Stamp—on a vector-based layer, you first have to convert it to pixels using a process called *rasterizing*.

NOTE You see the same dialog box if you try using anything in Photoshop's healing toolset—the Spot Healing Brush, Healing Brush, Patch, and Content-Aware Move tools—on a smart object. While smart objects aren't necessarily vector based, you still can't use pixel-based tools on them because of their *protective wrappers*.

Beware: There's no going back once you've rasterized a layer. You can't resize former smart objects or shape layers without losing quality, you can't double-click a former fill layer and change its color, *and* you can't edit a rasterized type layer—because rasterizing converts them all to pixel-based image layers. That's why it's a good idea to do your rasterizing on a *duplicate* layer so you can go back to the original. Just duplicate the layer by pressing ⌘-J (Ctrl+J) before you rasterize, and then turn off the original layer's visibility so you don't accidentally rasterize the *wrong* layer.

Rasterizing is easy: Activate a vector-based layer or smart object, and then choose Layer→Rasterize→Layer. (Choose Layer→Rasterize→All Layers to rasterize *everything* in your document.) Better yet, activate the layers(s), Control-click (right-click) near the layer's name in the Layers panel, and then choose Rasterize Layer from the shortcut menu.

Merging Layers

Layers are great, but sometimes you need to squash 'em together. Yes, this goes against what you've learned in this chapter so far—that you *should* keep everything on its own layer—but in some situations you have no choice but to *merge* or *stamp* layers—or worse, completely *flatten* your document. Here's what those scary-sounding commands do, along with info about how and why you might need to use 'em:

- **Merge.** If you've whipped pixels into perfection and know that you'll *never* want to change them, you can merge two or more layers into one. Not only does doing that reduce the length of your Layers panel, it also knocks a few pounds off the file's size. Photoshop gives you several ways to merge layers:

 - **Merge down.** To merge two *visible* layers that live next to each other in the Layers panel—and the bottom one is a pixel-based layer—activate the top layer, and then choose Layer→Merge Down, choose Merge Down from the Layers panel's menu, or press ⌘-E (Ctrl+E).

NOTE You can merge any kind of layers, but you need to have a *pixel-based* layer underneath them in the Layers panel to use the merge commands, or else they're dimmed (if necessary, just add a new image layer). Photoshop then merges everything onto that pixel-based layer.

 - **Merge visible.** To merge just some of your layers, hide the ones you *don't* want to squash, activate a pixel-based layer as your target, and then go to Layer→Merge Visible, choose Merge Visible from the Layers panel's menu, or press Shift-⌘-E (Shift+Ctrl+E).

- **Merge active.** Activate the layers you want to merge (either pixel- or vector-based), and then go to Layer→Merge Layers, choose Merge Layers from the Layers panel's menu, or press ⌘-E (Ctrl+E).

- **Merge linked.** If you've linked layers together (page 109), you can merge them in one fell swoop. First, activate them by choosing Layer→Select Linked Layers or choosing Select Linked Layers from the Layers panel's menu, and then merge the layers (see the previous bullet point).

- **Stamp.** You can think of stamping as a *safer* version of merging because it combines the active layers into a *new* layer, leaving the original layers intact (see Figure 3-29). This command is great when you need to edit multiple layers with tools that affect only one layer at a time (like filters and layer styles). Your stamping options are:

 - **Stamp active layers.** Activate the layers you want to stamp, and then press Option-⌘-E (Alt+Ctrl+E).

 - **Stamp visible.** Turn off the layers you *don't* want to stamp by turning off their visibility in the Layers panel, and then press Shift-Option-⌘-E (Shift+Alt+Ctrl+E). You can also perform this feat by holding Option (Alt) as you choose Merge Visible from the Layers panel's menu.

FIGURE 3-29

If you need to edit multiple layers using tools that affect just one layer at a time, you can create a stamped copy of those layers (like the top layer here) to avoid having to flatten the file. (Photoshop names and color-codes the stamped layer to match the topmost layer group.)

An alternative to stamping layers is to use layer groups (page 111) or create a smart object from multiple layers, as explained on page 134.

- **Flatten.** This command makes your document flatter than a pancake, compressing all its layers into a single locked background layer that, as you know from the box on page 88, doesn't allow transparency (any areas that were transparent become white instead). Alas, if you're exporting a file to a format that doesn't *support* layers (like JPEG, PNG, and so on—see page 45), you have no choice but to flatten it. Just be sure to save the document as a PSD file *first* so you can go back and edit that version later.

 You've got three flattening options:

 - **Flatten Image.** To flatten a whole file, go to Layer→Flatten Image or choose Flatten Image from the Layers panel's menu.

WARNING Danger, Will Robinson! After flattening a document, be sure to choose File→Save As instead of File→Save to avoid saving over your original, layered document. And if you flatten a document by accident, you can get the layers back using the History panel or by pressing ⌘-Z (Ctrl+Z). Whew!

 - **Flatten All Layer Effects.** Instead of flattening a whole file, you can flatten just its layer styles (page 139) so they become one with the layer they're attached to. But be aware that, if you've applied any layer styles to vector-based layers (like type and shape layers), this process will rasterize those layers. To flatten layer styles, choose File→Scripts→Flatten All Layer Effects.
 - **Flatten All Masks.** To permanently apply masks to their associated layers, choose File→Scripts→Flatten All Masks.

Layer Blending

In Photoshop, *blending* refers to the way colors on one layer interact with colors on other layers. The program gives you some pretty powerful blending options in the form of layer blend modes, advanced blending, and "blend if" sliders. You can do some amazing stuff with these tools, as illustrated in the quick exposure fix described on page 125. However, since blending is most handy when you're combining images, these tools are covered in depth beginning on page 296.

Layer Masks: Digital Masking Tape

Remember the last time you gave your walls a fresh coat of paint? You probably broke out a roll of masking tape and taped up the baseboards and molding so you wouldn't get paint all over them. Sure, you could've taken the baseboards *off* and put them back on once the paint had dried, but *dadgum,* that's a lot of work. Besides, masking tape covers everything just fine. Hiding and protecting is masking tape's special purpose and—what luck!—Photoshop has a digital equivalent: *layer masks*.

By adding paint to a layer mask, you can hide the content of the layer that the mask is attached to, whether it's a pixel-based image layer, a smart object, a shape layer, a fill layer or—in the case of adjustment layers—a color or lighting change.

Learning to use layer masks will keep you from having to *erase* parts of an image to produce the effect you want. Once you erase, there's no going back, and if your hand isn't steady enough to erase around detailed areas, you may accidentally erase bits you want to keep. So, for example, instead of *deleting* a background so you can swap it with another one, you can use a layer mask to *hide* it, as shown in Figure 3-30. (You'll find all kinds of other uses for layer masks sprinkled throughout this book.) As long as you save the document as a PSD file, you can go back and edit the mask anytime.

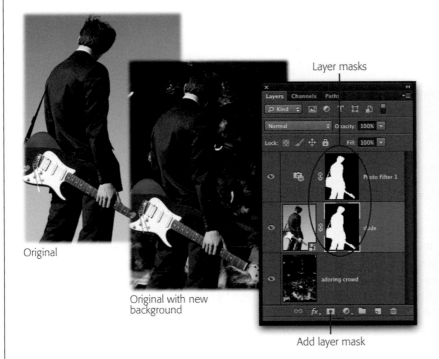

Layer masks

Original

Original with new background

Add layer mask

FIGURE 3-30

Wanna be a rock star? A layer mask can make that happen.

Left: Here you can see the original, boring, blue background, as well as the new, exciting, clamoring crowd.

Right: In this Layers panel, you can see that the original background wasn't deleted—it was just hidden with a mask. (To make the color of the guitarist and the crowd match a bit better, a photo filter adjustment layer—page 359—was added that uses the same mask.) Like layer thumbnails, a mask's thumbnail is an exact miniature of your document.

Adding Layer Masks

You can add a mask to any layer, though some layers—like fill, adjustment, and shape layers—*automatically* come with their own masks. As you can see in Figure 3-30, the mask shows up in the Layers panel to the right of the layer's thumbnail.

NOTE These days, Photoshop *automatically* converts the background layer to a regular layer when you add a layer mask to it (even a vector mask; page 606), which means you don't need to unlock the background layer first. Hooray for change!

Layer masks are grayscale creatures, so when you're dealing with them you work only in black, white, and shades of gray. A black mask hides the layer completely, a white mask reveals it completely, and a gray mask falls somewhere in between—it's partially transparent. All this is easy to remember if you memorize the rhyme, "Black conceals and white reveals."

NOTE Layer masks can be pixel- or vector-based. This section covers pixel-based masks; vector-based masks are covered on page 606.

To add a layer mask, activate the layer you want to add it to, choose Layer→Layer Mask, and then pick one of the following commands:

- **Reveal All.** Creates a solid white mask that shows everything on the layer, so it doesn't change anything in your image. You can also add a white mask by clicking the Add Layer Mask icon at the bottom of the Layers panel (the circle within a square labeled in Figure 3-30). If you want to hide just a *little* bit of a layer, this command is the way to go; after you add the mask, just paint the areas you want to hide with a black brush.

- **Hide All.** Creates a solid black mask that conceals everything on the layer. (Option-clicking [Alt-clicking] the Add Layer Mask icon does the same thing.) If you want to hide the majority of the layer, choose this command and then use a white brush to reveal specific areas.

TIP You can invert a layer mask (flip-flop it from white to black and vice versa) by activating it, and then pressing ⌘-I (Ctrl+I). This is a great keyboard shortcut to memorize, as you'll use it often.

- **Reveal Selection.** Choose this command if you've created a selection and want to hide everything *but* the selection. Photoshop adds a mask in which the selected area is white and the rest is black. (You'll learn all about selections in Chapter 4.)

- **Hide Selection.** This command adds a mask in which the selected area is black and the rest is white.

TIP You can also add a pixel- or vector-based layer mask via the Properties panel (shown on page 127).

- **From Transparency.** This command creates a layer mask from the *transparent* pixels in an image layer (handy if you're working with an image layer that has no background, like a brushstroke). Just activate a partially transparent layer before choosing this command, and Photoshop adds a layer mask that's black in the transparent areas, gray in the areas that are partially transparent, and white in the areas that contain info. (This command doesn't work with shape layers or smart objects.)

Using Layer Masks

You can use any painting tool to add black, white, or gray paint to a layer mask, although the Brush tool is especially handy (Chapter 12 covers all your brush options), and the Gradient tool is great if you want to create a smooth transition from black to white (see the color-fade effect on page 87). Selection tools (Chapter 4) also work in layer masks, and once you create a selection, you can fill it with black, white, or shades of gray by choosing Edit→Fill.

One of the simplest uses for layer masks is to hide bits of text so the text looks like it's behind a person or an object, as shown in Figure 3-31. Here's how to create that ever-useful effect:

1. **Open a photo and then press T to activate the Type tool.**

 Don't worry about unlocking a background layer (if your document has one); you don't need to touch your original image in this technique.

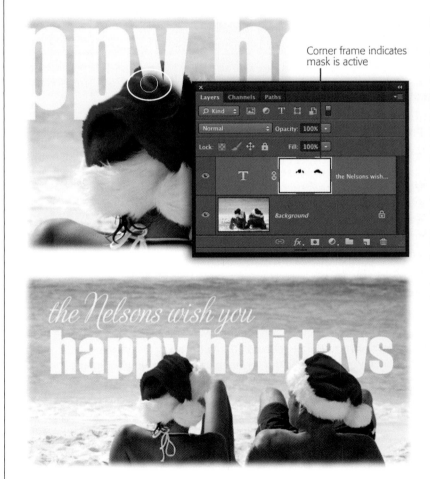

Corner frame indicates
mask is active

FIGURE 3-31

Top: This couple and the text live on different layers. If you add a layer mask to the text layer and then paint within the mask with a brush set to paint with black (circled), you can hide parts of the text, revealing the couple's cute hats. Over in the Layers panel, the corner frame lets you know which part of the document is active: the type layer or its mask.

Bottom: Magazines such as Rolling Stone use this trick all the time on their covers to make text look like it's behind the "person of the moment."

2. **In the Options bar, pick a font, a size, and a color.**

For this technique, select a thick font like Impact and set it to a fairly large size, like 70 points (for a high-resolution image, you'll need an even bigger size). You'll learn all about formatting text in Chapter 14.

3. **Mouse over to your document, type some text, and then commit it.**

Click where you want the text to begin and start typing. To move the text around, mouse away from the text until your cursor turns into a little arrow, and then drag the text wherever you'd like. To let Photoshop know you're finished, click the little checkmark in the Options bar.

4. **Add a layer mask to your type layer by clicking the circle-within-a-square icon at the bottom of the Layers panel.**

Photoshop adds an all-white layer mask to the type layer so that everything on that layer is visible. In the Layers panel, you see the mask's thumbnail next to the type layer's thumbnail. The thin border around the corners of the mask's thumbnail (labeled in Figure 3-31) means the mask is active and you're about to paint on *it* (good) instead of the photo (bad).

> **TIP** One of the biggest mistakes folks make when working with layer masks is not paying attention to which thumbnail is active in the Layers panel (it takes a single click to activate either one). The little corner frame always shows which is active: the layer's mask or the layer content itself.

5. **Press B to grab the Brush tool and pick a soft-edged brush set to black.**

After you activate the Brush tool, head up to the left side of the Options bar and open the Brush Preset picker (page 530) by clicking the down-pointing triangle next to the little brush preview. Pick a soft-edged brush that's about 60 pixels (or larger if you're working with a high-resolution image). Since you want to *hide* bits of the text, you need to paint with black (remember, black conceals and white reveals). So, take a peek at the color chips at the bottom of the Tools panel, press D to set 'em to factory-fresh black and white, and then press X until black hops on top. *Now* you're ready to start painting.

6. **Mouse over to your document and paint the parts of the text you want to hide.**

In the example in Figure 3-31, you'd position your cursor over one of the Santa hats and click to start painting (hiding). When you release the mouse button—you don't have to do all your painting with one brushstroke—you'll see black paint on the layer mask in the Layers panel, but *not* in your image.

7. **If you accidentally hide too much of the text, press X to swap color chips so you're painting with white, and then paint that area back in.**

When you're working with a layer mask, you'll do tons of color-chip swapping (from black to white and vice versa). You'll also use a variety of brush sizes to paint the fine details as well as large areas. To keep from going blind when you're

doing detailed work like this, zoom in or out of your document by pressing ⌘ and the + or – key (Ctrl and the + or – key on a PC).

> **TIP** You can change your brush cursor's size and hardness by dragging, which is handy when it comes to painting on layer masks. To resize your brush, Control-Option-drag (Alt+right-click+drag on a PC) left to decrease brush size or right to increase it. The same keyboard shortcut also lets you change brush hardness: Drag up to soften the brush or down to harden it.
>
> When you perform any of these keyboard shortcut+dragging maneuvers, inside your brush cursor, you'll see a red preview of what the new brush will look like—*if* your computer supports OpenGL (see the box on page 66). To change that preview color to something other than red, flip to page 532.
>
> Or, if you prefer, you can decrease brush size by pressing the left bracket key ([) and increase it by pressing the right bracket key (]).

That wasn't too bad, was it? You just learned *core* Photoshop skills that you'll use over and over. The more you use layer masks, the more natural this stuff will feel.

■ FIXING EXPOSURE WITH AN ADJUSTMENT LAYER AND ITS MASK

As you learned on page 75, each adjustment layer you create automatically includes a layer mask, making it super easy to hide that adjustment from certain areas of your image. For example, if you've got an over- or underexposed image (one that's too light or too dark), you can fix it with an adjustment layer and then use the included mask to hide the lightening or darkening from the parts of the image that don't need changing. This particular exposure-fixing trick is important to have up your sleeve if you're short on time, or if other lighting fixes (see Chapter 9) aren't working. Here's what you do:

1. **Open an image and add a brightness/contrast adjustment layer to it by clicking the half-black/half-white circle at the bottom of the Layers panel, and then choosing Brightness/Contrast.**

 You're not actually going to adjust the Brightness/Contrast sliders (page 379); you're merely adding an empty adjustment layer so you can swap blend modes and then use the mask that tags along with the adjustment layer. The reason you're using a Brightness/Contrast adjustment layer is because that kind of layer doesn't *do* anything to your image the second you add it. Sure, you *could* duplicate your image layer and then add a layer mask, but this method is faster and won't bloat the document's file size.

2. **At the top of the Layers panel, using the unlabeled drop-down menu to change the adjustment layer's blend mode from Normal to Multiply.**

 Blend modes control how colors on one layer interact with colors on other layers (you'll learn all about blend modes in Chapter 7). For now, you'll focus on two blend modes that you'll use often because they let you quickly darken or lighten an image, respectively: Multiply and Screen (see Figure 3-32). For this exercise, pick Multiply from the menu at the top of the Layers panel to darken

your image. (You'll hide the too-dark bits with the adjustment layer's mask in the following steps.)

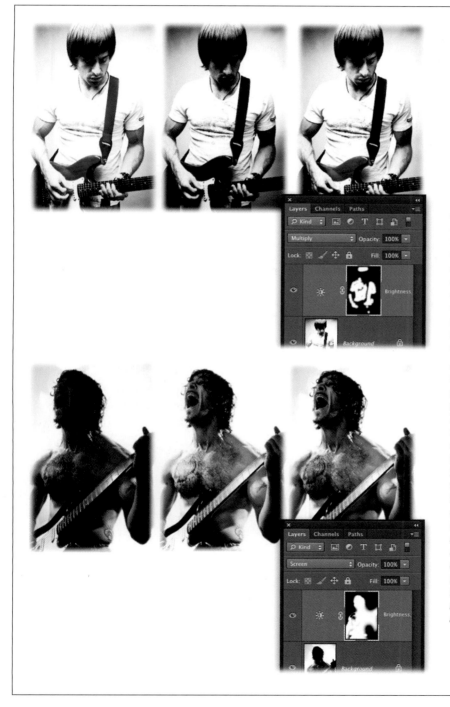

FIGURE 3-32

To quickly darken or lighten an image, add an empty adjustment layer and change its blend mode to Multiply or Screen (respectively). To control where the change is visible on the image, use a brush to fine-tune the adjustment layer's mask.

Top: This guy's shirt and arms are too light in the original image (left). If you change the adjustment layer's blend mode to Multiply, his face and guitar are too dark (middle). But if you then hide the adjustment from his face and guitar using the layer mask, he looks much better (right).

Bottom: The same trick works for a photo that's too dark. On the left is the super-dark original. The middle image shows what happens when you change the adjustment layer's blend mode to Screen. You can then use the accompanying layer mask to hide the over-lightened areas (mainly the background and his tattoo) as shown on the right. Now you can see the rocker dude's face (though on second thought, maybe that's not such a good idea after all!).

3. **Press B to grab the Brush tool and set your foreground color chip to black.**

Check to make sure the adjustment layer's *mask* is active (it will be unless you clicked on another layer after adding it). To hide the over-darkened areas, you'll paint them with black because—all together now!—black conceals and white reveals. Peek at your color chips, and if black isn't on top, press X (if you don't see black, press D to set your color chips to black and white first). Now you're ready to paint.

4. **With a big soft brush, paint the areas that are too dark.**

The keyboard shortcuts for resizing and changing brush hardness come in handy here (see the Tip on page 125). Remember, if you mess up and hide too much of the darkened part of the image, simply flip-flop your color chips by pressing X, and then reveal the dark part again by painting it with white.

5. **If your image is still a little too dark, lower the empty adjustment layer's opacity (page 99).**

Editing a Mask

Once you've gotten your hands on a layer mask, you'll undoubtedly need to fine-tune it, turn it off or on, and so on. In pre-CS4 versions of Photoshop, you had to mouse *all* over your workspace to do that stuff. Thankfully, these days all of your mask tasks are consolidated in the Properties panel (Figure 3-33).

FIGURE 3-33

The Properties panel is your one-stop shop for working with layer masks (both pixel- and vector-based), adjustment layers, and new in this version of the program, managing any smart objects your document contains.

The panel's Density slider controls the layer mask's opacity (which makes you wonder why Adobe didn't name it the Opacity slider instead).

The Feather slider lets you feather a mask's edge on the fly, and nondestructively to boot!

NOTE If you double-click a mask thumbnail in your Layers panel that's attached to a smart object, you see the embedded or linked smart object's badge at the top left of the Properties panel, and you can click this icon to see that smart object's properties. (An embedded smart object's badge is visible in Figure 3-33.)

You'll find the following controls in the Properties panel (Window→Properties) *when a mask is active* in the Layers panel:

- **Add/Select Layer Mask, Add/Select Vector Mask.** The two icons at the top right of the Properties panel let you add or select (activate) a layer mask or vector mask (see page 606), depending on whether the active layer already *has* one or the other. If the active layer already has a layer mask, clicking one of these icons activates the mask; if not, they add one. If you opened the Properties panel by double-clicking a layer mask, the appropriate mask button is darkened as if it's depressed.

- **Density.** If you've hidden an adjustment or effect with a mask and want to make the mask *semi-transparent* so the adjustment or effect shows through just a *little*, drag this slider to the left.

- **Feather.** This slider lets you soften the edges of the mask so that it blends into the image's background a little better. (Unless you added a feather to the selection you used to create the mask, its edges are sharp.) Drag it right to increase softening or left to decrease it. You'll also use this slider when making a soft-oval vignette collage (explained on page 155).

- **Mask Edge.** When you click this button, Photoshop opens the Refine Mask dialog box, where you can smooth the mask's edges, make the mask smaller or larger, add a feather to it, and so on. Page 181 has the details on this powerful dialog box (which is also called Refine Edge).

- **Color Range.** This button opens the Color Range dialog box, where you can add to or subtract from the mask based on the colors in your image. You can also use this dialog box to create a selection that you can then make a mask *from*; page 165 has more info.

- **Invert.** This button lets you flip-flop the mask so what *was* masked isn't and what *wasn't* masked is (you're gonna use this button a *lot*). Alternatively, you do the same thing by activating a mask and then pressing ⌘-I (Ctrl+I).

- **Load Selection from Mask.** Once you've created a layer mask, you can click this icon to load it as a selection that you can then use somewhere else, like in another fill or adjustment layer's mask.

- **Apply Mask.** Once you get the mask just right, you can permanently (eek!) apply it to the layer by clicking this icon. Applying a mask permanently alters the layer and limits the changes you can make later, so don't use this option unless you're *certain* you won't need to change the mask down the road. If you click this icon by accident, use the History panel or the Undo command (⌘-Z or Ctrl+Z) to get the mask back or you won't be able to edit it ever again.

- **Disable/Enable Mask.** This visibility eye works just like the one in the Layers panel (page 84): Click it to turn the mask off or on.

- **Delete Mask.** If you decide you don't want the mask, you can kick it to the curb by clicking this little trash can at the bottom of the Properties panel.

> **TIP** To copy a mask to another layer, press and hold Option (Alt on a PC), click the mask in the Layers panel, and then drag it to the other layer. (You have to press Option or Alt *before* you click the mask or you'll merely move it from one layer to the other.) When you drag, your cursor turns into a double black-and-white arrowhead and you see a ghosted image of the mask.

When a layer mask is active, the Properties panel's menu contains these goodies:

- **Mask Options.** When you're editing layer masks, you've got a few different viewing options. In the masking examples discussed earlier, you edited the mask while viewing the image in full color. But as Figure 3-34 explains, you can also work on a mask while you're looking at a grayscale version of the mask itself (meaning it fills your document window), or you can turn the mask into a color overlay. Which one you should choose depends on the colors in your image and the area you're trying to select. If you go the color-overlay route and Photoshop's standard red isn't doing it for you, choose this command from the Properties panel's menu, and then use the Layer Mask Display Options dialog box (Figure 3-34, bottom) to pick another color that makes it easy to distinguish the mask from the unmasked parts of the image.

> **TIP** Several of the commands in this list are *also* available via the shortcut menu that appears when you Control-click (right-click) the layer mask's thumbnail in the Layers panel. Handy!

- **Add Mask To Selection.** If you create a mask and then make a selection (see Chapter 4), you can choose this command to add the area you've masked to the selection. This is an easy way to expand the currently selected area to include the mask.

- **Subtract Mask From Selection.** This command deletes the shape of the mask from your selection.

- **Intersect Mask With Selection.** To select only areas where your selection and the mask overlap, choose this command.

■ Using Smart Objects

A *smart object* is a very special layer that protectively wraps its content, which can be raw files (page 54), vectors (drawings) from programs like Adobe Illustrator (Chapter 13), other layers, and even a whole PSD document, among other things. Smart objects are smart because Photoshop protects what you put into them by

applying your edits to the *wrapper* instead of what's *inside* of it. This lets you do the following:

- **Transform or resize it without losing quality.** Instead of resizing the content inside a smart object, Photoshop resizes the wrapper. In the blink of an eye, Photoshop updates your document with the newly resized content *without* making it look blocky (so long as you don't exceed the file's original dimensions too much—unless it's vector-based). You can also use the full range of transform tools (page 276) on smart objects repetitively without losing quality.

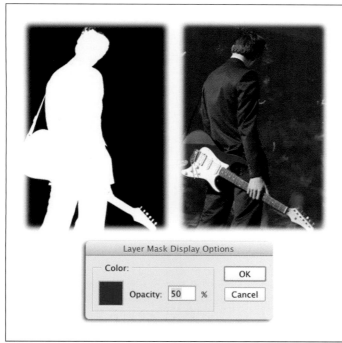

FIGURE 3-34

Left: To get inside a layer mask and edit it in full grayscale glory—handy for ensuring your subject is fully revealed—Option-click (Alt-click on a PC) the mask's thumbnail in the Layers panel.

Once you're inside the mask, you can then copy and paste pixels—including text—right into it. (Page 661 has a cool example involving snatching texture from a photo and pasting it into a mask to add it to text.) When you're finished editing the mask, click the layer's thumbnail.

Right: To edit the mask with a red overlay (like Quick Mask Mode; page 193), click the mask in the Layers panel to activate it, and then press the backslash key (\). To change the overlay's color, open the Properties panel's menu and choose Mask Options. In the dialog box that appears (shown here), click the color square and then pick a new color from the resulting Color Picker. Press the backslash key again to send the overlay packin'.

Unlinking a Layer from Its Mask

Photoshop assumes that if you reposition the contents of a layer, you want its mask to come along for the ride. But that's not always the case. For example, if you use a mask to frame a photo (see the oval vignette instructions on page 155), you may want to move what's *inside* the mask (the photo) independent of the mask itself, or vice versa. No problemo—you just need to unlink 'em first.

Over in the Layers panel, there's a tiny chain icon between the layer's thumbnail and the mask's thumbnail (you can see it in

Figure 3-32). To separate the layer from the mask, either click this icon or choose Layer→Layer Mask→Unlink (you'll know they're separated because the chain disappears). Then press V to grab the Move tool, click the thumbnail of the piece you want to move (the layer or the mask), and then drag.

Once you've got everything where you want it, relink 'em by clicking where the chain *used* to be (between the layer and mask thumbnails) or choosing Layer→Layer Mask→Link. Easy, huh?

- **Nondestructively wrap a bunch of layers into a single-layer bundle.** Unlike merging layers (page 118), converting several layers into a single smart object *preserves* the original layers. This ability is super helpful if you want to edit several layers as if they were one; for example, you can mask multiple layers at once (say, if you need to mask them all in the exact same way) or apply filters or layer styles. This is also helpful when you need to bring one Photoshop document into *another* Photoshop document. By placing the first document as a smart object, you can easily open it for editing in the second document (and, as you learned on page 138, access any layer comps the first document contains).

- **Run filters nondestructively.** When you run a filter on a smart object, Photoshop automatically adds a mask to the smart object (labeled in Figure 3-35) and does the filtering on *its* own layer (similar to layer styles) so you can tweak, hide, or undo the filter's effects. See page 670 to learn how to run filters on smart objects (nearly *all* Photoshop's filters can run on smart objects).

- **Update multiple instances of the same content.** When you duplicate a smart object, the duplicate is *linked* to the original so it functions like an exact clone. So, for example, if you've placed the same smart object in several places in your document—like a large version of a logo, shape, or image in one spot and a smaller version of it somewhere else—and then you make changes to the original smart object in Photoshop or in another program (like Camera Raw or Illustrator), Photoshop automatically updates that content wherever it appears in your document. (Your author uses this trick to create label templates for bottles of specialty liquors for her spirit-making design clients.)

- **Swap content.** Once you've formatted a smart object, you can swap its contents for something else, and the new content takes on the original's size and placement, as well any other attributes you applied via masking, smart filters, or adjustment layers (provided they live above the smart object in the Layers panel). This content swapping is *powerful* magic when it comes to making creative templates that you can use over and over with different images (photographers love this kind of thing). Figure 3-35 has the details.

For designers, the ability to swap content is helpful when you've got several pieces of art that need to be placed at the same size within a design (think multiple album covers in a concert ad or book covers in an author-event poster). You can also swap the contents of one smart object *without* changing the others by creating an *unlinked* copy, as explained on page 135.

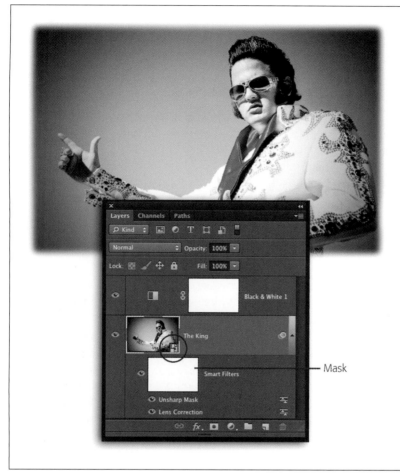

FIGURE 3-35

You can create some pretty amazing templates using smart objects. Just open an image as a smart object (as described later in this section), and then make all the changes you want using filters and adjustment layers, like giving it a sepia tint, adding a dark-edge vignette, and sharpening it, as shown here. (The little badge at the bottom right of the layer's thumbnail [circled] indicates that the layer is a smart object.)

Then, to swap the original photo for another one, activate the smart object layer, and then choose Layer→Smart Objects→Replace Contents (or Control-click [right-click] near the layer's name in the Layers panel and choose Replace Contents from the resulting shortcut menu). Navigate to another photo on your hard drive, click Open, and it'll take on the same characteristics automatically!

Thank ya, thank ya very much.

— Mask

NOTE Smart objects are also useful when you're working with raw files because you can double-click 'em in Photoshop to open them in Camera Raw (page 54), and therefore access any edits you made in Camera Raw. However, placing multiple smart objects in a single document that contains raw files will bloat your document's file size in a hurry because the raw files themselves are so big. The fix is to use the Place→Linked command instead of Place→Embedded, as page 134 explains. Otherwise, Photoshop may run out of memory and run...as slow...as molasses.

The following sections teach you how to create and manage smart objects.

Creating Smart Objects

How you create a smart object depends on a few things: where the original content lives, which document you want to put it in and—new in this version of Photoshop CC—whether you want the file to be embedded into the document or externally linked to it instead. Here are your options:

- **To create a new document containing a file that lives on your hard drive, choose File→"Open as Smart Object."** In the resulting Open dialog box, navigate to the file, and then click Open. Photoshop create a new document containing a single smart object (without a background layer). The image you've opened appears at its original size, and you'll see the smart object badge (circled in Figure 3-35) on its layer thumbnail.

> **TIP** To open more than one file as a smart object, Shift-click multiple files in the Open dialog box. When you click Open, each file opens as its own document with a single smart object layer.

FREQUENTLY ASKED QUESTION

Clipping Masks

What the heck is a clipping mask? Is it similar to a layer mask?

Clipping masks and layer masks are similar in that they both *hide* parts of an image, but that's about all they have in common. Clipping masks are like Photoshop's version of stencils: They let you take one layer's contents (a photo of bluebonnets, say) and shove it through the contents of the layer directly below (for example, text that says "Texas"). The result? The image on the top layer is "clipped" so that you only see the bluebonnets inside the text. (Hop over to page 664 for step-by-step instructions on this technique.)

You can give clipping masks a spin by opening a photo and, in the Layers panel, single-clicking the background layer's padlock icon to unlock it. Next, add a new image layer *below* the unlocked background layer by ⌘-clicking (Ctrl-clicking) the "Create a new layer" icon at the bottom of the Layers panel. Then press B to grab the Brush tool and paint a big ol' brushstroke across the new layer (don't worry about what color it is). Next, in the Layers panel, activate the photo layer (which should be on top of your layer stack), and then choose Layer→Create Clipping Mask or press Option-⌘-G (Alt+Ctrl+G), and Photoshop makes your photo visible *only* through the brushstroke, regardless of what color the brushstroke is (layer transparency

is the only thing that matters). Option-clicking [Alt-clicking] the dividing line *between* the two layers in the Layers panel does the same thing.

When you use a clipping mask, you don't get another thumbnail in your Layers panel like you do with a layer mask. Instead, the photo layer's thumbnail scoots to the right and you see a tiny down arrow indicating that it's clipped to the layer below. And in Photoshop CC, the name of the layer that's being used as the mask—the layer on the bottom—gets underlined.

You can clip together as many together as you want. For example, you can clip three image layers to a layer containing a brushstroke so all the photos show *through* it (provided you've adjusted their blending modes [page 296] so you can see through 'em). To release a clipping mask, activate the clipped layer(s)—in this example, the three image layers—choose Layer→Release Clipping Mask, choose Release Clipping Mask from the Layers panel's menu, or press Option-⌘-G (Alt+Ctrl+G). Alternatively, you can Option-click (Alt-click) the dividing line *above* the layer that you're shoving the images through (say, the brushstroke layer). Whew! Whichever method you use, you should see your entire photo(s) again.

- **To place a file into a document that's currently open, choose File→Place Embedded or File→Place Linked.** The Place Embedded command places a full-sized copy of the file into the current document. The Place Linked command, on the other hand, creates an external *link* to the file, which can *greatly* reduce the file size—and thus the memory demands—of your Photoshop document. You still *see* the contents of a linked smart object in your document, but that content isn't embedded into the document.

 You'll want to use the Place Linked command when you're placing big files, such as raw files, video clips, or whole Photoshop documents. The slick part is that, if you update the linked file in a program other than Photoshop, the next time you open the Photoshop document containing the linked smart object, you see a message notifying you that the linked file has been updated (at which point you can click a button to update the linked smart object's content). The only downside to this method is that, if you move or rename the linked file on your hard drive—or worse, delete it—you'll need to *relink* the file; otherwise, you may be forced to rasterize the smart object in order to perform whatever command you're trying to use. (You'll learn all about managing linked smart objects on page 137.)

 No matter which Place command you use, you see the same Open dialog box so you can navigate to the file you want to place. The file opens as a smart object *inside* the current document, and Photoshop also puts little handles around the object so you can resize it. When you press Return (Enter on a PC) to accept the object, you'll see the smart object badge appear on the new layer's thumbnail. Unfortunately, you can't place multiple files using either command.

> **NOTE** Photoshop also automatically opens any files you drag into its window as smart objects. If you've got a document open, the smart object appears on a new layer inside that document; if you don't, it opens as a smart object in a *new* document.

- **Copy and paste an Adobe Illustrator file.** If you copy Illustrator art into your computer's memory, you can paste it into an open Photoshop document using ⌘-V (Ctrl+V). Photoshop will then ask whether you want to paste it as a smart object, pixels, path, or shape layer (the last three are covered in Chapter 13).

- **In Bridge, choose File→Place→In Photoshop.** If you're using Bridge to peruse files (see Chapter 22), this command pops 'em open as smart objects in Photoshop.

- **To turn existing layers into a smart object in the current document, activate the layer(s), and then, from the Layers panel's menu, choose "Convert to smart object."** If you're working with an image that has a bunch of adjustment layers associated with it, you can use this command to group the whole mess into a single smart object. That way, you can apply additional changes to *all* those layers at once with tools that work only on individual layers (like filters and layer styles). Figure 3-36 has the details.

FIGURE 3-36

Top: To convert multiple layers into a smart object, activate them in the Layers panel, and then choose "Convert to Smart Object" from the panel's menu or from the shortcut menu you get by Control-clicking (right-clicking) near a layer's name (it doesn't matter which one). Alternatively, you can choose Layer→Smart Objects→"Convert to Smart Object," or choose Filter→"Convert for Smart Filters." All these commands do the same thing.

Bottom: Photoshop converts all those layers into a single smart object, and if you Control-click (right-click) it, you get the menu shown here. To change an embedded smart object into one that's linked, choose "Convert to Linked" and Photoshop opens the smart object's content in another window, which you can then save to your hard drive. How cool is that?

NOTE You can add a layer mask to smart objects just like you can to any other layer (page 120). When you do, Photoshop automatically *links* the mask to the layer so you can move 'em around together. To unlink them, just click the little chain icon between their thumbnails in the Layers panel. (See the box on page 130 for more on linked masks.)

Managing Smart Objects

Once you've created a smart object, you can duplicate it, edit it, and export its contents. You'll find the following commands in the Layer→Smart Objects submenu, and *most* of 'em in the shortcut menu you get by Control-clicking (right-clicking) near the layer's name in the Layers panel:

- **New Smart Object via Copy.** When you choose this command, Photoshop makes a duplicate of your smart object that's *not linked* to the original, so if you edit the content of the original smart object, the duplicate won't change. An unlinked copy is helpful when you want to place several pieces of art at the

same size in your design; place the first piece of art as a smart object and size it just right, then make an unlinked copy of the smart object and swap its contents.

> **TIP** To create a duplicate smart object that *is* linked to the original, drag the smart object onto the "Create a new layer" icon at the bottom of the Layers panel, or just activate the smart object in the Layers panel and then duplicate it by pressing ⌘-J (Ctrl+J).

This is handy when you repeat graphical element in your design because—if you edit that element in the original smart object—Photoshop updates *all* the copies of it. For example, if you create a document that includes several sizes of the same image (like the picture packages you got in grade school or a label template), using linked smart objects lets you swap *all* the images for a different one in two seconds flat.

- **Edit Contents.** Choose this option or double-click the smart object's thumbnail in the Layers panel if you want to edit the original file in the program that created it (for example, Camera Raw or Adobe Illustrator). Once you save the file in the other program (or you click Done in Camera Raw), it gets updated in your Photoshop document automatically. For this trick to work, you *must* use Photoshop to open the original file for editing; it won't work if you edit the file behind Photoshop's back.

- **Replace Contents.** As you learned back in Figure 3-35, you can use this command to swap the contents of a smart object so the new image takes on the editing treatment you gave the original one.

- **Export Contents.** This command pulls the contents of the active smart object out of the current document and puts it into a new file that's the same format as the original. For example, if the content began life as a raw file, Photoshop will save the smart object's contents in raw format; if the content is a pixel-based image or Photoshop layers, you get a new Photoshop document that contains the image or layers; and so on. When you choose this command, Photoshop displays a dialog box so you can name the new file and choose where to save it.

- **Convert to Linked.** New in this version of Photoshop CC is the ability to create an externally linked version of an embedded smart object's content. Choosing this command opens the content in a new Photoshop document that you can then save to your hard drive. (The next section has more about linked smart objects.)

- **Stack Mode.** This option, which lives only in the Layer→Smart Object submenu, contains a slew of processing options that you can apply to a smart object composed of a series of similar images (called an *image stack*) in order to produce a perfect image that's free of noise or other accidental elements that snuck into the shot (like birds flying across the sky, a car passing in front of the subject, and so on).

- **Rasterize.** As you learned on page 129, when you edit a smart object, you're editing the *wrapper,* not its contents. That's why you can't use any of Photoshop's painting, healing, fill, or eraser tools on a smart object (though, if the smart object contains other pixel-based layers, you can double-click the smart

object to expand it into a temporary document and edit that instead). However, if you're ready to give up all the goodness that comes with using a smart object, choose this option to rasterize it and make it behave like any other layer.

■ USING LINKED SMART OBJECTS

Externally linked smart objects are just the ticket for combining really big files into a single Photoshop document. They're super handy, too: if you change a linked file in another program—say, Illustrator or Camera Raw—and the Photoshop document containing that linked content is open, Photoshop automatically updates the Photoshop document to reflect the change. If the Photoshop document is closed, then you can update the content manually using the methods described in this section.

But how on earth do you keep track of all this stuff inside Photoshop? By using the Properties panel (Figure 3-37), which lets you see where the linked content lives on your hard drive, whether the content needs updating, and whether the link is broken (if it is, broken the Properties panel lets you fix the link). And—if you linked to a whole Photoshop document—the Properties panel (Window→Properties) lets you access any *layer comps* that document includes.

TIP You can also use the status bar (which lives at the bottom left of any open Photoshop document window—see the box on page 61) to check the status of linked smart objects. Simply click the tiny right-facing arrow (the one *without* a square behind it), and then choose Smart Objects. When you do, Photoshop displays the number of missing linked smart objects your document contains, as well as how many need updating. The Info panel can show you this info, too: choose Panel Options from its panel menu and, in the Status Information section, turn on Smart Objects.

The Layers panel is helpful, too, as it displays slightly different badges on linked smart objects than it does on embedded ones (an embedded-smart-object badge is circled back in Figure 3-35):

- Linked smart objects have badges with a tiny chain icon. Figure 3-37 includes one of these badges.

- Linked smart objects whose content you've modified but haven't yet updated in the Photoshop document have badges with a yellow triangle with an exclamation inside it. To update the content, activate the offending smart object in the Layers panel, and then Control-click (right-click) near its name and choose Update Modified Contents from the shortcut menu that appears. To update *all* the modified smart object content in your document, choose Update All Modified Content instead.

- Linked smart objects with broken links sport a badge with a red circle with a question mark inside it (Figure 3-37 shows two of these badges). To fix the link, activate the smart object in the Layers panel, and then Control-click (right-click) near its name and choose Resolve Broken Link. In the Open dialog box that appears, navigate to where the file now lives.

FIGURE 3-37

Top: The Properties panel shows you where the linked smart object file lives and, if it's a Photoshop document, you can use the drop-down menu beneath the file path to access any layer comps it contains (this example has a layer comp named "Earthy no rays"). Edit the linked file's contents by clicking Edit Contents or switch it to an embedded smart object by clicking Embed.

Bottom: If you move or rename the linked file, its layer badge changes to a red circle. To relink the file, click the same icon in the Properties panel, and then choose Resolve Broken Link. Alternatively, you can replace the smart object's contents with another file by choosing Replace Contents.

NOTE Don't create linked smart objects from content that lives on an external *network* drive. If you do, the time delay in accessing the network—or worse, if the drive is offline—can make Photoshop report the link as broken when it's really not.

This linked smart object business is all well and fine for *you*, but what if you need to give a Photoshop document containing linked smart objects to someone else? In that case, you need to gather up all the linked files, too. Happily, the current version of Photoshop CC makes this really easy to do: choose File→Package and, in the resulting dialog box, specify a landing spot for the copy of the Photoshop document and all its linked files, and then click Choose. Photoshop then copies the open document to the destination you specified, creates a new folder named Links in the same location, and tucks a copy of all the linked files into it (you see a nice status bar noting Photoshop's progress). If your document contains any *missing* files

(due to broken links), you get an error message. Use the techniques listed above to fix the links or replace the content, and then choose the Package command again.

NOTE Unlike in Illustrator and InDesign, Photoshop's File→Package command *doesn't* gather up any fonts you used in the document.

■ Layer Styles

After all that hard work learning about the different kinds of layers, you're probably ready for some fun. This section is all about *layer styles*: a set of fully adjustable, ready-made special effects for layers that you can apply in all kinds of cool ways. Consider this section your reward for sticking with this chapter till the bitter end.

Layer styles are a lot of fun and, since they appear on their own layers, they're non-destructive *and* they remain editable as long as you save the document as a PSD file. Layer styles are great for adding finishing touches to designs, and they can make text and graphical elements pop off the page (see Figure 3-38). They also update automatically as your layer content changes.

POWER USERS' CLINIC

Nested Smart Objects

Believe it or not, there will be times when you need to convert a smart object into *another* smart object, to create a *nested* smart object. Don't roll your eyes just yet; consider these practical scenarios:

Let's say you're retouching a portrait and you converted multiple layers into a smart object so you can apply sharpening to all those layers (called global sharpening). Now you decide to add *another* round of sharpening to only certain areas—say, your subject's hair, eyelashes, lips, or the iris of each eye (called selective sharpening). Sure, you can run the sharpening filter on the smart object a second time, but if you use the included mask, you'll end up hiding *both* rounds of sharpening because you get only *one mask* per smart object. The fix is to create a second smart object out of the first in order to get another mask.

Now let's go in a completely different direction, just for fun. Say you designed a wine bottle label in a Photoshop document consisting of multiple layers and smart objects, and now you need to create *another* Photoshop document in order to print

multiple labels on a single page. No problem! Use File→Place to add the *first* document—that's right, the whole enchilada—to the *second* document as a smart object. Next, duplicate that smart object however many times you need to create multiple labels, and then arrange them accordingly. Not only does this let you work with fewer layers in the label template, but it also gives you the ability to change *all* the labels at once. Just double-click one of the smart objects—it doesn't matter which one because they're all linked—to expand it into a temporary document containing the layers from the first document, primed and ready for editing. Press ⌘-S (Ctrl+S) to save your changes, close the temporary document, and kapow! Back in the second document, the labels change en masse.

These are but two of a *bazillion* scenarios where nesting smart objects is a necessity for maintaining a nondestructive workflow (meaning you can always get back to your original layers). Just activate the smart object(s), and then use any of the methods discussed in this section to create another one. Happily, Photoshop lets you nest smart objects inside of smart objects, inside of smart objects...

FIGURE 3-38

Here's a peek at all the cool styles you can tack onto layers, be they image, shape, or type layers, or even smart objects. Adobe refers to them individually as "styles" and collectively as "effects," but most folks just call 'em "layer styles."

These styles are listed in the Layers panel's "Add a layer style" menu (see step 2 below) in the order that Photoshop applies them to layer content. For example, Bevel & Emboss appears on top of any other styles you've applied to the same layer, while a drop shadow appears below other styles (which makes sense if you think about where these styles would physically appear on real objects).

NOTE If you add a layer style to a path (page 570), its gray outline temporarily disappears while the Layer Style dialog box is open.

Here's how to add The Lord of All Styles, the drop shadow, to a layer:

1. **In the Layers panel, activate the soon-to-be-shadowed layer or layer group.**

 You can only apply layer styles to a single layer or layer group.

 TIP If you apply a layer style to a layer group, Photoshop treats the group as if it were *flattened* (page 118), so you get slightly different results than you do by adding the style to individual layers. For example, if you've got a slew of layers and you add a drop shadow to each of 'em, you end up with a shadow on top of a shadow on top of a shadow—yuck. The fix is to stuff those layers inside a layer group and then add the layer style to the *group* instead. That way you end up with one nice, subtle shadow instead of a big ol' shadowy mess.

2. **At the bottom of the layers panel, click the *fx* icon and choose Drop Shadow (see Figure 3-39, top).**

 The *fx* stands for "layer *effects*" (though this book refers to them as layer styles).

Click to change drop shadow color

Click to temporarily save settings

FIGURE 3-39

When it comes to drop shadows, the classiest ones are rarely black—instead, they pick up a darker color from the image. Just click the color swatch labeled here, and Photoshop summons the Color Picker (page 522). To snatch a color that lives in the image, mouse over the image and, when your cursor turns into an eyedropper, click once; your shadow takes on that color.

You'll likely need to lower the shadow's opacity so it's nice and soft, and use the Spread and Size sliders to make it wider. Don't bother messing with the Angle dial or the Distance slider because you can change those settings right in your docu-ment—while the Layer Style dialog box is still open—by dragging the shadow around, as shown here (bottom).

Once you get the drop shadow just right, click Make Default (labeled). The next time you need to add a drop shadow, Photoshop will use those same settings.

3. **In the Layer Style dialog box, adjust the settings to produce a respectable (soft)—not gaudy (black and 10 feet away from the object)—drop shadow.**

There are tons of options for each style in the Layer Style dialog box, as Figure 3-39 shows, and it's a good idea to experiment with all of 'em so you know how they work. If you want to create a light-colored shadow instead of a dark one, change the Blend Mode menu from Multiply to Normal.

> **TIP** You can also open the Layer Style dialog box by double-clicking a layer's thumbnail or double-clicking near (but not *on*) the layer's name in the Layers panel.

4. **Click OK when you're satisfied with the effect, and then marvel at your very first drop shadow.**

Photoshop closes the Layer Style dialog box and adds a couple of things to the Layers panel: a category named Effects and, beneath it, an item named Drop Shadow. (If you add *more* layer styles, they stack up beneath the word "Effects.") The program also adds a special badge to the right of the image layer's name (it looks like a cursive *fx*).

To edit the style later, double-click it in the Layers panel. To move it to another layer, just grab it and drag (you'll see a big *fx* as you drag). You can add as many different styles to a layer as you want, all from the Layer Style dialog box. Just turn on the checkboxes for the various styles (they're all in the Styles column on the left), and then click a style's name to see its options. And remember the Layers panel's Fill setting discussed back on page 99? You can use it to make a layer's *contents* see-through while its *style* remains 100 percent solid (great for creating hollow text).

FREQUENTLY ASKED QUESTION

Hiding Styles with Masks

Help! I have a mask on my layer and Photoshop is showing the styles through the darn mask! How do I hide those pesky styles?

Ah, you seek the elusive style cloak. To summon it, you must boil the stalk of a West Texas tumbleweed, season it with eye of toad, and drink it from the shell of an armadillo three days dead...

Just kidding. To hide styles with a layer mask, you've got to change the layer's blending options. In the Layers panel, double-click the word "Effects," and Photoshop opens the Layer Style dialog box set to display the Blending Options settings (in other words, Blending Options is highlighted at the dialog box's upper left).

In the Advanced Blending section in the center of the dialog box, you'll see a list of checkboxes that includes Layer Mask Hides Effects and Vector Mask Hides Effects. Turn on the appropriate option for the kind of layer you're working with (Vector Mask [page 606] for vector-based layers, and Layer Mask for all other layers), and then click OK. Back in your document, the mask should hide any styles you've applied to that layer. In the Layers panel, a tiny icon that looks like two intersecting squares appears at the far right of the layer to indicate that you've changed its blending options.

Now, back to that magic potion...

Managing Layer Styles

Once you've tacked on a layer style or two, you'll undoubtedly want to apply them to other layers and turn them off or on. Here's how:

- **To copy a style from one layer to another,** head over to the Layers panel and Option-drag (Alt-drag on a PC) the style to the new layer. Your cursor turns into a double black-and-white arrowhead when you drag, and you see a big, ghosted *fx*.

- **To turn a style off,** click the visibility eye to the left of the style's name in the Layers panel.

If you Control-click (right-click) a layer style in the Layers panel, you see a shortcut menu with these options:

- **Disable Layer Effects** turns off *all* the styles on that layer. To turn them back on, open the menu again and choose Enable Layer Effects. (You can do the same thing by clicking the visibility eye to the left of the word "Effects" in the Layers panel.)

- **Copy Layer Style** copies all the styles you've applied to the active layer so you can apply them to other layers. After you choose this command, Shift- or ⌘-click (Ctrl-click) to activate the layer(s) you want to apply the styles to, and then Control-click (right-click) to open the shortcut menu again and choose Paste Layer Style.

- **Clear Layer Style** deletes the style from the active layer(s). You can also drag a style to the trash can at the bottom of the Layers panel to remove it from a layer.

- **Global Light** tells Photoshop to use the same lighting angle in every style you add, which is useful when you're applying drop shadows or inner shadows. If you've got more than one drop shadow in your document, you *probably* want to turn on this option so the lighting stays consistent.

- **Create Layer** takes the style applied to the active layer and converts that *style* into an image layer, which means you lose the ability to edit the style. Though it sounds limiting, you can use this option to further customize a layer style into your own personal vision; once it's a regular layer, you can run filters on it, use the painting tools, and so on.

- **Hide All Effects** turns off the styles applied to *every* layer in your document. After you've hidden them, this menu item changes to read "Show Effects" so you can choose it to turn 'em back on.

- **Scale Effects** lets you resize the style itself, independent of the layer's contents, by entering a percentage. This option is useful if you want to fine-tune drop shadows and glows by making them slightly larger or smaller.

Last but not least, there may be a time when you want to rasterize a layer style so it's part of the layer itself (though it's tough to think of a reason why). You can do that by heading to the Layers panel, Control-clicking (right-clicking) to the right

of the layer's thumbnail, and then choosing Rasterize Layer Style. When you do, Photoshop *permanently* applies the layer style to the layer.

The Styles Panel

Photoshop comes with all kinds of layer-style presets made from some pretty psychedelic style combinations. You'll find a couple of them useful, but most of them are just funky , which is why it's good to know how to load some of the other built-in style presets and create your own. To get at them, open the Styles panel by clicking its tab in the panel dock on the right side of your screen or by choosing Window→Styles (see Figure 3-40).

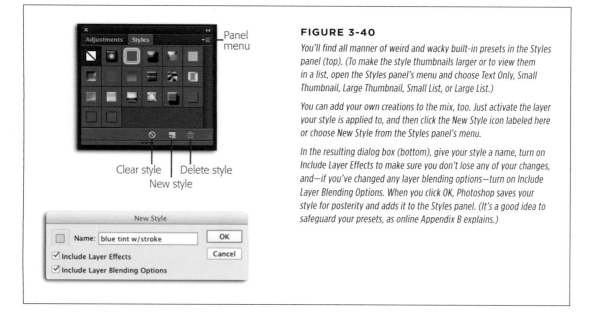

Panel menu

Clear style | Delete style
New style

FIGURE 3-40

You'll find all manner of weird and wacky built-in presets in the Styles panel (top). (To make the style thumbnails larger or to view them in a list, open the Styles panel's menu and choose Text Only, Small Thumbnail, Large Thumbnail, Small List, or Large List.)

You can add your own creations to the mix, too. Just activate the layer your style is applied to, and then click the New Style icon labeled here or choose New Style from the Styles panel's menu.

In the resulting dialog box (bottom), give your style a name, turn on Include Layer Effects to make sure you don't lose any of your changes, and—if you've changed any layer blending options—turn on Include Layer Blending Options. When you click OK, Photoshop saves your style for posterity and adds it to the Styles panel. (It's a good idea to safeguard your presets, as online Appendix B explains.)

TIP To bypass the New Style dialog box next time you want to save a style, Option-click (Alt-click on a PC) the Style panel's New Style icon. You'll get a new style, cleverly called "Style" that you can rename later, but you don't get to change any other settings.

Admittedly, the built-in styles that are initially displayed in the Styles panel aren't anything to write home about, but if you open the Styles panel's menu, you'll see 10 *more* sets you can load: Abstract Styles, Buttons, Photographic Effects (a variety of color tints applied via the Color Overlay layer style), Web Styles, and so on. To load a set, just choose it from the menu; Photoshop asks if you'd like to add them to the existing styles or replace the existing ones. You'll need to root around in these sets to see if any of 'em look useful; in the doing so, you'll likely come up with ideas for creating new time-saving styles on your own!

To apply one of the presets, simply activate the layer you want to use it on, and then click the style's thumbnail (if you're working with a background layer, make sure to single-click its padlock icon to unlock it first). You can tweak the style by double-clicking its layer in the Layers panel or by choosing its name from the left-hand list in the Layer Style dialog box. You can also drag and drop a style's thumbnail from the Styles panel onto a layer in the Layers panel, but doing so makes that style replace any styles you've already added to that layer. To add a saved style on *top* of existing styles instead, hold down the Shift key as you drag and drop or as you click the style's thumbnail.

■ EXPORTING AND LOADING STYLES

If you're proud of the styles you've created and want to share them with the masses (or at least load 'em onto another computer), here's what to do: From the Styles panel's menu, choose Save Styles, give your style a name, and tell Photoshop where to save it. You can then take the resulting file to another computer, launch Photoshop, and pick one of the following options from the Styles panel's menu:

- **Load Styles** adds the new style to the ones currently in the Styles panel.

- **Replace Styles** zaps the ones you've got in favor of the new one.

- **Reset Styles** returns your styles to the factory settings.

Selections: Choosing What to Edit

Life is all about making choices, and the time you spend in Photoshop is no exception. Perhaps the biggest decision you'll make is which *part* of an image to edit—after all, your edits don't have to affect the whole thing. Using a variety of tools, you can tell Photoshop exactly which portion of an image you want to tinker with, right down to the pixel, if you so desire. This process is called *making a selection*.

You can draw selections by hand, although that requires a bit of mouse (or digital drawing tablet) prowess. As you'll learn in this chapter, Photoshop has a bunch of tools that you can use to create selections based on shape, color, and other attributes. And this version of the program sports a brand-new selection method called *Focus Area,* which lets you quickly select the part of your photo that's in focus.

True selection wisdom lies in learning which tool to start with, how to use the tools together, and how to fine-tune your selections quickly and efficiently. The following pages will help you with all that and then some.

◼ Selection Basics

What's so great about selections, anyway? Lots. After you make a selection, you can do all kinds of neat things with the selection itself, as well as the pixels that live inside it:

- **Move it around.** To move the pixels in part of an image, you need to select them first. You can even move selections from one document to another, as discussed on page 194. For example, a little head swapping is great fun after breakups—you can stick your ex's head onto a ballerina's body using selections

(see page 197). You can even scoot your selection around while you're making it, in case you didn't get it in the right spot at first (see the Tip on page 151).

- **Resize or transform it.** Need to change the size or shape of a selection before you manipulate the pixels inside it? No problem: Once you've made the selection, you can transform it into whatever size or shape you need (page 191). With this maneuver, Photoshop won't reshape any pixels that are inside the selected area; it just changes the shape of the *selection* itself. This trick is handy when you're trying to select part of an image that's in perspective, as shown on page 192. Likewise, you can also transform the *pixels* you've selected, which is helpful when you're resizing or slimming your subject (page 458).

- **Fill it with color, a repeating pattern, or nearby pixels.** Normally, the Edit→Fill command or a fill layer floods an *entire* layer with color, but by creating a selection first, you can color just that area (handy when fixing animal white-eye, as described on page 470). You can also use selections in conjunction with Photoshop's content-aware tools to remove a person or object from a photo as if they were never there (page 436).

- **Add an outline.** You can add a *stroke* (Photoshop's term for an outline) to any selection. For instance, you can use selections to give a photo a classy, thin black border or to circle yourself in a group photo (page 199). You can also add a stroke to shapes and paths; you'll learn all about that on page 596.

- **Use it as a mask.** When you create a selection, Photoshop protects the area outside it, so anything you do to the image affects only the selected area. For example, if you paint with the Brush tool across the edge of a selection, it paints only the area *inside* the selection (helpful when adding color to an image that doesn't have any). Likewise, if you create a selection before adding a layer mask (page 120), Photoshop automatically loads the selected area into the mask, letting you adjust only that area. Selections are crucial when you need to swap backgrounds, correct color or lighting in just one area (Chapter 9), or change the color of an object (page 347).

This chapter discusses all these options and more. But first you need to understand how Photoshop indicates a selection.

Meet the Marching Ants

When you create a selection, Photoshop calls up a lively army of animated "marching ants" (shown in Figure 4-1). These tiny soldiers dutifully march around the edge of the selected area, awaiting your command. Whenever you have an active selection (that is, whenever you see marching ants), Photoshop has eyes only for that portion of the document—any tool you use (except the Type, Pen, and shape tools) will affect only the area *inside* the selection.

Here are the commands you'll use most often when making selections:

- **Select All.** This command selects the entirety of the currently active layer and places marching ants around the perimeter of your document, which is helpful

when you want to copy and paste an image from one document into another or create a border around a photo (see page 199). To run this command, choose Select→All or press ⌘-A (Ctrl+A).

FIGURE 4-1

To let you know an area is selected, Photoshop surrounds it with tiny, moving dashes that look like marching ants. Here you can see the ants running around this armadillo.

If you Control-click (right-click) inside the selection, you see the shortcut menu shown here, which gives you super quick access to frequently used, selection-related commands.

Selections don't hang around forever— when you click somewhere outside the selection with a selection tool, the original selection disappears, forcing you to recreate it. However, you can summon the last selection you made by choosing Select→Reselect. Page 197 explains how to save a selection so you can use it again later.

(FYI, the nine-banded armadillo is the state animal of Texas. Didn't think you'd learn that from this book, did ya?)

- **Deselect.** To get rid of the marching ants after you've finished working with a selection, choose Select→Deselect or press ⌘-D (Ctrl+D). Alternatively, if one of the selection tools described in the next section is active, you can click once *outside* the selection to get rid of it.

- **Reselect.** To resurrect your last selection, choose Select→Reselect or press Shift-⌘-D (Shift+Ctrl+D). This command reactivates the last selection you made, even if it was five filters and 20 brushstrokes ago (unless you've used the Crop or Type tools since then, which render this command powerless). Reselecting is helpful if you accidentally deselect a selection that took you a long time to create. (The Undo command [⌘-Z/Ctrl+Z] can also help in that situation.)

- **Inverse.** This command, which you run by choosing Select→Inverse or pressing Shift-⌘-I (Shift-Ctrl+I), flip-flops a selection to select everything that *wasn't*

selected before. You'll often find it easier to select what you *don't* want and then inverse the selection to get what you *do* want. The box on page 167 has more on this useful technique.

- **Load a layer as a selection.** When talking to people about Photoshop, you'll often hear the phrase "load as a selection," which is Photoshop-speak for activating a layer that contains the object you want to work with and then summoning the marching ants so they run around that object; that way, whatever you do next affects *only* that object. To load everything that lives on a single layer as a selection, mouse over to the Layers panel and ⌘-click (Ctrl-click) the layer's thumbnail. Photoshop responds by putting marching ants around everything on that layer. Alternatively, you can Control-click (right-click) the layer's thumbnail, and then choose Select Pixels from the resulting shortcut menu.

> **TIP** Although you can find most of the commands in this list in the Select menu at the top of your screen (except for loading a layer as a selection), if you want to be smokin' fast in Photoshop, you should memorize their keyboard shortcuts.

Now it's time to discuss the tools you can use to make selections. Photoshop has a ton of 'em, so in the next several pages, you'll find them grouped according to which *kind* of selections they're best at making: by shape, color, and so on. That way, you'll know which tool to start with the next time you need to select something.

Selecting by Shape

Selections based on shape are probably the *easiest* ones to make. Whether the object you want to grab is rectangular, elliptical, or rectangular with rounded corners, Photoshop has just the tool for you. You'll use the first couple of tools described in this section often, so think of them as your bread and butter when it comes to making selections.

The Rectangular and Elliptical Marquee Tools

Photoshop's most basic selection tools are the Rectangular and Elliptical Marquees. Any time you need to make a selection that's squarish or roundish, reach for these little helpers, which live at the top of the Tools panel, as shown in Figure 4-2.

FIGURE 4-2

You'll spend loads of time making selections with the Rectangular and Elliptical Marquee tools. To summon this menu, click and hold down your mouse button for a couple of seconds.

To make a selection with either marquee tool, just grab the tool by clicking its icon in the Tools panel or by pressing M, and then mouse over to your document. When your cursor turns into a tiny + sign, drag across the area you want to select (you'll see the marching ants as soon as you start dragging). Photoshop starts the selection where you clicked and continues it in the direction you drag as long as you hold down the mouse button. When you've got marching ants around the area you want to select, release the mouse button.

You can use a variety of tools and techniques to modify your selection, most of which are controlled by the Options bar (Figure 4-3). For example, you can:

- **Move the selection.** With a selection tool active, click anywhere *within* the selected area, and then drag to another part of your image. (If you were to drag with the Move tool instead, you'd move the pixels *inside* the selection rather than the selection itself.)

TIP When you start drawing a selection, Photoshop activates the Options bar's "New selection" icon (see Figure 4-3). In this mode, you can move a selection *as you're drawing it* by moving your mouse while pressing the mouse button *and* the space bar. When you've got the selection where you want it, release the space bar—but not your mouse button—and continue drawing the selection.

- **Add to the selection.** When you click the Options bar's "Add to selection" icon (labeled in Figure 4-3) or press and hold the Shift key, Photoshop puts a tiny + sign beneath the cursor to let you know that whatever you drag across next will get added to the current selection. This mode is handy when you need to select areas that don't touch each other, like the doors in Figure 4-3, or if you've selected *most* of what you want but notice that you missed a spot. Instead of starting over, simply switch to this mode and draw around that area as if you were creating a new selection.

- **Subtract from the selection.** Clicking the "Subtract from selection" icon (also labeled in Figure 4-3) or pressing and holding the Option key (Alt on a PC) has the opposite effect. A tiny – sign appears beneath your cursor to let you know you're in this mode. Mouse over to your document and draw a box (or oval) around the area you want to *deselect*.

- **Intersect one selection with another.** If you click the Options bar's "Intersect with selection" icon after you make a selection, Photoshop lets you draw another selection that overlaps the first; the marching ants then surround only the area where the two selections *overlap*. (It's a little confusing, but don't worry—you'll rarely use this mode.)The keyboard shortcut is Shift-Option (Shift+Alt on a PC). Photoshop puts a tiny multiplication sign (×) beneath your cursor when you're in this mode.

- **Feather the selection.** To soften the edges of your selection so that it blends into the background or another image, use *feathering*. You can enter a value (in pixels) in the Options bar's Feather field *before* you create the selection, as this setting applies to the next selection you make. As you'll learn later in this

chapter, feathering a selection lets you gently fade one image into another image or into a color. See the box on page 154 for the full scoop on feathering, including how to feather a selection *after* you create it.

New selection
Add to selection
Subtract from selection
Intersect with selection

FIGURE 4-3

Using these Options bar icons (or better yet, the keyboard shortcuts mentioned in this section), you can add to or subtract from a selection, as well as create a selection from two intersecting areas.

All selections begin at the point where you first click, so you can easily select one of these doors by dragging diagonally from its top-left corner to its bottom right. You can tell from the tiny + sign next to the crosshair-shaped cursor that you're in "Add to selection" mode, so this figure now has two selections: the blue door and the red door.

As you drag to create a selection, you also get a helpful overlay that displays width and height info. If you move a selection, you instead see X and Y axis info that indicates how far you've moved the selection.

Give this selection technique a spin by downloading the practice file Doors.jpg from this book's Missing CD page at www.missingmanuals. com/cds.

- **Apply anti-aliasing.** Turn on the Options bar's Anti-alias setting to make Photoshop smooth the color transition between the pixels around the edges of your selection and the pixels in the background. Like feathering, anti-aliasing softens the selection's edges slightly so that they blend better, though with anti-aliasing you can't control the *amount* of softening Photoshop applies. It's a good idea to leave this checkbox turned on unless you want your selection to have super crisp—and possibly jagged and blocky—edges.

- **Constrain the selection.** To constrain your selection to a fixed size or aspect ratio (so that the relationship between its width and height stays the same), pick Fixed Size or Fixed Ratio from the Options bar's Style menu, and then enter the size you want in the resulting Width and Height fields. (If you choose Fixed Size, be sure to enter a unit of measurement into each field, too, such as *px* for pixels.) If you leave the Normal option selected, you can draw any size selection you want.

Here's how to select two objects in the same photo, as shown in Figure 4-3:

1. **Click the marquee tool icon in the Tools panel, and then choose the Rectangular Marquee from the menu shown in Figure 4-2.**

 Photoshop remembers which marquee tool you last used, so you'll see that tool's icon in the Tools panel. If that's the one you want to use, just press M to activate it. If not, in the Tools panel, click and hold whichever marquee tool icon is showing until the menu appears, and then choose the tool you want.

TIP To cycle between the Rectangular and Elliptical Marquee tools, press M to activate the marquee toolset and then press Shift-M to activate each one in turn. If that doesn't work, make sure a gremlin hasn't turned off the preference that makes this trick possible: Choose Photoshop→Preferences→General (Edit→Preferences→General on a PC) and confirm that "Use Shift Key for Tool Switch" is turned on.

2. **Drag to draw a box around the first object.**

 For example, to select the blue door shown in Figure 4-3, click its top-left corner and drag diagonally toward its bottom-right corner. When you get the whole door in your selection, release the mouse button. Don't worry if you don't get the selection in exactly the right spot; you can move it around in the next step.

3. **If necessary, move your selection into place.**

 To move the selection, click *inside* the selected area (your cursor turns into a tiny arrow), and then drag the selection box where you want it. You can also use the arrow keys on your keyboard to nudge the selection in one direction or another (you don't need to click it first).

4. **In the Options bar, click the "Add to selection" icon, and then select the second object by drawing a selection around it.**

 Photoshop lets you know that you're in "Add to selection" mode by placing a tiny + sign below the cursor. Once you see it, mouse over to the second door and drag diagonally from its top-left corner to its bottom right, as shown in Figure 4-3. (Alternatively, you can press and hold the Shift key to put the tool into "Add to selection" mode.)

If you need to move this second selection around, do that *before* you release the mouse button or you'll end up moving both selections instead of just one. To move the selection while you're drawing it, hold down your mouse button, press and hold the space bar, and then drag to move the selection. When it's in the right place, release the space bar—but keep holding the mouse button—and then continue dragging to draw the selection. This maneuver feels a bit awkward at first, but you'll get used to it with practice.

You've just made your first selection and added to it. Way to go!

> **TIP** To draw a perfectly square or circular selection, press the Shift key as you drag with the Rectangular or Elliptical Marquee tool, respectively. To draw the selection from its center outward (instead of from corner to corner), press and hold the Option key (Alt on a PC) instead. And to draw a perfectly square or circular selection from the center outward, press and hold Shift-Option (Shift+Alt) as you drag with either tool. Just be sure to use these tricks only on new selections—if you've already got a selection, pressing the Shift key pops you into "Add to selection" mode.

FREQUENTLY ASKED QUESTION

The Softer Side of Selections

How come my selections always have hard edges? Can I make them soft instead?

While the selections you make in Photoshop start their lives with hard edges, you can apply *feathering* to soften 'em up. Feathered selections are perfect for blending one image—or a portion of an image—into another image (or another color), as in the soft oval vignette effect, an oldie but goody shown in Figure 4-4. You can also feather a selection when you retouch an image so that the retouched area fades gently into the surrounding pixels and looks more realistic. This technique is especially helpful when doing things like fixing animal white-eye (page 470) or swapping heads (page 197).

You can feather a selection in a variety of ways:

After you choose a selection tool from the Tools panel—but *before* you create the selection—hop up to the Options bar and enter a Feather amount in pixels (you can enter whole numbers or decimals, like *0.5*). Feathering by just a few pixels blurs and softens the selection's edges only slightly, whereas increasing the Feather setting creates a wider, more intense blur and a super-soft edge.

After you draw a selection, you can change its Feather setting either by choosing Select→Modify→Feather and then entering a number of pixels, or by Control-clicking (right-clicking) the selection and then choosing Feather from the resulting shortcut menu (shown in Figure 4-1).

However, if the selection you made is destined to live inside a layer mask, then by far the *best* method is to use the Properties panel's Feather slider, which lets you *see* how the feathered edge will look and gives you the option of changing it later on. To use this method, create a selection, and then add a layer mask. Next, open the Properties panel by choosing Window→Properties and, with the mask active in the Layers panel, drag the Feather slider to the right; Photoshop shows the feathering in your document in real time. If you decide to change the amount of feathering later on, just activate the mask, pop this panel back open, and then tweak the same slider.

You can also use the Refine Edge dialog box to add and view feathering in real time, though this technique is best in cases where you need to feather the selection and tweak it in other ways (such as expanding or contracting it). That said, this method *doesn't* give you the ability to change the feathering amount later. (For more on using the Refine Edge dialog box, see page 181.)

■ CREATING A SOFT VIGNETTE

The Elliptical Marquee tool works just like the Rectangular Marquee tool except that it draws round or oval selections. It's a great tool for selecting things that are, well, *round*, and you can use it to create the ever-popular, oh-so-romantic, soft oval vignette collage shown in Figure 4-4. Here's how:

1. **Open two images and combine them into the same document.**

 Simply drag one image from its Layers panel into the other document's window, as shown on page 107.

2. **In the Layers panel, reposition the layers so the soon-to-be-vignetted photo is at the top of the layer stack.**

 Make sure that both layers are unlocked so you can change their stacking order. If you see a tiny padlock to the right of a background layer's name, single-click it to unlock it (in previous versions of Photoshop, you had to *double*-click the padlock). Then drag the layer containing the photo you want to vignette (in Figure 4-4, that's the armadillo pic) to the top of the Layers panel.

Mask

FIGURE 4-4

By creating a selection with the Elliptical Marquee tool, adding a layer mask (page 120), and then feathering the mask, you can create a quick two-photo collage like this one. Wedding photographers and moms—not to mention armadillo fans—love this kind of thing!

By using the Properties panel to apply the feather, you gain the ability to change or even remove the feather later on (provided you save the document as a PSD file).

Once you get the hang of this technique, try creating it using the Ellipse tool (one of Photoshop's vector shape tools) set to draw in Path mode, as described on page 568.

3. **Grab the Elliptical Marquee tool and select the part of the image you want to vignette (here, the armadillo's head and, um, shoulders).**

Peek at your Layers panel to make sure the correct image layer is active (the armadillo), and then—in the main document window—position your cursor near the center of the image. Press and hold the Option key (Alt on a PC), and then drag to draw an oval-shaped selection from the inside out. When you've got the selection big enough, release the Option (Alt) key and your mouse button.

4. **Hide the area outside the selection with a layer mask.**

You *could* simply inverse the selection (page 149) and then delete the area outside it, but that'd be mighty reckless. What if you changed your mind? You'd have to undo several steps or start over completely! A less destructive and more flexible approach, which you learned about back on page 120, is to *hide* the area outside the selection with a layer mask. To do that, over in the Layers panel, make sure the correct layer is active (the armadillo), and then add a layer mask by clicking the circle-within-a-square icon at the bottom of the panel. Photoshop hides everything outside the selection, letting you see through to the bluebonnet layer below. Beautiful!

5. **Use the Properties panel's Feather slider to feather the selection's edges.**

With the layer mask active, open the Properties panel by choosing Window→Properties or double-clicking the mask thumbnail itself. In the panel that appears, drag the Feather slider to the right and Photoshop softens the selection in the document as you watch. (Alternatively, type a number or decimal value in the text box above the Feather slider.)

6. **Choose File→Save As, and then pick Photoshop as the format.**

Doing so lets you tweak the Feather amount later on by activating the layer mask and then reopening the Properties panel.

That armadillo looks right at home, doesn't he? You'll want to memorize these steps because this method is perhaps the easiest—and most romantic—way to combine two images into a new and unique piece of art. (You'll learn how to use the vector shape tools to do the same thing on page 607.)

The Single Row and Column Marquee Tools

The Marquee toolset also contains the Single Row Marquee and Single Column Marquee tools, which can select exactly one row or one column's worth of pixels, spanning either the width or the height of your document. You don't need to drag to create a selection with these tools; just click once in your document and the marching ants appear.

You may be wondering, "When would I want to do that?" Not often, it's true, but consider these circumstances:

- **Mocking up a web page design.** If you need to simulate a column or row of space between certain areas in a web page, you can use either tool to create a selection and then fill it with the website's background color.

- **Create a repeating background on a web page.** If you're creating an image that you'll use as a repeating background, select a horizontal row and then instruct your HTML-editing program to repeat or stretch the image as far as you need it. This trick can make the page load a lot faster.

- **Stretching an image to fill a space.** If you're designing a web page, for example, you can use these tools to extend an image by a pixel or two. Use either tool to select a row or column of pixels at the bottom or side of the image, grab the Move tool by pressing V, and then tap an arrow key on your keyboard while holding the Option key (Alt on a PC) to nudge the selection in the direction you need and duplicate it at the same time. However, a better option is to use Content-Aware Scale (see page 271).

- **Making an image look like it's melting or traveling through space at warp speed.** Arguably the most amusing use for these tools, you can create a selection and then stretch it with the Free Transform tool (see Figure 4-5).

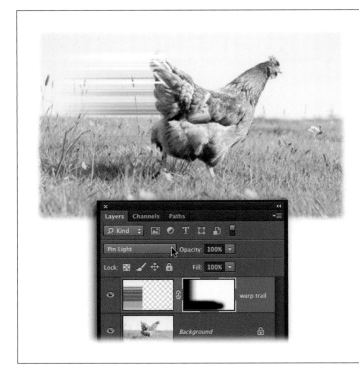

FIGURE 4-5

Good luck catching this hen!

To achieve this look, use the Single Column Marquee to select a column of pixels. Then "jump" the selection onto its own layer by pressing ⌘-J (Ctrl+J). Next, summon the Free Transform tool by pressing ⌘-T (Ctrl+T), and drag one of the square, white center handles leftward. Last but not least, add a gradient mask (page 294), and then experiment with blend modes until you find one that makes the stretched pixels blend into the image (page 296 has more on blend modes).

(Unfortunately you can't activate the Single Row and Single Column Marquee tools with a keyboard shortcut; you've got to click their icons in the Tools panel.)

Create your own speeding hen by downloading the practice file Hen.jpg from this book's Missing CD page at www.missingmanuals.com/cds.

The Vector Shape Tools

Technically, vector shapes aren't selection tools, but you *can* use them to create selections (turn to page 580 to learn more about vector shapes). Once you get the hang of using them as described in this section, you'll be reaching for 'em all the time.

Perhaps the most useful of this bunch is the Rounded Rectangle tool. If you ever need to select an area that's rectangular but has rounded corners, this is your best bet. For example, if you're creating an ad for a digital camera, you can use this technique on a product shot to replace the image shown on the camera's display screen with a different image. Or, more practically, you can use it to give photos rounded corners, as shown in Figure 4-6. Here's how:

1. **Open a photo and activate the Rounded Rectangle tool in the Tools panel.**

 The vector shape tools live near the bottom of the Tools panel. Unless you've previously activated a different tool, you'll see the Rectangle tool's icon. Click it and hold down your mouse button until the drop-down menu appears, and then choose the Rounded Rectangle tool.

 TIP To cycle through all of Photoshop's shape tools, press Shift-U repeatedly.

2. **In the Options bar, set the tool's drawing mode to Path and change the Radius field to 40 pixels (or whatever looks good to you).**

 As you'll learn on page 568, the vector shape tools can operate in various modes. For this technique, you want to use Path mode. Click the unlabeled drop-down menu near the left end of the Options bar (it's probably set to Shape) and choose Path.

 Next, change the number in the Radius field, which controls how rounded the image's corners will be: A lower number causes less rounding than a higher number. This field was set to 40 pixels to create the corners shown in Figure 4-6. However, you'll need to use a higher number if you're working with a high-resolution document.

3. **Draw a box around the image.**

 Mouse over the image and, starting in one corner, drag diagonally to draw a box around the whole image. When you let go of the mouse button, Photoshop displays a thin gray outline atop your image called a *path*, which you'll learn all about in Chapter 13. If you need to move the path while you're drawing it, press and hold the space bar. If you want to move the path *after* you draw it, press A to grab the Path Selection tool (its Tools panel icon is a black arrow), click the path to activate it, and then drag to move it wherever you want.

4. **Add a layer mask to hide the area outside the path.**

 In the Options bar, click the Mask button and Photoshop adds a *vector* layer mask to the image. (Why a vector mask? Because the path you drew with the

shape tool is *vector*-based, not pixel-based. As you learned in the box on page 52, you can resize a vector any time without losing quality by activating it and then using Free Transform [page 276]. For more on vector masks, skip to page 606.) You can do the same thing by ⌘-clicking (Ctrl-clicking) the circle-within-a-square icon at the bottom of the Layers panel to do the same thing. Either way, Photoshop hides the photo's boring, square edges.

FIGURE 4-6

If you're tired of boring, square corners on your images, use the Rounded Rectangle tool to produce smooth corners like the ones shown here. Be sure to put the tool in Path mode first using the drop-down menu near the left end of the Options bar, or else you'll create a shape layer that you don't really need. (You can use this same technique with the Ellipse tool to create the vignette effect shown in the previous section.)

To feather the layer mask after adding it (see step 4), double-click the mask and then drag the resulting Properties panel's Feather slider to the right.)

Happily, you can alter the roundness of these corners after you've drawn the shape. Page 588 has the scoop.

Who knew that giving your photo rounded corners was so simple?

To place your newly round-edged photo on top of another background in presentation software or on a website, choose File→Save As and pick PNG as the format.

(As you know from Chapter 2, the PNG format supports transparency. You'll learn more about this format on page 770.)

Selecting by Color

Photoshop also has several tools that let you select areas by *color*. They're helpful when you want to select a chunk of an image that's fairly uniform in color, like someone's skin, the sky, or the paint job on a car. Photoshop has lots of color-selecting tools to choose from, and in this section, you'll learn how to pick the one that best suits your needs.

The Quick Selection Tool

The Quick Selection tool is shockingly easy to use and lets you create complex selections with just a few brushstrokes. As you paint with this tool, your selection expands to encompass pixels similar in color to the ones you're brushing *across*. It works insanely well if there's a fair amount of contrast between what you want to select and everything else. This tool lives in the same toolset as the Magic Wand, as you can see in Figure 4-7.

FIGURE 4-7

You can press the W key to activate the Quick Selection tool. (To switch between it and the Magic Wand, press Shift-W.)

When you activate the Quick Selection tool, the Options bar sports icons that let you create a new selection as well as add to—or subtract from—the current selection.

To use this friendly tool, click anywhere in the area you want to select or *drag* the brush cursor across it, as shown in Figure 4-8. When you do that, Photoshop thinks for a second and then creates a selection based on the color of the pixels you clicked or brushed across.

The size of the area it selects is proportional to the size of the *brush* you're using: A larger brush creates a larger selection. You adjust the Quick Selection tool's brush size just like any other brush: by choosing a new size from the Options bar's Brush picker, or by using the left and right bracket keys ([and]) to decrease and increase brush size (respectively). (Chapter 12 covers brushes in detail.) For the best results, use a hard-edged brush to produce well-defined edges (soft-edged brushes produce slightly transparent edges) and turn on the Auto-Enhance setting shown in Figure 4-7 and discussed in the box on page 162.

When the Quick Selection tool is active, the Options bar includes these settings (see Figure 4-7):

- **New selection.** When you first grab the Quick Selection tool, it's set to this mode, which creates a brand-new selection when you click or drag. After you do that, the tool automatically switches to "Add to selection" mode (explained next). You'll only want to switch back to "New selection" mode if you've made a selection and then decide to start over with a *new* one. (The old selection disappears as soon as you start a new one.)

FIGURE 4-8

When using the Quick Selection tool, you can either click the area you want to select or drag your cursor (circled) across the area as if you were painting. When you start painting with this tool, you see a tiny + sign inside the cursor (as shown here) and Photoshop puts the tool in "Add to selection" mode, which lets you add to an existing selection.

- **Add to selection.** This mode, which Photoshop automatically switches to once you create an initial selection with the Quick Selection tool, lets you *add* any areas you brush over or click to the current selection. If you don't like the selection Photoshop has created and want to start over, press ⌘-Z (Ctrl+Z) to undo it, or click the Options bar's "New selection" icon and then brush across the area again. To get rid of the marching ants altogether, choose Select→Deselect.

- **Subtract from selection.** If Photoshop selected more than you wanted it to, click the "Subtract from selection" icon (a tiny – sign appears in your cursor), and then paint across the area you *don't* want selected to make Photoshop exclude it. You can also press and hold the Option key (Alt on a PC) to enter this mode.

NOTE To get the most out of the Quick Selection tool, you'll probably need to do a fair amount of adding to and subtracting from your selections (unless there's a ton of contrast between the item you want to select and its background). That said, you can change how picky this tool is by adjusting the Magic Wand's *Tolerance* setting, which—strangely—affects how the Quick Selection tool behaves, too. Flip to page 164 to learn how.

- **Brush Size/Hardness.** Use this unlabeled drop-down menu to pick a brush. Pick a larger brush to select big areas and a smaller brush to select small or hard-to-reach areas. As explained earlier, you'll get better results with this tool by using a hard-edged brush instead of a soft-edged one.

> **TIP** You can change a brush cursor's size by Control-Option-dragging left or right (Alt+right-click+dragging on a PC); to adjust hardness, press the same keys but drag up or down instead. Alternatively, you can press the left bracket key ([) to decrease brush size or the right bracket key (]) to increase it.

- **Sample All Layers.** This setting is initially turned off, which means Photoshop selects only the pixels on the active layer (the one that's highlighted in the Layers panel). If you turn this setting on, Photoshop examines the whole enchilada—all the layers in your document—and grabs every pixel you paint across no matter which layer it's on.

- **Auto-Enhance.** Because the Quick Selection tool makes selections extremely quickly, their edges can end up looking blocky and imperfect. Turn on this checkbox to tell Photoshop to take its time and think more carefully about the selections it makes. This feature gives your selections smoother edges, but if you're working with a really big file, you could do your taxes while it's processing. The box below has tips for using this feature.

> **TIP** If you're using the Quick Selection tool on really big images and it seems to create selections at a snail's pace, try upping the Cache Levels in Photoshop's Performance preferences (page 26).

The Magic Wand

The Magic Wand lets you select areas of color by *clicking* rather than dragging. It's in the same toolset as the Quick Selection tool, and you can grab it by pressing Shift-W (it looks like a wizard's wand, as shown back in Figure 4-7). The Magic Wand is great for selecting solid-colored backgrounds or large bodies of similar color, like a cloudless sky, with just a couple of clicks. (The Quick Selection tool is better at selecting objects.)

WORKAROUND WORKSHOP

Smart Auto-Enhancing

The Quick Selection tool's Auto-Enhance feature is pretty cool, but it's a bit of a processing hog. If you have an older computer, you may have better luck using the Refine Edge dialog box (page 181) to create selections with smooth edges.

That said, you don't have to avoid Auto-Enhance altogether. When you're working with a large file (anything over 100 MB), leave Auto-Enhance turned off until you're *almost* finished

making the selection. Then, when you've got just one or two brushstrokes left to complete the selection, turn on the Auto-Enhance checkbox to make Photoshop re-examine the edges of the selection it's already created to see if it needs to extend them. That way, you get the benefit of using Auto-Enhance *and* keep your computer running quickly until the last possible moment.

When you click once with the Magic Wand in the area you want to select, Photoshop magically (hence the name) selects all the pixels on the currently active layer that are both similar in color *and* touching one another (see page 164 to learn how to tweak this behavior). If the color in the area you want to select varies a bit, Photoshop may not select all of it. In that case, you can add to the selection either by pressing the Shift key as you click nearby areas or by modifying the Magic Wand's *tolerance* in the Options bar as described in a sec and shown in Figure 4-9. To subtract from the selection, press and hold the Option key (Alt on a PC) while you click the area you don't want included.

TIP Give this selection technique a shot by downloading the practice file *Dallas.jpg* from this book's Missing CD page at *www.missingmanuals.com/cds*.

FIGURE 4-9

With its tolerance set to 32, the Magic Wand did a good job of selecting the sky behind downtown Dallas.

You've got several ways to select the spots it missed, like the area circled at bottom left: You can add to the selection by pressing the Shift key while you click that area; increase the tool's Tolerance setting, and then click the sky again to create a brand-new selection; or flip to page 164 to learn how to expand the selection with the Grow and Similar commands.

When you activate the Magic Wand, the Options bar includes these settings:

- **Sample Size.** This menu lets you change the way the Magic Wand calculates which pixels to select (prior to CS6, you had to switch to the Eyedropper tool to see this menu). From the factory, it's set to Point Sample, which makes the tool determine its selection based only on the color of the specific pixel you clicked. However, the menu's other options cause it to look at the original pixel *and* average it with the colors of surrounding pixels. For example, you can make the Magic Wand average the pixel you clicked plus the eight surrounding pixels by choosing "3 by 3 Average," or as many as *10,200* surrounding pixels by choosing "101 by 101 Average." The "3 by 3 Average" setting works well for

most images. If you need to select a really big area, you can experiment with one of the higher settings, like "31 by 31 Average."

- **Tolerance.** This setting controls *both* the Magic Wand's and the Quick Selection tool's sensitivity—how picky each tool is about which pixels it considers similar in color. If you increase this setting, the tools get less picky (in other words, more tolerant) and selects every pixel that could possibly be described as similar to the one you clicked. If you decrease this setting, the tools get pickier and select only pixels that *closely* match the one you clicked.

 The tolerance is initially set to 32, but it can go all the way up to 255. (If you set it to 0, Photoshop selects only pixels that *exactly* match the one you clicked; if you set it to 255, the program selects every color in the image.) It's usually a good idea to keep the tolerance fairly low (somewhere between 12 and 32); you can always click an area to see what kind of selection you get, increase the tolerance if necessary, and then click that area again (or add to the selection using the Shift key, as described earlier).

NOTE When you adjust the Magic Wand's tolerance, Photoshop doesn't adjust your *current* selection. You have to click the area *again* to make Photoshop rethink its selection.

- **Anti-alias.** Leave this setting turned on to make Photoshop soften the edges of the selection ever so slightly. If you want a super-crisp edge, turn it off.

- **Contiguous.** You'll probably want to leave this setting turned on; it makes the Magic Wand select pixels that are adjacent to one another. If you turn it off, Photoshop goes hog wild and selects all similar-colored pixels no matter where they are.

- **Sample All Layers.** If your document has *multiple* layers and you leave this checkbox turned off, Photoshop examines only pixels on the active layer and ignores the other layers. If you turn this setting on, Photoshop examines the whole image and selects all pixels that are similar in color, no matter which layer they're on.

NOTE The Magic Wand is rather notorious for making the edges of selections jagged (that's why some folks refer to this tool as the *Tragic* Wand!). That's because it concentrates on selecting *whole* pixels rather than partially transparent ones (this doesn't happen as much with the Quick Selection tool). The fix is to click Refine Edge in the Options bar after you make a selection, and then adjust the Smooth slider in the resulting dialog box. Skip ahead to page 181 to learn all about the Refine Edge dialog box.

■ EXPANDING YOUR SELECTION

Sometimes the Magic Wand makes a *nearly* perfect selection, leaving you with precious few pixels to add to it. If this happens, it simply means that the elusive pixels are just a little bit lighter or darker in color than what the Magic Wand's tolerance setting allows for.

You *could* Shift-click the elusive areas to add them to your selection, but the Select menu has a couple of options that can quickly expand the selection for you:

- **Choose Select→Grow** to make Photoshop expand the selection to all similar-colored pixels adjacent to it (see Figure 4-10, top).

- **Choose Select→Similar** to make Photoshop select similar-colored pixels throughout the *whole* image, even if they're not touching the original selection (see Figure 4-10, bottom).

FIGURE 4-10

Top: Say you're trying to select the red part of this Texas flag. After clicking once with the Magic Wand (with a Tolerance setting of 32), you still need to select a bit more of the red (left). Since the red pixels are all touching one another, you can run the Grow command a couple of times to make Photoshop expand your selection to include all the red (right).

Bottom: If you want to select the red in these playing cards, the Grow command won't help because the red pixels aren't touching each other. In that case, click once with the Magic Wand to select one of the red areas (left) and then use the Similar command to grab the rest of them (right). Read 'em and weep, boys!

> **NOTE** Because both of these commands base their calculations on the Magic Wand's Tolerance setting (page 164), you can adjust their sensitivity by adjusting that setting in the Options bar. You can also run these commands more than once to get the selection you want.

The Color Range Command

The Color Range command is similar to the tools in this section in that it makes selections based on colors, but it's *much* better at selecting areas that contain lots

of details (such as the flowers in Figure 4-11). The Magic Wand tends to select *solid* pixels, whereas Color Range tends to select more *transparent* pixels than solid ones, resulting in softer edges. This fine-tuning lets Color Range produce selections with smoother edges (less blocky and jagged than the ones you get with the Magic Wand) and get in more tightly around areas with lots of details. As a bonus, you also get a handy preview in the Color Range dialog box, showing you which pixels it'll select *before* you commit to the selection (unlike the Grow and Similar commands discussed in the previous section).

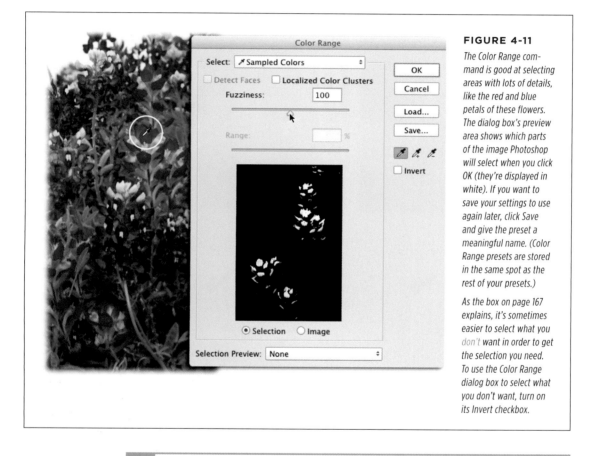

FIGURE 4-11

The Color Range command is good at selecting areas with lots of details, like the red and blue petals of these flowers. The dialog box's preview area shows which parts of the image Photoshop will select when you click OK (they're displayed in white). If you want to save your settings to use again later, click Save and give the preset a meaningful name. (Color Range presets are stored in the same spot as the rest of your presets.)

As the box on page 167 explains, it's sometimes easier to select what you don't want in order to get the selection you need. To use the Color Range dialog box to select what you don't want, turn on its Invert checkbox.

TIP You can also use the Color Range command's Skin Tones option to select people. The box on page 169 has the details.

Open the Color Range dialog box by choosing Select→Color Range, either before or after you make a selection. If you haven't yet made a selection, Photoshop examines the entire image. If you already have a selection, Photoshop looks only at the pixels in the selected area, which is helpful if you want to isolate a certain area. For example, you could throw a quick selection around the red flower in the center of

Figure 4-11, and then use Color Range's subtract-from-selection capability (explained in a moment) to carve out just the red petals. By contrast, if you want to use Color Range to help *expand* your current selection, press and hold the Shift key while you choose Select→Color Range.

Use the Select menu at the top of the Color Range dialog box to tell Photoshop which colors to include in the selection. The menu is automatically set to Sampled Colors, which lets you mouse over to the image and click the color you want to select (your cursor turns into a tiny eyedropper as shown in Figure 4-11). If you change the Select menu's setting to Reds, Blues, Greens, or whatever, Color Range will examine your image and grab that range of colors all by itself once you click OK.

> **TIP** The Select menu also includes Highlights, Midtones, and Shadows, which can help you create selections based on those parts of a photo. Nice!

If you're trying to select adjacent pixels, turn on Localized Color Clusters. When you do, the dialog box's Range slider becomes active so you can tweak the range of colors Photoshop includes in the selection. Increase this setting and Photoshop includes more colors and makes larger selections; lower it and Photoshop gets pickier about matching colors and creates smaller selections.

You can tweak the point at which Photoshop *partially* selects pixels by adjusting the Fuzziness setting. Its factory setting is 40, but you can set it to anything between 0 and 200. As you move this slider (or type a number in the text box), keep an eye on the dialog box's preview area—the parts of the image that Photoshop will fully include in the selection appear in white, and any pixels that are partially selected appear in gray (see Figure 4-11).

UP TO SPEED

Selecting the Opposite

You'll often find it easier to select what you *don't* want in order to get the selection you *do* want. For example, look back at the photo of the Dallas skyline in Figure 4-9. If you want to select the buildings, it's easier to select the sky instead because its color is practically uniform. (It'd take you a lot longer to select the buildings because they're irregularly shaped and vary so much in color.)

After selecting the sky, you then can inverse (flip-flop) your selection to select the buildings. Simply choose Select→Inverse or press Shift-⌘-I (Shift+Ctrl+I). The lesson here is that it pays to spend a few moments studying the area you want to select and the area *around* it. If the color of the surrounding area is uniform, reach for one of the tools described in this section, select that area, and then inverse the selection to save yourself tons of time!

TIP The Color Range dialog box remembers the settings and sample colors you used the *last* time you opened it. This is different from previous versions of the program, in which it remembered nothing and automatically used your foreground color chip as the sample color. If you *want* to use your foreground color chip as the sample color, press and hold the space bar when you choose the Color Range command from the Select menu. When the Color Range dialog box opens, the Select menu reads "Selected Colors" and any areas in your image that are the same color as your foreground color chip are automatically selected and shown in white.

Use the eyedroppers on the dialog box's right side to add or subtract colors from your selection; the eyedropper with the tiny + sign adds to the selection, and the one with the – sign subtracts from it. (Use the plain eyedropper to make your initial selection.) When you click one of these eyedroppers, mouse over to your image, and then click the color you want to add or subtract, Photoshop updates the dialog box's preview to show what the new selection looks like. It sometimes helps to keep the Fuzziness setting fairly low (around 50 or so) while you click repeatedly with the eyedroppers.

TIP You can use the radio buttons beneath the Color Range dialog box's preview area to see either the selected area (displayed in white) or the image itself. But there's a better, faster way to switch between the two views: With the Selection radio button turned on, press the ⌘ key (Ctrl on a PC) to temporarily switch to the image preview. When you let go of the key, you're back to selection preview.

The Selection Preview menu at the bottom of the dialog box lets you display a selection preview on the image itself so that, instead of using the dialog box's dinky preview, you can see the proposed selection right on your image. But you'll probably want to leave this menu set to None because the preview options that Photoshop offers (Grayscale, Black Matte, and so on) get really distracting!

Selecting Skin Tones and Faces

The Color Range dialog box can help you to select skin tones, which can come in really handy. For example, say you need to make a quick selection of skin tones in order to correct just that part of an image, or to create a layer mask that *protects* skin tones when you're sharpening, blurring, and so on.

To do so, head to the dialog box's Select menu and choose Skin Tones. Photoshop immediately hunts down all the colors in the image that are similar to those found in a wide variety of human skin (though don't expect it to work well on all ethnicities). Then use the Fuzziness slider to fine-tune the selection: drag it left to include less skin or right to include more.

If you're specifically after *faces,* turn on the Detect Faces checkbox, and Photoshop looks for faces and includes 'em in your selection. (This checkbox becomes active when you choose

Skin Tones from the Select menu; if you choose Sampled Colors instead, you have to turn on Localized Color Clusters before you can turn on Detect Faces.) Selections made with Detect Faces turned on include partially transparent pixels around the faces' edges so the changes you make will blend better with surrounding pixels (partially transparent pixels look gray in the preview area).

When Adobe introduced these features in CS6, it worked on only a handful of images, though Adobe has since beefed up its abilities. That said, if your image includes a face that's turned in profile or the image includes skin-like colors—think light-colored hair, a nude-colored shirt, and so on—you're better off using the Quick Selection tool *first* and then having a go with Color Range.

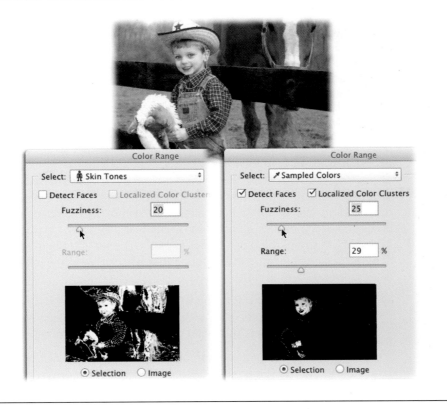

The Background and Magic Erasers

These two tools let you erase parts of an image based on the color under your cursor *without* having to create a selection first. You're probably thinking, "Hey, I want to create a selection, not go around erasing stuff!" And you have a valid point except that, after you've done a little erasing, you can always *load* the erased area (or what's left) as a selection. All you have to do is think ahead and create a duplicate layer before you start erasing, as this section explains.

Say you have an image with a strong contrast between the item you want to select and its background, like a dead tree against the sky (Figure 4-13). The Background Eraser and Magic Eraser tools (Figure 4-12) can help you quickly erase the sky in order to select the tree. Sure, you *could* use the Magic Wand or Quick Selection tool to do the opposite—select the sky and then delete or mask it (page 120)—but the Background Eraser lets you erase more carefully around the *edges* of the tree.

FIGURE 4-12

You may never see these tools because they're hidden inside the same toolset as the regular Eraser tool. Just click and hold the Eraser tool's icon until this little menu appears. Pick an eraser based on how you want to use it: You drag with the Background Eraser (as if you were painting, which is great for getting around the edges of an object), whereas you simply click with the Magic Eraser.

> **TIP** The Eraser tool's keyboard shortcut is the E key. To switch among the various eraser tools in its toolset, press Shift-E repeatedly.

■ THE BACKGROUND ERASER

This tool lets you delete an image's background by painting (dragging) across the pixels you want to delete. When you activate the Background Eraser, your cursor turns into a circle with tiny crosshairs in its center. The crosshairs control which pixels Photoshop deletes, so be extra careful that they touch *only* pixels you want to erase. The size of the brush cursor controls how far into the image Photoshop hunts for pixels to erase. Up in the Options bar, you can tweak the following settings (see Figure 4-13):

- **Brush Preset picker.** This is where you choose the shape and size of your brush cursor. For best results, stick with a soft-edged brush. Just click the down-pointing triangle next to this menu, and then lower the Hardness setting slightly.

- **Sampling.** This setting is made up of three icons that include eyedroppers (they're labeled in Figure 4-13). Sampling controls how often Photoshop looks at the color the crosshairs are touching to decide what to erase. If your image's background has a lot of color variation, leave this set to Continuous so Photoshop

keeps a constant watch on what color pixels the crosshairs are touching. But if the background's color is fairly uniform, change this setting to Once; Photoshop then checks the color the crosshairs touch just once and resolves to erase only pixels that closely match it. If you're dealing with an image where there's only a small area for you to paint (like a tiny portion of sky showing through a lush tree), change this setting to Background Swatch, which tells Photoshop to erase only colors that are similar to your current background color chip (*how* similar they have to be is controlled by the tool's Tolerance setting, which is described in a sec). To choose the color, click the background color chip at the bottom of the Tools panel, mouse over to your image, and then click an area that's the color you want to erase.

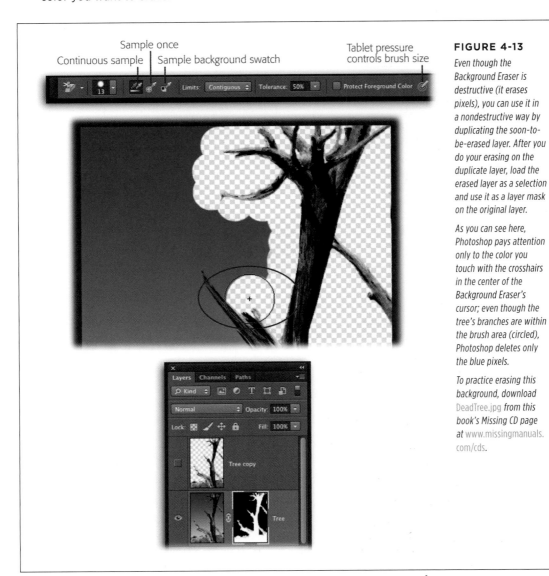

FIGURE 4-13

Even though the Background Eraser is destructive (it erases pixels), you can use it in a nondestructive way by duplicating the soon-to-be-erased layer. After you do your erasing on the duplicate layer, load the erased layer as a selection and use it as a layer mask on the original layer.

As you can see here, Photoshop pays attention only to the color you touch with the crosshairs in the center of the Background Eraser's cursor; even though the tree's branches are within the brush area (circled), Photoshop deletes only the blue pixels.

To practice erasing this background, download DeadTree.jpg from this book's Missing CD page at www.missingmanuals.com/cds.

- **Limits.** From the factory, this field is set to Contiguous, which means the tool erases only pixels adjacent to those you touch with the crosshairs. If you want to erase similar-colored pixels elsewhere in the image (for example, the background behind a really thick tree or a bunch of flowers), change this setting to Discontiguous. Find Edges erases only adjacent pixels, but preserves the sharpness of the object's edge.

- **Tolerance.** This setting works just like the Magic Wand's Tolerance setting (page 164): A lower number makes the tool pickier about the pixels it erases, and a higher number makes it less picky.

- **Protect Foreground Color.** If you've cranked down the Tolerance setting and you're *still* erasing some of the area you want to keep, turning on this setting can help. When it's on, you can tell Photoshop which area you want to keep (the foreground) by Option-clicking (Alt-clicking on a PC) that area. When the area you're erasing around *changes* to a different color, be sure to Option-click (Alt-click) to update the protected color (you'll do this often when erasing pixels around hair or fur).

TIP To use the Background Eraser on a *uniformly* colored background around fine details like hair or fur, try setting the Sampling method to Once, the Limits menu to Discontiguous, and turning on Protect Foreground Color. Next, mouse over to the image and Option-click (Alt-click on a PC) one of the strands of hair. Then, when you paint across the image, Photoshop *should* protect anything that's the same color as the hair, keeping it from being erased. Increase your brush size to erase bits of the background that are peeking through strands of hair. For the best results, perfect your erasing on the duplicate layer and skip adding a layer mask, as the following steps describe, because the fine edges around hair or fur won't look as good after you load 'em as a selection and add a mask. There's a tutorial on this technique on your author's website; just visit *www.photolesa.com* and enter *background eraser* into the search field at upper right.

Here's how to use the Background Eraser to remove the sky behind a dead tree *without* harming the original pixels, as shown in Figure 4-13:

1. **Open a photo, duplicate the image layer (or background layer) by pressing ⌘-J (Ctrl+J), and then hide the original layer.**

 Because you'll do your erasing on the duplicate layer, you don't need to see the original layer. Over in the Layers panel, click the visibility eye to the left of the original layer's thumbnail to turn it off.

2. **Grab the Background Eraser tool and paint away the background.**

 This tool is in the same toolset as the Eraser tool (see Figure 4-12). Once you've activated it, mouse over to your document, and your cursor morphs into a circle with tiny crosshairs in the center. Remember that the trick is to let the crosshairs touch *only* the pixels you want to erase; adjust the size of the brush cursor to control how far into your image Photoshop looks for pixels to delete. If you need to, increase or decrease the brush cursor's size by pressing the left or right bracket keys on your keyboard, respectively.

3. **If the tool is erasing too much or too little of the image, tweak the Options bar's Tolerance setting.**

 If an area in the image is *almost* the same color as the background, lower the tolerance to make the tool pickier about what it's erasing so that it erases only pixels that closely match the ones you touch with the crosshairs. Likewise, if it's not erasing enough of the background, raise the tolerance to make it zap more pixels.

TIP It's better to erase *small* sections at a time instead of painting around the entire object in one continuous stroke. Drag to erase some of the area around the object, let go of the button, drag again to erase a little more, and so on. That way, if you need to undo your erasing with the History panel or the Undo command (⌘-Z or Ctrl+Z), you won't have to watch *all* that erasing unravel before your eyes. This technique also lets you be very precise with your erasing, as you can undo small sections and adjust the tool's settings to do a better job around tough areas such as hair and fur.

4. **Once you get a clean outline around the object, switch to the regular Eraser tool or the Lasso tool (page 174) to get rid of the remaining big chunks of background.**

 After you erase the hard part—the area around the edges—with the Background Eraser, use the regular Eraser tool, set to a large brush, to get rid of the remaining background quickly. Or use the Lasso tool to select the remaining areas, and then press the Delete key (Backspace on a PC) to get rid of 'em.

5. **Load the erased layer as a selection, and then turn off its visibility.**

 Over in the Layers panel, ⌘-click (Ctrl-click) the thumbnail of the layer you did the erasing work on to create a selection around the tree. When you see the marching ants, click the layer's visibility eye to hide it. (As the Tip at the beginning of this list explains, if you're erasing around hair or fur, skip this step and the next one.)

6. **Activate the original layer, turn on its visibility, and then add a layer mask to it.**

 In the Layers panel, click once to activate the original image layer (or background layer), and then click the area to the left of its thumbnail to make it visible again. While you have marching ants running around the newly erased area, add a layer mask to the original layer by clicking the circle-within-a-square icon at the bottom of the Layers panel.

You're basically done at this point, but if you need to do any cleanup work (if the Background Eraser didn't do a perfect job getting around the edges, say), now's the time to edit the layer mask. To do so, click the mask's thumbnail over in the Layers panel, press B to grab the Brush tool, and then set your foreground color chip to black. Now, when you brush across the image, you'll hide more of the sky. If you need to reveal more of the tree, set your foreground color chip to white instead, and then paint the area you want to reveal. (See page 120 for a detailed discussion of creating

and editing layer masks.) Alternatively, you can use the Refine Edge dialog box to fine-tune your selection *before* adding the mask; page 181 tells you how.

Sure, duplicating the layer you're erasing adds an extra step, but it means you're not deleting any pixels—you're just hiding them with a layer mask, so you can get 'em back if you want to. How cool is that?

■ THE MAGIC ERASER

This tool works just like the Background Eraser except that, instead of a brush cursor that you paint with, its cursor looks like a cross between the Eraser tool and the Magic Wand. Just as the Magic Wand can select color with a single click, the Magic Eraser can *zap* color with a single click, so it's great for instantly erasing areas of solid color. Since this tool is an eraser, it really will *delete* pixels, so you'll want to duplicate your background layer before using it.

You can alter the Magic Eraser's behavior by adjusting these Options bar settings:

- **Tolerance.** This setting works just like the Magic Wand's Tolerance setting (page 164). A lower number makes the tool pickier about the pixels it erases, and a higher number makes it less picky.

- **Anti-alias.** Turning on this checkbox makes Photoshop slightly soften the edges of what it erases.

- **Contiguous.** To erase pixels that touch one another, leave this checkbox turned on. To erase similar-colored pixels no matter *where* they are in the image, turn it off.

- **Sample All Layers.** If you have a multilayer document, turn on this checkbox to make Photoshop look at the pixels on *all* the layers instead of just the active one.

- **Opacity.** To control how strong the Magic Eraser's effect is, enter a value here. Initially, this option is set to 100, which removes 100 percent of the image, but you can enter *50* to make it wipe away 50 percent of the image's color, for example.

■ Selecting Irregular Areas

As you might imagine, areas that aren't uniform in shape *or* color can be a real bear to select. Luckily, Photoshop has a few tools in its arsenal to help you get the job done. In this section, you'll learn about the three lassos and the Pen tool, as well as a few ways to use these tools together to select hard-to-grab spots.

The Lasso Tools

The lasso toolset contains three freeform tools that let you draw an outline around the area you want to select. If you've got an amazingly steady mouse hand or if you use a digital drawing tablet (see the box on page 552), you may fall in love with the plain ol' Lasso tool. If you're trying to select an object with a lot of straight edges, the Polygonal Lasso tool will do you proud. And the Magnetic Lasso tries to create

a selection *for* you by examining the color of the pixels your cursor is over. This section explains all three tools, which share a slot near the top of the Tools panel (see Figure 4-14).

Modes

FIGURE 4-14

So many lassos, so little time!

The regular Lasso tool is great for drawing a selection freehand, the Polygonal Lasso is good for drawing selections around shapes that have a lot of straight lines, and the Magnetic Lasso is like an automatic version of the regular Lasso—it tries to create the selection for you.

■ LASSO TOOL

The regular Lasso tool lets you draw a selection completely freeform as if you were drawing with a pencil. To activate this tool, simply click it in the Tools panel (its icon looks like a tiny lasso—no surprise there) or press the L key. Then click in your document and drag to create a selection. When you release the mouse button, Photoshop completes the selection with a straight line (that is, if you don't complete it yourself by mousing back over your starting point) and you see marching ants.

WORKAROUND WORKSHOP

Erasing Every Bit of Background

Now that you know how to use the Background and Magic Erasers, keep in mind that you can't always believe what you see onscreen. Most of the time, you'll use these tools to erase to a transparent (checkerboard) background like the one shown in Figure 4-13. And while it may *appear* that you've erased all the background, you may not have. The checkerboard pattern is notorious for making it hard to see whether you've missed a pixel or two here and there, especially if the background you're trying to delete is white or gray (like clouds).

Fortunately, it's easy to overcome this checkered obstacle. The next time you're ready to use one of these eraser tools, first add a solid color fill layer, pick a bright color that contrasts with what you're trying to delete, and then place the layer at the bottom of the layer stack. Here's how: Click the half-black/half-white circle at the bottom of the Layers panel and choose Solid Color from the menu. Select a bright color from the resulting Color Picker, and then click OK. Drag the new layer beneath the layer you're erasing, and you're good to go. (See Chapter 3 for more on using fill layers.) Now, you can see whether you've erased everything you wanted to.

Alternatively, if you're erasing the background of one image to replace it with another, go ahead and add the new background to your document.

The Options bar sports the same settings for both the Lasso tool and the Polygonal Lasso tool:

- **Mode.** These four icons (labeled in Figure 4-14) let you choose among the same modes you get for most of the selection tools: New, "Add to selection," "Subtract from selection," and "Intersect with selection." They're discussed in detail back on page 151.

- **Feather.** If you want Photoshop to soften the edges of your selection, enter a pixel value in this field. Otherwise, the selection will have a hard edge. (See the box on page 154 for more on feathering.)

- **Anti-alias.** If you leave this setting turned on, Photoshop slightly blurs the edges of your selection, making them less jagged—page 152 has the details.

- **Refine Edge.** This button summons the mighty Refine Edge dialog box, which you can use to fine-tune your selection (it's *especially* helpful when you're selecting hair and fur). You'll learn all about it starting on page 181.

■ POLYGONAL LASSO TOOL

If your image has a lot of straight lines in it (like the star in Figure 4-15), the Polygonal Lasso tool is your ticket. Instead of letting you draw a selection that's any shape at all, the Polygonal Lasso draws only *straight* lines. It's super simple to use: click once to set the starting point, move your cursor along the shape of the item you want to select, and then click again where the angle changes; repeat this process until you've outlined the whole shape. To complete the selection, point your cursor at the first point you created. When a tiny circle appears below the cursor (it looks like a degree symbol), click once to close the selection and summon the marching ants.

FIGURE 4-15

The Polygonal Lasso tool is perfect for selecting geometric shapes and areas that have a lot of angles. If you need to temporarily switch to the regular Lasso tool to perfect your selection, press and hold Option (Alt on a PC) to draw freehand.

Conversely, if you're using the regular Lasso tool, it's nearly impossible to draw a straight line unless you've got the steady hand of a surgeon. But if you press and hold the Option key (Alt on a PC), and then release your mouse button, you'll temporarily switch to the Polygonal Lasso tool so you can draw a straight line. When you release the Option (Alt) key, Photoshop completes your selection with a straight line.

TIP To bail out of a selection you've *started* drawing with any Lasso tool, just tap the Esc key.

■ MAGNETIC LASSO TOOL

This tool has all the power of the other lasso tools, except that it's smart—or at least it tries to be! Click once to set a starting point, and the Magnetic Lasso tries to *guess* what you want to select by examining the colors of the pixels your cursor is over (you don't even need to hold your mouse button down). As you move your cursor over the edges you want to select, it sets additional *anchor points* (fastening points that latch onto the path you're tracing; they look like tiny, see-through squares). To close the selection, put the cursor over your starting point. When a tiny circle appears below the cursor, click once to close the selection and summon the marching ants (or triple-click to close the selection with a straight line).

As you might imagine, the Magnetic Lasso tool works best when there's strong contrast between the object you want to select and the area around it (see Figure 4-16). If you reach an area that doesn't have much contrast—or a sharp corner—you can give the tool a little nudge by clicking to set a few anchor points of your own. If it goes astray and sets an erroneous anchor point, tap the Delete key (Backspace on a PC) to get rid of that point and then click to set more anchor points until you reach an area of greater contrast where the tool can be trusted to set its own points.

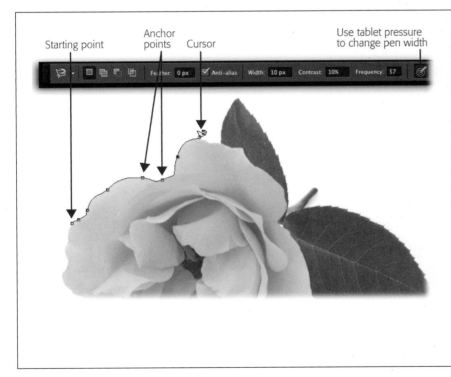

FIGURE 4-16

The Magnetic Lasso works great for selecting objects on plain, high-contrast backgrounds because it can easily find the edge of the object. For best results, glide your cursor slowly around the object's edge (you don't need to hold your mouse button down). To draw a straight line, temporarily switch to the Polygonal Lasso tool by Option-clicking (Alt-clicking on a PC) where you want the line to start, and then clicking where you want it to end. Photoshop then switches back to the Magnetic Lasso, and you're free to continue gliding around the rest of the object.

You can get better results with this tool by adjusting its Options bar's settings (shown in Figure 4-16). Besides the usual suspects like selection mode, feather, and anti-alias (all discussed on pages 151 and 152), you also get:

- **Width** determines how close your cursor needs to be to an edge for the Magnetic Lasso to select it. From the factory, this field is set to 10 pixels, but you can enter a value between 1 and 256. Use a lower number when you're trying to select an area whose edge has a lot of twists and turns, and a higher number for an area with fairly smooth edges. For example, to select the yellow rose in Figure 4-16, you'd use a higher setting around the petals and a lower setting around the leaves because they're so jagged.

TIP You can change the Width setting in 1-pixel increments *while* you're using the Magnetic Lasso by pressing the [and] keys. You can also press Shift-[to set the width to 1 and Shift-] to set it to 256.

- **Contrast** controls how much color difference there needs to be between neighboring pixels for the Magnetic Lasso to recognize it as an edge. You can try increasing this percentage when you want to select an edge that isn't well defined, but you might have better luck with a different selection tool. If you're a fan of keyboard shortcuts, press the comma (,) or period (.) key to decrease or increase this setting in 1 percent increments, respectively *while* you're making a selection; add the Shift key to these keyboard shortcuts to set it to 1 percent or 100 percent, respectively.

- **Frequency** determines how many anchor points the tool lays down. You need more anchor points to select an area with lots of details than for a smooth area. Setting this field to 0 makes Photoshop add very few points, and 100 makes it have a point party. The factory setting—57—usually works fine. You can press the semicolon (;) or apostrophe (') key *while* you're using the tool to decrease or increase this setting by 3, respectively; add the Shift key to these keyboard shortcuts to jump between 1 and 100.

- **Use tablet pressure to change pen width.** If you have a pressure-sensitive digital drawing tablet, turning on this setting—whose icon looks like a pen tip with circles around it—lets you override the Width setting by pressing harder or softer on the tablet with your stylus. (The box on page 552 has more about digital drawing tablets.)

- **Refine Edge.** If you need to fine-tune your selection, click this button to open the Refine Edge dialog box, which you'll learn about beginning on page 181.

Selecting with Focus Area

It's not often that new selection tools come along, but when they do, they're extremely helpful (case in point: the Quick Selection tool). New in this version of Photoshop CC is the Focus Area command, which you can use to automatically select the area of a photo that's *in focus* (in other words, the part that's *sharp* not blurry). It works best on images with a strong, in-focus subject and a soft, blurry background, like the one in Figure 4-17.

NOTE To try this new command yourself, trot on over to this book's Missing CD page at *www.missingmanuals. com/cds* and download the file *Cowgirl.jpg*.

Zoom tool
Hand tool

Add
Subtract

FIGURE 4-17

With decent contrast, the selection you get with this command is pretty darn good! Rare is the photo where Focus Area generates a perfect selection, but you can tweak the result easily enough using the settings shown here. Plus, this command is a great first step in creating a selection that you intend to fine-tune in the Refine Edge dialog box.

The View menu lets you change the way Photoshop previews the selection in your document; see page 183 for a discussion of these options.

To use this handy new selection helper, open an image and choose Select→Focus Area. Photoshop analyzes your image and automatically generates an initial selection. If the result isn't perfect (and it won't be), in the Focus Area dialog box, drag the In-Focus Range slider left to select fewer pixels of the in-focus area, or right to select more. You can also mouse over to your image and paint across any areas that Photoshop missed that you want *included* in the selection (Photoshop automati-

cally activates the Add brush labeled in Figure 4-17). When you release your mouse button, Photoshop analyzes what you painted across. If there's a decent amount of contrast between your subject's edge and the background in that area, Photoshop includes that part of the subject in the selection.

TIP When you're fine-tuning a selection created by the Focus Area command, it's helpful to zoom into your image by pressing ⌘-+ (Ctrl-+ on a PC) repeatedly. Pressing the spacebar summons the Hand tool, which you can use to move around within the image once you're zoomed in. (Alternatively, you can use the Zoom and Hand tools in the Focus Area dialog box.)

To *remove* an area from the selection, click the Subtract brush to activate it, and then brush across that spot, or simply Option-drag (Alt-drag on a PC) with the Add brush to put it in subtract mode. Either way, when you release your mouse button, Photoshop analyzes the area you painted across and (hopefully) removes it from the selection (again, how well Photoshop does depends on the amount of contrast between your subject and background).

Clicking the flippy triangle next to Advanced reveals an Image Noise Level slider that you can use to keep Photoshop from including too much of a noisy image's background in your selection. Dragging it left includes more of your image's noisy areas in the selection; dragging right excludes them.

TIP If the selection *still* needs more work, click Refine Edge to open the selection in the powerful Refine Edge dialog box, which is covered starting on page 181.

When the selection looks good, turn on Soften Edges to apply a small amount of blur around the selection's edges so they don't look jagged, and then use the Output menu to tell Photoshop what to *do* with the selection. (Your choices are self-explanatory; they're identical to the ones you get in the Refine Edge dialog box, which are covered on page 187.) Click OK when you're finished.

Selecting with the Pen Tool

Another great way to select an irregular object or area is to trace its outline with the Pen tool. Technically, you don't draw a selection with this method; you draw a *path* (page 570), which you can then *load* as a selection or use to create a *vector mask* (page 606). This technique requires quite a bit of practice because the Pen tool isn't your average, everyday, well...*pen*, but it'll produce the smoothest-edged selections this side of the Rio Grande. Head on over to Chapter 13 to read all about it.

Creating Selections with Channels

As you'll learn in Chapter 5, the images you see onscreen are made up of various colors. In Photoshop, each color is stored in its own *channel* (which is kind of like a layer) that you can view and manipulate. If the object or area you're trying to select is one that you can isolate in a channel, you can load that channel as a selection with a click of your mouse. This incredibly useful technique is described starting on page 221.

Using the Selection Tools Together

As wonderful as Photoshop's selection tools are *individually*, they're much more powerful if you use 'em *together*.

Remember how every tool discussed so far has an "Add to selection" and "Subtract from selection" mode? This means that, no matter which tool you start with, you can add to—or subtract from—the active selection with a completely different tool. Check out Figure 4-18, which gives you a couple of ideas for using the selection tools together. And thanks to the spring-loaded tools feature—press and hold a tool's keyboard shortcut to temporarily switch to it, then let go of the key to switch back to the current tool (see the Tip on page 14)—switching between tools is a snap.

As you can see, there are a gazillion ways to create selections, though any selection you make will likely need tweaking no matter *which* method you use. The next section is all about *perfecting* selections.

NOTE You can also *paint* selections onto your image by using Quick Mask mode; see page 193.

■ Modifying Selections

The difference between a pretty-good-around-the-edges selection and a perfect one is what separates Photoshop pros from mere dabblers. As you'll learn in the following pages, there are a bunch of ways to modify, reshape, and even *save* selections.

Refining Edges

The best selection modifier in town is the Refine Edge dialog box (Figure 4-19), which is great for selecting the tough stuff like hair and fur. It combines several edge-adjustment tools that used to be scattered throughout Photoshop's menus, and includes an extremely useful preview option.

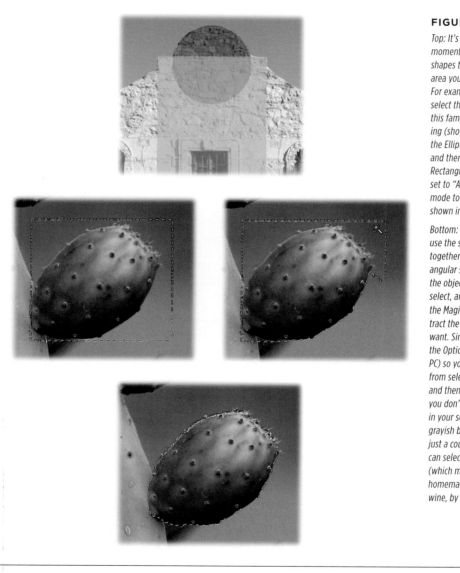

FIGURE 4-18

Top: It's worth taking a moment to try to see the shapes that make up the area you want to select. For example, you can select the circular top of this famous Texas building (shown in red) using the Elliptical Marquee, and then switch to the Rectangular Marquee set to "Add to selection" mode to select the area shown in green.

Bottom: Another way to use the selection tools together is to draw a rectangular selection around the object you want to select, and then switch to the Magic Wand to subtract the areas you don't want. Simply hold down the Option key (Alt on a PC) so you're in "Subtract from selection" mode, and then click the areas you don't want included in your selection, like this grayish background. With just a couple of clicks, you can select the prickly pear (which makes superb homemade jelly and wine, by the way!).

TIP For the quickest selections in the west, try using the new Focus Area command to create an initial selection of the in-focus areas of your image, and then hand the selection over to Refine Edge for fine-tuning. Flip back to page 181 for the scoop.

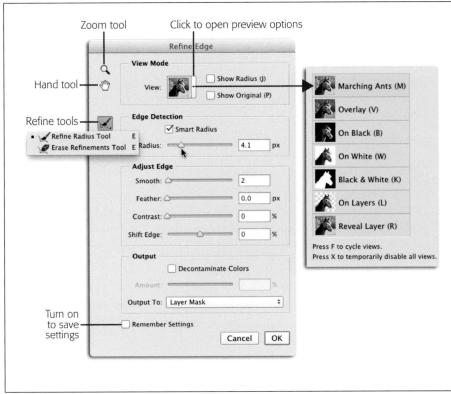

FIGURE 4-19

The Refine Edge dialog box not only lets you see a live, continuously updated preview of what your selection will look like after fine-tuning, but you also get seven different views to choose from (Overlay is particularly handy if you're dealing with hair or fur) and two tools you can use to refine your selection before clicking OK.

If you forget what the dialog box's various settings do, never fear: Just point your cursor at a setting and a tooltip appears explaining what it does.

Any time you have a selection tool active and some marching ants on your screen, you'll see the Refine Edge button sitting pretty up in the Options bar; simply click it to open the dialog box. You can also open it by choosing Select→Refine Edge, pressing Option-⌘-R (Alt+Ctrl+R), or clicking the Properties panel's Mask Edge button (see Figure 3-33 on page 127).

The Refine Edge dialog box gives you *seven* different ways to preview your selection. (Because Photoshop displays the preview in the main document window, you'll want to move the Refine Edge dialog box aside so it's not covering your image.) Depending on the colors in the image, one of these View modes will let you see the selection better than the rest:

- **Marching Ants.** This view just shows the selection on the image itself. Keyboard shortcut: M.

- **Overlay.** As its name indicates, this view displays your selection overlaid with the Quick Mask (page 193), which, unless you've changed its color, is red. (The box on page 196 explains how to change that color.) Because the red overlay is

see-through, this view is the best choice when your selection will include hair or fur that isn't included in the selection just yet. Keyboard shortcut: V.

> **TIP** You can cycle through the preview modes by pressing the F key repeatedly when the Refine Edge dialog box is open. To temporarily see your original image, press the X key; press X again to go back to the preview mode you were using.

- **On Black.** This view displays the selection on a black background, which is helpful if your image is light colored and doesn't have a lot of black in it. Keyboard shortcut: B.

- **On White.** Choose this view if your image is mostly dark. The stark white background makes it easy to see both your selection and the object you're selecting while you're fine-tuning it using the dialog box's settings. Keyboard shortcut: W.

- **Black & White.** This view displays your selection as an *alpha channel* (page 216). Photoshop makes your selection white and the mask black; transitions between the two areas are subtle shades of gray. The gray areas let you see how detailed your mask is, so you'll spend a fair amount of time in this mode. Keyboard shortcut: K.

- **On Layers.** To see your selection atop the gray-and-white transparency checkerboard, choose this mode. Keyboard shortcut: L.

- **Reveal Layer.** This mode displays your image *without* a selection. Keyboard shortcut: R.

Once you've chosen a view, you can tweak the following settings (and for the best results, Adobe suggests you adjust them in this order):

- **Smart Radius.** Turn this checkbox on to make Photoshop look closely at the edges of your selection to determine whether they're hard (like the outline of your subject's body) or soft (like your subject's hair or fur). It's a good idea to turn this setting on each time you open the Refine Edge dialog box. (If you turn on Remember Settings at the bottom of the dialog box, Smart Radius will *stay* on until you turn it off.)

> **TIP** If the edges of the object you're trying to select vary greatly in softness (like a girl in a hat with long hair blowing in the wind), it can be helpful to copy parts of the image onto another layer so you can use a different Smart Radius setting. To do that, create a selection, press ⌘-J (Ctrl+J) to jump that bit onto its own layer, and then open the Refine Edge dialog box.

- **Radius.** This setting controls the size of the area affected by Refine Edge—in other words, how far beyond the edge of your selection Photoshop looks when it's refining that edge. You can think of this setting as the selection's degree of difficulty. For example, if your selection is really complex, like the horse's mane in Figure 4-20, increase this setting to make Photoshop look beyond the original selection's boundary for all the wispy stuff (which also makes the

program slightly soften the selection's edge). If your selection is fairly simple, lower this setting so Photoshop analyzes just the selection's boundary, which creates a harder edge. There's magic numbers for this setting—it varies from image to image—so you'll need to experiment to get your selection just right.

- **Refine Radius tool.** Once you've turned on Smart Radius, you can use this tool (visible in Figure 4-19) to paint over the edges of your selection and make Photoshop fine-tune them even more in particular spots (see Figure 4-20, top). This is where the Refine Edge dialog box *really* works its magic: As you drag with this tool's brush cursor, you can extend your selection beyond its original boundaries, creating a more precise selection of fine details. This tool is also intuitive: As you brush across the edges of your selection, it tries to *learn* how you want it to behave.

- **Erase Refinements tool.** If Photoshop gets a little overzealous and includes too much of the background in your selection as you drag with the Refine Radius tool, drag with this tool across the areas you *don't* want to include in the selection.

- **Smooth.** Increasing this setting makes Photoshop smooth the selection's edges so they're less jagged, but increasing it *too* much can make you lose details (especially on selections of things like hair). To bring back some details without decreasing this setting, try increasing the Radius and Contrast settings.

- **Feather.** This setting controls how much Photoshop softens the selection's edges, which is useful when you're combining images as discussed in the box on page 154.

- **Contrast.** This setting sharpens the selection's edge, even if you softened it by increasing the Radius setting mentioned above. A higher number here creates a sharper edge (which can help Photoshop create a better selection) and can reduce the noisy or grainy look that a high Radius setting sometimes causes.

- **Shift Edge.** To tighten your selection (make it smaller), drag this slider to the left—a good idea if you're dealing with hair or fur. To expand the selection and grab pixels you missed when making the initial selection, drag this slider to the right instead.

- **Decontaminate Colors.** This option helps reduce *edge halos*: leftover colored pixels around the edges of a selection that you see only *after* putting the object on a new background (see page 189). Once you turn on this checkbox, Photoshop tries to replace the color of the selected pixels with the color of pixels *nearby* (whether they're selected or not). Drag the Amount slider to the right to change the color of more edge pixels, or to the left to change fewer. To see the color changes for yourself, either choose Reveal Layer from the View menu near the top of the dialog box, or press R.

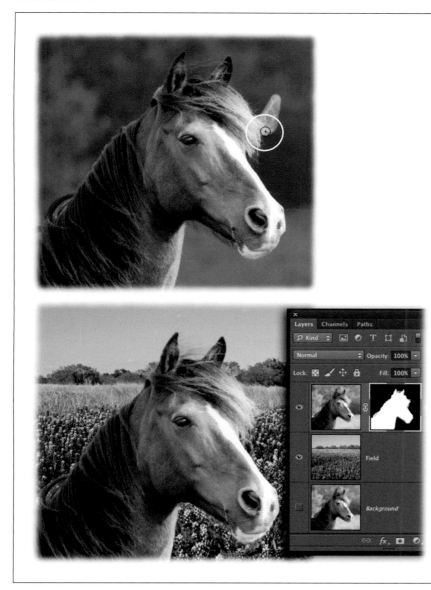

FIGURE 4-20

Top: After creating a rough selection with the Quick Selection tool, you can use the Refine Edge dialog box's Refine Radius tool to brush across areas you want to add to the selection.

Bottom: Within minutes, you can settle this mare onto a new background, as shown here. What horse wouldn't *be happier hanging out on a field of bluebonnets?*

To try this yourself, head to this book's Missing CD page at www.missingmanuals.com/cds *and download the file* Horse.zip.

When the Refine Edge dialog box is open, you can temporarily switch between the Refine Radius and Erase Refinements tools while pressing and holding the Option key (Alt on a PC). Alternatively, you can flip-flop between the tools by pressing Shift-E.

- **Output To.** This setting tells Photoshop what to *do* with your new and improved selection:

 - **Selection** merely leaves you with the new-and-improved selection, so you end up with marching ants on the active layer you started with. (If you've turned on Decontaminate Colors, this option is dimmed.)

 - **Layer Mask** adds a layer mask—based on the selection you just made—to the current layer. You'll choose this option most of the time. (This option is also unavailable if you've turned on Decontaminate Colors.)

 - **New Layer** deletes the background and creates a new layer containing only the selected item, with no marching ants.

 - **New Layer with Layer Mask** adds a new layer complete with a layer mask based on your selection.

 - **New Document** deletes the background and sends only the selected item to a brand-new document.

 - **New Document with Layer Mask** sends the selected item to a new document complete with an editable layer mask.

Whew! Those settings probably won't make a whole lot of sense until you start using 'em. To get you off and running, here's how to select a subject with wispy hair, like the horse in Figure 4-20:

1. **Open an image, and select the subject using the Quick Selection tool or the Focus Area command (page 179).**

 Press W to grab the Quick Selection tool and paint across the object you want to select (Figure 4-20, top). Or, if your subject is in focus and the image's background is nice and blurry, give the new Focus Area command a spin (page 179). Don't worry too much about the quality of your selection, because you'll tweak it in a moment.

2. **Hop up to the Options bar and click Refine Edge.**

 The mighty Refine Edge dialog box opens.

3. **Choose Overlay as your View mode.**

 To see the horse's mane better—in all its wispy goodness—press V to view it with a red overlay.

4. **Turn on the Smart Radius checkbox and drag the Radius slider to the right.**

 There's no magic Radius setting that works on every selection (a setting of 3.2 was used in Figure 4-20); how far you should drag this slider depends on your image. Your goal is to drag it as far to the right as you can while still maintaining some hardness in the selection's edges. You won't see much of anything change in your image when you tweak this setting, though a tiny rotating circle at the bottom left of the dialog box indicates that Photoshop is rethinking your selection.

5. **Use the Refine Radius tool to brush across the soft edges of your selection (Figure 4-20, top).**

 Press E to grab this tool, or click its icon on the left side of the Refine Edge dialog box (it looks like a tiny brush atop a curved, dotted line). Then mouse over to your image and brush across the soft areas you want to add to the selection, like the wispy bits of the horse's mane. Try to avoid any areas that are correctly selected (such as the horse's nose), as Photoshop tends to overanalyze them and exclude parts it shouldn't. If you end up adding too much to the selection, press and hold Option (Alt) to switch to the Eraser Refinement tool, and then brush across the areas you *don't* want selected.

6. **Turn on Decontaminate Colors and adjust its Amount slider.**

 Turn on this checkbox, and then drag the slider slightly to the right to shift the color of *partially* selected edge pixels so they more closely match ones that are *fully* selected. Once again, this value varies from image to image (15 percent was used for Figure 4-20).

7. **From the Output To menu, choose "New Layer with Mask."**

 Photoshop adds a layer mask based on your selection to the active layer, as shown in the Layers panel in Figure 4-20 (bottom).

Exhausted yet? This kind of thing isn't easy, but once you master using Refine Edge, you'll be able to create precise selections of darn near anything!

■ ADDING A CREATIVE EDGE

You can also use the Refine Edge dialog box to add creative edges to photos. For example, grab the Rectangular Marquee tool and draw a box about half an inch inside the document's edges (Figure 4-21, top). Then click the Options bar's Refine Edge button and, in the resulting dialog box, drag the Radius slider to the right for a cool, painterly effect (how *far* you drag it is up to you). Before you click OK, be sure to choose Layer Mask from the dialog box's Output To menu to keep from harming your original image.

FIGURE 4-21

Top: The first step toward creative edges is to draw a rectangular selection around the image's focal point. The wider the space between the edges of your selection and the edges of the document, the wider the soon-to-be-creative edge will be.

Bottom: Once you turn on Smart Radius and drag the Radius slider to the right, the image's edges begin to change. Use the remaining sliders to tweak the look to your liking. As you can see, the Refine Edge dialog box makes short work of giving images an interesting painted edge (here, the image is shown atop a deep-red solid color fill layer).

Fixing Edge Halos

When you're making selections, you may encounter *edge halos* (also called *fringing* or *matting*), a tiny portion of the background that stubbornly remains even after you try to delete it (or hide it with a layer mask as explained on page 120). They usually show up after you replace the original background with something new (see Figure 4-22).

FIGURE 4-22

Here you can see the intrepid cowboy on his original green background (top) and on a new, blue background (bottom).

The green pixels stubbornly clinging to his hat are an edge halo.

This aggravatingly tiny rim of color can be your undoing when it comes to creating realistic images because they're a sure sign that the image has done time in Photoshop. Edge halos make a new sky look fake and won't help convince anyone that Elvis actually came to your cookout.

Here are a few ways to fix edge halos:

- **Contract your selection.** Open the Refine Edge dialog box (page 181) and drag its Shift Edge slider left, or choose Select→Modify→Contract to contract the selection (the latter method doesn't give you a preview). Use this technique while you still have marching ants—in other words, before you delete the old background (or, better yet, hide the background with a layer mask [page 120]).

- **Run the Minimum filter on a layer mask.** Once you've hidden an image's background with a layer mask, you can run the Minimum filter on the *mask* to tighten it around the object. Page 714 explains this super-useful technique, which is an *excellent* quick fix to have in your bag of Photoshop tricks.

- **Use the Defringe command.** Run this command after you delete the background (alas, it doesn't work on layer masks or while a selection is active). Choose Layer→Matting→Defringe, and then enter a value in pixels. Photoshop analyzes the active layer and changes the color of the pixels around the object's edge to the color of nearby pixels. For example, if you enter *2 px*, it'll replace a 2-pixel rim of color all the way around the object.

- **Remove Black/White Matting.** If Photoshop has blessed you with a halo that's either black or white, you can make the program try to remove it automatically. After you've deleted the background, activate the offending layer, and then choose Layer→Matting→Remove Black Matte or Remove White Matte. (Like Defringe, this command doesn't work on layer masks or while you have an active selection.)

Creating a Border Selection

If you peek at the Select→Modify submenu, you'll find the same options as in the Refine Edge dialog box (but without a preview). There is, however, one addition: Border, which lets you turn a solid selection into a hollow one.

Let's say you drew a circular selection with the Elliptical Marquee tool (page 150). You can turn that selection into a ring (handy if you want to make a neon sign or select the outer rim of an object) by choosing Select→Modify→Border. Just enter a pixel width, click OK, and poof! Your formerly solid selection is now as hollow as can be.

Transforming a Selection

Have you ever tried to make a slanted rectangular selection like the one shown in Figure 4-23? If so, you may have found the experience frustrating. Sure, you can try using one of the lasso tools, but it's quicker to *transform* (meaning "reshape") a rectangular selection instead. (Page 276 has more on the transform tools.)

> **NOTE** When you use the Select→Transform Selection command to transform a *selection*—as opposed to part of your image—Photoshop won't mess with any of your image's pixels. The program merely changes the *selection's* shape—in other words, the shape of the marching ants.

Once you've made a selection, choose Select→Transform Selection or Control-click (right-click) inside the selection and, from the shortcut menu that appears, choose Transform Selection. Either way, Photoshop puts a rectangular *bounding box* with square resizing handles on its four sides around the selection. You can move the selection around by clicking inside the bounding box and dragging in any direction. (To get rid of the bounding box without making any changes, press the Esc key.)

The bounding box's resizing handles let you do the following:

- **Scale (resize).** Drag any handle to change the size and shape of the selection. Drag diagonally toward the center of the selection to make it smaller or diagonally away to make it bigger.

- **Rotate.** When you position your cursor outside one of the bounding box's corners, the cursor turns into a curved, double-headed arrow. That's your cue that you can drag to rotate the selection (just drag up or down in the direction you want to rotate).

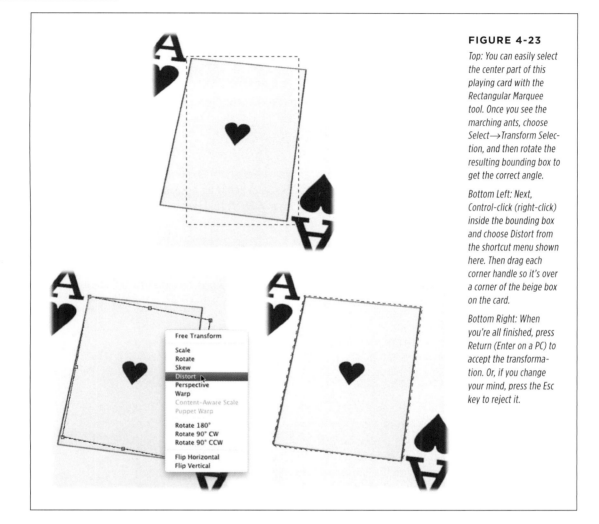

FIGURE 4-23

Top: You can easily select the center part of this playing card with the Rectangular Marquee tool. Once you see the marching ants, choose Select→Transform Selection, and then rotate the resulting bounding box to get the correct angle.

Bottom Left: Next, Control-click (right-click) inside the bounding box and choose Distort from the shortcut menu shown here. Then drag each corner handle so it's over a corner of the beige box on the card.

Bottom Right: When you're all finished, press Return (Enter on a PC) to accept the transformation. Or, if you change your mind, press the Esc key to reject it.

If you need to change the shape of the selection, Control-click (right-click) inside the bounding box and you'll see a shortcut menu with the following options (see Figure 4-23, bottom left):

- **Free Transform** lets you apply any of the transformations listed below freely and in one action (instead of having to choose and apply them one at a time). See page 276 for more info.

- **Scale** and **Rotate** work as described in the previous list.

- **Skew** lets you slant the selection by dragging one of the bounding box's side handles.

- **Distort** lets you drag any handle to reshape the selection.

- **Perspective** lets you drag any corner handle to give the selection a one-point perspective—that is, a vanishing point where it seems to disappear into the distance.

- **Warp** makes Photoshop place a grid over the selection that lets you reshape it in any way you want. Drag any *control point* (the two evenly spaced points on all four sides of the selection) or gridline to twist the selection however you like, or choose a ready-made preset from the Options bar's Warp menu.

TIP Using Warp is your ticket to creating a slick page-curl effect. For the scoop, visit *www.lesa.in/pagecurltut* to see a tutorial on this technique.

- **Content-Aware Scale** can intelligently resize the unimportant background areas of your image while keeping the subject unchanged. You'll learn all about it on page 271.

- **Puppet Warp** lets you twist and turn the selection any which way you want, like Silly Putty. It's covered in detail beginning on page 474.

- **Rotate 180°, Rotate 90° CW,** and **Rotate 90° CCW** turn your selection 180 degrees, 90 degrees clockwise, or 90 degrees counterclockwise, respectively.

- **Flip Horizontal** and **Flip Vertical** flip your selection either horizontally (like it's reflected in a mirror) or vertically (like it's reflected in a puddle).

When you're finished transforming the selection, press Return (Enter on a PC) to accept your changes. If you change your mind and want to reject your changes, press Esc instead.

Using Quick Mask Mode

If you'd rather fine-tune selections by painting with a brush, no problem—in fact, you can even *create* a selection from scratch using this method. Just enter Quick Mask mode and you'll find all of Photoshop's painting tools (even filters!) waiting to help tweak your selection. This mode gives you the freedom to work on selections with almost any tool.

You can enter Quick Mask mode by pressing the Q key or clicking the circle-within-a-square icon at the bottom of the *Tools* panel (*not* the Layers panel). When you do, Photoshop looks to see whether you have an active selection and if so, it puts a red overlay over everything *but* the selection. (If you don't have an active selection, you won't see any change in your image, but you can still use the directions in this section to *create* a selection.) This color-coding makes it easy to edit your selection *visually* by painting.

In Quick Mask mode, you can use the Brush tool to:

- **Deselect a portion of the selection**—in other words, add an area to the mask—by setting your foreground color chip to black and then painting across the unwanted area.

- **Extend the selection** by painting with white in the spot you want to add (you may need to press X to flip-flop your color chips).

- **Create a soft-edged selection or semi-transparent area** by painting with gray. For example, by painting with 50 percent gray (to do that, lower a black brush's opacity in the Options bar to 50 percent), you'll create a selection that's partially see-through. You can create a similar effect by painting with a soft-edged brush.

All the usual tools and document tricks work while you're in Quick Mask mode: You can zoom in or out by pressing ⌘ and the + or – key (Ctrl and + or – on a PC) or by using scrubby Zoom (page 58), press and hold the space bar to move around within the document once you're zoomed in, and use any of the selection tools covered in this chapter. You can also fill the entire mask—or the selection—with black or white (see pages 92 and 198), which is helpful when you have a large area to paint or when you want to paint the entire selection by hand. You can also run filters in this mode to create interesting, similar to the one shown on page 546.

Once you finish fine-tuning your selection, press the Q key to exit Quick Mask mode and the marching ants come rushing back, as shown in Figure 4-24, so you can see the newly edited selection.

Moving Selections

If you create a selection that's not in exactly the right spot or you've got several objects of the same shape that you want to select, you can move the selection itself. Or maybe you need to move the pixels *underneath* the selection, or move them onto their own layer. In any of those cases, you've got plenty of options:

- **Move the selection (the marching ants) within the same layer.** Make sure you have a selection tool active (it doesn't matter which one), and then click inside the selection and drag it to another part of the document. You can also nudge the selection into place with the arrow keys on your keyboard.

TIP To move a selection as you're drawing it, press and hold the space bar while pressing the mouse button. Drag to move the selection, release the space bar, and then continue dragging to draw the selection.

- **Move the selected object (the actual pixels) within the same document.**
 Press V to activate the Move tool, and then drag the object to reposition it.
 Just be aware that a big, gaping hole will appear where the object used to be!
 (If you're on a background layer, the hole will be filled with your current fore-
 ground color.) To *duplicate* the selection so you can move it to another part of
 the image without leaving a hole, Option-drag (Alt-drag on a PC) it instead.

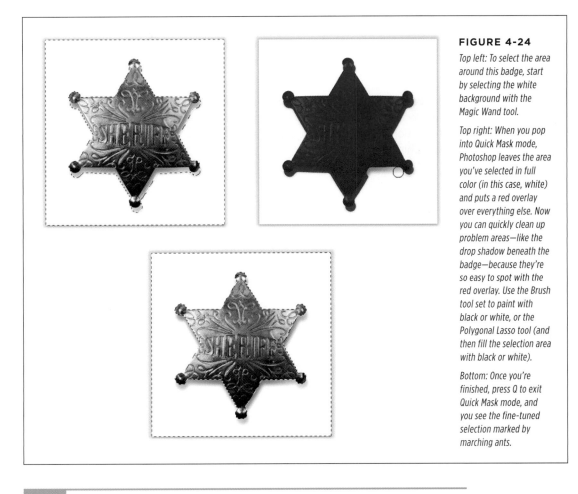

FIGURE 4-24

Top left: To select the area around this badge, start by selecting the white background with the Magic Wand tool.

Top right: When you pop into Quick Mask mode, Photoshop leaves the area you've selected in full color (in this case, white) and puts a red overlay over everything else. Now you can quickly clean up problem areas—like the drop shadow beneath the badge—because they're so easy to spot with the red overlay. Use the Brush tool set to paint with black or white, or the Polygonal Lasso tool (and then fill the selection area with black or white).

Bottom: Once you're finished, press Q to exit Quick Mask mode, and you see the fine-tuned selection marked by marching ants.

NOTE You can also use the Content-Aware Move tool to scoot a selected object from one place to another.
Jump ahead to page 472 for the scoop!

- **Move the selected object onto its own new layer within the same document.** Press ⌘-J (Ctrl+J) to "jump" the selected pixels onto their very own layer, just above the current layer. Now, whatever you do to the selected area won't harm the original image. If you don't like your changes, you can throw the extra layer away or reduce its opacity if the change is a little too strong. (Flip back to Chapter 3 for more on layers.)

- **Move the selected object to another document.** Press ⌘-C (Ctrl+C) to copy the selected pixels, open the other document, and then press ⌘-V (Ctrl+V) to paste the pixels. The pasted object appears on its very own layer that you can reposition with the Move tool. This technique is *essential* for performing the classic head swap shown in Figure 4-25.

- **Move the selected object to a new document.** Copy the object as described in the previous bullet, and then choose File→New. Photoshop opens a new document, sized to match the object you copied; press ⌘-V (Ctrl+V) to paste the object.

FREQUENTLY ASKED QUESTION

Changing Quick Mask's Color

Why is Quick Mask red? Am I stuck with red? And while we're at it, why does the mask mark unselected areas? Can I make it mark the selected areas instead?

Whoa, now! Just hold your horses; one question at a time.

First, a bit of history: The Quick Mask's default color is red because of its real-world counterpart, rubylith plastic, which came in sheets like paper. Back in the days before desktop publishing, this red plastic was cut with X-Acto knives and placed over the parts of images that needed to be hidden.

Printing technology has come a long way since then—there's no need for X-Acto knives when you've got Photoshop. And since you're working with modern printers and not old-fashioned printing presses, you're not stuck with using a red mask; you

can change Quick Mask's color to anything you want (which is quite helpful when the area you're trying to select has red in it). So if the red overlay isn't working for you, make sure you're in Quick Mask (press Q), and then double-click the circle-within-a-square button at the bottom of the *Tools* panel. In the Quick Mask Options dialog box that opens, click the color swatch, and then choose any color you like from the resulting Color Picker. You can also make the overlay more or less intense by changing the dialog box's Opacity setting.

And, yes, you can make Quick Mask mark the areas you've selected instead of the unselected areas. Simply open the Quick Mask Options dialog box, turn on the Selected Areas radio button, and then click OK.

FIGURE 4-25

Here's a fun little prank to pull on your family, friends, and exes.

Open a photo of someone and select their head using any of the selection tools discussed in this chapter (the Quick Selection tool was used here). Be sure to feather the selection so it doesn't have a hard edge (see the box on page 154), and then copy it by pressing ⌘-C (Ctrl+C). Next, open the document that contains the new body, and then paste your selection into it by pressing ⌘-V (Ctrl+V).

You can then use the Move tool to reposition the head onto its new body. If necessary, add a layer mask and fine-tune it to make the head blend a little better with the body. You can also use the Clone Stamp tool (page 447) on a new layer (set to sample all layers) to hide parts of the original head.

Good times!

Saving a Selection

If you'd like Photoshop to remember a selection so you can use it again later, the program is happy to oblige. After you create the selection, choose Select→Save Selection. In the resulting dialog box (Figure 4-26), give your selection a meaningful name (like *handsome devil*), and then click OK. When you're finished working with that document, be sure to save it as a PSD file (see page 45).

FIGURE 4-26

If you think you'll ever want to use a selection again, go ahead and save it—just in case.

It's also a good idea to save detailed selections that took you a long time to create.

When you're ready to use the selection again, pop open the document in which you saved it, and then choose Select→Load Selection. In the resulting dialog box, pick your selection from the Channel menu (if you've saved only one selection in this document, Photoshop chooses it automatically). Leave the Operation section set to New Selection to bring back the saved selection as a whole (instead of adding to or subtracting from another selection), and click OK. The marching ants reappear, just like you saved them.

TIP Although the radio buttons in the Load Selection dialog box's Operation section let you add to, subtract from, or intersect other selections with the saved selection, it's easier just to load the selection, close the dialog box, and *then* edit it using the selection tools discussed in this chapter.

Filling a Selection with Color

Filling selections with color is a great way to create shapes and add colorful photo borders to images. After you've created the selection of your dreams, you can fill it with color in a couple of ways.

One option is to choose Edit→Fill and, from the Use drop-down menu, choose Color. Pick something nice from the resulting Color Picker, and then click OK twice to dismiss the dialog boxes. Photoshop fills your selection with the color you picked.

A more *flexible* way to fill a selection with color is to add a solid color adjustment layer. Once you've made a selection, click the half-black/half-white circle at the bottom of the Layers panel and choose Solid Color (or choose Layer→New Fill Layer→Solid Color instead). Then grab a color from the resulting Color Picker and click OK. Photoshop dutifully fills the selected area with color, and a new solid color fill layer appears in your Layers panel. To change this layer's color, simply double-click its thumbnail to reopen the Color Picker. (Chapter 3 has more on using solid color, gradient, and pattern fill layers.)

> **TIP** You have yet *another* option for filling selections: Content-Aware Fill, which works with the Fill command and the Spot Healing brush. You'll learn all about it beginning on page 436.

Stroking (Outlining) a Selection

Sometimes you'll want to give your selection a *stroke* (as in an outline, not the medical condition). While you can stroke selections of any shape, this technique comes in really handy when you use it in conjunction with the Photoshop's vector tools. You can stroke *any* vector shape you create—whether it's with the Pen tool or one of the shape tools—with a variety of line widths and colors, including dashes or dots. This feature is covered on page 587.

If you want to add a stroke to a pixel-based layer, you can do that with layer styles (page 139). For example, when it comes to adding a bit of class to a photo, few effects beat a thin black outline (see Figure 4-27). If the image lives on its own layer, click the tiny *fx* at the bottom of the Layers panel and choose Stroke. In the resulting Layer Style dialog box, enter a size for the stroke, and then choose a Location from the drop-down menu (if the image is the same size as your document, be sure to choose *Inside* so the stroke appears inside the document's margins). Last but not least, click the colored square to pop open the Color Picker and choose a color for the stroke. Click OK to close the Layer Style dialog box and call it done. To edit the stroke's size or color later on, just double-click the stroke layer style in the Layers panel and the Layer Style dialog box pops open.

If the object you want to stroke *isn't* isolated on its own layer—your image is comprised of several layers, say, as shown in Figure 4-27—then you can add the stroke to an empty fill layer. To do this, create a selection of your whole document by pressing ⌘-A (Ctrl+A). Next, click the half-black/half-white circle at the bottom of the Layers panel and choose Solid Color; when the Color Picker opens, immediately click OK to close it. Make sure the new fill layer lives at the top of your layer stack, and then drop its Fill setting to 0 (see page 99 for more on this setting). Now you can use the *fx* button to add a stroke as described above.

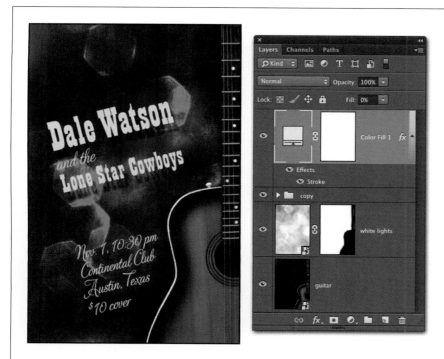

FIGURE 4-27

Whether you're floating an image within text in a newspaper, newsletter, or magazine—or even if you're posting it in your blog—a thin outline gives your image's edge a little definition, making the design look nicely finished.

Understanding Channels

At the heart of any Photoshop file lie *channels*—storage containers for all the color information in your image, selections you've saved, masks you've created, and instructions for printing with special inks. Channels sound intimidating at first, and folks have been known to shudder at their mere mention and avoid them completely. But to really understand Photoshop, it's good to get a grip on channels. Luckily, you don't need a PhD to do that—just a little patience.

This chapter gets a little technical at times, but if you soldier through, you'll be rewarded with wisdom that will help you perform some amazing pixel wizardry. You'll get a warm, fuzzy, enlightened feeling as you learn to:

- Use channels to make complex selections and masks (page 221).

- Map one image to the contours of another (page 324).

- Create a beautiful black-and-white image from a color version (page 211 and page 214).

- Perform highly targeted color adjustments (see Figure 9-23 on page 420).

- Sharpen your images without introducing noise (page 229).

And that's just the tip of the iceberg. *Everything* you do in Photoshop involves channels (well, save for working with paths and text, which you'll learn about in Chapters 13 and 14), so it's important to get familiar with them. If you understand *how* Photoshop does what it does, you can make it do even *more* in less time and with less effort. That's called working smarter, not harder—which is why, dear Grasshopper, you're reading this book.

To understand how channels work, you first need to learn a bit about the two color systems you'll encounter during your Photoshop career: *additive* and *subtractive*; the next section explains them both. Once you've got that under your belt, you'll dive into the color channels themselves to see what kind of info lives there and how you can use it to manipulate your images. Last but not least, you'll explore *alpha channels*, an entirely different kind of channel that lets you save selections that you can use again later or access through various commands, such as Content-Aware Scale (page 271). Read on!

How Color Works

The images you see on computer monitors and TVs are made of light; without light, the screens would be completely dark. While your eyes are sensitive to hundreds of wavelengths of light (each associated with a different color), it takes just three—red, green, and blue—to produce all the colors you see onscreen. So to create color, monitors *add* pixels of colored light. That's why the onscreen color system is called "additive." Each tiny *pixel* (short for *picture element*) can be red, green, blue, or some combination of the three. All image-capture and input devices—digital cameras, video cameras, and scanners—use the additive color system, as do all digital-image display devices.

> **NOTE** Onscreen images are also called *composite* images because they're made up of a combination of red, green, and blue light (also known as *RGB*).

In the additive color system, areas where red, green, and blue light overlap appear white (see Figure 5-1). Does that ring a bell from high school physics? Think about it this way: If you aim red, green, and blue spotlights at a stage, you see white where the three lights overlap. Interestingly, you also see cyan, magenta, or yellow where *two* of the three lights overlap (also shown in Figure 5-1). Areas where no light is shining appear jet black.

Now it's time to talk about printed color, which—brace yourself—works in a totally different way.

Printing presses use what's called a *subtractive* color system, where the colors result from a combination of light that's reflected (which you see) and light that's absorbed (which you don't see). In a printed photo, magazine, or book, the subtractive system operates as kind of a joint venture between the inks used (generally cyan, magenta, yellow, and black, all of which absorb color) and the paper the ink is printed on (a reflective surface). The ink serves as a filter by absorbing some of the light that hits the paper (you can think of this as "subtracting" that light from what you see). The paper bounces the rest of the light back at you, so the whiter the paper, the truer the colors will look when they're printed.

FIGURE 5-1

If you overlap red, green, and blue spotlights, you see white light. This is a prime example of the additive color system, which starts with darkness and adds light to produce different colors. Notice how cyan, magenta, and yellow appear where just two lights overlap.

You can try this spotlight experiment in Photoshop yourself by creating red, green, and blue circles on separate layers on a black background. Make the circles overlap, switch each layer's blend mode to Lighten, and voilà—the other colors appear where the circles overlap.

In the subtractive system, different-colored inks absorb different-colored light. For example, cyan ink absorbs red light and reflects green and blue light back at you, so you see a mix of green and blue—in other words, cyan. Similarly, magenta ink absorbs green light and reflects red and blue light; in other words, magenta. One last example: A mix of cyan, magenta, and yellow ink absorbs *most* of the primary colors—red, green, and blue—so you see what's left over: dark brown.

NOTE In order to produce true black, grays, and shades of color (colors mixed with black to produce darker colors), the folks who run printing presses add black as a fourth printing ink. They can't abbreviate it with B because it might be confused with blue (as in RGB), so they used K instead—as in "blacK." That's where the abbreviation CMYK comes from: Cyan, Magenta, Yellow, and blacK.

To summarize: Subtractive color is generated by light hitting an object and bouncing back to your eyes, whereas additive color is generated by different-colored light mixing together *before* you see any of it.

RGB Mode vs. CMYK Mode

Photoshop stores all the color information that gets relayed to your monitor, your printer, and so on, in separate *channels*. The channels' names change depending on which *color mode* (a.k.a. *image mode*) you're using for that particular Photoshop document. As a rule of thumb, you should use RGB mode for images destined for onscreen viewing or inkjet printing, and CMYK mode for images you plan on sending to a commercial printing press.

NOTE These days it's best to ask your printing company which color mode they prefer before you start editing. Some printing companies prefer RGB because they get better results by using their *own* software to convert images from RGB to CMYK.

To find out what color mode your image is in, choose Image→Mode; the current mode has a checkmark to the left of its name. In *RGB mode*, your Photoshop document has a red channel, a green channel, and a blue channel. When you look at each channel individually—you'll learn how in a moment—you actually see a grayscale representation of where and at what strength that particular color appears in your image. (Why doesn't Photoshop display them in color? The box on page 206 has the answer.) One of the best things about RGB mode is that it can display an enormous range of colors.

If you're preparing an image for a commercial printing press, they'll probably print it using a mix of cyan, magenta, yellow, and black inks. Enter *CMYK mode*, where your document includes—you guessed it—cyan, magenta, yellow, and black channels. The drawback to working in this mode is that ink reproduces *far fewer* colors than light, so this mode limits the hues at your disposal. But never fear: Even if you need to *end up* in CMYK mode, there's no harm in starting off in RGB. Heck, Photoshop even has a feature called soft-proofing (page 755) that lets you see how your image looks in one color mode versus another, though a CMYK version of an RGB image always looks less vibrant. (Chapter 16 explains more than you ever wanted to know about when and how to change color modes.)

As you discovered in Chapter 3, Photoshop includes other color modes, such as Grayscale and Lab, which are handy for specific tasks you'll learn about throughout this book. But you'll spend the vast majority of your time in RGB mode.

Now that the really confusing stuff is out of the way, it's time to focus on where in Photoshop you can *see* channels and the different flavors of channels you'll find there.

The Channels Panel and You

To peek inside a channel, open the Channels panel (Figure 5-2)—its tab is lurking in the Layers panel group on the right side of your screen. (If you don't see it, choose Window→Channels.) This panel looks and works like the Layers panel, which you learned about in Chapter 3.

When you single-click a channel in the panel, Photoshop highlights it to let you know it's active and temporarily turns off the other channels (see Figure 5-2); anything you do from that point on affects only the active channel. This is extremely useful when you want to, say, blur only the red channel in order to soften skin (since this channel usually has the least amount of texture in it). To activate more than one channel at a time, Shift-click each one (handy for sharpening two channels at once, as shown in Figure 5-15 on page 231).

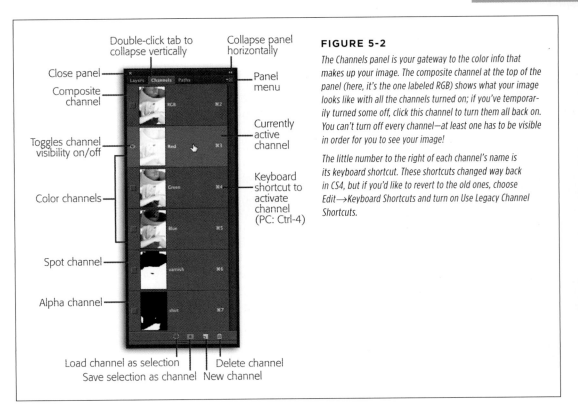

Double-click tab to collapse vertically

Collapse panel horizontally

Close panel

Composite channel

Toggles channel visibility on/off

Color channels

Spot channel

Alpha channel

Panel menu

Currently active channel

Keyboard shortcut to activate channel (PC: Ctrl-4)

Load channel as selection

Save selection as channel New channel

Delete channel

FIGURE 5-2

The Channels panel is your gateway to the color info that makes up your image. The composite channel at the top of the panel (here, it's the one labeled RGB) shows what your image looks like with all the channels turned on; if you've temporarily turned some off, click this channel to turn them all back on. You can't turn off every channel—at least one has to be visible in order for you to see your image!

The little number to the right of each channel's name is its keyboard shortcut. These shortcuts changed way back in CS4, but if you'd like to revert to the old ones, choose Edit→Keyboard Shortcuts and turn on Use Legacy Channel Shortcuts.

Photoshop uses several kinds of channels, all of which this chapter covers in detail:

- **Composite channels.** Technically, these aren't really channels; they're *combinations* of channels and are for your viewing pleasure only. When you're using a mode that contains more than one color channel (like RGB, CMYK, and Lab—all discussed later in this chapter), the composite channel shows all the channels *simultaneously*, revealing your image in its full-color glory. The name of the composite channel depends on which mode you're in. In RGB mode, for example, the composite channel is named RGB (creative, huh?). No matter what Photoshop calls it, the composite channel is always at the top of the Channels panel.

- **Color channels.** As explained earlier, if you're working in RGB mode, your color channels are Red, Green, and Blue. In CMYK mode, they're Cyan, Magenta, Yellow, and Black. In Lab mode (page 213), they're Lightness, a, and b. In most other modes, you'll find only a single channel that's named after the mode you're in.

- **Alpha channels.** These ever-so-useful channels are grayscale representations of a temporary selection you're in the process of using Quick Mask mode (page 193), or a selection that you've saved in your Photoshop document (page 197). The latter version comes in handy when you're making tough selections that you may need to tweak later, when using Content-Aware Scale (page 271), or when you can't complete the selection before your coffee break. Page 216 explains alpha channels in detail.

- **Spot channels.** Used only in commercial printing, these channels let you define areas in your image that should be printed with special premixed inks (like Pantone colors) or with a fancy coat of varnish, foil, or metallic ink. For example, if you're designing a holiday card and you want the snow to be sparkly, you can create a spot channel for the glitter so the printer knows where it goes. Page 744 has details on when to use spot channels and how to create them.

At the bottom of the Channels panel, you'll find the following icons (they're labeled in Figure 5-2):

- **Load channel as selection.** This icon, which looks like a tiny dotted circle, creates a selection of whatever's in the active channel based on its lightness values (not everything gets selected). This is handy when you're using channels to swap backgrounds (page 221) or create silhouettes (page 226). You can also load a channel as a selection by ⌘-clicking (Ctrl-clicking on a PC) the channel's thumbnail.

FREQUENTLY ASKED QUESTION

Why Are Channels Gray?

With all this talk about color, how come Photoshop displays channels in grayscale?

Although you *can* make Photoshop display channel info in color, you really don't want to; the colors would be so bright and distracting that it'd be hard to see anything useful. It's much easier to see a particular color's strength (called *luminosity*) when it's represented in shades of gray.

In RGB mode, white areas indicate a color at its full strength, and black areas indicate the color at its weakest. (In CMYK mode, the reverse is true—black indicates full strength and white indicates the weakest concentration.) For example, take a peek at the Red channel in Figure 5-2. The lighter-colored pixels represent high concentrations of red, whereas the darker pixels represent almost no red at all (and the tiny preview in the RGB channel shows that the image really *does* contain a lot of red).

As you can see, just glancing at grayscale channel information shows you quite clearly where a color is at full strength, where it's lacking, and what lies somewhere in between. That said, if you're determined to see channel info in color, choose Photoshop→Preferences→Interface (Edit→Preferences→Interface on a PC) and, in the Options section of the dialog box, turn on "Show Channels in Color"—and then see if you can make heads or tails of anything.

Actually, there is one situation where you *do* see channels displayed in color—in your document, at least—whether you like it or not: If you activate more than one channel, Photoshop previews your image in just those colors (see Figure 5-15 on page 231). Why? Because if the program displayed multiple channels in grayscale, you wouldn't be able to tell *which* shades of gray represented which color.

- **Save selection as channel.** When you have an active selection in your document, click this icon (the circle within a square) to save it as an alpha channel so you can continue to edit it or use it again later. Photoshop cleverly names your selections Alpha 1, Alpha 2, and so on. If you want a more memorable name, simply double-click the channel's name and change it to something like "Tony's toupee" or "Nancy's nose." If you'd rather name your selection before you save it, Option-click (Alt-click on a PC) this icon or choose Select→Save Selection instead.

- **Create new channel.** If you *drag* an existing channel onto this icon (which looks like a tiny piece of paper with an upturned corner), Photoshop duplicates that channel. This is helpful if you need to lighten or darken a channel in order to create a good selection (page 227), as altering the original channel can destroy your image. If you *click* this icon instead, Photoshop creates a new, empty alpha channel that you can use to create a selection from scratch using Quick Mask mode (see Figure 5-8).

- **Delete current channels.** Clicking this tiny trash can deletes the currently active channel(s); you can also drag and drop a channel onto this icon to do the same thing. After you've tweaked a duplicate channel or an alpha channel to create the perfect selection, you can toss it by clicking this icon. (Unlike with layers, you *can't* delete a channel by pressing Delete or Backspace on your keyboard.)

Just like every other panel in Photoshop, the Channels panel has a menu tucked into its top-right corner (it looks like a down arrow next to four little lines). This handy menu includes some of the same commands mentioned earlier and a few all its own:

- **New Channel.** This command creates a brand-new alpha channel, just like clicking the "Create new channel" icon at the bottom of the panel. The difference is that, by going this route, you get a nifty dialog box where you can name the new channel and tell Photoshop how to display the channel's information (see Figure 5-7 on page 219). However, it's quicker to Option-click (Alt-click) the "Create new channel" icon.

- **Duplicate Channel.** To create a copy of a channel so you can edit it, choose this command. When you do, Photoshop displays a dialog box so you can name the new channel and choose its destination (the same document or a new one). The destination option is helpful when you're creating a displacement map (page 324) or using channels to make a high-contrast, black-and-white image (page 211).

- **Delete Channels.** This command deletes the current channel or, if you've Shift-clicked to activate more than one channel, *all* active channels. You have to keep one channel, though, so if you've activated all of 'em, you can't choose this command.

- **New Spot Channel.** This option lets you create a new channel to mark an area that should be printed with a premixed, specialty ink—including varnish, foil, metallic ink, and so on—called a *spot color*. Chapter 16 has more about spot channels beginning on page 744.

- **Merge Spot Channel.** Only commercial printing presses use spot channels, so if you need to print a proof on a regular desktop printer, you first have to run this command to merge your spot channels. See the box on page 759 for details.

- **Channel Options.** This menu item is available only if you have an alpha channel active. Choose this command to change the way Photoshop displays masked and selected areas. Page 219 has the scoop.

- **Split Channels.** If you need to put each channel into its own document, choose this command. Photoshop grabs each channel and copies it into a new, grayscale document (page 41 has more on Grayscale mode). This technique is useful when, for example, you're creating a black-and-white image based on one of its color channels and you need the resulting document to end up in Grayscale mode so it can be printed in a newspaper. (The box on page 337 has tips for preparing grayscale images for a printing press.)

- **Merge Channels.** You might think this command merges more than one channel into a single channel. Negative, good buddy. Instead, it merges the channels of up to four Grayscale documents into a single document, whose resulting color mode depends on how many documents you had open when you began: RGB if you started with three open documents, CMYK if you started with four. You can also choose this command to have Photoshop merge all the open documents' channels into a Multichannel document (page 215). This command comes in handy if you've used Split Channels to work on each channel separately and now you want to reunite them in one document.

- **Panel Options.** In the Channels panel, Photoshop displays a thumbnail preview of each channel (see Figure 5-2). To turn off this preview or choose a different thumbnail size, pick this menu item. If you've got a decent-sized monitor (17-inch or larger), do your eyes a favor and go for the biggest preview possible.

- **Close** and **Close Tab Group.** Choose Close to make the Channels panel disappear, or Close Tab Group to get rid of a whole group of related panels (such as Layers, Channels, and Paths). See Chapter 1 for more on panel wrangling.

Meet the Color Channels

Understanding what you're seeing in each channel gives you the know-how to create complicated selections and fine-tune your images. In this section, you'll look inside the different color channels, beginning with the most common color mode: RGB.

> **NOTE** This section doesn't cover alpha channels; they're so important, they get their very own section that begins on page 216.

RGB Channels

Unless you're preparing an image that's headed for a commercial printing press and they *require* you to use CMYK, RGB mode is the place to be. After all, your monitor, digital camera, and scanner are all RGB-based. But as the box on page 206 explains, Photoshop doesn't display individual channels in red, green, and blue—they're in grayscale so you can easily see where the color is most saturated. Because colors in RGB mode are made from light (page 203), white indicates areas where the color is at full strength, black indicates areas where it's weakest, and shades of gray represent everything in between (Figure 5-3).

> **TIP** No matter which color mode you're in, you can cycle through its various channels by pressing ⌘-3, 4, 5, and 6 (Ctrl+3, 4, 5, and 6 on a PC), though you'll only use that last one if you're in CMYK mode—which has four channels instead of three—or if you're trying to activate an alpha channel in RGB mode. To go back to the composite channel so you can see the image in full color, press ⌘-2 (Ctrl+2). When you use these shortcuts, be sure to hold down the ⌘ or Ctrl key; otherwise, typing numbers will change layer or Brush tool opacity instead (see page 101).

Each color channel contains different information:

- **Red.** This channel is typically the lightest of the bunch and shows the greatest difference in color range. In Figure 5-3, this channel is very light because there's a lot of red in the woman's skin, hair, and hat. This channel can be *muy importante* when you're correcting skin tones (page 412). You can also run a blur filter on this channel to instantly soften skin (page 460).

- **Green.** You can think of this channel as "contrast central" because it's usually the highest in, well, *contrast*. (This makes sense because digital cameras have twice as many green sensors as red or blue ones in order to mimic the human eye, which is most sensitive to green light.) Remember this channel when you're creating an edge mask for sharpening (page 505) or working with displacement maps (page 324).

- **Blue.** Typically the darkest of the group, this channel is useful when you want to create complex selections in order to isolate an object (page 221). It's also where you'll find problems like *noise* and *grain*. See the box on page 487 to learn how to run the Reduce Noise filter on this channel.

CMYK Channels

Although you'll probably spend most of your time working with RGB images, you may also need to work with images in CMYK mode. Its name, as you learned earlier, stands for the cyan, magenta, yellow, and black inks commercial printing presses use in newspapers, magazines, product packaging, and so on. It has a composite channel at the top of the Channels panel named CMYK. You can pop into this mode by choosing Image→Mode→CMYK Color.

Composite

Red

Green

Blue

FIGURE 5-3

Most likely, your image is already in RGB mode, especially if it came from a digital camera or a stock-image company.

See how the red, green, and blue channels differ in this cute cowgirl portrait? White areas indicate where the color in that channel is most concentrated, and black areas indicate where the color is weakest.

Back in early versions of Photoshop, if you wanted to generate a black-and-white version of a color photo, you typically picked the channel with the highest contrast and used that. Now, Photoshop gives you much better ways to convert from color to shades of gray such as black & white and gradient map adjustment layers (described on pages 330 and 333, respectively).

If you plan to print your image at home on a regular laser or inkjet printer, you don't need to be in CMYK mode (unless you want to create a quick, high-key effect as described in a moment). Also, this mode limits you to precious few filters (Chapter 15) and color or lighting adjustments (Chapter 9).

A professional printing press separates the four CMYK channels of your image into individual *color separations* (see page 754). Each separation is a perfect copy of the color channel you see in Photoshop, printed in its respective color (cyan, magenta, yellow, or black). When the printing press places these four colors atop each other, they form the full-color image. This technique is known as *four-color process* printing.

Because CMYK channels represent ink rather than light (as explained back on page 202), the grayscale information you see in your Channels panel represents the *opposite* of what it does in RGB mode. In CMYK mode, black indicates color at full strength and white indicates color at its weakest (see Figure 5-4). Does your brain hurt yet?

■ CREATING A HIGH-KEY PORTRAIT EFFECT

Even if you're not sending your image to a printing press, you can still have some fun in CMYK mode. For example, you may have noticed that the Black channel in Figure 5-4 looks pretty darned neat. It resembles a popular portrait effect called *high-key* lighting, in which multiple light sources are aimed at the victim, er, subject to create a dazzling image with interesting shadows. Some folks labor long and hard to achieve this look in Photoshop, but they could simply resort to a bit of channel theft. To create this effect, just extract the Black channel from a CMYK version of the image. Here's how:

1. **If your image is in RGB mode, make a copy of it by choosing Image→Duplicate.**

 Because you're going to change color modes in the next step, it's a good idea to do that on a copy of your image since you lose a *tiny* bit of color info when you switch from one mode to another. If your image is already in CMYK mode, skip ahead to step 3.

2. **In the duplicate image, choose Image→Mode→CMYK Color.**

 If your document includes more than one layer, Photoshop asks if you want to combine them into one by flattening the image (compressing all layers into one). If those additional layers affect the way your image looks (for example, adjustment layers), click Flatten; if not, click Don't Flatten. (Flattening a document is typically a scary move, but here you're working with a *duplicate* of your original document.)

 If you see another dialog box asking about color profiles, just click OK. You'll learn about profiles in Chapter 16. For now, all you need to know is that, since you'll end up back in your original RGB document in step 5, the CMYK profile won't affect anything.

3. **In the duplicate image's Channels panel, click the Black channel to activate it.**

 When you activate the Black channel, Photoshop automatically turns off the other channels' visibility.

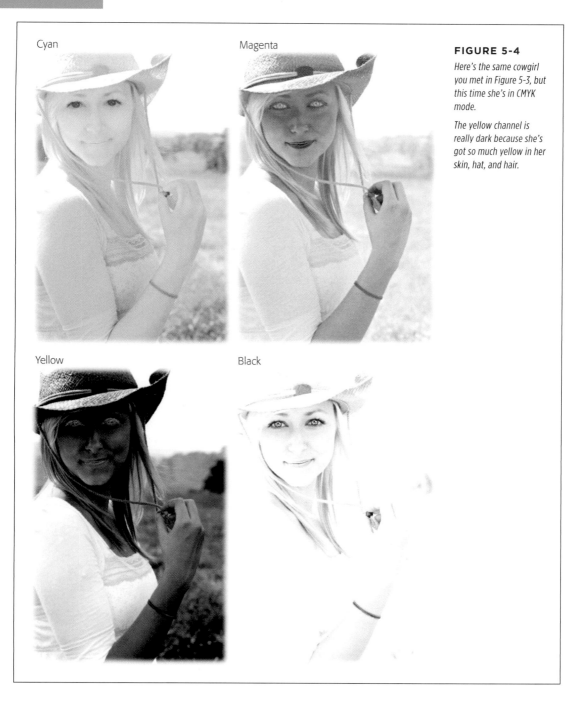

Cyan

Magenta

Yellow

Black

FIGURE 5-4

*Here's the same cowgirl
you met in Figure 5-3, but
this time she's in CMYK
mode.*

*The yellow channel is
really dark because she's
got so much yellow in her
skin, hat, and hair.*

TIP If you're preparing the high-key image for printing in *true* grayscale—meaning the image will be printed with black ink only (think newspapers)—then you can skip the following steps and instead choose Split Channels from the Channels panel's menu. Photoshop instantly creates separate documents from each color channel. Simply find the one with "Black" in its name and call it a day. (For more on preparing grayscale images for a printing press, see the box on page 337.)

4. **Copy the Black channel.**

 Press ⌘-A (Ctrl+A) to select everything in the Black channel, and then copy it by pressing ⌘-C (Ctrl+C).

5. **Switch back to your original RGB document and paste the Black channel into the Layers panel.**

 Click the original RGB image's tab or inside its window. Next, open the Layers panel by clicking its icon in the panel dock or choosing Window→Layers. Then paste the Black channel by pressing ⌘-V (Ctrl+V). (You don't have to create a new layer; Photoshop does that for you.) The beauty of producing this effect inside your original RGB document is flexibility. For example, you can lower the opacity of the new black layer for a completely different, yet interesting, partial high-key/partial color effect.

6. **Close the duplicate document (you don't need it anymore).**

That's it! You've got yourself a beautiful, high-contrast look that took only minutes to achieve. And if the image doesn't have quite enough contrast for you, try adding a brightness/contrast adjustment layer and changing its blend mode to Multiply (this maneuver is shown back on page 125).

Spot Channels

In the realm of CMYK printing, there's a special kind of premixed ink called a *spot color*, which requires a different kind of channel that lets the printer know exactly where to put that ink. If you're a graphic designer working in prepress (see the Note below), in packaging design, or at an ad agency, you need to know this stuff, and page 744 has all the details. If you're a photographer or a Web designer, save your brainpower and forget you ever heard of spot channels.

NOTE *Prepress* refers to the process of preparing images and documents—usually in a page-layout program like Adobe InDesign or QuarkXPress—for printing on a commercial press.

Lab Channels

Lab mode separates an image's lightness values (how bright or dark it is) from its color information. This mode gets its name from the channels it includes: Lightness, a, and b. Lab mode isn't used for output like RGB and CMYK modes; instead, it's useful when you want to alter an image's lightness values—when you're sharpening or brightening, for instance—but not its colors. (Likewise, you can adjust the image's color information without affecting its lightness values to, say, get rid of a color cast.)

You can pop into Lab mode by choosing Image→Mode→Lab Color, and if you peek at the Channels panel, you'll see x-rayish images like the ones in Figure 5-5.

Lightness

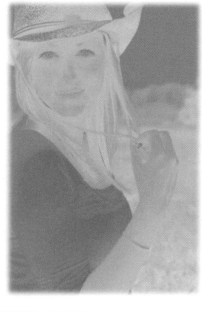

a (red and green)

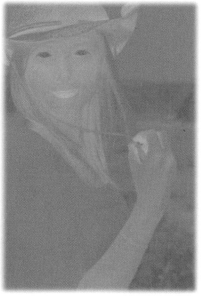

b (yellow and blue)

FIGURE 5-5

Here's that cowgirl again, now in Lab mode. In the a channel, lighter areas represent greens and darker areas represent magentas (reds). In the b channel, lighter areas represent blues and darker areas represent yellows.

Some folks swear that by splitting the Lightness channel into its own document and then making a few adjustments, you can create a black-and-white image worthy of Ansel Adams. See page 335 for the scoop on how to do that and then judge for yourself!

Here's what's in each channel:

- **Lightness.** This is where you'll find the details of your image, minus color; it looks like a really good black-and-white version.

- **a.** This channel contains half of the color information: a mixture of magenta (think red) and green.

- **b.** Here's the other half: a mixture of yellow and blue.

Techniques that involve Lab mode are sprinkled throughout Part Two of this book.

Multichannel Mode

Unless you're preparing an image for a commercial printing press, you'll never use this mode—although you may switch to it accidentally. If you delete one of the color channels in an RGB-, CMYK-, or Lab-mode document, Photoshop plops you into Multichannel mode without even asking. If that happens, just use the History panel to go back a step or press ⌘-Z (Ctrl+Z) to undo and bring back the channel you accidentally deleted.

Multichannel mode doesn't have a composite channel; it's strictly for two- or three-color print jobs. So whether you enter this mode on purpose (by choosing Image→Mode→Multichannel) or accidentally as described above, Photoshop converts any existing color channels to spot channels (page 744).

When you convert an image to Multichannel mode, Photoshop promptly does one of the following (depending on which color mode you were in before):

- **Converts the RGB channels** to cyan, magenta, and yellow spot channels.

- **Converts the CMYK channels** to cyan, magenta, yellow, and black spot channels.

- **Converts the Lab channels** to alpha channels named Alpha 1, Alpha 2, and Alpha 3.

- **Converts the Grayscale channel** to a black spot channel.

These radical channel changes cause drastic color shifts, but you can edit each channel individually—both its contents and its spot color—to create the image you want. When you're finished editing, save the image as a Photoshop (PSD) file by choosing File→Save As and picking Photoshop from the format menu.

Single-Channel Modes

The rest of Photoshop's image modes aren't very exciting when it comes to channels: they each have just *one*. They include Bitmap, Grayscale, Duotone (super useful for adding creative color tints, as page 345 shows), and Indexed Color mode (used in GIF files), and most of 'em are discussed back on page 41.

■ The Mighty Alpha Channel

Photoshop has one other type of channel: alpha channels. Their special purpose is to store selections so you can use or edit them later.

These channels get their name from a process called *alpha compositing*, which combines a partially transparent image with another image. (Filmmakers use this process to create special effects and fake backdrops.) Information about the shape of the transparent area and the pixels' level of transparency has to be stored somewhere, and that somewhere is an alpha channel.

This is powerful stuff because the same technology lets you save selections. And, as you've learned, making selections can take a *ton* of time. (Heck, you may not have the stamina to finish creating a particularly challenging selection in one sitting!) And since clients change their minds occasionally—"Put the model in front of *this* bush, and change her hair color while you're at it"—the ability to save selections so you can mess with them later is a lifesaver. Likewise, a saved selection is crucial for making the Content-Aware Scale feature behave because the selection lets you tell Photoshop not to mess with certain areas in your image (see page 271 for the full scoop). As long as you save your document as a Photoshop file (page 45), that alpha channel will always be there for you to use. That ought to make you sleep better at night!

> **TIP** You can drag alpha channels between documents as long as both documents have the exact same pixel dimensions.

Folks sometimes refer to alpha channels as *channel masks* because, once you've created an alpha channel (you'll learn how in a sec), you can use it to help you adjust certain portions of your image—kind of like when you use a layer mask (page 120). In fact, creating a layer mask by loading an alpha channel as a selection is a common use for alpha channels. That's because, as you'll learn on page 221, you can use channels to make incredibly detailed selections that are tough to get any other way.

> **NOTE** When you're in Quick Mask mode (page 193), you're actually working on a temporary alpha channel. Who knew?

Creating an Alpha Channel

It can be helpful to think of an alpha channel as a grayscale representation of your selection. Unless you change Photoshop's settings, the black parts of the channel are the unselected portion of your image—also referred to as the *protected* or *masked* part—and the white parts are the selection (see page 219 to learn how to reverse these colors). And, just like in a layer mask, shades of gray represent areas that are only partially selected, which means they're partially transparent.

Photoshop gives you several different ways to create an alpha channel:

- **Create a selection and then choose Select→Save Selection** (see page 197).

- **Create a selection and then click the "Save selection as channel" icon at the bottom of the Channels panel.** It looks like a circle within a square and is circled in Figure 5-6.

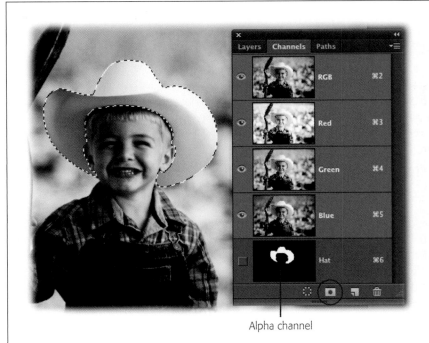

FIGURE 5-6

In most cases, you'll find it easier to create a selection first (even if it's rough) and then *add your alpha channel, as shown here. That way, you see the full-color image instead of a screen full of black or red.*

To do that, select something in your image and then, once you've got marching ants, click the "Save selection as channel" icon (circled). Photoshop adds an alpha channel—which includes your selection—to the bottom of the Channels panel.

Alpha channel

- **Click the "Create new channel" icon at the bottom of the Channels panel** (see Figure 5-2). When you do that, Photoshop creates an alpha channel named Alpha 1 and sticks it at the bottom of the Channels panel. The new channel is solid black because it's empty. To create a selection, turn on the composite channel's visibility to summon the red overlay of Quick Mask mode so you can see your image. Then grab the Brush tool (page 528) and paint the area you want to select with white (think of this process as painting a hole through the mask so you can see—and therefore select—what's below it).

NOTE Though you can certainly start with an empty alpha channel, it's usually easier to create your selection (or at least a rough version of it) on the full-color image *before* adding the alpha channel (say, with the Quick Selection tool, discussed on page 160). Then you can fine-tune the alpha channel using the methods explained in the box on page 225.

• **Choose New Channel from the Channels panel's menu** (see Figure 5-2). When you choose this command, a dialog box opens so you can name the new channel and tell Photoshop how to display the channel's info.

Straight from the factory, Photoshop shows selected areas (the parts of your image inside the marching ants) in white and unselected areas in black. Partially selected areas, which have soft edges, appear in shades of gray. If you'd rather see your *selections* in black and everything else in white, turn on the dialog box's Selected Areas radio button. If you want to edit your alpha channel using Quick Mask mode (as described later in this section), you can change the Quick Mask's color and opacity here. When you've got everything the way you want it, click OK to make Photoshop create your alpha channel.

> **TIP** If you *Option*-click (*Alt*-click on a PC) the "Save selection as channel" icon at the bottom of the Channels panel, you get the same dialog box as if you had chosen New Channel from the panel's menu, which lets you name your shiny new alpha channel. (You can rename a channel anytime by double-clicking its name.)

Editing Alpha Channels

Once you've got yourself an alpha channel, you can fine-tune it just like a layer mask (page 127) by painting with the Brush tool or using any selection tool. If you use a selection tool, you can choose Edit→Fill and then pick black or white from the Use menu, depending on whether you want to add to or subtract from your selection (selected areas are white, and everything else is black). If you want to *reverse* the way Photoshop displays the channel's info—so that your selection appears black instead of white—just double-click the alpha channel's thumbnail in the Channels panel and, in the resulting Channel Options dialog box, choose Selected Areas. When you do, Photoshop flip-flops your mask's colors, as shown in Figure 5-7.

> **NOTE** It doesn't matter whether you use black to mark the masked or selected areas of your image—it's a personal preference. Just pay careful attention to what the ants are marching around when you load an alpha channel as a selection, as *that's* the part of the image you'll modify when you start making changes. And remember that, as you learned in the box on page 167, it's often easier to select what you *don't* want and then use Select→Inverse to flip-flop your selection than it is to select what you *do* want.

You can also edit your alpha channel using Quick Mask mode. To do that, in the Channels panel, activate the alpha channel and then click the composite channel's visibility eye, circled in Figure 5-8. When you do, Photoshop puts Quick Mask mode's signature red overlay atop your image. (If you're editing an alpha channel in an image with a lot of red in it, you won't be able to see diddly through the mask, so you'll need to change the overlay color as described in Figure 5-7.)

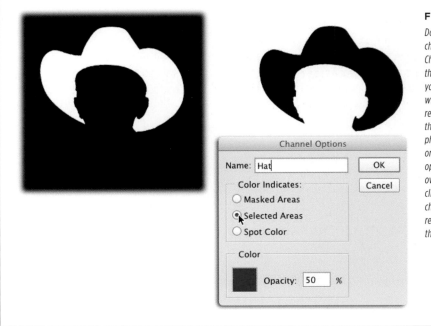

FIGURE 5-7

Double-clicking an alpha channel's thumbnail in the Channels panel summons this dialog box, which lets you tell Photoshop to reverse what the mask color (black) represents. You can also use this dialog box to turn the alpha channel into a spot color or to change the color and opacity of the Quick Mask overlay. To do the latter, click the red color swatch, choose a new color from the resulting Color Picker, and then click OK.

You can also run filters on an alpha channel, just like you can with a layer mask. Among the most practical are Gaussian Blur for softening the selection's edge (helpful in making the pixels you're changing blend in better with surrounding pixels) and the Minimum filter for tightening your selection (page 714). Chapter 15 shows these filters in action.

Loading an Alpha Channel as a Selection

Once you're finished editing an alpha channel, you can transform it into a selection so you can actually *do* something with it. You can summon the marching ants in several ways:

- **Use ⌘-click (Ctrl-click) the alpha channel's thumbnail** in the Channels panel.

- **Click the "Load channel as selection" icon** at the bottom of the Channels panel (the tiny dotted circle) while you've got an alpha channel active.

- **Drag the alpha channel onto the "Load channel as selection" icon** (let go of your mouse as soon as Photoshop highlights the icon).

Now you can perform all the amazing color and lighting adjustments explained throughout this book, and they'll affect only the area you've selected.

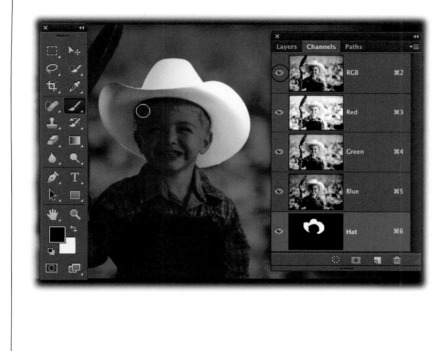

FIGURE 5-8

Activate an alpha channel and turn on the composite channel's visibility eye (circled) to edit or create a selection from scratch in Quick Mask mode. Here, the Brush tool (the white circle beneath the hat brim) is set to paint with black and used to fine-tune the masked area around the boy's forehead. If you mask too much—by painting with black across part of the hat, say, thereby subtracting it from your selection—press X to flip-flop your color chips and paint across that area with white to add it back to your selection (just like you would with a layer mask).

Deleting Alpha Channels

When you're finished using an alpha channel (or if you want to start over with a new one), you can get rid of it by dragging it onto the little trash can at the bottom of the Channels panel. Or just click the trash can while the alpha channel is active and then click Yes when Photoshop asks if you're *sure* you want to throw it away.

NOTE Unless you're a panel neat freak, you don't have to throw out old alpha channels; Photoshop lets you store up to 56 channels in a document. They don't add all that much to your document's file size because they're black and white (if they contain a lot of gray, they'll add slightly more to the file size, but not enough that it's worth tossing 'em). If you've created a slew of incredibly complex alpha channels, then you might see a bump in file size. But if there's even the *slightest* chance you'll ever use them again, save your document as a PSD file (or TIFF, for that matter) to keep those hard-earned alpha channels intact.

■ Basic Channel Stunts

Now that you know what channels are all about, it's time to learn some of the cool things you can do with them. This section covers a few of the most practical channel tricks, and you'll find other techniques involving channels throughout this book.

Selecting Objects with Channels

As you learned in Chapter 4, true selection wisdom lies in knowing which tool to start with so you'll have the least fine-tuning to do later. If you have an image with a decent amount of contrast between the item you want to select and its background, you can give channels a spin. All you need to do is create an alpha channel that contains only black-and-white objects, load it as a selection, and then use it to make a layer mask. Here's how to use channels to select all the balloons in Figure 5-9 so you can, for example, swap in a new sky:

1. **Open an image that's in RGB mode and has a background you want to swap.**

 If your image came from a scanner or digital camera, it's already in RGB mode. To check, choose Image→Mode. If necessary, choose RGB Color to switch modes.

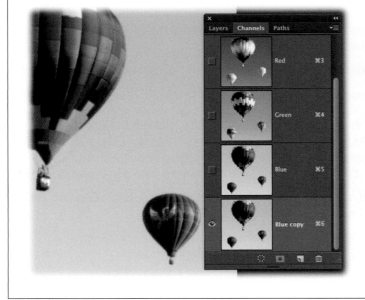

FIGURE 5-9

Once you find the channel where the objects you want to select appear the darkest (typically the blue channel), make a copy of that channel so you don't mess up your original photo with the lightening or darkening you're about to perform.

To copy a channel, simply drag it onto the "Create new channel" icon, and Photoshop adds the copy to the bottom of your Channels panel, as shown here.

Want to follow along? Visit this book's Missing CD page at www.missingmanuals.com/cds and download the practice file Balloons.jpg.

2. **Find the channel where the objects you want to select look the darkest.**

 In the Channels panel, click each channel to find the one where the balloons are the darkest. (You can also cycle through channels by pressing ⌘-3, 4, and 5 [Ctrl+3, 4, 5 on a PC].) Objects will usually be darkest on the blue channel, as is the case here.

TIP In the past, using channels was the only way to create really tough selections around hair and fur. However, using the new Focus Area command (page 179) combined with the powerful Refine Edge dialog box (page 181) may be faster. That said, it's good to know what all of your options are; plus, using Channels to create a selection that you then fine-tune with the Refine Edge dialog box is a handy technique to have up your sleeve.

3. **Duplicate the blue channel so you don't destroy your original image.**

 Either Control-click (right-click) the blue channel in the Channels panel and then pick Duplicate Channel from the shortcut menu, or drag the channel onto the "Create new channel" icon. (You can also choose Duplicate Channel from the Channels panel's menu, but dragging is quicker.) Whichever method you use, Photoshop puts the duplicate at the bottom of the Channels panel and cleverly names it "Blue copy."

4. **Adjust the duplicate blue channel's Levels to make the balloons black and the background white.**

 Chapter 9 covers Levels in detail, but this exercise gives you a sneak peek at how useful this kind of adjustment can be. With the duplicate blue channel active in the Channels panel, choose Image→Adjustments→Levels or press ⌘-L (Ctrl+L) to summon the Levels dialog box. To make the balloons darker, drag the shadows slider (circled in Figure 5-10, top) to the right until the balloons turn *almost* black. (As you drag the slider, the background gets darker, too. That's OK—you'll fix the background in the next step.) Don't close the Levels dialog box just yet!

5. **Using the white eyedropper, click the gray background to make it white.**

 This eyedropper (circled in Figure 5-10, bottom) lets you tell Photoshop what should be white (pros call this technique "resetting the white point"). Click the eyedropper to activate it, mouse over to your document, and then click a gray part of the background as shown in Figure 5-10, bottom. Keep clicking different gray areas until the background is completely white (or as close to white as you can get it). When you're finished, click OK to close the Levels dialog box.

6. **If necessary, touch up the inside of the balloons with black paint and the background with white paint.**

 If adjusting the shadows slider in step 4 didn't make the balloons *completely* black (as in Figure 5-10, top), use the Brush tool to touch them up (otherwise the balloons will be only *partially* selected). Press B to grab the Brush tool, set your foreground color chip to black (press D to set the color chips to black and white, and then press X until black hops on top), and then mouse over to the balloons and paint them solid black. And, if resetting the white point in step 5 didn't get rid of all the gray in the background, you can use the Brush tool to paint those areas white. (Alternatively, you can use the Lasso tool to hand draw a selection around an area; choose Edit→Fill, pick Black from the Use menu, and then click OK.) When you're finished, you should have a pure black-and-white image.

TIP When you're touching up an alpha channel using the Brush tool, be sure to zoom into your image to make sure you're being precise with your brushstrokes (on a 4 MB image, for example, you need to zoom in to at least 500 percent). You may also need to switch to a hard-edged brush using the Brush Preset picker in the Options bar to ensure you don't create too soft an edge around the object you're painting. See page 56 for more on zooming and page 530 for more on changing Brush tool options.

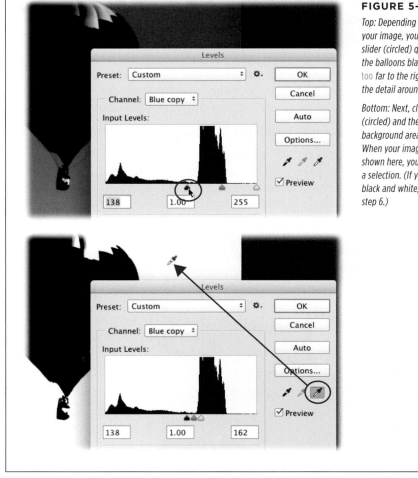

FIGURE 5-10

Top: Depending on the amount of contrast in your image, you may have to drag the shadows slider (circled) quite a ways to the right to make the balloons black. But be careful: If you drag it too far to the right, you'll start to lose some of the detail around their edges.

Bottom: Next, click the white eyedropper (circled) and then, over in your image, click the background area until it's as white as it'll get. When your image is pure black and white, as shown here, you're ready to load the channel as a selection. (If you can't seem to make it pure black and white, don't panic; just proceed to step 6.)

7. **In the Channels panel, load the duplicate blue channel as a selection by ⌘-clicking (Ctrl-clicking) the channel's thumbnail or clicking the "Load channel as selection" icon (the dotted circle) at the bottom of the panel.**

 Now that you've got a perfectly black-and-white image (it looks just like a layer mask or alpha channel, doesn't it?), you can load it as a selection. When you do, Photoshop puts marching ants around the *background* of your image,

which is the opposite of what you want. No worries! You'll solve that problem in the next step.

8. **Invert the selection to select the balloons instead of the background.**

 Choose Select→Inverse or press Shift-⌘-I (Shift+Ctrl+I) to flip-flop your selection so the marching ants run around the balloons instead of around the edges of the document.

9. **In the Channels panel, turn on the composite channel and hide the duplicate blue channel.**

 Scroll to the top of the Channels panel and click near the composite channel's name (RGB) to turn it back on so you can see the full-color version of your image again. (This also turns off the visibility of the duplicate blue channel.) You can delete the duplicate blue channel by dragging it to the tiny trash can at the bottom of the Channels panel or leave it hanging around in case you need to edit it later.

10. **Open the Layers panel, unlock the background layer, and then add a mask.**

 Click the Layers tab to open the Layers panel or choose Window→Layers. If the background layer has a little padlock icon next to it, double-click the icon to unlock the layer. If you like, type a name for the background layer in the resulting dialog box, and then click OK. (If you're working with an image you've edited before, you may have already named your background layer something other than "Background.") To add a layer mask, click the circle-within-a-square icon at the bottom of the Layers panel. Photoshop adds a layer mask that hides the photo's original background (the sky), as shown in Figure 5-11, left. Sweet!

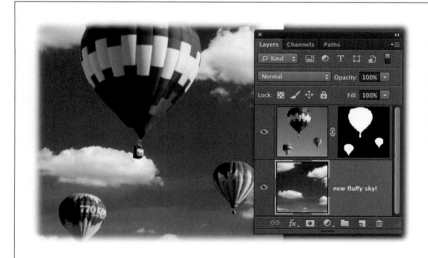

FIGURE 5-11

Look, Ma, no selection tools! Whenever you have an image that's got a decent amount of contrast between its subject and its background, like the original balloon image here, using channels is an easy way to create an accurate selection fast.

You're all finished! You can now copy and paste a new background into the Layers panel and then drag it to the bottom of the layer stack to put the balloons on

a brand-new sky (see Figure 5-11). If you need to edit the layer mask (page 127), activate it in the Layers panel and then paint with either black or white according to what you want to do (conceal or reveal, respectively).

Touching Up Alpha Channels

When you're editing an alpha channel to make a selection, it's important that you end up with a pure black-and-white channel with few (if any) shades of gray. (The alpha channel shown in Figure 5-10, bottom, is almost there but needs a tiny bit of touch-up on the balloons). If there are any gray areas around the edge of the object, those edges will look soft—as if you've feathered them (page 151). If there's any gray in the center of the object, then those pixels will be only *partially* selected (and if there's any white, they *won't* be selected at all). Adjusting the alpha channel's Levels usually gets your image *close* to pure black and white, but that method can only do so much: You're often left with stray gray pixels here and there, a selection that isn't quite solid black or white, or some stuff in the background that you don't need. Your only choice at that point is to touch up the image by hand.

Sure, this kind of work is tedious, but it goes much quicker if you use one of the following methods. Remember that when you're in Channels Land, you've got most (but not all) of Photoshop's tools at your command. With that in mind, here are a few tricks for doing it faster:

- **Fill the background with black or white.** If you've managed to make your object pure black, you can use a selection tool to grab everything else in the channel and make it white. For example, use the Lasso tool to draw a rough selection around your black object and then choose Select→Inverse to select the background instead. Next, choose Edit→Fill, pick white from the Use menu, and then click OK. Now your background is solid white and your touch-up work is limited to the area right around your object. (If the object you want to select is solid white, use this method to fill the background with black instead.)

- **Paint or fill the object with black or white.** When the object you want to select isn't *quite* solid black or white, your best bet is to set the Brush tool to either black or white and then paint the object by hand. Or you can use the Lasso tool to draw a rough selection around that area, choose Edit→Fill, and then pick black or white from the Use

menu. (If the area is square or oval, use the Rectangular or Elliptical Marquee tool to select it instead.) When you click OK, Photoshop fills that area with color. (For more on the selection tools, see Chapter 4.)

- **Get rid of stray gray pixels inside a black object.** If you've cleaned up the rest of your alpha channel but still see a few gray pixels in your black object, use Levels to turn them black. Remember how you used Levels to turn gray pixels white by resetting the white point (step 5 on page 222)? You can use the same technique to turn gray pixels black. Just open the Levels dialog box by pressing ⌘-L (Ctrl+L), activate the black eyedropper, mouse over to your image, and then click one of those pesky gray pixels. Photoshop turns all the gray pixels in your document black.

- **Get rid of stray gray pixels next to a black object.** If you end up with a few gray pixels near the object you want to select, use a brush set to Overlay mode (page 305) to paint them white. Press B to select the Brush tool and set your foreground color chip to white. Then hop up to the Options bar and set the Mode menu to Overlay and the Opacity to 100%. In this mode, the Brush tool *completely* ignores black and turns gray pixels white, letting you brush away gray pixels near black areas without fear of messing anything up. Even if you *paint right over* the black area, nothing happens to it.

- **Turn gray pixels in delicate edges black.** If you're dealing with hair or fur, some of the wispier edges may end up more gray than black. If that happens, grab the Brush tool and set your foreground color chip to black. Then trot up to the Options bar and set the Mode menu to Soft Light (page 305). Now, when you paint over the hair or fur, Photoshop turns the gray pixels black. However, you may not want to turn those delicate parts *completely* black or they'll have hard edges and won't blend into the background very well. You'll have to experiment to see what looks best.

Creating a Silhouette Effect

Apple made silhouettes famous by using them in its iPod and iTunes advertising campaigns. You can use the channel-selection technique described in the previous section to create the same effect. The only difference is that, instead of adding a layer mask, you'll add a solid-color fill layer set to black. That way, the silhouette lives on its own layer, making it easy for you to edit later, as the Apple-esque images in Figure 5-12 show.

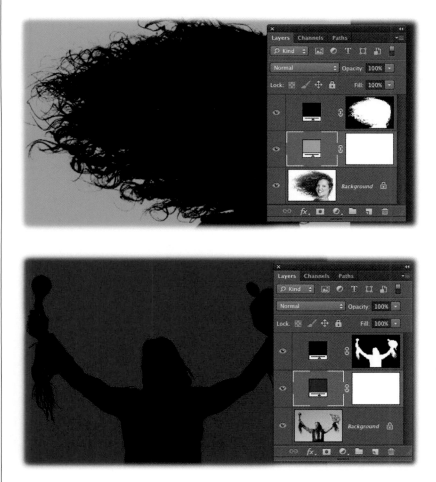

FIGURE 5-12

Using channels to make a selection lets you create a slick silhouette in no time flat. You can even get a clean selection of curly hair (top) and dangling feathers (bottom).

When dealing with delicate edges like those around hair, be careful not to drag the Levels dialog box's shadows slider (circled back in Figure 5-10, top) too far to the right or the edges will become really jagged. You'll have a little more touch-up work to do before you're finished, but it's worth it. Here, the Lasso tool was used to select areas that didn't become black by dragging the shadows slider, and then they were filled with black using the Edit→Fill command.

Heck, these two images require less fine-tuning than the balloons back in Figure 5-11!

NOTE Try this silhouette technique by visiting this book's Missing CD page at *www.missingmanuals.com/cds* and downloading the practice file *Indian.jpg.*

To create a quick silhouette, follow steps 1–9 in the previous section so you've got a nice selection and you're looking at the full-color image. Then:

1. **Add a new solid-color fill layer at the top of your layer stack.**

 When you see marching ants running around your subject, you're ready to create a solid-color fill layer. Take a peek at the bottom of the Layers panel and click the Adjustment layer icon (the half-black/half-white circle). Choose Solid Color from the menu to make Photoshop open the Color Picker; pick black, and then click OK. (See page 93 for the full story on Fill layers.) Photoshop adds the new layer to the top of your layer stack, thereby creating a silhouette.

2. **Add a new background by creating another solid-color fill layer and filling it with a bright color.**

 Create another solid-color fill layer as you did in step 1, but this time choose a bright color such as lime green, and then click OK.

3. **In the Layers panel, drag the bright-colored fill layer below the silhouette layer.**

 This keeps the new background from covering your silhouette. You can also press ⌘-[(Ctrl+[) to move a layer down one position, or Shift-⌘-[(Shift+Ctrl+[) to move it to the bottom of the layer stack.

Now you're starting to see the power of using channels to help make selections! If you need to edit the silhouette—maybe you want to erase something or do a little touch-up with a black brush—activate the black solid-color fill layer's mask and have at it. Likewise, if you want to change the silhouette or background color, simply double-click the appropriate solid-color fill layer's *thumbnail* and then choose a new color from the resulting Color Picker (double-clicking the layer itself opens the Layer Style dialog box instead).

Lightening and Darkening Channels

There will be times when you wish a channel were lighter or darker so you'd have an easier time making a selection. Remember back in Chapter 3 when you learned how to quickly lighten and darken photos using blend modes? While there's no blend mode menu in the Channels panel, you can make a channel lighter or darker with the Apply Image command. Folks mainly use this command to blend two images together (as shown in the "The Apply Image Command" PDF available from this book's Missing CD page at *www.missingmanuals.com/cds*)—which is why the Apply Image dialog box has a blend mode drop-down menu—but you can also use it to apply a channel to *itself* (as if the channel were duplicated) and change its blend mode at the same time.

To lighten or darken a channel, activate it in the Channels panel and then create a copy of it (page 207) so you don't destroy your original image. Then choose Image→Apply Image and, in the resulting dialog box's Blending menu (Figure 5-13), choose either Screen (to lighten) or Multiply (to darken). When you click OK, Photoshop applies the channel to *itself* using the blend mode you picked. Depending on the image

you're working with, your channel will lighten or darken by about 15 to 30 percent. If it needs to be even lighter or darker, simply run the Apply Image command as many times as necessary.

FIGURE 5-13

With the Apply Image command, you can apply a channel to itself but with a different blend mode.

As you can see here, applying the Screen blend mode to a duplicate of the red channel made this horse quite a bit whiter, making it easier to turn the horse solid white in an alpha channel.

If the Apply Image command isn't lightening or darkening your duplicate channel enough to make a good alpha channel, you can always pump up the contrast by adding a temporary brightness/contrast adjustment layer (page 379) and then, in the resulting Properties panel, dragging the Contrast slider to the right. By using an adjustment layer, the temporary contrast boost happens on its own layer, so you can throw it away after you've created the alpha channel.

TIP If the Apply Image command isn't lightening or darkening your duplicate channel enough to make a good alpha channel, you can always pump up the contrast by adding a temporary brightness/contrast adjustment layer (page 379) and then, in the resulting Properties panel, dragging the Contrast slider to the right. By using an adjustment layer, the temporary contrast boost happens on its own layer, so you can throw it away after you've created the alpha channel.

Combining Channels

Not all images have enough contrast to let you make a good alpha channel by using just one channel—sometimes you'll have to use *two*. This process takes a bit more time, but the steps are essentially the same.

For example, if you want to select the hat and guitar in Figure 5-14, a quick glance at the Channels panel tells you that the hat is darkest in the red channel, but the guitar has the most contrast in the green channel. So your best bet is to build your selection one channel at a time, using the optimal channel for each part.

Duplicate the red channel and adjust it using Levels, the Brush tool, and so on until the hat is solid black. Next, duplicate the green channel and work on the guitar while you erase (or paint over) the parts of that channel you don't need (the hat). When you're finished, you may want to merge them, but, alas, Photoshop won't let you. But you *can* combine them into a brand-new channel using the *Calculations* command.

Choose Image→Calculations to summon the Calculations dialog box (if this command is dimmed, check to make sure you've got only *one* channel active in the Channels panel). From the drop-down menus in the Source 1 and Source 2 sections, pick the channels you want to combine (see Figure 5-14). This dialog box also lets you set the blend mode, so if you're working with a black object and a white background as shown in the figure, set the blend mode to Multiply so Photoshop keeps the darkest parts of both channels and gets rid of everything else. (If you're working with a white object and a black background, use the Screen blend mode instead so Photoshop keep the *lightest* parts of both channels.) When everything's set, click OK, and Photoshop creates a new channel based on the two you picked.

> **NOTE** You can also use the *Channel Mixer* to simulate combining channels to create grayscale images. It doesn't actually combine channels, but it makes your image *look* like it did. The box on page 509 has the details.

Sharpening Individual Channels

As you'll learn in Chapter 11, if you sharpen an image that has a lot of noise in it, you'll sharpen the noise and grain right along with the rest of the image, making it look ten times worse than it did before (see the box on page 487). That's why it's important to get rid of—or, at the very least, reduce—those nasties *before* you sharpen an image.

> **NOTE** What's the difference between noise and grain? They both describe tiny flecks in an image, but, technically speaking, noise occurs in digital images, whereas grain occurs in analog prints, film, and transparencies. In other words, grain becomes noise once you scan the image.

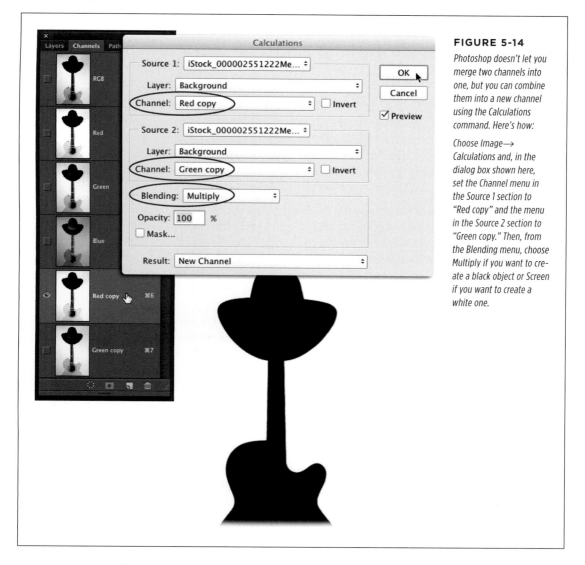

FIGURE 5-14

Photoshop doesn't let you merge two channels into one, but you can combine them into a new channel using the Calculations command. Here's how:

Choose Image→ Calculations and, in the dialog box shown here, set the Channel menu in the Source 1 section to "Red copy" and the menu in the Source 2 section to "Green copy." Then, from the Blending menu, choose Multiply if you want to create a black object or Screen if you want to create a white one.

However, let's say you're in RGB mode and you dutifully followed the instructions in the box on page 487 and ran the Reduce Noise filter on your blue channel (which typically has the most noise, though sometimes noise can hide in the red channel, too), and it didn't do squat. What do you do? You can try bringing out some of the details in your image by sharpening *only* the red and green channels, as shown in Figure 5-15.

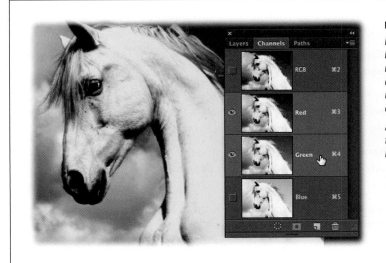

FIGURE 5-15

If you activate the red and green channels before running a sharpening filter, you restrict the sharpening to just those two channels. This helps you avoid sharpening—and therefore accentuating—noise or other unwanted, ahem, skin textures.

Alternatively, you can try sharpening with the Smart Sharpen filter and using its Reduce Noise slider.

TIP The next time you need to sharpen a portrait of someone who's sensitive about his or her appearance, try sharpening only the red channel to avoid bringing out unwanted details in the person's skin. (As you learned earlier in this chapter, your camera has twice as many green sensors as red or blue, meaning that a lot of the fine details lurk in the green channel.)

Here's how to sharpen an image without making the noise in it any worse than it already is:

1. **Open your image and make a copy of the layer(s) you're going to sharpen.**

 If you're working with a document that has just one layer, activate it in the Layers panel and then duplicate it by pressing ⌘-J (Ctrl+J). If you like, double-click the layer's name and rename it *Sharpen*.

 If you're working on a multilayer document, activate the topmost layer and press ⌘-Shift-Option-E (PC: Ctrl+Shift+Alt+E) to create a stamped copy—a *new* layer that contains the content of all visible layers. Or you can Shift-click to activate all the layers and then choose Layer→Smart Objects→Convert to Smart Object; Photoshop combines all the layers into a single smart object. (To access the individual layers again, double-click the smart object and a new temporary document opens with the original layers fully intact; just perform your edits, choose File→Save, close the temporary document and your changes appear back in the *original* document that houses the smart object.)

2. **Open the Channels panel and activate the red and green channels.**

Click to activate one channel and then Shift-click to activate the other one, so they're both highlighted in the Channels panel. Don't panic if your image turns a weird color, like the horse in Figure 5-15; Photoshop is just showing you the image using only those two color channels.

3. **Choose Filter→Sharpen→Unsharp Mask (page 488), or pick the sharpening filter of your choice.**

When you run a filter while you've got only certain channels active, Photoshop applies the sharpening to just those channels. In this example, it won't apply any sharpening to the blue channel. Click OK to close the Unsharp Mask dialog box.

4. **In the Channels panel, turn on the composite channel (here, that's RGB) to see your new and improved full-color image.**

You're done! If you want to see before and after versions of the image, open the Layers panel and toggle the sharpen layer's visibility eye—or the unsharp-mask filter layer, if you used a smart object—off and on.

> **TIP** Another, more advanced way to sharpen an image is to use the channel with the highest contrast to create an intricate edge mask, or for foolproof sharpening, try using the High Pass filter. You can read all about those techniques—including how to sharpen only certain areas of an image—in Chapter 11.

FREQUENTLY ASKED QUESTION

Selecting with the Lightest Channel

How come I always have to make objects black and the background white when I'm using channels to create a selection? Can I do it the other way around instead?

Trying to buck the system, are ya? Lucky for you, the answer is yes—you can make the object white and the background black, if you prefer. It doesn't matter whether the area you want to select is black or white; all that matters is what the marching ants surround once you load that channel as a selection.

For example, if you're trying to select a light object that lives on a dark background, it's *much* easier to make the object white and the background black. In that case, search for the *lightest* channel (in RGB mode, that's usually Red). Once you find it, duplicate that channel and then use Levels to make it pure black and white (see step 4 on page 222). You won't even need to inverse your selection: You'll see marching ants around your object as soon as you load the channel as a selection (page 223, step 7).

Editing Images

Cropping, Resizing, and Rotating

ropping and resizing affect your entire document (not just the active layer), and are among the most basic edits you'll ever make—but they're also among the most *important*. A bad crop (or no crop) can ruin an image, while a good crop can improve it tenfold by snipping away useless or distracting material. And knowing how to resize an image—by changing either its file size or its overall dimensions—can be crucial when it's time to email the image, print it, or post it on a website.

Cropping is pretty straightforward (though the process has changed from how it worked in earlier versions of Photoshop); resizing, not so much. To resize an image correctly, you first need to understand the relationship between pixels and resolution—and how they affect image quality (that can of worms gets opened on page 254.) And if you want to make Photoshop resize your image's background without touching its *subject or focal point*, the Content-Aware Scale command can do that, but there's a trick to using it successfully. Rotating images, on the other hand, is just plain fun.

In this chapter, you'll learn more than you ever wanted to know about cropping, from general guidelines to the many way to crop (and straighten) in both Photoshop and Camera Raw (a powerful photo-correcting application that comes with Photoshop—see Chapter 9). Perhaps most important, you'll understand once and for all what resolution really is and when it matters.

You'll also discover how to resize images for print, email, and the Web, presentation software, and other uses *without*—and this is crucial—losing image quality. Need to resize a slew of images? No problem, this chapter will teach you how to use the Image Processor command to get it done fast. Finally, you'll learn the secrets of using the Content-Aware Scale command, and spend some quality playtime with the various Transform commands.

Cropping Images

There's a reason professional photos look so darn good. Besides being shot with fancy cameras and receiving some post-processing fluffing, they're also composed or cropped (or both) extremely well. *Cropping* means eliminating distracting elements in an image by cutting away unwanted bits around the edges. Good crops accentuate the subject, drawing the viewer's eye to it; and bad crops are, well, just bad, as you can see in Figure 6-1.

FIGURE 6-1

Left: A poorly cropped image can leave the viewer distracted by extraneous stuff around the edges, like the wall and shadows here.

Right: A well-cropped image forces the viewer to focus on the subject by eliminating distractions (in this case, the empty space in the background). This crop also gives the subject a little breathing room in the direction she's facing, which is always a good idea (see Figure 6-2 for more examples).

Technically, you can crop *before* you take a photo by moving closer to your subject (called "cropping with your feet") and repositioning the subject within the frame. However, if you don't get the shot right when you're out in the field, Photoshop can fix it after the fact. But before you go grabbing the Crop tool, you need to learn a few guidelines.

The Rule of Thirds

Once you understand the rule of thirds, a compositional guideline cherished by both photography and video pros, you'll spot it in almost every image you see. The idea is to divide every picture into nine equal parts using an imaginary tic-tac-toe grid. If you position the image's horizon on either the top or the bottom line—never the center—and the focal point (the most important part of the image) on one of the spots where the lines intersect, you create a more interesting shot. It's simpler than it sounds—just take a look at Figure 6-2.

> **NOTE** The Crop tool includes a rule-of-thirds grid, making this rule easier than ever to grasp and follow!

Creative Cropping

Along with applying the rule of thirds, pros also crop in unexpected ways. Unconventional cropping is yet another way to add visual interest in order to catch the viewer's eye. Figure 6-3 shows some examples.

FIGURE 6-2

Top: Imagine a tic-tac-toe grid atop every image. Notice that the interesting bits of the photos are positioned where the lines intersect. Most digital cameras let you add such a grid to the camera's screen to help you compose shots, though to figure out how to turn it on, you may have to root through the camera's menus or (shudder) dig out the owner's manual.

Bottom: Before you crop, notice the direction the subject is facing. A good crop gives the subject room to move—or, in this case, fly—through the photo. If the image were cropped tightly to the boy's face on the right side, it'd look weird because he'd (theoretically) smack into the edge of the image if he flew away.

FIGURE 6-3

Top: Challenge yourself to think outside the box and crop in unexpected ways. You may not think cropping someone's face in half is a good idea, but here's an example where it works.

Middle: When you're close-cropping, you often don't need to reveal the whole subject. For example, this piece of zebra is more visually interesting than the whole animal, and it's still obvious what it's a photo of.

Bottom: Here's proof that you can't always trust what you see. Cropping can alter the perceived meaning of an image. For example, the left-hand photo has been creatively cropped to suit the headline "Sea Muffin Wins by a Mile!" But the original photo on the right reveals another story.

Creative cropping is especially important when you're dealing with super-small images, such as those in a thumbnail gallery or on a website where several images vie for attention. In such tiny images, people can see few—if any—details. And if the photo contains people, *forget* being able to identify them. Here are some tips for creating truly enticing teensy-weensy images:

- **Recrop the image.** Instead of scaling down the original, focus on a single element in the image. You often don't need to include the *whole* subject for people to figure out what it is (Figure 6-3, middle, is a good example).

- **Sharpen again after resizing.** Even if you sharpened the original, go ahead and resharpen it post-resizing using one of the techniques covered in Chapter 11.

- **Add a border.** To add a touch of class to that tiny ad or thumbnail, give it an elegant hairline border (page 199) or a rounded edge (page 158).

Now that you've absorbed a few cropping guidelines, you're ready to learn the many ways you can crop in Photoshop, starting with the most common.

The Crop Tool

Photoshop tools don't get much easier to use than the good ol' Crop tool, which got a major overhaul back in CS6. Press C to grab it from the Tools panel and a crop box with transparent handles automatically surrounds your image (these handles are circled in Figure 6-4, bottom). Grab any handle to resize the box (the handles darken when you do this), and then click *inside* the box and drag to reposition *your image* underneath it (your cursor turns into a tiny arrow). If you don't like your changes, press Esc to start over.

If you'd rather draw your *own* crop box instead of resizing the one Photoshop put around the image, just click and drag in your image to draw another box *inside* the automatic one (it feels weird but it works). To move the crop box *as* you're drawing it, press and hold the space bar while dragging; when you've got the crop box where you want it, let go of the space bar and continue drawing the box.

Either way, as soon as you let go of your mouse, Photoshop helpfully darkens the outer portion of the image to give you an idea of what's destined for the trash can (this darkened portion is called a *shield*) and places a rule-of-thirds grid over the unshielded portion (Figure 6-4). When you like what you see, press Return (Enter on a PC) or double-click inside the crop box to accept it, and Photoshop deletes the unwanted pixels.

> **TIP** Happily, in CC, you don't see a crop box around your image *whenever* the Crop tool is active. Once you press Return (Enter) to accept a crop, the automatic crop box is gone for good. That said, if you switch to another tool and then switch *back* to the Crop tool, the automatic crop box reappears.

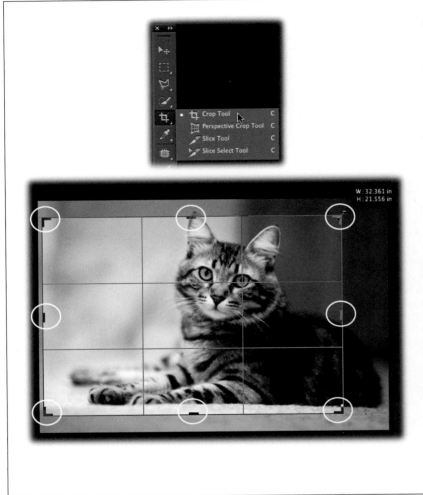

FIGURE 6-4

Top: The Crop tool lives near the top of the Tools panel; just click its icon and hold down your mouse button to expand its toolset, as shown here. It shares its toolset with the Perspective Crop tool (page 243).

Bottom: After you tweak the automatic crop box or draw your own, Photoshop places a rule-of-thirds grid atop the image and gives you an idea of what the result will look like by darkening the parts that'll be cropped. You can easily resize and rotate the crop box by dragging the handles circled here (their colors change depending on the image colors underneath 'em). When you do, a handy info overlay appears near your cursor. If you're dragging a handle to resize the crop box, the overlay includes info about the size of the box (as shown here). If you're repositioning the crop box, the overlay indicates how much the crop box has moved, and if you're rotating the box, it indicates the rotation angle. Handy!

The Options bar's Overlay drop-down menu (labeled in Figure 6-5) includes a bushel of crop overlay options. Once you click the crop box to activate it, you can cycle through the various overlays by pressing the O key repeatedly. To change an overlay's orientation (to, say, make the Golden Spiral appear at the upper left of your image instead of the lower right), press Shift-O repeatedly.

FIGURE 6-5

The Crop tool's behavior and Options bar settings changed drastically in CS6, and were streamlined in CC. These changes take some getting used to, and if they drive you crazy you can revert to the behavior of pre-CS6 Crop tool by pressing P or clicking the gear icon shown here and turning on Use Classic Mode.

Tool presets Swaps height and width Overlay options Crop options

Aspect ratio & crop size presets Enter custom aspect ratio (width & height) Clear ratio fields Reset settings

TIP To temporarily hide the soon-to-be-cropped edges so you can better judge what the cropped image will look like, press the H key; press it again to make the edges reappear. You can also change the shield's color and transparency using the Crop Options drop-down menu (the gear icon labeled in Figure 6-5, top).

Keep in mind that, when you accept a crop, Photoshop *permanently deletes everything in the shielded area*—that is, unless you turn *off* (uncheck) the Delete Cropped Pixels checkbox in the Options bar (circled in Figure 6-5, top), which is automatically turned *on* when you install the program. So if you change your mind immediately after wielding the crop ax, press ⌘-Z (Ctrl+Z) to undo it or step backward in the History panel (page 17).

If you turn *off* Delete Cropped Pixels, Photoshop doesn't vaporize the cropped material; instead, it politely dangles it outside the document's margins (in other words, hides it). That way, even though you don't see the material onscreen, it's still part of your document. To resurrect the cropped portion—*even after you've saved and closed the document*—press C to activate the Crop tool, and then immediately press Return (Enter on a PC). Photoshop displays the previously hidden edges of the image and places an active crop box around the previously cropped area. At this point, you can get those edges back by resizing the crop box to encompass them, repositioning the crop box, and so on.

■ CROPPING TO A SPECIFIC SHAPE, SIZE, AND RESOLUTION

The Crop tool lets you constrain your crop box to the image's original *aspect ratio*—the relationship between its width and height (a good idea if you want the cropped image to be the same shape as the original). To do so, head to the aspect-ratio-and-crop-size preset menu shown in Figure 6-6, and choose Original Ratio; the crop box restricts itself accordingly. This menu also includes common aspect ratios such as 1:1, 4:5, 5:7, and so on; give one a click and that aspect ratio appears in the fields to the menu's right. If you don't see the aspect ratio you want, leave the menu set to Ratio and just enter the values into the fields yourself.

Choosing an aspect ratio from this menu or entering numbers manually changes the *shape* of the image, but not its resolution (as explained on page 254, resolution controls pixel size). For example, if you're preparing an image for a 5″ × 7″ frame, changing the aspect ratio lets you adjust the photo's *shape* to fit the frame; Photoshop then trims pixels off the edges of the image to make it match the aspect ratio you picked, but it doesn't change the pixel's dimensions to a specific size, nor does it mess with the image's resolution. Once the image is the right shape, you can use the Image Size dialog box to alter its pixel dimensions (to make 'em *exactly* what you want) and resolution, if necessary (see page 255).

If you frequently enter the same dimensions into the Options bar's aspect ratio fields, you can save them as a preset. To do so, enter them into the Options bar and then, from the aspect-ratio-and-crop-size preset menu, choose New Crop Preset; in the resulting dialog box, give the preset a meaningful name, and then click OK. Your new preset shows up in that same menu for easy access later on.

If you *want* to change the image's pixel dimensions and resolution, choose W × H × Resolution from the aspect-ratio-and-crop-size preset menu. When you do, a new field appears in the Options bar so you can enter resolution (see Figure 6-6). Just enter the size you want into the width and height fields, and be sure to include a unit of measurement (use *px* for pixels or *in* for inches), or else Photoshop uses the unit of measurement you've specified in the Units and Rulers preferences (page 28). For example, if you want to print a 5″ × 7″ image, enter *5 in* in the width field, *7 in* into the height field, and *300* in the resolution field. If you want an 800 × 600 pixel image to email or post on the Web, enter *800 px* in the width field, *600 px* in the height field, and then leave the resolution field empty (because the image will be displayed onscreen, its resolution doesn't matter). That way, Photoshop changes the dimensions *and* resolution of the image rather than merely trimming it to a certain aspect ratio (shape). Alternatively, you can choose one of the generic size-and-resolution combos listed in the presets menu.

Width Height Resolution

FIGURE 6-6

To change the dimensions and resolution of an image while you're cropping it, choose W × H × Resolution from the aspect-ratio-and-crop-size preset menu visible here, and those fields appear in the Options bar. Use the menu to the right of the resolution field to switch between pixels per inch and pixels per centimeter (the latter is standard outside the U.S.).

If you think you'll use the same size-and-resolution combo later, choose New Crop Preset to save what you entered.

TIP To copy another image's dimensions so you can base a crop on them, open that image, open the preset menu shown in Figure 6-6, and then choose Front Image or press I (this keyboard shortcut is relatively new; in pre-CC versions of Photoshop, it was F).

Once you accept the crop by pressing Return (Enter on a PC), Photoshop uses a mathematical formula to resize the image for maximum quality (the formula is called *Automatic* and you'll learn all about it on page 257). The result is that the image area inside the box perfectly matches the dimensions you entered or picked from the preset menu (you can pop open the Image Size dialog box [page 255] to verify the change).

NOTE Once you've clicked to activate the crop box, you can rotate it by pressing the X key. This is helpful when you want to crop a landscape oriented image in portrait orientation instead (or vice versa).

If the image gets *bigger* inside the document window after you crop to a specific size and resolution, it means you've *enlarged* the image by entering too high a resolution for the crop box. Depending on what you intend to use the image for (personal vs. professional projects), this may not be a big deal. But if image quality is important, press ⌘-Z (Ctrl+Z) to undo the crop and then enter smaller dimensions or a lower resolution (or both) in the Options bar. (If you need to make the image bigger, see the box on page 258 to learn about Photoshop's excellent enlargement voodoo.)

TIP As page 247 explains, you can also use the Crop tool to *straighten* images.

■ CROPPING WITH PERSPECTIVE

If you shoot an image at an angle and then need to straighten it (like the painting shown in Figure 6-7, top), you can crop the image *and* change its perspective at the same time using the Perspective Crop tool, which shares a toolset with the Crop tool. Just click the Crop tool's icon in the Tools panel and hold down your mouse button to pop open the toolset, and then choose Perspective Crop (or press Shift-C repeatedly to cycle through the Crop tools).

To use this tool, click the four corners of the object you want to straighten, and Photoshop places a crop box containing a grid overlay atop the object. (The box doesn't have to be *exactly* aligned with the object, but be sure that it surrounds the whole object; if necessary, you can drag the box's square corner handles to adjust them.) When everything's lined up, press Return (Enter on a PC) or double-click inside the box to accept the crop. If the planets are properly aligned, the cropped image looks nice and straight, as shown in Figure 6-7 (bottom).

FIGURE 6-7

As you can see here, cropping to perspective can straighten objects shot at an angle, such as this painting. This kind of thing works well on inanimate objects, but not so great on living things (unless you like that distorted, fun-house-mirror look).

To adjust the perspective of one part of your image—say, to correct a crooked building—skip ahead to page 479 to learn about the new Perspective Warp command.

(Painting by iStockphoto/ Renee Keith.)

■ ADDING POLAROID-STYLE PHOTO FRAMES

The Crop tool isn't *all* work and no play; you can use it for fun stuff like creating a Polaroid-style photo frame like the one in Figure 6-8. Besides being a fast way to add a touch of creativity to an image, adding this kind of frame lets you include a caption to commemorate extra-special moments. Here's what you do:

1. **Open an image and, if necessary, unlock its background layer.**

 Remember, the background layer is initially locked for the reasons explained on page 88. To unlock it, head to the Layers panel and click its padlock icon.

 NOTE To practice the Polaroid maneuver yourself, visit this book's Missing CD page at *www.missingmanuals. com/cds* and download the practice file *Trekkers.jpg*.

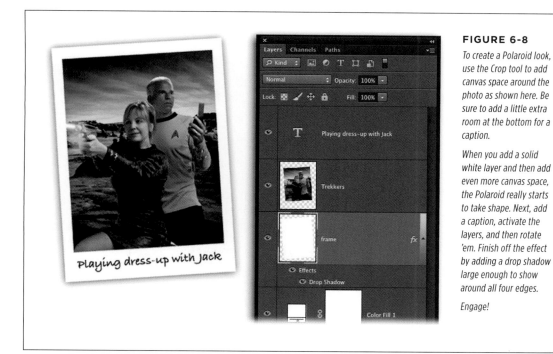

FIGURE 6-8

To create a Polaroid look, use the Crop tool to add canvas space around the photo as shown here. Be sure to add a little extra room at the bottom for a caption.

When you add a solid white layer and then add even more canvas space, the Polaroid really starts to take shape. Next, add a caption, activate the layers, and then rotate 'em. Finish off the effect by adding a drop shadow large enough to show around all four edges.

Engage!

2. **Use the Crop tool to add canvas space.**

 Activate the Crop tool by pressing C and then, while holding down the Option key (Alt on a PC), drag one of the crop box's corner handles outward beyond the image's edge about a quarter inch, and then release the key. Holding down Option (Alt) while you drag the corner handle forces *opposite sides* of the box to expand or shrink simultaneously by the same amount. (Otherwise, you'd have to move each handle one after another.)

Next, drag the bottom-middle crop handle down another quarter inch (that's where the caption goes). Finally, press Return (Enter on a PC) to tell Photoshop you want to keep the new canvas space. You should see a checkerboard background around the photo as shown in Figure 6-8, right.

NOTE If you don't unlock the background layer before you increase the canvas space, the area around the photo ends up the color of your background color chip instead of transparent, so you don't see the checkerboard pattern. If you have this problem, press ⌘-Z (Ctrl+Z) and start over with step 1.

3. **Create a new layer named *frame* and drag it *below* the original photo layer.**

 Press Shift-⌘-N (Shift+Ctrl+N on a PC) to create a new layer. In the resulting New Layer dialog box, type *frame,* and then click OK. Then, to keep from covering up the whole photo in the next step, drag the frame layer's thumbnail *below* the original layer in the Layers panel.

4. **Fill the new frame layer with white to form the Polaroid edges.**

 Choose Edit→Fill, pick "white" from the Use drop-down menu, and then click OK. Now you've got a Polaroid-style frame around the photo. (Why can't you use a solid color fill layer [page 93] for this step? Because that type of layer automatically resizes to fill your canvas, making the Polaroid effect impossible.)

5. **Add your caption.**

 Press T to activate the Type tool (page 619), and then add a caption in the white space at the bottom of the frame. Here's your big chance to use a handwriting typeface! (Bradley Hand was used in Figure 6-8.) When you're done, accept your prose by clicking the checkmark in the Options bar or clicking the type layer in the Layers panel.

6. **Increase your canvas space *again* so you have room to rotate the image and add a drop shadow.**

 If the Crop tool is still active, you'll need to draw a new crop box by clicking and dragging from the top left edge of your image diagonally downward to the bottom right edge. (If, for whatever reason, you switch to another tool and then *reactivate* the Crop tool, a crop box appears automatically; you can also double-click the Crop tool's icon in the Tools panel to summon a new crop box.) Add equal space on opposite sides by dragging any corner handle of the crop box while holding down the Option key (Alt on a PC). Press Return (Enter) to accept the crop. You'll want to add about an inch of new canvas on each side.

7. **Activate all three layers.**

 When you have everything just right, hop over to the Layers panel and ⌘-click (Ctrl-click) the image layer, type layer, and white Polaroid-frame layer to activate them all.

8. **Rotate the image a bit to give it more character.**

 Summon the Free Transform command by pressing ⌘-T (Ctrl+T) and then rotate the photo by positioning your cursor just below the bottom-right handle of the bounding box that appears. When the cursor turns into a curved, two-headed arrow, drag slightly up or down. Press Return (Enter) to accept the rotation or Esc to reject it and try again.

9. **Activate the frame layer and add a drop shadow (page 140).**

 In the Layers panel, click the frame layer to activate it. Next, click the tiny cursive *fx* at the bottom of the panel and choose Drop Shadow. In the Layer Style dialog box, soften the shadow by lowering its Opacity setting, and then increase the shadow's Size setting quite a bit so it's visible on all four sides of the Polaroid frame. Move the shadow around by adjusting the Angle setting, or, better yet, by clicking and dragging within your document. Click OK to close the Layer Style dialog box.

10. **If you like, add a solid color fill layer to the bottom of your layer stack.**

 If you're going to place your new Polaroid on another background on a web page or in a slideshow, you can skip this step (for more on saving images with transparency, see page 770). But if you want to add a colored background—like the white one shown in Figure 6-8 (left)—you need to add a fill layer. Choose Layer→New Fill Layer→Solid Color or click the half-black/half-white circle at the bottom of the Layers panel and choose Solid Color. Either way, pick a hue in the resulting Color Picker, and then click OK. Drag the new layer to the bottom of your layer stack.

When you're all done, save the document as a PSD file so you can go back and edit it later. Fun stuff!

Cropping with Selection Tools

You can also crop an image within the boundaries of a *selection*. This technique is helpful if you've made a selection and then need to trim the image down to roughly that same size. The Rectangular Marquee tool (page 150) works best for this kind of cropping—though *all* the selection tools work. Photoshop, bless its electronic heart, can crop only in rectangles (though you can remove a background from an object and *then* save it in a format that understands transparency, but that's a discussion for page 770).

After you draw a selection, press C to activate the Crop tool and Photoshop places a crop box atop the image that matches the shape of your selection. Easy peasy!

Trimming Photos Down to Size

If your image has a solid-colored or transparent (checkerboard) background, you may find yourself chipping away at its edges to save space in the image's final destination (a website, a book—whatever). The Trim command is *incredibly* handy in such situations, especially when you're trying to tightly crop an image that has a

drop shadow or reflection. Such embellishments make the image's *true* edges hard to see—and therefore tough to crop—because they're partially transparent and fade into the background. So it's easy to, say, accidentally chop a drop shadow in half when you're cropping. Fortunately, you can enlist Photoshop's help in finding the edges of those transparent pixels in your image and have it handle the cropping *for* you.

To whittle a photo down to its smallest possible size, choose Image→Trim and, in the resulting dialog box (shown in Figure 6-9), use the radio buttons to tell Photoshop whether you want to zap transparent pixels or pixels that match the color at the document's top left or bottom right (the program needs *some* instructions to know what part of the image to trim!). Next, choose which sides of the image you want to trim by turning on their checkboxes, and then click OK. Photoshop trims the document down to size with zero squinting—or error—on your part.

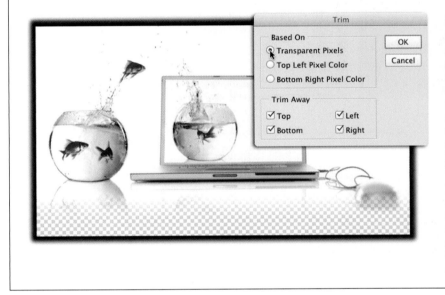

FIGURE 6-9

If you have a hard time seeing the edges of an image you want to crop tightly, let the Trim command do it for you. Here, the goal is to get rid of the extra transparent space at the bottom. You can do that by choosing Transparent Pixels in the Trim dialog box.

The Trim command was used on every screenshot in this book to crop the images as closely as possible. It's a massive timesaver if you work in a production environment!

Cropping and Straightening Photos

You can use the Crop tool to straighten an image in a snap. To do so, open the image and then press C to activate the Crop tool. Next, in the Options bar, click the Straighten Image icon (it looks like a tiny level), mouse over to your image, and then drag to draw a line across something that *should* be straight, such as the fridge door in Figure 6-10. When you let go of your mouse button, Photoshop rotates the image. If you like the results, press Return (Enter on a PC) to accept the crop; if not, press Esc to undo it. As Figure 6-10 shows, Photoshop gives you two ways to straighten images with the Crop tool.

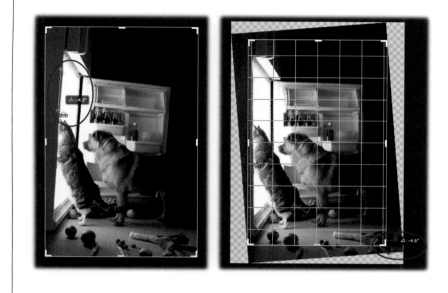

FIGURE 6-10

Left: Click the Straighten icon in the Options bar and then draw a line across an area that should be straight (it doesn't matter whether the line is horizontal or vertical).

Right: Or position your cursor just outside a corner of the crop box, and then click and drag to rotate the image (your cursor turns into a curved double arrow). Photoshop shrinks the crop box to fit the rotated photo so you don't end up with any extra space around its edges.

Straightening one image at a time is all well and good, but if you've painstakingly scanned a *slew* of photos into a single document (say, to restore some vintage photos), you can save yourself a lot of work by having Photoshop crop, straighten, *and* split them into separate files—all with a single menu command. With the page of photos open, choose File→Automate→"Crop and Straighten Photos." Photoshop instantly calculates the angle of the overall image's edge (that is, the edge of the photo bits) against the white background, rotates the images, and then duplicates all the photos into their own perfectly cropped and straightened documents, as shown in Figure 6-11. It's like magic!

NOTE The "Crop and Straighten Photos" command also works on a layer that contains just *one* image (provided the picture has white space on all four sides of it). It works on layered files, too: Just activate the layer that contains the image(s) you want to extract, run the command, and Photoshop copies the newly straightened content into another document. (If the layer contains several images, they get copied out into their own individual documents, too.)

TIP If you want Photoshop to crop and straighten only a *few* of the photos that reside on a single layer (but not all of them), draw a selection around each of the photos you want it to straighten before you run the "Crop and Straighten Photos" command (use any selection tool and hold the Shift key to add to the selection). Photoshop then processes only those photos, provided they (and their individual selection boxes) are next to each other. If they're not, Photoshop also crops and straightens everything in between, forcing you to close the unwanted new documents.

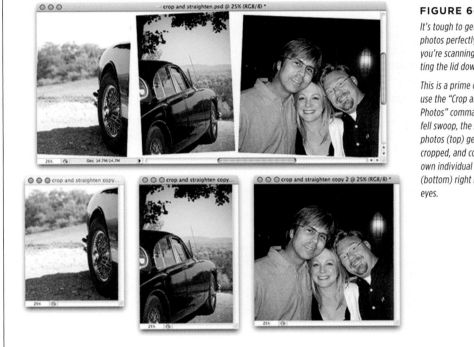

FIGURE 6-11

It's tough to get a bunch of photos perfectly straight when you're scanning (heck, just putting the lid down moves 'em!).

This is a prime opportunity to use the "Crop and Straighten Photos" command. In one fell swoop, the scanned photos (top) get straightened, cropped, and copied into their own individual documents (bottom) right before your eyes.

Cropping and Straightening in Camera Raw

Camera Raw is an amazing piece of software that photographers use to edit the color and lighting of images; you'll learn loads more about it in Chapter 9. It gets installed with Photoshop, so you don't have to download it or pay for it separately. Using Camera Raw to crop and straighten photos has two big advantages:

- **You can undo the crop or straighten (or both) any time**—whether the file you're working on is raw, JPEG, or TIFF. In Chapter 9, you'll learn how to use Camera Raw with all three file formats.

- **If you have several photos that need to be cropped in a similar manner, you can crop them all at once.** Talk about a timesaver!

While you *can* open Camera Raw as a filter from within Photoshop CC (yay!), the filter version is missing the Crop tool (darn!). So, to open an image in Camera Raw,

either double-click the image's icon on your hard drive or—if you've *installed* Adobe Bridge; see page 910—choose File→"Browse in Bridge." Once Bridge opens, Control-click (right-click on a PC) the image and choose "Open in Camera Raw" from the shortcut menu. (You can also click the image in Bridge to activate it and then press ⌘-R [Ctrl+R]; see Chapter 22 for more on using Bridge.)

■ CROPPING IMAGES

With one or more images open in Camera Raw, click the Crop tool icon at the top of the window and hold down your mouse button to reveal a handy menu that includes common aspect ratios, as well as the "Constrain to Image" option, which maintains the shape of your original image, and the Show Overlay option, which places a rule-of-thirds grid atop the image (both are turned on in Figure 6-12). Next, click and drag diagonally downward around the part of the image that you want to keep. (If you didn't turn on the "Constrain to Image" setting, you can Shift-drag to constrain the image's ratio *manually*.)

> **TIP** You can exit the crop box by pressing the Esc or Delete key (Backspace on a PC) while the Crop tool is active or by choosing Clear Crop from the menu shown in Figure 6-12.

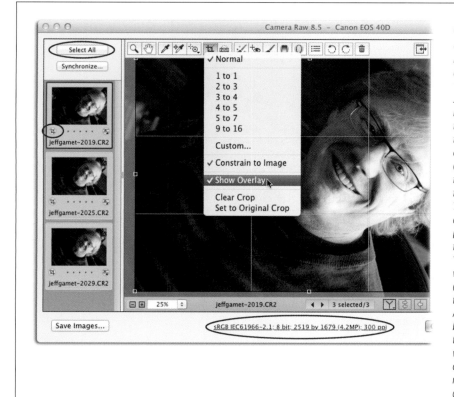

FIGURE 6-12

Open one or more images in Camera Raw and then use the Crop tool to whittle 'em down to size. Simply drag across the image to draw a box and then press Return (Enter) to accept the crop. If you opened multiple images (as shown here), their thumbnails appear in the filmstrip on the left. To crop them all at once, click Select All in the up-per left (circled, top) and then draw the crop box. You'll see the crop, along with a tiny Crop tool icon (circled, left), applied to all active thumbnails. As you adjust the crop box, the blue, underlined text below the preview window (circled, bottom) changes to reflect the resulting image's pixel dimensions.

If the aspect ratio you want isn't in the Crop tool's menu, choose Custom and a dialog box appears where you can enter a specific ratio or dimensions in pixels, inches, or centimeters. Click OK and Camera Raw places a crop box atop the image, which you can resize by dragging any of its handles or reposition by dragging within the box itself. Press Return (Enter on a PC) to see what the newly cropped image looks like. If you need to edit the crop, just activate the Crop tool again to make the crop box reappear.

TIP Camera Raw lets you *undo* a crop by choosing "Set to Original Crop" from the Crop tool's menu. In the blink of an eye, Camera Raw returns your image to its original, uncropped state (any *other* edits you've made in Camera Raw stick around).

When you're finished, click one of the buttons at the bottom of the Camera Raw window to close the image or pop it open in Photoshop:

- **Save Image(s)** lets you convert, rename, or relocate the file(s)—or any combination of those tasks—so you don't overwrite the original(s). If you save them in Photoshop format, you can tell Camera Raw to preserve the cropped pixels in case you want to resurrect 'em later (see Figure 6-13 for details).

- **Open Image(s)** applies your changes and opens the photo(s) in Photoshop.

- **Cancel** exits Camera Raw without applying the changes.

- **Done** applies your changes (which you can edit the next time you open the image[s] in Camera Raw) and exits Camera Raw.

If you open Camera Raw as a *filter* (see the box on page 393), you don't get as many choices—you get a Cancel and OK buttons and that's it.

TIP You can use keyboard shortcuts to change how the Save Image, Open Image, and Cancel buttons at the bottom of the Camera Raw window behave: To open a copy of the image in Photoshop without updating the original raw file, Option-click (Alt-click on a PC) the Open Image button (it changes to an Open Copy button). To open the image as a smart object, Shift-click the Open Image button (it changes to Open Object). To skip the Save As dialog box and make Camera Raw use the same location, name, and format you used last time you saved the file, Option-click (Alt-click) the Save Image button. And to change the Camera Raw settings back to what they were originally, Option-click (Alt-click) the Cancel button (it changes to Reset).

FIGURE 6-13

Once you crop an image in Camera Raw, you can see and work with the original, uncropped image in Photoshop. To do that, click Camera Raw's Save Image(s) button. Then, near the bottom of the Save Options dialog box shown here, choose Photoshop from the Format drop-down menu, turn on Preserve Cropped Pixels, and then click Save.

The next time you open that file in Photoshop, you can use the Move tool to drag the hidden, cropped bits back into view, or you can simply choose Image→Reveal All.

■ **STRAIGHTENING IMAGES**

If you need to straighten a bunch of images at a similar angle, Camera Raw can handle 'em all at once. Open the images and then click the Select All button at the top left of the Camera Raw window. Then grab the Straighten tool (it looks like a tiny level and is circled in Figure 6-14) and draw a line across the horizon—or anything in the image that's supposed to be straight—as shown in Figure 6-14.

The image won't straighten immediately—instead, you see what looks like a rotated crop box so you can check the angle. If it's OK, press Return (Enter on a PC) and Camera Raw straightens the photo. If you didn't get it *perfectly* straight, you can have another go by activating the Straighten tool again.

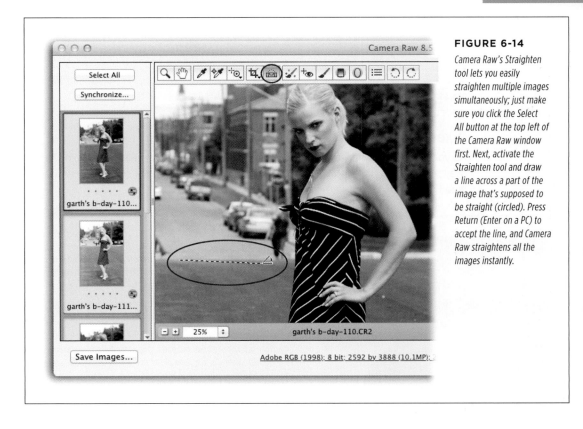

FIGURE 6-14

Camera Raw's Straighten tool lets you easily straighten multiple images simultaneously; just make sure you click the Select All button at the top left of the Camera Raw window first. Next, activate the Straighten tool and draw a line across a part of the image that's supposed to be straight (circled). Press Return (Enter on a PC) to accept the line, and Camera Raw straightens all the images instantly.

Resizing Images

No matter what you've whipped up in Photoshop, there will come a time when you need to change the size of your image. For example, if you want to print it, email it, or post it on a website, you need different-sized versions for each task. Changing an image's size isn't hard—Photoshop gives you oodles of options. The challenge lies in doing it *without* sending the image's quality down the tubes.

Sure, you can let the "Save for Web" dialog box (page 771) or the Print dialog box (see the note on page 261) do the resizing for you, but if you're aiming to be a serious pixel-pusher, you'll want *far* more control. That, dear friend, brings you up against the granddaddy of Photoshop principles: image resolution—the measurement that determines the *size* of the pixels in the image, which in turn controls the quality of your prints.

Resolution is arguably one of the toughest digital-image editing concepts to wrap your brain around. Many people grapple with questions like "How do I change an image's resolution?" and "What's the minimum resolution I need to print good-looking photos?" In the following pages, you'll learn all the nitty-gritty you need to answer these—and other—questions.

> **NOTE** Resolution doesn't mean a hill of beans unless you're sending the image to a printer. So if you're not going to print it, don't worry about resolution—focus on the pixel dimensions instead.

Pixels and Resolution

As you learned in Chapter 2, the smallest element of a raster image is a pixel. When they're small enough and viewed together, these tiny blocks of color form an image (see Figure 6-15).

FIGURE 6-15

Raster images are comprised of individual blocks of color called pixels. To see them, zoom into the image by pressing ⌘-+ (Ctrl-+) repeatedly or use the Zoom tool. (Press ⌘ or Ctrl and the – key to zoom out.)

At 3,200 percent magnification, you can see the individual pixels that make up a tiny section of this sunflower.

(Some digital images aren't comprised of pixels—they're made up of vectors, a series of points and paths. One of the best things about working with vectors is that none of the size-versus-quality challenges you run into with pixel-based images apply: You can make vectors as big or as small as you like and they'll always look great. To learn more about 'em, trot over to Chapter 13.)

Pixels have no predetermined size, which is where *resolution* enters the, uh, picture. Resolution is the measurement that determines how many pixels get packed into a given space, which in turn controls how big or small the pixels are. It's helpful to think of resolution as *pixel size.* In the U.S., it's measured in terms of pixels per inch (*ppi*, as folks typically call it); in most other countries, it's measured in pixels per centimeter (ppc).

> **NOTE** You'll also hear resolution referred to as *dpi*, which stands for "dots per inch." This usage isn't strictly accurate because dpi is technically a measurement used by printers (since they actually print dots). Nevertheless, many folks mistakenly say "dpi" when they mean "ppi."

One helpful way to understand resolution is to relate it to something in the real world. Imagine that you have a bag of marshmallows (hang in there; it'll make sense in a

minute). If you poke a hole in the bag and then *squeeze* the bag to force the air out, the marshmallows get compressed so they take up less space. You still have the same number of marshmallows (which are like pixels); they're just smaller because they're packed more tightly together (which is like a higher resolution) in the confines of the bag (the Photoshop document). The loosely packed marshmallows you started with are like low resolution, and the smaller, more tightly packed ones are like high resolution. (Hungry yet?)

Increasing image resolution—from, say, 72 ppi to 300 ppi—makes the pixels *smaller* because they're packed together more *tightly;* the result is a printed image that's *physically* smaller but also smoother and better-looking. Lowering image resolution, on the other hand, enlarges and loosens the pixels, which results in a physically larger image that, as you might suspect, looks like it was made from Legos because the pixels are so big you can see each one.

Printers can produce much higher-resolution images than computer monitors (*thousands* of dots per inch rather than hundreds), plus they're one of the few devices that can modify their output (that is, the print) based on image resolution. In other words, if you send your inkjet printer a low-res version and a high-res version of the same picture and it'll spit out images that differ vastly in size and quality. The resolution on a computer monitor, on the other hand, is handled by the computer's *video driver* (the software that controls what appears on the monitor) *not* the resolution specified in the image. That's why an 85 ppi image looks identical to an 850 ppi image onscreen if you choose View→"Fit on Screen."

The bottom line: Printers can take advantage of higher resolutions (scanners can, too, but that's a story for the box on page 54), but monitors can't.

The Mighty Image Size Dialog Box

If you can't trust your monitor to show an image's true resolution, what can you trust? Why, the Image Size dialog box, shown in Figure 6-16, which not only displays the current resolution of any open document, but also lets you *change* it. Adobe redesigned this dialog box in the first version of Photoshop CC to include an image preview that lets you *see* the results of the options you enter in this dialog box *before* you commit to them (yay!). It also sports a Fit To drop-down menu that includes a handy list of commonly used sizes (you can add your own presets, too).

NOTE The chain-link icon between the dialog box's Width and Height fields locks the image's aspect ratio (the relationship between its width and height) so it doesn't get squashed or stretched when you resize it. This setting is turned on straight from the factory and you'll want to leave it that way.

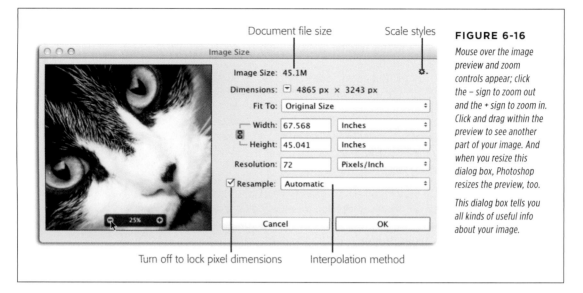

Document file size Scale styles

FIGURE 6-16

Mouse over the image preview and zoom controls appear; click the − sign to zoom out and the + sign to zoom in. Click and drag within the preview to see another part of your image. And when you resize this dialog box, Photoshop resizes the preview, too.

This dialog box tells you all kinds of useful info about your image.

Turn off to lock pixel dimensions Interpolation method

To summon this dialog box, choose Image→Image Size or press Option-⌘-I (Alt+Ctrl+I). It reveals all kinds of info about the image: its file size (how much space it takes up on your hard drive), its dimensions (use the drop-down menu to its right to see 'em in a variety of units), how big it would be if you printed it (that is, if the Width and Height fields' drop-down menus are set to Inches), and its resolution. By changing the Width, Height, and Resolution fields, you can change the image's size and resolution.

The dialog box's Resample checkbox is your key to changing resolution *without* changing image quality. *Resampling* is the process by which Photoshop responds to your size-change request by either adding or subtracting pixels. The problem, as you'll learn in a moment, is that resampling involves guesswork on Photoshop's part, which can obliterate image quality. When the Resample checkbox is turned *on*, Photoshop increases or decreases the number of pixels in the image by either inventing pixels that weren't there to begin with or by picking which ones to eliminate, respectively. By turning this checkbox *off*, you protect the image's quality by *locking* its pixel dimensions. If you plan to print the image, turning this setting off lets you fiddle with the resolution without altering the image's quality because you're just changing pixel *size*, not pixel *quantity*. (Take a peek at page 261 to see this concept in action.)

NOTE There are two kinds of resampling: If you delete pixels, you're *downsampling* (see page 263); if you add them, you're *upsampling* (the box on page 258 has tips for that). When you upsample, Photoshop adds pixels that weren't originally in the image using a mathematical process called *interpolation,* in which it uses the pixels that *are* there to guess what the new ones should look like.

When the Resample checkbox is turned *on*, you get to choose a resample method from the drop-down menu to its right. Why would you want to go this route? Well, if you've got a 300-ppi image that's 4″ × 6″ but you *need* a 5″ × 7″ *and* you have to maintain that 300-ppi resolution (say, for print), you can turn on this checkbox to make it so. On the flip side, if you've got an image that's too big to email, you can use resampling to make Photoshop reduce its pixel dimensions (and thus file size).

The menu next to the Resample checkbox determines which kind of mathematical voodoo (interpolation) Photoshop uses to add or delete pixels. Here are your choices:

TIP Happily, the Resample menu's options have keyboard shortcuts, which make it easy to switch between different interpolation methods and find the one that works best for a particular image (check the Image Size dialog box's preview to see the results you get with each method before committing to one). You'll find these shortcuts next to each entry in the menu, and in the bulleted list below.

- **Automatic** tells Photoshop to pick the best method depending upon the content of your image *and* whether you're making the image bigger or smaller. Believe it or not, the Crop tool and Free Transform command use this method, too, but the resizing option in the "Save for Web" dialog box doesn't (weird!). Keyboard shortcut: Option-1 (Alt+1 on a PC).

- **Preserve Details (enlargement)** sharpens areas of fine detail in your image in order to preserve 'em when you make the image bigger (resulting in a higher quality enlargement). The downside is that the extra sharpening can introduce noise (see the box on page 487) in the shadows where there wasn't any. That's why, when you choose this option, a Noise slider appears beneath the Resample menu; drag the slider to the right to reduce noise (effectively applying a slight blur to the areas this option just sharpened). This is where the preview in the Image Size dialog box comes in really handy, as you can *see* the effects of the Noise slider in real time. Keyboard shortcut: Option-2 (Alt+2).

- **Bicubic Smoother (enlargement)** is similar to Bicubic (smooth gradients)—explained in a sec—in the way it creates new pixels, but this method blurs pixels slightly to blend the new ones into the old ones, making the image smoother and more natural looking. As this method's name implies, Adobe recommends it for enlarging images. Keyboard shortcut: Option-3 (Alt+3).

- **Bicubic Sharper (reduction)** is also similar to Bicubic (smooth gradients)—described next—in the way it creates new pixels, but instead of blurring whole pixels to improve blending between the new and old like Bicubic Smoother, it softens only the pixels' *edges*. Use this method for downsizing images, though some Photoshop gurus claim that it also produces better *enlargements* than Bicubic Smoother (enlargement). Keyboard shortcut: Option-4 (Alt+4).

- **Bicubic (smooth gradients)** makes Photoshop figure out the colors of new pixels by averaging the colors of pixels *surrounding* the new one. This method takes a little longer than the others but produces smoother transitions in areas where one color fades into another. Keyboard shortcut: Option-5 (Alt+5).

- **Nearest Neighbor (hard edges)** gives you the lowest image quality. With this method, Photoshop looks at the colors of pixels surrounding the new one and copies them. Nearest Neighbor is known for creating jagged edges, so you'll want to use it only on images with hard edges like illustrations that aren't anti-aliased. Keyboard shortcut: Option-6 (Alt+6).

- **Bilinear** tells Photoshop to guess at the color of new pixels by averaging the colors of the pixels directly surrounding the ones it's adding. Bilinear produces slightly better results than Nearest Neighbor, but you're usually better off using one of the other methods instead. Keyboard shortcut: Option-7 (Alt+7).

Clicking the gear icon at the dialog box's top right displays but one menu item—Scale Styles—which determines whether, when you resize your image, Photoshop also resizes any layer styles you've applied to the image. This menu is tied to the Resample checkbox, so as soon as you turn *that* option on, you can click the gear icon and choose Scale Styles (otherwise, the menu item is dimmed). If your document harbors layer styles, you'll want to turn this option on; otherwise, that pretty drop shadow you added might end up bigger or smaller than the image itself.

If you know your printer's *lpi* or *lpc* (lines per inch or lines per centimeter—see the box on page 259) setting, head to the Image Size dialog box's Fit To menu and choose Auto Resolution; when you do that the dialog box in Figure 6-17 opens. Just enter the lpi, pick a quality setting, and let Photoshop calculate the proper resolution for a good print.

Upsampling Without Losing Quality

If you leave the Image Size dialog box's Resample checkbox turned on and increase an image's resolution, Photoshop adds pixels to the image that weren't there originally. Greatly increasing resolution this way is *usually* a bad idea because faked pixels never look as good as real ones; however, this is far less of a problem than it used to be thanks to Photoshop's Preserve Details algorithm (page 257).

There may come a time when you've got no choice but to hugely enlarge an image. For example, say the image needs to be printed in an *extremely* large format (like a billboard). If you find yourself in such a pickle, you've got a couple of options. Happily, the first one is free:

- **Method 1.** Open the Image Size dialog box, make sure the Resample checkbox is turned on, and then choose Preserve Details (enlargement) or Bicubic Smoother (enlargement) from the drop-down menu to its right (use the dialog box's preview to see which one works best). Next, change either the Width or Height drop-down menu to Percent (the other field changes automatically),

and then enter a number into the Width field—such as *200* to double the pixel dimensions—and click OK (the Height field changes to the same number automatically). Photoshop enlarges your image by the percentage you entered. (In pre-CS6 versions of the program, adding pixels 5 to 10 percent at a time *repeatedly* using this technique didn't damage image quality quite as much as doing it all at once, though these days you end up with an image that looks mushy because the details get softened over and over again.)

- **Method 2.** Buy a third-party plug-in specifically designed to help you upsample, like Perfect Resize (known as Genuine Fractals years ago) available at *www.ononesoftware.com*, PhotoZoom Pro at *www.benvista.com*, or Blow Up at *www.alienskin.com*. All of these plug-ins manage to pull off some *serious* pixel-adding witchery with truly amazing results. (See Chapter 19 for info on installing plug-ins and for more plug-in recommendations.)

FIGURE 6-17

If you know the lpi of your printer, enter it in the Screen field here, and Photoshop calculates the resolution (ppi) for you. You've got a choice of three different quality settings: Draft gives you a resolution of 72 ppi, Good multiplies the lpi by 1.5, and Best multiplies it by 2.

TIP The settings in the Image Size dialog box are *sticky*, meaning they stay changed until you change them back (that is, except for the resample *method*). Nevertheless, if you find yourself entering the same settings over and over, you can use the dialog box's Fit To menu to save 'em as a preset. The same menu also lets you *load* presets that you've gotten from somewhere else (say, a coworker who's toiling away on the same project).

■ RESOLUTION GUIDELINES FOR PRINT

Now that you understand what resolution is and how it works, you're probably wondering, "How much resolution do I need when I print?" Because different printers work in different ways—inkjets spray, dye-subs fuse, laser printers and professional presses print shapes, and so on—the resolution you need for a beautiful print depends on the *printer*.

FREQUENTLY ASKED QUESTION

Understanding LPI

What the heck is lpi? I thought all I had to worry about was ppi!

Laser printers and professional printing presses work a little differently than inkjet and dye-sublimation printers. Inkjets spray dots of color onto paper and simulate shades of gray by using wide or narrow dot dispersal patterns. Dye-subs fuse color dyes—including shades of gray—onto paper through a heating process (they tend to produce water- and smudge-proof prints that are higher-quality than what you get from inkjets, but also more expensive).

Professional printing presses use yet another printing method: If you hold a magnifying glass to a professionally printed newspaper or magazine, you can see that the images are comprised of a gazillion tiny shapes (typically circles, though they can also be diamonds or squares, depending on the printer). If

the shapes are small enough, you'll never see them with your naked eye (although some folks have been quite successful recreating them at *galactic* proportions and calling it pop art—think Lichtenstein and Warhol).

The setting that determines how many lines of little shapes get printed in an inch of space is called *lines per inch*, or lpi. (It's also referred to as screen frequency, line screen, or halftone screen.) It's important to understand lpi because there may come a day when you're forced to figure the appropriate ppi based on lpi (also helpful in scanning; see the box on page 254). When this happens, breathe deeply, smile smugly, and proceed to Table 6-1 on page 260. Or, in the Image Size dialog box, choose Auto Resolution from the Fit To menu and let Photoshop figure out the ppi from lpi *for* you, as explained in Figure 6-17.

It's tempting to practice resolution overkill just to be on the safe side, but doing that makes for larger files that take up more hard drive space and take longer to process, save, *and* print (and in some cases, the print can look every-so-slightly blurred). Instead, rein yourself in and consider the resolution guidelines in Table 6-1.

TABLE 6-1 *Resolution guidelines for print*

DEVICE	PAPER	RESOLUTION	BEST USES
Desktop laser printer	Any kind	Resolution should match the printer's dpi (which is listed in the owner's manual) up to 1200 ppi. Some folks call this resolution 1:1, which just means ppi matches dpi exactly. For color or grayscale images, shoot for 200 ppi.	Business documents and line art
Inkjet printer	Regular or textured	150–240 ppi	Color and grayscale images, black-and-white documents
Inkjet printer	Glossy or matte photo	240–480 ppi. Use the upper end of this range only for large images (13x19 inches and up).	Color and grayscale images
Dye-sublimation printer	Any kind	Resolution should match the printer's dpi.	Color and grayscale images
Web offset press	Newsprint or uncoated stock	1.5–2 times the lpi, depending on how detailed you want the print to be (use 2 if what you're printing has a slew of sharp edges in it).	Newspaper ads and community papers (like *Auto Trader* and *The Village Voice*)
Commercial printing press	Uncoated or coated stock	2–2.5 times the lpi	Magazines, coffee table books, fancy brochures, business cards, and line art

NOTE When you send files off to a professional print shop, it's *always* a good idea to ask how much resolution they want. If they don't know, find another printer—fast!

Resizing Images for Print

Throughout your Photoshop career, you'll need to resize and change the resolution of images so they'll print well. Perhaps the most common situation where you'll have to do this is when you download stock photography or import a snapshot from a digital camera.

Keep in mind that today's digital cameras can capture *tons* of info: Consumer-level, 10-megapixel cameras produce images packed with around 3648 × 2048 pixels (width by height), and pro-level, 22-megapixel models capture images in excess of 5760 × 3840 pixels. That's a veritable *smorgasbord* of pixels, letting you crop the image and alter resolution however you like.

Resizing images is a snap, but there's a high risk of reducing image quality in the process. As you learned in the previous section, the key to preserving quality lies in turning on the Image Size dialog box's Resample checkbox, as Figure 6-18 illustrates.

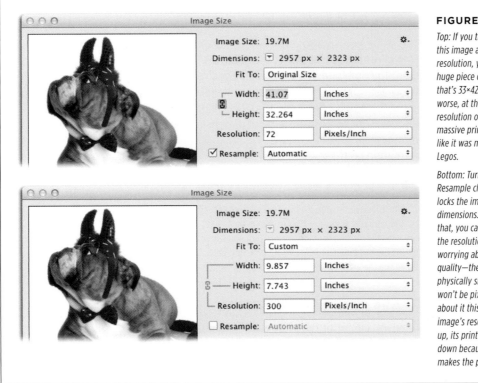

FIGURE 6-18

Top: If you tried to print this image at its current resolution, you'd need a huge piece of paper—one that's 33×42 inches! Even worse, at the current resolution of 72 ppi, that massive print would look like it was made from Legos.

Bottom: Turning off the Resample checkbox locks the image's pixel dimensions. Once you do that, you can increase the resolution without worrying about print quality—the print will get physically smaller, but it won't be pixelated. Think about it this way: As the image's resolution goes up, its print size goes down because Photoshop makes the pixels smaller.

> **NOTE** If you're printing a generic-size image (like 8" × 10" or 5" × 7") straight from Photoshop, you can turn on the Print dialog box's "Scale to Fit Media" setting to make the program calculate the resolution *for* you, according to the paper size you pick (though you'll probably end up with resolution overkill and you have no control over how the image is cropped to fit the paper). Flip to page 733 to see Photoshop's Print dialog box.

Here's how to use the Resample checkbox to resize an image for printing *without* sacrificing quality:

1. **Open a photo, and then choose Image→Image Size or press Option-⌘-I (Alt+Ctrl+I) to open the Image Size dialog box.**

 The image shown in Figure 6-18 (top) weighs in at 2957 × 2323 pixels at a resolution of 72 ppi. If you want to print it, you need a ridiculously big piece of photo paper (roughly 41″ × 32″). Luckily, those dimensions will come way down once you increase the resolution in step 3. Remember, increasing resolution makes the pixels smaller, creating a physically smaller print whose quality (that is, resolution) is higher.

2. **Lock the image's quality by turning off the Resample checkbox.**

 In Figure 6-18 (bottom), see how the gray line on the left side of the dialog box's fields connects width, height, *and* resolution? That line is there to remind you that changing *one* of these fields now affects the other two.

3. **Increase the image's resolution.**

 The value you should enter in the Resolution field depends mostly on which kind of printer you're using; see Table 6-1 for some recommended settings, and then do some tests to see which ones work best for you. For example, if you know your printer does a respectable job printing at 300 ppi, enter that value in the Resolution field, and the document's dimensions decrease to 9.8″ × 7.7″ (Figure 6-18, bottom). The pixel dimensions and file size, however, remain the same—the image is still 2957 × 2323 pixels and 19.7 MB; only the print size and resolution changes.

 NOTE Popping open the Image Size dialog box is a handy way to learn what size print you can make with the pixel dimensions you've got. If your printer does a decent job at 240 ppi, for example, turn *off* the Resample checkbox and type that value into the Resolution field to see how big a print it'll create. If it's a funky size, you can always crop the image to a specific, more common size using the Crop tool (see page 241). Alternatively, you can enter the desired print size in the Width or Height field and let Photoshop set the resolution *for* you. If that doesn't give you the exact print size you need, grab the Crop tool.

4. **Click OK when you're done.**

 Now you can print the image and it'll look great.

Did you notice how much the onscreen image changed when you tweaked the resolution? That's right: Not at all. That's part of the reason resolution is so confusing. Onscreen, the 72 ppi image looks *just* like the 300 ppi version because your monitor's resolution can't go that high. The lesson here is that, as long as you turn off the Resample checkbox, you can tweak an image's resolution 'til the cows come home without altering its quality. Sure, you'll change the image's print size, but you won't add or remove any pixels.

Resizing for Email and the Web

Not everyone has a high-speed Internet connection...at least, not yet. Some poor souls are doomed to live with dial-up for the foreseeable future, and even wireless hotspots don't exactly provide warp-speed connections (especially when a lot of people are using 'em). That's why it's important to decrease the file size of that photo you snapped when your bird landed on your cat's head *before* emailing it to your pals—if you don't, it might take 'em forever to download it (though it'd be worth it!). The same goes for images you plan to post online: The smaller their file size, the faster they'll load in a web browser. (You'll learn a lot more about posting images online in Chapter 17, but the info in this section will get you started.)

To make an image smaller, you have to decrease its pixel dimensions. This process is called *downsampling*, and you can go about it by using the Image Size dialog box that you learned about in the previous section (in which case you'd leave the Resample checkbox turned *on*), or by using the "Save for Web" dialog box, as described below.

> **NOTE** If you'd rather resize images destined for the Web *visually* by entering a reduction percentage (rather than pixel dimensions) into the Image Size or "Save for Web" dialog box, see page 767.

If you want to see a preview of the new, smaller image and maybe experiment with different file formats (if you're torn between a JPEG and a PNG, say), use the "Save for Web" dialog box. This method is a great way to reduce file size while monitoring image quality. Here's how to resize a photo you want to email or post online:

1. **Open a photo and then choose File→"Save for Web."**

 The dialog box shown in Figure 6-19 takes over your screen. It lets you choose from a variety of file formats and quality levels that Photoshop can use to make the image Web- or email-friendly. You can see up to four previews of what the image will look like in various formats before you choose one, which is why the dialog box is so darn big.

2. **In the upper-left part of the dialog box, make sure the 4-Up tab (circled in Figure 6-19) is active and then, in the top-right corner, pick JPEG High from the Preset drop-down menu (also circled).**

 The 4-Up tab is great for monitoring the size and quality difference between the original image and, say, a JPEG at various quality settings (as you learned on page 46, JPEG is a good choice for photos). To keep the photo's quality relatively intact while you reduce its file size, choose JPEG High from the preset drop-down menu (circled in Figure 6-19, top right). To make the file smaller, Photoshop tosses out some details, but the overall quality doesn't suffer much. If you choose a quality level of Low (numeric equivalent: 10), Photoshop throws away *significantly* more details and the result is a low-quality image. (See page 769 for more about JPEGs.)

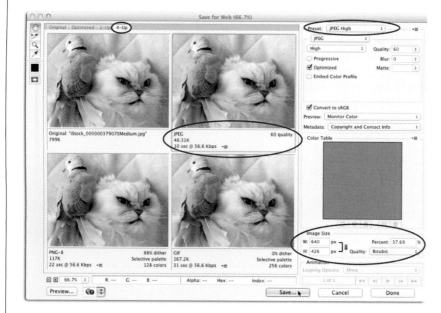

FIGURE 6-19

This dialog box lets you reduce the image's size and save it in a different format in one fell swoop, complete with up to four previews.

That said, if you're working with a huge image from a high-end digital camera (say, over 5000 pixels in width or height) this dialog box will take ages to open—or worse, you'll get an error message saying the file is too big to deal with. In that case, reduce the image's size using the Image Size dialog box before opening this dialog box.

3. **Reduce the image's size.**

 At the bottom right of the dialog box lies a section labeled Image Size (it's circled in Figure 6-19). If you know the dimensions you want, enter the width or height (it's best to make the width 640 pixels or less). If you don't know what size you want and are only concerned with making the *file size* smaller, you can enter a percentage reduction, like 25 percent. (That's a good percentage if you're emailing an image captured on a 10-megapixel camera at a high quality setting.)

4. **Choose a resample method.**

 In the dialog box's Image Size section, choose Bicubic Sharper from the Quality drop-down menu (unfortunately, Automatic isn't available here). This method (explained on page 257) works particularly well when you're downsampling. As you can see in the middle of Figure 6-19, the resulting file is 48.31 KB at a quality setting of 60. That's a 94 percent reduction in size!

5. **At the bottom of the dialog box, click Save, and then give the file a new name so you don't overwrite the original.**

TIP It's a good idea to sharpen images after you downsample them because they tend to get blurry from both losing details and getting compressed. (See Chapter 11 for more sharpening methods than you can shake a stick at.) However, if the image you've downsampled is for email only, you don't need to bother sharpening it.

Resizing Web Images for Print

Unfortunately, there will come a time when you need to print an image snatched from the Web (just make sure you have the proper *permissions*, as the box on page 266 explains). Such images are usually fairly small so they'll load quickly in web browsers, which also means they contain precious few pixels for you to work with. As you learned on page 255, you don't have to specify resolution when creating web graphics, though when you pop one open in Photoshop, the program *automatically* gives it a resolution of 72 ppi—a resolution so low that, when printed, the individual pixels are big enough to see from outer space. So unless you like that blocky look, you *have* to increase the image's resolution before printing it. And, as you learned earlier in this chapter, when you bump up resolution, you wind up with a print the size of a postage stamp. It's a lose-lose situation.

TIP A good rule of thumb is that Web images print decently at about *half* the size they appear onscreen. So if you start with an image that looks to be about 2" × 2" onscreen, it should print decently at 1" × 1".

For all those reasons, printing a Web image isn't ideal, but if you have no choice, you've got to make do. In that case, follow these steps to beef up its print quality:

1. **Save the image to your hard drive.**

 Find the image on the Web and Control-click (right-click on a PC) it to summon your web browser's shortcut menu, and then choose Save Image As. Or you can choose Copy Image from the shortcut menu and then paste the image into a new Photoshop document.

2. **Open the image in Photoshop and then choose Image→Image Size.**

 Photoshop displays the now-familiar Image Size dialog box (Figure 6-16).

3. **In the Image Size dialog box, turn *off* the Resample checkbox, enter *150* in the Resolution field, and then click OK.**

 A resolution of 150 ppi works okay if you're printing to an inkjet printer. The resulting print may not be *frame*-worthy, but it'll be identifiable.

4. **Back in the main Photoshop window, save the resulting file as a PSD or TIFF.**

 Choose File→Save As, and then pick PSD or TIFF from the format drop-down menu (see page 724 for more on TIFFs). The photo is now primed and ready for popping into Word, InDesign, or any other word-processing or page-layout program.

If the image is *still* too small after you follow these steps, visit the box on page 258 for tips on upsampling.

Resizing Images for Presentations

You're probably thinking, "I thought this book was about Photoshop and here you are talking about *presentations*. What gives?" Someday, you may be asked to prepare presentation graphics, and if that happens, the info in this section can save your skin. Luckily, in that situation, you don't have to worry about resolution; since your audience will view the images onscreen, it's the pixel dimensions that matter most.

Some folks claim to be more afraid of public speaking than they are of death. Standing before an expectant audience *can* be unnerving (after all, humans *are* predators); obviously, you want everything to run smoothly and the graphics to look perfect. Oversize images bloat the presentation's file size and can cause it to run slowly, or worse, crash. On the flip side, small images may look fine on a computer monitor but terribly blocky when projected onto a large screen.

The solution to both problems is to decide how big the images need to be and resize them *before* you import them into PowerPoint or Keynote. It's OK to resize images a little bit in those programs, but you don't want to put a dozen ginormous, 10 MB photos in your presentation—that's just asking for trouble.

If you want an image to fill a whole slide, find out the pixel dimensions of the projector you'll be using (the slides should be that size, too). If you don't know, find out how big the slides are. Here's how to sniff out (and change) slide dimensions in the two most popular presentation programs:

- **Microsoft PowerPoint 2013.** Head to the Design tab and click Slide Size→Custom Slide Size. In the dialog box that appears, look for the Width and Height fields. Now, here's where things get tricky: For some unknown reason, PowerPoint lists slide dimensions in inches instead of pixels. This poses a challenge because, to ensure that the image fills the slide perfectly, you have to convert the inches to pixels. Luckily, Table 6-2 lists the most common conversions, so you can enter the dimensions listed there, and then click OK. Once you've done that, hop over to page 241 for instructions on how to crop the image so that it fits the slide perfectly.

- **Apple's Keynote.** Click the Document icon at the top right (it looks like a vintage slide) and peek at the Slide Size drop-down menu that appears. Pick one of the menu's presets—Standard (4:3) or Widescreen (16:9)—and then open the menu *again* and choose Custom Slide Size. A dialog box opens listing the slide dimensions in points; those are the magic numbers, so jot them down. Then, back in Photoshop, grab the Crop tool, set the Options bar's aspect-ratio-and-crop-size preset menu to W x H x Resolution (page 241), and then enter those numbers in the Options bar. (The resolution doesn't matter because the image won't be printed, so you can leave the resolution field blank.) Once you've cropped the image, save it as a PNG for maximum quality (as discussed on pages 47 and 771).

TABLE 6-2 *Slide size conversions*

PIXEL DIMENSIONS	SLIDE SIZE
1024 × 768	14.22" × 10.66"
1280 × 720	17.77" × 10"
1920 × 1080	26.66" × 15"

> **TIP** Older projectors have a resolution of 1024 × 768 or 1280 × 720 pixels, and newer high-definition models are 1920 × 1080 pixels. If you've got no idea which kind of projector you'll be using, 1280 × 720 is *probably* a safe bet.

Resizing Smart Objects

When designing a document—a poster, a magazine cover, whatever—you'll probably do a fair amount of resizing before you get the layout just right. What if you shrink a photo down only to realize it worked better at its original size? Can you enlarge the image without lessening its quality? Negative, good buddy—unless you opened or placed it as a smart object.

As you learned in Chapter 3, smart objects are the best thing since sliced bread. They let you apply *all kinds* of transformations to files, including decreasing and then increasing their size over and over again—all without affecting the quality of that image as it appears in your document. Here's how to resize a smart object no matter what it contains (text, imagery, or a whole Photoshop document):

- **To *decrease* the size of a smart object,** activate the relevant layer in the Layers panel and then choose Edit→Free Transform. Grab any of the resulting square handles and drag diagonally inward to reduce the object's size (hold the Shift key as you drag if you want to resize it proportionately). Let Photoshop know you're finished by pressing Return (Enter on a PC).

> **NOTE** If you've used the Place command to import the smart object, or if you drag and drop a raster image into an open Photoshop document, then resizing handles appear *automatically* when the image opens in your document on its very own layer.

- **To *increase* the size of a smart object,** make sure you've got that layer activated in the Layers panel, and then choose Edit→Free Transform. Drag any of the resulting corner handles diagonally outward (hold down the Shift key if you want to preserve the image's proportions). If you don't enlarge the image beyond its original pixel dimensions, its quality remains pristine (and even if you make it a little bigger than its original size, you probably won't notice the difference, as each version of Photoshop gets better at faking pixels). Unfortunately, there's no quick and easy way to *return* the smart object to its original size if you forget what it was.

Automated Resizing with the Image Processor

As you'll learn in Chapter 18, you can record a series of steps as a replayable *action* that resizes and saves a batch of images en masse. But Photoshop has a niftier automatic resizing feature built right in: the Image Processor. This little *script* (which you can think of as a program within a program) was developed specifically to convert images' file formats and change their sizes—fast. It can save you tons of time whenever you need to convert files to JPEG, PDF, or TIFF format (it doesn't convert PNGs or GIFs). Here's how to run the Image Processor script:

1. **Choose File→Scripts→Image Processor.**

 Photoshop opens the Image Processor dialog box (Figure 6-20).

2. **In the top section of the dialog box, tell Photoshop which images you want to run the Image Processor on.**

 Your options are to run it on the images you currently have open (Use Open Images) or on a folder of images (Select Folder). If you choose the latter, you can also include all subfolders and open the first image Photoshop changes—just to make sure everything looks OK—by turning on the appropriate checkbox(es).

3. **Tell Photoshop where to save the images.**

 You can save the images in the same folder they're currently in or pick a new one by clicking the radio button next to Select Folder. If you're sending the files somewhere new, turn on the "Keep folder structure" checkbox to make Photoshop preserve your organization scheme.

4. **Pick the format(s) you want Photoshop to save the files as and, if you want to resize them, enter a new maximum size in pixels.**

 Here's where the real magic lies. You have three file formats to pick from and resizing options for each:

 - **Save the files as JPEGs** and choose a quality setting (see page 769); you can also convert the color profile to sRGB (as page 724 explains, this is a good idea if the images are destined for the Web).

 - **Save them as PSD files** and maximize their compatibility with other versions of Photoshop so you can open them with an earlier version of the program.

 - **Save them as TIFFs**, with or without compression (see page 724).

You can choose one option, two, or all three. No matter what the original format, Photoshop will convert the files to match the options you choose. You can also have the program resize the files while it's at it; just turn on the "Resize to Fit" checkbox next to the format(s) you picked, and then enter a maximum pixel value for either width or height.

FIGURE 6-20

Russell Brown, Adobe's chief evangelist, developed the Image Processor a few years back. If you run this clever script on a folder of images, Photoshop automatically saves them in the format you choose or resizes them instantly—or both. It's amazingly cool. And as you can see at the bottom of the dialog box, you can even apply an action while you're resizing and/or changing file format. Page 823 has more on that particular trick.

You can also access this dialog box within Adobe Bridge, though in that case it doesn't work on folders, only multiple documents. Chapter 22 has more on using Bridge.

TIP If you're resizing a batch of files that includes images with both portrait and landscape orientations, then enter the *same* size in both the W and H fields. Don't worry; you *won't* end up with square-shaped files.

5. **If you want, enter custom settings in the Preferences section.**

 Here's your opportunity to run an additional action. Just turn on Run Action, pick an action category from the first drop-down menu, and then choose an action from the second menu. You can also include copyright info in the files by entering it in the text box. Unless you turn off the Include ICC Profile checkbox, Photoshop automatically includes an ICC profile (see the Tip on page 721) in the files.

6. **When you've got all the settings just right, click Run to make the Image Processor work its magic.**

It may take Photoshop a while to run this script, depending on how many files you chose and how big they are. But it certainly won't take as long as it would for you to do all this stuff yourself!

Resizing the Canvas

In addition to resizing images, you can also resize your Photoshop canvas to make room for more artistic goodness. You can add this extra canvas space either visually by using the Crop tool (see page 244, step 2) or manually by choosing Image→Canvas Size. The manual method lets you enter specific dimensions, as Figure 6-21 shows.

FIGURE 6-21

You can increase canvas space by entering dimensions or a percentage change.

Use the Anchor option to determine where your document's existing content lands within the new space. If you don't pick an Anchor setting, the content lands in the middle.

The Canvas Size dialog box includes the following options:

- **Current Size** and **New Size.** Ever informative, Photoshop lets you know how big the document is now and how big it'll be once you click OK. These sections include info on both file size and physical dimensions (width and height).

- **Width** and **Height.** Photoshop assumes you want to measure the canvas's dimensions in inches, but you can use the drop-down menus here to change them to percent, centimeters, millimeters, points, picas, or columns. Change

either the Width or Height field's unit of measurement and the other field's unit changes automatically. Then enter a dimension in each field. (Technically, you can Shift-click a unit of measurement in the Width or Height menu to change *just that field's* unit of measurement, though it's tough to imagine why you'd want to do that.)

- **Relative.** Turning on this checkbox makes Photoshop expand or contract the canvas by the amount you enter in the Width and Height fields. If you know the exact size you want the canvas to be, leave this option turned off. If you're just trying to create some extra elbow room in which to work and you've already got an image in your document, turn it on. (For example, to add an inch all the way around your document, enter 2 inches in both fields.)

- **Anchor.** Tell Photoshop where to put the document's existing content when you click OK. (If you don't choose anything here, the existing content ends up in the middle of the canvas.)

- **Canvas extension color.** If you want the new space to be a certain color, choose that color here. If you don't pick a color—and the background layer is locked (page 88)—Photoshop uses your current background color. If the background layer is *unlocked*, the new space will be the gray-and-white transparency checkerboard (which is typically what you want).

> **TIP** If the image is in landscape orientation and needs to be portrait instead (or vice versa), you can rotate the canvas by choosing Image→Image Rotation→90° CW (clockwise) or 90° CCW (counterclockwise).

■ Content-Aware Scaling

Once in a blue moon, a software company adds a feature that works almost like magic. Adobe did exactly that with *Content-Aware Scale* (affectionately known in nerdy circles as CAS). CAS examines what's in an image and intelligently adds or removes pixels from unimportant areas as you change the overall size of the image. The magic part? It leaves the important bits—such as people—unchanged. Think of web pages you've used that resize themselves smoothly and fluidly as you make the browser window bigger or smaller; now imagine doing the same thing with an image.

A picture really is worth a thousand words when it comes to CAS, so take a peek at Figure 6-22 to see what this feature can do.

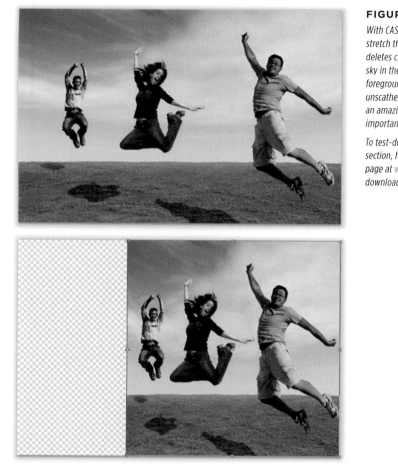

FIGURE 6-22

With CAS, Photoshop doesn't squash or stretch the whole *image; it only adds or deletes chunks of things like the big ol' sky in the background and the grass in the foreground, leaving the important parts unscathed. As you can see here, CAS does an amazing job of resizing only the not-so-important areas in this image.*

To test-drive CAS using the images in this section, head to this book's Missing CD page at www.missingmanuals.com/cds *and download the file* CAS.zip.

You can use CAS in all kinds of situations. For example, say you need room for text in your image, so you need to make it taller or wider. Or perhaps you need to drop a picture into a 4-inch ad space but the subjects are too far apart for it to fit without cropping someone out. In circumstances like these, CAS can help. You can use it on layers and selections in RGB, CMYK, Lab, and Grayscale image modes (page 41) and at all bit depths (see the box on page 42). However, you *can't* use it on adjustment layers, layer masks, channels, smart objects, 3D layers, or video layers.

When you're ready to take CAS for a spin, here's what to do:

1. **Open an image, duplicate your image layer(s), and then press Q to pop into Quick Mask mode.**

 Content-Aware Scale won't work on a locked background layer or a smart object, so it's best to duplicate the image layer first by pressing ⌘-J (Ctrl+J); then turn off the original layer's visibility so it's not in your way. If your image consists of *multiple* layers, create a stamped copy instead by pressing Shift-Option-⌘-E (Shift+Alt+Ctrl+E).

 Why switch to Quick Mask mode? Because CAS isn't perfect—you'll get better results if you help it out by *marking* the areas you want to protect, and Quick Mask mode is the fastest way to do that.

2. **Press B to grab the Brush tool and then set your foreground color chip to black.**

 Press D to set your color chips to factory-fresh black and white, and then press X until black hops on top.

3. **Mouse over to the image and paint the areas you want to protect.**

 When you start painting, you'll see the red overlay of Quick Mask mode (visible in Figure 6-23, top). When everything you want to protect is covered with red (like the shrubs, golfers, and flag), press Q to exit Quick Mask mode. You'll see marching ants appear around everything *except* those areas; you'll fix this in the next step.

4. **Flip-flop your selection by choosing Select→Inverse or pressing Shift-⌘-I (Shift+ Ctrl+I).**

 Since Photoshop selected everything *except* the area you painted in the previous step, you need to invert the selection.

5. **Save the selection as an alpha channel, and then deselect.**

 As you learned in Chapter 5, alpha channels let you save selections. Open the Channels panel by choosing Window→Channels, and then save the selection as an alpha channel by clicking the circle-within-a-square icon at the bottom of the panel (circled in Figure 6-23, top); Photoshop adds a channel called Alpha 1 to the panel. You don't need the marching ants anymore, so get rid of them by choosing Select→Deselect or by pressing ⌘-D (Ctrl+D).

6. **Tell Photoshop you want to resize the image by choosing Edit→Content-Aware Scale or pressing Shift-Option-⌘-C (Shift+Alt+Ctrl+C).**

 Photoshop puts see-through, square resizing handles all around the image; but don't grab them just yet!

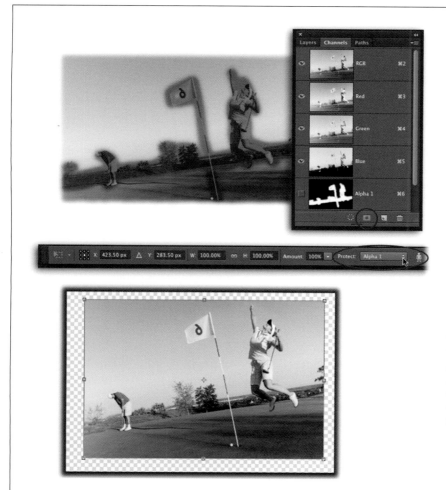

FIGURE 6-23

Top: The areas you paint in Quick Mask mode turn red, as shown here. This mode is one of the fastest ways to make a selection, and you don't have to be that careful about the area you paint; anything you touch with the brush is protected. Once you exit Quick Mask mode and flip-flop the selection, click the "Save selection as channel" icon at the bottom of the Channels panel (circled).

Middle: Once you've activated the Content-Aware Scale tool, you can choose the protective alpha channel from the Options bar's Protect drop-down menu (circled).

Bottom: Because you protected the shrubs, golfers, and flag, Photoshop leaves them alone and resizes everything else.

7. **From the Options bar's Protect menu, choose Alpha 1 (Figure 6-23, middle).**

 Choosing the alpha channel you just created tells Photoshop which areas to protect. And if the image contains people, you can preserve their skin tones by clicking the silhouette icon to the right of the Protect menu.

 NOTE To make the image smaller or larger by a certain percentage, enter numbers in the W (width) and H (height) fields or the Amount field. (Most of the time, you won't mess with these fields because it's easier to resize the image visually, as you'll do in step 8.)

8. **Mouse over to the image, grab one of the resizing handles, and drag it toward the center of the image.**

As you can see in Figure 6-23, bottom, the image has been narrowed, but the bushes, golfers, and flag remain unchanged. CAS did a great job of resizing only the unimportant parts of the image.

Is this technology amazing? Yes. Is Adobe still working to improve it? Heck, yes! Even so, it has lots of practical uses. For example, if you have to fit an image into a small space (like wedging a photo into a tiny spot in a magazine article), you can use CAS to scoot the subjects closer together instead of cropping the image. Or if you've created a panorama, you can stretch out the sky a little to fill it back in. Just don't expect CAS to work on images that don't have plain backgrounds like a portrait or other close-up image.

Nevertheless, this exciting feature keeps getting better in each new version of Photoshop. And just wait till you see what its cousins Content-Aware Move (page 472), Content-Aware Fill (page 436), and Content-Aware Patch (page 441), can do! Adobe improved all three of those features in Photoshop CC 2014 so you get better color accuracy when moving (or removing) objects.

■ Rotating and Distorting

Photoshop gives you lots of ways to rotate, distort, and otherwise skew images, all mighty useful techniques to have in your bag of tricks. By rotating an image, you can add visual interest (as in the Polaroid technique on page 244), convert vertical elements to horizontal ones (or vice versa), and straighten crooked items. Distorting comes in handy when you want to slant an object or line of text or turn it slightly on its side, and if you want the object or text to fade into the distance with perspective. And the Puppet Warp tool lets you distort specific objects in an image while leaving the rest of it unchanged.

This chapter has touched on rotation here and there: You learned how to rotate a crop box, rotate an image with the Free Transform command, and rotate the whole canvas. In this section, you'll learn about simple rotations as well as the tougher stuff.

NOTE To learn how to reshape pixels using the Liquify filter and Puppet Warp tool, trot on over to Chapter 10. The new Perspective Warp tool, which you can use to change the perspective in specific *parts* of images, is covered there, too.

Simple Rotations

Not surprisingly, the Image Rotation command rotates images. Simply choose Image→Image Rotation, and then pick what you want to do. You can spin the whole document—layers and all—90 degrees (clockwise or counterclockwise), 180 degrees, or by an arbitrary amount. You can also flip the canvas (or layer) horizontally or vertically. Photoshop doesn't get any simpler than this!

The Transformers

Another way to resize and rotate (not to mention flip, skew, and distort) images is to use the Transform commands, which can make a selected object—or an entire layer—bigger or smaller without altering the size of the document. If you hop up to the Edit menu, you'll see the Free Transform and Transform options about halfway down the list. The Free Transform command, discussed later in this section, lets you perform *all* the tasks listed on the Transform submenu (see Figure 6-24).

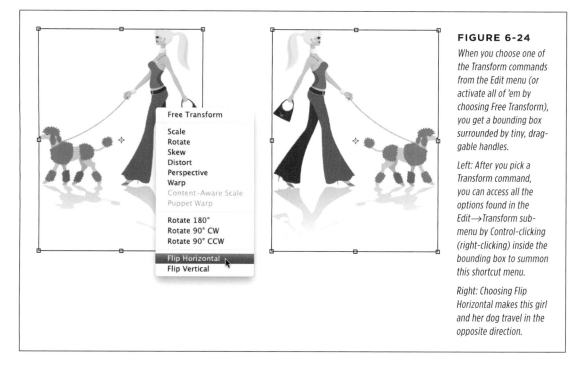

FIGURE 6-24

When you choose one of the Transform commands from the Edit menu (or activate all of 'em by choosing Free Transform), you get a bounding box surrounded by tiny, drag- gable handles.

Left: After you pick a Transform command, you can access all the options found in the Edit→Transform sub- menu by Control-clicking (right-clicking) inside the bounding box to summon this shortcut menu.

Right: Choosing Flip Horizontal makes this girl and her dog travel in the opposite direction.

> **NOTE** If you have a shape or a whole path (see Chapter 13) active, the Edit menu's command changes to Free Transform Path (instead of Free Transform). If you have just *part* of a path active, the menu item reads Free Transform Points instead.

Choosing one of the Transform commands summons a bounding box that has tiny square handles on all four sides. You can use these commands on objects you've selected (Chapter 4), on individual layers, or across *many* layers (page 78 covers activating multiple layers). The Transform commands resize the active layer(s) or selection but not the whole document; the only way to resize the whole document is by changing its image size (page 255) or canvas size (page 270).

NOTE You may find yourself wondering, "Why does Photoshop have both a Free Transform command *and* a Transform menu if I can use them to do the exact same things?" The only real difference between these two options is that choosing an item from the Transform menu locks you into performing that particular task (using the Scale tool, for example), whereas the Free Transform command lets you perform *several* transformations at the same time (without having to press Return [Enter] between transformations).

You can transform any objects you wish. Vectors, paths, shape and type layers, and smart objects are especially good candidates for transformation because you can size them *without* harming (pixelating) the image. Don't try to enlarge raster images very much because you have no control over resolution, resampling, or any of the other important stuff mentioned back on pages 255–258. To play it *really* safe, resize images using the Transform commands for only the following reasons:

- **To *decrease* the size of a selection on a single layer.** Page 191 has more info about transforming a selection without altering any pixels on that layer.

- **To *decrease* the size of everything on a single layer or multiple layers.** You can activate multiple layers by Shift- or ⌘-clicking (Ctrl-clicking on a PC) them, and then Free Transform can change 'em all simultaneously.

- **To *increase* the size of a vector, path, portion of a path, shape layer, type layer, or smart object on one layer or across several layers.**

No matter what you're resizing, simply activate the layer(s) or path(s) or create a selection, and then press ⌘-T (Ctrl+T) or choose Edit→Free Transform. Photoshop puts a bounding box around the object, complete with handles that let you apply any or all of the following transformations to the object (they're all illustrated in Figure 6-25):

- **To scale (resize) an object,** grab a corner handle and drag diagonally inward to decrease or outward to increase the size of the object. Press and hold the Shift key while you drag to resize proportionately so the object doesn't get distorted. You can drag one handle at a time or press and hold the Option key (Alt on a PC) to scale from the center outward (meaning that all four sides of the bounding box move simultaneously).

TIP If you summon the Free Transform command to resize something big, the bounding box's handles may end up outside the document's edges (or margins), making them impossible to see, much less grab. To bring them back into view, choose View→"Fit to Screen" or press ⌘-0 (that's the number zero, not the letter O) or Ctrl+0 on a PC. This is quite possibly *the* most useful keyboard shortcut in all of Photoshop!

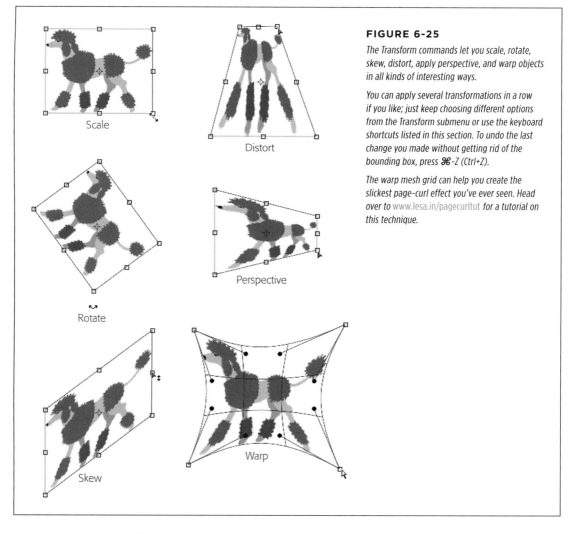

FIGURE 6-25

The Transform commands let you scale, rotate, skew, distort, apply perspective, and warp objects in all kinds of interesting ways.

You can apply several transformations in a row if you like; just keep choosing different options from the Transform submenu or use the keyboard shortcuts listed in this section. To undo the last change you made without getting rid of the bounding box, press ⌘-Z (Ctrl+Z).

The warp mesh grid can help you create the slickest page-curl effect you've ever seen. Head over to www.lesa.in/pagecurltut for a tutorial on this technique.

- **To rotate an object,** put your cursor outside any corner handle. When the cursor turns into a curved, double-headed arrow, drag up or down in the direction you want to turn the image. To rotate in 15-degree increments, press the Shift key while dragging.

- **To skew (slant) an object,** press ⌘-Shift (Ctrl+Shift) while dragging one of the side handles; your cursor turns into a double-headed arrow.

- **To distort an image freely,** press ⌘ (Ctrl) while dragging any corner handle.

- **To alter an object's perspective,** press Shift-Option-⌘ (Shift+Alt+Ctrl) while dragging any corner handle (your cursor turns gray). This maneuver gives the object a one-point perspective (in other words, a single vanishing point).

- **To warp an object,** click the Options bar's "Switch between free transform and warp modes" icon (labeled in Figure 6-26). Photoshop puts a warp mesh over the image so you can reshape it in any way you want. Drag a control point or line on the mesh to warp the image, or choose a ready-made preset from the Options bar's Warp drop-down menu. See page 633 for the scoop on warping text, or skip to page 474 to read about the Puppet Warp tool, which lets you warp part of an image.

- **To rotate or flip an object,** Control-click (right-click on a PC) inside the bounding box and choose one of the shortcut menu's options (see Figure 6-24) If you choose one of these little jewels, you won't get a bounding box; Photoshop just rotates or rotates or flips the image.

When you're finished transforming the object, press Return (Enter on a PC), double-click inside the bounding box, or click the checkmark in the Options bar to accept them.

If you apply a transformation and then realize that it's not quite enough, you can repeat that transformation by choosing Edit→Transform→Again. You don't get a bounding box—Photoshop just reapplies the same transformation. For example, if you rotated the image 90 degrees, Photoshop rotates it *another* 90 degrees. If you're resizing a raster image, try to transform it only once: The more you transform a pixel-based image, the blurrier and more jagged it can become.

If you want more precise transformations than the ones you get by dragging handles around, you can enter specific dimensions in the Options bar for scaling, rotating, and skewing, as Figure 6-26 illustrates.

TIP All transformations are based on a tiny *reference point* that appears in the center of a transform box—it looks like a circle with crosshairs (you can see 'em in each example in Figure 6-25). You can drag it around or set your own point by heading up to the Options bar and either clicking one of the reference point locator squares labeled in Figure 6-26 or entering X and Y coordinates. Skip ahead to page 820 to see the reference-point-location control in action.

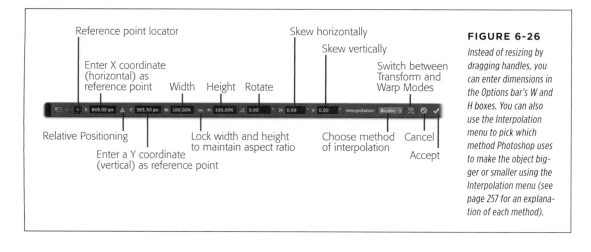

FIGURE 6-26

Instead of resizing by dragging handles, you can enter dimensions in the Options bar's W and H boxes. You can also use the Interpolation menu to pick which method Photoshop uses to make the object bigger or smaller using the Interpolation menu (see page 257 for an explanation of each method).

In the figure labels:
- Reference point locator
- Enter X coordinate (horizontal) as reference point
- Width
- Height
- Rotate
- Skew horizontally
- Skew vertically
- Switch between Transform and Warp Modes
- Relative Positioning
- Enter a Y coordinate (vertical) as reference point
- Lock width and height to maintain aspect ratio
- Choose method of interpolation
- Cancel
- Accept

TIP You can have Photoshop display the Free Transform bounding box around the contents of a layer whenever the Move tool is active *without* having to choose the Free Transform command. To do so, press V to activate the Move tool and then, in the Options bar, turn on Show Transform Controls. The only problem with this tactic is that you might end up resizing something when you don't mean to.

■ CREATING A REFLECTION

A great trick you can perform with the Transform command is to add a simple image reflection (see Figure 6-27). Though this technique takes a few steps, it's well worth the effort. Besides adding depth to an otherwise flat photo, a reflection can make an object look like it was shot on another surface, like a table (handy for making product shots without a proper studio setup).

Here's what you do:

1. **Open a photo and duplicate the layer where the photo lives.**

 Activate the photo layer and then duplicate it by pressing ⌘-J (Ctrl+J); if your image is comprised of several layers, create a stamped copy instead (page 119). While you're at it, single-click the original background layer's padlock icon to unlock it, if you haven't done so already. Name the duplicate or stamped copy *Reflection*, just to keep the layers straight.

TIP You can duplicate an item *while* transforming it by pressing Option (Alt) while choosing Edit→Free Transform or Edit→Transform. That way, the transformation gets applied to a duplicate item on a duplicate layer.

2. **Add some canvas space so you've got room to add the reflection.**

 You need room at the bottom of the document for the reflection. Press C to activate the Crop tool, and then drag the bottom handle down about 2 inches. Press Return (Enter on a PC) to accept the Crop.

FIGURE 6-27

Here's what this kids and leaves image looks like after placing the reflection on a black background and lowering the reflection's opacity slightly to soften the effect. Adds a bit of visual interest, don't you think?

To follow along, visit this book's Missing CD page at www.missingmanuals.com/cds *and download the file* Leaves.jpg.

3. **Flip the reflection layer.**

 Activate the reflection layer and then press ⌘-T (Ctrl+T) to summon the Free Transform command. Then Control-click (right-click) inside the bounding box and, from the resulting shortcut menu, choose Flip Vertical. When the layer is upside-down, press Return (Enter) or double-click inside the bounding box to accept the transformation.

4. **Move the reflection below the photo.**

 With the reflection layer active, press V to grab the Move tool and then hold down the Shift key while you drag the reflection toward the bottom of the document. Then press the down arrow key to nudge the two layers slightly apart (they should *almost* touch, as in Figure 6-27).

TIP Holding down the Shift key while you move a layer *constrains* the layer so that it can move only in a straight line horizontally or vertically. In this example, holding the Shift key ensures that the reflection lines up perfectly with the original photo.

5. **Add a gradient mask to fade the reflection.**

 At the bottom of the Layers panel, click the circle-within-a-square icon to add a layer mask to the reflection layer, and then press G to activate the Gradient

tool. In the Options bar, next to the gradient preview, click the tiny downward-pointing triangle to open the Gradient Preset picker. Choose "Black, White" from the drop-down menu, and then choose Linear as the gradient type. (See page 295 for more on gradients.)

6. **Draw the gradient.**

 In the document, press and hold the Shift key as you drag from the bottom of the image upward to roughly the height you'd like the reflection to be. (Holding down the Shift key locks the gradient vertically so it doesn't move from side to side.) If you're displeased with your first dragging attempt, just give it another go; Photoshop keeps updating the gradient—and thus the mask—as you drag.

7. **Add a solid color fill adjustment layer for your new background.**

 At the bottom of the Layers panel, click the half-black/half-white circle and choose Solid Color. In the resulting Color Picker, choose black and then click OK. Finally, drag the new layer to the bottom of the layer stack.

> **TIP** By using a solid color fill layer (rather than an image layer *filled* with color), you can experiment with the background color to see what looks best by double-clicking the adjustment layer's thumbnail in the Layers panel to reopen the Color Picker. While this example uses black, fuchsia may be more your speed!

8. **Finally, soften the reflection by lowering its layer opacity to about 50 percent.**

 This final step is really about personal preference: If you want the reflection to be faint, use the Opacity setting near the top of the Layers panel to lower the reflection layer's opacity to about 50 percent. If you want the original image to look like it's hovering above a mirror, go with an opacity of 75 percent or higher.

Now you've got yourself a professional-looking reflected image without all the hassle of setting up a reflective table. That's called working smarter, not harder!

Combining Images

One of the most rewarding projects you can tackle in Photoshop is combining images. Whether you're swapping skies, creating a complex collage, or building a panorama, this is where things start getting mighty fun. This chapter teaches you *all kinds* of techniques for mixing images together, from simply chopping a hole through one layer so you can see what's on the layer below it to a trick used by Photoshop heavyweights: mapping one image to the curves and contours of another.

Along the way, you'll learn how *layer blend modes* and *blending sliders* can help turn the images you have into the images you want. You'll also find out how to make Photoshop align and blend layers, as well as stitch multiple images together into a larger one.

This chapter also explains how to use the Clone Source panel to combine parts of separate Photoshop documents, which is helpful when you only want to use bits and pieces of an image instead of the whole thing. Finally, you'll get tips on combining illustrations and photos into unique pieces of art that marry the real and the imaginary. The techniques discussed in the following pages draw on *everything* you've learned so far—layers, selections, resizing, and so on—so get ready to put your new skills to work!

Cut It Out

The easiest way to combine two images is to start with the images on different layers in the same document, and then simply chop a hole *through* one layer so you can see what's on the layer below. It's not elegant, but it works. For example,

if you long to replace a dull window scene with something more exciting, like the sunbathing dude in Figure 7-1, you can just cut a hole through the window so the new object fills the void.

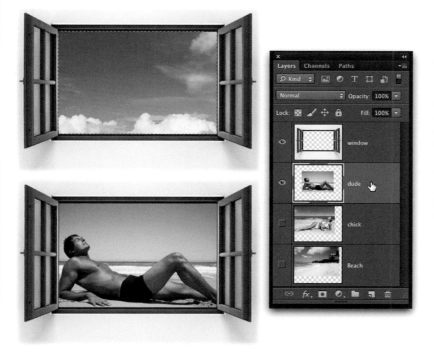

FIGURE 7-1

The simplest way to combine images: Cut a hole in one so you can see through to the other.

Once you've selected the hole (as shown in the top-left image here), you can delete it and then try out new vistas.

To practice this maneuver yourself, visit this book's Missing CD page at www. missingmanuals.com/ cds *and download the file View.zip.*

Here's how to get yourself a brand-new view:

1. **Open an image, unlock the background layer (if there is one) by single-clicking its padlock icon in the Layers panel, and then select the area you want to delete.**

 Since you'll delete pixels in the following steps, you need to convert the background layer (if your image file has one) into a *regular* layer first. Then, to cut a hole in the image shown in Figure 7-1, use the Rectangular Marquee tool to select the window, since it's square. Press M to grab the tool and then draw a box just inside the window frame. (Chapter 4 has the full scoop on selection tools.)

 NOTE The ability to unlock a background layer by single-clicking its padlock icon is new in Photoshop CC 2014. It's a small but supremely handy improvement!

2. **Use the Refine Edge dialog box to soften the selection's edges slightly.**

 Softening the edges makes the images blend better. Click the Refine Edge button in the Options bar and, in the dialog box that appears, use the sliders to smooth the selection by 1 to 2 pixels, and then feather it by 0.5 to 1 pixel. (See page 181 for more on using Refine Edge.)

TIP If your selection is larger or smaller than the area you want to cut, you can use the Shift Edge slider near the bottom of the Refine Edge dialog box to enlarge or shrink it a little.

3. **Press Delete (Backspace on a PC) to cut a hole through the image, and then choose Select→Deselect to get rid of the marching ants.**

 Now that your selection is all set, you're ready to send it packin'. Peek in your Layers panel to make sure you're on the right layer before you perform this part of the surgery. Once you press Delete (Backspace), the transparent checker-board pattern appears in the hole, letting you know that area doesn't contain any pixels. At this point, you're finished with the selection, so you can get rid of it by choosing Select→Deselect or pressing ⌘-D (Ctrl+D).

4. **Add other images to your document and position them below the layer with the hole.**

 Here's where you add the image that you want to appear *inside* the original one. As you learned on page 91, you can copy and paste from other Photoshop documents or from other programs. So copy an image and then paste it into your Photoshop document, where it'll land on its own layer. Or, open an image in Photoshop and then drag it from its Layers panel into the document window of the image with the hole in it. Alternatively, drag an image from your desktop into the open Photoshop document, or choose File→Place Embedded. You can add as many new layers as you want.

 When you've got all the images added, position them *below* the original layer so you can see them *through* the hole you made in step 3. (Remember, whatever's at the top of the layer stack can hide what lies below it.)

5. **Use the Move tool to position the glorious new vista(s) within the window frame.**

 Press V to grab the Move tool, activate the layer you want to move, and then drag it into place. If you need to make the new vista smaller so you can see *all* of it through the window frame, use Free Transform (page 276): Press ⌘-T (Ctrl+T) and then Shift-drag one of the resulting corner handles *inward* to make the image smaller (drag outward to make it bigger).

6. **Preview the new vistas by turning the layers' visibility on or off.**

 For example, in Figure 7-1 you could compare dude vs. chick vs. plain beach. Click each layer's visibility eye to turn it on or off to see which view you prefer.

Pasting into a Selection

Instead of cutting a hole through an image, you can combine two images by using the Paste Special submenu (Edit→Paste Special). The handy commands in this submenu let you tell Photoshop exactly *where* to paste an image you've copied to your computer's clipboard:

- **Paste in Place.** Use this command to paste the image in the exact same position it lived within the document you copied it *from*. For example, if the image you copied was centered in the original document, it'll be centered when you paste it into the *new* document (even if the two documents have different dimensions). The keyboard shortcut for this command is Shift-⌘-V (Shift+Ctrl+V).

- **Paste Into.** Use this command to paste an image *inside* a selection you've made (in other words, inside the marching ants). Photoshop puts the pasted image on its own layer and creates a layer mask for you, as Figure 7-2 illustrates. You see the pasted image only in the selected area; the layer mask hides the rest of it. Keyboard shortcut: Shift-Option-⌘-V (Shift+Alt+Ctrl+V).

- **Paste Outside.** This option makes Photoshop paste the image *outside* your selection. You get an automatic layer mask, although this time the area *inside* the selection is hidden; the pasted image is visible only outside the selection. This command is useful for swapping an image frame or border. (Adobe must be running low on keyboard shortcuts because this command doesn't have one.)

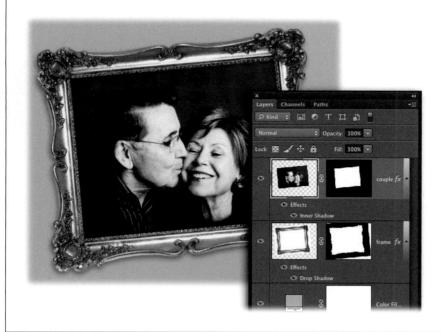

FIGURE 7-2

The Paste Into command tells Photoshop to create a layer mask that hides the outer bits of the pasted image so you see it only through the selection.

This image combination was created using Paste Into to tuck the couple inside a gold frame. Add a well-placed layer style or two (for example, drop and inner shadows) and the photo of the couple looks right at home in its new digs.

Here's how to use Paste Into to combine two images *without* deleting any pixels:

1. **Open one image and select the area where you want the other image to appear.**

 As you learned in Chapter 4, it's wise to spend a few minutes looking at the area you want to select so you can pick the best tool for the job. For example, in Figure 7-2, the picture frame has a solid white interior that you can easily select based on color. So press W to grab the Magic Wand, and then click once in the white area to summon the marching ants. (The Quick Selection tool would also work.)

 NOTE If you'd like to follow along, download the exercise file named *Framed.zip* from this book's Missing CD page at *www.missingmanuals.com/cds*.

2. **Use Refine Edge to smooth and soften the selection slightly.**

 Once you see the selection box's marching ants, click the Refine Edge button in the Options bar. The edges of Magic Wand selections tend to be a little rough, so you can use the Refine Edge dialog box to smooth them, as well as contract or expand them, if needed. (A Smooth setting of 3 and a Feather setting of 0.25 was used in this low-resolution example.)

3. **Open the image you want to put *into* the frame (the area you just selected) and then copy it to your computer's clipboard.**

 Press ⌘-A (Ctrl+A) to select the whole image and then copy it by pressing ⌘-C (Ctrl+C).

4. **Jump back to the frame document and then choose Edit→Paste Special→Paste Into or press Shift-Option-⌘-V (Shift+Alt+Ctrl+V).**

 Over in the Layers panel, Photoshop plops the pasted image onto its own layer, complete with a layer mask. In the document window, you see part of the pasted image peeking through the frame.

5. **If necessary, resize the pasted photo and adjust its position inside the frame.**

 If the photo is bigger than the frame (as in this example), you can make it smaller using Free Transform. With the pasted image layer active, press ⌘-T (Ctrl+T), and then Shift-drag one of the corner handles diagonally inward, as shown in Figure 7-3 (top) to shrink the image proportionally. Next, position your cursor inside the bounding box; the cursor turns into an arrow that lets you drag the photo around *inside* the frame (Figure 7-3, bottom). When you're done adjusting the image, press Return (Enter).

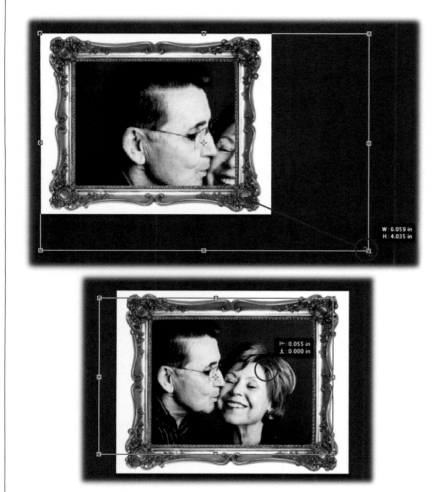

FIGURE 7-3

Top: If the photo is too big for the frame, you can resize it using Free Transform. Just make sure to press and hold Shift as you drag one of the corner handles (circled) so you don't squash or distort the image. (If the Free Transform bounding box hangs off the edges of your document, press ⌘-0 [Ctrl+0] to make Photoshop resize the document window just enough so you can see all four corners of the box. This keyboard shortcut is worth memorizing 'cause you'll use it all the time.)

Bottom: Once you get the image sized just right, click and drag within the bounding box to move it around inside the frame. (The cursor is circled here.)

6. **Lock the pasted photo and the mask together.**

 Once you get the photo sized and positioned just right, lock it to the layer mask that Photoshop created in step 4 so everything stays in place. Over in the Layers panel, click the blank space *between* the layer thumbnail and the mask thumbnail. When you do, a little chain icon appears (you can see it on each layer in Figure 7-2). At this point, you're basically finished with this image-combining technique, but you can add even *more* creativity by rotating the frame, adding a shadow, and giving it a new background. The next few steps explain how.

7. **Hide the white area around the frame with a layer mask.**

 The frame in Figure 7-2 was originally on a white background. To get rid of the white edges, activate the frame layer in the Layers panel, press W to grab the Magic Wand, and then click the white area outside the frame to select it. (If you've chosen a frame with all kinds of nooks and crannies around its edges, you can then choose Select→Similar to make sure you've got *all* the white areas selected.)

 Once you've got a good selection, use the Refine Edge dialog box to smooth the selection's edges. Then flip-flop the selection by choosing Select→Inverse to make Photoshop place the marching ants around the frame instead of the white edges. Finally, add a layer mask to the frame layer by clicking the circle-within-a-square icon at the bottom of the Layers panel.

8. **Use the Crop tool to make your canvas bigger.**

 In order to rotate the frame and add a nice, fluffy drop shadow, you need some extra canvas space. The menu command for increasing canvas size is discussed on page 270, but it's quicker to use the Crop tool: Press C to grab it, Option-drag (Alt-drag on a PC) one of the crop box's corner handles outward to make it bigger on all four sides, and then press Return (Enter). Now you've got all kinds of room to work!

9. **Activate the frame and photo layers, and then rotate them with Free Transform.**

 In the Layers panel, Shift-click both layers to activate them, and then press ⌘-T (Ctrl+T) to summon Free Transform. Position your cursor outside the bounding box that appears and, when it turns into a curved double arrow, drag upward slightly to rotate the frame and photo. When you've got them at an angle you like, press Return (Enter).

10. **Add an inner shadow to the photo layer.**

 To make the photo look like it's really *inside* the frame, it needs a shadow. First, click the photo layer so it's the only one active in the Layers panel. Next, click the *fx* at the bottom of the Layers panel and, from the menu that appears, choose Inner Shadow. Tweak the settings in the resulting Layer Style dialog box to your liking, and then click OK.

11. **Add a drop shadow to the frame layer.**

 To add a little depth and make the frame look as if it's really hanging on a wall, activate the frame layer in the Layers panel, click the panel's *fx* icon, and then choose Drop Shadow. (See page 140 for more on adding drop shadows.)

12. **Add a solid color fill layer and pick a color.**

 To complete the design, add a new, colored background beneath the frame layer. Choose Layer→New Fill Layer→Solid Color, or click the half-black/half-white circle at the bottom of the Layers panel and choose Solid Color from the menu

that appears. In the resulting Color Picker, choose the color you want for the frame's background, and then click OK. (To change this color later on, simply double-click the fill layer's thumbnail to summon the Color Picker again.)

> **TIP** If you mouse over your image while the Color Picker is open, your cursor turns into an eyedropper, which lets you click anywhere in the image to choose a color. Snatching a color that's already in the image is a *great* way to pick a background color that matches the image.

13. **Drag the solid color fill layer to the bottom of the layer stack.**

 In your document window, the background appears behind the newly framed image.

Whew! That was a lot of steps, but you're done. Be sure to save the document as a Photoshop (PSD) file in case you want to change the color of the new background. Now go find a place to digitally hang your new masterpiece.

Sky Swapping

You can also use the Paste Into technique described in the previous section to replace a bland sky with a more pleasing vista, as shown in Figure 7-4. Using the Paste Into command makes Photoshop add a layer mask *for* you, but it's just as easy to add a mask yourself (either method gets you the same result). Here's how:

1. **Open an image with an area that you want to replace (like the sky), and then select that area.**

 You can use any of the myriad selection techniques you learned in Chapter 4. The channels method—discussed on page 221 and used to create the image in Figure 7-4—is a good one, as is using the Quick Selection tool, or the Select menu's new Focus Area command (page 179), and then fine-tuning the selection using Refine Edge.

2. **Add a layer mask to hide the old sky.**

 To do so, click the circle-within-a-square icon at the bottom of the Layers panel.

> **TIP** If the mask hides the *opposite* of what you want to hide, double-click the mask in the Layers panel, and the Properties panel pops open. Click Invert near the bottom of the panel and Photoshop flip-flops the mask. Onward ho!

3. **Open and copy the image with the replacement sky.**

 Press ⌘-A (Ctrl+A) to select the whole image, and then press ⌘-C (Ctrl+C) to copy it.

4. **In the other document (the one with the mask), paste the new sky onto its own layer by pressing ⌘-V (Ctrl+V).**

If copying and pasting isn't your thing, arrange your workspace so you can see both open documents (page 63) and then drag the sky layer from the Layers panel into the other document's window (page 107). You can also drag the document from your desktop into the Photoshop document or choose File→Place Embedded.

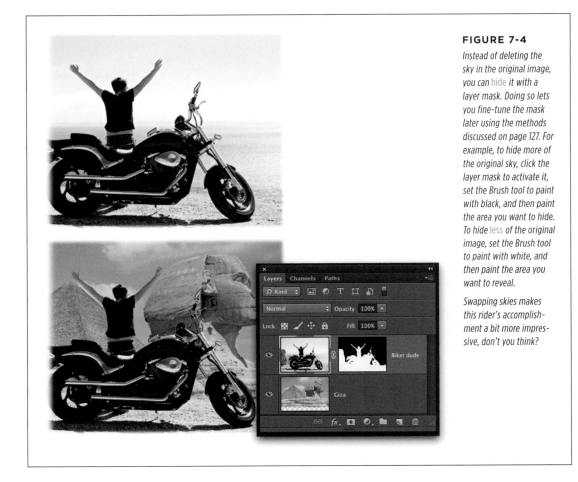

FIGURE 7-4

Instead of deleting the sky in the original image, you can hide it with a layer mask. Doing so lets you fine-tune the mask later using the methods discussed on page 127. For example, to hide more of the original sky, click the layer mask to activate it, set the Brush tool to paint with black, and then paint the area you want to hide. To hide less of the original image, set the Brush tool to paint with white, and then paint the area you want to reveal.

Swapping skies makes this rider's accomplishment a bit more impressive, don't you think?

5. **Position the sky at the bottom of the layer stack.**

In the Layers panel, drag the new sky to the bottom of the layer stack, so it's beneath the layer you masked.

You just swapped your first sky! If you want to try out other skies, just paste or drag them into the document and position them below the layer with the layer mask. Then hide the first new sky by clicking its visibility eye in the Layers panel.

◼ Fading Images Together

So far, you've learned how to combine images with relatively high contrast, such as wedging a portrait into the white part of a digital frame or adding a brand-new sky to a light-colored background. But if your soon-to-be-combined images don't have such stark boundaries, then you're better off using big, soft brushes to do your erasing or, better yet, *hiding* parts of your image with a layer mask. You can also use the Gradient tool to create a gradual transition from one image to another as if they're faded together. Read on to learn all these methods.

Soft Erasers

Because you can set the Eraser tool to use a brush cursor, you can use a soft brush to erase part of an image so you can see the image on the layer below.

Once you've wrangled the two images you want to combine into the same document (each on its own layer), grab the Eraser tool by pressing E and then, in the Options bar, set the Mode menu to Brush. Next, from the Brush Preset picker (page 530), choose a big, soft brush (see Chapter 12 for more on brushes). Then, in the Layers panel, drag the layer you want to partially erase to the *top* of the layer stack, and then mouse over to your image and simply brush away the parts you want to get rid of. If you mess up or change your mind, undo a step by pressing ⌘-Z (Ctrl+Z) or use the History panel to go back a few brushstrokes.

Sure, this technique gets the job done, but keep in mind that it's *just* as destructive as cutting a hole—if you change your mind about how to combine the images, you have to start over. A *better* idea is to do the erasing *nondestructively* by using a soft-edged brush inside a *layer mask*, as explained in the next section.

Soft Brushes and Layer Masks

A wonderfully practical and flexible way to fade two images together is to paint on a layer mask with a big, fluffy brush. That way you're merely *hiding* part of the image instead of deleting it. For example, say you want to create a striking image for a photography client by blending an image of a baseball player into an image of a baseball, as in Figure 7-5. Here's how:

1. **Combine the images into one Photoshop document with each image on a separate layer.**

 If you're following along, name the layer with the boy *player* and the other layer *baseball*.

2. **Position the player layer at the top of the stack, and then add a layer mask to it.**

 In the Layers panel, drag the player layer to the top of the layer stack. (If you're using your own images, just decide which layer you want to be on top of the collage.) Then, at the bottom of the panel, click the circle-within-a-square icon to add a layer mask.

3. **Press B to grab the Brush tool and pick a big, soft brush.**

In the Options bar, use the Brush Preset picker to choose a big (500-pixel, say), soft-edged brush.

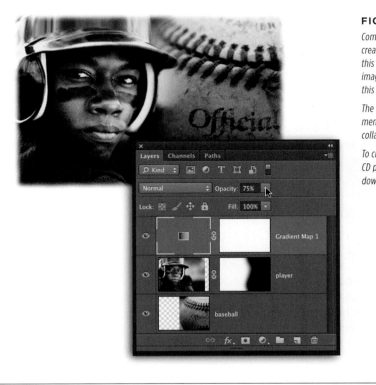

FIGURE 7-5

Combining images is a wonderful way to create eye-catching imagery. As you can see in this Layers panel, nary a pixel in the original images was harmed during the making of this collage.

The extra step of using a gradient map adjustment layer to hide most of the color in the collage creates a moody, grungy feel.

To create this collage, visit this book's Missing CD page at www.missingmanuals.com/cds *and download the file* Player.zip.

4. **Set your foreground color chip to black.**

As you learned in Chapter 3, in the realm of layer masks, painting with black *conceals*, which is what you want to do here. So peek at your color chips at the bottom of the Tools panel and, if they're black and white, press X until black hops on top. If they're not, press D to reset them to black and white and *then* press X until black is on top.

5. **Mouse over to your image and paint to hide part of the player layer.**

If you mess up and hide too much of the boy, press X to flip-flop your color chips (so white is on top) and then paint that area with white to reveal it again. You're basically done at this point, though the next step explains how to create the color effect shown in Figure 7-5.

6. **Add a black-to-white gradient map adjustment layer to the top of your layer stack and lower its opacity to 75 percent.**

 With your color chips set to black and white, press X to flip-flop them so that black is on top. Then click the half-black/half-white circle at the bottom of the Layers panel and choose Gradient Map. Photoshop drains the color from both image layers, but you can lower the adjustment layer's opacity a bit (to 75 percent or so) to bring back a *smidgeon* of color. (As you'll learn in Chapter 8, a gradient map adjustment layer creates beautiful high-contrast black-and-white images.)

7. **Save the document as a PSD file so you can go back and tweak it later on.**

 After seeing the final version, you may decide to tweak the adjustment layer's opacity to achieve the color effect you want. In that case, you can pop open the document, activate the adjustment layer, and then change its settings without having to start over.

If you're a pro photographer, this kind of collage is a *fantastic* additional product to offer your clients...for an extra fee, of course!

Gradient Masks

The way to create the smoothest fades between two images is to use a *gradient*—a gradual transition from one color to another. The steps for combining two images using a gradient are basically the same as the soft-brush method in that you're adding both images to one Photoshop document and then adding a layer mask to the top layer. But instead of painting inside the layer mask with a brush, you use a black-to-white gradient for a smooth and seamless fade from one image to the other, as shown in Figure 7-6.

Once you've put two images into one document (each on its own layer), take a spin through these steps:

1. **In the Layers panel, drag the image you want on the top of the collage to the top of the layer stack and then add a layer mask to it.**

 In this example, you want the baby image on top, so drag it to the top of the Layers panel. Then add a layer mask to it by clicking the circle-within-a-square icon at the bottom of the panel. The layer mask's thumbnail appears in the Layers panel, but your document doesn't change because the mask is empty. (Technically the mask is white, but because "black conceals, white reveals," a white mask fully reveals the layer.)

2. **Press G to grab the Gradient tool, and then choose a black-to-white, linear gradient.**

 In the Options bar, click the down-pointing triangle labeled in Figure 7-6 (top) to open the Gradient picker. From the preset menu that appears, choose the black-to-white gradient (third from left in the top row) and, in the Options bar's row of gradient types, click the linear gradient button (circled in Figure 7-6, top).

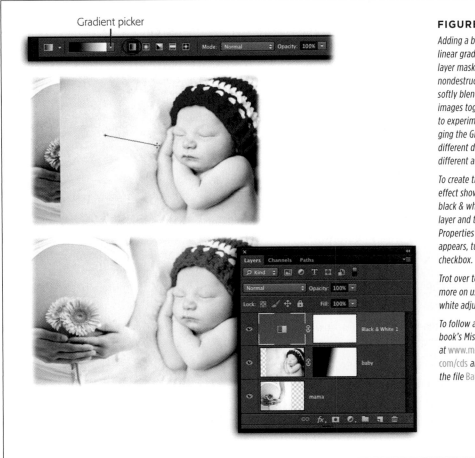

Gradient picker

FIGURE 7-6

Adding a black-to-white linear gradient to a layer mask is an easy and nondestructive way to softly blend two or more images together. Be sure to experiment by dragging the Gradient tool different distances and at different angles.

To create the sepia-tint effect shown here, add a black & white adjustment layer and then, in the Properties panel that appears, turn on the Tint checkbox.

Trot over to page 330 for more on using black & white adjustment layers.

To follow along, visit this book's Missing CD page at www.missingmanuals. com/cds and download the file Baby.zip.

3. **Mouse over to your image, click where you want the fade to begin, drag slightly downward and to the right, and then let go of your mouse.**

 As you drag, Photoshop draws a line that represents the width of the fade: The shorter the line (the less distance you drag), the narrower the fade and the harsher the transition (it won't be a hard edge, but it'll be close); the longer the line, the wider the gradient and the softer the fade. As soon as you release your mouse button, Photoshop plops the gradient into the layer mask, which effectively fades your images together. If you're not happy with the gradient, just keep clicking and dragging until you get it right; Photoshop updates the mask automatically. To empty the mask and start over, make sure the mask's thumbnail is active in the Layers panel, select the whole thing by pressing ⌘-A (Ctrl+A), and then press Delete (Backspace on a PC).

4. **Save the document as a PSD file so you can go back and edit the gradient mask later.**

Not bad, eh? Incidentally, this technique is a *great* example of how to use your own images along with stock photos. Just think of the possibilities: a wedding photo faded into a bouquet of flowers, piano keys faded into a sheet of music, Captain Kirk faded into a shot of the Starship Enterprise, and so on.

TIP You can also *rotate* a layer to get the image in the right spot for your collage. Just activate the layer you want to twirl and then summon Free Transform by pressing ⌘-T (Ctrl+T). Next, position your cursor just outside a corner of the bounding box that appears, and when your cursor turns into a double-sided arrow, click and drag in the direction you want to rotate the image. Press Return (Enter on a PC) when you're finished.

Layer Blend Modes

Perched near the top-left corner of the Layers panel is an unlabeled menu of *blend modes*, which control how pixels on different layers interact with one another. (Unless you change it, this menu is set to Normal.) For example, when layers overlap, the top one can either block the bottom one completely, or the colors on those layers can blend together in some way (these effects, and many more, are shown in Figure 7-7). You control exactly *how* the colors blend together by using blend modes.

This section covers how to use *layer* blend modes, but you can find other blend-mode menus all over the place in Photoshop:

- In the Layer Style dialog box, where you can add effects like drop shadows, glows, and so on (page 141).

- In some filters' dialog boxes and in *most* filters' Blending Options dialog box, which you get by using smart filters (see Chapter 15).

- In the Fade dialog box, which you can access via Edit→Fade *right* after you run a filter (see the box on page 493) or after applying most of the adjustments in the Image→Adjustments menu.

- In the Options bar when you're using a tool you can paint with, like the Brush, Paint Bucket, Healing Brush, Pencil, Clone Stamp, History Brush, Gradient, Blur, Sharpen, and Smudge tools, and the shape tools (when they're set to Pixel drawing mode).

- In the Calculations (page 229) and Apply Image dialog boxes. (To learn how to combine two images using the Apply Image command, which lets you pick the *channel* Photoshop uses to do the blending, head to this book's Missing CD page at *www.missingmanuals.com/cds*.)

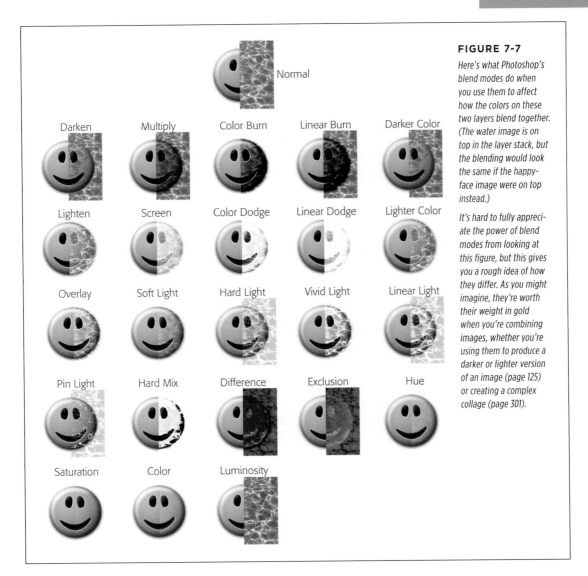

FIGURE 7-7

Here's what Photoshop's blend modes do when you use them to affect how the colors on these two layers blend together. (The water image is on top in the layer stack, but the blending would look the same if the happy-face image were on top instead.)

It's hard to fully appreciate the power of blend modes from looking at this figure, but this gives you a rough idea of how they differ. As you might imagine, they're worth their weight in gold when you're combining images, whether you're using them to produce a darker or lighter version of an image (page 125) or creating a complex collage (page 301).

TIP To get acquainted with these blend modes, try duplicating an image layer and then using your keyboard to cycle through 'em all: Press Shift-+ to go forward through the blend mode menu or Shift-– (that's the minus key) to go backward—there's no need to open the blend-mode menu near the top of the Layers panel (though you'll see it change as you press these keys). That said, if the currently active tool has its own blend-mode menu in the Options bar, these keyboard shortcuts change *that* blend mode menu instead.

When you're dealing with blend modes, it's helpful to think of the colors on your layers as being made up of three parts, as shown in Figure 7-8:

- **Base.** This is the color you start out with, the one that's already in your image. While layer stacking order doesn't matter with *most* blend modes, you can think of the base color as the color on the bottommost layer.

- **Blend.** This is the color you're *adding* to the base color, whether it's in an image on another layer or a color you've added to another layer using one of Photoshop's painting tools.

- **Result.** This is the color you get after mixing the base and blend colors using a blend mode.

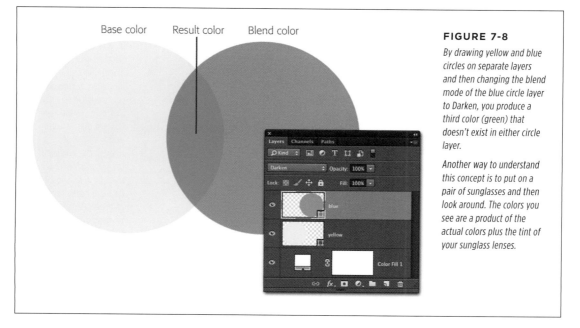

FIGURE 7-8

By drawing yellow and blue circles on separate layers and then changing the blend mode of the blue circle layer to Darken, you produce a third color (green) that doesn't exist in either circle layer.

Another way to understand this concept is to put on a pair of sunglasses and then look around. The colors you see are a product of the actual colors plus the tint of your sunglass lenses.

To help you make sense of Photoshop's growing set of blend modes (and you'll need all the help you can get), the blend mode menu is divided into categories based on each mode's *neutral color*—the color that causes *no* change in that particular mode. For example, some modes ignore white, some ignore black, and so on. This info doesn't mean a hill of beans to you just yet, but it'll start to make sense as you learn more about the various modes in the next few pages. Here's a quick tour of the Layers panel's blend mode menu.

Normal and Dissolve Blend Modes

These two modes are at the very top of the blend mode menu. Here's what they do:

- **Normal.** All the layers you create in Photoshop are initially set to this mode, which *prevents* any color blending; as Figure 7-7 shows, the pixels on the top

layer (the water image) totally block what lies below (the happy face). This mode's keyboard shortcut is Shift-Option-N (Shift+Alt+N on a PC).

> **NOTE** Photoshop includes a slew of keyboard shortcuts for changing the current layer's blend mode. However, if you're using one of the painting tools listed at the beginning of this section (page 296), these shortcuts change the Options bar's blend mode setting for that particular *tool* instead of changing the *layer's* blend mode.

- **Dissolve.** This mode turns semi-transparent pixels into a spray of dots (if you don't have any semi-transparent pixels, your image won't change). You can use Dissolve to make a drop shadow look coarse instead of soft (see Figure 7-9), or to add shading to an object you've drawn in Photoshop (see the box on page 544). Keyboard shortcut: Shift-Option-I (Shift+Alt+I).

FIGURE 7-9

To create the spatter effect shown here (bottom), add a drop shadow using layer styles (page 140) and then, in the Layer Style dialog box, change the shadow's blend mode to Dissolve. (Because the drop shadow was made with the Layer Style dialog box, that's also where you need to change the blend mode). Photoshop changes the formerly see-through drop shadow into a spray of pixels.

Darken Blend Modes

The modes in this category have the power to darken, or *burn*, images (see page 463 for an explanation of this darkroom term). Simply put, when you apply these modes, the base and blend colors go to war and the darkest color wins, meaning you end up with a *darker* image than you started with. These modes are incredibly useful when you want to swap a light-colored background for something darker, or when you're adding texture to a collage (also called a composite). The neutral color in this category is white, which means that white has no effect on the blend at all. (If you're dealing with a two-layer document and only one of those layers contains white, the white parts of that layer are hidden.)

- **Darken.** In this mode, Photoshop analyzes each channel in the image, compares the base and blend colors, and keeps the *darkest* ones, which become the result color (layer order doesn't matter). Colors darker than the blend color don't change, but colors lighter than the blend color are replaced with the result color. This mode is helpful when swapping a light background for something darker, and for fixing areas in an image that are too light or overexposed. Keyboard shortcut: Shift-Option-K (Shift+Alt+K on a PC).

- **Multiply.** In Multiply mode, Photoshop analyzes each channel and *multiplies* (increases) the base color by the blend color (layer order doesn't matter). You can think of this mode like a double coat of ink since the result color will always be darker than the base. Multiply does a lot of cool things, including fixing images that are too light or overexposed (see page 125), or creating an *overprint* effect in which the graphic on the top layer looks like it's been printed on the layer below (like the fake tattoo in Figure 7-10). Keyboard shortcut: Shift-Option-M (Shift+Alt+M).

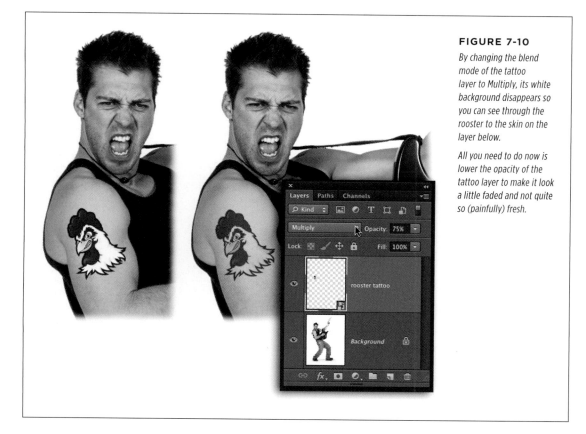

FIGURE 7-10

By changing the blend mode of the tattoo layer to Multiply, its white background disappears so you can see through the rooster to the skin on the layer below.

All you need to do now is lower the opacity of the tattoo layer to make it look a little faded and not quite so (painfully) fresh.

- **Color Burn.** In this mode, Photoshop looks at each channel and then darkens the image by increasing the contrast between the base and blend colors (layer order matters when using this mode). The darker the blend color, the darker and more high-contrast the base color becomes. When you use this mode on a layer filled with 50 percent gray (explained in the Tip below), it intensifies color on the layers below, which can beautify an ugly sky in a hurry. You can also use this mode on a dark-colored texture to add depth and interest to a light background on the layer below. To make the effect of this blend mode more subtle, try reducing the layer's *Fill* setting instead of its Opacity setting (page 99). Keyboard shortcut: Shift-Option-B (Shift+Alt+B).

TIP Fifty percent gray is, as you might suspect, the color exactly halfway between pure black and pure white. An easy way to fill a layer with 50 percent gray is to make a new layer, go to Edit→Fill, and then choose 50% Gray from the Use drop-down menu. Those Photoshop engineers think of everything!

- **Linear Burn**. In this mode (which is actually a combination of Multiply and Color Burn), Photoshop analyzes each channel and then darkens your image by decreasing the brightness between the base and blend colors (layer order doesn't matter); the darker the blend color, the darker the result. Linear Burn produces the darkest colors of any darken blend mode, though with a bit more contrast than the others. It has a tendency to turn dark pixels solid black, which makes it ideal for grungy, textured collages like the one in Figure 7-11. Keyboard shortcut: Shift-Option-A (Shift+Alt+A).

FIGURE 7-11

In this Layers panel, you can see the original image near the bottom and a threshold adjustment layer above it (see page 342 for more info). Popping in two pieces of art (circled) and changing their blend modes to Linear Burn created this trendy ad.

Happily, Photoshop lets you change the blend mode of multiple layers at once by activating them and then choosing a new option from the blend mode menu (this fabulous feature was added back in CS6).

- **Darker Color.** This mode compares the total numeric value of all channels for the base and blend colors and then keeps the lower values, resulting in the darkest pixels. There's no blending going on here—the lighter colors just vanish, making this mode ideal for removing white backgrounds (a technique sometimes called "knocking out"), as Figure 7-12 illustrates. (Darker Color doesn't have a keyboard shortcut, because this mode didn't come around until Photoshop CS3 when Adobe apparently started running out of keyboard shortcut combos! Same goes for Lighter Color mode [page 304]).

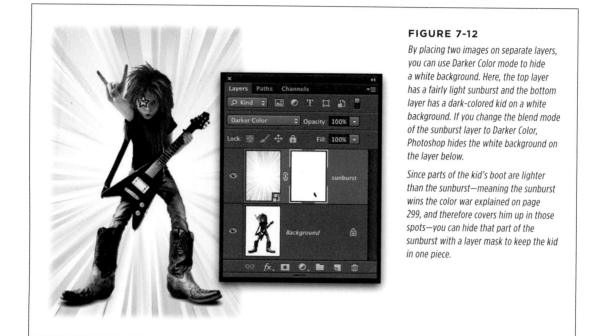

FIGURE 7-12

By placing two images on separate layers, you can use Darker Color mode to hide a white background. Here, the top layer has a fairly light sunburst and the bottom layer has a dark-colored kid on a white background. If you change the blend mode of the sunburst layer to Darker Color, Photoshop hides the white background on the layer below.

Since parts of the kid's boot are lighter than the sunburst—meaning the sunburst wins the color war explained on page 299, and therefore covers him up in those spots—you can hide that part of the sunburst with a layer mask to keep the kid in one piece.

Lighten Blend Modes

These modes, not surprisingly, do the *opposite* of the darken modes: They lighten, or *dodge*, your image (see page 378 info on the Dodge tool). Black is the neutral color for this group; it disappears in all but one of the following modes:

- **Lighten.** In this mode, the lightest pixels win the color war (layer order doesn't matter). Photoshop analyzes each channel and keeps the *lightest* ones from the base and the blend. Pixels lighter than the blend color don't change, and pixels darker than the blend are replaced with the result color. Everything else is nixed (including black), which makes this mode useful for blending a dark background with something lighter (see Figure 7-13). Keyboard shortcut: Shift-Option-G (Shift+Alt+G on a PC).

- **Screen.** In this mode, Photoshop analyzes each channel and then multiplies the *opposite* of the blend and base colors, making everything a lot lighter as though a bottle of bleach was spilled on it (layer order doesn't matter). It's *great* for fixing images that are too dark or underexposed (like when your camera's flash doesn't fire; see page 126), and it's just the ticket for brightening eyes (page 466). Keyboard shortcut: Shift-Option-S (Shift+Alt+S).

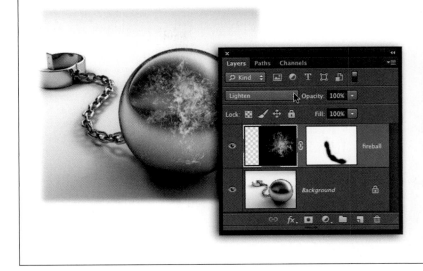

FIGURE 7-13

To hide most of the black background of this fireball, change its blend mode to Lighten. Now the flames are visible only where they're lighter than the colors in the steel ball.

A layer mask was added to the fire layer to hide a few rogue flames that appeared underneath the ball.

- **Color Dodge.** The opposite of Color Burn, this mode makes Photoshop look at each channel and then lighten your image by *decreasing the contrast* between the base and blend colors (layer order matters when using this mode). The lighter the blend color, the lighter and less contrast-y the base color becomes. This mode has a tendency to turn light pixels solid white, and—unlike the other lighten blend modes—it keeps black pixels, so the dark parts of the image don't change. You can use this mode on a light-colored texture to add depth and brightness to a dark background on the layer below. And by using it on a layer filled with 50 percent gray, you can give dark hair instant highlights, as shown in Figure 7-14). Keyboard shortcut: Shift-Option-D (Shift+Alt+D).

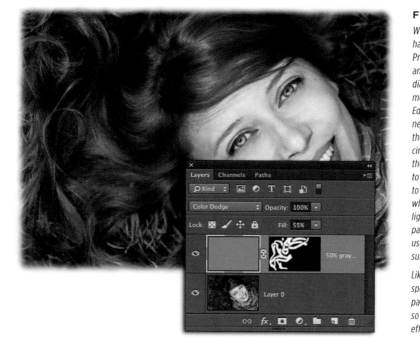

FIGURE 7-14

Wish your model (or even you) had highlights? No problemo. Press ⌘-Shift-N (Ctrl+Shift+N) and, in the resulting New Layer dialog box, change the blend mode to Color Dodge. Use the Edit→Fill command to fill the new layer with 50% gray, and then Option-click (Alt-click) the circle-within-a-square icon at the bottom of the Layers panel to add a solid black layer mask to hide the lightening from the whole image. Next, reveal the lightening—in other words, paint highlights onto the hair—using a soft white brush (be sure to get close to the roots!).

Like Color Burn, Color Dodge responds differently to the Layers panel's Fill and Opacity settings, so try reducing Fill to make the effect more subtle.

- **Linear Dodge (Add).** This mode causes Photoshop to peek at each channel and then lighten your image by increasing the brightness between the base and blend colors (layer order doesn't matter); the lighter the blend color, the brighter the result. This mode is a combo of Screen and Color Dodge modes, so it lightens images more than any other blend mode. But since it tends to turn *all* light colors white, it can make images look unnatural (though it can be useful in adding lighter texture to a dark background). Keyboard shortcut: Shift-Option-W (Shift+Alt+W).

- **Lighter Color.** With this mode, Photoshop compares the total numeric value of all channels for the base and blend colors and then keeps the higher values, resulting in the lightest pixels. There's no color blending in this mode; the darker colors simply disappear. If you're trying to replace a dark background with something lighter, give this mode a spin. (Alas, there's no keyboard shortcut for this mode.)

Lighting (Contrast) Blend Modes

In contrast to the lighten and darken blend modes described above, lighting blend modes do a little darkening *and* a little lightening to increase the contrast of images.

They have a neutral color of 50 percent gray, which doesn't affect the result color; it just disappears.

- **Overlay.** In this mode, if the base color is *darker* than 50 percent gray, Photoshop multiplies its color value with the base color. If the base color is *lighter* than 50 percent gray, Photoshop multiplies its color value with the *inverse* of the base color (like it does in Screen mode). You can use this mode to increase contrast or colorize a grayscale image. It's also commonly used in conjunction with the High Pass filter to sharpen images (page 494). Keyboard shortcut: Shift-Option-O (Shift+Alt+O on a PC).

- **Soft Light.** As its name suggests, this mode is equivalent to shining a soft light on your image. It makes any areas that are lighter than 50% gray even *lighter* (as if they were dodged) and areas that are darker than 50% gray even *darker* (as if they were burned). If you paint with black in this mode, you'll darken the underlying image layer; if you paint with white, you'll lighten it. You can use this mode to add texture to an image or make it look like it's reflected in metal (see Figure 7-15). Seasoned Photoshop jockeys use Soft Light on a layer filled with 50% gray to make the Brush tool behave like nondestructive versions of the Dodge and Burn tools (page 462 has the scoop). Keyboard shortcut: Shift-Option-F (Shift+Alt+F).

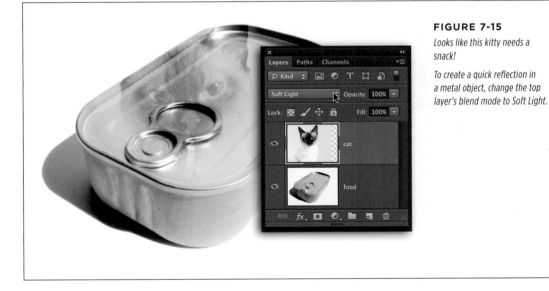

FIGURE 7-15

Looks like this kitty needs a snack!

To create a quick reflection in a metal object, change the top layer's blend mode to Soft Light.

- **Hard Light.** This mode, which is equivalent to shining a harsh light on your image, combines Multiply and Screen modes: If the blend color is *lighter* than 50 percent gray, the image gets lighter (like Screen mode); if it's *darker* than 50 percent gray, the image gets darker (like Multiply). If you paint with black or white in this mode, you simply get black or white. If you *really* want to increase the level of detail in an image—say, if you're trying to fix a slightly blurry

image—use this mode in conjunction with the Emboss filter (page 712). You can also use Hard Light with the High Pass filter to sharpen an image (page 494); doing so produces a slightly stronger sharpening effect than using Overlay mode. Keyboard shortcut: Shift-Option-H (Shift+Alt+H).

- **Vivid Light.** In this mode, Photoshop applies Color Burn to increase the contrast of colors that are *darker* than 50 percent gray and Color Dodge to decrease the contrast of colors that are *lighter* than 50 percent gray (layer order matters in this mode). Use Vivid Light to make the colors in an image really pop, or use it on another image layer to add texture. Keyboard shortcut: Shift-Option-V (Shift+Alt+V).

- **Linear Light.** This mode combines Linear Burn and Linear Dodge blend modes: It uses Linear Burn to decrease the brightness of colors *darker* than 50 percent gray and Linear Dodge to increase the brightness of colors *lighter* than 50 percent gray. Linear Light is great for adding texture to images, as shown in Figure 7-16. Keyboard shortcut: Shift-Option-J (Shift+Alt+J).

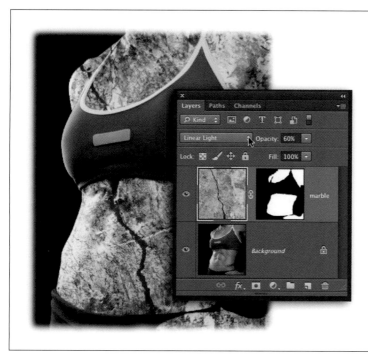

FIGURE 7-16

Want to turn a loved one to stone? Simply use the Quick Selection tool to select the person's skin, and then add a layer mask to a layer containing marble or stone (like the top layer here). Change the marble layer's blend mode to Linear Light, and you've got an instant statue.

In this example, the opacity of the marble layer was lowered to 60 percent to reveal more of the skin tone.

- **Pin Light.** This mode combines Lighten and Darken: If the blend color is *lighter* than 50 percent gray, it replaces areas of the base color that are darker than 50 percent gray with the blend color; pixels that are lighter than 50 percent gray don't change. If the blend color is *darker* than 50 percent gray, Pin Light replaces lighter areas of the base color with the blend color, and the darker areas don't change. You'll rarely use this mode because it can produce odd results (or none

at all), but feel free to experiment with it—especially with filters (see Chapter 15). Keyboard shortcut: Shift-Option-Z (Shift+Alt+Z).

- **Hard Mix.** This mode reduces the range of colors in your image to six (plus black and white)—an effect known as *posterizing*—so you end up with large blocks of super-bright colors like red, green, and blue. In this mode, Photoshop takes the sum of the RGB values in the blend color and adds them to the base color. For example, if the value of the red, green, or blue channel is 255, Photoshop adds that value to the base; if the value is less than 255, Photoshop doesn't add anything to the base. (See the box on page 42 for more on color values.) You can reduce the effect of this mode to a visually pleasing level by lowering the Fill setting of the layer you set to Hard Mix to about 25 percent, resulting in a nice contrast boost (see Figure 7-17). Keyboard shortcut: Shift-Option-L (Shift+Alt+L).

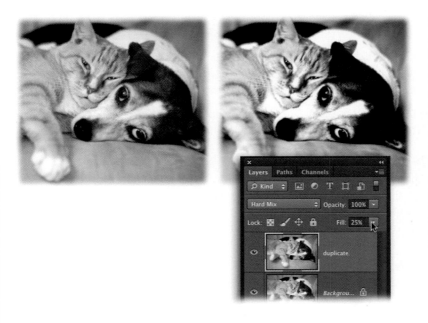

FIGURE 7-17

In Hard Mix mode, Photoshop changes all the pixels to primary colors (see the figure on page 360), leaving you with solid blocks of bright, high-contrast color. By lowering that layer's Fill setting to 25 percent, you get a nice color boost.

As you can see here, combining images isn't just about using different images; there's opportunity aplenty to combine different versions of the same image.

TIP To quickly change the Layers panel's Fill setting to 25 percent, press Shift-2-5. To change its *Opacity* setting instead, just press the number you want to apply, such as 2-5. You can also set Fill to zero by pressing Shift-0-0, and Opacity to zero by pressing 0-0 respectively. (All of these shortcuts work only if you're *not* currently using the Brush, Spot Healing, or Healing Brush tools.)

Comparative Blend Modes

This category could be called "psychedelic" as its modes can produce freaky results that are really only useful on Halloween or in grungy collages. However, as you'll soon find out, they can be *temporarily* useful. Black is the neutral color in these modes.

- **Difference.** This mode compares the brightness of both the base and the blend colors and subtracts the brightest pixels. If you use white as your blend color, Photoshop inverts (flip-flops) the base color, making the image look like a film negative. You can use this mode to locate the midtones in an image (see the box on page 408 for details) and to *align* two layers that contain different versions of the same image (if, say, they were shot at different exposures or if you're trying to create one perfect shot from many): Just change the top layer to Difference mode and then use the arrow keys on your keyboard to move the image until both versions line up (at which point you don't see any colored outlines, and the image looks mostly black). Keyboard shortcut: Shift-Option-E (Shift+Alt+E on a PC).

- **Exclusion.** This mode is *similar* to Difference but results in a little less contrast. Blending with white inverts the base color. This mode produces some fairly freaky effects so you won't use it much. That said, you can use Exclusion to align images by following the steps in the previous bullet point. Keyboard shortcut: Shift-Option-X (Shift+Alt+X).

- **Subtract.** This mode subtracts the blend color from the base color, which significantly *darkens* your image (layer order matters with this mode). The results are practically the same as inverting the colors on a given layer (see page 362).

- **Divide.** This mode divides the blend color by the base color, which significantly *brightens* your image. It's used a lot in astrophotography and microscopy.

Composite Blend Modes

All the modes in this category relate to color and luminance (brightness) values. Depending on the colors in the layers you're working with, Photoshop applies one or two of these values to produce the result color (these modes don't have a neutral color). Composite blend modes are extremely practical because you can use 'em to change, add, or intensify colors.

- **Hue.** This mode keeps the lightness and saturation (color intensity) values of the base color and adds the *hue*—a pure color that hasn't yet been lightened with white or darkened with black—of the blend color. Use this mode to change an object's color without changing how light or dark it is (see page 354). However, this mode *can't* introduce a color that isn't already there in order to colorize a black-and-white image, so you have to use another mode for that (like Color, explained in a sec). Keyboard shortcut: Shift-Option-U (Shift+Alt+U on a PC).

- **Saturation.** This mode keeps the luminance and hue of the base color and picks up the *saturation* of the blend color. This mode can help increase an image's color intensity (though try using a vibrance adjustment layer first [page 426], as it usually produces better results). You can also use this mode to drain color from part of an image by painting that area black; because black has no saturation value, black *desaturates* any colors that intersect with it. Keyboard shortcut: Shift-Option-T (Shift+Alt+T).

- **Color.** In this mode, Photoshop keeps the luminance of the base color and picks up the hue and saturation of the blend color, which makes it handy for colorizing black-and-white images (see page 363). Keyboard shortcut: Shift-Option-C (Shift+Alt+C).

- **Luminosity.** This mode keeps the base color's hue and saturation and picks up the blend color's luminance. Use this mode to keep your image's colors from shifting when you're sharpening (page 486) or using a Curves or Levels adjustment layer (see Chapter 9). Keyboard shortcut: Shift-Option-Y (Shift+Alt+Y).

Hiding Backgrounds with Blending Sliders

If the subject of your image is radically brighter or darker than its background, you'll want to sit up and pay attention to this section. While blend modes are pretty powerful in their own right (and several of 'em can instantly pulverize a white or black background), *another* set of blending options in the Layer Style dialog box can eat backgrounds for lunch—nondestructively!

Photoshop gives you a few different ways to open the Layer Style dialog box (Figure 7-18). Once you've activated the image layer you want to work with, open the dialog box using one of the following methods:

- **Double-click the layer's thumbnail in the Layers panel**.

- **Click the *fx* at the bottom of the Layers panel and choose Blending Options**.

- **Choose Layer→Layer Style→Blending Options**.

> **NOTE** The Blending sliders don't work on locked background layers. So before you use them, you have to unlock the background layer by single-clicking its padlock icon in the Layers panel.

UP TO SPEED

Pass Through Mode

When you create a layer *group* (a folder for layers; see page 111), Pass Through appears at the top of the Layers panel's blend mode menu. In this mode, Photoshop makes sure that any blend modes, blending slider settings, opacity settings, and fill settings you've applied to layers in the group trickle down to layers *below* the group.

For example, say you're making a grunge collage so you've created a layer group consisting of several image layers set to Linear Burn mode. Pass Through mode makes the Linear Burn effect trickle down to any layer content *below* the group. If you *don't* want the blending to affect the layers below the group, change the group's blend mode to Normal instead.

FIGURE 7-18

You can use the Blend If sliders in this dialog box to make short work of removing solid-colored backgrounds. In this image, the black background has been hidden by dragging the shadow slider to the right.

To soften the edges of the bits that remain, you can split the slider in half (as described momentarily) and then drag its left half back toward the left of the This Layer slider, as shown here (circled).

If you save your document as a PSD file, you can adjust these sliders any time you want by simply double-clicking the layer's thumbnail in the Layers panel to summon this dialog box.

At the bottom of the Layer Style dialog box lie two pairs of sliders (they look like triangles): one set for the This Layer bar and another for the Underlying Layer bar, shown in Figure 7-18. Each slider lets you make parts of your image transparent based on the brightness value of the pixels. The left-hand sliders represent the shadows (blacks) in the image, and the right-hand ones represent the highlights (whites). To affect the currently active layer, tweak the This Layer slider (you'll learn about the Underlying Layer slider in a minute).

For example, if the active layer's background is black and the subject (or object in the foreground) is much brighter, you can hide the black part by dragging the shadow slider (the black one on the left) right toward the middle of the This Layer bar until the black part of the image is transparent. To hide a white background instead, drag the highlight slider (the light-colored one on the right) left toward the middle of the bar until the white part of the image is transparent.

The only problem with hiding a portion of an image in this way is that the edges of the *remaining* bits of the image appear jagged. The fix is to *soften* the edge pixels by splitting the shadow or highlights slider in half to make the edge pixels partially *transparent*. To

soften the edge pixels after you've hidden a black background, for example, Option-drag (Alt-drag on a PC) the left half of the shadows slider slightly back to the left (circled in Figure 7-18). Likewise, if you've hidden a white background, you can Option-drag (Alt-drag) the right half of the highlights slider slightly to the right to tell Photoshop to make pixels with that particular brightness value partially transparent.

TIP You can perform this pixel-hiding magic on colors, too. Just pick the channel you want to work with from the Layer Style dialog box's Blend If menu, and then that particular *color* appears in the bars below it instead of shades of gray.

The Underlying Layer sliders let you control the range of visible colors on layers *below* the active layer. As you drag the sliders, parts of the image on underlying layers appear *through* the pixels on the active layer as though you'd cut a hole in it. If you drag the shadows slider right toward the middle of the Underlying Layer bar, you'll begin to see the *darkest* parts of the underlying image show through the active layer. If you drag the highlight slider left toward the middle of the bar, you'll start to see the *lightest* parts of the underlying image.

As Figure 7-19 shows, the blending sliders can do an amazing job of hiding backgrounds based on color. But if your *subject* contains some of the same colors that are in the background, the blending sliders will hide those areas, too. In that case, you'll have to use a different method to hide the background, like another blend mode or a layer mask (as discussed earlier in this chapter).

FIGURE 7-19

Once you've hidden the black in this Matrix-like background, you can see through to the image on the layer below, which makes for a quickie collage.

In the Layers panel, Photoshop adds a special badge to the right of the layer's name to let you know its blending options have changed; the badge looks like two intersecting squares and is visible on the matrix layer here.

■ Auto-Aligning Layers and Photomerge

If you've ever needed to combine a few group shots to get an image where everybody is smiling and their eyes are open, you'll appreciate the Auto-Align Layers command. Sure, you can *manually* align layers (using the Difference blend mode; page 308), but when you run this command, Photoshop does all the hard work *for* you by examining the active layers and aligning them so identical areas overlap (see Figure 7-20).

FIGURE 7-20

The Auto-Align Layers command is great for merging a few imperfect shots into one perfect image (or at least one where each subject is smiling). To do that, combine the images into one document and place the non-smiling layer (left) above the smiling layer (right). Then run the Auto-Align layers command. Finally, add a layer mask to the top layer and then paint the non-smile away with a black brush so your smiling pal shows through from the layer below!

Once you've arranged your images on different layers in the same document—they need to be *exactly* the same size or pixel dimensions—activate at *least* two layers by Shift- or ⌘-clicking them (Ctrl-clicking on a PC) in the Layers panel. Next, choose Edit→Auto-Align Layers (this menu item is dimmed unless you have two or more layers activated). In the resulting dialog box, choose an alignment method:

- **Auto.** If you're not sure which method will work best to align your images, choose this method to let *Photoshop* decide. The program picks either Perspective or Cylindrical, depending on which one it thinks will create the best composition. It usually does a good job of aligning images, though you may notice some distortion (as explained in the following bullet points).

- **Perspective.** When you choose this method, Photoshop adjusts the four corners of your layers and repositions, stretches, and skews each one so any overlapping areas match in perspective. The final image looks slightly *warped*—both ends are a little larger than the center of the image, as if they were closer to you. This method can also make one of your layers look like it's coming out of the screen toward you, which can be visually interesting.

- **Collage.** This method tells Photoshop to scale, rotate, and reposition the layers to align their overlapping content *without* changing their shape. Choose this method if you don't want your images to get distorted.

- **Cylindrical.** If you're combining several images into a *panorama*, choose this option. In addition to repositioning, stretching, and skewing your layers, Cylindrical helps get rid of any bow-tie lens distortion (where the subject looks like it's being pinched inward) by curving the images slightly (see Figure 7-21, middle).

FIGURE 7-21

Top: You can use the Auto-Align Layers command or Photomerge (page 314) to stitch these forest images together.

Middle: To compensate for bow-tie lens distortion, the Cylindrical alignment method curves the final image slightly (notice that the top and bottom edges of the image aren't straight).

Bottom: The Spherical method gives you a perfectly rectangular panorama.

Honestly, the Auto-Align Layers command isn't magic. For it to work, all the shots need to have the angle and the same distance from the subject. However, this command takes a peek at the lens-correction profiles specified in the Lens Correction dialog box (page 679), which helps it accurately align layers and create panoramas.

When you auto-align layers, Photoshop automatically picks its own reference layer—the layer it tries to align all the other layers with. However, you can designate reference layer your own by activating the layer you want Photoshop to use, and then clicking the Lock All layer icon (the padlock) near the top of your Layers panel (see page 110). Photoshop generally does a decent job of selecting a reference layer, but now you know how to change it if you're unimpressed with the results you get with the Auto-Align Layers command.

- **Spherical.** Like Cylindrical, this method repositions, stretches, and skews layers to match up overlapping areas. It also tries to correct barrel distortion (where the subject looks rounded) by making the panorama perfectly rectangular (see Figure 7-21, bottom).

- **Reposition.** If you're aligning a group shot to hide a frown or closed eyes, choose this option. It won't stretch or skew the layers; it'll just reposition them so they line up.

The Auto-Align Layers dialog box also gives you two ways to correct camera lens distortion. Turn on Vignette Removal to get rid of darkened or soft edges caused by

wide-angle lenses, and Geometric Distortion to make Photoshop warp your image slightly to reduce the spherical look caused either by wide-angle lenses or by being too close to your subject with a regular lens.

Once you've aligned the images, hop to the bottom of this page to see how to make Photoshop blend 'em together seamlessly using the Auto-Blend command.

Building Panoramas with Photomerge

Photoshop has an automatic photo-stitcher, called Photomerge, that gives you *all* the same options as the Auto-Align Layers dialog box, but you don't have to combine the images into a single document first—Photoshop does that *for* you. This is really helpful when you're merging images into a wide shot, though you *can't* use it to manually arrange your images into a panorama (that feature disappeared back in CS4).

To use Photomerge, choose File→Automate→Photomerge. In the resulting dialog box's Use menu, tell Photoshop whether you want to use individual files or a folder. Then click Browse to find the images on your hard drive, or, if you've already opened the documents, click Add Open Files. On the left side of the dialog box, pick an alignment method or leave it set to Auto so Photoshop will choose for you. If you want Photoshop to use layer masks to help cover up any seams, leave Blend Images Together turned *on* (this setting has the same effect as running the Auto-Blend command discussed in the next section). The Vignette Removal and Geometric Distortion Correction settings work the same way here as they do in the Auto-Align Layers dialog box.

When you've got all the settings the way you want them, click OK. Photoshop combines your images into a new document with each image on its own layer, rotated and positioned to fit with all the others. All you need to do now is crop the image to get rid of any transparent bits around the edges, or recreate that portion of the image by hand using the Clone Stamp tool or the Content-Aware Scale command.

TIP You'll find cropping and cloning easier if you stamp (page 119) or flatten (page 118) the layers first—though, if you pick the latter method, be sure to choose File→Save As and give the document another name so you can flatten it without accidentally saving over the original. Also, you can choose Edit→Content-Aware Scale (page 271) to slightly *stretch* the image to fill in empty pixels so you don't have to crop it quite so much.

▉ Auto-Blending Layers

The Auto-Blend Layers command was designed to be used after the Auto-Align Layers command. It helps you blend images for a panorama or collage, or combine multiple exposures of the same image to create an extended *depth of field* so more of an object looks like it's in focus (though you can also use it for special effects like the ballerina pictured in this section). When you use this command, Photoshop creates complex layer masks to blend your images together, saving you a *lot* of masking time.

To get the best results, run the Auto-Align Layers command as explained on page 312, and then choose Edit→Auto-Blend Layers. In the resulting dialog box (Figure 7-22, left), choose a blending option:

- **Panorama.** Pick this option to have Photoshop search for overlapping areas in your images so it can piece them together into a *single* image.

- **Stack Images.** If you've fired off several shots of an object with different parts of it in focus (known as different depths of field) and you want to combine them into a single shot where the *whole* object is in focus, pick this option. Let's say you took a photo of a tiger—with a long zoom lens, of course—that was stretched out lengthwise and facing you. If one photo has the tiger's head in focus, another has the middle of his body in focus, and a third has his tail in focus, you can choose Stack Images to make Photoshop combine the three photos into a single shot with the *whole* cat in focus.

TIP You can also use Photoshop's Blur Gallery filters—Field Blur, Iris Blur, Tilt-Shift, Path Blur, and Spin Blur—to produce even more complex depth of field effects than you can with Stack Images. For full coverage of those filters, skip to Chapter 15.

- **Seamless Tones and Colors.** Leave this setting on to make Photoshop smooth out any noticeable seams and color differences between the images during the blending process.

As mentioned earlier, the Auto-Blend command has a *ton* of potential uses. One visually interesting possibility is to make a collage of two or more action shots to create a stop-motion effect. Figure 7-22 has the scoop.

TIP You can also use the Auto-Blend Layers command to help scan really big images. For example, if the image is too big to fit onto your scanner in one piece, scan different sections of it—being careful to create overlapping areas—and then let Photoshop piece it together for you by first running the Auto-Align Layers command and then running Auto-Blend Layers. (Interestingly, the Photomerge command actually uses the Auto-Align and Auto-Blend commands to build panoramas.)

FIGURE 7-22

You can use the Auto-Blend Layers command to create interesting collages like this one in mere seconds! The best part is that Photoshop does all the masking for you, as shown in this Layers panel.

Just remember that you can use the Auto-Blend Layers command only when you're working in RGB or Grayscale mode.

UP TO SPEED

Shooting Panoramas

If you're taking photos specifically to make a big honkin' panorama, here are a few things to keep in mind while you're snapping away in order to produce the best results:

- **Use a tripod.** A tripod or some other stabilizing surface (like your mate's shoulder) helps you take steadier shots. This keeps the end result from being blurry and helps Photoshop align overlapping areas of the images.

- **Include an overlapping element in each shot.** If you're taking three shots, make sure you include some of what's in the *first* shot in the second shot, and some of what's in the *second* shot in the *third* shot (about 40 percent overlap in each instance, if you can). That way you have plenty of overlapping areas that Photoshop can use to align the images.

- **Keep the lighting (exposure) consistent.** Although Photomerge is pretty darn good at stitching images together, you're going to notice if you took one shot in the *shade* and the other in direct *sunlight*. For the best results, keep the lighting consistent by exposing for the brightest portion of the image manually (you may have to consult your camera's manual to figure out how).

- **Make sure the angles are the same.** Photoshop has one heck of a time matching up images taken at different angles, though mismatched shots can make for some interesting creative possibilities!

Cloning Between Documents

The Clone Stamp tool is great for retouching tricks like duplicating pixels to get rid of something in a photo (page 447), banishing shiny spots (page 445), and repeating an object in a photo (page 448). You can also use it to copy pixels from one open document to *another*. Using the Clone Source panel—the *clone source* is the object you're copying—you can clone from up to five different sources regardless of whether they're in the same Photoshop document. Here's how to clone from one open document into another:

1. **Open the source document(s)—the image(s) you're cloning *from*—and the target document (the image you're cloning *to*) and arrange your workspace so you can see them both.**

 You can't clone from a document that isn't *open*, so start by opening both images you want to work with. Next, choose Window→Arrange and pick a setup that lets you see all the open documents, or just click each document's tab to activate it (Chapter 2 has more on working with tabbed documents).

 > **NOTE** For info on using the Clone Stamp tool within the *same* document, skip to page 444.

2. **Press S to grab the Clone Stamp tool, and then open the Clone Source panel.**

 Choose Window→Clone Source or click the panel's icon near the left end of the Options bar—it looks like a tiny panel with a rubber stamp icon on it. (Full coverage of the Clone Source panel's many options starts on page 319.)

3. **In the source document, set the clone source.**

 Click the window (or tab) of the document containing the image you want to clone *from*, like the kittens in Figure 7-23 (top left). Next, Option-click (Alt-click on a PC) the area you want to copy to set those pixels as the clone source.

4. **In the target document, create a new layer.**

 Unless you want to clone the new image on top of your original image (and you don't!), head back to your target document and add a new layer to it by clicking the "Create a new layer" icon at the bottom of the Layers panel. That way, if you don't like the result, you can simply toss the new layer instead of starting over. Or, if you clone a little too much from the other document, you can hide it by adding a layer mask and then painting across that area with a black brush.

5. **In the target document, paint to clone the item.**

 As shown in Figure 7-23 (bottom left), Photoshop displays a preview *inside* the brush cursor of the pixels you're about to clone, which is incredibly handy. As you paint, the clone source point moves as your cursor moves. If you don't like that behavior—because you want to create *multiple* instances of an object, for example—turn off the Options bar's Aligned checkbox and the clone source point stays put.

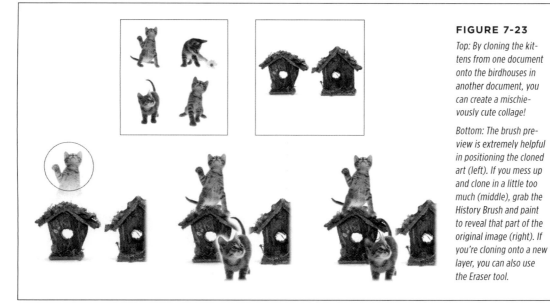

FIGURE 7-23

Top: By cloning the kittens from one document onto the birdhouses in another document, you can create a mischievously cute collage!

Bottom: The brush preview is extremely helpful in positioning the cloned art (left). If you mess up and clone in a little too much (middle), grab the History Brush and paint to reveal that part of the original image (right). If you're cloning onto a new layer, you can also use the Eraser tool.

You need a pretty steady hand when working with the Clone Stamp tool because it's easy to clone too much and cover up parts of your image (though a well-placed layer mask can fix that). You can solve that problem by creating a selection *before* reaching for the Clone Stamp tool; doing so *restricts* your brushstrokes to that part of the image. This technique is handy when you want to fill an area with another image, as shown in Figure 7-24.

FIGURE 7-24

If you select the destination area (like these silhouettes) before grabbing the Clone Stamp tool, you don't have to be as careful with your brushstrokes. As you can see here, the brush cursor (circled) extends well past the edges of these digital business dudes, but Photoshop clones the Matrix-like background only within the selected area.

If you want to get fancy and start doing things like pulling source points from *multiple* documents and changing the *angle* of your cloned pixels, then you need to enlist the help of the Clone Source panel (Figure 7-25).

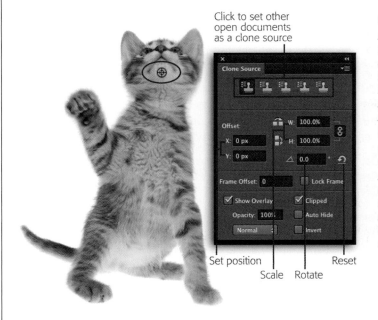

Click to set other
open documents
as a clone source

Set position

Scale Rotate Reset

FIGURE 7-25

Assigning multiple clone sources is handy when you want to clone items between open documents or create a complex scene from different elements. For example, if you're trying to remove a cat that's standing in front of a birdhouse, one source can be the cat and another can be the birdhouse.

Once you've activated the Clone Stamp tool, you can use the five source buttons shown here to quickly switch between different source points without having to reset them manually each time. To set a source point, Option-click (Alt-click on a PC) the area you want to clone, and your cursor turns into the crosshair circled here.

The Clone Source panel includes the following settings:

- **Offset.** Use this section of the panel to move, resize, or rotate the object you're copying (a.k.a. the clone source). If you want to move the clone source, you can change its X and Y coordinates (measured in pixels) here. If you've got Show Overlay (explained next) turned on, you see a *preview* of the source point on your image that moves as you tweak these settings. To clone pixels at a size other than their original, enter new percentages in the W and H (width and height) fields (see page 449 for an example). To *rotate* your clone source—so the cloned item appears at a different angle than the original pixels—enter a number of degrees in the field next to the triangle icon. To reset all these options, click the curved arrow labeled in Figure 7-25.

TIP You can position your cursor above any of the field labels in the Offset section—X, Y, W, and so on—to get the handy scrubby cursor (see Figure 8-14 on page 349). Then drag left to decrease the setting and right to increase it. You can Shift-drag to change it in larger increments or Option-drag (Alt-drag on a PC) for smaller increments. If you're a fan of keyboard shortcuts, press Option-Shift-{ (Alt+Shift+{ on a PC) to decrease your clone source's width and height proportionally and Option-Shift-} (Alt+Shift+}) to increase them. To rotate the source, press Option-Shift-< (Alt+Shift+<) to turn it counterclockwise or Option-Shift-> (Alt+Shift+>) to turn it clockwise.

- **Frame Offset and Lock Frame.** These options let you clone content in video or animation frames.

- **Show Overlay.** With this setting turned on (it's on automatically), you see a preview of what you're about to paint *inside your brush cursor.* That way you can see exactly what the cloning will look like before you commit to it.

- **Opacity.** Use this field to adjust the opacity of the overlay preview. (To adjust the opacity of what you're *cloning*—in other words, your actual brushstrokes—use the Options bar's Opacity setting instead.)

- **Clipped.** This option *restricts* the preview overlay to the area inside your brush cursor. For Thor's sake, leave this setting turned on. If you don't, Photoshop previews the *entire* clone source image underneath your cursor, which keeps you from seeing anything *except* the preview.

- **Auto Hide.** If you turn on this setting, the overlay preview disappears as soon as you click to start cloning. It's a good idea to turn it on so you can see how much you've painted so far.

- **Invert.** Turning on this option makes Photoshop invert the overlay preview so it looks like a *film negative*, which can be helpful if you're trying to align the cloned area with something that's already in your image.

- **Blend Mode.** Use this menu to change the blend mode of the overlay preview. Your choices—Normal, Darken, Lighten, and Difference—are explained earlier in this chapter, starting on page 296. (To change the blend mode of the *cloned pixels*, use the Options bar's Mode menu instead.)

Combining Vectors and Rasters

A fun trend in the design world is to combine vectors with rasters (the box on page 52 explains the difference); in other words, to combine illustrations with photographs, a technique that produces a unique look and lets you get incredibly creative. Because you can place vectors as smart objects (page 129), they remain infinitely resizable, which lets you experiment with them as backgrounds, artful embellishments, and even ornamental photo frames. As you can see in Figure 7-26, adding vectors to photos is a *ton* of fun.

You can add vector art to images in a couple of ways:

- **Place it.** With a document open, choose File→Place Embedded and find the vector file on your hard drive (these files are usually in EPS [Encapsulated Post-Script] or AI [Adobe Illustrator] format). This inserts the file into the currently open document as a smart object (page 129). Since you'll most likely need to resize the artwork, Photoshop considerately surrounds it with the Free Transform bounding box and resizing handles. Just Shift-drag any corner to make the art bigger or smaller, or rotate it by placing your cursor *outside* the bounding box

and then dragging in the direction you want to rotate. Press Return (Enter on a PC) when you're finished.

FIGURE 7-26

A dash of vector art can spice up any photo by blending real images with imaginary ones.

Even if you can't draw these little goodies your-self, stock-image com-panies like iStockphoto.com and Fotolia.com sell affordable vector images so you can join in the fun. In fact, if you visit www.lesa.in/istockdeal or www.lesa.in/fotoliaoffer you can download 10 im-ages for free! Other great resources for vectors are GraphicAuthority.com and the Market link on the Creative Cloud applica-tion's Assets screen.

- **Paste it.** If you're working in a vector-based program like Adobe Illustrator, you can copy artwork in that program and then switch to Photoshop and paste the artwork into a document by choosing Edit→Paste or pressing ⌘-V (Ctrl+V). When you do, Photoshop displays the dialog box shown in Figure 7-27 (left) so you can tell it *how* you want to paste the art. If you choose smart object, you can resize the illustration as much as you want without losing quality!

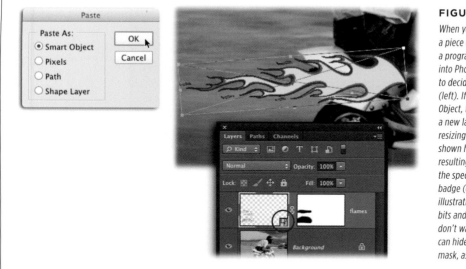

FIGURE 7-27

When you copy and paste a piece of vector art from a program like Illustrator into Photoshop, you get to decide how to paste it (left). If you choose Smart Object, the art lands on a new layer with helpful resizing handles, as shown here (right). The resulting layer also sports the special smart object badge (circled). And if the illustration includes other bits and pieces that you don't want to use, you can hide 'em with a layer mask, as in this image.

Framing a photo with an illustration is not only fun, it's also *incredibly* flexible because you can resize the frame without starting over. Here's how:

1. **Open the photo you want to frame and then choose File→Place Embedded to import the illustration you'll use as the frame.**

 In the Place Embedded dialog box, find the illustration file on your hard drive, and then click Place. Photoshop adds the illustration to your document as a smart object.

 > **NOTE** If the image you want to frame consists of *multiple* layers, then either convert those layers into a smart object (page 134) or create a stamped layer (page 119) *before* you place the illustration.

2. **Resize the illustration.**

 Conveniently, the illustration appears in your document with resizing handles around it, which you'll probably need to use to make it bigger or smaller. Grab a corner handle and Shift-drag until the frame is big enough to hold the photo. (To resize all four sides of the illustration at once, press and hold Shift-Option [Shift+Alt on a PC] as you drag a corner handle.) Drag inside the bounding box to move the illustration around. When it's just right, press Return (Enter).

3. **Over in the Layers panel, drag the illustration layer** *below* **the image layer.**

The maneuver you're performing won't work if the illustration layer is *above* the image layer. Why? Because you're about to tell Photoshop to shove the content of one layer through the shape of what's on the layer below.

4. **Clip the image layer to the illustration layer.**

With the image layer (or smart object or stamped layer, as described in step 1) active, choose Layer→Create Clipping Mask. Alternatively, press and hold Option (Alt on a PC) while pointing your cursor at the dividing line between the two layers in the Layers panel; when the cursor turns into a square with a down-pointing arrow, click once. Either way, the image layer's thumbnail scoots to the right, and a tiny downward-pointing arrow appears to its left to indicate that it's clipped (masked) to the illustration layer below it, as shown in Figure 7-28. You should now see the photo peeking through the illustration.

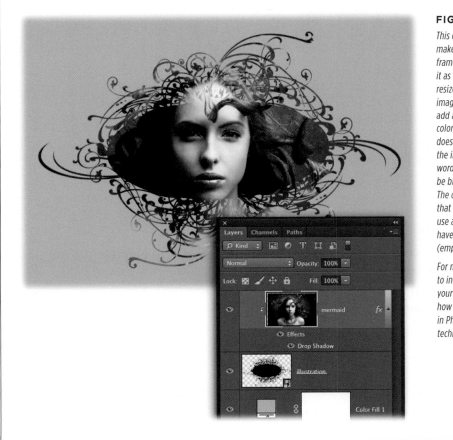

FIGURE 7-28

This detailed illustration makes a gorgeous photo frame. After you place it as a smart object and resize it, just clip it to an image layer (bottom), add a new background color, and you're done! It doesn't matter what color the illustration is (in other words, it doesn't have to be black like this one). The only requirement is that the illustration you use as a frame needs to have some transparent (empty) areas.

For more ideas about how to incorporate vectors into your photos, including how to colorize a vector in Photoshop, see the technique on page 372.

5. **Use the Move tool to position the photo and frame.**

Press V to grab the Move tool and reposition the image layer and/or illustration layer as necessary; just be sure to activate the correct layer first.

6. **Activate the illustration layer, and then add a fill layer to create a colorful background for your new frame.**

Activating the illustration layer first ensures that the new fill layer will appear *below* the image layer, allowing you to snatch a new color from it. Once you've activated that layer, choose Layer→New Fill Layer→Solid Color, or click the half-black/half-white circle at the bottom of the Layers panel and choose Solid Color. Either way, once the Color Picker opens, mouse over to your image and click to steal a color from it (such as the copper color of the mermaid's hair in Figure 7-28). Click OK to close the Color Picker.

7. **Save your document as a PSD file.**

You're done! To resize the frame, activate the illustration layer and summon Free Transform by pressing ⌘-T (Ctrl+T), and then Shift-drag one of the corner handles to resize the illustration; press Return (Enter) when you're finished. And to give the frame a little depth, you can tack on a drop shadow using layer styles (page 140).

■ Mapping One Image onto Another

You can combine two images in an impressive way by wrapping one around the contours of another so the first image follows every nook and cranny of the second. To perform this feat, you need to create a *displacement map*—a grayscale image that Photoshop uses to warp and bend one image to the curvature of another.

Applying this technique to photos of friends and family is great fun. For example, you can take a circuit board and wrap it around a body or face, as in Figure 7-29. Here's what you do:

1. **Open the image you want to map another image *onto* (like a face), and then hunt down the channel with the greatest contrast.**

To make the best possible displacement map, you need the channel with the highest contrast. If you're in RGB mode (and you probably are), you can cycle through (and thus activate) different channels by pressing ⌘-3, 4, and 5 (Ctrl+3, 4, and 5 on a PC); stop when you land on the one you want to use. (As you learned in the box on page 206, Photoshop displays channels in grayscale.) Because digital cameras tend to have so many more green sensors than red or blue ones, you'll most likely pick the green channel.

2. **Duplicate the high-contrast channel, and then send it to a new document.**

Open the Channels panel by clicking its icon in the panel dock or choosing Window→Channels. With the highest contrast channel active, choose Duplicate Channel from the Channels panel's menu. In the resulting dialog box, choose New

from the Destination section's Document menu and, in the Name field, name the channel something memorable like *Map*. When you click OK, Photoshop opens a new document containing the channel you picked in step 1.

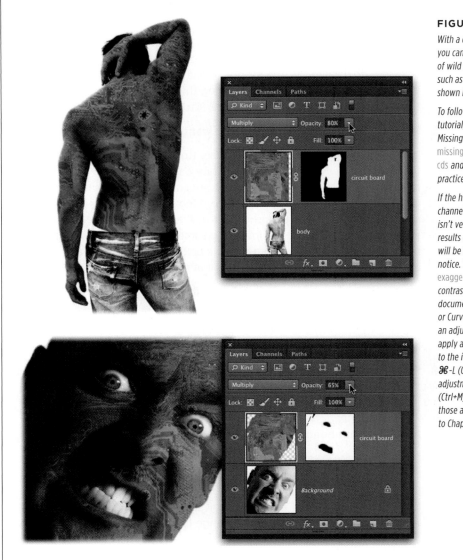

FIGURE 7-29

With a displacement map, you can apply all kinds of wild textures to skin, such as the circuit board shown here.

To follow along with this tutorial, visit this book's Missing CD page at www.missingmanuals.com/cds *and download the practice file* Map.zip.

If the highest-contrast channel in your image isn't very contrasty, the results of this technique will be too subtle to notice. The fix is to exaggerate *the channel's contrast in your Map document with a Levels or Curves adjustment (*not *an adjustment* layer*). To apply a Levels adjustment to the image layer, press* ⌘*-L (Ctrl+L); for a Curves adjustment, press* ⌘*-M (Ctrl+M). For more on those adjustments, skip to Chapter 9.*

3. **In the new document, blur the channel slightly.**

 With the new Map document active, choose Filter→Blur→Gaussian Blur. Enter a value of 1–4 pixels (try 1 for low-resolution images and 4 for high-resolution images), and then click OK. The goal here is to blur the image just a bit so the map is slightly smooth. (Page 461 has more on the Gaussian Blur filter.)

4. **Save the new document, and then close it.**

Choose File→Save As and make sure the format menu at the bottom of the dialog box is set to Photoshop. Make sure the Alpha Channels option is turned *on,* and then click Save. Then close the file by pressing ⌘-W (Ctrl+W).

5. **Go back to the original document and turn the composite channel back on.**

When you cycled through the different channels in step 1, Photoshop temporarily turned off the *composite* channel (the one that shows your image in full color). So go back to the original document (the one you opened in step 1) and turn all the channels back on by clicking the composite channel at the top of the Channels panel, or by pressing ⌘-2 (Ctrl+2 on a PC).

6. **Select the face (or other object) you want to map another image onto.**

In this example image—visible at the bottom right of Figure 7-29—it's easy to select the face because it's on a white background. Grab the Magic Wand by pressing W, click once in the white area, and then Shift-click to select the other white areas until you have everything *except* the face selected. Then, invert your selection by pressing Shift-⌘-I (Shift+Ctrl+I on a PC) or choosing Select→Inverse; Photoshop flip-flops your selection so the face is surrounded by marching ants. (As you learned in the box on page 167, sometimes it's easier to select the *opposite* of what you want and then flip-flop the selection.)

7. **Feather the edges of your selection slightly.**

Click the Options bar's Refine Edge button and feather the selection by 1 pixel (be sure to set all the *other* fields in the Refine Edge dialog box to 0). Page 151 has more about feathering.

8. **Save the selection by choosing Select→Save Selection, and then deselect it.**

Give the selection a meaningful name so you can find it again later, such as *Face,* and then click OK. Next, get rid of the marching ants by pressing ⌘-D (Ctrl+D).

9. **Add the circuit board to the face document.**

Open the image you want to map onto the face, like the circuit board shown in Figure 7-29. After you open the image, choose Select→All to select it, and then copy and paste it into the face document. Alternatively, you can activate the face document and add the circuit board to it by choosing File→Place Embedded, or use the Window→Arrange menu to see both the circuit board document and the face document, and then drag the circuit board layer *into* the face document. Whichever way you go about it, make sure the circuit board layer is positioned *above* the face layer in your Layers panel.

10. **Choose Filter→Distort→Displace.**

 In the resulting Displace dialog box, leave the factory settings as is and click OK. If you're not sure whether the settings have ever been tampered with, press and hold the Option key (Alt on a PC) to change the Cancel button into a Reset button; click it and you're back to the original settings.

11. **In the resulting Open dialog box, navigate to the map document you saved in step 4 and, while keeping your eyes trained on the circuit board, click OK.**

 If you watch your document closely when you click OK, you'll see the circuit board *shift* to the contours of the face. It's extremely cool.

12. **Load the face selection.**

 Choose Select→Load Selection and, from the resulting dialog box's Channel menu, choose the selection you saved earlier (*Face*, in this example). You should then see marching ants around the shape of the face (you can't see the actual face because it's beneath the circuit board).

13. **Add a layer mask to the circuit board layer.**

 Make sure the circuit board layer is active, and then click the circle-within-a-square icon at the bottom of the Layers panel to add a layer mask.

14. **Change the circuit board layer's blend mode to Multiply (page 300) and lower its opacity.**

 The second you change blend modes, you see the face through the circuit board. If the circuit board is too dark, lower its Opacity setting at the top of the Layers panel.

 For even *more* creative fun, experiment with other blend modes such as Darken, Color Burn, and Linear Burn. Depending on the colors in the two images you're working with, one blend mode will work better than another (a great excuse to experiment with them all!). In the images used here, because the circuit board is dark and the face is light, Multiply works well.

15. **Use the layer mask to hide some of the circuit board layer.**

 In this example, the circuit board covers the crazy man's eyes and teeth, but you can fix that by hiding those areas with a layer mask. Click to activate the layer mask and then activate the Brush tool by pressing B. With black as your foreground color, paint over the guy's eyes and teeth to hide them, as shown in Figure 7-29 (bottom).

Congratulations! You just mapped one image to the contours of another, one of the slickest Photoshop tricks ever.

Draining, Changing, and Adding Color

When you want to make a big difference with one simple change to a photo, you can't beat converting it from color to black and white. The Ansel Adams approach doesn't just evoke nostalgia, it also puts the focus on the *subject* in a powerful way. Going grayscale also lets you salvage an image that you can't color-correct, as well as beautify a subject whose teeth need heavy-duty whitening or whose skin needs retouching. Those problems all but *disappear* when you enter the realm of black and white.

Does that mean you should set your digital camera to shoot in black and white? Heck, no! It's *much* better to photograph in color and then drain the color in Photoshop. That way, you have a truckload of artistic options like bringing back just a touch of the original color for a partial-color effect.

And, speaking of color, Photoshop has several tools that let you *change* the color of anything, whether it's a car or the hair on your head. You can also breathe new life into vintage black-and-white photographs by *adding* a dash of color, and a similar technique lets you add digital makeup to your subject.

This chapter teaches you how simple it is to drain, change, and add color to photos in a variety of ways. The following pages are packed with creative color techniques you'll use again and again!

■ Draining Color

You've probably heard the saying, "You get what you pay for." In Photoshop, that saying translates to, "The quickest method ain't always the best!" In other words,

some techniques take a little extra time, and converting a color image to black and white is one of 'em—but it's well worth the effort.

To drive that point home, open a colorful image—if you want to follow along, you can download *Dragon.jpg* from this book's Missing CD page at *www.missingmanuals. com/cds*—and then choose Image→Adjustments→Desaturate. (*Desaturating* means draining all color from an image.) Photoshop converts your image to black and white all right, but the results are less than inspiring (see Figure 8-1, top). Alternatively, you can glance through the image's channels (see Chapter 5), pick the one with the highest contrast, and then choose Image→Mode→Grayscale. Photoshop keeps the currently active channel, tosses the rest, and you're left with a black-and-white image...that *nobody* is going to write home about. As you're about to find out, Photoshop has several ways to produce beautiful black-and-white conversions, *not* including the two methods mentioned above.

FIGURE 8-1

Top: Sure, the Desaturate command lets you convert photos to black and white in one step, but as you can see, this method produces a very lame dragon.

Bottom: A black & white adjustment layer lets you introduce all kinds of contrast, making it a much better option for black-and-white conversions (and for producing a respectably menacing creature).

Another (older) way to create a black-and-white image is to use a channel mixer adjustment layer. Cruise on over to this book's Missing CD page at www.missingmanuals.com/cds *to learn how.*

Black & White Adjustment Layers

Adding a black & white adjustment layer is hands down the easiest way to convert a color image to a beautiful black and white in no time flat. The process couldn't be simpler, and, best of all, it's nondestructive. As Chapter 3 explains, when you use adjustment layers, Photoshop makes the changes on *another* layer—not on your original image—letting you tweak the opacity, toggle the visibility on or off, and so on. (You'll learn about other kinds of adjustment layers throughout this book.)

NOTE To follow along with this technique, head to this book's Missing CD page at *www.missingmanuals. com/cds* and download the practice file *Dragon.jpg*.

To create a black-and-white image, follow these steps:

1. **Pop open your soon-to-be-colorless image and add a black & white adjustment layer.**

 Choose Layer→New Adjustment Layer→Black & White; in the resulting New Layer dialog box, give the layer a name, if you'd like, and then click OK. Photoshop turns your image black and white, and opens the Properties panel, which contains several sliders you can use to fine-tune the image's contrast (Figure 8-2).

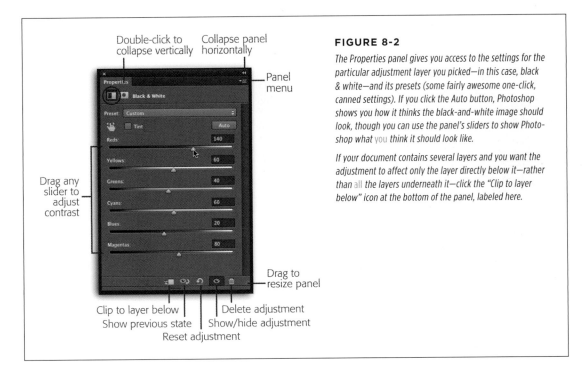

FIGURE 8-2

The Properties panel gives you access to the settings for the particular adjustment layer you picked—in this case, black & white—and its presets (some fairly awesome one-click, canned settings). If you click the Auto button, Photoshop shows you how it thinks the black-and-white image should look, though you can use the panel's sliders to show Photoshop what you think it should look like.

If your document contains several layers and you want the adjustment to affect only the layer directly below it—rather than all the layers underneath it—click the "Clip to layer below" icon at the bottom of the panel, labeled here.

TIP You can also create a black & white adjustment layer by clicking the Black & White icon in the Adjustments panel (choose Window→Adjustments if the panel isn't visible)—it's the same half-black/half-white square that's circled in Figure 8-2. Or you can click the half-black/half-white circle at the bottom of the Layers panel and choose Black & White from the menu that appears.

2. **Use the Properties panel's sliders to adjust the contrast of your newly black-and-white image.**

 Even though Photoshop has sapped the color from your image, there may be room for improvement. Drag a particular color's slider to the left (toward black) to make areas that include that color darker, or to the right (toward white) to

make areas that include that color lighter. (The colored bars under each slider give you a clue as to what dragging in each direction does to your image). Or, instead of using the sliders, you can tweak a certain color by dragging atop the image itself, as Figure 8-3 explains. Also, the Preset menu at the top of the panel has a slew of useful canned settings—just click each one to see what it looks like applied to your image (on a PC, you can use your keyboard's up and down arrow keys to cycle through the presets; this trick doesn't work on Macs).

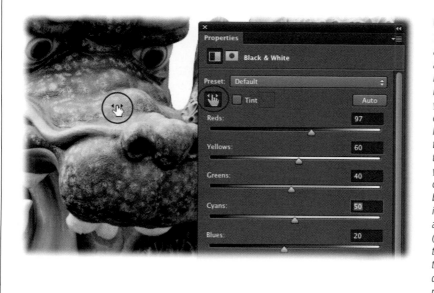

FIGURE 8-3

To adjust contrast visually, click the on-image adjustment tool circled here (right), and then mouse over to the image; your cursor turns into an eyedropper (not shown) to let you know you're about to sample a color. Position the cursor atop the area you want to adjust, then click and hold your mouse button. The cursor turns into a pointing hand with an arrow on each side (circled, left) to indicate that you can drag from side to side to adjust that color; drag left to darken it or right to lighten it.

TIP For better results with the on-image adjustment tool, activate it and then, in the Options bar, changing the Sample Size drop-down menu to "3 by 3 Average." That way, the tool's eyedropper samples *several* pixels around the area you click instead of just one.

3. **Save your document as a PSD file so your layers remain intact.**

Once you save your document as a PSD file, you can reopen the black & white adjustment layer's settings by simply double-clicking its thumbnail in the Layers panel (it's that familiar half-black/half-white square icon). Or, if the Properties panel is already open, click the layer's thumbnail once to activate it and you'll see the Black & White sliders reappear in the Properties panel. Being able to edit these settings later keeps you from having to start over if, for example, you print the image and then decide it needs more contrast.

TIP If your newly black-and-white image is headed for a professional printing press (it's being printed in a newspaper, say), you're not quite finished; flip ahead to the box on page 337 to learn your next step.

■ WARP-SPEED COLOR TINTING

You can give a black-and-white image a *uniform* color tint by using a black & white adjustment layer's Tint checkbox (it lives near the top of the Properties panel when a black & white adjustment layer is active). Turn on this checkbox, and Photoshop adds a brown tint (called a *sepia tone*) to your image, as shown in Figure 8-4 (top). This technique produces what's known as a *fake duotone*; the real ones are explained on page 345.

FIGURE 8-4

Top: After adding a black & white adjustment layer, you can give your image a color overlay by turning on the Tint checkbox (circled). As you can see, adding a tint dramatically changes the image's mood.

But are you stuck with brown, you ask? Heck no. To choose a different color, click the colored square to the right of the Tint checkbox to summon the Color Picker.

Bottom: In the Color Picker, choose a range of color by clicking within the vertical, rainbow-colored bar (circled, right). Let Photoshop know how light or how dark you want the new color to be by clicking inside the large colored area on the left (circled, left). Click OK to close the Color Picker and the new overlay color appears in the Properties panel and atop your image.

Pretty slick, huh?

Gradient Map Adjustment Layers

Gradient map adjustment layers can also make *spectacular* black-and-white images, as Figure 8-5 shows. In fact, many pros believe this method produces the most beautiful black-and-white images you can create in Photoshop (that is, without us-

ing the Silver Efex Pro plug-in; see page 840). This technique is also super fast, as you can see from these steps:

1. **Open an image and set your color chips to black and white by pressing D, and then pressing X until black hops on top.**

 The gradient map adjustment layer you'll add in the next step uses your foreground and background colors, so if you don't set them to black and white (respectively) *first*, the layer's effect can be rather startling—if your color chips are red and green, for example, then you get a red-and-green image (handy during the holidays, but that's about it). And make sure black is your *foreground* color, not your background color, or the image will end up looking like an x-ray.

Gradient preview
(click to open Gradient Editor)

Gradient presets

Click to load
more presets

FIGURE 8-5

If you forgot to set your color chips to black and white before adding the adjustment layer, just head to the Properties panel, open the Gradient presets menu (labeled), and in the resulting menu, click the black-to-white gradient in the first row (third from the left). Photoshop instantly transforms your image to black and white. And if you accidentally had white as your foreground color instead of black, just turn on the Properties panel's Reverse setting (not shown here).

2. **Add a gradient map adjustment layer.**

 Choose Layer→New Adjustment Layer→Gradient Map, or open the Adjustments panel and click the Gradient Map icon (it looks like a horizontal black-to-white fade). You can also click the half-black/half-white circle at the bottom of the Layers panel and choose Gradient Map. No matter which method you use, Photoshop maps the shadows in the image to your foreground color (black) and the highlights to your background color (white), creating a gorgeous black-and-white image.

Told you this method was quick! Even though you can't adjust the image's contrast like you can with a black & white adjustment layer, it still produces *consistently* awesome black-and-white versions of most images.

TIP To get more creative with this technique, you can use the Gradient Editor (page 371) to create a black-to-gray-to-white gradient, which adds extra depth and richness to a black-and-white image.

■ PHOTOGRAPHIC TONING

Photoshop also includes a bunch of creative gradient presets that you can use with gradient map adjustment layers to add beautiful color overlays to images. Once you've added a Gradient Map adjustment layer, head to the Properties panel, open the Gradient presets menu, and then click the little gear at the top right of the resulting menu (circled in Figure 8-6). Choose Photographic Toning, and in the resulting dialog box, click Append so Photoshop adds the new gradients to the bottom of the current list...and there's a slew of 'em!

Selenium 1

Copper 1

FIGURE 8-6

The 38 photographic toning presets you see here were introduced back in CS6, but few folks found 'em. To apply one of these beauties to an image nondestructively, just single-click it (if you point your cursor to a preset, Photoshop tells you its name in a little yellow tooltip). You can even tweak the Opacity setting of the resulting gradient map adjustment layer to let a little of the image's original color show through.

It's well worth taking two seconds to load these goodies because you can use them to produce some amazing and—if you're a photographer—sellable results.

The Lightness Channel

As you learned back on page 213, Lab mode gets its name from its three channels. The "L" stands for the Lightness channel where Photoshop stores all the image's lightness (brightness) values—and therefore its visible contours and details. The "a" and "b" are

for the a and b channels, which store color info. This means the Lightness channel makes for a lovely black-and-white version of your image (see Figure 8-7), though isolating it requires more effort than the adjustment-layer methods in the previous sections.

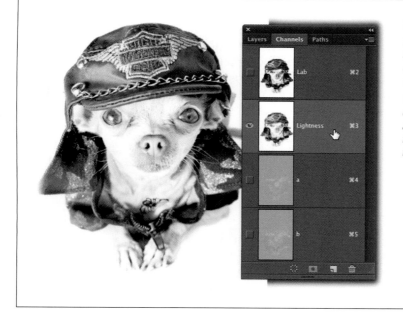

FIGURE 8-7

Because the Lightness channel contains all your image's details but none of its color, it often makes a nice black-and-white version all by itself.

To darken or lighten your newly colorless image, you can use any of the adjustments explained in Chapter 9, or the Screen and Multiply blend mode tricks mentioned back on page 125.

To see what your image's Lightness channel looks like, first make a copy of the image by choosing Image→Duplicate (because switching color modes flattens a multi-layered document, it's a good idea to do that on a *copy* of the image). Then, choose Image→Mode→Lab Color. If your document includes any adjustment layers, Photoshop displays a dialog box asking whether you'd like to flatten or discard them; since you're working with a duplicate file, go ahead and click Flatten. Then, over in the Channels panel, activate the Lightness channel, tilt your head contemplatively, and see what you think. If you like the result, choose Image→Mode→Grayscale, and then click OK when Photoshop asks if it can toss the image's color information. You can then return to the color mode from whence you came by choosing Image→Mode→RGB (or CMYK).

Going Grayscale in Camera Raw

If you're shooting photos in raw format, you may as well use the Camera Raw plug-in (page 385) to convert images to grayscale. It's easy to use and does a nice job with the conversion. Plus any edits you make in Camera Raw are nondestructive, so you can always get back to your original image.

To open a raw image on a Mac, just double-click its file icon, and it opens in Camera Raw automatically; on a PC, right-click the file, and then choose Open With→Adobe Photoshop CC 2014. If you're using Adobe Bridge (Chapter 22) to peruse your images,

double-click the image's thumbnail or Control-click (right-click) it and then, from the resulting shortcut menu, choose "Open in Camera Raw."

TIP You can also open the Camera Raw plug-in as a *filter*. The box on page 393 has the full story on using this incredibly handy feature.

Once the image is open in Camera Raw, open the HSL/Grayscale panel by clicking the icon circled in Figure 8-8, and then turn on the panel's "Convert to Grayscale" checkbox. A set of sliders appears that you can use to adjust contrast: Lighten a specific color by dragging its slider to the right, or darken it by dragging its slider to the left. When you're finished, click Done to close the Camera Raw window and apply your adjustments, or click Open Image to open the image in Photoshop. (If you opened Camera Raw as a *filter*, click OK.) Clicking Cancel closes the image *without* applying your adjustments.

UP TO SPEED

Preparing Grayscale Images for a Printing Press

Say your color image is part of a document headed for a professional printing press, and you've been assigned the task of transforming it into a grayscale image. In addition to using one of the color-draining techniques covered so far in this chapter, you need to perform one more step: change the document's *color mode* to Grayscale. (If the image is headed for an inkjet printer or destined for posting on the Web, you can stop reading this box now and skip to something more interesting.)

That's right: Even though your image *looks* grayscale onscreen, it's still made from colors whose saturation values Photoshop has lowered to zero (saturation is the degree of color strength). If you're shaking your head in disbelief, open the Channels panel by choosing Window→Channels, and you'll find color channels peering back at you (which channels you see depends on which color mode you're working in).

If you don't change the image's mode to Grayscale before you send it off to a printing press, the image will print with the colors listed in the Channels panel instead of with black ink alone. While the result would still *look* like a grayscale image, it would actually be made from colored inks, which cost more (the more colors you use on press, the higher the cost).

This info is important, so it's worth recapping: To prepare a grayscale image for a printing press, start by getting rid of the color using one of the methods described in this chapter. Otherwise, Photoshop will do it for you when you switch to Grayscale mode—with mediocre results like those you

get with the Desaturate command (page 330). Next, save your document as a PSD file by choosing File→Save As to preserve any adjustment layers you may have added. Then, change the document's color mode to Grayscale by choosing Image→Mode→Grayscale. Photoshop pops open a dialog box asking if you'd like to flatten your layers. Click OK and yet *another* dialog box appears asking if you'd like to discard color info (in other words, throw away all the color channels in the document.) Click OK and you're left with a *real* grayscale image that contains only a single channel named Gray.

If your image is headed for a local publication that's printed on *newsprint* (in other words, it's not *USA Today* or *The Guardian*) and you *haven't* attached a color profile (page 720) to it, you'll also want to adjust its *output levels* to keep the shadows from printing too dark and the highlights from printing too light. Press ⌘-L (Ctrl+L on a PC) and, in the Output Levels section at the bottom of the resulting Levels dialog box, enter 30 into the first field and 225 into the second field, and then click OK to close the dialog box. (For more about output levels, see page 403.)

To save the image for use in a page-layout program like InDesign or QuarkXPress, choose File→Save As and then, from the format drop-down menu near the bottom of the Save As dialog box, choose TIFF or PSD (see page 724 for more on when to use which format). Voilà—you've got yourself a *true* grayscale image that will cost less to print.

Panel menu

FIGURE 8-8

In the Camera Raw window, click the HSL/ Grayscale icon (circled) to see the "Convert to Grayscale" option.

Since the Camera Raw plug-in doesn't apply changes to your original image—as page 385 explains, it saves a list of your requested edits instead—you can always change your mind about the edits you've made. So if you decide an hour (or a year) from now that you don't want a black-and-white image, reopen the file in Camera Raw and then, from the menu labeled here, choose Camera Raw Defaults and presto! You'll be looking at your image exactly as it was shot. Nifty, eh?

You've now got yourself a lovely grayscale version of the image with loads of detail (though you may want to do a bit of sharpening; Chapter 11 explains how to do that *both* in Photoshop and in Camera Raw).

NOTE To learn how to apply creative color effects in Camera Raw, check out your author's video course, *Photoshop Deep Dive: Adobe Camera Raw*, at *www.lesa.in/lesacl.*

Partial-Color Effect

A classy way to accentuate part of an image is to leave that area colored and make everything else black and white. You can do that easily by using a black & white, channel mixer, or gradient map adjustment layer to convert the image to black and white (as discussed earlier in this chapter), and then employ a layer mask to hide the

conversion from the parts you want to keep in color. This technique is a *wonderful* way to add creativity to an image.

As luck would have it, *all* adjustment layers come with a layer mask. It starts out empty (white) and automatically appears in the Layers panel to the right of the adjustment layer's thumbnail (see Figure 8-9). So just use whichever adjustment layer-based conversion method you like best to make the image black and white, and then follow these steps:

1. **In the Layers panel, click the adjustment layer's mask thumbnail.**

 When you click the mask thumbnail (circled in Figure 8-9), Photoshop puts a tiny white outline around it to let you know it's *active* (meaning the next thing you do will affect the mask and not the layer content itself).

TIP If the thumbnails in your Layers panel are *really* small, you may not see the white outline around the mask thumbnail. Thankfully, you can make the thumbnails bigger by heading to the Layers panel's menu and choosing Panel Options. Pick the biggest thumbnail size, and then click OK. *Now* you should be able to see the outline without squinting!

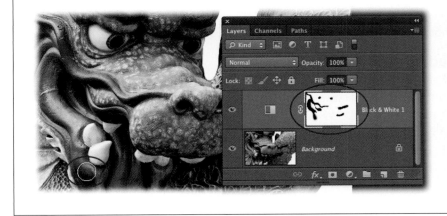

FIGURE 8-9

Adjustment layers come with layer masks that let you hide the adjustments from certain parts of images. For example, by painting with black to mask certain areas on a black & white adjustment layer, you can hide the adjustment and bring back the original color (the brush cursor is circled here, left).

NOTE Want to follow along? Visit this book's Missing CD page at *www.missingmanuals.com/cds* and download the file *Dragon.jpg*.

2. **Set your foreground color chip to black, grab the Brush tool, and then hide part of the adjustment layer by painting on your image.**

 When you're about to work with a mask, take a moment to think about what you want to do: To *hide* parts of the adjustment layer, you need to paint with black (remember the layer mask rhyme, "Black conceals and white reveals"), so press D to set your color chips to black and white, and then press X until black

hops on top. Then press B to grab the Brush tool and choose a soft-edged brush from the Options bar's Brush Preset picker (page 530). Finally, mouse over to your image and paint an area to let the image's original color show *through* the layer mask, as in Figure 8-9.

If you reveal too much color, no problem. Just press X to swap color chips so white is on top, and then *repaint* that area to reveal the adjustment again. (When you're working with masks, it's helpful to keep a finger poised over the X key.)

> **TIP** To make sure your brushstrokes are precise, *zoom into* your image by pressing ⌘-+ (Ctrl-+). Once you're zoomed in, you can toss the image from side to side with the Hand tool—very helpful if you need to view a different portion of the image. To grab the Hand tool, just press the space bar and drag, or click the hand icon near the bottom of the Tools panel. (For more tips on viewing images at close range, see page 56.) To zoom out again, press ⌘ (Ctrl) and the minus key [–].

3. **When you're finished painting the mask, save your document as a PSD file.**

 This makes Photoshop keep all the image's layers, so you can go back and edit the black-and-white treatment or the mask later on if the mood strikes.

To see a quick before-and-after preview of your image, mouse over to the Layers panel and turn off the adjustment layer's visibility eye. This partial color technique is incredibly useful in both graphic design *and* photography (imagine a wedding photo where only the bride's *flowers* are in color—adorable!).

Fading Color to Black and White

You can use a technique similar to the one covered in the previous section to create a soft fade from full color to black and white (Figure 8-10). After you've made your image black and white using one of the *adjustment layer*-based methods described earlier, follow these steps:

1. **In the Layers panel, activate the adjustment layer's mask thumbnail (circled back in Figure 8-9, right).**

2. **Press G to fire up the Gradient tool and then, in the Options bar, choose a black-to-white linear gradient.**

 In the Options bar, open the Gradient Preset picker by clicking the down arrow labeled in Figure 8-10, top, and then click the gradient thumbnail circled in Figure 8-10, top. (If you've got Photoshop's tooltips turned on [page 5], point your cursor at each gradient preview to see its name; the one you want is named "Black, White.")

> **TIP** If your foreground and background color chips are set to black and white, respectively, you can use the "Foreground to Background" gradient instead, which is the first item in the Gradient Preset picker and the one Photoshop automatically uses (saving you from having to open the preset picker).

To the right of the Gradient Preset picker, make sure the Linear Gradient icon labeled in Figure 8-10 is active (it should be unless you've changed gradient styles recently); you can point your cursor at each gradient-style icon to see its name.

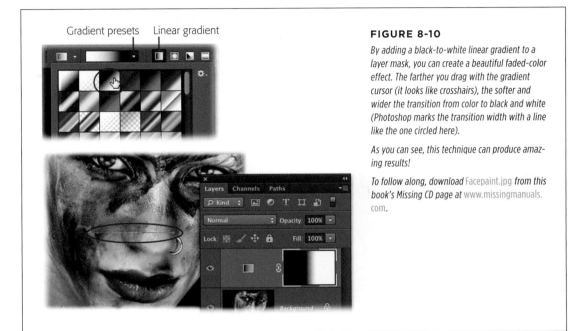

Gradient presets Linear gradient

FIGURE 8-10

By adding a black-to-white linear gradient to a layer mask, you can create a beautiful faded-color effect. The farther you drag with the gradient cursor (it looks like crosshairs), the softer and wider the transition from color to black and white (Photoshop marks the transition width with a line like the one circled here).

As you can see, this technique can produce amazing results!

To follow along, download Facepaint.jpg *from this book's Missing CD page at* www.missingmanuals.com.

3. **Mouse over to your document, click where you want the color to start fading out, and then drag in any direction for an inch or two.**

 The beauty of using a mask for this technique is that if you're unhappy with your first gradient-dragging attempt, you can have another go at it...and another, and another until you get it right—Photoshop keeps updating the mask. Try dragging from corner to corner or top to bottom and see what you get—depending on your image, one gradient angle may look better than another. For the facepaint image, a horizontal gradient works well.

4. **When you're finished, save your document as a PSD file and marvel at your handiwork.**

TIP If you start editing a layer mask and then decide you want to clear it out and start over, just activate the mask by clicking its thumbnail in the Layers panel, press ⌘-A (Ctrl+A) to select its contents, and then press Delete (Backspace). Photoshop empties the mask (or rather, fills it with white) so you can try again. Alternatively, you can activate the mask, choose Edit→Fill, and then pick White from the Use drop-down menu.

High-Contrast Black and White

The highest contrast black-and-white images of all are *just* black and white, with no shades of gray, like the one in Figure 8-11 (right). It's a striking yet versatile effect that gives images an edgy look. In Photoshop, you can create this effect with a Threshold adjustment layer, which lets you specify a brightness threshold where all the lighter-colored pixels become pure white and the darker pixels become pure black. Put more simply, Photoshop turns your shadows black and your highlights white.

> **NOTE** To practice the following technique, download the file *Girl.jpg* from this book's Missing CD page at *www.missingmanuals.com/cds*.

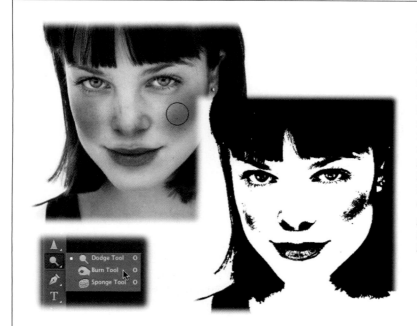

FIGURE 8-11

Left: Threshold adjustment layers make shadows pure black and highlights pure white. If you use one on an image of a face that doesn't have many shadows around the cheeks, nose, or lips, you'll end up with a solid white face, which is pretty creepy. The fix is to grab the Burn tool and do some darkening on a duplicate image layer after *you add the Threshold adjustment layer (so you can see what you're doing).*

Right: You can't get any contrastier than this! As you can see, the effect is eye-catching and unique.

> **TIP** If you've ever wanted to create Andy Warhol–style pop art portraits (also called *serigraphs*), applying a Threshold adjustment layer to your image is the first half of the technique. You'll learn the second half later in this chapter on page 367.

Before you get started, it's worth noting that this technique works better if your subject is on a solid white or light-colored background; if it is, the background will disappear when you make the adjustment. If the background is dark, you may have to clean it up later with the Brush tool set to paint with white. (If you have a photography business and you're considering selling photos with this technique applied, you'll want to *shoot* with this technique in mind.)

Here's how to use a Threshold adjustment layer to make a pure black-and-white image:

1. **Pop open a photo and then duplicate the image or background layer by pressing ⌘-J (Ctrl+J).**

 If your image consists of multiple layers, create a stamped copy instead (page 119). Either way, this maneuver creates a new layer on which you can do a little darkening with the Burn tool (which you'll do in step 3)—helpful if your image lacks shadows in areas of fine detail. If you like, go ahead and turn off the original layer's visibility.

2. **Create a Threshold adjustment layer.**

 Choose Layer→New Adjustment Layer→Threshold. You can also click either the Adjustments panel's Threshold icon (it looks like a rectangle with a couple of jagged black stripes across it), or the half-black/half-white circle at the bottom of the Layers panel and then choose Threshold. Whichever method you use, Photoshop displays the Properties panel, which includes a histogram (page 398) and a single slider. Drag the slider right to increase the amount of shadows in your image (making it more black), or left to increase highlights (making it more white). Your goal is to achieve a nice level of detail in the image and make sure folks can still tell what it's a photo *of*.

 TIP If you have trouble remembering what all the Adjustments panel's icons are for, just point your cursor at each one to make Photoshop display its name at the top of the panel.

3. **If necessary, press O to grab the Burn tool, activate the duplicate image layer (or stamped copy), and then darken parts of your image.**

 The lady in Figure 8-11 has pale skin, so you need to darken her lips, nose, and cheeks with the Burn tool to keep her features from *disappearing*. And since you've already added a Threshold adjustment layer, your edits appear in pure black and white, which lets you see the Burn tool's effect. If parts of the image become *too* dark, switch to the Dodge tool (shown in Figure 8-11) and paint across those areas to lighten them.

 You're basically finished at this point, but with a couple more steps you can put your high-contrast face on a bright red background to create the Che Guevara look shown in Figure 8-12.

4. **Create a smart object out of the face layer and the adjustment layer.**

 Shift-click to activate both layers in the Layers panel. Then open the Layers panel's menu and choose "Convert to Smart Object." Photoshop sandwiches *both* layers into a single smart object.

5. **Soften the smart object slightly with a dose of the Gaussian Blur filter (page 461).**

 The high-contrast version of the image is super sharp around the edges, but you can soften it up with a blur filter. In the Layers panel, make sure the smart object

is active, and then choose Filter→Blur→Gaussian Blur. Enter a pixel value of 0.5 to 2 depending on the pixel dimensions of your image (use a lower number for smaller images and a higher number for bigger ones), and then click OK.

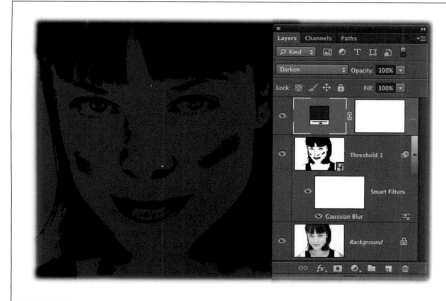

FIGURE 8-12

By adding a layer of solid color, you can create this popular look. Feel free to experiment with other background colors, too!

To change the color of the fill layer later on, just double-click its thumbnail to summon the Color Picker.

6. **Create a new layer for the red background.**

 Click the half-black/half-white circle at the bottom of the Layers panel and choose Solid Color. Photoshop opens the Color Picker, where you can pick a nice, bright red. Click OK to close the dialog box, and Photoshop adds the new layer to the top of your layer stack. (If the new layer appears somewhere else in your Layers panel, just *drag* it to the top.)

7. **Change the red layer's blend mode to Darken.**

 With the red layer active, use the unlabeled drop-down menu near the top of the Layers panel to change its blend mode to Darken. As you learned on page 299, blend modes in the darken category tell Photoshop to look at the colors on the active layer and the colors on the layers below and keep the darkest ones. In this case, those colors are black and red, so you end up with the black face on a red background. Pretty neat, huh?

8. **Save the document as a PSD file and rejoice at your creativity.**

The High-Key Effect

Another nifty black-and-white effect is known as *high key*. You can create this effect by aiming *tons* of lights at your subject (or, in this case, victim) and shooting a picture. This creates a high-contrast image—though not nearly as high-contrast as the technique explained in the *previous* section—where the shadows are shades of

gray and everything else is almost pure white. Fortunately, you can get this same look in Photoshop *without* a lot of lighting equipment. Mosey back to page 211 for the scoop on accomplishing this technique using channels.

Delicious Duotones

There are several reasons you may be interested in learning to create duotones. First, duotones can be drop-dead gorgeous and Photoshop includes a slew of scientifically developed presets. Second, duotones can save on professional printing costs. And third, you can use duotones to create some *seriously* high-end looking black-and-white prints, like the ones in Figure 8-13. (Most black-and-white images displayed in galleries actually contain a little bit of color!) To understand what's going on, you first need a quick primer on duotones—they're covered in more detail in Chapter 16—and a *brief* excursion into some of the color mode nitty-gritty you learned back in Chapter 5.

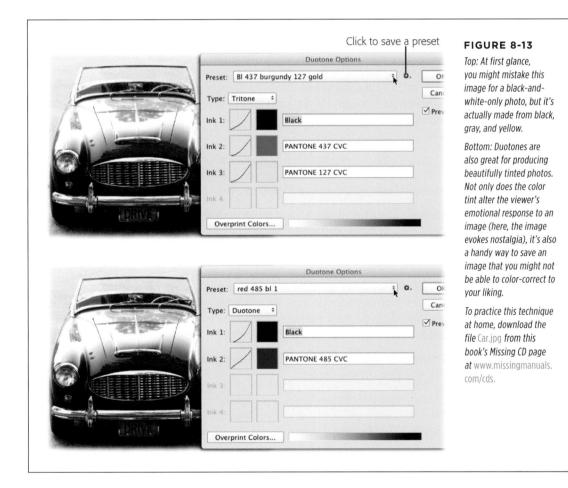

Click to save a preset

FIGURE 8-13

Top: At first glance, you might mistake this image for a black-and-white-only photo, but it's actually made from black, gray, and yellow.

Bottom: Duotones are also great for producing beautifully tinted photos. Not only does the color tint alter the viewer's emotional response to an image (here, the image evokes nostalgia), it's also a handy way to save an image that you might not be able to color-correct to your liking.

To practice this technique at home, download the file Car.jpg from this book's Missing CD page at www.missingmanuals.com/cds.

Duotone refers to an image that's made from two colors (black being one of them). Photoshop's Duotone mode lets you add special color combos to *genuine* grayscale images. (See the box on page 337 to learn what qualifies as *true* grayscale.) If you add one color to a grayscale image, you get a duotone. If you add another color, you get a *tritone* (grayscale plus two colors), and if you add one more you get a *quadtone* (grayscale plus three colors). For the purposes of this discussion and as far as Photoshop is concerned, the term "duotone" includes tritones and quadtones, too (as confusing as that is).

As you learned in Chapter 5, printing presses generally use CMYK ink that prints on four separate plates, which correspond to the four channels in CMYK mode. A duotone or tritone has fewer channels than that, so it prints on fewer plates—grayscale plus one or two special inks (for duotone and tritone, respectively)—and *that* reduces printing costs. So if your document is headed for a printing press, making a duotone is an affordable way to produce a striking, one-of-a-kind image. (See page 751 for the scoop on preparing duotones for print.)

Another reason to love duotones is that, because they're used so much in professional printing, Adobe has spent *beaucoup* bucks concocting color combinations that produce some of the most amazing images you've ever seen, though you can access them *only* in Duotone mode. In fact, most (if not all) award-winning black-and-white photos hanging in galleries aren't black and white at all—they're duo-, tri-, and quadtones with subtle color tints that give them extra depth and richness (Figure 8-13 shows two examples).

Even if your image *isn't* headed for a professional printer, you'll want to get your paws on Photoshop's built-in color combos. You can get at them by popping into—and then back *out* of—Duotone mode. Here's how:

1. **Make a copy of your document by choosing Image→Duplicate; convert the duplicate to black and white using one of the methods described earlier in this chapter; and then save it as a PSD file.**

 Since you'll flatten your document in the next step, it's safer to work on a duplicate so you don't accidentally save over your original document. It doesn't matter which method you use to convert the image to black and white; just don't let Photoshop do the conversion for you or you'll end up with a drab grayscale image like the one you saw back on page 330.

2. **Change the document's mode to Grayscale and let Photoshop flatten the file and discard the colors.**

 Choose Image→Mode→Grayscale and, when Photoshop asks if you want to flatten or preserve your layers (if you've got more than one), take a deep breath and click Flatten. Then, when it asks if you want to discard the image's color information, steel yourself and click Discard.

3. **Trot back up to the menu bar and choose Image→Mode→Duotone.**

 You have to be in Duotone mode to access the built-in color combos.

4. **In the Duotone Option dialog box, pick a color combo from the Preset menu.**

 Photoshop lists *hundreds* of duo-, tri-, and quadtones in this menu. In fact, you could spend a whole evening looking through all the options (highly recommended!). When you pick one, Photoshop sets the dialog box's Type menu to the appropriate option (Duotone, Tritone, or Quadtone).

 If you'd rather have a go at mixing colors *yourself*, pick Duotone, Tritone, or Quadtone from the Type menu. Next, click the little color squares below the menu to choose your inks (remember, Duotone mode thinks you're going to send this file to a professional printing press that uses actual ink). To save the color combination you create, click the gear icon to the right of the Preset menu (labeled in Figure 8-13, top) and give your combo a name. When you do that, Photoshop adds it to the Preset menu. When you're finished, click OK to close the Duotone Options dialog box. (Page 751 has more on creating custom duotone combos and the printing concerns that go along with making 'em yourself.)

5. **Return to the color mode from whence you came by choosing Image→ Mode→RGB.**

 Because Duotone mode is a special mode meant for *printing* (not editing), you don't want to hang around there. When you go back to RGB mode, you won't notice anything different—except the awesome new color of your image.

That's it! You just snatched your first color combo from Duotone mode. It's like bank-robbing for Photoshop experts.

▉ Changing Color

Photoshop is the ultimate recolorizing tool because it gives you the power to put a fresh coat of paint on *anything*. You can repaint clothing, vehicles, flowers...heck, you can even recolor *hair*. You can also use Photoshop to convert a photo into cartoonish pop art or *reverse* the color in an image, which is a handy for images that you use as textures. The next few pages describe how to perform all these stunts and more!

Hue/Saturation Adjustment Layers

If you're experimenting with a color change, start by creating a hue/saturation adjustment layer, which offers a friendly set of sliders that let you change the overall color of an image or a specific range of colors (see page 351). Because you're working with an adjustment layer, color changes take place on a separate layer, leaving the original image unharmed. And since a layer mask automatically tags along with the adjustment layer, you can use it to hide the color change from certain parts of the image.

If you take the time to select an object or specific area of the image *before* adding a hue/saturation adjustment layer, you can change the color in just that one spot. Here's how:

1. **Open an image and create a selection using one of the techniques from Chapter 4.**

 For example, to change the color of a car, you could use the Quick Selection tool to select it.

 > **NOTE** To practice the following technique, download the file *Corvette.jpg* from this book's Missing CD page at *www.missingmanuals.com/cds*.

2. **Add a hue/saturation adjustment layer.**

 To do so, choose Layer→New Adjustment Layer→Hue/Saturation. You can also open the Adjustments panel and click the Hue/Saturation icon (it looks like three vertical stripes above a gradient), or click the half-black/half-white circle at the bottom of the Layers panel and choose Hue/Saturation. No matter which method you use, Photoshop opens the Properties panel containing the three sliders shown in Figure 8-14, bottom. (In the Layers panel, notice how Photoshop automatically fills the adjustment layer's *mask* based on the area you selected! If you don't make a selection before adding the adjustment layer, the mask is empty and white—meaning the color change affects the *whole* image.)

3. **In the Properties panel, drag the Hue slider to change the selected area's color.**

 Hue is just graphic geeks' way of saying "color" (though technically it refers to *pure* color, before it's been tinted with white or shaded with black). As you drag the Hue slider, watch the two rainbow-colored bar near the bottom of the Properties panel. The upper bar shows the original color and the lower one shows what you're changing that color *to*. (In Figure 8-14, you can see the turquoise of the original Corvette at the far left of the top bars and the purple it's been changed to at the far right of the bar below it.) It's helpful to think of these bars as flattened-out color wheels (flip ahead to page 517 to see a *real* color wheel).

 > **NOTE** This color-changing trick works only on *colored* areas; anything that's black, white, or gray doesn't change one dadgummed bit.

4. **To adjust the new color's intensity, drag the Properties panel's Saturation slider.**

 To decrease the intensity, drag the slider to the left (if you drag it *all* the way to the left, you desaturate the image, making it look black and white). To increase the intensity, drag the slider to the right (if you drag it too far, the new color will be so vivid you'll need sunglasses, and skin tones will be an otherworldly hot pink). The slider itself gives you an idea of what this adjustment does: it ranges from gray on the left to a vivid red on the right.

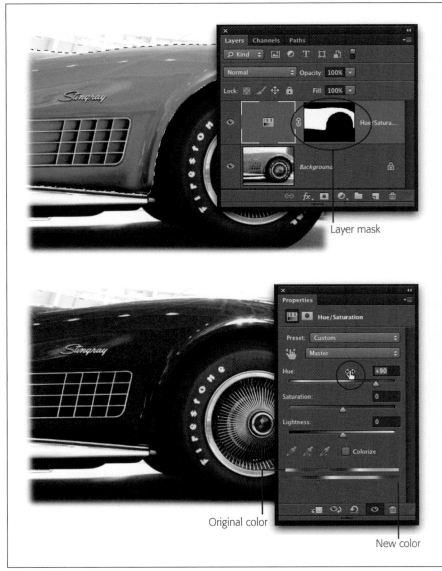

FIGURE 8-14

Top: If you select an object (like the car body shown here) before you add a hue/saturation adjustment layer, Photoshop automatically fills the adjustment layer's mask (circled) based on your selection, limiting the color change to that area. As shown here, the area outside of your selection appears black in the mask, thereby keeping the color change from being visible in that area.

Bottom: To change the colors of the selected area, grab the triangle-shaped Hue slider and drag it in either direction. If you point your cursor at the word "Hue" (without clicking), it turns into a scrubby cursor (circled) that you can drag left or right. The scrubby cursor does the same thing as the triangular sliders, but it's a bit easier to control.

Layer mask

Original color

New color

5. **To adjust the new color's brightness, drag the Properties panel's Lightness slider.**

 Lightness is what civilians call "brightness"; think of it as the amount of light shining on the selected object. Drag this slider left to darken the color or right to lighten it.

6. **Save the image as a PSD file.**

Doing so lets you go back and edit your color changes any time by double-clicking the hue/saturation adjustment layer's thumbnail in the Layers panel. This editing flexibility is extremely handy if you're recoloring an object for a nitpicky client (even if that client is you!).

Here are a few other handy settings lurking in the Properties panel for hue/saturation adjustment layers:

- **On-image adjustment tool.** This tool lets you pick a *range* of colors to adjust and then change the saturation of those colors—or the hue itself, if you know the trick—by clicking on the image instead of using the sliders. In the upper left of the Properties panel, give the tool a click to activate it (it looks like a pointing hand with a double-headed arrow), and then mouse over to your image; your cursor turns into an eyedropper. Click an area that's the color you want to change, and Photoshop activates the appropriate color channel in the Properties panel's Edit menu (described later in this list). Then, drag left to decrease the saturation (make the color less intense) or right to increase it (make the color more vivid).

 To use the on-image adjustment tool to change only the *hue* of the colors you clicked, ⌘-click (Ctrl-click on a PC) your image instead, and then drag left or right. To go back to changing saturation, release the ⌘ (Ctrl) key.

- **Preset menu.** This menu lets you choose from a few canned recipes for increasing saturation, boosting the reds or yellows, and so on. If you find yourself using the same hue/saturation adjustment layer settings repeatedly—you use it to produce a color tint as described later in this list, say—choose Save Hue/Saturation Preset from the Properties panel's menu. In the resulting dialog box, give your custom settings a meaningful name, and then click Save; from that point on, you can access 'em in the Preset menu. However, if you start tweaking the Properties panel's sliders, Photoshop sets this menu to Custom (Figure 8-14, bottom).

- **Edit menu.** This menu, which doesn't have a label, lets you pick the *color channels* you want to adjust (see Chapter 5). This menu is normally set to Master, which means you're changing the composite channel and affecting *all* the colors in your image. If you want to target a *specific* channel, pick it from this menu, and then any changes you make affect *only* the colors in that particular channel.

 For example, say you've got an image with too much red in it (a common problem in photos of people). You can choose the red channel from this menu and then drag the Saturation slider slightly left to desaturate the reds *without* affecting the other colors (a *great* method for fixing color casts that you can't get rid of any other way). If you don't know which channel to pick, use the on-image adjustment tool described earlier in this list to click a color in your image and make Photoshop pick the channel *for* you. Once you've picked a color to change, you can drag the panel's sliders like you normally would.

- **Eyedroppers.** The panel's three eyedroppers also let you pick the colors in your image that you want to change. You'll see these guys in action in the next section.

- **Colorize.** This setting lets you use the Hue slider to add color to an image that doesn't have any, like a black-and-white photo. If you're working with an image that *does* have color, turning on this checkbox adds a color tint to the whole image, much like the kind you can make with a gradient map adjustment layer or with Duotone mode, as shown in Figure 8-15.

> **TIP** Remember, you can restrict any adjustment layer so that it affects just *one* layer beneath it instead of *all* of the layers beneath it by clicking the icon at the bottom left of the Properties panel (it looks like a square with a down-pointing arrow to its left). This maneuver is handy when you've created a collage and want to apply *different* color tints to different layers.

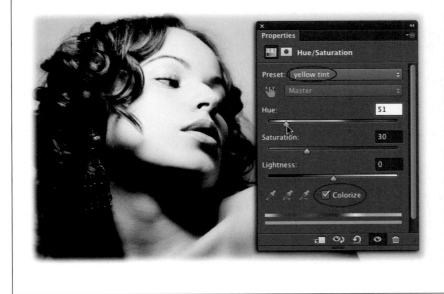

FIGURE 8-15

Turning on the Colorize checkbox (circled) lets you add a color tint to your image; use the Hue, Saturation, and Lightness sliders to create the look you want. To reuse the same settings later, save 'em as a preset by going to the Properties panel's menu and choosing Save Hue/Saturation Preset. In the resulting dialog box, give the settings a meaningful name ("yellow tint" was used here), click Save, and from then on you can access it in the preset menu (also circled).

■ TARGETING A SPECIFIC RANGE OF COLORS

When you add a hue/saturation adjustment layer, Photoshop assumes you want to change *all* the colors in your image, which is why the Properties panel's Edit menu is initially set to Master. But if you want Photoshop to change just the reds, yellows, greens, or whatever, then choose the appropriate option from that menu. To narrow your focus even *more*, you can use the on-image adjustment tool along with the Properties panel's eyedroppers to adjust very specific *ranges* of color.

Let's say your client can't decide which color scooter works best for their ad campaign. If the scooter's current paint job isn't super dark, you can do your experimenting in Photoshop rather than at the photo shoot (if the object is really dark, you can

try lightening it first). This technique is also handy when you need to change the colors in a photo to match the color palette of a design. Here's how to target and change a range of colors:

1. **Open an image and leave the background layer locked (if there is one).**

 If you're experimenting on an image that you've worked with before, this layer may be named something besides "Background." If the image is comprised of *many* layers, activate 'em all and then, in the Layers panel's menu, choose "Convert to Smart Object," or create a stamped copy (page 119).

2. **Add a hue/saturation adjustment layer as described in step 2 of the previous section.**

3. **Use the on-image adjustment tool to choose the color you want to change.**

 In the upper left of the Properties panel, click the on-image adjustment tool (the hand with the two arrows poking out of it), mouse over to your image, and then click the color you want to change (the red scooter, for example). Photoshop picks the predominant color channel in the panel's Edit menu (in Figure 8-16, this menu is set to Reds) and marks that color range with a small gray bar *between* the two rainbow-colored bars at the bottom of the panel (circled in Figure 8-16, top).

TIP If you duplicate the adjustment layer by pressing ⌘-J (Ctrl+J), you can experiment with all kinds of scooter colors before heading to the body shop!

4. **Use the Properties panel's eyedroppers to fine-tune the range of colors that'll be affected.**

 The eyedroppers let you add or subtract colors from the targeted range you picked in the previous step. For example, to expand the range to catch all the different shades of red in the scooter, grab the eyedropper with a + sign, mouse over to your image, and then click another part of the scooter (you'll see the gray bar circled in Figure 8-16, top, get a little wider). To narrow the range of colors, use the eyedropper with a – sign to subtract the colors you don't want to change.

 As usual, Photoshop gives you several ways to do the same thing. You can also edit the color range by dragging the tiny sliders on the gray bar circled in Figure 8-16, top, which is two different shades of gray. The light gray part in the middle of the bar represents the hues that will change *completely* when you make a change (to see those hues, just look at the rainbow-colored bars directly above and below the gray one), and the darker gray parts on either end of the bar represent hues that will *partially* change. To narrow the range of colors, drag the little half triangles on the ends of the bar *inward* toward the middle of the bar; to widen the range, drag them *outward*.

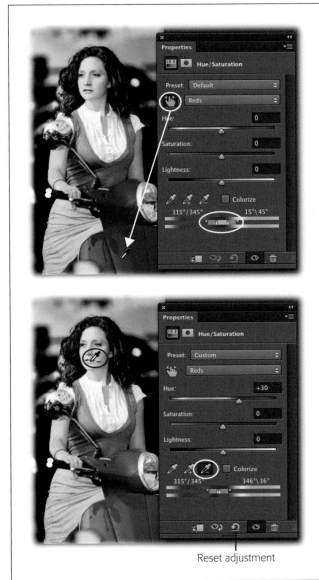

FIGURE 8-16

Top: Instead of changing all the colors in an image, you can use the Properties panel's Targeted Adjustment tool and eyedroppers to target a certain color range. When you click the on-image adjustment tool (circled, top), the unlabeled Edit menu near the top of the panel changes to reflect the predominant color channel for the part of the image you clicked (in this case, Reds), and the small gray bar near the bottom of the panel indicates the color range you picked (circled, bottom).

Bottom: If other parts of the image start changing color as you adjust the panel's sliders—such as this girl's face and skin—just grab the eyedropper with a minus sign (circled) and click those areas to make Photoshop leave 'em alone, as shown here. You can also start over anytime by clicking the Reset icon labeled here.

Alternatively, instead of moving the panel's sliders, you can use the on-image adjustment tool. Once you activate the tool, click the color in your image that you want to change, keep holding down your mouse button, and then drag left to make that color less intense (desaturate) or drag right to make it more intense (saturate). To change the hue instead, ⌘-drag (Ctrl-drag on a PC) left or right.

If the gray bar representing your targeted color range (technically called the range indicator) gets split across the left and right ends of the rainbow bars, press ⌘ (Ctrl on a PC) and drag the pieces to the left or right until the bar is in one piece.

If you'd like to follow along, download the file Scooter.jpg from this book's Missing CD page at www.missingmanuals.com/cds.

Reset adjustment

5. **Recolor the scooter by tweaking the Properties panel's Hue, Saturation, and Lightness sliders as discussed in the previous section.**

Photoshop reflects your changes in real time, so you can watch as the scooter changes from green to blue to magenta. Good times!

6. **If necessary, use the adjustment layer's mask to hide the color change from parts of your image.**

When you move the Hue slider, you may notice that the scooter isn't the *only* thing that changes color. If any part of the image is similar in color to the area you're targeting, it may change, too. To fix this, you can try using the + and – eyedroppers to exclude those areas (as described in step 4), but that may not work if the colors are really similar. In that case, use the adjustment layer's mask to keep the rest of the image from getting a color makeover. Just activate the mask thumbnail in the Layers panel, press B to grab the Brush tool, and set your foreground color chip to black (press X if you need to flip-flop color chips). Then mouse over to your image and paint the parts that you *don't* want to change. If you hide too much, flip-flop your color chips by pressing X, and then paint the area white.

> **NOTE** If you decide to edit the hue/saturation adjustment layer later—assuming you've saved the document as a PSD file—remember to set the Properties panel's unlabeled Edit menu to the color channel you edited. Although Photoshop remembers all the changes you make with the *sliders*, it can't remember which color channel you used, so it resets this menu to Master each time you double-click the hue/saturation adjustment layer's thumbnail in the Layers panel. Consider yourself warned.

You can use this technique to experiment with hair color before heading to the salon. But if your skin color is similar to your hair color, select your hair *before* adding the hue/saturation adjustment layer. (The Refine Edge dialog box makes it easy to select wily wisps of hair. Page 181 has the scoop.)

Hue Blend Mode

Another easy way to repaint an object is to put the paint on a separate layer and then change the paint layer's *blend mode* to Hue. (As you learned in Chapter 7, blend modes control how color on one layer interacts with color on another; page 308 explains how the Hue blend mode works.)

To give this method a spin, open an image and then create a new layer by pressing Shift-⌘-N (Shift+Ctrl+N). In the resulting New Layer dialog box, type *paint* into the Name field, change the Mode drop-down menu to Hue, and then click OK. Next, press B to grab the Brush, click your foreground color chip, pick a color from the resulting Color Picker, and then click OK. Then, with the new layer active, start painting over the object as shown in Figure 8-17.

> **NOTE** To try this technique yourself, download the file *Superbike.jpg* from this book's Missing CD page at *www.missingmanuals.com/cds*.

If you end up changing too much color, temporarily switch to the Eraser tool by pressing and holding the E key (the tool's keyboard shortcut). Or you can fix the problem by adding a layer mask to the paint layer and then hiding the areas you want to leave unchanged by painting them black.

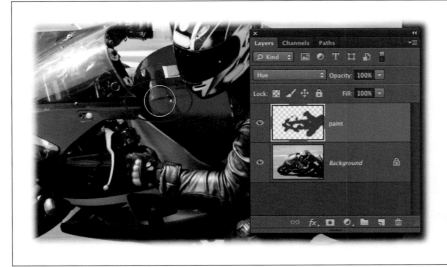

FIGURE 8-17

The goal here is to turn this red motorcycle blue. If the area you want to repaint has a lot of black, white, and gray around it (like this bike), you can paint right over those areas and they won't change (note the brush cursor circled here). Why? Because, in Hue blend mode, the new paint affects only areas that previously contained color.

Selective Color Adjustment Layers

Selective color adjustment layers are gloriously useful because they let you make a single color in an image brighter or darker—helpful when you need to make whites whiter or blacks blacker. You can also use them to shift one color to another, but that technique can be a bit challenging if you don't know anything about color theory (that is, mixing certain colors together to create *other* colors).

To add a selective color adjustment layer, choose Layer→New Adjustment Layer→Selective Color. You can also click the Selective Color icon in the Adjustments panel (it looks like a square divided into four triangles), or click the half-black/half-white circle at the bottom of the Layers panel and choose Selective Color.

Then, from the Colors menu at the top of the Properties panel, choose the color *closest* to the one you want to change. For example, to change the color of the bike and the matching leathers shown in Figure 8-18, choose Reds. Next, use the panel's Cyan, Magenta, Yellow, and Black sliders to change that color to something else. (Don't let it throw you that these sliders represent the CMYK color mode—they work just fine on RGB images.)

FIGURE 8-18

With a well-placed selective color adjustment layer, you can change this red bike and matching leathers to hot pink in seconds. Just point your cursor at one of the Properties panel's sliders; when the cursor pointer turns into a scrubby cursor like the one shown here (top), drag left or right.

To try this technique yourself, download Superbike.jpg from this book's Missing CD page at www.missingmanuals.com/cds.

The direction you drag each slider determines how the color you chose in the Colors menu changes. By dragging a slider to the left, you decrease the percentage of that color. For example, if you choose Reds from the Colors menu and then drag the yellow slider all the way to the left, you drain all the yellow out of the reds, making them look hot pink (as shown in Figure 8-18). If you drag a slider to the right, you increase the percentage of that color. (How can you know what color you'll end up with after some quality slider dragging? Through experimentation or by learning to read a color wheel. Flip to page 518 for a short lesson that'll get you started.)

Replacing Color

You can use the Replace Color command to select one color and swap in another. This command works *really* well if the color you want to change is fairly consistent

and concentrated in one area, like the car in Figure 8-19. This command lets you choose a paint color from a color picker, which is a bit easier than trying to mix the color yourself using a bunch of sliders (as you did in the previous section).

NOTE To follow along with this technique, download *Vintage.jpg* from this book's Missing CD page at *www. missingmanuals.com/cds.*

Start by duplicating your image layer or, if the image is comprised of multiple layers, creating a stamped copy by of all visible layers by pressing Shift-Option-⌘-E (Shift+Alt+Ctrl+E). Next, choose Image→Adjustments→Replace Color to summon the Replace Color dialog box shown in Figure 8-19. Photoshop automatically activates the Eyedropper tool, so just click in your image to tell Photoshop what *predominant* color you want to change (you may need to move the dialog box to get a good view of your image), and that color appears in the Color square in the dialog box's top right. Next, use the dialog box's eyedropper tools to add to or subtract from the range of colors you want to change. Stop clicking when the selection preview in the middle of the dialog box looks good to you.

FIGURE 8-19

Photoshop displays a preview of your selection in white. It can be helpful to zoom into your image while you're using the eyedroppers to fine-tune the selection (just press ⌘-+ [Ctrl-+] repeatedly).

Since Replace Color isn't available as an adjustment layer, it affects your original image, so it's a darn good idea to duplicate the image layer (or create a stamped copy) before using this command. (Alas, Replace Color doesn't work on smart objects—darn!)

At the bottom of the dialog box, click the color square above the word "Result" to choose a new hue from the Color Picker. When you click OK, the new color appears in the square and in your image. To adjust the color you picked, use the dialog box's Hue, Saturation, and Lightness sliders.

If you think you'll want to reuse the selection you made—if it's likely you'll need to experiment with different colors for the object, say—click the dialog box's Save

button. In the dialog box that appears, give the selection a meaningful name (say, Car), and then click Save. To load the selection again later, open the Color Range dialog box and click its Load button. In the resulting dialog box, click the selection's name, click Open, and Photoshop loads the selection for you. Sweet!

Matching Colors

The Match Color command makes the colors in one image resemble those in another. It's a *huge* timesaver when you're working with several images in a magazine spread or book and need to make their colors somewhat consistent (see Figure 8-20). Since this command isn't available as an adjustment layer, be sure to *duplicate* your image layer first by pressing ⌘-J (Ctrl+J on a PC). (If your image consists of multiple layers, create a stamped copy instead [page 119]; this command doesn't work with smart objects.)

To get started, open two images in RGB mode: the one whose color you're trying to match (the *source*) and the one whose color you want to change (the *target*). Next, click within the target document to activate it, and then choose Image→Adjustments→Match Color. In the resulting dialog box (Figure 8-20), Photoshop automatically picks the current document as the target. Tell Photoshop the name of the source document by choosing it from the Source menu in the lower half of the dialog box (you'll see a thumbnail of the image at the bottom right).

FIGURE 8-20

The Match Color dialog box lets you copy the colors from one image (like the golds in the tiny image on the left here) onto another. The result? The golden-hued bike shown at bottom right. You can use the Luminance (lightness) and Color Intensity (saturation) sliders to make the colors match a little better, and adjust the Fade slider to use more or less of the source document's original color. If your target image has a color cast, turn on the Neutralize checkbox and Photoshop tries to get rid of it for you.

If the source document has several layers, use the dialog box's Layer menu to choose the one whose colors you want to match, or choose Merged to have Photoshop

combine those layers into one (handy if you've used several adjustment layers to create the color you want). If the source document has only one layer, Photoshop automatically chooses it in this menu.

To confine your color-matching to specific spots in the source and target images, create selections in each document before opening the Match Color dialog box. If the dialog box detects an active selection, it lets you turn on the "Use Selection in Source to Calculate Colors" and "Use Selection in Target to Calculate Adjustment" checkboxes, both of which can be helpful when you're trying to match colors in two different images—skin tones, for example.

TIP If you've got a source color that you might want to use on other images, save your Match Color settings as a preset: When you get everything just right, click the dialog box's Save Statistics button, and then give your preset a name. The next time you want to use those settings, you won't have to open the source image—just open the Match Color dialog box, click Load Statistics, and then choose your preset.

Photo Filter Adjustment Layers

Photo filter adjustment layers let you *gently* adjust the colors in an image, as if you'd attached a subtly colored filter to your camera's lens. For example, you can quickly warm an image with golden tones like those in the "after" photo in Figure 8-21. The effect is fairly subtle, making the image look like it's been *lightly* tinted with a color rather than having its color changed completely.

FIGURE 8-21

Photo filter adjustment layers are really handy when you've combined images whose color doesn't quite match or when you want to add a subtle, barely there tint to an image.

A warming tone was added to this image, as indicated by the change in the background color; however, it's barely visible atop the subject.

To get started, click the Photo Filter icon in the Adjustments panel (it looks like a camera with a circle on it) or click the half-black/half-white circle at the bottom of the Layers panel and choose Photo Filter. Then, in the Properties panel's Filter menu,

choose from a list of 20 presets that range from warming and cooling filters to shades of red, violet, and so on. Or, to choose your own color instead, select the Color option, and then click the color swatch to its right; choose a color from the resulting Color Picker, and then click OK. You can use the Density slider to soften or strengthen the effect (just pretend the slider is called "intensity"). Keep the Preserve Luminosity checkbox turned on to prevent Photoshop from lightening or darkening the image.

You can also use photo filter adjustment layers to reduce color casts. For example, if your image has a strong blue cast, you can neutralize it by introducing a little orange with a photo filter adjustment (orange is opposite blue on the color wheel). If your image has a yellow cast, use purple to even it out. Skip to Chapter 12 to learn more about color wheels.

Posterizing: Your Ticket to Cartoon Art

You'll only use this adjustment once in a blue moon, but if you need to make an image look like a cartoon, a posterize adjustment layer is just the thing. Choose Layer→New Adjustment Layer→Posterize or, in the Adjustments panel, click the Posterize icon (the one with diagonal stripes). (You can also click the half-black/half-white circle at the bottom of the Layers panel and choose Posterize.) Photoshop analyzes the image's colors and throws out the majority of 'em, leaving you with big ol' blocks of solid color. On some images, posterizing has interesting results, as Figure 8-22 shows. On other images...not so much.

FIGURE 8-22

Posterizing doesn't work well on portraits (unless you use a Blur filter afterward to smooth the image's edges). But on images with relatively solid colors, like this one, the results are pretty neat, as you can see on the right.

Using Color Lookup Adjustment Layers

Yet *another* way to alter the color in images is to use color lookup adjustment layers, which were introduced in CS6 but went relatively unnoticed. These layers take their name from *color Lookup Tables*—LUTs, in geek circles—which are used in the film industry to apply the overall color and lighting of one film clip to another and to apply a creative look to footage. These tables specify how the colors in an image are *remapped* to completely new ones.

To use a color lookup adjustment layer, click the half-black/half-white circle at the bottom of the Layers panel and choose Color Lookup. Photoshop then opens the Properties panel, which includes two categories of presets: Abstract and Device Link. (If you're on a Mac, you've got six more LUTs in the Abstract category than Windows folks, simply because of how OS X handles graphics.) Pick a preset to see how it affects your image.

New in Photoshop CC 2014, you can *create* and *export* LUTs for use in Photoshop and other image- and video-editing programs such as Adobe Premiere Pro, SpeedGrade, and After Effects. To make your own LUT, use any of the techniques discussed in this chapter to infuse your image with creative color. Next, choose File→Export→Color Lookup Tables. In the resulting dialog box, enter a name for the LUT in the Description field. Type your name in the Copyright field (Photoshop automatically adds the copyright symbol and year to the exported files), pick a quality setting, and choose which formats to export (or export them all). Click OK and Photoshop creates the necessary files, which takes a little while.

You can then add the LUT to Photoshop, so it's accessible in a color lookup adjustment layer, by copying the exported file(s) to *Applications/Photoshop CC 2014/Presets/3DLUTs*. On a PC, they're in *C:Program Files\Adobe\Adobe Photoshop CC 2014\Presets\3LUTs*.

These presets are incredibly handy for producing creative color effects. Even if you *never* create your own LUT, there are a slew of them to experiment with. When you've got some free time, grab your favorite beverage, pop open an image, and take 'em for a spin!

Inverting Colors

Graphic designers, this one's for you! If you need to reverse the colors in an image—turning orange to blue, yellow to purple, and so on—you can add an invert adjustment layer.

TIP To find out the *reverse* (or opposite) of a color, use a color wheel like the one on page 517.

If you're a photographer, you'll use this adjustment even *less* often than posterize because it turns most images into negatives (which might be useful on Halloween). That said, if you've got an image of a black silhouette that you want to make white, this adjustment layer can do that in one click (see Figure 8-23). To add an invert adjustment layer, choose Layer→New Adjustment Layer→Invert, or open the Adjustments panel and click the Invert icon (the half-black/half-white icon with the half-black/half-white circle in it). You can also click the half-black/half-white circle at the bottom of the Layers panel and then choose Invert.

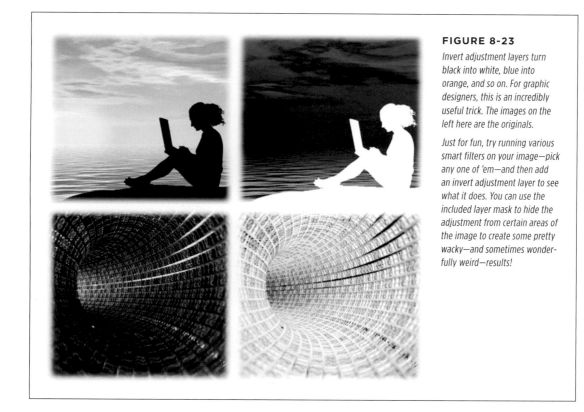

FIGURE 8-23

Invert adjustment layers turn black into white, blue into orange, and so on. For graphic designers, this is an incredibly useful trick. The images on the left here are the originals.

Just for fun, try running various smart filters on your image—pick any one of 'em—and then add an invert adjustment layer to see what it does. You can use the included layer mask to hide the adjustment from certain areas of the image to create some pretty wacky—and sometimes wonderfully weird—results!

Adding Color

There will be times when you want to *add* color that wasn't originally part of an image, and Photoshop gives you lots of ways to do that. The techniques in this section will serve you well whether you're colorizing a black-and-white image or adding color to an empty canvas. Read on!

> **NOTE** A few versions of Photoshop ago, you could use a variations adjustment to add color that wasn't originally in an image. Then, in more recent versions, the adjustment worked only in 32-bit mode in Windows. But in Photoshop CC 2014, Adobe removed the variations adjustment completely.

Colorizing Images

Due to the expense of color film, full-color images didn't become commonplace until the late '60s. So chances are good that you've got some vintage black-and-white photos lying around, just dying to be scanned. Happily, you can use Photoshop to give them a little color (which, by the way, can be a nice side business if you get really good at it). Colorizing a black-and-white (or true grayscale) photo *seems* straightforward—just grab a brush and paint the image. Unfortunately, while that method adds color, it *also* covers up all the photo's details, as shown in Figure 8-24, left.

FIGURE 8-24

Left: Unless you change the paint layer's blend mode, the paint covers up all the details of this girl's cute dress.

Right: Setting the paint layer's blend mode to Color lets the details come shining through.

> **TIP** Before you colorize a black-and-white image, choose Image→Mode and make sure the document's color mode is set to RGB Color. If it's in Grayscale mode, Photoshop won't let you add any color no matter *how* hard you try.

Fortunately, you can use blend modes to add color while keeping an image's details intact. Here's how:

1. **Add a new layer for the paint and change its blend mode to Color.**

 Since you don't want to mess up your original image by painting directly on it, you need to add a new layer. Press Shift-⌘-N (Shift+Ctrl+N) and, in the New Layer dialog box, name the layer *pink paint* and set the Mode menu to Color; then click OK. (As explained in the box on page 366, this mode not only keeps the brightness of the gray tones in your photo, it will also add the hue and saturation values from the paint you're about to add, letting the details of the image show through.) Make sure the paint layer is positioned above the photo layer in your layer stack.

 NOTE To follow along, visit this book's Missing CD page at *www.missingmanuals.com/cds* and download the file *Dress.jpg*.

2. **Grab the Brush tool and set it to whatever color you want to paint the dress.**

 Press B to activate the Brush tool. Then, in the Tools panel, click the foreground color chip, choose a nice pastel color from the Color Picker, and then click OK.

 TIP In Photoshop CC 2014, the Color panel can serve as a color picker that's *always open*. If the panel isn't already visible in the upper right of your screen, choose Window→Color and then, from the Color panel's menu, choose Hue Cube (if it's not set to that already). Poof! You've got yourself a mini color picker that you can use to *quickly* change your foreground color chip. See page 527 for more info.

3. **Paint the part of the image that you want to colorize.**

 It's a good idea to zoom into the image when you're doing this kind of detailed work. You can use the Zoom tool, press ⌘-+ (Ctrl-+ on a PC) repeatedly, or use any of the other zooming techniques described on page 56.

4. **To fix any mistakes, use the Eraser tool set to Brush mode.**

 Press and hold down the E key to temporarily switch to the Eraser tool. While still holding down the E key, set the Options bar's Mode menu to Brush, and then pick a soft-edge brush from Brush Preset picker. Then, to fix your mistake, mouse over to your document—while *still* holding down the E key—and paint across the areas that don't need painting. When you're finished, release the E key to switch back to the Brush tool. (Alternatively, you can add a layer mask to the paint layer and then hide your mistakes using a brush set to paint with black.)

5. **When everything looks good, save the document as a PSD file to preserve your layers.**

 If you decide to change the little girl's dress to yellow instead of pink, simply load the paint layer as a selection by ⌘-clicking (Ctrl-clicking on a PC) its thumbnail in the Layers panel, and then use a hue/saturation adjustment layer to change the color (page 347). That's a *heck* of a lot quicker than repainting the dress! But don't tell anyone—let 'em think it took you hours.

Just think how much fun you can have using this technique with a graphics tablet and the Rotate View tool (page 62)! Another option is to *select* the area you want to paint, add a solid color fill layer, and change its blend mode to Color. The benefit of the latter method is that you can experiment with paint color *after* you've finished painting; simply double-click the fill layer's layer thumbnail to reopen the Color Picker. If you need to adjust where the paint is visible, click the fill layer's mask and use the Brush tool set to paint with black (to *conceal* the paint) or white (to *reveal* the paint). You'll see this technique in action on page 369.

Which method should you use? If you'll do a lot of experimenting with the color you're adding, go with a solid color fill layer. Otherwise it's one of those "six of one, half a dozen of the other" situations—just pick the technique you like best.

ADDING DIGITAL MAKEUP TO PORTRAITS

You can use the colorization technique you just learned to add *digital* makeup to portraits. Follow the steps in the previous section but instead of picking the *Color* blend mode in step 1, choose *Overlay*. Then, in steps 2 and 3, paint makeup onto your subject. To help the makeup blend in with surrounding pixels, you may need to blur the paint layer(s) by choosing Filter→"Convert for Smart Filters," and then choosing Filter→Blur→Gaussian Blur. You'll need to experiment with the filter's Radius setting; 10 pixels was used on the 1698 × 1131 pixel image in Figure 8-25.

Instead of painting on a regular image layer to add the makeup, you can use a solid color fill layer as mentioned at the end of the previous section. Doing so lets you experiment with color a little more easily. For example, you can convert the fill layer for smart filters, run a blur filter on it, and then double-click its layer thumbnail to open a temporary Photoshop document containing your original fill layer. To change its color, double-click its layer thumbnail and the Color Picker opens. When you're finished, choose File→Save, and then close the temporary document. Photoshop then reflects your color changes in the *original* document. Sweet!

> **TIP** In some cases, you might want to run the blur filter *twice* so the new makeup blends in better with the rest of the image. To rerun the last filter you used, press ⌘-F (Ctrl+F). And after blurring the digital lipstick, you'll likely need to add a layer mask to hide any paint that now extends beyond your subject's lips.

FIGURE 8-25

When adding digital makeup, you'll get better results if your subject has some makeup on before you take the picture—even if it's a subtle neutral color, as shown on the left—so you've got realistic texture to work with.

Add each piece of makeup on a separate layer so you can soften it using a blur filter (page 461), lower its opacity (35% was used here), and fine-tune its color using a hue/saturation adjustment layer that's attached to the layer below it, a shown here (see step 5 in the previous section for details).

POWER USERS' CLINIC

Adjustment Layer Blend Modes

When you're adding or shifting colors with adjustment layers, you can experiment with changing the adjustment layer's blend mode, too. For example:

- The **Hue** blend mode alters the image's color but not its brightness (how dark or light it is) or saturation (how intense the colors are). This mode is useful for changing an object's color, as described on page 354.

- The **Color** blend mode changes the image's color and saturation but leaves its brightness alone—handy when you're adding color.

- The **Luminosity** blend mode changes the image's brightness but not its color—helpful when you need to lighten or darken an image.

If you want to change the adjustment layer's blend mode *before* you add the adjustment layer—so you can actually *see* what the adjustment looks like as you're making it—Option-click (Alt-click on a PC) the half-black/half-white circle at the bottom of the Layers panel. Photoshop then opens the New Layer dialog box so you can name *and* change the blend mode of the adjustment layer you're about to add. To learn more about blend modes, check out page 296.

Adding Solid Blocks of Color

Remember the high-contrast face from earlier in this chapter (page 342)? With just a little modification and a few well-placed blocks of color, you can turn that face into an Andy Warhol–style portrait like the one in Figure 8-26.

FIGURE 8-26

You can create all kinds of interesting art by adding color to images (this technique produces a serigraph).

If you downloaded Girl. jpg and used it to follow along with the high-contrast face tutorial back on page 342, you can use that edited image for the maneuver described in this section.

Flip back to page 343 and follow steps 1–4 to add a Threshold adjustment layer to create a high-contrast face. Then, once you've got yourself a smart object, follow these steps:

1. **Select all the black areas in the smart object you created.**

 Grab the Quick Selection tool or the Magic Wand, click a black area, and then choose Select→Similar to make Photoshop grab *all* the black bits in the smart object. By creating a selection first and *then* adding the fill layer, Photoshop will only apply the color you're about to add to the selected areas.

2. **Add a solid color fill layer (page 93) and choose black from the Color Picker.**

 This maneuver puts all the shadows in your image onto a single layer with transparency so that the colored background you'll add in step 10 will be visible beneath 'em.

3. **In the Layers panel, double-click the new layer's name and rename it** *shadows.*

 Since you're about to add a bazillion layers, it's helpful to give each one a descriptive name.

4. **Turn off the original photo layer's visibility.**

 You don't need the original layer anymore, so go ahead and turn it off. Now you're ready to start adding color!

5. **Grab the Polygonal Lasso tool and draw a loose selection around the woman's face and shoulders (Figure 8-27, top left).**

Since the Polygonal Lasso tool uses straight lines, it's perfect for creating blocks of color. Just click once where you want the selection to start and then click again each time you need to change angles. Don't worry about being precise; the point is to make it blocky. When you're finished, close your selection by putting your cursor over the starting point. When you see a tiny circle next to the cursor (it looks like a degree symbol), click once to complete your selection.

6. **Add another solid color fill layer named *skin*, pick a nice peachy color for the woman's skin, and then position this layer *below* the face layer.**

Sure, you could add a new layer and then manually fill it with color, but using fill layers makes it a breeze to change colors later on.

7. **Create a selection around the woman's lips, add a solid color fill layer named *lips*, choose hot pink from the Color Picker, and then change the layer's blend mode to Darken.**

As in step 3, use the Polygonal Lasso to create a selection, but this time select the area around her lips. Remember, you want to make the colored areas blocky, so don't be afraid to make your selection go *outside* of her lips. Next, Option-click (Alt-click on a PC) the half-black/half-white icon at the bottom of the Layers panel and choose Solid Color. In the resulting New Layer dialog box, enter *lips* in the Name field and set the Mode menu to Darken (this lets the black face layer show through the color you're adding).

8. **Keep repeating step 7 to give her some eye shadow and to add color to the iris of each eye.**

When you're done, your Layers panel should look something like the one in Figure 8-27.

9. **Follow the instructions in Figure 8-27 to create multiple versions of the portrait.**

10. **Create a background for the whole shebang by adding a solid color fill layer, choosing a bright color from the Color Picker, and then making this layer your background.**

Drag this layer *below* the skin layer so it becomes the background of the whole piece of art you're building. (You don't need to change the blend mode of this layer—Normal is fine.)

Congratulations—you've just finished your first Warhol-style portrait! The really fun thing about this technique is how creative it lets you be (not to mention that you're using almost every skill you've learned in the preceding chapters). Sure, you *could* seek out Warhol's pop-style art online and use the same colors he did, but what fun is that? By using your own vision, you're creating something unique. Try experimenting on pet pictures and images of people with light-colored hair. (If the model for this portrait were blonde, you could color her hair, too.) The possibilities are endless!

FIGURE 8-27

To make five more versions of this portrait, activate the layers that make up this version and stuff them into a group by pressing ⌘-G (Ctrl+G). This helps you keep track of each version and makes creating additional versions easier: just duplicate the layer group instead individual layers. And since you wisely used solid color fill layers, changing colors is as simple as double-clicking a layer's thumbnail to reopen the Color Picker. Because your duplicated layer group is positioned on top of the original, toggle the visibility of each group off or on while you're chang-ing colors. Once you've created several versions of the portrait, enlarge your canvas and use the Move tool to position the layer groups next to one another to create the artwork shown back in Figure 8-26.

Building a Better Sunrise (or Sunset)

Believe it or not, you can use a gradient map adjustment layer to turn a mediocre sunrise photo into something spectacular. Rather than letting you add just one color to your image, gradient map adjustment layers let you add as many colors as you want. Here's how to use one to add a punch of color to a big ol' boring sky:

1. **Add a gradient map adjustment layer and change its blend mode to Color.**

 Option-click (Alt-click on a PC) the half-black/half-white circle at the bottom of the Layers panel and choose Gradient Map. In the resulting dialog box, name the layer *sun* and set the Mode menu to Color. (That way, the gradient you're

about to add will affect only the image's color values and not its lightness values; see page 309 for more on this blend mode.) Click OK and Photoshop adds the new layer and opens the Properties panel. Don't worry about what color the gradient is—you'll pick colors in the next step.

2. **In the Properties panel, open the Gradient presets menu.**

 Click the downward-pointing triangle labeled in Figure 8-28, left, to open the presets menu. In the menu that appears, you can choose a preset gradient (best for newcomers) or make one of your *own* by performing the next couple of steps (which requires a bit of patience and practice).

 You can load even *more* built-in gradient recipes by clicking the gear icon at the top right of the presets menu (also labeled in Figure 8-28). In fact, there's a nice orange-to-yellow gradient lurking in the Color Harmonies 2 set that works quite well for this technique. If you go that route, when Photoshop asks if you'd like to replace your current gradients with the new set, click Append to make Photoshop add the new gradients *beneath* the factory set. Locate the aforementioned orange-yellow gradient and give it a swift click.

 You're basically done at this point, but if you want to build your own gradient, keep on truckin' through the next two steps.

FIGURE 8-28

As you can see, a gradient map adjustment layer set to Color mode took this sky from boring to beautiful by adding a gradual blend of bright colors. To reverse the gradient's colors—say, to turn a sunset into a sunrise—turn on the Properties panel's Reverse setting (not shown).

If you want to keep any part of your image from being affected, click the adjustment layer's mask thumbnail in the Layers panel, grab the Brush tool, and then paint those areas with black.

Gradient presets Click to load more presets

3. **In the Adjustments panel, click the gradient preview to open the Gradient Editor and then tweak the color stops to create a yellow-to-orange-to-red gradient.**

The Gradient Editor dialog box contains colored squares called *color stops* (see Figure 8-29) that you can drag around to control the width of the color fade. When you click a stop, its color appears in the Color field (also called a *color well*) at the bottom of the dialog box. To change the stop's color, click the color well and Photoshop opens the Color Picker.

To add a new stop, click *between* existing color stops.

Once you click a color stop, tiny diamonds appear beneath the gradient that you can drag left and right to determine where one color stops and another one starts.

FIGURE 8-29

The Gradient Editor lets you choose from tons of existing gradients (click the gear icon circled here to load another gradient set), or create your own by editing any of the presets and adding color stops.

If you create the perfect sunset gradient, save it by clicking the Gradient Editor's Save button and then giving it a name. Photoshop adds it to the Gradient presets menu, giving you easy access to it in the future.

Happily, the Gradient Editor got a couple of upgrades in Photoshop CC 2014. For example, you can now create a gradient that has just one color stop. To create variations in that color, use the two opacity stops that appear beneath the gradient preview (one appears at the far left and another at the far right). You can also add a new color stop that's the same color as what's in the gradient preview bar at any given point by Option-clicking (Alt-clicking on a PC) beneath the gradient preview.

Click to change stop color Color stops

4. **Save the document as a PSD file in case you want to edit it again later.**

You're all finished! Nothing like a beautiful sunset, is there?

Adding Color to a Semi-Transparent Layer

If the item you want to colorize lives on its own layer *and* it has some transparent (empty) areas, you can skip creating a selection or painting the darn thing, and simply use a fill layer that's *clipped* to that layer instead. This causes Photoshop to shove the contents of the fill layer *through* whatever's on the layer below it.

This handy maneuver makes colorizing a vector embellishment, brushstroke, or even *text* an absolute piece of cake (see page 664 for a similar technique involving shoving a photo through text). Figure 8-30 explains how to do it, and offers practical examples for photographers *and* designers.

FIGURE 8-30

Be sure to place the fill layer above the layer containing the art you want to colorize. Then just press the Option key (Alt on a PC) while you point your cursor at the dividing line between the two layers in the Layers panel; when your cursor turns into a square with a down-pointing arrow (shown here), click to clip the fill layer to the layer below it.

For photographers, adding a colored vector embellishment to a photo (like the swirly stars in the top image) can produce another sellable product. For designers, things like the colored shamrocks in the bottom image add visual interest and depth to ads.

Correcting Color and Lighting

When you think about all the variables that come into play when you're capturing images, it's a wonder *any* photos turn out halfway decent. You're dependent on Mother Nature or the quality of artificial lighting, and even then it's easy to over- or underexpose an image. You need a good camera that can snap the shot before you miss it, a high-quality lens, and so on. Even if the stars are aligned and you get all that right, the camera itself may introduce a *color cast*, making your image look like it has overdosed on a particular color.

All these variables mean you need to spend some time correcting both the color and the lighting of your images. Not to worry: You've got an *arsenal* of tools at your disposal in Photoshop and its trusty sidekick, Camera Raw. In this chapter, you'll learn how to use all the automatic fixer-uppers like Auto Tone, Auto Color, the Shadows/Highlights adjustment, and so on. After that, you'll explore the glorious realm of Camera Raw for the easiest adjustments in the West. Then, you'll dive headfirst into professional-strength adjustments such as Levels, Curves, and creating High Dynamic Range images. And last but not least, you'll learn some tricks for saving images you can't fix any other way.

> **NOTE** Photoshop lets you apply most adjustments in two different ways. One is to run the adjustment on the currently active layer, meaning Photoshop permanently applies the change to your image (eek!). Another is to use adjustment layers (which come with layer masks) so that the change happens on a *separate* layer, thereby preserving your original image and giving you the ability to tweak the adjustment later by popping open its Properties panel. The benefit of the latter method is *galactic*, so that's the one this book uses most of the time (and so should you).

This chapter also uses real-world imagery—specifically, travel photos taken by your humble author—that really needs fixing, rather than near-perfect studio shots (though the same editing techniques apply to both).

Lighting Basics

Before getting started, it's worth knowing about the three categories of brightness values that make up images:

- **Shadows** are created when light is blocked (you knew that). They're rarely jet black (though if they are, they're described as "plugged"), and can be different colors depending on how much light is hindered.

- **Highlights** represent the lightest or brightest parts of an image, where the light is at full strength. When an image is overexposed, the highlights are described as "blown out."

- **Midtones** are tonal values that fall between the darkest shadows and lightest highlights. By enhancing midtones, you can increase the contrast and details in an image.

All the color and lighting fixer-uppers covered in this chapter use this terminology, so commit these terms to memory.

TIP A handy way to get rid of distractions so you can focus on fixing an image is to go to the bottom of the Tools panel, click the Screen Mode icon, and then choose Full Screen Mode With Menu Bar. You can also press the F key repeatedly to cycle through Photoshop's screen modes. The various modes are described on page 6.

Quick Fixer-Uppers

Before you dive into making color and lighting adjustments *manually*, it's worth seeing whether Photoshop can fix this stuff automatically. The program has lots of auto fixer-uppers, which have improved quite a bit in recent years.

For example, Adobe changed the mathematical voodoo that Photoshop uses when you apply the Auto Color adjustment, *and* when you click the Auto button in a Levels, Curves, or Brightness & Contrast adjustment (all discussed in this chapter). And instead of the old Enhance Per Channel Contrast method—wherein Photoshop adjusted the red, green, and blue channels *individually* so that the highlights got a little lighter and the shadows got a little darker whether they needed it or not—Photoshop now uses the "Enhance Brightness and Contrast" method, which *analyzes* your image and then adjusts the brightness and contrast accordingly. Bottom line: You no longer have to change the way these automatic tools work in order to get good results. Hip hip hooray!

NOTE While you may get satisfactory results using combinations of the following adjustments, they're *nothing* compared to what you can do if you master Levels and Curves (both covered later in this chapter). In other words, use the methods in this section only while you're learning or as quick-and-dirty fixes.

Fixing Color

If your image looks flat (like it has no contrast) or has a noticeable color cast, give the following methods a spin:

- **Auto Color.** If your image has a *color cast* (everything looks a little yellow, say) or if its colors just look *off*, this command can help (see Figure 9-1). When you run it, Photoshop hunts down the image's shadows, highlights, and midtones and changes their color values. To use it, duplicate your image layer by pressing ⌘-J (Ctrl+J) and then choose Image→Auto Color or press Shift-⌘-B (Shift+Ctrl+B). This command works only on images that are in RGB mode, so if the menu item is dimmed, choose Image→Mode→RGB Color first.

TIP If you find yourself using the Auto Color command often, you can *trick* Photoshop into running it on an adjustment layer. To do that, click the Levels or Curves icon in the Adjustments panel—or click the half-black/half-white circle at the bottom of the Layers panel and choose Levels or Curves—and then, in the Properties panel, Option-click (Alt-click) the Auto button. In the resulting dialog box, choose the Find Dark & Light Colors algorithm, turn on Snap Neutral Midtones, and then click OK.

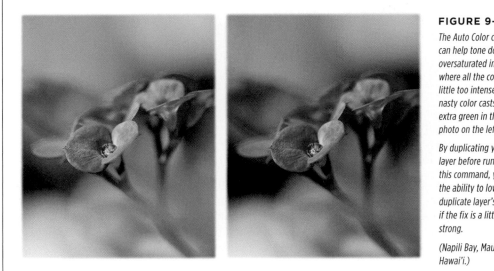

FIGURE 9-1

The Auto Color command can help tone down oversaturated images— where all the colors look a little too intense—and fix nasty color casts, like the extra green in the original photo on the left.

By duplicating your image layer before running this command, you gain the ability to lower the duplicate layer's opacity if the fix is a little too strong.

(Napili Bay, Maui, Hawai'i.)

• **Color Balance.** This adjustment changes the overall *mixture* of colors in an image or selection by shifting the highlights, midtones, and shadows to opposite sides of the color wheel (see page 516 for a quick lesson on color theory). It's also handy for adding color to a black-and-white image or fixing a problem area, like a dull sky (see Figure 9-2).

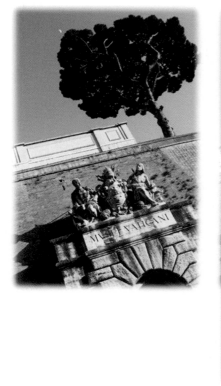

FIGURE 9-2

As you can see here, a color balance adjustment layer can zap a color cast fast!

Use the Properties panel's Tone drop-down menu to tell Photoshop which color categories to adjust. Here, the Midtones were selected, and then all the sliders were adjusted to tone down the blue cast. Dragging the last slider toward yellow helped warm the image up a bit, too.

(Entrance to the Vatican Museum, Vatican City, Italy.)

The only drawback to Color Balance is that you have to know *which* color you want to shift the image *toward* (which is why color theory comes in handy). That said, when you apply this adjustment, Photoshop opens the Properties panel, which contains sliders you can drag, making Color Balance pretty easy to play with. Because it's available as an adjustment layer, it's nondestructive, and you can use the layer mask that tags along with it to limit its effect to certain parts of an image.

Photoshop gives you lots of ways to summon the Color Balance adjustment:

• Choose Layer→New Adjustment Layer→Color Balance.

• In the Adjustments panel, click the Color Balance icon (it looks like a scale).

- Click the half-black/half-white circle at the bottom of the Layers panel, and then choose Color Balance.

NOTE To preserve an image's brightness values when you apply a Color Balance adjustment, be sure to leave the Properties panel's Preserve Luminosity checkbox turned on.

- **Photo Filter.** To change an image's mood, you can add a photo filter adjustment layer to warm it up with a golden tint or cool it off with a bluish tint, for example. Or, if the image has a color cast, you can neutralize it by adding the opposite color (again, a little color theory comes in handy). To use this adjustment, choose Layer→New Adjustment Layer→Photo Filter, or click its icon in the Adjustments panel (it looks like a tiny camera with a circle in front of it). See page 359 for more about this adjustment.

TIP You don't have to apply these adjustments to the *whole* image. If you make a selection before applying one of 'em, the adjustment affects only the *selected* area—Photoshop fills in the included layer mask *for* you. For adjustments that *aren't* available as adjustment layers (in other words, ones that are only available from the Image→Adjustments menu), you can *duplicate* the original layer, run the adjustment on it, and *then* add a layer mask to it.

UP TO SPEED

A Word on Workflow

Each adjustment you make can reduce the quality of your image a little, so the order in which you work is important. Because some techniques (like sharpening)are more destructive than others, it's wise to save them for last. Here's a quick workflow cheat sheet to follow:

1. Import pictures from your camera onto your computer using Adobe Bridge (see Chapter 22) or the powerful Photoshop Lightroom (which is also part of Creative Cloud).

2. Have Bridge (or Lightroom) save copies of the images to an external hard drive as it imports them (you could also burn a high-quality, dual-layer DVD for off-site safekeeping).

3. View your photos, rate the best ones, and mark the bad ones as rejected (see Chapter 22).

4. Crop, resize, and (if necessary) straighten your images. (There's no point in fixing pixels you're not going to keep!) See Chapter 6 for the scoop.

5. Fix whatever you can in Camera Raw (white balance, exposure, contrast, and so on). As you'll discover later in this chapter, corrections are a *breeze* in Camera Raw. And these days, you can also access Camera Raw as a filter inside Photoshop! The box on page 393 has the details.

6. Fix the *remaining* problems in Photoshop (reducing wrinkles, enhancing eyes, correcting colors, and so on) using adjustment layers, duplicate layers, and layer masks as described in this chapter.

7. Apply special effects like fancy edges, do a little head swapping, apply filters, create composites (collages), and so on.

8. Sharpen the image using the techniques in Chapter 11.

9. Print the image (Chapter 16) or save it for the Web (Chapter 17).

If you make your edits in this order, you'll end up with the sharpest, highest-quality images possible.

Fixing Lighting

Unless you cart around a lighting kit with your camera (and you may), you're totally dependent on ambient light, which is less than perfect on a good day. Fortunately, Photoshop has several tools that can help fix almost any lighting problem:

- **Auto Tone.** If your image needs a *little* lighting boost, this adjustment can get it done. It brightens your image, adding a bit of contrast. To apply Auto Tone, duplicate your image layer by pressing ⌘-J (Ctrl+J), and then press Shift-⌘-L (Shift+Ctrl+L).

 Better yet, run Auto Tone as an *adjustment layer*. In the Adjustments panel, click the Levels or Curves icon—or, at the bottom of the Layers panel, click the half-black/half-white circle and choose Levels or Curves—and then, in the Properties panel, Option-click (Alt-click) the Auto button. In the resulting dialog box, choose the Enhance Per Channel Contrast algorithm, and then click OK.

- **Auto Contrast.** This adjustment is an automatic version of the Brightness/Contrast adjustment covered on the next page. It increases any image's contrast by lightening and darkening pixels. It doesn't adjust channels *individually*, so if the image has a color cast, it'll still have one after you make this adjustment. And if the image is flat to begin with, it'll still be flat afterward. But if the image has a *decent* amount of contrast, this adjustment can boost it a little. To run Auto Contrast, duplicate the image layer as described above and then press Shift-Option-⌘-L (Shift+Alt+Ctrl+L).

 To run Auto Contrast as an adjustment layer, click the Adjustments panel's Levels icon or, at the bottom of the Layers panel, click the half-black/half-white circle and choose Levels. In the Properties panel that opens, Option-click (Alt-click) the Auto button; in the resulting dialog box, choose the Enhance Monochromatic Contrast algorithm; and then click OK.

- **Shadows/Highlights.** If your image's color looks good but you need to lighten its shadows or darken its highlights, this tool can do an *amazing* job in no time flat (though it can't compete with what you can do using Camera Raw). It's discussed in detail on page 380.

- **Equalize.** This adjustment evens out the image's brightness by turning its lightest pixels white and darkest pixels black, handy when some areas of a photo are decently lit but the image lacks overall contrast (see Figure 9-3). Equalize isn't available as an adjustment layer, so you'll definitely want to duplicate your original layer by pressing ⌘-J (Ctrl+J on a PC) before you run it by choosing Image→Adjustments→Equalize.

- **Dodge and Burn tools.** These tools are useful when you need to lighten or darken detailed areas of an image by hand, and they're no longer as harmful to images (and especially skin tones) as they were in pre-CS5 versions of Photoshop. For example, you can use the Burn tool to selectively darken your subject's eyes and the Dodge tool to lighten deep wrinkles (so long as you lower their Exposure settings in the Options bar). But unless you duplicate the

original layer first, there's no way to use these tools nondestructively. Luckily, there's a trick that makes the Brush tool *behave* like the Dodge and Burn tools. Flip to page 462 for step-by-step instructions.

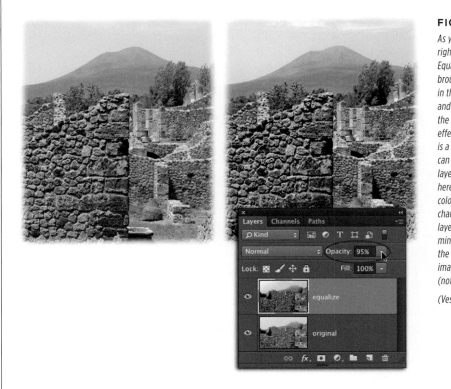

Flip to page 462 for step-by-step instructions.

FIGURE 9-3

As you can see in the right-hand image, the Equalize adjustment brought out more details in the sky and mountain, and boosted contrast in the stone ruins. If the effect of this adjustment is a little too strong, you can always lower the layer's opacity, as shown here. However, if the colors shift too much, try changing the equalize layer's blend mode to Luminosity, which restricts the change to just the image's lightness values (not its color values).

(Vesuvius, Pompeii, Italy.)

■ BRIGHTNESS/CONTRAST ADJUSTMENT LAYERS

These adjustment layers do exactly what you'd think: They brighten an image or increase its contrast—or both. In days of old, these adjustments didn't work worth a darn because they changed your whole image the same amount, which usually resulted in nice-looking shadows but blown-out highlights. Thankfully, Brightness/Contrast got a much-needed overhaul in recent years, so it's actually a useful tool especially on lighter images and black-and-whites. (Just be sure to leave the Properties panel's Use Legacy checkbox turned *off*, or this adjustment will behave like it used to!)

To add one of these layers, either click the Adjustments panel's Brightness/Contrast icon (it looks like a sun) or, at the bottom of the Layers panel, click the half-black/half-white circle, and then choose Brightness/Contrast. In the resulting Properties panel, click the Auto button (circled in Figure 9-4, left) to make Photoshop analyze the image and adjust the sliders for you. If you'd rather control the adjustment manually, drag the Brightness slider left to darken the image or right to brighten it.

To increase the image's contrast, drag the Contrast slider to the right; to decrease it, drag the slider to the left and watch as the image becomes flatter than a pancake (tonally speaking).

> **TIP** Unless you tell Photoshop otherwise, adjustment layers affect *all* the layers that live beneath 'em. To restrict the adjustment to only the layer directly below the adjustment layer, click the leftmost icon at the bottom of the Properties panel (it looks like a tiny square with a downward-pointing arrow next to it). Commit this trick to memory because you'll use it a *lot*.

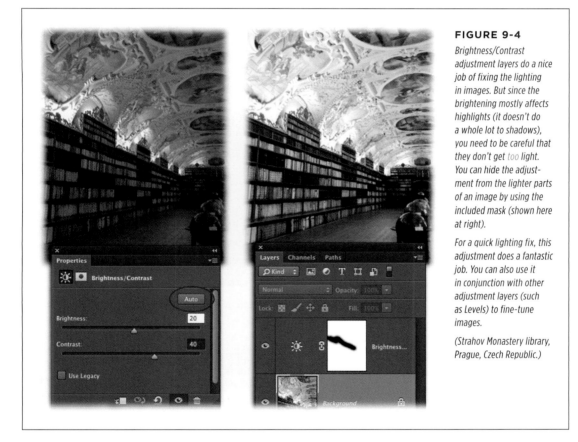

FIGURE 9-4

Brightness/Contrast adjustment layers do a nice job of fixing the lighting in images. But since the brightening mostly affects highlights (it doesn't do a whole lot to shadows), you need to be careful that they don't get too light. You can hide the adjustment from the lighter parts of an image by using the included mask (shown here at right).

For a quick lighting fix, this adjustment does a fantastic job. You can also use it in conjunction with other adjustment layers (such as Levels) to fine-tune images.

(Strahov Monastery library, Prague, Czech Republic.)

■ SHADOWS/HIGHLIGHTS ADJUSTMENTS

The most useful of all the quick-fix adjustments is Shadows/Highlights. If your camera's flash didn't fire and your subject is way too dark, for example, this command can bring the photo back to life by analyzing each pixel and then adjusting it according to the lightness values of neighboring pixels. This is a big deal because even the much-lauded Levels and Curves features adjust lightness values *equally* among all pixels, whether they need it or not.

You can apply this adjustment by choosing Image→Adjustments→Shadows/Highlights, but because it's destructive, be sure to duplicate your image layer first (or better yet, convert it into a smart object as described in the steps below). In the dialog box that appears when you apply this adjustment, at first you see just two sliders: Shadows and Highlights. Because Photoshop *assumes* you want to lighten the shadows—and you usually do—it automatically sets the Shadows slider to 35 percent, and leaves the Highlights slider set to 0 percent. To get the most out of this adjustment, at the bottom of the dialog box, turn on Show More Options; the following steps explain all the settings that appear.

Here's how to lighten overly dark shadows using a Shadows/Highlights adjustment:

1. **Activate your image layer(s), choose Filter→"Convert for Smart Filters," and then, in the dialog box that appears, click OK.**

 Because the Shadows/Highlights adjustment isn't available as an adjustment layer, it'll run on your original image. To use it nondestructively, you can either duplicate the layer(s) first by pressing ⌘-J (Ctrl+J), create a stamped copy of multiple layers by pressing Shift-Option-⌘-E (Shift+Alt+Ctrl+E), *or* you can convert it to a smart object. The smart-object method forces Photoshop to list the adjustment separately in the Layers panel as if you had run a smart filter (page 670), plus you gain the ability to *reopen* the adjustment and tweak it later. No matter which method you use, you can hide parts of the image with a mask, though by using a smart object, Photoshop adds the mask *for* you.

2. **Choose Image→Adjustments→Shadows/Highlights, and then turn on Show More Options (circled in Figure 9-5).**

 This checkbox lets you see *all* of the Shadows/Highlights dialog box's settings.

POWER USERS' CLINIC

Fixing Colored Edge Fringe

If you see a slight blue or purple fringe loitering around the edges of near-black objects in your images, you've got a dreaded *color fringe problem*. This kind of thing is especially noticeable when the object is on a white background. For example, if you take a picture of a white clock face, you may see a purplish or bluish tinge around the edges of the clock's black numbers and hands.

Fortunately, you can use the Gaussian Blur filter to get rid of the tinge, but there's a trick to it. Flip to page 686 for the step-by-step scoop. You can also get rid of color fringe using Camera Raw; page 394 tells you how.

Shadows/Highlights

Shadows

Amount: 35 %

Tone: 70 %

Radius: 300 px

OK
Cancel
Load...
Save...
☑ Preview

Highlights

Amount: 10 %

Tone: 40 %

Radius: 300 px

Adjustments

Color: +20

Midtone: 0

Black Clip: 0.01 %

White Clip: 0.01 %

Save Defaults
☑ Show More Options

FIGURE 9-5

Turning on Show More Options (circled) gives you a slew of sliders.

If your image's shadows are OK but its highlights need darkening, apply the settings shown here in the Shadows section of the dialog box (Amount: 25, Tonal Width: 50, Radius: 275) in the Highlights *section instead. Just be sure to set the Shadows section's Amount slider to 0 percent to turn that section off. (Peek ahead at Figure 9-6 to see the image these setting were used on.)*

When you're finished, click Save Defaults so you don't have to remember these magic numbers the next time you use this adjustment (though you'll still have to tweak them slightly for each image).

Another way to use this adjustment is to set all the sliders to 0 and then begin dragging them rightward, one at a time and in small increments, until the image looks good.

After applying this adjustment, if the image still needs more contrast, you can add a brightness/contrast adjustment layer, as discussed in the previous section.

3. **In the Shadows section of the Shadows/Highlights dialog box, adjust the three sliders.**

These settings work well for most images:

- **Set the Amount slider to between 20 and 35 percent.** If you go much higher, you'll start to see noise (graininess) in the image.

- **Leave the Tonal Width slider set to 50 percent.** This slider controls exactly which shadows Photoshop adjusts. If you lower this number, Photoshop changes only the darkest shadows; if you raise it, Photoshop changes a wider range of shadows. You may want to lower this setting if your image looks grainy.

- **Increase the Radius slider to between 250 and 300 pixels.** The Shadows/Highlights adjustment works by looking at the brightness values of neighboring pixels, and this setting determines how big that neighborhood is. Pump this baby up to make Photoshop analyze more pixels.

4. **In the Adjustments section at the southern end of the dialog box, adjust the various settings.**

Here are some guidelines:

- **Set the Color slider to 20 or less.** Doing so adds a little saturation to your image, which it'll likely need after you tweak its shadows and/or highlights. Set this slider much higher, especially on portraits, and you run the risk of introducing funky pinks into skin tones.

- **Leave the Midtone slider at 0.** When you use this setting, Photoshop increases the contrast in the image by making dark pixels a little darker and light pixels a little lighter. But since the point of a Shadows/Highlights adjustment is usually to lighten shadows, increasing this setting would pretty much cancel out what you're trying to accomplish.

- **Leave the Black Clip and White Clip fields set to 0.01 percent.** Leaving these fields alone keeps your light and dark pixels from getting clipped. (*Clipping* is when Photoshop turns a light pixel pure white or a dark pixel pure black, stripping the pixel of all its details. Clipping is more worrisome in highlights than shadows, since highlights usually contain more important details.)

5. **Click the Save Defaults.**

Photoshop saves the current settings so you don't have to reset everything the next time you use this adjustment. You'll still have to tweak the settings some because each image is different, but at least you won't have to *memorize* the magic numbers mentioned above.

6. **Click OK to close the Shadows/Highlights dialog box.**

In the Layers panel, you'll see a new layer called Smart Filters with the Shadows/Highlights adjustment beneath it (Figure 9-6), indicating that Photoshop ran the adjustment as a smart filter instead of applying it directly to the image.

7. **If necessary, hide the adjustment from a portion of the image by painting within the mask that came with the smart filter.**

Click the smart filter mask's thumbnail to activate it (Photoshop puts a tiny white border around it so you can tell it's active). Next, press B to grab the Brush tool, press D to set your color chips to black and white, and then press X until black hops on top. Then mouse over to your image and paint the areas you don't want adjusted. Pretty cool, huh? You can think of this technique as Smart Shadows.

8. **For a quick before-and-after comparison, turn the Shadows/Highlights adjustment's visibility eye off and on.**

As Figure 9-6 shows, this adjustment—run as a smart filter—does a bang-up job of lightening shadows without introducing a funky color cast. If, for whatever reason, you don't like the adjustment, send it packin' by dragging the Shadows/Highlights adjustment down to the trash can icon at the bottom of the Layers panel.

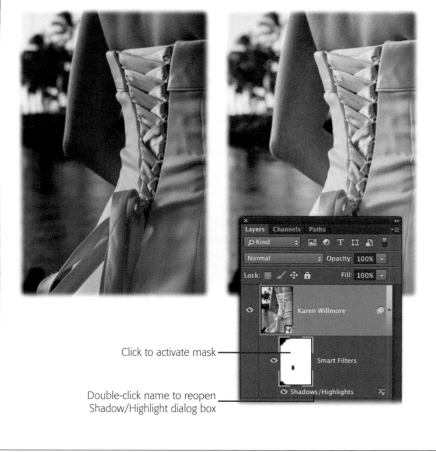

FIGURE 9-6

Here's an image before (left) and after (right) applying the Shadows/ Highlights adjustment. (The exact settings used to correct this image are shown back in Figure 9-5.)

By painting with black within the mask that comes from running this adjustment as a smart filter, you can hide the change from the parts of your image that don't need it. You can also use the mask's Density setting to make the mask somewhat see-through (say, to hide a little of the adjustment but not all of it). To do so, double-click the mask, and its settings open in the Properties panel. Simply drag the Density slider leftward to make the mask partially transparent.

(Willmore wedding, Big Island, Hawaii.)

Click to activate mask

Double-click name to reopen
Shadow/Highlight dialog box

To get even *better* results, run the Shadows/Highlights adjustment on the Lightness channel in Lab mode. It sounds hard, but it's not—just follow these steps:

1. **Duplicate your original layer by pressing ⌘-J (Ctrl+J), or create a stamped copy of multiple layers (page 119).**

 For reasons known only to the Lords of Adobe, if you've converted your image layer to a smart object, you can't run the Shadows/Highlights adjustment on just *one* channel, which means you can't run the adjustment as a smart filter as described in the previous list. So to keep this adjustment from running in Super Destructo mode, you've got to duplicate the image layer (or create a stamped copy of multiple layers) first.

2. **Switch to Lab mode by choosing Image→Mode→Lab Color, and then click Don't Flatten (and, if necessary, Don't Rasterize).**

It doesn't matter whether you were originally in RGB or CMYK mode (as you know from Chapter 2, you'll *usually* be in RGB mode). When Photoshop asks if you want to flatten layers, click Don't Flatten. If there are any smart objects in your document, it'll also ask if you want to rasterize them; in that case, click Don't Rasterize.

3. **Activate the Lightness channel.**

Open the Channels panel by clicking its tab in the Layers panel group or by choosing Window→Channels, and then click once to activate the Lightness channel. As you learned back in Chapter 5, one of the great things about Lab mode is that it separates an image's light info from its color info. Since you want to lighten the image's shadows without shifting its color, you'll run the Shadows/Highlights adjustment only on the Lightness channel, which often makes the adjustment work *noticeably* better.

4. **Choose Image→Adjustments→Shadows/Highlights, turn on Show More Options, and then adjust the various settings and click OK.**

As you learned earlier, Show More Options gives you lots of extra settings to play with. Adjust the settings according to the advice on page 382, and then click OK when you're finished.

5. **Switch back to your original color mode.**

Choose Image→Mode→RGB (or CMYK) to go back to the mode you started in.

6. **To see before and after versions of the image, turn the duplicate (or stamped) layer's visibility off and on.**

Sure, this method takes a little longer than the previous technique, but the results can be well worth it. And if you need to adjust an image's highlights *instead* of its shadows, you can use the same magic numbers in the Highlights section of the Shadows/Highlights dialog box—just be sure to set the Shadows section's Amount slider to 0.

Correcting Images in Camera Raw

As you learned in Chapter 2, Camera Raw is a powerful plug-in that converts images shot in raw format into *editable* pixels (before this conversion, the files are kind of like digital *negatives*—the image info is there, but it's not in a form you can edit in Photoshop). Camera Raw—which works on JPEGs and TIFFs, too—also gives you tools that you can use to crop, straighten, and correct color and lighting. Since most of Camera Raw's settings are slider-based, it's hands down the *easiest* place to fix your images (and that's why this section comes before the ones about Levels and Curves, which are—truth be told—*100* times more confusing).

NOTE You can also open the Camera Raw plug-in as a *filter* from within Photoshop, which is incredibly handy. The box on page 393 has the scoop.

The adjustments you make in Camera Raw plug-in are 100 percent *nondestructive*: Instead of applying them to your image, Camera Raw keeps track of them in a list it stores within the image or in a file called *Sidecar XMP* (could that name be more cryptic?). Simply put, you can undo anything you've done in Camera Raw whenever you want.

The Camera Raw plug-in is covered in several places throughout this book. Here's a handy cheat sheet:

- Information about the raw file format: page 54
- Opening files in Camera Raw: page 55
- Cropping and straightening in Camera Raw: page 249
- Going grayscale in Camera Raw: page 336
- Editing multiple files in Camera Raw: see the box on page 429
- Removing dust spots in Camera Raw: see the box on page 436
- Fixing red eye with Camera Raw: page 470
- Sharpening in Camera Raw: page 508

POWER USERS' CLINIC

Fixing Lighting with Blend Modes

If your image is *still* too dark or too light after using one of the aforementioned quick-fix adjustments, you can usually fix it really fast with blend modes. The technique is described in step-by-step glory back on page 125, but it's so useful that it deserves a mention here, too.

To *darken* an image, create an empty adjustment layer by clicking the half-black/half-white circle at the bottom of the Layers panel and choosing Brightness/Contrast (this option is the first one in the list that doesn't actually *do* anything to your image unless you mess with its sliders). Then use the drop-down menu near the top of the Layers panel to change the new layer's blend mode to Multiply (or press Shift-Option-M [Shift+Alt+M

on a PC]). Finally, in the layer mask that automatically tags along with the adjustment layer, paint with a black brush to hide the darkened bits from areas that don't need darkening.

To *lighten* an image, add an empty adjustment layer and change its blend mode to Screen instead (keyboard shortcut: Shift-Option-S [Shift+Alt+S]). Then use the provided layer mask to hide the *light* bits, if necessary.

If the image needs to be darker or lighter still, duplicate the empty adjustment layer. To reduce the effect of the darkening or lightening layer, lower its Opacity setting at the top of the Layers panel.

In this section, you'll learn how to use Camera Raw to fix both color and lighting, plus you'll pick up some tricks that can make images' color leap off the page. When you're finished adjusting your image, you can use the buttons at the bottom of the Camera Raw window to do the following:

- Click **Save Images** to convert, rename, or relocate the file(s)—or any combination of those options—so you don't overwrite the original(s).

- Click **Open Images** to apply the changes you've made and then open the image in Photoshop, or Shift-click this button to open the image in Photoshop as a smart object.

- Click **Cancel** to bail out of Camera Raw without saving or applying your changes.

- Click **Done** to apply the changes (which you can edit the next time you open the image in Camera Raw) and exit Camera Raw.

If you use Camera Raw's adjustments in the order they're presented in this section (which is also the order they appear in the Camera Raw window—how handy!), you'll be *amazed* at the results.

TIP You can zoom in/out of the Camera Raw preview window by pressing ⌘-+/− (Ctrl-+/− on a PC). To move around within your image, press the space bar while dragging with your mouse. And to see a before/after preview of your image, press the P key to toggle the Preview option at the top right of the window off and on.

Changing White Balance

Because different light sources—whether it's a light bulbs (tungsten), fluorescent lights, a cloudy sky, or whatever—give off unique color casts, digital cameras let you adjust the *white balance* of your images accordingly (though you may have to dig out your owner's manual to find where that setting lives; if you're shooting on auto, your camera is setting the white balance for you). When you set an image's white balance, you're telling Camera Raw what color the light in the image *should be*. As you might suspect, changing the light's color changes *all* the colors in the image, as shown in Figure 9-7.

TIP Camera Raw lets you adjust the white balance *selectively* in certain parts of an image by using the Adjustment Brush. Skip to page 393 to learn how.

One of the *big* advantages of shooting in raw format is that if you get the white balance wrong in your camera, you can always *reset* it using Camera Raw. For example, if you're shooting indoors using a white balance of Fluorescent and then walk outside and shoot in the courtyard, the color will be off in the outdoor images. But if you shoot the photos in raw format, fixing their color later is a snap.

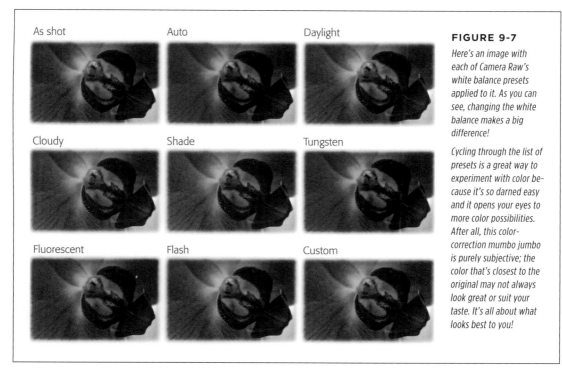

FIGURE 9-7

Here's an image with each of Camera Raw's white balance presets applied to it. As you can see, changing the white balance makes a big difference!

Cycling through the list of presets is a great way to experiment with color because it's so darned easy and it opens your eyes to more color possibilities. After all, this color-correction mumbo jumbo is purely subjective; the color that's closest to the original may not always look great or suit your taste. It's all about what looks best to you!

In Camera Raw, you change white balance by choosing one of the presets in the Basic tab's White Balance drop-down menu. Or you can set it manually (and maybe more accurately) using Camera Raw's White Balance tool (see Figure 9-8). Press I to grab the tool (which looks like an eyedropper), and then mouse over to your image and click an area that *should be* white (yet still has a few details), or click a light gray area. Just keep clickin' till the image looks right, and then adjust the Temperature and Tint sliders until you get the color you want (doing so changes the White Balance menu to Custom). Drag the Temperature slider right to warm the image, or left to cool it off. The Tint slider adjusts the balance of green and magenta.

NOTE Compared with raw images, you don't have as much flexibility when resetting the white balance of JPEGs or TIFFs because those file formats have already been processed a bit by the camera or scanner that captured them—the only presets Camera Raw gives you for such files are As Shot and Auto. But you can still set a custom white balance using the White Balance tool, and tweak the light's color by adjusting the Temperature and Tint sliders.

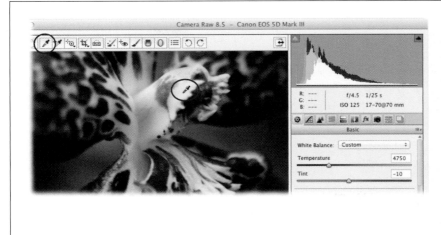

FIGURE 9-8

When using the White Balance tool, click an area that's light gray, or a white area that still contains a few details—like this orchid's center—rather than a white reflection or a specular highlight. If you click a color that's too bright to use for white balance (say, pure white with no details), Camera Raw prompts you to click elsewhere.

Fixing Exposure

The next group of sliders in Camera Raw's Basic tab—Exposure through Blacks—lets you adjust an image's exposure and *contrast* (the difference between its light and dark pixels). Adobe upgraded these controls back in Camera Raw 7 and simplified the Basic panel to give you a more powerful—yet simpler—way to produce images with nice contrast. These six sliders are all initially set to 0 and, except for Exposure, have a range of –100 to +100. By adjusting these sliders in the order they're listed in the panel, you should be able to produce better-looking images faster than ever.

As you learned on page 374, images consist of three categories of color: highlights, midtones, and shadows. Problems can arise in one of those categories or all three. Luckily, you can fix 'em all in Camera Raw using the following sliders:

- **Exposure.** Exposure is determined by how much light your camera's sensor captures; it's measured in *f-stops* (the number indicating how much light your camera's lens lets in) and has a range of –5 to +5. You can think of this slider as controlling overall image brightness; drag it right to lighten your image or left to darken it. Be careful not to drag this slider *too* far either way or you'll start to lose details. For that reason, it's a good idea to turn on Camera Raw's clipping warnings (shown in Figure 9-9) so you can see if you're destroying details: Press U (as in Underexposed) to turn on the shadow clipping warning and O (for Overexposed) to turn on the highlight clipping warning. If no pixels are being clipped, both clipping warning icons are black. But if either triangle turns a color, some clipping has occurred (the color of the triangles depends upon which channel the clipping is occurring in). That said, it's OK to lose a *few* details because you can bring 'em back using some of Camera Raw's other sliders.

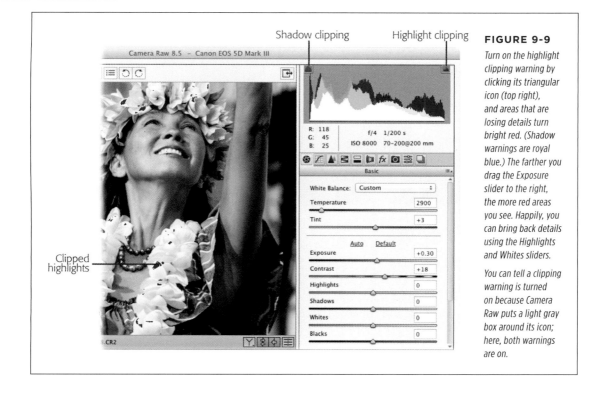

FIGURE 9-9

Turn on the highlight clipping warning by clicking its triangular icon (top right), and areas that are losing details turn bright red. (Shadow warnings are royal blue.) The farther you drag the Exposure slider to the right, the more red areas you see. Happily, you can bring back details using the Highlights and Whites sliders.

You can tell a clipping warning is turned on because Camera Raw puts a light gray box around its icon; here, both warnings are on.

TIP If you're not up to fiddling with these six sliders, you can make Camera Raw adjust the image *for* you by clicking the word "Auto" above the Exposure slider. That said, you'll get far better results if you tweak these settings by hand.

- **Contrast.** Drag this slider right to increase the image's contrast (the difference between its light and dark pixels) or left to decrease it. Increasing contrast makes the light pixels lighter and the dark pixels darker. *Every* image needs some extra contrast, including portraits.

- **Highlights/Shadows.** These two sliders control *tone mapping*, which is the way Camera Raw shifts (remaps) the image's colors from what was captured by your camera to what can be displayed onscreen or printed. Drag the Highlights slider left to darken an image's highlights (which can help recover lost details and get rid of a highlight clipping warning), or drag it right to lighten them. The Shadows slider works the same way: Drag it left to darken shadows, or right to lighten them (which, you guessed it, helps recover lost details and get rid of a shadow clipping warning). To produce *natural*-looking images, try not to drag these sliders past 50 in either direction. To even out the lighting in your image, try setting the Highlights to −25 and the Shadows to +25.

- **Whites/Blacks.** These two sliders let you reset the white and black points in your image and, as a result, recover lost details in overexposed highlights and underexposed shadows (thereby getting rid of clipping warnings). If you drag the White slider *slightly* to the left, you darken what Camera Raw considers white (which can also recover highlight details and make red clipping warnings in your image disappear). Dragging it *slightly* to the right lightens what Camera Raw considers white, but if you drag it too far, you'll overexpose your highlights.

 The Black slider works similarly: To lighten what Camera Raw considers black—and recover a few details, which helps clear any blue clipping warnings—drag this slider *slightly* to the right. Dragging it *slightly* to the left darkens what Camera Raw considers black, and can make details in shadowy areas disappear into a big ol' black hole.

 Both these sliders are meant for fine-tuning images, so Adobe advises that you keep adjustments to a minimum. That said, some photographers like the blacks in their images to be nice and inky, so feel free to adjust *either* slider until the image looks good to you. Keep in mind that changes you make here affect how the image will print or be reproduced on someone else's screen, so you might want to do some *testing*—say, make a print or peek at the image on another monitor—with the settings that look good to you.

> **TIP** To *temporarily* see clipped areas (without turning on the clipping warnings), Option-drag (Alt-drag on a PC) the Whites or Blacks slider. The image preview turns *black* when you Option-drag the Whites slider, and *white* when you Option-drag the Blacks slider. Either way, clipped areas appear in bright colors as you drag.

FREQUENTLY ASKED QUESTION

Raw versus JPEG

What's the big deal about shooting in raw format? My raw files look worse than my JPEGs! What gives?

It's true that if you compare the same image captured in both raw and JPEG format, the JPEG will look vastly better. That's because of the processing your camera automatically performs when you shoot a JPEG. That's right: Your camera applies a little noise reduction and sharpening, and boosts saturation (color intensity) before your image ever becomes a *twinkle* in Photoshop's eye. (To learn how to turn this stuff off, you'll have to dig through your camera's owner's manual.)

But when you shoot in raw format, you get the *raw*, completely unprocessed and uncompressed info from your camera instead, which is why raw files are so much bigger and, as a result, more flexible. For example, you can change the white balance to one of the presets shown on page 387, recover lost details in overexposed highlights and underexposed shadows, and so on.

Think of it this way: Raw files are like raw cookie ingredients. Before you mix and roll cookie dough into balls and bake it, you've got all kinds of flexibility; you can change the ingredients, add nuts or chocolate chips, and form the cookies into fun shapes. A JPEG, on the other hand, is like a *baked* cookie; there's very little you can do to it because it's already cooked. Sure you can add a topping or two, but it's much less flexible than the raw (pun intended!) ingredients.

The point is that if you *can* shoot raw (and can afford the extra processing time and disk space that it requires), you *should*.

Making Colors Pop

To intensify your image's colors, give the next three sliders in Camera Raw's Basic tab a tug (see Figure 9-10):

- **Clarity.** This slider boosts contrast in the midtones, increasing their depth so your image looks clearer. You'd be hard-pressed to find an image that wouldn't benefit from dragging this slider to about +30. However, this control works a lot like Unsharp Mask (page 488), so avoid using it on photos of people (especially portraits). In fact, an easy way to soften skin is to drag the Clarity slider *left* into negative numbers (say, –10 or whatever looks good to you).

NOTE If you'd like to experiment with using the image in Figure 9-10, download *UncleGeorge.jpg* from this book's Missing CD page at *www.missingmanuals.com/cds*. And visit his website, *www.kahumoku.com*, for Grammy-winning Hawaiian slack-key guitar CDs!

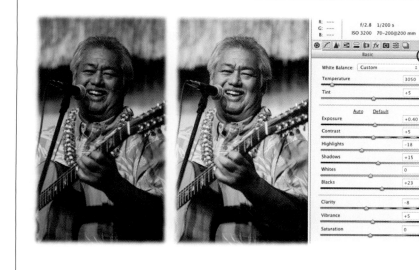

FIGURE 9-10

As you can see here, Camera Raw can greatly improve images. The original, underexposed and seriously yellow image is on the left and the updated version is on the right. That's an impressive result from just dragging a few sliders back and forth!

To reset any slider in Camera Raw back to its original position, double-click the slider. To reset the image to its original state, open the Camera Raw panel menu (circled) and choose Camera Raw Defaults.

TIP If you open an image that you adjusted in an *older* version of Camera Raw (version 7 or earlier), take a peek at the bottom right of your image and you'll see a small light-gray box with an exclamation point inside it. To switch to the new *process version* (the set of instructions Camera Raw uses to adjust images), give the box a 'swift click.

- **Vibrance.** Use this slider to intensify colors without altering skin tones; it has less effect on highly saturated (intense) colors. If there are people in your image, this is the adjustment to use.

- **Saturation.** Intensifies *all* the colors in an image, including skin tones. So don't use it on people pictures unless you like fluorescent skin.

Camera Raw's Adjustment Brush

The Adjustment Brush lets you *selectively* tweak certain areas of an image by painting atop them (see Figure 9-11). When you activate the Adjustment Brush by pressing K, a *host* of adjustments appears on the right side of the Camera Raw window. They're the same adjustments you've learned about so far, along with these extras:

- **Sharpness** lets you accentuate areas of high contrast to make them look sharper (you'll learn all about sharpening in Chapter 11). Use this slider to add extra sharpening to important areas, like the image's focal point. (You may not realize it, but Camera Raw applies a round of sharpening to your *whole* image as soon as you open it. To find out how much or to turn it off—if, say, you plan on sharpening in Photoshop instead—skip to page 510.)

NOTE The Noise Reduction, Moire Reduction, and Defringe sliders only appear if you're using Camera Raw's most current process version (as of this writing, that's 2012). So if these sliders are missing, flip back to the Tip on page 392 to learn how to update the process version Camera Raw is using for your particular image.

- **Noise Reduction** lets you selectively paint away the colored speckles that appear in images shot in extremely low-light conditions, or at a high *ISO* (your camera's light-sensitivity setting).

- **Moiré Reduction** helps remove the repeating pattern that sometimes appears in scans of printed images (think dots upon dots but not precisely lined up).

UP TO SPEED

Using the Camera Raw Filter

Yes, you read that correctly: You can access the Camera Raw plug-in through Photoshop's *filter menu*. This makes it easier than ever to use Camera Raw's powerful yet easy-to-use sliders on *any* layer content, including (but not limited to) JPEGs, TIFFs, and 8- or 16-bit images (as long as they're in RGB or Grayscale mode, though it does work on *single* channels in CMYK and Lab modes).

To give it a whirl, activate the image layer(s), and then choose Filter→"Convert for Smart Filters" (click OK in the dialog box that appears). Then, trot *back* up to the Filter menu and choose Camera Raw Filter. Photoshop opens a *version* of Camera Raw that lacks a few features (such as the Crop, Straighten, the two Rotation tools; the ability to open Camera Raw's prefer-

ences; and a few of the panel menu items), but, honestly, who cares? The point is that you're accessing Camera Raw *inside* Photoshop! (You don't *have* to use the Camera Raw filter as a smart filter, but it's a darn good idea to do so.)

Once you make your adjustments, click OK and the filter appears in the Layers panel complete with a mask, just like any other smart filter (you'll learn more about 'em in Chapter 15). In the Layers panel, you can double-click the tiny icon that appears to the right of the Camera Raw filter to open a Blending Options dialog box that lets you adjust the opacity and blend mode of the changes you made with the filter. You can also summon it by pressing Shift-⌘-A (Shift+Ctrl+A).

- **Defringe** lets you selectively remove any weird color fringe that's loitering along an object's high-contrast edges (called *chromatic aberration*). Alternatively, you can have Camera Raw try to get rid of the color fringe *automatically* by switching to the Hand tool, and then opening the Lens Correction panel (it's the sixth tab in the row of panels on Camera Raw's right side). Click the Color tab, and then turn on Remove Chromatic Aberration. If necessary, adjust the Defringe sliders until the fringe is gone. (Page 686 explains how to get rid of chromatic aberration in Photoshop.)

- **Color** lets you paint a colored tint onto an image, which is great for adding a little digital make-up to portraits.

The sliders *below* the Color setting—you may have to scroll down to see them all—control the Adjustment Brush's cursor, and are explained in Figure 9-11.

> **TIP** When using the Adjustment Brush, it can be tough to see *exactly* where Camera Raw is applying your brushstrokes. In that case, turn on the Mask checkbox at lower right or press Y to see the mask as a white overlay, which indicates your brushstrokes and, therefore, where the adjustment is visible. You can change the overlay's color by clicking the white square to the right of the Mask checkbox, and then choosing a new color from the resulting Color Picker.

To use the Adjustment Brush, choose the type of adjustment(s) you want to make using the sliders on the right, mouse over to your image, and then paint to apply the adjustment(s). Or, paint the area you want to adjust first and *then* tweak the sliders. Either way, a little greenish pin appears to mark the area you adjusted (in Figure 9-11, the pin is on the same flower as the cursor); press V to show or hide the pin. Behind the scenes, Camera Raw creates a mask that hides the rest of your image so you can continue to tweak the adjustment sliders even after you've finished painting. Camera Raw updates the area you painted to reflect those changes.

> **TIP** Click the little + and – signs on either end of an adjustment's slider to strengthen or lessen that adjustment (respectively) by a preset amount: 0.5 for Exposure (whose scale ranges in f-stops from –4 to +4) and 25 for most other sliders, which range from –100 to +100.

To apply an existing adjustment to *more* areas in your image, turn on the Add radio button in the upper-right part of the Camera Raw window, and then paint across the parts that need adjusting. To add a new adjustment, turn on the New radio button, set the sliders to your liking (if there are any sliders you *don't* want applied in the new adjustment, set them to 0), and then paint across that area. If you've added more than one adjustment and you want to add to just one of 'em, click the Add button and Camera Raw displays pins representing the different adjustments you've made; simply click the pin that represents the one you want to add to, and *then* paint across that part of your image.

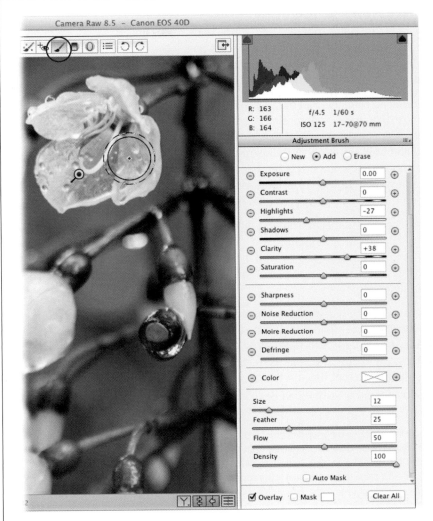

FIGURE 9-11

Here the Adjustments Brush (circled) is being used to darken highlights and add clarity to a single flower (note the Highlights and Clarity values on the right).

The dotted line around the cursor indicates the brush's feather amount, which softens the edge of the adjustment so it blends better with surrounding pixels. The solid line indicates brush size, and the crosshairs let you know where you're applying the adjustment. To adjust the feather amount or cursor size, drag the Feather or Size slider, respectively. The Flow slider controls the adjustment's strength, and the Density slider controls the transparency of your brushstroke (think of it as the brush's opacity).

To *undo* part of an adjustment in your image, turn on the Erase radio button and, if necessary, click the pin that represents the adjustment you want to erase (if, say, you've used the Add button mentioned above to create multiple adjustments), and then paint the area in question or, better yet, simply Option-drag (Alt-drag on a PC) across that area. To delete a *single* adjustment, click its pin, and then press Delete (Backspace on a PC). To erase *all* the adjustments you've made with the Adjustments Brush, click the Clear All button near the bottom right of the Camera Raw window.

TIP Turn on the Auto Mask checkbox shown in Figure 9-11 to limit your adjustment to pixels that are similar in color to the ones you're painting across.

Camera Raw's Graduated Filters

The Graduated Filter tool lets you apply adjustments much like a *real* graduated filter that screws onto the end of a camera lens. (The filter is a thin piece of glass that fades from gray [or some other color] to clear in order to subtly change the brightness or colors of the scene you're shooting.)

When you activate this tool by clicking its icon at the top of the Camera Raw window (circled in Figure 9-12) or pressing G, you get the same set of adjustments as with the Adjustment Brush (except for Erase mode). The difference is that, with the Graduated Filter tool, you apply the adjustment by dragging a line to apply a gradient (like Photoshop's Gradient tool) rather than *painting* across the area that needs adjusting. This adjustment is great for fixing overexposed skies because Photoshop gradually applies it across the full width or height of your image in the direction you drag.

Behind the scenes, this tool creates a gradient mask, which restricts the adjustment to specific parts of your image. By clicking and dragging, you can create a gradient at *any* angle. Even after you've used this tool, you can continue to make adjustments using the sliders on the right side of the window; the previous section explains what all the sliders do.

To constrain the Graduated Filter tool's adjustment so that it's perfectly horizontal or vertical, press and hold the Shift key as you drag. To move its midpoint (where the adjustment begins to fade), drag the green and red pins. To move an adjustment, click and drag the line *between* the red and green pins. To delete an active adjustment (one that has a red pin), press Delete (Backspace on a PC), or simply Option-click (Alt-click) a pin or the line connecting the adjustment's pins (the latter trick works on both active *and* inactive adjustments).

TIP New in Camera Raw 8.5 is the ability to *edit* the mask of an adjustment you applied with the Graduated Filter or Radial Filter tool. To do so, click either tool's icon at the top of the Camera Raw window, and then click an adjustment's pin(s) to activate it (an active adjustment has a red pin, as Figure 9-12 shows). Next, click the Brush radio button at upper right (also visible in Figure 9-12)—or press Shift-K—and then use the resulting + and – brush buttons to tell Camera Raw what you want to do: increase the adjustment or lessen it (you can also press Option [Alt] to swap between brush modes). Adjust the various sliders (Temperature, Tint, Exposure, and so on), and then paint between the green-and-white and red-and-white lines of your adjustment to alter it.

■ USING THE RADIAL FILTER

The Radial Filter (labeled in Figure 9-12), works *exactly* like the Graduated Filter except that it lets you apply *circular* adjustments that gradually radiate from either the inside or outside of where you place it. To determine its behavior, scroll to the bottom of the panel on the right side of the Camera Raw window and click the Outside or Inside radio button (you can also press X to flip between an outside or inside adjustment).

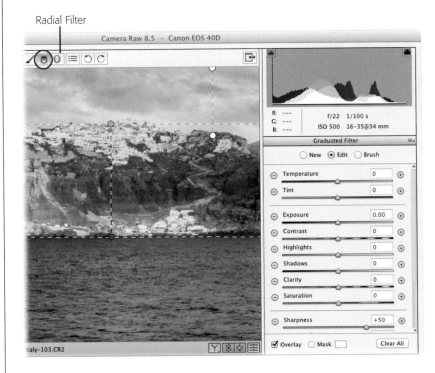

Radial Filter

FIGURE 9-12

Here you can see two Graduated Filter adjustments. One gradually darkens the sky (it's the inactive adjustment at upper right with two white dots), and another sharpens the city and cliffs (it's currently active). The green-and-white dotted line that runs through the green pin represents the start of the mask, and the red-and-white dotted line running through the red pin represents the end. The Radial Filter (labeled) works like a circular version of this adjustment, though it contains just one pin.

(Santorini, Greece, from the Aegean Sea.)

This tool is *really* handy for creating custom dark- or light-edge vignettes, wherein you softly darken or lighten an image's edges (to do that, you'd adjust only the Exposure slider). While you *can* use Camera Raw's Effects panel's Post Crop Vignette sliders to create a vignette, if you do, the center point—the part of the image that isn't darkened or lightened—is always in the *middle* of the image, which is rarely where your subject is positioned. By using the Radial Filter instead, you control the center point's exact placement, so you can put it anywhere you want—upper left, right, or whatever. (You can create an edge vignette in Photoshop, too; page 677 tells you how.)

> **TIP** To create a new radial adjustment that covers the whole image, activate the Radial Filter tool by clicking its icon or pressing J, adjust its settings (for example, set it to Outside so it adjusts only the *outer* edges of your image), and then double-click your image. You can also double-click an *existing* radial adjustment to make it *expand* to affect your whole image.

More Fun with Camera Raw

As you can see, the Camera Raw plug-in is crazy powerful, and each version sports useful new features. You can use it to adjust Curves (page 413), remove spots (see

the box on page 436), fix perspective problems with the Lens Correction panel's Automatic Upright feature, and so much more. Camera Raw deserves a whole book all to itself, and there are plenty of 'em out there.

That said, Adobe Photoshop Lightroom works *exactly* the same way as Camera Raw, though it also includes a powerful database, as well as tools that let you create photo books, slideshows, and web galleries. So if you fall in love with Camera Raw, you might want to give Lightroom a spin. Heck, it's part of Adobe's Creative Cloud, so you may already have access to it!

TIP To learn more about Camera Raw or Photoshop Lightroom, check out your author's online video courses at *www.lesa.in/lesacl* and her ebook series at *www.theskinnybooks.com*.

Using Levels

The adjustments you've seen so far are okay when you're just starting out with Photoshop, and they're darn handy when you're pressed for time. But sooner or later you'll encounter images that can only be whipped into shape by more *powerful* tools, such as Levels and Curves. (Though these days you could simply use Camera Raw to fix all your images, which is *much* easier. After all, it's available as a filter inside Photoshop, as the box on page 393 explains.)

With a single Levels adjustment, you can fix lighting problems, increase contrast, and—in some cases—balance the color in your image. (If you've got *major* color problems, you need to use Curves instead; skip ahead to page 413 to learn how.) Levels adjustments change the intensity levels (hence the tool's name) of shadows, midtones, and highlights, and are a very visual and intuitive way to improve images. And because they're available as adjustment layers (yay!), they're nondestructive and won't harm your original image; plus they come with an automatic layer mask.

In this section, you'll learn how to use Levels adjustments in a few different ways so you can pick the one you like best. But first, you need to get up close and personal with the mighty *histogram*, your secret decoder ring for interpreting the info in your photos.

Histograms: Mountains of Information

A histogram (Figure 9-13) is a visual representation—a collection of tiny bar graphs, to be precise—of the info contained in an image. Once you learn how to read it, you'll gain an immensely valuable understanding of why images look the way they do. More importantly, you'll learn how to tweak the histogram itself or (more commonly) make changes with other tools while using the histogram's changing readout to monitor the image's vibrancy. It sounds complicated, but once you watch the histogram in action, you'll see that it's actually pretty straightforward—and tremendously powerful.

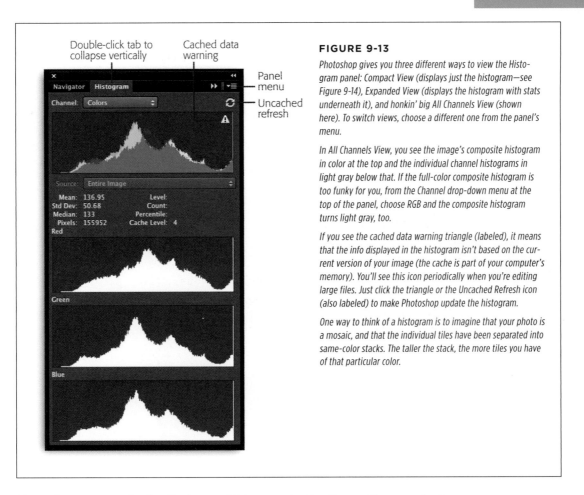

Double-click tab to collapse vertically

Cached data warning

Panel menu

Uncached refresh

FIGURE 9-13

Photoshop gives you three different ways to view the Histogram panel: Compact View (displays just the histogram—see Figure 9-14), Expanded View (displays the histogram with stats underneath it), and honkin' big All Channels View (shown here). To switch views, choose a different one from the panel's menu.

In All Channels View, you see the image's composite histogram in color at the top and the individual channel histograms in light gray below that. If the full-color composite histogram is too funky for you, from the Channel drop-down menu at the top of the panel, choose RGB and the composite histogram turns light gray, too.

If you see the cached data warning triangle (labeled), it means that the info displayed in the histogram isn't based on the current version of your image (the cache is part of your computer's memory). You'll see this icon periodically when you're editing large files. Just click the triangle or the Uncached Refresh icon (also labeled) to make Photoshop update the histogram.

One way to think of a histogram is to imagine that your photo is a mosaic, and that the individual tiles have been separated into same-color stacks. The taller the stack, the more tiles you have of that particular color.

Photoshop automatically displays a histogram in the Properties panel when you create either a Levels or a Curves adjustment layer. You can also choose Window→Histogram to open the Histogram panel shown in Figure 9-13.

The histogram looks like a mountain range, which is a perfectly fine way to think about it (more on that analogy in a moment). Its width represents your image's *tonal range*—the range of colors between the darkest and lightest pixels—on a scale of 0 to 255. Pure black (0) is on the far left and pure white (255) is on the far right. All told, the histogram measures 256 values. If that number sounds familiar, it should—it's the same 256-value range you learned about back in Chapter 2, which represents the minute gradations between a total absence of light (black) and full-on illumination (white).

NOTE The histogram's width is also referred to as the image's *dynamic range*, which you'll learn more about in the High Dynamic Range (HDR) section later in this chapter (page 421).

The histogram's height at any particular spot represents how many pixels are at that specific brightness level. Using the mountain analogy, a noticeable cluster of tall, wide mountains means that particular brightness range makes up a good chunk of your image. Short or super-skinny mountains mean that particular brightness range doesn't appear much. And a big ol' flat prairie means there are few or no pixels in that range. In other words, the histogram can tell you at a glance whether you've got a good balance of light and dark pixels, whether the shadows or highlights are getting clipped, whether the image is over- or underexposed (see Figure 9-14), and whether the image has been adjusted before.

FIGURE 9-14

These histograms—shown here in Compact View—can tell you whether an image is underexposed (left), has a good balance of color (center), or is overexposed (right).

(Great Synagogue and Szechenyi Baths, Budapest, Hungary.)

Here are a few tips for understanding the histogram:

- An extremely jagged mountain range means the image's color is unbalanced—it may contain a decent amount of some colors but very little of others.

- A narrow mountain range means you've got a narrow tonal range and little difference between the darkest and lightest pixels. The whole image probably looks rather flat and lacks both details and contrast.

- If you see a sharp spike on the left side of the histogram, the image's shadows have probably been clipped by the camera or scanner. If the spike is at the right side of the histogram, the *highlights* may have been clipped instead. (See page 383 for a definition of clipping.)

- If the mountain range is bunched up against the left side (near 0, a.k.a. black) with a vast prairie on the right, the image is underexposed (too dark); see Figure 9-14, left. If the mountain range is snug against the right side (near 255, a.k.a.

white) with a vast prairie on the left, the image is overexposed (too light); see Figure 9-14, right.

- An image that has a good balance of light and dark colors has a wide mountain range—one that spans the entire width of the histogram—that's fairly tall and somewhat uniform in height. Basically, you want the histogram to look like the older, eroded Appalachians (Figure 9-14, center) rather than the newer, super-jagged peaks of the Himalayas (Figure 9-14, right).

- If the histogram looks like a comb—with a bunch of gaps between its spikes (see Figure 9-16, right)—the image is either a really lousy scan or was adjusted at some point in the past. (Anytime you shift the brightness values of pixels, you introduce gaps between the histogram's tiny bar graphs.)

All this histogram and correction business is subjective; if your histogram looks terrible but the image looks great to you, that's fine—in the end, your opinion is all that matters.

Thankfully, you can fix a lot of the problems listed above using the correction methods discussed in this chapter. For example, you can balance an image's color to smooth out the height of the histogram's mountains, or expand the image's tonal range and increase its contrast to widen the mountain range. And by keeping the Histogram panel open, you can watch how it changes in real time as you edit images.

If the whole histogram concept is clear as mud, don't fret—it'll make more sense once you start using Levels. And if you've got a little free time, you can use the Dodge and Burn tools to help gain an understanding of the relationship between what you see in an image and how the histogram looks. With the Histogram panel open, use the Dodge tool to lighten dark areas and see how the histogram changes, and then use the Burn tool to darken light areas and see how that affects it. With a little experimentation, you can get a clearer idea of what the histogram is telling you.

> **TIP** Most digital cameras can display a histogram, though you may have to root through your owner's manual to learn how to turn it on. Once you get comfy with histograms, you can use them to see whether the shot you're about to take will have good exposure.

The Levels Sliders

Now that you know how to read histograms, you're ready to make a Levels adjustment, which involves using a set of three sliders to reshape and expand the information in your histogram. You can add a levels adjustment layer by choosing Layer→New Adjustment Layer→Levels, by clicking the Levels icon in the Adjustments panel (it looks like a tiny histogram), or by clicking the half-black/half-white circle at the bottom of the Layers panel and choosing Levels. (You can also summon a Levels adjustment by pressing ⌘-L [Ctrl+L on a PC] or by choosing Image→Adjustments→Levels, though in both cases the adjustment happens on your *original* image instead of on an adjustment layer. Scary!) Whichever method you use, Photoshop displays a light-gray histogram in the Properties panel (see Figure 9-15).

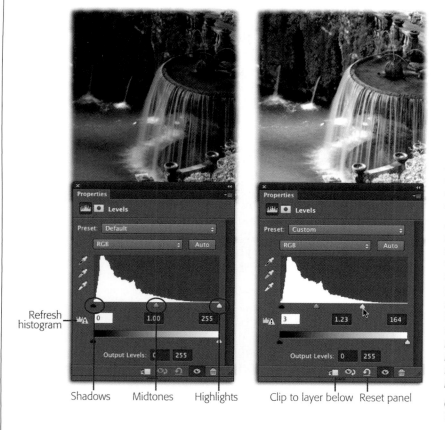

FIGURE 9-15

The simplest way to make a Levels adjustment is by dragging the Input Levels sliders circled here. You'll also find a slew of options in the Preset drop-down menu at the top of the Properties panel; feel free to give them a spin to see what they do to your image and how they change your histogram.

After adjusting each slider, press the backslash key (\) to see what your image looked like previously to see whether you like the results of your changes. To apply the adjustment to just one layer below it (instead of all layers below it), click the "Clip to layer below" icon labeled here.

(Hadrian's Fountain, Tivoli, Italy.)

Refresh histogram

Shadows Midtones Highlights Clip to layer below Reset panel

TIP When you add a levels adjustment layer, you'll spot an Auto button near the top right of the resulting Properties panel. Back in CS6, Adobe changed the math that Photoshop uses when you click this button: Instead of the Enhance Per Channel Contrast method (where Photoshop adjusted the red, green, and blue channels individually, so the highlights got a little lighter and the shadows got a little darker—whether they needed it or not), it now uses the "Enhance Brightness and Contrast" method, which makes Photoshop analyze your image and then adjust its brightness and contrast accordingly. So feel free to go give this button a click and see if you like the results.

As shown in Figure 9-15, the black slider on the left side of the histogram represents the shadows in your image. It starts out at 0, the numeric value for pure black. The white slider on the right side, which represents highlights, starts out at 255—pure white. To give your image the greatest possible tonal range and contrast, move these sliders so they point to wherever your histogram's values begin to slope upward

(at the foot of the mountains, so to speak). In other words, if there's a gap between the shadows slider and the bars on the left end of the histogram, drag that slider to the right. And if there's a gap between the highlights slider and the bars on the right end of the histogram, drag that slider to the left, as shown in Figure 9-15, right.

When you move the sliders, Photoshop adjusts the image's tonal values accordingly. For example, if you drag the highlights slider left to 164, Photoshop changes all the pixels that were originally 164 or higher to 255 (white). (Translation: They get brighter.) Similarly, if you move the shadows slider right to 3, Photoshop darkens all the pixels with a brightness level of 3 or lower to 0 (black). Photoshop also redistributes the brightness levels between 3 and 164, boosting the image's overall contrast by increasing its tonal range (widening the histogram's mountain range). Figure 9-15 shows what a difference this can make.

The gray midtones slider in the middle lets you brighten or darken an image by changing the intensity of the middle range of grays (the box on page 414 explains why you're dealing with grays instead of color). Drag it left to lighten your image (or decrease contrast), or right to darken it (or increase contrast), as shown in Figure 9-16. Because this slider focuses on the image's midtones, it won't make the highlights too light or the shadows too dark—unless you go hog wild and drag it *all* the way left or right!

■ OUTPUT LEVELS

To help you—or the person you're handing the image off to—differentiate between an adjustment made to *correct* an image and an adjustment made only to suit a particular *printing* method (say, newsprint), the Properties panel includes *Output* Levels settings: the black-to-white bar and two fields near the bottom of the panel, shown in Figure 9-15 (you may need to increase the height of your Properties panel to see 'em). The black-to-white bar includes a couple of sliders you can use to control the darkness of dark pixels and the lightness of light pixels in your image. Drag the black slider to the right to lighten the pure-black pixels or the white slider to the left to dim the pure-white pixels.

These adjustments used to be crucial if you were sending grayscale images to a commercial press because the printing process was notorious for making highlights too light and shadows too dark (mainly due to the absorbency of the paper). Nowadays, if you use good-quality color profiles (page 720), these settings aren't such a big deal, but knowing how to change the way your blacks and whites will print is still useful if you can't trust your printer to properly reproduce shadows and highlights. (For more on preparing images for newsprint, see the box on page 337.)

Four histograms are accessible within the Properties panel

RGB histogram after adjusting individual channels

FIGURE 9-16

Left: In the Properties panel, the unlabeled menu above the histogram lets you view and adjust the composite channel (page 205) or individual channels. If each channel's histogram differs greatly, it's worth adjusting each one separately; but if their histograms are similar, you can get away with adjusting only the composite channel. Here you see the composite and individual color-channel histograms for an RGB image. Since the gaps on the right side vary quite a bit, you should adjust each channel separately.

Right: Here are the before (top) and after (bottom) versions of ruins at the Roman Forum in Italy, along with the new composite-channel histogram. The mountain range is flatter and wider meaning the tonal range has expanded. (You can tell this image has been adjusted because its histogram looks like a comb.)

The Levels Eyedroppers

Another way to apply a Levels adjustment is to use the eyedroppers on the left side of the Properties panel's histogram (visible in Figure 9-16). Instead of dragging the sliders below the histogram, you use these eyedroppers to sample pixels that should be black (the darkest shadows that contain details), white (the lightest highlights that contain details), or neutral gray (midtones), and Photoshop adjusts the sliders *for* you. The only problem with this method is that it can be darn tough to figure

out *which* pixels to sample, though there's a trick you can use to solve this problem, as you'll learn shortly.

Open an image, and then follow these steps:

1. **Grab the Eyedropper tool and change the Options bar's Sample Size drop-down menu to "3 by 3 Average."**

 Press I to activate the Eyedropper tool. Because you're about to use eyedroppers in a Levels adjustment to reset black and white points, you need to change the way the tool measures color (the eyedroppers for both Levels and Curves use the main Eyedropper tool's settings). In the Options bar, set the Sample Size menu to "3 by 3 Average" to make Photoshop average several pixels around the spot where you click, which is much better for color-correcting.

TIP If you have the Eyedropper or Color Sampler tool (see page 410) active, you can also pick a new sample size by Control-clicking (right-clicking) anywhere in your image. If you're working with extremely high-resolution files, the pixels are so tiny and tightly packed that you may want to increase the sample size to, say, 51 x 51 or higher. (Page 254 has the scoop on resolution.)

POWER USERS' CLINIC

Histogram Statistics

If you choose Expanded View or All Channels View from the Histogram panel's menu, you'll see a bunch of cryptic info below the histogram. The most useful thing there is the Source drop-down menu, which lets you choose whether the histogram represents the whole image, the active layer, or an *adjustment composite*. If your document contains adjustment layers, that last option displays a histogram that's based on the active adjustment layer and all the layers below it.

The other stuff below the Source menu is pretty heady, but here's the gist of what each item means:

- **Mean** represents the average intensity value of the pixels in the image.
- **Std Dev** (standard deviation) indicates how widely the image's intensity values vary.
- **Median** is the midpoint of the intensity values.
- **Pixels** tells you how many pixels Photoshop analyzed to generate the histogram.

- **Cache Level** shows the current image cache Photoshop used to make the histogram. When this number is higher than 1, Photoshop is basing the histogram on a representative sampling of pixels in the image rather than on all of them. You can click the Uncached Refresh icon (labeled in Figure 9-13) to make the program redraw the histogram based on the current version of the image.

If you position your cursor over the histogram, you also see values for the following:

- **Level** displays the intensity level of the area beneath the cursor.
- **Count** shows the total number of pixels that are at the intensity level beneath the cursor.
- **Percentile** indicates the number of pixels at or below the intensity level beneath the cursor, expressed as a percentage of all the pixels in the image.

Math geeks, bless their hearts, love this kind of stuff.

2. **Add a levels adjustment layer.**

 At the bottom of the Layers panel, click the half-black/half-white circle and choose Levels. Photoshop adds an adjustment layer to your image and opens the Properties panel.

3. **In the Properties panel, click the black eyedropper to the left of the histogram.**

 The left side of the panel sports three eyedroppers. The black one resets the image's black point (shadows), the gray one resets its gray point (midtones), and the white one resets its white point (highlights). Simple enough!

4. **Mouse over to your image and click a spot near the image's focal point that should be black.**

 In most cases, it's fairly obvious which parts of an image should be black, though sometimes it's hard to tell. If you need help figuring out where the darkest pixels in your image live, make sure the black eyedropper is active, and then hold down the Option key (Alt on a PC) as you drag the Properties panel's shadows slider to the right (see Figure 9-17). At first, your image turns completely white, but as you continue to drag, Photoshop displays neon colors in some areas; the first colored area that appears is the darkest spot in your image. While still holding down the Option (Alt) key, mouse over to your image, and then click that spot with the black eyedropper. When you mouse away from the Properties panel, your image goes back to its regular colors, but as soon as the cursor is over your image in the document window, it'll go back to funky neons (if it *doesn't*, you forgot to activate the black eyedropper first).

 When you click, the colors in your image will probably shift a bit. If you don't like the results, click somewhere else to set a *new* black point, or undo your click by pressing ⌘-Z (Ctrl+Z on a PC).

5. **In the Properties panel, click the white eyedropper, and then click a spot in your image that should be white.**

 The same rules apply when it comes to choosing a new white point as choosing a black one: Try to pick a spot that's close to the focal point of your image and not pure white (because a pure white area doesn't have any details). You also don't want to pick a reflection from a light source as your white point because it's not a *true* white. You can use the same Option-drag (Alt-drag on a PC) trick to find the image's lightest highlights, though this time you'll need to activate the *white* eyedropper, and the image turns black rather than white. As you drag the highlight slider to the left, the first area that appears in color is the lightest. While still holding the Option (Alt) key, mouse over to your image and click that spot (your image temporarily changes to full color when you mouse away from the Properties panel, but it reverts to neon once your cursor reaches your image).

FIGURE 9-17

Top: It's tough to spot the darkest and lightest pixels in this image, so try this trick: In the Properties panel, Option-drag (Alt-drag) the shadows slider to the right (see the circle with an arrow on the right here). Your image turns white and the first areas to appear in color are the darkest ones. Mouse over to the image and click the darkest spot (circled at left). While the holes on the manhole look like the darkest spots, they're actually shadows, so you shouldn't click them because they're not true blacks.

Middle: Likewise, when you Option-drag (Alt-drag) the highlights slider to the left, your image turns black and the first colors to appear are the lightest. Mouse over to the image and click the lightest spot (circled, left).

Bottom: See the box on page 408 to learn a trick for finding a neutral gray, or just click the gray eyedropper and then find a spot in your image that looks gray and give it a click (both are circled here). As you can see, a little Levels adjusting can go a long way toward improving an image's color and contrast!

If you'd like to play around with the image shown here, download Manhole.jpg from this book's Missing CD page at www.missingmanuals. com/cds.

(Prague Castle, Prague, Czech Republic.)

6. **Activate the gray eyedropper, and then click an area that should be neutral gray.**

 Unfortunately, the Option-drag (Alt-drag) trick doesn't work here, but if you're willing to jump through a few hoops, you can track down a neutral gray. (The box below has the details.) If you don't have time for that, simply click gray areas until the image's color looks good to you.

7. **To see before and after versions of your image, turn off the levels adjustment layer's visibility.**

 In the Layers panel, click the visibility eye to the left of the levels adjustment layer to see whether the adjustment improved your image.

Good Gray Hunting

Alas, if you're looking for a neutral gray to click with the gray Levels or Curves eyedropper and nothing in your image is gray, there's no quick trick for finding a good gray. Some images don't even *have* any neutral grays.

One way to look for them is to open the Info panel (Figure 9-18) and activate the Eyedropper tool by pressing I. Then, keep an eye on the Info panel's R, G, and B, values as you put your cursor over areas in the image that appear gray. When you find a spot with *nearly* equal RGB values (like R: 222, G: 222, B: 224, for example), you've found a neutral gray—so click it.

The Info panel method works fine if you've got a few extra hours to spend mousing around an image checking pixel values. But if you're pressed for time, here's a foolproof way to hunt down neutral grays—if they exist in your image:

1. Add a new layer by clicking the "Create a new layer" icon at the bottom of the Layers panel. Make sure this layer is positioned *above* the image layer.

2. Fill the new layer with gray by choosing Edit→Fill, picking 50% Gray from the Use drop-down menu, and then clicking OK.

3. Use the drop-down menu near the top of the Layers panel to switch the gray layer's blend mode from Normal to Difference. Your photo now looks really funky, but don't panic; this layer won't live long.

4. Create a Threshold adjustment layer by choosing Layer→New Adjustment Layer→Threshold.

5. In the resulting Properties panel, drag the Threshold slider all the way to the left until the image turns solid white, and then slowly drag the slider back to the right. The first areas that appear black are your neutral grays. As soon as you see a good-sized black spot, stop dragging.

6. Remember that spot or mark it with the Color Sampler tool (page 410): Press Shift-I repeatedly to activate the tool (it looks like an eyedropper with a tiny circle above it), and then click once in the black spot. A tiny circle with the number 1 next to it appears where you clicked. (Feel free to mark more than one spot if you'd like; the Color Sampler tool lets you place up to four markers.)

7. Delete both the Threshold adjustment layer and the gray layer. Shift-click to activate them both in the Layers panel, and then press Delete (Backspace on a PC).

That's it! With the neutral gray point marked, you don't have to wonder where to click with the gray eyedropper in a Levels or Curves adjustment. To delete the marker once you've set your gray point, grab the Color Sampler tool, mouse over the marker, and then Option-click (Alt-click) it. Your cursor turns into the tiniest, *cutest* pair of scissors you've ever seen.

FIGURE 9-18

The Info panel displays some extremely helpful stats about your image.

Once you've applied an adjustment, the top two sections show before and after color values. In this image, you can see that the white cloud the cursor is over is pure white (255,255,255) so this wouldn't be a good spot to click when resetting your white point, as described earlier (page 406). If you happen upon a gray area with (nearly) equal RGB values, congratulations—you've found a neutral gray!

Click one of the little eyedroppers (circled) in the panel's top two sections to summon this menu, and then choose the info you want displayed in that section. To change the info displayed in the panel's other sections, choose Panel Options from the Info panel's menu.

(Charles Bridge, Prague, Czech Republic.)

Correcting by the Numbers

Ever heard the phrase "numbers don't lie"? That old adage applies to color correcting in Photoshop, too: Using numbers helps you take the guesswork out of it. Instead of relying on what looks good to your naked—and possibly tired—eye, you can use color values to balance an image's color perfectly.

To see pixels' color values, open the Info panel by choosing Window→Info. Once you do that, you can mouse over your image with any tool and the panel displays a numeric value for the particular pixel your cursor is over (see Figure 9-18). For RGB images, you'll see values for R, G, and B. If you're in CMYK mode, you see C, M, Y, and K values instead; in Lab mode you get L, a, b; and so on. (When you're in RGB mode, you also see C, M, Y, and K values in the Info panel, which is useful if you need to keep an eye on the values of one mode while you're working in another.)

In RGB mode (which is where you spend the majority of your time), these values correspond to the 0–255 scale you learned about earlier in this chapter. Depending

on the color your cursor is over, the numbers may lean more toward one channel than the others. For example, when it's over a pixel in a sky, the B (blue) value spikes higher than the R or G (red or green) values. When it's over reddish skin, the R value is higher than the B or G values. This info is useful in several situations:

- **You can use it to figure out what's causing a color cast.** For example, if your cursor is over a white cat and the B value is really high, you have a problem in the blue channel. If the G value is off the charts, then that's where the problem is.

- **It can help you find the darkest and lightest pixels when you're making a Levels or Curves adjustment.** Put your cursor over the area you're considering using to reset the black or white point to see whether it's *really* pure black (0, 0, 0) or pure white (255, 255, 255).

TIP If you're mousing around a shadowy area and the Info panel's numeric values keep changing, that means there are details lurking in that spot; if you lighten the image's shadows using the techniques in this section, you may be able to bring 'em out.

- **Monitoring these values can keep you from over-adjusting the image and losing details.** For example, since you know that three 0s means pure black and three 255s means pure white, when you're making an adjustment, you can take care that pixels in the important parts of your image don't reach those values. Step 4 on page 411 explains how to use the Color Sampler tool and the Info panel to monitor the original and adjusted values of up to four sample points.

Here's how to correct an image in RGB mode by the numbers:

1. **Open the Info panel by choosing Window→Info.**

 As you move your cursor over various parts of your image, watch how the Info panel's numbers change to reflect the pixel underneath the cursor.

2. **Grab the Color Sampler tool and make sure its sample size is set to "3 by 3 Average."**

 Press I to activate the Eyedropper tool, and then press Shift-I until you see the Color Sampler tool (it lives in the same toolset). Take a peek in the Options bar and make sure the Sample Size menu is set to "3 by 3 Average."

3. **Create a levels adjustment layer.**

 At the bottom of the Layers panel, click the half-black/half-white circle and choose Levels, or click the Levels icon in the Adjustments panel. Technically, you don't *have* to create this layer just yet, but if you've already got a Levels adjustment open, you can use the Option-drag (Alt-drag on a PC) trick described in Figure 9-17 on page 407 to help you find the highlights and shadows points in the next two steps—just don't forget to drag the sliders *back* to their original positions when you're done performing the trick!

4. Mark the darkest shadow and lightest highlight in the image.

Following the guidelines explained in the previous section (starting on page 406), locate the darkest shadow that's not pure black (0) and click it once with the Color Sampler tool; Photoshop adds a marker like the ones circled in Figure 9-19. Then find the lightest highlight that's not pure white (255) and mark it, too (you'll see a little 2 next to the marker). Photoshop adds two sections to the Info panel—one for each of the markers you added (they're boxed in Figure 9-19).

FIGURE 9-19

Top: When you place sample-point markers (circled), the Info panel sprouts new sections that correspond to each of the markers. These sections let you monitor the marked pixels' values before and during an adjustment (the two values are separated by a slash).

As explained in steps 5 and 6, your goal is to make the highlight's color values 245 and the shadow's color values 10. You may not be able to get your numbers to match these exactly because they change as you adjust individual channels, but if the image has a halfway decent exposure, you should be able to get pretty close.

Bottom: As you can see, making adjustments based on the Info panel's data took care of this image's yellow color cast and improved its contrast.

Strictly speaking, you don't have to activate the Color Sampler tool to place sample-point markers. If you're using the Eyedropper tool, you can Shift-click to place a marker, and Option-Shift-click (Alt+Shift-click on a PC) a marker to delete it.

5. In the Properties panel, use the histogram to adjust each channel's highlight value.

Your goal in fixing the highlights is to make all three channels' color values match the *optimal* highlight value, which is about 245 (close to—but not quite—pure

white). To balance the channels' highlight values, you have to adjust the highlight in *each* channel. To do that, head over to the Properties panel and pick a channel from the unlabeled drop-down menu near the top of the panel. Then, while watching the numbers in the Info panel (if necessary, undock it from its panel group), drag the Properties panel's highlights slider (labeled back in Figure 9-15) left until it reaches 245, or just type *245* into the text field below the slider. Repeat this step for the other two channels. When all three channels' highlight values are nearly (or exactly) equal, you've got yourself a balanced image (well, in the highlights at least!).

6. **Adjust each channel's shadow value.**

 Use the same process to balance the shadows: Choose each channel from the menu near the top of the Properties panel, and then drag the shadows slider to the right until it reaches 10 (close to—but not quite—pure black), or type *10* into the slider's text field.

7. **If necessary, adjust the image's midtones.**

 You don't always have to adjust midtones—the image may look just fine the way it is (though you may not realize how much better it *could* look!). In the Properties panel, pick the composite channel (RGB) and then drag the gray slider left to lighten the image, or right to darken it.

8. **Turn off the levels adjustment layer to see the "before" version of the image.**

 In the Layers panel, click the layer's visibility eye so you can see what a difference your changes have made.

If you need to go back and make further adjustments, in the Layers panel, double-click the levels adjustment layer to reopen its settings in the Properties panel. As you can see back in Figure 9-19, this technique makes a big difference.

> **TIP** If you really dig having the Info and Properties panels open—and you will once you get used to using them—you can create a custom workspace that includes them. Flip back to page 12 to find out how.

Color-Correcting Skin

You're not limited to monitoring the Info panel's values of highlights and shadows; you can slap sample points anywhere you want. If you're correcting a people picture, you most certainly want to monitor the values of skin tones. While you won't find any magic target values that work for *every* skin type, here are a few tips that can help you make sure skin tones at least look human, which is (hopefully!) your goal:

• When color-correcting photos of women, try to place sample points on your subjects' necks. Women don't typically put makeup on their necks, so you get a more accurate reading of the woman's *real* skin tone based on her neck than you would based on, say, her cheek.

- Skin tones should have red values greater than their green values and green values greater than their blue values. This rule is easy to remember because that's the order of the letters in RGB.

- The difference between the red and green values in skin should be about double the difference between the green and blue values. For example, if the difference between the red and green values is 60, the difference between the green and blue values should be around 30.

- The fairer a person's complexion, the closer the RGB values should be to one another.

- The darker a person's complexion, the lower the blue value in her skin should be.

By following these guidelines, you should end up with nicely balanced skin colors in your images. And if you'd like to use a color swatch as a reference, you can find skin tone color charts lurking on the Web. An oldie but goodie is Bruce Beard's skin tone and hair color chart, available at *www.lesa.in/brucebeard*.

TIP Photoshop provides yet *another* way to select the skin tones in an image. This method involves using the Color Range command; flip back to the box on page 169 to learn all about it.

■ Working with Curves

The last stop on the Color Correction Express is Curves, the most powerful—and fear-inducing—adjustment in all of Photoshop. The basic idea is that, by curving a diagonal line on a grid, you change the brightness of the pixels in your image. Instead of three main adjustment sliders like you get with Levels (shadows, highlights, and midtones), Curves gives you up to *16* adjustments. (The Curves grid shows up in the Properties panel, just like Levels.) But that's not as scary as it sounds.

If you survived the section on Levels relatively unscathed, you already know a *ton* about Curves. For example:

- You can use Curves as an adjustment layer so that it's nondestructive, and you can use the included layer mask to restrict the adjustment to certain areas.

- A Curves adjustment uses a histogram and the same 256 shades of gray you saw in Levels. It also has the same shadows and highlights sliders (though no midtones slider), and it harbors the same trio of eyedroppers for resetting the black, white, and gray points (page 404). So far so good!

- You can Option-drag (Alt-drag on a PC) the shadows and highlights sliders to find the darkest and lightest areas of your image, like you learned on page 407.

- You can use Curves to correct an image using the Info panel and the Color Sampler tool, and you can type target values into the Properties panel's Input field. To summon the Input field (shown in Figure 9-20), click a point on the curve (you

may need to resize the panel—or scroll down in it—to see the field). Or, if you haven't added any points yet (which you'll learn how to do shortly), beneath the grid, click either the shadows or highlights slider to activate the corresponding *curve point* at the tip of the diagonal line and summon the Input Field.

> **NOTE** You can make the Curves grid bigger (to a point) by dragging the left edge of the Properties panel or—if you've undocked the panel (page 10)—*any* side of it, including the bottom-right corner.

- Just like with Levels, you can use the unlabeled drop-down menu near the top of the Properties panel (to the left of the Auto button) to pick individual channels to adjust.

- The Properties panel's Presets drop-down menu has some settings that are quite useful. It's worth taking them for a spin just to see how they affect both the curve and your image.

There Is No Color

What's all this talk about black, white, and gray? I'm trying to fix color!

Consider this concept: There *is* no color in Photoshop, so you can't use the program to *fix* color.

Take a moment to think about the channel information you learned about in Chapter 5. Remember how Photoshop displays it all in grayscale (see the box on page 206)? That's because the information really *is* grayscale in each channel that's captured by your camera or scanner: red, green, and blue. The color you see is actually created by output devices like your monitor, printer, and professional printing presses (which you'll learn more about in Chapter 16); they convert the grayscale info your camera captured into colors they can reproduce.

Your computer (and the programs on it, like Photoshop), your digital camera, and your scanner are all digital devices, so all they understand are *bits*, which represent either zero or one (see the box on page 42). When you send these bits to an output device, the device assigns color values to that information.

If you can wrap your brain around this mind-bending concept, a few things start to make sense. For example:

- **Why it's so hard to make what you see onscreen match what you print.** When you realize that output devices are responsible for how grayscale info is translated into color, you understand why it's such a nightmare getting colors

to match across devices that work differently (like LCD and CRT monitors) or that use different inks (like inkjet printers and printing presses). Chapter 16 has more on *color management*, the science behind making colors match.

- **Why color-correction tools like Camera Raw's Basic panel, Levels and Curves focus on white, gray, and black values.** Since you're working with grayscale info, it makes sense that, to correct an image, you have to change what Photoshop *thinks* should be black, neutral gray, or white (or change their intensity or brightness values). Shades of gray are all that matter when you're correcting color in Camera Raw or Photoshop.

- **Why the histogram measures color intensity (brightness) on a scale from 0 to 255.** A typical RGB image has 256 shades of gray, which correspond to brightness values of 0 percent to 100 percent gray. You see this 0–255 scale in the Info panel when you put your cursor over pixels in an RGB image: For each channel, each pixel has a value ranging from 0–255.

All this talk of grayscale can sound pretty abstract since we see in color. But what it boils down to is that your *real* goal in color-correcting images is to get the *grayscale* information right. Once you do, your output device has a much better chance of getting the colors right.

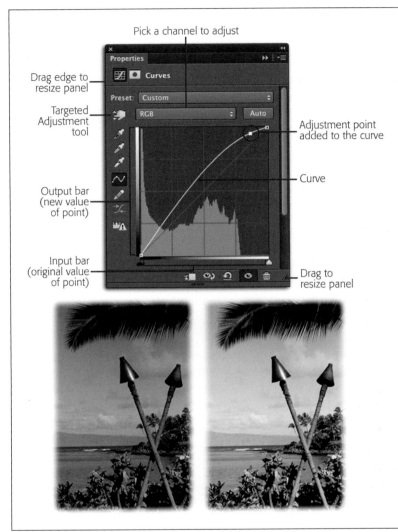

Pick a channel to adjust

Drag edge to
resize panel

Targeted
Adjustment
tool

Output bar
(new value
of point)

Input bar
(original value
of point)

Adjustment point
added to the curve

Curve

Drag to
resize panel

FIGURE 9-20

*Top: Photoshop's Curves adjustment
is incredibly flexible—and that's what
scares most folks: They don't know
when, how, or why to add adjustment
points or which direction to move
them. Fear not: You'll learn everything
you need to know about this powerful
feature in the following pages.*

*Once you add points to the curve—
here, they were added by clicking
the Auto button—you can use the
grayscale bars on the left and bottom
of the grid to figure out which direc-
tion you need to drag each point. You
can follow a point down the grid to see
its original brightness value (on the
input bar) and follow it to the left to
see its new brightness value (on the
output bar). After you click a point on
the curve, those numeric values also
appear in the Input and Output fields
below the grid (not visible here—you
have to scroll down the Properties
panel to see them).*

*Bottom: Clicking the Properties panel's
Auto button makes Photoshop analyze
your image and adjust brightness
and contrast all by itself. As you
can see here, the new math Adobe
implemented back in CS6 makes a big
difference and, in some cases, may be
all your image needs.*

(Napili Bay, Maui, Hawaii.)

To create a Curves adjustment layer, choose Layer→New Adjustment Layer→Curves.
You can also click the Curves icon in the Adjustments panel (it looks like a grid with
an S curve on it), or click the half-black/half-white circle at the bottom of the Layers
panel and choose Curves. No matter which route you choose, the Properties panel
pops open to reveal a grid with a diagonal line running from the bottom left to the
top right (see Figure 9-20). This line—which is the actual *curve* even though it starts
out straight—represents the original brightness values (tonal range) of your image.
To adjust these values, you can place up to 14 points along the line. (You can't delete
the points at either end of the curve, but you can adjust them like any other point.)

NOTE To try your hand at the Curves adjustments described in this section, download *Lisbon.jpg* (shown in Figure 9-21 and Figure 9-23) from this book's Missing CD page at *www.missingmanuals.com/cds*.

To add a point to the curve, simply click the diagonal line, or make Photoshop add it by clicking the Auto button or activating the Targeted Adjustment tool and then clicking your image (Figure 9-21 explains how that maneuver works). Each point on the line corresponds to a brightness value in the horizontal black-to-white gradient bar below the grid (called the *input bar*). The direction you drag a point determines whether the brightness of pixels in that tonal range increases or decreases: Drag *upward* to *increase* brightness or *downward* to *decrease* it. (Even if nothing else about Curves makes sense, that certainly does!)

Photoshop wizard Ben Willmore (*www.digitalmastery.com*) compares Curves adjustment points to a row of dimmer switches, which makes perfect sense. Just as turning up a dimmer switch gradually turns up the light, raising a point on the curve gradually makes your image brighter and lighter. Likewise, just as lowering a dimmer switch gradually turns down the light, lowering a point on the curve makes your image darker. It's the perfect analogy because the adjustments you make with Curves are *gradual* like dimmer switches, though Curves adjustments are more *sensitive* than dimmer switches: you generally don't have to move a point very far to introduce a big change. As you move a point, the diagonal line curves in the direction you drag, and you can see its new brightness level represented on the *output bar* (the vertical gradient bar on the grid's left side).

TIP Instead of dragging the Curves adjustment points around, you can *nudge* them with the up and down arrow keys on your keyboard. It's easier to make precise adjustments this way, and it keeps you from accidentally changing contrast (discussed in the next section) by dragging the point left or right. In the Properties panel, simply click a point on the curve, and then use the up arrow to brighten your image or the down arrow to darken it.

Bar on bottom
shows original
brightness
value of point

Point your cursor at a certain spot and a preview (hollow) point appears on curve

Bar on left
shows new
brightness
value of point

Clicking sets adjustment point on curve; drag down to darken

Click to set another adjustment point; drag up to lighten

FIGURE 9-21

Top: Curves is a lot easier to use than it used to be thanks to the Targeted Adjustment tool, which lets you add and move adjustment points by clicking and dragging in your image. To use this tool, head to the Properties panel, click the pointing-hand icon (circled, top), and then put your cursor over an area you want to darken (your cursor turns into an eyedropper). A white preview circle appears on the curve (circled, right) that corresponds to the tonal value of the pixels your cursor is over.

Middle: When you're ready to add an adjustment point to the curve, click once in your image and then—while still holding down your mouse button—drag downward to darken those pixels (your cursor turns into a hand with an up-and-down arrow [circled, left]). As you drag, the curve bends in the direction you're dragging, as shown here.

Bottom: Release your mouse button and click in your image to add another point. This time, pick an area you want to lighten, and then drag upward, as shown here.

(Vasco da Gama monument, Lisbon, Portugal.)

The grid behind the curve is merely a visual aid to help you move points around and determine which part of the tonal range you're affecting. It's set to a 25 percent, quarter-tone grid wherein shadows, midtones, and highlights are split into four parts: The left-hand column represents the darkest shadows, the middle two columns represent the midtones, and the right-hand column represents the lightest highlights. You can change it to a 10 percent grid that displays 10 rows and columns by Option-clicking (Alt-clicking on a PC) the grid in the Properties panel or by opening the Curves Display Options dialog box, shown in Figure 9-22.

FIGURE 9-22

To open this dialog box, choose Curves Display Options from the Properties panel's menu. To switch from a 25 percent grid to a 10 percent grid, just click the icons that look like tiny grids. If you change your mind and want to go back to the 25-percent grid, you don't have to reopen this dialog box: Just Option-click (Alt-click) the grid in the Properties panel.

Here's a rundown of the other settings in the Curves Display Options dialog box:

- **Show Amount of.** Unless you change it, this option is set to "Light (0–255)," which means your image's shadows correspond to the bottom-left corner of the Curves grid and its highlights to the top-right corner. You can choose the "Pigment/Ink %" option instead to show ink percentages on the input and output bars instead of the 0–255 brightness scale.

- **Show.** This setting has several options that are all turned on to start with:

 - **Channel Overlays** lets you see a separate curve for each channel in your document. If you're new to Curves and find a panel riddled with colorful diagonal lines distracting and alarming, turn off this checkbox.

 - **Histogram** determines whether Photoshop displays a light-gray version of your image's histogram behind the grid. If you find the histogram distracting, turn this setting off.

 - **Baseline** tells Photoshop to display the original curve as a straight diagonal line, which is a great way to know at a glance just how much you've adjusted the image.

 - **Intersection Line** makes Photoshop display horizontal and vertical "helper" lines when you drag a point, to help you align it properly (which isn't really necessary if you use arrow keys to nudge points instead of dragging them).

Changing Contrast

When working with Curves, the angle of the curve in the Properties panel controls your image's contrast. If you steepen it, you increase the contrast; if you flatten it, you decrease the contrast. Just select an adjustment point by clicking it and then use the left or right arrow key to nudge it one way or the other.

Another way to increase contrast is to make a subtle S curve, as shown in Figure 9-23 (middle). Here's how: Darken the image's shadows slightly by clicking to add an adjustment point to the lower-left grid intersection, and then use the down arrow to nudge it 2–3 notches for a low-resolution image or more for a high-resolution image (you can also use the Targeted Adjustment tool as described earlier). Next, lighten the image's highlights by adding a point to the top-right grid intersection, and then nudge it up the same amount. Finally, adjust the midtones by adding a point to the very center of the grid and then nudging it slightly upward to lighten or downward to darken.

If the effect of the curves adjustment layer is a little too strong, simply lower the Opacity setting at the top of the Layers panel. If you inadvertently intensify a certain color while making a Curves adjustment, just tweak that particular channel: In the Properties panel, choose the appropriate channel from the drop-down menu directly above the grid, and then click the panel's Targeted Adjustment icon. Then, in your image, click the color that you want to adjust and press the down arrow key to neutralize it, as shown in Figure 9-23 (bottom).

> **TIP** Remember, you can also change any adjustment layer's *blend mode* (see the box on page 366). For example, to preserve the image's color, you can change a Curves adjustment layer's blend mode to Luminosity so the adjustment affects the image's lightness values but not its color balance—a great way to avoid color shifts.

Getting good at using Curves takes practice. But as long as you use it as an adjustment layer, you'll never harm your original image. Heck, if you're feeling really frisky, you can click the pencil icon on the Properties panel's left, and then draw your *own* curve by hand. (If you go that route, click the "Smooth the curve values" icon just beneath the pencil to smooth the line you drew.) To add points to adjust the curve, click the "Edit points to modify the curve" icon above the pencil. And when you're ready to learn more about Curves, check out Ben Willmore's video course, Photoshop Mastery: Color and Tone (*www.lesa.in/bwillmorecl*).

> **TIP** If you create a really useful or incredibly funky Curve, you can save it by choosing Save Curves Preset from the Properties panel's menu. (You can save a favorite Levels adjustment in the same way.) From then on, it'll show up in the Preset menu at the top of the panel.

FIGURE 9-23

Top: Here's a flat and rather uninspiring image, but you can use a couple of curves adjustment layers to fix it fast.

Middle: After you adjust the shadows and highlights, you can add a point in the center of the grid (circled) to create a magic contrast-inducing S curve. It doesn't take much of an adjustment to make a major change in an image, so try using the arrow keys to nudge the adjustment points up or down.

Bottom: You can add as many curves adjustment layers as you want to a document. For example, you can create one to fix shadows, highlights, and midtones, and another to neutralize the too-blue sky. If you choose Blue from the Channel menu (circled), you can use the Targeted Adjustment tool to select the super-bright blue and then use the down arrow key to darken it a bit.

(Vasco da Gama monument, Lisbon, Portugal.)

Creating HDR Images

Once you get used to peeking at the histogram, you'll notice that *very* few images exploit the full range of brightness values from light to dark. More often than not, you'll have more info on one end of the histogram than the other, meaning the highlights *or* shadows look really good, but rarely both. That's because digital cameras can collect only so much data in a single shot. If you've got a scene with both light and dark areas—like a black cat on a light background—you have to choose which area to expose for: the cat or the background. To capture more info, you can shoot multiple versions of the same shot at different *exposure values* (called EVs) by varying your camera's shutter speed, aperture, or ISO, and then combine 'em in Photoshop into what's known as a *high dynamic range* (HDR) image.

Adobe has put a lot of effort into making it easy for mere mortals to create HDR images. But before you get started, you need to dig out your camera's manual and hunt for a feature called *auto bracketing*, which makes the camera take a series of shots with different exposure settings (you can also set the exposure differences up yourself *manually*—see your camera's manual to learn how). Bracketing lets you tell the camera how many shots to take (use a minimum of three, though more is better) and how much of an exposure difference you want between each one (pick one or two EV steps if you have the choice). For example, for three shots, you'd have one at normal exposure, one that's one or two EV steps *lighter* than normal, and one that's one or two EV steps *darker* than normal. After you've taken a few series shots with these settings, transfer them to your computer (see Chapter 22 to learn how to import images using Bridge).

POWER USERS' CLINIC

Keyboard Curves

If you're a fan of keyboard shortcuts and keyboard/mouse combinations, dog-ear this page—or better yet, print a copy of the shortcuts included on this book's Missing CD page at *www.missingmanuals.com/cds*—because there are a slew of 'em that you can use with Curves:

- To cycle through a document's channels (starting with the composite channel), press ⌘-2, 3, 4, 5, 6 (Ctrl+2, 3, 4, 5, 6 on a PC). To cycle through a document's channels in the Properties panel, press Option-2, 3, 4, 5 (Alt+2, 3, 4, 5 on a PC) and 6, if you're in CMYK mode.

- To show clipped shadows and highlights, Option-drag (Alt-drag) the Properties panel's shadows or highlights slider, or click the shadows or highlights eyedropper and then press and hold Option (Alt) as you move your cursor over the image.

- To switch between the Properties panel's 25 percent to 10

percent Curves grid (page 418), or vice versa, Option-click (Alt-click) the grid.

- To cycle forward (left to right) through curve points, press = (that's the equal sign).

- To cycle backward through curve points, press – (that's the minus sign).

- To activate multiple points, Shift-click them.

- To deactivate the currently active point(s), press ⌘-D (Ctrl+D).

- To delete a single point, activate it and then press Delete (Backspace), drag it off the grid, or ⌘-click (Ctrl-click) it.

- To nudge the active point two units, press one of the arrow keys.

- To nudge the active point 16 units, press and hold Shift, and then use the arrow keys.

Here's how to merge several exposures of the same shot into one:

1. **In Photoshop, choose File→Automate→"Merge to HDR Pro."**

 In the resulting dialog box (Figure 9-24) navigate to where the images (or folder) live on your hard drive, and then click OK. Photoshop combines the images into one document and auto-aligns them on separate layers. Depending on your computer, this process might take a while. When it's finished, you see the resulting image (Figure 9-25).

FIGURE 9-24

This dialog box lets you choose individual images or an entire folder. When it comes to HDR, the more exposures you use, the more realistic your final image will be.

You can also summon this dialog box in Bridge: Just Shift-click to activate the images you want to merge, and then choose Tools→Photoshop→"Merge to HDR Pro." For more on using Bridge, see Chapter 22.

2. **If the subject of your images moved between shots or has a lot of soft edges, in the full-size "Merge to HDR Pro" dialog box (Figure 9-25), turn on "Remove ghosts."**

 Even if you used a tripod, this setting is likely to improve the final image. When you turn it on, Photoshop compares all the images and tries to ignore content that doesn't match throughout the majority of the shots.

Bit-depth Mode menu Conversion method

Preset panel menu
Curves panel menu

Multiple exposures to merge

FIGURE 9-25

The bottom of this dialog box includes the five shots used to create this image (photos by Karen Nace Willmore, www.karennace.com*). As the thumbnails show, the sky is brighter than the car. If you first expose for the car, then shoot the same shot with your EV a step apart, and then change it again by another step, you eventually have a series of images that span a broad tonal range. Experiment with the recipes in the dialog box's Preset menu, and then adjust the sliders to your liking. Once you've got your settings just right, save 'em by clicking the Preset panel menu (labeled) and choosing Save Preset. The Curves panel menu (also labeled) lets you load and save Curves presets, too.*

3. **From the Mode menu near the top of the "Merge to HDR Pro" dialog box, choose a final bit depth for your image.**

Choosing 32-bit makes Photoshop retain all the dynamic range information captured in the original images. However, 32-bit images contain *far* more info than your monitor can display (plus they take up a huge chunk of your computer's memory when they're open), so you'll see only a portion of the images' tonal range. To compress the information into something you can actually *use*, you can convert them to 16- or 8-bit, as explained in the next step. (For more on bit depth, see the box on page 42.) This conversion process is called *tone mapping*: mapping one set of colors to another.

NOTE These days, you can use Camera Raw to tone your 32-bit HDR image. Once you choose 32-bit from the "Merge to HDR Pro" dialog box's Mode menu, you'll spot a checkbox called "Complete Toning in Adobe Camera Raw" (it's turned on by default). Click the "Tone in ACR" button at the lower right of the dialog box, and Photoshop makes a smart object out of the images you've merged, and then pops open the Camera Raw filter. When you're finished tweaking the image in Camera Raw, click OK to return to Photoshop.

That said, just because you *can* do tone-mapping in Photoshop doesn't mean you *should*. Even though the process improved back in CS5, you may still find third-party plug-ins—like Photomatix (*www.hdrsoft.com*) or HDR Efex Pro (*www.niksoftware.com*)—faster and easier to use. Both programs work on Macs and PCs, and are relatively inexpensive.

4. **If you picked 8- or 16-bit in the previous step, choose a conversion method from the drop-down menu to the right of the Mode menu.**

 This whole HDR business is purely subjective—there's no right or wrong way to do it—so you'll want to spend some time experimenting with the various settings to figure out what makes the image look good to you:

 - **Local Adaptation** gives you a slew of additional options (visible in Figure 9-25), and even lets you apply a Curves adjustment to your image right there in the "Merge to HDR Pro" dialog box. Choose this option if you've mastered Curves, and then tweak the settings in the following sections of the dialog box:

 — **Edge Glow** behaves much like the Clarity slider in Camera Raw (page 392). Use the Radius slider to control the size of the hazy glow around soft-edged items where there's little or no contrast; drag it left to make the edge glow smaller, or right to make it larger. The Strength slider controls the glow's contrast (drag it right to increase contrast, or left to decrease it).

 — **Tone and Detail** has controls much like those in Camera Raw's Basic tab (page 390) with the addition of Gamma, which modifies the image's overall flatness and brightness.

 — **The Advanced panel** lets you tweak the image's Vibrance and Saturation to alter the intensity of its colors, as well as its Shadow and Highlight brightness values.

 — **The Curve panel** (click its tab to display it) lets you make a Curves adjustment (page 413).

NOTE Peek inside the Image→Adjustments menu and you'll spot an HDR Toning option. If you choose it, Photoshop opens a dialog box with the same options discussed here, but you can apply them to *normal* images—ones that weren't shot with multiple exposures—including TIFFs. If you go this route, expect some interesting and rather unusual results!

- **Equalize Histogram** compresses the image's dynamic range while trying to maintain contrast (it gives you a peek at what your blended image looks like). This method doesn't work quite as well as the others because it doesn't have as many options and tends to make the darkest shadows black.

- **Exposure and Gamma** lets you adjust the image's exposure to make the highlights brighter or the shadows darker, or both. Drag the Exposure slider right to brighten the highlights, and use the Gamma slider to set the comparative brightness difference (across the series of shots) between shadows and highlights (drag it left to darken the shadows or right to brighten them).

- **Highlight Compression** compresses the image's highlights to order preserve detail. Pick this method if you want to see details in your image's highlights without changing its overall contrast.

5. **Click OK to create the HDR image.**

 Photoshop applies your tone-mapping settings and makes the final HDR image (see Figure 9-26).

Be warned: Once you go HDR, you may not come back. The conversion process takes time, but it can produce amazing (though sometimes unrealistic) images. Once you've recovered from poring over this section, check out *Practical HDR* by David Nightingale (*www.lesa.in/2014hdrbook*) to learn more about HDR photography.

■ Making Colors Pop

Once you've corrected an image's color and lighting, you can have some *serious* fun by boosting or intensifying its colors. You've already learned how to do that in Camera Raw with the Clarity, Vibrance, and Saturation adjustments; this section focuses on what you can do in Photoshop.

> **TIP** Remember, you can use the Adobe Camera Raw *filter* to make your colors pop. To learn how, flip back to the box on page 393.

Intensifying Colors

After you've got an image's colors just right using what you've learned in this chapter, you can boost 'em so they *pop* right off the page. One of the simplest ways to emphasize colors is with a vibrance adjustment layer (see Figure 9-26), which has less of an effect on intense colors (because they're already highly saturated) than on lighter tones—yet it miraculously manages to leave skin tones relatively unchanged. You can also use a vibrance adjustment layer to tweak an image's saturation (its settings include a Saturation slider), but when you do, Photoshop applies that change *evenly* to the whole image no matter how intense the colors already are and with *zero* regard for skin tones. So if your picture includes people, stay away from the Saturation slider and stick to Vibrance instead...unless your clients *like* hot-pink skin.

To create a vibrance adjustment layer, choose Layer→New Adjustment Layer→ Vibrance. You can also click its icon in the Adjustments panel (it looks like a triangle) or click the half-black/half-white circle at the bottom of the Layers panel and choose Vibrance.

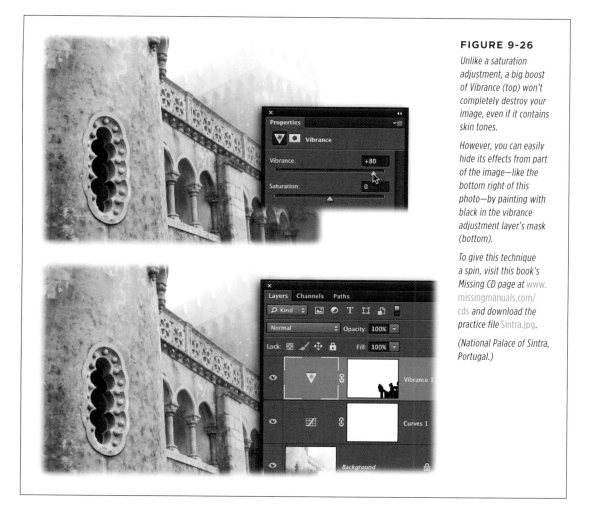

FIGURE 9-26

Unlike a saturation adjustment, a big boost of Vibrance (top) won't completely destroy your image, even if it contains skin tones.

However, you can easily hide its effects from part of the image—like the bottom right of this photo—by painting with black in the vibrance adjustment layer's mask (bottom).

To give this technique a spin, visit this book's Missing CD page at www. missingmanuals.com/ cds and download the practice file Sintra.jpg.

(National Palace of Sintra, Portugal.)

TIP If a vibrance adjustment layer's effect is a little too strong, you can reopen the adjustment by double-clicking its layer thumbnail, and then tweaking its settings in the Properties panel. But a faster method is to adjust the Layers panel's Opacity field to lessen the adjustment's effect.

Adjusting Hue/Saturation

If you want to make a *specific* color pop, you can use a hue/saturation adjustment layer to boost one color channel's contrast. It's a simple and nondestructive way to accentuate a certain range of colors.

To create a hue/saturation adjustment layer, choose Layer→New Adjustment Layer→Hue/Saturation. You can also click its icon in the Adjustments panel (it looks like two horizontal gradient bars) or click the half-black/half-white circle at the bottom of the Layers panel and choose Hue/Saturation. Next, choose the color you want to intensify from the unlabeled drop-down menu near the top of the Properties panel—which is set to Master until you change it—and then drag the Saturation slider to the right. Be careful not to go hog wild or your image's colors will enter the dreaded Neon Realm. You should be fine with a 10–15 percent saturation increase. Good times!

Adding Lab Pop

Another way to make colors leap out of an image is to creatively blend color channels in Lab mode. It's incredibly easy and the results can be amazing, as shown in Figure 9-27. With an image open, follow these steps:

1. **Pop into Lab mode by choosing Image→Mode→Lab Color.**

2. **Duplicate the original layer by pressing ⌘-J (Ctrl+J), or create a stamped copy of multiple layers (page 119).**

3. **Choose Image→Apply Image.**

4. **In the Apply Image dialog box, choose the layer you just created from the Layer drop-down menu, and then set the Blending drop-down menu to Soft Light.**

 As you learned on page 305, this blend mode makes bright areas brighter and dark areas a little darker.

5. **In the dialog box's Channel menu, pick the channel that makes your image look best.**

 As you choose different channels, take a peek at your image to see how it changes. Remember, this kind of color adjustment is purely subjective; there's no right or wrong channel to pick, and the channel that looks the best to you in *this* image may not look best in another image. Figure 9-27 shows how the channels can differ.

6. **Lower the channel's opacity (if necessary), and then click OK.**

 If the effect is too intense, lower the channel's opacity by entering a new number in the dialog box's Opacity field. Then click OK to close the Apply Image dialog box.

7. **Switch back to RGB mode.**

 Choose Image→Mode→RGB. If Photoshop asks whether you want to merge layers, say no.

You're done! Put your sunglasses on and smile as you enjoy your image's brilliant new colors. You can toggle the duplicate layer's visibility eye off and on to see before and after views. If you want to tone down the extra color, just lower the duplicate layer's opacity.

FIGURE 9-27

You can create some super colorful and interesting images using this "Lab Pop" technique. The hardest part is picking which channel looks best!

The Lightness version, for example, has a retro look thanks to its slight orangeish-greenish tinge.

To follow along, visit www.missingmanuals.com/cds and download Prague.jpg.

(Mála Strana district, Prague, Czech Republic.)

Rescuing the Unfixables

Sadly, even with all the tricks you've learned in this chapter, you can't fix *every* image. If you run into what seems to be a truly unfixable photo and you're desperate to salvage it (if you can't reshoot the scene or subject, say), try one of these techniques:

- Use the "Lab Pop" technique described on page 427, and try the Lightness channel to create unique, retro-style color.

- Create an overexposed, high-key version (see page 211).

- Convert it to black and white (the whole thing or just part of it) using one of the methods in Chapter 8. By draining the color from the image, any color problems you have will vanish.

- Add a color tint using a black & white or photo filter adjustment layer (page 333 or page 359, respectively).

- Turn it into a gorgeous duotone (page 345).

- Use a Threshold adjustment to create a pure, super-high-contrast, black-and-white image (page 342).

- Use a combination of filters to turn it into a pencil sketch (page 710).

POWER USERS' CLINIC

Processing Multiple Files

By now, you've probably realized how time-consuming all this image-correction business can be. That's why it's important to know how to save time by correcting more than one image with a single adjustment. Happily, there are several ways to do that:

- **Open multiple files in Camera Raw.** If you're using Camera Raw, you can adjust multiple files at once by selecting 'em, and then Control-clicking (right-clicking) one and choosing "Open in Camera Raw." In the upper left of the window that appears, click Select All. From then on, Camera Raw applies anything you do to all the images.

- **Drag and drop adjustment layers.** If you've (wisely) corrected an image using adjustment layers, you can drag and drop them into other open documents (use the Window→Arrange menu to position your documents so you can see 'em both at the same time; page 63 explains how). That way, you can quickly fix a bunch of images from the same shoot that have similar lighting. Even if you have to tweak the adjustment a tiny bit, it's faster than hunting for highlights, shadows, and midtones in *each* photo.

- **Record repetitive tasks with actions.** While you can't record *every* aspect of color-correcting because it's unique

to each image (or at most applies only to images taken during a single photo shoot), you *can* automate the little things you do over and over—like duplicating the original layer and adding an adjustment layer—using *actions*. You can also automate finishing touches like making colors pop (see the previous section), record an action for the sharpening techniques in Chapter 11, and so on. Chapter 18 tells you all about actions.

- **Use Adobe Bridge to copy and paste Camera Raw settings.** If you're working on photos from the same shoot that have similar lighting, you can adjust one using Camera Raw, and then copy and paste those settings using Bridge. See page 922 for the lowdown.

- **Use Adobe Bridge to rename a bunch of files.** OK, so this one has nothing to do with correcting images, but it can still save you some time! If you rename your processed files—before correcting them—and then save them in a different location than the originals (a wise move), you can have Bridge do that *for* you for an entire folder of images. The box on page 923 explains how.

Retouching, Removing, and Repositioning

I t's no secret that the beautiful models gracing the covers of magazines have been Photoshopped to within an inch of their lives. They've had the digital equivalent of every plastic surgery you can imagine, and then some: skin smoothing, blemish banishing, tummy tucking—they get it all.

This chapter shows you all those tricks and more, but that doesn't mean you should use every technique on every photo (that is, unless your client *wants* that level of pixel-pushing). It's easy to get carried away with this kind of stuff, and with great editing skills comes great responsibility. The challenge is to retouch your subjects enough to *enhance* their appearance without making them look fake. For example, if you're tempted to remove wrinkles completely, soften 'em instead. If you'd like to hack off 30 pounds, be content with 5 or 10.

All that aside, there's nothing wrong with a little vanity, and it's darn comforting to know you can zap a zit, whiten teeth, and fix red-eye whenever necessary (you'll never want to let photos of yourself out into the wild until you've spent some quality time with them). When you're finished with this chapter, you'll be able to fix shiny spots, smooth skin, add makeup, remove unsightly bulges, and enhance eyes with the best of 'em. In other words, you're about to become the most popular picture-fixer-upper in your entire social network.

> **NOTE** For a fascinating profile of a leading Photoshop-using, model-enhancing guru, check out this older (yet still informative) *New Yorker* article: *www.lesa.in/nyretouching*.

Of course, these kinds of changes aren't limited to pictures of *people*. You can also use Photoshop to remove objects from photos and scoot stuff from one spot to

another using the Content-Aware tools (which now work better than ever thanks to better color blending), as well as twist and turn objects *any* which way you want using Puppet Warp.

This chapter explains everything you need to know about turning the photos you *have* into the photos you *want*...all without harming your original images. Read on!

The Great Healers

Some of the simplest retouching you can do is to remove dark circles and bags under eyes, as well as other blemishes. In the old days, you were stuck with cloning (copying) skin from one area to another, which never looked quite right; texture and tonal (color) differences always made the fix stick out like a sore thumb. These days, Photoshop has a set of tools specifically for retouching skin. Instead of grafting skin by cloning, these tools blend two patches of skin together so the texture and tones actually match (see Figure 10-1).

The Spot Healing Brush

This tool's cursor is a round brush—perfect for fixing round problem areas like pimples, moles, and so on. It's literally a one-click fixer-upper—you don't even have to drag, though you can if you want. When you click a spot with this tool, Photoshop looks at the pixels just *outside* the cursor's edge and blends them with the pixels *inside* the cursor. It's great for retouching people, fixing dust and specks in old photos, and removing anything that's roundish. You can also drag with this tool to remove, say, power lines on a relatively solid background (like a sky) or to fix scratches in old photos. And with the Content-Aware Fill option (explained in a moment), the Spot Healing Brush does an amazing job at zapping unwanted stuff in images.

To use the Spot Healing Brush, grab it from the Tools panel by pressing J (its icon looks like a Band-Aid with a circle behind it). Then put your cursor over the offending blemish and adjust the cursor's size so it's slightly larger than the area you want to fix (see Figure 10-2).

The Options bar's settings let you control how the Spot Healing Brush works:

- **Mode.** This menu lists some of the blend modes discussed back in Chapter 7: Replace, Multiply, Screen, Darken, Lighten, Color, and Luminosity. Unique to the Healing brushes (Spot and regular), Replace mode is handy if you're using a soft-edged brush because it preserves some of the texture and details around the brush's edges. However, Normal mode usually works just fine.

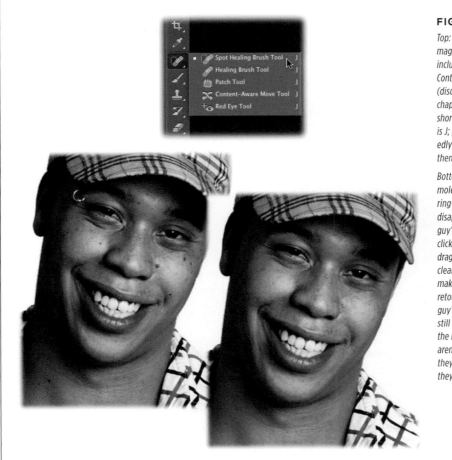

FIGURE 10-1

*Top: Photoshop's
magical healing tools,
including the Patch and
Content-Aware Move tools
(discussed later in this
chapter). The keyboard
shortcut for all these tools
is J; press Shift-J repeat-
edly to cycle through
them.*

*Bottom: A lot of
moles—and an eyebrow
ring—have completely
disappeared from this
guy's face. With a few
clicks here and a few
drags there, you can
clean up a photo without
making it look obviously
retouched. Some of the
guy's lighter freckles are
still hanging around, and
the bags under his eyes
aren't completely gone;
they're just lightened so
they're not as noticeable.*

FIGURE 10-2

The key to success with the Spot Healing Brush is to make your cursor a little bigger than the area you want to fix.

You can change the cursor's size by Control-Option-dragging (Alt+right-click+dragging on a PC) to the left or right, or by using the Brush Preset picker at the left of the Options bar or the Brush Presets panel (page 530).

Alternatively, you can resize it using the bracket keys on your keyboard: Press [to make the cursor smaller, or] to make it bigger.

- **Type.** This setting controls which pixels Photoshop looks at when it's healing. You've got three modes to choose from:

 - **Proximity Match** tells Photoshop to use pixels just outside the edge of the cursor to fix the blemish.

 - **Create Texture** is useful when the area you want to fix is surrounded by tons of details. Instead of looking at pixels outside the cursor, Photoshop tries to recreate the texture by looking at the pixels *inside* the cursor.

 - **Content-Aware** is pure magic, and Photoshop comes from the factory set to use it. It's great for removing objects from photos such as power lines, an ex-boyfriend, and so on. You can either single-click or simply drag to remove the item, and Photoshop fills in the area with surrounding pixels. Amazingly, the program can even recreate complex structures like brick walls. You've got to use it to believe it, as Figure 10-3 shows.

> **TIP** Want to give this technique a spin? Skip on over to this book's Missing CD page at *www.missingmanuals.com/cds* and download *Fence.jpg*.

- **Sample All Layers.** Turn on this setting to make Photoshop sample pixel info from *all* the layers in your image instead of just the active one. This setting also lets you do the healing on another layer instead of on the original image: Just create a new layer *above* the photo layer and make sure the new layer is active; when you click to fix a spot, the fix happens on the new layer. This technique builds a *ton* of flexibility into your document because, if you decide you've done too much healing, you can erase specific areas from the healing layer or lower its opacity to soften the effect.

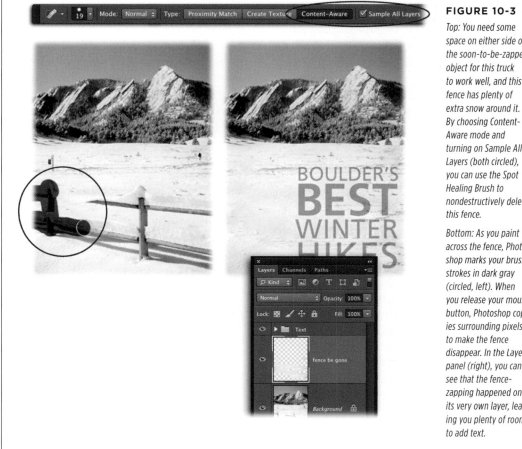

FIGURE 10-3

Top: You need some space on either side of the soon-to-be-zapped object for this truck to work well, and this fence has plenty of extra snow around it. By choosing Content-Aware mode and turning on Sample All Layers (both circled), you can use the Spot Healing Brush to nondestructively delete this fence.

Bottom: As you paint across the fence, Photoshop marks your brush-strokes in dark gray (circled, left). When you release your mouse button, Photoshop copies surrounding pixels to make the fence disappear. In the Layers panel (right), you can see that the fence-zapping happened on its very own layer, leaving you plenty of room to add text.

- **Always Use Pressure for Size.** This icon, which looks like a pen drawing tiny circles, is for folks using a digital drawing tablet (see the box on page 552). It lets you control the size of the Spot Healing Brush's cursor by applying pressure with your stylus (the pressure-sensitive pen that comes with the tablet). Press harder to increase the size of the brush, or lighter to decrease it.

Content-Aware Fill

If you've got plenty of good pixels on either side of the ones you want to delete, the Spot Healing brush's Content-Aware mode works well. But if you want to be more *precise* with your pixel zapping—if, say, the item you want to delete is super close to something you want to keep—create a selection, and then use the Content-Aware version of the Fill command instead. For example, here's how to zap one of the cows in Figure 10-4.

Fixing Spots in Camera Raw

If you find yourself using the Spot Healing Brush to fix a pesky speck that appears in the *exact* same place in every photo you take, there's dust on your camera's sensor. Take the camera to a trustworthy shop and have them clean it, or do it yourself with a bit of bravery and the right tools.

But fixing the camera doesn't fix the photos you've *already* taken with it. Fortunately, you can make Camera Raw zap those spots automatically. Here's how:

1. Open some of the problem images in Camera Raw (see the box on page 429). Because raw files are really big, you won't be able to open *thousands* at a time, but you should be able to get away with 200 or so on a newer machine with lots of memory. (If you're dealing with thousands of images, check out Adobe Photoshop Lightroom; it's *far* more efficient at handling large numbers of raw files.)

2. Press B to grab Camera Raw's Spot Removal tool, and then resize your cursor (the blue-and-white dashed circle) so it's *slightly* bigger than the spot itself. You can either use the Size slider on the right side of the window or the bracket keys on your keyboard: The left bracket key ([) makes the brush smaller and the right bracket key (]) makes it bigger.

3. Click the offending spot to set your sample point (or, if the problem area isn't round, click and drag over it).

When you release your mouse button, the pesky spot should vanish. Camera Raw displays a green-and-white circle near where you clicked (which is connected to the red-and-white circle by a black-and-white line) to mark the *sample point* Camera Raw is using to remove the spot. Camera Raw usually does a good job of picking a sample point, but if you want to move it to another area that better matches the problem spot, put your cursor inside the green-and-white circle and drag it somewhere else (a four-headed arrow appears next to your cursor). If you need to fix several specks, repeat this step for each one until they're all gone. Turn on the Visualize Spots checkbox and drag its slider rightward to make darn sure you got *all* of 'em, and then turn it back off. *Now* you're ready to apply the fix to the other open images.

4. In the Camera Raw window, activate all the open images by clicking Select All, and then click Synchronize to apply the changes you just made to them, too. In the resulting dialog box, choose Spot Removal from the Synchronize menu.

5. Click OK to close the Synchronize dialog box and then, at the bottom of the Camera Raw window, click Done to save your changes. Clicking Open Image instead would pop 'em *all* open in Photoshop, which could send both your computer and Photoshop into a deep freeze (eek!).

FIGURE 10-4

Top: There's precious little space between these two cows, so it's best to create a selection of the one you want to delete. In order for Photoshop to remove the cow completely (instead of leaving a funky outline of what used to be there), you need to include a bit of the background in your selection by using the Expand command.

Middle: Once you've created a selection and expanded it, you can use the Fill command set to use Content-Aware to replace the selected pixels with those nearby. Turn on the new Color Adaptation checkbox for more accurate color blending.

Bottom: As you can see, this command does an amazing job! And by duplicating the image layer first, the original remains unchanged.

Want to try this yourself? Trot on over to this book's Missing CD page at www.missingmanuals.com/cds and download Cows.jpg.

TIP The Fill command's Content-Aware mode works best if there's plenty of background on either side of the object you want to remove. So it's best to use the Fill command for some quality pixel-zapping *before* you crop the image.

1. **Open an image and duplicate the background layer by pressing ⌘-J (Ctrl+J).**

 Since the Fill command can't sample all layers (bummer!), it won't work on an empty layer. You could use it on a locked background layer, but that wouldn't protect your original image.

2. **Use the selection tool of your choice to select the cow on the left.**

 Because there's a decent amount of contrast between the cow and the grassy meadow, the Quick Selection tool does a great job. Grab it from the Tools panel by pressing Shift-W until you see its icon. Next, mouse over to the image, and then click and drag to paint a selection onto it. (For more on using this tool, flip back to page 160.)

3. **Expand your selection to include some of the background by choosing Select→Modify→Expand.**

 If you're working with a low-resolution image, try entering a number between 5 and 10 pixels into the Expand Selection dialog box; use a higher number on high-resolution images. When you click OK, the selection expands outward.

4. **Choose Edit→Fill and then, in the Fill dialog box, set the Use menu to Content Aware and turn on Color Adaptation.**

 The Color Adaptation checkbox is new in Photoshop CC 2014, and it produces better color blending between the original and new pixels, especially when there's a gradient involved (if you're removing a bird from a big blue sky, say). As soon as you click OK, Photoshop fills the selection with pixels from the surrounding area.

The voodoo Photoshop uses to fill your selection is random and changes each time you use the command. In other words, if at first you don't succeed, try choosing Edit→Fill again—you'll get slightly different results. Until you can actually *wish* an object out of a photo, the Fill command's Content-Aware mode ought to suit you just fine.

The Healing Brush

Like the Spot Healing Brush, this tool also blends two areas together, but you have to tell it *where* to find the area that looks good (which makes it handy for fixing things that aren't round). This process, called *setting a sample point*, is how you let Photoshop know which portion of skin—or fur, or whatever—you want it to *sample* (blend with the offending spot).

Start by adding a new, empty layer; this is the layer where you'll perform the healing. To set a sample point, activate the Healing Brush by pressing J (or Shift-J to cycle through the healing tools), and then Option-click (Alt-click on a PC) an unwrinkled area of skin or whatever. Then mouse over to the wrinkled skin and brush it away. This tool works really well on most *anything* including under-eye bags, scratches, and so on. You also get a live preview of the sample point right inside your brush cursor (Figure 10-5, bottom left).

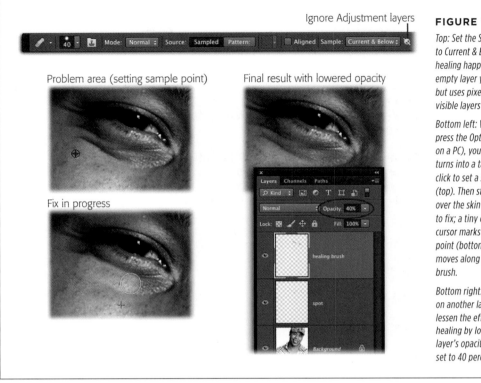

FIGURE 10-5

Top: Set the Sample menu to Current & Below so the healing happens on the empty layer you added but uses pixels from all visible layers below it.

Bottom left: When you press the Option key (Alt on a PC), your cursor turns into a target; simply click to set a sample point (top). Then start painting over the skin you want to fix; a tiny crosshairs cursor marks your sample point (bottom) that moves along with your brush.

Bottom right: By healing on another layer, you can lessen the effect of the healing by lowering that layer's opacity. Here it's set to 40 percent.

TIP When you set a sample point, try choosing a spot that's as close to the problem spot as possible so the texture and color match better. For example, you wouldn't want to repair skin on your model's nose with skin from her neck.

When you activate the Healing Brush, the Options bar includes these setting:

- **Mode.** You get the same set of blend modes for the Healing Brush as you do with the Spot Healing Brush. Both tools work really well in Normal mode, so you probably don't need to change this setting.

- **Source.** You can use either a sample (which you choose by Option-clicking [Alt-clicking on a PC] in your image) or a pattern as your source. Photoshop assumes you want to use a sample, but if you switch this setting to Pattern instead, you can pick an option from the Pattern Preset picker to its right. Healing from a pattern is useful if you don't have enough area in your image to heal *from*. For example, if you're using the Healing Brush to remove graffiti from a wall, you can create a pattern from part of the wall's texture and save it as a reusable pattern (page 94).

TIP You can also sample from *another* open document as long as both images are in the same color mode. Just hop over to the other document, Option-click (Alt-click) to set a sample point, and then click back in your original document to do the healing (use the Window→Arrange submenu to position both document windows so you can see them [see page 63]). This technique is handy when you want to snatch texture from one image and apply it to another; the Healing Brush blends the sampled texture with existing pixels.

- **Aligned.** Turn on this checkbox to keep the sample point aligned with (next to) your cursor, even if you release your mouse button and move to another part of the image. When this setting is turned off, Photoshop reverts to the original sample point each time you release your mouse button, even if you move your cursor a mile away. If your healing requires several brushstrokes, it's helpful to turn this setting on.

- **Sample.** This menu lets you choose which layers you want to sample *from*. To make the healing happen on a separate layer, create a new layer above the one you want to fix, and then choose Current & Below here. To sample from all visible layers, choose All Layers instead; if you do that, you can make Photoshop ignore adjustment layers by clicking the icon to the right of this menu (explained next).

- **Ignore Adjustment Layers.** If you added adjustment layers to alter the image's color or lighting, you can have Photoshop ignore them by clicking this "slashed" half-black/half-white circle icon.

- **Always use Pressure for Size.** If you have a digital drawing tablet (see the box on page 552), clicking this icon lets you control the size of the Healing Brush's cursor by applying pressure with your stylus (the pressure-sensitive pen that comes with a graphics tablet). Just like with the Spot Healing brush, pressing harder increases brush size and pressing lighter decreases it.

Here's how to use the Healing Brush:

1. **Add a new layer above the one you want to fix.**

 Click the "Create a new layer" button at the bottom of the Layers panel, and then name the new layer something like *Healing*. Make sure that it's above the layer you're fixing and that it's active.

2. **Choose the Healing Brush from the Tools panel.**

 Press J to activate this brush, whose icon is an itty-bitty Band-Aid.

3. **In the Options bar, set the Sample menu to Current & Below.**

 This setting tells Photoshop, "Set a sample point using pixels on the current layer and any visible layers below it, but make the change on the current layer." This process gives you a ton of flexibility: You can lower the layer's opacity to lessen the fix's strength, change the layer's blend mode, or toss it in the trash if you decide you don't like it.

4. **Mouse over to your document and set a sample point by Option-clicking (Alt-clicking on a PC).**

 Photoshop has no clue where the pixels you want to copy (and then blend) live, so you have to tell it. Option-click (Alt-click) an area that's similar in texture and color to the area you're fixing. Now you're ready to start healing.

5. **Click (or drag across) the area you want to fix.**

 Mouse over to the problem area and click it, or click and drag to paint it away. You see tiny crosshairs marking the sample point as you drag, and a *preview* of the sample area inside your cursor. If you're fixing a small area, like the bags beneath the guy's eyes in Figure 10-5, you're probably OK with setting just one sample point (or two). If you're fixing a larger area, you may need to set a new sample point every few brushstrokes to match the tone and texture of what you're fixing.

TIP If you accidentally introduce a repeating pattern when using the Healing Brush, it's easy to fix. Just set another sample point and then paint the error away, or switch to the Spot Healing Brush and then click the problem area.

The Patch Tool

The Patch tool may become one of your favorite Photoshop tools because it's easy to use and does an amazing job of removing, well, just about anything. It works like the Healing Brush in that you set a sample point, but it's often *faster* than the Healing Brush for fixing big areas like dark circles or bags beneath tired eyes. It's also handy for removing piercings, tattoos, and with its Content-Aware mode, whole *objects*.

To use the Patch tool, grab it from the Tools panel (it lives in the same toolset as the Healing and Spot Healing brushes), mouse over to your image, and then drag to draw an outline around the area you want to fix (marching ants appear when you let go of your mouse). Next, click anywhere *inside* the selected area and hold down your mouse button as you drag to reposition the selection outline so it's over the area you want to copy the pixels from (see Figure 10-6, top right). (To move the selection perfectly vertically or horizontally, hold down Shift as you drag.) A live preview of the repair appears inside the selection as you drag. When you let go of your mouse, Photoshop blends the two areas together. (If you're less than pleased with the results, and put the tool in Content-Aware mode instead, as explained on page 443.)

TIP If you need to adjust the selection while you're drawing it, use the icons near the left end of the Options bar to add to or subtract from the selection or to create one from two intersecting areas. Better yet, use these keyboard shortcuts: Shift-drag to add to the selection, Option-drag (Alt-drag on a PC) to subtract from it, or Option-Shift-drag (Alt+Shift-drag) to select an intersecting area.

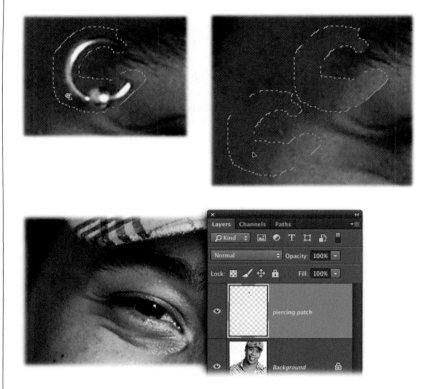

FIGURE 10-6

If you need to get rid of a piercing—before the parents see it or if your client doesn't want it in the photo shoot—the Patch tool can get that done fast.

Top: First, draw an outline around the offending area freehand (left). Once you see marching ants, click inside the selection and drag it to a good patch of skin, and then release your mouse button (right).

Bottom: Problem solved! The Patch tool can help you keep that piercing secret for a little while longer. And by doing the patching on an empty layer, the original image remains intact.

The Patch tool's Options bar settings include the selection-mode icons you're familiar with from working with the selection tools. The Options bar's *other* settings are determined by what you choose from its Patch menu:

- **Normal.** Straight from the factory, the Patch menu is set to this mode, and you see the following settings to the right of the menu:

 - **Source/Destination.** If you leave Source selected here, Photoshop takes the texture from the area you drag the selection to and tries to match it with the color and lighting of the area just outside your original selection. To produce convincing patches, leave this mode selected. But if you'd rather select the good skin first and *then* drag it atop the bad skin, click Destination here instead. (See? Photoshop is more accommodating than you thought.)

- **Transparent.** Turn on this setting to copy an area's texture but *not* its content. For example, if you're working on a photo of a brick wall, you could use this option to copy the texture of grungy bricks onto newer bricks *without* duplicating the grungy bricks in their entirety. This setting works best in conjunction with Use Pattern, explained next.

- **Use Pattern.** To apply a pattern to the area you've selected with the Patch tool, click this button and then choose a pattern from the menu next to it. However, you'll rarely use this option because, instead of merely making Photoshop copy and blend pixels from one area to another, it adds the pattern you picked from the menu to the selected area. That said, it's useful if you're trying to add texture to an area that doesn't have any.

> **TIP** It's a little-known fact that you can actually select the area you want to patch *before* activating the Patch tool. That way, you can use any selection method you want—the Quick Selection tool (page 160), Quick Mask mode (page 193), or whatever. This keeps you from having to draw the selection *freehand*. You can also draw straight lines with the Patch tool by holding down the Option key (Alt on a PC). Who knew?

- **Content-Aware.** Choosing this mode from the Patch menu (circled in Figure 10-7) *greatly* improves the Patch tool's ability to realistically remove objects of all sizes. Instead of merely copying and blending pixels from the area you drag the selection to, this mode also creates *new* pixels that match *surrounding* ones. When you choose this mode, you see the following settings in the Options bar:

 - **Adaptation.** This menu, which looks like a tiny gear icon, lets you determine how much blending Photoshop does *inside* the selected area. Previous versions of Photoshop CC included several presets ranging from Very Loose to Very Strict, but you can now be far more precise (and, theoretically, get better results). Click the gear to open the menu and enter a number from 1–5 in the Structure field, for a lot of blending or very little (respectively). In the Color field, you enter a number from 0–10 to specify how much color blending Photoshop does, from none to the maximum amount (respectively).

> **TIP** The exact values you should enter in the Structure and Color fields for best results depend upon the image you're fixing. The best way to find out what works for the current image is to adjust these fields *after* you perform the patch—immediately after you move the selection but before you deselect. Otherwise it's impossible to compare the effect these settings have. (If you highlight a number in either field, you can tap the up or down arrow keys on your keyboard to change it!)

- **Sample All Layers.** This setting (also circled in Figure 10-7) makes Photoshop sample pixel info from *all* layers instead of just the currently active layer. This lets you use the Patch tool on an *empty* layer instead of a duplicate of your image layer, resulting in a slightly smaller file size.

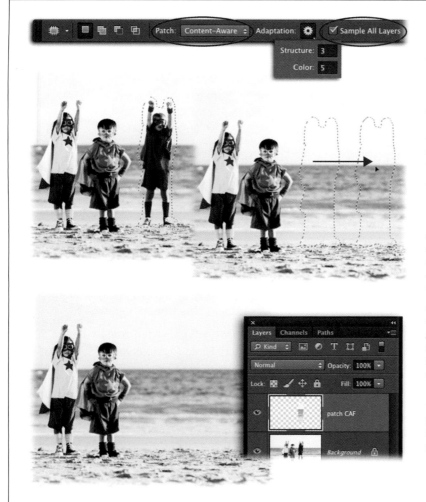

FIGURE 10-7

Top: With the Patch menu set to Content-Aware mode (circled), Photoshop performs extra blending to make any lines or patterns in the selected area match its surroundings. This feature is handy if your image contains a horizon line, buildings, or man-made objects.

Middle: After creating a selection, drag it to a new area in your image. Here, the selection was moved to the right and positioned so that the horizon lines remain parallel. Lastly, in the Options bar, adjust the Adaptation menu's Structure and Color fields.

Bottom: As you can see, Photoshop did a remarkable job of removing this little guy from the beach scene. (Hey, even bands of superheroes break up!)

Try this technique yourself by visiting this book's Missing CD page at www.missingmanuals. com/cds and downloading the practice file Heroes.jpg.

Using the Clone Stamp Tool

Unlike the Healing brushes and the Patch tool, the Clone Stamp tool doesn't do any blending at all. Instead, it merely copies pixels from one area of an image to another. You saw this tool in action back in Chapter 7, when you used it to copy parts of an image from one document into *another* document (page 317). In this section, you'll learn how to use it to perform a *partial* copy in order to fix shiny and shadowy areas of skin, as well as how to remove—and duplicate—objects in photos.

Zapping Shines and Shadows

Shiny spots (or *hot spots*, as some folks call them) are truly evil. They can ruin a perfectly good photo by making your subject look like a big ol' sweat ball. That's OK if the person just finished a marathon—glistening skin is expected then—but not if she's sitting for a portrait. Fortunately, the Clone Stamp tool can get rid of shiny spots and unsightly shadows in a hurry, as Figure 10-8 illustrates.

> **NOTE** Take these steps for a spin by visiting this book's Missing CD page at *www.missingmanuals.com/cds* and downloading the practice file *Shine.jpg*.

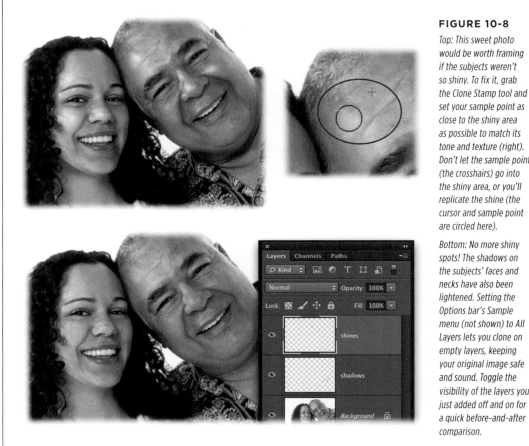

FIGURE 10-8

Top: This sweet photo would be worth framing if the subjects weren't so shiny. To fix it, grab the Clone Stamp tool and set your sample point as close to the shiny area as possible to match its tone and texture (right). Don't let the sample point (the crosshairs) go into the shiny area, or you'll replicate the shine (the cursor and sample point are circled here).

Bottom: No more shiny spots! The shadows on the subjects' faces and necks have also been lightened. Setting the Options bar's Sample menu (not shown) to All Layers lets you clone on empty layers, keeping your original image safe and sound. Toggle the visibility of the layers you just added off and on for a quick before-and-after comparison.

> **TIP** Be careful not to completely remove *all* the shine and shadows from your images—you want to leave a little bit hanging around so the photos look real. The goal is to remove just enough shines and shadows that viewers aren't *distracted* by them.

Here's how to reduce shine and shadows with the Clone Stamp tool:

1. **Open a photo and then add a new layer named** *shines*.

 Click the "Create a new layer" button at the bottom of the Layers panel, name the layer in the resulting dialog box, and then click OK. Make sure this layer is active and is *above* the image layer you want to fix. By doing your skin-fixing on this layer, you protect the original image and give yourself the option of reducing the strength of the fix by reducing the layer's opacity.

2. **Grab the Clone Stamp tool from the Tools panel.**

 Press S to activate this tool, which looks like a rubber stamp (in fact, it used to be called the Rubber Stamp tool).

3. **In the Options bar, choose a soft-edged brush and set the Opacity to 20–30%.**

 Soft-edged brushes produce partially transparent pixels around their edges, which makes the change look more realistic. If you leave the tool's opacity at 100%, you'll perform a full-on skin graft—a straight copy with *no* blending—and the retouching will be painfully obvious. Lowering the opacity lets you fix the area little by little; the more you paint, the more skin Photoshop copies.

4. **Set the Options bar's Sample menu to All Layers.**

 To make the cloning (copying) happen on its own layer, you have to tell Photoshop to sample other layers.

5. **Create a sample point for the first shiny part.**

 Mouse over to your image and Option-click (Alt-click on a PC) some *non*-shiny skin. Make sure this sample point is close to the shiny skin so it'll match.

6. **Click and drag across the shiny area to paint away the shine.**

 As you drag, you see little crosshairs representing the sample point. Keep a close eye on it because if it heads into a shiny patch, you'll paint a shine with a shine. If that happens, don't panic; just set another sample point by performing step 5 again.

 When you've fixed one shiny spot, mouse over to another and repeat steps 5 and 6.

7. **When all the shiny spots are fixed, add another new layer and name it** *shadows*.

 Not surprisingly, you'll use this layer to lighten shadowy areas.

8. **Set a new sample point and then paint across a shadow.**

 Option-click (Alt-click) to set a sample point as close to the shadowy area as possible, and then drag across the shadow to make it lighter. This technique works *wonders* for decreasing double chins, deep crevices, and pretty much any problem area that's too dark (even if it's merely underexposed).

 Repeat this step until you've taken care of all the problem shadows.

9. **Save the document as a PSD file.**

 That way, you can go back and adjust your fixes later.

Print that baby out and slap it into the nearest frame!

NOTE As usual in Photoshop, there are many ways to accomplish the same thing (in this case, zapping shines and shadows). If the Clone Stamp tool doesn't do you proud, try using the Patch tool in Content-Aware mode on an empty layer instead, and then lower that layer's opacity to send shines and shadows packin'.

Removing an Object

The steps for completely removing something in a photo are *exactly* the same as the ones for fixing shines and shadows (covered in the previous section), except that you don't lower the Clone Stamp tool's opacity. Keeping it set to 100% makes the tool perform a full-on copy, which is handy when you *don't* want any blending to occur in and around the thing you're removing.

Let's say you're retouching a portrait and the subject has a few stray hairs across her face, as in Figure 10-9, left. While you could remove them using one of Photoshop's healing tools or even the Patch tool, the blending that those tools perform may make the areas where the hairs used to be look slightly soft or mushy (especially if they're long hairs). If that happens, reach for the Clone Stamp tool instead.

Create a new, empty layer, and then activate the Clone Stamp tool and make sure the Options bar's Opacity field is set to 100%, and that the Sample menu is set to Current & Below. Next, Option-click (Alt-click) the tooth to set a clone source *near* the hair, and then drag across the hair to remove it (you may need to set new source points as you go to erase it completely).

FIGURE 10-9

With the Clone Stamp tool, you can remove the hair from this little girl's teeth without destroying teeth's texture.

As you can see in this Layers panel, each bit of retouching was performed on a new layer using different tools. Doing so gives you great editing flexibility, protects your original image, and lets you play each tool to its strength.

Duplicating an Object

As you might suspect, the technique for *duplicating* objects is similar to the one for removing objects: add a new layer, grab the Clone Stamp tool, set the Options bar's Opacity setting to 100%, set the Sample menu to Current & Below, Option-click (Alt-click on a PC) the object you want to replicate to set a sample point, and then paint across the area where you want the duplicate to appear.

The duplicate doesn't even have to be the same *size* as the original, nor does it have to be at the same *angle*. Just pop open the Clone Source panel by choosing Window→Clone Source, and then adjust the W (width) or H (height) fields and/or the Rotation field below them (circled in Figure 10-10) before you start painting. If you're duplicating an object several times, be sure to create each duplicate on its own layer so you don't have to start over if you mess up. As you can see in Figure 10-10, you can have a duplicating party!

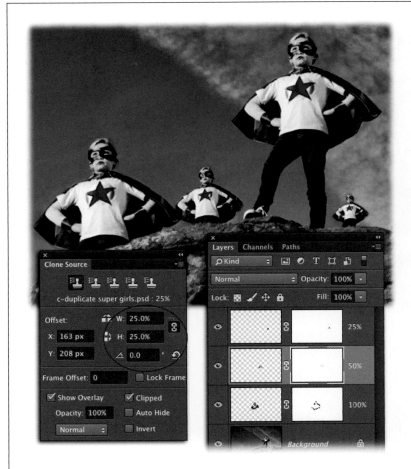

FIGURE 10-10

Using the options in the Clone Stamp Source panel, you can duplicate an object photo at different sizes and at different angles. (You often see this technique used on album covers.) It's helpful to zoom into your document and use a small brush so you can duplicate precisely.

To duplicate an object at half the size of the original, enter 50% in the W or H field (circled). To change the angle of the duplicate, enter a degree value in the Rotation field (also circled). If you painted outside the original object when you were cloning it, you can use a layer mask (page 120) to hide extra pixels around the duplicate's edges.

Whitening Teeth

If you've ever enjoyed a Texas-sized goblet of red wine and then had your picture taken, you'll want to bookmark this page. Stained teeth are even more embarrassing than shiny spots, but fortunately they're easier to fix (see Figure 10-11). You *could* start by selecting the teeth—the Quick Selection tool works well—and then feather the selection, though it's *much* easier to apply the lightening to the whole image, hide it with a layer mask, and then reveal the lightening atop the teeth using the Brush tool.

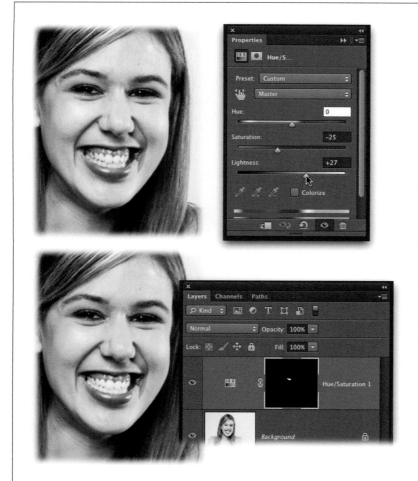

FIGURE 10-11

You can easily whiten teeth with a hue/saturation adjustment layer, as shown here. That way, you don't harm the original image because the fixing happens on its own layer, plus you can lower the adjustment layer's opacity to keep the teeth from looking too white.

Because the teeth are so small, it's easiest to lighten the whole photo and then reveal the lightening only on the teeth using the included layer mask.

You can use the same technique to whiten eyes, too, but you don't have to reduce the adjustment layer's saturation; just increasing the lightness should do the trick. Page 466 explains another way to accentuate eyes, which also works on teeth. (You can't say Photoshop doesn't give you enough options!)

Here's how to make those pearly whites, well, *white*:

1. **Open an image and zoom in so you can see the subject's teeth.**

 Press ⌘-+ (Ctrl-+ on a PC) to zoom in.

2. **Add a hue/saturation adjustment layer.**

 Click the half-black/half-white circle at the bottom of the Layers panel and choose Hue/Saturation.

3. **Lower the adjustment layer's saturation and increase its lightness.**

 In the Properties panel, drag the Saturation slider to the left and the Lightness slider to the right. Keep an eye on your image to make sure you don't make the person's teeth unnaturally white. The whole image lightens as you drag the sliders, but don't worry—you'll fix that in the next step.

4. **Fill the hue/saturation adjustment layer's mask with black.**

 Since you'll reveal this adjustment only on your subject's teeth, it's faster to *fill* the mask with black than to *paint* with black to hide the adjustment from the rest of the image. So activate the mask and then press ⌘-I (Ctrl+I) to *invert* the mask. Photoshop fills the mask with black, which hides the adjustment from the entire photo (you'll reveal the lightening on the teeth in the next steps).

5. **Activate the Brush tool and choose a soft-edged brush set to paint with white.**

 Press B to grab the Brush tool and, in the Options bar, use the Brush Preset picker to choose a soft-edge brush. Then press D to set your color chips to black and white, and, if necessary, press X to flip-flop your color chips so white is on top.

6. **Click and drag to paint across your subject's teeth.**

 As you paint, Photoshop reveals the lightening in that area. If you mess up and reveal too much, just press X to flip-flop your color chips so that black is on top, and then paint across the area you didn't mean to lighten.

7. **Save the document as a PSD file.**

 If you decide to tweak the teeth later, just open the file again, double-click the hue/saturation adjustment layer, and then fiddle with the sliders to your heart's content.

This method will whip most teeth into shape, but if you encounter a set with a *serious* yellow cast, there's one extra step you can take: Click the hue/saturation adjustment layer's thumbnail in the Layers panel; next, in the Properties panel, choose *Yellows* from the unlabeled drop-down menu near the top of the panel, and then drag the Saturation slider slightly to the left. Sweet!

Super Slimmers

Photoshop has a slew of tools you can use to do some serious slimming like fixing flabby chins, shrinking paunchy waistlines, and instantly shaving off pounds. Tools of the body-sculpting trade include the Pinch and Liquify filters, and the Free Transform command. They're all explained in this section.

Fixing Flabby Chins

You can suck the life out of a flabby chin with the Pinch filter. Sure it sounds gross, but it makes a *huge* difference and takes mere seconds. All you have to do is duplicate the image layer and then make a rough selection—the Lasso tool works well—that includes the flab and some of the surrounding details, as shown in Figure 10-12, bottom left. Next, choose Filter→Distort→Pinch. In the resulting dialog box, enter *100* in the Amount field, and then click OK. If you need to pinch the chin a little more, press ⌘-F (Ctrl+F) to run the filter again. Easy, huh?

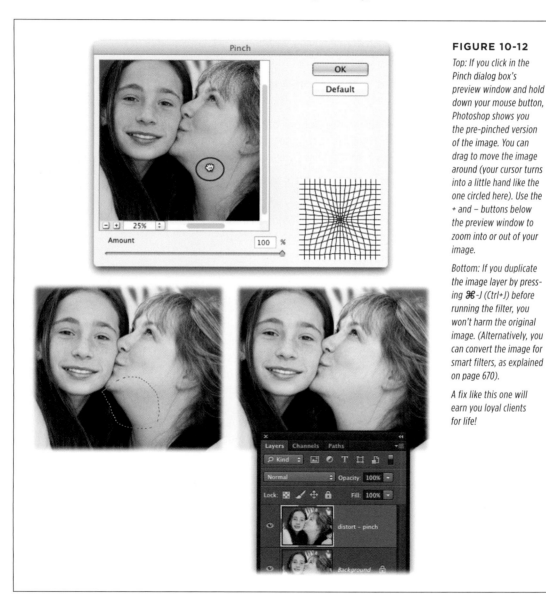

FIGURE 10-12

Top: If you click in the Pinch dialog box's preview window and hold down your mouse button, Photoshop shows you the pre-pinched version of the image. You can drag to move the image around (your cursor turns into a little hand like the one circled here). Use the + and − buttons below the preview window to zoom into or out of your image.

Bottom: If you duplicate the image layer by pressing ⌘-J (Ctrl+J) before running the filter, you won't harm the original image. (Alternatively, you can convert the image for smart filters, as explained on page 670).

A fix like this one will earn you loyal clients for life!

Liquifying Bulges

Drastic bulges call for drastic action, and the Liquify filter is as drastic as it gets in Photoshop. This filter lets you push, pull, and pucker pixels any which way. You can use it to get a waistline under control, add a smile, enlarge lips, and so on (see Figure 10-13). If only this trick worked in real life!

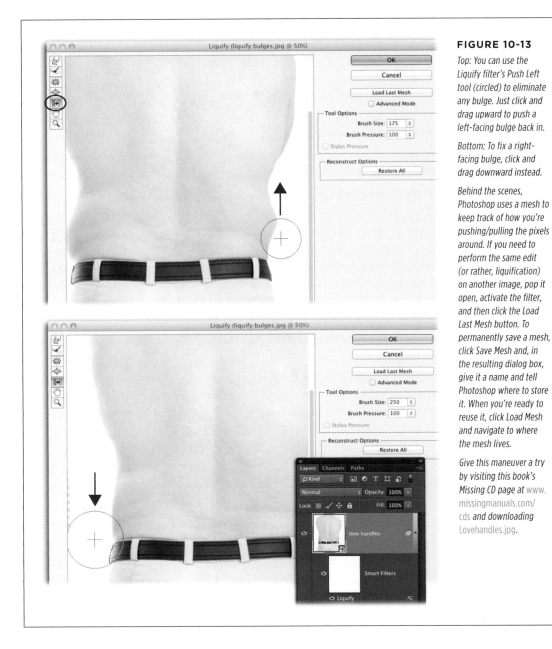

FIGURE 10-13

Top: You can use the Liquify filter's Push Left tool (circled) to eliminate any bulge. Just click and drag upward to push a left-facing bulge back in.

Bottom: To fix a right-facing bulge, click and drag downward instead.

Behind the scenes, Photoshop uses a mesh to keep track of how you're pushing/pulling the pixels around. If you need to perform the same edit (or rather, liquification) on another image, pop it open, activate the filter, and then click the Load Last Mesh button. To permanently save a mesh, click Save Mesh and, in the resulting dialog box, give it a name and tell Photoshop where to store it. When you're ready to reuse it, click Load Mesh and navigate to where the mesh lives.

Give this maneuver a try by visiting this book's Missing CD page at www.missingmanuals.com/cds and downloading Lovehandles.jpg.

Here's how to do some serious bulge busting:

1. **Pop open a photo and convert it into a smart object.**

 Happily, the Liquify filter now works with smart filters, which lets you use it nondestructively on *any* kind of layer including shape, type (yep, you can use it on text!), and video. If your document consists of a single layer, choose Filter→"Convert for Smart Filters" to create a smart object. If your document consists of *multiple* layers, activate 'em, and then Control-click (right-click) near one of the layer's names in the Layers panel, and then choose "Convert to Smart Object."

 Alternatively, you can *start* with a smart object by choosing File→"Open As Smart Object."

2. **Choose Filter→Liquify.**

 Photoshop opens the humongous Liquify dialog box, which may take over your whole screen. You can resize it by dragging its bottom-right corner.

3. **Grab the Push Left tool and increase its brush size.**

 The Liquify dialog box has a small toolbar on its left side. Grab the Push Left tool by pressing O (that's the letter O, not the number zero) or clicking its icon in the toolbar (it's circled in Figure 10-13, top). You can use the Tool Options section on the right side of the dialog box to pick a bigger brush, but it's simpler to press the right bracket key (]) to increase the brush size or the left bracket key ([) to decrease it. You can also Control-Option-drag (Alt+right-click+drag on a PC) to change brush size.

4. **Mouse over to the bulge on the right side of the body and drag upward.**

 If you need to, move your image around in the dialog box's preview area by pressing the space bar while dragging. Once you've got a good view of the bulge, position your cursor so the crosshairs touch the background and the edge of the brush touches the bulge where it starts down at the waistband. Then push the bulge back toward the torso by dragging *upward,* as shown in Figure 10-13, top. If you think that's weird, you're not alone; nobody knows why this process scoots pixels to the left, but it does.

5. **Move to the left side of the body and drag downward.**

 This time, position your cursor at the *top* of the left bulge and then drag *down* to nudge the pixels to the right. Again, why this tool works this way is a mystery. (If you can't *see* the other side of your image, reposition the image within the preview area by dragging while pressing space bar.)

6. **Click OK when you're finished.**

 To reopen the Liquify filter for more editing, simply double-click its name in the Layers panel.

TIP To undo a single nudge, press ⌘-Z (Ctrl+Z). To undo *everything* you've done with the Liquify filter *without* closing its dialog box, press Option (Alt) and the dialog box's Cancel button changes to read "Reset"; click it to get the original image back. You can also use the Reconstruct tool discussed below.

All the tools in the Liquify dialog box work by holding down your mouse button or by dragging. Here's a rundown of the tools besides Push Left, since you already learned about that one:

- **Forward Warp.** The most practical of all the Liquify tools, you can use Forward Warp to push pixels forward (ahead of your cursor in the direction you're dragging) or Shift-drag with it to push pixels in a straight line. This is another great bulge-buster, waist-nipper, and arm-slimmer, plus you can use it to make your subjects smile whether they want to or not, as Figure 10-14 shows. Its keyboard shortcut is W.

- **Reconstruct.** Think of this one as a customizable undo brush. If you alter pixels with any of the Liquify dialog box's other tools and then change your mind, you can paint over that area with this tool to restore the pixels to their original state. If you turn on the Liquify dialog box's Advanced Mode setting and then click Reconstruct (both shown in Figure 10-15, though the Reconstruct button is dimmed), you get a slider that you can use to lower the tool's strength. (If you want to zap *all* of your changes without painting across 'em, click Restore All instead.) Keyboard shortcut: R.

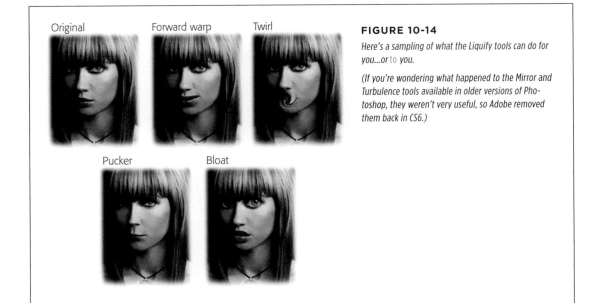

Original Forward warp Twirl

Pucker Bloat

FIGURE 10-14

Here's a sampling of what the Liquify tools can do for you...or to you.

(If you're wondering what happened to the Mirror and Turbulence tools available in older versions of Photoshop, they weren't very useful, so Adobe removed them back in CS6.)

- **Pucker.** This tool collapses pixels in on themselves like the Pinch filter (page 452). You can use it to make a tummy or thigh look smaller, or to shrink a flabby chin, a large nose, and so on. To make it have the opposite effect, press Option (Alt) so that it acts like the Bloat tool. Keyboard shortcut: S.

- **Bloat.** Use this tool to enlarge pixels from the center out. If you're considering collagen injections to fluff up your lips, try this tool first. It's also useful for opening squinty eyes. Keyboard shortcut: B.

- **Hand.** This tool is the same one that you get by pressing the space bar or clicking the hand icon in the Tools panel. You can use it to move the image around when you're zoomed in. Keyboard shortcut: H.

- **Zoom.** This tool lets you zoom in and out of the document, but it's quicker to press ⌘ (Ctrl on a PC) and the + or – key instead. Keyboard shortcut: Z.

By turning on the Advanced Mode setting (circled in Figure 10-15), you get four more super useful tools (as well as oodles of controls that appear on the right side of the Liquify dialog box and are explained in Figure 10-15):

- **Smooth.** You can use this tool to smooth an area that you've tweaked, which is incredibly helpful in making your changes look more realistic. When you use this tool, Photoshop applies a slight Gaussian Blur to areas of your image that you drag across. Use this tool enough and you'll eventually undo your liquification (in fact, you can think of it as a more subtle version of the Reconstruct tool). Keyboard shortcut: E.

- **Twirl Clockwise.** To spin pixels clockwise as if they were going down a drain, grab this tool. You can click and hold or drag with this tool. Option-drag (Alt-drag on a PC) to make the pixels rotate counterclockwise. Keyboard shortcut: C.

TIP New in Photoshop CC 2014 is the Pin Edges checkbox (visible in Figure 10-15), which lets you lock down the edges of your image so they aren't affected when you use the Liquify dialog box's tools near 'em. (This is really only a concern when you're using the Forward Warp and Push Left tools.)

- **Freeze Mask.** If the area you want to change is close to an area that you *don't* want changed, you can use this tool to create a mask that basically tells Photoshop not to touch the area you paint across. As you drag, Photoshop marks the frozen bits with a red overlay, though you can change that color by using the Mask Color drop-down menu (circled in Figure 10-15). Aside from freezing body parts that you want to remain unchanged, be sure to freeze any horizontal or vertical lines and patterns that are near the area you're changing. Otherwise, the resulting distortion in those areas will be a dead giveaway that you used the Liquify filter. Keyboard shortcut: F.

But there's another way: Rather than using the Freeze Mask tool to mark the areas you want to protect, you can make use of an existing selection, a layer mask, or even a layer's transparent areas. While the Liquify dialog box has access to all that stuff, you can't use it (or see it) until you turn on that selection,

transparent area, or mask on using one of the five unlabeled drop-down menus in the Mask Options section (you can see a tooltip of each menu's label if you place your cursor over its overlapping-circle icon):

- **Replace Selection.** If you've already done some masking with the Freeze Mask tool, this menu replaces that mask with a red overlay representing whatever you pick from this menu. For example, let's say you added a layer mask to hide your image's background, and then you ran the Liquify filter. If you choose Layer Mask from this menu, the image's background turns red in the Liquify dialog box's preview, thereby freezing that area (without you having to use the Freeze Mask tool). You can also fine-tune an existing layer mask in the Liquify dialog box using the Freeze Mask and Thaw Mask tools. However, when you close the Liquify dialog box, the changes you made to the existing layer mask in the dialog box don't carry over to the layer mask in your document.

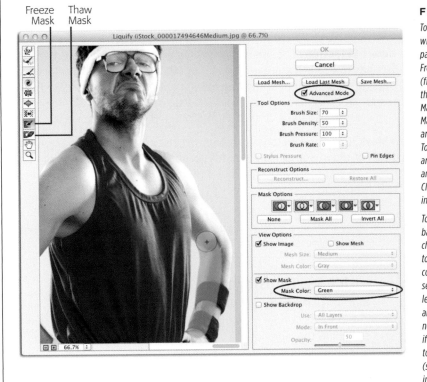

FIGURE 10-15

To slim this guy's waist without affecting his left arm, paint across the arm with the Freeze Mask tool. To mask (freeze) a large area fast, in the Mask Options section, click Mask All, and use the Thaw Mask tool to paint across the areas you don't want frozen. To flip-flop the mask so the areas that weren't frozen are and vice-versa, click Invert All. Click None to thaw the whole image.

To see the mesh described back in Figure 10-13 or to change its color from gray to something else, use the controls in the View Options section. The Backdrop section lets you view the contents of another layer (one that you're not editing), which is handy if you're distorting one image to look like it's part of another (say, if you're adding art to an image of a waving flag).

NOTE The next four menus behave a bit differently than Replace Selection, and may do the *opposite* of what you expect. Instead of combining the selection, transparency, or layer mask with the mask you created with the Freeze Mask tool, they apply the selection, transparency, or layer mask to the changes you've made with the Freeze Mask tool. So, for example, areas you've protected with a layer mask will protect your image from the *changes* you've made in the Freeze Mask tool.

- **Add to Selection.** If you've frozen an area with the Freeze Mask tool, this menu lets you adjust that area by applying the document's existing selection, layer mask, or transparency to it. So, the areas you've frozen with the Freeze Mask tool will be included only in whatever area was outside the selected area, in the transparent area, or protected by your layer mask.

- **Subtract from Selection.** This one is the same as "Add to Selection" except that Photoshop adds the area that *wasn't* protected by the layer mask (or wasn't in the transparent area, or was inside the selection) to the areas protected by the Freeze Mask tool.

- **Intersect with Selection.** Photoshop adds the unprotected areas of the layer mask (or the area outside the selection, or the transparent area) to the areas protected by the Freeze Mask tool.

- **Invert Selection.** The areas that you've protected with the Freeze Mask will stay frozen in the areas that overlap protected areas of the layer mask, outside the selection, or the transparent area. Photoshop also adds to the frozen areas the area that's inside the selected areas of your document, that's not transparent, or that's not protected by the layer mask.

- **Thaw Mask.** Use this tool to unfreeze any frozen areas if, say, you froze a little too much of the image or you're ready to perform a different kind of edit on that spot. As you drag with this tool, Photoshop removes the mask overlay. Keyboard shortcut: D.

TIP While the Liquify filter is great for retouching people pictures, you can also use it to create all manner of special effects including melting text or a melting clock that would do Salvador Dali proud!

Slimming with Free Transform

Years ago, Hewlett-Packard came out with a "slimming camera" that promised to make you look five pounds skinner in every picture. Behind the scenes, the camera's software was squishing the sides of the images *inward,* narrowing the photo and making people appear slightly thinner. In Photoshop, you can do the *exact* same thing with the Free Transform tool, as shown in Figure 10-16.

NOTE Follow along by visiting this book's Missing CD page at *www.missingmanuals.com/cds* and downloading the practice file *Belly.jpg.*

Here's how to lose five pounds instantly:

1. **Pop open the soon-to-be-slimmer photo, duplicate the image layer by pressing ⌘-J (Ctrl+J), and then turn off the original layer's visibility.**

 If your image consists of *multiple* layers, create a stamped copy (page 119) by pressing Shift-Option-⌘-E (Shift+Alt+Ctrl+E on a PC).

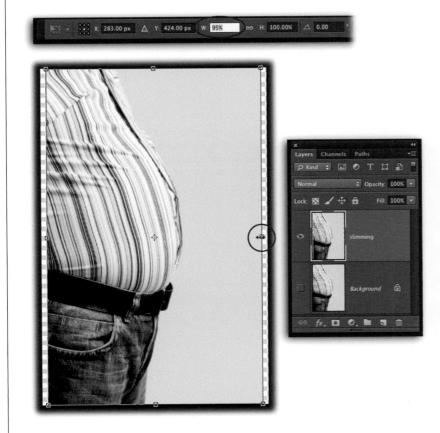

FIGURE 10-16

Top: If you do this kind of retouching while you're working in public, be sure to look over both shoulders first—you don't want to reveal this secret to just anyone!

Once you've summoned the Free Transform bounding box, simply type 95 into the Options bar's W field (circled).

Bottom: By duplicating the image layer first, you don't mess up your original. Just be sure to turn off the original layer's visibility so you can see the newer, slightly slimmer version, and then crop the image to get rid of the extra space on each side.

2. **Summon Free Transform and slim the image.**

 Press ⌘-T (Ctrl+T) and Photoshop puts a bounding box around the whole image. Grab the little square handle in the middle of the right or left edge of the photo (it doesn't matter which), and then drag the handle toward the center of the image while keeping an eye on the Options bar's W field. You want to make the image 5–8 percent narrower (so the W value is 92–95 percent); if you narrow it any more than that, it'll look weird. When you've got the width just right, release the mouse button and press Return (Enter) to accept the transformation.

 Alternatively, you can just type a new width into the W field, which is easier but not as much fun.

3. **Trim the image to get rid of the newly transparent area.**

Choose Image→Trim and in the resulting dialog box, choose Transparent Areas, and then click OK. Photoshop deletes the transparent bits.

This simple retouch is absolutely impossible to spot—*if* you keep it between 5 and 8 percent, that is. Anything more than that and your subject will look decidedly squished.

■ SELECTIVE SLIMMING

In addition to using Free Transform to squish a *whole* image, you can also use it to squish only a certain part. Just create a selection and *then* summon Free Transform by pressing ⌘-T (Ctrl+T). Figure 10-17 has the details.

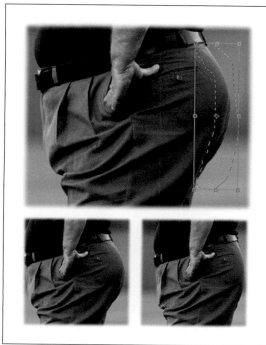

FIGURE 10-17

Top: If you select an area before activating Free Transform, you can use it to shrink just the selected area. You may need to go back and use the Healing Brush or Clone Stamp tool—on a new layer, of course—to blend certain areas after you're finished.

Bottom: This before-and-after shot shows quite a difference, no?

■ Skin Softeners

Skin is the body's largest organ, but not everyone gives it the respect it deserves. Folks sometimes forget to use sunblock, moisturizer, and so on. This section explains how to make anyone's skin look like it's *really* well cared for. You'll learn how to make it appear soft and glowing, and even how to reduce lines and wrinkles, all without spending tons of money on anti-aging creams.

Selective Blur

One of the fastest ways to smooth skin is to give it a good dose of the Gaussian Blur filter (named for the gentleman who invented this blur method, Carl Gauss). This filter is often the only skin fixer you need, and it's faster than the Healing brushes you learned about earlier in this chapter. The beauty of this filter is that you can run it as a smart filter, lower the filter's opacity, and then use the included mask to apply the filter only where you need it (see Figure 10-18).

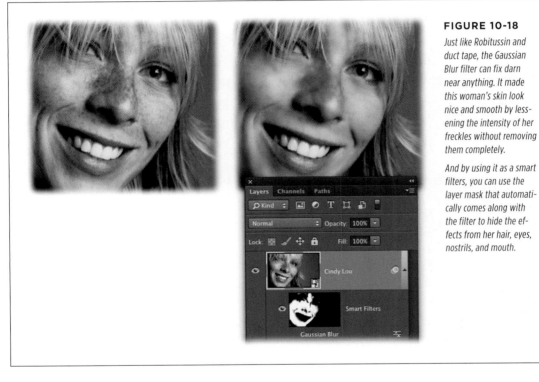

FIGURE 10-18

Just like Robitussin and duct tape, the Gaussian Blur filter can fix darn near anything. It made this woman's skin look nice and smooth by lessening the intensity of her freckles without removing them completely.

And by using it as a smart filters, you can use the layer mask that automatically comes along with the filter to hide the effects from her hair, eyes, nostrils, and mouth.

To soften skin, follow these steps:

1. **Open a photo and convert it for smart filters.**

 Activate the layer you want to blur and then choose Filter→"Convert for Smart Filters." If your image consists of multiple layers, activate 'em all, and then Control-click (right-click) near one of their names in the Layers panel and choose "Convert for Smart Object."

2. **With the smart object active, choose Filter→Blur→Gaussian Blur, and then adjust the blur.**

 In the resulting dialog box, drag the Radius slider until the image is severely blurred (a radius of 8 was used in Figure 10-18). Don't worry if you start to lose details; in step 6, you'll tweak the layer's opacity to lessen the effect. Click OK to close the dialog box and blur the layer.

3. **Fill the Smart Filter's mask with black.**

As you've learned, when it comes to layer masks, black conceals and white reveals. Since you need to keep the majority of the image unblurred so folks can tell it's a face, save yourself some time by starting with a black mask. To do so, head to the Layers panel and activate the smart filter mask (the big white thumbnail beneath the smart object), and then press ⌘-I (Ctrl+I) to invert the mask. Photoshop fills the mask with black, which hides all the blurring.

4. **Press B to grab the Brush tool, and then set your foreground color chip to white.**

Peek at the color chips at the bottom of the Tools panel. Press D to set them to black and white, and then press X so white hops on top.

5. **With a fairly large, soft-edged brush, paint the parts of the skin you want to blur.**

Painting with white reveals the blurry layer. Be sure to avoid your subject's eyes, lips, nostrils, and hair. (If you reveal too much of the blur layer, press X to flip-flop color chips and paint that area with black.)

6. **Lower the Gaussian Blur filter's opacity to around 60 percent.**

In the Layers panel, double-click the icon to the right of the words "Gaussian Blur" to open the filter's Blending Options dialog box. There, lower the Opacity setting to about 60 percent so the skin looks more natural, and then click OK.

Easy Glamour Glow

Running the Diffuse Glow filter is a quick way to add an ethereal glow to skin. As with Gaussian Blur, you want to create a smart object to run this filter on.

Perform the skin-softening technique described in the previous section, and then activate the smart object and turn it into *another* smart object by Control-clicking (right-clicking) near its name in the Layers panel, and then choosing "Convert to Smart Object." (It's a good idea to rename the new smart object *diffuse glow* so you remember which filter you're about to run!)

Next, press D to set your color chips to factory-fresh black and white, and then press X until black is on top. Next, if you've turned on all the Filter menu's categories as explained in the box on page 674, choose Filter→Distort→Diffuse Glow. Otherwise, choose Filter→Filter Gallery and up pops the giant dialog box shown in Figure 10-19, top; click the flippy triangle next to the Distort category to expand it, and then click Diffuse Glow. Figure 10-19 explains what to do after all that.

Softening Wrinkles with Faux Dodge and Burn

You've already seen a couple of tools that can reduce wrinkles: the Healing Brush and the Clone Stamp tool. Another option is to slightly lighten or darken the wrinkled area so the wrinkling isn't so severe.

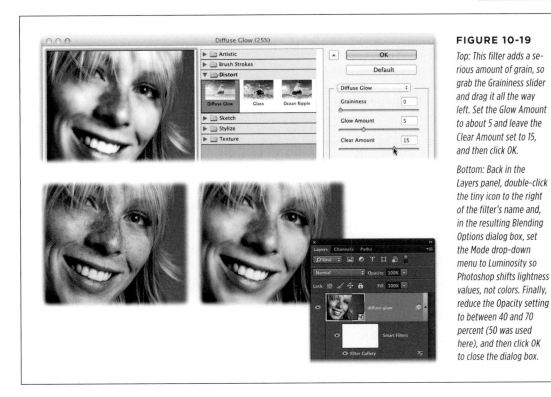

FIGURE 10-19

Top: This filter adds a serious amount of grain, so grab the Graininess slider and drag it all the way left. Set the Glow Amount to about 5 and leave the Clear Amount set to 15, and then click OK.

Bottom: Back in the Layers panel, double-click the tiny icon to the right of the filter's name and, in the resulting Blending Options dialog box, set the Mode drop-down menu to Luminosity so Photoshop shifts lightness values, not colors. Finally, reduce the Opacity setting to between 40 and 70 percent (50 was used here), and then click OK to close the dialog box.

You could reach for the Dodge and Burn tools to perform this task—after all, they're designed to lighten and darken pixels (respectively). These tools hail from the days when photographers developed their own film, disappearing into a mysterious broom closet with an amber light and emerging hours later with dilated pupils and clothes reeking of pungent chemicals.

Without diving *too* deeply into what goes on in darkrooms, a photo is created by projecting an image onto special paper. During this process, if you block some of the light by holding an object in front of the light's source, the resulting image will be lightened or *dodged* in the area that was exposed to less light. If you *increase* the amount of light that hits a certain area, that part of the image will be darkened or *burned*.

NOTE The Dodge tool's icon looks like a lollipop because you could theoretically block light from hitting your developing image by holding something in front of it that looks like a circle on a stick. The Burn tool's icon looks like a hand because you could use your hand to cover the areas that you want to keep lighter while letting light through your curled fingers. The icons are a bit of a stretch, but they make more sense when you know the techniques they're based on.

You've got a fair amount of control over how the Dodge and Burn tools work. They each have a Range setting that lets you choose which pixels get altered—shadows, midtones, or highlights. You can also control the *strength* of the tools' effects by adjusting the Exposure setting, which works kind of like opacity. But it's important to remember that these tools are destructive, and that both of them can cause color shifts, which can make the image look worse than it did before. That said, these tools can certainly lighten and darken parts of an image—just be sure to duplicate the image layer first (or create a stamped copy; page 119) so you're not affecting the original. And lower the Exposure setting in the Options bar before you use either of them.

However, a *better* option—if you have a little extra time—is to use the Brush tool so it *behaves* like the Dodge and Burn tools. By filling a layer with 50 percent gray and changing its blend mode to Soft Light, you do exactly that (see Figure 10-20).

Here's how to do some faux dodging and burning:

1. **Open an image, press Shift-⌘-N (Shift+Ctrl+N) to open the New Layer dialog box, and then adjust its settings.**

 Alternatively, at the bottom of the Layers panel, Option-click (Alt-click on a PC) the "Crete a new layer" icon. Either way, the New Layer dialog box opens.

 Name the new layer *Dodge Burn*, set the Mode menu to Soft Light, turn on the "Fill with Soft-Light-neutral color (50% gray)" checkbox, and then click OK. (Sure, you *could* create a new layer, use the Edit→Fill command to fill it with gray, and then change its Mode setting, but this method is faster.)

2. **Press B to grab the Brush tool, and then set its opacity to 10–20 percent.**

 To retouch the image gradually, you need to lower the brush's opacity. Yes, the process takes longer this way, but it lets you dodge and burn little by little, which is far better than doing too much at once.

3. **Set your foreground color chip to white for dodging.**

 Take a peek at the color chips at the bottom of the Tools panel. Press D to set them to black and white, and then press X to flip-flop them so white is on top.

4. **Mouse over to your image and paint across the dark wrinkles.**

 Use a small brush to lighten just the shadowy parts of the wrinkles, or else you'll lighten areas that don't need it. It's helpful to zoom *way* in on the image when you're doing detailed work like this by pressing ⌘ (Ctrl on a PC) and the + key. Photoshop switches to a pixel-grid view when you zoom to more than 500 percent (see page 57).

5. **Press X to swap color chips so black is your foreground color, and then paint light areas you want to burn (darken).**

 For example, if the wrinkles are so deep that they cause highlights, you can darken those a little. In Figure 10-20, the edge of each iris was also darkened to make the man's eyes look brighter.

FIGURE 10-20

Top: The New Layer dialog box is a quick way to create a layer to use for faux dodging and burning; press Shift-⌘-N (Shift+Ctrl+N) to summon it. Set the Mode menu to Soft Light, turn on "Fill with Soft-Light-neutral color (50% gray)," and then click OK.

Bottom: When you faux dodge and burn, your subject retains his character but his wrinkles become less distracting. Notice how much brighter his eyes are, too. The whites were dodged and the darker rim of color around the outer edge of each iris was burned.

Not only is this technique good for softening wrinkles, it's also a great way to lighten or darken any part of an image, though it's especially helpful on portraits.

6. **Lower the Dodge Burn layer's opacity slightly.**

 If you've overdone the changes a bit, you can lower the layer's opacity.

7. **Save the document as a PSD file in case you ever need to go back and alter it.**

TIP For maximum flexibility, you can do your faux dodging on one layer and faux burning on *another* layer. That way, you can adjust the opacity of the lightening and darkening layers separately.

Show-Stopping Eyes

One of the simplest yet most impressive eye-enhancing techniques is waiting for you over in Chapter 11 (page 501), which explains how to use sharpening to make eyes stand out. In this section, you'll learn how to lighten both the irises and whites of eyes, fix red-eye a bazillion different ways, and even fix the eyes of your furry friends.

Lightening Eyes

A quick and painless way to make eyes stand out and look sultry is to lighten them by changing their blend mode to Screen. This technique enhances the iris *and* brightens the white bits, as Figure 10-21 shows. To achieve this effect without duplicating the original layer (which increases your file's size), just use an empty adjustment layer.

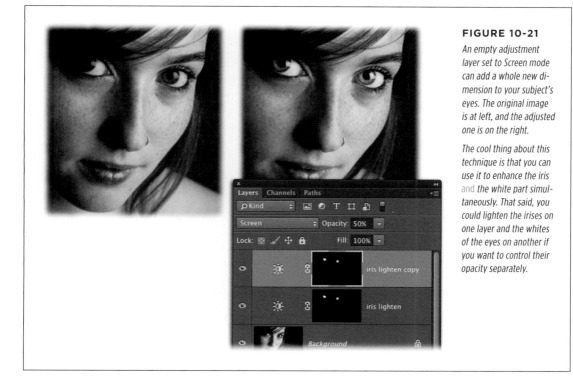

FIGURE 10-21

An empty adjustment layer set to Screen mode can add a whole new dimension to your subject's eyes. The original image is at left, and the adjusted one is on the right.

The cool thing about this technique is that you can use it to enhance the iris and the white part simultaneously. That said, you could lighten the irises on one layer and the whites of the eyes on another if you want to control their opacity separately.

Here's what you do:

1. **Pop open a photo and add an empty adjustment layer.**

 Click the half-black/half-white circle at the bottom of the Layers panel and choose Brightness/Contrast from the menu. When the Properties panel opens, single-click its tab to close it (you don't need to actually make a Brightness/Contrast adjustment; you're just adding an adjustment layer that doesn't *automatically* change your image).

2. **Set the adjustment layer's blend mode to Screen.**

 Near the top left of the Layers panel, change the drop-down menu from Normal to Screen. When you do, Photoshop makes your whole photo *way* too light, but don't worry—you'll fix that in the next step.

3. **Fill the adjustment layer's mask with black.**

 Peek at your Layers panel and make sure the adjustment layer's mask is active (it should have a tiny outline around it). Then, to hide the over-lightening that happened in the previous step, choose Edit→Fill, pick Black from the Use pop-up menu, and then click OK.

4. **Grab the Brush tool and set your foreground color chip to white.**

 Press B to grab the Brush tool, and then check the color chips at the bottom of the Tools panel. If white is on top, you're good to go; if it's not, press D to set the chips to black and white, and then press X to put white on top. Now you're ready to paint a hole through the mask so the lightening shows through only on your subject's eyes.

5. **Paint the eye area.**

 Mouse over to your image and paint each iris and, if they also need lightening, the whites of the eyes. If you mess up, just press X to flip-flop the color chips and paint with black. Be careful not to paint across the dark rim of the iris or you'll lighten it, too.

TIP Sometimes it's helpful to brighten the *entire* eye area including the upper and lower lids, eyeballs, and the area *beneath* each eye (and doing so is actually faster than brightening just the iris and whites because you don't have to be so careful with your brushstrokes). If you go that route, click to activate the adjustment layer's mask, run the Gaussian Blur filter (Filter→Blur→Gaussian Blur) set to a small Radius (say, 1 or 2) to blur the effect a tiny bit so it looks more realistic, and then continue on with steps 6 and 7.

6. **If you want to enhance the effect, duplicate the adjustment layer, and then lower its opacity.**

 Press ⌘-J (Ctrl+J) to duplicate the layer, and then lower the duplicate's opacity until the image looks good to you (50% was used in Figure 10-21).

7. **Save the image as a PSD file.**

Ta-da! This technique makes a galactic difference, and your subject's eyes will pop off the page (well, not literally).

Fixing Red-Eye

One of the most annoying things about taking photos with a flash is the creepy red eyes it can give your subjects. Photoshop's Red Eye tool does a good job of fixing most cases of red-eye, though sometimes you'll encounter a really stubborn case that just refuses to go away. That's why it's good to have a few other tricks up your sleeve, including using the Color Replacement tool, using a hue/saturation adjustment layer, or fixing 'em in Camera Raw. This section covers all those techniques.

■ THE RED EYE TOOL

Oh, man, if only *all* of Photoshop's tools were as easy to use as this one! The Red Eye tool is part of the Healing Brush toolset (it looks like an eye with a plus sign next to it). Just grab the tool, mouse over to your image, and then drag to draw a box around the offending eye, as shown in Figure 10-22, top. As soon as you let go of your mouse button, Photoshop hunts for the red inside the box and makes it black. That's all there is to it!

> **TIP** If this tool doesn't zap the red-eye completely on your first attempt, press ⌘-Z (Ctrl+Z) to undo the change. Increase the Options bar's Pupil Size and Darken Amount settings, and then have another go at it.

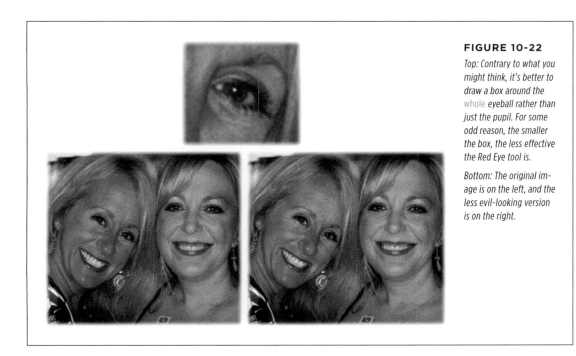

FIGURE 10-22

Top: Contrary to what you might think, it's better to draw a box around the whole *eyeball rather than just the pupil. For some odd reason, the smaller the box, the less effective the Red Eye tool is.*

Bottom: The original image is on the left, and the less evil-looking version is on the right.

■ THE COLOR REPLACEMENT TOOL

Another option for getting rid of stubborn red-eye is the Color Replacement tool, which you can use to replace the red with black. Because this tool is destructive (and there's no way of knowing what kind of job it'll do), it's best to select the eyes and jump them onto their own layer first. Here's how:

1. **Select the eyes and copy them onto another layer.**

 Using the Lasso tool, draw a rough selection around both eyes (grab the *whole* eye, not just the pupil) and then press ⌘-J (Ctrl+J) to jump them onto their own layer. That way, if this technique goes south, you can toss this layer and start over. (Alternatively you can duplicate the whole image layer.)

2. **Grab the Color Replacement tool from the Tools panel.**

 It's hiding in the Brush toolset, and it looks like a brush with a tiny curved arrow and a square (the square represents the foreground color chip).

3. **Set your foreground color to black.**

 Press D to set your color chips to black and white, and then press X until black hops on top. Alternatively, you can set the foreground color by Option-clicking (Alt-clicking on a PC) an eyelash or other black part of the eye.

4. **In the Options bar, set the Mode menu to Hue, the Limits menu to Contiguous, and the Tolerance field to around 30 percent.**

 The Hue blend mode makes this tool replace color without altering its brightness. The Contiguous setting tells Photoshop to replace only the red pixels that are clustered in one spot and not separated by other colors. And the Tolerance setting determines how picky the tool is: Lower numbers make it pickier; higher numbers result in a color-replacing free-for-all.

5. **Paint the red away.**

 You'll want to use a small brush for this maneuver. Press the left bracket key ([) to cycle down in brush size (the right bracket key cycles up), or Control-Option-drag (Alt-right-click-drag on a PC) to the left to decrease your brush size. When you've got a size that looks good, mouse over to the pupils and paint over the red, being careful to touch *only* the red with the cursor's crosshairs.

6. **When you're done painting, if necessary, use the Eraser tool or a layer mask to clean up the area outside the pupil.**

 If you end up with a little black outside the pupil, use the Eraser tool to fix it because that tool erases to the original layer below. Press E to activate the Eraser and carefully paint away any extra black pixels. Alternatively, you can add a layer mask to the eye layer, and then paint with black to hide the excess black.

7. **Save the document as a PSD file and call it a day.**

You won't need to use this technique very often, but at least you know it just in case!

■ **FIXING RED-EYE IN CAMERA RAW**

Camera Raw's Red Eye Removal tool looks and works similar to Photoshop's. It's handy to have this option in Camera Raw because, if you're shooting in raw format and you don't need to do any other editing in Photoshop, you don't have to switch programs just to fix red pupils.

After you open the image in Camera Raw (page 55), press E to grab the Red Eye Removal tool. Then simply drag to draw a box around the eyeball, as shown in Figure 10-23, and let go of your mouse button.

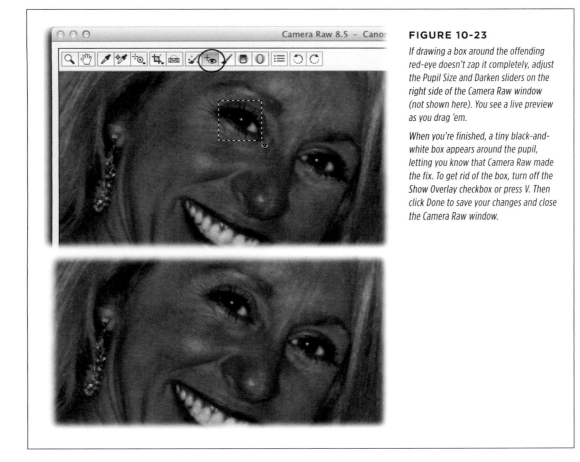

FIGURE 10-23

If drawing a box around the offending red-eye doesn't zap it completely, adjust the Pupil Size and Darken sliders on the right side of the Camera Raw window (not shown here). You see a live preview as you drag 'em.

When you're finished, a tiny black-and-white box appears around the pupil, letting you know that Camera Raw made the fix. To get rid of the box, turn off the Show Overlay checkbox or press V. Then click Done to save your changes and close the Camera Raw window.

Fixing Animal White-Eye

OK, *technically* animals aren't people—though to some folks (your author included), they might as well be. Our furry friends also have a version of red-eye; it's called *white-eye*, and it can ruin their photos, too.

White-eye is actually more challenging to fix than red-eye because there aren't any pixels in the eye left to work with—the pupils turn white, gold, or, in some cases,

light green. The Red Eye tool won't work because the pupils aren't red, and the Color Replacement tool won't work because the pixels are just too light in color. The solution is to select the pupil and fill it with black, and then add a couple of well-placed glints (tiny light reflections) to make the new pupils look real (see Figure 10-24).

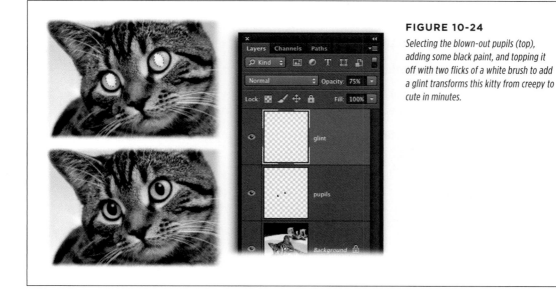

FIGURE 10-24

Selecting the blown-out pupils (top), adding some black paint, and topping it off with two flicks of a white brush to add a glint transforms this kitty from creepy to cute in minutes.

Here's how to fix your furry friend's eyes:

1. **Open the image and select the oddly colored pupils.**

 Since you're selecting by color, you can use either the Magic Wand or the Quick Selection tool; just click one pupil and then Shift-click the other.

2. **Feather the selection with Refine Edge.**

 Once you've got marching ants around the pupils, in the Options bar, click Refine Edge. In the resulting dialog box, set the Feather field to 1 pixel and the Smooth field to 1. To make sure you get *all* the white or gold bits, you might want to expand the selection 10–20 percent or so by dragging the Shift Edge slider to the right. When you're finished tweaking the sliders, click OK.

 NOTE Remember, the settings in the Refine Edge dialog box are sticky—they reflect the last settings you used. So take a second to make sure all the sliders *other than* the ones mentioned here are set to zero.

3. **Add a new layer named** *pupils.*

 Click the "Create a new layer" icon at the bottom of the Layers panel, name the layer, and make sure it's at the top of the layer stack.

4. **Fill the selection with black.**

To recreate the lost pupil, press D to set your color chips to black and white, and then press X until black is on top. Next, press Option-Delete (Alt+Backspace on a PC) to fill the selection with black. If the color doesn't seem to reach the edges of the selection (which can happen if you feathered or smoothed the edges a little too much in step 2), fill it again by pressing Option-Delete (Alt+Backspace). Once the pupils are filled with black, get rid of the marching ants by pressing ⌘-D (Ctrl+D).

5. **Add another new layer and name it** *glint*.

You'll want to soften the glints you're about to create by lowering their opacity, so you need to put them on their own layer.

6. **Grab the Brush tool, set your foreground color to white, and then add the glints.**

Press X to flip-flop color chips and, with a very small brush (10 pixels or so), click once in the left eye to add a glint to mimic the way light reflects off eyes. Next, click in the *exact* same spot in the right eye to add a sister glint. Then lower the glint layer's opacity to about 75 percent.

7. **Save the document as a PSD file.**

Pat yourself on the back for salvaging such a great shot of your pet.

■ Other Creative Madness

The retouching techniques you've learned thus far are relatively benign. Save for the Liquify filter, you haven't really done anything *drastic* to your images…until now. In this section, you'll learn how to use the Content-Aware Move tool to make objects bigger, smaller, taller, or shorter, or to move them around within in an image. You'll also find out how to reshape pixels using the Puppet Warp command. Read on for some serious image-changing voodoo!

Repositioning with Content-Aware Move

The Content-Aware Move tool lets you ever so slightly change the height, width, and position of a selected object. It uses Photoshop's Content-Aware technology to match up any lines or patterns in your selection so the changes look realistic.

To scoot an object around, pop open an image and create a new, empty layer (this is where you'll do the actual pixel moving). Then activate the Content-Aware Move tool by choosing it from the Tools panel—it lives in the Healing toolset—or by pressing Shift-J until you see its icon appear (it looks like two arrows overlapping to form an X). In the Options bar, set the Mode menu to Move and turn on Sample All Layers. Then, mouse over to your image and drag to create a selection around an object, like the left-hand soapbox racer in Figure 10-25, and then drag it elsewhere in the image.

Now, *before you deselect*, click the Options bar's Adaptation menu (its icon is a tiny gear) and adjust the new Structure and Color fields until the change looks realistic.

OTHER CREATIVE MADNESS

> **TIP** Here's a faster way to experiment with the Structure and Color settings: Highlight a number in either field, and then tap the up or down arrow keys on your keyboard to change it!

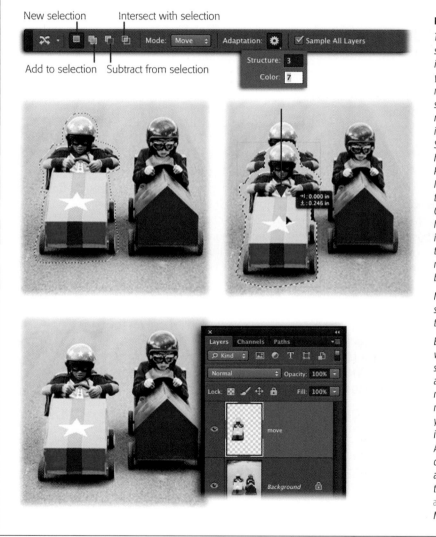

New selection Intersect with selection

Add to selection Subtract from selection

FIGURE 10-25

Top: Use the new, add, subtract, and intersect icons labeled here to alter your selection. The Mode menu lets you tell Photoshop what you want to do: move the object or extend it. The Adaptation menu's Structure field controls how much blending Photoshop does in the selected area, from a lot (1) to not very much (5). The Color field lets you specify how much color blending it does, from none (0) to tons (10). (Both of these new options are explained back on page 443.)

Middle: Once you've selected the object, drag it to another spot.

Bottom: This tool performs well if there's a good-sized chunk of background around the object you're moving and you're not moving it very far, though you can use the Spot Healing Brush (set to Content-Aware) or Clone Stamp to clean up areas that went astray (be sure to perform the cleanup on new layers above the Content-Aware Move layer).

> **NOTE** Follow along by visiting this book's Missing CD page at *www.missingmanuals.com/cds* and downloading the practice file *Racers.jpg*.

The Content-Aware Move tool also lets you change an object's height and width to, for example, make a building taller, wider, shorter, or thinner. To do so, create a new, empty layer, activate the Content-Aware Move tool, and then choose Extend from the Options bar's Mode menu. Then simply select the object you want to change and drag it up to increase its height, or drag left/right to increase its width. This feature works only if you make *very* small changes, and even then you'll probably need to use the Spot Healing Brush or the Clone Stamp tool (on empty layers) to make the edit look real.

> **TIP** You can also create a selection *before* activating the Content-Aware Move tool. If you've already created an empty layer where you'll do the aforementioned scooting, go ahead and grab the Quick Selection tool and, in the Options bar, turn on Sample All Layers to make the tool look *through* the empty layer to where the pixels live below. Once you've made the selection, switch back to the Content-Aware Move tool and scoot to your heart's content...and don't forget to adjust the Adaptation menu's Structure and Color fields to make the change look more realistic!

Reshaping Objects with Puppet Warp

The Puppet Warp command made its debut way back in Photoshop CS5, and most folks are *still* trying to figure out how and when to use it. It lets you distort selected objects—even text!—while leaving the rest of your image unscathed (though it can warp whole images, too, if you like). You can use it to make subtle changes such as repositioning your subject's hair, or do more drastic stuff like repositioning an arm, leg, or tail. (Another great use for Puppet Warp is to twist and turn an object such as rope, wire, or whatever into readable text—it's time consuming but worth it!)

Using this tool is a complicated process that puts *all* your Photoshop skills to work. To warp an object, you select it, copy it onto a new layer, remove it from the original layer, and then drop a series of markers (called *pins*) onto the copied object to let Photoshop know what area you want to change. Photoshop places a grid-like mesh atop the object that includes handles you can drag to distort the object. Once you finish moving the handles, Photoshop tries to adjust the *rest* of the image so it matches, making your change look real.

You certainly won't use this command daily, but it can come in handy for moving your subject's arm or leg into a more visually pleasing or amusing position, as shown in Figure 10-26.

> **NOTE** You can use Puppet Warp on darned near everything: image layers; smart objects (a good choice because you can distort 'em nondestructively); shape and type layers (provided you've converted them into smart objects first, or else you have to rasterize 'em); as well as pixel- and vector-based layer masks.

The Puppet Warp command doesn't work on locked background layers, so either duplicate that layer or, better yet, protect your original image by using Puppet Warp on a smart object, as described in the steps starting on page 476.

Pin forward Pin backward

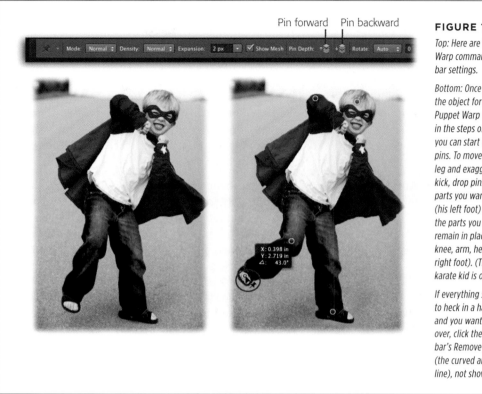

FIGURE 10-26

Top: Here are the Puppet Warp command's Options bar settings.

Bottom: Once you prepare the object for use with Puppet Warp as described in the steps on page 476, you can start dropping pins. To move this boy's leg and exaggerate the kick, drop pins onto the parts you want to move (his left foot) as well as the parts you want to remain in place (his left knee, arm, head, and right foot). (The original karate kid is on the left.)

If everything seems to go to heck in a handbasket and you want to start over, click the Options bar's Remove All Pins icon (the curved arrow over a line), not shown.

Once you choose Edit→Puppet Warp, you see the following settings in the Options bar (see Figure 10-26, top):

- The **Mode** menu lets you tell Photoshop how *elastic* (stretchable) you want the mesh to be. Your choices are Rigid (handy for precise warping of objects you've marked with pins), Normal (the general-purpose mode), and Distort (great for warping an image shot with a wide-angle lens or creating an interesting texture for mapping onto another image [page 324]).

- **Density** controls the spacing of the mesh's points. Adding more points makes your change more accurate, but it'll take Photoshop longer to process. Fewer points speed up the process, though depending on the object you're warping, the change might not look as real.

- **Expansion** lets you expand or contract the outer edge of the mesh by a pixel value between –20 and 100. Higher numbers expand the outer edge (even beyond your document's edges), and lower values shrink it. Entering a negative value shrinks the mesh so it's inside your document's edges but doing so also shrinks the image.

- **Show Mesh** controls the mesh's visibility. If you turn this setting off, you see only the pins you dropped on the image. You can also toggle the mesh on and off using the keyboard shortcut ⌘-H, *unless* you use that shortcut to hide the program instead (see the box on page 8).

- The **Pin Depth** icons (labeled in Figure 10-26) let you determine how the objects you've warped overlap each other. Once you start setting pins, Photoshop treats the pinned areas like layers, which means you can change their stacking order. For example, if you set pins on your subject's hand and elbow and then drag the pinned hand atop his chest, the hand appears in front of his chest. However, if you then click the Set Pin Backward icon once, Photoshop moves the pinned hand *behind* his chest instead. Depending upon how many pins you've set and how you've warped the object(s), you may have to click these icons several times to arrange the object(s) to your liking.

- **Rotate** lets you turn the item you've dropped pins onto while you're dragging it into a new shape or position. Straight from the factory, this menu is set to Auto, which means the mesh around a pin automatically rotates as you drag the pin. If you instead want the mesh to rotate a fixed number of degrees, click to activate the pin, and then press and hold the Option (Alt on a PC) key, and Photoshop displays a light gray circle around the pin representing rotation angle; just click and drag around the circle to rotate the mesh (when you do, this menu changes to Fixed). When you're finished, release the Option/Alt key. Figure 10-27 (top) shows this maneuver in action.

It's next to *impossible* to grasp how this command works until you try it. Go to this book's Missing CD page at *www.missingmanuals.com/cds* and download the practice file *Karate.jpg*, and then follow these steps to change the position of the kid's limbs:

1. **Open the image, duplicate the background layer (or, if the image contains multiple layers, create a stamped copy of them), and then turn off the visibility of the original layer(s).**

 Puppet Warp won't work on a locked background layer, plus this command is about as destructive as it gets! So press ⌘-J (Ctrl+J on a PC) to duplicate the background layer and then turn off the original layer's visibility. If you've got multiple layers, create a stamped copy of 'em by pressing Shift-Option-⌘-E (Shift+Alt+Ctrl+E). (Using a smart object won't work for this technique because you won't be able to use the Edit→Fill command in step 4.)

2. **Create a selection of the object you want to change (like the kid in Figure 10-26, bottom left), jump it onto a new layer named *karate kid*, and then turn off the new layer's visibility.**

 Select the item you want to warp using the techniques you learned in Chapter 4 (the Quick Selection tool was used here). If necessary, click Refine Edge in the Options bar to fine-tune your selection. Once you have the selection just right, press ⌘-Option-J (Ctrl+Alt+J) to put the object on a new layer, and then click this layer's visibility eye to turn it off.

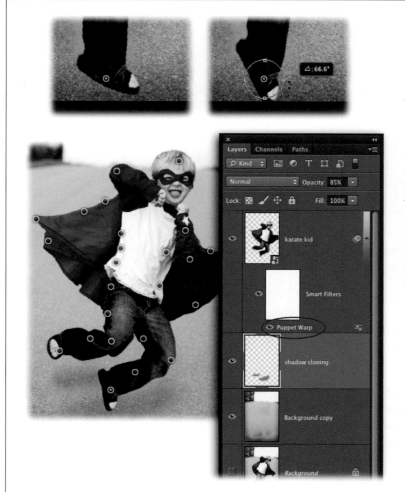

FIGURE 10-27

Top: To spin the pixels beneath a pin, click the pin to activate it (left), and then press and hold Option (Alt) to reveal this handy circle (right); just click and drag around the circle to rotate the object beneath it. Photoshop displays the rotation angle as you drag.

Bottom: Here you can see all the pins needed to expand his cape and move his legs so it appears that he's jumping and kicking at the same time. To edit the pins later, just double-click the Puppet Warp layer in the Layers panel (circled).

Compare this image to the original back in Figure 10-26 and you'll appreciate the power of Puppet Warp!

3. **Activate the duplicate background or stamped layer you created in step 1, load a selection of the *karate kid* layer's contents, and then expand the selection to include more of the background.**

To keep from creating another instance of the object you're warping, you have to remove that object from the original image (or rather, from the copy you made in step 1), which is easy to do by expanding the selection and then using the Fill command's Content-Aware mode. Activate the copy of the background or stamped layer, and then ⌘-click (Ctrl-click on a PC) the *karate kid* layer's thumbnail to load it as a selection. Next, expand the selection to include a little of the image's background by choosing Select→Modify→Expand. In the resulting

dialog box, enter 10 pixels if you're working with a low-resolution image (use a higher number for a high-resolution image) and then click OK. Photoshop expands the selection by the amount your entered.

4. **Use the Fill command's Content-Aware mode to delete the object from the image, and then deselect.**

Now that you've expanded the selection to include more of the background, Photoshop will have an easier time removing the object from the image. Simply choose Edit→Fill and, in the resulting dialog box, make sure the Use menu is set to Content-Aware, turn on Color Adaptation (for better color blending), and then click OK. (If some of the original item is still visible, create a new, empty layer, and then use the Spot Healing Brush, Healing Brush, or Clone Stamp tool to fix it.) When the object is history, press ⌘-D (Ctrl+D) to deselect everything.

5. **Activate the *karate kid* layer, turn its visibility on, and then Control-click (right-click) near the layer's name in the Layers panel and choose "Convert to Smart Object."**

Using Puppet Warp on a smart object lets you come back and edit the warping later, provided you save the document as a PSD file (which of course you will!). Now you're *finally* ready to start warping the object.

6. **Choose Edit→Puppet Warp and then, in the Options bar, turn off Show Mesh.**

As soon as you summon Puppet Warp, Photoshop plops a mesh on top of the layer's contents (the kid), which keeps you from seeing anything useful. Turning off Show Mesh lets you can see what you're doing.

7. **Click in the image to drop pins on the object you want to move *and* on the items you want to remain in place.**

You can think of dropping pins as placing control handles that you can then drag (or spin) to move (or rotate) the object underneath them. Not only do these pins let you tell Photoshop which parts of the image you want to warp or move, but they also anchor areas in place—if you *don't* drag or spin a pin, the area where you placed it stays perfectly still. To move this little boy's left leg, drop a pin on his left foot and knee. Next, lock the rest of his body in place by dropping pins on his left elbow, head, and right foot (if you don't, his whole body will rotate as you drag the pin on his left foot).

TIP If you try to add a pin too close to an existing one, Photoshop displays an error message. The fix is to either set the Options bar's Density drop-down menu to More Points, or to press ⌘-Z (Ctrl+Z) to remove the pin, and then click to place it a little farther away from the others.

8. **Click to activate the pin on his left foot, and then drag it slightly up and to the left (see Figure 10-26, bottom right).**

As you drag the pin, the pixels beneath it move, stretch, or contract depending on how far you drag and in what direction. To make the change look realistic,

don't drag the pins very far (you don't have to move 'em much to create seriously cartoonish results). Once you start moving pins, you can change the stacking order of the pixels underneath them by using the Pin Depth icons in the Options bar (labeled back in Figure 10-26, top). For example, if you swing the kid's foot to the *right* instead of left, his foot moves *behind* his right leg. Click the "Set forward" icon to bring his foot forward in front of his leg.

To *rotate* the pixels beneath a pin rather than move them, click the pin to activate it, and then press and hold Option (Alt) and put your cursor *near* the pin (but not directly over it); when a circle appears around the pin (Figure 10-27, top right), drag clockwise or counterclockwise around it to rotate those pixels (you'll see the degree of rotation next to your cursor).

> **TIP** If you want to move several pins at once, you can activate more than one pin by Shift-clicking them, or activate 'em all by Control-clicking (right-clicking) one pin and then choosing Select All Pins from the resulting shortcut menu. To delete a pin, Option-click (Alt-click) it (your cursor turns into a tiny pair of scissors); to delete *multiple* pins, activate them, and then press Delete (Backspace).

9. **When you're finished, press Return (Enter), and then save the document as a PSD file.**

 Photoshop adds a new layer named Puppet Warp beneath the smart object's mask (Figure 10-27, bottom) and your pins disappear. Saving the file as a PSD lets you edit the pins anytime; simply double-click the Puppet Warp layer in the Layers panel and they reappear.

As you might imagine, using Puppet Warp involves a *lot* of trial and error, but isn't that what Photoshop is all about? A more *practical* use for Puppet Warp is to twist and turn ordinary objects into something extraordinary. For example, you could contort a piece of rope or barbed wire into letters or shapes. The possibilities are limited only by the amount of time you've got to experiment.

Warping with Perspective

New in Photoshop CC 2014 is the Perspective Warp command, which lets you correct the perspective in *parts* of your image, while leaving the rest of the image's perspective alone. For example, if you shoot a square object from different angles and distances, it may not look square in the photo, even though it really is—*that's* when to reach for Perspective Warp. You'll find it useful on architectural photos, or those that have a lot of straight lines in them.

To use it, make sure Photoshop can tap into your computer's graphics processor by choosing Photoshop→Preferences→Performance (Edit→Preferences→Performance on a PC). Click Advanced Settings and make sure Use Graphics Processor is turned on, and then click OK. Next, convert your image layer(s) into a smart object (page 134), and then choose Edit→Perspective Warp. A handy animated tip on how to use this command appears; click the tiny X at its top right to dismiss it. You're now in

Perspective Warp's *Layout* mode, which you use to let Photoshop know where the problem area is (the mode buttons are visible in Figure 10-28, top).

Next, draw a *quad*—a four-sided grid—around one side of whatever you're fixing: click atop your image, hold down your mouse button, and then drag to adjust the quad. (If you just click and don't drag, Photoshop drops a quad onto the document that you can adjust). Click any of the resulting quad's round, gray corner pins to active them (a black dot appears on a pin when it's active), and drag to position them just outside each corner of your object (see Figure 10-28, middle). Make sure the lines you draw are *parallel* to the lines in your photo. Repeat this process to draw a quad atop the *next* side of your object and, while you're drawing the second plane, point your cursor at the first quad; when a blue line appears on the edges of *both* quads, release your mouse button, and the two quads snap together to form a corner. Keep drawing quads until your object is surrounded.

Now you're ready to fix the object in your image. Click the Warp button in the Options bar, or press W on your keyboard to enter Warp mode. At this point you have two choices: You can drag the pins into place *manually* to fix perspective (Photoshop warps your image as you drag), or you can use the three Level icons labeled in Figure 10-28 (top) to make Photoshop fix it *for* you.

> **TIP** Once you activate a pin, you can use the arrow keys on your keyboard to nudge them into place. Also, when you're in Warp mode, pressing the H key on your keyboard hides the grid (quad), which helps you see the results of your warping a little better.

When the image looks good, let Photoshop know by clicking the checkmark in the Options bar. You'll likely end up with some transparent spots at the edges of your document, as shown in Figure 10-28, bottom. They're easy to fix with the Crop tool or the Fill command's Content-Aware mode.

If the perspective needs a bit more tweaking, double-click the Perspective Warp smart filter in the Layers panel and continue adjusting it (Photoshop automatically puts you in Warp mode, but you can press L or click the Options bar's Layout button to switch to Layout mode). And that, dear Grasshopper, is the beauty of using a *smart object* for this technique: you retain the ability to edit your perspective changes later on. Using Perspective Warp on a duplicate image layer or a stamped copy of several layers doesn't give you that luxury.

Level near vertical lines Level vertical and horizontal lines

Level near horizontal lines Reset Cancel Commit

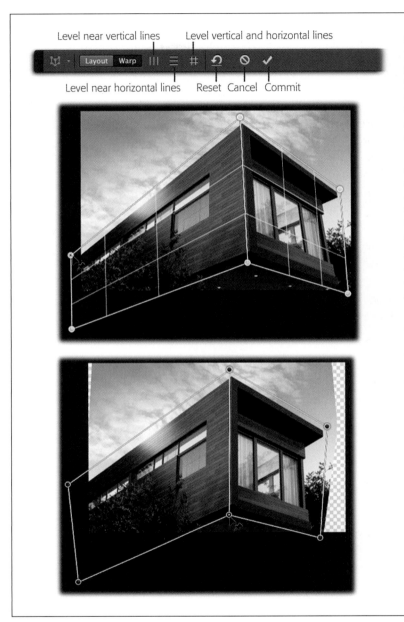

FIGURE 10-28

Top: The two buttons at the left of the Options bar, Layout and Warp, let you tell Photoshop what you want to do: create a quad or warp the image. Clicking the Reset icon while in Layout mode clears all quads, while clicking it in Warp mode clears all the warping you've done.

Middle: In Layout mode, these two quads were snapped together to form a corner. Click each quad's pins and then drag them into place, being careful to keep the quad's lines parallel with the lines in the photo.

Bottom: Here you see the warped, straighter building. Use the Crop tool or the Fill command's Content-Aware mode (page 436) to fill in the transparent areas.

Perspective Warp actually appeared in an earlier version of Photoshop CC as one of Adobe's quarterly updates. However, in the current version of the program, Adobe removed the ability to Shift-click a pin to keep that side of the quad straight while manipulating other pins.

The Art of Sharpening

You know the saying "last but not least"? Well, that definitely applies to *sharpening*—a digital attempt to improve an image's focus. Because it's such a destructive process, it's generally the last thing you do before sending images off to the printer or posting them on the Web. Sharpening is *muy importante* because it brings out details and makes images pop, but it's also one of the least understood processes in Photoshop. In addition to teaching you *how* to sharpen, this chapter also gives you some guidelines about *when* and *how much* to sharpen, so you're not just guessing.

In case you're wondering which of your photos need sharpening, the answer is *all of them*. If your image came from a digital camera or a scanner, it needs sharpening. Why? In their comprehensive book on sharpening, *Real World Image Sharpening, Second Edition* (*www.lesa.in/rwsharpen*), Jeff Schewe and the late Bruce Fraser explain that images get softened (their pixels lose their hard edges) when cameras and scanners capture light and turn it into pixels. Then, those images get softened even more when they're printed. (Even if you create an image from scratch in Photoshop, the same deterioration occurs if you shrink it.)

While Photoshop is pretty darned good at this sharpening business, it's not magic—it can't take an out-of-focus image and make it *tack sharp* (photographer slang for super-duper sharp, derived from the phrase "sharp as a tack"). One of the few ways you can produce well-focused photos is to shoot using a tripod (to keep the camera stable), a remote (so you don't move the camera when you press the shutter button), and a lens (or camera body) that includes an image stabilizer. Photoshop doesn't have a magical "make my blurry picture sharp" button, though its Shake Reduction filter gets you closer to that goal. What Photoshop *can* do is

take an in-focus image and make it nice and crisp. But before you start sharpening, it's important to understand exactly how the whole process works. Read on.

> **NOTE** Happily, all may not be lost if you took a slightly blurry photo. Try using the Shake Reduction (page 495) or Emboss (page 712) filter to salvage it.

What Is Sharpening?

Sharpening an image is similar to sharpening a kitchen knife. In both instances, you're emphasizing edges. On a knife, it's easy to identify the edge. In a digital image, it's a little more challenging: The edges are where vastly different colored pixels meet (in other words, areas of high contrast), as shown in Figure 11-1.

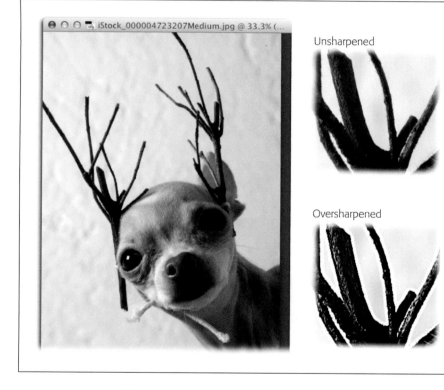

FIGURE 11-1

Left: It's easy to spot the edges in this image because its contrast is pretty high, especially between the antlers and the light background.

Right: In this before-and-after closeup of the Chihuahua's antlers—who does that to their pet?—see how the edges are emphasized after some overzealous sharpening (bottom)? The weird white glow around the antlers is the dreaded sharpening halo.

When you sharpen an image—whether in Photoshop, Camera Raw, or a darkroom—you exaggerate its edges by increasing their contrast: Where two colors meet, you make the light pixels a little lighter and the dark pixels a little darker. Though it may sound similar to increasing the overall contrast of the image, it's not. When you run one of Photoshop's sharpen filters, the program analyzes your image and increases

the contrast *only* in areas it thinks are edges (and, as you'll learn in a bit, you have some control over what it considers an edge).

Sharpening is a bit of an art: If you don't sharpen enough (or at all), your image will look unnaturally soft and slightly blurred; if you sharpen too much, you'll get a *sharpening halo*, a nasty white or light-colored gap between light and dark pixels (Figure 11-1, bottom right). But if you sharpen just the right amount, no one will notice the sharpening—they'll just know that the image looks really good.

One of the downsides to sharpening is that it also emphasizes any kind of *noise*—graininess or color specks—in your image. One way around that problem is to get rid of the noise *before* you sharpen, or at least have a go at reducing it (see the box on page 487 for tips). That said, you can reach for the Smart Sharpen filter (page 491), which includes a handy Reduce Noise slider.

Now that you know what sharpening does, you're ready to give it a whirl. The next few pages focus on basic sharpening techniques; more advanced methods are covered later in this chapter.

Basic Sharpening

If you've peeked inside Photoshop's Filter menu, you've probably noticed a whole category of filters devoted just to sharpening. They include the following:

- **Shake Reduction.** This filter attempts to fix the blurriness introduced by camera movement (called *camera shake*) when using slow shutter speeds and/or a long focal length (meaning you're zoomed in to shoot something far away). If you're not shooting with a tripod and a remote shutter release, it's impossible *not* to move the camera a little bit when you breathe or press the shutter button. This filter works best on images with decent lighting, very little noise or specular highlights (geometric shapes caused by reflections of light), and *without* moving subjects. You can also use this filter to make blurry text easier to read, which should make forensic scientists jump for joy.

- **Sharpen, Sharpen Edges, Sharpen More.** When you run any of these filters, you leave the sharpening up to Photoshop (scary!). Each filter analyzes your image, tries to find the edges, and creates a relatively narrow sharpening halo (Figure 11-1, bottom). However, *none* of these filters give you any control, which is why you should forget they're even there and stick with other methods listed here.

- **Smart Sharpen.** When you see three dots (…) next to a menu item (like there are next to this filter's name in the Filter→Sharpen submenu), it means there's a dialog box headed your way—and when it comes to sharpening, that's good! Smart Sharpen lets you control how much sharpening happens in your image's shadows and highlights *independently* of one another, plus it lets you save frequently used settings as presets. It also includes a slider for reducing noise, making it the perfect choice for sharpening images shot in low light.

- **Unsharp Mask**. This filter has been the gold standard sharpening method for years because, until the Smart Sharpen filter came along, it was the only one that gave you dialog box–level control over how it worked. A lot of folks still prefer this filter, though mainly out of sheer habit. Page 488 has the lowdown.

> **NOTE** Though it doesn't live inside the Filter→Sharpen submenu, the High Pass filter is a fantastic sharpening tool because you get a preview of exactly which areas of your image will be sharpened. It's also simpler to use than Unsharp Mask—it has just one setting to tweak instead of three. You can give it a spin on page 494.

No matter which filter you choose, sharpening is a destructive process, so it's a good idea to protect your image by following these guidelines:

- **Resize the image first.** Make sharpening your last step before you print the image or post it on the Web—in other words, after you've resized and retouched it. Why? Because pixel size depends on an image's resolution and sharpening has different effects on different-sized pixels, so it's important to sharpen the image *after* you make it the size you want.

- **Get rid of any noise first.** If you see any funky color specks or grains that shouldn't be in the image, get rid of them *before* you sharpen or they'll look even worse. The box on page 487 tells you how.

- **Sharpen the image on a duplicate or stamped layer, or run it as a smart filter.** Before you run a sharpening filter, activate the image layer and duplicate it by pressing ⌘-J (Ctrl+J). Or, if your image has multiple layers, create a stamped copy as explained on page 498. That way, you can toggle the sharpened layer's visibility on and off to see before and after versions of the image. You can also restrict the sharpening to certain areas by adding a layer mask to the sharpened layer, and reduce the sharpened layer's opacity if the effect is too strong. You can also convert your image layer(s) for smart filters so Photoshop does the sharpening on its own layer *and* includes a layer mask automatically; page 500 has the details.

- **Change the sharpening layer's blend mode to Luminosity.** Because you're about to make Photoshop lighten and darken a whole lot of pixels, you risk having the colors in your image shift. However, if you change the sharpening layer's blend mode to Luminosity, the sharpening affects only the brightness of the pixels, not their color. (If you use the smart filter method described on page 489, change the *filter's* blend mode to Luminosity instead, using the Blending Options dialog box.) This trick does virtually the same thing as changing the color mode to Lab and then sharpening the Lightness channel, but it's a whole lot faster.

- **Sharpen the whole image and the details separately.** As you learned at the beginning of this chapter, every image needs sharpening, but what if you want certain parts of the image, like eyes and hair, to really stand out? If you sharpen enough for those details, then the rest of your image can look too sharp. The fix is to apply *two* rounds of sharpening: one for the entire image and another round for the details. Pages 501–503 explain how to do this without harming your original.

In the following pages, you'll learn various ways to sharpen, starting with the most popular method: the Unsharp Mask filter.

UP TO SPEED

Keeping the Noise Down

Shooting in low-light conditions can introduce noise—black-and-white or colored speckles—into your images. This is especially true if you've increased your camera's ISO (it's light sensitivity setting). If that happens, be sure to reduce or get rid of the noise before you sharpen the image, or you'll end up sharpening the noise along with the edges (though the Smart Sharpen filter does sport a Reduce Noise slider).

Photoshop gives you a variety of noise-reducing filters that are discussed on page 704. All of 'em work by *reducing* the amount of contrast between different-colored pixels—a process that's the exact opposite of sharpening, which is why removing noise also reduces sharpness!

Because all filters run on the currently active layer—meaning they affect your original image—be sure to convert your image to a smart object before running a noise-reducing filter so the filter runs nondestructively, or run it on a duplicate image layer or a stamped layer (pages 498–500).

The aptly named Reduce Noise filter is the best of the bunch because it gives you more control than the others. To use it, choose Filter→Noise→Reduce Noise and, in the resulting dialog box, adjust the following settings:

- **Strength.** If you've got a lot of *grayscale noise*—luminance or brightness noise that looks like grain or splotches—or *color noise* that looks like little specks of color, increase this setting to make Photoshop reduce the noise in each color channel. This setting ranges from 1 to 10 (it's set to 6 unless you change it).

- **Preserve Details.** You can increase this setting to protect the detailed areas of your image, but if you do, Photoshop can't reduce as much grayscale noise. For best results, tweak this setting along with the Strength setting and find a balance between the two.

- **Reduce Color Noise.** If there are colored specks in your image, try increasing this setting so Photoshop zaps 'em.

- **Sharpen Details.** Because every noise-reducing filter blurs your overall image, this option lets you bring back some of the sharpness. However, resist the urge to use this option and set it to 0%; it's better to go with one of the other sharpening methods described in this chapter instead.

- **Remove JPEG Artifact.** If you're dealing with an image that's gotten blocky because it was saved as a low-quality JPEG—or because it was saved as a JPEG over and over again—turn on this checkbox and Photoshop tries to reduce that Lego look.

- **Advanced.** This setting lets you tweak each color channel individually (for more on channels, see Chapter 5). If the noise lives in one or two color channels—it's usually bad in the blue channel—turn on this radio button and adjust each channel's settings individually. (Because Reduce Noise can make images blurry, it's better to adjust as few channels as possible.)

Once you're finished modifying these settings, click OK to run the filter and then toggle the filter's (or duplicate layer's) visibility off and on to see how much effect the filter had. (You can preview the effect on your image by pressing P while the filter's dialog box is open.) You can also use the smart filter's included layer mask to restrict the noise reduction to certain parts of the image (handy if the noise is only in the shadows, for example).

And if you determine that the filter didn't help one darn bit, turn to page 834 to find a third-party, noise-reduction plug-in that can. Or, if buying a plug-in isn't in your budget, flip to page 229 to learn how to sharpen individual channels, which lets you bypass the noise-riddled channel altogether.

You may now proceed with sharpening your image.

Sharpening with Unsharp Mask

This filter is many people's favored sharpening method, but its name is confusing—it sounds like it does just the opposite of sharpen. The odd name came from a technique used in darkrooms, which involves using a *blurred* (or "unsharp") version of an image to produce a *sharper* one. In Photoshop, the Unsharp Mask filter studies each pixel, looks at the contrast of nearby pixels, and decides whether they're different enough to be considered an edge (you control how picky the filter is using the Threshold setting, discussed below). If the answer is yes, Photoshop increases the contrast of those pixels by lightening the light pixels and darkening the dark pixels.

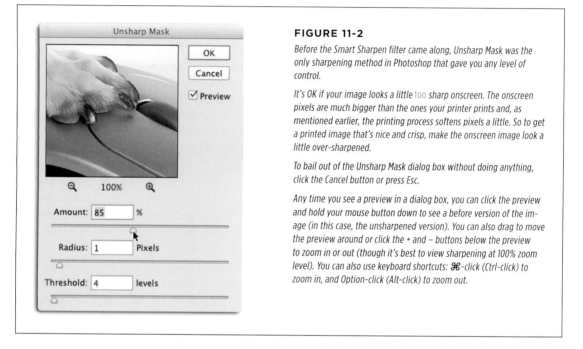

FIGURE 11-2

Before the Smart Sharpen filter came along, Unsharp Mask was the only sharpening method in Photoshop that gave you any level of control.

It's OK if your image looks a little too sharp onscreen. The onscreen pixels are much bigger than the ones your printer prints and, as mentioned earlier, the printing process softens pixels a little. So to get a printed image that's nice and crisp, make the onscreen image look a little over-sharpened.

To bail out of the Unsharp Mask dialog box without doing anything, click the Cancel button or press Esc.

Any time you see a preview in a dialog box, you can click the preview and hold your mouse button down to see a before version of the image (in this case, the unsharpened version). You can also drag to move the preview around or click the + and – buttons below the preview to zoom in or out (though it's best to view sharpening at 100% zoom level). You can also use keyboard shortcuts: ⌘-click (Ctrl-click) to zoom in, and Option-click (Alt-click) to zoom out.

Here are the settings you can adjust in the Unsharp Mask dialog box:

- **Amount** controls the sharpening *intensity*, and ranges from 1 percent to 500 percent. The higher the setting, the lighter Photoshop makes the light pixels and the darker it makes the dark pixels. If you set it to 500 percent, Photoshop makes all the light pixels along the edges white and all the dark ones black, giving your image a sharpening halo that's visible from outer space. For best results, keep this setting between 50 percent and 150 percent (you can find other magic numbers starting on page 489).

- **Radius** controls the *width* of the sharpening halo by telling Photoshop how many pixels on either side of the edge pixels it should analyze (and therefore lighten or darken). When you increase this setting, you may need to reduce the Amount setting to avoid creating a Grand Canyon–sized sharpening halo. For best results, don't set the Radius higher than 4.

- **Threshold** lets you control how *different* neighboring pixels have to be from each other before Photoshop considers them an edge. Oddly enough, Threshold works the opposite of how you might expect: Setting it to 0 sharpens *every* pixel in your image! For best results, keep this setting between 3 and 20 (it ranges from 0 to 255).

Here's how to run the Unsharp Mask filter nondestructively using smart filters:

1. **Convert your image to a smart object.**

 Choose Filter→"Convert for Smart Filters" and Photoshop displays a dialog box letting you know that the Image layer will be converted into a smart object. Click OK and you'll see a tiny smart object badge appear at the bottom right of the image's layer thumbnail.

TIP If your document contains multiple layers, activate 'em all *and then* choose Filter→"Convert for Smart Filters." That way, Photoshop creates a single smart object out of the layers, primed and ready for filter action.

2. **Choose Filter→Sharpen→Unsharp Mask.**

 In the resulting dialog box (Figure 11-2), tweak the settings to your liking. In the next few pages, you'll find some recommended values that you can memorize, but for now, adjust the settings until the image in the preview looks good. Click OK when you're finished to close the dialog box; when you do, an item named Unsharp Mask appears in the Layers panel (Figure 11-3, left).

3. **Change the filter's blend mode to Luminosity.**

 Double-click the tiny icon to the right of the Unsharp Mask item (labeled in Figure 11-3, left) to view the filter's blending options. In the resulting dialog box, set the Mode menu to Luminosity and then click OK.

Sit back and marvel at your new, nondestructive Photoshop sharpening prowess. You'll learn more about using smart filters (and their masks) in Chapter 15, though you've gotten a nice head start here!

■ HOW MUCH TO SHARPEN?

Some images need more sharpening than others. For example, you don't need to sharpen a portrait as much as you do a photo of Times Square because they have different amounts of detail (the Times Square photo has lots of angles and hard lines). If you sharpen the portrait too much, you'll see pores and blemishes with enough details to haunt your next power nap.

Photoshop guru Scott Kelby came up with some especially effective values to use in the Unsharp Mask dialog box, which he's published in his many books. With his blessing, here they are:

- **Sharpening soft stuff.** If you're sharpening images of flowers, puppies, babies, and other soft, fluffy subjects (stuff that often blends into its background), you

don't want to apply much sharpening at all. For extremely soft sharpening, try setting the Amount to 150 percent, the Radius to 1, and the Threshold to 10.

- **Sharpening portraits.** While close-up portraits need a bit more sharpening than the items mentioned above, you don't want to sharpen them as much as something hard like a building with lots of straight lines and angles. To sharpen portraits enough to make their subjects' eyes stand out, try setting the Amount to 75 percent, the Radius to 2, and the Threshold to 3.

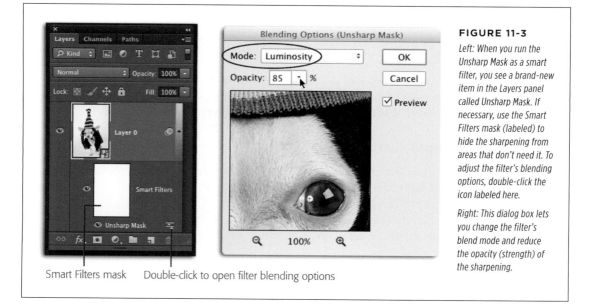

Smart Filters mask Double-click to open filter blending options

FIGURE 11-3

Left: When you run the Unsharp Mask as a smart filter, you see a brand-new item in the Layers panel called Unsharp Mask. If necessary, use the Smart Filters mask (labeled) to hide the sharpening from areas that don't need it. To adjust the filter's blending options, double-click the icon labeled here.

Right: This dialog box lets you change the filter's blend mode and reduce the opacity (strength) of the sharpening.

- **Sharpening objects, landscapes, and animals.** This stuff tends to be a little harder and contain more details (sharp angles, fur, and so on) than portraits, so it needs a moderate amount of sharpening. Try setting the Amount to 120 percent, the Radius to 1, and the Threshold to 3.

- **Maximum sharpening.** For photos of cars or of buildings (which are chock-full of hard lines, angles, and details) and photos that are a little out of focus, try entering an Amount of 65 percent, a Radius of 4, and a Threshold of 3.

- **Sharpening anything.** For everyday sharpening, regardless of what's in your image, enter an Amount of 85 percent, a Radius of 1, and a Threshold of 4, and then call it a day.

- **Sharpening for the Web.** If you've resized an image so it's small enough to post on the Web (see page 263), it needs more sharpening because downsizing often makes an image appear softer. Set the Amount to 200 percent, the Radius to 0.3, and the Threshold to 0.

NOTE These numbers are merely guidelines—they're not absolute rules. The most important variable is image resolution: Small pixels require *more* sharpening than big ones (and as you know from page 254, the higher the resolution, the smaller the pixels). Be sure to experiment with your own images and printer to see which settings give you the best results.

The Smart Sharpen Filter

The Smart Sharpen filter gives you a *lot* more options than Unsharp Mask. It lets you specify how much sharpening happens in the shadows and highlights *separately*, so if you like maximum control over your images, then this is the sharpening filter for you.

The Smart Sharpen filter was recently redesigned to work better *and* be easier to use, as Figure 11-4 explains. It includes a Reduce Noise slider that's great for sharpening images shot in low light. It also lets you save your favorite sharpening settings as *presets*, which is a nice timesaver, and its dialog box is resizable. Like Unsharp Mask, this filter is destructive, so be sure to run it as a smart filter (as described in the previous section) or make a copy of the layer you're sharpening first—either by duplicating the image layer or by creating a stamped copy of visible layers (page 498). When you're ready, run this filter by choosing Filter→Sharpen→Smart Sharpen.

TIP When it comes to sharpening, the ability to *see* what's happening to the edges in your image is crucial. That's why it's a good idea to set the document's zoom level to 100 percent and the dialog box's preview zoom level higher than that to see the details, no matter *which* sharpening filter you use (they've all got + and – zoom controls beneath their image previews).

In the resulting dialog box, you'll see a Preview checkbox, a Preset menu, and the (now familiar) Amount and Radius sliders (discussed in the previous section). You'll also find the following settings:

- **Reduce Noise.** This slider lets you lessen any noise that might be loitering in your image; drag it to the right for more noise reduction (it's automatically set to 10 percent and goes up to 100).

- **Remove.** This menu is where you pick what kind of blur you want Photoshop to remove—or, more accurately, *reduce*. Your choices are:

 - **Gaussian Blur.** Think of this as the basic mode; it's the one that the Unsharp Mask filter uses.

 - **Lens Blur.** This setting attempts to detect the detail or edges in an image and then make the sharpening halos *smaller*. Pick this setting if your image has a lot of details and/or noise.

 - **Motion Blur.** If your image is blurry because the camera or subject moved, you can use this setting to make Photoshop *try* to fix it, though it doesn't do a very good job. You're better off using the Shake Reduction filter (page 495) or the Emboss filter technique described on page 712.

FIGURE 11-4

The Smart Sharpen filter includes the handy Reduce Noise slider (perfect for sharpening photos taken in low-light conditions with a high ISO setting), and you can specify exactly how much sharpening occurs in the shadows or highlights. In this example, highlight sharpening is reduced by half (50% Fade Amount) across all highlights (100% Tonal Width).

To save your settings, click the Preset drop-down menu and choose Save Preset. For example, you might save these particular settings with the name, "high sharp-half highlights." (The same menu also lets you load and delete presets.)

Since choosing Gaussian Blur basically makes this filter work like Unsharp Mask (in which case you could just *use* Unsharp Mask instead) and you use Motion Blur only when your picture is blurry, go with Lens Blur. However, you could set this menu to Gaussian Blur in order to create Smart Sharpen presets that *work* like Unsharp Mask (since the Unsharp Mask filter doesn't let you save presets).

- **Angle.** If you choose Motion Blur from the Remove menu, use this dial to set the angle of the blur in your image. For example, if you have a square image and the subject is moving diagonally across the shot from the lower-left corner to the upper-right corner, set this field to 45 degrees.

The Shadows and Highlights sections both contain the exact same settings, which let you control the following:

- **Fade Amount** lets you reduce the sharpening Photoshop applies to your image's shadows or highlights, depending on which section you're in. For example, if you enter *150* in the dialog box's Amount field but want Photoshop to do a bit *less* sharpening in the shadows, click the Shadows flippy triangle and enter a Fade

Amount of 25 percent or so. If you don't want Photoshop to do *any* sharpening in the shadows (say, if they're noisy), enter 100 percent here and then set the Tonal Width (explained next) to 100 percent, too. (Likewise, if you don't want any sharpening in the highlights, set the Highlight section's Fade Amount and Tonal Width sliders to 100 percent.)

- **Tonal Width** lets you control exactly *which* shadows and highlights Photoshop sharpens. These settings start out at 50 percent, meaning the shadows and highlights get sharpened evenly throughout their tonal range. If you enter a lower number, Photoshop sharpens only the lightest highlights or the darkest shadows (depending on which section you're in); if you enter 100, Photoshop sharpens *all* the highlights or shadows. But unless you've set the Fade Amount above 0, this setting doesn't do a darn thing.

- **Radius** lets you control how many pixels Photoshop analyzes to figure out whether it thinks a pixel is in a shadow or a highlight. In other words, this setting controls how wide an area Photoshop sharpens in either shadows or highlights (depending on which section you're in). Like the Tonal Width setting, Radius doesn't do squat unless you increase the Fade Amount beyond 0 first.

Fading Filters

You may feel that this chapter is jumping the gun a little by covering sharpening filters because there's a *whole chapter* on filters headed your way (Chapter 15). However, some of the things you can do with filters—like fading one you've applied—are too dad-gummed useful to wait until then, especially if, for whatever reason, you need to run a filter on your *original* image layer.

If you run a filter (or an image adjustment, for that matter) and the effect is a little too strong, you can lower its opacity to lessen its effect and/or change its blend mode. But Photoshop only lets you do this *immediately* after running the filter, so it's easy to miss your chance. If you didn't duplicate the original layer, create a stamped copy (page 498), or use smart filters (page 500), then this fix is your *only* saving grace.

After you run the filter and before you do or click *anything* else, head up to the Edit menu and choose "Fade [name of the last filter you ran]." In the resulting Fade dialog box, enter a percentage in the Opacity field. For example, if you think the filter is twice as strong as you need, enter *50* to reduce its effect by half. (If you click OK and then change your mind, you can choose Edit→"Fade [name of filter]" again and enter a new number.) The Edit menu's Fade option remains clickable until you run another command or use another tool.

The Fade dialog box also has a Mode menu that lets you change the filter's blend mode to adjust how the sharpened pixels blend with the original pixels. Changing this setting to Luminosity has the same effect as running the filter on a duplicate layer and setting that layer's blend mode to Luminosity. When you click OK, Photoshop lessens the filter's effect by the percentage you entered in the Opacity field.

Of course, you can forget the Fade command ever existed by getting into the habit of using smart filters or running your filters on duplicate image layers.

Sharpening with the High Pass Filter

When you want foolproof sharpening that you can see before applying it *and* that doesn't require messing with a swarm of sliders, give this method a spin. It's quick and lets you add a bit more depth to an image by increasing contrast in the midtones (the colors in the image that fall between the lightest and darkest). It involves using the High Pass filter, which essentially exaggerates the highest-contrast edges in the image (the ones with the biggest difference between colors) and makes everything else in the image *gray* (see Figure 11-5).

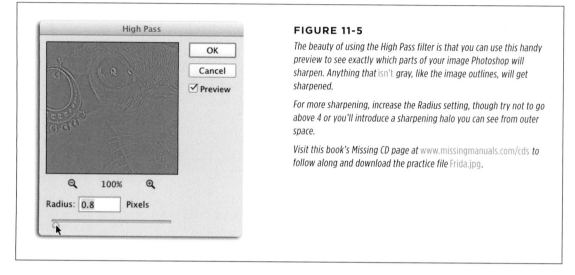

FIGURE 11-5

The beauty of using the High Pass filter is that you can use this handy preview to see exactly which parts of your image Photoshop will sharpen. Anything that isn't *gray, like the image outlines, will get sharpened.*

For more sharpening, increase the Radius setting, though try not to go above 4 or you'll introduce a sharpening halo you can see from outer space.

Visit this book's Missing CD page at www.missingmanuals.com/cds *to follow along and download the practice file* Frida.jpg.

To use the High Pass filter, create a duplicate layer for sharpening by pressing ⌘-J (Ctrl+J). Alternatively, you can create a stamped copy of visible layers (page 498) or use smart filters (described in the section on using Unsharp Mask on page 500). Next, change the duplicate or stamped layer's blend mode to Overlay, as shown in Figure 11-6 (or change the smart filters' blending options). (As page 305 explains, the neutral color in Overlay mode is gray, meaning that color will completely disappear, leaving behind the exaggerated high-contrast edges mentioned above, making the image look sharper.) Next, choose Filter→Other→High Pass and enter a Radius between 0.5 and 4. That's it! Check out your image to see if you like it, and turn off the sharpening layer's visibility to see what the original image looked like for a quick comparison.

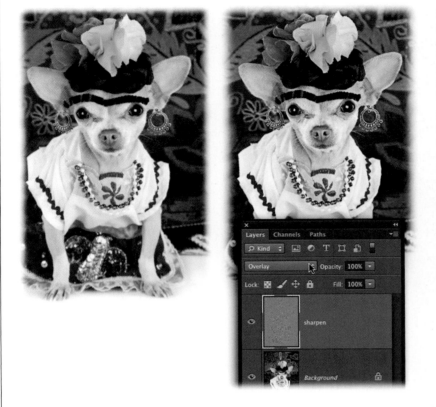

FIGURE 11-6

Here are the results of sharpening using the High Pass filter (right). For fast, fuss-free sharpening, this filter is the only way to go!

If you use smart filters instead of a duplicate Image layer, you can change modes by opening the filter's blending options. To do that, in the Layer's panel, double-click the icon to the right of the filter's name. In the resulting dialog box, change the blend mode to Overlay and adjust the Opacity field to your liking.

The Shake Reduction Filter

This filter's special power is sharpening images that are slightly blurred due to movement of the camera itself (known as *camera shake*). When you run it, Photoshop analyzes the image from the center outward to locate the blurry bits, and then tries to discern a *pattern* from the blur by tracing it (creating what's called a *blur trace*). For example, if your camera moved in a straight line or in multiple directions during the shot, the blur pattern might be linear or zig-zagged. If you moved your camera in an arc or you rotated it slightly, then the blur pattern might be curved instead. Miraculously, you can use this filter to detect *all* these various blur patterns, even if there's *more* than one in your image. It works best on images that don't have a lot of noise (though it applies some noise reduction automatically) or any specular highlights or moving subjects. That said, the results are pretty darned amazing.

To use this filter (be sure to run it on a duplicate image layer or as a smart filter as described back on pages 498 and 500), choose Filter→Sharpen→Shake Reduction,

and the dialog box shown in Figure 11-7 commandeers your screen. Photoshop automatically analyzes a small, square portion of your image to detect a blur pattern (in the Detail section at the bottom right of the dialog box, you see a light gray status bar while Photoshop is thinking). Once it's done analyzing (it takes a few seconds), lift your jaw off the floor and evaluate the image.

> **TIP** After the Shake Reduction filter analyzes of your image, you can click anywhere within the big preview area on the left to see it at 100 percent zoom level in the Detail section at the bottom right of the dialog box.

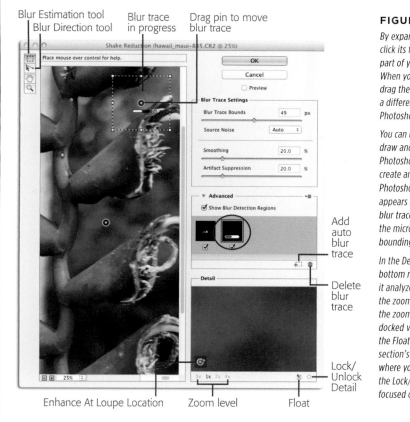

Blur Estimation tool
Blur Direction tool
Blur trace in progress
Drag pin to move blur trace

Add auto blur trace

Delete blur trace

Lock/ Unlock Detail

Enhance At Loupe Location
Zoom level
Float

FIGURE 11-7

By expanding the Advanced section (just click its flippy triangle), you can see which part of your image Photoshop scrutinized. When you do, a bounding box appears; drag the pin in the middle of the box to a different spot in your image to have Photoshop analyze that area instead.

You can use the Blur Estimation tool to draw another bounding box to make Photoshop analyze that area, too, and create another blur trace (circled). While Photoshop is thinking, a gray status bar appears inside the bounding box and the blur trace icon. To stop the analysis, click the microscopic cancel button inside the bounding box.

In the Detail section at the dialog box's bottom right, Photoshop displays the area it analyzed at 100 percent zoom level; use the zoom controls labeled here to change the zoom level. To have a floating, un-docked version of the Detail section, click the Float icon. From the factory, the Detail section's preview changes according to where you click in the large preview; click the Lock/Unlock Detail button to keep it focused on a particular spot.

> **TIP** You can press Q to undock the Detail section (it's called the *detail loupe* when it's undocked). When the detail loupe is visible, you can press Q or click the tiny X at its top left to dock it in the Detail section. You can also single-click a blur trace icon to make it bigger so you can see the blur pattern that Photoshop traced. The blur pattern looks like a whitish-gray area in a sea of black.

On the left side of the dialog box you'll spot the Blur Estimation and Blur Direction tools (labeled in Figure 11-7), as well as the familiar Hand and Zoom tools. On the right side are several settings; here's what they do:

- **Blur Trace Settings.** Straight from the factory, the Shake Reduction filter opens in Basic mode (though there's no label telling you that). In this mode, Photoshop analyzes your image to find a blurry area and then creates a blur trace to remove the blur. Evaluate the big honkin' image preview to see if your image needs further tweaking. If it does, here's what this section's settings do:

 - The **Blur Trace Bounds** slider lets you tell Photoshop how wide the blur is (in pixels)—in other words, how much you moved the camera during the shot. Drag this slider to the right to increase width (if you moved the camera a lot), or to the left to decrease it (if you didn't move the camera much).

 - The **Source Noise** slider tells Photoshop how much noise is in your image. From the factory it's set to Auto, though you can also choose Low, Medium, or High.

 - The **Smoothing** and **Artifact Suppression** sliders let you fine-tune how Photoshop handles *sharpening artifacts*, problems that are introduced or exaggerated as a result of sharpening (told ya this process was destructive!). They include such nasties as noise, halos, exaggerated texture, detail loss in shadows and highlights, and so on. Drag the Smoothing slider to the right to blur noise in areas of fine detail (also called *high-frequency sharpening noise*). Use the Artifact Suppression slider to lessen the number of larger artifacts that Photoshop introduces (alas, some artifacts are unavoidable). Unless you change 'em, both sliders are set to 30 percent.

- **Advanced.** In order to make Photoshop analyze and create blur traces of *multiple* areas, you need to enter Advanced mode by clicking the flippy triangle next to the word "Advanced" to display more options. When you do, Photoshop adds a pin to your image, surrounds it with a small (resizable) bounding box, and creates a *new* blur trace of that region (two blur traces are shown in Figure 11-7). To move the bounding box, drag its pin.

> **NOTE** Once you enter Advanced mode, the filter will always open in Advanced mode until you close that section by clicking its flippy triangle.

To create *additional* blur traces, click and drag with the Blur Estimation tool to draw another box.

Once you're in Advanced mode, you can *manually* tell Photoshop the direction and width of the blur. To do so, grab the Blur Direction tool and then zoom *way* in on your image so you can try to see a blur pattern. Then, drag across it in the direction the blur is headed and keep dragging to mark the blur's width (which likely won't be very far). When you're finished dragging, use the bracket keys to nudge the direction of

the blur to the left ([) or right (]). To nudge the width, press ⌘-[or] (Ctrl+[or]). In the Advanced section, you'll spot a new blur trace with a red M on it (for "manual").

The Advanced section also includes the following settings:

- **Show Blur Estimation Region.** When this checkbox is turned on, you can click anywhere in your image to see that area in the Detail section.

- **Add Auto Blur Trace.** Click this button to make Photoshop add an *automatically generated* blur trace (as opposed to one you draw yourself using the Blur Estimation tool).

- **Delete Blur Trace.** Clicking this button deletes the active blur trace (you can tell which one is active by the blue outline around its icon).

When you've adjusted all the settings to your liking, click OK to close the dialog box and admire your less-blurry image.

> **TIP** While the Shake Reduction filter works wonders, don't depend on it to save every photo. To capture sharper images *without* schlepping a tripod around, try putting your camera in *burst mode* (consult your owner's manual to figure out how). This makes the camera fire off three to five shots (depending on the make and model) each time you press the shutter button. The image in the *middle* will usually be the sharpest, because it was taken while the shutter button was depressed.

Sharpening Layered Files

When you run a sharpening filter, it affects only the *currently active layer*—there's no way to make it affect *all* the layers in a document. So what happens if your image is made from more than one layer because, say, you've combined several images and/or used adjustment layers? The solution is to *merge* all those layers into a brand-new layer you can sharpen. The "sharpenable" layer can be either an image layer or a smart object. Since the jury is out regarding which method is more efficient, this section covers both.

> **NOTE** Whether the smart object method is faster or better is anyone's guess. Depending on how many and what kind of layers are in your document, the smart object method can produce slightly larger file sizes (though a much shorter Layers panel). Nevertheless, one of the techniques covered in this section will likely feel more comfortable to you than the other, so just choose the one you prefer. The important thing is that you do the sharpening somewhere *other* than on your original imager layer.

■ COMBINING LAYERS INTO A NEW IMAGE LAYER

Perhaps the most straightforward method of sharpening a layered document is to merge all the existing layers into a *new* image layer. With this method (called *stamping*), your original layers remain visible in the Layers panel for further tweaking, should they need it.

When you have a multilayered file, it's a good idea to name the layers so you know what's what. Just double-click the new layer's name and type a descriptive name like *sharpen*. Organizing layers into groups (page 111) is another great option.

Here's how to create a new image layer from multiple layers:

1. **Open a layered file and, in the Layers panel, click the topmost layer to activate it.**

 Since the sharpening layer needs to be *on top of* your layer stack, activate the topmost layer; that way, the new sharpening layer will appear above it (Figure 11-8, left).

2. **Make sure you've turned on the visibility eyes of all the layers you want to merge.**

3. **Open the Layers panel's menu by clicking the upper-right part of the panel (circled in Figure 11-8, left) and then Option-click (Alt-click on a PC) the Merge Visible menu item.**

 If you simply *click* Merge Visible, Photoshop compresses all your layers into one layer, flattening your document into an un-editable mess. Option-clicking (Alt-clicking) it instead makes Photoshop compress your layers onto a completely *new* layer, perched atop your layer stack (circled in Figure 11-8, right). You can also press Shift-Option-⌘-E (Shift+Alt+Ctrl+E) to do the same thing.

FIGURE 11-8

If you need to sharpen a multi-layered document—especially one riddled with adjustment layers—first you'll want to combine all the layers into a new image layer by Option-clicking (Alt-clicking) Merge Visible on the menu shown here. Otherwise, you'll drive yourself crazy trying to figure out exactly which layer needs sharpening!

Now you can sharpen the new stamped layer using any of the methods described in the previous pages. To hide the sharpening from areas of your image that don't need it, add a layer mask by clicking the circle-within-a-square-icon at the bottom of the Layers panel (see page 120 for more on layer masks). To decrease the sharpening's intensity, lower the layer's opacity setting.

■ COMBINING LAYERS INTO A SMART OBJECT

Another option for sharpening a multilayered document is to store the *content* of those layers in a smart object. The benefit to this approach is twofold. First, when you run a filter on a smart object, you automatically get a layer mask, saving you the step of adding one if you need to hide the sharpening from a certain spot. Second, creating a single smart object from multiple layers shortens a long Layers panel; you can always get back to the individual layers if you need to, say, tweak an adjustment layer, but they don't remain visible in your Layers panel.

With this method, your original layers are stored inside the smart object—like a sandwich in a protective wrapper—and hidden from view. Tell Photoshop which layers to include in your new smart object by Shift- or ⌘-clicking (Ctrl-clicking) them in the Layers panel to activate them. Then, choose Filter→"Convert for Smart Filters" or, from the Layers panel's menu, choose "Convert to Smart Object." If you need to get back to those layers for more editing, you can expand the smart object by double-clicking its layer thumbnail. When you do, Photoshop displays the message shown in Figure 11-9.

This technique is also handy when you want to add more sharpening to specific areas, called *localized* or *selective* sharpening (discussed in the next section). For example, you could apply sharpening to the whole image (called *global* sharpening), and then create a smart object out of the layer you used to do the sharpening—whether it's a stamped layer or a smart object—and then add *another* round of sharpening that you only reveal in certain spots using the included layer mask.

FIGURE 11-9

When you expand a smart object to edit its contents, the original layers open in a temporary Photoshop document. When you're finished making changes, be sure to choose File→Save so your edits are stored in the same location as the original document. Then close the temporary document and your changes appear back in the original document. Amazing!

Adobe Photoshop

After editing the contents, choose File > Save to commit the changes. Those changes will be reflected upon returning to skier lesa.psd.

The file must be saved to the same location. If the Save As dialog appears, choose Cancel, and flatten the image before saving.

☐ Don't show again

OK

Sharpening Part of an Image

To make certain parts of an image *really* stand out—such as ones that have interesting texture—you can add additional sharpening to those areas. For example, one of the most useful portrait-retouching techniques you'll ever learn is to accentuate your subject's eyes and lips, as shown in Figure 11-10.

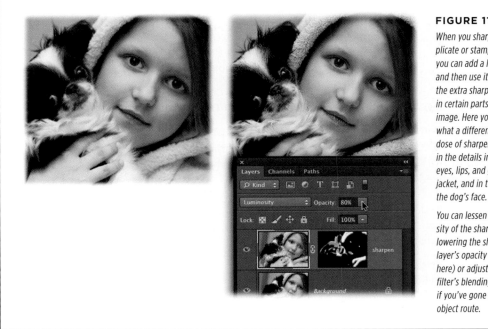

FIGURE 11-10

When you sharpen a duplicate or stamped layer, you can add a layer mask and then use it to reveal the extra sharpening only in certain parts of the image. Here you can see what a difference an extra dose of sharpening makes in the details in the girl's eyes, lips, and green jacket, and in the fur near the dog's face.

You can lessen the intensity of the sharpening by lowering the sharpening layer's opacity (as shown here) or adjusting the filter's blending options if you've gone the smart-object route.

If you've followed the advice in the previous section about sharpening a smart object or merging several layers into a stamped layer specifically *for* sharpening, then you're more than halfway there. If you went the smart object (or smart filter) route, you automatically got a layer mask (shown back in Figure 11-3). If you merged several layers into one, you need to add a mask yourself by clicking the circle-within-a-square icon at the bottom of the Layers panel.

> **NOTE** You can follow along by visiting this book's Missing CD page at *www.missingmanuals.com/cds* and downloading the practice file *Puppy.jpg.*

Here's how to apply extra sharpening to certain parts of an image:

1. **Create a duplicate layer or stamped layer to use for sharpening and change its blend mode to Luminosity.**

 If you're dealing with a single-layer file, activate the original layer and then press ⌘-J (Ctrl+J) to duplicate it. If you've got a multilayered file, combine all the layers into a single sharpening layer as explained in the previous section. (If

you've already added one round of sharpening but want to add more, duplicate the layer you *previously* used for sharpening.) Then use the drop-down menu at the top of the Layers panel to change the new layer's blend mode to Luminosity and, if you'd like, double-click its name and rename it *extra sharpening*.

If you're working with a smart object, change the blend mode of the *sharpening filter*, not the smart object. In other words, wait and switch modes only *after* you run the sharpening filter.

2. **With the new layer active, choose Filter→Sharpen→Unsharp Mask.**

 Enter an Amount of 120 percent, a Radius of 2, and a Threshold of 3. These numbers are rather arbitrary; the goal is to over-sharpen your image so you can then reduce the effect.

3. **Run the Unsharp Mask filter one or two more times.**

 Have a little faith, will ya? You'll reduce this extreme over-sharpening in a minute. To run the filter again, press ⌘-F (Ctrl+F) or choose Filter→Unsharp Mask (the last filter you ran always appears at the top of the Filter menu).

 If you're in Smart Object Land, you'll see two or three Unsharp Mask layers appear in the Layers panel (one for each time you run the filter). To change their blend modes, double-click the tiny icon to the right of each one to open its blending options. In the resulting dialog box, set the Mode menu to Luminosity and then click OK.

NOTE Remember, sharpening affects different-sized pixels in different ways. If you're performing this technique on a high-resolution image (where the pixels are tiny), you'll need *more* sharpening, so either increase the Amount value listed in step 2 or run the filter a few more times.

4. **Add a solid black layer mask to the sharpened layer.**

 At the bottom of the Layers panel, Option-click (Alt-click on a PC) the circle-within-a-square icon to add a layer mask filled with black, hiding the sharpened layer. (In the realm of layer masks, black *conceals*.)

 If you're using a smart object, click to activate its mask—the big white thumbnail beneath the Image layer—and press ⌘-I (Ctrl+I) to invert the mask.

5. **Grab the Brush tool and set your foreground color chip to white.**

 Press B to activate this tool and then take a peek at the bottom of the Tools panel. If the foreground color chip is white, you're good to go (white *reveals*). If it's not, press D to return the color chips to the factory setting of black and white and then press X to flip-flop the chips. To reveal the sharpening in differing amounts across your image, switch to painting with gray (black conceals and white reveals, so gray does a little of *both*).

6. **With the layer mask active, mouse over to the image and paint your subject's irises.**

 When you're doing detail work like this, it's helpful to zoom in on the image by pressing ⌘-+ (Ctrl-+) a few times. You also need to adjust your brush's size: Press the left bracket key ([) to make it smaller and the right bracket key (]) to make it bigger. Be sure to paint only the iris of each eye. If you mess up and reveal too much of the sharpening layer, don't panic; just press X to flip-flop color chips so you're painting with black, and then paint over that area again to hide the sharpening.

 TIP You can also change your brush size by holding Control-Option as you drag left or right (on a PC, Alt+right-click+drag instead).

7. **When you're finished painting the eyes, hold the space bar and drag to move the image so you can see your subject's lips, and then reveal the sharpening in that area, as well.**

 Painting over your subject's lips is like adding a bit of digital lip gloss. You'll probably want to increase your brush size a bit for this step.

8. **Lower the sharpened layer's opacity until you get a realistic effect.**

 At the top of the Layers panel, change the Opacity setting to lessen the effect of the sharpening you applied in step 3. (Eighty percent opacity was used in Figure 11-10.)

 Smart object folks need to open the filter's blending options by heading to the Layers panel and clicking the tiny icon to the right of the filter's name. Then lower the Opacity setting in the resulting Blending Options dialog box.

9. **Save the image as a PSD file.**

With this method, you're not harming the original pixels, and you can alter the sharpened layer's opacity to lessen the effect and make it look real instead of otherworldly. Saving the document as a PSD file lets you go back and edit the layer mask or change the sharpened layer's opacity, which is a great option if you print the image and then think, "If only it were just a *tad* sharper..."

Advanced Sharpening Techniques

Now that you understand the basics of sharpening, it's time to delve into the realm of advanced sharpening. Consider yourself warned that this is pro-level stuff and not for the faint of heart. (Basically, these methods involve many more steps than the techniques you've learned so far.) In this section, you'll learn how to create a detailed edge mask and make a new high-contrast channel. Read on, brave warrior!

NOTE This book doesn't cover *every* Photoshop sharpening technique (if it did, it'd be too heavy to lift!), just the most practical and frequently used methods. If you want to learn more, pick up a copy of *Real World Image Sharpening*, Second Edition by Jeff Schewe and Bruce Fraser (*www.lesa.in/rwsharpen*). That book is a few years old, but it teaches you more than you ever wanted to know about the art of sharpening.

FREQUENTLY ASKED QUESTION

The Sharpen Tool

What's all this talk about sharpening with filters? Why can't I use the Sharpen tool instead?

While it seems like a no-brainer that the Sharpen tool would be your best bet for sharpening (it's specifically designed for that, right?), you can actually get better results using other methods. However, if you're sharpening a few image *details* instead of the whole enchilada, this tool can be very useful. Here's how it works:

The Sharpen tool is part of the blur toolset. When you click its icon (which looks like a triangle) and mouse over to your image, you see a familiar brush cursor. You can then paint areas you want to sharpen and, well, that's it. You don't get nearly as much control with this tool as you do with the sharpen filters discussed so far in this chapter. Up in the Options bar, you can adjust the following settings:

- **Brush.** This menu lets you pick brush size and type (big or small, hard or soft).

- **Mode.** Use this menu to change the tool's blend mode from Normal to Darken, Lighten, Hue, Saturation, Color, or Luminosity.

- **Strength.** This field is automatically set to 50 percent. But unless you want to over-sharpen your image, lower this setting to 25 percent or less before you use the Sharpen tool. That way, you apply reasonable amounts

of sharpening and can brush over areas repeatedly to apply more.

- **Sample All Layers.** Photoshop assumes you want to sharpen only the active layer. If you want to sharpen *all* the layers in your document (or rather, the ones that you can see through the current layer, if it's partially transparent), turn on this checkbox. This setting is also your ticket to sharpening on an empty image layer, thereby *protecting* your original.

- **Protect Detail.** This option prompts Photoshop to be extra careful about what it sharpens (technically, it triggers a set of sharpening instructions called an *algorithm*). Added in CS5, this setting is a definite improvement, and it can be handy if you need to sharpen a small area quickly without fussing with Smart Filters or a duplicate (or merged) layer. But the extra thinking Photoshop has to do to accomplish this feat means it'll run like molasses on large images (or slow computers).

As you might imagine, using this tool can be a time-suck of epic proportions because you're sharpening with a brush *by hand*, so it's best to use it only on small areas. And be sure to do your sharpening on a new, empty image layer so you're not harming the original (just make sure to turn on the Sample All Layers checkbox or Photoshop will squawk at ya).

Creating an Edge Mask

An *edge mask* is simply a layer mask that accentuates the edges in an image. (Pop back to page 484 if you need a refresher on what "edge" means in this context.) The mask itself, which you apply to the layer you want to sharpen, is black except for a white outline of your image. Because black conceals and white reveals in the Land of Layer Masks, this makes the sharpening show only on those edges. However, instead of drawing such a complicated mask yourself—that would take days!—you can have Photoshop create one for you by using the (rather lengthy) method described in this section. It takes some time, but it can be worth the effort (*especially* if other sharpening methods introduce too many artifacts [page 497]):

1. **Find the channel with the greatest contrast and duplicate it.**

 As you learned in Chapter 5, an image's color info is stored in individual containers called channels. To create an edge mask, you need to find the channel with the greatest contrast (which channel that is depends on your image). To do that, open the Channels panel and cycle through 'em—if you're in RGB mode—by pressing ⌘-3, 4, and 5 (Ctrl+3, 4, and 5 on a PC). (If you're in CMYK mode, you've got one more channel to look at, so add ⌘-6 [Ctrl+6] to that list.)

 To leave your original image intact, you need to keep your channels intact, too, so that means creating an edge mask on a *duplicate* of the highest-contrast channel. So once you find the channel with the most contrast, activate it in the Channels panel, Control-click (right-click) it, and then choose Duplicate from the shortcut menu. In the dialog box that appears, name the channel *mask*. (Another option is to create a brand-new, even *higher*-contrast channel by using the Calculations adjustment or Channel Mixer. See the box on page 509 for the scoop.)

2. **With the mask channel active in the Channels panel, choose Filter→Stylize→ Find Edges.**

 You don't get a dialog box when you run this filter; it's an all-or-nothing kind of deal. Photoshop instantly makes your image look like a drawing, with the edges shown in dark gray and black. This is the exact *opposite* of what you want, but you'll fix that in the next step.

3. **Invert the mask channel by choosing Image→Adjustments→Invert.**

 Photoshop flip-flops the info in the mask channel so the image's edges are white instead of black (see Figure 11-11). That way, when you copy the mask channel and paste it into a layer mask on the sharpened layer, the sharpening will be revealed *only* along the edges (because, in the realm of layer masks, black conceals and white reveals).

NOTE If you'd like to work with the image used in this example, download *Building.jpg* from this book's Missing CD page at *www.missingmanuals.com/cds*.

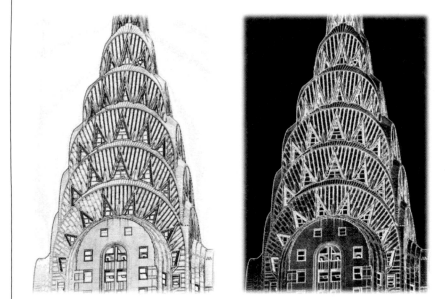

FIGURE 11-11

Left: When you first run the Find Edges filter, your image looks like a pencil sketch, as shown here. (To see the original photo, check out Figure 11-12, left.) The edges in the image are black, which is the opposite of what you want.

Right: After you invert the mask channel, the edges turn white and everything else turns black. Now, when you paste this channel into a layer mask, the sharpening will show through only in the white areas.

4. **Tweak the mask channel's contrast with a Levels or Curves adjustment.**

 To control how much of the image gets sharpened, you can change the mask channel's contrast with a Levels adjustment: Choose Image→Adjustments→Levels, and then move the gray slider to the left for more sharpening or to the right for less. Remember, the sharpening won't show in the black areas of the mask channel, only the light gray and white areas. Click OK when you're finished to close the dialog box. (See page 398 for more on using Levels.)

5. **Blur the mask channel slightly with the Gaussian Blur filter.**

 To avoid harsh sharpening halos, blur the mask channel a little by choosing Filter→Blur→Gaussian Blur. Enter a radius between 0.5 and 4 to soften the mask's edges (use a lower number for low-resolution images and a higher number for high-resolution ones).

6. **Load the mask channel as a selection, and then turn on the composite channel.**

 Since you're already in the Channels panel, go ahead and load the mask channel as a selection by clicking the tiny dotted circle at the bottom left of the Channels panel; you'll see marching ants appear. (You don't need this selection just yet, but you will in a minute; with an active selection, Photoshop will automatically fill in the layer mask you create in the next step.)

Next, at the top of the Channels panel, click the composite channel—either RGB or CMYK, depending on your document's color mode—to simultaneously turn the composite channel *on* and the mask channel *off*.

7. **Back in the Layers panel, duplicate the layer you want to sharpen (or combine several layers to create a new one, as described on page 498), name it *sharpening*, and add a layer mask to it.**

 Activate the layer you want to sharpen and duplicate it by choosing Duplicate Layer from the Layers panel's menu (the usual ⌘-J [Ctrl+J] trick won't work because it'll only duplicate the *selected* parts). In the resulting Duplicate Layer dialog box, type *sharpening* into the As field, and then click OK. Next, add a layer mask to the sharpening layer by clicking the circle-within-a-square-icon at the bottom of the Layers panel.

8. **Run the Unsharp Mask filter on the sharpening layer.**

 Click the sharpening layer's thumbnail and then choose Filter→Sharpen→Unsharp Mask. In the resulting dialog box, adjust the settings as described on page 488, and then click OK.

9. **Change the sharpened layer's blend mode to Luminosity and lower its opacity, if necessary.**

 To avoid weird color shifts that sharpening can cause, use the Layers panel's drop-down menu to change the sharpened layer's blend mode to Luminosity (Figure 11-12, right). And if the sharpening looks too strong, lower the layer's opacity (you may not need to, but it's sure nice to have the option).

Whew! That was a lot of work, but your image should look light-years better, as shown in Figure 11-12. You can toggle the sharpened layer's visibility off and on to see what a difference the edge sharpening made. Thanks to the edge mask, only the building's details got sharpened, leaving areas like the sky untouched (which all but eliminates sharpening-induced noise).

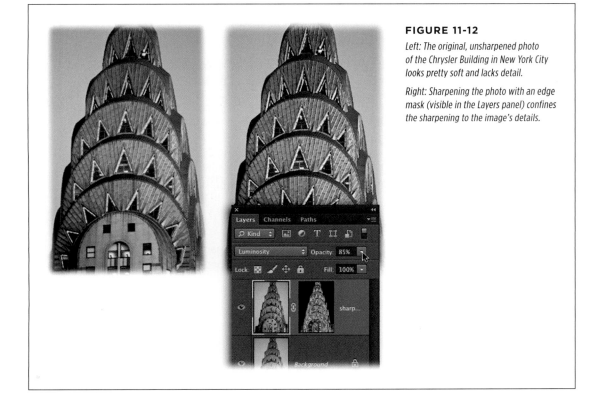

FIGURE 11-12

Left: The original, unsharpened photo of the Chrysler Building in New York City looks pretty soft and lacks detail.

Right: Sharpening the photo with an edge mask (visible in the Layers panel) confines the sharpening to the image's details.

Sharpening in Camera Raw

Camera Raw's sharpening capabilities are incredible. Sharpening in Camera Raw affects your image's *luminosity* (lightness or brightness values) but leaves the color alone so you shouldn't see any unexpected color shifts.

But *should* you use Camera Raw for sharpening? The answer is yes—*if* you're not going to edit the image much in Photoshop. If you *are* going to do a lot of editing in Photoshop, you should make sharpening the very last step (after resizing and re-touching) and then use one of the methods described earlier in this chapter instead.

You *don't* want to sharpen in both programs—at least, not the whole image. Sharpening in Camera Raw is a global process, meaning it affects the entire image (though you can wield a little control using Camera Raw's Adjustment Brush, discussed later in this section). It's also a somewhat automatic process: The image gets sharpened the minute you open it in Camera Raw, unless you turn off automatic sharpening as described in the next section. If you let Camera Raw sharpen your image, you'll

then need to practice local or selective sharpening (page 501) once the image is in Photoshop to avoid over-sharpening it.

Global Sharpening

You can sharpen in Camera Raw by first opening an image and then clicking the tiny Detail icon circled in Figure 11-13. If you don't want any global sharpening, drag the Amount slider to zero (from the factory, it's set to 25). If you *do* want to sharpen the image, mosey on down to the lower-left corner of the Camera Raw window and change the view percentage to 100 so you can see the effect of the changes you make (otherwise it'll look like your sharpening isn't having any effect and boy howdy, that's frustrating). Then, tweak the following settings:

- **Amount.** This setting works just like Unsharp Mask dialog box's Amount slider (page 488); it controls the sharpening's intensity. Setting it to 0 means no sharpening, no how; setting it to 150 means tons of sharpening (way too much). Try setting it to 40 and toggling the Preview checkbox at the top of the Camera Raw window off and on to see if it makes a difference (be sure you're zoomed in to 100 percent).

POWER USERS' CLINIC

Creating a High-Contrast Edge Mask

If you're trying to create an edge mask (page 505) but your color channels don't have much contrast, you can create a *new* channel with contrast aplenty. Don't worry—it's easier than you think. There are two ways to go about it:

- **The Calculations adjustment** can combine two channels for you. After strolling through your channels to see which ones have the most contrast (let's say they're the red and green channels), head up to the Image menu and choose Calculations. In the resulting dialog box, tell Photoshop which channels you want to combine by choosing Red from the Channel drop-down menu in the Source 1 section and Green from the Channel drop-down menu in the Source 2 section. From the Blending menu near the bottom of the dialog box, pick one of the blend modes in the Overlay category like Soft Light (Chapter 8 describes all these blend modes in detail). Click OK, and Photoshop creates a brand-new channel you can tweak into a high-contrast edge mask. *Now* you're ready to

proceed with step 2 back on page 505. (Since this channel is totally new, you don't have to duplicate it like you did in step 1 on that page.) To learn more about the Calculations adjustment, flip to page 229.

- **The Channel Mixer** doesn't really create another channel; instead, it lets you create a black-and-white version of your image that you can use as if it *were* a channel. Duplicate your image layer by pressing ⌘-J (Ctrl+J), and then choose Image→Adjustments→Channel Mixer. In the dialog box that appears, turn on the Monochrome checkbox and then tweak the various sliders. When you get some really good contrast, click OK. Next, start with step 2 on page 505 but run the Find Edges filter in the *Layers* panel instead of the Channels panel (the steps are exactly the same). For more on using the Channel Mixer, head to this book's Missing CD page at *www.missingmanuals.com/cds*.

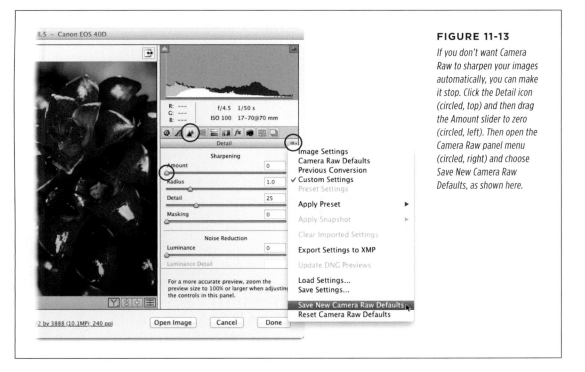

FIGURE 11-13

*If you don't want Camera
Raw to sharpen your images
automatically, you can make
it stop. Click the Detail icon
(circled, top) and then drag
the Amount slider to zero
(circled, left). Then open the
Camera Raw panel menu
(circled, right) and choose
Save New Camera Raw
Defaults, as shown here.*

- **Radius.** This slider controls the size of the details that Camera Raw sharpens. If your photo has lots of fine details, leave this set to 1. If your photo doesn't have many details, you can pump this setting up to 1.5, or if you're feeling wild and crazy, *maybe* 2.

- **Detail.** This slider lets you control the level of detail Camera Raw brings out (how much it emphasizes the edges). Crank this setting way up (to 90 or so) if you've got an image with tons of details and textures (like a rocky landscape, a close-up of a tree, or a fancy-schmancy building). This slider ranges from 0 to 100; for most images, keep it around 40 (but be sure to experiment to see what looks good).

- **Masking.** This setting lets you control which areas of your image Camera Raw sharpens. If you set it to 0, Camera Raw sharpens everything; set it to 100, and Camera Raw sharpens only the high-contrast edges. Using this setting is sort of like using a layer mask on a sharpened layer in Photoshop except that the masking is *automatic*. The only problem with this setting is that your eyes can't *see* any difference that it might be making.

The solution is to Option-drag (Alt-drag on a PC) the slider to get a *preview* of the areas that'll be sharpened. When you do, your whole image appears white

and then, as you drag the slider rightward, black areas start to appear. White areas *will* be sharpened and black areas will *not*, so keep dragging until all the important edges in your image are white.

- **Luminance.** This setting controls the amount of grayscale noise (see the box on page 487) that Camera Raw tries to decrease in your image by *smoothing* the pixels (similar to blurring). Make sure you're zoomed in to at least 100 percent and then drag this slider to the right to reduce the grains or splotches in your image. For example, a setting of 25 should provide a reasonable balance of noise reduction and image detail, though you'll need to experiment with your own photos.

- **Luminance Detail.** This slider controls the *luminance noise threshold*—how much smoothing Camera Raw performs on grayscale noise in detailed parts of the image. Drag it to the right to preserve more details and apply less noise reduction in those areas. On really noisy images, drag it to the left to produce a smoother image and apply more noise reduction (though doing so can zap detail, so keep an eye out for that). Straight from the factory, Luminance Detail is set to 50.

- **Luminance Contrast.** This setting lets you safeguard the image's contrast. Drag it right to preserve contrast and texture, or left to throw caution to the wind and produce a smoother, less noisy image. From the factory, this slider is set to 0.

> **NOTE** The Luminance Detail and Luminance Contrast sliders are *dependent* on the Luminance slider—if it's set to 0, they'll both be dimmed. Increasing the Luminance setting activates the other two.

- **Color.** If your image has a lot of color noise (funky specks of color), which can happen if you shoot in really low light or at a high ISO (your camera's light-sensitivity setting), move this slider to the right to make Camera Raw try to remove the specks. A value of 25 usually does a decent job.

- **Color Detail.** This slider controls the image's *color noise threshold*. Drag it left to remove more color specks, though that may cause color to bleed into other areas. If your image has a lot of thin, detailed, high-contrast areas of color (in other words, edges), drag the slider to the right for less noise reduction.

> **TIP** To see what's *really* going on with any of Camera Raw's sharpening options, zoom in to 100 percent or more and then hold the Option key (Alt on a PC) as you drag the sliders. Your image goes grayscale, letting you see which areas Camera Raw is adjusting (though it's tough to see *anything* when you're tweaking the Radius setting). The most useful setting is Masking—if you hold the Option (Alt) key while you tweak it, you see what looks like an edge mask that shows exactly which parts of your image Camera Raw is sharpening and which parts are hidden by the mask.

Local Sharpening

As you learned in Chapter 9, Camera Raw sports an Adjustment Brush that lets you paint slider-based adjustments directly onto an image. Behind the scenes, Camera Raw builds a mask to hide the adjustments from the rest of the image. How does that relate to sharpening, you ask? The Sharpness slider in the Adjustment Brush panel lets you selectively increase or decrease the amount of global sharpening you set in the Detail tab by painting certain areas with the Adjustment Brush. Sure, the global sharpening still affects your whole image, but by using the Adjustment Brush, you can turn the volume of that global sharpening up or down in specific areas, as shown in Figure 11-14. The Sharpness slider ranges from –100 to +100.

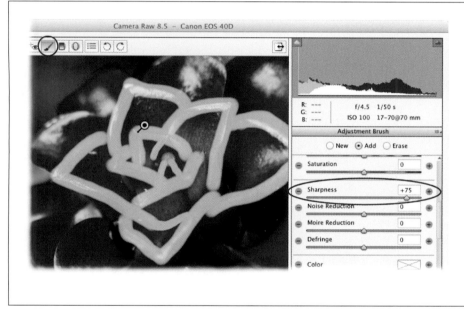

FIGURE 11-14

If you apply a round of sharpening to an image using the Detail tab's settings, you can add more sharpening to specific areas, like the edges of this flower, using the Adjustment Brush. Press K to grab it, increase the Sharpness setting (circled), and then paint the edges. To decrease the sharpening in a specific area, lower the Sharpness setting instead.

> **TIP** To better see the area you're adjusting, turn on the Show Mask option near the bottom of the Adjustment Brush panel (not visible in Figure 11-14—you may have to scroll down to see it) or press Y, and Photoshop highlights your brushstrokes with a white overlay.

The Artistic Side of Photoshop

Painting in Photoshop

Many artists who learned to sketch and paint using pencils, oils, and brushes have come to *love* the creativity that the digital realm affords. The biggest advantage is that there aren't any brushes to clean or paints to mix! And you can't beat the infinitely forgiving Undo command. Most important, as you can see in Figure 12-1, there's no limit to the kind of artwork you can create in Photoshop.

If you're a traditional artist, the techniques covered in this chapter will set you on the path of *electronic* creativity. You'll learn how to use Photoshop's color tools and built-in brushes to create a painting from start to finish, in full step-by-step detail. Happily, the program's brushes behave more realistically than ever before! You'll also discover how to load additional brushes, customize the ones Photoshop provides, and create new ones of your very own.

If you're a graphic designer or a photographer, there's a ton of info here for you, too. Just think about how much time you spend with brushes when you're working in Photoshop. Whether you're retouching an image with one of the healing brushes, painting on a layer mask to hide layer content or an adjustment, or removing objects with the Clone Stamp tool, *all* of those techniques (and more) involve either the Brush tool itself or a tool that uses a brush *cursor*. For that reason, learning how to work with and customize brushes is extremely important. Plus you'll learn all kinds of other fun and useful stuff like the basics of color theory, how to use Photoshop's various tools to pick the colors you work with, and how to give your photos a painted edge.

Since painting is all about using *color*, that's where your journey begins.

FIGURE 12-1

This beautiful painting by Deborah Fox of her daughter, Jordan, was created entirely in Photoshop using a Wacom digital drawing tablet (an Intuos Pro, to be exact, which runs around $350). To learn more about Wacom's excellent products, visit their website at www.wacom. com.

You can see more of Deborah's artwork at www.deborahfoxart.com.

■ Color Theory: The Basics

Color can evoke emotion, capture attention, and send a message. That's why choosing the *right* color is so important. It may also explain why picking colors that go well *together* can be an exercise in frustration. Some colors pair up nicely, some don't, and who the heck knows why.

The great thing about using Photoshop is that you don't actually need to know *why* certain colors go together. Instead, thanks to a circular diagram called a *color wheel*, you can easily identify which colors live in sweet visual harmony. A color wheel won't turn you into the next Matisse, but for most mortals it's the tool of choice for deciding which colors to use in a project.

Before you take the color wheel for a spin, you need to understand a few basic color concepts. Consider this section *Color Theory: The Missing Manual*:

- **A color scheme** (also called a color palette) refers to the group of colors you use in a project or painting. Just take a look at any book cover, magazine ad, or website and you'll see that it's made from a certain set of colors (usually three to five colors, plus white or black). The designer usually picks a main color, and then chooses the *other* colors according to how they look together and the feeling they evoke when they're viewed as a group. There's a whole science behind picking colors based on what they mean to us humans and how they make us feel (and those emotions vary based on geographic location). For example, hospitals are typically bathed in pale blue, lavender, or green because researchers have found that those colors have a soothing effect. If this type of thing interests you, pick up a copy of *Pantone's Guide to Communicating with Color*

by Leatrice Eiseman (*www.lesa.in/leatricecolorbook*) or *The Designer's Guide to Global Color Combinations* by Leslie Cabarga (*www.lesa.in/lesliecabarga*).

- **A color wheel** is a tool that helps you pick colors that look good together. Without diving too deeply into the science of color relationships, let's just say that all colors are related because they're derivatives of one another. The color wheel, which dates back to the 17th century, arranges visible colors on a round diagram according to their relationships. It's based on the three basic colors: yellow, blue, and red—the *primary colors*—from which all other colors spring. By mixing equal amounts of the primary colors, you get a second set of colors called—surprise—*secondary colors*. As you might suspect, mixing equal parts of the secondary colors gives you a third set of colors called *tertiary colors*. Together, all these colors form the color wheel shown in Figure 12-2.

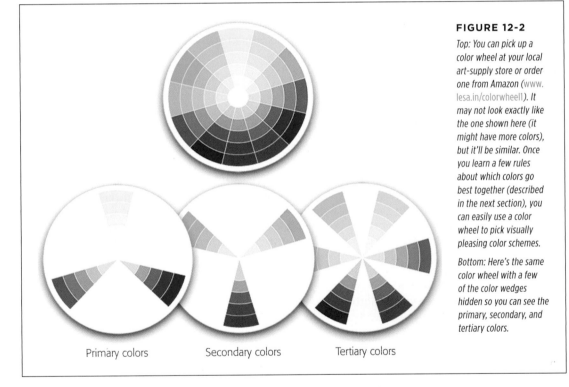

FIGURE 12-2

*Top: You can pick up a color wheel at your local art-supply store or order one from Amazon (*www.lesa.in/colorwheel1*). It may not look exactly like the one shown here (it might have more colors), but it'll be similar. Once you learn a few rules about which colors go best together (described in the next section), you can easily use a color wheel to pick visually pleasing color schemes.*

Bottom: Here's the same color wheel with a few of the color wedges hidden so you can see the primary, secondary, and tertiary colors.

Primary colors Secondary colors Tertiary colors

You'll also run into three different terms used to describe color: hue, saturation, and brightness (you've seen 'em mentioned here and there throughout this book). Together, they form all the glorious colors the human eye can perceive:

- **Hue** is a term for *pure color*, before it's had any white or black mixed with it. For the purposes of this discussion, think of hue as another word for "color," as in red, blue, lime green, or cotton-candy pink. So when you see it in a Photoshop dialog box, just substitute the word "color" in your mind.

- **Saturation** describes a color's strength or intensity. For example, a highly saturated hue has a vivid, intense color. A less saturated hue looks dull and gray. Think "vibrancy" and you'll have this one down pat.

- **Brightness** (or lightness), which is usually measured in percentages, determines how light or dark a color appears. You can think of brightness as the amount of light shining on an object, ranging from white (100 percent) to black (0 percent). For example, if you shine a powerful flashlight on an apple, the apple looks almost white (100 percent lightness). When the flashlight is off, you've got no light, so the apple appears almost black (0 percent lightness).

Choosing a Color Scheme

As mentioned earlier, if you're picking a color scheme for your project, you usually begin by choosing a main (or *base*) color. This color can come from a piece of art that you're starting with (like a logo or photo) or it can be a color that you want to build your design around.

Once you know the main color, you can use a few simple rules to find other colors that go well with it. In this section, you'll learn how to use a color wheel to pick a color scheme based on four popular *color scheme harmonies* (color combinations that go well together). You'll also learn where to find tools to automate this process, in case picking colors *manually* isn't your cup of tea.

> **NOTE** The rule of thirds you learned about back on page 236 applies to colors, too. Imagine splitting the colors in your painting or design into two categories: dominant and accent. You can think of the *dominant* color as the color of the environment in the image (like white in a photo of a field of snow); it sets the mood of your piece. The *accent* color is the color of the focal point (like a brown tree or red barn in the field of snow). If you shoot for using two-thirds dominant color and one-third accent color, you can't go wrong!

Using a Color Wheel

Let's say you've gotten your hot little hands on a color wheel. Great! Now, what the heck do you do with it?

To get started, pick the *main* color you want the color scheme to revolve around and then find it on the color wheel. Next, use one of the following color scheme harmonies to pick *other* colors that go well with it (to see what these color schemes look like, skip ahead to Figure 12-4):

- **Monochromatic** schemes use colors from the *same* wedge of colors on the color wheel.

- **Analogous** schemes use colors from the wedges on *both sides* of the main color.

- **Complementary** schemes use colors from the wedge directly *across* from the main color.

- **Split complementary** schemes use colors from the wedges on *either side* of the main color's complement.

> **NOTE** For more on choosing colors and mastering graphic design, check out your author's online video course *Graphic Design for Everyone* (*www.lesa.in/lesacl*).

To use a color wheel to pick a color scheme, follow these steps:

1. **Open an image and choose a main color.**

 Every project starts with *some* kind of graphical element, whether it's a photo, a company logo, or a piece of art. Give it a good long stare and decide on a main color to use for the color scheme. For example, say you want to add color to the design shown in Figure 12-3. Since there's quite a bit of blue in the photo, you could designate one of the blues as your main color.

FIGURE 12-3

Instead of racking your brain trying to pick colors for the text and background of this design, it's much easier to start with a color that's already in the design somewhere.

In this case, you could start with one of the blues in the photo.

Previous versions of Photoshop included the Kuler panel, which let you tap into a color scheme generator. Alas, Adobe removed it from this version, but you can still access it on the Web, and then download your color scheme into Photoshop's Swatches panel (page 521 tells you how).

You can also download Kuler from the Adobe Add-Ons website as an HTML-based panel; just choose Help→Browse Add-Ons, and then enter Kuler into the search field that appears.

2. **Once you've picked a color, find its general location on the color wheel.**

 If you've got an actual color wheel in your hand, you can do this simply by looking at the wheel.

3. **Locate other colors that go with the main color by using one of the color scheme harmonies described earlier in this section and shown in Figure 12-4.**

 If you choose your other colors from the related color wedges, you can be sure they'll look good when you use them together.

FIGURE 12-4

Here you can see what the design looks like using monochromatic (top left), analogous (top right), complementary (bottom left), and split complementary (bottom right) color schemes. There are tons of color scheme harmonies out there (you'll need to study up on color theory to learn about 'em all), but you can think of these particular ones as the Fantastic Four.

The red box marks the main color's location on the wheel, and each color wedge used in the color schemes is highlighted (the other wedges are faded).

These are only the four most common color scheme harmonies. To learn others, grab a copy of Color Index, Revised Edition by Jim Krause (www.lesa.in/colorindex).

Other Color Scheme–Generating Tools

If this whole color-picking business feels overwhelming, never fear—helper applications aplenty are lurking around the Web. The gist is that you pick a base color and a color-scheme rule, and then the site generates the *rest* of the scheme based on the rule you chose. Helpful sites include:

- **Kuler.** "Kuler" is the Mauritian Creole (a French-based creole language) word for color. It's also the name of an amazingly useful, community-driven color scheme generator that you can access at *https://kuler.adobe.com*. You can choose from many color *themes* that folks in the Kuler community have created, or create your own from scratch or by uploading a photo.

TIP Adobe removed the Kuler panel from Photoshop CC 2014 because it was Flash based, but you can download an HTML-based version from the Adobe Add-Ons site. Choose Help→Browse Add-Ons, and in the Search field, type *Kuler,* and then press Return (Enter on a PC). On the search results page, click its name to open the Kuler download page, and then click the blue Free button at the upper left to download and install it. If Photoshop is open, you'll need to restart it. After you do, Kuler will be sitting pretty in the Window→Extensions menu.

To generate and save a color scheme from a photo, visit the Kuler website, click Sign In at the top right, and then enter your Adobe ID. Once you're signed in, click the Create heading at the top of the page, and then click the camera icon to upload a photo. Navigate to where the photo lives on your computer, click Open, and Kuler creates a color scheme based on your image. You can customize it however you like using the on-image controls; when you're happy with it, click the blue Save button. On the page that appears, in the Actions section, click Download. This makes your computer download an *.ase* file, which typically lands in your Downloads folder.

If you subscribe to the full Creative Cloud (see the box on page xxvii), the scheme is *automatically* loaded into Adobe Illustrator's Swatches panel (if you've downloaded the program, that is). To load your new scheme into Photoshop, choose Window→Swatches, and then, from the Swatches panel's menu, choose Load Swatches. In the resulting dialog box, find the .ase file you just downloaded and click Open. Poof! The new colors land *below* your other swatches in the panel. (Alternatively, you can double-click the .ase file to install it.)

For even *more* Kuler fun, download the free Adobe Kuler iPhone app. It lets you take a photo and then create a color scheme from it. Ain't technology grand?

- **Color Scheme Designer 2.** Free, Web-based version only (*www.colorschemedesigner.com*).

- **Color Schemer.** Free, Web-based and iPad/iPhone version, or $50 downloadable versions for both Mac and Windows (*www.colorschemer.com*).

- **GenoPal.** $25 downloadable Mac and Windows versions (*www.genopal.com*).

■ Choosing Individual Colors

Once you decide on the colors you want to use, the next step is to summon 'em in Photoshop. As you learned in Chapter 1, you can click the color chips at the bottom of the Tools panel to open the Color Picker (discussed next). But, as with *most* things in Photoshop, you've got plenty of other options, including the Eyedropper tool, the updated Color panel—which can now serve as a color picker that *stays open*—and the Swatches panel. This section teaches you how to use all of these features.

The Color Picker

To choose the color you want to paint with, click the foreground color chip at the bottom of the Tools panel to open the *Color Picker* (Figure 12-5). The Color Picker is a fine tool for choosing colors, and you'll use it a lot because so many dialog boxes call it into action. It displays all the colors available in the color workspace (page 723) you're using.

If you're not trying to summon a *specific* color value—as you learned in the box on page 42, each color has a numeric value—simply use the vertical, rainbow-colored slider to pick a *range* of colors, and then click inside the big, square color field on the left side of the Color Picker to tell Photoshop how light or dark you want that color to be. The color you pick shows up in the swatch at the upper right of the dialog box. Click OK to close the Color Picker, and your foreground color chip changes to the color you chose.

> **NOTE** You can summon a heads-up version of the Color Picker while painting with the Brush tool: Just press ⌘-Control-Option-click (Alt+Shift+right-click on a PC). Flip ahead to page 536 to see this on-image version of the Color Picker in action!

As you learned back in Chapter 2, each color mode identifies colors with specific numeric values. When you click within the color field on the left side of the Color Picker, the values on the right side change to reflect the color you selected. If you need to pick a *specific* color, enter its color values in the HSB (hue, saturation, brightness), RGB (red, green, blue), hex number, Lab, or CMYK (cyan, magenta, yellow, black) fields. Or, to use a color that already exists in your Photoshop document, just mouse away from the Color Picker and your cursor turns into an eyedropper. When you click the color you want to snatch, it appears in the Color Picker. Sweet!

> **TIP** Photoshop lets you create your own colors by using the Mixer Brush. Skip to page 532 to learn how!

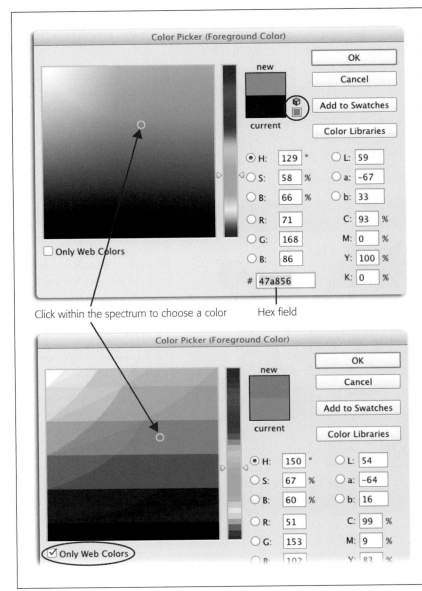

FIGURE 12-5

Here you can see the difference between viewing all possible colors in a given color workspace (top) and only those that are considered web safe (bottom). When you open the Color Picker, its hex field (the numeric value used on the Web) is automatically highlighted (provided you're in RGB mode), making it easy to copy and paste that number to use elsewhere in Photoshop or in another program.

The little 3D cube beside the swatch (circled) means the currently selected color isn't web safe (the box on page 771 explains what that means and why it's not such a big deal anymore). If you see a dark gray triangle with an exclamation point (shown beside one of the color swatches in Figure 12-7), it means the color can't be reproduced with CMYK ink (see Chapter 16 for more on printing images).

Once you get used to working with colors and seeing their numeric values, you may begin to visualize the color from the values alone. But to really understand how colors mix to make other colors, you need to study color theory.

Click within the spectrum to choose a color Hex field

The Eyedropper Tool

When you're developing a color scheme, it's helpful to start by grabbing colors that are already in your image. The Eyedropper tool is perfect for that job, and it includes a handy *sampling ring* that helps you snatch the *exact* color you're after (see Figure 12-6).

To use the Eyedropper, grab it by pressing I (pressing Shift-I repeatedly cycles through all the tools in that toolset). Adjust the Options bar's Sample menu to tell Photoshop which layer(s) you want to sample from. For example, Current & Below samples the current layer and any layers below it, "All Layers no Adjustments" samples all layers *except* adjustment layers, and "Current & Below no Adjustments" samples the current layer and any layers below it *except* adjustment layers.

Once you've decided which layer(s) to sample, mouse over to your image and click to make your foreground color chip match the color your cursor is over. If you want to hunt around for a good color, press and hold your mouse button, drag around your image until you find just the right hue, and then let go of your mouse to choose it. To use the Eyedropper tool to set your *background* color chip, Option-click (Alt-click on a PC) your image instead.

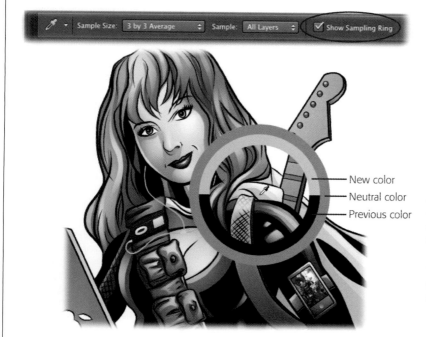

FIGURE 12-6

The Eyedropper tool's sampling ring displays the current foreground color on the bottom and the new color (the one your cursor is pointing at) on the top. To help isolate those colors from the rest of the colors in your image so you can actually see 'em, Photoshop places a neutral gray ring around them. If you're not impressed by the sampling ring, turn it off by clicking the Options bar's Show Sampling Ring checkbox (circled).

The talented Richard and Tanya Horie created this caricature of your humble author.

New color
Neutral color
Previous color

TIP When you're painting with the Brush tool and want to pick up a color from your image, you can Option-click (Alt-click) to *temporarily* switch to the Eyedropper tool. The box on page 779 explains how to snatch color from a document or web page *outside* Photoshop.

Loading Color Libraries

Sometimes, you need to be precise when picking colors. Maybe a client has given you specific colors to match or you're creating a piece of art that needs to mesh

with another designer's work. Enter Photoshop's built-in *color libraries*, which feature specialized color collections. Figure 12-7 shows you how to get started with them.

FIGURE 12-7

In the Color Picker (page 522), click the Color Libraries button to open this dialog box (you can also load libraries using the Swatches panel, discussed in the next section). Choose a library from the Book menu, and then use the multicolored slider (or your up and down arrow keys) to move through the list. Once you've found the color you want, click it to make it your foreground color. Then click OK to close this dialog box or click Picker to go back to the Color Picker.

The most popular library is the Pantone Matching System (PMS), which helps designers keep colors consistent across projects. Each PMS color has a number corresponding to a very specific ink mixture that lets professional printers reproduce the color with the same results every time. That said, to use *true* PMS colors, you have to create spot channels (see page 744). If you pick a color from a color library without using a spot channel, Photoshop picks the nearest RGB or CMYK equivalent (depending on which color mode your document is in).

TIP If the Color Libraries dialog box is open and you know the name of the color you want (for example, Pantone 360 or Pantone Green), you can choose it by entering its name with your keyboard; simply type the color's number or name. This feels weird because there's no text field to enter it in, but you must trust in the Force! Type *360* or *green*, for example, and you'll see a lovely light-green swatch appear in the dialog box's list. (If nothing happens, it means that particular color doesn't exist in the color library you're viewing.)

The Swatches Panel

Photoshop's built-in color libraries are actually just collections of color *swatches*. If you want to save a certain group of colors you've created—using the Kuler website (page 521), say—you can store them in the Swatches panel for easy access (see Figure 12-8). Think of this panel as a holding pen for frequently used colors, each of which you can summon with a click. To open the panel, choose Windows→Swatches. To use a swatch as your foreground color, just click it.

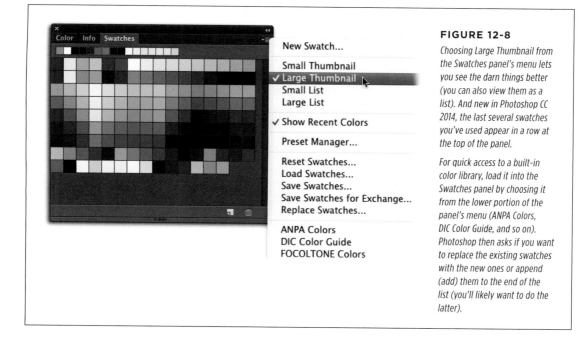

FIGURE 12-8

Choosing Large Thumbnail from the Swatches panel's menu lets you see the darn things better (you can also view them as a list). And new in Photoshop CC 2014, the last several swatches you've used appear in a row at the top of the panel.

For quick access to a built-in color library, load it into the Swatches panel by choosing it from the lower portion of the panel's menu (ANPA Colors, DIC Color Guide, and so on). Photoshop then asks if you want to replace the existing swatches with the new ones or append (add) them to the end of the list (you'll likely want to do the latter).

Here's how to manage the Swatches panel like a pro:

- **To add a new swatch that matches your current foreground color,** point your cursor at an empty area of the panel. (You'll need to resize the panel, or undock it, to see a blank area; page 10 tells you how.) When a tiny paint bucket appears next to your cursor, click to add the swatch. Photoshop displays a dialog box where you can give the new swatch a meaningful name.

- **Use the Preset Manager to arrange your swatches.** Since Photoshop lets you load additional swatches only at the *end* of the Swatches panel's list, you may want to use the Preset Manager to rearrange them by project, client, and so on. To do so, open the Preset Manager by choosing it from the Swatches panel's menu, and then drag the swatches to rearrange them (oddly, this works even though your cursor is an *eyedropper*). Unfortunately, you can't control how many swatches appear per row, though you could always add, say, a white swatch to use as a *spacer* between related swatch sets.

TIP Photoshop can automatically create swatches from colors specified in an HTML, CSS, or SVG file, though you'd *never* know it because there's no menu item for it. To get it done, head to the Swatches panel's menu and choose either Load Swatches or Replace Swatches and, in the resulting dialog box, navigate to one of those files. When you click Load, Photoshop creates swatches from *all* the colors in the file. This kind of thing is *insanely* handy when you're creating Web graphics!

- **To make a swatch's color your foreground color,** click the swatch.

- **To make a swatch's color your background color,** ⌘-click (Ctrl-click on a PC) the swatch.

- **To delete a swatch,** Option-click (Alt-click) it.

- **To reset your swatches** to the factory-fresh set, choose Reset Swatches from the panel's menu. This is handy if you've gone hog wild and loaded a ton of colors into the panel, and now need to clean it out.

The downside of using the Swatches panel is that there's no way to *organize* swatches into sets—they're always intermingled with other swatches in the panel. That said, Photoshop now displays the last several swatches you used at the top of the panel for easy access, which is a handy new feature.

One idea for organizing swatches is to keep certain ones together by rearranging them using the Preset Manager as described in the bulleted list above. Or you could create a *swatch layer* in your Photoshop document, which can serve as your digital painter's palette. To do so, create a new layer and then use the Brush tool to add blobs of color from your project or color scheme to it. Next, lock the layer (page 109) so you can't accidentally paint on it, and then use the Eyedropper tool to sample colors from it when you need them. Hide the swatch layer when you're not using it by turning off its visibility.

The Color Panel

Photoshop has yet *another* place where you can choose colors: the Color panel. In this version of the program, the panel's factory-fresh state shows a *hue cube* (Figure 12-9, top), which makes it look (and work) just like the Color Picker dialog box (page 522). But since it's a panel, it won't pop open a dialog box that (inevitably) hides your image, plus you can easily resize it and *keep it open all the time*, saving you the trouble of opening the Color Picker. (If you've got dual monitors, you might want to undock this panel and keep it open on your second screen.)

To open this wonderfully updated panel (if it's not open already), choose Window→Color. The left side of the panel shows your foreground or background color chips; just click the chip you want to pick a new color for, and a tiny white outline appears around it, indicating that it's active. Then, just like in the Color Picker, use the vertical, rainbow-colored bar to pick a range of colors, and then click within the color field on the left to pick the exact color you want. Figure 12-9 has more.

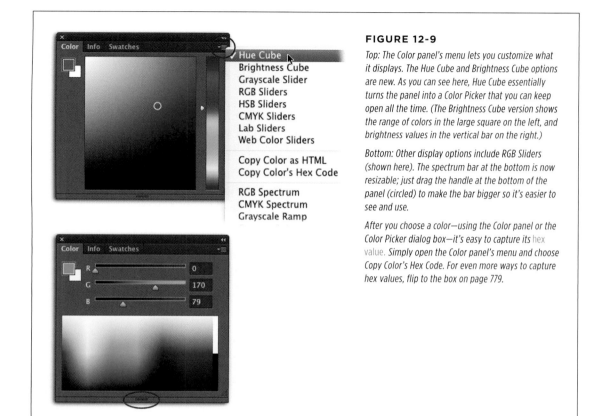

FIGURE 12-9

Top: The Color panel's menu lets you customize what it displays. The Hue Cube and Brightness Cube options are new. As you can see here, Hue Cube essentially turns the panel into a Color Picker that you can keep open all the time. (The Brightness Cube version shows the range of colors in the large square on the left, and brightness values in the vertical bar on the right.)

Bottom: Other display options include RGB Sliders (shown here). The spectrum bar at the bottom is now resizable; just drag the handle at the bottom of the panel (circled) to make the bar bigger so it's easier to see and use.

After you choose a color—using the Color panel or the Color Picker dialog box—it's easy to capture its hex value. Simply open the Color panel's menu and choose Copy Color's Hex Code. For even more ways to capture hex values, flip to the box on page 779.

▪ (Re)Introducing the Brush Tool

You've already used the Brush tool for all *kinds* of things in previous chapters: editing layer masks, creating selections, colorizing grayscale images, and so on. In this section, you'll learn how to *paint* with it, and these days it's a more realistic experience than ever before. But first you need to understand a bit more about how this tool works. Grab the Brush tool by pressing B or clicking its icon in the Tools panel.

TIP You can control brush size and edge hardness with a keyboard/mouse maneuver: Control-Option-drag (Alt+right-click+drag on a PC) *left or right* to change the size, or *up or down* to change edge hardness. When you use this trick, you'll see brush diameter, edge hardness, and opacity info appear next to your cursor.

The brush tool's Options bar (Figure 12-10) contains a slew of settings:

- **Tool presets.** This drop-down menu at the left end of the Options bar lets you access brush settings you've previously saved.

- **Brush Preset picker.** Photoshop has a ton of built-in brushes, and this drop-down menu lets you access and manage them, control brush size (up to a whopping 5000 pixels) and edge hardness, *and* save your settings as a preset. New in this version of Photoshop CC, the last 30 brushes you used are perched in the upper part of the panel. You can think of the Brush Preset picker as a mini version of the Brush Presets *panel* (described next), except that the Brush Preset picker only shows you a preview of the *tip* of Photoshop's preset brushes (see Figure 12-10), not the *brushstroke* you can make with it (the Brush Presets panel gives you previews of both).

- **Brush panel.** This tiny icon gives you one-click access to the Brush panel discussed starting on page 549, which lets you customize brushes in more ways than you can possibly imagine. Opening this panel also gives you quick access to the *Brush Presets panel*, which is basically a larger version of the Options bar's Brush Preset picker. It shows you a preview of built-in brush tips and, even more helpfully, a *brushstroke* created with each preset. The Brush Presets panel also includes a handy row of icons that let you manage your brush presets (see Figure 12-13 on page 533).

- **Mode.** This menu contains all the blend modes you learned about in Chapter 7, along with two more: Behind and Clear. Behind mode acts like the pixels you're painting are *behind* the pixels already on that layer (which is essentially the same as, though not quite as *safe* as, painting on a new layer below it)—if there are transparent pixels on that layer, then your brushstrokes are visible; if there aren't, nothing happens. Clear mode mimics the Eraser tool and makes the pixels you paint over transparent.

TIP In Photoshop CC 2014, when you activate a brush preset, a blue outline appears around its icon rather than of the barely visible light gray outline of earlier versions. You can see this outline in both the Brush and Brush Presets panels, but not in the row of recently used brushes. However, once you change that brush's settings in the Brush panel, the outline turns *gold* to let you know it's been modified.

- **Opacity.** This setting controls how transparent your brushstrokes are; you'll use it a lot since it lets you change the appearance of the paint you're applying. For example, you can start by painting with bright green at 100 percent opacity and then keep lowering the opacity to produce *lighter* greens.

- **Tablet pressure controls opacity.** If you use a digital drawing tablet (such as those from *www.wacom.com*), click this icon to make the Brush tool's opacity vary when you change the amount of *pressure* you're applying to the tablet with the stylus. Press harder to increase opacity or more lightly to decrease it.

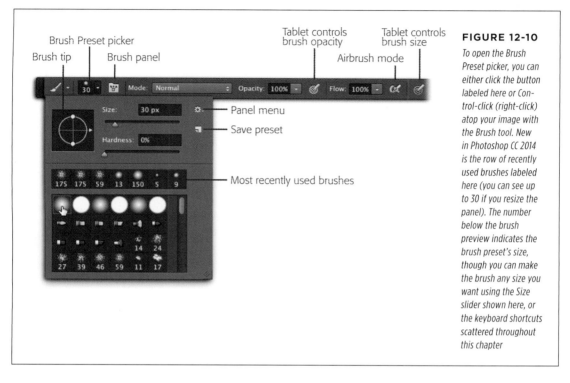

Brush Preset picker

Brush tip Brush panel

Tablet controls brush opacity Tablet controls brush size

Airbrush mode

Panel menu

Save preset

Most recently used brushes

FIGURE 12-10

To open the Brush Preset picker, you can either click the button labeled here or Control-click (right-click) atop your image with the Brush tool. New in Photoshop CC 2014 is the row of recently used brushes labeled here (you can see up to 30 if you resize the panel). The number below the brush preview indicates the brush preset's size, though you can make the brush any size you want using the Size slider shown here, or the keyboard shortcuts scattered throughout this chapter

- **Flow.** To control the flow of paint to the brush (the rate at which the color is applied to your image), adjust this setting. Use a low number for less paint and a high number for more paint. When you paint by dragging across an area multiple times, the paint builds up in that spot.

- **Airbrush.** Click this icon to make your brush work like an artist's airbrush, which sprays paint onto the canvas with compressed air (see Figure 12-11). Photoshop includes several airbrush brush tips that behave like a professional airbrush system.

- **Tablet pressure controls size.** If you have a digital drawing tablet, click this icon to control brush size with your stylus.

Once you've adjusted these settings, you can paint with the Brush tool by mousing over to your image and dragging. Your cursor reflects the size and shape of the brush tip you picked. Most of the time, the cursor is round like in Figure 12-11, top, unless you've chosen one of the textured or more creative brushes discussed later in this chapter. When you mouse over a dark part of your image, the ring representing your cursor turns white; when you mouse over a light area, it turns black.

FIGURE 12-11

Top: In Airbrush mode, the Brush tool "sprays" paint onto your canvas with (fictitious) compressed air. If you drag or hold down your mouse button, it keeps applying more paint (left) than you get with a single click (right), or when you're using the Brush tool not in Airbrush mode. Several of the tool's airbrush brush tips also trigger this spray-paint behavior.

Middle: Here you can see the difference in edge hardness between a soft-edged brush (top), which has very soft, semitransparent pixels around the edge, and a hard-edged brush (bottom).

Bottom: Photoshop's Bristle Tips work like their real-world counterparts, letting you create more natural strokes. If you're using a digital drawing tablet, pressing down with the stylus (pen) makes the bristles splay, just like a real brush (the Round Blunt Medium Stiff brush was used here). You can also use these tips with other Photoshop tools that employ a brush cursor, such as the Mixer Brush (discussed in the next section), the Eraser, and Clone Stamp tool.

TIP To paint a straight horizontal or vertical line (or one that's at a 45-degree angle) with the Brush tool, click once where you want the line to start and then Shift-click where you want it to end. This process isn't exactly *intuitive*, but that's why you bought this book!

Controlling the Brush Cursor's Appearance

Straight from the factory, your brush cursor reflects the size and shape of whatever brush tip you've chosen, but you can change the cursor using Photoshop's preferences. Choose Photoshop→Preferences→Cursors (Edit→Preferences→Cursors on a PC) to see the dialog box shown in (Figure 12-12).

Most of the time, you'll want to stick with either the Normal Brush Tip or Full Size Brush Tip setting because they give you the most natural painting experience (the Normal Brush Tip is slightly smaller than your actual brushstroke). The Precise version of the cursor has crosshairs so small they're nearly *impossible* to see; the Standard option is even less useful because it makes the cursor look like the Brush tool's icon, and *neither* option gives you any indication of the brush's size. The "Show only Crosshair While Painting" option came along back in CS5, but again, the crosshairs

icon gives you no indication of size and is so darn small you'd probably use it for painting only the tiniest of details when you're zoomed in.

> **TIP** If the brush cursor suddenly turns into a microscopic dot inside the crosshairs, check your keyboard to see if Caps Lock is turned on. Pressing Caps Lock lets you switch between the precise cursor (the crosshairs) and the cursor you're currently using, which can be useful when you're zoomed in and painting tiny details. (Turning on Caps Lock is a *fantastic* trick to play on your coworkers; just make sure you 'fess up before they reinstall Photoshop! Another naughty-but-good trick is to set the Brush tool's blend mode to Behind.)

FIGURE 12-12

The Painting Cursors settings control the Brush tool's cursor, while the Other Cursors settings let you pick between the standard, tool-shaped version or a precise (crosshair) version for tools like the Eyedropper, Patch, and Eraser. To put a crosshair in the middle of the cursor so you know exactly where it's centered, turn on "Show Crosshair in Brush Tip."

> **TIP** In the Brush Preview section visible in Figure 12-12, the color swatch indicates which color you see when you use the drag-to-resize keyboard shortcuts mentioned in the Tip on page 125.

Meet the Mixer Brush

Back in CS5, Photoshop's brush engine—the electronic brains behind its Brush tool—got a major overhaul, and Adobe also added the Mixer Brush. As the name implies, you can use it to mix colors just like you can mix paints in real life, as well as load multiple colors onto its tip.

You can use this tool on a blank canvas or in a document containing a photo to create realistic, "painterly" effects, as shown in Figure 12-13. The Options bar lets you control the "wetness" of the canvas, the amount of paint you're mixing from canvas to brush, and whether Photoshop *cleans* or *refills* the brush after each stroke. (If you're feeling creative, you can paint with a *dirty* brush!)

To turn a photo into a painting, follow these steps:

1. **Open a photo and add a new layer at the top of the layer stack.**

 At the bottom of the Layers panel, click the "Create a new layer" icon, and then position the new layer above your image layer. (This new layer is where the paint will go, as shown in Figure 12-13.) If you like, name the new layer something clever like *Paint*.

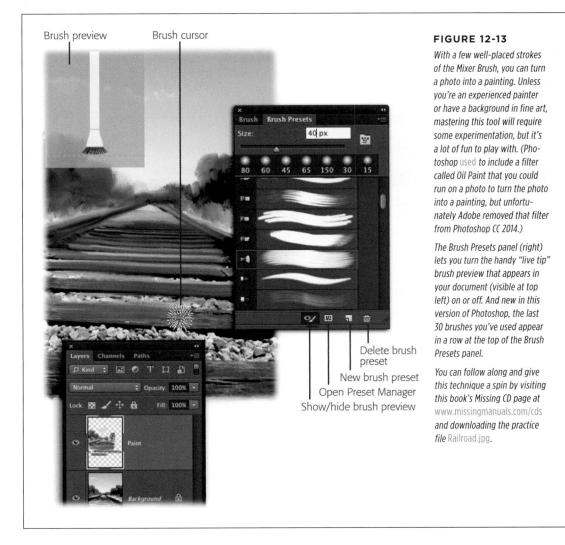

Brush preview Brush cursor

Delete brush preset
New brush preset
Open Preset Manager
Show/hide brush preview

FIGURE 12-13

With a few well-placed strokes of the Mixer Brush, you can turn a photo into a painting. Unless you're an experienced painter or have a background in fine art, mastering this tool will require some experimentation, but it's a lot of fun to play with. (Photoshop used to include a filter called Oil Paint that you could run on a photo to turn the photo into a painting, but unfortunately Adobe removed that filter from Photoshop CC 2014.)

The Brush Presets panel (right) lets you turn the handy "live tip" brush preview that appears in your document (visible at top left) on or off. And new in this version of Photoshop, the last 30 brushes you've used appear in a row at the top of the Brush Presets panel.

You can follow along and give this technique a spin by visiting this book's Missing CD page at www.missingmanuals.com/cds and downloading the practice file Railroad.jpg.

2. **With the Paint layer active, grab the Mixer Brush by pressing Shift-B repeatedly until you see its icon appear in the Tools panel.**

 The Mixer Brush lives in the Brush toolset and looks like a brush with a drop of paint above it.

3. **In the Options bar, turn on Sample All Layers.**

 This setting makes Photoshop sample colors from the image layer *below* the active layer, though the paint itself will appear on the active layer. This keeps you from destroying the original image.

4. **In the Options bar, click the Brush panel's icon (see Figure 12-14) to open it and then in the panel, click Brush Presets.**

 In the Brush panel's top-left corner, click either the Brush Presets button or tab to open another panel—within the same panel group—that includes a list of built-in brushes (see Figure 12-13). Sure, you could get at Photoshop's built-in brushes by opening the Brush Preset *picker* (also labeled in Figure 12-14), but the Brush Presets *panel* shows you what each brush's *brushstrokes* look like, which is really handy.

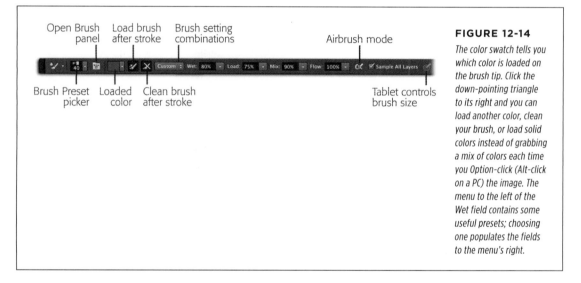

FIGURE 12-14

The color swatch tells you which color is loaded on the brush tip. Click the down-pointing triangle to its right and you can load another color, clean your brush, or load solid colors instead of grabbing a mix of colors each time you Option-click (Alt-click on a PC) the image. The menu to the left of the Wet field contains some useful presets; choosing one populates the fields to the menu's right.

5. **In the Brush Presets panel, scroll down the list of brushes until you see Round Fan (the active brush in Figure 12-13), and then give it a click to activate it.**

 If your computer can use OpenGL (see the box on page 66), then near the top left of your document window, you'll see a preview of the active brush's bristles like the one in Figure 12-13. If not, well—you won't. You can turn this preview off and on by clicking the show/hide icon at the bottom of the Brush Presets panel (labeled in Figure 12-13).

6. **Adjust the brush's size.**

 Use the Brush Preset panel's Size slider to make your brush smaller (by dragging left) or larger (by dragging right). Better yet, resize your brush with a keyboard shortcut—Control-Option-drag (Alt+right-click+drag on a PC) to the right to increase the brush's size, or to the left to decrease it. (If that's one too many

keys to remember, you can also decrease/increase brush size by tapping the left/right square bracket keys.)

7. **From the Options bar's Brush Combinations menu, choose "Wet, Light Mix."**

 This menu lets you tell Photoshop how you want the brush to behave. After you make a choice from this menu, you can fine-tune it using the Wet, Load, and Mix settings shown in Figure 12-14.

NOTE If you're using a digital drawing tablet, try assigning the scroll button on your stylus (pen) to resize brushes. To find out how, you'll need to dig out your tablet's manual.

8. **Mouse over to your image and start painting.**

 Photoshop begins applying paint to the layer you created in step 1. As you brush across the image, the Mixer Brush samples color from the image and *mixes* it with the color shown in the Options bar's color swatch (which comes from your foreground color chip). You can vary your brushstrokes by tweaking the Brush panel's Brush Tip Shape settings (page 549), or switch brush tips by picking a new one in the Brush Presets panel.

9. **Change the Options bar's Mix setting to 70 percent and then Option-click (Alt-click) a color in your image to load it onto the brush tip.**

 You can change the Mix setting by double-clicking its field in the Options bar and typing a new percentage, or by clicking its down-pointing triangle and dragging the resulting slider. Option-clicking (Alt-clicking) your image lets you add more colors to your brush tip to create a different painting effect. To switch to a completely different color, summon the *heads-up display* (HUD) Color Picker by Control-Option-⌘-clicking (Shift+Alt-right-clicking on a PC). Figure 12-15 has the scoop.

TIP Be careful not to load *too* many colors onto the Mixer Brush, as the paint can quickly turn to a yucky muddy-brown. If that happens, in the Options bar, turn on "Clean brush after each stroke."

10. **Continue painting until you've covered the whole image with brushstrokes.**

 If you like the results, save the image as a PSD file. If you don't, delete the paint layer by activating it and pressing the Delete key (Backspace on a PC).

Whew! Painting a photo is a lot of work, but it's also lots of fun (if you like painting, that is). If you're a photographer who happens to have a fine-art background (or merely a knack for painting), you can use this technique to create additional sellable products in your photography business.

And you don't have to start with a photo—you can use a blank canvas instead. In fact, that's what the next section is all about.

TIP Photoshop includes a set of *actions* (see Chapter 18) created by painting wizard John Derry that *automatically* prepares all the layers you'll need for painting. To use it, open a photo and then choose Window→Actions. In the Actions panel, scroll down the list and double-click the Mixer Brush Cloning Paint Setup action to run it. Photoshop instantly creates a *slew* of layers, complete with proper opacity and blend modes, primed and ready for your next masterpiece.

FIGURE 12-15

Top: To summon the HUD Color Picker (shown here in Hue Strip mode), Control-Option-⌘-click (Shift+Alt+right-click on a PC) your image. You have to keep your mouse button pressed to keep the HUD onscreen; as soon as you let go, it disappears. This handy feature lets you swap paint colors while you're painting (though you can now do that via the Color panel, too!).

While the HUD Color Picker is onscreen, mouse over to its rainbow-colored hue selector bar (right) until your cursor is over the color range you want (purples, for example), and then mouse horizontally (so as not to change the color range) over to the square lightness-and-saturation selector (left) to pick the exact color you want to paint with (just point at it with your cursor). Release your mouse button and the HUD Color Picker disappears. This process takes some getting used to, as any additional clicks—or letting go of your mouse button—closes the HUD Color Picker. Oy!

Bottom: You can change the HUD Color Picker to this groovy Hue Wheel by opening Photoshop's Preferences (Photoshop→Preferences→General on a Mac; Edit→Preferences→General on a PC). Then, from the HUD Color Picker menu near the top of the Preferences dialog box, choose Hue Wheel. (The Hue Wheel works the same way as the Hue Strip.) The menu lets you choose small, medium, and large versions of both the Hue Strip and Hue Wheel.

Painting from Scratch

Now you're ready for the really good stuff: actually *painting* in Photoshop. Not only is it fun, but it's a fabulous way to master the Brush tool.

One thing to remember about painting is that different people use different techniques. Some folks start by drawing a sketch, while others dive right into painting. People even have different ways of creating sketches—some draw pencil sketches on paper, scan them into their computers, and then paint over them, while others sketch right in Photoshop. And some folks use a digital drawing tablet, which makes painting a *lot* easier and more natural, while others fare quite well with a mouse or trackpad. The following steps are very basic and explain how most folks paint from

scratch, but, in the end, it's all about what works for you, so feel free to adapt these steps to suit your style.

> **TIP** You can rotate the canvas so it's at a more natural angle while you paint. Just press R to grab the Rotate View tool, and then click and drag the canvas to spin it. See page 62 for more details.

Turn on some music, think about what you want to draw, and then follow these steps:

1. **Create a new document by pressing ⌘-N (Ctrl+N), give it a white background, and then save it.**

 What canvas size and resolution to use depends on what you want to *do* with your painting. You may as well make it big enough to print just in case it turns out really well. If you've *no* idea what size to make it, try 3600 × 5400 pixels at a resolution of 300 ppi. If you have a slow computer and/or you're going to post your drawing on the Web or view it only onscreen, then try 1200 × 1800 at a resolution of 72 ppi. It's a good idea to make your document at *least* 1200 pixels wide or high (it doesn't matter which) so you'll have enough pixel info to show details when you zoom in to work on tiny stuff. (If it's less than 1200 pixels in one direction, it'll look blocky when you zoom in.)

 Since the steps ahead are a bit long and involved, protect your hard work by saving the document as a PSD file now by choosing File→Save As.

2. **Create a new layer and name it *Sketch*.**

 It's usually best to start with a rough sketch, but you don't have to. You can draw the sketch on paper and scan it into Photoshop (see the box below for the scoop on isolating a sketch on its own layer) or sketch it using the Brush tool, as explained in the following steps. (If you're starting with a photo, skip ahead to page 710 for tips on quickly creating a pencil sketch from it.)

 To add a layer to the document so you can draw the sketch in Photoshop, click the "Create a new layer" icon at the bottom of the Layers panel or press Shift-⌘-N (Shift+Ctrl+N).

FREQUENTLY ASKED QUESTION

Isolating a Scanned Sketch

Help! I scanned my sketch, but it's got a white background! How do I get rid of it?

If you go the pencil-and-paper route rather than drawing a sketch in Photoshop, when you bring the scanned image into Photoshop, you'll end up with a white background. Luckily, you can get rid of it *quickly* using channels.

Flip back to page 221 for the scoop on using channels to create a selection. Once you've got marching ants around the sketch, open the Layers panel and click the "Create a new layer" icon to add a layer for the sketch. Then fill the selection with the color of your choice by choosing Edit→Fill. Poof! That's all there is to it. Now you've got an inked outline of the sketch, ready for you to fill with paint.

3. **Press B to grab the Brush tool, choose a brush, and pick a color.**

 Trot up to the Options bar and pick a fairly small, round, hard-edged brush using the Brush Preset picker (Figure 12-10, right). Then set your foreground color chip to dark gray (the color of pencil lead).

 > **NOTE** If you want to follow along, download the file *Angel.psd* from this book's Missing CD page at *www.missingmanuals.com/cds*.

4. **Draw your sketch.**

 With the Sketch layer active, mouse over to your document and draw a rough sketch of what you want to paint, like the one shown in Figure 12-16, left. Don't worry about fine lines or getting things perfect; you can add details later.

5. **Lower the Sketch layer's opacity to about 40 percent.**

 At the top of the Layers panel, lower the Opacity setting until the sketch looks kind of ghostly. You'll create a more detailed drawing in the next step.

6. **Create a new layer named** *Refined Drawing* **and set its blend mode to Multiply.**

 Press Shift-⌘-N (Shift+Ctrl+N) to add another new layer, name it, set the New Layer dialog box's Mode menu to Multiply, and then click OK. This blend mode will make this layer's content appear *darker* so it's easier to paint over later.

 This new layer helps you fine-tune your sketch—think of it as a piece of tracing paper you've placed on top of the original sketch. The Sketch layer underneath acts like a guide to help you draw more precise and intricate details on the Refined Drawing layer (see Figure 12-16, right).

7. **Using the Brush tool, refine the drawing until you're happy with it.**

 By refining your sketch on the Refined Drawing layer, you're protecting your original sketch. If you need to erase some of your brushstrokes, hold the E key to switch temporarily to the Eraser tool. Once you're satisfied with the refined drawing, hide the original sketch layer by clicking its visibility eye.

8. **Create another new layer named** *Blue Background* **and drag it below the Refined Drawing layer.**

 Adding the background before you paint gives you a strong color foundation on which to build the painting. That way, you can bind the painting together using the background color(s).

9. **Fill the Blue Background layer with whatever you want the dominant background color to be—such as blue!**

 Over in the Tools panel, click the foreground color chip, choose a fairly dark blue from the Color Picker, and then fill the Blue Background layer with that color by pressing Option-Delete (Alt-Backspace on a PC). Alternatively, you can

choose Edit→Fill and pick Other from the Use drop-down menu to open the Color Picker; then click OK twice to fill the layer—once to close the Color Picker and again to close the Fill dialog box. (Because you'll paint on this layer in the next step, using a fill layer won't work.)

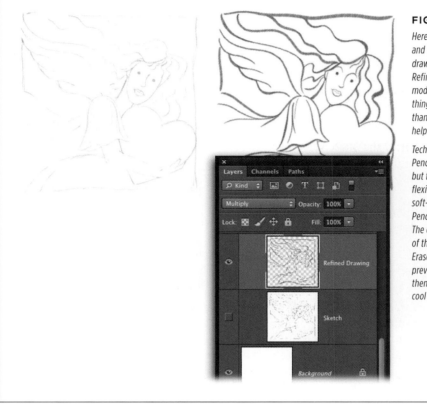

FIGURE 12-16

Here's the original sketch (left) and the more detailed, refined drawing (right). Setting the Refined Drawing layer's blend mode to Multiply makes anything you draw appear darker than it normally would, which helps you paint over it later.

Technically, you could use the Pencil tool to draw your sketch, but the Brush tool is far more flexible and can produce nice, soft-edged lines instead of the Pencil tool's hard, jagged edges. The only redeeming feature of the Pencil tool is its Auto Erase option that lets you erase previous strokes by drawing over them again (which is mainly just cool to watch!).

TIP Instead of clicking the foreground color chip to open the Color Picker, try using the Color panel set to Hue Cube, as described on page 528.

10. **Pick a slightly different color than you did in the previous step, switch to a large, round, textured brush and then start painting over the background.**

 Why add even *more* paint to the Blue Background layer? To add texture and keep the angel from looking flat. Use the Color panel set to Hue Cube (page 528) to pick a slightly different color than the background color (a lighter or darker blue, say, or an altogether different color such as purple). Next, from the Brush Preset picker (or Brush Preset panel) choose a textured brush or one with rough edges (like the speckled spatter brushes). Then mouse over to your document and start painting over the dominant background color until you get

the look you want. To create an interesting texture, be sure to vary brush tips, brush sizes, and the Options bar's Opacity setting (for color variation) as you go (see Figure 12-17, top).

To paint with a color that's already in your document, Option-click (Alt-click on a PC) the color you want to use. This temporarily turns the brush cursor into an eyedropper and sets your foreground color chip to the color you clicked. You can also use the Color panel or the HUD Color Picker described back on page 536.

TIP Putting your brush in Dissolve mode can also come in handy when you're shading an object by hand. See the box on page 544 for the scoop.

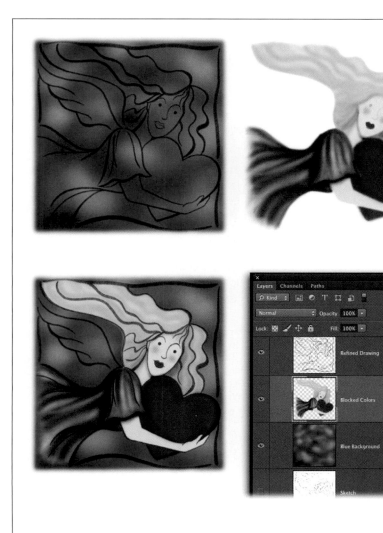

FIGURE 12-17

Top left: A variety of grainy, textured brushes at varying sizes and opacities were used to create this chalky pastel look. To give the background depth, use darker versions of similar colors for shadows and lighter versions of similar colors for highlights. (Using pure white for highlights and pure black for shadows makes paintings look flat. However, experienced painters can use white or black sparingly at reduced opacities, and then build the highlight or shadow by repeatedly brushing over the same area.)

Top right: You'll want to keep the Blue Background and Refined Drawing layers visible when you're adding color to your sketch, but they're turned off here so you can see the blocked colors. The areas of dark shading may look black, bit they're really purple and red.

Bottom: Here are the colors and refined drawing on top of the background.

11. **Create a new layer named** *Blocked Colors* **and position it between the Blue Background and Refined Drawing layers (Figure 12-17, bottom).**

You'll use this layer to add colors to your drawing (also referred to as "blocking with color" or "roughing in" because you'll add more details later).

TIP If all this color-picking business feels overwhelming, you can always create a painting with black, white, and shades of gray—which is a great way to learn!

12. **Colorize the drawing using a big, round brush with an opacity of 25 percent.**

For this step, pretend you're a kid with a coloring book; you don't have to worry much about staying within the lines. Start with the big stuff first—painting works best when you work from the general (larger areas) to the specific (tiny details). Using a big brush at a low opacity lets you build up color with multiple strokes (see Figure 12-17, top right). For a smooth look, paint with a soft-edged brush. To add character, use one of the textured or spatter brushes. When you need to change colors, use the foreground color chip or any of the other color-picking tools you learned about earlier in this chapter.

13. **Create a new layer named** *Refining & Detailing* **and drag it above the Blocked Colors layer.**

You'll use this layer to add fine details like lined edges and other embellishments. That said, if the lined edges on your Refined Drawing layer are good enough (as is the case in the angel painting), you don't *need* to add more lines, so concentrate on adding other color details to the Refining & Detailing layer instead.

14. **Use a variety of brush sizes to add details to your painting.**

Use a big, soft brush set to 65 percent opacity for large areas of color and blend them by painting over them again and again, changing colors as necessary. Switch to a small (about 5-pixel), textured brush at 100 percent opacity for finer details (see Figure 12-18, top).

TIP If you're having trouble getting certain colors to blend, try the Mixer Brush or the Spot Healing Brush—both can do wonders for blending stubborn areas. Steer clear of the Smudge tool (see Appendix C, online at *www. missingmanuals.com/cds*) because all it does is smear the paint and move it around, creating a truly *awful* effect.

15. **Create a new layer named** *Effects* **and drag it to the top of your layer stack.**

If your painting needs a bit more punch, use this new layer to add some special lighting effects. Figure 12-18 (right) shows blue-tinted shadows around the edges of the angel's face and in her hair. If you change this layer's mode to Multiply, the blue paint acts like a double coat of ink (lowering the layer's opacity to about 75 percent makes the effect subtle).

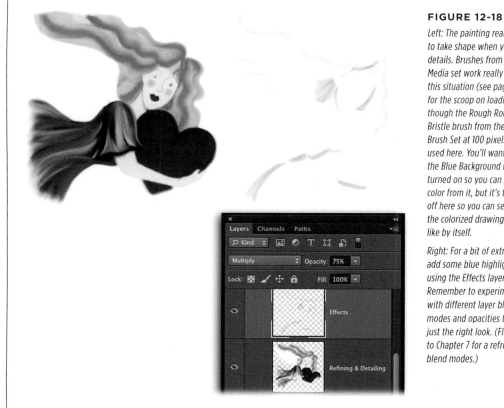

FIGURE 12-18

Left: The painting really starts to take shape when you add details. Brushes from the Dry Media set work really well in this situation (see page 543 for the scoop on loading 'em), though the Rough Round Bristle brush from the Assorted Brush Set at 100 pixels was used here. You'll want keep the Blue Background layer turned on so you can pick up color from it, but it's turned off here so you can see what the colorized drawing looks like by itself.

Right: For a bit of extra polish, add some blue highlights using the Effects layer. Remember to experiment with different layer blend modes and opacities to get just the right look. (Flip back to Chapter 7 for a refresher on blend modes.)

16. **Add some texture by painting with a grainy brush on another new layer, or by adding a photo of some texture to the document.**

 To keep the painting from looking too perfect and, well, *digital*, try messing it up by adding texture. You can use *any* technique to create texture, including adding a new, empty layer, and then painting on it with a grainy, funky-edged brush. However, it's faster to add a *photo* of some texture to the top of your layer stack with the File→Place Embedded (or Place Linked) command, and then changing its layer blend mode to Overlay (feel free to experiments with other blend modes, too). Figure 12-19 shows this texture-inducing maneuver in action using—get this—a photo of a piece of *tile*.

17. **Save your finished painting by pressing ⌘-S (Ctrl+S).**

 Congratulations for sticking through a *ton* of steps to create your first digital painting from scratch!

FIGURE 12-19

Texture can give a painting life and keep it from looking plastic because it's too perfect (left). In this example, a photo of a slate tile was added at the top of the layer stack. Changing the photo layer's blend mode to Overlay gives the painting a little depth and makes it look more believable (right).

*This image, created by Deborah Fox (*www.deborahfoxart.com*), was recognized for creative excellence in advertising with an ADDY award.*

As you can see, Photoshop paintings are a lot of work, but they can be very rewarding. Putting every aspect of the painting on a separate layer lets you build the image gradually so you don't destroy the whole thing if you mess up. OK, who needs a nap?

TIP To learn more about digital painting techniques, pick up a copy of *ImagineFX* magazine (*www.imaginefx.com*) or visit these websites: Computer Graphics Society (*www.cgsociety.org*), Deviant Art (*www.deviantart.com*), and Epilogue (*www.epilogue.net*). You'll be glad you did!

Loading More Built-in Brushes

For all the brushes you see in the Brush Preset picker and the Brush Presets panel, there are *hundreds* more built-in brushes lying in wait—you just have to load 'em. More brushes mean more creativity for stuff like digital paintings, applying a painted edge to a photo (described in the following steps), adding a sparkle (page 546), or aging a photo so it looks torn and tattered (pages 564–565).

Here's how to load more brushes *and* give your photo a painted edge (if you want to skip the technique and go straight to loading brushes, see step 6):

1. **Open a photo and, if the document includes a locked background layer, single-click the background layer's padlock icon to unlock the layer.**

 This technique involves adding a layer *beneath* the background layer, which Photoshop won't let you do. The fix is to unlock the background layer first by clicking its padlock icon in the Layers panel.

POWER USERS' CLINIC

Shading an Object by Hand

On page 299, you learned that the Dissolve blend mode turns semi-transparent pixels into a spray of dots. While that's not very useful on a *daily* basis, it turns out that when you set the Brush tool to Dissolve mode, you get a brush that's absolutely *perfect* for hand-shading objects you've drawn in Photoshop.

For example, let's say you used the Custom Shape tool—set to Shape mode so it creates a new layer—to draw a heart (one of Photoshop's built-in shapes). And then you used the Options bar's Fill setting to fill the heart with red. To give the shape some depth, you can add some soft, dark shading around its edges

Load the heart as a selection by ⌘-clicking (Ctrl-clicking on a PC) its layer thumbnail. Then add a new, empty layer for the shading. Grab the Brush tool and, in the Options bar, choose a big, soft-edged brush from the Brush Preset picker and set the Mode menu to Dissolve. Next, set your foreground color chip to black, and then mouse over to your image and paint all the way around the heart's edges. Since you wisely selected that area that you wanted to paint, your brushstrokes only affect the area *inside* the selection, keeping you from painting outside the lines.

To soften the shading, lower its layer opacity and/or run a Gaussian Blur filter. That's all there is to it!

2. **Add a solid white fill layer to the bottom of your layer stack.**

In a few steps, you're going to hide the image's edges with a layer mask. If you don't add a layer filled with color, then when you hide the image's edges, you'll see through to the transparent checkerboard pattern, which makes it tough to see the creative edges you're about to add. A white background (or other solid color) works much better. Click the half-black/half-white circle at the bottom of your Layers panel and choose Solid Color. In the resulting Color Picker, choose white and then click OK. Drag this layer to the bottom of your layer stack.

3. **Press M to grab the Rectangular Marquee tool, and then draw a selection box about an inch or so *inside* the edges of your image.**

You'll paint the edges *outside* this box in step 8. The more space you leave between the edge of the document and your selection, the wider your painterly edge will be.

4. **Activate the image layer and then add a layer mask to it.**

In the Layers panel, activate the image layer, and then click the circle-within-a-square icon to add a layer mask. When you do, Photoshop hides the part of the photo that's outside the selection you made in the previous step.

5. **Press B to grab the Brush tool and then, in the Options bar, open the Brush Preset picker.**

Head up to the Options bar and click the down-pointing triangle next to the second icon from the far left to see all the brush presets. (The Brush Preset picker is labeled back in Figure 12-10).

6. **In the Brush Preset picker, click the gear icon and choose Faux Finish Brushes.**

Click the gear icon to see brush preview sizes, options for loading and saving brushes, and so on. (You can find these same options in the Brush Presets panel's menu.) At the bottom of the list are several brush categories, such as Assorted Brushes, Basic Brushes, and so on. Click Faux Finish Brushes; when you do, Photoshop asks if you want to replace your current brushes with the new ones. Instead of clicking OK, click *Append* to make Photoshop add them to the bottom of your brush list.

7. **Pick one of the new brushes.**

Scroll down the list of brushes until you see "Rolled Rag – Terry 120 pixels," and then click it. Mouse over to your document and you'll see the funky, square-ish brush cursor circled in Figure 12-20.

8. **Set your foreground color to black, activate the layer mask, and then paint along the edges of the image to create a unique border.**

Peek at the color chips at the bottom of the Tools panel and press D to set them to black and white, and then press X until black hops on top. With the layer

mask active, paint over the edges of the photo as shown in Figure 12-20. If you hide too much of the image, press X to swap color chips so white is on top, and then paint the areas you want to reveal.

FIGURE 12-20

Be sure to use short brushstrokes or you'll create an edge that looks like a repeating pattern of your brush cursor's shape. Just keep brushing back and forth until you get an interesting look. (Alternatively, skip ahead to page 551 to learn how to adjust Angle Jitter in the Brush panel.)

By using a layer mask to create this effect, the original image remains unharmed, as shown in this Layers panel. If you like this edge effect, you can create something similar by using the Refine Edge dialog box. Flip back to page 189 for instructions.

9. **Save your image as a PSD file.**

 If you decide to go back and edit the painted edges, just activate the layer mask, grab the Brush tool, and have a ball.

■ MAKING AN OBJECT SPARKLE

Another fun use for interesting brushes is to make an object look like it's sparkling. To get started, perform steps 6 and 7 of the previous list, but instead of loading the Faux Finish Brushes, load the Assorted Brushes.

Once the new brushes are in your Brush Preset menu, scroll down the list of brush previews and you'll spot a couple of *crosshatch* brushes that make perfect sparkles once you rotate 'em (see Figure 12-21). Click one of the crosshatches to activate it, click your foreground color chip at the bottom of the Tools panel, and then pick a nice gold from the resulting Color Picker (or use the Color panel to change foreground colors, as describe on page 527).

FIGURE 12-21

Top: The Assorted category's crosshatch brushes, like the one circled here, are perfect for making an object look like it's sparkling.

Bottom: The beauty of putting each sparkle on its own layer is that you can move them around, spin 'em, and control their intensity with the layers' opacity settings.

If you load a new set of brushes and then want to get back to the set you had when you first started using Photoshop CC, click the gear icon labeled back in Figure 12-10 and then choose Reset Brushes.

Then, over in the Layers panel, create a new layer for each sparkle, so you can rotate 'em individually. With the *first* new layer active (it should be at the top of the Layers panel), click once in your image to add a sparkle. Add another new layer, and then click again to add another sparkle. Finally, rotate the sparkle using Free Transform by pressing ⌘-T (Ctrl+T); page 276 has the lowdown on using the transform tools. Press Return (Enter) when you're finished rotating, and then Shift-click both sparkle layers in the Layers panel to activate them. Then press V to grab the Move tool and drag the sparkles into place.

> **TIP** You can press the V key to *temporarily* switch to the Move tool. When you let go of the key, you switch back to whatever tool you were using before.

Painted photo edges and sparkles are just two of an infinite number of visually interesting effects you can create using the brushes that come with Photoshop. Look through the various brush sets and see if some of the unusual shapes inspire you to try another technique!

Customizing Brushes

Once you get comfortable with the Brush tool, you can experiment with changing the way it *behaves*. For example, maybe you'd like to adjust the spacing between brush marks in a single stroke, or have the brush apply a texture. Happily, the Brush panel (Figure 12-22) gives you an *amazing* amount of control over brushes. To open it, click the Brush panel icon that you see in the Options bar whenever the Brush tool is active (it looks like a tiny panel), or choose Window→Brush.

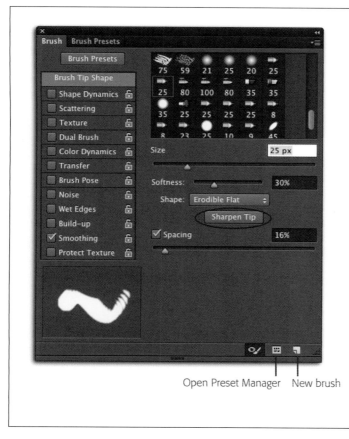

Open Preset Manager New brush

FIGURE 12-22

The Brush panel gives you a gaggle of options for changing the way brushes behave. By mastering these controls, you can create some super-cool brushes that make your brushstrokes look realistic (not too perfect).

Start by choosing one of the brush tips in the top-right part of the panel (the number beneath each tip represents its default size in pixels). If you don't see any brush tips, click the Brush Tip Shape category on the panel's left side. And if the panel's settings are all dimmed, simply switch to a tool that uses a brush cursor, like the Brush tool (obviously) or the Eraser tool.

Here, one of Photoshop's Erodible brush tips is active. These tips wear down as you use 'em, just like real chalk or graphite (pencil lead), though you can use the Softness slider shown here to control how fast the tip melts away (a setting of 100 percent prevents it from wearing down at all). After using the tip, you can restore it to its original shape by clicking Sharpen Tip (circled). For easier access to this command, assign it a keyboard shortcut by choosing Edit→Keyboard Shortcuts; set the Shortcuts For drop-down menu to Tools, and then scroll down until you see the Sharpen Erodible Tip command (see the box on page 31 for more on customizing keyboard shortcuts).

TIP As noted in the Tip on page 529, once you use the Brush panel to change a brush preset's settings, its outline in the Brush and Brush Presets panels turns *gold* to let you know it's been changed.

Brush Panel Settings

The following pages explain the various settings you can tweak in the Brush panel, but here's the *basic* procedure for customizing brushes:

1. **Pick a brush tip preset from the Brush panel's top right or by opening the Brush Presets panel.**

 You choose a brush tip by simply clicking its icon; Photoshop outlines the icon in blue to let you know it's active.

2. **In the Brush panel, click a category on the panel's left side, and then tweak the various settings that appear on the right.**

As you adjust settings, the preview at the bottom of the panel shows how those changes affect the brush. Once you've got the brush's settings just right, in the list on the left side of the panel, click the padlock icon to the right of that setting's name to lock those options.

The next few sections explain the various ways to customize brushes—Photoshop gives you a *ton* of choices, including options that you let you alter the individual *brush marks* (the look of pixels created by a single dab of the brush tip) that comprise a *brushstroke*.

> **NOTE** In the following pages, you'll learn a million ways to customize brushes (OK, maybe not quite that many, but a bunch). It'd be great to list an example of what each customization is best suited for, but there's just not enough room in this book. You can use a brush to paint nearly anything in Photoshop, so how you use the following options depends more on your personal preferences and experimentation than on a specific formula. The majority of these settings are geared toward introducing randomness into brushstrokes so they don't look too perfect and computery.

■ BRUSH TIP SHAPE

Not surprisingly, the settings in this category affect how the *tip* of the brush is shaped, which determines how your brushstrokes look. Once you pick a brush tip from the list of presets at the top right of the Brush panel, you can control the following characteristics:

> **NOTE** The options in this category differ depending on which brush *tip* you pick. For example, if you choose a Soft Round brush tip, you see the options in the following list. But if you choose a Round Fan brush tip instead, you get a *different* set of options including bristle shape, length, thickness, and so on. This list covers some of the most common settings.

- **Size.** This setting controls how big the brush is. You can also change size by going to the Options bar, clicking the down-pointing triangle to the open Brush picker, and then adjusting the Size slider. Another option is Control-Option-dragging (Alt-right-click-dragging on a PC) left to decrease the brush size or right to increase it. (When you drag, a handy info overlay appears next to your cursor showing the brush's diameter, hardness, and opacity.) You can also

decrease/increase brush size by pressing the left/right square bracket keys on your keyboard ([]), respectively.

- **Flip X.** Turning on this setting flips the brush tip horizontally. For example, if the brush is shaped like a curved line that points to the right, turning on this checkbox makes it point left instead. If the brush is symmetrical, you won't notice any change.

- **Flip Y.** This checkbox flips the brush vertically. If your brush tip is a leaf that points up, for example, this setting will make it point down.

- **Angle.** If you're working with an irregular-shaped or elliptical brush, this setting lets you change its angle, which is great for making a chiseled stroke (imagine an ellipse tilted to one side, similar to calligraphy). You can either enter a number in the Angle field or drag the right-facing arrow in the crosshairs diagram to the right of the field.

- **Roundness.** This setting controls the brush's shape, from perfectly round (100%) to elliptical. You can enter a percentage or click one of the white dots on the crosshairs image and drag up or down to change this setting.

- **Hardness.** This slider controls the brush's *edges*, from 0 percent (very soft) to 100 percent (hard). The harder the edges, the cleaner your lines; softer edges create an airbrushed look, which is useful for making colors blend together. Unfortunately, you can't adjust this setting on custom brushes you've made from images. Bummer!

- **Spacing.** This slider lets you adjust the amount of space between brush marks when you make a stroke. The lower the percentage, the closer they are, creating a more solid, cleaner line. Higher percentages cause gaps between the brush marks, which is *excellent* if you've also tweaked the Scattering settings (page 552). If you turn off the Spacing checkbox, Photoshop bases the spacing on how quickly you move the mouse while you paint: Drag slowly for narrow spacing and quickly for wider spacing.

◼ SHAPE DYNAMICS

When you paint with a real brush, the strokes aren't perfectly uniform (you'd be hard-pressed to make two identical strokes). These options let you create brushes that produce natural, realistic-looking brushstrokes that are made up of a series of brush marks rather than solid, perfect-looking brushstrokes.

- **Size Jitter** and **Control.** These settings determine how much the size of the brush marks varies (see Figure 12-23). With this setting, you can specify how much jitter you want by entering a percentage or dragging the slider, or turn it off altogether by setting this Control menu to Off. The Control menu's Fade setting makes each stroke taper off (like the brush ran out of paint) within the number of steps you enter in the text box that appears. Setting the Control menu to Pen Pressure makes the stroke taper off at the beginning and end of the mark *if* you're using a digital drawing tablet. If you have a high-end tablet

like an Intuos or Cintiq (*www.wacom.com*), you can choose the Stylus Wheel or Pen Tilt setting for other variations (like being able to tilt the brush by tilting your pen).

FIGURE 12-23

The jitter controls let you introduce a bit of randomness into the brush marks in your stroke. Here's an example of a brushstroke with no jitter (left) and one with size and angle jitter turned on (right).

Some of the settings in the Shape Dynamics category may not work for you. For example, Pen Pressure doesn't work with a mouse, so if you choose it from the Control menu and you don't have a digital drawing tablet attached to your computer, you'll see a tiny triangular warning symbol next to the menu.

- **Minimum Diameter.** This setting controls how small the brush can get. It's helpful on custom brushes when you don't want them to get too small, and on round or elliptical brushes when you don't want them to get too thin.

- **Tilt Scale.** This setting is available only if you have a digital drawing tablet (otherwise it's dimmed); it lets you resize the brush by tilting your stylus.

- **Angle Jitter** and **Control.** These settings determine how much the angle of the brush marks vary within a single stroke. It's automatically set to 0 percent, but if you want a lot of variation in the angle of your brushstrokes, set it higher. Use this Control drop-down menu to choose from settings like Off, Fade, Pen Pressure, Pen Tilt, and Stylus Wheel, discussed earlier in the Size Jitter bullet. The other options are Rotation, which rotates the brush marks; Initial Direction, which bases the brush-mark angle on the way you *initially* drag the mouse when you start the brushstroke; and Direction, which bases the brush-mark angle on the direction of the brushstroke. Adjusting the angle jitter of sampled brushes (custom brushes you've made from images—see page 562) can turn a flat, repetitive brushstroke into a richly textured one.

- **Roundness Jitter** and **Control.** These settings control how much the roundness of your brushstrokes varies. This Control menu includes Off, Fade, Pen Pressure, Pen Tilt, Stylus Wheel, and Rotation options. If you've turned on Brush Projection (see the last bullet in this list), these settings are dimmed.

- **Flip X Jitter** and **Flip Y Jitter.** These checkboxes let you flip the jitter on its x- or y-axis (or both), much like you can flip the brush's shape.

- **Brush Projection.** If you're using a digital drawing tablet, this option lets you apply tilt and rotation settings to the brush tip to make it behave more like a real brush. For example, if you're using a brush tip that has a shape to it (say, a fan brush), the brush marks inside the brushstroke curve, stretch, and rotate as you tilt and rotate your stylus. Turning on this checkbox overrides the Round-ness Jitter and Control settings mentioned above.

■ SCATTERING

Head to this category when you want to make the spacing between brush marks a bit random as if your brushstroke were splattered onto the canvas instead of applied evenly (see Figure 12-24). You can adjust the following settings:

- **Scatter**, **Both Axes**, and **Control.** Unless you change this setting, all your brush marks will follow the line of your stroke. The Scatter slider distributes the brush marks above and below the center of the stroke line, giving them a random look. Turn on the Both Axes checkbox to make Photoshop scatter to the right and left, too. This Control menu's options are described in the previous section.

The Joy of Painter

If you got a charge out of creating a painting from scratch (page 536), then you may enjoy using a program called Painter (*www.corel.com/painter*) as a companion to Photoshop. For years, Painter has been revered by fine artists, commercial designers, and entertainment artists who work on everything from special effects to character and set design.

Painter is designed *by* artists *for* artists: It's the digital equiva-lent of a traditional art studio. It works on both Macs and PCs, and it costs about $60 for the junior version (called *Essentials*) or $400 for the full version. If you want to get really *serious* about digital painting, it's a must-have. Here's a sampling of what you can do with it:

- See the bristles of each brush and how they splay on your canvas, just like real-world brushes.
- Control how fast the paint dries, where the wind is coming from, and how many bristles are in the brush.
- Create color swatches from an image, layer, or a mixer pad, letting you have custom swatch sets for different projects.
- Blend paints using a mixer pad just as if you were mixing two colors of wet paint together.
- Specify the kind of (virtual) paper you're drawing on and whether your brush picks up its texture. You can also

create custom brush- and paper-texture palettes (the equivalent of Photoshop's panels).

- Turn a photo into a painting, and use Painter's new physics-based Particle brushes to create realistic fire, smoke, fabric, and hair.
- Automatically save the settings you use for individual brushes so you don't have to keep resetting them. For example, if you tweak one brush, switch to another brush, and then go back to the *first* one, Painter remembers the settings you used for it (unlike Photoshop, which *resets* the original brush completely unless you save it as a preset).

You can save Painter projects as layered PSD files that you can open in Photoshop for more fine-tuning like color-correcting (Chapter 9) and sharpening (Chapter 11). You can also work the other way around and open PSD files in Painter.

For *true* bliss, invest in a Wacom digital drawing tablet while you're at it (*www.wacom.com*) and then you may *never* leave your studio again. A digital drawing tablet is an electronic pad that you draw on using a special pen called a *stylus*. You can control brush size and opacity by varying the amount of pressure you apply to the tablet with the stylus. Combined with the Rotate View tool (page 62), a tablet gives you a truly natural painting experience—without all the mess!

- **Count.** This setting controls the number of marks Photoshop applies at each spacing interval, which you set using the Spacing setting in the Brush Tip Shape category (page 549). Increasing this setting means more marks; lowering it means fewer marks.

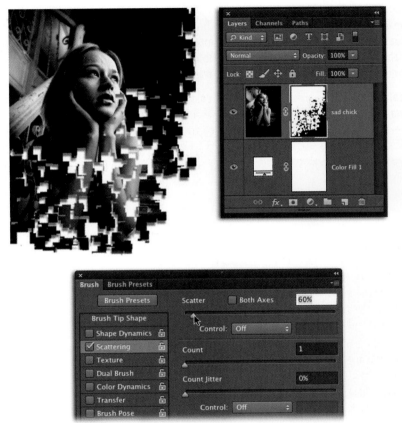

FIGURE 12-24

When you use a scatter brush inside a layer mask, you can break a photo into pieces.

To create this effect, add a layer mask to an image layer. Activate the Brush tool, open the Brush Presets panel and load the Square Brushes category (see steps 6 and 7 on page 545). Pick a square brush and then, in the Brush panel, turn on Scatter and set it to 60 percent. Also, in the Brush panel's Brush Tip Shape category, make sure the Spacing setting is 25 percent (it will be unless you've changed it). Finally, with the layer mask active and black as your foreground color, paint to hide the image in the shape of the brush tip, as shown here.

- **Count Jitter** and **Control.** These settings control how random the number (quantity) of brush marks is. If you're using a digital drawing tablet, set this Control menu to Pen Pressure to make the brush marks be dense in the middle of the stroke but thin out at the beginning and end.

■ TEXTURE

These options let you apply a repeating pattern to your brushstrokes, which makes them look textured. Photoshop comes with a ton of built-in pattern recipes—although you have to load most of 'em as explained in Figure 12-25. You can also create your own by choosing Edit→Define Pattern (see page 94).

- **Invert.** In Photoshop, *texture* doesn't literally mean that some parts of your image stick up farther than others (like a relief map), so the program bases texture on the *colors* in a pattern. It considers dark areas "lower" than lighter ones, which makes sense because, in the real world, more light reaches the parts of a textured surface that protrude and lower areas are darker because they're filled with shadows. Also as in real life, when you paint over a textured part of a document, the lighter (higher) areas get more paint than darker (lower) ones since the hairs on your brush have a hard time reaching down into those low areas. If you turn on this checkbox, Photoshop reverses the high and low points of the texture, so light areas are low points that don't get very much paint and dark areas are the high points that get lots of paint.

- **Scale.** This slider adjusts the pattern's size. Drag it left to make the pattern smaller or right to make it bigger.

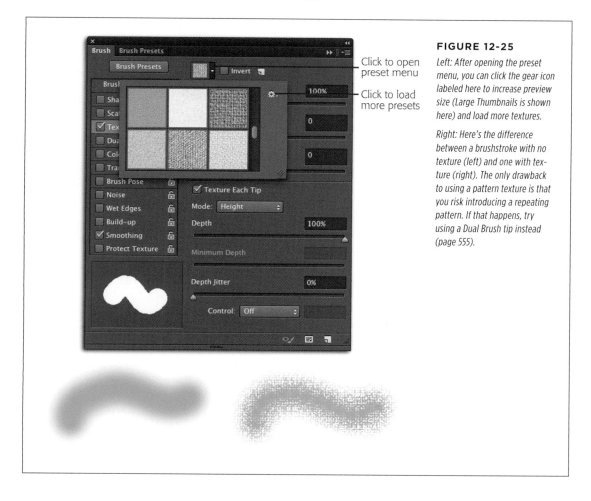

Click to open preset menu

Click to load more presets

FIGURE 12-25

Left: After opening the preset menu, you can click the gear icon labeled here to increase preview size (Large Thumbnails is shown here) and load more textures.

Right: Here's the difference between a brushstroke with no texture (left) and one with texture (right). The only drawback to using a pattern texture is that you risk introducing a repeating pattern. If that happens, try using a Dual Brush tip instead (page 555).

- **Brightness** and **Contrast.** These two sliders let you tweak the brightness and contrast of the texture within a brushstroke. Before CS6, there was no way to do this; you had to create different *versions* of the texture to produce lighter, darker, or higher-contrast brushstrokes.

- **Texture Each Tip.** This checkbox makes Photoshop apply the texture to each brush mark *within* the stroke, rather than the *whole* stroke, creating a more textured look (and slightly less chance of a painfully obvious repeating pattern). You have to turn this setting on to use the Depth Jitter setting discussed later in this list.

- **Mode.** Here's where you pick the blend mode Photoshop uses to apply the pattern to the brushstroke (see Chapter 7 for the lowdown on blend modes).

- **Depth.** This slider controls how deeply the paint "seeps into" the texture by increasing the contrast of the colors in the texture. Choosing a high percentage here means the "low" points of the texture won't get any paint, and entering a low percentage here means all the areas get the same amount of paint—which reduces the contrast so much you can't see the texture.

- **Minimum Depth.** This slider lets you set the minimum depth that paint can seep into the texture. (This slider is dimmed unless you pick an option from the Control menu, described next.).

- **Depth Jitter** and **Control.** When the Texture Each Tip checkbox is turned on, these settings let you introduce randomness into how the depth varies. Drag this slider left to decrease the amount of depth jitter, or right to increase it. In the Control menu, you can choose Off, Fade, Pen Pressure, Pen Tilt, Stylus Wheel, or Rotation (discussed on pages 550 and 551). Picking an option other than Off activates the Minimum Depth slider described above.

■ DUAL BRUSH

These options let you combine two brush tips to introduce more texture and randomness into a brushstroke or give texture to a brush that doesn't have any. Photoshop applies the second brush's texture to the first brush's brushstrokes wherever the two strokes overlap, as shown in Figure 12-26 (brush tips of differing shapes will overlap in different places). To choose two brushes, pick your first brush from the Brush Tip Shape category by clicking one of the presets and then adjusting its options. Then click the Dual Brush category, choose a second brush there, and then adjust its options.

The Dual Brush category includes these options (they all apply to the *second* brush):

- **Mode** lets you set the blend mode Photoshop uses to combine your brush marks into a brushstroke. (This drop-down menu is at the top of the Brush panel, above the list of presets.)

- **Flip** introduces a bit of randomness into the frequency with which Photoshop uses each brush tip within a brushstroke.

- **Size** controls the size of the second brush tip.

- **Spacing** controls the distance between each tip's brush marks in a stroke.

- **Scatter** controls how the brush marks are distributed throughout the stroke.

- **Count** lets you specify the number of brush marks at each spacing interval.

FIGURE 12-26

To introduce texture to a brush that doesn't have any, like the leaf brush shown here (left), head to the Dual Brush category and choose a textured brush tip as your second brush.

The image on the right shows what such a combination looks like.

■ COLOR DYNAMICS

These settings control how the paint color varies throughout a brushstroke—another way to introduce a bit of variety into your strokes so they don't look uniform (see Figure 12-27).

FIGURE 12-27

The Color Dynamics settings can make a brushstroke look like it's made from more than one color. With green as your foreground color and Color Dynamics turned off, your brushstroke will look like the one on the left. But if you turn on Color Dynamics and set your background color to yellow, you can use the Foreground/ Background Jitter slider to create a brushstroke that randomly combines those two colors (middle). And if you turn on the Hue Jitter setting, Photoshop introduces all kinds of funky colors (right).

- **Apply Per Tip.** Turn on this checkbox to apply variations to every brush mark in a brushstroke (rather than varying the brush mark *once* per brushstroke).

- **Foreground/Background Jitter** and **Control.** These settings let you control how the paint alternates between your foreground and background colors throughout a stroke. In this Control menu, you can choose from Off, Fade, Pen Pressure, Pen Tilt, Stylus Wheel, or Rotation (all described on pages 550 and 551).

- **Hue Jitter.** Lets you control color variation in your brushstroke; a higher setting introduces all kinds of funky colors. Drag the slider to the right to shift the color farther away from the original color, or drag it left to shift the color less. If you have Apply Per Tip turned on, the color will vary within the stroke, as shown in Figure 12-27 (right).

- **Saturation Jitter.** Increasing this setting makes Photoshop vary the color saturation once per stroke. If you turn on the Apply Per Tip checkbox, then it varies the saturation for each brush mark inside the stroke.

- **Brightness Jitter.** Use this setting to vary the brightness of the color once per stroke, or for each brush mark *inside* a stroke if you turn on the Apply Per Tip checkbox. A setting of 0 represents 100 percent of the color you're using, and dragging this slider to the right darkens the color's brightness.

- **Purity.** This setting controls how far the color varies from its original saturation value once you've tweaked Saturation Jitter. Adjust this setting to a positive percentage for more variation, or to a negative percentage for less variation.

▪ TRANSFER

This category lets you adjust how much paint Photoshop transfers to the "paper" (your document) with each brushstroke (see Figure 12-28). The Opacity and Flow settings here *override* the ones in the Options bar, so if you tweak them, you may find that the Options bar's settings don't seem to work. For example, if you set the Brush panel's Opacity Jitter to 60 percent, that's the most opaque your brush can be, even if you set Opacity to 100 percent in the Options bar. (You've been warned!) Here are your options:

- **Opacity Jitter** and **Control.** These settings control how transparent the paint is throughout the brushstroke. A higher percentage here makes the stroke more see-through (see Figure 12-28, bottom). In this Control menu, your choices are Off, Fade, Pen Pressure, Pen Tilt, and Stylus Wheel (see pages 550 and 551).

- **Flow Jitter** and **Control.** This lets you specify how much paint the brush lays down throughout the brushstroke. A higher percentage means the flow varies more, and a lower percentage means it varies less. This Control menu gives you the same options as the Opacity Jitter Control menu.

FIGURE 12-28

*To make your brushstroke's opacity vary randomly,
increase the Opacity Jitter setting.*

*Here you see the difference between a brushstroke with
no opacity jitter (top) and one with the opacity jitter set to
100 percent (bottom).*

- **Wetness Jitter** and **Control.** When you're painting with the Mixer Brush, you can use this setting to make Photoshop vary how wet (liquidy) your brushstrokes are.

- **Mix Jitter** and **Control.** Also available when you're using the Mixer Brush, these settings let you vary how much paint you're mixing from the canvas onto your brush.

- **Minimum.** Once you make a choice from the Control drop-down menus for the Opacity Jitter, Flow Jitter, Wetness Jitter, and Mix Jitter settings, you can use these sliders to set their minimum values.

■ BRUSH POSE

You can use the settings in this category to control brush tilt, rotation, and pressure with a digital drawing tablet or mouse. If you're using a tablet, you can override its input by turning on the Override checkboxes beneath each slider, which can be handy when you need to create exactly the same brushstroke over and over and over again. If you don't have a tablet, these settings let you make your mouse behave more like a stylus.

■ NOISE

This setting lets you introduce more texture and randomness into brushstrokes you make with soft-edged brushes. Turn on this checkbox to make Photoshop apply a dose of random, grainy texture to the semi-transparent edges of a soft brush tip (if you're using a dual brush tip, the noise applies to both tips; if you're using a hard-edged brush, nothing happens).

■ WET EDGES

Turning on this checkbox makes the center of your brushstrokes transparent, so the paint looks like it's building up along the edges of the stroke (similar to painting with watercolors).

■ BUILD-UP

Turn on this checkbox to make your brush behave like a professional artist's airbrush rig. This setting has the same effect as clicking the Options bar's Airbrush icon (page 530). Basically, Photoshop adds brush marks as long as you hold down your mouse button, and extends the brush marks past your cursor to create a real-world spray effect.

■ SMOOTHING

To make your brushstrokes look smoother than they were when you painted them, turn on this checkbox. It's especially helpful if you don't have a very steady hand, which can make for jagged brushstrokes.

■ PROTECT TEXTURE

This checkbox lets you apply the same texture, pattern, and size to all the built-in brush presets that have a texture. For example, you could use this option to make it look like you're painting on the same surface with a variety of brushes without actually having to turn on the Texture category for each brush. You can think of this as a *global* texture option.

Suggested Brush Customizations

With so many settings to choose from, it can be confusing to figure out which brushes really need changing. You'll find the built-in presets really handy, and with just a few tweaks here and there, they can become *indispensable*. Figure 12-29 shows a sample of some simple, extremely useful customizations. If you like what you see, check out Table 12-1 to learn about specific settings.

FIGURE 12-29

There's no limit to the number of brushes you can customize or create, so feel free to go hog wild!

Here are a few brushes digital artists can't live without. The first column shows what a single dab of paint looks like using each brush so you can get an idea of the brush's shape. The second column shows a single brushstroke, and the third column shows multiple brushstrokes using three different colors of paint (yellow, green, and blue).

If any of these brushes strike your fancy, Table 12-1 lists the specific settings used to create each one.

TABLE 12-1 *Suggested brush customizations*

BRUSH NUMBER IN FIGURE 13-30	DESCRIPTION	OPACITY[1]	SPACING[2]	SHAPE DYNAMICS	OTHER DYNAMICS	USES
1	Round, hard-edged brush	25%	0%	Size Jitter = Pen Pressure	None	Shading, blocking in color, sketching
2, 3	Rough-edged brush	25%	0%	None	With (2) or without (3) Flow Jitter = Pen Pressure	Shading, adding texture, making hair
4	Rough brush (custom)[3]	30%	0%	Angle Jitter = 20%; Control = Off	None	Adding texture, shading
5	Small dot brush (custom)[3]	30%	0%	Size Jitter = Pen Pressure	Opacity Jitter = Pen Pressure	Making hair, shading
6	Round, rough-edged brush	100%	20–25%	Size Jitter = Pen Pressure	Opacity Jitter and Flow Jitter = Pen Pressure	Shading, blocking in color
7	Textured round brush	30%	0%	None	Flow Jitter = Pen Pressure	Adding texture, shading
8	Textured round brush	100%	0%	Size Jitter = Pen Pressure	Flow Jitter = Pen Pressure	Sketching, creating line art, adding fine details in small areas
9	Scattered spot brush (custom)[3]	70%	25%	Scatter = 20%; Size Jitter = Pen Pressure	Opacity Jitter and Flow Jitter = Pen Pressure	Adding texture

1. Adjust this setting in the Options bar.
2. Set this in the Brush panel's Brush Tip Shape category (page 549).
3. Meaning a custom brush you make from scratch as described in the next section.

■ Defining a New Brush

For some seriously creative fun, try making your own brushes. You can make them out of anything—a stroke that you've drawn with another brush, your logo, even an image that you've scanned into your computer to use as texture (like a leaf). Some folks call brushes that you create yourself *sampled brushes* because you *sample* part of a pattern, object, or image to create them; in other words, you have to create a selection of the pattern, object, or image you want to base the brush on.

The first step is to create the *paint dab*—a dab of paint that will form the shape of the new custom brush tip (see Figure 12-30, left). You can create a paint dab in a variety of ways, which range from quick to incredibly involved. The basic premise is to create a 300 × 300–pixel document and then use a variety of brushes at various opacity settings to create the dab. You can even add texture to it—the more irregular and messy the dab, the more interesting your brush will be. To turn the dab into a brush that you can use to apply color, you *have* to create it using black and gray paint at 100 percent opacity (that's the *Options bar's* opacity setting). When you paint with the brush later, the 100 percent black areas will create opaque color and the gray areas will be semitransparent.

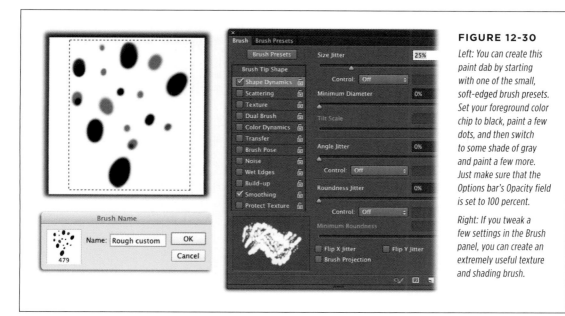

FIGURE 12-30

Left: You can create this paint dab by starting with one of the small, soft-edged brush presets. Set your foreground color chip to black, paint a few dots, and then switch to some shade of gray and paint a few more. Just make sure that the Options bar's Opacity field is set to 100 percent.

Right: If you tweak a few settings in the Brush panel, you can create an extremely useful texture and shading brush.

NOTE To practice making a custom brush using the paint dab shown in Figure 12-30, download *DotsBrush. psd* from this book's Missing CD page at *www.missingmanuals.com/cds*.

Once you've created a paint dab, follow these steps to turn it into a brush:

1. **Use the Rectangular Marquee tool to select the dab.**

 Press M (or Shift-M) to grab the Rectangular Marquee and draw a selection around the dab (Figure 12-30, top left).

2. **Choose Edit→Define Brush Preset.**

 In the resulting dialog box (Figure 12-30, bottom left), name your brush and then click OK.

3. **Create a new document (it can be any size), and then press B to grab the Brush tool.**

 Press ⌘-N (Ctrl+N) to open a new document so you can test drive your new brush.

4. **In the Options bar, choose your new brush from the Brush Preset picker and then open the Brush panel.**

 Once you've activated your new brush, open the Brush panel by clicking the icon to the right of the Brush Preset picker or choosing Window→Brush. Alternatively, you can open the Brush panel first: Just click the Brush Presets button at the top of the Brush panel (or the Brush Presets tab, if you've already opened that panel) and then choose your new brush from there (it'll be at the end of the list).

5. **In the Brush panel, adjust the settings in the Brush Tip Shape category.**

 To create a brush similar to number 4 in Figure 12-29, set the size to 100 pixels, the angle to 70 degrees, and the spacing to 1 percent. If you have a digital drawing tablet, click the Other Dynamics option and then set the Opacity Jitter and Flow Jitter options' Control menus to Pen Pressure.

6. **Adjust the Shape Dynamics category's settings.**

 If you have a digital drawing tablet, set Size Jitter to Pen Pressure and Minimum Diameter to 30 percent. If you don't have a digital drawing tablet, try entering a Size Jitter of 25 percent instead (you just won't be able to change it by applying more or less pressure with your pen).

7. **Turn on the Smoothing checkbox, if it isn't already on.**

 As explained on page 559, this setting makes your brushstrokes less jagged.

8. **Save your brush again.**

 At the Brush panel's bottom right, click the "Create new brush" icon (it looks like a piece of paper with a folded corner). In the resulting dialog box, give the brush the same name that you did in step 2.

Not only have you created a brush that's great for adding textures to digital paintings, but you can also use it to create some interesting grunge effects when you're editing photos. The ability to make your own brushes gives you a ton of control when you're applying textures.

■ Sharing and Installing New Brushes

If you feel the need to *share* your custom brushes with the masses, you're not alone. Folks love sharing the custom goodies they make in Photoshop. That's why all manner of free and low-cost brushes are available on the Web. You can even download a brush set that'll make your image look like it was printed on wrinkled or torn paper, as shown in Figure 12-31.

To share your new brush with the masses, head to the Brush Preset panel's menu and choose Save Brushes (the Brush panel's menu doesn't have this option). Give the brush a name and then hop on over to the Adobe Add-Ons website and upload your file to achieve Photoshop fame. You can access this site by choosing Help→Adobe Add-Ons or Filters→Browse Filters Online. Once you're on the site, click Photoshop in the list of applications on the left, and then either scroll through the resulting list of goodies or enter a term in the search box. For example, you could type brush, action, gradient, or whatever to see just those items.

Once you've downloaded the brush (or brushes) to your hard drive, activate the Brush tool, and then head to the Options bar and open Brush Preset picker. Next, click the gear icon labeled in and choose Load Brushes. Navigate to where you saved the file (look for a file whose name ends in ".abr," such as *Paper_Damage.abr*), and then click Load. The new brushes appear in the Brush Preset picker, at the bottom of the list, ready for you to use.

> **TIP** You can also find brushes, and other downloadable goodies using the Creative Cloud application. To do that, open the app by clicking the Creative Cloud icon in the menu bar at the very top of your screen (it looks like two intersecting Cs). On the screen that appears, click Assets, and then click the Market link near the top to see a list of stuff you can download.

The streaks shown in Figure 12-31 (bottom) were made by setting the foreground and background chips to white and brown (respectively), creating a new layer, and then choosing Filter→Render→Cloud, followed by Filter→Blur→Motion Blur. Next, the streak layer's blend mode was changed to Hard Light. A few streaks combined with a few clicks with the Paper Damage brushes makes the photo look ancient!

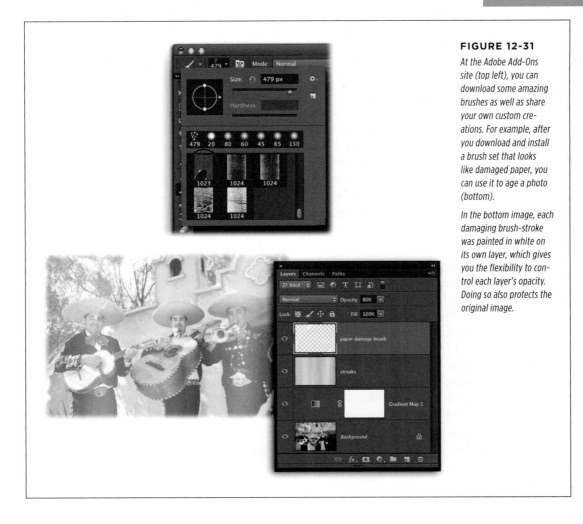

FIGURE 12-31

At the Adobe Add-Ons site (top left), you can download some amazing brushes as well as share your own custom creations. For example, after you download and install a brush set that looks like damaged paper, you can use it to age a photo (bottom).

In the bottom image, each damaging brush-stroke was painted in white on its own layer, which gives you the flexibility to control each layer's opacity. Doing so also protects the original image.

The Art History Brush

Adobe would have you believe that you can use the Art History Brush to turn a photo into a painting, but the darn thing doesn't work very well (as is painfully clear in the figure below). It's similar to the more useful History Brush in that you can choose a snapshot of your image (a previous version saved at a particular time) to work from, which is why it's in the same toolset. That said, take this tool for a spin and decide for yourself whether it deserves a spot in your regular tool rotation. Here's how:

1. **Grab the Art History Brush by pressing Y.** (If pressing Y activates the History Brush, simply press Shift-Y to snag the Art History Brush instead.)

2. **In the History panel, pick a snapshot or history state.** Open the History panel by choosing Window→History, and then choose a state by clicking the left column beside the state or snapshot you want to work with.

3. **In the Options bar, pick a small, soft-edged brush.** You can set the tool's blend mode and opacity in the Options bar just like you can with the Brush tool, and use the Control-Option-drag (Alt+right-click+drag on a PC) trick to resize your brush cursor on the fly—drag left to make it smaller or right to make it bigger.

4. **From the Options bar's Style menu, choose Tight Short.** You'll find 10 different painting styles in this drop-down menu, including Loose Medium, Loose Long, and so on. Any option with the word "tight" in its name works a little better than the others because it keeps the brushstrokes close together.

5. **Adjust the Options bar's Area field.** This setting controls the area covered by the artsy (and totally destructive) brushstrokes you'll create as you brush across the image. Enter a large number for more strokes or a smaller number for fewer strokes. If you want to keep the object you're painting recognizable, keep this number relatively low (less than 40 pixels).

6. **Make sure the Tolerance field is set to 0 percent.** A low tolerance lets you paint strokes anywhere you want. A high tolerance limits them to areas that differ from the color in the snapshot or history state you picked in step 2.

7. **Mouse over to your image and paint it.** As you paint, your clear, recognizable photo will be replaced with random, "artistic" swaths of paint, transforming it into madness and mayhem. Undo command, anyone?

Drawing with the Vector Tools

I f your first thought when someone mentions drawing is, "But I can't even draw a straight line!" don't worry: You *can* draw in Photoshop. To draw a straight line, just grab the Line tool (it's one of the shape tools—see page 580) and drag from one spot to another. Or, as you learned in the previous chapter, grab the Brush tool, click a spot, and then Shift-click another spot; it's that simple. The program also includes all kinds of built-in shapes like circles, rectangles, and rounded rectangles that are incredibly easy to use (page 159 shows an example of masking with the latter).

But what about creating more sophisticated drawings and illustrations? The good news is you don't have to worry about drawing *anything* freehand, whether it's a line or a curvy shape. Instead, the vector drawing tools you'll learn about in this chapter let you create a series of *points*; Photoshop then adds a *path* between those points to form the outline of the shape. Unlike the things you draw by hand with the Brush tool or a real-world pencil, these vector objects are infinitely tweakable: You can move points and adjust the paths to create any shape you want, letting you make complex yet flexible works of art from scratch, as Figure 13-1 shows.

If you're tempted to bail from this chapter because you're not an artist, hold your horses—you can use the vector drawing tools in a variety of other ways. For example:

- Once you get the hang of these tools, you can use them to add elements to images that don't exist and can't be photographed, like the ornamental shapes and embellishments shown on page 321.

- You can use the drawing tools to create precise selections that you can't make any other way. In fact, the Pen tool is a favorite of seasoned Photoshop jockeys because of its selection prowess (page 601).

- You can use the shape tools to mask (hide) parts of an image (pages 158–606). Because those masks are vector based, they're more flexible than regular layer masks.

Learning to draw with Photoshop's vector tools takes time and patience because they work *very* differently from any other tool you've used so far. But taking the time to master them sets you on the path (pun intended) to becoming a true Photoshop guru.

Before you dive into using the tools themselves, though, you need a quick tour of the different drawing modes you can use. Take a deep breath and read on!

FIGURE 13-1

Top: Here you can see the paths that make up the basic shapes of this digital painting by Bert Monroy called "Red Truck." You read that correctly: It's not a photograph—Bert drew every detail by hand. He created the basic shapes using the Pen tool, and then filled in the details with the Brush tool. Instead of a mouse, he used a Cintiq interactive pen display (a monitor you can draw directly on; see www.wacom.com).

Bottom: This wire-frame drawing (called "Oakland" and also by Bert) is even more complex. If you look closely, you can make out the shapes he created with the Pen tool to create the neon tubes and the sockets that the tubes go into. Now that's something to aspire to!

You can see more of Bert's amazing work at www.bertmonroy.com.

Photoshop's Drawing Modes

In the real world, the word "drawing" implies sketching lines and shapes by hand. But in Photoshop and in this book, drawing refers to creating objects using Photoshop's vector tools: the Pen tool and the various shape tools. Drawing with these tools is more like drafting (think technical illustrations such as blueprints) because you're creating precise *outlines* of shapes instead of the varying lines of a sketch or painting.

NOTE Here's one way to make sense of the difference between Photoshop's painting tools and its vector drawing tools: If Van Gogh or Michelangelo had used Photoshop, they would have liked the Brush tool because of its similarity to real-world paintbrushes. However, artists like Matisse, Mondrian, and Picasso would have favored the vector drawing tools because their painting styles are more precise and angular, and depend on creating smooth, clean geometric shapes and lines.

Photoshop has three different drawing modes, accessible in the Options bar (see Figure 13-2), that determine exactly what happens when you use the Pen and shape tools (though just *two* modes work with the Pen tool). Here's what each mode does:

FIGURE 13-2

When you use the Pen tool and shape tools, the Options bar includes a menu for different drawing modes. The buttons to the right of the word "Make" let you specify what you want to create out of the shape you've drawn: a selection, a vector mask, or a shape layer.

- **Shape.** When you're in this mode and you make your first click with any vector drawing tool, Photoshop creates a new shape layer for you to work on. When you finish drawing the shape, you can use the Options bar's Fill and Stroke settings to add a fill color and a solid, dashed, or dotted outline (skip ahead to page 587 for more on this fabulous feature). Drawing in this mode is similar to using a pair of scissors to cut shapes out of a piece of construction paper—these shapes can *hide* content on any layers below 'em, where the layers overlap.

NOTE In Photoshop CC, the shape layer thumbnails in the Layers panel display the contents of your *entire document*, not just the shape itself. It's turned on from the factory, though you can switch it to show just what's on that layer by choosing Panel Options from the Layers panel's menu, and turning on Layer Bounds.

Shape mode works with the Pen tool and the shape tools. It's great for creating geometric shapes filled with color that you can use in designs or overlay onto images (like the embellishments shown on page 372). You can also use this mode to add a symbol or a logo to a product in an image (see page 581). Photoshop comes with a slew of built-in shapes to choose from, but you can also create your own (page 590) and download shapes created by other folks. As Chapter 4 explained, you can also use the shape tools to create selections.

- **Path.** As you just learned, paths are lines and curves between *points*, which you'll learn about in the next section. Path mode doesn't create a new shape layer or fill the path with color; instead, when you're in this mode, Photoshop turns whatever you draw into an empty outline. Use this mode when you want to use the Pen tool to make selections (page 601) or create a clipping path (page 603), or when you want to create a vector mask that you may need to resize (see page 606). You can also fill paths with color (page 598) and give them a stroke (page 596), but Photoshop doesn't automatically create a new layer when you use the Pen tool or a shape tool in Path mode; you have to create a new layer first *and then* add the fill or stroke. The paths you create in this mode live in the Paths panel, which you'll learn about on page 578. While you're in Path mode, you can use the Path option menu (labeled in Figure 13-2) to turn on Rubber Band mode. Doing so shows you the path you'll make—after you set an initial point—just by waving your mouse around (in other words, before you click to set a *second* point).

- **Pixels.** This mode works only with the shape tools. When you use it, Photoshop creates a *pixel*-based shape on the currently active pixel-based layer, filled with your foreground color. This is handy if you need to edit the shape using tools that don't work with vectors, like filters, painting tools, and so on. That said, you could just as easily rasterize a shape layer and then use those tools, or you could convert the vector layer for smart filters. So unless you know *for sure* that you'll never need to change the shape of the object you're drawing, use Shape mode instead of Pixels mode.

The basic drawing process is the same no matter which mode you choose: You pick the Pen tool or one of the shape tools, choose a drawing mode, draw the shape, edit the shape, and then—if you went the Path mode route—save it for future use. In the following sections, you'll learn how to do all that and more.

Drawing Paths with the Pen Tool

The Pen tool made its debut in Adobe Illustrator way back in the late '80s, and offered people precision and control the likes of which they'd never seen. The only problem was that the tool was (and still is) hard to use. It was met with all kinds of resistance from the artistic community because it didn't conform to the way folks were used to working with digital graphics (not to mention pens and pencils). Instead of dragging to draw a line with the Pen tool, you create *anchor points* and *control handles*, which are collectively referred to as *vector paths* or *Bézier curves* (named for their inventor). The handles aren't actually part of the line; they're little levers you use to control each line segment's *curvature* (see Figure 13-3).

As you know from Chapter 3, you can edit and resize vectors without losing quality. For example, you can adjust an object's points and paths (see Figure 13-3, bottom) to tweak its shape and then use Free Transform to resize, rotate, distort, warp, or flip the object. When it's just right, you can fill the shape with color, trace its outline with one of the painting tools, or use it to create a mask.

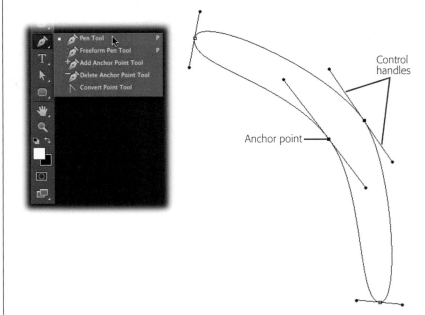

FIGURE 13-3

Left: The mighty Pen tool lives near the bottom of the Tools panel (when the panel is in single-column mode, that is).

Right: This boomerang shape is made from a series of points and paths. The points mark the beginning and end of each line segment; in Photoshop-ese, a line segment is called a path. To change a path's shape, you can drag the points, adjust the control handles, and add or subtract points.

To create a line with the Pen tool, you have to click *twice*: The first click creates the line's starting anchor point, the second click adds the ending anchor point, and Photoshop *automatically* adds the path in between. It's kind of like digital connect-the-dots: Each time you add a new anchor point, a path appears connecting it to the previous point.

You use two different kinds of anchor points to tell Photoshop whether you want a curved or straight path:

- **Smooth.** Use these anchor points when you want the path to curve. If you click to set an anchor point and then drag in any direction—before releasing your mouse button—the Pen tool creates a *control handle* that you can drag to make the next path curve. (The direction you drag is extremely important, as you're about to learn.) When you click to make the second anchor point, Photoshop adds the actual path—a curved line between the two points.

- **Corner.** Use these anchor points when you want to draw a straight line. Simply click *without* dragging to set a point, and you don't get any control handles; instead, the Pen tool creates points connected by straight paths. To draw perfectly horizontal or vertical lines, press and hold the Shift key while you click to set more points. Doing so limits the Pen tool to drawing straight lines at angles that are multiples of 45 degrees (45, 90, and so on), which is great when you want to draw geometric shapes.

Once you have, well, a *handle* on points and handles, you can make any shape you want. In the following pages you'll learn how to create both straight and curved paths.

Drawing Straight Paths

The easiest thing you'll ever do with the Pen tool is to make a straight path. To give the tool a spin, create a new document by choosing File→New, and then follow these steps:

1. **Press P to grab the Pen tool.**

 Its icon looks like a fountain pen nib.

2. **In the Options bar, choose Path mode.**

 From the drawing mode drop-down menu near the left end of the Options bar (labeled in Figure 13-2), choose Path.

NOTE You *could* use Shape mode for this exercise, but in that mode, Photoshop starts filling the path with color as soon as you start drawing it, which gets visually confusing (and these techniques are hard enough as it is!). So to see only the path itself—with no fill color—work in Path mode instead.

3. **Mouse over to your document and click once to create an anchor point.**

 Photoshop puts a tiny black square where you clicked (Figure 13-4, top).

First click

Second click

FIGURE 13-4

Each time you click, Photoshop adds another anchor point, and connects each point with a path that forms your shape.

If you want to start a new path instead of adding to an existing one, just tap the Esc key and then click somewhere else in the document.

4. **Move your cursor to the right of the first anchor point and click to create a second anchor point.**

 Photoshop adds a straight line that connects the two points.

5. **Move your cursor down an inch or so, and click to create another anchor point.**

 As you add each point, Photoshop connects them with paths. If you want to create a perfectly horizontal or vertical line, press and hold the Shift key as you click to add another anchor point (you can also use this trick to create lines at 45-degree angles).

6. **When you're finished adding points, press the Esc key or ⌘-click (Ctrl-click on a PC) elsewhere in the document.**

 The anchor points you created disappear, and you see a thin gray line representing the path you just drew.

7. **If you want to move an anchor point to change the angle of the line, grab the Direct Selection tool by pressing Shift-A until a white arrow appears in the Tools panel (see Figure 13-4, bottom).**

 You'll learn more about the Direct Selection tool when you start *editing* paths on page 591.

8. **Click one of the line's anchor points, and then drag it somewhere else.**

 As long as you hold your mouse button down, you can move the point wherever you want. When you get it positioned just right, release the mouse button.

Congratulations! You've just drawn your first path with the Pen tool. Savor your success because it gets a *lot* harder from here on out.

Drawing Curved Paths

Drawing curves with the Pen tool is much more complicated than drawing straight paths because you have to use control handles to tell Photoshop how *big* you want the curves to be and in what *direction* you want them to go. Here's what you do:

1. **With the Pen tool active, click within the document to set an anchor point and then—without letting go of your mouse button—drag left or right to make the point's control handles appear.**

 The control handles pop out from the point you created, and one of the handles sticks to your cursor. These handles indicate the direction the path will take; if you drag to the right, the path curves right when you add the next anchor point; if you drag left, the path curves left. For this exercise, drag upward and to the right about half an inch, and then release your mouse button (see Figure 13-5, top).

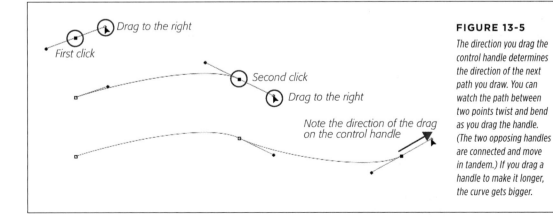

Drag to the right

First click

Second click

Drag to the right

Note the direction of the drag on the control handle

FIGURE 13-5

The direction you drag the control handle determines the direction of the next path you draw. You can watch the path between two points twist and bend as you drag the handle. (The two opposing handles are connected and move in tandem.) If you drag a handle to make it longer, the curve gets bigger.

> **NOTE** It's next to *impossible* to get a sense of how the control handles work by reading about 'em. So if you're near a computer, fire up Photoshop and follow along. Better yet, visit this book's Missing CD page at *www.missingmanuals.com/cds* and download the file *Curve.tif* so you can practice drawing the curves shown in Figure 13-5.

2. **About two inches to the right of the first point, click to add a second point and, while still pressing your mouse button, drag the new handle downward and to the right half an inch, and then release your mouse button.**

 In step 1, you pulled the first handle upward and the curve obediently bent upward. By dragging this second control handle downward, your next curve will head downward (see Figure 13-5, middle).

3. **Create a third point by clicking and dragging upward and to the right.**

 The path that appears when you click to add this third point curves downward because you pulled the control handle downward in the previous step. Drag the third point's control handle upward and slightly to the right to make the curve shown in Figure 13-5, bottom.

4. **Press the Esc key to let Photoshop know you're done drawing the path.**

 You can also ⌘-click (Ctrl-click) elsewhere in the document.

You've just drawn your first curved path! With practice, you'll get the hang of using control handles to determine the direction and size of curves. And as you may have guessed, the drawing process gets even more complicated from here.

Converting Anchor Points

As you learned on page 571, there are two kinds of anchor points in Photoshop: smooth and corner. To draw complicated paths, you need to know how to *switch* between these point types so you can create curves *within* a single path that go the same direction. (Flip ahead to Figure 13-7, bottom, to see what this looks like.) To do that, you start by creating a series of curves, and then convert some of the smooth points to corner points. Here's how:

1. **With the Pen tool active, click and hold your mouse button to create a point, and then drag the control handle up and away from the anchor point to set the direction of the next curve (Figure 13-6, top left).**

 Release your mouse button when you're ready to set the next anchor point.

2. **Move your cursor an inch or so to the right, and then click to set a second point to the right of the first and drag downward (Figure 13-6, top right).**

 When the path has the curve you want, release your mouse button.

3. **Move your cursor another inch to the right and then click and drag downward to create a third point (Figure 13-6, middle).**

4. **Hop right another inch and then click and drag downward once again to create a fourth point (Figure 13-6, bottom).**

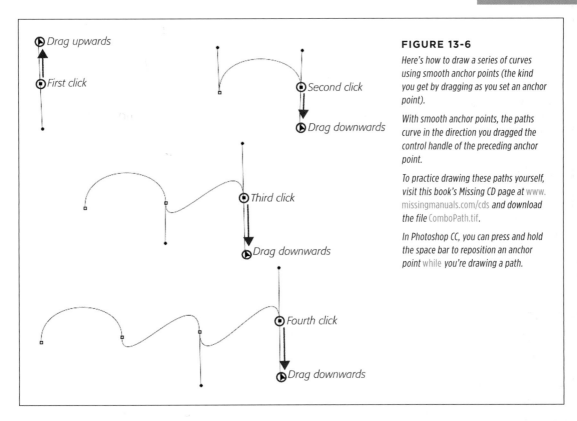

FIGURE 13-6

Here's how to draw a series of curves using smooth anchor points (the kind you get by dragging as you set an anchor point).

With smooth anchor points, the paths curve in the direction you dragged the control handle of the preceding anchor point.

To practice drawing these paths yourself, visit this book's Missing CD page at www. missingmanuals.com/cds and download the file ComboPath.tif.

In Photoshop CC, you can press and hold the space bar to reposition an anchor point while you're drawing a path.

5. **Head over to the Tools panel and grab the Convert Point tool (Figure 13-3).**

 This tool is tucked inside the Pen toolset (its icon looks like an upside-down V). Just click and hold the Pen tool's icon to see the rest of the toolset, and then give the Convert Point tool a click. Oddly, this tool doesn't have a keyboard shortcut, but you could always assign one by choosing Edit→Keyboard Shortcuts (see the box on page 31). Heck, if you assign it a shortcut of the letter P, you could use the Shift-P trick to cycle through the tools in the Pen toolset!

6. **As shown in Figure 13-7, top, drag the bottom control handle that's attached to the third anchor point up so it's close to the upper control handle on that same anchor point.**

 The Convert Point tool "breaks" the bottom half of the control handle away from the top half so it can move independently. This nifty maneuver converts the anchor point from a smooth point to a corner point and changes the path from a smooth curve to a sharp angle. Once you break control handles apart, you can move them independently to adjust the angle and curve of the path.

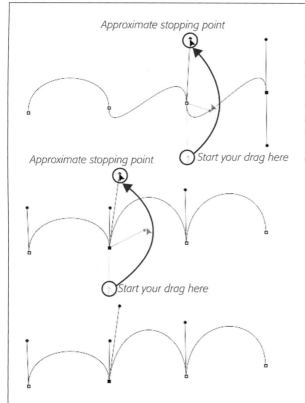

Approximate stopping point

Start your drag here

Approximate stopping point

Start your drag here

FIGURE 13-7

Once you convert smooth anchor points into corner anchor points, you can adjust each control handle separately to create a series of curves that bend in the same direction, as shown here.

If you move both parts of the control handle so they're on top of each other, you see only one handle (like the third anchor point shown at the middle and bottom), just as you see only one hand of a clock at noon, when the hour and minute hands overlap. If that happens, grab the Direct Selection tool and drag one of the handles out of the way so you can see them both.

7. **Use the Direct Selection tool to grab the path's second point from the left.**

 Unfortunately, you can't activate points with the Convert Point tool, so to see the second anchor point's control handles, you have to use the Direct Selection tool. But there's a trick that saves you a trip to the Tools panel: Hold down the ⌘ key (Ctrl on a PC) to temporarily switch from the Convert Point tool to the Direct Selection tool. So simply ⌘-click (Ctrl-click) the anchor point to activate it and make its control handles appear, and then let go of the ⌘ key (Ctrl) and you're back to using the Convert Point tool.

8. **With the Convert Point tool, click the bottom control handle that just appeared and drag it upward next to its partner (see Figure 13-7, middle).**

 When you're finished, you should have a series of curves that all bend in the same direction (Figure 13-7, bottom).

Path Drawing Tips

Here are some things to keep in mind when you're drawing curved paths with the Pen tool:

- **Exaggerating curves.** If you want to create an exaggerated curve or one that curves back on itself, you need to drag one side of the control handle in the opposite direction from the way you drew the path (see Figure 13-8, left). Also, keep in mind that the length of the handle determines the height or depth of the curve. (You lengthen a control handle by dragging it farther in any direction.) Figure 13-8, right, shows the effect of different-length handles on two similar paths.

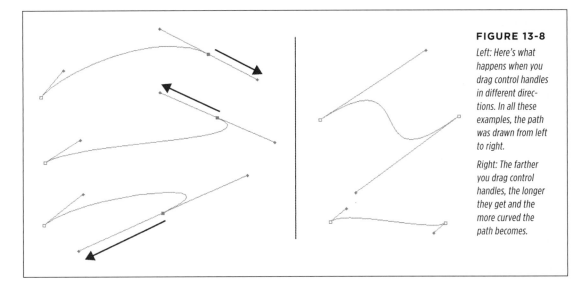

FIGURE 13-8

Left: Here's what happens when you drag control handles in different directions. In all these examples, the path was drawn from left to right.

Right: The farther you drag control handles, the longer they get and the more curved the path becomes.

- **Closing a path.** The paths you've seen so far have all been left *open*, meaning the starting and ending anchor points aren't connected. If your goal is to draw an arc, for example, you *want* to leave the path open. To make an open path, after you create the last anchor point, just press the Esc key, ⌘-click (Ctrl-click) somewhere else in the document, or activate another tool in the Tools panel. But if you want to fill the path with color, you need to close it to create a *closed shape*, where the path's two ends are connected. To create a closed path, add the last anchor point and then put your cursor over the path's starting anchor point until a tiny circle (like a degree symbol) appears next to it. Once you see that circle, click the starting anchor point and Photoshop adds a straight path that connects the two points and closes the shape.

TIP If you Option-click (Alt-click on a PC) to close a path, Photoshop adds *smooth* anchor point handles to it automatically.

- **Adding control handles.** If you want to add a control handle to an anchor point that doesn't have one—like the starting or ending anchor point of a straight line—grab the Pen tool and Option-click (Alt-click on a PC) the anchor point. You'll see a tiny, upside-down V (called a *caret*) appear next to your cursor. Keep holding the mouse button down and drag outward to create a *new* control handle that you can adjust to any angle you want, as shown in Figure 13-9. (If you Option-click [Alt-click] an anchor point that already has handles, you'll just grab that point's existing handles instead of creating a new one.)

New handle being pulled
from anchor point

FIGURE 13-9

To change the direction of a curve, you need to create a control handle, as shown here. When you drag the new control handle away from the path, you get a curve that heads in the direction you're dragging. But if you Option-click (Alt-click on a PC) the control handle and drag toward the path, you'll create a corner point that changes the direction of the curve. This gives you independent control over each of the point's control handles.

TIP You can adjust the length of a path's control handles by ⌘-dragging (Alt-dragging on a PC) the path. This trick changes the depth of the curve as you drag. If the anchor point at the other end of the path segment doesn't have control handles, you'll end up with an angled corner at the far end of the path segment. You can move anchor points that don't have control handles by ⌘-dragging them (Ctrl-dragging on a PC). These tricks make it easier to edit paths while you're drawing 'em.

Saving Paths

After all your hard work creating a path, it's a good idea to save it so you can edit it (as explained later in this chapter) and use it again later. Or you might want to use the path to make a vector mask, as explained on page 601. Since paths are vector-based, they don't take up much memory and won't increase a file's size much at all, so feel free to save as many of 'em as you want.

To work with paths, open the Paths panel by choosing Window→Paths. As you're drawing a path, Photoshop stores it in the Paths panel as a temporary *work path* (see Figure 13-10) and displays the path in your document as a thin gray line. If you want to hide the gray line—so it's not a visual distraction—just press Return (Enter on a PC). To create *multiple* paths in a single document, click the "Create new path" icon at the bottom of the Paths panel (otherwise, you'd have to save each path before starting on the *next* one to keep Photoshop from adding the subsequent path to the previous one).

Panel menu

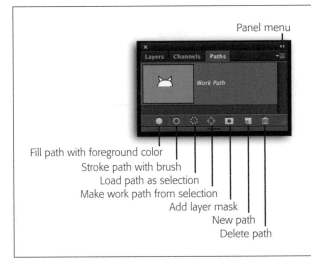

FIGURE 13-10

The Paths panel works pretty much like any other panel. When you're working with a particular path, Photoshop highlights it in the panel. To delete a path, activate it and then press Delete (Backspace on a PC) or drag it onto the trash can at the bottom of the panel.

As with layers, you can change paths' stacking order, double-click to rename them, and so on. Changing the stacking order is a good way to keep related paths together; unfortunately, you can't organize paths into groups like you can with layers.

To activate multiple paths, Shift- or ⌘-click (Ctrl-click) them in the Paths panel. This lets you delete, duplicate, or change their stacking order en masse.

Fill path with foreground color
Stroke path with brush
Load path as selection
Make work path from selection
Add layer mask
New path
Delete path

NOTE Miraculously, Photoshop keeps an unsaved work path in your document even if you close the file and don't open it for a *year*. The catch is you can have only *one* unsaved work path in a document at a time. If you reopen the document and want to add to that work path, activate it in the Paths panel, and then use the tools discussed in this chapter to edit it or add to it. Activating the unsaved path in the Paths panel is important because, if you grab the Pen tool and just start drawing, the original work path *vanishes.* To be safe, you're better off saving a path if you think you'll ever want to reuse it.

Photoshop gives you several ways to save a path:

- Before you start drawing, **choose Shape mode** (page 569) from the Options bar so Photoshop stores the path on its own layer. Don't forget to name the layer so you can keep track of your various paths.

- **Save the path before you draw it** (or rather, create a *placeholder* for it) by clicking the "Create new path" icon at the bottom of the Paths panel (it looks like a piece of paper with a folded corner). Photoshop names the placeholder *Path 1*, but you can double-click its name to change it.

- **Save the path after you draw it** by choosing Save Path from the Paths panel's menu.

- **Save the path as a custom shape** (page 590) that you can access via the Options bar's Custom Shape menu. This is handy when you know you'll reuse the shape you've drawn (a repeating element in a design, say, or a custom goodie such as a logo). You can save as many paths as you want (they won't bloat the document's file size), so go ahead and have a path-saving party if you think you'll reuse 'em again later.

• Follow the instructions on page 604 to **save the path as a clipping path** that you can use to *isolate* an object (hide its background) in a page-layout program like InDesign or QuarkXpress. If you plan on working with the image in *older* versions of these programs—which don't understand layered Photoshop documents—this method is your best bet.

◼ Drawing with the Shape Tools

Photoshop has a pretty good stockpile of built-in, vector-based shapes, which are perfect for adding artistic embellishments or using as vector masks. They include a rectangle, a rounded rectangle (great for making round-edged selections; see page 158), an ellipse (handy for romantic, soft-edge vignette collages; see page 607), a polygon, a line, and a *gazillion* custom shapes (page 589). These preset goodies are huge timesavers because they keep you from having to draw something that already exists. And since these preset shapes are made from paths, you can use the techniques described later in this chapter to morph them into anything you want.

UP TO SPEED

Drawing with a French Curve

This Bezier curve business is tough to wrap your brain around. But if you've taken any kind of art class—even if it was as far back as middle school—there's a real-world counterpart that makes the curved paths you draw with the Pen tool a *little* easier to understand.

Drawing with Photoshop's Pen tool is similar to using a brush, pencil, or art knife with a set of *French curves*—plastic stencils that folks use as guides to create flowing, curved lines. French curves have some of the same limitations as the Pen tool. For example, the main challenge when using French curves is picking the stencil that will give you the longest sweep (or

arc) possible. You often have to switch stencils or change its position to follow a particular sweep.

With the Pen tool, you can take a similar approach: To keep your paths as simple—that is, with as few anchor points—as possible, try creating the longest possible distance between two points. The more points in a path, the less smooth the curves will be, and using fewer points also makes your paths a little easier to edit. If you want to *print* what you've drawn, the printer has to translate and draw the path, so keeping it as simple as possible helps avoid problems.

The shape tools work in all three drawing modes (page 568), but this section focuses on the first mode: Shape. This mode's super power is that it lets you change the shape's fill or stroke color, stroke size, as well as stroke *style*, on the fly. (Remember, in Photoshop, the word "stroke" means "outline.") This gives you the ability to create dashed or dotted strokes, and when used with the Pen tool set to Shape mode, dashed or dotted *lines*.

Here's one situation where you'd save time by using a shape tool: Say you want to create a starburst to draw a viewer's attention to some important text in an ad (Figure 13-11); there's no sense in drawing the starburst from scratch because Photoshop *comes* with one. And since the built-in shapes are all vector-based, they're resizable, rotatable, and colorable. If you need to make the shape bigger, for example, just activate the shape layer, press ⌘-T (Ctrl+T) to summon Free Transform, and Shift-drag one of the handles that appear to make it as big as you want with *zero* fear of quality loss (the Shift key preserves the shape's aspect ratio). You can even resize the shape *multiple* times and its edges remain crystal clear (great when you're experimenting with a design). When you're finished resizing the shape, press Return (Enter) to let Photoshop know you're finished.

FIGURE 13-11

You can save time and energy by using Photoshop's built-in shapes. Unless you tell the program otherwise (see the section on drawing multiple shapes on page 589), it puts each shape on its own shape layer (circled). You can resize and rotate the shape using Free Transform (both the shape and type layers are active here so they rotate together; a handy info overlay shows the rotation angle).

When you have a shape tool and a shape layer active, you can change the shape's color by double-clicking its layer thumbnail to open the Color Picker or by using the Options bar's Fill menu. You can gussy it up even more by adding a stroke (via the Options bar's Stroke menu) and a layer style, such as the drop shadow shown here.

The next section explains even more shape-formatting options.

Using the Shape Tools

The shape tools couldn't be easier to use: If you can move your mouse diagonally, you can draw a shape. Each shape—rectangle, rounded rectangle, and so on—has its own Options bar settings; Figure 13-12 (bottom) shows the Line tool's settings. These settings let you create shapes that are certain sizes or have certain proportions, specify the number of sides in a polygon, indent the shape's sides to make a star, and so on. You also get a bunch of formatting options that let you change the shape layer's fill, stroke, stroke style (solid, dashed, or dotted), and so on.

However, you *don't* want to use the Line tool to create a dashed or dotted line. Why? Because Photoshop treats shapes made with the Line tool as *rectangles*, so you get dashes or dots on all four sides of the line. The fix is to use the Pen tool set to Shape mode instead. Flip ahead to page 586 for details.

> **TIP** When you have a shape tool active (in any drawing mode), you can click within your document to summon a dialog box where you can enter precise dimensions for the shape (be sure to enter a unit of measurement, such as *px* for pixels or *in* for inches). Click OK and Photoshop creates the shape *for* you. Alas, this trick doesn't work with the Line tool.

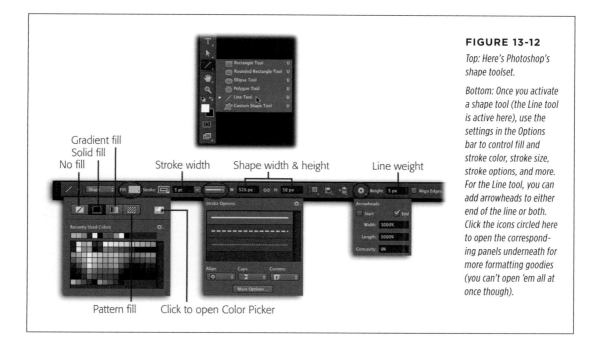

FIGURE 13-12

Top: Here's Photoshop's shape toolset.

Bottom: Once you activate a shape tool (the Line tool is active here), use the settings in the Options bar to control fill and stroke color, stroke size, stroke options, and more. For the Line tool, you can add arrowheads to either end of the line or both. Click the icons circled here to open the corresponding panels underneath for more formatting goodies (you can't open 'em all at once though).

Gradient fill
Solid fill
No fill
Stroke width
Shape width & height
Line weight
Pattern fill
Click to open Color Picker

> **TIP** Need to copy a shape's exact size, color, and position on the page for use with a website that uses CSS (cascading style sheets) to control its formatting? No problem. You can grab *all* that info in one fell swoop by heading to the Layers panel, Control-clicking (right-clicking) near a shape layer's name, and then choosing Copy CSS. Photoshop copies the info to your computer's memory so you can hop over to a text editor or web-design program (Adobe Muse or Dreamweaver, say) and paste it right in. Nice!

All the shape tools work pretty much the same way, though they have slightly different Options bar settings. Here's how to use the Line tool to draw a solid line with an arrowhead:

1. **Grab the Line tool from the Tools panel.**

 The Line tool lives in the shape toolset near the bottom of the Tools panel (Figure 13-12, top). If you've never used the shape tools before, the Rectangle tool is probably on top. Click it, hold down your mouse button, and then choose the Line tool from the resulting menu, or cycle through the various shape tools by pressing Shift-U repeatedly.

2. **In the Options bar, set the tool's drawing mode to Shape (see Figure 13-2, page 569).**

 If you've used any other drawing mode, the Options bar will still be set to that previous mode, so it's always a good idea to check it.

UP TO SPEED

Drawing with the Freeform Pen Tool

Lurking in the Pen toolset is the *Freeform Pen* tool, which lets you draw by simply *dragging* (kind of like how you draw with a real pen) instead of clicking to add points and tugging on control handles. Once you've used it to draw a path, you can edit that path using any of the techniques discussed in this chapter. If you're comfortable working with a digital drawing tablet (see the box on page 552), the Freeform Pen tool may be the way to go. For precise shapes, however, you're better off sticking with the Pen tool.

When using the Freeform Pen tool, you can turn on the Options bar's Magnetic setting to switch to *Magnetic Pen* mode, which lets you create a path by clicking and then moving your cursor around the edge of the shape you want to select, trace, or mask (like you do with the Magnetic Lasso tool). (Photoshop puts a tiny horseshoe magnet next to your cursor to let you know you're in this mode.) The downside to this mode is that this tool sometimes produces more points than you can shake a stick at, which means you have to go back and do some point pruning, as explained in a moment.

To change the Magnetic Pen tool's settings, in the Options bar, click the gear icon. The resulting menu includes the following settings:

- **Curve Fit** lets you control the error tolerance when Photoshop fits Bezier curves along the path you're making. Straight from the factory it's set to 2 pixels.

- **Width** determines how close to an edge your cursor has to be before Photoshop puts down a point, like the Magic Wand's Tolerance setting. You can enter a value from 1 to 256 pixels.

- **Contrast** tells the tool how much contrast there has to be between pixels before it considers an area an edge and plunks down points. You can enter a percentage between 1 and 100; use a higher value for objects that don't have much contrast.

- **Frequency** lets you control how many points the Magnetic Pen tool adds. Enter a value between 0 and 100; the higher the number, the more points it adds.

- **Pen pressure**. If you're using a graphics tablet and pressure-sensitive stylus, turn on this setting.

When you're ready to start drawing, click once to set the starting point and then trace the outline of the object with your cursor. If the tool starts to go astray and adds points in the wrong spot, just click to add a point of your own. To delete a point the tool created, put your cursor over the point and then press Delete (Backspace on a PC). When you've got an outline around the object, move your cursor over the starting point (a little circle appears next to your cursor) and then click once to make Photoshop close the path. That's it! Now you've got yourself a custom path to play with.

3. **In the Options bar, choose a fill color, and then choose a solid line from the Stroke options menu.**

Click the Fill menu that's circled in Figure 13-12 (bottom) and, from the resulting panel, pick a color for the line—and the arrowhead you'll add in the next step (if you don't pick a color, Photoshop uses your foreground color). Then click the Stroke Options menu (also circled in Figure 13-12, bottom) and choose the solid line preset at the top of the resulting panel.

TIP If you want the line (and arrowhead) to have a stroke that's a *different* color than the line, click the Stroke menu (not the Stroke *Options* menu) and pick a color from the resulting panel (which is identical to the Fill panel). Set a stroke size by entering a value in the unlabeled stroke-width field to the right of the Stroke menu (it's measured in points); just be sure the stroke is narrower than the line or the stroke will hide the line's fill color.

4. **Add an arrowhead.**

Click the Options bar's gear icon to open the Arrowheads menu shown in Figure 13-12 (bottom), and then turn on the Start or End checkbox (or both). If you like, specify a size for the arrowhead(s) by entering percentages in the Width and Length fields (the factory setting of 500 percent of the line weight usually works fine). To curve the sides of the arrowhead inward, enter a percentage in the Concavity field.

NOTE Unfortunately, you can't add an arrowhead *after* drawing a line, nor can you edit an arrowhead's settings after you've drawn it. Instead, you have to delete the shape layer, adjust the arrowhead settings, and then *redraw* the line.

5. **Enter a weight for the line.**

In the Options bar's Weight field, enter a thickness for the line in pixels. Alas, you can't change this setting once you've drawn a line. To alter a line's weight, delete the shape layer, change the Weight setting, and then redraw the line.

6. **Mouse over to the document and click where you want the line to start, drag, and then release your mouse button where you want the line to end.**

Photoshop creates a new shape layer in the Layers panel, containing the line. If the line isn't quite at the angle you wanted or isn't long enough, summon Free Transform by pressing ⌘-T (Ctrl+T) and then use the resizing handles to rotate the line or make it longer—Shift-drag to keep the arrowhead(s) from getting squished or stretched in the process! Alternatively, you can start over and enter a width and height for the line in the Options bar's W and H fields.

7. **Just for fun, change the line's fill color using the Options bar's Fill menu.**

As soon as you make a new choice in the Fill menu, the line *and* the arrowhead change color. You can also double-click the shape layer's thumbnail in the Layers panel and choose a different color from the resulting Color Picker.

If you don't like how the line turned out, you don't have to start over (well, unless you want to change *arrowhead* settings and *line weight*, as described in steps 4 and 5; in that case, you *do* have to start over). Instead, with the shape layer active, grab the Direct Selection tool (press A or Shift-A) and click the line you drew to reveal its anchor points; then, move 'em around until you get the look you want.

> **TIP** These days, you can adjust the Options bar's fill, stroke, and stroke style settings *while* the Direct Selection tool is active!

For practice, try performing the steps listed above using the Rectangle or Ellipse tool instead. And remember, once you've created a shape you can modify it in several ways:

- Grab the Direct Selection tool (press A or Shift-A) and move the shape's anchor points or alter their control handles. To activate *several* points at once, click and drag with the Direct Selection tool to encompass the points you want to edit. Happily, this maneuver no longer activates anchor points of any *overlapping* shapes on *other* layers. That's because, in Photoshop CC 2014, the Direct Selection tool's Options bar includes a Select menu. From the factory, it's set to Active Layers, meaning only points on the currently active layer are selected, no matter where you click and drag. To select points across *multiple* layers, set it to All Layers instead.

- Use the Pen tool to add or subtract points. You'll learn more about editing paths on page 591.

- Change the shape's fill color by double-clicking the shape layer's thumbnail in the Layers panel or, if the shape tool and the shape layer are active, by using the Options bar's Fill menu to open the Fill panel shown in Figure 13-12 (bottom).

- Change the shape's stroke color, stroke size, and stroke style by using the Options bar's Stroke menu, size field, and style menu. (A shape layer *and* a shape tool have to be active for you to see those controls.)

- Use Free Transform to resize, distort, or rotate the shape.

- Use layer styles to add special effects to the shape layer.

> **TIP** To draw a symmetrical shape (like a perfect square or circle), press and hold the Shift key as you drag with a shape tool. That makes Photoshop keep the shape's sides the same size. To draw a shape from the center out, press and hold Option (Alt on a PC) as you drag. And what if you want to draw a perfect circle from the center out? You guessed it: press and hold Shift-Option (Shift+Alt) as you drag.

You can do all kinds of wonderful things with shape layers, so it's worth taking the time to experiment with all the different shape tools and their various settings.

For example, Photoshop's shape tools are also helpful when making custom patterns (page 94). To create a diamond-shaped pattern, simply draw a shape using

the Rectangle tool, adjust its fill and stroke as discussed earlier, and then rotate it using Free Transform (page 276). Next, use the Rectangular Marquee tool to select the shape—be sure to include a little empty space around it so the repeating pattern has some breathing room—and then follow the instructions on page 94 to define the pattern. To fill your document with the new pattern, use a pattern fill layer (which also lets you adjust the *size* of the pattern via the Pattern Fill dialog box's Scale field).

■ CUSTOMIZING STROKE OPTIONS

There's no end to the different kinds of strokes you can add to shape layers in Photoshop; Figure 13-13 (top) shows some examples. And as you saw back in Figure 13-12, the Stroke Options panel has some useful presets for dashed and dotted lines.

It's important to remember that, in Photoshop, the term "stroke" means "outline." Since Photoshop treats lines you draw with the Line tool as *rectangles*, changing the tool's stroke style to dashed or dotted produces dashes or dots on *all four sides* of the line that intersect if the line's weight isn't thick enough (and if you make it thicker, you simply end up with a rectangle with dashes or dots around it).

So how do you create a dashed or dotted line? Simple: use the Pen tool set to Shape mode (page 569). Simply draw a line and then set the Options bar's Fill menu to none, the Stroke menu to the color you want the line to be, and the Stroke width field to the size you want the *dashes* or *dots* to be. Finally, pick a dashed or dotted preset from the Stroke Options menu circled in Figure 13-12, or customize the stroke further as described below. Problem solved!

Clicking the More Options button at the bottom of the Stroke Options panel (shown back in Figure 13-12) displays the Stroke dialog box (Figure 13-13, bottom). The dialog box's settings let you customize a shape's stroke in the following ways:

- **Presets.** Use this menu to access Photoshop's stroke presets, which are initially a solid, dashed, or dotted line. Once you customize a stroke, you can save it as a preset by clicking the Save button to this menu's right. When you do, Photoshop adds the new preset to this menu, as well as to the Stroke Options menu in the Options bar. You can't name your preset; instead, Photoshop shows you a preview of what the line *looks* like.

- **Align.** This menu controls the alignment of the stroke itself (not the shape the stroke is attached to). From the factory, it's set to Inside, meaning the stroke appears on the inside of the shape you've attached it to. Your other choices are Center and Outside.

- **Caps.** You can use this menu to control the stroke's *line cap style*, which determines what the end of an open line (a straight line that doesn't change directions) looks like. Your choices are Butt, Round (the factory setting), and Square. Butt creates squared ends and Round creates semicircular ends. Square *also* creates squared ends, though the ends extend past the line's end points by half the line's width.

- **Corners.** Use this menu to choose a *join* type for the stroke, which controls the way a straight line changes direction or turns a corner. Your choices are Miter (creates pointed corners), Round (creates rounded corners), and Bevel (creates squared corners that are ever so slightly rounded).

FIGURE 13-13

Top: Shape layers let you create several kinds of strokes, including ones that look like dashes or dots. Here, the dotted stroke preset was used on a shape drawn with the Rounded Rectangle tool.

Bottom: Clicking More Options at the bottom of the Stroke Options panel (visible back in Figure 13-12) opens this Stroke dialog box, which lets you customize how the stroke looks (some of these settings are also available in the Stroke Options panel). Here the Pen tool was used in Shape mode to draw a line with no fill, but with a 10 pt stroke. The first two lines were made using stroke style presets. The last line (dash-dot-dash) was made by entering different dash and gap settings in the Stroke dialog box.

Sometimes it's easier to customize the Options bar's Fill and Stroke options after drawing a shape, instead of setting 'em before you start drawing. For example, if you've got one of the shape tools and a shape layer active, then changing the Fill and Stroke menus changes the fill and stroke of the active shape layer.

- **Dashed Line, Dash, Gap.** To create a dashed or dotted line, turn on the Dashed Line setting. To increase dash length, enter a number in the Dash fields (a dot is just a dash set to 0 length). To increase the space between dashes or dots, enter a number in the Gap field. You can use the other Dash and Gap fields to vary individual dashes within the *same* stroke.

As you adjust these settings, Photoshop displays a preview in the Preset field that changes to match your choices. Once you've formatted a stroke to your liking, you can copy and paste it onto other shapes. Just click the gear icon at the top right of the Stroke Options panel (see Figure 13-12) and choose Copy Stroke Details. Then

click to activate another shape (or a different shape layer), pop open the Stroke Options panel, click the panel's gear icon, and then choose Paste Stroke Details. This same menu also lets you *save* your customizations as a preset you can use again later, though that's not necessary for simply copying and pasting stroke settings.

■ USING LIVE SHAPE PROPERTIES

You can use the Properties panel to change the formatting options of shapes you've drawn with the Rectangle, Rounded Rectangle, and Ellipse tools. You get nearly the same settings as in the Options bar, as well as X and Y fields that let you *reposition* the shape on your document horizontally and vertically (respectively).

The big honkin' deal about these *Live Shape Properties*, as Adobe calls 'em, is the ability to change the radius of corners you've drawn with the Rounded Rectangle tool—set to Shape mode (page 569)—*after* you've drawn them, as Figure 13-14 explains. (In the past, you had to start over instead.) This handy bit o' corner magic also works with the Rectangle tool, so if you draw a rectangle and then decide you'd rather have rounded corners, you don't have to start over; just use the Properties panel's Live Shape Properties settings to change them.

> **NOTE** The ability to access Live Shape Properties is fleeting. When you activate another layer and then *reactivate* the shape layer, the Properties panel refuses to show you Live Shape Properties. The trick is to *reactivate the shape itself* using the Path Selection tool or by Option-clicking (Alt-clicking on a PC) the shape in the Paths panel to make 'em reappear. However, if you use Free Transform on the shape layer, Live Shape Properties are gone for good.
>
> Also, you can't use Live Shape Properties with actions (Chapter 18). Bummer!

FIGURE 13-14

The Rounded Rectangle tool is incredibly handy, but it can be tough to get the radius (roundness) of the rectangle's corners just right. To alleviate the radius guessing game, the Properties panel's Live Shape Properties let you change this setting *after* you've drawn the shape.

To adjust each corner's roundness after creating a shape layer with the Rectangle or Rounded Rectangle tool, enter a new value into one of the Radius fields labeled here. Click the chain link icon (circled) to unlock the four Radius fields so you can adjust each corner individually to create some nifty looks.

Alas, these options are only available when you've used the tool in Shape drawing mode.

From the factory, the Properties panel automatically pops open each time you create a shape layer with the Rectangle, Rounded Rectangle, or Ellipse tool. To keep it closed unless you specifically summon it, head to the Properties panel's menu and choose "Show on Shape Creation" to turn that setting off (the checkmark next to it disappears).

Drawing Multiple Shapes on One Layer

Each time you draw with a shape tool in Shape mode (page 569), Photoshop adds a *new* shape layer to your document. If you want to keep drawing on the *same* shape layer instead of creating new ones, use the Options bar's Add, Subtract, Intersect, and Exclude buttons (they're nestled in the Path Operations menus labeled in Figure 13-2 and Figure 13-14; flip ahead to page 594 for details on how they work). But rather than hunting for those menus, you can press and hold the Shift key to add shapes to the active shape layer; just release the Shift key once you've clicked to start drawing the shape to keep from constraining it to be perfectly square, elliptical, and so on—unless that's what you *want* to do.

TIP You can move shapes independently of one another even if they live on the same shape layer. To do that, press A (or Shift-A) to grab the Path Selection tool from the Tools panel (the black arrow—see page 572), click within your document to activate the shape, and then drag it wherever you want. Or, instead of dragging, use the arrow keys on your keyboard to nudge the shape one pixel at a time (add the Shift key to nudge it *10* pixels at a time).

Using Custom Shapes

To find the *really* useful shapes that come with Photoshop, you have to do a bit of foraging. Grab the Custom Shape tool (which looks vaguely like a starfish) from the Tools panel—it's in the shape toolset visible in Figure 13-12, top. Then head up to the Options bar and open the Custom Shape picker by clicking the field labeled in Figure 13-15.

TIP Technically, you don't have to trot all the way up to the Options bar to access Photoshop's custom shapes; just Control-click (right-click on a PC) within your document with the Custom Shape tool, and the Custom Shape picker menu appears next to your cursor. Who knew?

In the Custom Shape picker, click the gear icon circled in Figure 13-15. In the resulting menu, choose All. A dialog box appears asking if you want to replace the current shapes; click OK. Now you can preview *all* of Photoshop's built-in shapes right there in the Custom Shape picker (why Photoshop doesn't load these shapes automatically is a mystery). You can also use this menu to change the size of the previews or to display them as a text-only list.

You draw with these shapes just as you do with the Line tool (page 583), except that instead of dragging horizontally or vertically, drag *diagonally* to create the shape (or Shift-click within your document to summon a dialog box where you can enter a dimensions for the shape). You can also press and hold the Shift key to make the

shape perfectly proportional so it looks like the little icon you picked in the Custom Shape picker. You can modify the shape by using the Options bar's Fill and Stroke settings, applying layer styles, or customizing it by using the Direct Selection tool to tweak its anchor points and control handles.

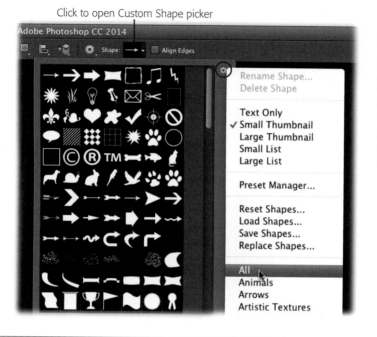

Click to open Custom Shape picker

FIGURE 13-15

If you create a shape with the Pen tool, you can save it as a custom shape by choosing Save Shapes from the menu shown here (click the circled gear icon to open it). Give your shape a name and it appears in the list of presets.

You can also do the same thing by creating a shape, activating its layer in the Layers panel, and then choosing Edit→Define Custom Shape.

> **TIP** Skip to page 800 to see how to add a *watermark* (custom copyright info) to your images using the Custom Shape tool. This is one of the few ways to protect your images from online theft. Alternatively, see page 819 to learn how to use actions to add a text-based watermark to images.

The *real* power of using custom shapes lies in defining your own, which can save you tons of time. For example, if you have a piece of vector art that you need to use over and over, you can save it as a custom shape. Choose File→Place to import the art into Photoshop, and then load it as a selection by ⌘-clicking (Ctrl-clicking) its layer thumbnail in the Layers panel. Next, save it as a path by opening the Paths panel and choosing Make Work Path from the Paths panel's menu. Finally, choose Edit→Define Custom Shape; in the resulting dialog box, give the shape a memorable name, and then press OK. From then on, your custom shape appears in the Custom Shapes picker any time you're using the Custom Shape tool. To draw the shape you added, just choose it from the menu and then drag in your document.

⬛ Editing Paths

All this talk about setting points, dragging handles, and creating shapes can sound a bit intimidating. But it's important to remember that the Pen and shape tools are *very* forgiving—if you don't get the path right the first time, you can always edit it by adding, deleting, and repositioning its points and dragging their control handles (yes, this applies to shapes drawn on shape layers, too). The trick lies in knowing *which* tool to use to make the changes you want. This section explains all your options.

Adding, Deleting, and Converting Points

At first, you may have a wee bit of trouble drawing paths—*especially* with the Pen tool—that look exactly like you want (surprise!). But don't stress; just add more points, move them around, and adjust the curves until you get the shape you're aiming for. You'll need fewer and fewer points as you get more comfortable using the vector drawing tools. And if you've had yourself a point party, you can delete the extra ones.

Adding and deleting points is really easy since the Pen tool figures out what you want to do depending upon what your cursor is pointed at. For example:

- **To add a point,** grab the Add Anchor Point tool (shown on page 571) from the pen toolset (it looks like the Pen tool's icon with a + next to it). When you see a tiny + appear next to the cursor, you can click an existing path to create a new point. You can also just grab the Pen tool, point your cursor at an existing path (but avoid pointing it at anchor points) and the cursor turns into the Add Anchor Point tool automatically. Click anywhere on the path to set new anchor points.

- **To delete a point,** open the Pen toolset and grab the Delete Anchor Point tool (it looks like the Pen tool with a – next to it). Or grab the Pen tool and then place your cursor over an existing point; a tiny – appears next to the cursor to let you know that the Delete Anchor Point tool (shown on page 571) is active. Either way, click once to get rid of that point.

- **To convert a point from smooth to corner (or vice versa),** use the Convert Point tool (see the exercise on page 574). To quickly change to this tool while using the Pen tool, press the Option key (Alt on a PC) and place your cursor over an anchor point. (Photoshop puts a tiny upside-down V next to the cursor to let you know that it's swapped to the Convert Point tool.) Click to make Photoshop change the anchor point from one type to the other.

NOTE　Prior to CS6, there was a bug involving the Convert Point tool when you used it to introduce a break into a curved path (dragging the resulting path segment ignored the break). Happily, that problem has been fixed. Now when you use this tool to break a curved path, dragging in the middle of a resulting path segment affects just that segment. If you click on a segment closer to an anchor point, the anchor still moves, but it doesn't straighten out the segment on the other side of it.

- **To add a segment to a path,** put your cursor over the ending anchor point of an open path, and then click or drag to continue drawing. (A tiny / appears next to the cursor.)

- **To join the ends of two open path segments,** grab the Pen tool, click one segment's endpoint and then put your cursor over one of the *other* segment's endpoints. When a tiny circle with a line on either side of it appears next to the cursor (it looks almost like a chain link), click to connect the two.

Activating and Moving Paths

Because Photoshop's paths are made from multiple line segments or individual shapes, you can activate, move, reshape, copy, or delete parts of a path—or the whole thing—using the Path Selection and Direct Selection tools, which share a toolset near the middle of the Tools panel (their icons look like arrows). To activate 'em, click the arrow icon in the Tools panel or press A (or Shift-A to switch between the two).

> **TIP** If you're editing an object drawn with one of Photoshop's shape tools, you can ⌘-click (Ctrl-click on a PC) *outside* the shape to deactivate a path whenever a shape tool is active.

The Direct Selection tool turns your cursor into a *white* arrow and lets you activate specific points in a path or individual line segments and apply changes only to them, leaving the rest of the path alone (see Figure 13-16, top left). The Path Selection tool turns your cursor into a *black* arrow and lets you activate a whole path (Figure 13-16, top right) so you can do things like move, resize, or rotate the whole thing. You can activate multiple points by drawing a box around them by dragging with either tool.

New in Photoshop CC 2014, switching to another shape layer *deactivates* any points that you've activated with either tool. Figure 13-16 (bottom) has more.

Once you've activated a path(s) or part of a path, you can do the following:

- **Copy it** by Option-dragging (Alt-dragging on a PC) it to another spot. This is handy if you're making a pattern or want to add a bunch of objects to your document. Add the Shift key to copy in a straight line. Either way, the copies are all part of the same work path or saved path.

> **TIP** You can also use the Paths panel (page 578) to activate, copy, and delete paths. To activate multiple paths, Shift- or ⌘-click (Ctrl-click on a PC) them in the Paths panel. To copy a path, Option-drag it (Alt-drag on a PC) somewhere else within the Paths panel. And to delete a path, activate it in the panel, and then press the Delete key (Backspace), or simply drag it to the trash icon at the panel's lower right.

- **Delete a segment** by pressing Delete (Backspace on a PC). If you've got a point activated, you can delete the *whole* path by pressing Delete (Backspace) *twice*.

- **Align it** using Photoshop's alignment tools (page 103). Simply use the Path Selection tool to activate two or more paths, and Photoshop displays the alignment tools in the Options bar.

- **Combine it** with another path by activating both paths and then clicking the Options bar's Combine button.

- **Resize it.** Summon Free Transform by pressing ⌘-T (Ctrl+T) and Photoshop adds a bounding box around the active path, complete with resizing handles.

FIGURE 13-16

Top: To move points and paths around, activate them with the Direct Selection and Path Selection tools (respectively) by clicking or clicking and dragging to encompass multiple points or paths. Use the Direct Selection tool to choose specific points (you can tell which points are active because they're black; here, two points are active). The Path Selection tool lets you activate a whole path; notice how all the points here are black. You can make the Direct Selection tool act like the Path Selection tool (and vice-versa) by pressing ⌘ (Ctrl on a PC).

Bottom: If you've got overlapping paths on different shape layers, you can use the Options bar's new Select menu to control which ones you activate. It's initially set to Active Layers, meaning the tools grab only points or paths on currently active layers. Changing it to All Layers means the can activate any point or path on any layer.

- **Change its intersect mode.** Lurking in the Options bar's Path Operations menu—which lives to the right of the W and H fields when the Path Selection or Direct Selection tool is active—are four options that let you intersect overlapping shapes (closed paths) in a variety of ways. These modes, which are described in the next section, let you combine paths to make new shapes.

- **Change it** without affecting the whole path. As shown in Figure 13-17, by activating certain segments, you can fill them with color or give them a stroke (you'll learn how on page 598 and 596, respectively).

FIGURE 13-17

Top: Here's a close-up of the painting shown in Figure 13-1, bottom, with certain paths activated (notice the black anchor points around the active shapes).

Bottom: Activating specific paths tells Photoshop to apply any changes you make only to those paths. Here, the active paths were filled with dark blue.

To temporarily hide a path's outline, press Shift-⌘-H (Shift+Ctrl+H).

Making Paths Intersect

You can use the Options bar's Path Operations menu (Figure 13-18, top) to change the *intersect mode* of two or more overlapping paths. These modes let you combine shapes in a variety of ways, as you can see in Figure 13-18 (bottom). Here are your options:

> **TIP** You can also access the Path Operations settings in the Properties panel when you've created a shape layer using the Rectangle, Rounded Rectangle, or Ellipse tools. They're labeled in Figure 13-14.

- **Combine Shapes.** Use this mode to add one shape to another. The combined shapes merge into one, and Photoshop deletes the paths in the overlapping areas. Keyboard shortcut: Shift.

- **Subtract Front Shape.** This mode cuts out the area where two shapes overlap. Keyboard shortcut: Option (Alt).

> **TIP** Want to see your work without lines and handles? You can hide the shape outlines and handles by pressing Shift-⌘-H (Shift+Ctrl+H); press those same keys again to bring 'em back.

- **Intersect Shape Areas.** Use this mode to get rid of the parts of your shapes that *don't* overlap. Keyboard shortcut: Shift-Option (Shift+Alt).

- **Exclude Overlapping Shapes.** This mode hides the areas where the shapes *do* overlap.

- **Merge Shape Components.** This mode combines the active shapes into a single shape.

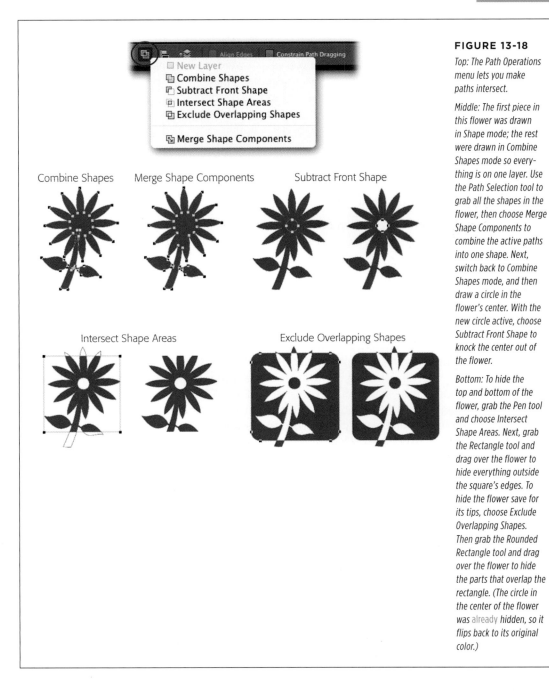

Combine Shapes Merge Shape Components Subtract Front Shape

Intersect Shape Areas Exclude Overlapping Shapes

FIGURE 13-18

Top: The Path Operations menu lets you make paths intersect.

Middle: The first piece in this flower was drawn in Shape mode; the rest were drawn in Combine Shapes mode so everything is on one layer. Use the Path Selection tool to grab all the shapes in the flower, then choose Merge Shape Components to combine the active paths into one shape. Next, switch back to Combine Shapes mode, and then draw a circle in the flower's center. With the new circle active, choose Subtract Front Shape to knock the center out of the flower.

Bottom: To hide the top and bottom of the flower, grab the Pen tool and choose Intersect Shape Areas. Next, grab the Rectangle tool and drag over the flower to hide everything outside the square's edges. To hide the flower save for its tips, choose Exclude Overlapping Shapes. Then grab the Rounded Rectangle tool and drag over the flower to hide the parts that overlap the rectangle. (The circle in the center of the flower was already hidden, so it flips back to its original color.)

■ **ALIGNING AND REARRANGING PATHS**

Photoshop includes a few more helpful settings for arranging paths just the way you want 'em. The following settings live in the Options bar to the right of the Path operations menu and are active any time more than one path or shape layer is active:

- **Path alignment.** This menu gives you the same alignment tools that you get with layers (page 103). Once you've activated more than one path, you can choose to align their left edges, horizontal centers, right edges, top edges, vertical centers, or bottom edges, as well as distribute their widths and heights. From the factory, this menu is set to Align To Selection, which aligns the right-most *path* edges. The Align To Canvas option aligns all the paths to the edge of the *canvas* instead.

- **Path arrangement.** Use this menu to control the stacking order of your paths. Your options are Bring Shape To Front, Bring Shape Forward, Send Shape Backward, and Send Shape To Back.

- **Align Edges.** Turn on this checkbox to align the edges of a path's stroke (if you've added one) to the pixel grid, ensuring sharper strokes.

- **Constrain Path Dragging.** This option is only available for the Path Selection or Direct Selection tools. Turn it on to adjust a single path contained *within* a shape instead of altering the *entire* shape.

Adding a Stroke to a Path

After you create a path with the Pen tool in *Shape* mode, you can add a *stroke* (outline) to it using the Options bar's Stroke menu (shown in Figure 13-12 on page 582). You can also stroke a path you've made with the Pen tool—or any of Photoshop's shape tools—in Path mode by using the Edit→Fill dialog box's scripted patterns option (new in this version of the program), or any of Photoshop's painting tools. The latter is handy when you're trying to draw a long, smooth, flowing line like the Z in Figure 13-19. Try drawing that path freehand using the Brush tool—it's *really* hard to create such a perfect Z shape. But with the Pen tool, you can draw the path in Path mode, edit it (if necessary) using the techniques described in the previous sections, add a new layer, and then add the fancy red stroke to it using your favorite brush (Chapter 12 has more on brushes).

> **NOTE** When you add a colored fill or stroke to a path you've drawn with the Pen or shape tools in Path mode, the color appears on the currently active layer. So it's a good idea to take a peek in the Layers panel and make sure you're on the *correct* layer first or perhaps add a *new* one to contain the stroke.

Once you've created a path and activated it in the Paths panel, open the Layers panel and add a new layer by clicking the "Create a new layer" icon at the bottom of the panel. With the new layer active, you can add a stroke to the path in the following ways:

- **From the Paths panel's menu, choose Stroke Path.** In the resulting dialog box (Figure 13-19, left), pick the tool you want to use for the stroke. The drawback to this method is that the stroke uses whatever settings you *last* applied to that tool (you don't get a chance to change them). For example, if you set the Brush tool to a certain blend mode and lowered its opacity, the stroke uses those settings.

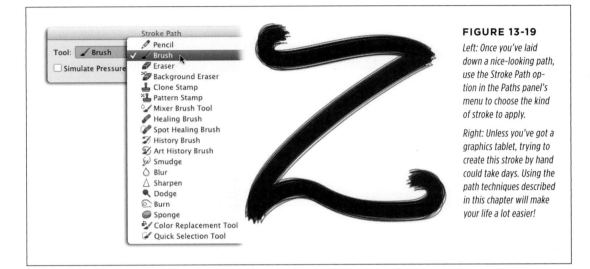

FIGURE 13-19

Left: Once you've laid down a nice-looking path, use the Stroke Path option in the Paths panel's menu to choose the kind of stroke to apply.

Right: Unless you've got a graphics tablet, trying to create this stroke by hand could take days. Using the path techniques described in this chapter will make your life a lot easier!

TIP You can also open the Stroke Path dialog box by Option-clicking (Alt-clicking on a PC) the Stroke Path icon at the bottom of the Paths panel (the hollow circle), or by Option-dragging (Alt-dragging) the path in the Paths panel onto the Stroke Path icon.

- **Activate the tool you want to use to stroke the path.** Adjust the tool's settings in the Options bar, and then click the Stroke Path icon at the bottom of the Paths panel. This method helps you avoid having to undo the stroke because the tool's settings were all screwy.

- **Apply a pattern to the path.** New in this version of the program, you can place a repeating pattern *along* a path. Choose Edit→Fill and, from the Use menu, pick Pattern. Pick the pattern you want to use from the Custom Pattern menu, turn on Scripted Patterns, and then choose Place Along Path from the Script menu. This trick is incredibly handy when you want to place a repeating image on top of (or next to) a path to create an artful embellishment or design element. For example, say you used the technique on page 94 to define a pattern from a chili pepper, and then you drew a path with no stroke. You could then use this technique to string the peppers along the curves in your path. As Figure 13-20 shows, the Place Along Path dialog box gives you get a slew of options that let you the control the pattern's size, spacing, and more.

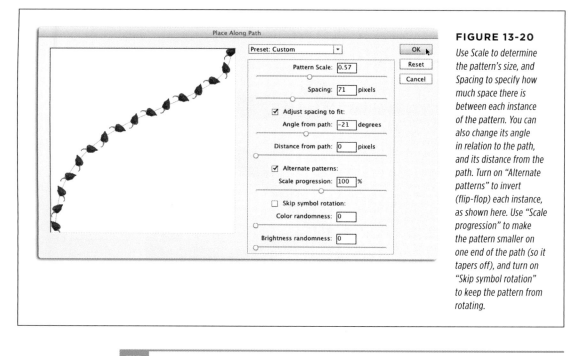

FIGURE 13-20

Use Scale to determine the pattern's size, and Spacing to specify how much space there is between each instance of the pattern. You can also change its angle in relation to the path, and its distance from the path. Turn on "Alternate patterns" to invert (flip-flop) each instance, as shown here. Use "Scale progression" to make the pattern smaller on one end of the path (so it tapers off), and turn on "Skip symbol rotation" to keep the pattern from rotating.

TIP You can save your Place Along Path settings as a preset by choosing Save Preset from the Preset menu at the top of the dialog box. The same menu also lets you load a preset that you snagged from someone else.

Filling a Path

Before you fill a path, take a moment to consider whether it's open or closed. As described on page 577, the starting and ending anchor points of an open path don't meet. Since you can't really fill a shape that's not closed, if you try to fill an open shape, Photoshop *imagines* a straight line that connects the path's starting point to its ending point, and then fills all the closed areas created by that imaginary line. This can lead to some rather strange results, as shown in Figure 13-21, top. When you fill a closed path—one where the starting and ending points *do* meet—Photoshop fills the whole shape just like you'd expect (Figure 13-21, bottom).

After you draw a path with the Pen tool—and after creating a new empty layer if you don't want the fill to happen on the currently active layer—choose from the following fill methods:

- **Use the Options bar's Fill menu.** If you created the path with the Pen tool in *Shape* mode, you can use the Options bar's Fill menu to add a fill to it. When you click this icon, Photoshop opens the Fill panel shown back in Figure 13-12, which lets you fill the path with a solid color, gradient, or pattern. It's discussed on page 584.

FIGURE 13-21

Top: When you fill an open path, Photoshop creates areas to fill by pretending there's a straight line connecting the path's start and end points.

Bottom: Not surprisingly, filling a closed path stocks the shape with color.

- **From the Paths panel's menu, choose Fill Path.** If you created the path with the Pen tool in *Path* mode, you can use the Fill Path dialog box (Figure 13-22) to choose what to fill the shape with. This is handy if you want to fill it with a pattern or use a specific blend mode for the fill.

- **At the bottom of the Path's panel, click the "Fill path with foreground color" icon (the gray circle).** If you drew the path in Path mode, this makes Photoshop fill the path with your foreground color (you don't get a dialog box with this method). Activating the path in the Paths panel and then dragging it onto this icon does the same thing.

- **At the bottom of the Paths panel, Option-click (Alt-click on a PC) the "Fill path with foreground color" icon.** Also for use on paths drawn in Path mode, this method summons the Fill Path dialog box (Figure 13-22). You can do the same thing by activating the path in the Paths panel and then Option-dragging (Alt-dragging) it onto this icon.

FIGURE 13-22

This dialog box lets you tell Photoshop exactly what you want to fill the path with. You can even choose the fill's blend mode or feather its edges.

To open the Color Picker, choose Color from this menu.

The Fill Path dialog box (Figure 13-22) is divided into three sections:

- **Contents.** The Use menu lets you decide whether to fill the path with your foreground or background color, Content-Aware (page 436), or a pattern you pick from the Custom Pattern menu. Choose Color to summon the Color Picker so you can choose any color you want. Choosing History makes Photoshop fill the path with the currently active History state or a snapshot of the document in a previously saved state (see page 17).

- **Blending.** Use the Mode menu to change the fill's blend mode and the Opacity field to change its opacity. If you're filling a path on a layer that's partially transparent and want Photoshop to fill only the part that's *not* transparent, turn on the Preserve Transparency.

- **Rendering.** To make the fill's edges soft and slightly transparent, enter a number in the Feather Radius field (this setting works like the Refine Edge dialog box's Feather slider; see pages 151 and 181). The higher the number, the softer the edges. Leave Anti-alias turned on to make Photoshop smooth the fill's edges by adding a slight blur; if you turn it off, the fill's edges will be hard and look blocky in curved areas.

Making Selections and Masks with Paths

As you learned in Chapter 4, Photoshop is loaded with selection tools. However, when you're trying to select something *really* detailed, like the column section shown in Figure 13-23, none of the regular selection tools can help. That's because the column's shape is complex and there's very little contrast between the area being selected and the surrounding pixels.

Luckily, you can use the Pen tool to draw a path that follows the contours of any shape you want to select (Figure 13-23, bottom), no matter how intricate it is.

FIGURE 13-23

The lack of contrast in this image makes it nearly impossible to select just part of this façade (top). However, you can use the Pen tool to draw a path around the section you want by hand (bottom).

The beauty of this method is that the Pen tool is so forgiving—if you don't get it right the first time, you can edit the path. When you've got the path in place, you can load it as a selection and proceed merrily on your way, doing whatever you want with the selected object.

To load a path as a selection, first create the path with the Pen tool in Path mode, and then use one of these methods:

- **In the Options bar, click the Selection button** to summon the dialog box shown in Figure 13-24, where you can adjust settings like the selection's feather amount and whether you want Photoshop to apply anti-aliasing. In the Operation section, tell Photoshop whether to create a new selection, add to or subtract from an existing one, or create a selection from the intersection of this one and an existing one.

Make Selection

Rendering

Feather Radius: 0 pixels

☑ Anti-aliased

Operation

- ⦿ New Selection
- ○ Add to Selection
- ○ Subtract from Selection
- ○ Intersect with Selection

OK

Cancel

FIGURE 13-24

The Make Selection dialog box lets you feather the selection, apply anti-aliasing to its edges, or combine it with an existing selection (discussed later in this section).

If you're a fan of keyboard shortcuts, you can load your path as a new selection by pressing ⌘-Return (Ctrl-Enter on a PC); add the path to the active selection by pressing Shift-⌘-Return (Shift+Ctrl+Enter); subtract the path from an active selection by pressing Option-⌘-Return (Alt+Ctrl+Enter); or intersect the path with an active selection by pressing Shift-Option-⌘-Return (Shift+Alt+Ctrl+Enter).

- **From the Paths panel's menu, choose Make Selection** and Photoshop opens the Make Selection dialog box (Figure 13-24).

- **At the bottom of the Paths panel, click the "Load path as a selection" icon (the dotted circle).** This method bypasses the Make Selection dialog box. Photoshop applies the settings you used the *last* time you used the Make Selection dialog box (like the feather radius). If you haven't used that dialog box yet, Photoshop sets the feather radius to zero, leaves anti-aliasing turned on, and—if a selection tool is active—creates a brand-new selection.

- **At the bottom of the Paths panel, Option-click (Alt-click on a PC) the "Load path as a selection" icon** at the bottom of the Paths panel to open the Make Selection dialog box (Figure 13-24).

- **In the Paths panel, drag the path's thumbnail onto the "Load path as a selection" icon**. This method bypasses the Make Selection dialog box and applies the settings you used last time.

- **In the Paths panel, ⌘-click (Ctrl-click) the path's thumbnail.** You won't see the Make Selection dialog box this way, either; Photoshop simply applies the last settings you used.

At the bottom of the Make Selection dialog box lies a section labeled Operation (Figure 13-24). If you don't have any active selections, Photoshop assumes you want to make a new selection and doesn't let you choose any of the other options. But if you already have an active selection, you can use the Operation section's other settings to make the selected path interact with it in different ways:

- **Add to Selection** adds the path's shape and attributes (like feather radius, fill color, stroke thickness, and so on) to the active selection.

- **Subtract from Selection** subtracts the path's shape and attributes from the active selection.

- **Intersect with Selection** selects only the area where the path and the active selection overlap.

Making a Path from a Selection

You can also do the *opposite* and create a path from an existing *selection*. This is helpful if you need to alter a selection you made with another tool. For example, you can start out with a selection you created with the Quick Selection tool (or another selection tool), turn it into a path, and then tweak it with the Pen tool.

Here's how: Create a selection, and then click the "Make work path from selection" icon at the bottom of the Paths panel (the circle with four tiny squares around it). Then, using the path-editing techniques you learned earlier in this chapter (page 591), edit away. Finally, to transform the path back into a selection, use one of the methods listed in the previous section.

TIP The paths Photoshop creates when you turn a selection into a path aren't terribly sharp. Pixel selections—especially ones you make with the Magic Wand—can create bumpy paths that have too many points. If you select an area that needs to be *smoothed*, open the Paths panel's menu and choose Make Work Path. In the resulting dialog box, adjust the Tolerance setting to smooth out the pixels. The higher the tolerance, the smoother the resulting path will be. But if you set the tolerance *too* high (anything over 5), you'll start to lose details.

Making a Clipping Path

If you want to isolate an object from its background so you can use it in an *older* version of a page-layout program like Adobe InDesign or QuarkXPress, you can create a *clipping path* (recent versions of both programs *prefer* PSD files instead). A clipping path is like a written description of your selection that those older programs can understand even if they can't handle PSD files, layers, and transparency. You still send the whole document to the page layout-program, but the clipping path specifies which *portion* of the image to display.

For example, Figure 13-25 shows a cup that's been isolated from its background in Photoshop using a clipping path, and then placed on a blue background in a page-layout program. The page-layout program understands the clipping path that travels along with the file, and uses it to hide the cup's original background.

FIGURE 13-25

Top: You can use a clipping path to isolate this cup from its background in a way that older page-layout programs understand.

Bottom: Here's the cup after it was placed on a totally different background in a page-layout program.

Both Adobe InDesign CS4 and later and QuarkXPress 8 can read layered Photoshop files with transparency and recognize paths saved in TIFF files. So if you're using the latest versions of those programs, you don't need to worry about clipping paths. But if you're dealing with an older version of either program, mastering clipping paths can make you the office hero.

To create a clipping path around an image like the cup in Figure 13-25, follow these steps:

1. **Draw a closed path around the cup with the Pen tool in Path mode.**

 Press P (or Shift-P) to grab the Pen tool, put it in Path mode (page 570), and then draw a path around the outside edge of the cup using the techniques discussed earlier in this chapter. (Zoom in nice and close when drawing the path, as in Figure 13-26, top.) When you're done, click the starting point to close the path.

2. **Draw a second path inside the cup's handle.**

 To knock out the area inside the handle, click the Options bar's Path Operations menu shown in Figure 13-18 (top) and choose Exclude Overlapping Shapes so the second path cuts a hole through the first (see Figure 13-26, bottom). Be sure to close this second path by clicking its starting point.

3. **Save the work path.**

 Photoshop won't let you make a clipping path until you save the work path you've created. Over in the Paths panel, activate the work path (page 578) and drag it onto the "Create new path" icon at the bottom of the panel, or choose Save Path from the panel's menu. In the dialog box that appears, give the path a descriptive name like *Cup outline*.

FIGURE 13-26

You can see that the path travels along the edge of the cup (top left) and continues until the entire cup is surrounded (top right).

To omit the space inside the handle, draw a second path around the inside of the handle (bottom).

When you're trying to isolate an object from its background, it's a good idea to draw the path about 1 or 2 pixels inside the object's edge to make sure that none of the background sticks around. That way, you're more likely to avoid jagged edges where bits of the background show through the selection.

Some stock photography comes with clipping paths, which save you a ton of work if you need to place the object on another background. The next time you download a stock image, open it in Photoshop and then take a peek in the Paths panel to see if the file contains a clipping path. If so, you can activate the path's thumbnail and then add a layer mask by clicking the "Add layer mask" icon at the bottom of the Paths panel (the circle inside a square). Sweet!

4. **Turn the path into a clipping path.**

 From the Paths panel's menu, choose Clipping Path. In the resulting dialog box (Figure 13-27, top), choose the path's name from the Path menu.

 Leave the Flatness field blank and click OK. This field controls how accurately printers will follow the path, so you only need to worry about it if you'll print the path. A lower number means the printer pays attention to more points on the path (so the print is more accurate), and a higher number means it pays attention to fewer points (so the print is less accurate). Some printers can't handle paths with lots of points, so setting this field to a higher number reduces the path's complexity and helps make things easier on your printer.

 In the Paths panel, the path's name now looks like a hollow outline to let you know that it's a clipping path (Figure 13-27, bottom).

5. **Save the document as an EPS or TIFF file.**

 Choose File→Save As, and then pick EPS or TIFF from the format drop-down menu. If you're paranoid about print quality, pick EPS to ensure the best results (this format is based on the same language PostScript printers use, so it tends to print a little more crisply).

FIGURE 13-27

Top: Pick your path from the drop-down menu at the top of this dialog box. You can typically ignore the Flatness setting, but if you get a call from your printing company complaining that your file caused a printing error, try redoing the clipping path and increasing the Flatness setting to 4 or 5. This cuts the printer a little slack as far as how precisely it has to follow the clipping path.

Bottom: Once Photoshop has converted the path into a clipping path, it displays the path's name in the Paths panel in extremely hard-to-read hollow text.

You've now got yourself a perfectly selected and isolated cup, ready to be beamed into the nearest page-layout program.

Using Vector Masks

Photoshop gives you two ways to create *vector masks*: using a path made with a shape tool in Path mode, or by using a path drawn with the Pen tool in Path mode. These masking methods are quick and easy, and you're absolutely gonna *love* their flexibility (vectors are infinitely resizable and editable, remember?).

That said, it's worth noting a few things about vector masks. First, they work just like the pixel-based masks you learned about in Chapter 3: They can hide any underlying layer content that's *beyond* the shape's edges. Second, because vector masks are made from vector-based paths, they give you much smoother edges than pixel masks. Third, you can feather them nondestructively on the fly using the Properties panel's Feather slider (you can do that with pixel-based masks, too).

■ MASKING WITH PATHS

You can easily create a vector mask from a path made by any shape tool or the Pen tool in Path mode (Figure 13-28). A mask created in this way works just like the regular layer masks you learned about back in Chapter 3 and adds a mask thumbnail to the currently active layer, but the mask is filled with gray instead of black. (If the background layer is locked, you'll need to double-click it before adding the vector mask.) The difference is that, since the mask is *vector* based, you can resize it all you want and its edges stay nice and sharp.

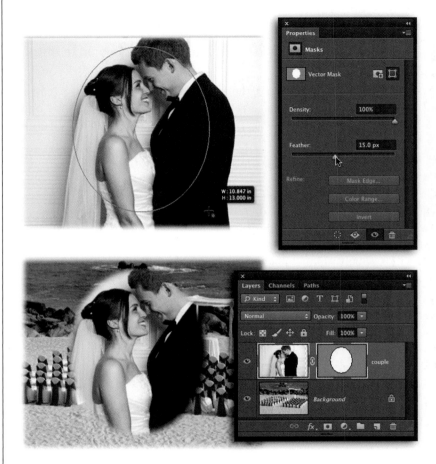

FIGURE 13-28

Top: Here's an oval drawn with the Ellipse tool in Path mode (the Ellipse shape tool, not the Elliptical Marquee tool).

Bottom: After creating a vector mask from the path, the photo is visible only through the oval mask. If you decide to resize the mask later on, simply activate it and summon the Free Transform tool (page 276).

Once you've combined two images into the same document and you've double-clicked the background layer to unlock it, follow these few steps to make a vector mask from a path:

1. **Grab the Ellipse tool by pressing Shift-U repeatedly and then, in the Options bar, choose Path mode.**

 If you prefer, you can use any of the other shape tools instead, or the Pen tool. No matter which tool you choose, set it to Path mode (page 570).

2. **Draw an ellipse atop your image by dragging diagonally.**

 The Tip on page 151 explains how to reposition the shape as you're drawing it.

3. **In the Layers panel, activate the layer you want to add the mask to, and then create the mask by ⌘-clicking (Ctrl-clicking on a PC) the "Add a layer mask" icon at the bottom of the panel.**

Photoshop adds an infinitely resizable vector mask to the layer and opens the Properties panel.

4. **In the Properties panel, drag the Feather slider to the right to soften the mask's edges.**

Photoshop softens the edges of the mask in real time. The beauty of feathering the mask this way is that you can always change it anytime by double-clicking the mask to reopen the Properties panel, and then adjusting the Feather slider. Woo hoo!

5. **Save the document as a PSD file so you can edit it later.**

That's all there is to it! It's a super-fast and super-flexible technique.

If you decide you need to edit the vector mask later on, pop open the document and activate the mask thumbnail in the Layers panel, and then use the Path Selection tool to activate its anchor points and control handles. Alternatively, to resize the vector mask, simply summon the Free Transform tool (page 276).

Creating Artistic Text

Text has the power to make or break a design, and Photoshop CC has a veritable *smorgasbord* of text-creation and formatting options—heck, it even has its own Type menu! But just because you *can* do something doesn't mean you *should*: The act of creating text is something of an art form (called *typography*), as it's all too easy to get carried away with *decorating* rather than creating legible prose.

Keep in mind that Photoshop isn't always the right place to be wordsmithing in the first place. (The box on page 612 can help decide whether to hunt and peck in another program.) Nevertheless, Photoshop has plenty of tools that, when used tastefully, can help you create beautiful text. Some of these tools are easy to find, while others are hidden so deep in the program that you'd need a treasure map to find 'em. This chapter guides you in the right direction, and more importantly, teaches you when and how to use each tool. You'll also learn quite a lot about the art of type in the process.

> **NOTE** Photoshop CC 2014 lets you access a special collection of online fonts through a service called *Typekit*, which is free with *any* Creative Cloud subscription. Once you download a font from Typekit, you can use it in any program you want—even Microsoft Word. Page 616 has more.

Typography 101

People have been creating and arranging symbols for thousands of years. In the early days of print, text and symbol wrangling was handled by exacting craftsmen called typesetters, who lovingly hammered letterforms into metal plates and then

physically set them onto printing presses (hence the phrase, *setting type*). With the advent of desktop publishing, however, everyone *and* their cocker spaniel started creating text. This has been both good and bad: It's great that you can whip up your own yard sale signs, invitations, and posters; but, as you might suspect, the quality of typography has suffered since most folks lack professional training. Figure 14-1 shows examples of good and bad typography.

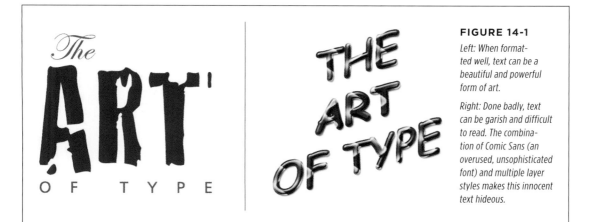

FIGURE 14-1

Left: When format- ted well, text can be a beautiful and powerful form of art.

Right: Done badly, text can be garish and difficult to read. The combina- tion of Comic Sans (an overused, unsophisticated font) and multiple layer styles makes this innocent text hideous.

Some of the most frequent typographic offenses include:

- **Overusing decorative fonts and using too many fonts per design.** Just because you have a ton of wacky fonts doesn't mean you should use them— *especially* not all in one document.

- **Setting whole sentences in capital letters.** All-capped text takes folks longer to read because they're not used to it. Even worse, it tends to imply that you're YELLING. That said, with the right formatting, small portions of all-capped text can look classy (flip to page 644 for a quick peek).

- **Underlining text that isn't a hyperlink.** Thanks to the Internet, when folks see an underlined word, they assume it's a hyperlink. Find another way to make your text stand out, such as bolding or italicizing it.

- **Centering large bodies of text.** It's best to reserve centered text for formal occasions; you'll learn why on page 650.

- **Misusing straight and smart (curly) quotation marks and apostrophes.** Use the straight ones to indicate units of measurement (feet and inches) and curly ones for everything else. You can switch between 'em using Photoshop's prefer- ences: choose Photoshop→Preferences→Type (Edit→Preferences→Type on a PC) and turn Use Smart Quotes on or off.

- **Misusing (or not using) hyphens, en dashes, and em dashes**:

 — **Hyphens** are for combining two words (like "pixel-jockey") and for line breaks (when a word gets split across two lines of text).

 — **En dashes** are slightly longer than hyphens and are a good substitute for the word "to," as in "Chapters 1–4" or "8:00 a.m.–5:00 p.m." On a Mac, you can create an en dash by typing Option-Hyphen (on a PC, press and hold Ctrl and then press the minus sign on your numeric keypad).

 — **Em dashes** are the longest of the bunch and imply an abrupt change—like this!—or a halt in thought or speech. Use them instead of a comma or period when the former is too weak and the latter too strong. To create an em dash on a Mac, press Shift-Option-Hyphen (on a PC, press and hold Ctrl+Alt and then press the minus sign on your numeric keypad).

TIP The names en dash and em dash are derived from the lead-setting days when an en dash was the width of the letter n, and an em dash was the width of the letter m. Who knew?

- **Improperly spaced ellipses (...).** An ellipsis indicates an omission, interruption, or hesitation in thought, as in, "But...but...you promised!" Instead of typing three periods (which can get broken across lines), let your computer create the dots for you. On a Mac, it's Option-; (on a PC, press Alt and type *0133* on the numeric keypad).

There are more offenses, to be sure—such as putting *two* spaces after each period instead of *one*—but this isn't *Typography: The Missing Manual* (now there's an idea!). Nonetheless, the guidelines listed above will serve you well throughout the rest of this chapter, if not your entire career.

The Face of Type

At the heart of typography lies the *glyph*, a unique graphical representation of a letter, number, punctuation mark, or pictographic symbol. In the digital realm, a collection of glyphs is called a *typeface* or *font*. Technically, a typeface is the overall shape or design of the glyphs and a font is the specific size, style, and weight, but people use the terms interchangeably. For example, Times is a typeface, while Times 14-point bold is a font—the latter being more descriptive. (For the purpose of this book—and your sanity—they'll both be referred to as fonts from here on out.) You may also encounter the term *font family*, a collection of various weights and widths of the same design. An example of a font family is Futura Book, Futura Semibold, Futura Heavy, Futura Sumo (kidding!), Futura Bold, Futura Extra Bold, and so on.

The size of a font is determined by the distance between the top of its tallest character (the *ascender*) to the bottom of the lowest character (the *descender*)—for example, the top of a lowercase *h* and the bottom of a lowercase *g*. That's why two fonts at the same point size can *appear* to be different sizes.

■ COMMON FONT FORMATS

Fonts come in various formats that determine how and what kind of information gets stored in each font file and ultimately, how they print. There are only three formats you need to worry about in Photoshop: PostScript, TrueType, and OpenType (Typekit fonts [page 616] are OpenType, too). All three formats create vector text, where the characters are made up of curves and lines, so you can resize 'em infinitely without losing quality. If you've already created some Photoshop text, you can discover what format it's in by taking a peek at the font family menu—the unlabeled drop-down menu showing the font's name—in the Options bar or Character panel, as explained in Figure 14-2.

Printing Photoshop Text

There's a time and a place for everything, and that includes Photoshop text. Although each new version of the program boasts new and improved text formatting capabilities, it's just not made for handling big hunks of text. This book, for instance, was written in Microsoft Word and formatted in InDesign, *not* Photoshop.

If your document includes a lot of text—or it's more than a single page—it's much better to use a page-layout program like Adobe InDesign or QuarkXPress because they produce *vector* text (each character is described mathematically as a series of curves and lines—see Chapter 13 for details), which looks nice and crisp in print. Plus, those programs both have special tools for dealing with multi-page documents.

Though Photoshop text starts out as editable vectors, it can get *rasterized* (converted to dots) when the document is flattened (page 120) and exported in TIFF or JPEG format, which can make it look fuzzy when it's printed, especially if you've *resized* the resulting TIFF or JPEG (take a peek at the ads in the back of any magazine, and you'll spot some examples). If you're printing straight from a Photoshop document (PSD), though, you don't have anything to worry about; your text will print just fine.

If you *have* to use Photoshop—because it's the only program you've got or the text is part of the image itself (if you've pushed a photo through text [page 664], say, or given it an artistic treatment like texture [page 660])—then be sure to save the file in either EPS or PDF format. With EPS, the file still gets flattened and rasterized, but the letterforms remain vectors; however, the text is no longer editable (the only advantage to using EPS is that it works with older workflows so some print shops may require it). With PDF, you can turn on the Preserve Photoshop Editing Capabilities option in the Save Adobe PDF dialog box so your layers remain intact and the text stays editable. So if you have a choice, go with PDF format.

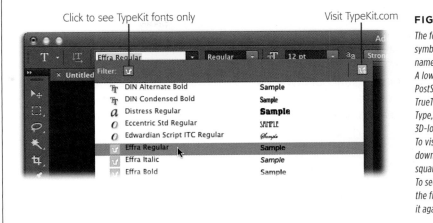

Click to see TypeKit fonts only

Visit TypeKit.com

FIGURE 14-2

The font family menu uses a symbol to the left of each font name to denote its format. A lowercase "a" means it's a PostScript font, TT stands for TrueType, an O indicates Open-Type, and a green square with a 3D-looking T stands for Typekit. To visit the Typekit site to download fonts, click the green square at the menu's top right. To see only Typekit fonts, click the filter icon labeled here (click it again to see all your fonts).

These days, font format isn't such a big deal—any printer with equipment less than 15 years old can print any format you throw at it. But in case you're curious, here's how the formats differ:

- **PostScript.** Most graphic design pros consider this format the safest and most reliable for printing because it's been around for years (it comes in both Mac and Windows flavors). Each PostScript font consists of two files: one that contains the shapes that get displayed onscreen (called the *screen* or *bitmap* file because monitors display bits or dots) along with font family and spacing info, and another that contains outline drawings of each glyph for the printer (commonly referred to as the *printer* file). This format produces high-quality text when printed on PostScript devices like laser printers and professional printing presses. The downside is that the two files can get separated or lost, which may make the font unusable (though, these days, most computers ignore the screen file and use the printer file for everything, but you shouldn't count on that). Folks who install and manage fonts manually (see the box on page 616) occasionally run into these kinds of problems.

- **TrueType.** Developed jointly by Apple and Microsoft, TrueType is the most common font format, and it's what you'll find in both the Mac and Windows operating systems (though they're likely different versions so they may not look the same). Both the screen and outline information are stored in a single file, so they can't be separated or lost. Though these fonts rival the quality of PostScript and they're increasingly used by the design community, many professional printers still prefer PostScript out of habit. TrueType fonts for Windows can be used on Macs, but not vice versa.

- **OpenType.** This format, created by Microsoft and Adobe, is the new standard. Like TrueType, OpenType fonts store the screen and outline information together in one file. They work well and look the same on both Macs and Windows computers, plus they can store more than 65,000 different glyphs in one font file. This makes them ideal for decorative and pictorial languages like Asian and Middle-Eastern ones, and for other fancy typographic goodness like ligatures and stylistic alternates (page 647). As an added bonus, you can use the same OpenType font on both Mac and Windows machines. (As mentioned earlier, all Typekit fonts are OpenType; see page 616 for more about Typekit). As with most things, change takes time, so a lot of printers don't yet support this format. But because it's so versatile, someday OpenType will rule the typographic world!

> **NOTE** If you're designing a graphic that'll be posted online, font format doesn't matter because the text isn't headed for a printer. And if you're printing to a non-PostScript device like an inkjet printer, *anti-aliasing* matters more than font format—see page 638 for details.

■ FONT CATEGORIES

Font foundries (the purveyors of fonts) crank out new fonts daily. Depending who you ask, there are between 50,000 and 150,000 known fonts in the wild. No wonder it's tough to pick one! Luckily, there are a few basic principles for choosing a font that's appropriate to your message—one that will reinforce it rather than distract from it. Figure 14-3 shows examples of the following font categories:

- **Serif.** These fonts have little lines (*serifs*) that resemble tiny feet extending from their letters' main strokes. The main strokes vary from thick to thin, and the serifs help lead the eye from one character to the next. Serifs are great for large bodies of printed text—like books, newspapers, and magazines—where legibility is paramount. However, they're not so good for large bodies of *online* text (the next bullet point explains why). Examples include Times New Roman, Garamond, and Minion.

- **Sans serif**. Fonts lacking the aforementioned feet are called *sans serif* ("sans" means "without"). They're perfect for headlines, subheads, and surprisingly enough, online body copy. (You're reading a sans-serif font now.) Because their main strokes are uniform—they don't vary from thick to thin—they display well at small sizes, so they're ideal for Web use. Examples include Arial, Helvetica, and Futura.

- **Slab serif.** These guys have uniform main strokes, thick serifs, and often appear bolded. Use them when you want to attract attention, or when printing body copy under less-than-optimal conditions (cheap paper, cheap printer, or fax machine). Examples include Bookman, Courier, and Rockwell.

- **Decorative, Display.** This group includes all kinds of distinctive, eye-catching fonts, from the big and bold, to the swirly, to letters made out of bunnies. Though gloriously unusual, they're harder to read due to the extra ornamentation or

stroke thickness. Use them sparingly and on small blocks of text (perhaps a single word). Examples include Impact, Party, and Stencil.

- **Scripts.** Casual scripts are designed to look as though they were drawn (quickly) by hand. Formal scripts have carefully crafted strokes that actually join the letters together, like cursive handwriting. Use casual scripts for small blocks of text (because they can be hard to read), and reserve formal scripts for fancy announcements (weddings, graduations, and so on). Examples include Brush Script, Freestyle, and Edwardian.

FIGURE 14-3

Different situations call for different fonts.

It would be silly to print a newspaper in a decorative font—it'd be nearly impossible to read.

And no one will come to your tea party if they're put off by the big, bold letterforms of a display font, which seem to say, "Come to my party or else!"

■ FONT STYLES

Most fonts include several *styles* (variations) like bold, semibold, italic, condensed, and so on. When these styles are included in the font itself (meaning they were designed by the font's creator), they're called *native* or *built-in styles*. To view all native styles for a particular font, use the font styles drop-down menu, which sits to the right of the font family menu in the Options bar and Character panel. Just click a style to apply it to highlighted text (page 623) or the next thing you type.

If the font doesn't include a bold or italic version, Photoshop can fake it for you. Just choose a font from the font family menu and then head over to the Character panel (choose Window→Character to open it) and click the bold or italic button (the bold button has a capital T on it, and the italic button has a slanted *T*). Photoshop will then do its best to make the characters thicker or tilt them, creating what's known as a *simulated* or *faux style*. These faux styles often look fine onscreen but terrible when printed, as the printer has no outline file (drawing) to go by. Whether it's font styles, shoes, or handbags, real is *always* better than fake.

■ PREVIEWING FONTS

Choosing a font is 100 times easier if you can actually *see* what it looks like. That's why Photoshop displays an example of each font in the font family menu shown back in Figure 14-2. And if these previews are hard to see, you can use the Type menu to make them bigger: Choose Type→Font Preview Size and pick one of the six options (Large is a good choice).

Meet Adobe Typekit

When Adobe introduced its Creative Cloud, one of the most exciting features was Typekit, an online service that lets you access and download a collection of fonts that you can use in *any* program—even *non*-Adobe ones—for *free* (well, with a Creative Cloud subscription). This is fantastic news for anyone who wants to use the same font across all their promotional materials for branding consistency—you can use the same font in your print materials *and* your website (if that particular font is available in both web and desktop versions, that is; not all Typekit fonts are).

Managing Fonts

Everybody adds new fonts to their computers; in fact, each *Adobe* program you install adds new fonts to your machine. That's great, but because fonts are actually little programs that are accessed by *other* programs, it's easy for problems to crop up.

What kind of problems, you ask? Well, you may run into font conflicts—when you have two or more fonts with the same name—or worse, *damaged* fonts that get corrupted and don't work properly. Either scenario can wreak havoc on the performance of both your computer and Photoshop, and can cause a crash. These problems are incredibly frustrating, and you could lose a lot of time trying to identify exactly what's causing them. Unfortunately if you've got a ton of fonts, it's a matter of *when* you'll run into a conflict, not if.

The solution is to invest a little time and money in font-management software. These programs serve as a repository for all your fonts so they're not scattered across your hard drive. They let you turn fonts on or off (so you don't have to scroll through a mile-long font list) and organize fonts in a *multitude* of ways—such as by favorites, font style, manufacturer, project, client, and so on—and they even manage duplicate fonts for you. Font managers can also help you choose fonts for a project, as most include some kind of font-comparison feature. (As page 617 explains, you can't use a font manager to manage Typekit fonts.)

There are some free font-management programs flitting around the Web, and Mac OS X includes the free Font Book program. But when it comes to working with professional design programs, such as the ones available via Adobe Creative Cloud, it's worth spending a few bucks on a pro-level offering. Extensis (*www.extensis.com*), Insider Software (*www.insidersoftware.com*), and Linotype (*www.linotype.com*) have very nice cross-platform font managers that are loaded with features designed to make your font life easier and, more importantly, headache free.

Extensis's Suitcase Fusion and Insider Software's FontAgent Pro (which are available for both Mac and Windows for about $100, though other languages are a little bit more expensive) have similar features: They track and manage the built-in system fonts that came with your machine as well as fonts you add to your computer, which is helpful if you have third-party fonts with the same names as your system fonts. They also let you activate fonts as you need them—in fact, if Photoshop encounters a missing font when opening a document, they'll activate it on the fly—assuming you have the font, that is!. (See the box on page 631 for more on missing fonts.) They also perform basic checks when you add new fonts to make sure the fonts aren't damaged. This alone could save your hide because damaged fonts are notorious for causing Photoshop crashes and printing problems.

But the best of the bunch is Linotype's FontExplorer X Pro for Macs and PCs. It performs all the tasks mentioned above but runs *rings* around the other two programs because of its friendly design, easier access to advanced features, excellent font sample printing feature, and much more. Plus, it costs just $80.

Any kind of Creative Cloud subscription (even a single-app subscription) includes Typekit's Portfolio Plan, which lets you use up to *100* fonts at a time. Unfortunately, each style or weight within a font family counts as a separate font (for example, Futura Semibold and Futura Heavy), so the actual number of font *families* you can use concurrently may be considerably smaller.

Before you dive into accessing Typekit fonts in Photoshop (a feature that's new in Photoshop CC 2014), here are a few things to keep in mind:

- **Typekit's desktop fonts** behave *almost* the same as other fonts installed on your computer. They live on your hard drive, and you can use them in any program that sports a font menu, embed them into PDFs, convert their characters to paths (page 665), and so on. However, you *can't* use a font-management program (see the box on page 616) to enable or disable them, nor can you include Typekit fonts when packaging up a document to have it printed *elsewhere* (the workaround is to send the printer a PDF with the font embedded into it). In other words, you can't share Typekit fonts with anyone...*ever*. Because the font files are stored *invisibly* on your hard drive (weird but true), you simply can't get at them, and neither can your font-management program. That said, if you need to share a Photoshop document that includes a Typekit desktop font, the other person will be able to open and print the document just fine, but she won't be able to edit the text. However, if the recipient has a standalone Typekit account of her own (or she has a Creative Cloud subscription), she can download those fonts *herself* and then edit the text. If, for whatever reason, you stop paying for your Creative Cloud subscription, the fonts stop working.

- **Typekit's web fonts** are stored on Adobe's servers and delivered to web browsers when visitors access the pages you've created. Adobe imposes a limit of 500,000 page views for each domain where the fonts are used, so if your website goes *viral*, you have to upgrade to a paid Typekit plan, which starts at $50–$100 per year for 1,000,000 page views. And, like Typekit's desktop fonts, if you stop paying for your Creative Cloud subscription, Adobe won't serve the web fonts to your server so they no longer appear on your website (at which point your site will substitute a standard serif or sans-serif font instead).

■ INSTALLING TYPEKIT FONTS

To access Typekit fonts in Photoshop, press T to activate the Type tool and then, in the Options bar, click the font family menu. Next, click the green square at the menu's upper right (visible in Figure 14-2). Your web browser springs into action and transports you to the Typekit website, shown in Figure 14-4, which offers a *slew* of ways to find just the right font for your project. (If this is your first time visiting the site, you may see a welcome screen. Simply click "I'm new to Typekit," read the helpful hints on the next screen, and then click "Start browsing fonts" to get started.)

FIGURE 14-4

The filters on the right side of Typekit's website let you limit your search by classification (serif, script, decorative, and so on), availability (web and/or desktop use), recommended use (paragraphs or headings), properties (weight, width, and so on), and languages supported.

Just click any filter's button to apply it (the button turns green); click it again to turn that filter off. In this example, the Sans Serif, Web Use, and Desktop Use filters are turned on.

> **TIP** Typekit's integration with Adobe apps like Photoshop, and with Adobe's services such as Behance (see the box on page 803), is still in its infancy, so the exact process of working with these fonts may change by the time this book is in your hands. For the most up-to-date info on using Typekit, click the Help link at *www.Typekit. com*, which links to demonstration videos and truly helpful FAQ documents!

When you find a font you like, you can mark it by adding it to your Favorites; just click the tiny heart at the thumbnail's upper right (it turns red). To download and use the font, point your cursor at the font's thumbnail and, in the green pop-up menu that appears, click "Use fonts." The resulting dialog box has two tabs that let you specify options for the font:

- **The Desktop tab** lets you pick which weights and styles (regular, italic, bold, and so on) to install on your computer. Simply turn on the checkboxes for the options you want, and then click "Sync selected fonts." The next screen reminds you that, in order to download the fonts, you need to have the Creative Cloud app running and font syncing turned on. If you *haven't* turned on font syncing, click "Launch the Creative Cloud application," and the app's Fonts panel opens; simply follow the onscreen instructions to turn on font syncing. If you've *already* turned on font syncing, you still see the message, but there's nothing left to do; the new fonts instantly appear in Photoshop's font family menu (complete

with the green Typekit badge shown in Figure 14-2)—you don't even have to restart Photoshop!

- **The Web tab** is for folks who want to use Typekit fonts on their websites. The tab walks you through the process of adding fonts to a *kit* or creating a new one. (A kit is a collection of fonts designed for online use, along with the code that tells Typekit to *display* those fonts when someone visits your web site.) Click "Create a new kit" and a screen appears that lets you name it something meaningful (this name is just for your own use), assign domains to it (a *domain* is a website's unique identifier, such as PhotoLesa.com; you can add up to 10 domains to a single kit), and agree (or not) to let Typekit add a colophon badge (logo) to each of your web pages that visitors can click to visit the Typekit site. Click Continue, and Typekit creates the kit and displays a few lines of JavaScript code for you to copy and paste near the top of the <head> tag in your website's CSS or HTML code. When a person visits your website, the JavaScript tells Typekit to deliver your fonts to that person's Web browser (this is also how Adobe counts your page views).

Click Continue *again* and you triumphantly arrive at the final options screen, where you can pick which font weights and styles to include (each weight or style increases the size of the font file that Typekit delivers to your viewer's web browser), as well as which languages you want to support. The Default option includes characters for English, Spanish, Italian, and Portuguese; to support any *other* language, choose All Characters (doing so *also* significantly increases the size of the font file that Typekit serves to visitors). Click Publish and Typekit adds the kit to the domains you entered.

After making all these choices (whew!), you can use the fonts in your kit when designing web pages in Adobe Muse, Adobe Edge, Dreamweaver, or any other website-creation tool—even WordPress. You access Typekit fonts in the Muse and Edge font family menus, just like in Photoshop. In Dreamweaver, it's another (complicated) story that's beyond the scope of this book.

> **NOTE** If you create a website using Behance ProSite—a slick portfolio website builder included in any Creative Cloud subscription (you can get there by visiting *www.ProSite.com*)—you can use Typekit fonts there, too. Follow the onscreen instructions at the ProSite website to create your site. Once you pick a basic design template, you're taken to a page that lets you customize the layout, design, and so on. On that page, locate the Settings button, give it a click and then, near the end of the resulting list of horizontal buttons that appears, click "Custom Type Integration (Typekit)." When you do, the exact (and current!) steps for hooking Typekit up to your ProSite appear on the right.

Creating and Editing Text

You can create all kinds of text in Photoshop, from plain ol' horizontal to up-and-down vertical. You can even make text flow around or inside a shape. No matter

what kind of text you create, it lives on a special layer called a *type layer*. You can do anything to a type layer that you can with any other layer: adjust its opacity, change its blend mode, apply layer styles, and so on. In the Layers panel, type layers are labeled with a big fat T, so they're easy to spot. Photoshop automatically names each new type layer with the first few words you type, though like any other layer, you can double-click its name in the Layers panel to rename it.

To create a type layer, grab either the Horizontal or Vertical Type tool from the Tools panel, as shown in Figure 14-5. Click once in the document where you want the text to start, and then let the hunting and pecking begin. When you're finished editing and formatting the text, let Photoshop know you're done by pressing Enter on your computer's numeric keypad (not Return!), pressing ⌘-Return (Ctrl+Return on a PC), or clicking the checkmark on the right side of the Options bar; technically, this is called *committing* text. (You can also commit text by activating another tool in the Tools panel or another layer in your Layers panel.)

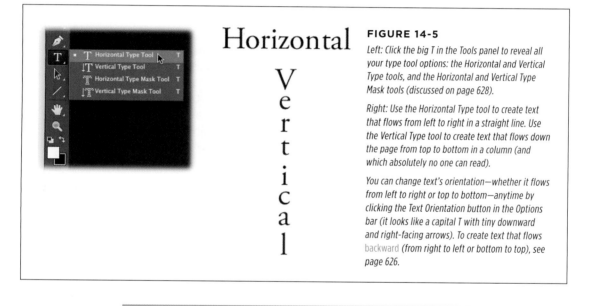

FIGURE 14-5

Left: Click the big T in the Tools panel to reveal all your type tool options: the Horizontal and Vertical Type tools, and the Horizontal and Vertical Type Mask tools (discussed on page 628).

Right: Use the Horizontal Type tool to create text that flows from left to right in a straight line. Use the Vertical Type tool to create text that flows down the page from top to bottom in a column (and which absolutely no one can read).

You can change text's orientation—whether it flows from left to right or top to bottom—anytime by clicking the Text Orientation button in the Options bar (it looks like a capital T with tiny downward and right-facing arrows). To create text that flows backward (from right to left or bottom to top), see page 626.

TIP To format multiple type layers at once, first activate 'em in the Layers panel and make sure the Type tool is also active. Then make your changes using either the Options bar or Character panel, and Photoshop applies them to *all* the active layers in one fell swoop—a huge timesaver. (Find and Replace is another great tool for multilayer changes—see page 634.)

You can locate multiple type layers fast by using the Layers panel's filtering options: From the drop-down menu at the panel's upper left, choose Kind, and then, to the right of the menu, click the T icon, and Photoshop instantly shows you only the type layers—even if they're nestled within a group (page 111). Then choose Select→All Layers and format 'em to your heart's desire. To see *all* your layers again, click the T button again. (For more on filtering layers, see page 79.)

Point Text vs. Paragraph Text

Chances are, most of the text you'll create in Photoshop will be *point text*, which starts at a certain spot (or *point*) and continues along a single line. To create point text, just activate the Type tool, click in your document, and start typing. If you type a bunch of text and want it to wrap to the next line, press Return (Enter on a PC) to force the line to break—otherwise, Photoshop is quite content to let text dangle off the edge of your document. To make Photoshop *automatically* wrap text to the next line, you have to create *paragraph text* instead.

NOTE Photoshop refers to these two kinds of text as point and paragraph, but you might hear people call them *character* and *area text*, respectively. (For example, Adobe Illustrator calls it paragraph text "area text.")

Paragraph text is text that lives inside a box. As the section beginning on page 649 explains, paragraph text gives you some extra formatting options (such as alignment and hyphenation) that you don't get with point text. When you create paragraph text, Photoshop automatically makes your prose flow from line to line. To create paragraph text, activate the Type tool and then either drag in your document to draw a box or Option-click (Alt-click on a PC) your document and then enter the desired width and height into the resulting dialog box, shown in Figure 14-6, left. (From the factory, Photoshop assumes these measurements are in points, though you can type another unit of measurement such as *in* for inches or *px* for pixels.) Click OK to dismiss the dialog box, and Photoshop places a dashed box in your document, with the upper-left corner in the spot where you clicked. If the box isn't the right size, press Esc and have another go at it, or simply adjust the box's size by dragging the tiny resizing handles strategically placed around its edges (see Figure 14-6, right).

Paragraph Text Size

Width: 320 pt OK

Height: 480 pt Cancel

Instead of clicking to create point text, drag with the the Type tool to draw a text box.

FIGURE 14-6

Left: To create a multiline text box, activate the Type tool, Option-click (Alt-click on a PC) in your document, and then enter the dimensions you want. Or drag with the Vertical or Horizontal Type tool to draw the box manually.

Right: To resize a text box, activate the type layer, click within the box, and then drag any of the resulting handles, like the one circled here.

TIP If you're designing an ad and the copy for it isn't ready yet, Photoshop can create placeholder text for you *automatically*. Grab the Type tool, create a text box, and then choose Type→Paste Lorem Ipsum. Photoshop instantly fills the box with a big ol' chunk of Latin gibberish that reads, "Lorem ipsum dolor sit amet…" (You can do the same thing with point text, too, though if you do, the placeholder text will continue off the edge of your screen for *miles*.)

When the text box is all set, just start typing. When your text hits the edge of the box, Photoshop automatically adds line breaks and hyphenates words. You can still resize the box after you type in it—just make sure the type layer is active in the Layers panel, and then click in the text box and drag any of the resulting handles. When you do that, the size of the *text* doesn't change, and Photoshop automatically reflows the text to fit inside the newly sized box. (Page 638 tells you how to change the size of the text itself.)

TIP Photoshop can convert point text to paragraph text (or vice versa) on the fly. Just activate the appropriate type layer in the Layers panel, and then choose Type→"Convert to Point Text" or "Convert to Paragraph Text." You can also Control-click (right-click) a type layer in the Layers panel while the Type tool is active and then choose the same items from the resulting shortcut menu (don't highlight or click within the text first; if you do, this menu item doesn't appear).

Finding and Previewing Fonts

Have you ever grown weary of scrolling through the font family menu, either to find the exact one you want or when experimenting with several to find one that works? The process used to be super tedious—but not anymore! This version of Photoshop sports a far better method for *both* situations.

You can now perform a *font search* by clicking within the font family field in the Options bar or Character panel, and the entering the name of the font you want to use. Bam! Photoshop instantly takes you right to that font in the list. You can even type a font *attribute*—bold, italic, condensed, and so on—and Photoshop limits the font family list to show only those fonts that include the attribute in their names. This is *extremely* handy when you need, say, a bold font and you want to see all your options. For real fun, try entering *multiple* attributes into the font family field (you can even abbreviate 'em); for

example, entering "m pro bold cond" finds all fonts that are bold, condensed, and that have "m" and "pro" in their names (Myriad Pro and Minion Pro are two of your author's go-to fonts).

And that's not all!

If you've got a type layer active that contains some text, you can see *previews* of that text in other fonts by simply *pointing* your cursor at another font in the font family list—you don't even have to highlight the text! (In fact, if you have a blinking I-beam cursor in your text, font previews won't work.) If you're not the pointing kind, use the up and down arrow keys on your keyboard to go through the list one font at a time (add the Shift key to scoot through entire font families).

If you set a lot of text, these two features will save you *loads* of time. Plus they make font hunting a *lot* more fun.

Moving Text

If you start typing and then decide the text isn't in the right spot, no problem—moving it is easy. Just grab your mouse and move the cursor *away* from the text box about a half inch. When the cursor turns into a tiny arrow with four arrows beneath it, simply click and drag the type layer to a new position in your document, and then continue typing.Another way to move text while typing is to press and hold ⌘ (Ctrl on a PC), place your cursor inside the resulting box, and then drag the text to a new spot.

If you've already finished typing, you can still move the text: Just make sure the appropriate type layer is active in the Layers panel—but don't click within the text—press V to grab the Move tool, and then drag the type layer to a new position in your document. If dragging isn't your thing, grab the Move tool and then nudge the layer by tapping the arrow keys on your keyboard.

Highlighting Text

Chances are, the text you create won't be perfect right off the bat; you'll need to massage, manipulate, and play with it (and honestly, that's half the fun). To tweak text, you have to activate the appropriate type layer in the Layers panel (it'll be highlighted, as in Figure 14-7, left), and then *highlight* the text you want to change (you'll learn how in a sec). When text is highlighted, you see a black background behind the characters (which are now white), as in Figure 14-7, top right.

> **NOTE** The color you see when you highlight text is actually a contrasting opposite of the color *underneath* the text (whether it's an image or a solid color). For example, if your text is on a white background, the highlight color is black; if it's on a blue background, the highlight color is orange. Neat, huh?

UP TO SPEED

Better-Looking Text in CC

For years, folks—mostly web designers—have claimed that text created in Photoshop looks a little too big or thick when anti-aliasing is turned on, especially at small point sizes like those used on the Web. (*Anti-aliasing* is when Photoshop slightly blurs the edges of letters so they don't look jagged.)

To fix that, in Photoshop CC, Adobe tweaked how the program blends the colors on type layers with colors on *other* layers, which makes for more balanced anti-aliasing and thus text that displays more accurately. (In technical terms, Photoshop uses linear gamma 1.0 blending instead of non-linear tone

reproduction curve encoding—don't ask.) Adobe also added two anti-aliasing methods that help web designers see what text will look like in popular web browsers (you'll learn about 'em starting on page 638).

The bottom line is that Photoshop text looks a bit cleaner and clearer than it used to. The improvement is more noticeable on smaller text sizes (12 points or less) where the anti-aliasing blur makes up a bigger portion of each letter's pixels. Also, dark text on a light background looks thinner, while light text on a dark background looks thicker.

Click to see only Type layers

FIGURE 14-7

To alter text in Photoshop, you've got to activate the type layer it's on and then highlight the portion you want to change, as shown here. To highlight all the text on a type layer, simply double-click its layer thumbnail.

When you highlight text, a colored background appears behind it and Photoshop temporarily makes the text a contrasting color so you can see it, as shown in the upper sentence here. (Why does the lower sentence look blurry? Because it's been loaded as a selection so each letter is surrounded by marching ants.)

> **TIP** The background that appears behind text when it's highlighted makes it nearly impossible to see any formatting changes you make. Fortunately, you can toggle this background off and on by pressing ⌘-H (Ctrl+H)—that is, unless you're on a Mac and have reassigned that keyboard shortcut to hide Photoshop, as explained in the box on page 8.

TROUBLESHOOTING MOMENT

Adding Type Layers

There are lots of benefits to putting different pieces of text on their own type layers. As you learned in Chapter 3, you can edit anything that lives on its own layer independently of everything else, letting you position it precisely within the document, change its blend mode and opacity, and so on, without messing with other layers. If you're creating a poster publicizing Woodstock IV, for example, it's a good idea to put the (obligatory) psychedelic heading on one layer and the details of the concert on layers of their own.

Creating your first type layer is easy: Simply click the big T in the Tools panel to activate the Type tool, and then click in your

document. However, it can be challenging to create *additional* type layers near the existing ones while the Type tool is active because, when you click in your document, Photoshop insists on activating the *existing* type layer nearest to where you clicked. Likewise, if you put your cursor close to an existing path, Photoshop assumes you want to create text on that path (see page 630) and promptly attaches the text to it.

The fix for both situations is to press the Shift key while you click within the document, which forces Photoshop to create a brand-new, bright and shiny type layer. Now, take back all those bad things you said about the Type tool.

Highlighting text—which most folks erroneously call "selecting text"—is totally differ-ent from *loading text as a selection*, which puts marching ants around each character as shown in Figure 14-7, bottom right. To load text as a selection, ⌘-click (Ctrl-click on a PC) the type layer's thumbnail. What's the difference, you ask? Highlighting text lets you edit the characters (to fix a typo, for example) or their spacing, whereas loading text as a selection lets you apply effects to the *shape* of characters, such as adding a stroke (page 657), altering other images in the shape of the characters (page 664), or creating another piece of art out of 'em altogether.

> **TIP** In this version of Photoshop, you don't have to highlight text to switch fonts. Simply activate the type layer you want to edit and then pop open the font family menu in either the Options bar or Character panel. Point your cursor to a font in the list and Photoshop temporarily displays your text in that font so you can see what it would look like. When you find the font you want, click its name in the list to apply it. That said, if you want to change the font of just a *portion* of text on a type layer, then you need to highlight that text first.

Like most tasks, Photoshop gives you several ways to highlight text. No matter which method you pick, you need to have the Type tool active:

- **To highlight a character,** click within the text and then, once your cursor turns into a blinking I-beam, drag across the character(s).

- **To highlight a word,** click within the text and then double-click the word.

- **To highlight a whole line,** click within the text and then triple-click anywhere in the line you want to highlight.

- **To highlight a paragraph,** click within the paragraph and then quadruple-click (that's four quick clicks).

- **To highlight all the text on a single type layer,** either double-click the layer's thumbnail in the Layers panel or, in your document, click within the text and then click five times really fast.

- **To activate multiple type layers,** mouse over to the Layers panel and Shift-or ⌘-click (Ctrl-click on a PC) the name—*not* the thumbnail—of each layer you want to activate.

- **To activate all the type layers in a document,** mosey over to the Layers panel and choose Kind from the drop-down menu at the top left, and then click the T button labeled in Figure 14-7. Photoshop instantly hides everything but the type layers in that document. To activate all of 'em, choose Select→All Layers.

> **TIP** When you've got a single type layer activated and the Type tool is *also* active (but no text is highlighted and you haven't clicked *within* the text), you can Control-click (right-click) anywhere in your document to sum-mon a shortcut menu with all kinds of useful text-related commands, including Check Spelling, Find and Replace Text, Rasterize, Create Work Path, anti-alias options, and more. (You get a similar menu when you've highlighted some text, but it offers fewer options.)

Resizing Text

Photoshop lets you create everything from nano-sized text that you'd need an electron microscope to read to ginormous letters fit for the side of a building. You can resize text by highlighting it using any of the methods described earlier, and then altering the point size in either the Options bar or Character panel. But where's the fun in that?

Unless you know the *exact* size your text needs to be, you're better off resizing it visually, either while typing or afterward. To resize visually, activate a type layer in the Layers panel and then click within the line of text (or the text box) so you see an I-beam cursor blinking there (if you're typing, you should already see this cursor). Next, press and hold ⌘ (Ctrl on a PC) to make Photoshop display a solid box with resizing handles around the text itself (the handles around a dashed *text box* resize the box, not the text). While keeping the ⌘ (Ctrl) key down, press and hold the Shift key, and then drag any handle to resize the text, as shown in Figure 14-8, left (adding the Shift key makes Photoshop resize the text proportionately so it doesn't get squished or squashed). As you drag, the point size displayed in both the Options bar and Character panel changes.

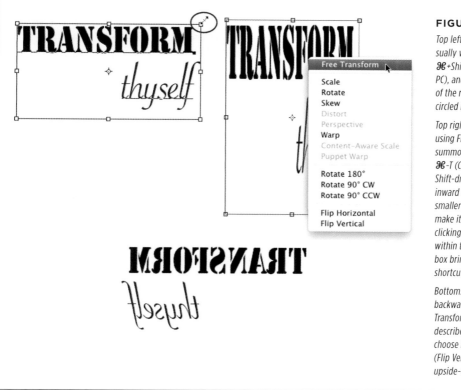

FIGURE 14-8

Top left: To resize text visually while typing, press ⌘+Shift (Ctrl+Shift on a PC), and then drag one of the resizing handles circled here.

Top right: To resize text using Free Transform, summon it by pressing ⌘-T (Ctrl+T), and then Shift-drag a corner handle inward to make the text smaller or outward to make it bigger. Control-clicking (right-clicking) within the transform box brings up this handy shortcut menu.

Bottom: To make text flow backward, open the Free Transform shortcut menu described above and choose Flip Horizontal (Flip Vertical gives you upside-down text).

TIP If you're a keyboard shortcut fan, you can increase the font size of highlighted text in 1-point increments by pressing Shift-⌘-> (Shift+Ctrl+>), and decrease it by pressing Shift-⌘-< (Shift+Ctrl+<). To increase or decrease in *5-point* increments, add the Option key (Alt on a PC) to those key combinations. These are *great* keyboard shortcuts to memorize if you want to format text quickly.

You can also use Free Transform to resize text. With a type layer active and *without* highlighting any of the text, summon Free Transform by pressing ⌘-T (Ctrl+T). A resizing box (complete with handles) appears around the text; simply Shift-drag these handles to resize the text proportionately. (You won't see the point size change as you drag, but the text's width and height appears next to your cursor.) For even *more* resizing options, Control-click (right-click) within the resizing box for a handy shortcut menu (see Figure 14-8, right).

WORD TO THE WISE

Beware of Rasterizing Text

Most of the text you create in Photoshop—whether it's horizontal, upside down, inside a shape, or what have you—begins life as *vector* text. (The exception is text you create with the Type Mask tool [page 628].) With vector text, each character is made up of curves and lines, rather than pixels. This is great because it means the text is editable and fully *scalable*, so you can make it bigger or smaller without worrying that it'll be blurry when you print it.

However, if you want to apply some of Photoshop's cool effects, you have to rasterize the text (convert it to pixels). (See the box on page 52 for a detailed discussion of raster vs. vector files.) For example, you have to rasterize text before running filters on it (though there is a workaround involving a layer mask—see page 664), distorting it, and applying perspective to it, to name a few. If you try to do any of these things to a type layer, you'll be met with an error message asking your permission to rasterize.

The bad news is that some things in Photoshop *automatically* rasterize text so that it becomes completely un-vectored, uneditable, and pretty much un-resizable. (You can *shrink* raster text without much quality loss, but enlarging it will give you disastrously jagged results.) Photoshop automatically rasterizes text—without asking for permission—when you:

- Merge a type layer with one or more other layers (see page 118).

- Flatten a file (page 114).
- Save a file in any format *other* than PSD, EPS, PDF, or DCS.
- Send a file to a non-PostScript (inkjet) printer (Chapter 16).

If you save a file in EPS or DCS format, Photoshop preserves the text by converting it to PostScript (page 613), which is pretty much the same thing as converting it to a vector. You won't be able to edit the text anymore, but it'll look nice and crisp when printed. Watch out, though: If you open *either* of these file types again in Photoshop, the program automatically rasterizes the text. However, you can preserve the text by importing the file into your document as a smart object instead; to do that, choose File→Place Embedded or Place Linked. (This method doesn't let you edit the text, though.) If you save the file as a PDF, you can keep the text editable by turning on the Preserve Photoshop Editing Capabilities option in the Save Adobe PDF dialog box (page 729).

If you truly wish to rasterize some text, it's a good idea to duplicate the type layer first (by pressing ⌘-J or Ctrl+J) just in case you want to edit it later. Once you've duplicated the layer, you can rasterize either the copy or the original by choosing Type→Rasterize Type Layer, or by Control-clicking (right-clicking) the type layer and choosing Rasterize Type.

Creating a Hollow Text Selection

Sometimes you don't really need letters *themselves* to create the effect you're after, you just need a *selection* of them—in other words, their outline. Enter the Type Mask tool, which is hidden in the type toolset shown on page 620. Instead of creating a type layer, this wonderful tool creates an empty text *selection*, which you can use on other layers, like one that contains an image.

When you use the Type Mask tool, it'll look like you're creating normal text, but once you're finished typing, marching ants will surround the edges of the characters, creating a hollow selection in the *shape* of that text, and Photoshop won't create a new type layer. Think of a type mask as one of those plastic stencils you used as a kid to draw perfectly formed letters and numbers—the letters are hollow so you can see through 'em to the layer below.

NOTE Sure, you could use the regular type tools to create text and then load it as a selection by ⌘-clicking (Ctrl-clicking) the type layer's thumbnail. But the Type Mask tool *creates the selection for you*, sparing you that extra step.

The Type Mask tool opens a boatload of graphic design possibilities because it lets you affect other graphical elements (meaning other layers) through the *shape* of the text, as shown in Figure 14-9. Like the regular Type tool, the Type Mask tool comes in two flavors: one for creating horizontal text and one for creating vertical text. They both merely create a selection of whatever you type without creating a new layer. You can then treat the text selection as you would any other selection: Move it around, use it to create a layer mask (page 193), wear it as a hat (kidding!), save it to use later (see page 197), or turn it into an editable path (page 603).

One of the many neat effects you can create with the Type Mask tool is a text-shaped photo fade, a unique look that can make an eye-catching magazine ad, for example. Here's how:

1. **Open a photo and grab the Horizontal Type Mask tool.**

 To activate the tool, click the big T in the Tools panel, hold down your mouse button, and then—in the toolset's menu—click the Horizontal Type Mask tool (you can also press Shift-T repeatedly to cycle through all the tools in the type toolset). You don't need to bother duplicating the background layer, because this technique is 100 percent nondestructive, meaning the original pixels will remain untouched.

2. **In the Options bar or Character panel, choose a font from the font family menu.**

 Be sure to choose a thick font so the selection area will be fairly big (thin or script fonts won't work). Arial Black and Impact are good ones to use for this technique.

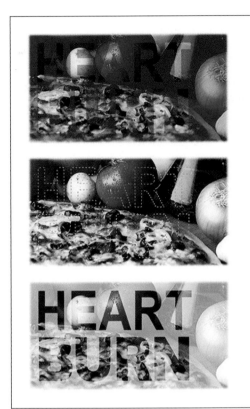

FIGURE 14-9

Top: When the Type Mask tool is active, clicking in a document causes a red overlay or mask to appear (see page 628 for more on this mask). As you type, the letters are revealed through the mask. The text remains editable (and resizable) until you accept the mask by clicking the Options bar's checkmark button or pressing Enter on your computer's numeric keypad (not Return).

Middle: Once you accept the mask, you'll see a selection of the text, indicated by the little army of marching ants surrounding the characters, as shown here (on your screen, they actually move).

Bottom: After you inverse (flip-flop) the selection, Photoshop selects the area around the text, letting you change the background of your design in the shape of the text. Here, the text selection was used in conjunction with an adjustment layer on a photo of pizza.

As you can see, all manner of graphic design goodness is possible with this technique.

3. **Click anywhere in the document and then enter your text.**

 You'll notice that the text appears hollow (you can see through it to the photo, as in Figure 14-9, top), while the background takes on the red cast of Quick Mask mode, though you can't use other tools or filters like you *normally* can in Quick Mask mode.

4. **Format the text to your liking.**

 If you don't like the font, change it by choosing something else from the font family menu (you *don't* have to highlight the text before you do this) and, if you want to, adjust its size. You can reposition the text by moving your cursor away from it about half an inch, and then dragging with the resulting arrow cursor. You can also move the text by pressing ⌘ (Ctrl on a PC), clicking inside the resulting box, and then dragging it or nudging it with your keyboard's arrow keys. Shift-drag any of the square handles to resize the text (holding the Shift key resizes it proportionately).

5. **Convert the mask to a selection.**

When the text looks good, click the checkmark in the Options bar or press the Enter key on your numeric keypad (*not* Return) to accept the mask. This creates a selection of the text (so you see marching ants) and gets rid of the red overlay, as shown in Figure 14-9, middle.

> **NOTE** If you decide to edit or reformat the text after accepting the mask, you have to start over. Just grab the Type Mask tool and retype the text (you don't have to deselect first).

6. **Inverse the selection.**

In order to fade the area of the photo around the letters, you need to flip-flop the selection. Choose Select→Inverse to select everything *except* the letters. Now you can adjust the photo's background while leaving the text alone.

7. **Create a hue/saturation adjustment layer and use it to desaturate and lighten the part of the photo in the selection area.**

Over in the Layers panel, click the half-black/half-white circle and choose Hue/Saturation from the resulting menu. (Using an adjustment layer lets you do the desaturating and lightening on a separate layer, instead of on the original image.) In the Properties panel that opens, drain most of the photo's color by lowering the Saturation setting to –65. Next, drag the Lightness slider to +60 to lighten the photo, making the text more legible.

> **NOTE** Since you had an active selection *before* creating the adjustment layer, Photoshop automatically plopped the selection into the adjustment layer's mask so the changes you made only affected the selected area.

You're done! Figure 14-9 (bottom) shows the final result: clear, photo-filled text with a faded background.

Creating Text on a Path

Photoshop lets you bend text to your every whim, and one of the coolest tricks is to make text march around a shape, as shown in Figure 14-10. The key is to use the Type tool on a *preexisting path* that you've drawn with the Pen tool or one of the shape tools (except for the Line tool) in either Shape or Path mode. (See Chapter 13 for a detailed discussion of Photoshop's drawing modes, paths, and shape tools.) When you attach text to a path, both the text and the path remain editable, so you can reformat the text or reshape the path anytime.

> **TIP** Heck, you can even turn text *into* a path (think outline) or shape—a nifty trick that lets you rotate individual letters and create cool intersecting effects. Head on over to page 665 for the details.

Here's how to attach text to a custom shape:

1. **Create a path.**

 Using either the Pen tool or a shape tool in either Shape or Path mode, create a path for the text to follow. Figure 14-10 shows a snail drawn with the Custom Shape tool (see page 589 to learn how to load built-in shapes).

 NOTE The direction you draw the shape (or path) determines the direction the text flows. For example, draw the shape from left to right and the text will flow normally; draw it from right to left and the text will be backward and upside down.

2. **Attach text to the path.**

 Grab the Horizontal Type tool (click the big T in the Tools panel) and then point your cursor just above the path or the shape's edge. You'll see a wavy line appear across the I-beam cursor (Figure 14-10, top). This is the Type tool's way of telling you that it recognizes the path you're about to attach the text to. Click once, and then start typing.

FREQUENTLY ASKED QUESTION

Type Warnings

Sometimes when I open a document, I see a little triangle on the type layer in the Layers panel. What the heck does that mean?

One day you're bound to open a Photoshop document only to be met with a *type warning*. They come in two flavors and show up in the Layers panel as a tiny yellow or gray triangle on a type layer's thumbnail:

- **A yellow warning symbol** means you're missing a font. You'll see this icon if you open a document that uses a font that's not installed on your machine. (You'll also likely see an error message *before* the document actually opens that lets you either cancel opening it or proceed; though new in this version of the program is a "Do not show again" checkbox, which lets you skip this message the next time you open the document.) If you don't need to edit the text, you've got nothing to worry about—just do what you need to do and then save the file. If you *do* edit the text, the moment you double-click the type layer, Photoshop will substitute *another* font for the missing one—and this substitution is permanent, even if you send the file back to its creator who *has* the original font. So

if it's important to keep the original font, you'll have to close the document (*without* saving it), quit Photoshop (unless you're running font-management software—see the box on page 616), install or activate the font, relaunch Photoshop, and then reopen the document.

- **A gray warning symbol** means that the document you've opened was created in a different version of Photoshop and that the text *may* get reflowed if you edit it. Because each new version of Photoshop contains new text-related features, text created in an earlier version might get spaced or hyphenated differently in the new version. So if you're not editing the document's text, you can ignore this warning. If you *are* editing the text, just keep an eye on it to make sure it looks okay.

Happily, Photoshop lets you take action on *both* kinds of warnings swiftly and easily. To replace missing fonts with something else so you can edit the text, choose Type→Replace All Missing Fonts, and Photoshop opens a dialog box asking which font you'd like to use as the replacement. To update all the text in a document created in a previous version of the program, choose Type→Update All Text Layers instead.

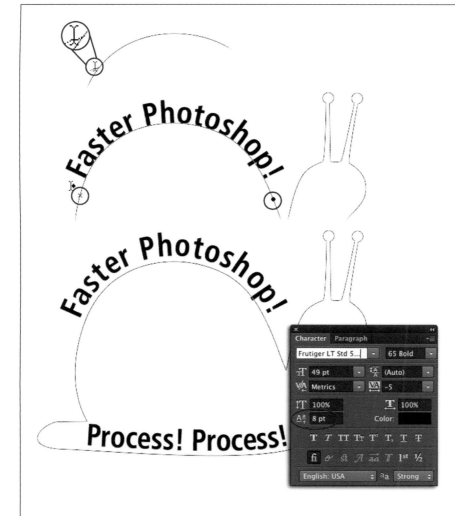

FIGURE 14-10

Top: With the Type tool active, put your cursor above any path and a little wavy line appears at the bottom of the cursor. That's Photoshop's way of saying "permission granted" for creating text on a path.

Middle: Slide the text along the path by dragging with the Path Selection tool (page 592). A tiny black arrow appears next to the cursor facing either left or right, depending on which end of the text your cursor is near (here it's facing right). The text's starting point is marked with a tiny X, and its end point is marked with a dot (both circled).

Bottom: To scoot your text away from the path it's attached to and give it a little breathing room, use the Character panel to adjust the baseline shift (page 644). You can also increase tracking (page 643) if the letters start crashing into each other.

3. **Align or reposition the text on the path.**

 You can use any of the alignment buttons in the Options bar or Character panel to align the text.

 You can also use the Path Selection tool (page 592) to slide the text back and forth along the path or flip it from the top of the path to the bottom—just click the black arrow below the Type tool in the Tools panel to activate this tool. Put your I-beam cursor over the text's starting point (which is marked with an *x*—see Figure 14-10, middle). When a tiny, right-facing arrow appears next to the cursor, drag to the left or right to move the text. (If you put your cursor

over the text's end point instead—it's marked with a black dot—then the little arrow points to the left.) To flip the text to the opposite side of the path—in this example, that means putting it *inside* the snail shell rather than on top—drag your cursor below the path (toward the bottom of the shape).

What's *really* happening here is that Photoshop is adjusting the start and end points of the text. You can move the start point by clicking the path with the right-arrowed cursor. Likewise, you can move the end point by putting your cursor at the end of the text and then clicking with the left-arrowed cursor. (If the text is center aligned, you'll see a tiny black diamond between the start and end points of the text, which you can also drag; pointing at it yields double-arrowed cursor.)

NOTE If your text disappears, that means the space between the start and end points is too small to house the text. In that case, adjust one of the points or reformat the text to make it fit.

You can format text on a path like any other text. Just switch back to the Type tool and then highlight it using one of the techniques described on page 623. (To highlight all the text on a layer *and* activate the Type tool at the same time, give the type layer a quick double-click in the Layers panel.)

Creating Text Inside a Path

Placing text inside a path or shape is even simpler than placing it on an object's edge, and it's a fun little exercise in type design. First, create a closed shape with the Pen tool or one of the shape tools in either Shape or Path mode (see Chapter 13 if you need help), and then grab the Horizontal Type tool. Next, put your cursor inside the shape and, when it turns into an I-beam surrounded by tiny dots (see Figure 14-11, top), just click and type your text. Easy, huh?

Warping Text

Another way to create text that follows a shape is to use the Create Warped Text feature. Be forewarned, though, that this process distorts the *shape* of the letters (so they might not be very legible when you're done), whereas type on a path alters only the baseline and orientation (direction) of the text.

Unlike placing type on a path or inside an object, you have to create the text *before* you use this feature. So first things first: Add some text to your document. Then summon the Warp Text dialog box (Figure 14-12) in one of two ways: If you have a type tool active, click the Create Warped Text button in the Options bar (it looks like a T with a curved line under it); if you're using any other tool, choose Type→Warp Text instead. Next, pick one of the 15 canned settings in the Warp Text dialog box's Style menu, and then customize the style by tweaking the Bend, Horizontal Distortion, and Vertical Distortion sliders (you may have to move the dialog box aside so you can see how your text is changing.)

FIGURE 14-11

Top: Once your cursor is surrounded by tiny dots, click inside the path or shape and start typing your text.

Bottom: When you're finished typing, you can format the text using any of the options discussed on page 636 and beyond. Centered alignment is especially useful for this technique, because it pushes the text away from the edges of the object, as shown here. And you can give the text a little more space using the Paragraph panel's Indent Left Margin and Indent Right Margin settings (page 654).

When moving to a new home, always put the cat in through a window instead of the door. That way it won't leave.
-Author Unknown

If you don't like the result, just press and hold Option (Alt on a PC) to turn the Warp Text dialog box's Cancel button into a Reset button. Click it to snuff out any changes you've made so far (or click Cancel to exit the dialog box completely). Once you've got your text looking good, click OK.

As long as you don't rasterize the type layer and turn it into pixels (see the box on page 627), you can change the warp settings at any time. Just activate the type layer and then choose Type→Warp Text to see the warp settings you used previously.

TIP For real fun, try *animating* a text warp as described on page 865. This trick lets you make text look like it's bulging, waving, or bending in real time!

Using Find and Replace

No matter what kind of text you work with, at some point you might need to change a word, phrase, or character to something else. It's usually easy enough to make such fixes manually, but if there's a fair amount of text in your document, reach for the Find and Replace command instead.

FIGURE 14-12

You can create super-funky text with the Warp Text dialog box. Among the many styles are Bulge, Arch, and Shell Lower (all shown here from top to bottom, respectively). Depending on what you're creating, this technique could be just the ticket or complete cheese. Use this feature sparingly, because it could go either way.

You'll see an error message if you try to warp text that's been faux bolded (see page 615). But Photoshop will let you warp faux italic text with nary a squawk.

For example, suppose you're working on a full-page ad for a sports-drink company and they've just changed the name of their flagship product from Dr. Bob's Thirst Remedy to Quenchtastic 4000. In that situation, you can save yourself lots of time by using Find and Replace. Photoshop will seek out the offending word or phrase and replace it with whatever you want.

Choose Edit→"Find and Replace Text" to summon the dialog box shown in Figure 14-13 (you don't even need to have the Type tool or a type layer active). Enter the offending word or phrase in the Find What field and its replacement in the Change To field. Use the checkboxes to tell Photoshop whether to search through all the type layers in your document; look only for instances that match the case (capital-ization) of what you've typed; search from a specific point in a type layer forward (this one's only available if you have the Type tool active and the cursor blinking

at a point within the text); look for whole words only; ignore accent marks; or any combination of these options.

FIGURE 14-13

Hopefully you'll never set enough text in Photoshop to need the Find and Replace Text feature, but it can come in handy in a pinch. You also have the option to ignore accents, which can be useful when you're working with languages other than English.

Formatting Text

Now that you've learned all about the different *kinds* of Photoshop text and how to create it, it's time to dig in to how to format it. Photoshop lets you control text to within an inch of its life. Beyond the basics of font, size, and color, you can adjust the softness of the letters' edges, the space between each letter, the space between lines of text, and so on.

The most commonly used settings live in the Options bar, while the more advanced typographic goodies are nestled inside the Type menu, as well as the Character and Paragraph panels. No matter where the settings live, if they control text, you'll learn about them in the following pages. Read on!

WORD TO THE WISE

Thou Shalt Spell Check

Few mistakes are as embarrassing (or avoidable) for a graphic artist as a misspelled word. Most software comes with a built-in spellchecker, and Photoshop is no exception, so there's little excuse for typos (on the other hand, *wordos*—real words in the wrong place—are another story). And let's face it: The people who create copy can rarely spot their own mistakes, either because they've been staring at it for too long or because they're rushing to meet a deadline. In those situations, using a spellchecker is essential.

To check spelling in Photoshop, choose Edit→Check Spelling or right-click within a document while a type layer is active

and choose Check Spelling from the shortcut menu that appears. Either way, Photoshop scours the document's type layers and, in the resulting dialog box, alerts you to words it considers suspect. It dutifully offers a list of suggestions that you can ignore or accept, changing just one instance or all of them. If it encounters an unknown word that you use a lot and is correctly spelled, click Add and Photoshop assimilates the word into its dictionary.

Whether you're typing five words or five paragraphs, take time to run the spellchecker—you'll be glad you did.

Formatting with the Options Bar

When you have the Type tool active, the Options bar (Figure 14-14) offers basic text-tweakers such as font family, style, size, anti-aliasing, alignment, and color. (The Character panel, discussed on page 640, offers all these settings and more.)

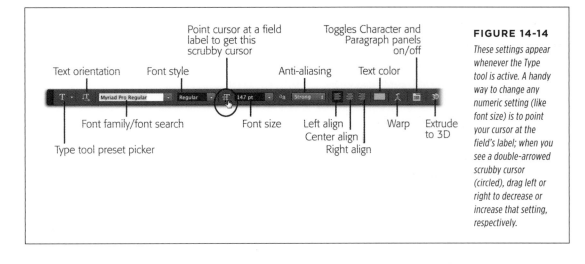

Point cursor at a field label to get this scrubby cursor

Toggles Character and Paragraph panels on/off

Text orientation

Font style

Anti-aliasing

Text color

Font family/font search

Font size

Left align
Center align
Right align

Warp

Extrude to 3D

Type tool preset picker

FIGURE 14-14

These settings appear whenever the Type tool is active. A handy way to change any numeric setting (like font size) is to point your cursor at the field's label; when you see a double-arrowed scrubby cursor (circled), drag left or right to decrease or increase that setting, respectively.

NOTE Remember, any settings you change in the Options bar *remain* until you change 'em back. So if you suddenly find that your text isn't behaving like you expect, chances are there's a Options bar setting that needs changing.

You can apply formatting either before or after you create text:

- **Before you type.** If you know exactly what font, style, and size you want to use before you start hammering out text, applying formatting beforehand is the way to go. Press T to grab the Type tool, and then head to the Options bar or the Character panel to pick your settings.

- **After you type.** This is the more common method, since it's easier to see how formatting choices affect *existing* text than try to imagine how it might look. With the Type tool active, use one of the methods listed on page 623 to highlight the text you want to format and then use the Options bar or Character panel (or keyboard shortcuts) to change its formatting. (That said, if you just want to change the *font* of *all* the text on a type layer, you *don't* have to highlight any text first—simply choose the new font and Photoshop changes all the text on the current type layer.)

From left to right, the Options bar includes the following:

- **Type Tool Preset picker.** From the factory, this setting performs the fairly useless service of letting you quickly summon horizontal 24-point type in the Myriad font. Thankfully, with just a little bit of work, you can create your own presets—a fantastic idea if you use the same formatting over and over. Start by formatting some text exactly the way you want it, and then make sure its type layer is active (you don't have to highlight the text itself). Next, click the triangle next to the Type Tool Preset picker, and then, in the palette that appears, click the gear icon and choose New Tool Preset. Enter a meaningful name in the resulting box, and then click OK. Photoshop memorizes how you formatted the text so it can apply that formatting automatically the next time around. Just grab the Type tool, pick your style from the Type Tool Preset picker, and then click in your document and start typing.

> **TIP** Photoshop also lets you create *character* and *paragraph styles*, detailed text formatting recipes that you can apply on the fly. See the box on page 651 for the lowdown.

- **Text orientation.** There's no need to decide whether you want horizontal (left to right) or vertical (top to bottom) text *before* you type: Clicking this button flips the whole type layer on the fly. You don't even have to highlight any text first.

- **Font family.** This menu lists every font that's active on your machine and includes a preview of what each one looks like. (If you want to turn off this preview, page 30 tells you how.) And in this version of Photoshop, you can perform a font search by entering a font's name or its attributes (even abbreviations) into this field. Flip back to the box on page 622 to learn more about this incredibly useful feature.

- **Font style.** Here's where you can choose a native style (page 615) for the font you picked, such as light, bold, or condensed.

- **Font size.** Enter a point size for the text in this field, or put your cursor over the field's label and then use the scrubby cursor shown in Figure 14-14 to change the size. Text size is typically stated in points, but you can change the unit of measurement to pixels or millimeters by choosing Photoshop→Preferences→Units & Rulers (Edit→Preferences→Units & Rulers on a PC).

> **TIP** If you need to create *super* large text, Photoshop will put up a fight. When you type a number greater than 1296 into the font size field, you'll see an error message asking you to enter a number between 1 and 1296. This is an odd quirk of Photoshop's, but if you're sneaky, you can work around this limitation by resizing your text with the Free Transform command (page 276): Enter *1296* into the size field and then choose Edit→Transform→Scale. Drag the resulting resizing handles outward to make the text really honkin' big, and then press Return (Enter on a PC) to accept the transformation.

- **Anti-aliasing.** Anti-aliasing was mentioned way back in Chapter 4 as a method for smoothing the edges of a selection. Similarly, this option smooths text by

blurring its edges ever so slightly, helping you avoid the dreaded jagged edges so common when printing with a low-resolution inkjet printer or posting on the Web.

Your choices here include None, Sharp, Crisp, Strong, and Smooth. Each setting has a different effect on various text sizes, so you might have to do a little experimenting. Use None on extremely small text to make it clean and sharp (especially if it's destined for the Web), and Strong or Smooth for larger text to keep it from looking jagged when printed (especially if it's headed for an older inkjet printer).

The two options at the bottom of the menu help make text look like it will when it's displayed onscreen in popular web browsers or other programs on your computer, which is handy if you're a mobile app or web designer. The first option, Mac LCD (Windows LCD on a PC) makes your text look like it would look in Safari (on a Mac) or Internet Explorer (in Windows). The second option, named simply Mac (Windows on a PC) makes your text look like it would in any other program (say, Microsoft Word). By choosing one of these options, you're turning *off* the Adobe type engine and turning *on* your operating system's type engine for slightly different-looking text.

- **Alignment.** These three buttons make text flush left, centered, or flush right (respectively) within a single line of text or a text box. Unless you specifically apply a different alignment, Photoshop automatically left-aligns text. To align a single line of text that's on a type layer that contains several paragraphs, press T to activate the Type tool, click anywhere within the line or paragraph, and then click one of these buttons. To align *everything* on a type layer, double-click the type layer's thumbnail in the Layers panel, and then click an alignment button.

> **TIP** You can also use keyboard shortcuts to align text. Highlight some text, and then press Shift-⌘-L (Shift+Ctrl+L) for left alignment, Shift-⌘-C (Shift+Ctrl+C) for center alignment, or Shift-⌘-R (Shift+Ctrl+R) for right alignment.

- **Text color.** You can set text's color by highlighting the text (page 623) and then clicking this colored swatch, which shows the current text color. (There's a similar swatch in the Character panel that does the same thing.) You can also set text color before you type by clicking the foreground or background color chip. To recolor some text to your foreground color, highlight the text, and then press Option-Delete (Alt+Backspace on a PC). To use the background color, press ⌘-Delete (Ctrl+Backspace) instead.

> **NOTE** When choosing a text color, resist the urge to go hog wild. Bear in mind that black text on a white background is easy to read, as is dark-colored text on a light background. The key is contrast—it's really hard to read text that's similar in color to its background. However, if you're adding text to a *dark* background, you risk the danger of introducing *too* much contrast. For example, a single line of pure white text on a black background is quite legible, but a large block of white text on a black background—especially on the Web—is eye-numbing. In that situation, you're better off using light-gray text instead so the contrast isn't quite so high.

- **Create warped text.** You can use this option to curve and distort text in all manner of exciting ways, as explained on page 633. This button is easy to spot: Its icon is a capital T perched atop a curved line.

- **Character and Paragraph panels.** Click this button to pop open the Character and Paragraph panels for even more text formatting goodness, as explained in the next two sections. Click it again to hide the panels.

- **3D.** This button lets you *extrude* your text so it looks 3D, as discussed at length in Chapter 21.

The Character Panel

If you've ever opened the Character or Paragraph panel, then those panels' icons are probably lurking near the right side of your screen in the panel dock—they look like a capital A and a paragraph symbol (¶), respectively. If you don't see 'em, choose Window→Character Panel (or Window→Paragraph Panel) and Photoshop adds them both to the dock for you (you can also open both panels by using the Type→Panels menu). It wisely assumes that if you're using one, you'll soon be using the other, which is a pretty safe bet.

The Character panel (Figure 14-15) has enough formatting options to please even the most discerning typesetter. It includes all the settings found in the Options bar when you're using the Type tool, plus it lets you control the space in and around individual characters, where they sit on a line, the height of the line, and more. It also holds the key to unlocking the amazing OpenType features discussed on page 614. Mastering this panel can help you turn ordinary text into a work of art.

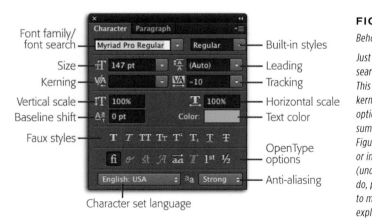

Font family/font search
Size
Kerning
Vertical scale
Baseline shift
Faux styles
Character set language

Built-in styles
Leading
Tracking
Horizontal scale
Text color
OpenType options
Anti-aliasing

FIGURE 14-15

Behold the option-riddled Character panel!

Just like the Options bar's, its font family menu is searchable (see the box on page 622 for the scoop). This panel also includes controls for tracking, kerning, adjusting text's baseline, and OpenType options. Point your cursor at numeric field's label to summon the ever-handy scrubby cursor (circled in Figure 14-14), and then drag left or right to decrease or increase the field's value, respectively. If you (understandably) forget what some of these settings do, put your cursor over any of the field's label to make Photoshop display a handy tooltip that explains what that setting does.

NOTE Like the Options bar, any changes you make to the Character panel's settings remain in effect until you change them back. So if you play with leading (explained below) on Monday and then add text to a brand-new document on Tuesday, the leading may look a bit off. Either use the leading drop-down menu to change it back to Auto or go to the Character panel's menu and choose Reset Character, which reverts *all* the panel's settings back to normal.

■ A LESSON IN LEADING

If you've ever added extra returns (by pressing Return [Enter on a PC]) between lines of text to create space or wondered how designers make lines of text appear all squashed together, you've encountered *leading* (rhymes with "bedding"). Leading controls the amount of blank space between lines of text. The term originated back in the days when type was set by hand onto printing presses, and strips of lead in various thicknesses were used to create space between lines. Learning to adjust leading is a useful design skill, and Photoshop gives you complete control over it, as shown in Figure 14-16.

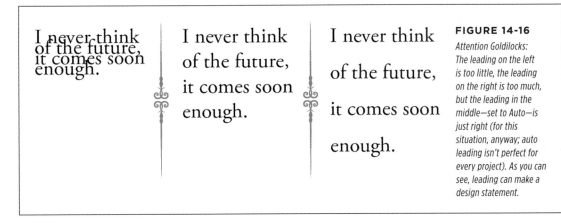

FIGURE 14-16

Attention Goldilocks: The leading on the left is too little, the leading on the right is too much, but the leading in the middle—set to Auto—is just right (for this situation, anyway; auto leading isn't perfect for every project). As you can see, leading can make a design statement.

Just like text, leading is measured in points, though it *includes* the point size of the text itself. Leading that's equal to the point size of text is called *solid leading*, which creates lines of text that almost touch (resulting in spacing that's somewhere between the left and middle examples in Figure 14-16). Unless you change it, Photoshop's leading is set to Auto, which is approximately 120 percent of the text's point size (see Figure 14-16, middle). For example, 10-point type has an auto leading of 12 points.

The Character panel's leading control is labeled with two A's stacked on top of each other. You can adjust the leading of several lines of text at once or one line at a time. To adjust the leading of all the lines of text that are on the same type layer, double-click the layer in the Layers panel so all its text is highlighted, and then choose a point size from the Character panel's leading menu or type directly into the text field. (Better yet, put your cursor over the field's label and then use the handy scrubby cursor.) To adjust the leading of a *single* line of text on a type layer that contains many lines, highlight the line of text first and *then* change its leading.

TIP You can also use keyboard shortcuts to change leading: Highlight the text and then press and hold Option (Alt on a PC) and tap the up or down arrow keys to change the leading in increments of 1 points; add ⌘ (Ctrl) to change it in increments of 5 points. To set leading back to Auto, press Shift-Option-⌘-A (Shift+Alt+Ctrl+A). These shortcuts work on vertical text, too.

■ LEARNING TO KERN

Kerning means adjusting the amount of space between pairs of letters. Poorly kerned (or unkerned) text looks funky and can be distracting to readers, as you can see in Figure 14-17, top. A lack of kerning is one of the *biggest* clues that text has been set nonprofessionally (nothing exposes a typographical novice faster!). Admittedly, the problem is more noticeable with less expensive—or free—fonts (think Frolicking Ferrets), scripts, and decoratives (*especially* fonts that mimic handwriting, like the one in the figure).

FIGURE 14-17

Top: Here's some text borrowed from a BMW motorcycle ad in a pitiful, unkerned state. Notice how several of the letters appear too close together? The punctuation is even worse—it's practically in a different Zip code.

Bottom: After a little kerning, the text looks normal instead of helter-skelter, so readers can focus on what the copy says instead of the weird spacing.

(Get it? My hairstylist is my motorcycle helmet? Oh, never mind.)

Over in the Character panel, the kerning setting is marked with V/A and a left-pointing arrow. The numbers in the kerning menu range from positive to negative; positive values increase space, and negative values decrease it. Kerning values are measured in 1/1000 *em*. An em is a relative measurement that's based on the point size of the text. For example, if the text size is 12-point, 1 em equals 12 points. Since you can create text of various sizes, this measurement ensures that your kerning is always based on the size you're currently working with.

NOTE Even though Photoshop tries to kern text automatically, it's best to do it manually as described here. The box on page 643 has more on auto vs. manual kerning.

Because the amount of space each letter needs on either side differs according to which letter comes next—an *A* can tuck in closer to a *V* than it can to an *M*, for example—you'll want to kern each space individually. Press T to grab the Type tool and position the cursor in the first problem area you spot. To widen the space, pick a positive value from the kerning menu, drag the scrubby cursor gently to the right,

or type a value into the kerning field. To narrow the space, pick a negative value or drag the scrubby cursor to the left.

> **TIP** There's a keyboard shortcut for changing kerning, but before you use it, you need to place your cursor between the letters you want to adjust. Once you've done that, press and hold Option (Alt on a PC) while tapping the left or right arrow key to change the kerning in increments of 20. Add the ⌘ key (Ctrl) to change it in increments of 100.

■ TRACK IT OUT

To change the spacing between *all* letters in a word by the same amount, you need to adjust *tracking*. This setting is great when you're trying to make text fit into a small area. Also, vast amounts of tracking can be a useful design trick, as in the word "conference" in Figure 14-18. Like kerning, tracking is measured in 1/1000 em. To make an adjustment, first highlight the word(s) you want to track, and then trot over to the Character panel and look for the setting marked with the V/A with a double-headed arrow beneath it. Pick a value from the drop-down menu, enter one manually, or use the scrubby cursor you get by putting your cursor over the V/A.

> **TIP** As you might suspect, there's a keyboard shortcut for this setting, too. To adjust tracking in increments of 20, highlight some text and then press and hold Option (Alt on a PC) while tapping the left or right arrow key. Add the ⌘ key (Ctrl) to change tracking in increments of 100.

UP TO SPEED

Auto vs. Manual Kerning

Ever helpful, Photoshop tries to kern text for you. If you open the Character panel's kerning menu, you'll see options for two auto-kerning methods: Metrics and Optical.

Metrics kerning is the most common method. It tells Photoshop to adjust the space between letters according to their *kern pairs*—the amount of spacing between pairs of letters (like *Tr, To, Ta,* and so on) that the designer specified when creating the font. Unless you set this menu to something else, Photoshop automatically applies metrics kerning any time you create or import text.

However, some fonts contain little or no info about kern pairs, but you won't know that until you start typing. So, if the kerning looks really bad, Adobe recommends that you manually switch to optical kerning, where Photoshop adjusts the space according to characters' shapes instead. Optical kerning is also helpful when you use more than one font (or font size) in a single word.

Using one of these automatic kerning methods is fine for large blocks of text—imagine hand-kerning this book!—but for standalone text, the best method is to kern it manually as described on page 642. It takes more time, but the results are *well* worth it.

FIGURE 14-18

Tracking is a great way to make a word fit in a small space or fill a big space. In this example, the word "conference" has been tracked out to stretch from the G in "digital" to the last A in "camera." Because the space between the letters is uniform and obviously deliberate, it becomes a useful design element. (This is also one of the few ways all-caps text looks good—the extra space makes it seem less like screaming.)

■ DOIN' THE BASELINE SHIFT

The invisible line on which text sits is called its *baseline*. Changing this line can make a character appear higher or lower than other characters on the same line. This is called *baseline shift*, and you can think of it as an exaggerated super- or subscript control (as in degree and trademark symbols). Remember the section on page 630 about text on a path? In that example, baseline shift was used to scoot the text above the path. It's also helpful when you want to create fractions, use initial caps (shown in Figure 14-19), or manually adjust characters in a decorative font. Basically, this setting keeps you from having to put the character on its own type layer in order to manually position it with the Move tool.

FIGURE 14-19

The big, fancy D is lower than the rest of the word "Domestic" because its baseline shift has been decreased to −30 points.

To shift the baseline in increments of 1 points, highlight some text, and then press Shift-Option (Shift+Alt on a PC) while tapping the up or down arrow on your keyboard. Add the ⌘ key (Ctrl) to shift it in increments of 5 points.

To adjust the baseline of a character, word, or phrase, highlight the text you want to tweak and then head to the Character panel. Use the baseline shift setting (it's marked with a big A, a little A, and an up arrow) to move the text up or down by picking a positive or negative value (respectively) from the menu, entering a value manually, or using the scrubby cursor. If you don't highlight anything before tweaking this setting, Photoshop applies the adjustment to the *next* thing you type.

■ OTHER CHARACTER OPTIONS

The Character panel is chock-full of other formatting controls. Just remember that, if you highlight some text before applying any of the formatting discussed in this section, Photoshop formats just that text; if you don't select text before applying this formatting, then Photoshop applies your changes to the *next* thing you type.

As shown back in Figure 14-15, the Character panel has a whole row of buttons that let you apply faux styles like bold and italic (meaning they're not built into the font, but faked by Photoshop instead). Feel free to use faux styles if you're creating a piece for online use or at-home printing. But if the project is bound for a professional printer, it's best to stay away from the faux stuff as it can cause unexpected results such as jagged text (due to rasterization); characters that refuse to print (which will cause Photoshop to substitute another font); or PostScript errors, which can halt printing altogether.

Among the other faux styles offered by the Character panel for your formatting pleasure are underline (which places a line under the text), and strikethrough (which places a line *through* the text).

TIP The keyboard shortcut for faux-bolding text is Shift-⌘-B (Shift+Ctrl+B); for faux-italicizing, it's Shift-⌘-I (Shift+Ctrl+I); for underlining, it's Shift-⌘-U (Shift+Ctrl+U); and for adding a strikethrough, it's Shift-⌘-/ (Shift+Ctrl+/). Whew!

The other options in the Character panel are:

- **Vertical** and **Horizontal scale.** These two settings (which stretch or shrink text vertically or horizontally) have the power to squish, cram, and spread text to within an inch of its life, rendering it utterly unreadable and unrecognizable, so use them at your own risk. If you're trying to save space, a better solution is to adjust kerning or tracking (or both). If you're trying to fill space, increase the type size or tracking instead.

TIP If you've played around with your text's scale, you can instantly get it back to normal with the flick of a keyboard shortcut. Reset the vertical scale to 100 percent by highlighting the text and then pressing Shift-Option-⌘-X (Shift+Alt+Ctrl+X), or reset the horizontal scale to 100 percent by pressing Shift-⌘-X (Shift+Ctrl+X).

- **All Caps** and **Small Caps.** To switch lowercase text to uppercase, just highlight the text and then click the All Caps button (marked with TT). But keep in mind that, unless you're creating a small amount of text and perhaps tracking it out

as shown in Figure 14-18, using all caps is a bad idea. It makes text extremely hard to read because the words all take on the same blocky shape and insinuate screaming (LIKE THIS), and that's not very reader friendly. The Small Caps button (marked with a big T and a smaller T) isn't much better, as it simply creates a smaller version of hard-to-read all caps. The keyboard shortcut for all caps is Shift-⌘-K (Shift+Ctrl+K); for small caps, it's Shift-⌘-H (Shift+Ctrl+H).

- **Superscript** and **Subscript.** These buttons cause the baseline and point size of the highlighted character(s) to change. Superscript increases the baseline shift so the character sits above other text in the same line (great for trademark symbols such as ™ and ®), while subscript decreases the baseline shift so the character sits below other text (perfect for footnotes and scientific or mathematical text).

> **TIP** The keyboard shortcut for superscript is Shift-⌘-plus (Shift+Ctrl+plus). For subscript, press Shift-Option-⌘-plus (Shift+Alt+Ctrl+plus).

- **Language.** The language menu at the bottom of the Character panel won't translate text for you; it merely means that Photoshop will adjust its spell-checking and hyphenation features to suit the language you picked. The 40 or so choices include everything from Bulgarian to Ukrainian. (The box on page 636 has info on spell checking.)

> **NOTE** Speaking of other languages, Photoshop supports East Asian, South Asian, and Middle Eastern characters, and Indic languages. To turn 'em on, choose Type→Language Options→East Asian Features. In that same submenu, you can also change the leading to Top-to-Top Leading or Bottom-to-Bottom Leading. To switch to Middle Eastern text, choose Photoshop→Preferences→Type (Edit→Preferences→Type on a PC) and turn on Middle Eastern and South Asian; then you can choose Type→Language Options→Middle Eastern Features.

- **Anti-Aliasing.** This setting in the Character panel's lower-right corner works just like the anti-aliasing setting on the Options bar (page 152), and slightly blurs the edges of text so they don't look jagged.

The following goodies—which *used* to live in the Character panel's *menu* but now have their own buttons in the panel (they're labeled back in Figure 14-15)—are reserved for OpenType fonts only, so they're dimmed if you're using a PostScript or TrueType font. As discussed on page 614, OpenType format lets font designers include alternative character designs and all manner of glyphs. Some have alternate *ligatures* (two or more characters that have been combined into one for better flow—like an *fi* or *fl* combo), fancy flourishes (see Figure 14-20), a whole set of ornaments, and more. These embellishments are perfect for creating fancy initial caps, formatting numbers, and adding a bit of typographic pizzazz.

From left to right, here's what the Character panel's OpenType options buttons do:

- **Standard Ligatures** are alternate character designs for certain letter combinations that tend to touch—like *fi, fl, ff, ffi*, and *ffl*.

- **Contextual Alternates** substitutes certain letterforms for others that join together more fluidly. This option is common in script fonts because it makes the letters look like cursive handwriting.

- **Discretionary Ligatures** are replacements for letter pairs like *ct, st*, and *ft*. They tend to have a bit more flourish than their standard ligature counterparts.

- **Swash** substitutes a standard character for one with an exaggerated stroke (think calligraphy).

FIGURE 14-20

The top line of text here is in standard Adios Script Pro, a truly gorgeous OpenType font.

The middle line was created using Contextual Alternates, which summons different letter designs depending upon where the letter falls within a word.

The last line was created using the extra-flourishy Swash option, which is best reserved for single letters and not whole words.

Keep in mind that some OpenType fonts have extras and some don't; if one of the OpenType buttons near the bottom of the Character panel is dimmed, it means that feature doesn't exist in that particular font.

- **Stylistic Alternates** are characters that have extra bits of decoration here and there, as shown at the bottom of Figure 14-20.

- **Titling Alternates** calls to action a special set of all-caps characters designed to be used at large sizes, for things like titles (hence the name).

- **Ordinals** decreases the size of letters next to numbers and increases their baseline shift so they look like this: 2nd, 3rd, 4th, and so on.

- **Fractions** converts a number-slash-number combination (like this: 1/2) into a real fraction (like this: ½).

But wait—that's not all! The Character panel has *even more* settings hidden in its menu, which lives in the panel's upper-right corner:

- **Change Text Orientation.** This menu item lets you switch horizontally aligned text to vertical, and vice versa. Just activate the type layer you want to change, not the text itself, and then choose this option.

- **Standard Vertical Roman Alignment.** This is a fun one, though it works only on vertical type. Instead of the letters flowing from top to bottom, perched atop one another, they'll flow from left to right as if they were turned on their sides. This formatting is often used on the spines of books so it's easy to read

their titles on bookshelves. Another way to create this effect is to use the Free Transform tool to spin the text 90 degrees.

- **OpenType.** As you just learned, the majority of Photoshop's OpenType formatting goodies have their own buttons near the bottom of the Character panel. They also live in the panel menu's OpenType submenu, along with a couple of extra options (though not *all* OpenType fonts include these options):

 - **Oldstyle** prompts Photoshop to use smaller numerals than normal; some even sit below the baseline so they blend more smoothly into the flow of text. Use this option when you want numbers to appear more elegant, but *not* when you need them to line up in a stack, as in an annual report.

 - **Ornaments** are symbols or pictographs. This option is usually available only for symbol-based fonts (like Wingdings). When you choose this option, Photoshop replaces the original symbols with an alternate set.

- **Fractional Widths.** This setting rounds character widths to the nearest *part* of a pixel instead of a whole pixel. This setting is automatically turned on because it usually tightens text spacing, making it more visually pleasing (like kerning, discussed on page 642). However, Adobe recommends turning this option *off* if you're working with anything smaller than 20-point text because the tighter spacing can make it hard to read. When this setting is off, Photoshop uses whole-pixel spacing, which gives characters a bit more breathing room and keeps them from running into each other.

> **NOTE** You can't apply the Fractional Widths setting to individual characters—it's an all-or-nothing, everything-on-the-type-layer-is-affected kind of thing. To use whole-pixel increments for your entire *document*, choose System Layout (explained next) from the Character panel's menu.

- **System Layout.** This option reverts text to the way your particular operating system displays it—similar to what you might see in TextEdit on a Mac or in WordPad on a PC. It switches character widths to whole pixels (as discussed in the previous bullet) and turns off anti-aliasing. This can be a good option to use when designing text for the Web, because the extra space and letter sharpness makes super small text a little easier to read. That said, Photoshop CC's two anti-aliasing methods do pretty much the same thing (see page 638).

- **No Break.** When it comes to hyphenation, some words are meant to be broken and some aren't (as shown in Figure 14-21). To prevent such typographical gaffes, highlight the word(s) you want to keep together and then choose No Break from the Character panel's menu. Doing so forces Photoshop to reflow the text so the word doesn't end up sliced in two. For more on hyphenation, see page 650.

- **Reset Character.** If you've gone a bit overboard with formatting and want to return some text to its original glory, highlight it and then choose this option from the Character panel's menu. (If you don't have any text highlighted, the newly restored character settings will affect the next thing you type.)

In MotoGP, Rossi is a leg-end.

Angry wife is jailed for mans-laughter.

FIGURE 14-21

This is what happens when hyphen-ation goes bad. The fix is to highlight the offending word and then choose No Break from the Character panel's menu.

The Paragraph Panel

The Paragraph panel (Figure 14-22) doesn't have anywhere *near* the number of options as the Character panel, though that doesn't make it any less important. Paragraph formatting controls alignment, hyphenation, justification, indentation, and spacing. Read on for a full discussion of each.

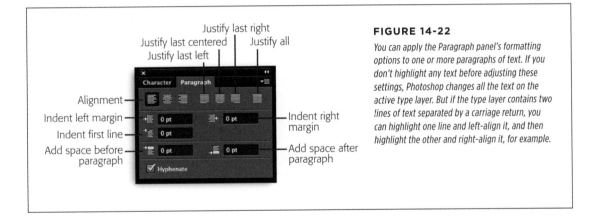

FIGURE 14-22

You can apply the Paragraph panel's formatting options to one or more paragraphs of text. If you don't highlight any text before adjusting these settings, Photoshop changes all the text on the active type layer. But if the type layer contains two lines of text separated by a carriage return, you can highlight one line and left-align it, and then highlight the other and right-align it, for example.

■ ALIGNING TEXT

Alignment gives readers' eyes a hard edge to follow as they read through text, with the edge itself forming an invisible line that connects items on a page. The basic alignment types are left, center, and right, and picking the correct one for your document can make it look stronger, cleaner, and more dramatic. So which option should you choose? It depends on what you're going for. Here are a few guidelines:

- **Use left alignment for big blocks of text.** Newspapers, books, and magazines (which should not be created in Photoshop, mind you) usually stick with left alignment because it's the easiest to read. Unless you tell it otherwise, Photo-shop left-aligns everything.

- **Use centered alignment for formal situations.** There's a reason the text of every graduation and wedding announcement—not to mention fancy restaurant menu—you've ever seen is centered: that formatting conveys a feeling of formality and elegance.

- **Use right alignment for small blocks of text or numbers.** Right alignment can make text stand out because it's unusual and therefore draws attention. But it's harder to read than left alignment, meaning you'll want to save it for relatively small chunks of text (so don't right-align your next novel). However, it's great for lists of numbers because it makes the decimals points (or commas) line up.

> **TIP** With vertical type, these options align the text based on a vertical line instead of a horizontal one. So instead of left, center, and right alignment, your options are top, center, and bottom.

You can align text on a single layer (or even a single line on a layer) or across multiple type layers:

- **Aligning text on a single type layer or on multiple type layers.** You can use different alignments on lines of text that live on the same type layer, so long as there's a *carriage return* after each line (to insert one, press Return [Enter on a PC]). First, activate the Type tool and the type layer you want to work on. To align a single line of text, click anywhere within that line, and then click the appropriate alignment button in the Options bar or the Paragraph panel. To align *all* the text on that layer, highlight it using one of the methods described on page 623, and then click an alignment button.

 To align the text on several type layers, in the Layers panel, activate the layers by Shift- or ⌘-clicking (Ctrl-clicking on a PC) to the right of their thumbnails, and then click an alignment button. (You can also use Photoshop's layer-filtering feature to isolate all the type layers; see page 79.)

- **Aligning type layers themselves.** To align the left edge of text across several layers, you use a whole different set of alignment tools. Activate the offending layers as described in the previous bullet point, and then press V to grab the Move tool and poof!—a whole flock of alignment options appear in the Options bar. Click the one you want to apply, and the active layers dutifully jump to the left, right, or center. These incredibly useful alignment options are covered in detail on page 103.

■ HYPHENATION AND JUSTIFICATION

Known to page-layout pros as H&J, these controls work together to spread out paragraph text so that both the left and right edges are perfectly straight, or *justified*. (The text in most magazines, newspapers, and books—including this one—is justified.) They also determine how the words are sliced and diced (*hyphenated*) in order to make them fit within a text box or to make the margins perfectly straight.

Character and Paragraph Styles

Character and paragraph styles give you the option of saving your hand-crafted text formatting to use on *other* text. Think of them as quick text recipes you can use to ensure consistent formatting across documents.

To use character styles, format some text using any of the Character panel options mentioned in the previous pages. Then, choose Type→Panels→Character Styles Panel. In the Character Styles panel, choose New Character Style from the panel's menu; back in the panel itself, double-click the style's name (Character Style 1) and give it a meaningful name like *callout*. To apply that formatting, activate the type layer, highlight the text, and then open the Character Styles panel and that style in the list.

Paragraph styles work the same way, but they let you save both character *and* paragraph formatting. They're useful when you're formatting text like headlines, subheads, and body copy where spacing, alignment, indentation, and so on, come into play. To create a paragraph style, choose Type→Panels→Paragraph Styles Panel, and then head to the panel's menu and choose New Paragraph Style.

If you apply additional formatting to an existing style, a tiny + appears next to its name in the relevant panel. To get rid of the extra formatting and revert back to the original style, click the Clear Override icon at the bottom of the panel. Or, to add the extra formatting to the style, click the checkmark. To edit or rename a style, double-click its name in the panel. If you copy text that has a style applied to it and paste it in another Photoshop document, the style comes along for the ride.

If you use certain styles regularly, you can save 'em so Photoshop automatically adds them to each *new* document you create, as well as to *existing* documents that don't yet contain any styles. To do so, from the Character Styles or Paragraph Styles panel menu (circled) or the Type menu, choose Save Default Type Styles. You can also activate multiple styles in either panel and then delete 'em en masse. Unfortunately, you can't import styles from other programs (not even InDesign), nor can you export the ones you create in Photoshop for use in *other* programs, but you can load styles you've made in Photoshop onto another machine for use in Photoshop.

While Adobe considers these styles great timesavers—and they may be in small doses, especially for photographers—it's doubtful you'll create enough text in Photoshop to use 'em very often. And if you do, that's a darn good indicator that you should be using a page-layout program such as InDesign instead.

Clear override
Redefine by
merging overrides
New style
Delete style

Photoshop's hyphenation feature is automatically turned on, but you can turn it off by clicking the checkbox at the bottom of the Paragraph panel, or by highlighting the text and then pressing Shift-Option-⌘-H (Shift+Alt+Ctrl+H). However, you have to turn justification on manually by picking one of the following options (just click the appropriate button near the top of the Paragraph panel—they're labeled in Figure 14-22):

- **Justify last left.** This setting spreads text so that the left and right edges are perfectly straight, with the last line of the paragraph left aligned (meaning it doesn't reach across to the right margin), like the text in this book. You can also apply this kind of justification by highlighting your text and then pressing Shift-⌘-J (Shift+Ctrl+J).

TIP Justification is affected by which *composition method* you've chosen (see the box on page 655).

- **Justify last centered.** This is the same as the previous setting, but with the last line center aligned instead.

- **Justify last right.** Same again, but with the last line right aligned.

NOTE When working with vertical text, your justification options are Justify last top, centered, and bottom.

- **Justify all.** With this setting, the left and right edges of text are perfectly straight, but the last line is spread out to span the entire width of the paragraph. The results usually don't look very good (the last line tends to be really sprawled out), but once in a while some rebellious designer manages to pull it off, as shown in Figure 14-23.

It's unlikely you'll ever need to adjust the H&J options, and if you do, that's a sign you should be creating text in another program. Nevertheless, you *can* customize hyphenation and justification via the Paragraph panel's menu. Figure 14-24 has the scoop.

TIP To prevent Photoshop from hyphenating a word or phrase, use the No Break option over in the Character panel's menu, described on page 648.

FIGURE 14-23

To truly tax your text, use "Justify all." This forces all the lines of text to line up vertically, even the last one. (Thank goodness newspapers and magazines are beginning to shift toward more reader-friendly left alignment instead.)

It's really hard to make blocked text look good, though the folks at www.QuotableCards.com managed it quite nicely in this magnet design.

FIGURE 14-24

Top: To get to this dialog box, head to the Paragraph panel's menu and choose Hyphenation. Here you can specify the minimum length of words that Photoshop can break across lines, where it can break them (after how many letters), and how many consecutive lines can have hyphenated words at the end (for the best results, leave this set to 2). The Hyphenation Zone field controls how close to the right margin text can get before Photoshop hyphenates it. Turn off the Hyphenate Capitalized Words checkbox to make sure names and proper nouns stay intact.

Bottom: Access this dialog box by choosing Justi-fication from the Paragraph panel's menu. This is where you control how far apart words and letters get spread when Photoshop makes the margins perfectly straight. You can also adjust how far the program stretches glyphs (page 611), and specify leading (page 641).

■ INDENTING TEXT

It should be clear by now that Photoshop is no word processor, so don't go rooting around expecting any serious margin controls. However, you do have *some* say in how much space Photoshop puts between the text and either the left or right edge of a single line (for point text) or the boundaries of a text box (for paragraph text). You can find the following options in the middle of the Paragraph panel (shown back in Figure 14-22):

- **Indent Left Margin** and **Indent Right Margin.** These settings scoot a line of text left or right, respectively, by the number of points you enter.

- **Indent First Line.** This option indents only the first line of the paragraph. If you need to create a *hanging indent*—where all lines of a paragraph are indented *except* the first—you can do that by entering a positive number (like 10) for the left indent and a negative number (like –10) for the first-line indent.

- **Roman Hanging Punctuation.** This totally awesome feature is actually tucked away in the Paragraph panel's menu. You can use it to make the punctuation sit *outside* the text margin, while the letters themselves remain perfectly aligned, as shown in Figure 14-25. (You don't need to highlight any text before applying this setting, as Photoshop applies it to everything on the active type layer.)

FIGURE 14-25

The Roman Hanging Punctuation setting moves punctuation (in this case, the initial quotation mark) outside the margin, leaving the text perfectly aligned.

Savvy graphic designers love this option!

■ SPACE BEFORE AND AFTER

Take a peek at the headers and subheads in this book. Notice how there's more space above them than below? This kind of spacing makes it easy for you to tell—even at a glance—that the paragraph following the header is related to it. That's because the spacing is a visual clue: Information that *is* related should appear closer together than information that's *not* related. (In design circles, this is known as the rule of proximity.) Proper spacing makes it a lot easier for people to read or scan a document quickly and understand how it's organized.

To adjust the spacing in your document, you could take the easy way out and add a few extra carriage returns, though chances are good that you'll introduce too

much—or too little—space. Instead, use the Paragraph panel's Space Before and Space After options, which let you control spacing right down to the point. To do that, activate a type layer and grab the Type tool by pressing T. Then click anywhere in the offending line (don't highlight it, just click it), and then head to the Paragraph panel and enter an amount (in points) into the Space Before or Space After field, or both (you can also use the scrubby cursor).

Special Text Effects

You can spice up Photoshop text in a variety of ways by adding fades, strokes, drop shadows, textures, and more. You can even take a photo and place it *inside* text. The great thing is that you can perform all these tricks without rasterizing the text, so it remains fully and gloriously editable. Read on to learn all kinds of neat ways to add a little something special to your text.

> **TIP** Perhaps the easiest special effect of all is creating partially opaque or *ghosted* text. All you have to do is lower the type layer's opacity in the Layers panel, as explained on page 99. That's it!

Faded Text

It's easy to make text look like it fades into an image, as shown in Figure 14-26. This technique is useful when you're creating a photo-centric advertisement or postcard, or want to showcase a collection of photos on your website. Here's what you do:

1. **Open a photo and add some text.**

 Press T to grab the Type tool and type a single word. Be sure to use a thick font such as Helvetica Bold or Black, Arial Black (used here), or Impact.

POWER USERS' CLINIC

Photoshop's Composition Methods

Displaying text is a complicated matter. To determine how it displays paragraph text, Photoshop takes into consideration word spacing, letter spacing, glyph spacing, *and* hyphenation. With that information, it uses a complex formula to determine how to space lines of text (and break them, if necessary) in order to fit them within the text box you created. This process is called *composition*, and the Paragraph panel's menu gives you two composition methods to choose from:

- Use **Single-line Composer** if you're dealing with just one line of text, or if you want to handcraft the spacing between letters and lines with kerning or by inserting

manual line breaks (carriage returns). With this method, Photoshop composes each line individually, no matter how many lines the paragraph contains.

- Go with **Every-line Composer** if you've got more than one line of text. (Photoshop uses this method automatically unless you tell it otherwise.) Choosing this method tells Photoshop to compose the paragraph as a whole, and it tries to arrange lines in a way that avoids nasty line breaks. This method generally creates more visually pleasing text, in part because it makes Photoshop avoid hyphenation whenever possible.

TIP Instead of straining your brain to choose a color for the text, you can snatch one from the photo instead; that way, it'll match. Simply highlight the text and then click the color square in the Options bar (or the Character panel) to open the Color Picker. Next, mouse away from the dialog box and, when your cursor turns into an eyedropper, click a spot in your image to grab that color; the text instantly changes color. Then simply click OK to close the Color Picker.

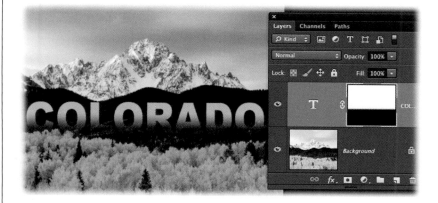

FIGURE 14-26

Text that looks like it fades into an image is eye-catching.

The best thing about this technique is that the text remains fully editable so you can experiment with formatting to get just the right effect.

2. **Add a layer mask to the type layer.**

 This mask will let you make the text look like it fades into your photo. With the type layer active, click the circle-within-a-square icon at the bottom of the Layers panel to add the mask.

3. **Use the Gradient tool to fill the mask with a black-to-white, linear gradient.**

 Press G to grab the Gradient tool and then, near the left end of the Options bar, click the down-pointing triangle to the right of the gradient preview to open the Gradient picker. From the resulting preset menu, choose the black-to-white gradient (it's the third one in the first row). Then, back in the Options bar, take a peek at the little Gradient Type buttons to the right of the Gradient picker and make sure the first one is active so you're creating a linear gradient. Next, mouse over to your image and, with the layer mask active, click and drag from the bottom of the text to the top of the text (or a little past it). When you let go of your mouse, Photoshop fills the mask with the gradient, hiding your text in such a way that it looks like it fades into the photo. If you're not thrilled by your first attempt, just keep dragging with the Gradient tool until the fade looks good to you.

4. **If necessary, use the Move tool to reposition the text or the mask.**

 The box on page 130 has the scoop on moving a layer independently of its mask, or vice versa.

That's it! Save the file as a Photoshop document and the text will remain editable until the end of time—well, until the end of *Photoshop*, at least!

Stroked Text

One of the easiest ways to enhance text that's fairly big is to give it an outline. Photoshop calls outlines *strokes*, and it's simple to add one using the Layer Styles menu. The following steps explain how to add a plain black stroke, as shown in Figure 14-27, top.

FIGURE 14-27

Here are a few ways of stroking text with a layer style. No matter what kind of stroke you create, you can edit it by double-clicking the stroke style layer in the Layers panel.

Top: A classic thick, black, outside stroke.

Middle: By changing the stroke Fill Type to Gradient and picking Shape Burst from the gradient Style menu, you can introduce more than one color into the stroke. This gradient stroke was made with the Silver preset from the Metal set (see page 370 for more on loading gradients).

Bottom: By using the Gradient Editor (page 371) to create a custom solid gradient, you can make multi-stroked text like this, as explained in the next section.

1. **Add some text and commit it.**

 Press T to grab the Type tool and type a word. If the letterforms are too thin, the stroke can overpower them, so be sure to choose a fairly weighty font like Futura bold or Cooper (the latter was used in Figure 14-27). When you're finished typing and formatting the text, tell Photoshop you're done by pressing Enter on your numeric keypad or by clicking the checkmark in the Options bar.

 > **TIP** You might be tempted to choose Edit→Stroke instead of following the steps below. Don't. To use the Edit menu's Stroke command, you have to *rasterize* the text first (in fact, if you've activated a type layer, the Stroke menu item will be dimmed since it's vector-based). Using layer styles is a much more flexible way to outline text, because the text remains *editable*.

2. **At the bottom of the Layers panel, click the *fx* and choose Stroke.**

 Photoshop pops open the Layer Style dialog box.

3. **Enter a stroke width.**

In the dialog box's Size field, enter a pixel width (or drag the slider). Use a lower number for a thin stroke and a larger number for something more substantial (in Figure 14-27, top, the size was set to 8).

4. **Make sure the Position menu is set to Outside.**

Using Outside works well for text because it tells Photoshop to put the stroke on the *outside* of the characters (as opposed to the inside, where it takes up more space, or straddling the characters' edges, as is the case if you choose Center). Leave the blend mode set to Normal and the opacity at 100 percent.

5. **From the Fill Type menu, choose Color.**

Photoshop assumes you want to fill the stroke with color (as opposed to a gradient, as explained in the next section) and automatically chooses black. To create a standard black stroke, as shown at the top of Figure 14-27, leave this setting alone. To pick something else, click the color swatch and then choose from the resulting Color Picker.

6. **Click OK to close the Layer Style dialog box and admire your newly stroked text.**

You can edit the new stroke anytime by double-clicking the stroke style in the Layers panel.

> **TIP** To produce *hollow* text, apply a stroke layer style and then, at the top of the Layers panel, lower the type layer's Fill setting to 0%. The stroke will still be visible, but everything *inside* it will vanish.

■ THE RARE MULTI-STROKED TEXT EFFECT

If you *really* want to make text stand out—like in a comic book—try giving it more than one stroke, like the "Shazam" at the bottom of Figure 14-27. This technique is rewarding, but it requires a few more steps than the plain ol' single-stroked method in the previous section. Begin with steps 1 and 2 for creating stroked text, and then proceed as follows:

1. **In the Layer Style dialog box, set the Fill Type field to Gradient and the Style menu to Shape Burst, as shown in Figure 14-28, top.**

Using a gradient lets you add a multicolored stroke to the text, though you'll need to do some gradient editing. Choosing Shape Burst as the gradient style makes the gradient stroke appear on the *outside* of the text. You don't *have* to pick a gradient style before editing the gradient; doing so just lets you see what you're creating.

2. **Open the Gradient Editor (Figure 14-28, bottom) and choose a new a gradient.**

To open the Gradient Editor, in the Layer Style dialog box, click the rectangular gradient preview. At the top of the resulting dialog box, click one of the handy

preset swatches. If you want to get really creative, proceed to the next step. If not, skip to step 4.

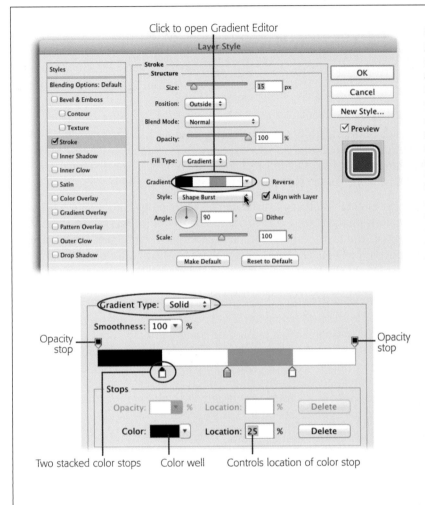

Click to open Gradient Editor

FIGURE 14-28

Here are the settings that were to create the multicolored strokes around "Shazam" in Figure 14-27.

Top: Once you get the hang of editing gradients, you can simulate space between the color strokes by creating a solid gradient that goes from black to white (or whatever your document's background color is) to green and then back to white. Note that the color that's closest to the text (white, in this case) is the last color in the gradient preview shown here.

Bottom: To make your gradient match this one, you'll need to create six color stops. Place two stops at the 25% mark and stack them directly atop each other so the white stop covers the black one. Next, add two stacked stops at 50% and arrange them so the green stop covers the white one. Then add two more stacked stops at 75% and make the white stop cover the green one. As shown here, you'll see just three color stops when you're finished because the other three are hidden directly underneath 'em.

3. **Set the Gradient Type menu to Solid and then edit the color stops.**

 To edit one of the gradient's colors, double-click a color stop like the one circled in Figure 14-28 to summon the Color Picker. Move the color stops around by dragging them or by entering a number in the Location field. You can create the illusion of space between the strokes by including white in the gradient, as shown in Figure 14-28.

4. **When the preview looks good, click OK in the Gradient Editor, and then click OK again to close the Layer Style dialog box.**

Pretty nifty, eh? Once again, if you want to edit the stroke, just double-click the stroke style layer in the Layers panel.

NOTE To learn how to create text that looks like it's made out of shiny metal—a technique you're allowed to use but once a year!—head to this book's Missing CD page at *www.missingmanuals.com/cds*.

Texturizing Text

Design trends come and go, but the distressed, tattered look has been popular for a long time. You can spot it everywhere: movie posters, magazine ads, and book and album covers. Admittedly, it looks pretty darn good when applied to text. After all, text doesn't always have to look new!

As with most effects, Photoshop gives you all kinds of ways to create a textured look. You can swipe the texture from a photo, run a filter (or several) on the text, or hide portions of the text using a layer mask and then paint it back with an artistic brush. Depending on your situation, one of these methods will work better for you than the rest (or at least be faster). They're all covered in the following pages.

■ TEXTURE FROM A PHOTO

You can come up with some unique effects by grabbing texture from a photo and applying it to text through a layer mask. And the great thing about this technique is that it's completely nondestructive: The type layer remains editable. Start with an extremely busy photo—one with lots of hard lines and angles, like a picture of wood, leaves, or an interesting piece of architecture. In the steps below, you'll use the Threshold adjustment to morph that photo into a high-contrast texture primed for plopping into the nearest layer mask, as shown in Figure 14-29.

Here's how to texturize text using a photo:

1. **Add some hefty text to your document.**

 Use a thick font (like Impact), and set its font size to something high (try 107 point) to make sure you have plenty of surface area to texturize.

2. **Open a photo and then convert it to a high-contrast, black-and-white image using a Threshold adjustment.**

 Choose Image→Adjustments→Threshold. Drag the slider in the Threshold dialog box *almost* all the way to the left to make the image's highlights completely white, and its shadows completely black. The black areas will become the texture, so bear in mind that too much texture (black) will render the text unreadable. When it looks good, click OK.

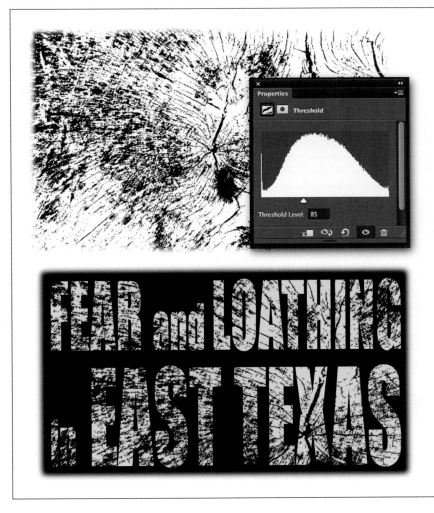

FIGURE 14-29

*Top: You can create a texture
from any photo using a
Threshold adjustment;
the more lines the photo
contains, the better. Areas in
shadow will become black
and the highlights become
white. For this technique
to work, you need to apply
the adjustment to your
image instead of using an
adjustment layer. Just be
careful not to save over
your original file with this
adjusted version—do a Save
As and give the adjusted
version a new name.*

*Bottom: Here's what the
wood texture looks like after
it's been copied into a type
layer's layer mask. Imagine
the possibilities!*

*Want to follow along? Visit
this book's Missing CD page
at www.missingmanuals.
com/cds and download the
practice file Wood.jpg.*

3. **Copy the new and contrast-riddled image.**

 Choose Select→All to surround your image with marching ants, and then copy
 the selection by pressing ⌘-C (Ctrl+C).

4. **Switch back to your text document, add a layer mask to the type layer, and
 then open the mask.**

 Give the type layer a layer mask by clicking the circle-within-a-square icon at
 the bottom of the Layers panel. Next, open the mask by Option-clicking (Alt-
 clicking on a PC) its thumbnail in the Layers panel. Your document should go
 completely white because the mask is empty.

5. **Paste the texture into the mask and, if necessary, reposition the text, mask, or both with the Move tool.**

 Once you're in the layer mask, press ⌘-V (Ctrl+V) to paste the texture. Feel free to move it around with the Move tool.

6. **Exit the layer mask to reveal the newly textured text.**

 To get out of the layer mask and see the newly textured results, in the Layers panel, single-click the type layer's thumbnail to the left of the layer mask, and then marvel at your creativity.

> **NOTE** Photoshop assumes that if you want to move a layer mask, you'll want to move whatever it's *attached* to as well, though this may not always be the case. For example, if you want to move the text independently of the mask, or vice versa, you have to unlink them first. Just head to the Layers panel and click the little chain icon that lives between the type layer and layer mask thumbnails; the chain vanishes. Next, activate the Move tool and then click the thumbnail of whatever you want to reposition—either the image or its mask—and drag it into place. To lock them back together, click between their thumbnails in the Layers panel and the chain icon reappears. (You can unlink adjustment layer masks, too!)

■ TEXTURE FROM A BRUSH

Another way to texturize text is by painting on a layer mask with the Brush tool. Photoshop has some amazingly funky-shaped brushes, so you might as well make good use of them! With this method, you can be a little more particular about exactly where the texture goes since you paint it by hand, as shown in Figure 14-30.

FIGURE 14-30

By using some of Photoshop's more creative brushes, you can paint a unique texture onto text using a layer mask (circled). The cursor even takes on the shape of the brush, as you can see on the left side of this image (it looks like a bunch of black squiggles).

As with most text effects, you'll want to start out with a weighty font so you can actually see the texture you've so painstakingly applied. Poplar Std at 134 and 236 points was used here.

To get started, add some big, thick text to your document, and then:

1. **Add a layer mask to the type layer.**

 Activate the type layer and add a layer mask to it by clicking the circle-within-a-square icon at the bottom of the Layers panel. This mask will let you *hide* bits of the text instead of deleting it.

2. **Grab the Brush tool and choose one of its more artistic manifestations, like Spatter or Chalk.**

 Press B to activate the Brush tool and then open the Brush Preset picker in the Options bar. Scroll through the brush previews and pick one of the more irregular, splotchy options. Photoshop has a *ton* of super-cool brushes built right in; page 543 explains how to load 'em.

3. **Increase the brush size to 100 pixels or so.**

 Making the brush fairly big will help you see its edges more clearly when you paint, so you'll know exactly what kind of texture you're painting where. While the Brush tool is active, you can press the right bracket key (]) repeatedly to increase brush size, or the left bracket key ([) to decrease it. This is an important keyboard shortcut to memorize, because this particular technique looks better if you vary the brush size quite a bit. (There are other, more complicated shortcuts for resizing brushes, but this one has been around forever—plus it's easy to remember!).

4. **Make sure your foreground color chip is set to black and that the mask is active, and then mouse over to your document and start clicking the text to apply the texture (clicking works better than dragging).**

 As you've learned, painting with black within a layer mask conceals (hides) whatever is on that layer, while painting with white reveals. To hide portions of the text in the shape of the brush, you need to paint with black, so take a peek at the color chips in the Tools panel and make sure black is on top. If it's not, press D to set the color chips to the factory setting of black and white, and press X to flip-flop the chips until black is on top.

 If you hide too much of the text, press X to swap color chips so that white is on top, and then click to paint that area back in. (When editing layer masks, you'll do a lot of color chip swapping!)

The best part of this technique is that, by using a layer mask, you haven't harmed the text. If you don't like the effect, just delete the mask and you're back where you started.

■ TEXTURE FROM FILTERS

Running a filter on text is one of the fastest ways to give it extra character. Like the previous two techniques, this method involves using a layer mask, though this time you need to create a selection of the text *before* adding the mask.

Add some chunky text to your document and then, in the Layers panel, ⌘-click (Ctrl-click) the type layer's thumbnail to load the text as a selection. Once you see marching ants, add a layer mask to the type layer as described in step 1 in the previous section. Then head to the Filter menu and choose Distort→Ocean Ripple. In the resulting dialog box, tweak the filter's settings until the text's edges look fairly tattered in the handy preview window. Figure 14-31 shows the results of changing the Ripple Size to 8 and Ripple Magnitude to 4, and then running the filter three times. Click OK to dismiss the Filter dialog box and admire your newly distressed text.

FIGURE 14-31

Top: By loading the text as a selection before adding the layer mask, the mask takes on the shape of the letters, giving you a safe place to run the filter (otherwise, you'd have to rasterize the type layer before running it).

Bottom: As you can see in this Layers panel, the type layer remains unscathed after applying this technique, so you can still change the text's color or size. To change the color, double-click the type layer and then click the color swatch in either the Options bar or Character panel. Page 626 explains how to resize text.

Other filters that work well with this technique include the Artistic and Distort sets, along with Torn Edges, all of which you can find in the Filter Gallery. To rerun the last filter you used, just press ⌘-F (Ctrl+F), and Photoshop uses the same settings you used last time (don't expect a dialog box, though). This trick works until you quit Photoshop.

Placing a Photo Inside Text

Ever wonder how designers place an image inside text? It takes *years* of practice. (Just kidding!) They do it by creating a *clipping mask* (see the box on page 133), which takes about 5 seconds. All you need is a photo, a type layer, and the secret layer stacking order. Here's how to create the effect shown in Figure 14-32:

1. **Open a photo and unlock the background layer.**

 Since the text you'll create in the next steps needs to be positioned *beneath* the image layer, you need to unlock the background layer by single-clicking its padlock icon in the Layers panel.

2. **Create some text.**

Press T to grab the Type tool and add some text to your document. It doesn't matter what color the text is (as long as you're able to see it while you're typing); what matters is that you pick a really big, thick font. Figure 14-32 used Impact—a display font—at 95 points. Short words work better than longer ones (they're easier to read), and you may want to use all caps so more of the photo shows through.

3. **Over in the Layers panel, drag the type layer** *below* **the image layer.**

If the type layer is *above* the image layer, this technique won't work.

4. **Clip the image layer to the type layer.**

With the image layer active, choose Layer→Create Clipping Mask. Alternatively, press and hold Option (Alt on a PC) while pointing your cursor at the dividing line between the two layers in the Layers panel and, when the cursor turns into a square with a down-pointing arrow, click once. Either way, the thumbnail of the photo layer scoots to the right and a tiny downward-pointing arrow appears to let you know that it's clipped (masked) to the type layer below it. You should now see the photo peeking through the text.

5. **Add a fill layer at the bottom of the layer stack.**

Rather than stare into the checkerboard of a transparent document, add a colorful background (in Figure 14-32, the background is sage green). Choose Layer→New Fill Layer→Solid Color and the Color Picker opens. Choose a color, click OK to close the dialog box, and then drag the new fill layer to the bottom of your layer stack. To make sure the background goes well with the photo, double-click the fill layer's thumbnail to reopen the Color Picker, mouse over to your image, click within the photo to snatch a color, and then click OK.

6. **Use the Move tool to reposition either the photo or the text (see the box on page 130 to learn how to move the layer independently of its mask, or vice versa).**

You're basically done at this point, but feel free to play around with text formatting, layer styles, and different fonts, or just sit back and admire your handiwork.

Converting Text to a Shape

Last but certainly not least, Photoshop lets you do all *kinds* of cool things with text that's been converted into a vector shape or path (for more on shapes, see Chapter 13). Though you can't *edit* the converted text, what used to be the type layer turns into a resizable, distortable piece of art or editable path that you can do all manner of interesting things to.

FIGURE 14-32

Even though it looks complicated, placing a photo inside text is one of the easiest Photoshop text tricks. Be sure to pick a nice, thick font like Impact so you can see a good chunk of the photo through the letters.

For even more fun, use layer styles to add a stroke and drop shadow to the type layer, as shown here.

Another neat trick is to place text behind an object. That technique, in all its step-by-step glory, is detailed on page 123.

To convert text into a shape, just activate the type layer in the Layers panel and then choose Type→"Convert to Shape." Once you've performed this miraculous transformation, you can do any of the following:

- **Edit the letterforms.** Want to add an extra flourish here or a swoosh there? Simply use the Path Selection tool to twist and pull the letters any which way you like.

- **Apply distort and perspective with Free Transform.** You may have noticed that the Free Transform tool's Distort and Perspective options are dimmed when a type layer is active, but they're ready for action on a shape layer. If you've ever wanted to create text that fades into the distance in proper perspective, here's your chance.

- **Rotate individual letters.** You can use the Path Selection tool to grab one letter at a time and rotate it with Free Transform, as shown in Figure 14-33. Graphic designers *love* doing this kind of thing.

- **Creating intersecting or intertwining text.** Since you're working with a vector shape layer, you have the full arsenal of drawing tools at your disposal, including the ever-useful Exclude Overlapping Shape Areas button, whose effect is shown in Figure 14-33. (For more on using Photoshop's drawing tools, see Chapter 13.)

- **Scale to infinity—and beyond!** Because the letter shapes are vectors, you don't have to worry about jagged edges. So feel free to resize the text using Free Transform without fear of losing quality.

- **Enjoy stress-free printing.** You can send the file off to a professional printer (or to an inkjet printer, for that matter) without a care in the world. Because you converted the text to a shape, you don't have to worry about including the original fonts or about how the text will print.

FIGURE 14-33

This effect was created by converting the text (Arial Black) into a shape and then spinning each letter individually using Free Transform. Don't forget to press Return—Enter on a PC—when you're done rotating each letter.

For added fun, you can use the Path Selection tool to move each letter so they overlap just a touch. Next, use the same tool to activate all the letters and then, in the Options bar, click the Path Operations icon (it looks like two overlapping squares) and choose Exclude Overlapping Shape Areas. This makes the color disappear from the overlapping areas, letting the image show through. To tweak the text's color, double-click the shape layer's thumbnail to open the Color Picker.

More Typographic Resources

This book is by no means the be-all and end-all on typography and fonts. To learn more about finding, identifying, and buying fonts, crack open a nice bottle of wine and check out some of the following resources:

- *www.lesa.in/lesacl.* Your humble author records a slew of online video courses. For more on typography, including how to create typographic logos, check out *Graphic Design for Everyone,* or the ebook of the very same name at *www.theskinnybooks.com.* You can also download a handy typographic cheat sheet by visiting *www.facebook.com/photolesa* and clicking Like.

- *The Non-Designer's Type Book,* Second Edition, by Robin Williams (*www.lesa.in/robinnddb*). This book is an easy read and well worth the time; you'll learn more than you ever wanted to know about typography.

- *Fonts & Encodings* by Yannis Haralambous (*www.lesa.in/fontsencoding*) is a priceless resource. If you've ever wondered how our current font situation came to be or how and why fonts work the way they do, you'll enjoy this tome.

- *www.Helveticafilm.com.* Visit this site for a feature-length film about typography and graphic design made in celebration of the Helvetica font's 50th birthday in 2007. It's fascinating!

- *www.fonts.com.* Hands down the Internet's number one resource for all things font related.

- *www.myfonts.com.* Another great site, which features a font-identification service called WhatTheFont. Just send them an image of some text and they'll tell you the closest matching font. How cool is that?

- *www.fontsite.com.* This is the place to go to get professional fonts at a fraction of their usual price.

- *www.lesa.in/jaymacworld.* Jay Nelson, who's the founder and publisher of DesignToolsMonthly.com, writes a column for *Macworld* magazine where he discusses all manner of font features and type-related news (full disclosure: he's married to yours truly). Visit this web address to see all his columns.

The Wide World of Filters

Photoshop's filters let you create a *multitude* of special effects that you can apply to images or use to conjure interesting backgrounds. You can run filters on image layers, masks, channels, smart objects, shape layers, and even type layers (provided you convert them into smart objects or rasterize 'em first). The list of special effects you can create by applying filters once, twice, or even *10* times is a mile long. There are a bunch of the little critters too, each with its own special brand of pixel wrangling.

These days, Photoshop's Filter menu *appears* to have fewer items than in older versions of the program—the result of a menu reorganization that happened in CS6—but it actually has tons. The program also includes two *new* blur filters—Path Blur and Spin Blur—that are sure to delight photographers, and possibly a few designers too (especially those who are called upon to add motion to photos!). In addition, 24 of Photoshop's filters now work on 16- and 32-bit documents (see the box on page 42 to learn more about bit depth).

You've already seen a few filters in action, like the ones for sharpening, blurring, adding texture to text, mapping one image to the contours of another, and so on. But that's just a tiny sliver of what's available. In this chapter, you'll be immersed in the realm of filters and discover how you can use 'em to do all kinds of fun and useful stuff. But before you start plowing through the Filter menu, you need to know how to use filters in ways that won't harm your original images. That means learning about smart filters. Onward, ho!

> **NOTE** If you like learning by watching videos, check out your author's online course, *Photoshop Deep Dive: Filters*, at *www.lesa.in/lesacl*.

■ The Joy of Smart Filters

Filters, by their very nature, are destructive—they move, mangle, distress, and distort pixels like you wouldn't believe, and they *always* run on the currently active layer, mask, or selection. Before Photoshop CS3, the only way to protect your image—and retain *any* level of editing flexibility—was to duplicate the image layer, and then run the filter on the copy. That way, you could lessen the filter's effect by reducing the duplicate layer's opacity or hide the filter from parts of the image using a layer mask. However, duplicating layers can bloat your Layers panel, and then there's the *extra* step of adding a layer mask. Yuck.

Then along came Photoshop CS3 with its nifty *smart filters*. If you convert a layer—or multiple layers—into a smart object *before* applying a filter, you can make the filter run in its *own* special spot in the Layers panel (similar to layer styles), complete with blend mode and opacity controls. It even comes with a layer mask. All of these features are what make smart filters *smart*.

Smart filters are the best thing since sliced bread, and almost all the filters in Photoshop CC take advantage of that capability. The exceptions are the Vanishing Point and Lens Blur filters, which work only on *regular* image layers (ones that haven't been converted to smart objects); to use one of *these* filters, just do things the old-fashioned way: Duplicate your image layer or create a stamped copy of multiple layers (page 119), and then run the filter on the copy.

Smart filters are also picky about which color mode your image is in. For instance, not all of 'em work in CMYK or Lab mode, but since you spend most of your time in RGB mode, that isn't a huge deal.

> **TIP** If you can't (or didn't) use a smart filter and you forgot to duplicate your image layer before running a filter, you can lessen the filter's strength and change its blend mode by choosing Edit→Fade—but you have to run this command before you do *anything* else, or it won't be available. Flip back to the box on page 493 for the skinny on the Fade command.

When smart filters *are* an option, they're the only way to roll, and using them couldn't be easier: All you do is activate the layer(s) you want to work on, and then choose Filter→"Convert for Smart Filters." You'll see a friendly message letting you know that Photoshop is about to turn the active layer(s) into a smart object, to which you should reply with a resounding OK. (You'll probably want to turn on the "Don't show again" checkbox to keep Photoshop from informing you of this in the future.) Alternatively, you can open an image (or several) by choosing File→"Open as Smart Object," and you're *immediately* ready to rock filters nondestructively.

> **TIP** If you convert your layer(s) for smart filters and then, before running a filter, create a *selection,* when you then run a filter, Photoshop fills in the smart filter mask *for* you so the filter's effects are hidden from the rest of your image. That's a nice timesaver!

Once you've made a smart object, the next filter you run will appear *beneath* that smart object as if it were a layer of its own (see Figure 15-1). You can run as many filters as you want; they'll just continue to stack up in the Layers panel, much like layer styles. If you need to rearrange their stacking order—say, to keep one from covering up the effect of another—just drag 'em up or down in the Layers panel. To collapse a layer containing smart filters (thereby temporarily hiding the filters' names and shortening the Layers panel) click the triangle at the far *right* of the smart object (it's labeled in Figure 15-1); click it again to expand the layer's effects.

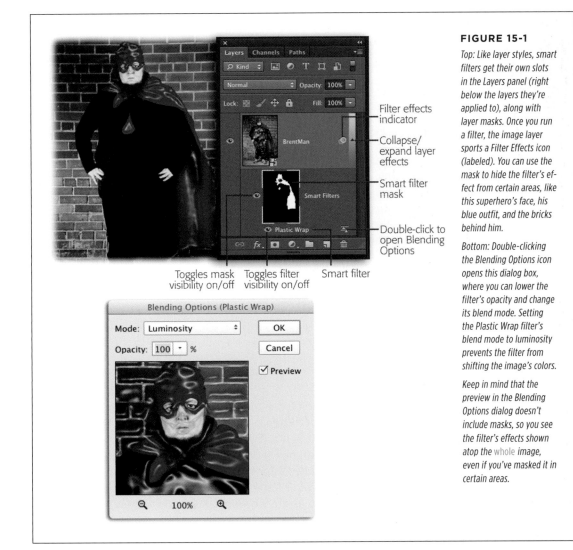

FIGURE 15-1

Top: Like layer styles, smart filters get their own slots in the Layers panel (right below the layers they're applied to), along with layer masks. Once you run a filter, the image layer sports a Filter Effects icon (labeled). You can use the mask to hide the filter's effect from certain areas, like this superhero's face, his blue outfit, and the bricks behind him.

Bottom: Double-clicking the Blending Options icon opens this dialog box, where you can lower the filter's opacity and change its blend mode. Setting the Plastic Wrap filter's blend mode to luminosity prevents the filter from shifting the image's colors.

Keep in mind that the preview in the Blending Options dialog doesn't include masks, so you see the filter's effects shown atop the whole image, even if you've masked it in certain areas.

> **NOTE** While it's fine to run multiple filters on a single smart object, you only get *one* layer mask per smart object. So if you need to mask the effects of filters *differently*, so they affect different parts of your image, you'll need to create *another* smart object out of the first in order to get another mask.

To apply the same smart filter to another layer, copy it from one layer to another by Option-dragging (Alt-dragging on a PC) it within the Layers panel. As you drag, you see a ghosted version of the *fx* icon beneath your cursor.

> **NOTE** You can delete a garden-variety layer by activating it and then pressing Delete (Backspace on a PC), but that doesn't work for smart filters (or layer styles, for that matter). You have to Control-click (right-click) the smart filter in the Layers panel, and then choose Delete Smart Filter from the resulting shortcut menu. Or, simply drag the smart filter to the trash can icon (or activate the layer, click the trash can icon, and then click OK in the resulting "Are you sure?" dialog box).

■ A Filters Tour

With so many filters to choose from, it can be tough to get a handle on what they all do. That's why, when you choose filters in several categories from the Filters menu—specifically, the Artistic, Brush Strokes, Distort, Sketch, Stylize, and Texture categories—Photoshop opens a large window called the Filter Gallery (Figure 15-2). (If you don't see some of these categories in the Filter menu, the box on page 764 explains how to turn them on.) The window has a nice big preview of your image on the left (you can zoom in or out by clicking the + and – buttons below it), a list of *all* the filters in these categories in the middle (with cute little preview thumbnails), and the specific settings associated with each filter on the right.

> **NOTE** Several filters automatically open the Filter Gallery, but you can also open it manually by choosing Filter→Filter Gallery. However, if you do that, any filter you run via the Filter Gallery gets the generic name "Filter Gallery" in the Layers panel. To make Photoshop name the filter *properly*, choose the filter from the Filter menu and let *it* open the Filter Gallery instead. For more on this filter-naming conundrum, see the box on page 674.

Once the Filter Gallery opens, you can test drive a filter by clicking its name and then tweaking its settings; Photoshop updates your image preview accordingly. You can even run additional filters *while* you're in the Filter Gallery by clicking the "Create new effect layer" icon at the window's bottom right (the section above this icon lists each filter you've applied). For example, you can make a photo look like a watercolor by running the Water Paper and Watercolor filters (both live in the Artistic category). You can also delete individual filters you've added by activating its effect layer, and then clicking the tiny trash can.

Throughout this chapter, you'll learn how to use at least one filter in each category (they're listed in the order they appear in the *long* version of the Filter menu—see the box on page 674 to learn how to repopulate it). You can think of this as a Filter's Greatest Hits Tour; a *complete* listing of every filter would swell this book to *War*

and Peace proportions. So grab your favorite beverage, sit back, and read on to discover the wide world of filters.

> **TIP** To rerun the last filter you used with the same settings, press ⌘-F (Ctrl+F). (To summon the filter's dialog box so you can adjust its settings *before* running it, press Option-⌘-F [Alt+Ctrl+F] instead). You can also head to the Filter menu, where the last filter you used is listed at the top of the menu.

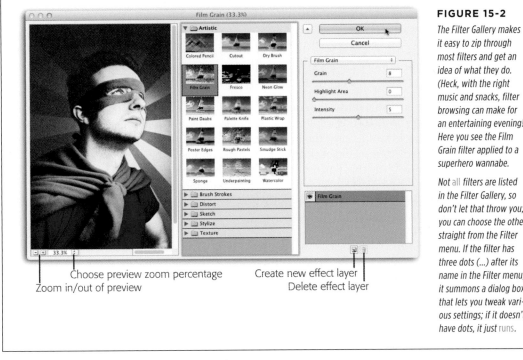

FIGURE 15-2

The Filter Gallery makes it easy to zip through most filters and get an idea of what they do. (Heck, with the right music and snacks, filter browsing can make for an entertaining evening!) Here you see the Film Grain filter applied to a superhero wannabe.

Not all filters are listed in the Filter Gallery, so don't let that throw you; you can choose the others straight from the Filter menu. If the filter has three dots (...) after its name in the Filter menu, it summons a dialog box that lets you tweak various settings; if it doesn't have dots, it just runs.

Choose preview zoom percentage
Zoom in/out of preview

Create new effect layer
Delete effect layer

Adaptive Wide Angle

This filter fixes distortion problems commonly found in photos shot with a wide-angle or fish-eye lens, as well as panoramas. For example, some lenses distort images so that tall buildings appear to *bend* toward a vanishing point in the sky (called *pincushion distortion*, where lines bend inward), or make people, objects, and horizon lines look bowed, as shown in Figure 15-3 (called *barrel distortion*, where lines bend outward). And sometimes the problem isn't the lens but your sense of balance—maybe you accidentally tilted the camera vertically or horizontally, making a lake or ocean look like it's running downhill instead of staying level (called *perspective distortion*).

Photoshop's Adaptive Wide Angle filter can fix all of these problems quickly and easily, and you don't have to spend a ton of time tweaking settings. If Photoshop can figure out which lens you used to take the shot (if you're using fairly recent

equipment, it probably can), all you have to do is draw a line across the part of the image that needs fixing and Photoshop does the rest.

> **NOTE** You can use this filter on smart objects *and* when you're recording actions, which is handy if you've got several photos that are distorted in the same way. (See Chapter 18 for more on actions.)

To use it, open an image and duplicate your image layer or choose Filter→"Convert for Smart Filters." Then choose Filter→Adaptive Wide Angle and Photoshop opens the giant Adaptive Wide Angle dialog box and tries to find a *lens profile*—a detailed set of info about common lenses—for your camera (it knows what kind of equipment you used because of the image's *metadata*). If it locates one, it sets the Correction menu on the right side of the dialog box to Auto. (The chances of Photoshop finding your lens profile are good because its database is updated constantly; if it *can't* find one, you'll learn what to do in a sec.)

Next, mouse over to the area that needs fixing and click once to mark the point where the distortion begins. (For example, in Figure 15-3, top, the horizon is bowed, so you'll want to click the horizon's left edge.) Then move your cursor to the *end* of the distortion and click again to set an endpoint (the horizon's right edge, in this example). The thin blue line that appears between the points is called a *constraint*. As soon as you click to set the endpoint, Photoshop adjusts the image according to the constraint's curvature (Figure 15-3, bottom). Click OK to apply the changes to your image and close the dialog box.

WORKAROUND WORKSHOP

Repopulating the Filter Menu

Back in Photoshop CS6, Adobe pruned the Filter menu by hiding some categories that are available in the Filter Gallery. While this makes for a *much* shorter Filter menu, it also makes it more difficult to keep track of which filters you've run in a document. For example, if you choose Filter→Filter Gallery, and then run a filter on a smart object, instead of listing the specific name of the filter in the Layers panel (Plastic Wrap, say), Photoshop just lists its name as "Filter Gallery," which is the exact *opposite* of helpful. (That said, if you apply *more* than one filter to your image while you've got the Filter Gallery open, such a generic naming scheme is to be expected as Photoshop can't give the smart filter *multiple* names in the Layers panel.)

You can always double-click the words "Filter Gallery" in your Layers panel, and then peek at the lower right of the resulting dialog box to see which filter(s) you ran,

but you can't rename a smart filter by double-clicking its name in the Layers panel. One possible solution is to make Photoshop list *all* its filters in the Filter menu by changing its Plug-Ins preferences (technically, filters are plug-ins). To do that, choose Photoshop→Preferences→Plug-Ins (Edit→Preferences→Plug-Ins on a PC), turn on the "Show all Filter Gallery groups and names" checkbox, and then click OK. After that, the Filter menu will be longer and, when you run a filter by choosing its name from the Filter menu, you'll see the filter's *actual* name in the Layers panel. (If you choose Filter Gallery from the Filter menu, then whatever filter[s] you run will still be named Filter Gallery in your Layers panel.)

This chapter describes filters in the order they appear in the *long* version of the Filter menu, so go ahead and turn on this preference.

NOTE You can give this filter a try by downloading the practice file *Horseshoe.jpg* from this book's Missing
CD page at *www.missingmanuals.com/cds*.

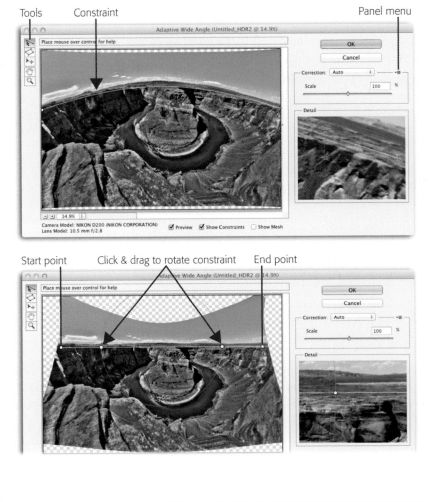

FIGURE 15-3

Top: Wide-angle and fish-eye lenses are great for exaggerating the depth and relative size of an object or scene, though you usually end up with some straight areas that look curved.

Bottom: If Photoshop can find your lens profile, it can fix an image like this in just two clicks. If you've clicked to set a start point and then decide to delete it, just press the Esc key. If you've already created a constraint and you press Esc, Photoshop asks if you're sure you want to close the dialog box without saving your changes. Click Don't Save to dismiss the dialog box without changing anything, click Cancel to return to the Adaptive Wide Angle dialog box for more editing, or click Save to close the dialog box and apply your changes.

Photo of Horseshoe Bend by Karen Nace Willmore (www.karennace.com).

If Photoshop *can't* find a lens profile, pick the type of lens you used from the Adaptive Wide Angle dialog box's Correction menu. Your choices are Fisheye, Perspective, and Full Spherical (think 360-degree panoramas). Photoshop then analyzes the metadata embedded in the image file and tries to figure out the image's *focal length* (which determines the view angle and how much the subject is magnified in relation to your camera's location) and *crop factor* (the level of magnification of your digital camera's sensor in relation to a 35 mm full-frame sensor). If it can't, Focal Length and Crop Factor sliders appear on the right side of the dialog box so you can adjust them manually.

Straight from the factory, the Adaptive Wide Angle filter produces irregularly shaped images that are smaller than the original and scaled to fit the area where you placed constraints (see Figure 15-3, bottom). To change the image's size to, say, end up with a *larger* image so there's less transparency to fill in or crop out, drag the dialog box's Scale slider to the right or enter a percentage in the Scale field. To make the image smaller, drag the slider left.

The toolbox in the upper-left corner of the Adaptive Wide Angle dialog box contains these tools:

- **Constraint tool.** Photoshop activates this tool automatically when you first open the dialog box. Use this tool to set as many constraints as you need to in order to correct your image. For example, click where the distortion begins, mouse over to where the distortion ends, and then click again, and Photoshop adjusts the distortion along the constraint to straighten your image.

 To create a *new* constraint with a start point near or atop an existing one, press and hold ⌘ (Ctrl) while you click. To create a horizontal or vertical constraint, press and hold the Shift key after you set a start point (when you go past 45-degrees, the resulting line is yellow for horizontal or magenta for vertical). To *delete* a constraint, click one of its points and then press Delete (Backspace on a PC), or Option-click (Alt-click) the point. To move a constraint, point your cursor at the start or endpoint (it turns into little crosshairs) and then drag it to a new location. Keyboard shortcut: C.

> **TIP** To change the color of the constraints or mesh, choose Preferences from the Adaptive Wide Angle dialog box's panel menu, and then click the colored swatches in the resulting dialog box.

- **Polygon Constraint tool.** Use this tool to create a polygonal constraint instead of a straight or curved one (useful when fixing 360-degree panoramas). Click once to set a start point, and then add additional points as needed. To close the polygon, click the start point. Keyboard shortcut: Y.

> **TIP** To save a constraint so you can use it again later (if you've got more photos from the same shoot that need fixing, say), choose Save Constraint from the Adaptive Wide Angle dialog box's panel menu (Photoshop gives it the file extension .wac). You can also import a constraint (one you created on another machine, say) by choosing Load Constraint from the same menu. In the resulting Load Constraints dialog box, navigate to where the .wac file lives on your hard drive, and then click Open.

- **Move tool.** If you increase the dialog box's Scale setting, part of your image will extend past the edges of the preview area so they won't get fixed. If that happens, use this tool to click and drag the important bits of your image back into the preview area so Photoshop can fix them. Keyboard shortcut: M.

- **Hand tool.** This tool lets you move around within the image after you've zoomed in using the Zoom tool (discussed next). Just drag within the preview area to view another part of the image. Keyboard shortcut: H.

- **Zoom tool.** As you might suspect, you can use this tool to change your view of the image (this tool is completely unrelated to image scale, discussed earlier). Simply click the image to zoom in on it, or click and drag to draw a box around part of the image to zoom in on just that area; then Option-click (Alt-click on a PC) to zoom back out. You can also use the zoom controls at the bottom left of the dialog box, or press ⌘ (Ctrl) and the + or – key. Once you zoom in past 100 percent, you can press and hold the X key to temporarily double the zoom percentage. Keyboard shortcut: Z.

You're not finished yet! These additional options live at the *bottom* of the dialog box:

- **Preview.** This checkbox is turned on from the factory, so you see a preview of the results using your current settings and constraints in real time. To see your original image instead, simply turn off this setting. Keyboard shortcut: P.

- **Show Constraints.** This setting is turned on automatically whenever the Constraint tool is active. Turn it off to hide the constraints so you can better see your image.

- **Show Mesh.** This checkbox places a green mesh atop your image preview and shows you exactly how Photoshop will warp, twist, and turn the image in order to fix it according to the constraints you've set.

Camera Raw Filter

As you know from Chapter 9, Camera Raw is an *incredibly* powerful plug-in that you can use to correct the color and lighting in images shot in raw format, though it also works—minus the color temperature controls—on *other* file formats such as JPEGs and TIFFs. Happily, you can access a *version* of this plug-in via the Filter menu, meaning you can use it on *any* kind of layer. To learn more, and to see which tools are missing from the filter version, flip back to the box on page 674.

Lens Correction

Back in CS5, this filter got a *major* overhaul. Not only can you use it to fix all kinds of weirdness that camera lenses can cause (see the box on page 679), but you can also use it to add a dark-edge vignette effect that can beautifully frame a photo, giving it a classy, finishing touch (see Figure 15-4). Here's how:

1. **Activate the image layer(s), and then choose Filter→"Convert for Smart Filters."**

 Alternatively, you can open an image as a smart object by choosing File→"Open as Smart Object."

2. **Choose Filter→Lens Correction.**

 Photoshop opens the petite (ha!) Lens Correction dialog box.

3. **Click the dialog box's Custom tab (circled in Figure 15-4) and adjust the Vignette settings.**

 The dialog box has two tabs: Auto Correction and Custom. Click the Custom tab and then, in the tab's Vignette section, drag the Amount slider all the way left; Photoshop softly darkens the edges of the image. Then, to widen the darkening, drag the Midpoint slider left to about 30.

4. **Click OK and then save the document as a PSD file so you can edit it again later.**

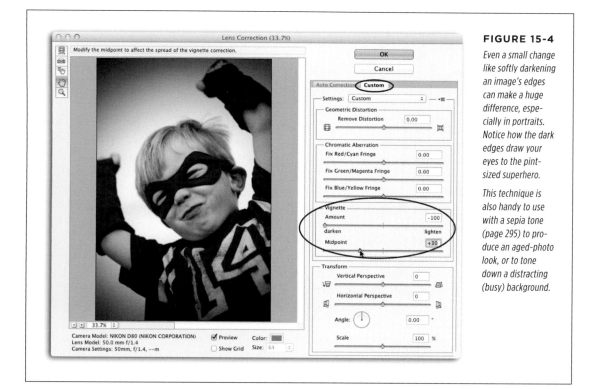

FIGURE 15-4

Even a small change like softly darkening an image's edges can make a huge difference, especially in portraits. Notice how the dark edges draw your eyes to the pint-sized superhero.

This technique is also handy to use with a sepia tone (page 295) to produce an aged-photo look, or to tone down a distracting (busy) background.

If, after admiring your handiwork, you decide the effect is a little too dark, mouse over to the Layers panel, double-click the icon to the right of the words "Lens Correction" to open the filter's Blending Options dialog box, and then lower the Opacity setting slightly. If the edge vignette affects part of your subject's face, you can always use the smart filter mask to hide it from that area.

Liquify

The amazingly powerful—and, in Photoshop CC, smokin' fast—Liquify filter lets you push, pull, stretch, bloat, and pinch pixels manually. It's great for reshaping facial features or entire bodies in order to change reality. It's covered in Chapter 10, beginning on page 453. Happily, this filter works with smart filters so you can easily reopen it by double-clicking its name in your Layers panel. Hooray for progress!

NOTE In previous versions of Photoshop, you could use the Oil Paint filter to create a fairly realistic piece of art incredibly fast. Unfortunately, Adobe removed that filter from Photoshop CC 2014 due to outdated code. Here's hoping it comes back someday! In the meantime, consider trying Corel's Painter program. The box on page 552 gives you an idea of what it can do.

UP TO SPEED

Fixing Lens Distortion

No matter what kind of image-editing voodoo you've got up your sleeve, you can't hide the quality of your camera's lens. Some potential problems include a darkening in the corners of images (called *vignetting*), or a weird color fringe along an object's edges (called *chromatic aberration*). Luckily, as long as your image is 8- or 16-bit and in RGB or Grayscale mode, the Lens Correction filter can fix these problems.

To get started, choose Filter→Lens Correction. Photoshop updates its database of lens profiles, and then opens the Lens Correction dialog box to the Auto Correction tab. This tab is where you tell Photoshop what kind of problem you have. If the program figures out what camera and lens you used, just turn on the checkbox for the kind of problem your image has: Geometric Distortion (a deformation of the image in a uniform manner), Chromatic Aberration, or Vignette.

If Photoshop *can't* find your camera and lens, then these checkboxes boxes are dimmed. In that case, use the tab's Search Criteria section to tell Photoshop what equipment you used to capture the image. Pick your camera's make, model (this one doesn't have to match exactly), and lens model from the drop-down menus. If Photoshop finds a matching profile, it appears in the Lens Profiles section below. To see all the profiles for a specific brand, choose the brand from the Camera Make menu, and then set the other two menus to All. If Photoshop still doesn't find a match, at the bottom of the tab, click Search Online. You can also click the Lens Profiles section's panel menu, and then choose Browse Adobe Lens Profile Creator Online, which also lets you create custom profiles. To snag an online profile so you can use it when you don't have an Internet connection, choose Save Online Profile Locally from the panel menu.

Once you find the right (or close-enough) lens profile, give it a click and then use the checkboxes near the top of the tab to let Photoshop know what kind of problem(s) your image has (you can turn on multiple checkboxes). The moment you click a checkbox, Photoshop uses the info in the lens profile to fix the problem. (To learn how to create your *own* lens profile, visit *www.lesa.in/createlensprofile*, and then scroll down to the Resources section to find info on the Adobe Lens Profile Creator.)

If fixing the image will cause it to expand or shrink beyond its original size (and you may not know until you try to fix it), leave Auto Scale Image turned on and use the Edge menu to tell Photoshop what to do with any resulting blank edges: fill the empty spots with transparency or black or white pixels, or enlarge the image to fill the edges (choose Edge Extension).

Vanishing Point

During your illustrious Photoshop career, there will be times when you need to edit an object so it appears in proper *perspective* (meaning it seems to get smaller as it disappears into the distance). Here are a few situations where you'll likely need to adjust perspective:

- If you need to affix a graphic or text to any surface that's not flat, like an image of a book cover, cereal box, or DVD case that's positioned at an angle to the camera (Chapter 21 explains how to do this using Photoshop's 3D tools).

- If you need to clone an object that's on a wall or on top of a table.

- If you want to make a building or other structure look taller than it really is (you can do this with the Content-Aware Move tool set to Extend mode [page 474]).

This kind of editing is a real challenge because Photoshop sees everything as flat, with no perspective at all (that is, unless you're using the 3D tools covered in Chapter 21). The fix is to use the Vanishing Point filter to draw a *perspective plane*—a mesh grid that Photoshop uses to make your edits conform to the perspective—*before* you start painting or cloning. After you draw the grid in the Vanishing Point dialog box (Figure 15-5, top), you can do your editing inside the dialog box, too: you can create a selection, copy and paste an image or text, and use the Clone Stamp and Brush tools—all in perfect perspective.

> **TIP** If you need to fix the perspective of just *part* of a photo—say, a building or other object—check out the new Perspective Warp command covered on page 479.

Here's how to paste one image on top of another in proper perspective:

1. **Copy the object you want to paste (for example, the cartoon superhero in Figure 15-5, bottom).**

 Open the image, select the object, and then press ⌘-C (Ctrl+C) to copy it.

 If you intend to add a layer mask to the image to make its background transparent, you need to apply the mask *before you copy the object*. Since copying the image doesn't copy the mask, duplicate that layer first by pressing ⌘-J (Ctrl+J) to keep the mask intact in case you need to edit it later. Then, on the duplicate layer, Control-click (right-click) the mask thumbnail and choose Apply Mask.

2. **Open the image you want to add the copied image *to,* and then create a new layer.**

 You can't run Vanishing Point as a smart filter, so it runs on the currently active layer. To run it nondestructively, you either have to duplicate the image layer or add a *new* layer, depending on what you want to do.

 For example, if you're going to use the Brush or Clone Stamp tool in the Vanishing Point dialog box, duplicate the image layer by pressing ⌘-J (Ctrl+J) so you don't harm the original. If, on the other hand, you're pasting another object

into this document—as in this exercise—you need to create a new layer for the pasted object to land on (because the pasting happens *inside* the filter's dialog box, and not in the Photoshop document), so click the "Create a new layer" button at the bottom of the Layers panel (in Figure 15-6, the new layer is named "perspective hero"). Since the new layer is transparent, you can see through it to the layer below—the original image layer—which you'll use as a guide when you draw the perspective plane in step 4.

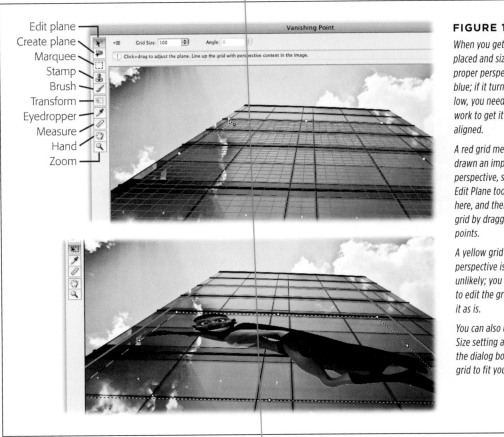

Labels on the figure, from top to bottom: Edit plane, Create plane, Marquee, Stamp, Brush, Transform, Eyedropper, Measure, Hand, Zoom

Toolbar text: Grid Size: 100 Angle: 0

Click+drag to adjust the plane. Line up the grid with perspective content in the image.

A FILTERS TOUR

FIGURE 15-5

When you get the grid placed and sized in the proper perspective, it turns blue; if it turns red or yellow, you need to do more work to get it properly aligned.

A red grid means you've drawn an impossible perspective, so grab the Edit Plane tool labeled here, and then resize the grid by dragging its corner points.

A yellow grid means the perspective is possible but unlikely; you can continue to edit the grid or keep it as is.

You can also use the Grid Size setting at the top of the dialog box to resize the grid to fit your object.

3. **Choose Filter→Vanishing Point or press Option-⌘-V (Alt+Ctrl+V).**

 Photoshop opens the *huge* Vanishing Point dialog box.

4. **Use the Create Plane tool to draw your perspective grid.**

 Photoshop automatically activates this tool when you open the Vanishing Point dialog box, so just click once in the image to set the first corner point of your plane (in this example, the building). Next, mouse over to the next corner point and click it, and then mouse to the third corner point and click it; when you do, Photoshop places a blue grid over the area as shown in Figure 15-5 (top). If you

have trouble seeing where to click to add corner points, zoom into your image
by holding the X key.

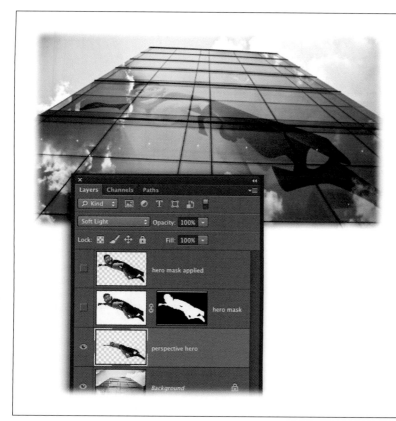

FIGURE 15-6

*As you learned back on page 305, the
Soft Light blend mode is great for creat-
ing reflections.*

*At the top of this Layers panel are two
layers with their visibility turned off.
Since the hero image had a white back-
ground, a layer mask was used to hide
it; however, the Vanishing Point dialog
box doesn't understand masks, so you
have to apply the mask to the layer
before running the filter (here, that
layer is named "hero mask applied").*

*By duplicating the layer with the mask
(here, that's the "hero mask" layer)
before you apply the mask, you keep
the mask intact in case you need to edit
it later. Turning off the visibility of those
extra layers keeps them from getting
in your way.*

5. **Use the Edit Plane tool to position and tweak the grid.**

 Once you've drawn the grid, Photoshop automatically activates the Edit Plane
 tool so you can resize the grid and/or reposition its corner points by dragging
 the white square handles that appear. To extend the bottom of the grid to make
 it larger, grab the handle at the bottom center of the grid and drag it downward.
 To move the *whole* grid, click inside it, and then drag.

 TIP If you need to draw *more* than one perspective plane in your image (you have two similar buildings to
 work on, say), you can copy a grid to another area by Option-dragging (Alt-dragging on a PC) it. If you're working
 with an object that has more than one side and you need to make the grid wrap around it (like a book cover and
 its spine), you can ⌘-drag (Ctrl-drag) one of the grid's handles (it doesn't matter which one) to tear off another
 grid that you can position at an angle.

6. **Paste the object you copied back in step 1, and then drag it on top of the grid.**

 Press ⌘-V (Ctrl+V) to paste the object into the Vanishing Point dialog box. At first, the object appears flat (not in perspective) and is surrounded by marching ants, but when you click and drag it on top of the grid, it twists and distorts to conform to the grid's perspective. (If you're working with an image that includes a layer mask and you forgot to *apply* it back in step 1, the pasted object won't be transparent. If that happens, press the Esc key to close the Vanishing Point dialog box and, unfortunately, start over.)

7. **If you need to resize the object you just pasted, press T to summon a resizable bounding box.**

 Photoshop puts a bounding box around the object. To resize it proportionately, hold the Shift key as you drag one of the box's corner handles. (If the object is bigger than the grid, you can't *see* the handles because they're beyond the edges of the grid. In that case, click the object and drag it in one direction or another until you can see one of the handles, and then drag the handle inward to make the object smaller.) If you need to move the pasted image, click inside it and then drag it to another position. When you're finished, click OK to close the dialog box; Photoshop adds the image to the layer you created in step 2.

 TIP Interestingly, you're allowed to perform *multiple* undos when you're in the Vanishing Point dialog box—just keep pressing ⌘-Z (Ctrl+Z) and Photoshop keeps undoing the last thing you did. To *redo* the last thing you did, press Shift-Z instead.

8. **In the Layers panel, change the pasted image layer's blend mode to Soft Light.**

 This blend mode makes the superhero's colors blend better with the colors in the building, as shown in Figure 15-6.

Here's what the other tools on the left side of the Vanishing Point dialog box are for:

- The **Marquee tool** lets you draw a selection (in perspective) to duplicate an area inside the grid. For example, if you want to make a building taller, you can use this tool to select and then duplicate the top few floors (though you could also try using the Content-Aware Move tool set to Extend mode [page 474]). Or, more practically, you can use the Marquee tool to restrict the effect of the Stamp and Brush tools (discussed later in this list) to a specific spot in your image. You can use the options at the top of the dialog box to feather the selection so its edges are soft, or change the opacity of the object inside your selection (handy if you're moving an object from one area of an image to another). Keyboard shortcut: M.

 TIP To activate the entire grid, simply double-click it with the Marquee tool.

If you're copying the selection to another area, use the Heal drop-down menu (it appears when the Marquee tool is active) to determine how the selection blends with the area you're dragging it to. Your options are Off (no blending), Luminance (blends the selected pixels with the lightness values of *surrounding* pixels), and On (blends the selected pixels with the color values of the pixels you're dragging the selection *onto*).

The Move Mode drop-down menu lets you specify how the selection *behaves:*

- Choose **Source** to make Photoshop *fill* the selection with the pixels you move your mouse over (you can ⌘-drag [Ctrl-drag] the selection to do the same thing). The selection itself won't move; it'll just get filled with the pixels you put your cursor over. Use this option when you want to remove an object like a window or a door by copying other pixels on top of it.

- Choose **Destination** to make Photoshop *select* the area you move the selection to; the selection moves, but Photoshop doesn't copy any pixels. Choose this option when you want to copy a selection so you can resize it using the Transform tool (discussed below) to make it *float*. For example, if you've removed a window using Destination mode, you can copy the selection and then move it to remove even *more* windows. You can also press Shift-⌘-T (Shift+Ctrl+T) to repeat your last duplicating move (helpful when you've got a bunch of windows to zap).

- The **Stamp tool** works just like the Clone Stamp tool (page 444). It lets you copy pixels from one area to another by painting while you use the perspective of the grid you drew. This tool comes in handy when you're extending an object or adding height to a building. Keyboard shortcut: S.

- The **Brush tool** lets you apply paint *and* puts your brushstrokes into proper perspective. If you activate this tool and then choose Luminance from the Heal menu, the new paint takes on the lightness values of the underlying pixels. To pick the brush's color, click the color well at the top of the dialog box. Keyboard shortcut: B.

- You can use the **Transform tool** to resize a selection that you've pasted. (Don't press Return [Enter] when you finish resizing or you'll close the Vanishing Point dialog box!) Turn on the Flip checkbox at the top of the dialog box to flip your selection horizontally, or the Flop checkbox to flip it vertically. Keyboard shortcut: T.

- Activate the **Eyedropper tool** to snatch a color from the image so you can use it with the Brush tool. Keyboard shortcut: I.

- The **Measure tool** lets you measure the distance and angle of items in a plane. Architects, interior designers, and scientists love this feature. Keyboard shortcut: R.

- Activate the **Hand tool** to reposition your image by dragging. Keyboard shortcut: H.

- The familiar **Zoom tool** lets you zoom in and out of the image. (You can also press ⌘ [Ctrl] and the + or – key or pick a magnification percentage at the dialog box's bottom left.) Keyboard shortcut: Z.

Artistic

To make an image resemble a painting or a cartoon, turn to the filters in this category. Their special purpose is to mimic real-world artistic effects created with brushes, pencils, and palette knives, though they can also give images an artsy look. If you're looking for a quick artistic touch, these filters can get the job done.

> **NOTE** If you don't see this category in the Filter menu, you need to tweak Photoshop's Plug-In preferences to display it. The box on page 674 tells you how.

For example, to soften an image and make it look like it's painted, try running the Paint Daubs filter to introduce brushstrokes, and then the Underpainting filter to give the image a little texture (as if it were painted on a canvas). But if you *really* want to make an image look like a painting, you need to use these filters along with the painting techniques covered in Chapter 12 (or paint the image from scratch).

You've already seen two filters from the Artistic category in action. Figure 15-1 shows the effects of Plastic Wrap, which makes an image look shiny (as if it were covered in plastic); it's also great for making objects look glossy or slimy. And the Poster Edges filter (shown in Figure 8-22 on page 822) makes the edges of an image black and reduces the whole thing to primary colors, which creates a cartoonish look.

Blur

You've already seen one of Photoshop's blur filters in action—Gaussian Blur was used to smooth skin back on page 461. The program includes a slew of these filters, which are worth their weight in gold when you need to soften pixels for better blending or to simulate motion, as shown in Figure 15-7.

To get your subject moving, open an image and then choose Filter→"Convert for Smart Filters." Next, trot back up to the Filter menu and choose Blur→Motion Blur. In the resulting dialog box, adjust the Angle setting to make the blur go in the direction you want. For example, to create a vertical blur like the one in Figure 15-7, set the angle to 90 degrees. To adjust the strength of the blur, drag the Radius slider right for more blurring or left for less. Click OK when you're finished, and then save the document as a PSD file so you can tweak the blur later by double-clicking the Motion Blur filter in the Layers panel.

FIGURE 15-7

Applying a Motion Blur to this super family makes it look like they're taking flight. To keep their heads in focus, a stroke of the Brush tool (set to paint with black) was added to the smart filter's mask.

To try this yourself, download the file Superfamily.jpg from this book's Missing CD page at www. missingmanuals.com/cds.

Two other great options for adding motion to a photo are the new Path and Spin filters. You'll learn all about 'em beginning on page 697.

■ FIXING COLOR FRINGE

You can also use one of Photoshop's blur filters to eliminate *color fringe* (or chromatic aberration)—the slight blue or purple haze loitering around the edges of near-black objects (Figure 15-8, bottom left). This problem is especially common when you shoot something really dark on a light background (like black numbers on a white clock face). The image may look OK at a glance, but a closer inspection often reveals some serious bluish or purplish fringing (also called *artifacts*) around the dark objects. If you're preparing to submit such an image to a stock image company, it's sure to be rejected.

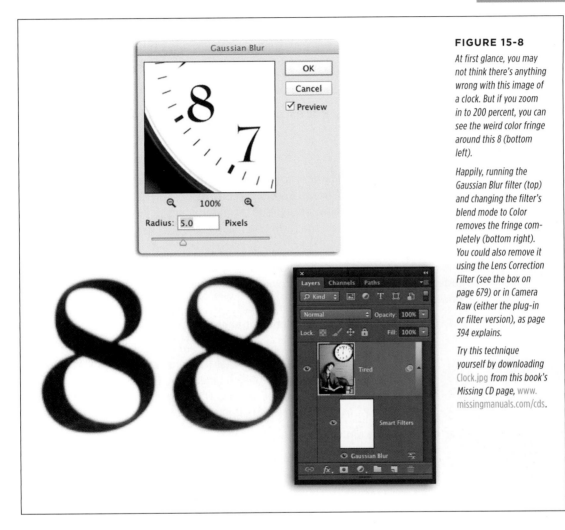

FIGURE 15-8

At first glance, you may not think there's anything wrong with this image of a clock. But if you zoom in to 200 percent, you can see the weird color fringe around this 8 (bottom left).

Happily, running the Gaussian Blur filter (top) and changing the filter's blend mode to Color removes the fringe completely (bottom right). You could also remove it using the Lens Correction Filter (see the box on page 679) or in Camera Raw (either the plug-in or filter version), as page 394 explains.

Try this technique yourself by downloading Clock.jpg from this book's Missing CD page, www. missingmanuals.com/cds.

Here's how to fix color fringe with a dose of the Gaussian Blur filter:

1. **Open the problem image and activate the layer you want to work with.**

2. **Choose Filter→"Convert for Smart Filters."**

3. **Choose Filter→Blur→Gaussian Blur, adjust the Radius setting, and then click OK.**

 In the Gaussian Blur dialog box, enter a Radius of 5–7 pixels (this setting controls how much blurring Photoshop applies to the image). Depending on the image's pixel dimensions, you may need to experiment with this value; increase it for larger images and reduce it for smaller ones.

4. **Change the filter's blend mode to Color and its opacity to 96 percent.**

 In the Layers panel, double-click the Blending Options icon next to the Gaussian Blur layer, and then set the Mode drop-down menu to Color. (This blend mode affects only hue, and since your goal is to blur the *colored* pixels—as opposed to the black ones—this mode is the perfect choice.) Then adjust the Opacity setting to 96 percent to keep the blur from being noticeable.

5. **Click OK when you're finished, and then save the document as a PSD file.**

A quick zoom-in reveals that the pesky color fringe has left the building, as shown in Figure 15-8.

■ LENS BLUR

You can use the Lens Blur filter to produce effects *similar* to the ones you get with the Blur Gallery's Field Blur and Iris Blur filters (explained in the next section), though doing so requires *far* more effort. But this filter is worth covering because it lets you create a blur mask (in the form of an alpha channel) by *hand*, which gives you maximum control.

These days, the Lens Blur filter works faster than it used to because it takes advantage of multi-core processors (provided your computer *has* more than one). Here's how to use it:

1. **Open an image and the Channels panel.**

 To tell Photoshop which part of the image to blur and which part should stay in focus, you need to create a selection that the Lens Blur filter can use. An easy way to do that is by adding an alpha channel, which you'll do in the next step. To get started, open the Channels panel by clicking its tab in the Layers panel's group or by choosing Window→Channels.

2. **Create a new alpha channel.**

 At the bottom of the Channels panel, click the New Channel icon. Then, at the top of the panel, click the visibility eye next to the RGB channel (a.k.a. the composite channel). Your entire image takes on the Quick Mask mode's red overlay so you can create your selection. Don't worry: The red overlay is just temporary—your image won't end up pink.

3. **Grab the Brush tool and set your foreground color chip to white.**

 Your goal here is to edit the mask so that the area you want to keep in focus doesn't have any red on it (the red areas will become blurry once you finish this technique). Make sure your color chips are set to black and white (if they're not, press D), and then press X until white is on top.

4. **Choose a big, soft brush and lower its opacity to 50 percent.**

 Hop up to the Options bar and, from the Brush Preset picker, choose a soft brush (one with fuzzy edges) that's fairly big (around 200 pixels). To create a subtle transition from in-focus pixels to blurry ones, lower the brush's opacity to 50 percent (and, while you're up there, make sure Flow is set to 100 percent).

 TIP You can resize the brush by Option-Control-dragging (Alt+right-click+dragging on a PC) left to make it smaller or right to make it bigger. To adjust the brush's hardness, use the same keyboard shortcut but drag *vertically* instead. As you drag, Photoshop displays the brush's size, hardness, and opacity next to your cursor.

5. **Paint across the areas you want to keep in focus.**

 In Figure 15-9, top, for example, paint over the boy's upper body. As you paint, the photo starts to show through just a little, but since you lowered the brush's opacity, you need to *keep* painting over an area to achieve 100 percent focus. Remember: Anything that's red will be blurry when you're done, and the rest of the image will remain sharp. To create a perfectly sharp area, lower your brush size and paint over that area until all the red is gone.

 If you mess up and bring back too much of the photo, press X to flip-flop the color chips and paint that area with black to make it red (blurry) again.

6. **Turn off the alpha channel's visibility eye and activate the RGB channel.**

 There's no need to leave the alpha channel turned on, so go ahead and hide it by clicking its visibility eye in the Channels panel. Next, click the RGB channel so you can see the full-color version of the image once you open the filter.

7. **Open the Layers panel and duplicate the original layer.**

 Since Lens Blur isn't available as a smart filter, the only way to protect your original image is to copy it and then run the filter on the *copy*. Click the image layer to activate it, and then duplicate it by pressing ⌘-J (Ctrl+J). (If your image is comprised of *multiple* layers, create a stamped copy instead; see page 119.)

8. **With the duplicate layer active, choose Filter→Blur→Lens Blur.**

 Don't worry that the parts of the image that you want to be blurry are in focus and vice versa; you'll fix that in step 10.

9. **In the Lens Blur dialog box's Depth Map section, set the Source menu to Alpha 1.**

 Unless you renamed the alpha channel you created in step 2, the channel goes by Alpha 1.

10. **Turn on the Invert setting.**

 Turning on this checkbox flip-flops the blurry and sharp areas, as shown in Figure 15-9 (bottom).

11. **Adjust the Shape menu and Radius slider until you get the blur just right.**

The Shape menu lets you change the shape of the blur, and the Radius slider determines how blurry the background is. As you adjust these settings, be sure to release your mouse button so Photoshop can generate a new preview.

12. **Click OK when you're finished, and save the document as a PSD file.**

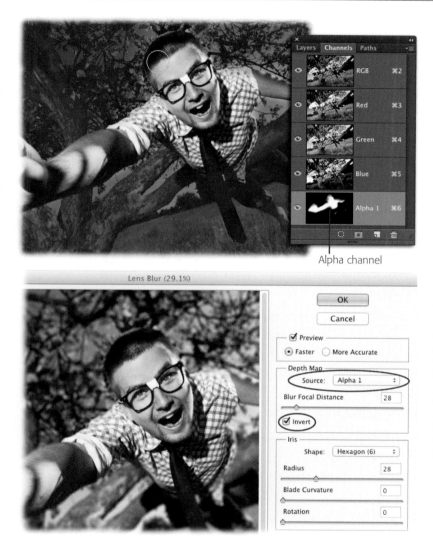

Alpha channel

FIGURE 15-9

Top: Since you used an al-pha channel to create this effect, you can change the results. If you don't like how the image looks, just toss the duplicate image layer, pop open the Channels panel, grab the Brush tool, and edit the alpha channel. Then repeat steps 6–12 to run the filter again.

Bottom: When you first run the Lens Blur filter, it does the exact opposite of what you want—it blurs what's supposed to be sharp. To fix that, just turn on the Invert setting circled here.

To make the image look less perfect, try adding a little noise to the blurry bits using the Amount slider in the Lens Blur dialog box's Noise section (not shown), and turning on both the Gaussian radio button and the Monochromatic checkbox (also not shown).

Blur Gallery

Back in CS6, Adobe added this category of filters, perhaps because of the unique, on-image controls these filters employ. This category includes three gems that let you change an image's depth of field to create a realistic, in-camera blurry background (Field, Iris, and Tilt-Shift blur). And in this version of Photoshop CC, you get two *new* filters that let you add motion to a static image: Path and Spin blur. All these filters feature a full-screen workspace (meaning any panels that you have open temporarily disappear) and on-image controls.

> **TIP** To temporarily hide the controls of any filter in the Blur Gallery, press the H key.

Happily, *all* the filters in this category work with smart filters, so you can give 'em a quick double-click to reopen and tweak them. (However, for reasons known only to Adobe, none of them have filter-blending options, so you can't tweak their opacity or blend modes.) And, thanks to OpenCL (see the box on page 66), you'll enjoy faster performance and previews than in CS6 or the first version of CC. Sweet!

> **TIP** The box on page 694 explains how to add convincing specular highlights with some of the filters in the Blur Gallery category.

■ FIELD BLUR

This handy filter is perfect for creating beautifully blurred backgrounds *after* you've taken a photo (images like this are said to have a *shallow depth of field*). It's a million times easier to use than the Lens Blur filter, and you don't have to select anything before you run it (though you can if you want). You create the blur by adding *pins* and adjusting each pin's blur strength, as shown in Figure 15-10.

> **NOTE** Try this technique yourself by heading to this book's Missing CD page (*www.missingmanuals.com/cds*) and downloading the file *Supergirls.jpg*.

Here's how to make part of an image blurry:

1. **Open an image and convert it for smart filters.**

 Simply activate the image layer(s), and then choose Filter→"Convert for Smart Filters."

> **NOTE** As mentioned earlier, using the Blur Gallery filters as smart filters doesn't give you access to the Blending Options dialog box like you do with every *other* smart filter (sigh). So if need the extra flexibility of adjusting the filter's *opacity*, duplicate your image layer first—or create a stamped copy of multiple layers (page 119)—and then run the filter on *that* layer instead.

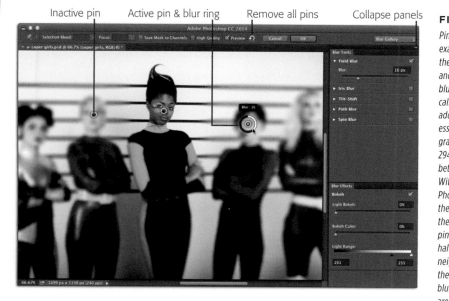

FIGURE 15-10

Pins let you control exactly which parts of the image are in focus and which parts are blurry. You automatically get one pin; if you add another, Photoshop essentially uses a linear gradient mask (page 294) to fade the blur between the two pins. With three or more pins, Photoshop constrains the blur so that it affects the area around each pin and extends about half the distance to the neighboring pin. Here, the middle pin is set to 0 blur, and the other two are set to 16.

2. **Choose Filter→Blur Gallery→Field Blur, and then adjust the initial pin's blur strength.**

 Your view changes to include a big image preview on the left and a set of collapsible controls on the right (Figure 15-10). In the image preview, you see a single *pin* (it looks like a dot inside a circle) with a black-and-white *blur ring* around it. The pin controls which part of the image is blurred—one pin makes the whole image blurry—and the blur ring lets you adjust the blur's strength; you see the ring any time a pin is active (Photoshop activates the initial pin automatically when you run the filter).

 To *increase* the blur, drag the black part of the ring clockwise in a circular motion (so there's more white on the ring than black; a solid white ring indicates 100 percent blur strength); to *decrease* the blur, drag the black part of the ring *counterclockwise* in a circular motion (so there's more black on the ring than white; solid black indicates a blur strength of 0 pixels). As you drag, a handy overlay appears showing the blur's strength from 0 to 500 pixels. Alternatively, you can drag the Blur slider on the right side of the window.

3. **Click the image's focal point to add another pin, and then reduce its blur strength to 0 pixels.**

 As you mouse around your image, your cursor looks like a pushpin with a tiny plus sign next to it, indicating that clicking will add a pin. To keep part of your image in focus (like, say, your subject's face), click it to add a pin. If you don't get the pin in quite the right spot, just drag the pin somewhere else. Then use the blur ring (or the Blur slider) to reduce the blur's strength to 0 pixels so there's no blurring in that spot (like the pin over the girl in the middle of Figure 15-10).

> **TIP** To delete a pin, click it and then press Delete (Backspace on a PC). To zap *all* the pins in one fell swoop, click the Options bar's "Remove all pins" icon (labeled in Figure 15-10).

4. **In the Options bar, click OK to apply the filter.**

 As soon as you click OK (or press Return/Enter), Photoshop applies the blur to the smart object or duplicate image layer, and switches you back to the regular Photoshop workspace. Alternatively, you can bail out of using Field Blur by clicking the Options bar's Cancel button or tapping the Esc key on your keyboard

Once you start adding pins, Photoshop creates a temporary mask that shows/hides the blur as you've specified by placing pins (you just don't see or have access to this mask). If you want Photoshop to save the mask as an alpha channel, turn on the Options bar's "Save Mask to Channels" setting before clicking OK. This is handy when you want to add another effect to the image using the exact same mask (say, to add a bit of noise or grain to make the image look less perfect).

> **TIP** Not only is this technique handy for drawing a viewer's focus to specific spots in your image, but you could use it to create a blurry—and thus less busy—area on which to place text. Designers love this kind of thing!

■ IRIS BLUR

For even *more* control over the shape and size of the blur Photoshop applies—and to create a *realistic* shallow-depth-of-field effect—reach for the Iris Blur filter. You get the same large preview and panels that you do with Field Blur, as well as on-image controls (though a lot more of 'em).

To use this filter, activate the layer(s) and convert it for smart filters, and then choose Filter→Blur Gallery→Iris Blur. (If you're already *in* the Blur Gallery window—say, you ran a Field Blur as discussed in the previous section—simply head over to the Blur Tools panel on the right side of your screen and click the checkbox next to Field Blur to turn it *off*, and then click the flippy triangle to the left of the Iris Blur filter's name to turn it on and see its options.)

In the center of your image, Photoshop places a pin inside a round blur shape with a white outline. To move the blur, drag anywhere inside the blur's outline. To change the blur's strength, use the blur ring as described in the previous section or adjust

the Blur slider. In the Options bar, the Focus setting determines how blurry the area inside the outline is (from the factory, it's set to 100 percent, which means no blur). Figure 15-11 explains how to use the filter's various controls to customize the blur's size and shape.

> **TIP** When you drag one feather handle, they *all* move. If you want to move 'em independently of one another, Option-drag (Alt-drag on a PC) instead.

■ TILT-SHIFT

This filter mimics the effects of a popular tilt lens called Lensbaby (*www.lensbaby. com*), a bendable lens—if you can imagine—whose rectangular focus band lets you control which part of the picture is in focus. It's a great way to draw viewers' eyes to your subject, but at $150 or more, it's not quite an impulse buy.

Fortunately, the Tilt-Shift filter doesn't cost extra, and it lets you do cool stuff like make a bird's-eye view of a cityscape look miniature. You won't want to use this kind of effect on *every* image, but it can certainly enhance some photos, especially those with distracting backgrounds.

UP TO SPEED

Making Highlights Sparkle with Bokeh

When you run a filter in the Blur Gallery category, you'll spot a panel in the window's lower right named *Bokeh*, which is a Japanese term for the aesthetic qualities of out-of-focus highlights (also known as *specular* highlights). You can use this panel's settings to make the highlights in the blurry areas of your image appear to sparkle (like the ones in Figure 15-12), or to create an interesting background out of something ordinary. For example, the grass in the image below was blurred using the Field Blur filter with a single pin set to a fairly high blur strength.

To do either, drag the Light Bokeh slider rightward to increase the brightness of any out-of-focus highlights—you may have to drag the slider fairly far to the right before you see any change. Next, use the Bokeh Color slider to shift the affected highlights from no color or white (0 percent) to colorful (100 percent) so that they begin to pick up some of the colors of surrounding pixels.

The Light Range slider lets you pick *which* lightness values are impacted by the Bokeh settings; just drag the black and white triangular sliders to set a range of colors (a fairly small range of the lighter highlights usually works well). Finally, to make Photoshop display a more accurate *preview* of your changes to the Bokeh settings, turn on the Options bar's High Quality setting.

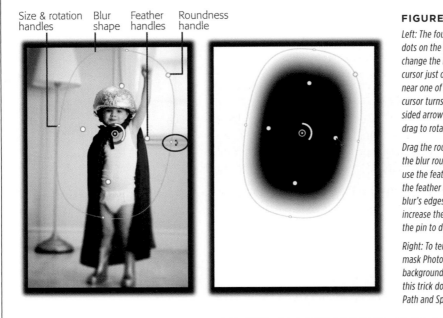

Size & rotation handles Blur shape Feather handles Roundness handle

FIGURE 15-11

Left: The four size handles (the tiny dots on the blur outline) let you change the blur's size. Position your cursor just outside the blur outline near one of these handles and the cursor turns into a curved, double-sided arrow (circled); you can then drag to rotate the blur.

Drag the roundness handle to make the blur rounder or squarer, and use the feather handles to adjust the feather amount around the blur's edges (drag toward the pin to increase the feather, or away from the pin to decrease it).

Right: To temporarily see the mask Photoshop's created in the background, press the M key. (Alas, this trick doesn't work on the new Path and Spin Blur filters.)

TIP You can also use the Tilt-Shift filter on video clips to produce interesting effects. Page 872 explains how.

The Tilt-Shift filter works just like the Field Blur and Iris Blur filters, though it gives you even *more* controls. Give this filter a spin by downloading *Dubai.jpg* from this book's Missing CD page at *www.missingmanuals.com/cds.* Convert the image layer(s) for smart filters (page 670), and then choose Filter→Blur Gallery→Tilt-Shift. Photoshop places an active pin and blur ring in the middle of the image and surrounds 'em with a horizontal focus band containing a series of solid and dashed lines that you can use to adjust the size of the in-focus and blurry areas (see Figure 15-12). The Options bar's Focus setting controls how in focus the non-blurry area is; you'll probably want to leave it set to 100 percent for no blur.

Focus lines Focus zone Transition zones
(no blur) (blur) Feather lines

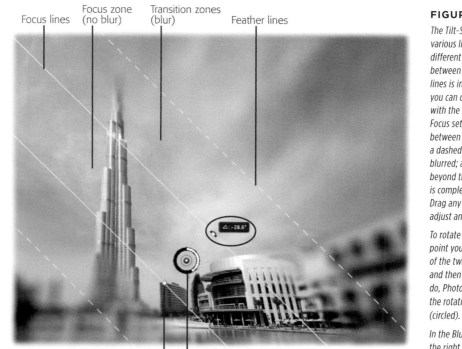

Size & rotation handles Active pin with blur ring

Before

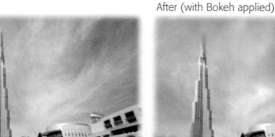

After (with Bokeh applied)

FIGURE 15-12

The Tilt-Shift filter's various lines control different things. The area between the two solid lines is in focus (though you can change that with the Options bar's Focus setting); the area between a solid line and a dashed line is partially blurred; and the area beyond the dashed lines is completely blurred. Drag any of these lines to adjust an area's size.

To rotate the focus zone, point your cursor at one of the two white dots, and then drag. When you do, Photoshop displays the rotation's angle (circled).

In the Blur Tools panel on the right, the Distortion slider lets you change the shape of the lower blur zone (here, that's the one on the left); drag left for a circular blur or right for a zoom effect. Turn on the Symmetric Distortion checkbox to make Photoshop adjust the blur zones on both sides.

TIP For serious fun, try applying a combination of the Blur Gallery filters to the *same* image. While you're applying one of 'em, you can turn on the others using the checkboxes next to their names in the Blur Tools panel on the right side of your screen.

Path Blur

This filter, which is new to the Blur Gallery family Photoshop CC 2014, lets you add a motion blur along a path. You get to tell Photoshop how *much* blur to add, what *speed* to mimic, and how much you want the motion to taper off. This filter lets you add motion in *any* direction you can think of—straight, curved, looping swirls, spirals, and so on.

Once you convert your layer(s) for smart filters, follow these steps to use Path Blur:

1. **Choose Filter→Blur Gallery→Path Blur and then, in the Blur Tools panel's Path Blur section, use the drop-down menu to tell Photoshop what *kind* of blur you want to add.**

 When you run this filter, Photoshop takes over your workspace and plops a short, straight, blue *blur path* atop your image, and indicates the direction of motion with a blue arrowhead (see Figure 15-13). To change the motion's direction, drag one of the endpoints to another spot on the image. Decide what kind of blur you want to add and choose it from the drop-down menu at the top of the Path Blur section on the right side of your screen. Most of the time, you'll leave this menu set to Basic Blur, but if you want to fake the look of flash fired from a camera, choose Rear Sync Flash instead.

2. **Reposition and reshape the blur path by dragging its points and adding new ones.**

 To lengthen the blur path, drag either endpoint. To curve the path, click the small white midpoint *between* the endpoints, and then drag it up or down (unlike the vector paths you learned about in Chapter 13, you don't get control handles). You can add as many points as you want—just click anywhere on the path between its endpoints to add another one. To move the blur path, ⌘-drag it (Ctrl-drag on a PC).

3. **If necessary, add additional blur paths to your image.**

 If you've got *more* than one object in your image that you want to blur in different ways, you can add additional blur paths. To add a simple, two-point path, click and drag somewhere in the image other than on the initial path; when you release your mouse button, Photoshop adds another path. To add a single curve to the path, drag its midpoint. Also, the direction in which you drag sets the motion's direction, so to create the illusion of moving left to right, for example, drag left to right to create the path. That said, you can also drag an endpoint in any direction to change that path blur's direction.

 To add a more complex, *multi-point* path that can go in multiple directions and have multiple curves, click once to set a starting point, and then release your mouse button. Photoshop adds a point that's connected to your cursor by a blue line; just keep clicking to draw the path in whatever shape you want. Each time you click, Photoshop adds another point. When you're finished, close the path by double-clicking to set an endpoint. Alternatively, you can press Enter,

the Esc key, the period key, or just click the last point you set (whew!). Once you close the path, the blue directional arrowhead appears.

To delete a blur path, activate one of its endpoints, and then press Delete. To copy a blur path, activate one of its points, and then Option-drag (Alt-drag) it elsewhere in your image.

TIP To convert a *smooth* point (one that creates a curve) to a *corner* point (one that creates a straight corner)—and vice-versa—Option-click the point (Alt-click on a PC).

4. **Activate each endpoint in turn and set its blur strength.**

 There may be times when you want one end of the blur path to have motion, but not both, or you may want to set different blur strengths for each end (say, to simulate a fast take-off, or for purely creative reasons). Click an endpoint to activate it (a dot appears inside it), and then use the Blur Tools panel's End Point Speed slider to set the point's "speed" (how much it's blurred); drag the slider right to increase the blur or left to decrease it. Alternatively, you can put your cursor *near* an active endpoint to summon a blur ring (page 692); click it, and then drag in a clockwise circular motion to increase the blur's strength, or in a counter-clockwise circular motion to decrease it.

5. **Adjust the blur's *shape* by activating an endpoint, turning on Edit Blur Shapes, and then dragging the red blur-shape controls.**

 Adjusting the shape of the blur (or *blur shape*) is how you tell Photoshop what kind of motion you want to introduce (as if you'd purposefully moved your camera in a certain direction when you took the shot). To do so, either double-click an endpoint (which automatically turns on the blur shape controls), or click to activate an endpoint *and then* turn on the Edit Blur Shapes checkbox. Either way, tiny red paths with a red arrow appear near both of the path's endpoints, as shown in Figure 15-13. These red paths work just like the ones on a blur path, except you can't add points to them. Drag one of the red-rimmed, white points to change the blur's shape. As you drag, the red path gets longer and the blur shape lengthens. Drag the white midpoint in any direction to curve the blur's shape.

TIP To adjust the blur shape (the appearance of motion) of *both* endpoints at once, Shift-drag one of the red-rimmed points. If you only want *one* end of your blur paths to have a blur shape but not the other, ⌘-click (Ctrl-click) an endpoint and the red blur shape controls disappear from it; ⌘-click (Ctrl-click) the endpoint again to bring 'em back.

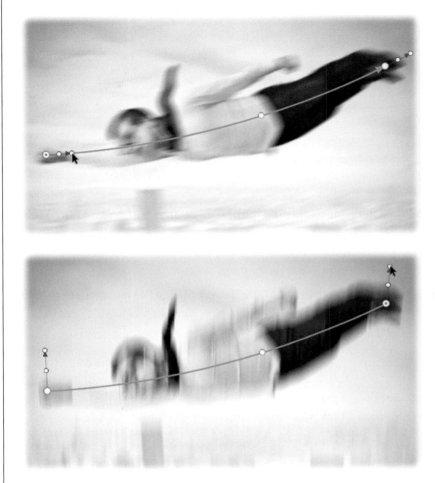

FIGURE 15-13

When you turn on the
Blur Tools panel's Edit
Blur Shapes checkbox
(not shown), the red
controls shown here
appear on the blur path's
endpoints.

Top: By dragging a red-
rimmed point rightward,
you can make this super
hero fly across the sky.

Bottom: If you drag a red-
rimmed point vertically
upward, you can make
him drop out of the sky.

Want to follow along?
Download Flying.jpg from
this book's Missing CD
page at www.missing-
manuals.com/cds.

6. **Use the Speed slider to adjust the blur strength of *all* the blur paths in your
 image.**

 As you learned in step 4, the *endpoints* of a blur path can each have their own
 speed value, which lets you control the amount of blurring at the beginning
 and end of each blur path. But the blur paths themselves have just *one* speed
 value, which is controlled by the Blur Tools panel's Speed slider. In other words,
 the Speed slider is a *global* setting that affects all the blur paths you made.

7. **Adjust the blur's taper, style, and quality settings.**

A real blur caused by camera motion would gradually diminish, and the Taper slider lets you mimic that effect. Like the Speed slider, the Taper slider affects *all* the blur paths in your image; drag it right to introduce a taper.

From the factory, the Centered Blur checkbox is turned *on*, which produces a more stable-feeling blur, because it centers the blur shape atop affected pixels. Turn this setting off for a more fluid-feeling blur.

To reduce any jagged pixel edges introduced by the motion blur, in the Options bar, turn on High Quality.

> **TIP** If you picked a Rear Sync Flash in step 1, Adobe recommends turning off the Blur Tools panel's Centered Blur checkbox, setting the Speed slider to 100%, and setting the Taper slider to 10%. And in the Motion Blur Effects panel (also on the right side of your screen), set Strobe Strength to 25% and Strobe Flashes to 1.

8. **When you're done adjusting the blur, click OK, and then save the document as a PSD file.**

By doing so, you can double-click Blur Gallery in your Layers panel to reopen the Path Blur filter's settings for more tweaking. Slick!

9. **If necessary, use the smart filter's mask to hide the blur from parts of your image, as Figure 15-14 explains.**

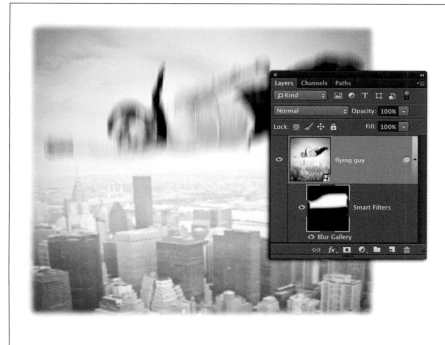

FIGURE 15-14

Photoshop gives you a couple of ways to hide the blur from certain spots. One is to click to activate the smart filter's mask, and then use the Brush tool, set to paint with black, to brush over the areas you want to remain perfectly still (like the city and sky in this image), as shown here.

The other method is to create another blur path atop the area you don't want to blur, and then click each of its endpoints and set the End Point Speed slider to 0.

It's a six-of-one, half-dozen-of-the-other kind of thing.

That's basically it, though there are a couple more settings worth knowing about. Take a peek at the lower right of your screen and you'll see the Motion Blur Effects panel, which includes settings that let you fine-tune how blurry your object looks:

- **Strobe Strength.** This slider controls how much blur is visible between the (virtual) camera's exposures; it adjusts how bright the strobe light (the flash) is in relation to the ambient light. You can set this slider anywhere from 0% (no strobe) to 100% (maximum strobe).

- **Strobe Flashes.** This slider controls the number of exposures taken by the (virtual) camera, from 0–100. For example, if you put a strobe light on a spinning object, you'll capture the object at various positions of its rotation. The *number* of positions you capture is determined by how often the strobe flashes, or rather, how often the camera shoots. The lower the number here, the blurrier your object.

Sure, the Path Blur filter's controls sure take some getting used to, but once you master 'em, you can introduce all kinds of realistic—or surreal!—motion effects to your images. Feel free to use Path Blur on 32-bit images, too, as you may get better results. And because you wisely used smart filters, you never have to worry about harming your original image.

Spin Blur

Also new in this version of Photoshop CC is the Spin Blur filter, which lets you add a realistic spinning motion to objects. It's incredibly handy to use on anything that rolls or spins, such as tires (see Figure 15-15), a Ferris wheel, or even on a photo of an incoming bird to simulate wing-flapping. The results are more realistic than what you'd get by using the Blur category's Radial Blur filter, and the Spin Blur filter is *ridiculously* easy to use. In fact, its controls are exactly like the ones for the Iris Blur filter (page 693).

To get your subject spinning, convert your layer(s) for smart filters, and then choose Filter→Blur Gallery→Spin Blur. Photoshop places a round blur shape—complete with blur pin, blur ring, and feather and size/rotation handles—in the center of your image (you have to mouse over the blur shape to see all these controls).

Drag the pin to reposition the blur, and then drag the size/rotation handles (the tiny white dots) to change the blur shape or to rotate it. Drag the feather handles inward to decrease the size of the in-focus area or drag them outward to increase it. If you want to spin more than one object in your image, click elsewhere in the image to add another spin blur (it's okay if the spin blurs overlap).

To move the center point of the rotation, Option-drag the blur pin (Alt-drag on a PC). To copy a spin blur to another spot in your image, ⌘-Option-drag (Ctrl+Alt-drag) its blur pin. To delete a spin blur, click its blur pin to activate it, and then press Delete (Backspace).

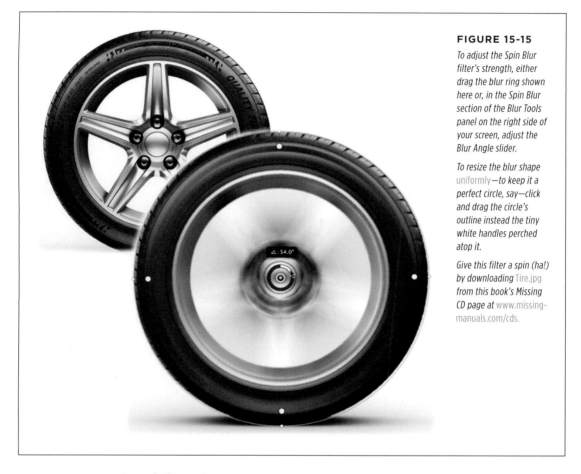

FIGURE 15-15

To adjust the Spin Blur filter's strength, either drag the blur ring shown here or, in the Spin Blur section of the Blur Tools panel on the right side of your screen, adjust the Blur Angle slider.

To resize the blur shape uniformly—to keep it a perfect circle, say—click and drag the circle's outline instead the tiny white handles perched atop it.

Give this filter a spin (ha!) by downloading Tire.jpg from this book's Missing CD page at www.missing-manuals.com/cds.

As with the Path Blur filter, you can tweak the Spin Blur filter's Strobe Strength and Strobe Flashes via the Motion Bur Effects panel (described in the previous section). You also get a Strobe Flash Duration slider that lets you set the *length* of a strobe flash—how long each flash lasts—by entering a degree value (0–20°). The higher the number, the blurrier your object appears. Use this setting in conjunction with the Strobe Strength slider to produce the effect you want (for example, a short duration with a high strobe strength makes the object look sharper and less blurry).

Brush Strokes

There are a slew of filters in this category and, like the Artistic set, they're geared toward creating traditional fine-art effects. If you want to add interesting edge treatments to your images, these filters work especially well when used with layer masks (see Figure 15-16). Among the most useful for these kinds of edge effects are Spatter and Sprayed Strokes (Filter→Brush Strokes→Spatter or Sprayed Strokes).

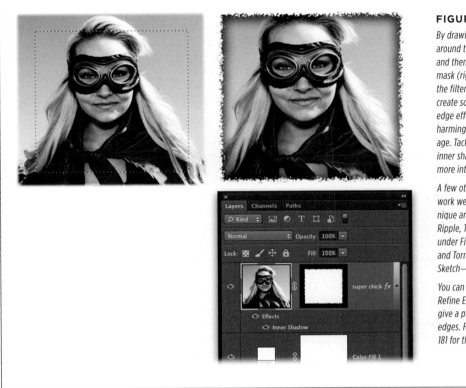

FIGURE 15-16

By drawing a selection around the image (left) and then adding a layer mask (right), you can run the filter on the mask to create some really nice edge effects—without harming the original image. Tack on a well-placed inner shadow for an even more interesting look.

A few other filters that work well for this technique are Glass, Ocean Ripple, Twirl (all found under Filter→Distort), and Torn Edges (Filter→Sketch→Torn Edges).

You can also use the Refine Edge dialog box to give a photo interesting edges. Flip back to page 181 for the scoop.

NOTE If you don't see this category in the Filter menu, flip to the box on page 674 to learn how to adjust your preferences so that it appears.

When you're ready to spice up an image's edges, try this technique:

1. **Open a photo, grab the Rectangular Marquee tool, and then draw a box where you want the new edges to be.**

 Since you'll run the filter on a layer mask, you don't need to use smart filters. For best results, draw the box at least a quarter of an inch inside the edges of your photo as shown in Figure 15-16, left. The filter will run *outside* this selection, on the edges of the image.

NOTE To give this technique a spin, trot on over to this book's Missing CD page at *www.missingmanuals. com/cds* and download *Superchick.jpg*.

2. **Add a layer mask.**

At the bottom of the Layers panel, click the circle-within-a-square icon to add a layer mask to the part of the image where you'll apply the filter.

3. **With the layer mask active, choose Filter→Brush Strokes→Spatter.**

In the resulting Filter Gallery dialog box, increase the Spray Radius to 20 and the Smoothness to 8. (These numbers are purely subjective, so adjust them until they look good to you.)

4. **Click OK to make Photoshop run the filter.**

For even funkier edges, run the filter *again* by pressing ⌘-F (Ctrl+F). And if you want to soften the new edges just a bit, you can run an additional filter: Choose Filter→Blur→Gaussian Blur, adjust the blur radius until you get the look you want, and then click OK.

Because the layer mask hides the image's edges, you'll see the checkerboard transparency pattern there. To create a new background, add a colored layer *beneath* the image layer by choosing Layer→New Fill Layer→Solid Color. Choose a color from the resulting Color Picker, click OK, and Photoshop adds the new layer. Now you can drag it below the image layer.

As a final touch, add an inner shadow or a drop shadow to the image by clicking the *fx* at the bottom of the Layers panel. (For more on layer styles, see page 139.)

TIP To reposition either the photo or the frame, you have to unlink the image layer from the mask by heading to the Layers panel and clicking the little chain icon between the layer and mask thumbnails. Then click the thumbnail of the layer or mask and reposition it with the Move tool. To link them back together, just click between the two thumbnails and the chain icon reappears.

Distort

The filters in this category, not surprisingly, distort and reshape images. It includes all kinds of goodies like the Displace filter, which lets you apply one image to the contours of another (page 324); the Pinch filter, which is great for shrinking double chins (page 452); and the Glass, Ocean Ripple, and Twirl filters, which—as mentioned in the previous section—work well as edge effects.

Noise

These filters let you add or remove *noise* (graininess or color speckles). If you're working on an extremely noisy image or restoring an old photo, these filters can come in handy. For example, if you've scanned an old photo that has scratches in it, run the Dust & Scratches filter to make Photoshop scour the image for irregular pixels and blur them to smooth 'em out. Of the filters in this category, you'll likely use the Reduce Noise filter most often; it helps lessen noise in the dark areas of images shot in low light (a good idea before sharpening). The box on page 487 has the scoop.

Sometimes, you may need to *add* noise to an image, as odd as that sounds. For example, if you're working with a portrait that's been corrected to within an inch of its life so that it looks *too* perfect (as if it were airbrushed), run the Add Noise filter to introduce some random speckles and make the image look more realistic.

Pixelate

You probably won't use these filters often, but once in a while they're useful for applying funky blurs and textures. For example, the Crystallize filter makes an image look like it's behind a textured shower door. And if you're aiming for a newspaper-image look (think lots of tiny, visible dots), try the Halftone filter.

Render

These filters can generate cloud patterns, introduce lens flare, and add lighting to images. Two in particular—Clouds and Difference Clouds—are great for creating all kinds of backgrounds, such as the splotchy-colored ones you see in studio portraits.

These filters mix your foreground and background colors into what look like soft, fluffy clouds. The more times you apply each filter, the more clouds you get (Difference Clouds gives you clouds with higher contrast than Clouds does). If you run the Motion Blur filter after the Cloud filter, you can create some *terrific* streaks that make an image look vintage.

> **TIP** A little-known fact about the Lens Flare filter is that Option-clicking (Alt-clicking on a PC) in its dialog box's preview area lets you reposition the flare and/or enter precise coordinates for it.
>
> For a lens flare that you can scoot around atop your image, try this: Press Shift-⌘-N (Shift+Ctrl+N on a PC) to create a new layer. In the resulting dialog box, choose Overlay from the Mode menu and turn on the "Fill with Overlay-neutral color (50% gray)" checkbox. Then run the Lens Flare on the new layer and you can move it around with the Move tool. Who knew?

Another useful filter in this category is Lighting Effects, which was *completely* redesigned back in CS6 to make it easier to use and work in 64-bit mode (page xxix). This filter, which works only on 8-bit RGB images, gives you a window with a big preview on the left and a Properties panel on the right (Figure 15-17) where you choose among three kinds of light sources: Point (shines in all directions like a light bulb), Spot (shines in a beam like a flashlight), and Infinite (shines from a distance and is slightly diffused, like sunlight through a cloud).

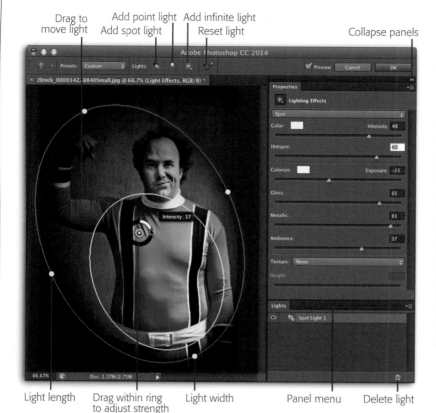

FIGURE 15-17

If you didn't get your subject lit right in the studio, there's a good chance you can fix it with the Lighting Effects filter.

Click the little light icons in the Options bar (labeled) to add additional light sources. To delete a light, activate its icon in the Lights panel, and then click the trash can icon at the bottom of that panel.

To save a light source as a preset so you can use it again later, choose Save from the Presets menu near the top left of this window. Give your custom light source a memorable name, and then click OK to add it to the Presets menu.

Once you choose a kind of light from the unlabeled drop-down menu near the top of the Properties panel, you can adjust its strength using the Intensity field or the slider below it (drag it left to weaken the light or right to strengthen it). To change the light's color, click the colored box to the left of the Intensity field and choose a new color from the resulting Color Picker. For example, instead of adding a stark white light to a portrait, you could change it to light peach or yellow to give the subject a slight warm glow. If you've chosen Spot, you can also adjust the angle of its *hotspot* (the brightest point of light) with the Hotspot slider; drag it left to make the light small and narrow or right to make it tall and wide (Figure 15-17 shows a fairly wide hotspot).

You can find some excellent presets for the Lighting Effects filter in the Options bar's Presets menu. Once you choose one, you can pick a different type of light (Point, Spot, or Infinite) as mentioned earlier, and adjust the following settings:

- **Exposure** controls the total amount of available light. Drag the slider left to decrease the amount of light or right to increase it. To change the color of the exposure (color of light), click the colored box to the left of this field, and then choose another color from the resulting Color Picker.

- **Gloss** controls how reflective the surface in the image is. For example, if you shine light onto a plain ol' piece of paper, it doesn't reflect much. But if you shine light onto a *glossy* piece of paper, it reflects a lot. Drag this slider left for less reflection or right for more.

- **Metallic** lets you change the surface the light is reflecting off of. For example, a plastic surface reflects the *light's* color, while a metallic surface reflects your *subject's* color. Drag this slider left to make the surface more plastic or right to make it more metallic (anything in between reflects both your light's color *and* your subject's color).

- **Ambience** lets you tone down the light source you've been painstakingly creating by mixing in more light from *another* source (as if the sun were also shining in the room or you turned on an overhead light). Drag this slider left to remove the additional light source or right to mix in more light from it.

- **Texture** lets you tell Photoshop to shine the light through your image's red, green, or blue channel information to give your lighting some depth (referred to as a *bump map*). (You may need to scroll down in the Properties panel to see this drop-down menu). Once you've made a choice in this menu, use the Height slider below it to intensify the effect (drag it right) or decrease the effect (drag it left).

Sharpen

The filters in this category let you exaggerate areas of high contrast in an image (called *edges*) to make them appear sharper. Since resizing and editing an image can make its pixels a little soft, it's a good idea to sharpen each and every image you open in Photoshop. Sharpening is incredibly important and it has the power to make or break an image. That's why you'll find *full* coverage of these filters—including the Shake Reduction filter for fixing blurry images—back in Chapter 11.

Sketch

To add a bit of texture to an image, reach for this category. It includes a variety of filter-driven pens, crayons, paper, and so on that give images a hand-drawn look. The Graphic Pen filter is perfect for adding realistic snow, as shown in Figure 15-18.

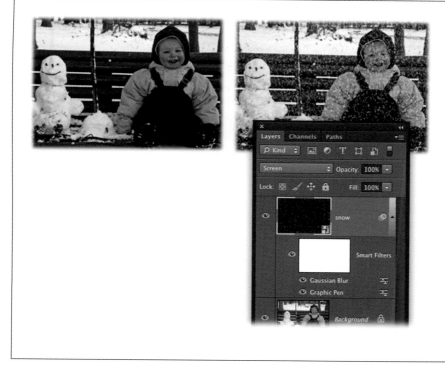

FIGURE 15-18

Meet the Graphic Pen filter, which generates random streaks in the direction and length you choose, so it's perfect for making fake snow.

To create a visually pleasing snowfall that doesn't completely bury your subject, lower the filter's Stroke Length setting to around 5 and increase its Light/Dark Balance setting to about 90. (If the Stroke Length is too high and the Light/Dark Balance is too low, your subject will look like he's stuck in a blizzard.)

NOTE If your Filter menu is missing the Sketch category, the box on page 674 tells you how to make it appear.

Here's how to use the Graphic Pen filter to add some realistic-looking flurries:

1. **Open a snowless photo, set your color chips to black and white, add a new image layer filled with black, and then position it at the top of your layer stack.**

 As you learned back in Chapter 7, blend modes have various neutral colors that disappear when you use a particular blend mode. If you run the Graphic Pen filter on a solid black layer and your color chips are set to black and white, you can use a blend mode to make the black disappear, leaving just the white streaks made by the filter (which look like snow). So press D to set your color chips to black and white, and then press X until black is top.

 To add the black layer, click the "Create a new layer" icon at the bottom of the Layers panel and fill it with black by pressing Option-Delete (Alt+Backspace on a PC). If this new layer isn't at the top of the layer stack, drag it up so it is.

2. **With the black layer active, choose Filter→"Convert for Smart Filters."**

 This step lets you run the Graphic Pen filter safely on this layer.

3. **In the Layers panel, change the black layer's blend mode to Screen.**

 As you learned on page 302, the Screen blend mode lightens the underlying photo and completely ignores black, so the snow-like streaks you create in the next step will lighten the photo and the black will disappear. So head to the unlabeled drop-down menu near the top of the Layers panel (it's initially set to Normal), and set it to Screen, as shown in Figure 15-18, right.

4. **Choose Filter→Sketch→Graphic Pen.**

 Photoshop opens the Filter Gallery dialog box.

5. **On the right side of the dialog box, set the Stroke Direction menu to Vertical.**

 This setting makes the snowflakes fall straight down.

6. **Set the Stroke Length to 5 and the Light/Dark Balance to 90.**

 Think of Stroke Length as flake size; lowering it to around 5 creates fairly small flakes. And think of Light/Dark Balance as the amount of snowfall: Set it to 60 for a blizzard or to a higher number (like 90) for lighter snow (you may have to experiment with different settings). Basically, more black in the filter's preview means more of your image will be visible. When you're done, click OK to close the Filter Gallery dialog box.

7. **Choose Filter→Blur→Gaussian Blur and, in the resulting dialog box, enter a Radius of about 1.5.**

 This filter *softens* the snowflakes so they don't have hard edges.

8. **Click OK when you're finished, and then save the document as a PSD file.**

The beauty of creating artificial snow using a smart filter is that you can control the snow's opacity—if the effect is too strong, just trot over to the Layers panel and double-click the icon to the right of the Graphic Pen smart filter and then, in the Blending Options dialog box, lower the Opacity setting. It's lots of fun to add snow to *completely* inappropriate photos, too! If the snow looks terrible, you can just trash the filter and start over.

Stylize

This category is also artistic, but its filters let you create looks with more contrast than you can get with the Artistic filters. One filter in this category (Emboss, discussed later in this section) can save out-of-focus images. Several of the filters found here enhance the edges in images, and Find Edges does such a good job of locating edges that you can use it to create a pencil-sketch effect. It's a great technique to have in your bag of tricks because it can single-handedly save an image with color problems that can't be fixed with any of the techniques you learned back in Chapter 9. As a bonus, you create an image with a *totally* different look and feel from the original (see Figure 15-19).

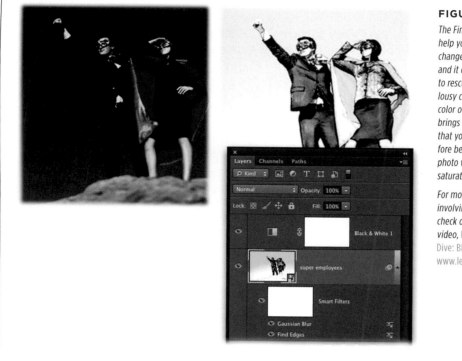

FIGURE 15-19

The Find Edges filter can help you completely change a photo's feel, and it can do wonders to rescue an image with lousy color. The lighter color of the pencil sketch brings out tons of details that you couldn't see before because the original photo was so dark and saturated.

For more fun effects involving blend modes, check out your author's video, Photoshop Deep Dive: Blend Modes, *at* www.lesa.in/lesacl.

Here's how to use Find Edges to convert a photo into a pencil sketch:

1. **Pop open a photo and add a black & white adjustment layer.**

 The first step toward a pencil sketch is to get rid of the image's color, which you can do easily with an adjustment layer. Click the half-black/half-white circle at the bottom of the Layers panel and choose Black & White. In the Properties panel that appears, adjust the various sliders until you're happy with the image's contrast.

2. **Activate the image layer(s), and then choose Filter→"Convert for Smart Filters."**

 To make the filter run safely, you have to convert the image for smart filters first. In addition to protecting the original image, smart filters also let you change the filter's blend mode and opacity (which you'll do in a couple of steps).

3. **Choose Filter→Stylize→Find Edges.**

 You don't get a dialog box with this filter—it just runs. Don't panic when your image turns into a freaky-looking outline; you'll reduce the filter's strength in a second.

4. **Open the Blending Options dialog box, and then change the Mode to Hard Mix and lower the Opacity to about 85 percent.**

 In the Layers panel, double-click the little icon to the right of the words "Find Edges" to open the Blending Options dialog box. As you change the dialog box's settings, keep an eye on your image (you may need to move the dialog box out of the way).

 As you learned in Chapter 7, the blend modes in the Lighting category increase an image's contrast, which is great when you're trying to create a pencil sketch. You may need to experiment with other Lighting blend modes for this technique because some will work better than others depending on the colors in your image.

 The best Opacity setting also varies according to how much contrast the image has, though a setting between 75 and 85 percent usually works well. Click OK to close the Blending Options dialog box. Your image should start resembling a pencil sketch at this point, though you'll want to soften it by blurring it slightly in the next step.

5. **Choose Filter→Blur→Gaussian Blur and, in the resulting dialog box, enter a Radius of 2.**

 This Radius setting works well for most photos, but again, you'll have to experiment. Click OK to close the Gaussian Blur dialog box.

6. **Open the Gaussian Blur layer's Blending Options dialog box, change the blend mode to Lighten, and then click OK.**

 In the Layers panel, double-click the icon to the right of the words "Gaussian Blur" to open the dialog box, and then change the Mode setting. When you choose Lighten, the Gaussian Blur filter blurs only the light pixels in the image, preserving the darker pixels' details (the edges you accentuated with the Find Edges filter).

You're finished, but if the sketch is too dark, try placing it atop a white background, and then lowering its opacity: Click the half-black/half-white circle at the bottom of the Layers panel, choose Solid Color, and then pick white from the resulting Color Picker. If the original image layer is a locked background layer, double-click it to unlock it (Photoshop won't let you place any layers beneath it if it's locked). Drag the white layer *below* the original image layer, and then activate the original image layer and lower its opacity to about 85 percent. That oughta soften your sketch right up!

TIP To create a watercolor look, activate the black & white adjustment layer and, in the Layers panel, lower its opacity slightly to let some of the original color show through. If you do this, you'll definitely need to add a white solid color fill layer below the image layer, as described in the previous paragraph.

■ EMBOSS

Although no magic fixer-upper can make an out-of-focus image look like it's perfectly in focus, the Emboss filter comes close. (So does the Shake Reduction filter described on page 495.) Technically, it doesn't really *fix* the image and make it sharp, it merely brings out the edges that are already there, making the image *look* sharper (see Figure 15-20). Here's how to use it:

1. **Open the out-of-focus image, and then choose Filter→"Convert for Smart Filters."**

2. **Choose Filter→Stylize→Emboss.**

 In the resulting dialog box, leave the Angle, Height, and Amount settings as they are. Your image will be mostly gray, and the edges of your subject will be brightly colored (see Figure 15-20, top), but that's exactly what you want, so click OK to close the Emboss dialog box. In the next step, you'll change the blend mode to make the gray parts disappear.

3. **Open the Emboss filter's Blending Options dialog box and change the Mode setting to Hard Light.**

 In the Layers panel, double-click the tiny icon to the right of the word "Emboss." As you learned on page 304, the blend modes in the Lighting category add contrast to images and ignore gray. Since the Emboss filter turned your image gray and gave it brightly colored edges, changing the blend mode to Hard Light makes the gray vanish, leaving only the edges visible so they stand out more and appear sharper than before. Nice, eh?

4. **Click OK to close the Blending Options dialog box, and save your document as a PSD file.**

That's all there is to it—well, aside from grinning *triumphantly* because you fixed the image.

Texture

As you'd expect, the filters in this category add texture to images, which can help add depth and visual interest, as shown in Figure 15-21. For example, to spice up an image's background, you can add a texture to just that area by selecting it and then running one of these filters.

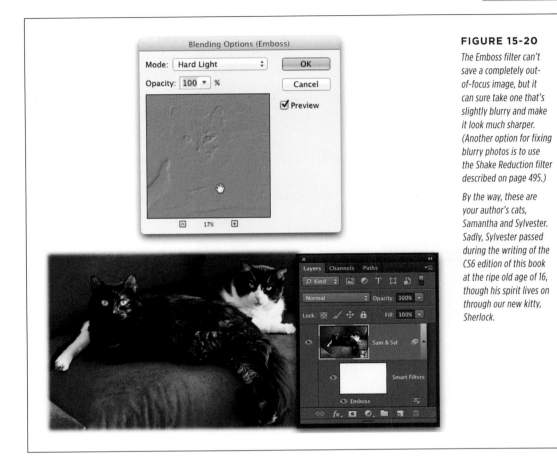

FIGURE 15-20

The Emboss filter can't save a completely out-of-focus image, but it can sure take one that's slightly blurry and make it look much sharper. (Another option for fixing blurry photos is to use the Shake Reduction filter described on page 495.)

By the way, these are your author's cats, Samantha and Sylvester. Sadly, Sylvester passed during the writing of the CS6 edition of this book at the ripe old age of 16, though his spirit lives on through our new kitty, Sherlock.

The technique is super simple: Just open an image and choose Filter→"Convert for Smart Filters." Then select the area behind your subject using any of the techniques described in Chapter 4. Next, choose Filter→Texture and pick one of the six options: Craquelure, Grain, Mosaic Tiles, Patchwork, Stained Glass, or Texturizer. (The Texturizer filter lets you load your *own* images and use them as a texture; see page 660 for an example of how you can snatch texture from a photo and use it on text.) Adjust the various sliders in the Filter Gallery dialog box, and then click OK.

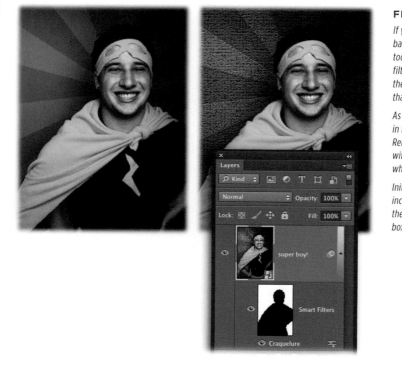

FIGURE 15-21

If you select the rays in this image's background with the Quick Selection tool before running the Craquelure filter (Filter→Texture→Craquelure), the filter's effect is visible in just that area.

As you can see here, Photoshop filled in the smart filter mask for you. Remember that, when you're dealing with layer masks, black conceals and white reveals.

Initially, the Texture category isn't included in the Filter menu. Happily, there's an easy fix—hop back to the box on page 674 to learn what to do.

Video

As the name suggests, the two filters in this category deal strictly with individual frames extracted from videos. De-Interlace smooths moving images, and NTSC Colors restricts the image's color palette to colors that TVs can display. For more on working with video in Photoshop, head to Chapter 20.

Other

Since these filters don't really fit into any *other* category, they get their own. Custom, for example, lets you design your own filters to manipulate images' brightness. As you learned on page 494, you can use the High Pass filter to sharpen images. Maximum and Minimum have more practical uses—you can use 'em to enlarge or shrink a layer mask, respectively. For example, if you select an object, add a layer mask, and then place it atop *another* image, you may find some stray pixels around the object's edges from the original background. To eliminate those strays, use the Minimum filter to shrink the mask (Figure 15-22, bottom right).

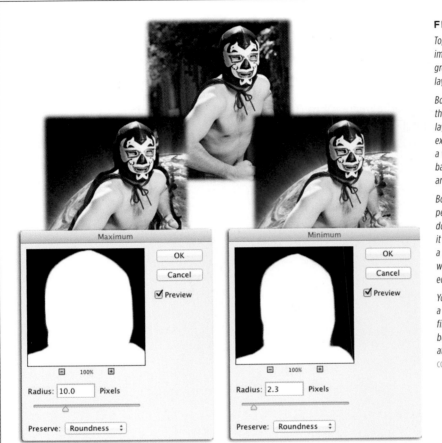

FIGURE 15-22

Top: Here's the original image before the background was hidden with a layer mask.

Bottom left: If you run the Maximum filter on the layer mask, Photoshop expands it. Notice how a wee bit of the original background is visible around the hero.

Bottom right: As you'd expect, the Minimum filter does the exact opposite— it shrinks the layer mask, a truly fantastic and fast way to snip away leftover edge pixels.

You can give these filters a try by downloading the file Spanish.zip from this book's Missing CD page at www.missingmanuals. com/cds.

NOTE The Maximum and Minimum filters have a nasty habit of making round things look square. To fix that, Adobe added a Preserve drop-down menu to their dialog boxes (visible in Figure 15-22), which lets you tell Photoshop to preserve the squareness or roundness of pixels in your image. When you choose Roundness from this menu, you can enter decimals into both filters' Radius fields for more precise control (yay!), which is *incredibly* handy when you're using these filters to fine-tune layer masks.

The last filter in this category is Offset, which you can use to shift a selected object horizontally or vertically a precise amount in pixels. Since *moving* a selection creates a hole in its original location, you get to tell Photoshop what to do with the empty spot. Your choices are "Set to Transparent," Repeat Edge Pixels, and Wrap Around.

Digimarc

This filter lets you add a nearly invisible watermark to your images to protect them from being stolen and used without your permission (a problem inherent in posting images online). Page 800 has the scoop.

Browse Filters Online

Since filters are basically little programs—called *plug-ins*—that run inside Photoshop, they're easy to install (see page 831 for instructions). When you choose Filter→Browse Filters Online, you'll be transported to the Adobe Add-Ons website, where you can download a slew of 'em. They range in price from free to a whopping $479 (for a cosmetic-dental-imaging plug-in), though most are around $5.

Printing and the Web

Photoshop and Print

Getting your prints to match what you see onscreen is one of the biggest challenges you'll face when dealing with digital images. Unless you prepare your monitor and files properly, it's *impossible* to make them match.

As you've learned, digital images actually contain grayscale information—it's the monitor and printer's job to translate that info into color. And with the sheer volume of monitors, printers, inks, and papers out there, producing consistent color can be a nightmare.

Thankfully, there's a solution, but it lies in understanding *why* creating consistent color is such a challenge. Unfortunately, that means learning about things like color modes, gamuts, and color profiles. These are heady topics, to be sure, but it's not rocket science. The main concepts are (fairly) straightforward, and if you can make it through this chapter (an energy drink will help), you'll know how to create consistent, predictable, high-quality prints.

> **NOTE** Photoshop CC 2014 can perform *3D printing*, meaning you can take a virtual 3D object that you've created in (or loaded into) Photoshop and then create a *physical object* out of it using a special 3D printer. For details, see Chapter 21.

■ The Challenge of WYSIWYG Printing

WYSIWYG (pronounced "wiz-e-wig") is an acronym for "What you see is what you get." For image-editing buffs, it describes the elusive goal of getting prints to match

what's onscreen. When you think about the different ways that monitors and printers produce colors, the problem starts to make sense.

A monitor's surface is made from glass or some other transparent material, and—as you learned in Chapter 5—it produces colors with phosphors, LCD elements, or other light-emitting doodads. In contrast, printers use a combination of paper, reflected light, and cyan, magenta, yellow, and black inks. To add even *more* excitement, some printers use additional colors like light cyan, light magenta, several varieties of black, and so on.

Given these two completely different approaches to creating colors, it's a miracle that the images on your monitor look *remotely* similar to the ones you print. And because there are a bazillion different monitors and printers on the market—each using different technologies—you'll see a big difference in how your images look depending on the monitor or printer you use. Heck, even changing the *paper* in your printer affects how your images print.

The only way to get consistent prints is to have a calibrated and profiled monitor of decent quality (you'll learn about that stuff shortly), to know which printer your image is headed for, which color mode that printer wants the image to be in, which range of colors that printer can reproduce, *and* exactly what type of paper you're using. Whew! Once you have all that info, you need to communicate it to Photoshop. This section describes how to do that.

Understanding Color Gamuts and Profiles

As a first step toward WYSIWYG printing, remember from Chapter 5 that, in most cases, your image starts life in RGB color mode and eventually ends up being converted to some version of CMYK when it's printed (as you'll learn later, either the printer can convert the image's color mode or you can do it manually). The next step is to understand more about how those two color modes differ. Enter the concept of *color gamuts*.

A color gamut is the *range* of colors a given device can reproduce. An RGB monitor, for example, can reproduce one range of colors, and a CMYK printer can reproduce *another* (and there's not a monitor or printer on the planet that can produce a color range as wide as your eyes can see). While the color gamuts of monitors and printers frequently overlap, they're never identical. Your printer's color gamut depends on the specific combination of printing technologies you're using, including:

- **Colorants (color-producing substances).** Some printers, like commercial offset presses, use pigment-based inks to produce color. Others, like inkjets, use dye-based inks, and still others—like laser printers and digital presses (which are like fancy laser printers)—use powdered toners.

- **Dot pattern.** All the printers mentioned above use a pattern of dots to reproduce images. Commercial offset presses typically use *halftone dots* that are commonly made from ellipses and diamonds.

- **Paper type.** Each printer can also use a wide range of paper, from plain to matte to super high-quality glossy. (Quick tip: You'll usually get *much* better quality using glossy paper.) If you want your inkjet printer to reproduce its full gamut of color, you need to use a specially coated paper made to work with specific dye-based inks.

To account for all these variations, you can use *color profiles* to tell Photoshop exactly which colorants and papers you want to print with. Color profiles contain detailed info about the printer's color gamut and, in some cases, the paper you're using, though usually that info lives in a separate file called a *paper profile*. Photoshop comes with a variety of all-purpose, generic profiles, but you can also get profiles from printer and paper manufacturers. Throughout this chapter, you'll learn how to use profiles both to *proof* (check and review) images and to print them on common printers like inkjets, commercial printing presses, and digital presses.

NOTE Manufacturers are inventing new printers all the time, and this book can't possibly cover them all. That said, if you're going to use a professional print shop, you'll want to work *very* closely with them to ensure an accurate print.

■ FINDING AND INSTALLING DRIVERS AND COLOR PROFILES

Most of the time, you can download *printer drivers*—the software that lets Photoshop communicate with your printer—right from the printer manufacturer's website, although you might have to poke around a bit to find 'em. It's *always* best to get printer drivers straight from the company that made the device. The manufacturer's site should explain how to install 'em.

Similarly, you can typically download color profiles from the paper company's website (be sure to get the profile for *your* printer), though you can also get custom color profiles from professional printing companies (they're usually happy to share 'em with you if you ask). Luckily, the profiles you get from larger companies, such as Epson, come with an installer program. If yours doesn't, ask the company it came from where you should put it on your computer (it depends on your operating system). The box on page 722 has more about color profiles.

TIP For high-quality ICC profiles—color profiles that have been vetted by the International Color Consortium Registry—visit *www.lesa.in/iccregistry*. The ICC's website also has a ton of great (and heady) info about color management.

Every printer and paper manufacturer's website is different, but they all have similar options. Typically, drivers and profiles live in the download or support section of the site, but it's usually easiest to Google your printer's name plus the item you're after, such as *Epson R3000 driver* or *Epson R3000 color profile*.

Once you've installed the appropriate printer driver and color profile, you can access them via the Printer Profile menu in Photoshop's Print Settings dialog box (see page 737) and in the Custom Proof dialog box (see page 755–759).

Calibrating Your Monitor

To ensure accurate prints, it's also important to make sure your *monitor* is displaying colors accurately. Both the Mac and Windows operating systems come with built-in calibration programs, but for best results, you should use an external measuring device like a *colorimeter* or *spectrophotometer* (hand-sized gadgets that clamp onto your monitor and measure the colors it displays). The calibration process involves adjusting your monitor so that it displays a series of colors and images consistently. Having a calibrated monitor also lets you more accurately preview how images and colors will print (a process called *soft-proofing*, discussed later in this chapter).

You can buy a calibrating device for your monitor for around $100 (USD), although the more sophisticated ones cost a little more. There's no harm in starting with an affordable model like Pantone's ColorMunki Smile (*www.lesa.in/colormunkismile*) or DataColor's Spyder4Express (*www.lesa.in/spyderexpress*), but to be able to *truly* trust the colors your monitor is showing you, you'll need to spend more. Options include the SpyderPro (*www.lesa.in/spyderpro*), which runs about $170, or the Pantone i1 Display Pro (*www.lesa.in/i1display*), which is around $270. However, a simpler and perhaps more *accurate* solution is to buy a monitor that comes with its *own* calibration software and colorimeter, such as an NEC model with SpectraView; you can pick up a 24"-inch model for around $1,000 (*www.lesa.in/necspectraview*).

Another step toward seeing your images the way they'll look when printed is telling Photoshop what *color workspace* your monitor should use. Choose Edit→Color Settings and, in the Working Spaces section of the dialog box that appears, choose a profile from the RGB menu. These color workspaces differ greatly in color gamut, as shown in Figure 16-1.

UP TO SPEED

Profiles Aren't All Equal

It's shocking but true: Some profiles are just plain wrong.

Photoshop comes with many built-in color profiles—like Adobe RGB (1998) and sRGB—that include general color-mode info for displaying images, as well as slightly more specific (though still generic) color profiles—like US Sheetfed Coated v2—that contain gamut information for printing on a typical sheetfed press using standard inks and coated paper. If your printing conditions are indeed standard, you may get decent results by using one of these built-in profiles.

You can also use printer-and-paper-specific profiles, commonly referred to as *paper* or *output profiles*, created by manufacturers like Epson, who make profiles to match almost every kind of paper they sell: glossy, luster, matte, and so on. The more closely a profile matches your printing conditions, the more accurate and useful it is. You'll find that high-quality paper profiles like the Epson ones provide invaluable help with proofing and printing.

When you're out paper shopping, it's wise to confirm that the paper manufacturer offers paper profiles that match your printer and ink (and be wary of buying paper from companies that don't!).

You'll also want to test the profiles by actually *printing* with them. If you've been printing with other paper and profiles, print some test images using the same image for both sets of papers and profiles and then compare the results. You'll probably find that some paper manufacturer's profiles are better than others.

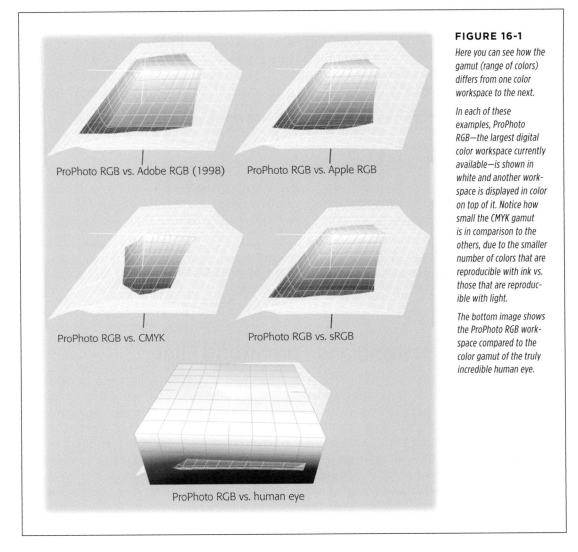

FIGURE 16-1

Here you can see how the gamut (range of colors) differs from one color workspace to the next.

In each of these examples, ProPhoto RGB—the largest digital color workspace currently available—is shown in white and another workspace is displayed in color on top of it. Notice how small the CMYK gamut is in comparison to the others, due to the smaller number of colors that are reproducible with ink vs. those that are reproducible with light.

The bottom image shows the ProPhoto RGB workspace compared to the color gamut of the truly incredible human eye.

Here's what you need to know about choosing the color workspace that's right for you:

- **Adobe RGB (1998).** This is the most popular workspace to date. It includes a *wide* range of colors, so it's perfect for designers and photographers. It's also great for printing on inkjet printers and commercial presses.

- **Apple RGB.** This workspace was designed for use on small Apple monitors. It's *slightly* smaller than Adobe RGB (1998), meaning it contains a narrower range of colors. So unless you're rockin' a vintage 13-inch display, don't use this workspace.

- **ColorMatch RGB.** Designed to match the color space of the old Radius Pressview monitors, this workspace has a slightly smaller gamut than Adobe RGB (1998). If you've got one of those Radius monitors, this workspace is a good choice.

- **ProPhoto RGB.** Currently the *largest* workspace in use, this one is used by software that processes raw images (page 54). It's the native workspace of Camera Raw (page 385) and Photoshop Lightroom (Adobe's professional-grade photo database and editing program). Choose this mode if you're a pro photographer shooting in raw format *and* you're working with 16-bit files in Photoshop.

- **sRGB.** Also slightly smaller than Adobe RGB (1998), this workspace is great for prepping images for use on the Web, in presentation programs, in videos, and submitting to online printing companies (labs like *www.mpix.com*). This is the RGB workspace Photoshop uses unless you pick another one.

If you routinely edit CMYK images, then head to the Color Settings dialog box and pick a profile from the CMYK menu that most closely describes the kind of press your images will be printed on. If you don't know which one to choose, ask your print shop.

> **TIP** You can also change your digital camera's color profile to match what you use in Photoshop. For example, most cameras are initially set to sRGB mode, but you can switch to Adobe RGB instead. Alas, you'll have to dig out your owner's manual to learn how, but the increased range of colors and monitor consistency is worth it!

◼ Resizing and Formatting Files

Besides making sure your images are in the right color mode, installing the right color profiles for your printer and paper, and calibrating your monitor—are you exhausted yet?—you also need to make sure your image's size matches the size you want to print. For example, to print an image at 5 × 7 inches, it should really *be* 5 × 7 inches (as opposed to, say, taking a 6 × 8-inch image and cramming it into that smaller format). And the image needs to have sufficient resolution (see the table on page 260 for resolution guidelines). Finally, you need to save the image in a file format that works well with your printer. This section walks you through all those steps.

Printer-Friendly File Formats

Printers can accept a wide range of file formats, including PSD (Photoshop), TIFF, EPS, PDF, and even JPEG. Don't worry: Choosing one isn't as hard as you might think. Once you've saved the master file in PSD format, choose File→Save As and then pick one of the following formats:

- **TIFF.** This format (whose name is short for "tagged image file format") has long been considered the print-safe gold standard, and for that reason, almost any program can work with TIFF files. Saving a file in this format doesn't compress it, so the quality remains as good as that of the original. TIFF also supports *layers*, provided you turn that option on in the Save As dialog box, though you'll end up with a larger file size than a PSD. If the image will be used in another

program but you don't know which one—for example, you're sending the image off to someone else to use in a book or magazine—saving it as a TIFF is a safe bet. This format is also a good option if you need to create an image for printing in a word-processing program (such as, heaven help you, *Microsoft Word*).

TIP If you have to email or upload a TIFF, be sure to create and send a .zip archive of the file first, because TIFFs are notorious for getting corrupted in transit. To do that on a Mac, Control-click the file's icon, and then choose "Compress [filename]" from the resulting shortcut menu. On a PC running Windows, right-click the file and then choose Send to→"Compressed (zipped) folder," or use a program like WinZip (*www.winzip.com*).

- **PDF.** This format (short for "portable document format") is hugely popular. While it *can* compress files, it doesn't do so automatically, which makes it perfect for images you plan to print, plus it preserves the smooth edges of vector illustrations and text. And if you need to email the file or upload it to an online print company, PDF is a better choice than TIFF because it produces smaller file sizes and it's a more modern format.

- **EPS.** If you've created a multitonal image (page 751) or one with spot colors (page 744), you can use this format (whose name stands for Encapsulated PostScript), which has long been the native format for vectors. However, PDF files can *also* handle multitonal images and ones with spot colors, and you'll find that saving an image in PDF format is simpler than saving it in EPS format (plus it usually results in a much smaller file size). For that reason, go with PDF format unless someone—like a prepress manager at your printing company—specifically requests an EPS file. (And if she does, ask her tactfully if she's heard about PDFs—and then duck!)

- **JPEG.** As you learned in Chapter 2, JPEG supports a wide range of colors, though it *compresses* images in order to reduce their file sizes. That said, if you're working with a first-generation JPEG (such as a high-quality one that came from your camera) in Photoshop and you save it at the highest quality setting, it should print just fine. In fact, most online printing services *require* you to submit JPEGs (see the box on page 732 for more on printing JPEGs).

Resizing and Saving as a TIFF

Here's how to prepare an image for a high-quality print even if you don't know exactly what resolution you need *or* which program will be used to print it:

1. **With the image open, summon the Image Size dialog box.**

 Choose Image→Image Size or press Option-⌘-I (Alt+Ctrl+I on a PC). See page 255 for a full description of this important dialog box.

2. **Near the bottom of the dialog box, turn off the Resample checkbox.**

 Doing this prevents you from changing the image's pixel count—and therefore changing its quality.

3. **Set the Width and Height fields to the size you want to print (for example, 10 × 10 inches).**

 Photoshop preserves your image's original aspect ratio (the relationship between its width and height), so if you can't get the dimensions just right, you can always crop the image first. And don't worry about changing the resolution—Photoshop changes it automatically as soon as you enter the width or height (because you turned off the Resample checkbox), and you'll save the file at its maximum resolution. If you're sending the file to a professional printer and the resolution is between 300 and 450 ppi, you can sleep well knowing it'll print nicely. (If the resolution is lower than that, see the box on page 258 for a workaround.) Click OK to close the Image Size dialog box.

4. **Save the file in TIFF format.**

 Choose File→Save As or press Shift-⌘-S (Shift+Ctrl+S) and, in the resulting dialog box, choose TIFF from the format drop-down menu.

5. **At the bottom of the Save As dialog box, make sure the Layers and Alpha Channels checkboxes are turned *off*.**

 Turning off these settings forces Photoshop to save a new, flattened version of your image that's good for printing.

6. **In the upper part of the dialog box, name the new file and tell Photoshop where to save it; then click Save.**

 You may want to develop your own naming system for the files you print, as shown in Figure 16-2, top. Click Save to close the Save As dialog box, and Photoshop opens the TIFF Options dialog box.

7. **Adjust the TIFF Options dialog box's settings (Figure 16-2, bottom).**

 In the Image Compression section, choose None to keep the file more compatible with other programs (though this makes for a bigger file size). Leave the Pixel Order section set to Interleaved, and in the Byte Order section, turn on the IBM PC radio button to make the file compatible with Windows computers (Macs can read either byte order). That said, all modern programs support all three Layer Compression options and both Byte Order settings.

8. **Click OK and Photoshop saves the image as a TIFF file.**

Following these steps lets you create an uncompressed, single-layer, print-ready copy of the image at the right size for printing from your fully editable, master PSD file. You can now print the TIFF image straight from Photoshop or hand it off to a page-layout program like InDesign or QuarkXPress (although these days *both* those programs are happier with PSD or PDF files).

Resizing and Saving as a PDF

Another high-quality format is PDF. You can use this format to save some of the
most complex images you'll ever create like those with spot colors (page 744) or
multitonal images (page 751) that historically required EPS format or its print-specific
variation, DCS (Desktop Color Separations) format (page 749).

As mentioned earlier, creating a PDF file is usually easier than making an EPS file,
and PDFs are safer to transfer over the Internet. Here's how to resize an image and
save it as a PDF:

1. **Open your Photoshop document and duplicate it.**

 Since this technique involves lowering the document's resolution, it's far safer to work with a *copy* of your image rather than the original. So choose Image→Duplicate and name the new file something like AlaskaLight_5x5_300, which includes info about the resulting file's size and resolution.

2. **Open the Image Size dialog box, turn off the Resample checkbox, and then resize the image.**

 Choose Image→Image Size or press Option-⌘-I (Alt+Ctrl+I), and then turn off the Resample option near the bottom of the dialog box. Then change the document's width and height if you need to. For example, the image in Figure 16-3 started at 9×9 inches (top), but is now 5 × 5 inches (bottom). This change caused the resolution to balloon from 384 ppi to 691 ppi, but you'll lower that number to a more reasonable level in the next step (see page 260 for a discussion of resolution overkill).

3. **Near the bottom of the Image Size dialog box, turn the Resample checkbox back** *on,* **and then lower the resolution to 300 ppi.**

 The Resample setting has to be turned on for you to change the resolution. After you turn it on, enter *300* in the Resolution field.

FIGURE 16-3

Anything over 450 ppi resolution is usually overkill, so aim for something closer to 300 ppi (between 120 and 200 for newsprint). Notice that when this file was resized, its pixel dimensions shrank from 3456 × 3456 to 1500 × 1500 and its file size decreased from 34.2 MB to 6.44 MB—a far more manageable size.

Now if you need to email or upload it to a file transfer service such as www.Dropbox.com, it'll transfer much faster—heck, it'll even print faster thanks to its new svelte size.

4. **From the Image Size dialog box's Resample menu, choose Automatic.**

 This setting makes Photoshop pick the best resample method *for* you. Alternatively, you can use "Bicubic Sharper (reduction)," which makes Photoshop reduce the softening (blurring) that results from making the image smaller (See page 256 for more about resampling.) Click OK to close the Image Size dialog box.

TIP After you resize and resample the image, you may want to apply a round of sharpening to help maintain its crispness (an amount between 50 percent and 75 percent should do the trick). See Chapter 11 for sharpening enlightenment.

5. **Summon the Save As dialog box by choosing File→Save As or pressing ⌘-S (Ctrl+S).**

 Since you're working on a copy of the document that you haven't saved yet, you need to tell Photoshop where to save it and in what format.

6. **From the format drop-down menu, choose Photoshop PDF, and then make sure the Layers and Alpha Channels checkboxes are turned off.**

 Turning off these settings forces Photoshop to create a single-layer PDF for printing.

7. **Name your file and tell Photoshop where to save it, and then click Save.**

 When you do, Photoshop alerts you that, "The settings you choose in the Save Adobe PDF dialog box can override your current settings in the Save As dialog box." Click OK and the gigantic Save Adobe PDF dialog box appears.

8. **On the left side of the Save Adobe PDF dialog box, choose General, and then make sure the Compatibility menu on the right side is set to Acrobat 5 (PDF 1.4) as shown in Figure 16-4, top.**

 While there are more recent versions of Acrobat in the Compatibility menu, sticking with the factory setting of Acrobat 5 (PDF 1.4) ensures that folks with *older* versions of Acrobat can open the file. If you think you'll want to edit this PDF in Photoshop later, make sure the Preserve Photoshop Editing Capabilities checkbox is turned on (although you're better off editing the PSD you made the PDF *from* instead).

9. **On the left side of the dialog box, click Compression and then set the first drop-down menu in the Options section that appears to Do Not Downsample and set the Compression menu to None (see Figure 16-4, bottom).**

 These options let you retain all the document's original pixel info so you can create a high-quality print. However, if you want to reduce the file's size without losing too much image quality, choose Zip and "8 bit," or JPEG and Maximum, from the Compression and Image Quality menus (respectively). A maximum-quality JPEG is a great choice when you're sending an image to a stock-image service or a print company that lets you upload files to its website.

FIGURE 16-4

The Save Adobe PDF dialog box has a slew of options. To go through them, choose a category on the left (General, Compression, and so on) and then adjust the settings that appear on the right.

10. **On the left side of the dialog box, click Output, and then pick No Conversion from the Color Conversion menu.**

 This setting makes Photoshop retain all the image's color info.

11. **Optionally, save these settings as a preset so you can use them again later.**

 Think about whether you'll ever want to use these settings again. If the answer is yes (and it probably is), click Save Preset (circled in Figure 16-5). Give your preset a descriptive name like *Print Image PDF*, and then click Save.

12. **In the Save Adobe PDF dialog box, click Save PDF.**

 You can place your newly created PDF file in an InDesign document or send it to somebody via email, upload it to *www.Dropbox.com* (a popular file-transfer site), or an FTP site. Unlike TIFF and EPS files, which usually need to be encased

in a protective .zip archive (a compressed document container—see the Tip on page 725), PDF files are Internet compatible and safe.

FIGURE 16-5

If you save your settings as a preset, you can access them via the Adobe PDF Preset drop-down menu at the top of the Save Adobe PDF dialog box. Photoshop lets you save as many presets as you want, which can be a huge timesaver.

You can also choose one of the built-in PDF presets listed in the Save Adobe PDF dialog box's Standard drop-down menu; when you make a choice from this menu, Photoshop sets all the other options for you. Ask your printer which standard they'd like you to use.

◼ Printing on an Inkjet Printer

If you're a photographer, you probably use an inkjet printer—most likely of the *expanded-gamut* variety that uses six to eight inks, rather than the standard four (they're technically *dyes*, but most folks call 'em inks). The most common combination of expanded-gamut ink includes the four standard *process colors*—cyan, magenta, yellow, and black (CMYK)—plus light cyan and light magenta. You may also have a choice of black inks, like glossy or photo black, matte black, light black, and even light *light* black (seriously!).

> **NOTE** Inkjet printers are more common than dye-sublimation or color laser printers, so they're the focus of this section. But no matter what kind of printer you use, you can use printer and paper profiles as explained in this section.

Nearly all expanded-gamut inkjet printers can convert RGB images to CMYK (plus any additional inks they may have). For the brightest and most saturated colors, let the printer convert the colors for you (see the discussion in Step 8 below). However, to get the most *accurate* results, manage the conversion *yourself* in the Photoshop Print Settings dialog box. Here's how to do just that when printing a high-quality image on an expanded-gamut printer (also called CcMmYyK or, if it's an HP printer, CMYK-Plus):

1. **Prepare your image for printing by cropping, editing, and resizing it.**

 Make sure you've cropped, color-corrected (Chapter 9), and resized the image and set its resolution to between 200 ppi and 450 ppi (Chapter 6). If you don't crop the image to the exact dimensions you want, your printer may crop it for you, so it's *far* better to do it yourself. It's also a good idea to double-check the Image Size dialog box to confirm that the document's dimensions and resolution are correct (open it by pressing Option-⌘-I or Alt+Ctrl+I on a PC).

2. **Choose File→Print or press ⌘-P (Ctrl+P) to summon the Photoshop Print Settings dialog box shown in Figure 16-6 (top).**

FREQUENTLY ASKED QUESTION

Why Not Print JPEGs?

Hey, what do you have against JPEGs? It seems like a decent enough file format.

You may be wondering why this chapter doesn't explain how to save and print images in JPEG format. That's a legitimate question because, after all, JPEG is the format understood by most digital cameras.

There's nothing wrong with printing first-generation JPEGs (the ones created by your camera); the problems occur once you start editing, resaving, and then printing *subsequent* JPEGs.

When you save images as JPEGs, Photoshop automatically shrinks 'em using a process known as *lossy compression*, which reduces the amount of color info in the image (mainly in areas of fine detail), lowering the image's quality. The amount of compression, and the resulting loss of info and quality, varies from one JPEG to another. (You can set the level of compression yourself, as discussed on page 729.) If you have no choice but to use JPEG—because you're sending the image to an online lab for printing, like your local camera store or *www.mpix.com*, for example—use the highest quality and lowest compression settings to preserve as much quality as possible.

However, when you *resave* a JPEG that you've edited (without changing its format to something else like PSD or TIFF), you apply yet *another* round of compression, and *that's* when everything goes to heck in a handbasket. Here's what you should do instead:

- When you first open JPEGs for editing in Photoshop, save them in PSD format, and then create a JPEG *from* the PSD if you need to (say, for posting on the Web, emailing, or uploading to an online printing service). To speed up this file-format conversion process, you can use Photoshop actions (Chapter 18) and/or the Image Processor script (page 268).

- If your images are going to be edited extensively, set your digital camera to capture photos in an uncompressed format like TIFF or raw to prevent any initial compression (and resulting loss of info and quality). As you learned in Chapter 2, raw is the most flexible format, so choose that option if possible. Most cameras can save images in raw format; consult your owner's manual to see whether yours can.

Now you can relax knowing you're not *re*-compressing already compressed files. Whew!

3. From the Printer menu at the top of the dialog box, pick your printer.

If your printer isn't listed, visit the manufacturer's website and download the latest driver for your printer (see page 721).

FIGURE 16-6

Top: Click the Print Settings button near the top for more printer-specific options like paper and quality. If you're on a Mac and your printer offers a utility for nozzle cleaning, you can summon it by clicking the printer icon to the right of the Printer menu (Windows users should click the Print Settings button).

Bottom: If your printer can print to the edges of the paper (called a full-bleed or borderless print), head to the Paper Size menu in your printer's dialog box (the one that opens when you click Print Settings at the top of the Photoshop Print Settings dialog box) and choose an option that includes the word "borderless." Otherwise, you'll get a white border in both Photoshop's print preview and on the print itself.

NOTE After you make changes in the Photoshop Print Settings dialog box and then click Done or Print, when you save the document, Photoshop *saves* your print settings in the document file and in its own *program* preferences. (If you *don't* save the document, your print settings fly out the window [unless you saved them as a preset]). This lets you quickly print the same document with the same print settings by choosing File→Print One Copy. In fact, *any* document you print will automatically use your previously saved print settings unless you change them (at which point, Photoshop will use those *new* settings the next time you print—provided you saved the document after changing them).

To start fresh with all *new* print settings, press and hold down the space bar when choosing File→Print; this can help you troubleshoot printing weirdness. (The print settings in your operating system aren't affected by the print settings you choose in Photoshop.)

4. **Near the top of the dialog box, click Print Settings.**

Most folks miss this critical step. The dialog box that opens when you click this button belongs to your *printer*, not Photoshop, so the settings you see might be slightly different than what's described in Steps 5 and 6 (which were written using an Epson model). In other words, you may have to hunt around a bit to find settings similar to the ones discussed here.

5. **In your printer's dialog box, from the Paper Size menu, choose your paper's dimensions.**

If you're printing borderless, be sure to choose a borderless version of the paper dimension you picked (see Figure 16-6, bottom). If you *don't* pick an option that includes the word "borderless," your image will print with a pesky white border around it. (If you don't see an option that includes "borderless," that means your printer can't create borderless prints).

6. **In your printer's dialog box, choose Print Settings (circled in Figure 16-7).**

The wording of your printer's dialog box may vary slightly, or you may not have this option at all. Instead, you may see some or all of the following settings:

- **Media Type.** Choose the paper you're printing on, like Ultra Premium Photo Paper Luster.

- **Print Mode.** Your printer controls this menu, which chooses the appropriate mode for the Media Type you picked, so you don't need to adjust this setting.

- **Color Mode.** This setting is controlled by the Color Management section of the Photoshop Print Settings dialog box. If you choose Photoshop Manages Colors (see Step 8), this setting is turned off. That said, it's important to make *sure* it's turned off so your printer doesn't try to adjust the document's color, too.

- **Output Resolution.** You can think of this as a quality setting. Your printer automatically adjusts this setting based on the Media Type you chose earlier so, once again, you don't need to change this setting.

- **High Speed.** This option lets your printer's *print head* (the bit that applies the ink to the paper) print while it's moving in *both* directions instead of just one. If you turn it off, your image will print more slowly, but it might look a little better. (If you like, fire off a couple of test prints—one with this setting turned on and one with it off—and then look closely to see if you can spot any differences.)

7. **Click Save (or OK, or the equivalent button) to close your printer's dialog box and return to the Photoshop Print Settings dialog box.**

Back in the Photoshop Print Settings dialog box, check the paper's orientation to make sure it's what you want; you can select portrait or landscape by clicking the Layout icons shown in Figure 16-6, top. Also, make sure your image fills the pertinent part of the dialog box's preview area: If you wisely cropped the image

to your exact print dimensions, it should fill the white document preview area perfectly (though you'll still see a dark gray background *behind* the preview).

FIGURE 16-7

Your printer's dialog box may look a little different from this one depending on your operating system and printer manufacturer, but you should be able to find similar settings lurking somewhere.

If your printer driver isn't the latest version, it may have trouble communicating with Photoshop and you may not be able to print to the edges of the paper or change paper size. Trot on over to the manufacturer's website to make sure you have the current driver, and then you should be good to go.

8. **From the Color Management section's Color Handling menu (see Figure 16-8), choose Photoshop Manages Colors.**

 Color management is the process of making the colors produced by the devices you work with—your digital camera, monitor, and printer—match as closely as possible by referencing specific color profiles. This menu controls whether Photoshop or your printer driver converts the image's colors from RGB to the printer's colors.

 For the brightest and most vibrant colors, choose Printer Manages Color and then skip to Step 10. For more *accurate* results, choose Photoshop Manages Colors. It's certainly worth experimenting with both options, but you'll likely

find that letting Photoshop manage colors will give you higher quality and more consistent results *if* you're using paper-specific profiles.

When you choose Photoshop Manages Colors, the program displays a warning that reads, "Remember to disable the printer's color management in the print settings dialog box." Most printers are configured to apply *some* kind of color management to your image, which can conflict with the color management you're trying to apply through Photoshop (usually with unsavory results). Exactly how you disable your printer's color-management feature depends on which printer you have, but the controls aren't too difficult to find. In the Photoshop Print Settings dialog box, click Print Settings and then, in the resulting dialog box, root around for a Color Matching menu item (or something similar). When you find it, the settings will be labeled something like "Epson Color Controls," and you'll likely find that Photoshop already disabled it *for* you, but it's always good to check!

9. **From the Color Management section's Printer Profile menu, choose the option that matches the paper and print settings you're using.**

 Click the Printer Profile menu and scroll through the long list of profiles (which gets longer each time you install new profiles) to find the appropriate one. For example, if you're using an Epson SPR3000 printer, look under E or S, and then pick the profile that matches your paper, such as Epson SPR3000 Premium Glossy.

 NOTE If you're letting Photoshop manage color (see Step 8), Photoshop communicates with your printer and picks the best printer profile *all by itself*. It does this by reading the printer's JobOptimalDestinationColorProfile tag (don't ask). But don't jump for joy just yet: As of this writing, hardly *any* printer manufacturers include this info, though boy howdy, it'll be cool when they do! (And at that point, you'll be able to skip Step 9 entirely.)

10. **From the Rendering Intent menu, choose Perceptual, and then make sure the Black Point Compensation checkbox is turned on.**

 These options help maintain the color relationships in your image, and preserve contrast by making sure that the black shadows in your original RGB image are black in the final print.

11. **In the "Position and Size" section, make sure the Center checkbox is turned on (see Figure 16-8, top).**

 If you *didn't* crop your image before starting this process, this setting will make your image print from the center outward—as much of it as will fit on the paper size you picked—instead of aligning the upper-left corner of the image with the upper-left corner of the paper.

FIGURE 16-8

Top: The Color Management and "Position and Size" sections of the Photoshop Print Settings dialog box let you determine who controls your document's color conversion and how it prints on the page (respectively).

Bottom: Fans of the old "Print to Selection" option that was nixed in CS5 will be glad to see that it's back at the bottom of the "Position and Size" section, though these days it's called Print Selected Area. This option is helpful for printing (and thus proofing) a small portion of an image (which helps conserve ink).

If you forget to make a selection before opening this dialog box, simply turn on the Print Selected Area checkbox (circled) and use the gray triangles shown here to mark the area you want to print. You can drag each triangle individually; Option-drag (Alt-drag) to move two at a time; or ⌘-drag (Ctrl-drag) to move 'em all at once. As you drag, Photoshop helpfully displays height and width info (use the Units menu to the right of the Print Selected Areas checkbox to switch to pixels, inches, or whatever).

To learn more about color management, check out Eddie Tapp's super affordable online video course at www.lesa. in/etcolor.

▼ **Color Management**

⚠ Remember to disable the printer's color management in the print settings dialog box.

Document Profile: Adobe RGB (1998)

Color Handling: Photoshop Manages Colors

Printer Profile: SPR3000 Premium Glossy

☐ Send 16-bit Data

Normal Printing ⬍

Rendering Intent: Perceptual

☑ Black Point Compensation

▶ **Description**

▼ **Position and Size**

Position

☑ Center Top: 0 Left: 0

Scaled Print Size

Scale: Height: Width:

100% 10 7.999

☐ Scale to Fit Media Print Resolution: 300 PPI

☐ Print Selected Area Units: Inches

Cancel Done Print

Bottom Top Left Right

11 in x ? in

H : 3.986 in
W : 5.250 in

12. **In the Scaled Print Size area, make sure the Scale option is set to 100%.**

 If you didn't crop your image before beginning this process, you can use this setting, along with the Position setting mentioned in Step 11, to control which

part of your image prints. However, just because you *can* scale (resize) an image while you're printing it doesn't mean you *should*. Besides preventing you from sharpening the image after you make it smaller, scaling it via the Photoshop Print Settings dialog box makes it take a little longer to print, plus Photoshop doesn't perform any resampling (see page 256 for more on resampling). If you don't care about such things, you can turn on "Scale to Fit Media" and Photoshop adjusts the Scale, Height, and Width settings in this section to make the image fit the paper size you picked earlier. That said, if you're not scaling it very much, then you've nothing to worry about.

> **TIP** In the Photoshop Print Settings dialog box, you can drag within the preview area to scale and position your image on the page (the "Scale to Fit Media" checkbox has to be turned *off* for this to work). Your cursor turns into a four-sided arrow when you mouse over the preview, and Photoshop displays height and width info as you drag; drag the corners or edges of the image to resize it. Just keep in mind that these adjustments cancel out any changes you've made in the "Position and Size" section.

13. **If you're using paper that's bigger than your image, take a peek at the options in the Printing Marks and Functions sections.**

These settings let you turn on different kinds of marks that can help you trim the image once it's printed, as well as control background and border colors (handy for making your print look like it has a matte behind it).

In the Printing Marks section, turn on Corner Crop Marks to make Photoshop place a small horizontal and vertical line just outside of each corner of the image. If you plan to fold the image in half (say, to make a greeting card), turn on Center Crop Marks. Professional printers use registration marks for printing separations, but you can leave 'em turned off. The Description option instructs Photoshop to print the info you've entered into the Description field of the File Info dialog box (page 777) below the image, but you can also use the Edit button to its right to add a description here. The Labels option prints the document's name above the image.

The Functions section lets professional print shops—like those that use offset presses, discussed in the next section—do things like flip the image on the film (Emulsion Down) and reverse its colors (Negative); this film is then used to make plates for the printing press. Professional printing aside, you can click the Background button to summon the Color Picker; choose a color and Photoshop prints it around the outside of the image like a matte. Use the Border button to add an outline around the image. The Bleed button lets you tell Photoshop how far to move the corner crop marks *into* your image so there's a little sliver of the image hanging outside the trim lines. (That way, you don't end up with a white strip around the edge of the image if your trim job isn't perfect.)

NOTE On the off chance that you're using a printer that understands the *PostScript* language (some laser printers and imagesetters do), you can use the PostScript Options section of the Photoshop Print Settings dialog box to control things like halftone line frequency, angle, and other options specific to your printer. If this section is labeled PostScript Options Disabled, your printer doesn't speak PostScript! (Don't confuse a PostScript *printer* with a PostScript *font*; while they share the same language, they're not the same thing. If you're using a non-PostScript printer, Photoshop rasterizes fonts the second you click the Print button, so the printer doesn't have to understand PostScript to draw the characters. If you're using a PostScript printer, Photoshop preserves both type- and shape-layer content as vectors.)

14. **If you picked Photoshop Manages Colors in Step 8, take a peek below the preview area and make sure the Match Print Colors and Show Paper White settings are turned on so you can view an onscreen proof (also called a *soft proof*).**

 Photoshop displays a simulation of what your printed image will look like in the preview area (see page 755 for more on proofing). Adobe improved Photoshop's soft-proofing accuracy several versions back, so the preview should give you a good sense of what the print will look like—assuming you've calibrated your monitor (page 722), of course.

15. **Turn on the Gamut Warning checkbox to make Photoshop highlight any out-of-gamut pixels in gray.**

 You can ask Photoshop to show you a proof of any colors in the image that are *out of gamut* (meaning unprintable) for the printer and paper you've picked. If you're using an expanded-gamut printer, you'll encounter far fewer out-of-gamut colors than you would with a standard CMYK printing press. If the gray areas aren't important parts of your image, then don't worry about this warning (though the printed color in those spots won't match the color you see onscreen). If the gray areas *are* important, use the techniques discussed in Chapter 9 to adjust the image's colors, which usually means desaturating those spots slightly. Alternatively, try printing on different paper or, if possible, using a different printer.

16. **Glance over your choices in the Photoshop Print Settings dialog box one last time and, if they look OK, click Print.**

 After *all* that hard work, you see the fruit of your labors in the form of a gloriously accurate, high-quality print. Yippee!

TIP You can save time by recording your print settings in an *action* (see Chapter 18). Bear in mind, though, that the program will memorize *everything* in the Photoshop Print Settings dialog box, including print size and positioning. So if you typically print both landscape and portrait images, you need to record two actions, one for each orientation. Then you can use conditional actions (page 819) to make Photoshop pick the right action for the image all by itself!

■ Printing on a Commercial Offset Press

If you prepare artwork for projects that are printed using a commercial offset printing press (magazines, product packaging, newspapers, and so on), you've got *loads* more to worry about than if you're sending an image to an inkjet printer. Unlike printing to an inkjet printer, where your images get converted from RGB to CMYK during the printing process, a commercial offset press usually requires you to convert the image to CMYK *before* it's printed. This section explains the very specific steps you need to follow to preserve an image's color when you convert it to CMYK. But before you dive too deeply into this conversion, you need to understand a bit more about how offset presses work.

Commercial offset presses are huge, noisy, ink-filled beasts. An inkjet printer sprays ink from a print head directly onto a page, whereas an offset press transfers, or *offsets*, ink from an image on a plate onto a rubber blanket and *then* onto a page. As you learned back in Chapter 5, offset presses split an image's four CMYK channels into individual color separations, which are loaded onto big cylinders aligned so that all four colors are printed, one on top of another, to form the final image. If these cylinders aren't aligned properly, you'll see faint traces of one or more colors peeking outside the edges of the image, making it look blurry (this blurriness is called being "out of registration").

Instead of the dyes used by inkjet printers, commercial offset presses use two types of ink: *process* and *spot*. Process inks include cyan, magenta, yellow, and black (CMYK), and they're printed as overlapping patterns of halftone dots (Figure 16-9, left) that can economically reproduce the wide range of colors found in *continuous-tone images* like photos (Figure 16-9, right).

FIGURE 16-9

Left: If you look closely at an image printed on a press, you can see the dots it's made from. (The next time you pick up a magazine or newspaper, stick it right up to your nose and you'll see 'em.) To keep the dots from printing on top of each other, they're printed at specific angles according to ink color.

Right: Images that contain a wide range of smooth colors are called continuous-tone images, like this beautiful photo by Arild Heitmann.

Spot inks, on the other hand, are used to match very *specific* color requirements (like a color in a corporate logo, such as the official UPS brown), and they're printed using *additional* plates on the press. More spot colors mean more plates and therefore more separations, which translates into higher printing costs. Since it's easy to get hit with unexpected costs when you're sending out a print job, make *darn* sure you know exactly how many colors it'll take to print the image (most print jobs involving color photos use only the four process colors). You'll learn all about spot colors later in this chapter.

Finally, unlike sending an image straight from Photoshop to your inkjet printer, you'll *rarely* (if ever) send a single image to an offset press. Instead, you'll send the image to a page-layout program like InDesign or QuarkXPress and put it in a document that contains other images and text (referred to as *copy*), and *that's* what you send to the printing company. So you need to make sure the image has the right print dimensions and resolution, and that it's in the right color mode *before* you place it in the page-layout program. The following pages explain how to do that as painlessly as possible.

Converting RGB Images to CMYK by Using Built-In Profiles

First and foremost, you need to know who's handling the conversion from RGB to CMYK mode. Historically, printing companies have requested (or required!) you to convert images yourself, but this is *slowly* changing, particularly with the increased use of digital presses.

If you have no idea whether you're supposed to convert the RGB image to CMYK yourself or if you want to know whether the printing company has a custom profile you can use for the conversion, *pick up the phone*. Communication is crucial in professional printing projects, because if your print job hits the press at 2:00 a.m., it'll be *your* phone that rings if there's a problem. This is definitely a call you're better off *making* than receiving.

If you have to convert the image yourself, it's important to choose the proper printer and paper profiles. You can do that in a couple of ways, but the following steps will lead you down a simple and foolproof path:

1. **Open your RGB image and duplicate it.**

 Choose Image→Duplicate to create a copy of the image to *guarantee* that you won't accidentally save over your original.

2. **Name the new file and save it in TIFF format.**

 Choose File→Save or press ⌘-S (Ctrl+S) and then give it a name. (It's a good idea to include the file's color mode in the name so you can see at a glance which mode it's in.) From the format drop-down menu at the bottom of the Save dialog box, choose TIFF, and then click Save.

 In the TIFF Options dialog box that appears, choose None in the Image Compression section and leave the Pixel Order section set to Interleaved. In the Byte Order section, turn on the IBM PC radio button. Leave the "Discard Layers and

Save a Copy" option turned on (it's dimmed if your image has just one layer), and then click OK.

3. **Choose Edit→"Convert to Profile."**

 In the Conversion Options section of the dialog box that appears (see Figure 16-10), set the Engine menu to Adobe (ACE) and the Intent menu to Perceptual. Also, make sure Use Black Point Compensation is turned on.

FIGURE 16-10

Don't panic when you open the Profile drop-down menu in this dialog box. The funky names listed there are simply the various color profiles you can use to convert RGB to CMYK.

As you learned at the beginning of this chapter, there are a bazillion printers, papers, and colorants (inks, dyes, toners) out there, so the Profile menu's length merely reflects that diversity.

4. **From the dialog box's Profile menu (Figure 16-10), choose an option that reflects the type of ink, press, and paper your printing company will use to print the image.**

 You can think of this menu as a printer profile menu. If you can't find a custom profile (see the next section), hunt for the best match for your print job. If the image is being printed in North America on a sheetfed printing press using coated paper stock, for example, you can pick the tried-and-true "U.S. Sheetfed Coated v2" profile. A newer commercial sheetfed profile that may also work is "Coated GRACoL 2006." But instead of guessing, *ask* your printing company what profile to use.

5. **Click OK to complete the color-conversion process, and then save the image.**

 Press ⌘-S (Ctrl+S) to save the image in the new color mode.

After you save the new CMYK image, you're ready to place it in a page-layout document.

Custom RGB to CMYK Profile Conversions

If your printing company has painstakingly created its own custom color profile, you're much better off using it than one of Photoshop's built-in options. The process

is similar to the one just described, but you need to *install* the custom profile before you can use it. Once you've downloaded it, follow these steps to put it into play:

1. **Find where color profiles are stored on your hard drive.**

 Figuring out where to store the profile is the biggest challenge, since different operating systems *and* different versions of Photoshop store profiles in different places:

 - **On a Mac**, they live in *Macintosh HD/Library/Application Support/Adobe/Color/Profiles*.

 - **On a PC** running Windows, simply right-click the profile file you downloaded, and then choose Install Profile from the resulting shortcut menu. That said, profiles are stored in *C:\Windows\System32\spool\drivers\color*. (If you don't see the Windows folder, you'll need to turn on hidden folders by going to Control Panel→"Appearance and Personalization"→Folder Options; in the dialog box that appears, click the View tab, turn on the "Show hidden files, folders, and drives" radio button, and then click OK.)

 If you have trouble finding the right folder or just want to double-check that you've found the right spot, call your printing company and ask them where to store profiles on your particular operating system.

 > **NOTE** If your computer uses Windows, you can use the Color Management Control Panel to add and remove profiles. Go to Start→Control Panel→Color Management.

2. **Copy the custom profile to the Profiles folder (the Color folder on a PC).**

 Printing companies that have embraced color management have CMYK color profiles for a *variety* of paper stocks, so be sure you load the one for the paper you're printing on by dragging the file into the folder.

3. **Open your image, duplicate it, and then save it as a TIFF file.**

 Choose Image→Duplicate, and then choose File→Save or press ⌘-S (Ctrl+S) and give the copy a name. At the bottom of the Save dialog box, pick TIFF from the format drop-down menu, and then click Save. In the TIFF Options dialog box that appears, choose None in the Image Compression section and leave the Pixel Order section set to Interleaved. In the Byte Order section, turn on the IBM PC radio button. Leave the "Discard Layers and Save a Copy" option turned on, and then click OK.

4. **Choose Edit→"Convert to Profile" and, in the resulting dialog box, choose the new profile from the Profile menu.**

 If you don't see the right profile in the list, try restarting Photoshop. Press ⌘-Q (Ctrl+Q) to quit, and then double-click the image file to relaunch the program.

5. **If necessary, change the file's Conversion Options settings.**

 Ask the printing company if you need to adjust any settings in the Conversion Options section of the "Convert to Profile" dialog box (Edit→"Convert to Profile").

6. **Click OK, and then press ⌘-S (Ctrl+S) to save the image.**

You've just completed your first custom CMYK conversion!

Using Spot Color

As mentioned earlier, commercial printing presses sometimes use special premixed, custom inks called *spot colors*. If you're a graphic designer working in *prepress* (the department that preps files for printing), the info that lies ahead is really important. If you're a photographer or web designer, save your brainpower and skip this section. Really.

Photoshop wizard Ben Willmore (*www.DigitalMastery.com*) has come up with a great analogy to explain spot colors. Remember the box of crayons you used as a kid? A small box had eight basic colors, like blue, orange, and yellow. And then there was the big box of 64—with a sharpener on the back!—that had special colors like cornflower, melon, and thistle. No matter how hard you tried, you couldn't reproduce those special colors with a box of eight crayons. In Photoshop, you can think of the box of eight crayons as CMYK color mode and those special colors as spot colors.

> **NOTE** The most popular brand of spot-color ink is Pantone (*www.pantone.com*). You'll also hear Pantone colors called *PMS* colors, which stands for "Pantone Matching System."

Because of the impurity and variety of CMYK inks, they can't produce all the colors you see in RGB mode (just like you can't reproduce, say, cornflower with those original eight crayons). No matter which color mode your document is in, if you're tooling around in the Color Picker and choose a color that *can't* be produced in CMYK, Photoshop alerts you by placing a little gray triangle next to it (see Figure 16-11, top). This triangle is known as an *out-of-gamut warning* (gamut, as you learned earlier, means the full range of colors possible within a color mode or workspace). If you click the triangle (or the tiny color swatch below it), Photoshop changes that color to the closest possible match that *can* be printed with CMYK inks.

In some cases, the closest color match is good enough, but spot-color ink comes in handy in certain situations, like when you need:

- **To reduce printing costs.** As you learned earlier, the more colors you use, the more cylinders and separations the printer needs and the more the job will cost. But if you print an image using black and just one or two spot colors, you can actually *reduce* printing costs because you'll use only two or three separations instead of four. This technique is common with line art (illustrations or outline drawings like those in a coloring book), though you can also use it for photos. (However, it's always best to discuss pricing with your printing company up

front because, in some situations, CMYK printing can be cheaper than two-color printing.)

- **To ensure color accuracy.** If your paycheck depends on color accuracy, you *have* to use spot colors. For example, if UPS hires you to design a flyer for their company party, you need *your* version of brown to match their *official* brown. Unless you use a spot color (which is consistent because it's premixed), your brown will be printed using a mix of CMYK inks and may end up looking, say, maroon.

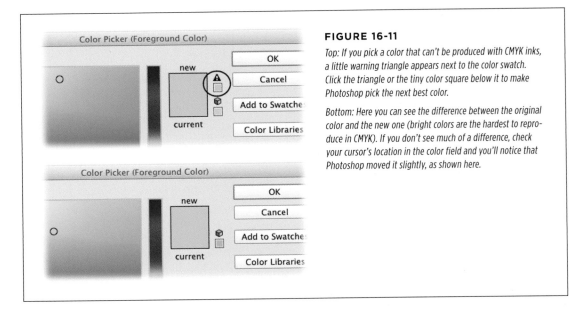

FIGURE 16-11

Top: If you pick a color that can't be produced with CMYK inks, a little warning triangle appears next to the color swatch. Click the triangle or the tiny color square below it to make Photoshop pick the next best color.

Bottom: Here you can see the difference between the original color and the new one (bright colors are the hardest to reproduce in CMYK). If you don't see much of a difference, check your cursor's location in the color field and you'll notice that Photoshop moved it slightly, as shown here.

- **To use specialty inks.** To add a bit of pizzazz to a printed image, you can use specialty inks like metallics or a varnish that looks glossy when it's printed. You can also add a vibrant spot color to a particular area to make that part stand out. But if you use specialty inks on a CMYK document, you're *adding* color separations to the job, which increases the cost.

Before you can use a spot color, you have to create a special channel for it called a *spot channel*. Each spot color you use needs its very own spot channel. (See Chapter 5 for more on channels.)

Let's say you're preparing the cover photo for the next issue of *Cutting Horse* magazine, and, to reduce printing costs, the magazine has decided to use a grayscale image with one spot color for visual interest. (That way, they're paying for two separations instead of four.) Your mission is to make the horse's bridle Pantone Red. No problemo! Just make a selection of the bridle, and then create a spot channel for the special ink (see Figure 16-12).

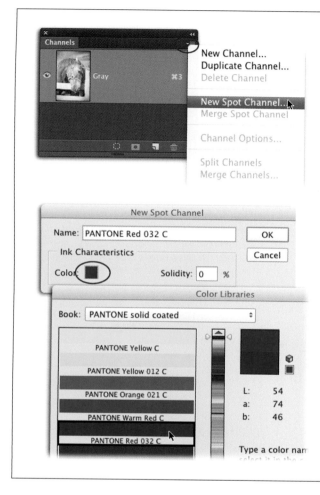

FIGURE 16-12

Top: Once you've selected the area you need to colorize, add a new spot channel by choosing New Spot Channel from the Channels panel's menu (circled, top).

Bottom: In the New Spot Channel dialog box, click the little color swatch (circled) to open the Color Picker. There, click the Color Libraries button (not shown) to see the oh-so-helpful list of Pantone presets visible here. Photoshop will automatically add the ink you choose here to your selection.

To follow along, download the practice image Bridle.jpg from this book's Missing CD page at www.missingmanuals. com/cds.

Here's how to add a spot channel:

1. **Select the area you want to colorize and, if necessary, convert the image to grayscale.**

 If you're lucky enough to start with the full-color version of the photo, you can easily select the horse's bridle by using the Quick Selection tool. Then see page 329 for the scoop on converting a color image to black and white and page 336 for info on changing the image's color mode to Grayscale.

2. **From the Channels panel's menu, choose New Spot Channel (Figure 16-12, top).**

 You can also add a spot channel by ⌘-clicking (Ctrl-clicking on a PC) the New Channel icon at the bottom of the Channels panel. Either way, Photoshop opens the New Spot Channel dialog box.

3. **In the New Spot Channel dialog box, name the new channel (if you like), and then click the color swatch to open the Color Picker and choose an ink color.**

 In the Color Picker, click the Color Libraries button to see a list of Pantone presets. In the Color Libraries dialog box (Figure 16-12, bottom), choose a color library from the Book menu. For example, if you're preparing a photo for a magazine that prints on glossy paper, pick "PANTONE solid coated"; if you don't know which one to choose, ask your print shop.

 Next, pick a spot color. If you know the number or name of the ink you want (like *150* or *red*), type the number or name and Photoshop will flip to that color in the list. You can also drag the triangles along the rainbow-colored vertical bar to find the one you want, or use the arrow keys on your keyboard to move through the list of ink swatches. When you find the right color, click its swatch to choose it, and then click OK to close the Color Libraries dialog box.

 NOTE By picking a color from a Color Library, you don't have to worry about naming your new spot channel—Photoshop names it automatically. As of this writing, it's a little buggy: sometimes it works, sometimes it doesn't.

4. **Back in the New Spot Channel dialog box, leave Solidity set to 0% and click OK to close the dialog box.**

 You can think of solidity as ink opacity, though it affects only the *onscreen* image and not the printed version. Depending on the image you're working with, increasing the ink's opacity so it appears solid and not see-through may be helpful (it's a personal preference).

 When you click OK, the new spot channel appears in the Channels panel (Figure 16-13).

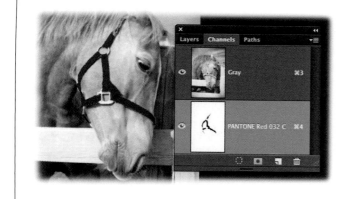

FIGURE 16-13

Here's the final cover shot for your magazine. As you can see, there are just two channels in the Channels panel, which means this image can be printed with just two separations.

If you send this grayscale Photoshop document straight to InDesign, that program adds a color swatch for the spot color and makes sure that the new color prints on top of the black ink (a technique called overprinting).

■ EDITING SPOT CHANNELS

Once you've created a spot channel, you can change its ink color by double-clicking it in the Channels panel. You can also add or remove color from the spot channel by painting with the Brush tool, or by using any selection tool and filling the selection with color as described on page 198.

Since Photoshop shows channel information in grayscale, you can edit a spot channel just like a layer mask—by painting with black, white, or shades of gray:

- **To add color at 100 percent opacity,** grab the Brush tool by pressing B and set your foreground color chip to black. Then mouse over to the image and paint where you want to add color.

- **To remove color at 100 percent opacity,** set your foreground color chip to white before you paint.

- **To add or remove color at any other opacity,** set your foreground color chip to a shade of gray before you paint.

■ SAVING A DOCUMENT WITH SPOT CHANNELS

To keep spot channels intact, you need to save the document in a format that understands them: DCS, PSD, or PDF. So which one do you pick? It depends on what you're going to do with the file.

If you're the hired Photoshop gun and you'll be handing the file off to someone else for further fluffing, save it as a PSD file, get your motor runnin', and head out on the highway (insert guitar riff here). You'll also want to save it as a PSD file if you plan to import the image into InDesign or QuarkXPress 6.5 or later.

If you're using the image in QuarkXPress 6 or *earlier*, you need to save it as a DCS 2.0 file or a PDF file (the next section explains how). DCS (short for Desktop Color Separation) is a special format that pre-separates the image's color channels into plates for a printing press. To save a document as a DCS file, make sure it's in either Grayscale or CMYK color mode, and then choose File→Save As and pick Photoshop DCS 2.0 from the format drop-down menu. When you click Save, you'll see the DCS 2.0 Format dialog box (Figure 16-14) where you can fine-tune the following settings:

- **Preview.** This menu controls which kind of image preview you see in QuarkX-Press. Your choices include "TIFF (1 bit/pixel)" and "TIFF (8 bits/pixel)." Choose the latter if you want a nice, 256-color preview. (The box on page 42 explains what "8 bits" means.) If you don't need to see the image preview in QuarkXPress (because, say, you're building a catalog with hundreds of images and that many previews would slow down your vintage computer), choose None.

- **DCS.** Leave this menu set to "Single File DCS, No Composite" so Photoshop doesn't generate all kinds of files that only the printing press peeps know what to do with.

- **Encoding.** This menu controls how Photoshop *encodes* (represents and stores) the print information in the file. If you're on a Mac, choose Binary. If you're on a Windows computer, choose ASCII or (for a more compact file) ASCII85.

> **NOTE** *ASCII,* which stands for "American Standard Code for Information Interchange," was developed as a way to convert binary (computer) information into text, and ASCII85 is the newest version. (This stuff is *great* bar-bet trivia.)

FIGURE 16-14

DCS 2.0 is one of three formats you can use to save spot channels intact. While most page-layout programs can read DCS files, you'll find that using a PDF is easier, as discussed below.

Leave all the checkboxes at the bottom of the dialog box turned off, and then click OK. You're now ready to import the DCS file into QuarkXPress 6 or earlier.

■ SAVING SPOT COLORS IN PDF FORMAT

DCS 2.0 has long been the standard format for saving documents with spot colors, but PDF format yields a smaller and more flexible file. To see for yourself, follow these steps:

1. **Open an image that contains a spot color, and then choose File→Save As.**

2. **In the Save As dialog box, pick Photoshop PDF from the format drop-down menu.**

 If your document has layers, turn off the Layers checkbox to flatten the image.

3. **Turn on the Spot Colors checkbox.**

 This step ensures that Photoshop includes your spot colors in the PDF, along with process colors (CMYK).

4. **Rename the image to indicate that it harbors a spot color, and then save it.**

 For example, call it "Autumn Art_CMYK_Spot" and then click Save. Photoshop warns you that the PDF settings you're about to adjust cancel out the settings in the Save As dialog box. Simply click OK and Photoshop opens the Save Adobe PDF dialog box.

5. **From the Compatibility menu at the top of the Save Adobe PDF dialog box (shown back in Figure 16-4), choose Acrobat 5 (PDF 1.4).**

 This setting lets you specify the PDF version. As of this writing, version 1.4 is the safest and most widely accepted choice.

6. **On the left side of the dialog box, click Compression, and then adjust the settings so your images don't get compressed.**

 From the first drop-down menu in the Options section, choose Do Not Downsample. Then, from the Compression menu, pick None.

7. **On the left side of the dialog box, click Output, and then make sure the Color Conversion menu is set to No Conversion.**

8. **Click Save PDF.**

That's it. You're now free to send the PDF file to the page-layout program of your choice.

If you save the settings you entered as a preset (see page 731), this method is much faster than saving a file in DCS 2.0 format. But be sure to ask your printing company if it accepts PDFs with spot colors. Although almost everyone can use PDFs these days (and most places prefer them), some companies using older equipment may not, so be sure to ask—change is hard, you know!

Printing Duotone (Multitonal) Images

One advantage of using a commercial printer is that you can print duotones and other multitonal images by adding *additional* ink to grayscale images (see the box on page 755). You can add Pantone inks, additional gray inks, or even process inks—great news if you want to add an overall color tint to a grayscale image, add some tonal depth and richness, or both. These techniques let you create some amazingly beautiful effects, as discussed back in Chapter 8. However, it's really easy to add *too* much ink, which can make the image way too dark once it's printed. If that happens, you lose details in the shadows and the image's contrast goes down the tubes.

TIP　Photoshop includes a set of 38 gradient presets called *Photographic Toning*. By using them with a gradient map adjustment layer, you can get the look of a multitonal image *without* having to use Duotone mode. See page 355 for more info.

To produce a truly amazing duotone or multitone image, you need to start with a good quality grayscale image—one that has high contrast and isn't overly dark. Once you've settled on an image, converted it to black and white (Chapter 8), and then switched it to Grayscale mode (page 41), follow these steps:

1. **Duplicate the image.**

 Choose Image→Duplicate, and then give the copy a name. Consider incorporating the word "duotone" into the name, as in "Cowgirl_Duotone."

2. **Choose Image→Mode→Duotone.**

 If this menu option is dimmed, you're not in Grayscale mode. In that case, choose Grayscale mode first, and *then* switch to Duotone mode. The Duotone Options dialog box opens, and shows that the image is a monotone made from nothing but black ink. (You can tell because the Type menu is set to Monotone, and only Ink 1 is active [and it's black].)

 Just for fun, open the Duotone Curve dialog box by clicking the Curve icon to the left of the black ink (it's circled in Figure 16-15, top). This is where you can peek at how the ink will be applied in your image. In this example, you have a straight 45-degree curve from the highlight to shadow areas, and the black ink is being applied at 100 percent. Fascinating, eh? Click OK to close the Duotone Curve dialog box.

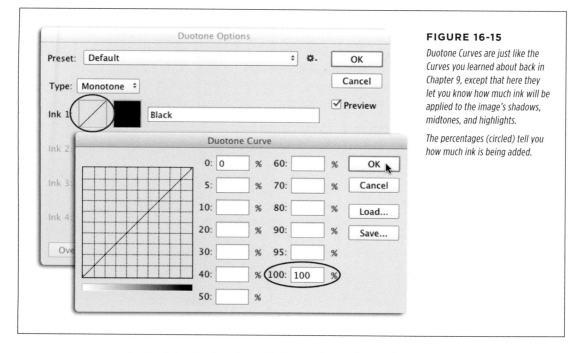

FIGURE 16-15

*Duotone Curves are just like the
Curves you learned about back in
Chapter 9, except that here they
let you know how much ink will be
applied to the image's shadows,
midtones, and highlights.*

*The percentages (circled) tell you
how much ink is being added.*

3. **Back in the Duotone Options dialog box, choose Duotone from the Type
 menu.**

 This menu lets you pick from various kinds of multitonal images. When you
 choose Duotone, Photoshop activates two inks in the dialog box (choosing Tri-
 tone activate three inks, and so on). However—and this is key—*both* inks have
 straight, 45-degree highlight-to-shadow curve lines, which means they print
 with the same amount of ink in the same color range. That's *not* good! Why?
 Because if you were to click the Ink 2 color swatch and choose a new color, you'd
 add too much of that ink for the image to print decently unless you edited the
 curve in the Duotone Curve dialog box (Figure 16-15, bottom), which is tricky to
 do. So instead, in the next step, you'll choose one of Photoshop's many presets.

4. **Click the Preset menu and choose one of the** *gazillion* **Duotone presets.**

 Feel free to experiment with the wide variety of options in this menu. Some items,
 like the true duotones, come in anywhere from one to four variations, which
 represent substitutions for the second ink ranging from stronger to weaker. (In
 other words, presets with a *1* in their names add the most color, and those with
 a *4* in their names add the least.) These are excellent starting points for your
 creations. There's nothing wrong with using the Duotone Curves dialog box to
 fine-tune your results (see Figure 16-16), but you'll want to print some tests to
 make sure you're not adding too much ink.

Testing duotones is tough because you *can't* proof them unless they're made from process colors (in which case they're really quadtones). If you pick a preset with inks that aren't available on your printer, you won't get an accurate proof. The best you can do is contact your printing company and see if *they* will print you a test on the paper they'll use for the final image. (If you don't need the proof right away, they may be able to hold onto it and slide it in with another job that uses a similar ink-and-paper combo.)

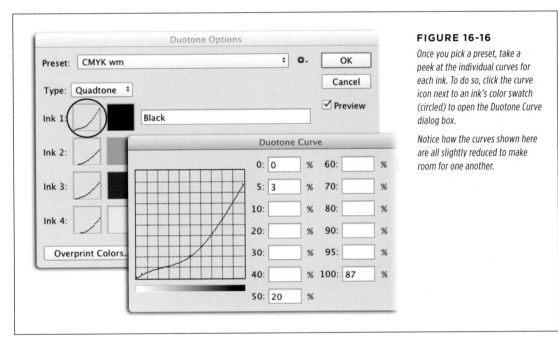

FIGURE 16-16

Once you pick a preset, take a peek at the individual curves for each ink. To do so, click the curve icon next to an ink's color swatch (circled) to open the Duotone Curve dialog box.

Notice how the curves shown here are all slightly reduced to make room for one another.

5. **Save the document in EPS or PDF format.**

 Here's yet *another* opportunity to chat with your printing company! Give 'em a ring and ask whether they prefer EPS or PDF format for duotones or multitones. If they say EPS, ask them which settings to use. Then choose File→Save As and pick Photoshop EPS from the format drop-down menu. In the EPS Options dialog box (Figure 16-17, bottom), choose an 8-bit option from the Preview menu, and pick Binary from the Encoding menu. Unless your printing company told you otherwise, leave the rest of the settings turned off, and then click OK.

FIGURE 16-17

If you want to add a unique color tint to an image, or if you want to create an image that looks black-and-white but has more depth and richness, try switching the document's color mode to Duotone. Then, in the Duotone Options dialog box, choose from the many gorgeous color combos in the Preset menu.

As you can see, the difference between a pure black-and-white image (top) and the quadtone preset "CMYK wm" (middle) is quite impressive. For real fun, pour your favorite beverage and trot through all the options in the Duotone Options dialog box's Preset menu. You'll be amazed at the results these scientifically concocted color combos can produce when applied to your image!

To save a duotone as a PDF file (instead of an EPS as described in this section), you can use the same settings you used to save a spot-color image in the previous section (page 750).

Printing Color Separations

To avoid running into unexpected printing costs, it's a good idea to print separations (called *seps* around the water cooler) before sending your image to a print shop. That way, you can make sure an extra color hasn't snuck its way into the document—especially if you've toyed with some spot colors that you're not going to use. However, you probably won't use Photoshop to print separations—in most cases, you'll place an RGB or CMYK image in a page-layout program along with text and other images, and then use *that* program to print the separations. But if you ever *do* need to print separations from Photoshop, visit this book's Missing CD page at *www.missingmanuals.com/cds* for step-by-step instructions.

Proofing Images Onscreen

When you're sending images out for printing, it'd be nice to peek into the future and see what they'll look like. Happily, Photoshop can create an onscreen proof simulation known as a *soft proof*, a straightforward process that involves the color profiles you learned about in the previous sections. Here's what you do:

1. **Calibrate your monitor, using the tools described earlier (page 722).**

 If your monitor isn't calibrated, soft-proofing is a *galactic* waste of time.

2. **Open an RGB image you intend to print.**

 You can soft-proof RGB and CMYK images, but it's especially cool to proof an RGB image and see what it will print like in CMYK without having to color-convert it first.

3. **Choose Window→Arrange→"New Window for [name of image file]" to open a second window containing a copy of your image.**

 Then position the two windows side by side by choosing Window→Arrange→2-up Vertical.

4. **Click the right-hand window to activate it, and then choose View→Proof Setup→Custom.**

5. **In the Customize Proof Condition dialog box, make sure the Preview checkbox is turned on (Figure 16-18, top).**

Understanding Duotones

The term *duotone* generally refers to a grayscale image that has had additional inks added to it. Technically, if you add one ink, it's a duotone; adding two inks make it a tritone; and adding three inks make it a quadtone. Technically, the correct *general* term for all these variations is "multitonal images." But, confusingly, most folks use the term "duotone" to refer to all these alternatives. So if someone mentions a duotone, they might actually be talking about a tritone or a quadtone.

Why add other inks to grayscale images? A couple of reasons: Some folks use duotones to add color to an image inexpensively (as you've learned, reducing the number of colors in an image can mean a cheaper print job). However, duotone (or multitone) aficionados will tell you the additional inks add tonal range and depth to an image—and they're right! In fact, you can even add a second *gray* ink to enhance tonality without adding any color at all.

The two keys to creating quality duotones are:

- **Start with a high-quality grayscale image with a good tonal range and lots of contrast.** See Chapter 8 for more black-and-white conversion methods than you can shake a stick at.

- **Substitute the second ink for part of the original black ink, rather than just adding it to the black** (see step 3 on page 752). This prevents the image from becoming too dark and flat because it's drowning in ink.

With a bit of practice, you'll gain confidence in creating duotones and enjoy doing it. However, it's always a good idea to plan extra time in your production schedule to print some tests. Since you can't trust your monitor or proof non-process duotones (page 751), a test print is worth its weight in gold.

FIGURE 16-18

Top: Soft-proofing isn't 100 percent accurate, but it's better than nothing and you'll almost always find it useful. It's also a good way to help manage your client's expectations, especially when the client is printing on cheap, low-quality paper.

Bottom: In this soft-proof example, the image on the right is ever so slightly less saturated and has lower overall contrast than the original on the left. You can try choosing different printer profiles to see how they affect your soft-proofing results.

6. **From the "Device to Simulate" menu, choose the profile for your final printer.**

 If the image is headed to a printing press, for example, pick your old profile friend, U.S. Sheetfed Coated v2.

7. **Choose Perceptual from the Rendering Intent menu, and make sure the Black Point Compensation checkbox is turned on.**

 The Perceptual option takes into account how humans see color. Black point compensation helps preserve the contrast of your original.

8. **In the Display Options (On-Screen) section, turn Simulate Paper Color.**

 You can watch your onscreen proof change if you turn this setting on and off.

9. **Click OK, and then sit back and examine the differences between the two windows.**

You can perform soft-proofing for other printers, too, like your inkjet printer or a digital press. All you need to achieve good results is a calibrated monitor, an accurate printer, and a paper-specific profile.

Printing Proofs

If you're working in a prepress environment—especially if you're *not* printing on a digital press—you're often proofing on a different printer than the one that will print the final document. For example, you might print a proof using an inkjet, but the final image will print on a commercial offset printing press. In that situation, you can make the inkjet print a *simulation* of what the printing press will produce.

Simulating an image involves reining in the proof printer's large color gamut to include only the colors that the printing press can reproduce. You do that using profiles and the proofing feature you learned about in the previous section. Here's how:

1. **Pop open an image and then choose File→Print.**

2. **At the top of the Photoshop Print Settings dialog box, pick your proofing printer from the Printer menu.**

3. **In the Color Management section, from the Color Handling menu, choose Photoshop Manages Colors.**

> **NOTE** If you leave the Color Handling menu set to Printer Manages Color—which you might do if your color-conversion tool is a special *RIP* (page 761) set up for proofing—then Photoshop has *zero* effect on your color; all the color conversion occurs at the RIP. In that case, you can't soft-proof your image by using the Photoshop Print Settings dialog box as discussed here, but you *can* use the soft-proofing tools discussed in the previous section.

4. **Click the Print Settings button and make *sure* your printer's color management is turned off.**

 In the resulting dialog box, pick your paper size, and then verify that the printer's color settings are turned off (they should be) to keep the printer driver from interfering with the color-management voodoo you've got going on in Photoshop. (See step 8 on page 735 for help finding this setting.) When everything looks good, click Save or OK (depending on your printer) to return to the Photoshop Print Settings dialog box.

5. **Back in the Photoshop Print Settings dialog box, from the Printer Profile menu, choose the setting that matches the printer, paper, and quality you'll use to print the proof.**

 Pick the settings that match the printer you're currently using, *not* the printer you're trying to simulate.

6. **In the next drop-down menu down (it doesn't have a label), choose Hard Proofing (see Figure 16-19).**

This setting lets Photoshop know you intend to simulate a proof on one printer as if it were *another* printer.

FIGURE 16-19

Choose Hard Proofing in the Color Management section to tell Photoshop that you want to print on one printer as if it were another.

Turning on the Gamut Warning checkbox beneath the preview image lets you see which colors may not print correctly on the final printing press. Photoshop displays those areas in gray, as shown here.

7. **From the Proof Setup menu, choose Custom Setup, and then pick a profile that matches the printer you're trying to simulate.**

Straight from the factory, this menu is set to Working CMYK. When you choose Custom Setup, Photoshop opens the Customize Proof Condition dialog box. Use the "Device to Simulate" menu there to pick a profile that matches your final output device (or is at least close to it), and then click OK.

8. **Back in the Photoshop Print Settings dialog box, turn on Simulate Paper Color.**

This setting will help you get the best possible simulation.

9. **Beneath the preview area on the left side of the dialog box, turn on all three checkboxes: Match Print Colors, Gamut Warning, and Show Paper White.**

These options let you see an onscreen view of your image that indicates which, if any, colors might not print on the final printer because they're out of gamut (Photoshop displays these area gray, as shown as Figure 16-19). If the gray areas aren't important parts of the image, then don't worry about this warning (though the printed color in those spots won't match the color you see onscreen). If the

gray areas *are* important, use the techniques described in Chapter 9 to adjust the image's colors (you'll likely want to desaturate those spots slightly).

For the fun of it, peek at the Gamut Warning results using both coated and uncoated paper to see how the paper affects the printed image. To do that, change the profile that you picked from the "Device to Simulate" menu in Step 7. You don't have to make a *print* with both a coated and uncoated profile; it's just interesting to see how the warnings in the preview area change based on paper type.

10. **Click Print and wait eagerly to see what your proof looks like.**

Isn't it amazing what you can do with color profiles? Quick, go tell everyone you know how cool this stuff is—and watch their eyes glaze over. (See the box on page 759 for info on printing proofs of spot channels.)

Printing on a Digital Press

It used to be the case (and sometimes still is) that, when you prepared a document for a commercial printer, you would convert the images to the CMYK color mode *before* you inserted them into a page-layout document and certainly before you fired them off to the printing company. However, that process is changing because an increasing number of print shops now use *digital presses*.

Most digital presses work just like laser printers or copiers; they use electrostatic charges to transfer images from cylinders to the print surface. Like commercial offset presses, digital presses are primarily CMYK printers, but they use powdered toners instead of inks, which is why they can't print spot colors. However, some digital presses, like the Kodak NexPress, actually *do* offer toner spot-color printing, but they're limited to very specific colors like red, green, or blue. And rather than using these additional spot colors for special objects like logos, they typically expand the gamut of the CMYK toners, much like light cyan and light magenta do in inkjet printers.

WORKAROUND WORKSHOP

Printing Spot-Channel Proofs

Since only commercial printing presses use spot channels, getting them to print on your *own* printer for proofing can be... exciting. The solution is to pop into RGB mode temporarily and merge the spot channels. Here's how:

To safeguard your original document, save it and then create a copy by choosing Image→Duplicate. Next, choose Image→Mode→RGB Color and then, in the Channels panel, Shift-click to activate each spot channel in the document. Then open the Channels panel's menu and choose Merge Spot

Channels. When Photoshop asks if it's OK to flatten the layers, click OK. Each spot channel is then instantly swallowed up by the closest matching RGB equivalent.

At this point, you can fire the document off to your printer without a fuss. The colors won't be *exact*, but you'll get a decent approximation of what the image will look like when you finish editing it. After you print the temporary RGB document, you can toss it and continue editing the original.

Because of these quirks, you have to perform some special steps if your project is headed for a digital printer. The following sections explain how to prepare various types of images for a run on a digital press.

Printing RGB Images on a Digital Press

Digital presses handle images much the same way that expanded-gamut inkjet printers do (page 731), so feel free to send 'em an RGB file. Because the RGB-to-CMYK-Plus conversion occurs at the printing press's processing *RIP* (see the box on page 761), you're dealing with RGB images the whole time instead of converting them to CMYK. That's great news because, as you learned at the beginning of this (exhausting!) chapter, RGB mode provides you with the widest range of printable colors. So if your image is already in RGB mode, you're good to go.

Printing CMYK Images on a Digital Press

If your images are in CMYK mode, it's OK to leave 'em that way. Most digital presses recognize CMYK values and print them well enough. That said, you might want to confirm with your printing company that the press will use your current CMYK values rather than converting the image to another color mode and then back to CMYK on the press. (This type of color-shuffling can lead to unpredictable—and usually terrible—results.) Also, keep in mind that CMYK images will be darker and more saturated if they're printed on a digital press than if they're printed on a conventional, ink-based printing press.

Printing Spot Colors on a Digital Press

Toner-based digital presses are becoming more common, so it's important to know which *kind* of digital press your document will end up on. If it's destined for one that uses gamut-expanding digital spot toners, leave it in RGB mode to take full advantage of the press's expanded color gamut.

But most digital presses *don't* print conventional spot color inks. If you send a file that contains any spot colors to a printing company that uses such a digital press, those colors will get converted into CMYK or CMYK-Plus colors (depending on the toners the press uses) before they're printed. The printing press automatically performs this conversion, using a built-in spot-to-process *color lookup table* (also called a *color LUT*). Just be sure to use the name provided by Photoshop when you created the spot channel. (For example, PANTONE 810 C is a proper color name, but "Logo spot color" is *not*.) That's because the printer's RIP (page 761) needs to identify the spot color properly in order to produce the best simulation of it.

TIP Back in Photoshop CS6, Adobe added color lookup adjustment layers, which are useful when you want to add a creative color treatment to your image. The box on page 361 has the scoop on using 'em. And new in Photoshop CC 2014, you can now *export* them for use in pro-level video editing programs like Adobe Premiere CC.

▮ Printing Multiple Images

Sometimes it's handy to print multiple images at once. For example, you can combine images into a single document that prints across several pages—so you don't have to wade through the Photoshop Print Settings dialog box 10 times—or gather several images onto a *single* page for comparison and/or client approval.

Photoshop *used* to include three handy features that let you quickly and easily organize, format, and print multiple images: PDF Presentation, Picture Package, and Contact Sheet. They were wildly useful and folks squawked when Adobe removed back them in CS4. Happily, two of 'em made their way *back* into Photoshop CC: PDF Presentation and Contact Sheet II. The following sections explain how to use them.

> **TIP** No matter which option you choose—PDF Presentation or Contact Sheet II—you can simplify things by gathering the images you want to print into a single folder *first*. That way, you can choose that folder instead of rooting through your hard drive for individual files scattered here and there.

PDF Presentation

To create a multipage PDF that contains one image per page, or a PDF that advances automatically like a slideshow, choose File→Automate→PDF Presentation. In the resulting dialog box (Figure 16-20), click Browse to pick the images you want to include, and then choose what color background you want 'em displayed on (white, black, or gray) and which tidbits of info you want printed with them (such as file name, description, and so on).

When you get your settings just right, click Save. In the Save dialog box, choose where you'd like to store the new PDF, name it, and then click Save. Up pops the Save Adobe PDF dialog box you saw back on page 730. Click Save PDF and Photoshop does all the heavy lifting of combining your images into a single PDF.

FREQUENTLY ASKED QUESTION

Meet the RIP

I thought RIP meant "rest in peace." What the heck does it have to do with printing?

Quite a lot, actually—and it has nothing to do with funerals.

The acronym RIP refers to a device known as a Raster Image Processor. It's a term you'll often hear tossed around at commercial printing companies (also called *service bureaus*).

RIPs convert raster images, vectors, text, and transparency info in page-layout documents into print-ready formats for specific printers, image-setters, sign-cutters, and other output devices. You can think of RIPs as super sophisticated printer drivers.

FIGURE 16-20

In the Output Options section, choosing Presentation (instead of Multi-Page Document) turns your images into a self-running PDF slideshow.

The Presentation Options section lets you control how long each image stays onscreen, whether the slideshow loops, and what kind of transition you'd like between slides, if any (Fade is a good choice).

Contact Sheet II

The Contact Sheet II plug-in works in the exact same way as it did in older versions of Photoshop, so if you've used it before, it'll feel familiar. Contact Sheet II lets you choose multiple images and then have Photoshop shrink them to fit on a single page (and if they won't fit on one page, Photoshop adds more pages). This kind of thing is incredibly handy when you need to compare and evaluate images for use in a project, or send images to a client so *she* can pick the one she likes best.

To create a contact sheet, choose File→Automate→Contact Sheet II. At the top of the resulting dialog box (Figure 16-21, in the Source Images section, click Choose and then locate the images you want to include. In the Document section, enter the paper size you want use (for example, to print on U.S. letter-size paper, enter 8.5 in the Width field and 11 in the Height field). Leave the Resolution set to 300 for a nice, high-quality print, and then use the Thumbnails section to tell Photoshop how many columns and rows you want (these settings determine the *size* of the thumbnails). If you want each image's file name to appear beneath its thumbnail, leave the checkbox below "Use Filename as Caption" turned on, and then choose a font and size for the file names from the drop-down menus to the right of the checkbox. Click OK and Photoshop creates a sheet of beautiful miniatures like the one in Figure 16-21.

FIGURE 16-21

Having trouble deciding which image of the northern lights your client will like the best? No problem—just create a contact sheet you can print and send to her.

If you want larger thumbnails, enter lower numbers in the Thumbnails section's Columns and Rows fields.

If you think you'll use the same settings again later, save them as a preset by clicking Save in the upper right.

Recap: Stress-Free Printing Tips

Congratulations! You've just waded through a *ton* of dense information. Some of it you'll remember and some of it you won't, but, no matter what, it's here whenever you need it. To recap, here are some of the most important tips:

- **Communicate with your printing company.** At the beginning of your project, find out *exactly* which file format and settings the company wants. Knowing this info ahead of time can help keep your project from going past its deadline and over its budget.

- **Calibrate your monitor with an external calibration tool.** This is the only way to accurately view and proof images onscreen.

- **Before you print, resize images to the print dimensions.** This ensures that the image will print at the size you want, with no unexpected cropping. Besides, physically smaller images print faster.

- **Make sure your image has enough resolution.** After resizing the image, check that its resolution is between 240 and 300 ppi so it will produce a high-quality print.

- **If you've made the image substantially smaller, sharpen it.** Any time you change the number of pixels in an image, it gets softened (blurred) a bit. A final round of sharpening (see Chapter 11) can help you get some focus back.

- **Save editable PSD files.** Saving your Photoshop document in its native format lets you go back and edit its layers, alpha channels, and so on. When you're creating a version for printing (described in the next bullet), duplicate the file or use File→Save As to make a copy so you don't overwrite the original.

- **Create a flattened version for printing.** Though this step isn't essential, flattening layers and removing alpha channels makes documents less complex, resulting in smaller files that print faster and more reliably.

- **Proof, convert, and print with printer- and paper-specific profiles.** Now that you've seen how powerful profiles can be, take the time to download and use them (or make your own). Using proper profiles lets you proof, change color modes, and print images with the most reliable, most predictable, and highest-quality results.

- **Know your target color mode.** Be sure to choose the correct color mode for your image, whether it's RGB for expanded-gamut printers like inkjets and digital presses or CMYK for commercial printing presses.

- **Choose a high-quality file format.** Use compression-free, print-compatible formats like PSD, TIFF, PDF, and EPS for saving, sending, and printing your images. If you must use JPEG, make sure you're editing a first-generation JPEG and that you save a *new* JPEG from your master Photoshop document at the highest quality possible, as the box on page 732 explains.

- **Use real names for spot colors.** When you're printing spot colors, use the names listed in Photoshop's Color Libraries dialog box instead of custom names. This increases the chance that the colors will be recognized by other programs like InDesign, or by RIPs that may have to convert them to process colors during printing.

- **Use duotone or multitone presets.** When you're creating duotones or multitonal images, be sure to use Photoshop's presets rather than adding additional colors yourself (at least as a starting point). The presets ensure that your original black ink and any additional inks are properly controlled by the Duotone Curves dialog box, which reduce the amount of ink used during printing. This keeps the image from losing details and contrast because it's dripping with ink.

Photoshop and the Web

Preparing graphics for a website is a journey into the unknown: You've got *no* idea what kind of monitor folks will use to view your images, how fast (or slow) their Internet connections are, or which web browsers they use. It's a proposition riddled with variables that you have zero control over; all you can do is prepare your imagery well and hope for the best.

The main challenge in preparing images for the Web is finding a balance between image quality and file size. Premium-quality, minimally compressed JPEGs look stunning under almost any condition—but if the person visiting your site has a pokey dial-up connection, she might decide to click elsewhere rather than wait for the darn thing to download. On the other hand, if you try to satisfy the slowest common denominator by making ultra-lightweight images, you'll deprive those with broadband (high-speed) connections from seeing the impressive details you've lovingly created.

Luckily, there are several tricks for keeping file sizes down *and* retaining quality. That's what this chapter is all about. You'll learn which size and file format to use when creating images destined for the Web. You'll also discover how to make an animated GIF, craft *favicons* (those tiny graphics you see in web browsers' address bars), mock up web pages and export the images, protect online images against theft, and export web graphics by using a new feature: Generator.

> **TIP** If you're using one of Apple's Retina displays (called HiDPI on Windows)—which sport *twice* as many pixels per inch as regular displays—then your web graphics will look *half* their normal size. To see 'em at the size they'll actually appear in a web browser, choose View→200%. Or, if you're on a Windows machine, you can go to Edit→Preferences→Experimental Features (page 30) and turn on "Scale UI 200% for high-density displays (Windows only)."

■ Creating Web- and Email-Friendly Images

Whether you're designing an image destined for life on the Web or creating an email-friendly version of a digital photo, you need to perform three very specific steps to create a high-quality image that people can download quickly. Consider the following a basic overview of the process; you'll learn detailed info about each step later in this section:

1. **Adjust the image's dimensions.**

 First, you need to decide how big the image should be. In some cases, someone else may give you the size (like when you're hired to create a web banner or an ad, or post an image in an online discussion forum). Other times, *you* choose the size (like when you email a digital photo or send a sample design to a client). Once you know the size you need, you can use the Image Size dialog box (page 255) to resize the image—provided it's already the correct aspect ratio. If your image needs a little pruning around the edges, grab the Crop tool and then choose "W x H x Resolution" from the Options bar's aspect-ratio-and-crop-size menu (page 241). Next, enter your desired dimensions in the width and height fields and *be sure* to include the unit of measurement, such as *800 px*. You can either leave the resolution field blank or enter *72*. (For more on resizing with the Crop tool, see Chapter 6.)

2. **Decide which file format to use.**

 The most common choices are JPEG, PNG, and GIF. See page 769 for the pros and cons of each Web-friendly format.

> **NOTE** As you learned in Chapter 2, you should always save your master file as a PSD file (Photoshop document) so you can open, edit, and resave it as often as you want without losing quality. The PSD format also retains any layers you created during the editing process.

3. **Save and compress the file.**

 When you're ready to create the version that'll live online, you can squeeze it down to the smallest possible size by using the "Save for Web" dialog box, which you'll learn about beginning on page 771.

If you follow each of these steps, you'll end up with images that are the dimensions you want, look great, and download quickly. The following pages explain the details of each step.

Resizing Images

As you learned in Chapter 6, resolution matters when you *print*, but it doesn't mean a hill of beans when you're preparing images for the Web or an email. In the online realm, it's the *pixel dimensions* that matter instead. If you reduce an image's pixel dimensions before posting or emailing it, you won't force unsuspecting folks to download an image that's so big it takes over their whole screen, and you'll end up with a smaller file that will download faster.

NOTE If you're emailing an image to someone who needs to print it, send him a full-size version in one of the print-friendly formats discussed on page 724. Just be sure to compress the image into a .zip file before you send it so it transfers as fast as possible (the Tip on page 725 explains how).

If you're a designer or you're posting an image to an online forum, someone may *give* you the pixel dimensions for your project so you can start with a document that size. But if you're emailing a digital photo or a sample design to a client, *you* pick the size. In that case, here are a few all-purpose width-by-height pixel dimension guidelines:

- **800 × 600 (or 600 × 800).** Use this size if you're sending a design or photo sample to a client who doesn't need to print the image. This size image is almost big enough to fill a web browser window (unless your viewer has a 30-inch screen, that is), so she won't have to scroll much to see the whole thing.

- **640 × 480 (or 480 × 640).** Use these dimensions if you're emailing a photo or posting it to an online forum. These dimensions produce an image big enough to see well and a file size of less than 1 megabyte (so it transfers nice and fast).

- **320 × 240 (or 240 × 320).** These dimensions work well if you're emailing multiple photos or posting to an online forum that contains *a lot* of images. If your recipient has a slow Internet connection, she'll appreciate the smaller file size. And if you crop wisely, these dimensions produce a photo that's big enough for your subject to be identifiable.

- **100×133 (or 133×100).** If you're creating headshots for the company website—a great way to humanize your firm—this size makes for a nice, small portrait. If you're building a catalog page with a ton of product thumbnails (small preview pictures), this size won't bog down the page. (Linking the thumbnails to full-sized versions lets visitors view enlargements if they want to.)

Once you pick a size, flip back to Chapter 6 for step-by-step instructions on how to resize images, using the Crop tool (page 238) or the Image Size dialog box (page 255).

TIP You can also use the Fit Image command to resize images. With an image open, simply choose File→Automate→Fit Image, enter a maximum dimension in either field, and then click OK. Short and sweet!

■ RESIZING IMAGES VISUALLY

Sometimes, it's easier just to choose the size you want for your resized image by *looking* at it. For example, you can use the Zoom tool to decrease the size of your image until it looks good onscreen, and then enter *that* zoom percentage in the Image Size dialog box. Here's how:

1. **Open the image you want to resize and zoom in or out until it looks like it's the right size on your screen.**

 Press Z to grab the Zoom tool and click within your image to zoom in, or Option-click (Alt-click on a PC) to zoom out. To use keyboard shortcuts instead, press ⌘ (Ctrl) and the + or – key to zoom in or out (respectively).

2. **Make a note of the zoom percentage.**

 You can find this percentage in several places: in the document's tab at the top of the screen, in its title bar if you're using floating windows (Figure 2-1 on page 38), and in the status bar at the bottom left of the document window; the last two are circled in Figure 17-1, top.

3. **Open the Image Size dialog box (Figure 17-1, bottom), turn on the Resample checkbox, and set the Resample menu to Automatic.**

 Choose Image→Image Size or press Option-⌘-I (Alt+Ctrl+I) to open the dialog box, and then make sure the Resample checkbox is turned on and the Resample menu is set to Automatic. Happily, this setting means Photoshop chooses the best resampling method *automatically*, so you shouldn't have to adjust it.

FIGURE 17-1

Top: After you use the Zoom tool or keyboard shortcuts to resize your image onscreen, make a note of the zoom percentage shown in the title bar or status bar (both circled). If you're working with tabbed documents instead of the floating windows shown here, you still see the zoom percentage in the document's tab.

Bottom: Next, pop open the Image Size dialog box and set the Width or Height field's unit of measurement Percent. Then enter the percentage in either the Width or Height field. Take a peek at the top of this dialog box to see how much smaller the file size is—instead of the original 5.49 MB, it's now a svelte 351.9 KB.

4. **Set the Width or Height drop-down menu to Percent.**

 Photoshop automatically changes the other menu to match.

5. **Enter the zoom percentage from Step 2 into the Width or Height field.**

 Photoshop automatically constrains the proportions of your image (so it doesn't get squished or squashed), so you only have to enter the percentage in *one* field.

6. **Click OK to close the Image Size dialog box.**

Now you can upload the image to the Web (or fire it off in an email) knowing you did your part to be a respectful web citizen. Your mom would be proud.

TIP To make up for the tiny amount of softening that occurs when you make an image smaller, give it a round of sharpening (see Chapter 11).

Choosing the Best File Format

Once you've resized an image, you need to save it in a format that's not only compatible with both the Web and email, but also reduces it to the smallest possible file size. As you learned back in Chapter 2, those formats include JPEG, PNG, GIF, and WBMP (see Figure 17-2). The one you should pick depends on how many colors are in the image and whether it has any transparent (empty) areas:

- **Use JPEG for photos.** This format supports millions of colors, although, as you learned in the box on page 732, it's a *lossy* format, meaning it throws away fine details in order to create a smaller file. However, you can choose the level of compression when saving a JPEG—whether you use the "Save As" or "Save for Web" dialog box (page 771)—by setting the amount of compression in the Quality drop-down menu (which ranges from Low to Maximum) or by entering a number between 0 and 100 in the Quality field (0 is the most compression and lowest quality; 100 is the least compression and highest quality).

TIP No matter which file format you choose, before you save it, be sure to crop the image as close to the artwork's edges as possible. That way, you shave off extra pixels you don't need. The Image→Trim command is especially handy for this task. In fact, that command was used on *every* figure in this book!

- **Use GIF for images with solid blocks of color.** If you're dealing with line art (black and white with no shades of gray) or images made from areas of solid color (logos, comic strips, and so on), GIF is the way to go (see Figure 17-2). It supports fewer colors than JPEGs, so it doesn't work well on photos or for imagery that has gradients (a smooth transition from one color to another). GIFs can be lossy or not; it's up to you. If you want to make 'em lossy, use the "Save for Web" dialog box's 0–100 scale (it works just the *opposite* of JPEGs: 0 is lossless and 100 is full-on lossy). To make the file smaller without resorting to lossy compression, you can limit the number of colors included in the image to anywhere between 2 and 256 (fewer colors equal a smaller file). You can do

this in either the "Save for Web" dialog box or the Indexed Color dialog box that you get when saving a GIF in the "Save As" dialog box.

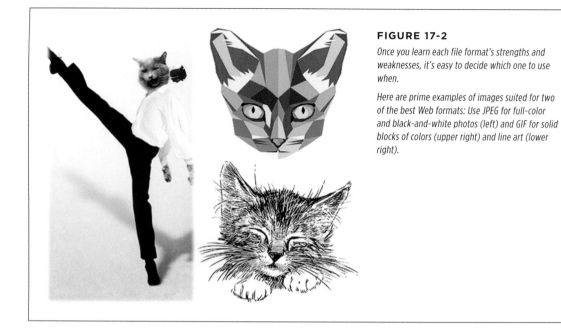

FIGURE 17-2

Once you learn each file format's strengths and weaknesses, it's easy to decide which one to use when.

Here are prime examples of images suited for two of the best Web formats: Use JPEG for full-color and black-and-white photos (left) and GIF for solid blocks of colors (upper right) and line art (lower right).

- **Use GIF or PNG for images with transparent backgrounds.** Use one of these formats when you want a graphic (a logo, say) to blend seamlessly into the background of a web page or presentation slide. If you've painstakingly deleted the background of your image, JPEG won't work since Photoshop *automatically* sticks a solid background behind any empty areas in that kind of file. Only GIF and PNG lets you retain transparent regions.

 The PNG-8 format is *lossless* (meaning it doesn't throw away any details) and can create a higher-quality file at smaller file sizes than GIF. The PNG-24 format supports 256 levels of transparency so it produces the highest-quality transparent image—making it perfect for images containing transparency *and* drop shadows—though the file size is substantially larger than a PNG-8 or GIF. The drawback to PNGs is that some older web browsers—Internet Explorer 6 in particular—don't display transparent PNGs properly and stick a white background behind 'em. PNG is still a relatively newish kid on the file-format block, so this problem shouldn't hang around forever. If you know your Web audience will view your site on outdated browsers, then stick with GIF; if you think they'll have the latest and greatest browsers, go with PNG instead.

- **Use PNG for super high-quality files.** If quality is more important than download speed, save your image as a PNG. For example, if you're a photographer trying to sell your images, use PNG-8 for the enlarged versions in your portfolio so potential clients can see every last detail of the images. (Resist the urge to use PNG-24 unless you need a super-high quality transparent image as mentioned previously, because this format can create files that are *twice* as big as PNG-8.)

- **Use GIF for animations.** If you want to combine several images into an automatic slideshow, save them as an animated GIF. These are handy when you have too much ad copy to fit in a small space on a website; an animated GIF can cycle through the content automatically. You'll learn how to create animated GIFs starting on page 780.

- **Use WBMP (Wireless Bitmap) for black-and-white images headed for mobile devices.** If you're designing black-and-white images for handheld devices like cellphones and smart phones, choose WBMP. This format supports only black and white pixels and gives you crisp text and logos that are readable on those itty-bitty screens.

Saving and Compressing Files

The "Save for Web" dialog box can save an image *and* compress the heck out of it at the same time. It also gives you four big preview windows—one for your original image and three for various file types and compression levels of the same image—so you can monitor the image's quality while you're trying to squeeze it into a smaller file size (see Figure 17-3).

FREQUENTLY ASKED QUESTION

A Farewell to Web-Safe Colors

Do I still have to use web-safe colors in my graphics? That feels so 1990.

Negative, good buddy. Computer monitors have come a long way over the years, and they can now display a much wider range of colors than they used to. Heck, today's iPods display more colors than the monitors of the early '90s! So there's no need to stick with the boring, 256-color web-safe palette anymore.

However, if you're convinced that the majority of your audience is afflicted with prehistoric monitors—ones that can display only 256 colors—you can find the web-safe color palette by turning on Only Web Colors at the Color Picker's bottom left.

You can also convert other colors to their web-safe equivalents by using the Color Table section of the "Save for Web" dialog box (see page 777).

These days, it's more important to make sure you have decent contrast in your images than to worry about web-safe colors. Sure, you can upload images and check their contrast on as many monitors or devices as you can get your hands on, but you can't possibly see how they look on *every monitor* (although the "Save for Web" dialog box can help with that; see page 777). The cold, hard fact is that your images will look darker on some monitors and lighter on others—that's just the way it is. But as long as there's a decent amount of contrast between their darkest and lightest colors, your images will still look good.

Tools Preview tabs Connection speed menu Format Optimize menu

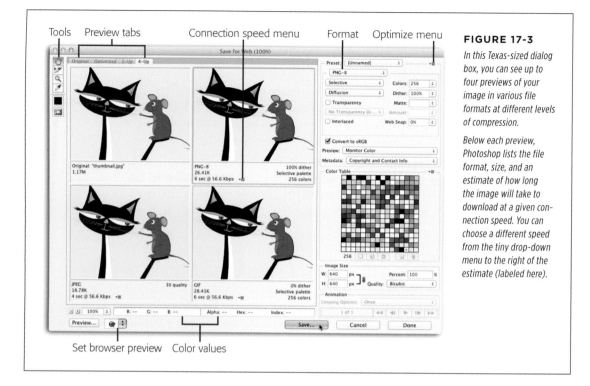

FIGURE 17-3

In this Texas-sized dialog box, you can see up to four previews of your image in various file formats at different levels of compression.

Below each preview, Photoshop lists the file format, size, and an estimate of how long the image will take to download at a given connection speed. You can choose a different speed from the tiny drop-down menu to the right of the estimate (labeled here).

Set browser preview Color values

You saw this dialog box in action when you resized a JPEG back in Chapter 6. To explore even *more* of its settings, follow these steps:

1. **With an image open, choose File→"Save for Web" and then, in the resulting dialog box, click the 4-Up tab.**

 At the top of the dialog box are four tabs that let you view the original image and up to three other versions so you can see what it looks like when you change its settings. The most useful tabs are 2-Up and 4-Up. Pick 2-Up if you already know the format you want to use and 4-Up if you want to make more comparisons. Optimize gives you no comparison at all and shows only the re-sized image, *not* your original.

2. **Click the upper-right preview window and then, from the Preset menu at the top right of the dialog box, choose a file format.**

 The Preset menu contains a list of frequently used file format/compression level combinations for the formats previously mentioned (all of which are discussed later in this section). When you choose one of these options, Photoshop changes the various settings on the right side of the dialog box accordingly, and displays the file size and estimated download time below the preview. (You can change

the connection speed Photoshop uses to calculate the download time by clicking the tiny icon to the right of the listed speed.)

If you don't want to go the preset route, pick a format from the unlabeled drop-down menu *below* the Preset menu, and then adjust the quality/color settings manually, as discussed in the next step.

> **TIP** If you've been experimenting with different file formats in "Save for Web" the dialog box's various preview windows, you can have Photoshop return them all to the *same* format automatically. Click to activate the preview window with the file type you want (say, JPEG) and then head to the dialog box's Optimize menu (labeled in Figure 17-3) and choose Repopulate Views. Photoshop looks at the active preview window's file format and then loads up the *other* windows with previews of the same format at different compression or color settings.

3. **On the right side of the "Save for Web" dialog box, adjust the quality and color settings for the format you picked.**

 Each item in the Preset menu has its own entourage of settings related to quality and color. Different settings appear in the upper-right part of the dialog box depending on the format you chose in the previous step. Here's the lowdown on what they all mean:

 - **JPEG.** This format is the one you'll probably use most often. When you choose one of the Preset menu's JPEG options, you see the following settings:

 — **Quality.** Right below the Format menu is an unlabeled drop-down menu that lets you set the image's compression level. This menu includes five settings that range from Low (highest compression, smallest file size) to Maximum (least compression, largest file size). You can fine-tune the image's quality by using the numeric Quality field to its right; 0 is the highest compression/smallest file size, and 100 is the least compression/largest file size. (The Preset menu changes if you happen to choose a format and quality level combination that matches one of the presets.)

 — **Progressive.** Normally, your computer has to download an image completely before it appears in a web browser, but if you turn on this checkbox, the image loads a little bit at a time (row by row), sort of like a waterfall effect. If your audience is still on dial-up, turn this setting on.

 — **Optimized.** This option creates a slightly smaller, though somewhat less compatible file. Turn it off if your audience is likely to use older browsers.

 — **Embed Color Profile.** If you want the image's color profile to tag along with the file, turn on this checkbox. If the viewer's monitor can actually *read* the profile correctly (some can't), the colors will look more accurate. If the monitor can't read the profile, you've added a

little file size for nothing. However, if color accuracy is really important (say, you're posting images of hair coloring or clothing online for sale), then go ahead and turn on this setting.

— **Blur.** Use this field to add a slight Gaussian Blur to the image to reduce its file size a little. For a decent-quality image, you can get away with a setting of 0.1 to 0.5 pixels, but anything higher looks terrible.

— **Matte.** This color swatch lets you pick a color to use in place of any transparent (or partially transparent) pixels in your image. Since JPEG format doesn't support transparency, those pixels will turn white unless you pick another color here. (Transparency options are discussed on page 775.)

- **GIF and PNG.** You get similar options for both these formats:

 — **Colors.** This menu is the most crucial setting. It controls the number of colors the image contains (they're shown in the Color Table a little lower in the panel). If you reduce the number of colors in the image, you greatly reduce its file size; the downside is that Photoshop substitutes the closest match for any missing colors, which can produce some weird-looking images. Both GIF and PNG-8 let you choose anywhere between 2 and 256 colors. You don't see this menu if you're using PNG-24, though, as that format gives you 16.8 *million* colors and you can't delete a single one of 'em.

 — **Color reduction method.** This unlabeled drop-down menu lives below the Format menu (see Figure 17-3). If you've reduced the number of colors as described in the previous bullet, this menu lets you pick the method Photoshop uses when it tosses them out. From the factory, it's set to Selective, which makes Photoshop keep colors that your eyes are most sensitive to, although it favors colors in large areas (like a sky) and those that are safe for the Web. Selective usually produces the most visually pleasing palette, so feel free to leave this menu alone. But in case you're interested, here's what the other options do: Perceptual is similar to Selective but ignores large areas of color, and Adaptive creates a palette from the most dominant colors in the image (like greens and blues in landscape images and peachy colors in portraits). Restrictive uses only the web-safe palette (see the box on page 771), and Custom lets you modify the color palette yourself (eek!), using the Color Table section of the panel. Choose "Black – White," Grayscale, Mac OS, or Windows to use those respective color palettes.

 — **Dither method and amount.** If your image contains colors that the viewer's monitor can't display, you can fake 'em with a process called *dithering*. As of this writing, only a tiny number of web users' monitors are still limited to 256 colors, so you can leave dither turned off (you'll end up with a smaller file size by doing so). But if for some reason you

want to turn it on—say, the image you're saving includes a *gradient* and you're seeing some color banding in the preview—here's how: Use the unlabeled drop-down menu to the *left* of the word "Dither" to choose a dither method (or to turn dithering on or off), and the numeric field to its *right* to set the amount. A high dither amount produces more accurate colors; the tradeoff is larger file size (try a setting between 80 and 90 percent). If you're desperate to make the file smaller, lower the dither amount.

You can choose from three dither methods: Diffusion simulates missing colors with a random pattern that's not too noticeable, so it's usually the best choice. Pattern simulates missing colors with a square pattern (which can sometimes create a weird color seam), and Noise uses a random pattern that doesn't spread across nearby pixels (so you won't get a weird seam). If you choose No Dither, Photoshop won't fake any colors.

— **Transparency and Matte.** If you've deleted the image's background, turn on the Transparency checkbox. If you want to change partially transparent pixels (those around the edges; see Figure 17-4) to a certain color, click the Matte swatch, and then choose a color from the Color Picker. You can also choose a matte color from within your image by choosing Eyedropper Color from the Matte menu. Then grab the Eyedropper tool at the far left of the dialog box—*not* the one in Photoshop's main Tools panel—and then, in the dialog box, click the image; whatever color you clicked shows up on the left side of the dialog box in the color swatch beneath the Eyedropper tool's icon. Use the drop-down menu below the Transparency checkbox to turn dithering on or off for any partially transparent pixels around the matte color, and use the numeric field to its right to set that dither amount. (You'll typically leave transparency dithering off.)

> **NOTE** If you've masked (hidden) your image's background by using the Refine Edge dialog box's Color Decontamination feature, this whole Matte color business is less of an issue. Flip back to page 181 for the scoop on using the Refine Edge dialog box.

— **Interlaced, Web Snap, Lossy.** Turn on the Interlaced checkbox to make your image appear a little at a time in your visitor's web browser. If you want to convert the image's colors to the web-safe color palette (see the box on page 771), use the Web Snap setting (the higher the number, the more web-safe colors you get). The Lossy setting (which is available only for GIF format, not PNG) lets you lower the image's quality to make the file smaller. You'll typically leave these settings turned off or set to 0, but feel free to experiment with them if you're feeling frisky.

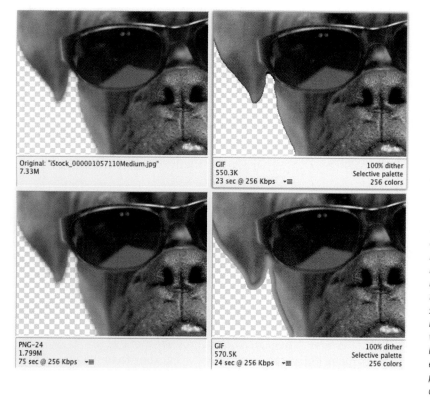

FIGURE 17-4

The edges of a transparent image with a drop shadow look better as a PNG-24 (bottom left) than a GIF (top right) because PNGs can display more colors and partially transparent pixels. But, as the file sizes beneath each preview show, the PNG is larger. If file size is more important than quality, use the Matte menu to change the shadow's partially transparent pixels to the color of your destination background (here that's blue, shown at bottom right). This trick makes the shadow look nice and soft because Photoshop mixes the matte color with the shadow. It also keeps you from seeing edge halos—leftover pixels from the image's original background.

- **WBMP.** If you've made a black-and-white image that's destined for a cellphone or other handheld device with an itsy-bitsy screen, choose this format from the unlabeled drop-down menu below the Preset menu. Since this format deals only with black and white pixels, you just need to decide whether to turn on dithering (to fake colors the viewer's screen can't display with shades of gray) and, if so, the amount. For the best results, choose Diffusion as the dither method and then shoot for the lowest percentage possible that lets you maintain some detail in the image.

TIP If you're saving a graphic that has to be a certain size (like a Web banner ad), you can choose "Optimize
to File Size" from the Optimize menu (labeled in Figure 17-3). In the resulting dialog box, enter the target size
and pick a Start With option. Choose Current Settings to make Photoshop use the settings in the "Save for Web"
dialog box. If you want Photoshop to pick a format, choose Auto Select GIF/JPEG instead. If you're dealing with
an image that contains slices (page 787), you can choose to optimize the current slice, each slice, or all of 'em.
When you click OK, Photoshop tries to make the image as close to your target size as possible. You may still have
some tweaking to do afterward, but the program does most of the work for you.

4. **Make sure the "Convert to sRGB" checkbox is turned on.**

 This option tells Photoshop to convert the image to sRGB, a color space designed
 to mimic the characteristics of a Windows monitor. Since the majority of moni-
 tors are attached to Windows computers, that's what you want.

5. **Use the Preview drop-down menu to see what the image looks like on a Mac
 or Windows computer with no color management or with the document's
 current color profile.**

 This setting doesn't change your image; it just lets you see it through the eyes
 of someone with a different monitor. From the factory, this menu is set to
 Monitor Color, so you see the image exactly as your monitor sees it. Choose
 Legacy Macintosh (No Color Management) to check what it looks like on a Mac
 running OS X 10.5 (Leopard) or earlier, and Internet Standard RGB (No Color
 Management) to check what it looks like in Windows or on a Mac running OS X
 10.6 (Snow Leopard) and later. (Windows monitors make images look darker
 than Macs due to a difference in *gamma* value. So if you're designing images
 for the Web on a Mac, it's worth choosing Internet Standard RGB here to see
 how dark they'll look.) If the image has a color profile attached to it, choose
 Use Document Profile to make the preview match.

6. **Set the Metadata menu to "Copyright and Contact Info."**

 This menu lets you include the information Photoshop captured from your
 camera (metadata) or the copyright and contact info you stored using the File
 Info dialog box (File→File Info). As you might suspect, including data in your
 document increases its file size a hair, but it's a good idea anyhow so your im-
 age includes info about where it came from; otherwise it can appear *orphaned*
 (visit Wikipedia.com and search for "orphan works" for more on this topic).

7. **If necessary, use the Color Table to edit the colors in your image.**

 This chart of color swatches lets you change or delete colors in your image
 (the number at the table's bottom left tells you how many colors the image
 contains). If your viewers are certain to have super old monitors, use the tiny
 menu near the table's upper right to shift the colors in a GIF or PNG-8 image
 to web-safe colors. If you need to make the file even smaller, you can delete
 colors by clicking the swatch you want to zap and then clicking the little trash
 can icon below the Color Table (shown in Figure 17-3). To make a certain color
 transparent, choose its swatch and then click the transparency button below

the table (it looks like a white-and-gray checkerboard). To shift a color to its closest web-safe equivalent, click the little cube. And to prevent a color from being tossed, click the tiny lock.

8. **When you're finished, click Save.**

 Photoshop opens the Save dialog box so you can pick a name and location for the new file.

TIP If you decide you've got some image editing left to do but you want Photoshop to remember your current settings, click Done instead.

The left side of the "Save for Web" dialog box contains these tools:

• **Hand.** This tool lets you move the image around within the dialog box's preview windows. You can also press the space bar (or H) to activate it and then drag to see another part of the image.

• **Slice Select.** If you've mocked up a web page and sliced it accordingly (see page 787), use this tool to choose slices you want to save in specific formats. Keyboard shortcut: C.

• **Zoom.** You can use this tool to zoom in and out of your image, though it's faster to press ⌘-+ or – (Ctrl-+ or – on a PC). Alternatively, in the field at the dialog box's bottom left, enter a zoom percentage or pick a preset from the drop-down menu. You can also Control-click (right-click) within the preview window, and then choose a zoom percentage from the shortcut menu. Keyboard shortcut: Z.

• **Eyedropper.** Use this tool to snatch colors from the image in the dialog box's preview area, which is helpful when you're creating a matte color for a transparent background as discussed on page 774. Keyboard shortcut: I.

• **Eyedropper Color.** This color swatch shows the Eyedropper's current color.

• **Toggle Slices Visibility.** To see the slices in your image, click this button. (Slicing is discussed starting on page 787.) Keyboard shortcut: Q.

And finally, here's what the buttons at the bottom of the dialog box do:

• **Preview.** To see what the image looks like in a web browser, click this button. Photoshop automatically uses the main browser on your computer, but you can choose a different one by choosing Other from the drop-down menu to the Preview button's right. In the Preview In Other Browser dialog box, find the browser you want, and then click Open. The next time you click the Preview button, Photoshop uses the browser you just picked.

- **Save, Cancel, Done.** Once you have the dialog box's settings just right, click the Save button to save the image and give it a name. If you want to bail and do nothing, click Cancel instead. Clicking Done makes Photoshop remember the current settings and close the dialog box. Holding Option (Alt on a PC) changes the last two buttons to Reset and Remember, respectively. Click Reset to revert all the dialog box's settings to the last ones you saved (in other words, what they were the last time you clicked the Save button). Clicking Remember makes Photoshop use your current settings the next time you open the "Save for Web" dialog box (whether you click Save or not).

Matching and Snatching Colors on the Web

If you're designing an image destined for an existing web page, you may find yourself in a color-matching conundrum. If you need to match the color scheme or colors in a company logo, you can do that by finding out the colors' *hexadecimal* values.

Hex numbers, as they're affectionately called, are six-digit, alphanumeric programming codes for color values. The first two digits represent red, the next two represent green, and the last two represent blue (since your image will appear only onscreen, RGB values are the only ones that matter). You can find a color's hex number in several different ways:

- If you've gotten your hot little hands on an HTML, CSS, or SVG file from the website you're trying to match, Photoshop can automatically import color info for you as swatches. (Those names stand for HyperText Markup Language, Cascading Style Sheets, and Scalable Vector Graphics, respectively.) Choose Window→Swatches, and then pick Load Swatches or Replace Swatches from the Swatches panel's menu. In the resulting dialog box, navigate to where one of those files lives, and then click Open. Magically, Photoshop creates a swatch out of every hex number it finds in that file.

- Grab the Eyedropper tool by pressing I, and then click a color in an open Photoshop document to load it as your foreground color. Next, choose Window→Color to open the Color panel and then, from the panel's menu, choose Copy Color's Hex Code. You can also choose "Copy Color as HTML" from the same menu; it does the same thing except that it adds the HTML tag "Color" to what's copied to your computer's Clipboard.

- Using the Eyedropper tool, click a color in an open Photoshop document and then click your foreground chip to open the Color Picker. The color's hex number appears at the bottom of the dialog box in the field labeled #.

- Choose Window→Info and, from the Info panel's menu, choose Panel Options. In the dialog box that appears, set the Mode menu to Web Color, and then click OK. After that, when you mouse over a color in your Photoshop document, its hex number appears in the Info panel no matter which tool is currently active.

- Using the Eyedropper tool, Control-click (right-click) any color in an open Photoshop document. From the resulting shortcut menu, choose Copy Color's Hex Code.

- Snatch color from *anywhere* on your screen, whether it's on your desktop or in a web browser. In Photoshop, click your foreground color chip to open the Color Picker, mouse over to your document, and then click and hold your mouse button down *while you're in the Photoshop window* and keep it held down as you mouse *outside* Photoshop. Point to the color you want to snatch *and then* release your mouse button. As long as you first click *within* Photoshop, your cursor remains an eyedropper no matter where you drag it. (You can do the same thing with the Eyedropper tool or by pressing and holding Option [Alt] while using the Brush tool.)

Once you've captured the hex number, you can enter in the # field at the bottom of the Color Picker, or paste it into your favorite HTML editor when you're building the web page.

Animating a GIF

You may think that creating an animation is a complicated process, but it's really not. In Photoshop, all you do is create a slideshow that plays automatically. You can control which images the program uses, how long it displays each one, whether it *loops* the slideshow (automatically starts over), and so on.

This kind of control is really handy when you're making website ads. For example, say you're designing a 140 × 140-pixel ad for a costume shop, and you need to include a logo, a few costume samples, and a 10% off coupon. Since you'll *never* fit all that into a tiny space, you can make an animated GIF that *cycles* through several images automatically. Here's how:

1. **Create a new document in the sRGB color workspace that's the size you want the animation to be.**

 Since sRGB is the predominant color space used on the Web, it's helpful to *design* in that color space, too (doing so prevents colors from shifting when you save the GIF using the "Save for Web" command). Choose File→New. In the resulting dialog box, enter the size of your animation in the Width and Height fields, choose sRGB from the Color Profile menu, and then click OK.

2. **Create the images you want to string together, putting** *each image on its own layer* **within the document you created in Step 1.**

3. **Open the Timeline panel by choosing Window→Timeline, and then create a frame animation.**

 At the bottom of the Photoshop window (or near the bottom of your screen if you've got the Application Frame turned off on a Mac), a long horizontal Timeline panel appears. This panel *also* has controls for video editing (see Chapter 20), so you need to switch it to animation mode by clicking the downward-pointing triangle to the right of the Create Video Timeline button (Figure 17-5, top). Choose Create Frame Animation, and then click the Create Frame Animation button to the triangle's left. Photoshop then creates a single frame representing what's currently visible in the Layers panel—each frame serves as a *placeholder* for the image you want to show onscreen.

4. **Add another frame.**

 At the bottom of the Timeline panel, click the "Duplicate frame" icon (it's labeled in Figure 17-5, middle) to create a new placeholder for the next image in your animation. Initially, it contains the same image as the starter frame—don't worry; you'll fix that in the next step.

5. **In the Layers panel, use the visibility eyes to display only the layer containing the** *next* **image in your animation.**

 When you turn off the visibility of every layer *except* the one you want to show next, Photoshop displays the visible layer in the frame you created in Step 3.

That's all there is to it! There's no dragging or dropping, just showing and hiding using the layers' visibility eyes.

6. **Repeat Steps 3 and 4 until you've made all the frames of your animation.**

7. **Click the Play button to see the slideshow.**

Photoshop displays your animation in the main document window. The images flash by quickly, but don't worry—the next section explains how to make 'em stick around longer.

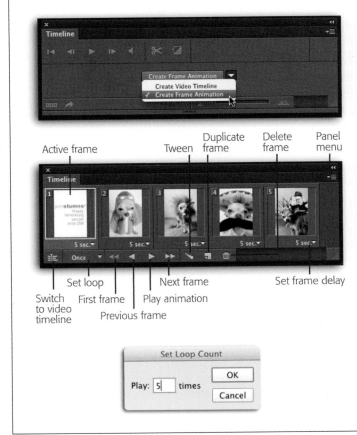

Active frame Tween Duplicate frame Delete frame Panel menu

Switch to video timeline Set loop First frame Previous frame Play animation Next frame Set frame delay

FIGURE 17-5

Top: The Timeline panel does double-duty for both video and animation, so you have to use the menu shown here to tell it which one you want to work with. Click the button to its left to apply your choice, and Photoshop sets up the panel accordingly.

Middle: Use the playback buttons at the bottom of the panel to move through your animation frame by frame. Photoshop highlights the active frame, as shown here. You can click a different frame to activate it.

Bottom: Open this dialog box by clicking the Set Loop triangle (labeled in the middle image in this figure) and choosing Other. This dialog box lets you determine how many times the animation plays. If you really want it to keep playing without stopping (yikes!), choose Forever.

You just created your first animated GIF! There's still some work to do, but you're more than halfway there.

NOTE Photoshop lets you open animated GIF files and preserves the individual frames from which they're made. This is *extremely* helpful when you need to edit an existing animation and don't have the original files. In other words, you don't have to start from scratch.

Editing Your Animation

Once you've created all the frames in your animation, including branding (a logo, say) and a call to action ("Click here to save 20%!"), you can edit it in the following ways:

- **Frame delay.** To control the length of time each image is visible, use the drop-down menus at the bottom of each frame (Figure 17-5, middle). These menus include options ranging from No Delay to 10 seconds. If you want to use a duration that's not listed, choose Other and then type a number in the Set Frame Delay dialog box. You can set the duration for each frame individually, or change several at once by Shift- or ⌘-clicking (Ctrl-clicking) to activate them, and then changing the duration of *one* of 'em.

- **Set loop count.** To make the animation play over and over, you can set it to loop a certain number of times. Click the down-pointing triangle at the bottom left of the Timeline panel and choose Once, 3 times, Forever, or Other (3 times is a safe choice). If you choose Other, Photoshop opens the dialog box shown in Figure 17-5 (bottom), where you can enter any number you want.

- **Rearrange frames.** To change the frames' order, simply click and drag them left or right. Easy peasy!

- **Delete frames.** Just like most panels in Photoshop, this one has its own little trash can icon. To zap a frame, activate it and then either click the trash can or drag the frame onto the trash can. To delete more than one frame, activate 'em by Shift- or ⌘-clicking (Ctrl-clicking) them, and then click the trash can. In the resulting "Are you sure?" dialog box, click Yes. Alternatively, choose Delete Frame from the Timeline panel's menu.

- **Tween frames.** At first, there isn't any transition between your frames; each one abruptly gives way to the next. To make the frames fade in and out, you can add *tweening* (short for "in-betweening"). Just tell Photoshop *which* frames to tween, along with how many frames of fading you want, and it adds the new frames for you. When you play the animation, the frames blend into one another.

 Be aware that each frame you add increases the animation's file size, so if you're trying to keep it lean and mean, don't add a ton of tweened frames. Instead, try adding 3 tweened frames *only* where it makes sense, such as in between a branding frame and a call-to-action frame, or a blank frame to a branding frame, as shown in Figure 17-6.

> **NOTE** Tweened frames take on the duration settings of the *first* frame, so once you start adding 'em, you may need to speed up the whole animation's frame duration so it doesn't take forever to play!

You can create all kinds of special effects using tweening. It's all about setting up a layer for each frame, creating the frames, and then adjusting what you want to happen *between* each frame. For example, if you move the contents of a layer in one frame, you can use tweening to make it look like the object is moving. You can also

turn layer styles on or off, add solid-colored frames to make the animation look like it fades into that color, and so on. The creative possibilities are endless!

FIGURE 17-6

To fade one frame into another, activate the first one and then click the Tween button (circled). In the resulting dialog box (top), choose Next Frame from the Tween With menu, enter 3 in the "Frames to Add" field, and then click OK.

Here, Photoshop added three frames (numbered 12–14) that gradually change opacity from a "blank" frame (solid white with a pink border) to a branding slide at the end. When you play the animation, it'll look like the frames fade together.

Saving Your Animation

When you've got the animation just right, you need to do a couple more things before you post it on the Web. Save it as a Photoshop (PSD) document so you can go back and edit it later, and then do the following:

- **Optimize it.** From the Timeline panel's menu, choose Optimize Animation to create a slightly smaller file, which makes the animation download faster and run more smoothly. The resulting Optimize Animation dialog box has two settings:

 - **Bounding Box** crops each changed frame to the part that's different from the previous frame. This is like running the Trim command on each frame, so that each one is cropped closely to the content.

 - **Redundant Pixel Removal** turns unchanged pixels transparent in subsequent frames, making the file a little smaller.

 Both settings are turned on straight from the factory, but Photoshop doesn't *apply* them until you choose Optimize Animation and then click OK.

- **Save it as an animated GIF.** Last but not least, choose File→"Save for Web" and, in the upper right of the resulting dialog box, choose GIF from the unlabeled format drop-down menu (below the Preset menu). When you do, Photoshop activates the Animation section at the bottom right of the dialog box, giving

you one last chance to change the Looping Options setting and preview your handiwork. When you've finished, click Save and exclaim, "I'm an *animator!*"

Designing a Website Favicon

You know those tiny little icons on the left edge of your web browser's address bar (Figure 17-7)? They're called *favicons*—short for "favorites icons"—and they're great for adding a bit o' branding to web pages. They show up not only in web browsers, but also in news feeds (clickable headlines from your favorite websites that you can access through a newsreader program or your browser). Creating them in Photoshop is a snap, and you'll be designing them like a pro after you read this section.

FIGURE 17-7

Here are the favicons for a couple of websites (circled), though you may have to squint to see 'em!

Creating favicons is a good way to test your design skills, since you're limited to just 16 pixels square.

The first step is to spend some quality time looking at other sites' favicons. Your goal is to brand your website with a graphic that's exactly 16×16 pixels—no more, no less. It's tough to design anything that small that's recognizable, but it *can* be done. For example, you might use a portion of your logo rather than the whole thing, or your company's initials rather than its full name.

Next, you need to download a plug-in that lets Photoshop save the file in the Windows Icon (ICO) file format. The free plug-in ICO Format is a good option: *www.telegraphics.com.au/sw*. Once you expand the file you downloaded (by double-clicking it), drag the file named "ICOformat.plugin" into the Plug-ins folder inside the Photoshop CC application folder. Then quit and relaunch Photoshop to load it.

> **NOTE** When you save a perfectly square document that's 256 pixels or smaller, you'll see only ICO (Windows Icon) listed in the Save As dialog box's format menu. This is helpful to keep in mind if you're checking to see whether the plug-in was *really* installed after relaunching Photoshop.

Now you're ready to create your teeny-weeny work of art. Here's how:

1. **Create a new document that's 64 × 64 pixels with a resolution of 72.**

 Choose File→New or press ⌘-N (Ctrl+N) to start a new document. Your favicon will *ultimately* be 16 × 16 pixels, but that's too small a size to work with initially. To save yourself some eyestrain, start with a 64 × 64-pixel canvas; you'll reduce its size later.

2. **Create or place your artwork in the new document.**

 If you designed a logo by using Adobe Illustrator, choose File→Place to add it as a smart object. If you're creating the artwork in Photoshop, be sure to turn off the anti-alias setting of whatever tool(s) you use to create it so the edges are nice and crisp (this is *especially* important when creating tiny text).

3. **If necessary, resize the artwork to fit the canvas.**

 If you added your artwork as a smart object, Photoshop automatically surrounds it with resizing handles. If you went another route, you can resize it by pressing ⌘-T (Ctrl+T) to summon Free Transform, and then dragging one of the corner handles. When you're happy with the size, press Return (Enter) to let Photoshop know you're done.

4. **Resize the document.**

 When your design is finished, choose Image→Image Size. Make sure the Resample checkbox is turned on, and then set the Width or Height field to 16 pixels. Photoshop automatically changes the *other* field to 16, too, provided the "Constrain aspect ratio" icon is turned on (it is unless you've turned it off). Click OK.

5. **Sharpen the image, if needed.**

 If your design looks a bit blurry, run a sharpening filter on it (see Chapter 11).

6. **Save the file in the ICO format and name it *favicon*.**

 Choose File→Save As, pick ICO (Windows Icon) from the format drop-down menu at the bottom of the dialog box, and then click Save. (Remember, you see this format only when saving a perfectly square document.)

That's it! You've created your very first favicon. If a client asked you to create the favicon and send it to her, email her the *favicon.ico* file. If you created it for your own site, you're ready to upload the file to the root level of your website, where your index (home) page lives. (If you have no idea what that last sentence means, check out *Creating a Website: The Missing Manual, Third Edition* by Matthew McDonald at *www.lesa.in/websitemm3*).

Be aware that not *all* web browsers support favicons, and some even want you to bury a link to the favicon in the code of each page. If you want to perform that extra step, insert the following code somewhere within the <head> section of your web pages:

```
<link rel="SHORTCUT ICON" href="/favicon.ico">
```

If you've got a multi-page website, adding that line of code can be time consuming, so you may want to use the "Find and Replace" command found in most HTML editors, which lets you search for a piece of code that appears in every page, like the closing </title> tag. For example, you could search for </title> and Replace it with </title><link rel="SHORTCUT ICON" href="/favicon.ico">.

NOTE Another fun exercise is to design your own custom Twitter page. Since this book can only hold so many techniques, that tutorial lives on this book's Missing CD page at *www.missingmanuals.com/cds*.

Creating Web Page Mockups and Image Maps

As you've learned throughout this book, Photoshop is an amazingly powerful image editor, which means it's great for designing web pages. In fact, Photoshop has a tool that'll let you *slice* your design into web-friendly pieces that, when clicked, lead to whatever web address you link them to. Photoshop churns out the proper code that you can then paste into your own web page using your favorite HTML editor.

But does all that mean you *should* use Photoshop to build a website? Heck, no! Remember how back in Chapter 14 you learned that, even though Photoshop has a powerful text tool, you shouldn't use it to write a book? The same principle applies here. While you *could* use it to build real web pages, you shouldn't; you're much better off using a program designed for the job, like Adobe Muse (which can import individual layers from a PSD), Adobe Edge, or Dreamweaver. That said, Photoshop's Slice tool comes in really handy in the following situations:

- **Building a website prototype.** If you've designed a website for a client in Photoshop and want to give him an *idea* of how the site will look and behave, you can use the Slice tool to get that done fast. If you slice up your design and assign different hyperlinks to navigation bars, you can give the client a good sense of how the navigation in the final website will *feel*.

TIP For an even *more* realistic mockup, create the website's text using Photoshop's "make it look exactly like it will in popular web browsers" anti-aliasing option: Mac LCD or Windows LCD. See page 639 for details.

- **Making an image map.** The Slice tool lets you add hyperlinks to certain portions of a single image.

- **Making an image-heavy page load a bit faster.** Chopping images into pieces makes them load a little at a time instead of in one big piece. However, this is becoming less necessary as more people get faster Internet connections.

TIP As mentioned earlier, Muse can import individual layers, alleviating the need for any slicing and dicing.

Slicing an Image

Once you've created an image or design that you want to chop up, you can use the Slice tool to draw the pieces by hand, or make *Photoshop* create slices from individual layers by choosing Layer→New Layer Based Slices. You can also make Photoshop slice an image according to guides you've drawn (discussed later in this section).

Here's how to slice and dice a web-page mockup with guides:

1. **Turn on Photoshop's rulers and draw guides around the areas you want to slice.**

 Instead of drawing each slice yourself, make Photoshop do the hard work by dragging a few well-placed guides around each slice you want to create. Turn on rulers by pressing ⌘-R (Ctrl+R), and then click within the horizontal ruler and drag down to create a horizontal guide. Do the same thing in the vertical ruler (but drag right instead) to create vertical guides until you've placed a guide around every slice you want to make, as shown in Figure 17-8.

2. **Press C to grab the Slice tool.**

 This tool, which looks like a tiny X-Acto knife, hides in the crop toolset (it's circled in Figure 17-8).

FIGURE 17-8

Here, Photoshop created slices from the guides. A bounding box and a tiny number appear at the top left of each slice; Photoshop numbers them beginning at the document's top left and working down to the bottom right. If you draw the slices yourself, the number appears in a blue box. If you make Photoshop draw the slices, the number appears in a gray box instead (not shown).

3. **Trot up to the Options bar and click Slices From Guides.**

 Photoshop draws slices around the areas you specified, following the guides you placed in Step 1.

If you decide *not* to use guides, you can slice areas yourself by clicking where you want the slice to begin and then dragging diagonally to the right. (To draw a perfectly square slice, hold Shift as you drag.) When you let go of your mouse button, Photoshop puts a blue bounding box around the slice, as shown in Figure 17-8. Slices created this way or with guides are called *user slices*.

Alternatively, you can choose Layer→New Layer Based Slice to make Photoshop create a slice out of whatever is on the active layer (say, a button graphic). If you go that route, you get a (you guessed it) *layer-based slice*. To account for the rest of your image (the areas you haven't yet sliced), Photoshop draws other slices (called *auto slices*) and marks them with gray bounding boxes. Auto slices are discussed in the next section.

> **TIP** If you've drawn a slice that's perfectly suited for another graphic, you can *duplicate* it by Option-dragging (Alt-dragging on a PC) the slice onto the other image.

Modifying Slices

Once you create a slice, you may need to move or change it. If so, activate it by using the Slice Select tool. (Press Shift-C to activate the tool or, if the Slice tool is active, you can grab the Slice Select tool temporarily by pressing ⌘ [Ctrl]; when you let go of that key, Photoshop switches back to the regular Slice tool.) To activate a slice, just click it. Its bounding box turns brown and little resizing handles appear in the center of each side, as shown in Figure 17-9.

UP TO SPEED

The Copy CSS Command

As you read on page 786, Photoshop really isn't the place to *build* a website (it's no HTML editor). However, it's the *perfect* place to design all the text and graphics that are destined to live on a website. For example, you can use type layers full of placeholder text (see the Tip at the top of page 622) to figure out exactly how big the text should be, what font and colors work best, and so on. Likewise, you can use shape layers to create all manner of colored bars, buttons, and background elements, complete with layer styles—drop shadows, strokes, and the like.

When you get everything designed just right in Photoshop, you can copy the formatting and page positioning of the content in any type or shape layer, and then paste it into the program you'll (wisely) use to build the site (like Muse, Adobe's visual HTML editor). Simply Control-click (right-click) near any type or shape layer's name in the Layers panel, and then choose Copy CSS. Photoshop analyzes that layer's content, copies the info to your computer's memory, and automatically formats it for Cascading Style Sheets (CSS)—programming code that controls the formatting and positioning of elements across web pages. What a huge timesaver!

New in Photoshop CC 2014 is the ability to copy the CSS of a shape layer's *inner shadow*. You can't do that on a text layer, though, but you *can* copy the CSS of a text layer's drop shadow.

FIGURE 17-9

*When you activate a
slice (bottom), all kinds
of buttons appear in the
Options bar, as shown
here (top).*

*These options are all
discussed in detail over
the next few pages.*

Arrange slices Slice Options

Now you're ready to:

- **Resize the slice.** Once you activate a slice, you can drag any of its corner or center handles (they look like tiny squares) to make it bigger or smaller.

- **Move the slice.** Click within the slice and then drag it to another location. To make it so you can drag the slice only horizontally or vertically, hold the Shift key while dragging.

TIP To make your slices to snap to guides, other slices, or objects, choose View→Snap To. (Unless you've previously turned it off, this setting is already turned on.)

- **Promote slices.** You can change a layer-based or an auto slice into a user slice by clicking the Options bar's Promote button (Figure 17-9, top). This is useful because you can't *edit* auto slices. For example, if you placed guides and had Photoshop create the slices for you, as described in the previous section, you can't move or resize any of those slices until you promote 'em to user slices (as shown in Figure 17-10). Similarly, layer-based slices are tied to the pixel content of that layer. Before you can change the slice itself or the layer's contents, you have to promote it to a user slice.

- **Arrange slices.** Because the Slice tool draws only rectangles, you have to overlap slices to make other shapes. To do that, you may need to fiddle with their stacking order by first activating a slice with the Slice Select tool, and then clicking the arrange buttons labeled in Figure 17-9, top.

FIGURE 17-10

Notice that the auto slices around the document's edges are tagged with gray icons while the user slices are tagged with blue ones.

Promoting auto slices to user slices lets you do things like divide them, as was done in the pink navigation bar shown here. (To see the difference, compare this screenshot to the one in Figure 17-8.)

- **Align slices.** Photoshop lets you align slices just like you can align layers. Using the Slice Select tool, Shift-click to activate *more* than one slice, and then click one of the alignment icons in the Options bar. (If just one slice is active, these icons are dimmed.)

> **TIP** To change the color of the slice lines, choose Photoshop→Preferences→"Guides, Grid & Slices" (Edit→Preferences→"Guides, Grid & Slices" on a PC). In the Slices section at the bottom of the dialog box, use the Line Color menu to pick a new color. You can turn off the Show Slice Numbers checkbox here, too.

- **Divide slices.** If you need to slice a slice (oy!), activate it with the Slice Select tool, and then click the Options bar's Divide button. In the Divide Slice dialog box, turn on either the Divide Horizontally Into or the Divide Vertically Into checkbox, enter the number of slices you want to create, and then click OK.

- **Combine slices.** Activate two or more slices by Shift-clicking with the Slice Select tool. Then Control-click (right-click) one and choose Combine Slices from the resulting shortcut menu. This technique is helpful when Photoshop creates too many auto slices and you want to combine 'em so they'll load as a single image.

- **Copy and paste slices.** You can copy and paste a slice by activating it and then pressing ⌘-C (Ctrl+C). Next, open the target document and press ⌘-V (Ctrl+V). The slice and graphics from the associated layers appear in your new docu-

ment, but they're all on one layer, which means you can't edit 'em individually (although you can back in your original document).

- **Add a link.** To transport visitors to a particular web address when they click a slice, activate the slice, and then click the Slice Options icon labeled in Figure 17-9 or double-click the slice itself. In the resulting Slice Options dialog box, enter the *full* web address into the URL field (for example, *http://www.petstumes. com*). The next section discusses this dialog box in detail.

- **Delete it.** To delete a slice, activate it with the Slice Select tool, and then press Delete (Backspace on a PC).

- **Hide.** If you find all those slice borders and numbers distracting, you can hide 'em temporarily by pressing ⌘-H (Ctrl+H)—unless you're on a Mac and have reassigned that keyboard shortcut to hide Photoshop, as described in the box on page 8.

- **Lock.** To lock all your slices so they can't be changed, choose View→Lock Slices (you can't lock individual slices).

- **Clear.** To get rid of all your slices (but not the images, of course), choose View→Clear Slices.

To forget you ever *heard* of slices, hire a web designer (kidding…sort of!).

■ SLICE OPTIONS

Once you've drawn slices and put them in the right spots, you can start controlling how they behave in your web browser. To do so, in the Options bar, click the Slice Options icon labeled in Figure 17-9. Photoshop opens the Slice Options dialog box (Figure 17-11), which lets you control the following:

- **Slice Type.** Most of your slices probably consist of an image, although they can also be solid blocks of color or plain text. To create an empty space that you can fill with HTML color or HTML text later, choose No Image from this drop-down menu, and a "Text Displayed in Cell" field appears that lets you enter text that'll be—you guessed it—displayed in that cell (the empty space).

- **Name.** Photoshop automatically gives slices generic names that include the document name and a number. To use a name that's more descriptive (and useful), enter it here.

- **URL.** One of the big benefits of slicing an image is that you can make part of it act as a *hyperlink* that takes visitors to another web page. Enter the full web address here to make that happen. Photoshop doesn't actually embed this info into your image; instead, it stores it in a separate HTML file that you can copy and paste into your *own* web page using an HTML editor.

> **NOTE** Assigning a hyperlink to part of an image is called *creating an image map*. Now if you hear image maps mentioned at the water cooler, you'll be in the know!

- **Target.** This field determines where the hyperlink opens. For example, to make the hyperlink open the website in another browser window, enter _blank into this field (complete with underscore). If you want the page to load within the same window, then leave this field blank.

FIGURE 17-11

To open this dialog box, click the Slice Options icon on the right side of the Options bar (it's labeled back in Figure 17-9). These settings let you assign a descriptive name and web address to each slice.

You can also open this dialog box by double-clicking a slice with the Slice Select tool.

- **Message Text.** Almost every web browser has a status bar at the bottom of the window that lets folks know what's going on in the background. For example, when you type a web address into your browser's address bar and then press Return (Enter on a PC), you'll see some kind of "loading" message. If you want to include messages in the status bar (like a love note to your visitors: "Thanks for clicking!"), enter it in this field. But since few folks ever look down that far, your efforts may be in vain.

- **Alt Tag.** Because some folks browse the Web with graphics turned *off* (to make sites load faster), you can use this field to give your image a text description. Visually impaired people using *web readers*—special software that speaks the contents of web pages—will hear this text read to them. The text also pops up as a balloon or tooltip when visitors point to the image with their cursors.

- **Dimensions.** This info lets you know the width and height of your slice, along with its X and Y coordinates.

- **Slice Background Type.** If you chose "No Image" in the Slice Type menu or if part of the image is transparent, you can use this menu to give the slice a color. Your choices are None, Matte (page 775), White, Black, and Other (which summons the almighty Color Picker).

Saving Slices

Once you've set all the options for your slices, it's time to save them to use on the Web (finally!). Use the File→"Save for Web" dialog box to set all the file-type, compression, and other options discussed earlier in this chapter. (If you use File→Save As, all your slice options will fly right out the window.)

If you're building a website *prototype*, choosing one file format for the whole design works just fine. But if you want to apply different format and compression settings to each slice, you can—just grab the Slice Select tool on the left side of the "Save for Web" dialog box and go wild. When you're finished, click Save and tell Photoshop where you want to store the files. If you've assigned web addresses to the slices, be sure to choose "HTML and Images" from the Format drop-down menu at the bottom of the Save Optimized As dialog box, as shown in Figure 17-12. (Then make sure to change the Format menu *back* to Images the next time you use the Save Optimized As dialog box.)

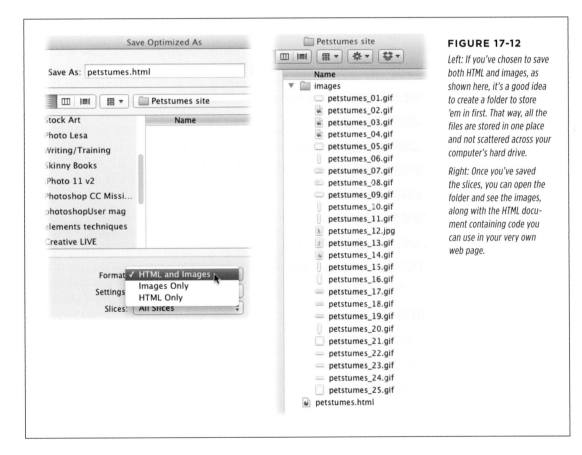

FIGURE 17-12

Left: If you've chosen to save both HTML and images, as shown here, it's a good idea to create a folder to store 'em in first. That way, all the files are stored in one place and not scattered across your computer's hard drive.

Right: Once you've saved the slices, you can open the folder and see the images, along with the HTML document containing code you can use in your very own web page.

◼ Exporting Web Graphics with Generator

Once you finish designing the imagery you'll use on a website, you need to *export* those graphics from Photoshop so you can use them in the web-design program of your choice. Photoshop makes this export chore a lot easier with *Generator*, a fairly new feature that lets you generate (hence the name) graphics in a variety of web-friendly formats—JPEG, PNG, and GIF—and even control the images' size and quality. And, new in Photoshop CC 2014, you even get to specify which *folder* Generator exports the files to. This is a huge timesaver for folks designing graphics for websites, especially sites for multiple devices—computers, smartphones, tablets, and so on—as each device may use different image sizes and file formats.

> **NOTE** If you're creating a website with Adobe Muse, you can access individual layers in Photoshop documents from *inside* Muse. That means there's no need to export your Photoshop imagery for use in that particular web editor. Slick!

First, you need to turn on Generator: Choose Photoshop→Preferences→Plug-Ins (Edit→Preferences→Plug-Ins on a PC) and turn on Enable Generator. After that, here's the basic process you use: Design your graphics, and then turn on Generator for your *document* by choosing File→Generate→Image Assets (when you choose this command, a checkmark appears next the command's name). Next, in the Layers panel, rename each layer that you want to export with the desired file name and file *extension* (.jpg, .png. or .gif), as shown in Figure 17-13. For example, you might name the layer containing a logo *petshadeslogo.jpg* and the layer containing the top row of photos *header.jpg* to make Generator export each one as JPEG. As you rename layers, Generator *instantly* exports one image for each layer whose name includes a file extension (see Figure 17-14).

If you've got multiple layers that you want to export as a *single* image—say, multiple layers that comprise a logo or a header—activate them and press ⌘-G (Ctrl+G on a PC) to tuck them inside a layer group (page 111). Next, rename the group, give it a file extension, and Generator exports one flattened image containing the group's contents. If you want Generator to export each layer *inside* the group, too, give them web-friendly names with format extensions. Figure 17-14 shows examples of both—groups whose layers Generator will and won't export individually.

FIGURE 17-13

*When renaming layers
for Generator, be sure to
use web-friendly names:
don't include any spaces,
forward slashes (/),
colons (:), or asterisks
(*). If there are layers or
groups you* don't *want
to export, don't include
a file extension in their
names.*

*In this example,
Generator will export
a flattened image of
the* petshades_header.
png *group, but not the
group's contents (you can
tell because the names
of the layers within the
group don't include file
extensions). And it will
export a flattened image
of the* shades_toprow.jpg
*group and each layer in
the group as a separate
file, since each one has a
file extension in its name.
(Figure 17-14 shows the
exported files.)*

If you edit a layer after exporting it with Generator, Generator *re-export* it with the
same name (so you don't get duplicates). However, if you change the layer's *name*,
Generator re-exports it with the new name, so if you want to get rid of the previously
exported version, you have to find that file and delete it manually.

FIGURE 17-14

The image files that Generator exports land in a folder named [Photoshop document name]-assets, *which Generator dutifully creates and tucks inside the same folder where you saved your Photoshop document. (If you haven't yet saved the document, Generator puts the exported images in a new folder on your computer's desktop instead.) Notice how the appropriate file extension was used for each layer's content: .jpg for photos (since JPEG format is great for photos—see page 769) and .png for the header (because it fades out on the right and PNG format retains transparency—see page 770).*

New in Photoshop CC 2014 is the ability to send the files Generator exports to a subfolder *inside the assets folder that it creates. For example, to place the exported file inside a subfolder named "header," put a forward slash (/) between the subfolder name and the layer name (with no spaces around the slash), like so:* header/topshades_heart.jpg.

In addition to specifying the exported file's name and format, you can *also* tell Generator what quality setting to use and what size file to export. Here are your options for each format:

- **JPEG.** From the factory, Generator exports JPEGs at 90% quality but you can change that by adding a *suffix* to the very end of the layer's name (*after* the file extension). You can use a numeric scale of 1–10 or enter a percentage from 1–100% (the higher the number, the higher the quality). For example, to export a layer as a JPEG with a quality setting of 5 (which is the same as 50%), name the layer *topshades_heart.jpg5* or *topshades_heart.jpg50%*. Be sure *not* to include a space after the file extension—just put the suffix immediately after it.

Changing the exported file's *size* works similarly, though you add the info as a *prefix* instead. You can make size change relative by entering a percentage, or you can set a specific size by including a unit of measurement (px, in, cm, or mm). For example, to shrink the exported file by half, name the layer *50% topshades_heart.jpg*. To make it *exactly* 200 millimeters square, name the layer *200mm x 200mm topshades_heart.jpg*. In this case, you *do* need to add a space between the prefix and the file name. (As of this writing, any size changes you make when exporting to a subfolder won't work; otherwise, size changes work just fine. See Figure 17-14 on page 796 for more on exporting to subfolders.)

TIP If you're indicating a size in *pixels*, you don't need to include a unit of measurement in the prefix. For example, to make the exported file 150 pixels by 200 pixels, name the layer *150 x 200 topshades_heart.jpg*. You can also *mix* units of measurement—*4in x 200 petshades_header.png*, say.

- **PNG.** As with JPEGs, you adjust the quality and size settings of PNGs by using suffixes and prefixes, respectively. Generator automatically exports this format at a quality setting of 32 (for 32-bit), but you can change that by adding a suffix to the layer's name. Your other two choices are 8 or 24. So to export a PNG at a quality setting of 24, name the layer *petshades_header.png24*.

- **GIF.** Unfortunately, you can't adjust the quality setting for GIFs (bummer!). You can, however, resize them just like JPEGs and PNGs. For example, to shrink a GIF by half, name the layer *50% petshadeslogo.gif*, or enter specific dimensions such as *300 x 300 petshadeslogo.gif*.

You can combine quality and size settings in a single layer name, and you can tell Generator *how many* copies of the file you want it to export. To specify quantity within the layer name, simply add a comma and repeat the layer's name as many times as you want copies. For example, the layer name *50% petshadeslogo.png24, 100 x 100 petshadeslogo.jpg80%* exports the following file content:

- *petshadeslogo.png* at half scale (50%) at a quality setting of 24

- *petshadeslogo.jpg* scaled to 100 × 100 pixels at 80% quality.

As you can see, the timesaving power of this feature is amazing, although you'll need to *widen* your Layers panel to about a mile or so to see such long layer names!

Setting Generator Defaults

This whole layer-naming business is all well and good, but it takes time to enter such long layer names. Happily, Adobe has added the ability to control Generator's standard settings for each document.

Before you start naming your layers to export them, create a new, empty layer in your Photoshop document, and then name the layer *default*, followed by the settings that you want Generator to use for *all* the images it exports from that document. You can only have *one* of these default layers in your document, but you can string parameters together as shown in last bulleted example below). Feel free to use all

the quality and size parameters covered in the previous section, as well as a forward slash (/) to make Generator store the files in a subfolder (see Figure 17-14 on page 796). You can also add a plus sign (+) to string together two or more parameters to make Generator export *more* than one file from a single layer.

Say you want to export high- and low-resolution images from each layer in your document. Here are a few examples of the types of default layers you could use to keep the exported files organized:

- **default hi-res/** puts all the exported images into a subfolder named "hi-res."

- **default hi-res/@2x** puts all the images into a subfolder named "hi-res" *and* adds the suffix @2x to each file name. (The @ symbol doesn't have a function, it's just part of the layer name in this example.)

- **default 50% lo-res/** exports all the images at half scale and puts them into a subfolder named "lo-res."

- **default hi-res/@2x + 50% lo-res/** exports *two* images from each layer: One lands in the subfolder "hi-res" and has the suffix @2x at the end of its file name, and the other goes into the subfolder named "lo-res" and is reduced to half scale (50%).

> **NOTE** If you specify default scaling as a default, you can override that scale setting by specifying a different scale in individual layer names.

Sure, it'll take a little while for you to memorize Generator's complicated layer-naming scheme, but the time you'll save is well worth it. And if you're used to working with programming code, you'll master it in no time flat!

Turning Generator Off

Once you open a document and turn Generator on, it *stays* on for that document until you choose File→Generate→Image Assets again.

If you want to turn Generator off for *all* your documents, choose Photoshop→ Preferences→Plug-Ins (Edit→Preferences→Plug-Ins on a PC), and then turn off Enable Generator. From that point on, the File→Generate command will be dimmed. To access it again, open Photoshop's Plug-Ins preferences and turn Enable Generator back on. Easy!

Protecting Your Images Online

Being able to share images with the world via the Web is a glorious thing, but, in doing so, you risk having your images stolen (gasp!). It's frighteningly easy for thieves to snatch photos from your website to sell or use as their own, so it's important to take steps to protect them. You can deter evildoers in several different ways, including posting small versions of your images (640 × 480 pixels, for example), using photo

galleries such as *www.smugmug.com* that *prevent* folks from right-clicking to copy images to their hard drives, embedding copyright info, adding watermarks, or using Zoomify (see the box on page 804). Keep reading for the scoop on each option.

Embedding Copyright Info

One step you can take to help protect your work is to embed copyright and contact info into the image file by choosing File→File Info (see Figure 17-15). Sadly, this won't keep folks from stealing your image (heck, they won't even *see* it unless they open your file and peek at its title bar or choose File→File Info themselves), but they *might* think twice about taking it if they do find a name attached to it. Alternatively, you can declare that the image is in the public domain, granting anyone and everyone a license to use it.

FIGURE 17-15

Choosing File→File Info lets you attach all kinds of descriptive info to an image. Once you change the Copyright Status drop-down menu to Copyrighted, Photoshop puts a © in the document window's title bar.

Alternatively, you can choose Public Domain from the Copyright Status menu to give anyone permission to use your image.

TIP The File Info dialog box includes a GPS Data pane that you can use to view any location info that was stored when you took the shot (assuming you have a GPS-enabled camera or memory card). The Camera Data pane also includes info about the moment of capture, such as the date and time, the lens you used, the metering mode, and the image's color space.

Watermarking Images

One of the best ways to protect images online is to add a *watermark* to them—a recognizable image or pattern that you either place atop the images (as in Figure 17-16, bottom) or embed into them invisibly. A watermark is a nice deterrent because it lets would-be thieves know that you're onto their game, and it can be difficult to get rid of, depending on where you put it and at what size.

You can add watermarks in Photoshop in a couple of ways:

- **Use text or custom shapes to add a copyright symbol or logo.** The *simplest* way to (elegantly) watermark an image is to create a text-based watermark that you tuck into the corner of your images using *actions* (flip to page 819 for the step-by-step process on watermarking and resizing images at the same time). Or, if you're posting images online at a fairly large size, you can take a more drastic approach and stick a big ol' copyright symbol (or your logo) in the middle of the image. If you make the shape or logo partially see-through, folks can still see the image but won't, *presumably*, steal it because of the huge graphic stamped on top of it. (However, some experts say that a large watermark serves as a deterrent for potential buyers.) Either way, this process is called *visual watermarking*.

- **Use the Digimarc filter.** This paid service creates a nearly invisible watermark by adding noise to your image (called *digital watermarking*). It's not cheap, but you also get other features like image linking and tracking, online backups, as well as visual watermarking. The cost depends on the number of images you use it on and the type of service you pick. A basic account runs $50 per year for 1,000 images; a pro account (which includes an online image-tracking service) is $100 for 2,000 images; and so on. You can learn all about it by visiting *www.digimarc.com*.

Since you've already plunked down good money on both Photoshop *and* this book, here's how to watermark images for *free* using the Custom Shape tool:

1. **Open an image and grab the Custom Shape tool.**

 You can find this tool in the shape toolset, or grab it by pressing Shift-U repeatedly (the tool's icon looks like a rounded star).

2. **Set your foreground color chip to light gray.**

 Setting the foreground color now means you won't need to change the watermark's color later. At the bottom of the Tools panel, click the foreground color chip, choose a light gray from the resulting Color Picker, and then click OK.

(Alternatively, you can change your foreground color by using the Color panel set to Hue Cube, as described on page 527.)

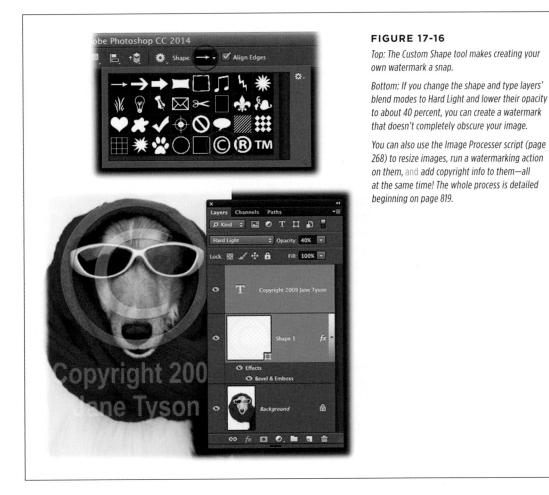

FIGURE 17-16

Top: The Custom Shape tool makes creating your own watermark a snap.

Bottom: If you change the shape and type layers' blend modes to Hard Light and lower their opacity to about 40 percent, you can create a watermark that doesn't completely obscure your image.

You can also use the Image Processer script (page 268) to resize images, run a watermarking action on them, and add copyright info to them—all at the same time! The whole process is detailed beginning on page 819.

3. **Open the Custom Shape menu and choose the copyright symbol.**

 In the Options bar, click the downward-pointing arrow to the right of the word "Shape" (circled in Figure 17-16, top) to open the menu of custom shape presets. Scroll down until you see the copyright symbol (©), and then click it once to activate it.

4. **Draw the shape on top of your image.**

 Mouse over to your image, click once where you want the shape to begin, and then Shift-drag diagonally to draw the shape. (Holding Shift keeps the symbol perfectly proportioned.) When you let go of the mouse, Photoshop adds a layer named Shape 1 to your document. If you want to tweak the shape's size, summon Free Transform by pressing ⌘-T (Ctrl+T), and then Shift-drag any corner handle.

5. **Add a Bevel & Emboss layer style.**

To give your watermark a little depth, tack on a layer style. Click the *fx* at the bottom of the Layers panel and choose Bevel & Emboss. Feel free to fiddle with the Layer Style dialog box's settings (though they're probably fine the way they are), and then click OK.

> **TIP** The shape's gray outline can make it darn difficult to see a preview of the layer style you're about to apply. Luckily, you can hide the outline by pressing ⌘-H (Ctrl+H). This trick works with paths, too!

6. **Grab the Type tool and type your name (or website address) below the copyright symbol.**

Press T to fetch the Type tool, mouse over to your image, and then click where you want the text to start (Photoshop adds a type layer to your document). You can type whatever you want, but it's a good idea to include "Copyright" followed by the current year and your name or studio name (better yet, use the address of your website if it's short enough). To change the font and text size, double-click the type layer in the Layers panel, and then tweak the Options bar's settings (Arial Black is a good choice). Flip back to Chapter 14 for more on formatting text.

7. **To make the text look similar to the copyright symbol, copy the shape layer's style to the type layer.**

You can copy a layer style from one layer to another in the Layers panel by Option-dragging (Alt-dragging on a PC) the layer effect to the new layer (your cursor turns into a double-headed arrow and you see a little *fx* icon behind it when you drag). In this example, Option-click (Alt-click) the layer named Bevel & Emboss, and then drag it to the new layer and release your mouse button. If you don't press Option (Alt) *before* you start to drag, you'll *move* the layer style instead; if that happens, just press ⌘-Z (Ctrl+Z) to undo, and then try again.

8. **Change the shape and type layers' blend modes to Hard Light.**

Doing this makes your watermark see-through. You can change the blend modes of *multiple* layers at the same time: In the layers panel, Shift-click to activate both the shape and type layers, and then change their blend modes to Hard Light using the drop-down menu at the top of the panel.

9. **Lower the shape and type layers' opacity to 40 percent.**

While you've got the shape and type layers active, lower their opacity to 40 percent using the Opacity slider at the top of the Layers panel. This keeps the watermark from overpowering your image.

10. **Save the file and upload it to the Web.**

Now you can enjoy peace of mind knowing that it'd take someone *weeks* to clone away your watermark.

Protecting your images takes a bit of effort, but it's well worth it. In fact, water-marking is *exactly* the kind of thing you should record as an action. Just follow the instructions in Chapter 18 for creating a new action (page 815), and then repeat the steps in this list (you can even include the act of embedding copyright info in your file, as explained on page 799). Once you create the action, you can run it on a whole folder of files to save yourself tons of time.

Building Online Photo Galleries

Once you've massaged and tweaked your images to perfection, why not have Pho-toshop prepare a web-ready photo gallery, complete with thumbnails and enlarge-ments? Actually, Bridge *CS6*—yes, you read that right—can do all the work using something called the Adobe Output Module (AOM). Unfortunately, Adobe removed that feature from Bridge *CC*. Why? Because that part of Bridge hasn't been updated to work on Apple's Retina displays (known as HiDPI on Windows machines), which sport twice as many pixels per inch as regular displays.

UP TO SPEED

Sharing Images on Behance

Behance (*www.Behance.net*) is an online community for creative types—photographers, graphic artists, musicians, videographers, and so on—that Adobe partnered with when they launched Creative Cloud. Behance has over a million members, making it a *great* place to get feedback on your art and projects. It's also a good place to find *inspiration*—you can follow specific members and explore their portfolios, as well as browse job listings (handy!).

Here's how it works: You upload images to Behance (these are called *works in progress*), and then solicit feedback either from the Behance community at large or from trusted community members that you designate. They can then "like" or comment on your image (you can see these "likes" and comments in the Community pane of the Creative Cloud app). When you complete the image or design, you upload a series of related images (up to 20) called a *project*, that you can easily incor-porate into Behance's surprisingly attractive, online portfolio website builder, ProSite (*www.prosite.com*).

Happily, *all* of this is free to Creative Cloud subscribers, no matter which plan you have. And because of Adobe's partner-ship with Behance, you can upload works in progress straight from Photoshop (or Illustrator or Lightroom, if you use those programs). Simply open a Photoshop document and choose File→"Share on Behance" or click the "Upload to Behance" icon near the left end of the status bar (the square with a curved arrow—it's labeled way back in Figure 1-1 on page 4). In the resulting dialog box, enter details about what you're upload-ing (such as whether this is a new work or a revised file), add search tags so folks can find it without knowing its file name, add a comment to get a conversation going ("Are the colors too bright?"), and set the visibility (Everyone or Feedback Circle—the latter lets you allow registered recruiters to see your work). Then click Publish to get the feedback party started.

For more on Behance, check out your author's ebook *The Skinny on Behance* at *www.theskinnybooks.com*.

That said, a lot of folks depend on this feature, so you can *add* the AOM to Bridge CC by downloading and installing the files available at *www.lesa.in/aomforbcc* (that page also includes full installation instructions). If you go that route, or if you *have* a copy of Bridge CS6 lying around (say, you didn't *uninstall* it when you got Photoshop CC), you can find the instructions for creating beautiful web galleries on this book's Missing CD page at *www.missingmanuals.com/cds*.

If you use Photoshop Lightroom, it can also make gorgeous web galleries. If you don't, you might try jAlbum (*www.jalbum.net*), a $30 program that lets you build and upload web galleries to any web server.

POWER USERS' CLINIC

Zoomify Your Enlargements

It can be dangerous to post your prize-winning image at full-size on the Web—you're practically *giving* thieves permission to steal it. But if you're a photographer and you want folks to see all the intricate details of your work, what else can you do? Happily, Photoshop can help you protect your images by using a built-in feature called Zoomify.

Here's how it works: Instead of posting an image as a *single* high-quality file, Zoomify chops it into *pieces* and displays it in a Flash-based window with controls that visitors can use to zoom in and move around the image. (Visitors need to have the Adobe Flash plug-in installed on their computers; if they don't, their browser should prompt them to get it [it's free].) That way, instead of seeing the whole image at full size, they see only one piece at a time, so they can't grab it by taking a screenshot or saving it to their hard drives. To see Zoomify in action, visit *www.zoomify.com/photoshop.htm*. (If you'd rather avoid Flash, you can buy a copy of Zoomify that exports images to HTML5 instead for about $30 [*www.zoomify.com/html5.htm*].)

To use Zoomify, follow these steps:

1. Adjust the image's size using the techniques discussed in Chapter 6. (This step is optional; if you want to upload a full-size image from your camera, feel free, although Zoomify doesn't work on raw files).

2. Choose File→Export→Zoomify to open the Zoomify Export dialog box.

3. Use the dialog box's Output Location section to name the file and tell Photoshop where to save it.

4. In the dialog box's Image Tile Options section, use the Quality field, drop-down menu, or slider to set the quality of the individual pieces. (Behind the scenes, Zoomify chops your image into a bunch of pieces—called *tiles*—that it reassembles on the fly when your visitor looks at a given area.) Leave the Optimize Tables checkbox turned on so Photoshop optimizes the compression tables for each tile.

5. Enter values in the Width and Height fields to determine how large (in pixels) the Zoomify window will be in your visitor's web browser.

6. Click OK, and Zoomify creates a block of code that you can paste into your web page. If you left the Open In Web Browser checkbox turned on, Photoshop opens your browser and shows you what your Zoomify window looks like.

Now all you have to do is open the HTML document that Zoomify made, copy and paste the code into your web page, and then upload the page and image pieces that Zoomify created to your server. After that, folks who look at your image online can see all its exquisite details but *can't* swipe it and claim it as their own.

Photoshop Power

Working Smarter with Actions

It's fun to spend hours playing and working in Photoshop, but once you've used the program for a while, you'll likely notice that you repeat the same steps over and over on most of your images. At first, the repetition probably won't bother you—it's actually good while you're learning—but when a deadline approaches and the boss is eyeing you impatiently, you need a way to speed things up. It would also be great to automate tasks that you don't enjoy doing yourself.

Luckily, Photoshop includes all manner of automated helpers (some of which you've already learned about), including:

- The Image Processor script, which resizes images *and* converts them to different file formats (page 268).

- The Contact Sheet II script (page 762).

- Automated photo stitching with Photomerge (page 312).

- The Lens Correction filter (page 677), which fixes distortion problems caused by your camera's lens and/or sensor.

- Automated layer aligning and blending with the Auto-Align and Auto-Blend Layers commands (covered starting on page 312).

Some of the best timesavers of all, however, are *actions.* An action is an all-purpose, amazingly customizable method for automating repetitive or complex tasks like adding or duplicating layers, running filters with specific settings, and so on. You can use actions to record nearly every keystroke and menu choice you make, and then play them back on another image or a whole *folder* of images.

NOTE Actions don't work on things that don't affect your image, such as zooming in or out, but page 824 has a workaround.

Because Photoshop doesn't need to press keys or move and click a mouse when it's running actions, it can *blast* through them at warp speed. Photoshop can even record strokes you make with the Brush and Pen tools, so you can replay—and thereby recreate—a painting or drawing from start to finish. Just imagine the You-Tube videos you can make!

This chapter explains how to use the built-in actions that come with Photoshop, and how to create, edit, and save your own. You'll also learn how to create drag-and-drop actions called *droplets*—icons you can drop files on to trigger an action—as well as how to find and load actions made by other folks. By the time you're finished reading, you'll be working 10 times smarter and not one bit harder.

The Actions Panel

You record, play, and edit keystrokes, using the Actions panel (Figure 18-1). Choose Window→Actions to display it in the panel dock on the right side of your screen (its icon is a triangular "play" symbol).

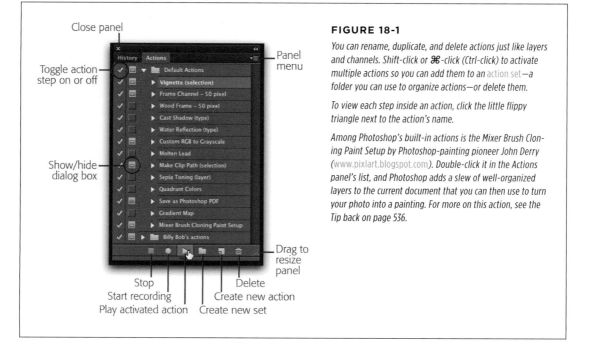

FIGURE 18-1

You can rename, duplicate, and delete actions just like layers and channels. Shift-click or ⌘-click (Ctrl-click) to activate multiple actions so you can add them to an action set—a folder you can use to organize actions—or delete them.

To view each step inside an action, click the little flippy triangle next to the action's name.

Among Photoshop's built-in actions is the Mixer Brush Cloning Paint Setup by Photoshop-painting pioneer John Derry (www.pixlart.blogspot.com). Double-click it in the Actions panel's list, and Photoshop adds a slew of well-organized layers to the current document that you can then use to turn your photo into a painting. For more on this action, see the Tip back on page 536.

Labels in figure: Close panel · Panel menu · Toggle action step on or off · Show/hide dialog box · Drag to resize panel · Stop · Delete · Start recording · Create new action · Play activated action · Create new set

The panel's controls are pretty straightforward. The Stop, Record, and Play buttons do what you'd expect: They stop, record, and play actions. The "Create new set" icon at the bottom of the panel (it looks like a folder) lets you store actions in a set just like you can store layers in a group. You can create a brand-new action by clicking the "Create new action" icon, and duplicate an action by dragging it onto that same icon or Option-dragging (Alt-dragging on a PC) it up or down in the panel. Duplicating an action comes in handy when you want to run the same filter more than once within an action, or when you want to edit a *copy* of an action to make it do something slightly different (which is faster than rerecording the action from scratch).

The Actions panel has three unlabeled columns that let you do the following:

- **Turn steps on or off.** The leftmost column lets you turn individual steps in an action on or off via a checkmark next to each step, which is useful if you've created a fairly complex action and only want to run, say, half of it. For example, if you record an action that creates a smart object out of all visible layers, sharpens your image (Chapter 11), and then saves it as a high-quality JPEG, you can turn off the "save" step and stop at sharpening instead. These checkmarks also come in handy when your action includes a step that will only work on *your* computer. For example, if you open a file while recording the action, Photoshop captures your hard drive name's, your user name, and so on. If someone else wants to use the action on his machine, you can turn that step off.

 To turn off a step, click the flippy triangle next to the action's name to expand it, and then click the checkmark to the left of that particular step. To turn off *all* the steps in an action or all the actions in a set, click the checkmark to the left of the action or set's name. To turn off all the steps in a particular action *except* one, Option-click (Alt-click on a PC) the checkmark next to the step you want to leave on.

> **TIP** In the Actions panel, a *gray* checkmark next to an action's name means Photoshop will run all the steps in that action, and a *red* checkmark means that it'll skip some steps (the ones you've turned off). This handy visual clue lets you keep actions *collapsed* in the panel but still see that you've turned some steps off.

- **Show/hide dialog boxes.** The middle column is for showing or hiding any dialog boxes that are included in the action's steps. For example, if you create an action for sharpening an image, the settings you enter in the sharpening filter's dialog box may not work for *every* image you run the action on. If an image is bigger or smaller than the one you used to create the action, for example, having Photoshop display the dialog box when it's playing back the action lets you enter specific settings for that image.

 To have Photoshop show dialog boxes for a particular action (or a *step* in an action) just click within this column and a light gray icon appears (it's supposed to look like a tiny dialog box). If the column is empty, Photoshop won't open any dialog boxes when you run that action.

- **Expand or collapse an action.** The rightmost column in the Actions panel lists each action's name and keyboard shortcut (if you've assigned one). To see the individual steps within an action, expand it by clicking the flippy triangle to the left of its name—handy when you want to turn off individual steps (as explained earlier) or explore the inner workings of an action (great for learning how to make your own or for troubleshooting the ones you created).

Straight from the factory, Photoshop displays actions in list form (see Figure 18-1), though you can also display them as clickable *buttons* (see Figure 18-2); just open the Actions panel's menu and choose Button Mode. Unless you're in the process of creating or editing actions, this is a great way to roll!

FIGURE 18-2

Switching the Actions panel to Button mode, shown here, can save you some time. In this mode, instead of triggering an action by choosing it in the panel and then clicking the Play button, you can just click the button with the action's name on it.

One drawback to using Button mode is that it doesn't let you edit actions or create new ones. You also can't turn individual steps within an action on or off (darn!). So for the purposes of this chapter, it's best to keep Button mode turned off by simply picking Bottom Mode from the Actions panel's menu again.

Using Actions

Photoshop comes with *dozens* of built-in actions, although only a smidgen of them initially appear in the Actions panel. *Nine* additional sets of built-in actions are tucked away in the panel's menu (shown in Figure 18-2): Commands, Frames, Image Effects, LAB - Black & White Technique, Production, Star Trails, Text Effects, Textures, and Video Actions. To load one of these sets, simply choose it from the menu and Photoshop adds it to the panel's main list.

Each set includes several actions that you can use as is or edit to your own personal taste. For example, if you think the Spatter Frame action (part of the Frames set) is a little lame with its 15-pixel spray radius, you can bump it up to 25 pixels instead. (Editing actions is discussed later in this chapter.) Or you can duplicate that particular step to make the Spatter filter run twice.

> **TIP** An easy way to duplicate an action that you want to customize is to Option-drag (Alt-drag on a PC) it to a different set in the Actions panel.

To use one of Photoshop's built-in actions, follow these steps:

1. **Open an image.**

 With most actions, you simply need to open an image and then you're ready to invoke the action's magic. You don't even have to unlock the background layer because Photoshop duplicates it for you.

2. **If necessary, tell Photoshop which *part* of the image you want to work with by creating a selection.**

 For some built-in actions, you need to create a selection before you run them. You can tell which ones these are because they have the word "selection" in parentheses after their names in the Actions panel, such as "Vignette (selection)" (this particular action was used in Figure 18-2).

3. **Choose the action you want to run.**

 In the Actions panel, click an action to activate it. If you're in Button mode (page 810), simply clicking an action's name triggers that action, so you're done. If you're not in Button mode, continue with the next step.

4. **Click the Play button.**

 Click the triangular Play button at the bottom of the Actions panel to run the action. Before you can blink, Photoshop is finished and dusting off its hands. If the program displays a dialog box that requires your input, the action pauses while you enter settings. Once you click OK, it continues on its merry way.

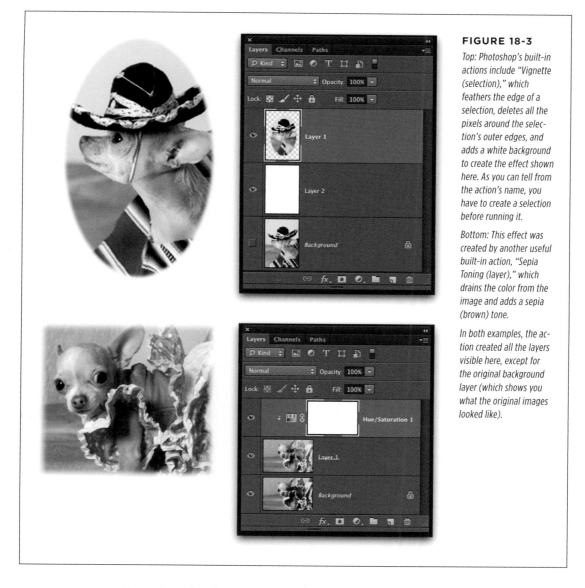

FIGURE 18-3

Top: Photoshop's built-in actions include "Vignette (selection)," which feathers the edge of a selection, deletes all the pixels around the selection's outer edges, and adds a white background to create the effect shown here. As you can tell from the action's name, you have to create a selection before running it.

Bottom: This effect was created by another useful built-in action, "Sepia Toning (layer)," which drains the color from the image and adds a sepia (brown) tone.

In both examples, the action created all the layers visible here, except for the original background layer (which shows you what the original images looked like).

Running Actions on a Folder

When you trigger an action, Photoshop performs the action's steps on the document you're currently working on. However, to *really* make actions work for you, you can run them on *more* than one document (this technique is called *batch processing* or *batching*). It takes an extra step or two, but it's worth it. For example, you can run an action that adds a color tint (or a black and white treatment) on all your open files

or on a folder of files instead of running it on each image individually. Just imagine the time you'll save!

> **TIP** You can record actions that trigger *other* actions, which is *extremely* helpful when you're batch process-ing. That way, instead of running the actions on the files one after another, you can simply run the action that triggers the rest. To include another action inside the one you're recording, ⌘-double-click the other action (Ctrl+double-click on a PC) in the Actions panel.

Here's how to run an action on more than one file:

1. **Open all the files or place them in a single folder.**

 Photoshop's Batch command works on all open files or a whole folder (unless you're using Bridge, as noted in Step 3 below). So depending on how many files you want to work on, you'll probably want to stick 'em in a folder first.

2. **Choose File→Automate→Batch, and then pick the action you want to run.**

 In the Batch dialog box (Figure 18-4), choose an action from the Actions menu.

FIGURE 18-4

To reap the full rewards of actions, use the Batch dialog box to run them on multiple files (called batches).

Turn on the Include All Subfolders checkbox if you want to process files in folders within a master folder. This setting is es-pecially handy if you use nested folders to organize your images.

3. **In the Batch dialog box, pick the files or folders you want to process.**

 Use the Source drop-down menu to tell Photoshop whether to run the action on all open files or on a folder. If you pick Folder, click the Choose button and navi-gate to the folder containing your images. You can also choose Import to snatch files parked in your scanner or on an attached digital camera or memory card.

 If you've picked a few files and/or folders in Adobe Bridge, you can run the action on them by choosing Tools→Photoshop→Batch in the Bridge window (see Chapter 22 for more on Bridge).

4. **Adjust other settings, if needed.**

Turn on "Override Action 'Open' Commands" if there's a step in your action that opens a file. That way, Photoshop opens the files you've picked in the Source menu instead of hunting for the file name recorded in the action. However, leave this setting off if you recorded the action to open a *specific* file that's necessary for the action to work properly, like when you're adding a particular texture file to the images.

If you've chosen Folder as your source and the folder you want to work with contains *other* folders of images that you want Photoshop to process, turn on Include All Subfolders.

If your action summons an Open dialog box and want to bypass it completely, turn on Suppress File Open Options Dialogs. Doing so prevents the Open dialog box from opening, so you can open a group of images without seeing that dialog box for each one (handy if you batch process raw images from your digital camera).

Finally, turn on Suppress Color Profile Warnings if you want Photoshop to always use its own color profile (page 43) without asking if that's OK.

5. **Tell Photoshop where to save the processed files.**

From the Destination drop-down menu, choose None to have Photoshop leave your files open *without* saving them (not a good idea if you're running the action on hundreds of files!). Pick "Save and Close" to overwrite the originals (scary!) and close the files. A safer option is to preserve the originals by choosing Folder, and then clicking the Choose button to tell Photoshop where it should save the newly processed files.

If your action includes any Save As steps, turn on "Override Action 'Save As' Commands" to make Photoshop use the settings you've specified in this dialog box. If you don't turn on this setting, Photoshop saves your images *twice*: once where you specified in the action and again in the location you picked in the Batch dialog box.

6. **If you want to rename the resulting files, enter a naming scheme in the File Naming section.**

You can name the new files anything you want. Choose Document Name from the first drop-down menu to have Photoshop keep the original file names, or enter something else in the name field. You can also rename files with the current date (in several formats), using an alphabetical code or numeric serial number, and so on. Keep the second field in each row set to "extension" so you don't encounter any problems with incompatible file formats down the road.

7. **Turn on the appropriate Compatibility checkbox(es) based on where the files are headed.**

 If you know your images will be opened or stored on a computer that runs a different operating system than yours, then turn on the checkboxes for each system your file is likely to end up on (Photoshop automatically turns on the checkbox for the operating system you're using). For example, if you're using a Mac and your images are destined for a Unix- or Windows-based machine, choose Unix or Windows. (It's OK if all three checkboxes are turned on.)

8. **From the Errors menu, choose an error-handling method.**

 This is where you tell Photoshop what to do if it encounters a problem while it's running the action. Your options are "Stop for Errors" and "Log Errors to File." If you choose the latter, Photoshop writes down all the errors in a text file and continues to process your images (yay!); click the Save As button below this drop-down menu to tell the program where to save this text file.

9. **Click OK to run the action.**

 Sit back and smile smugly as Photoshop does all the work for you (and cross your fingers that you don't get any errors!).

TIP Yet *another* option for applying actions to a slew of files is to use the Image Processor (File→ Scripts→Image Processor; see page 268). The Image Processor dialog box has fewer settings than the Batch dialog box, so it's a little easier to use, plus you get the option of resizing your images and changing file formats during the save process (say, from a PSD to a JPEG).

■ Recording Actions

When you're trying to decide on an action to record, start by thinking of any repetitive tasks you perform often. For example, back in Chapter 4, you learned that a simple one-pixel black border adds a classy touch to an image destined for a magazine, newspaper, or newsletter (page 199). If you add those borders regularly, that process is an *excellent* candidate for an action. Likewise, adding a custom watermark to images that you want to post online is a great excuse to record an action.

Before you hit the record button, you need to create a new *action set* (think folder or group) for the new action to live in. Sets are just the ticket for organizing your actions into logical groups, and Photoshop requires you to use 'em: you can't record an action without choosing an existing set or creating a new set. For example, you might put your sharpening and creative-border actions in a set named "finishing touches," or create a set based on a certain project or client (your author has an action set named "missing manuals"). There's no limit to how many sets you can create or how many actions you can add to each one. If you forget to create a set before you record an action, it's no big deal—you can drag and drop the action into a set later. You can also copy actions *between* sets by Option-dragging (Alt-dragging) them.

WARNING Oddly enough, Photoshop doesn't capture Undo commands when you're recording actions. For example, if you mess up during the recording process, use the Undo command to fix the mistake, and then continue recording the rest of the action, Photoshop records everything *except* the Undo command, so the action won't run as you expect. So if you mess up while recording an action, just click the Stop button. Delete the bad steps in the Actions panel by dragging them to the trash can icon, and then choose Edit→Step Backward to get your image back to the last good step. Make sure the good step is active in the Action's panel, and then click the Record button to continue.

Here's how to create an action that adds a thin black border around an image:

1. **Open the image.**

 To record the steps, you have to perform them, so you need an open image to play with.

2. **Open the Actions panel (if it isn't open already), and then create a new set.**

 Choose Window→Actions, and then click the folder icon at the bottom of the panel. In the resulting dialog box (Figure 18-5, top), enter a descriptive name for your new set, and then click OK.

WORKAROUND WORKSHOP

Different Files, Different Results

When you're recording actions, it's important to realize that not only does Photoshop record every step *exactly* as you perform it, but it also memorizes info about your document, such as file size, color mode, layer names, and even what color your foreground color chip is set to.

For that reason, if you try to run an action on a file that's in a different color mode or is a different size than the document you used to record that action, you may encounter errors or unexpected results. To fix that kind of thing, you've got several options:

- If you create an action that resizes a landscape-oriented image to 800 pixels in width using the Image Size dialog box and then you run it on a portrait-oriented image, you won't get the same results. The fix is to re-record the action using the File→Automate→Fit Image command instead, which lets you enter maximum dimensions for either width or height.

- If you use certain tools while you're recording an action, Photoshop remembers the tool's *position* within the image by snagging coordinates from the program's vertical and horizontal rulers. Among these are the Marquee, Slice, Gradient, Magic Wand, Lasso, Shape,

Path, Eyedropper, and Notes tools. So if you run an action involving these tools on files of varying pixel dimensions, you'll have problems. For example, if you record an action that includes drawing an elliptical marquee in the center of a document and then run that action on a document with vastly different pixel dimensions, the document's center won't be in the same place. The fix is to change the unit of measurement for the rulers to *percentages* before you record the action. That way, Photoshop records your cursor's location as a *relative* position instead of an absolute one. To switch to percentages, press ⌘-R (Ctrl+R) to turn on Photoshop's rulers, right-click either ruler, and choose Percent from the shortcut menu.

- If you create an action that requires an image to be in a specific color mode (say, RGB), make the first step of your action be choosing File→Automate→Conditional Mode Change. The dialog box that appears includes a series of checkboxes that you can use to take an image that's in any color mode (say, Grayscale or CMYK) and convert it to RGB (or whatever mode you want).

The other option is to use *conditional actions*, which are explained on page 819 and are easier to use than you might think!

3. **Click the panel's "Create new action" icon.**

This icon looks like a piece of paper with a folded corner (just like the "Create new layer" and "Create new channel" icons in the Layers and Channels panels, respectively). In the resulting dialog box (Figure 18-5, bottom), give the action a short but meaningful name, like *Black border*. You can also assign it a keyboard shortcut and a color (you see these colors only in Button mode [page 810], but they're still handy). When everything looks good, click the Record button to close the dialog box and start recording your action.

NOTE You can edit the settings you applied in the New Action dialog box *after* you record the action by activating it in the Actions panel and then choosing Action Options from the panel's menu, or by simply double-clicking to the *right* of the action's set or name in the panel.

FIGURE 18-5

Top: You can keep the Actions panel organized by storing your actions in sets. This lets you keep the actions you've made (or downloaded—see page 828) separate from those that come with Photoshop, as well as group 'em together by task or project.

Bottom: This dialog box lets you name your action and assign it a keyboard shortcut for faster access. The shortcut can be a function key (the F keys at the top of your keyboard) and, if you want, a modifier key (Shift or ⌘ [Shift or Ctrl on a PC]). By combining F keys and modifiers, you can create as many as 76 custom action shortcuts (depending on the number of function keys on your keyboard).

TIP Unfortunately, you can't assign F1 as a shortcut key on a PC. You can, however, assign F keys as shortcuts on a Mac, but you first have to head to System Preferences→Keyboard and turn on the "Use all F1, F2, etc. keys as standard function keys." If you don't *want* to change the behavior of your function keys, the workaround is to add ⌘ or Shift to your shortcut instead (for example, ⌘-F1).

4. **In the New Action dialog box, click the Record button, and then perform the steps you want to record.**

When you click Record, the Record icon (the circle) at the bottom of the Actions panel turns red to let you know Photoshop is recording nearly every keystroke and mouse click you make. To record the border action mentioned earlier, consider whether you'll always start out with a locked background layer. If so, begin by double-clicking that layer to unlock it. If not, click the square Stop icon at the bottom of the Actions panel, double-click the background layer to unlock it *before* you start recording the action, and then click the Actions panel's Record icon.

Another solution is to *duplicate* the image layer, using the keyboard shortcut ⌘-J (Ctrl+J) so Photoshop doesn't capture the layer's name. If you think the images you'll run this action on will be comprised of *multiple* layers, you can activate all the layers by pressing ⌘-Option-A (Ctrl+Alt+A) so Photoshop doesn't capture specific layer names, and then create a smart object (page 133) or stamped layer (page 119) out of 'em. The box on page 819 has more about actions and layer names. (See? There are a *ton* of things to consider when you're recording actions!)

Next, press ⌘-A (Ctrl+A) to select the whole image and then click the *fx* at the bottom of the Layers panel and choose Stroke. In the Layer Style dialog box, enter a pixel value in the Size field *even* if the correct pixel value is already there—you never know what you might change in this dialog box between now and when you run the action. (Since Photoshop's dialog box, Options bar, and panel settings are sticky, you need to make sure your action includes resetting *anything* that may have changed in those spots.) From the Position drop-down menu, choose Inside—even if it's *already* set to Inside—set the Fill Type menu to Color, and then click the color swatch underneath it. When the Color Picker opens, choose black, and then click OK *twice* to close the Color Picker and Layer Style dialog boxes.

> **TIP** If you record a File→Save As command, *don't* enter a name for the document. If you do, Photoshop will use that exact file name every time you run the action, no matter what your original document is named. Instead, use the Save As dialog box to navigate to another folder on your hard drive and let Photoshop save the edited document *there*, with its original file name. That step tells Photoshop to save the edited version of your image in the folder you picked, but without renaming the file.

5. **When you're finished recording, click the square Stop icon at the bottom of the Actions panel.**

 Alternatively, you can press the Esc key to end your recording. Either way, the Actions panel's Record icon turns gray.

6. **Choose File→Revert and test your action on the open image.**

 To make sure your action works, return your image to its original state, click the new action's name in the Actions panel, and then click the Play icon. If you run into problems, you can delete the action by dragging it to the trash can icon at the bottom of the panel and then have another go at recording it, or edit the action using the techniques discussed later in this chapter.

Give yourself a big pat on the back for successfully recording your first action! Seriously, this stuff isn't easy so it's important to celebrate *all* victories, even the small ones.

TIP Photoshop lets you capture strokes made with the brush tools and paths drawn with the Pen and shape tools, though you have to turn that feature on *before* you start recording by heading to the Actions panel's menu and choosing Allow Tool Recording. This is a great way to capture the creation of a painting from start to finish so you can replay it later. You can even create the action in a low-resolution document and then replay it in a higher-resolution document later! (Photoshop captures your *strokes* but not the tool's *settings*, so if you used a particular brush tip for the recording, set that up *before* playback or Photoshop will use the tool's current settings).

Recording a Conditional Action

If you want to resize and watermark images for posting on the Web, you can save tons of time by using actions that you access *inside* the Image Processor dialog box (page 268). The following steps show you how to create a *conditional* action for watermarking landscape- and portrait-oriented images—applying a different watermark to each orientation—that you access by running the Image Processor script:

1. **Open a landscape-oriented image, and then choose Image→Image Size.**

 In the resulting dialog box's Width field, enter the width to which you'll *eventually* resize the image (say, 700 pixels, or you can specify a size-reduction amount by entering a percentage instead), using the Image Processor script, and then clicking OK. This maneuver lets you design and view the watermark exactly how it'll appear atop the resized images.

WORKAROUND WORKSHOP

Beware of Recording Layer Names

Using actions is typically a trial-and-error operation—it can be challenging to get 'em just right because there are so many variables to consider. If Photoshop encounters *any* condition that varies from what you recorded, it slings an error dialog box at you and comes to a full stop.

One of the most common errors you'll encounter when running actions is Layer Unavailable, because most folks don't realize that Photoshop captures *layer names* when you record an action. For instance, if you start an action by double-clicking the background layer to unlock it, Photoshop searches for a layer named Background when you run that action on other images. If it doesn't find one, you'll be greeted with an error message that says, "The object 'layer Background' is unavailable." At that point, you can either continue running the action (by clicking Continue) or stop right there (by clicking Stop). If you choose to proceed and Photoshop *can* finish the remaining steps, it will. If it can't, you get (surprise!) another error message expressing Photoshop's regret.

Admittedly, having to click Continue once in a while is no biggie, but it brings your action to a screeching halt. To cut down on this type of error, use *keyboard shortcuts* to activate layers instead of clicking them in the Layers panel. That way, Photoshop records the *shortcuts* instead of specific layer names. (The box on page 85 has a honkin' big list of shortcuts for activating and moving layers.)

You also don't want to record the act of *double-clicking* a layer to rename it because Photoshop captures the layer's *original* name in the action. Instead, activate the layer you want to rename by *using a keyboard shortcut* and then choose Layer→Rename Layer. Type the new name into the resulting dialog box and click OK. By doing it this way, Photoshop changes the name of the currently active layer instead of hunting for a layer with a specific name. Neat, huh?

2. **In the Actions panel, create a new set and a new action.**

 At the bottom of the panel, click the "Create new set" icon (the folder). In the resulting dialog box, type *Watermarks*, and then click OK. Next, click the "Create new action" icon (the folded piece of paper); type *Landscape* in the resulting dialog box, and then click Record. Photoshop will now record everything you do.

3. **Use the Type tool to add a simple text watermark (Figure 18-6, top).**

 For a classy yet simple watermark, press T to grab the Type tool and, in the Options bar, pick a font, style, and size (Myriad Pro Semibold or Bold at 18 points is a good choice). For a nice gray color, click the color swatch in the Options Bar to open the Color Picker, enter *999999* in the # field, and then click OK. Next, click your image and Photoshop creates a type layer. Press Option-G (Alt+1069 on a PC keyboard's *numeric keypad*) to add a copyright symbol, and then type the year you took the photo, and your name or—better yet—URL. Let Photoshop know you're finished editing the text by clicking the checkmark in the Options bar.

FIGURE 18-6

Top: Lots of folks use their logos as watermarks, but subtlety can be key in attracting clients or art buyers, or for getting your image shared via social networks (a big ol' watermark in the middle of an image is incredibly distracting). This text watermark is simple yet classy.

Bottom: An easy way to rotate the watermark (step 9 on page 821) is to use the reference-point icon (circled, left). Just click one of the nine squares to set the point you want the watermark to rotate around, and then enter the degrees of rotation in the angle field (circled, right).

4. **Set the type layer's blend mode to Luminosity and add a drop shadow.**

 To make the watermark slightly transparent, use the menu near the top of the Layers panel to change the type layer's blend mode to Luminosity. Then, to keep the watermark readable atop other gray-colored pixels, click the *fx* button at the bottom of the Layers panel and choose Drop Shadow. In the resulting Layer Style dialog box, enter 20% for Opacity, 30° for Angle, 1 px for Distance, 0% for Spread, and 1 pixel for Size; then click OK.

5. **With the type layer active, press ⌘-A (Ctrl+A) to select everything on it.**

 By selecting your whole canvas, you can use Photoshop's alignment tools to put the watermark in a certain spot (say, bottom right), which makes this action work on *both* landscape and portrait images; but, for the sake of experimenting with *conditional* actions, you'll create a variation for portrait images in a moment.

 Once you see marching ants around the edges of your document, press V to grab the Move tool and then, in the Options bar, click the Align Bottom Edges and Align Right Edges icons (see Figure 3-18 on page 103). Next, get rid of the marching ants by pressing ⌘-D (Ctrl+D) to deselect, and then tap the up and left arrow keys on your keyboard approximately 10 times each to nudge the text away from the image's edge.

6. **In the Actions panel, click the Stop icon (the square) and, in your Layers panel, delete the watermark you just created, and then play the Landscape action to test it.**

 Once you stop recording the action, test it to make sure it works. In the Layers panel, delete the type layer by pressing Delete (Backspace), and then test the action by activating it in the Actions panel and then clicking the Play icon. If you encounter a problem, delete the action and have another go at recording it. When you get the action just right, go ahead and close the image (there's no need to save the document).

7. **Open a portrait-oriented image and resize it as you did in Step 1.**

 Choose Image→Image Size and then, in the resulting dialog box's Height field, enter the height to which you'll eventually resize the image (for example, 700 pixels, or you can specify a size-reduction amount by entering a percentage instead). Then click OK.

8. **In the Actions panel, create another new action in the Watermarks action set.**

 Unless you've clicked to activate a different action set, the Watermarks set should still be active. So click the "Create new action" icon and, in the resulting dialog box, name it Portrait, and then click Record.

9. **Repeat Steps 3–5, and then rotate the watermark 90°.**

 To create a variation on the landscape watermark, you can *rotate* the portrait watermark so that it runs along the side of the image. With the type layer active, press ⌘-T (Ctrl+T), and then, in the Options bar, choose the upper-right

reference point and enter 90° for the angle (see Figure 18-6, bottom). Click the checkmark in the Options bar to accept this transformation, and then lower the watermark by pressing V to grab the Move tool, and then tapping the down arrow key a few times.

10. **Stop recording the Portrait action, delete the type layer in your Layers panel, and then play the action to test it.**

 Repeat Step 6 to stop recording the portrait-watermark action, zap the type layer, and then play the portrait action to make sure it works the way you want it to.

11. **Create yet** *another* **new action in the Watermarks action set, name it Conditional, and start recording.**

 In the Actions panel, make sure the Watermarks set is still active, and then click the "Create new action" icon. Name the new action Conditional, and then click Record.

12. **From the Actions panel's menu, choose Insert Conditional, and then adjust the various settings.**

 In the resulting dialog box, set the If Current drop-down menu to Document Is Landscape, set the Then Play Action drop-down menu to *Landscape*, and set the Else Play Action menu to *Portrait*. Click OK to close the dialog box, and then click the Stop icon in the Actions panel.

13. **Choose File→Scripts→Image Processor and set your resizing and action options (Figure 18-7).**

 Here's where you get to put your new actions, well, in action! In Section 1 of the Image Processor dialog box, click Select Folder, find the images you want to watermark (a folder of PSD files, say), and then click Open (OK on a PC). In Section 2, tell Photoshop where to save the resized, watermarked images (be sure to choose a different folder to keep from overwriting your original files!), and then click OK.

 In Section 3, turn on "Save as JPEG," enter 12 in the Quality field, and turn on "Convert Profile to sRGB" (because the images are destined for the web). To resize the images, turn on "Resize to Fit" and then enter the dimension of the longest edge into *both* the W and H fields (700 pixels, in this example). Don't worry—this won't create square images.

 In Section 4, turn on Run Action, and then set the first menu to *Watermarks* and the second menu to *Conditional*. If you like, enter your watermark text into the Copyright Info field to embed it into each image's metadata. Finally, click Run to resize and watermark your images, regardless of their orientation!

TIP If you need help with the Image Processor dialog box's settings, flip back to page 268.

RECORDING
ACTIONS

FIGURE 18-7

You learned about using the Image Processor script for resizing images en mass back in Chapter 6 (page 268). The power of this script doubles when you use it to combine image resizing with a conditional watermark action!

Whew! Sure, it takes a while to create these actions, but just imagine how much time you'll save when next you need to resize and watermark a slew of images that are destined to live online.

◼ Managing Actions

If you don't get your action quite right the first time (and most likely you won't, which is perfectly normal), you can go back and edit it, though it's *usually* easier to just start over from scratch. That said, the Actions panel's menu (Figure 18-2) includes a few commands that can help you whip misbehaving actions into shape:

- **Record Again.** When you choose this option, Photoshop runs through all the steps in the action, opens all the dialog boxes associated with them so you can adjust their settings, and then updates the action accordingly.

> **TIP** When you're troubleshooting an action, it can be helpful to run it one step at a time; as you run each step, you can see it applied in the image and in your Layers panel, and therefore figure out where the action went astray. To run an action step by step, first expand the action so you can see all its step by clicking its flippy triangle in the Actions panel's list (so you can't be in Button mode [page 810]). Then ⌘-double-click the step you want to start with in the Actions panel (Ctrl+double-click on a PC), or single-click a step and then ⌘-click (Ctrl-click on a PC) the panel's Play icon. This maneuver also lets you nest an existing action *inside* a new action that you're currently recording.

- **Insert Menu Item.** For some unknown reason, when you're creating an action, you can't record any items in the View and Window menus (such as zooming in or out of your document, fitting it onscreen [very helpful when sharpening], or arranging the document windows on your screen), but you can *insert* them—or any other menu item—using this command, either while you record the action or after. Simply activate the step above where you want the menu item to go, or, if you want to insert the menu item at the end of the action, activate the action's name. Then head to the Actions panel's menu, choose Insert Menu Item; in the resulting dialog box, pick the item, and then click OK. If the menu item pops open a dialog box, Photoshop won't record any settings you enter, so you'll have to enter them manually when you run the action.

> **TIP** There's no way for you or anyone else running an action to turn off a dialog box that you've added using the Insert Menu Item command (though you can turn off *other* action dialog boxes—see page 809), so this command is a good way to *force* whomever is running the action to enter a particular menu's settings.

- **Insert Stop.** Use this command to pause the action so you can give the person who's running it instructions on what to do next, or tell them to do something that you can't record, such as open a specific file (because Photoshop captures the path name of where the file lives) or edit a layer mask. To add a stop after a particular step (it's helpful to think of it as a *message*), activate the step in the Actions panel and then choose Insert Stop (see Figure 18-8). Photoshop displays a dialog box where you can type instructions, such as, "Change the Brush tip to Charcoal Pencil," "Adjust the Radius setting until the image looks sharp enough to you," or "Use the layer mask to hide the texture from your subject's face." This kind of thing is especially helpful if you plan to give the action to someone

else to run on a variety of images with different sizes and resolutions (because the settings would need to be tweaked for each image).

FIGURE 18-8

Top: When you insert a stop, you get to include instructions for the person running the action. The message appears when that person triggers the action's stop point. If you want to let them continue with the action after they've preformed the step described in the message, turn on Allow Continue.

Bottom: Here's what you see when you run the action and hit the stop point. If you turned on Allow Continue, you get a Continue button. If you didn't, your only choice is to click Stop. After you've performed the part of the action that couldn't be recorded, click the Actions panel's Play icon to finish off the action—and if you go that route, be sure to include the text, "...and then click the Play icon in the Actions panel" in your Stop message so folks know what action (ha!) to take.

- **Insert Conditional.** This option lets you record a *conditional* action that chooses among several *previously* recorded actions in order to meet criteria you set. To use this incredibly handy feature, start by recording *separate* actions for each eventuality you expect to encounter: different document sizes, color modes, bit depths; documents with and without selections, multiple layers, alpha channels, locked layers, adjustment layers, and so on. Place those individual actions inside a set, and then record *another* action—in the same set—that riffles through 'em to find the right action to run. Here's how: Choose Insert Conditional from the Actions panel's menu. In the resulting dialog box, use the If Current drop-down menu to pick a criteria, and then use the Then Play Action drop-down menu to pick the action that should play if that criteria *is* met. Finally, use the Else Play Action drop-down menu to tell Photoshop what action to run if that criteria *isn't* met.

 Don't panic: it's not as hard or as time-consuming as it sounds. You'll likely have just two or three conditions to plan for, as described in the steps for creating a watermark action on page 819.

 WARNING If you've created conditional actions, you should *never* rename your existing action sets. Why? Because the conditional actions *include* set names. So if you rename a set used by a conditional action, then that action won't work.

- **Insert Path.** Photoshop can record the act of drawing a path (as explained in the last bullet in this list), though it can't record the Pen tool's *settings*, so you can use this command to insert a path you've *already* drawn. Just open the Paths panel, activate the one you want to insert, and then choose this command.

- **Action Options.** This command (which works on both custom and built-in actions) opens the Action Options dialog box so you can edit the action's name, keyboard shortcut, and color. You can also open this dialog box by Option-double-clicking (Alt-double-clicking on a PC) the action in the Actions panel. (To rename an action, simply double-click its name in the Actions panel.)

- **Playback Options.** If you can't figure out where an action has gone haywire, you can make Photoshop play the action more slowly by choosing this command. In the resulting dialog box, choose Accelerated (normal speed), "Step by Step" (Photoshop completes each step and refreshes the screen before going to the next step), or "Pause For _ seconds" (Photoshop pauses between each step for the length of time you specify).

- **Allow Tool Recording.** This option tells Photoshop to capture strokes you make with the brush tools and paths you draw with the Pen and shape tools (though it doesn't capture the tool's particular *settings*, such as brush tip, size, and so on). Be sure to turn this setting on *before* you begin recording the painting of your next masterpiece, and you'll be able to replay—and thus recreate—the painting any time you want.

Editing Actions

As you might suspect, you can add, delete, and tweak actions' steps, as well as scoot 'em around within the Actions panel, just like layers. To rearrange your Actions panel, just drag an action to a new position in the panel; when you see a light-colored line where you want the action to go, release your mouse button. This lets you keep certain actions together so they're easier to spot, which is handy when you're in Button mode (page 810).

You can also drag and drop steps *within* an action to rearrange 'em; because there are *so* many things to consider when you're recording an action, some step rearranging will likely be in order. To change an action's *settings* (such as those found in a filter's dialog box), make sure you have an image open, double-click the relevant step, enter a new value in the resulting dialog box, and then click OK.

> **NOTE** By clicking OK in a dialog box while editing an action's settings, you'll actually *run* the command associated with that dialog box (sharpening the active image, for example). The fix is to immediately undo it by pressing ⌘-Z (Ctrl+Z). Photoshop still remembers the new settings you entered and will simply use 'em the next time you run that action.

You can also add steps to an action. Simply activate the step that comes *before* the one you want to add, and then click the Actions panel's Record icon; perform the new step(s), and then click the Stop icon. Photoshop adds the new steps below the one you picked.

To get rid of a step, action, or set of actions, just activate what you want to delete and then drag it onto the trash can icon at the bottom of the Actions panel. (To bypass the "Are you sure?" dialog box Photoshop displays when you use that method,

activate the items and then Option-click [Alt-click on a PC] the trash can button to delete 'em.) To do a *thorough* spring cleaning of the Actions panel, choose Clear All Actions from the Actions panel's menu and, when Photoshop asks if you *really* want to delete everything (including Photoshop's built-in Default Actions set), take a deep breath and click OK.

> **TIP** To get the Default Actions set back after using the Clear All Actions command, just choose Reset Actions from the Actions panel's menu.

Creating Droplets

Droplets are actions that you trigger by dragging and dropping files onto special icons, so they're great for running actions on images without actually *opening* the images. Droplets can do things like change file formats, image size, convert images to black and white, or apply an overall color boost. As self-contained mini-applications, they can live outside Photoshop on your desktop, as *aliases* (pointer or shortcut files) in your Dock (taskbar on a PC) or on someone else's computer.

It's easy to create a droplet from an action; just follow these steps:

1. **Trot over to the Actions panel and choose an existing action.**

 You can't put the cart before the horse! To make a droplet, you've got to record the action first.

2. **Choose File→Automate→Create Droplet.**

 The resulting dialog box looks kind of like the Batch dialog box shown back in Figure 18-4 (page 813). Click the Choose button to tell Photoshop where to save your droplet, and then set the other options according to the advice on pages 812–815.

3. **Click OK and you're finished.**

 Your droplet (which looks like the one shown in Figure 18-9, top) magically appears wherever you specified.

Sharing Actions

When it comes to actions, folks love to share—there are tons of actions floating around on the Web. Most are free (though you'll probably have to register with the website you download them from), but you have to pay for the more useful and creative ones. Sharing your own actions is pretty easy; the only requirement is that you save your actions as a set *outside* of Photoshop before uploading them to a website. This section explains how to load actions that other people have created, and how to save your own actions as a set so you can share 'em.

FIGURE 18-9

Top: A droplet looks like a big, fat, blue arrow.

Bottom: To use a droplet, simply drag and drop a file or folder onto its icon, and Photoshop performs the droplet's action on the file(s).

If Photoshop isn't running when you drop files onto the droplet, it launches automatically.

> **NOTE** For a brief while, Photoshop CC included an Adobe Exchange panel that gave you easy access to actions others had shared with the Adobe Photoshop community. Alas, Adobe recently removed this Flash-based panel so it doesn't exist anymore, but at least you know you didn't imagine it!
>
> These days you can visit the Adobe Add-Ons site, described on page 564, to find actions or, in the Creative Cloud application, you can click the Market link on the Assets screen.

Loading Actions

Downloading and analyzing actions made by other folks is a fantastic way to learn what's possible. That said, actions that are short and sweet—ones that expand your canvas, add a new layer and fill it with color, and so on—can be even *more* useful than more complex actions because you'll use 'em more often.

One of the best places to find useful actions is the Adobe Add-Ons website; you can get there by choosing Help→Browse Add-Ons. Others include Action Central (*www.lesa.in/actioncentral*) and ActionFx (*www.lesa.in/actionfx*). (These sites are also great resources for brushes, textures, and so on.) Most of these sites arrange their goodies by category, so you'll probably have to choose Actions from a menu.

Here's how to load somebody else's action onto your computer:

1. **Download the action or action set.**

 What you're actually downloading is an ATN file (if the set is compressed, you'll end up with a .zip file that you need to double-click to expand). Save it somewhere you'll remember (like on your desktop or in your Downloads folder).

2. **Drag the action and drop it into an empty Photoshop window (one with no documents open), as shown in Figure 18-10.**

<div style="float:right; text-align:right;">SHARING
ACTIONS</div>

You can also load an action by choosing Load Actions from the Actions panel's menu, by double-clicking the ATN file, or by right-clicking the ATN file and choosing Open With→Adobe Photoshop CC. No matter which method you use, the new action appears in your Actions panel.

FIGURE 18-10

You can quickly load an action by dragging and dropping its ATN file into the Photoshop workspace. The action then appears in your Actions panel.

3. **Choose the action and give it a whirl.**

Test drive your new action by opening an image, clicking the action's name in the Actions panel, and then clicking the panel's Play icon. That's the only way to find out whether the action is lovely or lame.

Saving Actions as an External Set

Photoshop temporarily stores the actions you create or load in a special spot on your hard drive. If you reinstall or upgrade Photoshop—or if it crashes—there's a decent chance your actions will get zapped in the process (although the Migrate Presets feature helps a lot when you're upgrading; see page 33 for details).

If you've grown fond of your actions, you can save 'em *outside* the Photoshop application folder for easy backup. That way, you can reload them if they accidentally get vaporized. As a bonus, once you save your actions as an external set, you can share 'em with others by uploading them to sites like the Adobe Add-Ons website mentioned in the previous section. Here's what to do:

1. **In the Actions panel, choose an action set.**

You can save only actions that are part of a set—you can't save individual actions. (Page 816 explains how to create sets and add actions to 'em.)

2. **Choose Save Actions from the Actions panel's menu.**

 In the resulting dialog box, Photoshop prompts you to save the file in the Presets folder. To keep from losing your actions when you reinstall or upgrade Photoshop, or to share 'em with others, you can save them somewhere *else*. No matter where on your hard drive you end up saving them, if you add or edit the set later, be sure to save it in the *same* spot that you did before, or else you'll end up with multiple versions of that action set scattered across your hard drive.

3. **Click Save.**

 Photoshop creates an ATN file that you can move between computers, back up to an external hard drive, or share with the planet via the Internet.

TIP On Macs, Photoshop saves your actions in *Macintosh HD/Users/[your user name]/Library/Application Support/Adobe/Adobe Photoshop CC 2014/Presets/Actions*. On computers running Windows 8, it saves them in *C:\Users\[your user name]\AppData\Roaming\Adobe\Adobe Photoshop CC 2014\Presets\Actions*. (If you use a different version of Windows, you can choose Save Actions from the Actions panel's menu to see where Photoshop puts your new action sets.)

FREQUENTLY ASKED QUESTION

Sharing Droplets

I want to send my extra-special Mac droplet to a Windows computer. Is that legal?

Sure! It's within your Photoshop User Bill of Rights to share droplets between computers with different operating systems. However, the droplet won't work unless you know these secrets:

- Save the droplet with an .exe extension, which tells a Windows computer that it's an *executable file*—in other words, a program you can run (this extension isn't necessary on Macs).

- If you created the droplet on a Windows computer and want to move it to a Mac, drag it onto the Photoshop CC icon on the Mac to make Photoshop update it so it works on Macs, too.

- Photoshop doesn't understand file name references between operating systems, so if your action includes an Open or Save As step that references a specific file, the action pauses and demands the file from the poor soul who's using the droplet. If that happens to you, use the error dialog box to find the file Photoshop is asking for so the droplet can resume its work.

Beyond Photoshop: Plug-Ins

With enough patience, practice, and keyboard shortcuts burned into your brain, you can get smokin' fast in Photoshop—but you'll *never* be as fast as a computer. As you've learned, some things—like creating complex selections, correcting colors, retouching skin extensively, and so on—are darned difficult, so they're going to take you a long time no matter how fast you get.

That's where plug-ins come in handy. Think of them as little helper programs that run inside Photoshop (though a few run outside Photoshop, too) and let you do the hard stuff faster. You can get plug-ins from all kinds of websites, and they range from free to pricey. The really good ones give you amazing results in seconds, rather than the hours it would take you to do the same thing manually (if you can do it at all). Plus, the newer ones do their things on a separate layer and, in some cases, run as smart filters, so you don't even have to duplicate your original layer first. Nice!

In this chapter, you'll learn how to add and remove these little jewels, as well as how to store them somewhere other than your Photoshop CC folder (it's often safer that way). You'll also be introduced to some of the most amazing plug-ins on the market today—the crème de la crème—that run on Macs *and* PCs.

Adding and Removing Plug-Ins

To install a plug-in on a Mac, download it or copy it from the installer disc it shipped with, and then drag it from wherever it's saved on your computer into the Plug-ins folder, which lives inside the Adobe Photoshop CC 2014 folder (Figure 19-1, top). On a PC, download the plug-in or copy it from the installer disc and look for an .exe (executable) file; then simply double-click that file to run the installer.

NOTE Adobe removed all the Flash-based panels from this version of Photoshop, including the short-lived Adobe Exchange panel (which was handy for finding and installing plug-ins). Easy come, easy go! That said, you can find plug-ins by choosing Help→Browse Add-Ons or by clicking the Market link on the Assets screen of the Creative Cloud application.

After you install the plug-in, quit Photoshop if it's running (File→Quit [File→Exit on a PC]) and then relaunch it. When Photoshop reopens, you should see the plug-in listed at the bottom of the Filter menu (though there are exceptions, as Figure 19-1 explains).

FIGURE 19-1

On a Mac, you can install a plug-in manually by dragging it into Photoshop's Plug-Ins folder (top) or by using the installer provided by the folks who made the plug-in (bottom).

On a PC, simply double-click the plug-in's .exe file (if it doesn't include one, just drag the file into the Adobe Photoshop CC 2014→Plug-Ins folder).

If you have trouble installing a plug-in, contact the person or company who created it.

Once you've installed the plug-in, you might have to dig through Photoshop's menus to find it. If a plug-in deals with batch processing (modifying multiple files at once), you may find it in the File→Automate menu instead of the Filter menu. And if it deals with selections or masking, you may find it lurking in the Select menu.

Some plug-ins, like the one shown in Figure 19-1 (bottom), come with an installer and an *uninstaller*, which is handy if you want to get rid of it. That said, you can remove a plug-in manually by opening the Plug-Ins folder and dragging it to the Trash. (On a PC running Windows 8, go to Start by pointing your cursor at the lower-left of the screen, then find the program and right-click its icon; click Uninstall on the toolbar at the bottom of the screen, and then—in the Programs and Features window that appears—click Uninstall. In Windows 7, go to Start→Control Panel→Programs→"Uninstall a program." Choose the plug-in from the list and then click Uninstall.) The next time you launch Photoshop, you'll see neither hide nor hair of the banished plug-in.

These days, Photoshop CC runs only in 64-bit mode (page xxix) on both Macs and PCs, so you may find that some of your older 32-bit plug-ins are incompatible with it and are therefore missing from Photoshop's menus even *after* you install 'em. What's your recourse? Contact the plug-in's creator or visit their website to see if they make a 64-bit version (there's a good chance they do).

■ Managing Plug-Ins

Unlike previous CS versions, Photoshop CC wants you to store plug-ins in its Plug-Ins folder and the Required folder (see the box on page 835), so that's where it looks each time you launch the program. That's all well and good, but there's an *awfully* good chance your plug-ins will get zapped if the program crashes, or you upgrade to a new version of Photoshop or reinstall the current one. (The same is true of actions, brushes, and other presets, though the Migrate Presets feature helps if you're upgrading [see the Note on page 33].)

To protect your precious plug-ins, you can store 'em elsewhere, but you have to tell Photoshop *where* you put them by using the Load command in the respective panel's menu (say, the Actions panel if you're loading an action that's stored somewhere else on your hard drive or the Brush panel if you're loading custom brushes). In Photoshop CC, you can't direct the program to look for another folder full of plug-ins by using its Plug-Ins preferences.

In the following pages, you'll find brief descriptions of some of the most amazing plug-ins on the market. Each one performs its own special brand of magic, such as noise removal, color enhancement, or special effects—one even turns your Photoshop document into a fully functional web page! These plug-ins range in price from $50 to $500, but don't let that scare you; if a plug-in saves you valuable hours, you'll make that money back in no time flat. There are *gobs* of Photoshop plug-ins, so don't be alarmed if you don't see your favorite one in the following list—it's simply impossible to catalog 'em all here.

NOTE For a comprehensive list of Photoshop plug-ins, visit the Adobe Add-Ons site by choosing Help→Browse Add-Ons.

■ Noise Reducers

If you've taken a photo in low light or set your camera to a high ISO (light sensitivity), chances are the image has a ton of *noise*—grainy-looking speckles—in it. While you'll find a couple of noise-reducing tricks in Chapter 11, if the image is *really* important, you can spring for one of these noise-reducing plug-ins instead.

Noiseware

This plug-in is the noise reducer of choice for professional photographers. Instead of blurring the whole image to make the noise less visible, Noiseware analyzes the image and reduces noise only in the areas that really need it. You also get a handy before-and-after view so you can see what it did. It's available from *www.imagenomic. com* and costs around $80.

> **TIP** You can often get plug-ins much cheaper if you buy 'em bundled together, or if you're upgrading from a previous edition. Be sure to look for special deals on the developer's website!

Dfine

This plug-in reduces noise in a simple and nondestructive way. When you launch Dfine and click its Measure button, it scours your image for noise in areas without much detail (where noise is easiest to see). Start by trying the factory setting and then increase or decrease the noise-reduction level with the easy-to-use sliders (see Figure 19-2). When you find a setting you like, click OK and Dfine copies the currently active layer and applies noise reduction to the duplicate.

FREQUENTLY ASKED QUESTION

Dude, Where's My Plug-In?

Help! I don't see my plug-in in the Filter menu. Did it load or what?

Peace, Grasshopper. You can find out whether your plug-in loaded in a couple of ways.

When Photoshop encounters a plug-in that won't load, it presents you with a dialog box that says, "One or more plug-ins are currently not available on your system. For details, see Help→System Info." To find out why the plug-in didn't load, choose Help→System Info and scroll down in the resulting dialog box until you see the offending plug-in, along with Photoshop's oh-so-brief explanation of what went wrong.

For example, if you try to learn why the variations adjustment (see the Note on page 363) didn't load in 64-bit mode, you'll see the following line of text: "Variations NO VERSION - 32-bit plug-in not supported in 64-bit - next to the text: 'Variations.

plug-in.'" In CC, if a plug-in doesn't load, it's likely that it works only in 32-bit mode. In that case, you're out of luck: Photoshop CC 2014 runs in 64-bit mode only.

If you don't get the "plug-in didn't load" message and your plug-in is *still* missing, take a peek in other menus—such as Select or File→Automate—to see if it ended up in there. You can also look at the list of loaded plug-ins by choosing Photoshop→About Plug-In (Help→About Plug-In on a PC). If your plug-in is included in the list but isn't loading, the only thing you can really do is install a fresh copy of it or, better yet, see if a newer version is available from the developer's website. Keep in mind that some plug-ins continue to work with newer versions of Photoshop, but some don't.

FIGURE 19-2

Dfine's handy split-screen
view lets you see how
much noise the plug-in
will remove from the
image before you commit
to the change. Here, the
original is on the left
side of the vertical red
line and the result is on
the right.

Finding Built-In Plug-Ins

Plug-ins come in two flavors: those that are installed with Photoshop and those that aren't. Back in CS6, Adobe changed where the program installs built-in plug-ins. This change keeps built-in plug-ins separate from plug-ins you install yourself—whether they're from another company or an optional plug-in from Adobe—which makes troubleshooting plug-in related problems a little easier for the poor souls at Adobe Technical Support. So where on earth does Photoshop put the built-in ones?

The standard plug-ins—filters, extensions, the "Save for Web" dialog box, and the like—are squirreled away in a folder named *Required*. To see this folder on a Mac, Control- or right-click the Photoshop CC application icon (which lives in Applications→Adobe Photoshop CC 2014), choose Show Package Contents, and then navigate to Contents→Required→Plug-ins. On a PC, the path is *C:\ Program Files\Adobe\Adobe Photoshop CC 2014\Required\ Plug-Ins*.

You really don't need to root around in the Required folder, but at least now you know why the regular Plug-Ins folder is practically empty!

Thanks to Nik Software's amazing *control points* technology, Dfine lets you reduce noise in certain areas of an image without adding a mask. It also figures out which kind of camera you used to take the photo and then applies the right amount of noise reduction for your particular model (which makes sense because your camera is what introduced the noise). Before Google purchased Nik Software in late 2012, you could buy Dfine as a separate product, but these days it only comes bundled with the rest of their plug-ins, including HDR Efex Pro, Sharpener Pro, Color Efex Pro, Analog Efex Pro, and Viveza (most are discussed later in this chapter) for $150. One nice thing about Nik Software's plug-ins is that they all have the same layout and controls, so once you learn how to use one, you can easily use 'em all (*www. google.com/nikcollection*).

Photo Ninja (formerly Noise Ninja)

Long considered the king of noise-reduction software, Noise Ninja has been used by photographers and newspaper production artists for years (though Noiseware has become extremely popular, too). It helps reduce noise (speckled imperfections) and grain (textured imperfections) while preserving details. It can tackle 16-bit images, handle batch processing, and work as a smart filter. These days, its noise-reducing features have been rolled into a *new* product named Photo Ninja, which you can use in place of Adobe's Camera Raw plug-in to edit and convert raw images into other formats. The new software will set you back about $130, though Noise Ninja owners can upgrade for $80 (*www.picturecode.com*).

TROUBLESHOOTING MOMENT

Disabling Plug-Ins

If Photoshop starts acting weird after you install a plug-in, you can temporarily disable that plug-in to see if it's the culprit by locating it on your hard drive and adding a tilde (-) to the beginning of its file name. Some manufacturers nest their plug-ins inside yet another folder; for example, you'll find a folder called Mask Pro *inside* your Plug-Ins folder. In that case, you can put the tilde to the beginning of the *folder's* name to disable everything inside it. Either way, adding the tilde means the plug-in won't load the next time you launch Photoshop. When you want the plug-in to load again, just delete the tilde and relaunch Photoshop.

You can also get Photoshop to temporarily disable *all* plug-ins (great for narrowing down why the program might be acting strange). Simply press and hold the Shift key when you launch Photoshop and you'll see a dialog box asking if you'd like to "Skip loading optional and third-party plug-ins" (that is, anything installed in the Adobe Photoshop CC 2014→Plug-Ins folder). Your choices are Yes and No (you don't get to pick and choose *which* plug-ins Photoshop skips; it's all or nothing).

Making Selections and Masking

As you've learned in previous chapters, selecting stuff like hair and fur is *really* hard. Sure, there are some tricks that make it simpler, but a plug-in specifically designed for that task can make your life a heck of a lot easier and save tons of time (especially if you do this kind of thing a lot). That said, you'll need a bit of patience when you start working with masking plug-ins because they're not for the faint of heart. But with practice, you can use them to create selections you just can't make any other way.

NOTE Adobe has put a lot of work into improving the Refine Edge dialog box (page 181) and creating the new Focus Area command (page 174). So before you pay for a masking plug-in, make sure you're up to speed on wielding those two tools.

Fluid Mask

This *powerful* plug-in helps you mask around complex areas like hair and fur. As soon as you open Fluid Mask, it analyzes your image and marks what it thinks are edges with blue lines (see Figure 19-3) so you can decide which edges keep and which to zap. Then it creates a cutout of the image you can send back to Photoshop to use as a mask. You can also save your project and return to it later—a nice touch. Fluid Mask costs about $150 (*www.vertustech.com*).

FIGURE 19-3

These blue lines mark the edges that Fluid Mask found in this image. You can use the plug-in's tools (on the left) to mark edges you want to keep and ones you want to throw away.

Perfect Mask

Perfect Mask helps you pick the precise colors you want to keep or remove as you build image masks. You do that using two eyedroppers: Use one to select colors you want to keep and the other to select colors you want to throw away. Then you can use its Magic Brush to paint away the image's background while the plug-in helps you along by referring to the Keep and Drop color palettes you made. It can also extract *partial* color from a pixel, leaving you with a partially transparent pixel—important when you're selecting hair or fur (the edges are so soft that they have to be partially see-through to blend in with a new background). You can also view the image in mask mode, which helps you see what the selection looks like because it's displayed in shades of gray (just like a layer or channel mask). Perfect Mask can handle 16-bit images and works as a Smart Filter, though you have to turn the layer into a smart object first; otherwise, the plug-in deletes the selected pixels as soon as you apply it.

This plug-in costs around $100, though it's cheaper if you buy the Perfect Photo Suite bundle, which includes Perfect B&W, Perfect Portrait, Perfect Effects, Perfect Resize, and FocalPoint (some of which are covered in this chapter). The whole enchilada costs $180 and gives you access to the plug-ins through Photoshop, Photoshop Elements, Photoshop Lightroom, and Apple's Aperture, as well as a standalone version that runs *independently* of other software (*www.ononesoftware.com*).

> **TIP** When you install plug-ins from onOne Software, be sure to peek in both the Window→Extensions menu as well as the File→Automate window to find your new goodies.

Correcting and Enhancing Color

The plug-ins in this category can spruce up or fix the color in your images and produce a startling array of special effects while they're at it. Read on for the scoop!

Viveza

As you've learned in previous chapters, before you can adjust the color of a specific part of an image, you need to *select* that area. Not so with Viveza. Since this plug-in made its debut in 2008, it has revolutionized selective color and light adjustments. By marking the areas you want to change with *control points* (the small gray circles shown in Figure 19-4), you can adjust the saturation, brightness, and contrast of those areas at warp speed. And Viveza performs its magic on a duplicate layer, so you don't have to worry about destroying your original image. It's available from *www.google.com/nikcollection,* bundled with the rest of their plug-ins (including Sharpener Pro, Color Efex Pro, and Viveza) for $150.

Color Efex Pro

If you could buy just one plug-in, this would be a darn good choice. Using the same control points as other Nik Software plug-ins, Color Efex Pro lets you selectively apply up to 55 enhancement filters to your images—all nondestructively. You can use them to enhance images in creative ways, as well as to fix color casts, smooth skin, and so on (see Figure 19-5). Drop as many control points as you want and use them to set the effect's opacity in certain areas of the image, or click the Brush button to paint the effect where you want it. This plug-in is included in the $150 Nik Software bundle available at *www.google.com/nikcollection.*

FIGURE 19-4

By dropping a control point on an image (like the circle near the cowgirl's neck), you can adjust each area's saturation, brightness, and contrast independently.

For example, on the right side of the image, the contrast and saturation of the woman's vest has been increased while the sky remains untouched.

Perfect Portrait

With the click of a button, this plug-in scans your image for faces and facial features so it can whiten eyes and teeth, define lips, soften wrinkles, and reduce shines and blemishes. Perfect Portrait can also zap color casts based on the ethnicity of each face in the image; it now includes the power of SkinTune, which was part of the now-discontinued PhotoTune plug-in. And age- and gender-specific presets give you a head start for a slew of common problems. A handy set of sliders let you adjust each and every improvement, and tools let you paint away stray hairs, blemishes, and wrinkles. When you find a combination of settings that works, you can save it as a preset for use on other photos. You even get to choose whether to apply these amazing fixes as a smart object or as an additional image layer. Perfect Portrait is available from *www.ononesoftware.com,* and is included in their $180 software suite.

FIGURE 19-5

Top: This split-screen preview shows you before and after versions of an image. This particular filter, called Bleach Bypass, creates a high-contrast grunge look.

Bottom: The Glamour Glow filter gives the original image (left) a seriously dreamy look (right). But because Color Efex Pro applies the effect on another layer, you can always lower the filter layer's opacity to blend it with the original and produce a more realistic result.

Miscellaneous Plug-Ins

Most of the plug-ins in this section relate to specific tasks like creating black-and-white images, making enlargements, merging HDR images, building websites, creating actions, and so on.

Silver Efex Pro

This plug-in isn't a black-and-white converter; it's a virtual black-and-white *darkroom* that helps you create stunning black-and-white images (Figure 19-6) from color ones

(though you can also use it to improve images that are already black and white). It has more than 30 black-and-white presets and also lets you create your own.

You can make global adjustments by using the plug-in's sliders, or drop control points to tweak the brightness, sharpness, contrast, and structure (level of detail) in specific areas of an image, such as eyes, patterned clothing, and so on. You can also add a color filter just as if you'd put a filter on your camera lens. Silver Efex Pro lets you choose from over 20 different film types to simulate the look and grain of real film, add tints, and burn the edges of your images. It works as a smart filter and is included in the $150 Nik Software bundle (*www.google.com/nikcollection*).

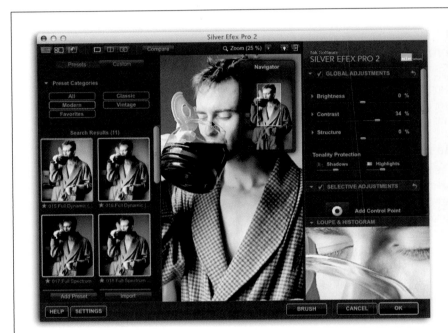

FIGURE 19-6

Silver Efex Pro, currently the most powerful black-and-white plug-in on the market, includes a gazillion gorgeous presets that you can fine-tune.

It even helps you create the look of black-and-white images captured on real film. If you want to add a little grain to an image, you can pick from several different options that look like real film grain.

Perfect Resize

This plug-in (which used to be called Genuine Fractals) will save your bacon if you need to *enlarge* an image. It lets you create printable versions of even low-resolution images (like those made for the Web or captured with a low-quality setting on your digital camera). It can blow images up to over 1,000 percent to make honkin' big panoramas, enlarge still frames from old videos to create higher-quality versions, and so on.

It can scale any Photoshop document—even if it's brimming with smart objects, paths, or type layers—without losing resolution or harming the image's quality. Just pick the pixel dimensions you want (if you know them), enter a percentage for the enlargement, or enter the final print size and resolution you want. If the image's proportions don't match those of the paper size you pick, Perfect Resize offers you

a cropping grid. It also batch-processes images. The premium version costs $150 and the stand-alone version runs $50, though it's also available as part of OnOne's $180 bundle (*www.ononesoftware.com*).

HDR Efex Pro

High dynamic range photography is all the rage these days, and while Photoshop lets you merge multiple exposures of the same image (page 421), this plug-in makes the process super simple. HDR Efex Pro offers an easy-to-use workspace, mathematical formulas to take your images from great to galactic in a flash, the ability to fine-tune the resulting image with precise adjustments, and a slew of incredible presets. This plug-in is included in the $150 Nik Software bundle available at *www. google.com/nikcollection*.

Eye Candy

This ever-popular set of special effects plug-ins now comes in one big honkin' set. It includes 30 filters that replicate the texture of everything from metal, glass, gel, fire, ice, and smoke to textures like lizard, fur, and stone. The Eye Candy plug-in set runs $130 and is available from *www.alienskin.com*.

Dashboard Pro

Need help with Photoshop actions? Look no further. Longtime pro photographer Kevin Kubota created Dashboard Pro, a *free* collection of 48 actions that are organized so you can easily find them (categories include black-and-white, color, creative enhancements, romantic, edgy, and so on). You can also assign keywords to your own actions and then search by keyword, name, or category. You can mark favorites for quick recall, and write a searchable description for any action. Kubota also sells dozens of action packs—including a collection of borders, textures, and artistic styles based on popular photographers—and you can try *any* of 'em inside Dashboard Pro before you buy 'em, which is a nice treat (*www.lesa.in/kkdashboardpro*).

Photoshop and Video

Everybody's shooting video these days, whether it's with a smart phone, video camera, point-and-shoot camera, or fancy digital SLR. You might not realize it, but Photoshop has been able to edit videos since CS3, though only in the more expensive Extended version (which doesn't exist anymore). This is great news because, since you already know how to use Photoshop, you don't have to learn another program *just* to edit videos.

Now, while you *can* create an extensive video project in Photoshop complete with a title sequence, closing credits, and dancing flamingos, other tools are much better suited for that, such as Adobe Premiere Pro and After Effects, Apple's Final Cut Pro, Sony's Vegas Pro, and Avid's Media Composer. Instead, you'll want to use Photoshop for creating small- to medium-sized video projects that contain only a handful of clips, or for cleaning up clips for use in those other programs. That said, Photoshop is *ideal* for creating promotional pieces, portfolio-based slideshows, and sellable add-ons to your photography business (imagine a combo of stills and video clips from a romantic wedding or family portrait sitting!).

Here's a more detailed list of what you can do with video in Photoshop:

- Trim and split clips, as well as add a nice array of transitions between 'em.

- Clean up unwanted objects or blemishes, frame by frame.

- Correct the color and lighting in a clip, as well as sharpen clips.

- Add a layer mask to a clip to give it a creative edge.

- Use adjustment layers and filters to give clips creative color and shallow-depth-of-field effects.

843

- Add still images, text, and other graphics (like logos) as well as apply motion to them (think panning, zooming, and rotating).

- Add multiple video tracks so you can stack content for a picture-within-a-picture effect.

- Animate layer content and masks in a variety of ways, including changing position, size, opacity, layer styles, and even warp text.

- Add, duplicate, and control multiple audio tracks to include background music *and* sound effects, for example.

- Export your project as a ready-to-use video file, or in a format suitable for further editing in a more advanced program.

What makes Photoshop so great for editing video is that everything you know about working with images applies to working with video, too—you just have to learn a few details about video formats and how to use Photoshop's Timeline panel to work with clips. Once you know that, you'll be ready to climb into the director's chair!

■ Creating Your First Video Project

The first step in creating your video masterpiece is to gather and organize the files you want to use. (Because Photoshop's Timeline panel is so small, organizing your content beforehand makes your life a *lot* easier.) Start by creating a folder for your project and then create two *more* folders inside the first: name one Audio (for background audio and sound effects) and the other Content (for video clips, still images, logos, and so on). Inside the Content folder, organize the content in the order you want it to play *before* you open it in Photoshop. For example, by including a letter or number at the beginning of each file name, the content will sort itself alphabetically or numerically when you import it into your Photoshop document.

Another reason to organize content up front is that Photoshop doesn't embed video files into your document. Instead, it links to the *original* file, keeping your Photoshop document's file size manageable and leaving the original video file untouched. The downside to this setup is that if you move the video file on your hard drive, you'll break the link. But the upside is that this linking lets you perform nondestructive editing—Photoshop applies your edits to a *copy* of the original clip when you export your project (page 874).

> **TIP** Before starting any video project in Photoshop, change your workspace to the one Adobe designed specifically for video editing by choosing Window→Workspace→Motion. When you do, Photoshop pops open all the panels that are most useful for video editing, including the Timeline panel, which appears at the bottom of the program's window. To make the Timeline panel's previews easier to see, open the panel's menu and choose Panel Options, and then click the largest thumbnail size.

Using Video Document Presets

Although you could begin your video project by opening existing clips (as explained in the next section), it's nice to start a video project with a fresh, empty Photoshop document. Not only do you get a slick set of guides (explained in a sec), but you also get a wonderfully handy set of commonly used video presets. To do that, choose File→New and, in the resulting dialog box, choose Film & Video from the Preset menu. The dialog box displays a slew of video-related settings, and you have to know a lot about your *final* video format to pick the right ones. Your options include:

- **Size**. This menu lets you tell Photoshop what size document to create, and includes presets for NTSC (North American) and PAL (anything outside North America) TV, high-definition video, and professional film industry standards. The choice you make here affects the Width and Height fields below this menu, as well as the Pixel Aspect Ratio setting at the very bottom of the dialog box.

- **Resolution**. This field determines the size of your pixels. Straight from the factory, it's set to 72 ppi (perfect for onscreen use), so you probably won't need to change it.

- **Color Mode**. Just as with any new Photoshop document, you can choose the color mode you want to use. Leave this menu set to RGB Color and the drop-down menu to its right set to 8 bit.

- **Background Contents**. This menu lets you pick a background color for your project, which is visible whenever there's a transparent area in a *frame* (the still images that make up your video). The most flexible option is Transparent, which results in a gray-and-white checkerboard pattern. However, if you're planning to start your video with a solid black or white screen that gently fades into your first image, pick black or white here.

- **Color Profile**. A *color profile* is a set of instructions that determines how computer monitors and printers display or print your document's colors, and they're discussed in depth back in Chapter 16. When it comes to video, a good choice is Adobe RGB (1998).

- **Pixel Aspect Ratio**. This menu changes automatically to suit the choice you made in the Size menu. This setting determines the shape of the pixels by changing their aspect ratio (the ratio of width to height). Your best bet is to leave this set to whatever Photoshop picks.

> **NOTE** If you choose a video format that uses a pixel aspect ratio that's different from your monitor (say, rectangular or anything not perfectly square), Photoshop automatically changes your view to the aspect ratio of your document so your clips don't look stretched. This bit of preview magic is handled by the View→Pixel Aspect Ratio Correction command, which is turned on from the factory.

When you click OK, Photoshop opens a new, empty document that includes handy guides that indicate where it's safe to place *titles* (text) and important parts of your video (see Figure 20-1).

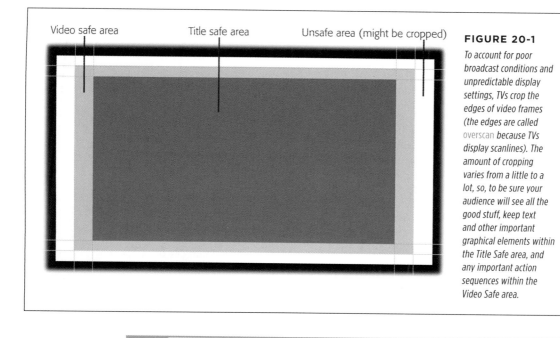

Video safe area Title safe area Unsafe area (might be cropped)

FIGURE 20-1

To account for poor broadcast conditions and unpredictable display settings, TVs crop the edges of video frames (the edges are called overscan because TVs display scanlines). The amount of cropping varies from a little to a lot, so, to be sure your audience will see all the good stuff, keep text and other important graphical elements within the Title Safe area, and any important action sequences within the Video Safe area.

NOTE If you're preparing a video for the Web (say, for posting on YouTube or your own website), you don't need to fret about the safe areas shown in Figure 20-1 because, online, the entire video image is always displayed.

The Timeline panel—which is described in detail on page 780—includes a Create Video Timeline button. (If you don't see this button, click the down-pointing triangle in the middle of the panel and choose Create Video Timeline to display it.) Give it a swift click and Photoshop adds a video and audio track to the panel. To add clips, click the tiny filmstrip icon next to the track's name in the Timeline panel, and then choose Add Media. In the resulting dialog box, navigate to where the clip(s) live (Shift- or ⌘-click [Ctrl-click on a PC] to choose more than one file), and then click Open.

Opening and Importing Video Clips

Another way to create a new video project is by opening an existing clip. You won't get the handy guides that appear when you create a blank video project as described in the previous section, but you can always add 'em yourself (page 67).

NOTE Photoshop understands Sony RAW, Canon RAW, MPEG-1, MPEG-2, MPEG-4, MOV, AVI, and FLV files, as well as the Image Sequence formats (where each frame of the video is saved as an individual file) BMP, DICOM, JPEG, OpenEXR, PNG, PSD, TARGA, TIFF, Cineon, and JPEG 2000. Whew!

To open a video clip as a new document, choose File→Open, find the clip on your hard drive, and then click Open. Photoshop creates a new document whose size matches the frames in the video, opens the Timeline panel (Figure 20-2, top), and plops the clip into a video track. Photoshop also creates a group in the Layers panel (named Video Group 1) and places the clip in that group on its own video layer (Figure 20-2, bottom).

Clips in a single video track play one after another. To add more clips to your track, in the Timeline panel, either click the tiny filmstrip icon next to the track's name and then choose Add Media, or click the + sign to the right of the video track. In the resulting dialog box, navigate to where the clip(s) live (Shift- or ⌘-click [Ctrl-click] to choose more than one file), and then click Open. The new clip(s) appear in the Timeline panel to the right of the first clip and in the Layers panel as a new layer (or layers) at the top of the currently active video group.

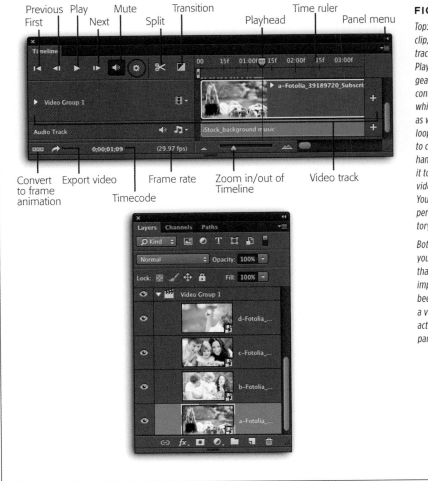

FIGURE 20-2

Top: Once you import a video clip, it appears in its own video track in the Timeline panel. The Playback Options menu (the gear icon circled here) lets you control the video's resolution while you're previewing it, as well as whether the track loops (starts over). Being able to control the resolution is handy because you can lower it to make Photoshop play the video a bit more smoothly. Your choices are 25, 50, or 100 percent (straight from the factory, it's set to 50 percent).

Bottom: In the Layers panel, you see a new video group that contains the clips you imported. (Four clips have been imported here.) Clicking a video layer in this panel activates it in the Timeline panel and vice versa.

Alternatively, you can add a single clip to your document by choosing Layer→Video Layers→"New Video Layer from File"; in the resulting dialog box, locate a clip, and then click OK (you can't add multiple clips this way). Photoshop imports the clip as a video layer and places it on a video track named Layer 1. (You can click the Create Video Timeline button in the Timeline panel to do the same thing, but you only see that button if you haven't created any video layers yet.) To add more clips, use the methods described in the previous paragraph and Photoshop adds 'em to the track and plops them into a new group in the Layers panel. You can also use Bridge or Mini Bridge to open or add clips to your project (see Chapter 22).

Keeping your video clips in one track (and thus, in a single video group in your Layers panel) is handy for organizing your project. For example, you could use the video track for clips that you want to play in succession, and then add another track for text (Chapter 14) or other graphical elements (your logo, say). If you want one clip to play at the same time as another (to create a special effect, for example), add another video track by heading to the Timeline panel, clicking the filmstrip icon next to the track's name, and then choosing New Video Group.

TIP If you want import a clip into a *new* video track instead of the current one, make sure you don't have any clips active by clicking an empty spot in the Layers panel, and *then* import the clip.

If you're working with multiple video layers (whether they're in a video group or not), be sure to give each one a meaningful name. This helps you keep 'em straight in your head and prepares the document for additional tweaking in a professional video-editing program, which may get confused by duplicate layer names (say, if you import the same video clip *twice* instead of just duplicating the video layer in Photoshop).

WORKAROUND WORKSHOP

Videos as Smart Objects

Once you've added some video clips to your document, you might want to turn 'em into smart objects so they're primed and ready for applying filters nondestructively. In fact, using smart objects is the *only* way to apply a filter to a whole video clip (otherwise, Photoshop applies the filter to only a *single frame*; you'll learn more about that on page 872). Using smart objects is also handy if you want the clip to be smaller onscreen than other clips (for a picture-in-picture effect), because using smart objects means you can resize it without losing quality.

In *previous* versions of the program, you couldn't use the File→Place command to import a clip as a smart object; if you

did, the clip arrived as a smart object, but Photoshop treated it as a *still image* instead of a video (because it embedded the file instead of linking to an external one). These days, you can use the relatively new File→Place Linked command to make the clip arrive as a smart object containing a real live video clip. To convert an *existing* video layer into a smart object, in the Layers panel, Control-click (right-click) near the layer's name and choose "Convert to Smart Object." You can also activate one or more video layers and then choose Filter→"Convert for Smart Filters." Hooray for progress!

Meet the Timeline Panel

The Timeline panel (Figure 20-2, top) is mission control for video projects. It appears at the bottom of your workspace when you create a new video document or open an existing clip. It lets you play, rewind, or fast-forward through your project, trim or split clips, skip to a specific spot within a clip, apply motion to stills and text, and more. Before diving into all that, it's good to know the basics of using this panel.

The first thing you'll want to do is to play the clip to determine whether it needs trimming or splitting. When you first import a clip, Photoshop positions the *playhead* (labeled in Figure 20-2, top) at the beginning of the clip; it looks like a blue triangle with a thin red line extending down through your tracks. The playhead moves across the track during playback to indicate which part you're viewing. You can move the playhead by dragging the blue triangle, or by using the first four buttons at the top left of the Timeline panel (labeled in Figure 20-2, top):

- Click the **First** button to move the playhead to the first frame of your project (the very beginning).

- Click the **Previous** button to position the playhead one frame to the *left* of its current position.

- Click the **Play** button to, well, play your project; when you do, the playhead moves rightward through your tracks. As soon as you click this button, the icon on it changes to a Pause symbol (two vertical lines); click it to halt playback. (You can do the same thing by tapping your space bar once to play and again to pause.) As your project plays, the *timecode* at the bottom of the panel lets you know exactly where you are in the video. Photoshop also displays the *frame rate* (the speed at which it plays the individual frames) to the right of the timecode.

> **NOTE** Even new computers can struggle with video playback, especially if the clips are high definition. If the Timeline panel's frame rate turns *red* during playback, you aren't seeing all the video's frames (Photoshop shows how many you *are* seeing, instead of the intended frame rate).

- Click the **Next** button to position the playhead one frame to the *right* of its current position.

Here's what the Timeline panel's other settings do:

- The **Mute** button lets you silence any audio that you've included in the document's tracks (page 852).

- Clicking the **Playback Options** button (the gear icon circled in Figure 20-2, top) displays two settings. The Resolution menu lets you tell Photoshop what resolution to use during playback (it's automatically set to 50 percent), and the Loop Playback checkbox lets you make the video start over once it finishes.

- Use the **Split** button to slice a clip in two at the playhead's current position (page 854).

- The **Transition** icon summons a menu of interesting effects that you can use to *transition* (hence the name) from one clip to another.

- The **time ruler** tells you where you are in your project. From the factory, it's set to display time intervals, but you can have it show frame numbers instead by heading to the Timeline panel's menu and choosing Panel Options→Frame Number.

- Use the **playhead** to tell Photoshop where to start playing back your project (just position it and then press your space bar or click the Play button) or where to split clips (position it and then click the Split button). You can also use the playhead to precisely position elements in your project. For example, if you put the playhead where you want a sound effect to occur, you can then drag the sound effect in the audio track and it'll automatically snap to the playhead's position.

To rearrange your clips to change the order in which they play, just click a clip in the Timeline panel and drag it left or right; while you drag, your cursor turns into a closed fist and you see a ghosted image of the clip. When you get it in the right spot, release your mouse button. That said, it's *much* easier to drag clips up or down in the Layers panel instead, as explained in the following Tip.

> **TIP** In the Layers panel, layers that are *lower* in the stack within a video group appear *earlier* in that video track, and layers that are *higher* in the stack appear *later*. (In other words, the bottom-to-top order of video layers in the Layers panel is the same as the left-to-right order of video clips in the video track.) So dragging a video layer up or down in the Layers panel also moves the clip right or left in the video track, respectively.

Editing Video

Few, if any, video clips begin and end at the perfect moments. That's why it's important to know how to trim or split clips in Photoshop. Fortunately, both methods are incredibly easy (and nondestructive to boot!). In this section, you'll also learn how to add transitions, text, other images, and audio. Read on!

Changing Clip Length

Photoshop makes it simple to trim a clip: just drag its endpoints left or right in the Timeline panel. As you shorten one clip in a video track, the others slide over to keep the track seamless, as shown in Figure 20-3.

You can also adjust the length of a clip by clicking the triangle in its top-right corner in the Timeline panel (circled in Figure 20-4, top). When you do, Photoshop opens a panel containing Video and Audio buttons (also circled). Either way, trimming clips is a nondestructive process, so if you decide to *undo* your trimming, just drag the clip's endpoint left or right (happily, Photoshop won't let you extend a clip beyond its original length).

NOTE If you've converted a video layer into a smart object (page 133), clicking the triangle in the clip's top-right corner opens the *Motion* panel instead of the Video/Audio panel shown in Figure 20-4. It includes presets such as Pan, Zoom, and Rotate; you can use it to add Ken Burns–style motion to still images, as described on page 858.

FIGURE 20-3

Point your cursor at the start or end point of a clip and the cursor turns into a bracket with a double-sided arrow (circled). The bracket points toward the clip that will be affected (here, the bracket faces left). Click and drag the bracket left or right and Photoshop opens the preview window visible here, which shows exactly which frame you're trimming the video down to. Handy, eh?

FIGURE 20-4

Top: Click the little triangle at the top right of a video clip to open this panel, which lets you enter a precise duration for the clip. You can also adjust each setting by dragging its slider, as shown here.

Bottom: The Audio portion of this panel (click the button circled here to display it) lets you set the volume and fade-in/fade-out times of any sound in the clip. You can also silence the audio by turning on the Mute Audio checkbox. (If only that worked in real life!)

NOTE To regain access to the Video/Audio panel (say, in order to mute any audio contained in a video clip), double-click the smart object in the Layers panel to open it in a separate (temporary) document. In this new document's Timeline panel, click the triangle in the clip's top-right corner—if you don't see the triangle, use the zoom controls at the bottom of the panel to enlarge the clip—and then adjust the audio as necessary. Finally, choose File→Save or press ⌘-S (Ctrl+S) to save the file, and then close it to return to your main document, which reflects your changes.

The Video portion of the panel includes the following controls:

- **Duration** sets the length of the clip by trimming frames from the end.

- **Speed** sets the playback speed of the clip, from 25% to 400%.

NOTE If you *increase* a clip's speed, Photoshop shortens the clip's duration accordingly. But if you reduce a clip's speed, Photoshop *doesn't* automatically lengthen the clip's duration—you have to do that manually (otherwise, Photoshop only plays part of the clip).

When you click the panel's Audio button, you get these options:

- **Volume** sets the clip's sound level from 0% to 200% of its original volume.

- **Fade In/Fade Out** controls the time at which the clip's sound fades in or out.

- **Mute Audio** does just that; turn on this checkbox to hear nothing but the sound of silence.

When you're finished tweaking the panel's settings, press Return (Enter on a PC) to accept your changes, and then click anywhere in the Timeline panel or within your document to close the Video/Audio panel. If you change your mind about editing the clip, press the Esc key instead to dismiss the panel and cancel your changes.

Adding Transitions

If your video project contains more than one clip, you can add a *transition* that connects two clips by fading them together in a variety of ways. You can also add transitions at the beginning and/or end of your project, which is a classy way to fade the video in from a solid color (black, say) when it starts, and then fade it out to a solid color when it ends.

To add a transition to a clip, click the Transition button circled in Figure 20-5. In the resulting Drag To Apply panel (Figure 20-5, top), drag a transition style (you'll learn about them in a sec) and drop it onto the beginning or end of a clip, or *between* two clips, as shown in Figure 20-5 (bottom). When you drop the transition, an icon appears on the clip where you placed it (it looks like one or two light-colored tri-angles inside a rectangle, depending on which transition you pick). If you drop the transition between two clips, the icon appears at the end of the first clip and the beginning of the second.

FIGURE 20-5

Choose a transition style and duration from the Transitions panel shown here, and then drag it onto the beginning or end of a clip.

If you add it to the beginning of a clip (so the clip fades in), you can adjust the transition's length by dragging its icon's right edge leftward to shorten the clip or rightward to lengthen it. If you add a transition to the end of a clip (so the clip fades out), drag the transition icon's left edge instead. As you drag, a handy overlay appears showing the transition's duration.

TIP If you add a Cross Fade transition, you can drag either end of its icon to adjust its length asymmetrically (to create a longer fade out and shorter fade in, or vice versa). To adjust a Cross Fade transition's length *symmetrically*, Option-drag (Alt-drag on a PC) its icon instead.

Photoshop offers the following transition styles for your video-viewing pleasure:

- **Fade.** Fades the clip in or out depending on which end of the clip you apply it to. Use this transition on *layered* video elements, such as text or a graphic (a logo, say) that appears atop other clips that you've placed in a separate video track that lives *beneath* this one in the Timeline panel.

- **Cross Fade.** This transition is used between clips to fade the first clip out as the second clip fades in, so you see a blending of the two video clips (or stills).

TIP If you've only got one video track, try using one of the last three fades in this list to fade to a solid color.

- **Fade With Black.** Fades the clip to solid black, which is handy for using at the beginning or end of your project (as are the next two options).

- **Fade With White.** Fades the clip to solid white.

- **Fade With Color.** Fades the clip to the solid color of your choice. You can choose the color when you add the transition by clicking the color chip that appears in the Drag To Apply panel when you click this style, or *after* you add it by Control-clicking [right-clicking] its icon in the Timeline panel.

You can control a transition's duration either by adjusting the Duration slider in the Transition panel *before* dragging the transition onto the Timeline panel, or by dragging the edge of the transition's icon *after* you've dropped it on the Timeline panel (see Figure 20-5). You can also Control-click (right-click) the transition's icon in the Timeline panel to make Photoshop display the Transition panel, which lets you change the transition's style and duration (see Figure 20-6).

FIGURE 20-6

Control-click (right-click) a transition's icon to display this handy panel. To delete the transition, click the panel's trash can icon. You can also delete a transition by clicking its icon in the Timeline panel and then pressing the Delete key (Backspace on a PC).

Splitting and Trimming Video Clips

Another kind of edit you'll likely need to make is to *split* a long clip into multiple pieces, or to chop a section out of the middle of a clip. The first maneuver is super easy; the second takes a little more effort.

To split a video clip into two pieces, click the clip in the Layers or Timeline panel to activate it, and then position the playhead where you want the split to occur. When it's in the right spot, click the "Split at Playhead" icon (the scissors) at the top of the Timeline panel, as shown in Figure 20-7.

Removing a section from the *middle* of a clip is slightly more complicated and there are a couple of ways to do it. If all you want to do is to delete a section of a clip, simply split the clip twice to isolate that section, click the doomed section to activate it, and then press Delete (Backspace on a PC). Photoshop scoots the clip segment on the right side over to the left so the clips play one right after the other.

Another way to remove part of a clip is to define a *work area*, which lets you tell Photoshop which section of the clip you want to work with. To do so, first drag the video layer *out* of its video group in the Layers panel, even if there's just one clip in the group—simply drag it above or below the video group to liberate the layer. (As Figure 20-8 explains, you don't *have* to perform this step, but you'll have more options if you do.) Then, click and drag the work area sliders labeled in Figure 20-8 (top) so they're on either end of the portion of the clip you want to work with. Alternatively, you can position the playhead where you want the work area to start and then, from the Timeline panel's menu, choose Work Area→"Set Start at Playhead"; then set the end of the work area by repositioning the playhead and, from the same

menu, choosing Work Area→"Set End at Playhead." Either way, the next change you make applies only to the work area you've defined, whether you delete that section from the clip or export that portion (say, to see what that portion of your video will look like when it's rendered).

FIGURE 20-7

When you split a video clip, Photoshop cuts it wherever the playhead is and a new video layer appears in the Layers panel (not shown) within the video group at the top of the layer stack. Photoshop cleverly adds the word "copy" to the end of the original layer's name.

You can also split a clip by positioning the playhead in the right spot and then Control-clicking (right-clicking) the clip itself and choosing Split Clip from the resulting shortcut menu.

Once you've defined the work area, you can delete that section of the clip by using the Timeline panel's menu. The menu gives you two different ways to accomplish this deletion, depending on the result you want. If you want the original clip to play uninterrupted where the axed section used to be, choose Work Area→Extract Work Area. This divides the original clip into two and places the pieces on separate video tracks; the second piece plays immediately after the first as if the missing section never existed (Figure 20-8, middle). If you instead want to leave a hole the duration of the deleted section, choose Work Area→Lift Work Area. This also divides the original clip into two and places the pieces on separate video tracks, but it leaves a *gap* between them the duration of the section you zapped (Figure 20-8, bottom).

> **TIP** To preview the portion of your clip that you defined as the work area, simply press the space bar. (This works whether or not you dragged the video layer out of its video group before defining the work area.)

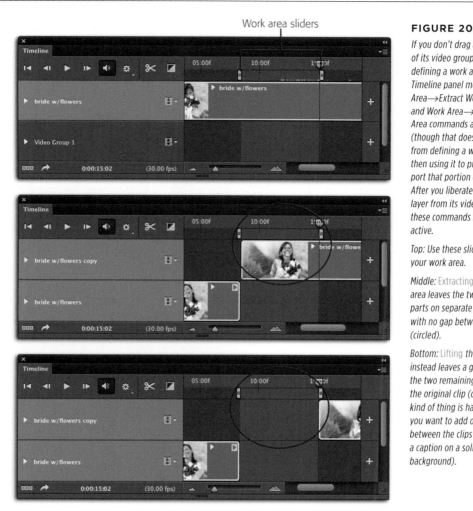

Work area sliders

If you don't drag a clip out of its video group before defining a work area in it, the Timeline panel menu's Work Area→Extract Work Area and Work Area→Lift Work Area commands are dimmed (though that doesn't keep you from defining a work area and then using it to preview or export that portion of your clip). After you liberate the video layer from its video group, these commands become active.

Top: Use these sliders to define your work area.

Middle: Extracting *the work area leaves the two remaining parts on separate video tracks with no gap between them (circled).*

Bottom: Lifting *the work area instead leaves a gap between the two remaining parts of the original clip (circled). This kind of thing is handy when you want to add other graphics between the clips (such as a caption on a solid-colored background).*

Adding Text, Logos, and Still Images

One common video-editing task is to add text, still images, logos, and other graphics to a video project (Figure 20-9). These are all great ways to add branding to a project, navigation elements to a video disc or kiosk, or visually interesting bits and pieces that you can animate.

FIGURE 20-9

Left: Adding text lets you personalize the video and add branding. Mixing stills with video clips also adds visual interest. When they play the video, the top image is the first thing the couple will see, and the bottom image is the last thing (a great way to remind clients how to contact you for more gigs!).

Right: By adding a separate video track for the text, you can position the type-layer clips atop the other content in the Timeline so they play simultaneously with the video and stills in the first video track (shown in Figure 20-10, top).

Adding this kind of stuff to a video is super simple. You can drag and drop 'em directly from Bridge or your computer's desktop; use the File→Place command so they arrive as smart objects; copy and paste them from another Photoshop document; drag and drop a layer from another Photoshop document; or create 'em from scratch in your current document. Whichever method you use, the new goodies appear on their very own layer, either above the currently active layer or, if no layers are active, at the top of the layer stack. If a video track or video group is active when you add the text or image, then the associated clip appears at the far *right* of that track in the Timeline panel; if not, then the text clip appears on its *own* track. In the Timeline panel, these added items look and behave just like video clips; the length of their *clips* determine how long they stay onscreen.

Adding text to video works just like any other text: simply press T to activate the Type tool, click within the document where you want the text to appear, and then start pecking away (be sure to commit the text by clicking the checkmark in the Options bar or by clicking any other layer in the Layers panel). Photoshop creates

a new type layer that you can format and reposition however you'd like. (For more than you ever wanted to know about formatting text, see Chapter 14.)

To add a still image—be it a photo, vector, or whatever—choose File→Place, navigate to where the file lives on your hard drive, and then click Place. Photoshop surrounds the item with a bounding box that you can use to resize or rotate it. To move the item, click and drag within the bounding box. When you're finished, press Return (Enter on a PC) to accept the transformation and Photoshop adds the item as a smart object.

> **TIP** When you're preparing still images for viewing on a TV (from a DVD, say), make sure the images are 720 × 534 square pixels or 720 × 480 non-square pixels. Also, the color gamut on a TV isn't the same as it is on a monitor. For the best results, try adding a levels adjustment layer and then, in the Properties panel, entering *16* into the Output field at the panel's bottom left and *235* into the Output field on the right (see page 403 for details). Doing so should pull any colors that are too bright back into the TV color gamut.

Once you've added some text and/or a few still images to your project, you may as well make 'em move a little! In the Timeline panel, click the triangle in a clip's top-right corner to open the panel shown in Figure 20-10.

> **TIP** If you're a photographer, make sure you capture some video along with stills (easy since most new DSLRs do both). For example, if you're a portrait photographer, capture some video between poses (especially if you're working with kids). Once you put it all together in Photoshop, you've got a fabulous video that you can sell to your clients.

> **TIP** When using the Motion presets to create a slideshow of still images, it's helpful to tweak their file names to number them in the order you want them to appear in the slideshow *before* you import 'em.

The five Ken Burns-style presets in the Motion panel are a great way to quickly get still images (or text) moving, whether you're using them on stills mingled with video or making a custom slideshow of your artwork. Choose the one you want to use from the panel's drop-down menu. Each preset offers different controls that you can tweak (they all include a "Resize to Fill Canvas" checkbox, which fills your frame with the image or text, regardless of its original size). Here's what each preset does:

- **Pan & Zoom.** *Panning* is the act of moving the image or text across the frame; the Pan dial controls the *direction* of this movement. The Zoom drop-down menu lets you choose whether the image or text grows (Zoom In) or shrinks (Zoom Out) during the panning.

- **Pan.** Use the Pan dial to adjust the direction of the movement.

- **Zoom.** The Zoom From setting controls where the zoom starts. In the microscopic box at the left of this panel, click the top-left square to make the image or text grow or shrink from the screen's top-left corner, click the center square to make it grow or shrink from the screen's center, and so on. The Zoom menu determines whether Photoshop zooms in or out.

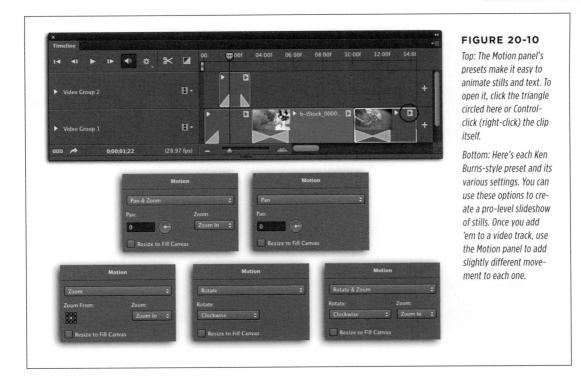

FIGURE 20-10

Top: The Motion panel's presets make it easy to animate stills and text. To open it, click the triangle circled here or Control-click (right-click) the clip itself.

Bottom: Here's each Ken Burns-style preset and its various settings. You can use these options to create a pro-level slideshow of stills. Once you add 'em to a video track, use the Motion panel to add slightly different movement to each one.

- **Rotate.** Use the Rotate menu to control whether the image or text rotates clockwise or counterclockwise.

- **Rotate & Zoom.** This preset lets you choose which direction the image or text rotates and whether Photoshop zooms in our out.

If you're an artist, designer, or photographer, animating stills in this way is just the ticket for creating a digital portfolio of your work. Just don't forget to add branding—text or your logo on an image or fill layer with contact info—at the beginning and end of the project. To keep the text readable atop an image, add a drop shadow to it (page 140). Or create a subtle block of color beneath the text: Add the text, grab the Rectangular Marquee tool and draw a selection that's a little bigger than the text, and then add a solid color fill layer. If your image is mostly dark, add a white fill layer; if it's fairly light, use black instead. Last but not least, lower the fill layer's opacity to around 15 percent to give the text a nice soft landing spot.

Adding and Controlling Audio

Photoshop automatically gives you one audio track that appears at the bottom of the Timeline panel, primed and ready for you to add a little background music to your project. (You'll learn how to add more audio tracks later in this section.) The advantage of using audio tracks is that doing so lets you control the volume of each

audio clip and how they fade in and out. (If you add an audio clip to a *video track*, Photoshop treats it like a video and you have far less control over it.)

To add an audio file to the audio track, mouse over to the Timeline panel and click the musical-note icon to the right of the words "Audio Track" (circled in Figure 20-11). From the drop-down menu that appears, choose Add Audio, and then find the audio file on your hard drive. Click Open, and Photoshop plops the file into the audio track.

> **NOTE** Photoshop understands most common audio file formats, including AIF, WAV, MP3, and AAC (but not FLAC). Basically, if iTunes can play it, Photoshop can import it. And if Photoshop *refuses* to import it, then it may be protected by a digital rights management (DRM) system (for example, an M4P file).

Just like a video, text, or image clip, you can adjust the start and end points of an audio clip to trim off its beginning or end. You can also drag the entire clip left or right to control when it plays. If you click the triangle at the right end of the audio clip (circled in Figure 20-11), you summon a panel that lets you set the time it takes the clips to fade in and out, as well as adjust its volume.

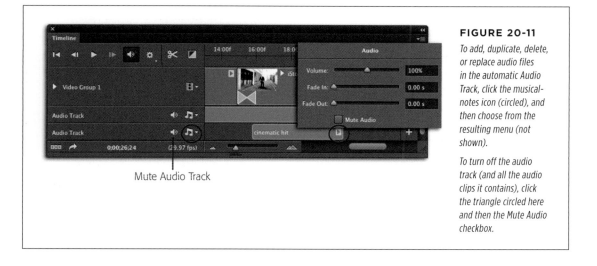

Mute Audio Track

FIGURE 20-11

To add, duplicate, delete, or replace audio files in the automatic Audio Track, click the musical-notes icon (circled), and then choose from the resulting menu (not shown).

To turn off the audio track (and all the audio clips it contains), click the triangle circled here and then the Mute Audio checkbox.

> **NOTE** Unlike all other tracks in the Timeline panel, audio tracks *don't* appear in the Layers panel, and you can't change their names.

To create a more complex and *layered* audio effect in which audio clips overlap, you can add *additional* audio tracks and place audio clips in them. (This is how you add sound effects to your project.) To do so, click the musical-note icon circled in Figure 20-11 and choose New Audio Track. Position the playhead where you want the sound effect to occur—when your superhero descends from the sky and lands on the ground, say—and then drag the audio clip to the playhead. To add *multiple* sounds to the same audio track, click to activate the audio clip and then, from the

musical-note icon mentioned above, choose Duplicate Audio Clip. Photoshop makes a copy of the clip, which you can then drag into the right spot in your Timeline.

WARNING Don't drag an audio file from Bridge or your computer's desktop into your Photoshop document. If you do, it appears as a new *video* track in the Timeline panel (and as a new layer in the Layers panel), and you have *no* control over the audio: You can't adjust its fade-in and fade-out times or its volume.

Also, don't steal audio for use in your projects. Audio is subject to the same copyright laws as imagery, so either create the audio yourself or purchase it from a royalty-free service such as Pond5.com, PremiumBeat.com, iStockphoto.com, or StockMusicStore.com.

UP TO SPEED

Timeline Panel Tricks

To master the Timeline panel, you'll need a few tricks up your sleeve. Here are some of the most useful:

- **Switch units.** From the factory, the Timeline panel's unit of measurement is time, and it displays this info both in the time ruler at the top of the panel and in the timecode at the bottom (both labeled back in Figure 20-2, top). To see frame numbers instead, Option-click (Alt-click on a PC) the timecode. To change the units back to time, simply Option-click (Alt-click) it again.

- **Show or hide track properties.** To expand a track to see any layer properties you can animate (such as the position of an image or type layer, its opacity, and so on), click the flippy triangle to the left of the track's name.

- **Show or hide clips.** To show only some of the clips in a document, first designate the ones you want to display by Shift- or ⌘-clicking (Ctrl-clicking on a PC) in the Timeline panel to activate 'em, and then, from the Timeline panel's menu, choose Show→Set Favorite Clips. Then, to specify which clips are displayed, from the same menu, choose Show→All Clips or Show→Favorite Clips Only.

- **Create a new video group from multiple clips.** If you have several clips in your Timeline panel that are related

and you *didn't* import them into a video group (say, you added your logo or type layers to the document), you can click and drag a clip from one video track onto another and Photoshop combines them into a new video group, making your Layers panel a bit more organized.

When it comes to the playhead, you can move it manually by dragging it or using the playback buttons, or do any of the following:

- Click anywhere on the time ruler to reposition the playhead at that point.

- Point your cursor at the timecode and, when the cursor turns into a double-sided arrow, click and drag left to move the playhead left, or right to move it right.

- Double-click the timecode, enter a time or frame number in the resulting Set Current Time dialog box, and then click OK.

- From the Timeline panel's menu, choose Go To→Time, and then enter a specific time in the resulting dialog box. (The other options in the Go To submenu are Next Frame, Previous Frame, First Frame, Last Frame, "Start of Work Area," and "End of Work Area.")

■ Animating Objects and Effects

In Photoshop, the term *animation* refers to anything that changes over time: an object can change position in your document and/or change in size. For example, if the starting position of some text is outside the document's margins, then it can appear to move across the screen. Or if an object starts out microscopically small, it can magically zoom into view.

Along those same lines, an *adjustment* you apply to a layer can change its opacity over time or even the area to which it's applied. Layer styles can also change over time. This section shows you how to include all these exciting changes, and more, in your video projects.

Adding and Deleting Keyframes

The key concept (ha!) to grasp about animations is that everything happens around a *keyframe*: the moment in an animation when something changes. This could be the direction of an object's movement, the object's size, the properties of a filter or image adjustment—whatever.

To create an animation in Photoshop, you create multiple keyframes, and then Photoshop creates the appropriate frames between them (these in-between frames are called *tween* frames). For example, to create a bouncing ball animation, you'd place the ball on the ground in one keyframe, then you'd move it to the sky in another keyframe, then to the ground again in yet another keyframe; Photoshop then adds all the frames in between to make it look like it's really bouncing.

A Word on Text in Videos

When it comes to adding text to videos, less is more. And aside from formatting it correctly (by using kerning, leading, and so on—see Chapter 14), there are a couple more things to consider:

Color. The most common color for text in video is white (even though an extremely light gray is a better choice because it's slightly lower in contrast). The second most common color is black. Both are quite legible, even atop a moving background. Feel free to choose other colors to complement the ones in your project. Just be sure to pick a very light or very dark shade. If you're working with a corporate client, they may have an official corporate color that you can specify by using the Pantone Matching System (page 525) to make your project match their branding.

Readability. Your computer monitor has a much finer resolution than most TVs (the pixels on TVs are bigger), and you're physically closer to the screen than your audience will be. For those reasons, what you're seeing in Photoshop *isn't* what your audience will see. To ensure that your text is readable, put Photoshop into full-screen mode (press the F key repeatedly to cycle through the different views). Next, zoom in so the project fills your whole screen (press ⌘-+ or Ctrl-+), and then step back at least 10 feet and see if you can easily read the text.

Last but not least, be sure to *preview* your video on the intended output device (if possible) after you export it (page 874), as the encoding process—the way Photoshop converts the project to a specific file format—can cause unexpected results.

To create your first keyframe, drag the playhead to the spot where you want the keyframe to be (in other words, put the playhead at the starting point of whatever you're going to make happen). Then set your object's location, size, layer opacity, and so on exactly the way you want it; once you've got it just right, in the Timeline panel, click the flippy triangle to the left of the track's name, and Photoshop displays several layer properties beneath the track's name (see Figure 20-12). Next, click the stopwatch icon to the left of the property you want to use. When you do, Photoshop creates a keyframe and a yellow diamond appears to the left of the stopwatch, between the Previous and Next triangles, as well as in the Timeline panel where the playhead is, also shown in Figure 20-12.

Now it's time to tell Photoshop when you want the animation to *end*. To do that, move the playhead to the spot where you want the change or motion to stop. Next, change your object's location, size, layer opacity, and so on. When you're finished—say, when you accept a size change using Free Transform or finish moving an object with the Move tool—Photoshop *automatically* adds another keyframe for you (that is, so long as you adjust the *same* layer property as you did in the first place). And that, dear Grasshopper, is the basic process of creating animations in Photoshop.

Because Photoshop automatically adds a keyframe any time you move the playhead and then change the contents of that clip (or rather, layer), it's easy to add too many. To delete a keyframe, click it to activate it and then either press Delete (Backspace on a PC) or head to the Timeline panel's menu and choose Keyframes→Delete. Alternatively, you can position the playhead atop the keyframe you want to delete and then click the yellow diamond between the Previous and Next triangles, or Control-click (right-click) the keyframe and then choose Delete from the resulting menu. To remove *all* keyframes for a property on that layer, click the stopwatch icon next to the property's name.

Editing and Copying Keyframes

Once you've created keyframes, you can move 'em around by dragging them left or right, or by copying them from one place to another. The quickest way to edit or copy a keyframe is to Control-click (right-click) its yellow diamond in the Timeline panel. When you do, Photoshop displays a shortcut menu that lets you delete, copy, or paste it (of course, you can't *paste* a keyframe until you've *copied* one). You can also use these commands on *multiple* keyframes by choosing Select All from the same shortcut menu, or by clicking and dragging *around* them in the Timeline panel; you won't see a selection marquee but the keyframes turn yellow to show they're active. (Once you're finished making changes, reopen the shortcut menu and choose Deselect All.) You'll also find these options in the Timeline panel's menu whenever one or more keyframes are active (meaning they're yellow).

Pasting a copied keyframe (or several) to another location is a three-step process. First, copy the keyframe(s) as described above, and then move the playhead to the new spot where you want the keyframe(s) to appear. Next, click the diamond between the Previous and Next Keyframe navigation triangles labeled in Figure 20-12, and Photoshop adds a keyframe at that position. Finally, Control-click (right-click)

the new keyframe (the yellow diamond that appeared beneath the playhead), and then choose Paste from the shortcut menu that appears. Whew!

Previous Next

FIGURE 20-12

Click the stopwatch icon to activate a layer property and Photoshop adds a yellow diamond to the property's left and beneath the playhead (circled). This diamond is called a keyframe indicator.

When you move the playhead to another position and then make a change to the contents of that clip (this change can be as subtle as changing its layer opacity from 100% to 50%), Photoshop automatically adds another keyframe.

You can use the triangles labeled here to move the playhead from keyframe to keyframe and see the results of your hard work. In this example, the type layer "Throttle" was positioned beyond the document's right margin in the first keyframe (top) and then left-aligned with the rest of the text in the second keyframe (bottom), to make it appear as if it slides onto the screen during playback. Pretty cool, eh?

If you press and hold the Shift key as you drag the playhead, it snaps to the next keyframe. However, if you're working with a long project, an easy way to move the playhead to the previous or next keyframe is to click the Previous or Next Keyframe triangles labeled here.

NOTE Don't try to use keyboard shortcuts such as ⌘-C (Ctrl+C) to copy, paste, or cut (delete) keyframes. If you do, Photoshop applies the commands to the *entire* video layer instead of individual keyframes!

Choosing an Interpolation Method

The most common use for keyframes is to indicate points in time where something changes, and then let Photoshop *interpolate* (make up) the frames in between. This process is called Linear Interpolation. When you have one or more keyframes activated, both the Timeline panel's menu and the shortcut menu you get by Control-clicking (right-clicking) a keyframe offer another choice: Hold Interpolation. This option tells Photoshop *not* to change the frames *between* the keyframes—instead, the program leaves the property the way it's set at the first keyframe and simply makes an abrupt change at the *new* keyframe.

Most often, you'll leave Photoshop set to Linear Interpolation, but there are creative uses for Hold Interpolation, such as when you really *want* to introduce an abrupt and shocking change in your video.

NOTE If you have a lot of keyframes and tracks, your project can begin to slow down and stutter when you preview it. One way to avoid this is to choose Allow Frame Skipping from the Timeline panel's menu. This tells Photoshop that it's okay to *skip* frames when you click the Timeline panel's Play button, making the preview run more smoothly. (Photoshop still *creates* all the frames correctly when you export the final video file.) One way to tell whether Photoshop is skipping frames is to look for a light blue line beneath the time ruler: If it's a solid line, you're seeing all the frames; if it's broken, you're not. You can also try to speed up playback by temporarily reducing the video's *resolution* by using the Playback Options icon (the gear circled back in Figure 20-2, top).

Warping Text

If you've arrived at this point in the chapter by reading the whole thing, you've already learned how to animate text in a couple of different ways: by using the Motion panel (page 851) or the Transform layer property (page 866). However, with text, you get an *additional* layer property called Text Warp. When you create a type layer, any Text Warp you apply appears in the Text Warp property in the Timeline panel, as shown in Figure 20-13.

How is this exciting? Well, it means you can make text look like it's bulging, twisting, arching, waving, and even being *squeezed*. Of course, you won't use this animation property on *every* project you create but when you do, you'll have a whole lot of fun!

Animating Masks

When you add a layer mask to a layer, it becomes a property that you can animate in the Timeline panel. (See page 121 for the scoop on creating layer masks.) This lets a background image or video poke *through* the mask. You can animate the mask's position and control whether it's turned on or off, but that's it.

FIGURE 20-13

Top: In this example, a type layer was placed and then distorted using the Wave Text warp, and two keyframes were added using the controls in the Timeline panel. Next, the playhead was moved to where the animation should end, the text was repositioned from bottom left to top right, and a Flag warp was applied to it. Photoshop added the second keyframe automatically.

Bottom: The yellow diamond marks the keyframe that controls the ending text warp. The gray diamond to its left (at the beginning of the clip) marks the keyframe where the first text warp was applied. The diamonds on the Transform property timeline indicate the beginning and ending positions of the text on the screen (starting at bottom left and ending at top right).

Starting text position keyframe Ending text position keyframe

Starting text warp keyframe Ending text warp keyframe

Rotoscoping and Onion Skins

Rotoscoping is the process of creating new animations from scratch: You create a video frame, put something on it, duplicate the frame, change its content a tiny bit, and repeat the process until you have a video (you need about 30 frames per second). If you have the patience, you can theoretically create a masterpiece this way.

While Photoshop gives you a tool for rotoscoping called *onion skins*, you're much better off using a program like Adobe After Effects instead because the process in Photoshop is just too tedious to bear. Nevertheless, onion skins let you see a ghosted image of a certain number of frames before and after the one you're working on (you control how many), which helps guide your edits.

To use onion skins, turn 'em on by choosing Enable Onion Skins from the Timeline panel's menu. Then set the frame options by choosing Onion Skin Settings from the same menu; Photoshop displays the dialog box shown in Figure 20-14.

FIGURE 20-14

This dialog box lets you control how many ghosted frames you see before and after the current frame, as well as the spacing, opacity, and blend mode of those frames.

You can change these settings anytime you want (to see more frames or fewer, say).

The Onion Skin Options dialog box contains these settings:

- **Frames Before/After.** Sets the number of frames that will show through the current frame. You can display up to eight frames before and after.

- **Frame Spacing.** Often, consecutive frames don't change much, so it's helpful to skip some. This setting lets you show only every other frame, every third frame, or whatever. Setting this field to 1 means Photoshop shows *all* the frames, setting it to 2 means Photoshop shows every other frame, and so on.

- **Max/Min Opacity %.** When viewing more than one frame before and after the current frame, you may want to see the closer frames at a higher opacity than those that are farther away. Max Opacity sets the opacity of the closest frame, while Min Opacity sets the opacity of the farthest frame. The frames in the middle range are between the two opacities.

- **Blending Mode.** Just like with layers, you can assign a blend mode to onion skins. Why? Because some videos are easier to see as onion skins when you use a different blend mode. Your options are Normal, Multiply, Screen, and Difference.

■ Global Lighting

When you add a layer style that includes embossing, a shadow, or other depth-related effect to a video layer, you can set its lighting angle. And if you apply layer styles to *multiple* layers in a video project, you probably want *all* the light to look like it's coming from the same angle.

To ensure consistent lighting, you can add a global lighting track, which overrides any *other* lighting angles that may have been set in individual layers. (To change the angle of the light over time, you can add multiple global lighting keyframes that have different lighting angles.)

To set a global lighting angle and apply it to your video project:

1. **From the Timeline panel's menu, choose Show→Global Light Track.**

 In the Timeline panel, Photoshop adds the Global Light track to the top of the track stack.

2. **Create a new layer by clicking the New Layer icon at the bottom of the Layers panel.**

3. **Add a layer style by clicking the *fx* at the bottom of the Layers panel.**

 Pick Bevel & Emboss, Inner Shadow, or Drop Shadow, as those styles offer a Use Global Light option. When you make your choice, Photoshop opens the Layer Style dialog box.

4. **In the Layer Style dialog box, set the lighting angle and make sure Use Global Light is turned on.**

 Use the Angle dial to set the angle you want for the first portion of your project (you can also type a number into the field to its right), turn on the Use Global Light checkbox, and then click OK.

5. **In the Timeline panel, move the playhead to the beginning of your project, and then add a keyframe.**

 To position the playhead, click the First Frame button (labeled back in Figure 20-2, top) or drag the playhead all the way left. To add the keyframe, click the stopwatch icon to the left of the Global Light track's name; the keyframe automatically adopts the lighting angle you set in the Layer Style dialog box.

 If you want the lighting angle to be the same throughout your project, you're done. If you want to change the angle anywhere in the project, continue to the next step.

6. **Move the playhead to where you want the light to change, and then adjust the lighting angle of the layer style you added in Step 2.**

 Back in the Layers panel, double-click the name of the style you applied to in Step 3 (for example, Bevel & Emboss). In the resulting Layer Style dialog box, change the Angle setting, and then click OK.

7. **Set a new keyframe where your playhead is.**

 Click the diamond in the Global Light track to add a new keyframe. The keyframe adopts the new lighting angle you set in the layer style and *keeps* this setting through the end of your project, or until you create a new global-lighting keyframe.

Adding Comments

Just like Photoshop's Note tool lets you add a hidden comment to a Photoshop document (see online Appendix D), you can use a comments track to add a hidden comment at a specific frame in your video (handy if there are multiple people working on the project and you need to explain an edit or mark a spot for additional editing).

To get started, turn on the comments track by going to the Timeline panel's menu and choosing Show→Comments Track. To add your first comment where the playhead is, click the stopwatch to the left of the word "Comments," and Photoshop displays the Edit Timeline Comment dialog box so you can enter some text (Figure 20-15, top). Once you click OK, a yellow square appears at that point on the comments track (Figure 20-15, bottom). To add more comments, position the playhead, and then click the yellow diamond near the left end of the comments track. To edit an existing comment, double-click its yellow square in the Timeline panel. You can also copy, paste, edit, or delete a comment by Control-clicking (right-clicking) its yellow square to reveal a shortcut menu.

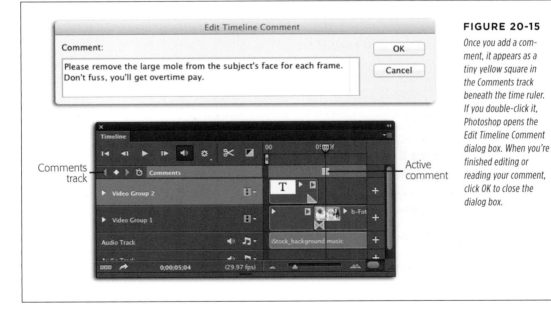

FIGURE 20-15

Once you add a comment, it appears as a tiny yellow square in the Comments track beneath the time ruler. If you double-click it, Photoshop opens the Edit Timeline Comment dialog box. When you're finished editing or reading your comment, click OK to close the dialog box.

To export all the comments in a video project, click the Timeline panel's menu and choose Comments→Export As HTML or Comments→Export As Text. Either way, Photoshop creates a document containing your comments, their frame numbers, and their timecodes. This is a great way to see *all* the comments in a single project.

◼ Adding Fill and Adjustment Layers

Just like still images, video clips often look better after you adjust their color and contrast or apply a creative color effect to them (think black-and-white or sepia). You can easily do all of these things with adjustment layers. There will also be times when you want your video to begin or end with a fade in or out to a solid color (say, black), which is the perfect use for a fill layer.

You add fill and adjustment layers to video projects exactly the same way you add 'em to other Photoshop documents. In the Layers panel, activate the layer that you want the adjustment or fill layer to appear above, and then click the half-black/half-white circle at the bottom of the panel. From the resulting menu, choose the kind of layer you want to add, and then tweak the settings that appear in the Properties panel. For example, to start your video with solid black, you can add a black fill layer to the bottom of your video group in the Layers panel (or drag it to the beginning of the video track in the Timeline panel). To add solid black at the *end* of your video instead, drag the fill layer to the top of the video group (in the Layers panel) or end of the track (in the Timeline panel).

When you add an adjustment layer, Photoshop automatically clips it to the active video layer, so you don't have to worry about it affecting other video layers. (Fill layers, on the other hand, *don't* get clipped to the active video layer and are visible across your whole document.) If you *want* the adjustment layer to affect all the video layers underneath it, click the "Clip to layer" icon at the bottom of the Properties panel (see page 331). However, unlike still images, the lighting in a video clip often changes over time. Fortunately, the Timeline panel also lets you control the *duration* of adjustment layers you apply to video clips (you'll learn how in a moment).

Adding a Color Tint

You can change the mood of a video by adding a color tint like a sepia tone, which is easy to do with a black & white adjustment layer. Just click the half-black/half-white circle at the bottom of the Layers panel and choose Black & White. Then, in the Properties panel, turn on the Tint checkbox (Figure 20-16), and Photoshop adds a nice brown tone to your video.

Changing Fill and Adjustment Layers' Duration

What if you want one fill or adjustment layer to affect part of a clip, and then you want *another* fill or adjustment layer to affect the rest? No problem—just make sure the video layer isn't part of a video group (if it is, simply drag it out of the group in the Layers panel). Next, add the fill or adjustment layer (it appears in the Timeline panel on its own track above the video track). Then change the layer's *duration* in the Timeline panel by dragging its start and end points, just like you would with any clip or transition, as shown in Figure 20-17. Then use the same process to add the second fill or adjustment layer.

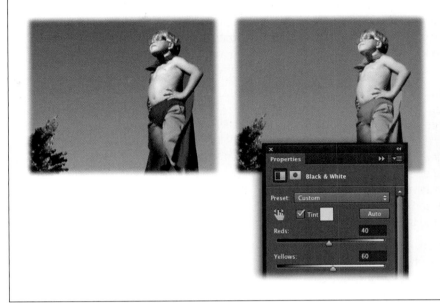

FIGURE 20-16

The Properties panel's Tint checkbox makes it a snap to add a nice sepia tone to your project, giving it a vintage feel.

You can change the tint color by heading to the Properties panel, clicking the color swatch next to the word "Tint," and then choosing another color from the resulting Color Picker.

FIGURE 20-17

After liberating this levels adjustment layer from a video group, it appears on its own video track. This lets you adjust its end points to match the duration of the video clip below it. (Unfortunately you can't add transitions to adjustment layers to make 'em fade in or out with a clip. Bummer!)

NOTE You can restrict the effects of fill and adjustment layers to one video layer by converting the video layer to a smart object before adding the fill or adjustment layer. Just activate the video layer in the Layers panel, and then choose Filter→"Convert for Smart Filters." Then double-click the smart object's layer thumbnail to display it in a new (temporary) document window. Add the fill or adjustment layer(s) to it, and then choose File→Save (*not* File→Save As); Photoshop updates the video layer in your main document.

■ Adding Layer Styles

You can apply any of Photoshop's layer styles to a video layer by clicking the *fx* at the bottom of the Layers panel or by choosing Layer→Layer Style. For example, if you've placed a small video clip on top of larger one (for a picture-in-picture effect), you can make the small clip appear to float above the larger one by adding a drop shadow to the smaller clip's layer. Another useful layer style is Inner Shadow, which can create the darkened-edge vignette effect shown in Figure 20-18.

FIGURE 20-18

To add a darkened-edge vignette effect to a video clip, apply an Inner Shadow layer style. (Any layer styles you add apply to the whole the video clip—you can't adjust their duration.)

As you can see here, a well-placed layer style can make quite a difference!

■ Using Smart Filters with Video

The good news is that you can run Photoshop's filters on video clips. The bad news is that, if you run a filter on a *regular* video layer, it only affects *the current frame* of that video. To make the filter affect *all* the frames in the clip, convert the clip to a smart object before applying the filter: activate the video layer(s) in the Layers panel, choose Filter→"Convert for Smart Filters," and *then* run the filter. Alas, you can't adjust the duration of the smart filter—it affects the *entire* video layer.

All the fancy Blur Gallery filters work with smart filters, too, meaning they're primed and ready to use with video clips (including the new Path and Spin Blurs). In fact, the Tilt-Shift filter produces a nifty effect when applied to time-lapse video (video captured at a very slow frame rate so that when it's played back, it appears to be

moving really fast, making the movement much more pronounced than in real time), as Figure 20-19 shows.

FIGURE 20-19

By rotating the Tilt-Shift filter's band of focus, this speeding shopping cart stays in focus while everything to its left and right is blurred.

There's simply no end to the creative effects you can add to video using Photoshop's amazing filters. Chapter 15 teaches you all about 'em!

Cloning and Healing

You can use Photoshop's cloning and healing tools on video clips, but it's *incredibly* tedious—you have to edit each frame individually (yawn!). Unfortunately, there's no magic technique that lets you follow an object through a whole scene to fix it in one go. So grab a beverage, settle into your chair, tweak one frame, and then use the navigation buttons in the Timeline panel to move to the next frame. Then repeat the process. And repeat. And repeat again.

NOTE When using the Clone Stamp tool to fix multiple frames of a video, consider turning on the Lock Frame option in the Clone Source panel (page 317). This makes Photoshop keep your source in the same frame you sampled, rather than moving it to the next frame as you clone onto a new frame. If your video clip is fairly stable, this will give you a clean source to clone from. But if the video is unstable, it may work better to set the Clone Source panel's Frame Offset field to 1 or 2 so that the source is more similar to your target frame.

▩ Exporting Videos

Once you're satisfied with your project, you can export it to a new video file via a process called *rendering*. Choose File→Export→Render Video or click the curved arrow at the bottom left of the Timeline panel. In the resulting Render Video dialog box, adjust the following settings (shown in Figure 20-20):

- **Name.** Use this field to name the video file you're about to export.

- **Select Folder.** Click this button to tell Photoshop where to save the exported file.

- **Create New Subfolder.** If you turn this checkbox on, Photoshop creates a new subfolder *inside* the folder you specified with the Select Folder setting and puts your video file in it. Enter a name for the subfolder in the text field next to this checkbox.

- **Export Encoder.** This unlabeled menu includes two options: Adobe Media Encoder and Photoshop Image Sequence. What you choose here determines the *other* settings you see in this section of the dialog box.

 Choosing **Adobe Media Encoder** tells Photoshop to render your project as a video file, and you see these settings:

 - **Format.** DPX (Digital Picture Exchange) is commonly used in the TV and movie industries. H.264 is used for consumer gadgets such as TVs, handheld devices, and iOS devices, as well as websites like YouTube.com and Vimeo.com. QuickTime format is used by desktop video programs.

 - **Preset.** This menu includes a number of useful options. When you choose one, the controls below this menu reflect the settings appropriate for that preset, though you can change any of those settings manually.

 - **Size.** Choose a video frame size appropriate for your intended viewing device. This menu includes sizes for common uses such as North American (NTSC) and PAL TVs, high-definition video systems, and professional film-editing systems. You can also enter a custom size.

 - **Frame Rate.** Determines how many frames Photoshop includes in each second of video. Choose from common rates or enter a custom one.

 - **Field Order.** While computers display video in a progressive series of complete frames, TVs slice each frame into two interlaced fields, each containing half the image. This option lets you choose whether the exported video should have complete frames (Progressive) or interlaced frames that start with the Upper or Lower Frame first. Choose Progressive if you're creating a video folks will watch on their computers, or one of the other options if they'll watch it on a TV.

 - **Aspect.** This determines the video's aspect ratio—its ratio of width to height.

- **Color Manage.** Turning on this checkbox tells Photoshop to pay attention to any color-management info that's included in your project. You'll probably want to leave this setting turned on to take advantage of color profiles included in any images you've added to your project.

Export Encoder menu

FIGURE 20-20

This is where you can give the exported video a name, save it to a specific location on your hard drive, and tell Photoshop exactly which format to use. You can also choose to render the whole video or only certain frames.

Once you click the Render button, Photoshop applies your edits to your clips, creates new video frames for any animations you've added, and then exports a video file or a sequence of image files, depending on the settings you picked.

Choosing **Photoshop Image Sequence** tells Photoshop to render your project as a sequence of images instead of a single video file, and you get these options:

- **Format.** Choose a format for your rendered frames. Some formats let you set various options by clicking the Settings button, including compression, transparency, metadata, and so forth. (If the Settings button is dimmed, the format you chose doesn't include any additional options.)

- **Starting #** and **Digits.** Since this encoding method tells Photoshop to render each frame as a separate file, each file needs a unique name. Photoshop names each file beginning with what you entered into the Name field at the top of the dialog box, and tacks on a sequence of numbers to the end of it. The Starting # field lets you specify the number it starts with, and the Digits field lets you tell Photoshop how many numerals to add to the end of the file name. (The "Ex:" item to the right of these fields shows you a preview of how your file names will look.)

- **Size** and **Frame Rate.** These settings are the same as the ones described earlier in this list.

- **Range.** Lets you to specify whether Photoshop renders all the frames in your project, a range of frames you specify, or only the currently active work area.

- **Alpha Channel.** This setting lets you specify how Photoshop should combine alpha channels with the video so that transparency can be preserved when you place your video on top of *other* videos or images. Your options are:

 - **None.** Photoshop doesn't include alpha channels in the rendered video.

 - **Straight - Unmatted.** Photoshop uses the alpha channel to generate transparency when it's rendering.

 - **Premultiplied with Black/White/Color.** These options make Photoshop place the transparency in the alpha channel over a black background (common in video that will be displayed on TVs), a white background, or a background color you choose by clicking the color swatch to the right of this setting.

- **3D Quality.** If your project includes 3D objects, this setting controls how Photoshop renders their surfaces. Interactive is suitable for video games and other onscreen uses; Ray Traced Draft creates a low-quality version that renders quickly; and Ray Traced Final is high quality but takes a long time to render.

When you've adjusted all the settings in the Render Video dialog box, click the Render button and Photoshop goes to work creating your video file.

Using Your Project in Other Video Editors

To go beyond Photoshop's editing capabilities, you can import your video project into *another* video-editing program. To do that, simply save your Photoshop document and then open it in the other program (such as Premiere Pro, which is included in Adobe's Creative Cloud).

If you're handing the project off to another member of your team, be sure to include all the fonts, audio files, and video files that you used in your project. Your Photoshop document merely *references* those files—it doesn't actually include the source files—so the other video editors will need them, too.

Additional Video Resources

This chapter is by no means a comprehensive guide to video editing. When you're ready to learn more, here are a couple of resources worth checking out:

- *www.lesa.in/lesacl.* Your author is continually pushing the limits of video editing in Photoshop and frequently records online video workshops for your viewing pleasure. If you like learning by watching videos, be sure to check out the full-day course *Photoshop Deep Dive: Video Editing and Animation.* (New classes will be added to this same URL.)

- *www.RichardHarrington.com.* Another author and video-editing pro, Richard Harrington has an informative blog that's worth visiting.

Working with 3D Objects

Photoshop has come a *long* way, baby, and thanks to the power and speed of modern computers, the program sports a nice array of 3D tools (they first appeared in the extended version of Photoshop CS3). And in Photoshop CC 2014, you can even *print* 3D objects, either on your own 3D printer or by having Photoshop upload the file to a printing service. Modeling 3D objects—or 3D models, as they're also called—isn't Photoshop's *main* purpose in life, but if you've ever dreamt of dabbling in 3D modeling, it's the perfect place to start.

You don't even have to create 3D objects from scratch. Just as you can buy stock images, illustrations, video, and audio clips, you can also buy pre-made 3D objects. Do a quick Google search for *3D models* and you'll find *oceans* of goodies for sale, along with some freebies, too. If those objects are already painted and lit (some aren't), you can bring all that info into Photoshop. The program also gives you a fair amount of control over the object's textures and lighting. If the object comes with a separate texture file, you can edit that file in Photoshop. You can also add and adjust lighting to make the model blend into your scene better.

If you're especially skilled, you can paint directly on the surface of a 3D model in real time (meaning you see your brushstrokes as you make them). It's really nice to be able to do this kind of painting in Photoshop, especially if you don't have a dedicated 3D painting program. You can even *render* (apply lighting and reflections using a technology called *ray tracing*) a portion of an object, and pause and restart the process, if necessary, which is a great timesaver when you want to focus on an important area of detail.

Learning to do a little 3D work can be both fun and beneficial, especially if you're a graphic designer. For example, you could enhance a map in a promotional piece

by adding a 3D push-pin or a flag on a pole. You can even build your own props. Say you forgot to include a stick of butter in the croissant shop shoot last week in France. Do you fly back and redo the lighting, hire talent, and so on? Heck, no! You can churn a stick of butter right in Photoshop and then toss it into your shot. Adobe has made the process of working with 3D objects fairly easy, too, since it treats them like souped-up layers. Even though 3D layers have special tools and panels associated with 'em, you can still run filters on them, change their layer blend modes, add layer styles to them, and so on.

Here's what you can do with 3D in Photoshop CC 2014:

- Create 3D text, shapes, and logos.

- Create *flying* postcards and billboards.

- Wrap artwork around basic 3D shapes.

- Animate 3D objects in a video file.

- Import 3D models created in other 3D programs.

- Export the result as a ready-to-use image file, or in a format suitable for further editing in a more advanced 3D-editing program.

- Print 3D objects (if you have a 3D printer, that is).

Photoshop includes a 3D panel that works a lot like the Layers panel: It lets you delete, reorder, group, and duplicate 3D objects. You can also make *instances* (copies) of a 3D object so that Photoshop updates them all whenever you make a change to any one of 'em (kind of like linked smart objects; see page xxv). And when you're painting on a 3D object, the Live 3D Painting mode lets you *see* your changes in real time.

However, if you want to work in Photoshop's 3D environment, your computer needs to have at *least* 512 MB of VRAM (video RAM) on its graphics processor. Previous versions of the program would *attempt* to let you work with less VRAM, but Photoshop CC won't even try. If you have less than 512 MB of VRAM, you can still work with 3D-ish features on a 2D image—such as the Blur Gallery, Lighting Effects, Liquify, and so on—but you can't use the program's 3D environment.

Photoshop can't do everything a dedicated 3D-modeling program (such as Autodesk's 3ds Max) can, so while it's *not* a smart choice for 3D professionals, it's useful for photographers, graphic designers, web designers, and motion graphic designers. As mentioned above, photographers can add objects or forgotten props to existing shots, and graphic designers can add 3D text or 3D objects to photos (say, their clients' products or packaging). Web designers can easily make buttons and banners with transparent shadows and materials, and motion graphic designers can create special graphics (with 3D text) for videos, or unfinished wireframe mockups to use in other 3D-editing programs.

This chapter explains the nuts and bold of working with Photoshop's 3D features.

3D Basics

If you're new to 3D, all the parts and pieces can be baffling. Here's the gist: A 3D object starts with a *mesh*. You can envision the mesh as chicken wire molded into a 3D shape, like one of those animal-shaped wire structures you sometimes see in gardens (normally, they're covered with ivy to create topiary critters). A mesh has one or more *surfaces*, each of which can have a *texture* applied to it. The whole kit-and-caboodle is referred to as a *3D object* (or a *3D model*), though Photoshop uses the term meshes to describe objects, too, which can be a bit confusing.

You can create a texture from one of your own images, or you can choose a texture preset that resembles a real-world material (such as fabric, stone, wood, glass, or plastic), or something fanciful like a checkerboard pattern. To customize the material, you can apply a color to it or open it in a separate document and change it any way you want.

Your 3D object lives in a *scene* that has one or more *lights* illuminating it, and one or more *cameras* providing different *views*. (To move the object around in 3D space, you move the camera's *view angle*.) The scene can contain more than one 3D object, and the scene lives in an *environment* that has global lighting for all the objects in the scene, as well as a *ground plane* on which shadows may fall, and an optional *background* image or panorama.

That's a lot to take in, but it'll start to make sense once you begin playing with 3D objects.

Photoshop's 3D Environment

When working with a 3D object, you'll use Photoshop's 3D menu, the Move tool, the 3D Mode icons (which appear in the Options bar when you have the Move tool and a 3D object active), and a few panels: 3D, Properties, and Layers. You'll also encounter a 3D *object cage,* Photoshop's representation of the 3D area that *encloses* the object—it looks like a rectangular wireframe. And finally, you'll work with a special tool that lets you control the *view axis* (the angle in which you're viewing the object) and a set of clever HUD (heads-up display) features, explained later in this chapter.

> **TIP** To prepare for your first foray into the realm of 3D, head to the right end of the Options bar and choose 3D from the unlabeled workspace menu. When you do that, Photoshop opens the Properties and 3D panels on the right side of the workspace, and plops the Timeline panel at the bottom of the document window (but it's collapsed, so all you see is its tab).

To create a 3D object, you start by activating an image, type, or shape layer, or a path you've drawn with a shape tool or the Pen tool. Then you use the 3D panel shown in Figure 21-1 to *extrude* the item into a 3D object.

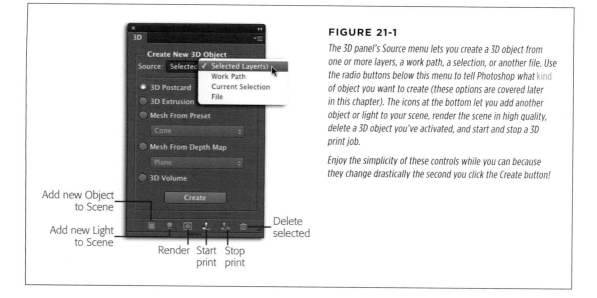

FIGURE 21-1

The 3D panel's Source menu lets you create a 3D object from one or more layers, a work path, a selection, or another file. Use the radio buttons below this menu to tell Photoshop what kind of object you want to create (these options are covered later in this chapter). The icons at the bottom let you add another object or light to your scene, render the scene in high quality, delete a 3D object you've activated, and start and stop a 3D print job.

Enjoy the simplicity of these controls while you can because they change drastically the second you click the Create button!

One of the easiest ways to create a 3D scene is to activate one or more layers in the Layers panel, and then make a choice from the 3D panel. You can also create a 3D object from a selection, a work path (which is merely an *unsaved* path—see page 578), or a separate file (say, a 3D object you've downloaded from the Web). No matter which option you choose in the Source menu, the process is the same as the one described in the next section.

Creating a 3D Postcard

The simplest way to dip your toes into Photoshop's 3D realm is to convert an existing image into a flying postcard that you can slide, roll, and rotate in 3D space. (It's far more fun than it sounds!)

To get started, pop open an image and then, in the Layers panel, activate the layer you want to convert into a 3D object. (Don't worry if the layer is locked—Photoshop will unlock it for you.) If your image consists of *multiple* layers—say, an image and some text—you need to combine them into one layer before converting them to a 3D object (or else you end up with multiple 3D layers). To do so, activate those layers and then either convert them into a smart object (in the Layers panel, right-click near one of the layer's names and choose "Convert to Smart Object"), or create a stamped copy of them (press ⌘-Option-E/Ctrl+Alt+E). If you do the latter, hide the original layers by turning off their visibility eyes.

TIP To follow along, visit this book's Missing CD page at *www.missingmanuals.com/cds* and download the practice file *Rome.zip*. Unzip that file and then, in Photoshop, open *Rome.psd*. Finally, in the Layers panel, click to activate the smart object (it's named "Greetings from ROMA"), and you're ready to make your first 3D postcard!

Next, locate the 3D panel on the right side of your screen (if you don't see it, choose Window→3D). Make sure the panel's Source menu is set to Selected Layers(s), turn on the 3D Postcard radio button, and then click Create.

Once you do that, the 3D panel changes to display the many editable attributes of your new 3D object (see Figure 21-2). The panel lists all your 3D objects, which Photoshop refers to as *meshes*, and their pieces and parts, as well as the environment (the world in which your 3D object lives), the current scene, and its lights and camera.

FIGURE 21-2

When you create a 3D object, Photoshop places it into a scene complete with a camera and a lighted environment.

If your scene contains multiple objects, you'll do a ton of scrolling in this panel to find the object or attribute that you want to work with. For that reason, you can limit what Photoshop displays in the 3D panel by clicking the Meshes, Materials, or Lights icons labeled here. Click Whole Scene to see everything again.

When you activate a 3D object by clicking its name in the 3D panel, you can then adjust its many attributes in the Properties panel (double-clicking the object in the 3D panel automatically opens the Properties panel). The Layers panel, on the other hand, is for activating layers that you'll convert into a 3D object, or for controlling the visibility of an object and its attributes (such as textures and illumination). That said, you can also control object visibility in the 3D panel.

NOTE Shortcut menus are an efficient way to access and change the attributes of a specific area in your scene. Just Control-click (right-click) a 3D object and a menu appears containing commands based on the area you clicked.

Press V to grab the Move tool and, in the document window, Photoshop displays the *ground plane* and controls for manipulating your *scene* (Figure 21-3). (With any other tool active, you don't see any of this stuff.) The ground plane helps you visualize where your object is in relationship to an imaginary grid that represents the ground, while the scene contains your object(s), cameras, lights, and so forth.

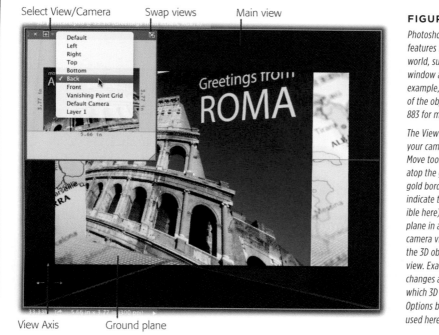

Select View/Camera Swap views Main view

View Axis Ground plane

FIGURE 21-3

Photoshop includes some nice features for navigating your 3D world, such as the Secondary View window at top left which, in this example, is set to show the back of the object (see the box on page 883 for more on this feature).

The View Axis (bottom left) shows your camera angle. With the Move tool active, click anywhere atop the ground plane and a gold border appears around it to indicate that it's now active (visible here); dragging the ground plane in any direction changes the camera view. You can also drag the 3D object itself to change the view. Exactly how your view angle changes as you drag depends on which 3D mode is active in the Options bar (Rotate mode was used here).

The following sections explain some of the things you can do with your new 3D postcard, as well as how to create other kinds of 3D objects. Grab a frosty beverage and buckle up, because there's heady stuff ahead!

Moving Objects in 3D Space

When you're working with 3D objects, you'll use the heck out of the Move tool. Once you activate it by pressing V, you can then tell Photoshop what *kind* of movement you want to perform by either clicking one of the 3D mode icons in the Options bar (Figure 21-4) and then dragging within the 3D space, or by clicking the object itself to summon the 3D Axis HUD, which is covered in the next section.

Rotate Slide Zoom

Roll Pan

FIGURE 21-4

The Options bar's 3D mode icons control how the Move tool will move your 3D object. To see these icons, you need to have a 3D layer and the Move tool active.

With the Move tool active, you can adjust the camera's view of the scene. In the Options bar, click the first 3D mode icon to put the Move tool in Rotate mode. Then drag anywhere in the document to see your postcard from various angles. Click and drag anywhere *outside* your object—on the ground plane—to rotate it in 3D space. Drag the object down to make it rotate toward you, or up to make it rotate away from you.

To work with the 3D object itself—instead of the ground plane, say—click it or click its name in the 3D panel. (It's named the same as the layer it was made from, plus the word "Mesh.") Photoshop displays a colorful 3D HUD in the middle of the object, but you can ignore that for now. (You'll learn about it later in this chapter.)

Give the other 3D modes a try by clicking their icons in the Options bar. In Roll mode, you can drag around the outside of the object to rotate it around its center. In Pan mode, you can slide the camera around the object as if you were walking around it. In Slide mode, you can make the object look like it's advancing toward you or retreating away from you. And in Zoom mode (which was named Scale in the previous version of Photoshop CC), you can enlarge or shrink the object in relation to its background. Try shrinking it to about a quarter of its original size by dragging downward on the area outside the postcard (the ground plane).

> **NOTE** The 3D modes are sticky, meaning that Photoshop remembers which one you were using the last time you worked with 3D objects and uses that same mode the *next* time you work in 3D (until you activate a different one).

At first, Photoshop's various 3D modes may seem mysterious. But once you get the hang of them, you'll know which one to use to get just the view you want.

UP TO SPEED

Room with a (Secondary) View

It can be difficult to work with 3D objects in 3D space when all you can see is one 2D view of it on your monitor! To make things easier, in the top-left corner of the document window, Photoshop includes a Secondary View window that shows your scene from a second angle to help you accurately place objects and lights (see Figure 21-3). At its standard size, the Secondary View window is small enough to stay out the way, but big enough to give you an idea of how your 3D object looks from a different perspective. To resize this window, drag its bottom-right corner.

To decide which view the Secondary window displays, click the Select View/Camera icon in its top-left corner (labeled in Figure

21-3) to summon a drop-down menu. Your options include Left, Right, Top, Bottom, Back, Front, Vanishing Point Grid (if you've set one up by choosing Filter→Vanishing Point), and any additional camera views you've saved (page 886). (In this chapter's flying postcard example, the only meaningful views are Front and Back.) If your scene has multiple 3D objects, the current camera angle for each one appears at the bottom of this list.

You can even *swap* the main view and secondary view. Just click the Swap Views icon in the top-right corner of the Secondary View window (labeled in Figure 21-3), and what was in the main viewing area now appears in the Secondary View window, and vice versa.

■ USING THE 3D AXIS HUD TO POSITION AN OBJECT

When you use the Move tool and the Options bar's 3D mode icons, you'll be doing a lot of clicking to switch to the 3D mode you want at any given time. A more fluid way to work with 3D objects is to use the HUD (heads-up-display) features that appear whenever you click a CD object to activate it (see Figure 21-5). These context-sensitive controls look like color-coded, arrow-tipped handles and circles. You can grab and drag them to change the camera's viewing angle.

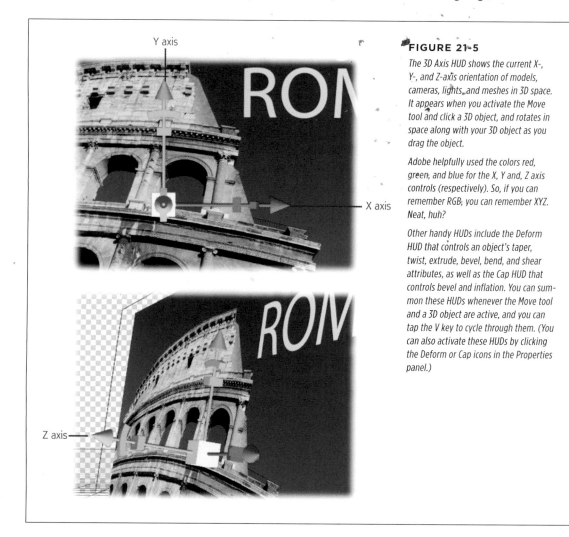

Y axis

X axis

Z axis

FIGURE 21-5

The 3D Axis HUD shows the current X-, Y-, and Z-axis orientation of models, cameras, lights, and meshes in 3D space. It appears when you activate the Move tool and click a 3D object, and rotates in space along with your 3D object as you drag the object.

Adobe helpfully used the colors red, green, and blue for the X, Y and, Z axis controls (respectively). So, if you can remember RGB, you can remember XYZ. Neat, huh?

Other handy HUDs include the Deform HUD that controls an object's taper, twist, extrude, bevel, bend, and shear attributes, as well as the Cap HUD that controls bevel and inflation. You can summon these HUDs whenever the Move tool and a 3D object are active, and you can tap the V key to cycle through them. (You can also activate these HUDs by clicking the Deform or Cap icons in the Properties panel.)

The best way to get comfortable working with the 3D Axis HUD is to give it a try. It behaves the same regardless of which 3D mode is active in the Options bar. In fact, it can replace *all* those modes once you get the hang of using it!

> **NOTE** You can snap your object to the ground plane by choosing 3D→"Move Object to Ground Plane."

As you point your cursor at the various parts of the 3D Axis HUD, the part your cursor is over turns yellow and a tooltip appears letting you know what it does. For example, dragging the white cube in the center of the HUD scales the object uniformly, while the smaller cubes on the control handles scale the object in only one dimension (X, Y, or Z). (You can think of X as left to right, Y as top to bottom, and Z as front to back.) Dragging the curved pieces on the control handles *rotates* the object along the X, Y, or Z axis, while dragging the arrowheads at the end of the control handles *moves* the object along the X, Y, or Z axis. This seems about as logical as one could hope for! (It makes more sense once you try it.)

To make your postcard look like it's flying, make sure that the background layer containing the map of Italy is turned on (this layer is included in the practice file *Rome.zip*, which you can download from this book's Missing CD page at *www. missingmanuals.com/cds*): In the Layers panel, click the visibility eye next to the background layer. Make sure your 3D postcard layer is active (the 3D layer you made from the smart object included in the practice file), and then use the 3D Axis HUD or the Move tool to drag and rotate the postcard so it's positioned in a way that looks good to you (see Figure 21-6).

FIGURE 21-6

Your 3D postcard hovers over a map of Italy, complete with a subtle stroke (outline) and drop shadow to offset it from the map (both are visible in the Layers panel). These effects were added using layer styles.

To finish your project, you need to tell Photoshop to use all its graphics muscle to generate a high-quality rendition of your art, taking into account all the lighting options, reflections, and other 3D goodness. To do that, click the Render icon at the bottom of the 3D panel or Properties panel (it looks like a tiny 3D cube inside a square), or choose 3D→Render. (Rendering is discussed in detail on page 903.)

When Photoshop is done rendering your file, save it in PSD format to retain all your 3D editing capabilities. Happily, you can still edit 3D layers even after you render them. You can also save or export the file in any of Photoshop's regular 2D formats for use in print, on the Web, or in other projects.

Working with the Camera

Everything you've done so far places a 3D object in its 3D space. Now you're ready to learn how to control your view of that object. In Photoshop's 3D world, a "camera" is a combination of viewing angle, location, and camera-specific settings such as Perspective, Field Of View, and Depth Of Field.

Cameras are listed in the 3D panel. When a 3D object is active in the Layers panel, the Current View item in the 3D panel represents the virtual camera that's at the location and direction from which you're viewing the object.

In the lower-left corner of the document window, the View Axis (labeled in Figure 21-3 on page 882) indicates the orientation of your Current View camera and lets you adjust it. You can change this orientation by clicking Current View in the 3D panel, and then grabbing the Move tool and dragging anywhere in the document window *other* than on top of the 3D object. As you drag, the camera moves based on which 3D mode is active in the Options bar. (Photoshop reminds you that you're manipulating your view—and not the object itself—by putting a gold border around your canvas.)

> **TIP** As you mouse over the View Axis, a shaded square appears around it. Drag within this square to make big changes to the Current View camera; drag outside it to make more subtle changes.

The Properties panel lets you make dozens of changes to the camera's characteristics, and its View drop-down menu includes several useful camera presets such as Front, Back, Top, Bottom, Left, and Right. (If your scene contains more than one 3D object, the View menu also includes presets that match the Current View of the other 3D objects in your project—their names match the names of the objects.) If you're into 3D stereoscopic imaging or lenticular printing, you can even turn on the panel's Stereo checkbox (Figure 21-7) and then customize to your heart's content!

If you find a camera position and a set of properties that you'd like to be able to use again later, you can save the location of the Current View camera and its properties by either Control-clicking (right-clicking) the View Axis and choosing Save, or by making sure that the Current View item is active in the 3D panel, and then choosing Save from the Properties panel's View menu. Give your new camera a name, and you can then summon it later from the Properties panel's View menu.

3D Text and Shapes

The flying postcard described earlier in this chapter is the simplest 3D object to work with, because it has no depth. The *second*-simplest 3D object to create and work with is 3D text or a 3D shape, which you'll learn how to create in this section.

Creating 3D Text

Creating a 3D object from some text is as simple as clicking the 3D button in the Options bar. To get started, activate the Type tool, add some text to your document, and then format the text to your liking (see Chapter 14 for details).

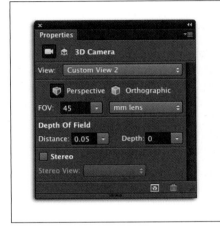

FIGURE 21-7

The Properties panel includes camera options that a cinematographer would love! Once you change your view, using the Move tool and the Options bar's 3D mode icons, or by using the 3D Axis HUD, the panel's View menu changes to read Custom. Picking another item from this menu changes your camera's viewing angle (you can undo the view change by pressing ⌘-Z/Ctrl+Z).

Unfortunately, a detailed explanation of all these settings is beyond the scope of this book.

NOTE A 3D type layer is *very* different from a normal, 2D type layer—it's more like a 3D object rather than a string of text. You can still edit the characters and formatting as described below, but you can't convert it back to a 2D layer. So if you want to keep a copy of your type layer handy for future use as a 2D type layer, duplicate the layer by dragging it onto the New Layer icon at the bottom of the Layers panel before you create a 3D version. You may want to turn off the duplicate layer's visibility so it doesn't get in the way while you're working in 3D—just click its visibility eye in the Layers panel.

Once you've formatted the text, click the 3D icon at the right end of the Options bar. (If you don't see the 3D icon in the Options bar, click your original type layer in the Layers panel to make it active, and then grab the Type tool; the 3D icon should then appear. Alternatively, you can open the 3D panel, turn on the 3D Extrusion radio button, and then click the Create button.) Photoshop converts the type layer to a *3D* type layer, and displays all the 3D controls. The new 3D type layer appears in the 3D panel, and in the Layers panel, the type layer's thumbnail now has a 3D cube on it.

Using the tools and panels described earlier in this chapter, you can manipulate the text to your heart's content. In addition to those tools, you'll also see the Extrusion Depth slider in the Properties panel; it lets you control how far your 3D text extends into space. The slider's center point is 0, which means no extrusion. Drag this slider

to the right to increase the extrusion behind the front face of the object, as in Figure 21-8. Drag the slider to the left to decrease the extrusion. If you drag the slider far enough to the left, you'll see negative numbers in the slider's value field and the front of your object will begin moving forward, leaving an extrusion behind it. The Properties panel's Shape Presets are also fun to play with—they let you make your text puffy, or beveled, or just plain.

FREQUENTLY ASKED QUESTION

Working in a Cage

What's with the wireframe box around my 3D object?

When you point your cursor at a 3D object or activate the object in the Layers or 3D panel, a wireframe box appears around it. This is called the *cage*, and in addition to indicating the active object, it also gives you another way to move and rotate the object. (Other ways include using the 3D Axis HUD or the Move tool in a specific 3D mode.)

If you click an edge of the cage and drag, your object moves around in 3D space. To move the object closer to you, drag downward (like you're pulling the object toward you); to move it farther away from you, drag upward (pushing it farther away).

If you click just outside the cage and drag, you can move or rotate the object according to on the 3D mode that's active in the Options bar (see page 882 for a refresher on the various modes). You can also drag on one of the cage's faces to move or rotate the object, again based on the current 3D mode. As you point your mouse to the different edges and faces of the cage, Photoshop displays the area in yellow (visible here) and a tooltip tells you what axis you'll affect if you drag.

It's helpful to remember that using the cage is just one way to manipulate a 3D object—depending on the object, you may find it easier to use a HUD feature or the Move tool in a specific 3D mode. Using the cage takes some practice, but once you get used to it, it can begin to feel intuitive.

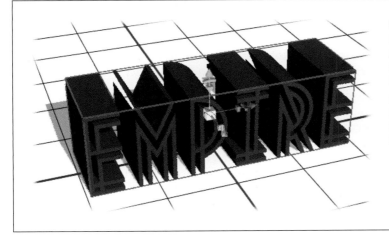

FIGURE 21-8

This 3D text is sitting on the ground plane. Its cage and 3D Axis are displayed because the Move tool is active and the 3D type layer is active in the Layers panel.

This text is set in Josip Kelava's Metropolis 1920 typeface, which is available for free from several online sources; just Google its name.

Even after you convert a regular type layer into a 3D type layer, you can still edit the text it contains, so feel free to make changes in the Character and Paragraph panels; simply click the type layer in the Layers panel to activate it, and then tweak away. To change the characters themselves (to correct a typo, say), in the Properties panel, click Edit Source. Photoshop opens a new, temporary document window containing only your type layer (you see this same behavior when you double-click a smart object), so you can edit the text using any of the techniques described in Chapter 14. When you're done editing, choose File→Save, close the temporary document, and Photoshop updates your text in the 3D type layer in your original document.

Here's how to create two pieces of text that angle away from each other in 3D space, and add a texture that's visible on the front of each. Once you've created a new document, gather your courage, and proceed as follows:

1. **Create some text on two separate type layers.**

 Press T to grab the Type tool, click within your document, and type a word in all caps using a thick font, such as Myriad Pro Bold. Then Shift-click within your document to add another type layer and type one or two more words.

2. **Extrude each type layer.**

 If the Type tool is still active, you see a 3D icon in the Options bar. Give it a click to extrude the first type layer and summon the 3D workspace. In the Layers panel, click the second type layer, and then, in the 3D panel, click the 3D Extrusion radio button, and then click Create.

3. **In the Layers panel, Shift-click to activate both 3D type layers, and then choose 3D→Merge 3D Layers.**

 In order for both type layers to share lighting and a ground plane, they need to be on a single 3D layer. Don't worry—you'll still be able to change the camera angle of each text object individually.

4. **With the Move tool set to Rotate mode, click the first text object to activate it, and then rotate it away from the second text object.**

 If it's not already active, press V to grab the Move tool, and then, if it's not already active, click the Rotate icon in the Options bar (see Figure 21-4). Next, position your cursor just beneath the object (so you don't mess with the 3D Axis HUD), and then Shift-drag left to rotate the text so it's facing the left instead of the center.

5. **Activate the second text object and rotate it in the other direction.**

 With the Move tool still active and in Rotate mode, click to activate the second text object, position your cursor a little ways *beneath* the object, and then Shift-drag right to rotate it so it's facing to the right.

6. **Activate both text objects and rotate them downward.**

 Still using the Move tool in Rotate mode, Shift-click the first object; Photoshop activates both pieces of text and puts a cage around them both. Next, click beneath the first object (outside the cage) and drag downward to change the camera view so you can see the top of the extruded characters.

7. **Adjust the depth of both text objects.**

 With both text objects active, open the Properties panel and adjust the Extrusion Depth slider (see Figure 21-9, top). Drag right to increase depth or left to decrease it; stop dragging when the text looks good to you.

8. **Add a bevel to each text object.**

 With both text objects active, click the Cap icon at the top of the Properties panel (circled in Figure 21-9, bottom). Then mouse over to the text, point your cursor at the Bevel HUD, and drag right to add a bevel to the edges of the characters. To make the front face of the characters puffy, point your cursor at the Inflate HUD and drag up.

9. **Apply a texture to the front face of the characters.**

 With the Move tool active, click to activate just *one* of the text objects and then, in the 3D panel, scroll down until you see that object's front inflation material (it'll be named the same thing as the text—in this example, it's named "HOW Front Inflation Material"), and then click it to activate it.

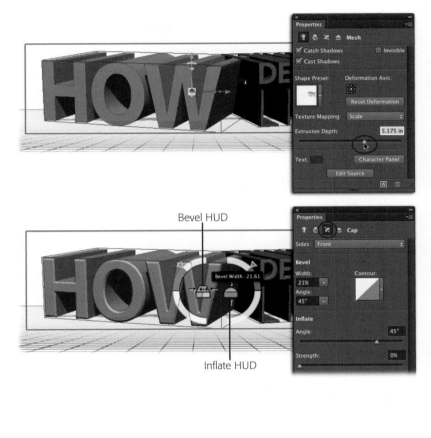

FIGURE 21-9

*Top: Drag the Extrusion
Depth slider far enough to
the right and you'll make
the extrusion from both
text objects overlap, as is
the case here. Drag left
into negative numbers
to make the extrusion
emanate from the front
instead, so the extrusion
advances toward you. To
change the text's color,
activate the object (The
word "How" is active
here) and then click the
Properties panel's color
swatch. To edit the text,
click Edit Source.*

*Bottom: Click the Properties
panel's Cap icon (circled)
to summon two HUDs
that you can use to add
a bevel (visible here) or
inflate an object's side.
Tell Photoshop what side
to bevel or inflate by
choosing from the Sides
menu.*

Next, in the Properties panel, click the tiny folder icon next to the Diffuse color
swatch (it's circled in Figure 21-10, top). From the resulting menu, choose Load
Texture, and then navigate to where a texture-riddled image lives on your hard
drive (it could be an image of anything; a photo of colorized metal was used
in this example). Click Open and Photoshop applies that texture to the front of
the characters.

Activate the *second* text object and repeat this process to apply a different
texture to it, as shown in Figure 21-10 (top).

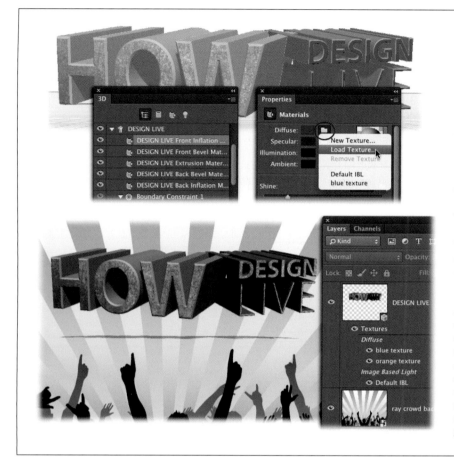

FIGURE 21-10

Top: To load a texture, click the folder icon circled here. In this example, a texture has been applied to the word "How" (specifically, a JPEG of blue cement). To get at these options in the Properties panel, you must first pick the portion of the object that you want to edit in the 3D panel (in this case, that's "DESIGN LIVE Front Inflation Materials").

Bottom: Here's the finished project, complete with a new background, which was added using the File→Place Embedded (or Place Linked) command. Happily, the objects' 3D properties are still editable even after you render them (in other words, the 3D layer doesn't get flattened during the rendering process).

At this point, you might want to reposition the two text objects within your document. To do that, make sure the Move tool is active, Shift-click to activate both objects, and then click the Options bar's Drag mode icon. Next, drag the objects to scoot them around (notice how the shadow moves as you drag). When you're finished, click Render at the bottom of the 3D or Properties panel to create a high-quality version of your slick 3D text. Last but not least, save the document as a Photoshop file so you can edit it again later. The final result is shown in Figure 21-10 (bottom).

Creating 3D Shapes

Using Photoshop's vector shapes is another easy way to experiment with 3D features. Try creating a new Photoshop document, and then use the Custom Shape tool in Shape mode to draw a heart (it's one of the built-in shapes you can choose from the Custom Shape picker; see page 589). For fun, use the Options bar's Fill setting to make it red.

> **TIP** You can also apply layer effects to the custom shape. If you do that, just be sure you convert the shape to a smart object (page 113) before you turn it into a 3D object.

Then, with the shape layer active, use one of the following methods to turn the heart into a 3D object:

- Control-click (right-click) the heart shape layer and choose "New 3D Extrusion from Selected Layer."

- Head to the 3D menu at the top of the Photoshop window and choose "New 3D Extrusion from Selected Layer."

- In the 3D panel, click the 3D Extrusion radio button, and then click Create.

You should end up with a red heart with a gray extrusion. Experiment with the tools and panels described earlier to customize your new 3D shape.

> **TIP** A quick way to create a 3D object from a layer is to draw a shape or selection on the layer (you can use any tool), and then, from the 3D panel's Source menu, choose either Work Path or Selection. The panel's 3D Extrusion radio button will automatically be active, so just click Create. Photoshop will then extrude your path or selection into 3D with the image on its front surface.

If, on the other hand, you want to create a more complex 3D object like a cone, cube, cylinder, sphere, and so on, use one of Photoshop's 3D mesh presets instead. For example, to create a sphere, first draw a circle with the Ellipse tool—one of Photoshop's shape tools (page 580)—set to Shape mode (Shift-drag to draw a perfect circle). Next, in the 3D panel, turn on the Mesh From Preset radio button and pick Sphere from the menu beneath it. Then click the 3D panel's Create button and Photoshop turns the circle into a sphere.

Colorizing the sphere is a bit more complicated than you might expect. If you used the Options bar's Fill setting to color the circle you drew, you'll be surprised that, when you create the sphere, Photoshop applies that color to a small portion of the sphere and makes the rest of it *grayscale*, which makes it look realistically lit. Sure, you could track down all the individual settings in the Properties panel to change each *area* of shading to a different color, but it's *far* easier to realistically colorize the sphere using a preset. Figure 21-11 tells you how.

As you can see, Photoshop's mesh presets are really handy. However, you can also add your *own* mesh presets to the 3D panel's Mesh From Preset menu. Photoshop CC understands a slew of 3D file formats (listed on page 904), including Collada (.dae) 3D model files. So to add a mesh to the menu, place its Collada model file in the Meshes folder inside the Photoshop application's preset folder (*Adobe\Adobe Photoshop CC 2014\Presets\Meshes*).

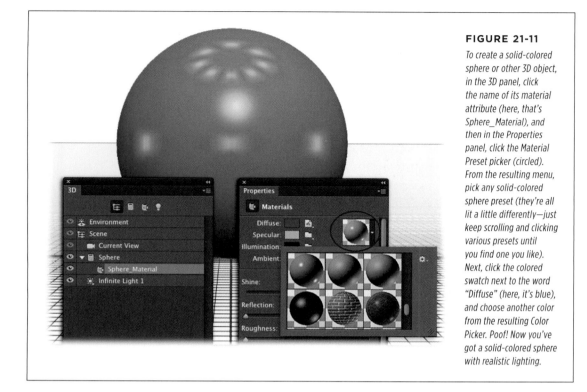

FIGURE 21-11

To create a solid-colored sphere or other 3D object, in the 3D panel, click the name of its material attribute (here, that's Sphere_Material), and then in the Properties panel, click the Material Preset picker (circled). From the resulting menu, pick any solid-colored sphere preset (they're all lit a little differently—just keep scrolling and clicking various presets until you find one you like). Next, click the colored swatch next to the word "Diffuse" (here, it's blue), and choose another color from the resulting Color Picker. Poof! Now you've got a solid-colored sphere with realistic lighting.

Wrapping Art around Basic Shapes

If you have an image that you'd like to wrap around a standard shape such as a soda can or wine bottle, Photoshop makes it fairly easy. Just head to the Layers panel and activate the layer(s) containing your artwork, and then, in the 3D panel, click the Mesh From Preset radio button, and then choose one of the shape options from the drop-down menu below it. Your options are Cone, Cube Wrap (a 3D cube that shows one layer's content on all its sides), Cube, Cylinder, Donut (torus), Hat, Pyramid, Ring, Soda (can), Sphere, Spherical Panorama, and Wine Bottle. Finally, click the Create button, and Photoshop wraps your artwork around the shape.

Once you've done that, you can move the image by using the hidden Texture Properties dialog box. To get there, pop over to the Layers panel and make sure the 3D object's layer thumbnail is active. Then switch to the 3D panel and click the material item nestled under your object's name (for example, Cube_Material). Once you do that, the Properties panel displays the Materials properties. At the top of the panel, click the tiny image icon to the right of the Diffuse color swatch and choose Edit UV Properties. Photoshop opens the Texture Properties dialog box, where you can change the artwork's scale and position (called Offset). Photoshop previews your

changes on the object in real time to help you get things just right (move the dialog box out of the way, if necessary). When everything looks good, click OK.

Importing 3D Models and Materials

In addition to building your own 3D objects from scratch, you can also import models and materials created in *other* programs, such as 3ds Max, Maya, modo, Cinema 4D, Poser, DAZ Studio, and SketchUp. You can also download models and materials from online services such as Google 3D Warehouse, TurboSquid, and 3DVIA.

TIP One way to get additional 3D goodies is to choose 3D→Get More Content. This opens your web browser to an Adobe web page with links to free and paid stuff you can download.

To import a 3D model you've created or downloaded, open a document, choose 3D→"New 3D Layer from File," and then, in the Open dialog box, find the file on your hard drive and click Open. The next dialog box you see lets you enter a size for the 3D object; just click OK to open the object at its original size. Photoshop then generates a 3D layer containing the object, which you can manipulate just like a 3D object you created yourself!

To import a material, in the Layers panel, activate a 3D layer and then, in the 3D panel, activate its material attribute (say, Cube_Material). Next, in the Properties panel, click the Material Preset picker (it's circled in Figure 21-11) and, in the resulting panel, click the gear icon at its upper right. Choose Load Materials, navigate to where the file lives on your hard drive, and then click Open. From this point on, the new material will be available as a preset in the Material Preset picker.

You can import the following types of 3D files into Photoshop CC 2014: 3D Studio (.3ds), Collada (.dae), Google Earth (.kmz), Stereo Lithography (.stl), and Alias|Wavefront (.obj).

Making a 3D Object from a Depth Map

Here's a powerful feature that average Photoshop jockeys will *never* use, but 3D professionals use all the time to build 3D shapes from scratch such as planets, mountains, or even *monsters* (Godzilla, anyone?). A depth map works like this: You create a grayscale image, and then Photoshop builds a 3D model from it, making the white areas in the image the *highest* (tallest) points on the model and the black areas in the image the *lowest* points. The results can be quite surprising if your brain doesn't think in terms of mapping grayscale images to 3D (and unless you're a professional 3D modeler, it probably doesn't).

To use this feature, start with a grayscale image on its own layer. Be sure the image includes both white and black areas. Activate the image layer (or multiple layers, if you like) and then, in the 3D panel, click the Mesh From Depth Map radio button and, from the drop-down menu below it, choose Plane, Two-Sided Plane, Cylinder, or Sphere. Plane uses your art to raise and lower the surface of a one-sided plane; Two-Sided Plane raises and lowers *both* sides of a plane; Cylinder maps it outward

from the center of a cylinder; and Sphere maps it radially outward from one center point. It can be hard to predict what kind of results you'll get from this feature, so the best way to find out is to simply click the 3D panel's Create button. If you don't like the results, edit the original grayscale image, remembering that black is the "floor" and white is the "ceiling." Good times!

Making a 3D Object from a Medical Scan

If you've ever had a medical scan, the results were likely converted to a DICOM file (Digital Imaging and Communications in Medicine). So if you've ever been interested in playing around with your scan results, here's your chance! Photoshop CC lets you open and work with DICOM files that have a .dc3, .dcm, or .dic extension, or no extension at all.

DICOM files sometimes contain multiple frames, each of which represents a different layer (slice) of a scan. Photoshop can convert those frames to layers, or open them as a 3D object (also called a *volume*) you can rotate in 3D space. To create a 3D object from a DICOM file, choose File→Open, navigate to the folder containing your DICOM files, and then activate some or all the files in the folder (the Select All button is handy for that). In the resulting Import Options dialog box, under Frame Import Options, turn on the "Import as volume" radio button, and then click Open. Photoshop creates a 3D object of the DICOM frames and places it on a 3D shape layer. You can then use Photoshop's 3D tools to view the object from any angle, render a scene, and save or export it to any format Photoshop understands.

■ Editing 3D Objects

Once you've created an object, you can do all kinds of things with it: apply materials to its surfaces, shine various kinds of lights on it, paint on it, run filters on it, adjust its opacity and blend mode, and even animate it over time. This section explains all these creative options.

Working with Materials

In Photoshop, a *material* is just what it sounds like: a flat image that gets applied to one or all sides of a 3D object. To get started working with materials, activate a 3D object in the Layers panel and then, in the 3D panel, look for a material nested under that object—every 3D object has one. Click the material item to activate it and Photoshop displays the Materials settings in the Properties panel (they're shown in Figure 21-11).

TIP You can activate multiple materials in the 3D panel and then adjust their properties all at once.

Materials can appear in lots of places on an object, so filtering what the 3D panel displays can really help when you want to adjust materials. Here's an effective approach:

1. **In the Layers panel, activate the object you want to work with.**

2. **At the top of the 3D panel, click the Materials icon (it's third from left at the top of the panel, and labeled *way* back in Figure 21-2).**

 This limits the panel to showing only the materials in the active object(s).

3. **Still in the 3D panel, activate the material(s) you want to edit.**

 To activate all of 'em, click the top one and then Shift-click the bottom one; to activate only some of them, click one and then ⌘-click (Ctrl-click) each of the others.

4. **In the Properties panel, make your changes to the materials using the various settings.**

To choose or switch a material, click the thumbnail at the top right of the Properties panel (this is called the Material Preset picker, and is circled in Figure 21-11). Photoshop opens a drop-down menu that includes thumbnails of built-in materials, including fabrics, gemstones, metals, woods, glass, plastics, and even moss and bricks. (To see a material's name, just point your cursor at its thumbnail without clicking.) To adjust the size of these thumbnails, click the gear icon in the upper-right corner of the materials list and choose Text Only, Small Thumbnail, Large Thumbnail (the default), Small List, or Large List.

If none of the built-in materials suit your fancy, you can download more than 100 additional materials by choosing 3D→Get More Content. On the web page that appears, scroll down and click Download Materials. Then, unzip the file you downloaded and drag the new goodies into the *Materials* folder (*Adobe\Adobe Photoshop CC 2014\Presets\Materials*). After you do that, quit Photoshop, relaunch it, and then open a document that contains a 3D layer. Next, head to the 3D panel and click the object's material attribute. In the Properties panel, click the Material Preset picker, and then click the gear icon at the top right of the resulting list. You'll spot some new categories at the bottom of the resulting menu. Pick a category to load it and, in the resulting dialog box, click Append; the new goodies appear below the existing ones in the list of material thumbnails.

The Diffuse, Specular, Illumination, and Ambient settings at the top of the Properties panel also let you apply colors and textures to the reflective areas of the current material. To change a color, click its color swatch, and then choose a new color from the Color Picker. To add a texture to a reflective surface of the material, click the tiny icon to the right of the Diffuse, Specular, or Illumination setting. In the resulting menu, you can choose to edit, replace, or remove the current texture, or create a new one. Once you've added a texture in this way, you can point your cursor at a setting's file icon to see a thumbnail of—and info about—the texture.

Other settings in the Properties panel include Shine, Reflection, Roughness, Bump, Opacity, and Refraction—all of which affect the look of the 3D object. You can adjust them by using the sliders, or you can load a texture for each attribute by clicking the tiny folder icon to the right of their names.

The last two Materials settings in the Properties panel—Normal and Environment (you may have to scroll down to see them)—let you apply a texture to the object's entire surface and to the environment around the object, respectively. (The environment texture is visible in any reflective areas of the object.) These settings are mainly used by 3D professionals.

You can copy and paste materials from one object surface to another, using the 3D tools in Photoshop's Tools panel:

- The **3D Material Eyedropper** is located in the Eyedropper toolset. It works similarly to how the Eyedropper tool works on 2D images: Click a 3D surface to sample its material, and then Option-click (Alt-click on a PC) another 3D surface to apply the sampled material to it.

- The **3D Material Drop tool** is located in the Gradient toolset. It works exactly the *opposite* of the 3D Material Eyedropper: Option-click (Alt-click) a material to sample it, and then click to apply it to another surface.

Painting on a 3D Object

If you're a creative soul, you're probably eager to learn how to paint directly on a 3D object. Well, here you go! You can use any of Photoshop's brush tools on either the object itself or on the texture you assigned to it—a texture can be literally *any* image that you apply to an object's surface—and watch as the program applies your brushstrokes to *both*.

To paint an object in Photoshop's ultra-cool Live 3D Painting mode, first activate a 3D object in the 3D or Layers panel, and then apply a texture to it using the techniques described in the previous section. (That said, if you *start* with a layer that you then wrap around a 3D object—say a Cube Wrap, Soda, Wine Bottle, and so on—then the original layer content is the texture.) Next, open the texture that you want to edit by double-clicking its name in the Layers panel. For example, if you created a Cube Wrap from a layer, then double-click the words "Cube_Material" in the Layers panel (you'll find it beneath the 3D layer, beneath the Textures heading). If you applied a texture to the 3D text as described on page 889, double-click the texture file's name beneath the Textures heading, underneath the 3D layer.

Alternatively, in the Properties panel, you can click the surface that you applied the texture to (for example, if you followed along with the 3D-text example on page 887, you'd click HOW Front Inflation). Next, click the icon of the attribute you added it to (say, Diffuse), and then choose Edit Texture from the menu that appears. Either way, the texture opens into its own window so you can edit it.

Choose Window→Arrange, and then pick one of the Tile options so you can see your 3D model and the texture document side by side. Then, activate the Brush tool and paint either the 3D model or the texture document; your brushstrokes automatically appear in the other view, too. How cool is that? When you're done painting, close and save the texture document, and Photoshop updates the texture on your 3D object.

TIP Another way to paint on a texture is to grab the Brush tool, and then click the 3D object. In the resulting dialog box, click Change Texture Target, and Photoshop opens the texture document in a new window.

To make a 3D object look like a sketch or illustration, first activate the 3D object's layer in the Layers panel. Next, in the 3D panel, click the Scene icon (it's the first one in the row of icons at the very top of the panel), and then, in the list of items in the panel, click the word "Scene." Finally, in the Properties panel, click an item in the Presets menu—sketch, illustration, wireframe, and so on—to see it applied to your object.

Lighting Your 3D Scene

Just like in your home or on a movie set, the final appearance of your 3D scene depends not only on the materials, textures, and camera angles you've chosen, but also on the number and types of light source. Photoshop has three kinds of basic lights. To add a basic light to a scene, click the New Light icon at the bottom of the 3D panel (it looks like a light bulb), and then choose an option:

- A **point light** is like a bare incandescent light bulb. It has a location and *falloff* (meaning it tapers off, so objects far away from it won't be affected by it), but it's not focused in any particular direction.

- A **spot light** has a location, falloff, direction, and *cone of illumination* (like the cone of light created by a real-world flashlight or spotlight).

- An **infinite light** sends light into the scene from a specific direction but it doesn't taper off. You can think of this like sunlight.

Adjusting the details of a basic light is easy: Just activate the light in the 3D panel, and then tweak the settings in the Properties panel (see Figure 21-12). The Properties panel's Preset menu has 14 really useful options. If you edit your basic light but don't like the results, choose Default Lights from the Preset menu to get back to where you started.

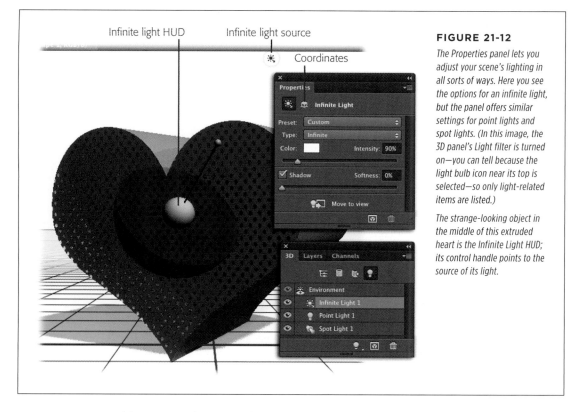

Infinite light HUD Infinite light source

Coordinates

FIGURE 21-12

The Properties panel lets you adjust your scene's lighting in all sorts of ways. Here you see the options for an infinite light, but the panel offers similar settings for point lights and spot lights. (In this image, the 3D panel's Light filter is turned on—you can tell because the light bulb icon near its top is selected—so only light-related items are listed.)

The strange-looking object in the middle of this extruded heart is the Infinite Light HUD; its control handle points to the source of its light.

After you've chosen a lighting preset, you can adjust its Color and Intensity settings, use the Shadows setting to determine whether it casts shadows (if it does, you can tweak the softness of its shadow), and—for spot lights and infinite lights—its falloff, cone, *hotspot* (width of its bright center), and other properties. You can also change the light's location by clicking the Coordinates icon labeled in Figure 21-12, but dragging the light around in the main view window is more intuitive: Just drag one of the handles on the light's HUD.

> **TIP** If you get lost while moving a light around, click the Properties panel's "Move to view" icon to reposition the light near your object. Or, click the panel's Coordinates icon, and then click Reset Coordinates to move the light to the center of your 3D object.

In addition to the three basic lights, Photoshop also lets you use a much more advanced light known as an *Image Based Light* (IBL), which is generated from an image file that was specifically created to shine light in various ways all the way around your scene. (Photoshop has a built-in IBL that it applies to every scene for you.) An IBL acts like a sphere around your scene and lights it from all directions based on the

color and intensity of the IBL's image. And, if the Reflection value in the Properties panel is greater than 0%, the IBL also shows up in the reflections of your materials.

The IBL applies to your scene's whole environment, so to edit one you first need to activate the Environment item in the 3D panel. Then, in the Properties panel, you can then adjust the built-in IBL's many settings. If you click the IBL's thumbnail (it looks like a gray rectangle with white dots on it), you can edit the image file that Photoshop uses for the IBL or replace it with a new image file.

TIP Once you've created a set of lights that you like, you can save them as a preset by choosing Save Lights Preset from the 3D panel's menu. The same menu also lets you delete or replace the current lights preset, or add a new preset from a file.

■ POSITIONING BASIC LIGHTS

How you position a basic light depends on what kind of light it is. But no matter what kind it is, you first have to activate it in the 3D panel. To make it easier to find your lights in the 3D panel, click the Lights icon at the top of the panel (labeled back in Figure 21-2), so the panel lists only lights.

NOTE You can't reposition IBLs because they wrap around your whole scene.

To reposition a point light, grab the Move tool and drag the handles of the HUD that appears. If you lose control of the light, reset its position by clicking the "Move to view" icon in the Properties panel. Doing so puts the light to the lower-left corner of your object.

You reposition a spot light the same way: Grab the Move tool and drag the handles of the HUD that appears. Another option is to click and drag anywhere in the document window; the light moves based on the 3D mode that's active in the Options bar (see page 882). A couple of icons in the Properties panel can be helpful when you're moving a spot light: "Point at origin" resets the light's angle to point directly at your object, and "Move to view" moves the light to the lower-left corner of your object.

To reposition an infinite light, grab the Move tool and, in the Options bar, set the 3D mode to Rotate (the first icon). When you activate an infinite light in the 3D panel, you see a HUD in the center of your window that looks like a giant satellite dish (see Figure 21-12). Simply drag anywhere in the document window to change the light's angle.

Instances

3D objects are complex, so keeping track of multiple copies of an object can be challenging. Also, each object contains lots of data, so Photoshop gives you a way to keep your files slim *and* save you the headache of keeping track of multiple copies of the same object. The trick is to make one or more *instances* from one object, so that when you edit the properties of the original object or any instance of it, they all

reflect the change. (If you use Adobe Illustrator, Fireworks, or Flash, you're familiar with this concept, which is similar to using a linked smart object in Photoshop.)

To create an instance from a 3D object, activate the object in the 3D panel. Then, from either the panel menu or the contextual menu that appears when you Control-click (right-click) the object in the panel's list, choose Instance Object. Photoshop adds a copy of the object to the 3D panel, named the same thing as the original object but with a number at the end of its name. (Its icon is dark to remind you that it's an instance.) If you activate the original object or any instance of it and then make changes in the Properties panel, Photoshop applies your changes to the original and all its instances.

If you want to *break* the link between an instance and the original (so that you can make changes to the instance without affecting the original or the other instances of it), activate the instance in the 3D panel, and then choose Bake Object from either the 3D panel's menu or the contextual menu that appears when you Control-click (right-click) the item in the panel's list.

Combining Objects

At some point, you may want to combine two or more 3D objects into one so that it's easier to position and light them, for example. To do that, in the Layers panel, activate the 3D layers you want to combine. Then hold down the Shift key while you choose 3D→Merge 3D Layers. Photoshop combines the 3D layers you activated into a single 3D layer.

Running Filters on a 3D Layer

Just like regular 2D layers, you can apply Photoshop's filters to 3D layers. It's always a good idea to first convert the 3D layer for use with smart filter (choose Filter→"Convert for Smart Filters"). For the full scoop on smart filters, flip back to page 670.

Changing a 3D Layer's Blend Mode and Opacity

You can change the blend mode and opacity of a 3D Layer just like you can with 2D layers. Simply activate the 3D layer in the Layers panel, and then adjust the panel's Opacity and Fill settings, as well as the unlabeled blend mode menu near the top of the panel (it's set to Normal unless you change it). To change any of these settings for multiple layers at once, simply activate all the layers first.

Rasterizing a 3D Layer

At some point, you may want to simplify a 3D project by boiling down a complex, multi-part 3D layer into a simple 2D image layer—essentially flattening it into a static picture. That's where rasterizing comes in. (Remember: Rasterizing [described on page 117] is different than *rendering* [page 903].)

Rasterizing a 3D layer is similar to rasterizing a type layer in that it removes all the layer's 3D-editing goodness. So before you rasterize your layer, either make a duplicate of it for future 3D editing, or be *real sure* that you're completely finished

adjusting it! When you're ready to rasterize, either choose Layer→Rasterize→3D, or head to the Layers panel and Control-click (right-click) the 3D layer's name and choose Rasterize 3D. Either way, Photoshop squishes your 3D layer down into a flat version of its former self, as if you'd taken a photo of it.

◼ Rendering 3D Objects

While you're working on a 3D object, Photoshop is actually only showing you a low-resolution preview. When you're finished with your work, or when you just want a glimpse of the fabulosity of your talent, you need to tell Photoshop to *render* the scene—generate a high quality version that you can use online, in print, or in an animation. Rendering uses ray tracing and a higher resolution than what you see in the preview to generate more realistic lighting and shadow effects. (*Ray tracing* is a lighting technique that generates realistic reflections and shadows by following rays of light as they emerge from their sources, pass through semi-transparent objects, and reflect off surfaces.)

When Photoshop renders a scene, it uses the Properties panel's render settings, which only appear when you have a *scene* active in the *3D panel*. (You can tell you're looking at these settings because you'll see the word Scene at the top of the Properties panel.) The Properties panel has 16 rendering presets (they're listed in the aptly named Presets drop-down menu); some are useful only to 3D pros, while others are fun for everyone (wireframe presets, for example).

Unless you're a 3D pro, your best bet is to stick with the presets. But if you're feeling adventurous, you can make hundreds of choices in the Properties panel's Cross Section, Surface, Lines, and Points sections. And there are a handful of simplification options that do things like remove shadows, back faces (literally the back face of a 3D object), and lines.

You can render only a *portion* of a scene, which saves time when you just need to see a higher-quality version of part of your object, such as a shadow. To do that, first activate the object in the Layers panel, and then use any tool to select the area that you want to see in higher detail. That way, Photoshop will render only the selected area.

There are several ways to tell Photoshop to start rendering your 3D scene: Choose 3D→Render, Control-click (right-click) the 3D layer in the Layers panel and choose Render, or click the Render button at the bottom of the 3D panel. Whichever method you use, Photoshop gets to work.

Rendering takes a long time. Photoshop keeps you informed of its progress by displaying a Time Remaining progress bar in the lower-left corner of your document window, and you can entertain yourself by watching dashed lines move around your window as the program processes each area multiple times. You can press the Esc key at any time to cancel the rendering—Photoshop will pick up where it left off the next time you tell it to render.

TIP If the rendering process is taking longer than you'd like, you can speed it up by changing Photoshop's preferences (Photoshop→Preferences→3D [Edit→Preferences→3D on a PC]). In the Ray Tracer section, if you change the High Quality Threshold from 5 to 4, the rendering quality will be just *slightly* lower, but the speed will be dramatically faster.

■ Saving and Exporting 3D Objects

When you're ready to share your 3D masterpiece with the world, you can either render your 3D scene and then save it in any of Photoshop's 2D image formats just like a regular file (page 44), or you can export your 3D model for use in another 3D program. To do the latter, choose 3D→Export 3D Layer, and then choose one of these file formats: Collada DAE, Flash 3D, Google Earth 4 KMZ, STL, or OBJ.

Be sure to save your file as a Photoshop (PSD) document to preserve all your 3D editing capabilities. If you need to give the file to someone else, save *another* copy in PDF or TIFF format. Whichever format you want to use, you save the file the same way: Choose File→Save or File→Save As, choose Photoshop (PSD), Photoshop PDF, or TIFF from the format drop-down menu, and then click Save.

TIP Sketchfab.com is an online 3D printing service. New in Photoshop CC 2014 is the ability to share your 3D masterpiece with the Sketchfab community—from *inside* Photoshop. First, create a free account at *www. sketchfab.com*. Then, in Photoshop, activate a single 3D layer, choose 3D→ "Share 3D Layer on Sketchfab" and in the resulting dialog box, enter your email address, title, description, and so on.

POWER USERS CLINIC

Budget 3D Scans

You may have heard about an up-and-coming technology: 3D scanners! They're just what they sound like, machines that can scan 3D objects so you can use the objects in 3D editing programs. Problem is, these devices are really pricey: A professional model, such as Artec's Eva 3D scanner, costs $12,899 and can only capture an object's shape; if you want to capture the object's texture, too, it'll run you $17,999. And you also need to buy their Artec Studio software for $649, so clearly 3D scanning can get *real* expensive real quick.

Happily, there's a way to scan objects and create 3D models from them *without* taking out a loan. You can buy Artec Studio and use it with a gaming sensor, such as Microsoft Kinect for XBox/Windows, the Asus Xtion/Xtion Pro Live, or another sensor based on PrimeSense technology (just Google it). The program can export the result into several 3D formats, including OBJ, which you can open in Photoshop. The results you get from using a gaming sensor won't be as good as what you'd get with a professional 3D scanner (you can't capture texture, for example), but you'll save several thousand dollars!

Printing in 3D

Want to create 3D objects in the *real* world, not just in Photoshop? No problem! 3D printers are now a reality. Instead of spraying ink like an inkjet printer, a 3D printer creates a stack of extremely thin layers—one on top of the other—of liquid plastic, metal, glass, gold, silver, or even a granular, resin-type substance to create the final object. Depending on the material, the layers either dry instantly, or a laser beam is used to heat and solidify each layer. Neat, huh?

Industry experts predict that by 2016, high-quality 3D printers will be available for less than $2,000. Meanwhile, there are 3D-printing companies that will create a 3D object from your exported 3D file. Happily, Photoshop CC 2014 lets you print directly to a 3D printer (if you have one) or send the file off to a company such as Shapeways (*www.shapeways.com*) or Sculpteo (*www.sculpteo.com*) for *them* to print.

Once you've perfected your 3D object and rendered it, choose 3D→3D Print Settings. Photoshop places your object inside a box with a grid on the bottom to give you an idea of what the printed object will look like, as shown in Figure 21-13. And in the Properties panel, you see the 3D Print Settings visible in Figure 21-13.

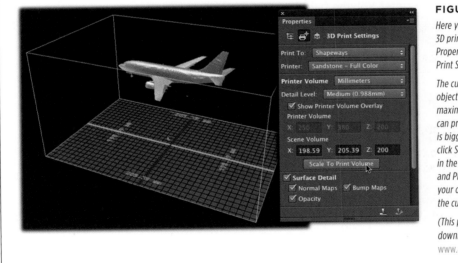

FIGURE 21-13

Here you see both the 3D print preview and the Properties panel's 3D Print Settings.

The cube around the object represents the maximum size the printer can print. If your object is bigger than the cube, click Scale To Print Volume in the Properties panel and Photoshop resizes your object to fit within the cube.

(This plane was downloaded for free from www.archive3d.net.)

NOTE If, out of habit, you press ⌘-P (Ctrl+P on a PC) or choose File→Print while a 3D layer is active, you get the *normal* Photoshop Print Settings dialog box, which isn't what you want. Printing a 3D object is quite a different animal than printing a 2D file, so to print it, you first have to choose 3D→3D Print Settings, and then pick a printer in the Properties panel.

Here's what all the settings in the Properties panel's 3D Print Settings are for:

- **Print To.** This menu lets you tell Photoshop *where* you'll print the object, either on your own printer (choose Local) or at a printing service such as Shapeways.com (choose Shapeways). Expect to see more printing-service options in this menu in the future.

- **Printer.** This is where you pick the actual printer. If you've got a 3D printer and you picked Local from the Print To menu, you see your printer's name here. If you picked Shapeways, you see a list of print *materials* instead; just pick the one you want and you see a preview of it in the document window.

- **Printer Volume menu.** This is where you pick the unit of measurement you'd like to see the printer's maximum volume in (see the Printer Volume fields described below).

- **Detail Level.** Use this menu to set the print quality; your choices are Low, Medium, or High.

- **Show Printer Volume Overlay.** Keep this option turned on to see a cube-like representation of the *printer's* maximum printing size around your object, which gives you an idea of how big the thing will be.

- **Printer Volume fields.** Indicates the maximum size the printer can produce (you pick the unit of measurement displayed here using the Printer Volume menu mentioned above).

- **Scene Volume.** Displays the size of your 3D object. You can use these fields to resize your object, say, to fit what the printer can, well, *print*.

- **Scale to Print Volume.** Click this button and Photoshop scales your object to the maximum size allowed by the printer.

- **Surface Detail.** Keep this checkbox turned on so any depth maps (page 895) you've added to the object print, too, giving the surface more texture. To print the object without any depth maps, turn off this setting, or turn off the individual checkboxes for Normal Maps, Bump Maps, and Opacity.

Once you get the settings just right, click the Start Print icon at the bottom of the 3D panel (it's the third one from the right, and is labeled *way* back in Figure 21-1). Photoshop displays a progress bar while it generates the print preview; when it's *eventually* finished, you see the 3D Print dialog box (Figure 21-14).

If the preview looks good, click Export and, in the resulting Save dialog box, give the file a name (Photoshop gives it a .wrl extension), and then click Save.

If you picked Shapeways from the Print To menu, Photoshop then displays a message asking if you'd like to upload the file to their website (*www.shapeways.com*). Click Yes and you can practically *feel* your object coming to life—that is, as soon as you give your credit card info to the folks at Shapeways! If you click No, Photoshop creates a zipped copy of the .wrl file that you can upload whenever you're ready.

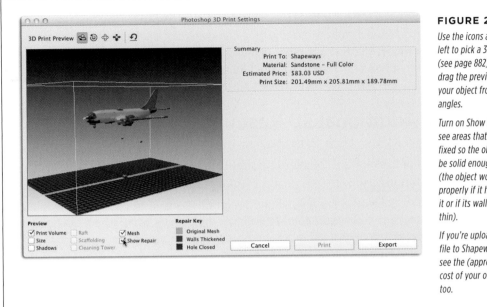

FIGURE 21-14

Use the icons at the top left to pick a 3D mode (see page 882), and then drag the preview to see your object from different angles.

Turn on Show Repair to see areas that Photoshop fixed so the object will be solid enough to print (the object won't print properly if it has holes in it or if its walls are too thin).

If you're uploading the file to Shapeways, you see the (approximate) cost of your object here, too.

If you picked a local printer, click the Start Print button at the lower left of the Properties panel. If the object is too big to print, you get an error message; adjust the object's size as described in the bulleted list above and try again. If it's good to go, Photoshop prepares the file—grab a beverage because it takes a while—and displays the Photoshop 3D Print Settings dialog box shown in Figure 21-14. Click Print and the printer springs into action.

Creating 3D Animations

Photoshop lets you animate a 3D object so it appears to move through space, plus you can change its appearance over time. To do that, open the file containing the 3D object and then open the Timeline panel (Window→Timeline), and then click the Create Video Timeline button. (If you don't see this button, click the triangle in the middle of the panel, choose Create Video Timeline panel, and *then* click the button.) When you do that, Photoshop adds all the layers in the Layers panel to the Timeline panel as video layers.

> **TIP** See Chapter 20 for a refresher on working with the Timeline panel.

To access a 3D object's animation properties, in the Timeline panel, click the flippy triangle next to the object's name. To create a keyframe animation for properties such as Position, Opacity, Style, 3D Camera Position, 3D Render Settings, 3D Cross Section, and so on, just click the stopwatch icon next to the property's name (if the property has a flippy triangle next to its name, click it to expand the property and then you'll see a stopwatch icon). You can then treat each object and property the same way you'd treat any other object you're animating in the timeline. (See page 862 for details on creating animations.)

Additional 3D Resources

This chapter is by no means a complete guide to 3D modeling—it's more of an heroic attempt to simplify a complex art form! To learn more, check out these resources:

- **CGSociety** (*www.lesa.in/3dcgtalk*) is a huge community of 3D modeling professionals who are helpful and insightful. Be sure to check out the site's 3D sections if you want to have your mind blown by what others are doing with professional-level 3D programs.

- **3Dtotal** (*www.3dtotal.com*) has endless resources for all things 3D (and 2D, for that matter).

- **PSD tuts+** (*www.lesa.in/3dpstuts*) has a fine selection of free 3D tutorials for Photoshop users. However, some are for older versions of Photoshop that had a very different set of 3D tools, so you may have to figure out how to accomplish them with the current toolset.

- **"60 Excellent Free 3D Model Websites"** (*www.lesa.in/603dmodels*) is an article by Kay Tan that highlights 60 valuable 3D resources.

- **Archive3D** (*www.archive3d.net*) has 35,000+ 3D models and props, and they're all *free!*

- **CG Textures** (*www.cgtextures.com*) offers zillions of free textures.

- **Blender** (*www.blender.org*) is a free suite of tools for creating 3D objects.

Using Adobe Bridge

As digital images pile up on your hard drive, the ability to sift through them quickly and efficiently becomes more and more important. Enter Adobe Bridge, an image-browsing and -organizing program that's been shipping with Photoshop for years. Its special purpose in life is to let you browse, compare, sort, manage, import, and even *manipulate* (to an extent) the files on your hard drive. The important thing to remember about Bridge is that you can use it to see preview thumbnails of most files on your machine, regardless of whether you used Bridge to import 'em. Think of it as an alternative to the Mac's Finder or Windows Explorer.

Bridge can display thumbnail previews of *multiple* file formats—more than either OS X or Windows currently can. For example, you can see multiple pages of PDFs and at least *two* pages of Adobe InDesign files (you can see more than two by tweaking InDesign's preferences, but that's fodder for another book). Bridge also lets you watch movie files and listen to audio files, all without opening the files themselves. However, Bridge *can't* peek into your iPhoto library because Macs squirrel that away for safekeeping, nor can it preview QuarkXPress files (a popular page-layout program).

Because *everything* you do to files in Bridge happens to those files on your *hard drive*, Bridge is typically the easiest place to perform mundane file-management tasks such as renaming, moving, copying, and deleting files. It also gives you easy access to several automated tasks that work on multiple files; for example, you can use it to copy and paste edits made in Camera Raw to other images without actually *opening* Camera Raw.

If you used Bridge years ago, you'll likely remember that browsing images was painfully slow and the program wasn't very intuitive. That's all changed in recent versions. Bridge CC is a 64-bit program just like Photoshop (page xxix), it's user-

friendly, and it sports an eye-relieving dark gray coat of paint. Bridge also includes a useful Review mode that photographers adore (page 916).

Now for the not-so-good news.

These days you have to install Bridge *separately* from Photoshop, and you no longer get a Mini Bridge panel in Photoshop. Also, in order to optimize Bridge CC for Retina displays (super-high-resolution displays made by Apple, called HiDPI on PCs), Adobe removed the Adobe Output Module, which let you create web galleries and PDFs. And if you go rootin' around for the Export panel—useful in converting images from one format to another and quickly posting images on Flickr, Facebook, and Photoshop.com—you won't find it, either. Also missing is the New Synchronized Window command, which lets you have *two* instances of Bridge open at the same time.

Will any of these features return in future versions? Probably not. However, if your current workflow *depends* on that stuff, you can either download and install the Adobe Output Module by visiting *www.lesa.in/aomforbcc*, or you can switch gears and download Photoshop Lightroom (it has all those features and more, and is part of Adobe's Creative Cloud) or you can keep using Bridge CS6. That said, if you're new to the program or if you never used those features, you won't miss 'em and you'll be pleasantly pleased by the zippier performance of Bridge CC.

In the following pages, you'll learn the basics of browsing, importing, and rating your images in Bridge. By the time you're finished reading, you'll likely be one of Bridge's newest fans!

> **NOTE** If you're using Photoshop Lightroom, the only reason to use Bridge is to preview or locate other files on your hard drive.

■ Installing Bridge

In order to keep the file sizes of Adobe's downloadable Creative Cloud programs as slim and trim as possible, Bridge is no longer automatically installed when you load Photoshop onto your machine. The installation process is simple: Open the Creative Cloud application and click Apps, and then scroll down until you see Bridge CC. Click Install, and then follow the onscreen directions. That's it!

Happily, Bridge CS6 and Bridge CC seem to *coexist* peacefully on a single machine, so if you need the missing features mentioned earlier, feel *absolutely* free to keep the CS6 version hanging around.

> **NOTE** Adobe removed all the Flash-based panels in Photoshop CC 2014, so you can no longer open a miniature version of Bridge (aptly named Mini Bridge) inside Photoshop. Bummer!

Unfortunately, Bridge doesn't have an equivalent of Photoshop's Migrate Presets feature (page 33), so if you've customized an earlier version of Bridge with favorites

(page 912), collections (page 918), and so on, you need to copy those files over to the new version *manually*. To do that on a Mac, find the *Macintosh HD/Library/Application Support/Adobe/Bridge CS6 Extensions* folder, and then open it to reveal your presets folder. Drag those files into the same folders inside the Bridge *CC* Extensions folder, and then restart Bridge.

Browsing through Photos

If you're working in Photoshop CC, you can open Bridge by choosing File→"Browse in Bridge." If Photoshop *isn't* running, you can double-click the Bridge icon in the Adobe Bridge application folder (on a PC, go to Start→All Programs→Adobe Bridge CC). Either way, you see the window shown in Figure 22-1.

FIGURE 22-1

You can use Bridge to browse all the images on your hard drive, not just ones you've downloaded from your camera, using Bridge (as explained on page 913).

The program's various panels harbor different kinds of info, and they're all movable and resizable: To move one, drag its tab; to resize one, drag the bar that divides it from other panels; and to combine two panels, drag one panel's tab into another panel.

Labels in figure: Back/Forward · Go to parent folder/Favorites · Recent files/folders · Go to Photoshop · Rotate photo · Path bar · Search · Drag to resize panels · Thumbnail size · Thumbnails · List · Details

NOTE If you open Bridge and it looks different from Figure 22-1, try clicking the word Essentials near the top of the Bridge window. That will switch you over to the built-in workspace shown here.

The Bridge window displays a variety of info about your images in collapsible panels—just double-click a tab to collapse or expand a panel or group of panels. You can use the Folders panel on the left to navigate to a specific spot on your hard drive and view the images stored there. When you click a folder in this panel, Bridge displays its contents as thumbnails in the Content panel in the middle of the window (the slider at the bottom right of the Bridge window controls how big these thumbnails are). Click an image in the Content panel to see a larger version of it in the Preview panel on the right.

> **TIP** To see a *larger* preview of an image whose thumbnail is displayed in Bridge, click the file to activate it and then tap the space bar; Bridge displays the image in all its full-screen glory. Press the space bar again to go back to the Bridge window.

At the top of the Bridge window are controls that help you find the files you want (they're labeled in Figure 22-1):

- **Forward and back arrows.** Click these buttons to move through the folders you've recently viewed. For example, if you went to your Pictures folder and then opened the Blackmail folder inside it, click the back arrow to return to the Pictures folder. (These buttons don't activate files, just folders.)

> **TIP** For quick access to certain folders, add them to Bridge's Favorites panel: Control-click (right-click) the folder while you're viewing it in Bridge, and then choose "Add to Favorites" from the resulting menu. (You can also choose File→"Add to Favorites" or simply drag a folder from the Content panel into the Favorites panel.) From then on, you'll have one-click, timesaving access to that folder in the Favorites panel.

- **Go to parent folder/Favorites.** Like the back-arrow button, this button lets you move up a folder level. For example, if you're perusing the Midnight Madness folder that lives inside your Photoshop World folder, you can click this button to reveal a menu that lets you quickly pop back to the Photoshop World folder (which is called the *parent* folder because it's one level above the Midnight Madness folder in your computer's file-organization family tree). You can also use this button to access folders that you've added to the Favorites panel.

- **Go to recent files/folders.** Click this button to see a list of all the files and folders you've recently viewed in Adobe programs, categorized by the program that made 'em. When you choose an item from this list, Bridge displays a preview of the item along with its location on your hard drive.

- **Path bar.** This outrageously useful bar is a clickable, virtual trail of breadcrumbs that helps you keep track of where you are on your hard drive. It shows which folder you're in, so if you want to jump to a different spot in the trail, simply click the name of another folder in this bar. Since the path bar shows you how you arrived at the folder you're in, you always know exactly where you are (and the clickable links offer a fast track backward). If you don't see this bar—or if it's mysteriously disappeared, as it sometimes does—choose Window→Path Bar.

TIP If the folder you're currently perusing contains *subfolders* (folders within folders), you can see a list of all those subfolders by clicking the > at the end of the path bar. To view the contents of *one* of those subfolders, simply choose it from the list. To see the individual files *inside all the subfolders*, choose "Show Items from Subfolders." (You'll still see the subfolders, but you can hide them from view by choosing View→Show Folders; the same command lets you turn 'em back on.) This maneuver is called *folder cruising*, and it's a great way to force Bridge to create thumbnail previews of everything inside a folder (handy when the folder contains a slew of images that Bridge hasn't yet drawn thumbnails of, meaning you can't find 'em using Bridge's search field). To turn folder cruising off, click the slash-within-a-circle icon in the same menu.

- **Search field.** If you know the name of the file you're looking for but don't remember where it lives, type its name (or the first few letters of it) into this field and then press Return (Enter on a PC). Bridge scours the current folder and its subfolders, and then lists the files that best match what you typed. You can also use this field to find images with specific keywords (descriptive words or phrases that you enter into Bridge's Keyword panel, such as *portraits*, *food*, *flowers*, and so on). Click the magnifying glass for a list of recent searches or to switch to a Spotlight search (a Windows Desktop search on a PC) to find specific file names anywhere on your hard drive (the latter doesn't work on keywords or metadata, however).

TIP For a more *powerful* Bridge search feature, choose Edit→Find. In the resulting dialog box, you can tell Bridge exactly *where* on your hard drive you want it to search, and set myriad criteria such as date created, date modified, file size, document type, and so on. You also get access to your image's metadata (page 914), which lets you search for stuff like Focal Length, ISO, and so on. Handy!

Importing and Managing Photos

Bridge makes importing images a snap, and it can perform all kinds of wonderful housekeeping chores, too. For example, it can automatically rename photos and add keywords, descriptions, and copyright info to each file. You can also have it back up your photos (either to an external hard drive or to another spot on your internal hard drive) while importing them from your digital camera or memory card.

To import images, make sure your card reader is attached to your computer (see the box on page 916), and then choose File→"Get Photos from Camera" or click the tiny camera icon near the top left of the Bridge window. Either way, Bridge opens the Photo Downloader in *Standard mode*, which isn't very impressive; its most redeeming feature is its Advanced Dialog button; click it to switch to *Advanced mode*, shown in Figure 22-2. (If this is the first time you've downloaded photos with Bridge on a Mac, you'll see the dialog box mentioned in the Tip on page 915.)

Customizing the Bridge Window

You can customize the Bridge workspace just like you can customize Photoshop, or use one of its built-in layouts. Near the top of the Bridge window is a row of workspace buttons that arrange the program's panels in a variety of ways (see Figure 22-1). Here's what each one does:

- **Essentials** is the arrangement you see when you first open Bridge: The Favorites and Folders panels are on the left, the Content panel is in the middle, and the Preview panel is on the right. It's a handy workspace for sifting through files.

- **Filmstrip** is great for looking at photos you've imported. The Favorites and Folders panels are still on the left, but the Content panel is down at the bottom as a wide, thin strip, and the Preview panel takes center stage. Photographers like this workspace because it gives 'em a nice big preview area.

- **Metadata** shows you all kinds of info about your images. There's no big Preview panel in this workspace; the Content panel takes precedence, displaying each file's creation date, size, type, and so on. The Favorites panel is on the left along with the Metadata panel, which includes stats about the active file like its dimensions, resolution, and so on.

- **Keywords** is similar to Metadata except that, in the Preview panel, you see folder icons displayed with info such as the date the image was captured or created, date modified, and color profile. This workspace also sticks the Keywords panel at the bottom left for easy access.

If these workspaces don't float your boat, you can make your own. Simply move and resize the panels however you like, and then click the triangle to the right of the word "Keyword" and choose New Workspace. Give it a meaningful name in the resulting dialog box, and then click Save. The name of your custom workspace appears at the top of the Bridge window, just like the built-in workspaces. If you want to get rid of it, click the triangle again, choose Delete Workspace, pick the offending workspace in the resulting dialog box, and then click Delete.

You can also customize the color theme in Bridge, just like in Photoshop. Simply choose Bridge→Preferences→General (Edit→Preferences→General on a PC). You'll see various color squares that you can click to change the color scheme, as shown here. You can also use the sliders underneath 'em to tweak the program's overall brightness, change its image backdrop (the background color Bridge displays your images on), and its accent color (the highlight color Bridge puts around an image's thumbnail when you activate it).

FIGURE 22-2

Importing photos from a camera or memory card with Bridge is a huge timesaver. Plus, if you've got an external hard drive plugged into your computer, you can turn on "Save Copies to" (circled, right) and sleep better knowing there are extra copies of your photos stored somewhere other than your main computer.

For more tips on importing photos from your camera, flip to the box on page 916.

At the top right of this extremely useful dialog box, tell Bridge where to save your precious pictures by clicking Choose (Browse on a PC). The Photo Downloader also lets you pick which images to import (turn on the appropriate checkboxes like the one circled in Figure 22-2, left), give the images meaningful names, *and* instruct Bridge to back 'em up (by turning on the "Save Copies to" checkbox circled in Figure 22-2, right). Once you've adjusted all these settings, click Get Media, and then sit back and relax.

TIP On a Mac, the first time you choose File→"Get Photos from Camera" or click the Bridge's camera icon, the program asks if you want it to *automatically* open each time you attach a card reader to your computer (or plug in your camera's USB cable). If you want to always use Bridge to import photos, click Yes. This saves you a couple of clicks each time you import, because Bridge automatically launches and opens the Photo Downloader dialog box. If you've already hightailed it past this dialog box, you can access it in Bridge's preferences. Choose Bridge→Preferences→General and turn on the "When a Camera is Connected, Launch Adobe Photo Downloader" setting.

In Windows, you don't see the dialog box described above. But you can still make the Photo Downloader open automatically: Go to Start→Control Panel→AutoPlay and, from the Pictures drop-down menu, choose Download Images Using Adobe Bridge CC, and then click Save. That way, each time your computer detects a memory card, the Photo Downloader dialog box automatically opens and picks your memory card as its source.

Review Mode

After you import images, you can use Bridge's excellent Review mode to view them in a giant, floating carousel (see Figure 22-3). This is a quick and easy way to check out your images, mark the ones you don't like, and apply star ratings to the ones you do.

> **NOTE** To mark an image as *rejected* (meaning you're tagging it as one you don't want to keep), simply activate the image's thumbnail in the main Bridge window (not in Review mode), and then press Option-Delete (Alt+Delete on a PC). Once you do that, you can delete all your rejected images in one fell swoop, as explained in the next section.

Tips for Importing Photos

Here are a few pointers for importing photos from a digital camera quickly and safely that will also help you find 'em on your hard drive later:

- **Always use a card reader.** The slowest way to import photos is by using the USB cable that came with the camera. It's sweet that the camera manufacturer included it, but those cables are super cheap. The cable's low quality also makes using it dangerous—the cheaper the cable, the greater the chance that something will go wrong. Fortunately, you can avoid this risk by getting a *card reader*, which imports photos much faster and more reliably. You simply take the memory card out of your camera, stick it in the card reader, and then connect the reader to your computer. Card readers are inexpensive (for example, you can get a SanDisk ImageMate 12-in-1 for around $20) and most models can read several different kinds of memory cards (that's what the "12-in-1" part means), which is a nice bonus if you have more than one brand of camera. Also, if you're on a Mac, take care that you don't yank a memory card out of the card reader until you've properly ejected it from your computer by choosing File→Eject in the Finder.

- **Erase memory cards only in your camera.** Most photo importing/organizing programs offer to erase photos from your memory card after importing them onto your computer. Resist the urge to say yes, and instead stick the memory card back into your camera, and then use the *camera's* menus to reformat the card to erase the images. This protects you from losing files if there's some

kind of crash or stall while they're importing, which can corrupt the photos (and, if the program has already erased them from the memory card, you can't reimport them). Also, many folks believe that reformatting memory cards rather than erasing them helps reduce the risk of cards getting corrupted and losing your photos. To learn how to reformat your memory card, dig out the manual that came with your camera.

- **Give photos meaningful names.** Instead of sticking with the completely useless names your camera assigns to photos, give them meaningful names when you import them. Programs like Bridge can automatically number the files for you and tack on a name like *Photoshop World*. You've got to admit that the name *Photoshop World 2014_1.jpg* is a lot more descriptive than *DCS_00102.jpg*.

- **Use several small memory cards instead of one big one.** No matter how well you care for them, memory cards—like any storage device—can fail and lose all the precious images stored on 'em. For that reason, consider carrying four 8 GB cards instead of a single 32 GB card; that way, you'll lose fewer photos if one of the cards goes south. When buying memory cards, do a little research to find a good brand. The cheapest cards can be unreliable and are usually slow. The faster the card, the faster your camera can take photos (and the faster your computer can import 'em). Checking reviews on Amazon.com is always a good idea. As of this writing, the SanDisk Extreme cards are blazing fast and are especially useful when shooting video.

Left/Right Reject Loupe Create Collection Exit

FIGURE 22-3

In Review mode, press ⌘-1, 2, 3, 4, or 5 (Ctrl+1, 2, 3, 4, or 5 on a PC) to give an image a rating of 1 to 5 stars, or click the down arrow in the window's lower left to remove an image from view (this doesn't mark the image as rejected; it simply removes it from view and deactivates it).

To take a closer look at part of an image, either click the Loupe icon in the window's bottom right or just click the image.

To use Review mode, activate a folder in the Folders panel or choose multiple images (more than four) in the Content panel by ⌘-clicking (Ctrl-clicking) or Shift-clicking them. Then either press ⌘-B (Ctrl+B) or click the Refine icon at the top of the Bridge window (it looks like a stack of paper) and choose Review Mode. Either way, Bridge takes over your screen and displays the images on a dark gray background. The left and right arrows at the bottom left let you quickly flip through images (the arrow keys on your keyboard work, too). You can also click any image in the background to bring it to the front, or drag an image off the bottom of your screen—or click the down arrow at the bottom of the window—to remove it from Review mode (it doesn't get deleted or tagged as rejected, just removed from view). To exit Review mode and return to the Bridge window, click the X in the bottom-right corner or press Esc.

TIP To rotate an image in Review mode, click the image to activate it, and then press the left or right bracket key to turn the image clockwise or counterclockwise, respectively. (To rotate images in one of Bridge's workspaces, add the ⌘ [Ctrl] key.) To see a list of all the keyboard shortcuts you can use while you're in Review mode, press H while in that mode.

Sorting and Filtering Images

Bridge gives you a lot of flexibility when it comes to viewing images. For example, you can use the Sort menu at the top of the Bridge window (labeled in Figure 22-4, bottom) to arrange them by name, date modified, size, and so on. You can also sort 'em manually: In the Content panel, drag them into any order you want.

Filtering is a quick way to toss the images you've rejected (see the Note on page 916). To do that, click the "Filter items by rating" icon (the star), choose Show Rejected Items Only, and then choose File→"Move to Trash."

The Filter panel (Figure 22-4, top) lets you weed out images by displaying only those that match certain criteria, like a specific star rating. (In most workspaces, this panel lurks near the bottom left of the Bridge window; if you don't see it, choose Window→Filter Panel.) If you didn't use Review mode to rate your images after importing them, you might want to rate them now so you can quickly view the best ones. Rating and sorting is handy if you're a stock photographer: You can give future submissions a 5-star rating and then find 'em quickly using the 5-star filter.

If you applied keywords when importing the files, you can use those keywords to filter your images. To see a list of keywords applied to the files in the folder you're viewing, head to the Filter panel and click the word "Keywords." (If you don't see the Filter panel, just open the Keywords panel instead by choosing Window→Keywords Panel). Click a keyword (it turns bold and a checkmark appears to its left) to make the Content panel display only images with that keyword applied. Nice!

Grouping Images into Collections

Another way to organize images is to put them into folders called *collections*. Bridge lets you create two types of collections:

- **User-defined collections** are ones you make by dragging and dropping images into a special folder. To create this kind of collection, click the Collections panel in the Bridge window's bottom left or choose Window→Collections Panel (if the panel is already open, this command closes it, so you may have to choose it *twice* to spot the panel!). Activate the images you want to include, click the New Collection button (labeled in Figure 22-5, top), and Bridge asks if you want to include the active files in the new collection. Click Yes and Bridge adds your new collection to the Collection panel and highlights its name so you can enter something more meaningful than "New Collection." To add more images, use the Folders or Favorites panel to find the ones you want to include, and then drag 'em onto the collection's brown envelope icon. To remove an image from the collection, make sure you're actually viewing the collection (it'll be highlighted in the Collections panel) and then, in the Content panel, Control-click (right-click) the image and choose Remove From Collection.

- Bridge creates **smart collections** based on criteria you set in the dialog box shown in Figure 22-5 (bottom). Just click the New Smart Collection icon at the bottom of the Collections panel and then enter your criteria. Click Save when you're finished, and Bridge finds all the images that match your requirements.

(If you've told Bridge to look through your *whole* hard drive, this may take a while!) Later, if you import a new image that meets your criteria, Bridge automatically adds it to the collection. Smart collections have blue envelope icons.

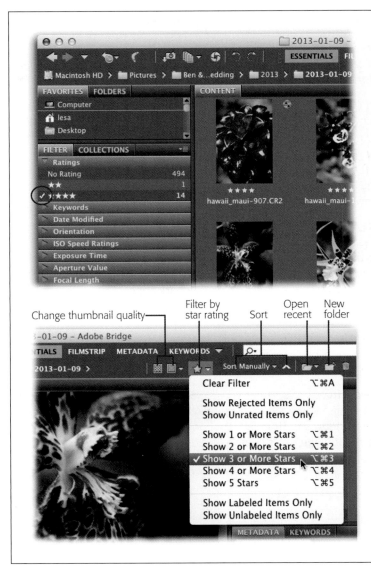

FIGURE 22-4

Top: The Filter panel (Window→Filter Panel) lets you limit the images Bridge displays. For example, if you've rated your images, you can filter your collection by clicking the panel's stars. In this example, Bridge is displaying only 4-star images; just click the star rating you want to see and a little checkmark appears (circled). To view all your images again, press Option-⌘-A (Alt+Ctrl+A on a PC).

To filter images using other criteria like the date they were created or their orientation, click a category in the Filter panel to expand that section, and then click to the left of an item to turn on that particular filter. For example, click Orientation, and then click Landscape or Portrait to place a checkmark next to it.

If you've filtered your images but now want to see 'em all, press ⌘-Option-A (Ctrl+Alt+A) to clear all filters.

Bottom: The star at the top of the Bridge window also lets you filter images. The Sort menu to its right controls the order in which Bridge displays thumbnails. If Bridge is taking a long time to display images as you scroll or after you filter them or perform a search, you can use the square icons labeled here to lower the thumbnails' quality, which makes Bridge display them a little faster.

FIGURE 22-5

Top: Once you create a user-defined collection, you can drag several photos into it at once, as shown here. (You can tell this is a user-defined collection because its envelope icon is brown.)

Bottom: To create a smart collection, use this dialog box to tell Bridge which photos to fetch. The "Look in" menu lets you tell the program where to look, and then you can set criteria by using the menus below it. To add more criteria, click the +.

Once you've made the smart collection, you can go back and tweak your criteria by clicking the Edit Smart Collection icon labeled in the top image here.

You can create a user-defined collection while you're in Review mode by clicking the Create Collection icon labeled back in Figure 22-3.

Grouping Images into Stacks

If you typically use your camera in burst mode (meaning it captures three or more images in rapid succession each time you press the shutter button), you can group those images into *stacks*. This is a great way to organize similar images and simplify what you see in Bridge's Content panel. For example, instead of scrolling past *several* versions of the same image, you see a single stack instead, as shown in Figure 22-6.

To create a stack, activate the images by Shift- or ⌘-clicking (Ctrl-clicking) them, and then choose Stacks→"Group as Stack" or press ⌘-G (Ctrl+G). You can then expand the stack by choosing Stacks→Open Stack, and Bridge displays the images as individual thumbnails (to close the stack, choose Stacks→Close Stack). If you ever want to *free* images from a stack, click the stack to activate it and then choose

Stack→"Ungroup from Stack" or press Shift-⌘-G (Shift+Ctrl+G). To change the image at the top of a stack (think of it as *representative* of what the stack contains), expand the stack, click the image you want to appear at the top, and then choose Stacks→"Promote to Top of Stack."

FIGURE 22-6

Top: Photoshop automatically creates image stacks when you stitch photos together into a panorama or a High Dynamic Range image, but you can create 'em manually, too. Bridge even lets you know how many images are in a stack by displaying a number at the top-left corner of each one, as shown here.

Bottom: To see all the images in a stack, put your cursor over it and a little triangular Play icon appears (you may need to increase the thumbnail size to see it). Give the icon a click and Bridge slowly displays the images in the world's tiniest slideshow (the icon turns into a pause icon, as shown here). To speed up the playback rate, choose Stacks→Frame Rate, and then choose a larger value from the list.

Opening Images in Camera Raw

One of the many benefits of organizing and browsing images in Bridge is that it gives you easy access to the Camera Raw plug-in. In fact, Bridge offers *several* ways to open images in Camera Raw:

- Double-click a raw file in the Content panel.

- Activate an image in the Content panel and then press ⌘-R (Ctrl+R). This method lets you open raw files, JPEGs, *and* TIFFs in Camera Raw.

- Activate an image in the Content panel and then choose File→"Open in Camera Raw."

- Control-click (right-click) the image in the Content panel and then choose "Open in Camera Raw."

- Activate an image in the Content panel and then click the camera-iris icon at the top of the window (next to the Refine icon).

Once you've edited an image in Camera Raw, a microscopic icon representing the edits you made appears next to the image's preview in Bridge's Content panel (see Figure 22-7). If you've got several images that need the same edits, you can copy the changes and apply them to others right in Bridge. Just Control-click (right-click) the image in the Content panel and then choose Develop Settings→Copy Settings. Then activate the images you want to apply the edits to, Control-click (right-click) one of them, choose Develop Settings→Paste Settings, and Bridge applies those same edits to the active images. Now that's working *smarter* rather than harder!

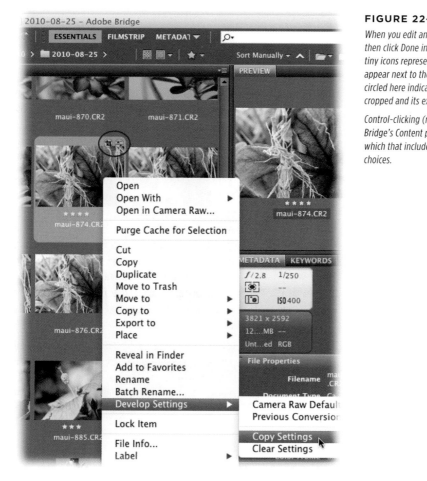

FIGURE 22-7

When you edit an image in Camera Raw and then click Done in the Camera Raw window, tiny icons representing the edits you made appear next to the image in Bridge. The icons circled here indicate that this image was cropped and its exposure was changed.

Control-clicking (right-clicking) an image in Bridge's Content panel brings up this menu, which that includes all kinds of timesaving choices.

Renaming Multiple Files

If you forgot to rename your photos when you imported them or if you'd like to rename other files on your hard drive, you don't have to change their names one at a time—that would take *weeks*. Happily, Bridge can rename entire folders of images for you by using a simple process called *batch renaming*. To get started, press Shift-⌘-R (Shift+Ctrl+R) or click to the Refine icon at the top of the Bridge window (it looks like a stack of paper) and choose Batch Rename (you need to have a least one image active in Bridge's Content panel, or else the command is dimmed).

In the resulting dialog box's Destination Folder section, tell Bridge whether you want to rename the images without moving them, or move or copy them to a different folder. The New Filenames section includes several options for customizing the files' names. Click one of the fields on the left side of this section to see the following options:

- **Text**. Choose this option to replace the filename with something more meaningful. For example, if you shot a series of photos at Photoshop World, you could use PSW for your filename—short and sweet!

- **New Extension** adds whatever you enter in this field to the *end* of the images' names, replacing the original extension. Beware, though: Changing a file's extension or adding a new extension to a file's name doesn't change the file's format, so your computer may not know what kind of file it is in order to open it if, for example, you add a .tif extension to the end of a .jpg file's name.

- **Current Filename** tells Bridge to keeps the filename that's already assigned to each image and add your other custom name changes to it (such as changing it to upper- or lowercase).

- **Preserved Filename** tells Bridge to keep the original metadata filename—the cryptic one assigned by your camera that tags along with your image—as part of the new filename.

- **Sequence Number** adds a unique number to each image's name. You pick the starting number, and Bridge counts up by one for each file it renames.

- **Sequence Letter** works just like Sequence Number, but it adds a unique *letter* to each filename instead.

- **Date Time** adds a date and time stamp to each filename.

- **Metadata** lets you include metadata in each filename. You can choose from several pieces of info that your camera embedded in your image files.

- **Folder Name** includes the name of the folder the images are in as part of the new filename.

- **String Substitution** lets you tell Bridge to find an element in the old filename (a piece of text, for example) and replace it with something else.

You can add and remove items from the New Filenames section by clicking the + or – to the right of each one. Be sure to remove items you don't plan on using so Bridge doesn't include info you don't want.

In the Options section, turn on "Preserve current filename in XMP Metadata" to leave the current filename that's stored in the file's metadata (in case you ever need to go back to it). And if there's a chance your renamed images will end up on different computer platforms, be sure to turn the Compatibility checkboxes for the appropriate operating systems. For example, if you use a Mac but your client uses PCs and Unix computers, turn on the Windows and Unix checkboxes.

At the bottom of the dialog box, Bridge displays an example of what your files *are* named and what they *will* be named. (If you think you'll use these settings again in the future, save 'em as a Preset by clicking the Save button in the Presets section.) If everything looks good, take a deep breath, click Rename, and Bridge makes your changes in the blink of an eye.

▉ Showing Off Your Work

Bridge CC includes a nifty slideshow generator that lets you quickly display your work onscreen. Bridge CS6 had even *more* features for showing off your work, including the now deceased Output panel for creating PDFs and Web galleries and the equally dead Export panel for automating the process of uploading photos to popular websites (such as Facebook, Flickr, and Photoshop.com) as well as creating JPEG versions of raw files (though the latter can be done using the Image Processor Script described on page 268).

This section teaches you how to create spectacular slideshows. And if you kept Bridge CS6 on your machine, you'll also learn how to use the now-missing features mentioned above. Read on!

> **NOTE** As mentioned earlier, you can download and install the Adobe Output Module by visiting *www.lesa. in/aomforbcc*.

Making a Slideshow

If you need to show your work to someone, you can quickly filter for your top-rated images (flip back to Figure 22-4) and then have Bridge play them as a full-screen slideshow. Here's how:

- **To start an instant slideshow,** activate a folder or several images by Shift- or ⌘-clicking (Ctrl-clicking) them, and then choose View→Slideshow or press ⌘-L (Ctrl+L). That's it! Your photos immediately appear onscreen, one after the other (each one stays onscreen for 5 seconds). To exit the slideshow, press Esc.

- **To customize the slideshow's settings first,** choose View→Slideshow Options or press Shift-⌘-L (Shift+Ctrl+L). In the resulting dialog box, you can make the slideshow repeat, control how many seconds each image stays onscreen, resize the slideshow window to fit your monitor, and add transitions between slides (see Figure 22-8). The only thing you *can't* do here is add music—but you can always open iTunes and play music in the background. When the settings are the way you want, click Play to start the show.

Bridge CS6's Export Panel

If you're using Bridge *CS6* and you like posting images on social-networking and photo-sharing websites such as Facebook, Flickr, and Photoshop.com, the Export panel can help you out. (Alas, this panel isn't included in Bridge CC.) It's also handy for converting a slew of images to JPEGs. The export process takes a few steps, but once you get things set up properly, it goes quite quickly.

Open the Export panel by clicking its tab at the bottom left of the Bridge CS6 window (if you don't see it and you're sure you're using Bridge *CS6*, choose Window→Export Panel). This panel includes icons for uploading photos to Facebook, Flickr, and Photoshop.com. If that's what you want to do, double-click the appropriate icon

(for example, Flickr). The first time you do this, you'll then need to double-click the Flickr icon and enter your account info in the resulting dialog box. This same dialog box also lets you choose which album to put the images into, as well as *whether* and *how* you want 'em resized. Click Save, and Bridge CS6 displays a status bar showing you the upload's progress.

FIGURE 22-8

By adding a transition and making sure the Zoom Back And Forth setting is turned on (which makes Bridge zoom in and then back out of each image), you can create a pretty slick slideshow in no time flat. This is a great way to assess your images.

To make a slideshow you can export, use the PDF option explained in the next section or the PDF Presentation option covered on page 761.

To create JPEGs from raw files, click the Export panel's "Save to Hard Drive" icon and then click the + at the bottom of the panel to add a new preset (set of instructions). In the resulting dialog box's Destination tab (Figure 22-9, top), pick the folder where you want the exported images to land. Then click the Image Options tab and let Bridge CS6 know whether you'd like it to make the images smaller and/or reduce their quality (both great for images you want to post on the Web; not so much if you plan to send the JPEGs to a stock-image site). At the bottom of the dialog box, enter a meaningful name for the preset, click Save, and Bridge CS6 adds a new hard drive icon with that name to the Export panel, as shown in Figure 22-9 (bottom).

Exporting Images from Bridge CS6 as PDFs

PDFs are really handy because you can open them on any kind of computer without having to buy any software. Bridge CS6 has a few templates you can use to create PDFs, and a slew of settings for customizing exactly how they look. You can even

add watermarks to individual images in your PDFs, instead of one watermark per
PDF page.

FIGURE 22-9

*Top: If you're a stock pho-
tographer, you can use
Bridge CS6's Export panel
to create high-quality
JPEGs from raw files so
you can submit them to
your favorite stock image
service, such as Fotolia.
com or iStockphoto.com.*

*Bottom: Once you've
created a preset, you
can drag images onto its
icon on the Export panel
(left) and Bridge CS6 adds
'em to its "to export" list
(right). You can delete
items from the list by
pointing your cursor at
the image's name and
then clicking the tiny X to
its right. When you get
the list just right, click
the upward-pointing
arrow (labeled here) to
the right of the preset to
send the images on their
merry way.*

> **TIP** You can't create PDFs in Bridge CC, but you *can* create a PDF in Photoshop CC by choosing File→
> Automate→PDF Presentation or Contact Sheet II. See page 762 for step-by-step details.

To get started, activate the image(s) you want to export and then click the Output
icon at the top of the Bridge CS6 window (it looks like a piece of paper with a down-
pointing arrow and is labeled in Figure 22-10) and choose "Output to Web or PDF."
The Output panel opens on the right side of the Bridge window.

At the top of the Output panel, make sure the PDF button is active (if not, click it),
and then choose an option from the Template menu. To see a preview of the tem-
plate you picked, click Refresh Preview. The Output Preview panel appears in the

center of the Bridge CS6 window (circled in Figure 22-10). Bridge CS6 offers some nice templates to choose from, though you can always customize them using the Output panel's various settings (use the scroll bar on the panel's right side to see all the settings—there are a ton of 'em).

To make your PDF to run as a slideshow, be sure the Playback options near the bottom of the Output panel are turned on. When everything looks good, click Save at the very bottom of the Output panel and Bridge exports your file as a PDF.

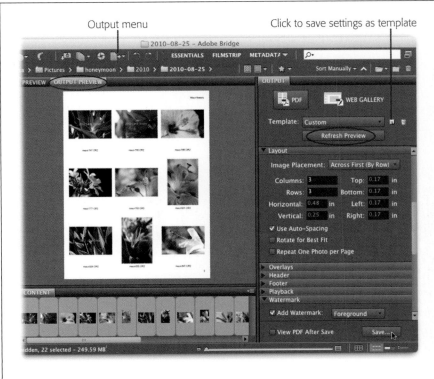

Output menu Click to save settings as template

FIGURE 22-10

The Template menu includes precious few options, but you can add your own. To see what your PDF will look like, click Refresh Preview (circled); the preview appears in the Output Preview panel. As you make changes to the Output panel's gazillion settings, you have to keep clicking Refresh Preview to make Bridge CS6 update the Output Preview panel.

Happily, you can save your custom settings by clicking the icon labeled here, which is a welcome option after you've worked hard to create a PDF template or web gallery style that meets your needs.

Making a Web Gallery

You can also use Bridge CS6 to make a quick online gallery of your images. Heck, it'll even upload the images for you! Flip back to page 924 for the scoop. (This feature was removed in Bridge CC.) That said, if you've got a full subscription to Adobe's Creative Cloud, you can use Photoshop Lightroom to do the same thing...and a lot more to boot!

Appendixes

APPENDIX A:
Installing Photoshop

APPENDIX B:
Troubleshooting and Getting Help

APPENDIX C:
Photoshop's Tools Panel

APPENDIX D:
Photoshop Menu by Menu

NOTE For all appendixes, see *www.missingmanuals.com/cds*.

Index

Photoshop CC

THE MISSING CD

There's no CD with this book; you just saved $5.00.

Instead, every single Web address, practice file, and piece of downloadable software mentioned in this book is available at *missingmanuals.com* (click the Missing CD icon). There you'll find a tidy list of links, organized by chapter.

Don't miss a thing!
Sign up for the free Missing Manual email announcement list at missingmanuals.com. We'll let you know when we release new titles, make free sample chapters available, and update the features and articles on the Missing Manual website.